2003
ARTIST'S & GRAPHIC DESIGNER'S MARKET

2,100 PLACES TO SELL YOUR ILLUSTRATIONS, FINE ART, GRAPHIC DESIGNS & CARTOONS

EDITED BY **MARY COX**

ASSISTED BY **CANDI S. CROSS**

WRITER'S DIGEST BOOKS
CINCINNATI, OH

If you are an editor, art director, creative director, art publisher or gallery director and would like to be considered for a listing in the next edition of *Artist's & Graphic Designer's Market*, send your request for a questionnaire to *Artist's & Graphic Designer's Market*—QR, 4700 East Galbraith Road, Cincinnati OH 45236, or e-mail artdesign@fwpubs.com.

Supervisory Editor, Annuals Department: Alice Pope
Editorial Director, Annuals Department: Barbara Kuroff

Writer's Market website: http://www.WritersMarket.com
Writer's Digest Books website: http://www.WritersDigest.com

International Standard Serial Number 1075-0894
International Standard Book Number 1-58297-122-6

Cover illustration © Kevin OShea/Illustration Works, Inc.

Attention Booksellers: This is an annual directory of F&W Publications. Return deadline for this edition is December 31, 2003.

contents at a glance

From the Editor 1

Quick-Start Guide to Selling Your Work 2

Articles 6-47

The Markets

Greeting Cards, Gifts & Products 48

Magazines 104

Posters & Prints 238

Book Publishers 282

Galleries 364

Syndicates & Cartoon Features 507

Stock Illustration & Clip Art Firms 517

Advertising, Design & Related Markets 523

Record Labels 608

Resources

Artists' Reps 637

Websites for Artists 659

Glossary 661

Indexes 663

Contents

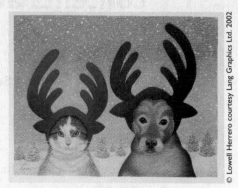

1 From the Editor
A Career Strategy You Can Live With

2 Quick-Start Guide to Selling Your Work
How to use this book to launch or advance your artistic career.

6 Andy Cowles: Communicating the Vision at *Rolling Stone*
A top art director reveals what he looks for in illustration.

Page 80

10 Promoting Your Work Through Direct Mail
How to create successful samples that get results.

19 Diary of a Career by Steven Verriest
Our intrepid artist returns with an update on his illustrious career.

22 Growing Your Business: Simple Systems for Staying on Track
A daily record-keeping system, postage pointers and tax tips.

30 Crash Course in Copyright
Knowledge of copyright helps you protect your artwork and negotiate higher fees.

34 Color Trends and the New Shade of Marketing by Candi Lace
International color expert Leatrice Eiseman tells how strategic use of color can boost your sales.

36 When Gruesome is Good: Your Complete Horror Roundtable
by Candi Lace
Publishers and artists dissect the gory details of a chilling niche.

43 From Psychedelic Sixties to Shabby Chic: Trend-tracking Boosts Sales by Linda Butler
Discover the trends art buyers look for in today's market.

46 *Artist's & Graphic Designer's Market* Reader Survey

THE MARKETS

48 Greeting Cards, Gift & Products

> *insider* report
>> 78 **Yvonne Groenevelt**, Product Development, The Lang Companies
>> Capturing card company's "look" is key to winning assignments.

104 Magazines

238 Posters & Prints

282 Book Publishers

364 Galleries

507 Syndicates & Cartoon Features

> *insider* report
>> 512 **Michael Jantze**, syndicated cartoonist
>> Cartoonist finds his voice and a path to syndication success.

517 Stock Illustration & Clip Art Firms

523 Advertising, Design & Related Markets

> *insider* report
>> 525 **J.P. Collins**, graphic designer
>> The benefits of collaborative design—Pylon Studios exposed.

608 Record Labels

RESOURCES

637 Artists' Reps

659 The Internet as Your All-purpose Bulletin: Websites for Artists

661 Glossary

663 Niche Marketing Index

670 General Index

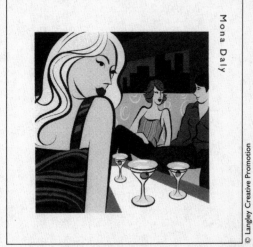

Mona Daly

© Langley Creative Promotion

Page 637

From the Editor

A Career Strategy You Can Live With

Joseph Campbell's advice, "follow your bliss" is often quoted in books, articles and commencement speeches. But does it really work?

Recently I spoke with an artist who would have made Mr. Campbell smile. After many twists and turns in his career, this artist told me he finally sat down and took inventory of his strengths and weaknesses. He asked himself, "What am I good at besides art? What do I like to do? How can I leverage that to help me promote my work?"

He realized that for some unknown reason he was very comfortable speaking in front of groups (something most people dread, but that he took for granted). He noted, too, that he liked to travel. He set about incorporating those factors into a strategy. He would continue submitting his work to galleries, but he would also travel several times a year to talk to college art classes about his work. As he lived his plan, not only did he enjoy himself more, but his career took off. Visiting schools turned out to be just the networking opportunity he needed, yielding more connections than he expected.

This artist's plan might not work as well for you or me. Not all of us have the freedom to travel, or are comfortable with public speaking. For this Joseph Campbell thing to work, each of us has to devise our own strategy based on our own individual strengths and interests, and just as important, what makes each of us happy.

Here's a way to start devising your blissful strategy. Take a piece of paper and list your strengths and interests, along with your likes and dislikes. Let that list be your guide as you choose fine art projects, illustration niches and potential clients. The articles and listings in this book will spark plenty of ideas. For instance, are you a great organizer who enjoys networking? Read how Steven Verriest organized a group mailing for fellow freelancers (page 19). Do you love reading horror novels? There's an entire niche waiting for you on pages 36-42. If you're a fan of pop culture, follow the example of Dominick Tucci (page 16) and specialize in portraying today's celebrities.

Your strategy doesn't have to be "all art all the time" either. One artist wouldn't dream of leaving her fascinating part-time job in a top legal firm because she's always been interested law. Another illustrator art directs for a monthly magazine in addition to freelancing. She loves the work and the steady paycheck it provides. She's also become a better freelancer because she knows first hand what art directors want.

David Holmes, whose work is featured on page 174, escorts tourists to Europe every spring, showing them an artist's view of Paris and Dublin. Not only does he get expenses paid, but he gets a lot of sketching done and even found his medium of choice while sketching in an Irish pub—graphite pencil with a Guinness wash.

So bottom line, you may never get filthy rich following your bliss, but you'll do fairly well and you'll have a smile on your face!

Have a great year creating and marketing your work!

Mary Cox

Mary Cox
artdesign@fwpubs.com

Quick-Start Guide to Selling Your Work

This article is written for artists who have never used this book before. It's one of several articles to help you submit your work to listings. Every article is important—especially for first-time users of *AGDM*—so don't just skip to the listings. There's a lot to learn (like how to prepare your promotional samples) before you'll be ready.

What you'll find in this book

In focus groups artists have told us *Artist's & Graphic Designer's Market* can be overwhelming at first. Don't worry, it's really not that difficult to navigate. Here's how.

The book is divided into five parts:
1. Business and marketing articles
2. Section introductions
3. Listings of companies and galleries
4. Insider Reports
5. Indexes

Section "intros" and listings: the heart of this book

Beyond this section, the book is further divided into 11 market sections, from Greeting Card companies to Record Labels (See Table of Contents for complete list). Each section begins with an introduction with tips and marketing advice to help you break in.

Listings are the life's blood of this book. In a nutshell listings are names, addresses and contact information of places that buy or commission artwork, along with a description of the type of art they need.

What are Insider Reports?

Insider Reports are interviews with artists and experts from the art world. "Insiders," as we call them, give you a richer understanding of the marketplace. Reading them gives you an important edge over artists who skip them. Insider Reports are listed in the Table of Contents under "Markets."

HOW *AGDM* "WORKS"

Following the instructions in the listings, we suggest you send to a dozen (or more) targeted listings. The more listings you send to, the greater your chances.

In the meantime, join an artist's group so you can network with your peers and learn more about your profession.

How to read listings

Each listing contains a description of the artwork and/or services it prefers. The information often reveals how much freelance material they use, whether computer skills are needed, and which software programs are preferred.

In some sections, additional subheads help you identify potential markets. Magazine listings specify needs for cartoons and illustrations. Galleries specify media and style.

Editorial comments, denoted by bullets (•), give you extra information about markets, such

as company awards, mergers and insight into a listing's staff or procedures.

It takes a while to get accustomed to the layout and language in the listings. In the beginning, you will encounter some terms and symbols that might be unfamiliar to you. Refer to the Glossary on page 661 to help you with terms you don't understand.

Listings are often preceded by symbols, which help lead the way to new listings ▣ , changes ✔ and other information. When you encounter these symbols, refer to the inside flap of the book for a complete list of their meanings.

Working with listings

1. **Read the entire listing to decide whether to submit your samples!** Do NOT use this book simply as a mailing list of names and addresses. Reading listings helps you narrow your mailing list and send the kind of submissions those listed here want.

2. **Read the description of the company or gallery in the first paragraph of the listing.** Then jump to the **Needs** heading to find out what type of artwork the listing prefers. Is it the type of artwork you create? This is the first step to narrowing your target market. You should only send your samples to listings that need the kind of work you create.

3. **Send appropriate submissions.** It seems like common sense to find out what kind of samples a listing wants before sending off just any artwork you have on hand. But believe it or not, some artists skip this step. Many art directors have pulled their listings due to artists sending inappropriate submissions.

 What's an inappropriate submission? I'll give you an example. Suppose you want to be a children's book illustrator. Don't send your sample of puppies and kittens to *Business Law Today* magazine. They would rather see related law subjects. If you don't like to draw legal subjects, skip to listings that take children's illustrations instead using our indexes to help you find them. You'd be surprised how many illustrators waste their postage sending the wrong samples. And boy, does that alienate art directors. Make sure all your mailings are *appropriate* ones.

4. **Consider your competition.** Under the **Needs** heading, compare the number of freelancers who contact the listing with the number they actually work with. This gives you an instant snapshot of your competition. You'll have a better chance sending your samples to listings that use a lot of artwork or work with many artists.

5. **Check preferred contact**. Look under the **First Contact & Terms** heading to find out how to contact the listing. Some companies and publishers are very picky about what kind of samples they like to see; others are more flexible.

6. **Look for what they pay.** In most sections, you can find this information in the next-to-last sentence under **First Contact & Terms**. Magazines and book publishers list pay rates under headings pertaining to the type of work you do, such as **Illustration**, **Cartoons** or **Book Design**.

 At first, try not to be too picky about how much a listing pays. You need experience (and tearsheets!— see **Glossary**, page 661 if you don't know what a tearsheet is). After you have a couple of assignments under your belt, you might decide to only send samples to medium- or high-paying markets.

 Some art directors are not willing to share pay rates with us. If the pay rate is not stated, other clues within the listing can help you determine what they probably pay. If a magazine does not state rates, compare its circulation to one with a similar circulation figure to see what it probably pays. In book publishers, check to see how many books they publish a year. If they publish 100 books a year, they will undoubtedly pay more than those who publish one or two books a year.

7. **Be sure to read the "tips!"** Artists say the information within the **Tips** helps them get a feel for what a company might be like to work for.

8. **We provide 20 categories of artwork in the Niche Marketing Index beginning on page**

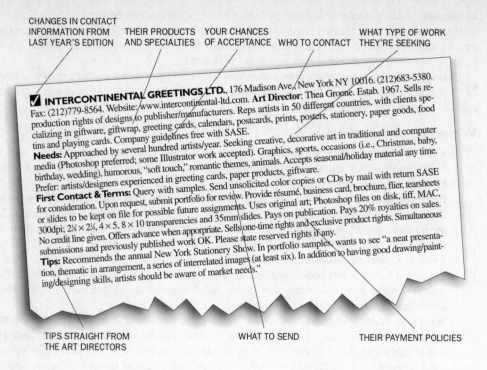

CHANGES IN CONTACT INFORMATION FROM LAST YEAR'S EDITION

THEIR PRODUCTS AND SPECIALTIES

YOUR CHANCES OF ACCEPTANCE

WHO TO CONTACT

WHAT TYPE OF WORK THEY'RE SEEKING

☑ **INTERCONTINENTAL GREETINGS LTD.**, 176 Madison Ave., New York NY 10016. (212)683-5380. Fax: (212)779-8564. Website: www.intercontinental-ltd.com. **Art Director**: Thea Groene. Estab. 1967. Sells reproduction rights of designs to publisher/manufacturers. Reps artists in 50 different countries, with clients specializing in giftware, giftwrap, greeting cards, calendars, postcards, prints, posters, stationery, paper goods, food tins and playing cards. Company guidelines free with SASE.
Needs: Approached by several hundred artists/year. Seeking creative, decorative art in traditional and computer media (Photoshop preferred; some Illustrator work accepted). Graphics, sports, occasions (i.e., Christmas, baby, birthday, wedding), humorous, "soft touch," romantic themes, animals. Accepts seasonal/holiday material any time. Prefer: artists/designers experienced in greeting cards, paper products, giftware.
First Contact & Terms: Query with samples. Send unsolicited color copies or CDs by mail with return SASE for consideration. Upon request, submit portfolio for review. Provide résumé, business card, brochure, flier, tearsheets or slides to be kept on file for possible future assignments. Uses original art; Photoshop files on disk, tiff, MAC, 300dpi; 2¼ × 2¼, 4 × 5, 8 × 10 transparencies and 35mm slides. Pays on publication. Pays 20% royalties on sales. No credit line given. Offers advance when appropriate. Sells one-time rights and exclusive product rights. Simultaneous submissions and previously published work OK. Please state reserved rights if any.
Tips: Recommends the annual New York Stationery Show. In portfolio samples, wants to see "a neat presentation, thematic in arrangement, a series of interrelated images (at least six). In addition to having good drawing/painting/designing skills, artists should be aware of market needs."

TIPS STRAIGHT FROM THE ART DIRECTORS

WHAT TO SEND

THEIR PAYMENT POLICIES

663. These categories will help you narrow your search for markets seeking specific styles and genres. They'll lead you to listings looking for Calendars; Calligraphy; Children's Books; and much more.

These steps are just the beginning. As you become more advanced in reading listings, you will think of more ways to mine this book for your best clients. Some of our readers tell us they peruse listings to find the speed at which a magazine pays its freelancers. In publishing, it's often a long wait until an edition or book is actually published, but if you are paid on "acceptance" you'll get a check reasonably quick.

When looking for galleries, savvy artists often check to see how many square feet of space is available and what hours the gallery is open. These details all factor in when narrowing down your search for target markets.

Pay attention to copyright information

It's also important to consider what **rights** listings buy. It is preferable to work with listings that buy first or one-time rights. If you see a listing that buys "all rights," be aware you may be giving up the right to sell that particular artwork in the future.

Look for specialties and niche markets

In the Advertising, Design and Related Markets section, we tell what kind of clients an ad agency has. If you hope to design restaurant menus, for example, you can target agencies that have restaurants for clients. But if you don't like to draw food-related illustration and prefer illustrating people, you might target ad agencies whose clients are hospitals or financial institutions. If you like to draw cars, you should look for agencies with clients in the automotive industry, and so on. Many book publishers specialize, too. Look for a publisher who specializes

in children's books if that's the type of work you'd like to do. The Niche Marketing Index on page 663 lists possible opportunities for specialization.

Read listings for ideas

You'd be surprised how many artists found new niches they hadn't thought of by browsing the listings. One greeting card artist read about a company that produces mugs. A lightbulb went off. Now this artist has added mugs to her repertoire, along with paper plates, figurines and rubber stamps—all because she browsed the listings for ideas!

Sending out samples

Once you narrow down some target markets, the next step is sending them samples of your work. As you create your samples and submission packets, be aware your package or postcard has to look professional. It must be up to the standards art directors and gallery dealers expect. Use the worksheets in this section to schedule time to plan your sample. Be sure to look at the samples sent out by other artists on pages 10, 11 and 12. Make sure your samples rise to that standard of professionalism.

New year, new listings

Use this book for one year. Highlight listings, make notes in the margins, fill it full of Post-it notes. In September of the year 2003, our next edition—the 2004 *Artist's & Graphic Designer's Market*—starts arriving in bookstores. By then, we'll have collected hundreds of new listings and changes in contact information. It is a career investment to buy the new edition every year. (And it's deductible! See page 26.) If you buy it every other year, as many artists do, you will be missing a lot of new listings and changes.

Becoming a professional

The most important information in this book isn't the listings. Artists who have the most success using this book are those who take the time to read the articles and Insider Reports to learn about the bigger picture. In our Insider Reports, you'll learn what has worked for other artists and what kind of work impresses art directors and gallery dealers.

You'll find out how joining professional organizations such as the **Graphic Artists Guild (G.A.G.)** or the **American Institute of Graphic Arts (AIGA)** can jump start your career. You'll find out the importance of reading trade magazines such as *HOW*, *Communication Arts* and *Greetings etc.* to learn more about the industries you hope to approach. You'll learn about trade shows, portfolio days, websites, art reps, shipping, billing, working with vendors, networking, self-promotion and hundreds of other details it would take years to find out about on your own. Perhaps most importantly, you'll read about how successful artists overcame rejection through persistence.

Being professional doesn't happen overnight. It's a gradual process. I would venture to say that only after two or three years of using each successive year's edition of this book will you have garnered enough information and experience to be a true professional in your field. So if you really want to be a professional artist, hang in there. Before long, you'll feel that heady feeling that comes from selling your work or seeing your illustrations on a greeting card or in a magazine. If you really want it and you're willing to work for it, it *will* happen.

Andy Cowles: Communicating the Vision at *Rolling Stone*

BY MARY COX

In the early part of 2002, the publishing world was astonished to notice an unexpected change in the masthead of one of the world's most talked about titles—a magazine regularly touted in the pages of *HOW*, *Print* and *Communication Arts*. Everyone knows there's a fairly high turnover rate in magazine design—but nobody expected famed art director Fred Woodward to leave *Rolling Stone* after nearly fourteen years.

When Woodward left *Rolling Stone* for *GQ*, everyone wondered who could replace him at the helm of a magazine known for its cutting-edge layouts, artsy photography and quirky illustrations—that is until Andy Cowles stepped up to the plate. A publishing phenomenon in his own right, although perhaps better known in the UK, Cowles has art-directed or consulted on no less than forty magazines on both sides of the Atlantic, including *Mademoiselle*, *Sky*, *Q* and *Mojo*.

Cowles is the first to say it hasn't been easy replacing a legend like Woodward. But the veteran art director has been quietly making his mark on the famed magazine, carrying forth much of what Woodward started and adding his own intellect, creativity and humor to the mix. Already, illustrators give him high marks for offering them great suggestions and creative freedom on dream assignments for the award-winning magazine.

We caught up with Cowles as he was working on the layout for *Rolling Stone*'s annual "What's Cool" edition.

How does it feel walking into a situation where you're replacing someone like Fred Woodward, an art director whose name is so synonymous with *Rolling Stone*?

It was difficult at first. Every magazine has its own history, its own culture, its own legends. Fred had been here a long time. He left a tremendous heritage. But at the same time I have to realize—and somehow convey—that I'm not Fred. Fred is Fred. I'm me. I wouldn't seek to fill his shoes. I wear different shoes.

Why do you think they chose you for the job?

There was a certain familiarity with my work. And I think they obviously liked what I did on *Q* and *Mojo*, and perhaps wanted to bring that sort of European sensibility to what was already there. Every art director dreams of working for a magazine like *Rolling Stone*. I was very fortunate in that I had the right background and then happened to be in the right place at the right time. I just want to represent the magazine in the best way possible to its readership—to communicate the vision of the magazine.

They don't teach you how to be an art director in school. What's your philosophy on art directing for *Rolling Stone*, or for any magazine?

You sort of learn it on the job. The whole point of being an art director is—very simply—that a magazine has a certain need. My job as art director is to fill that need. Every magazine has a unique vision, a point of view, based on its audience. By audience I mean a very tightly-defined

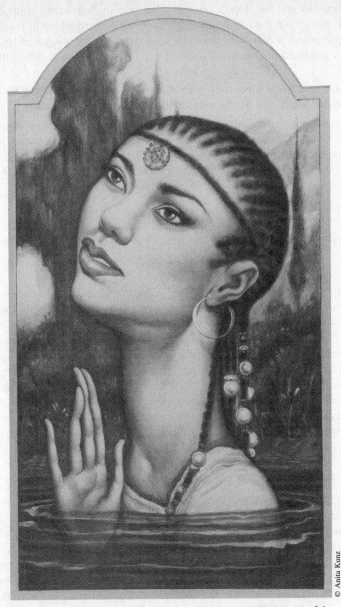

© Anita Kunz

Andy Cowles commissioned illustrator Anita Kunz to paint this portrait of the popular recording artist Alicia Keys. Cowles discussed the style of the portrait with Kunz ahead of time, suggesting she portray Keys's timeless beauty.

group of people. The art director makes choices on how to present the content appropriately to that group. That's the trick to being an art director. That's the expertise.

How would you describe the *Rolling Stone* audience? *RS* seems to appeal to a wide group of people—from young musicians to Baby Boomers.

Well, that's true. It is a large group of people so it is very challenging in that way to appeal to so many different types. The content ranges from long thoughtful political pieces, to regular

interviews with artists and then lots of reviews. You have to look for the common denominator in all of that. The common denominator really is above all else the love of music, isn't it? And a certain curiosity about pop culture. So everything we put in the magazine has to reflect that. Everything. The photography has to reflect that. The illustration has to reflect that. Everything.

How do you choose your freelance illustrators? Does an emerging illustrator stand a chance to work with you or do you only hire famous illustrators?

Of course someone just starting out could get commissioned to do an illustration for us. That's not far-fetched. Although we are familiar with all of the well-know illustrators and tend to hire them. But we look at everything. I use *American Illustration* when I have a certain style in mind. We also look at the postcard promotional samples illustrators send in. In the end, the people we choose will be the most appropriate for the job at hand.

OK, give us your idea of the ideal freelancer?

To be available, and to hand the work in on time. And secondly, work to the brief.

The brief?

This is basically a ten-minute phone call where I discuss with the artist the point of view we need for the particular illustration. You see, every illustration appearing in *Rolling Stone* (or any magazine I would art direct) has to have a point of view—the point of view of the article to be illustrated and the point of view of the magazine, naturally. So in that ten-minute phone call, I try to convey what I'm thinking about for the point of view. For example, I might say "I want this illustration to look very rough—very raw." A good illustrator will know what I mean. Often the illustrator will respond with some ideas of his or her own during the conversation and it becomes a collaboration. The artist has a tremendous amount of freedom within the parameters, but in the end there must always shine through a certain "attitude" we've discussed in advance. It's portraying where that recording artist or band is at this moment in time—at this instance in their careers.

Can you give examples of how this works?

When we wanted a portrait of Alanis Morissette to accompany the review for *Under Rug Swept*, we asked illustrator Michelle Chang to paint Alanis looking very sort of "New Agey" because the review talked about the fact that Alanis's lyrics on the CD were very involved with self-inquiry. You see?

My responsibility, along with other members of *Rolling Stone*'s art department, is very much about identifying what style will be appropriate for the layout and then finding the artist or photographer who works in that style and communicating the "feel" we want them to capture.

For the portrait of Alicia Keys, our idea was to convey her sort of timeless beauty. We contacted Anita Kunz because Anita's work is very beautiful and lush. I briefed Anita on the assignment and asked for a painting of Alicia with a Pre-Raphaelite feel to it. And the portrait turned out beautifully. Right now we are assigning illustrations for a three-part series on Mexican migrant workers. I want the accompanying illustrations to be very painterly and heroic. Every story is different—so every story calls for a different illustration style.

What if the illustrator isn't familiar with the subject?

We give the illustrator reference material to work with. At *Rolling Stone*, when we assign an illustrator to paint or draw a recording artist, we'll send along a folder of reference photographs, album reviews, even a CD to listen to or the recording artist's video.

How do you approach each edition? How do you decide what point of view you want to portray in each layout?

Well I'm very fortunate. There are four of us here who divide things among us. Gail Anderson, senior art director, has been here 14 years and has a tremendous amount of expertise. We also have Deputy Art Director Siung Tjia and Designer Ken DeLago. We all work very closely with Photography Editor Fiona McDonagh and her staff.

What do you love most about your job?

I love the opportunity to work with the world's greatest illustrators and photographers.

What bugs you most about your job?

(Long silence.) I can't think of anything at all.

Promoting Your Work Through Direct Mail

So you're ready to launch your freelance art or gallery career. How do you let people know about your talent? One way is by introducing yourself to them by sending promotional samples. Samples are your most important sales tool so put a lot of thought into what you send. Your ultimate success depends largely on the impression they make.

We divided this article into three sections, so whether you are a fine artist, illustrator or designer, check the appropriate heading for guidelines. Read individual listings and section introductions thoroughly for more specific instructions.

As you read the listings, you'll see the term SASE, short for self-addressed, stamped envelope. Enclose a SASE with your submissions if you want your material returned. If you send postcards or tearsheets, no return envelope is necessary. Many art directors this year specify they only want nonreturnable samples. More and more, busy art directors do not have time to return samples, even with SASEs. So read listings carefully and save stamps!

Illustrators and cartoonists

You will have several choices when submitting to magazines, book publishers and other illustration and cartoon markets. Many freelancers send a cover letter and one or two samples in initial mailings. Others prefer a simple postcard showing their illustrations. Here are a few of your options:

Postcard. Choose one (or more) of your illustrations or cartoons that is representative of your style, then have the image printed on postcards. Have your name, address and phone number printed on the front of the postcard, or in the return address corner. Somewhere on the card should be printed the word "Illustrator" or "Cartoonist." If you use one or two colors you can keep the cost below $200. Art directors like postcards because they are easy to file or tack on a bulletin board. If the art director likes what she sees, she can always call you for more samples.

Promotional sheet. If you want to show more of your work, you can opt for an 8×12 color or black and white photocopy of your work. If you send 8×12 photocopies or tearsheets, do not fold them in thirds. It is more professional to send them flat, not folded, in a 9×12 envelope, along with a typed query letter, preferably on your own professional stationery.

Tearsheets. After you complete assignments, acquire copies of any printed pages on which your illustrations appear. Tearsheets impress art directors because they are proof that you are experienced and have met deadlines on previous projects.

Photographs. Some illustrators have been successful sending photographs, but printed or photocopied samples are preferred by most art directors. It is probably not practical or effective to send slides.

Query or cover letter. A query letter is a nice way to introduce yourself to an art director for the first time. One or two paragraphs stating you are available for freelance work is all you need. Include your phone number, samples or tearsheets. See Dominick Tucci's query letter on page 16.

E-mail submissions. E-mail is another great way to introduce your work to potential clients. When sending e-mails provide a link to your website or attach files of your best work. Humorous illustrators and cartoonists should follow the same guidelines as illustrators when submitting to publishers, greeting card companies, ad agencies and design firms. Professional-looking photo-

copies work well when submitting multiple cartoons to magazines. When submitting to syndicates, refer to the introduction for that section on page 507.

Designers and computer artists

Plan and create your submission package as if it were a paying assignment from a client. Your submission piece should show your skill as a designer. Include one or both of the following:

Cover letter. This is your opportunity to show you can design a beautiful, simple logo or letterhead for your own business card, stationery and envelopes. Have these all-important pieces printed on excellent quality bond paper. Then write a simple cover letter stating your experience and skills.

Sample. Your sample can be a copy of an assignment you have done for another client, or a clever self-promotional piece. Design a great piece to show off your capabilities. For ideas and inspiration, browse through *Fresh Ideas in Promotion 2*, by Betsy Newberry and *Creative Self-Promotion on a Limited Budget*, by Sally Prince Davis (North Light Books).

Stand out from the crowd

You may only have a few seconds to grab art directors' attention as they make their way through the "slush" pile (an industry term for unsolicited submissions). Make yourself stand out in simple, effective ways:

Tie in your query letter with your sample. When sending an initial mailing to a potential client, include a query letter of introduction with your sample. Type it on a great-looking letterhead of your own design. Make your sample tie in with your query letter by repeating a design element from your sample onto your letterhead. List some of your past clients within your letter.

Send artful invoices. After you complete assignments, a well-designed invoice (with one of your illustrations or designs strategically placed on it, of course) will make you look professional and help art directors remember you (and hopefully, think of you for another assignment!)

Follow up with seasonal promotions. Holiday promotions build relationships while reminding past and potential clients of your services. Bob McMahon regularly sends out holiday-themed promo cards. The reverse of the card lists his name, address, phone number and e-mail address, and the sentence "Please visit my website portfolio at www.bobmcmahon.com." McMahon does six postcard mailings a year. He has them printed through www.Americasprinter.com where he orders 2,500 postcards for $130. "I like postcards because art directors tend to tack them up in their cubicles. You never know when they'll get results. Sometimes years later I'll get a phone call from someone I sent a card to."

So get out your calendar now and plan some special promos for one of this year's holidays!

Are portfolios necessary?

You do not need to send a portfolio when you first contact a market. But after buyers see your samples they may want to see more, so have a portfolio ready to show.

Many successful illustrators started their careers by making appointments to show their portfolios. But it is often enough for art directors to see your samples.

Some markets in this book have drop-off policies, accepting portfolios one or two days a week. You will not be present for the review and can pick up the work a few days later, after they've had a chance to look at it. Since things can get lost, include only duplicates that can be insured at a reasonable cost. Only show originals when you can be present for the review. Label your portfolio with your name, address and phone number.

Portfolio pointers

The overall appearance of your portfolio affects your professional presentation. It need not be made of high-grade leather to leave a good impression. Neatness and careful organization are essential whether you are using a three-ring binder or a leather case. The most popular

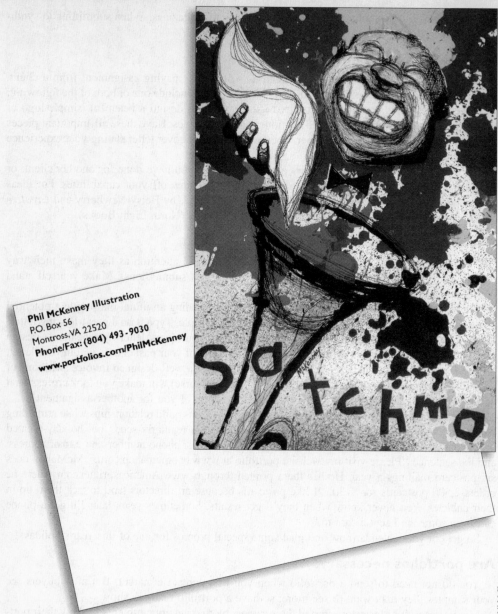

Phil McKenney Illustration
P.O. Box 56
Montross, VA 22520
Phone/Fax: (804) 493-9030
www.portfolios.com/PhilMcKenney

Want a simple and direct way to reach clients? Try sending postcards. Include your name and contact information on the reverse of the card. If you have an e-mail address or website, include those too. When Phil McKenney graduated from Virginia Commonwealth University, he had postcards made of this Satchmo portrait he created in his senior year. He had 300 cards printed through Modern Postcard, (800)959-8365, and mailed them to listings in *Artist's & Graphic Designer's Market*. A year and a half later *American West Airlines* magazine asked to reproduce the piece for $250. Since then several art directors have told him they've kept the postcard pinned up in their offices. McKenney launched his art career in his early forties after twenty years of managing liquor stores for the Virginia ABC board. "For years I had this creative urge inside me that could no longer be denied," says McKenney. So he went back to school as an art major. Today he's a freelance illustrator with a signature style—pen and ink drawings over a splashy background—and he hasn't looked back since.

Bob McMahon's New Year's promos are fun and effective. Lively characters accompanied by bubbly phrases are common in McMahon's direct mail efforts to acquire assignments.

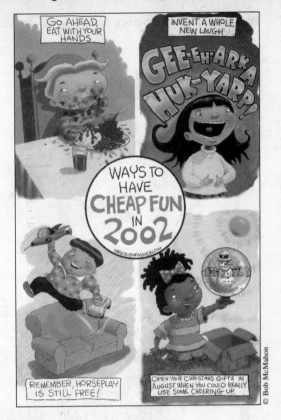

portfolios are simulated leather with puncture-proof sides that allow the inclusion of loose samples. Choose a size that can be handled easily. Avoid the large, "student" size books which are too big to fit easily on an art director's desk. Most artists choose 11×14 or 18×24. If you are a fine artist and your work is too large for a portfolio, bring your slides and a few small samples.

- Don't include everything you've done in your portfolio. Select only your best work and choose pieces germane to the company or gallery you are approaching. If you're showing your book to an ad agency, for example, don't include greeting card illustrations.
- In reviewing portfolios, art directors look for consistency of style and skill. They sometimes like to see work in different stages (roughs, comps and finished pieces) to see the progression of ideas and how you handle certain problems.
- When presenting your portfolio, allow your work to speak for itself. It's best to keep explanations to a minimum and be available for questions if asked. Prepare for the review by taking along notes on each piece. If the buyer asks a question, take the opportunity to talk a little bit about the piece in question. Mention the budget, time frame and any problems you faced and solved. If you are a fine artist, talk about how the piece fits into the evolution of a concept, and how it relates to other pieces you've shown.
- Don't ever walk out of a portfolio review without leaving the buyer a business card or sample to remember you by. A few weeks after your review, follow up by sending a small promo postcard or other sample as a reminder.

GUIDELINES FOR FINE ARTISTS

Send a 9×12 envelope containing material galleries request in their listings. Usually that means a query letter, slides and résumé, but check each listing. Some galleries like to see more.

8½×11 color copies work well as samples

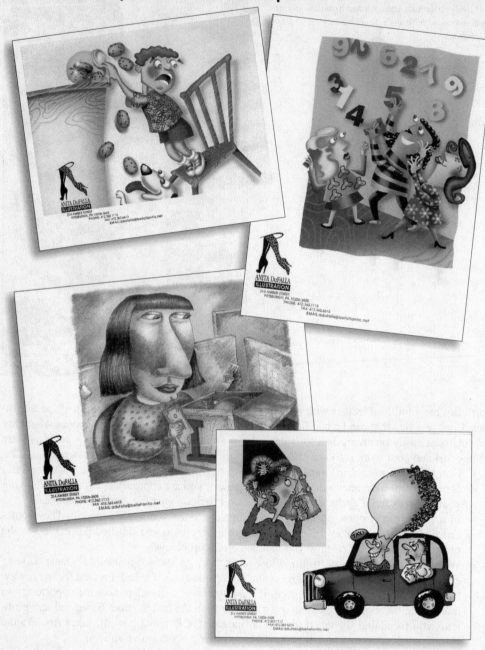

© Anita DuFalla

Anita DuFalla's high-heeled shoe logo does a fine job of projecting a unified image to her rather varied style. DuFalla easily moves between children's illustration and more sophisticated imagery. But when art directors see the legs striding off the page, they know it's DuFalla. DuFalla's samples are clean and bright looking. She makes good use of the space. The page doesn't look busy. It looks roomy, yet it manages to include all her contact information—address, phone, fax, and e-mail. The 8½×11 color copy promo samples are as easy to send as postcards—and some might say, even more effective.

Sourcebook ads double as samples

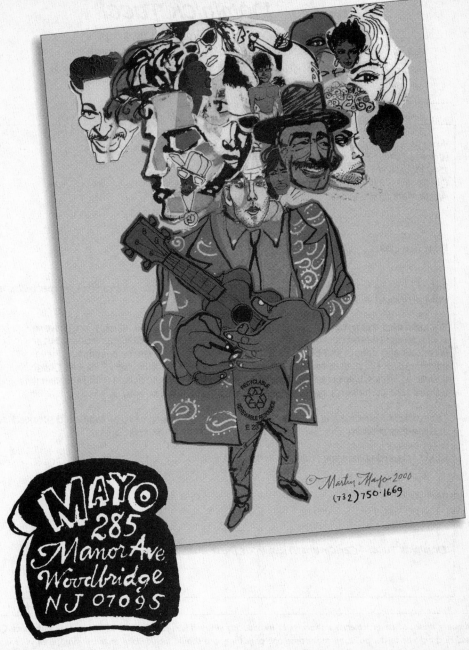

Martin Mayo has created a logo for himself—a piece of bread with "Mayo." Creating that logo was a super strategy for Mayo because it is so memorable and helps art directors associate his name with his memorable art style. This 8½ × 11 sample was actually a bonus as a result of Mayo taking out an ad in *Black Book Illustration 2001*. One of the benefits of taking out sourcebook ads is that you generally receive a thousand copies of the advertisements for your own use—which you can then send out to potential and current clients. They are generally beautifully printed and show off your work to its best advantage. This particular sample was printed in color on a high gloss stock paper. "This promo landed me an illustration assignment—a two page spread—in *The Advocate*," says Martin.

What's a query letter?

Dominick Tucci

Caricature - Humorous Illustration
31 Valley Drive West, Glenwood, NJ 07418
973-764-5583 (phone & fax)
e-mail: caricatuci@aol.com

Artist's & Graphic Designer's Market
Writer's Digest Books
1507 Dana Ave
Cincinnati, OH, 45207
Attn: Mary Cox - Editor

Dear Ms. Cox,

Please allow me to introduce myself, my name is *Dominick Tucci*. I'm an artist who specializes in *caricature* and *humorous illustration*.

Enclosed with this letter are samples of my fun, entertaining style of illustration. I have the ability to manage and coordinate creative development of projects/illustrations with art directors and clients and be successful with meeting all pertinent deadlines. I have illustrated art for such clients as Blah Blah, Yada-Yada-Yada, Mummble-Mummble, Cough, Sneeze & Sniffles, Weezer & Co., Gag, Ho-Hum, and Yawn just to name a few. I feel that my unique style of humorous art *can* and *will* be a great asset to you.

I appreciate your time and consideration in reviewing my samples to be evaluated for possible assignments/projects that may require my unique style of illustration.

I look forward to hearing from you soon.

Best Always,

Dominick Tucci - Caricaturist/Humorous Illustrator

A query letter, or cover letter, is a short letter introducing yourself and your artistic talent to potential clients. Query letters should be to-the-point, no more than one page long, and should include one or more samples of your work. Above, humorous illustrator Dominick Tucci simply describes his abilities and encloses a very creative sample. Notice that he includes his name, address and phone number prominently.

Design a "total look" for your promotion material

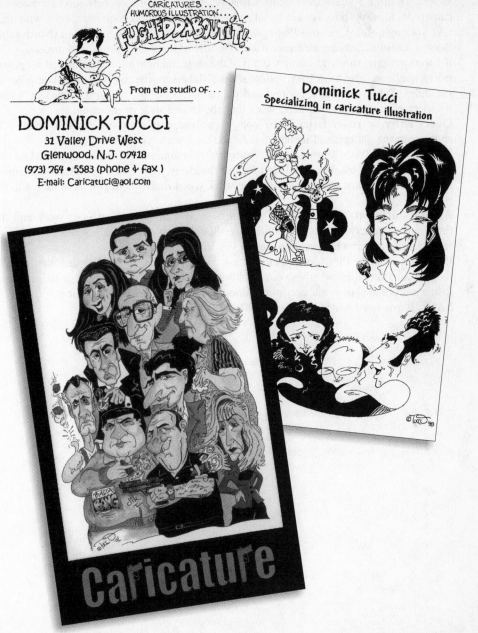

Dominick Tucci wanted to make sure art directors didn't "fugheddabout" his samples. So he designed stationery, envelopes and samples that all tied together to promote his signature caricature style. The artwork he used for his promo packet was based on the HBO blockbuster hit, *The Sopranos*. He even designed his own font for the word "Caricature" at the bottom of his postcard sample. "I wanted the type to keep with the look of the show," says Tucci. The reverse side of each postcard shows a self-portrait of Tucci along with a balloon saying "Fugheddaboutit!" The other sample pictured shows Tucci's flair for capturing the essence of today's celebrities, including Oprah Winfrey, David Letterman and the Seinfeld gang.

Here's an overview of the various components you can include:

- **Slides.** Send 8-12 slides of similar work in a plastic slide sleeve (available at art supply stores). To protect slides from being damaged, insert slide sheets between two pieces of cardboard. Ideally, slides should be taken by a professional photographer, but if you must take your own slides, refer to *Photographing Your Artwork*, by Russell Hart (North Light Books). Label each slide with your name, the title of the work, media, and dimensions of the work and an arrow indicating the top of the slide. Include a list of titles and suggested prices they can refer to as they review slides. Make sure the list is in the same order as the slides. Type your name, address and phone number at the top of the list. Don't send a variety of unrelated work. Send work that shows one style or direction.
- **Query letter or cover letter.** Type one or two paragraphs expressing your interest in showing at the gallery, and include a date and time when you will follow up.
- **Résumé or bio.** Your résumé should concentrate on your art-related experience. List any shows your work has been included in and the dates. A bio is a paragraph describing where you were born, your education, the work you do and where you have shown in the past.
- **Artist's statement.** Some galleries require a short statement about your work and the themes you are exploring. Your statement should show you have a sense of vision. It should also explain what you hope to convey in your work.
- **Portfolios.** Gallery directors sometimes ask to see your portfolio, but they can usually judge from your slides whether your work would be appropriate for their galleries. Never visit a gallery to show your portfolio without first setting up an appointment.
- **SASE.** If you need material back, don't forget to include a SASE.

Diary of a Career

BY STEVEN VERRIEST

Steven Verriest

Regular readers of Artist's & Graphic Designer's Market *might recognize Steven Verriest's face from past editions. We've been running his Diary of a Career Launch entries since 2000. We followed the intrepid artist as he sent out mailings, landed some plum illustration assignments, found a rep, launched a website, and even found some success with gallery sales. No longer a neophyte, Verriest is now a seasoned freelancer with a proven track record. But there's always lots to learn at every stage in an art career. Without further ado, here's his latest entry . . .*

Marketing artwork is an experiment. There's no one way to do it. I believe the more marketing strategies you have on your side, the more exposure you will receive. I'm going into my third year as a full time artist, and I've experienced some ups and downs and continue to learn.

There's power in numbers

I'm always trying to come up with better, less expensive ways to promote my artwork. Through brainstorming with other artists and number crunching, fellow illustrator Scott Bakal and I finally came up with an inexpensive, attention-getting promo. Basically, we divide a very large 8½ × 12 postcard into six sections. Then, six illustrators can include one image each on one extra large postcard. We've sent out a dozen different postcards using this method and have gotten a lot of good results. The huge format of the postcard really grabs the art director's attention. One art director was so impressed she photocopied the postcard and passed copies around the office. These postcards have led to several projects for me and the others involved.

Printing and mailing 1,000 of these postcards costs participants about $100 less than if they sent 1,000 of their own individual postcards. (That includes printing and postage.) Scott and I take care of all the details of printing and mailing the large cards. We pool together our mailing lists to come up with 1,000 names and addresses. Often a participant doesn't have any names and addresses, so we pitch in some extra names for them. The beauty of this project is that once we combine everyone's list into one list of 1,000 names, we then give that list to all the members of the individual group. It's like getting 1,000 free names and addresses.

I've also created another similar group marketing strategy. I put 8½ × 11 tearsheets of eight illustrators into one envelope and mail them. Most participants use the 1,000 tearsheets they got when they advertised in a sourcebook, like *Workbook* or *Showcase*. Some had tearsheets custom printed for the project. I collated the tearsheets and put them in 9 × 12 envelopes. The envelopes are printed up with everyone's artwork on the front. We pool together names and addresses of art directors to create our mailing list. We've gotten a lot of good responses from this tearsheet project and I'm always looking for new participants.

I like the idea of sharing lists among the members of these groups. It builds a kind of team spirit within a career that's traditionally known for its isolation. You would be surprised by how many people actually want to get involved in list sharing, even outside of our groups. I've shared lists with dozens of artists and I now have a list of more than 5,000 contacts. Sharing lists cuts

down on the hours of research that goes into creating a custom list. Sure, you must have a list before you can start sharing, but once you get over the initial hump, your mailing list can grow exponentially.

If you have a group of artists with similar goals, I suggest splitting up the work load. In list sharing I've discovered some very interesting magazine niches such as university magazines, in-flight magazines, and alumni magazines. In many ways, a custom list has better qualities than a store-bought list. However, you can buy a list from Adbase, Steve Langerman, Morgan Shorey, Labels To Go, or others. The biggest advantage to these lists is that they consist of the clients with the largest budgets. Maintaining a large custom list does become tedious. It's best to use a combination of a store-bought list and a custom-made list so that you have the best of both worlds.

Selling art online

To increase my mailing list, and get exposure from a new audience, I've begun experimenting with selling some prints on eBay. Originally, I had these $8\frac{1}{2} \times 11$ four-color process prints made to promote my illustration. Compared to other art auctions on eBay, some of my prints sell for a pretty good price. I've only been doing this for a couple of weeks and have a feeling that eventually the novelty will wear off and I won't want to do this any more. But, when someone from Guam buys a print, it's pretty exciting. I've heard other artists say that more serious art sales stemmed from putting small prints up for auction on eBay. I put my website—www.YourArt Slave.com—on my eBay ads so people can visit while they're bidding on my prints.

I've created a new section on my website called Art For Sale. I was a little unsure about adding a section like this, especially since illustration fees vary based on usage. I was worried about what clients might think if they see some of my work selling for less than they commissioned it for. But, I think clients understand that sometimes at the beginning of an artist's career at least, it could cost more to purchase the reproduction rights than to purchase the actual

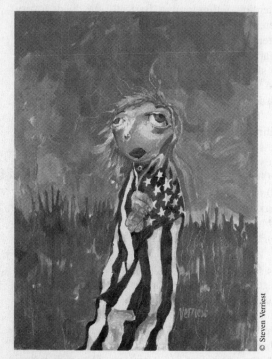

Steven Verriest created this illustration, *Miss America* for *Syracuse New Times*, an alternative newspaper. You can view it in full color on www.yourartslave.com.

painting. I opened the Art For Sale section on YourArtSlave.com by having an invitation-only reception on the web. For the opening, I only invited a select group of clients and art buyers. I offered them a special deal to show my appreciation for them. It worked really well, and I got a lot of responses and sales.

Put it in writing

I've made a practice of writing a contract for every new project that comes in. It helps both parties to communicate the details of the assignment in writing. It is also used as a reference if there's a question as to a deadline or size of the art. Finally, it opens up the lines of communication between artist and client so there is no misunderstanding about the use of reproduction rights. To make discussions with the client more concise I have a cheat sheet taped up over my desk that briefly lists the six major points of my contract. I keep a generic contract template on the computer, and just change a few details when necessary. There's a standard contract in the Graphic Artist Guild's *Handbook: Pricing and Ethical Guidelines*. The contract I use is simpler than that one, but GAG's sample contract is a good starting point.

Using a contract is important. During my move from San Diego to Detroit I lost a job because I didn't act fast enough and sign a contract right away. I did an illustration of a woman wearing a flag like a cape for an alternative newspaper. A few days after it came out, I got an e-mail from the director of a blues festival. He wanted to hire me to illustrate the festival's t-shirt. I sent him an e-mail right away, asking a bunch of questions about the project: "How many t-shirts will you print?" "What advertising will the illustration be used on?" etc. It was about five months before the festival, so I thought I had plenty of time to deal with this. I told him I was going to spend a lot of time moving across the country and that I'd call him back once I was settled in. It took a while to settle in, and I didn't think it was urgent to get back to him.

While I was procrastinating, he bumped into an old friend who he immediately hired to do the illustration. I was really disappointed. It was going to be my first blues festival t-shirt. The only thing I can take away from that experience is—experience. Now I live by the cliché, "strike while the iron is hot." Normally, I'm really good about calling clients back within an hour. If I would have negotiated the contract and closed the deal, I wouldn't have to tell this precautionary tale. Instead, I would have a blues festival t-shirt with my name on it. Well, the director did say he might use me next time, so I wrote a note in my day planner to give him a call next year.

A career as an artist is always an adventure. I hope I can continue to survive and move upward. I have some interesting plans for the upcoming year. Visit my website at www.yourartslave.com regularly to see what I'm up to.

Tell us about your career!

If you'd like to share your career strategies with fellow freelancers, e-mail Mary Cox at artdesign@fwpubs.com or drop a note to *Artist's & Graphic Designer's Market*, 4700 East Galbraith Road, Cincinnati OH 45236.

Growing Your Business:
Simple Systems for Staying on Track

One of the best ways to combat against the dreaded "flaky artist" label is to find simple systems to help yourself get organized. Your goal is not to turn into some super-effecient automaton, but to make yourself appear efficient to your clients—and yourself. You'll feel so much more professional if you have that invoice number ready by the phone *before* you call the client to ask about a payment. Get a big calendar and write down all your mailing dates and deadlines. Enter new contacts and potential clients into a notebook or database instead of jotting them on a scrap of paper.

If you bring your creativity to the business aspects of your work you will come up with some pretty nifty ideas for keeping your business on track. The most important rule of all is to find a system that works for you and stick with it!

YOUR DAILY RECORD-KEEPING SYSTEM

Every artist needs to keep a daily record of art-making and marketing activities. So before you do anything else, visit an office supply store and pick out the following items (or your own variations of these items.) Feel free to get creative and colorful, but be sure to keep it simple so you can remember your system and use it on "automatic pilot" whenever you make a business transaction.

What you'll need:

- A packet of colorful file folders.
- A notebook to serve as a log or journal to keep track of your daily art-making and art marketing activities.
- A small pocket notebook to keep in your car to track mileage and gas expenses.

How to start your system

- Designate a permanent location in your studio or home office for two file folders and your notebook.
- Label one red file folder "Expenses."
- Label one green file folder "Income."
- Write in your daily log book: Today's date _____ "Started business system."

Every time you purchase anything to help you run your business, such as envelopes or art supplies, place the receipt in your red "Expenses" folder. When you receive payment for an assignment or painting, photocopy the check or place the receipt in your green "Income" folder.

That's all there is to it. By the way, if you purchased the log book or any suggested supplies at the store, place your receipt in the above-mentioned red "Expenses" file folder. Congratulations! You've already begun to use your record-keeping 'system!'

Establish "job jackets" to keep assignments on track

Depending on whether you are an illustrator or fine artist, you will want to also devise a system for keeping track of assignments and artworks. Most illustrators assign job numbers to each assignment they receive and create a "job jacket" or file folders for each job. Some file these folders by client name; others keep their file folders in numerical order. The important

thing is to keep all correspondence having to do with each assignment in a spot where you can easily find it. If you are a fine artist, you might do better with painter Bert Small's system below.

A *simple art tracking system*

At any one time, I may have three paintings in one gallery, four in another, one entered in a competition and two submitted to a local art show. To keep track of my paintings, I devised a simple system:

As soon as I finish a painting, I make an index card detailing its title, image size, price and any pertinent comments. I then number each card, starting with the year painted, followed by its place in sequence (i.e. 99-001, 99-002, etc.). I then file it in front of a 3 × 5 index card box—the kind containing alphabet files—in a section marked "Paintings on Hand."

When I send a painting to a gallery or show, I move its index card into section B: "Location of Paintings," which consists of the alphabet files. I file the cards under the letter of the alphabet that will identify where I've sent the painting (i.e. S for Seagull Art Gallery or F for Federation of Painters.) When the paintings are returned, I put the cards back in section A: "Paintings on Hand." If any paintings were sold, I pull their index cards; put a red dot on them; note any details of the sale (i.e., Sold by Gallery "X" on "date" for "price.") and if possible, the name and address of the buyer. I then file the cards in section C: "Paintings Sold."

In addition to the card file, I keep a master list of my work, including the title of each painting with sequence number and details, in a journal and on computer file. I also keep a three-ring binder with slides of all of my paintings for reference.

—*Bert Small*

This tip originally appeared in *Watercolor Magic.*

Pricing illustration and design

One of the hardest things for artists and freelancers to master is what to charge. It's difficult to make blanket statements about what to charge for illustration and design. Every slice of the market is somewhat different. Nevertheless, there is one recurring pattern: hourly rates are generally only paid to designers working inhouse on a client's equipment. (Clients are more likely to pay hourly if they can easily keep track of the hours freelancers work.) Freelancers working out of their own studios (this is nearly always the arrangement for illustrators) are almost always paid a flat fee or an advance against royalties.

If you are unsure about what to charge, begin by devising an hourly rate, taking into consideration the cost of your materials and overhead and what you think your time is worth. (If you are a designer, determine what the average salary would be for a full-time employee doing the same job.) Then estimate how many hours the job will take and quote a flat fee based on these calculations. *Setting the Right Price for Your Design & Illustration*, by Barbara Ganim (North Light Books), includes easy-to-use worksheets to help you set prices for 33 kinds of projects.

There is a distinct difference between giving the client a job estimate and a job quotation. An estimate is a "ballpark" figure of what the job will cost, but is subject to change. A quotation is a set fee which, once agreed upon, is pretty much set in stone. Make sure the client understands which you are negotiating. Estimates are often used as a preliminary step in itemizing costs for a combination of design services such as concepting, typesetting and printing. Flat quotations are usually used by illustrators, as there are fewer factors involved in arriving at fees.

For recommended charges for different services, refer to the *Graphic Artist's Guild's Handbook of Pricing & Ethical Guidelines.* Many artists' organizations have hotlines you can call to find out standard payment for the job you're doing.

A simple system for pricing your fine art

There are no hard and fast rules for pricing your fine artwork. Most artists and galleries base prices on market value—what the buying public is currently paying for similar work. Learn the market value by visiting galleries and checking prices of works similar to yours. When you are starting out don't compare your prices to established artists, but to emerging talent in your region. Consider these when determining price:

Medium. Oils and acrylics cost more than watercolors by the same artist. Price paintings higher than drawings.

Expense of materials. Charge more for work done on expensive paper than for work of a similar size on a lesser grade paper.

Size. Though a large work isn't necessarily better than a small one, as a rule of thumb you can charge more for the larger work.

Scarcity. Charge more for one-of-a-kind works like paintings and drawings, than for limited editions such as lithographs and woodcuts.

Status of artist. Established artists can charge more than lesser-known artists.

Status of gallery. It may not be fair, but prestigious galleries can charge higher prices.

Region. Works usually sell for more in larger cities like New York and Chicago.

Gallery commission. The gallery will charge from 30 to 50 percent commission. Your cut must cover the cost of materials, studio space, taxes and perhaps shipping and insurance, and enough extra to make a profit. If materials for a painting cost $25; matting, framing cost $37; and you spent five hours working on it, make sure you get at least the cost of material and labor back before the gallery takes their share. Once you set your price, stick to the same price structure wherever you show your work. A $500 painting by you should cost $500 whether it is bought in a gallery or directly from you. To do otherwise is not fair to the gallery and devalues your work.

As you establish a reputation, begin to raise your prices—but do so cautiously. Each time you "graduate" to a new price level, you will not be able to come back down.

As you set fees, certain stipulations call for higher rates. Consider these bargaining points:

- **Usage (rights)**. The more rights bought, the more you can charge. For example, if the client asks for a "buyout" (to buy all rights), you can charge more, because by relinquishing all rights to future use of your work you will be losing out on resale potential.
- **Turnaround time**. If you are asked to turn the job around quickly, charge more.
- **Budget**. Don't be afraid to ask a project's budget before offering a quote. You won't want to charge $500 for a print ad illustration if the ad agency has a budget of $40,000 for that ad. If the budget is that big, ask for higher payment.
- **Reputation**. The more well-known you are, the more you can charge. As you become established, periodically raise your rates (in small steps) and see what happens.

What goes in a contract?

Contracts are simply business tools to make sure everyone is in agreement. Ask for one any time you enter into a business agreement. Be sure to arrange for the specifics in writing, or provide your own. A letter stating the terms of agreement signed by both parties can serve as an informal contract. Several excellent books such as *The Artist's Friendly Legal Guide* (North Light Books) provide sample contracts you can copy, and *Business and Legal Forms for Illustrators*, by Tad Crawford (Allworth Press), contains negotiation checklists and tear-out forms. The sample contracts in these books cover practically any situation you might run into.

The items specified in your contract will vary according to the market you are dealing with

and the complexity of the project. Nevertheless, here are some basic points you'll want to cover:

Commercial contracts

- **A description of the service you are providing**.
- **Deadlines for finished work**.
- **Rights sold**.
- **Your fee**. Hourly rate, flat fee or royalty.
- **Kill fee**. Compensatory payment received by you if the project is cancelled.
- **Changes fees**. Penalty fees to be paid by the client for last-minute changes.
- **Advances**. Any funds paid to you before you begin working on the project.
- **Payment schedule**. When and how often you will be paid for the assignment.
- **Statement regarding return of original art**. Unless you are doing work for hire, your artwork should always be returned to you.

Gallery contracts

- **Terms of acquisition or representation**. Will the work be handled on consignment? What is the gallery's commission?
- **Nature of the show(s)**. Will the work be exhibited in group or solo shows or both?
- **Time frames**. At what point will the gallery return unsold works to you? When will the contract cease to be in effect? If a work is sold, when will you be paid?
- **Promotion**. Who will coordinate and pay for promotion? What does promotion entail? Who pays for printing and mailing of invitations? If costs are shared, what is the breakdown?
- **Insurance**. Will the gallery insure the work while it is being exhibited?
- **Shipping**. Who will pay for shipping costs to and from the gallery?
- **Geographic restrictions**. If you sign with this gallery, will you relinquish the rights to show your work elsewhere in a specified area? If so, what are the boundaries of this area?

How to send invoices

If you are a designer or illustrator, you will be responsible for sending out invoices for your services. Clients generally will not issue checks without them. Most graphic designers arrange to be paid in thirds, billing the first third before starting the project, the second after the client approves the initial roughs, and the third upon completion of the project. Illustrators are generally paid in full either upon receipt of illustration or on publication. So mail or fax an invoice as soon as you've completed the assignment.

Standard invoice forms allow you to itemize your services. The more you spell out the charges, the easier it will be for your clients to understand what they are paying for. Most designers charge extra for changes made after approval of the initial layout. Keep a separate form for change orders and attach it to your invoice.

If you are an illustrator, your invoice can be much simpler, as you'll generally be charging a flat fee. It's helpful, in determining your quoted fee, to itemize charges according to time, materials and expenses (the client need not see this itemization—it is for your own purposes).

Most businesses require your social security number or tax ID number before they can cut a check, so include this information in your bill. Be sure to put a due date on each invoice; include the phrase "payable within 30 days" (or other preferred time frame) directly on your invoice. Most freelancers ask for payment within 10-30 days.

Sample invoices are featured in *The Designer's Commonsense Business Book*, by Barbara Ganim (North Light Books) and *Business and Legal Forms for Illustrators*, by Tad Crawford (Allworth Press).

If you are working with a gallery, you will not need to send invoices. The gallery should send you a check each time one of your pieces is sold (generally within 30 days). To ensure

that you are paid promptly, call the gallery periodically to touch base. Let the director or business manager know that you are keeping an eye on your work. When selling work independently of a gallery, give receipts to buyers and keep copies for your records.

Should you take tax deductions?

You have the right to take advantage of deducting legitimate business expenses from your taxable income. Art supplies, studio rent, advertising and printing costs, and other business expenses are deductible against your gross art-related income. It is imperative to seek the help of an accountant or tax preparation service in filing your return. In the event your deductions exceed profits, the loss will lower your taxable income from other sources.

To guard against taxpayers fraudulently claiming hobby expenses as business losses, the IRS requires taxpayers to demonstrate a "profit motive." As a general rule, you must show a profit three out of five years to retain a business status. If you are audited, the burden of proof will be on you to demonstrate your work is a business and not a hobby.

The nine criteria the IRS uses to distinguish a business from a hobby are: the manner in which you conduct your business, expertise, amount of time and effort put into your work, expectation of future profits, success in similar ventures, history of profit and losses, amount of occasional profits, financial status, and element of personal pleasure or recreation. If the IRS rules that you paint for pure enjoyment rather than profit, they will consider you a hobbyist. Complete and accurate records will demonstrate to the IRS that you take your business seriously.

Even if you are a "hobbyist," you can deduct expenses such as supplies on a Schedule A, but you can only take art-related deductions equal to art-related income. If you sold two $500 paintings, you can deduct expenses such as art supplies, art books, magazines and seminars only up to $1,000. Itemize deductions only if your total itemized deductions exceed your standard deduction. You will not be allowed to deduct a loss from other sources of income.

How to fill out a Schedule C

To deduct business expenses, you or your accountant will fill out a 1040 tax form (not 1040EZ) and prepare a Schedule C. Schedule C is a separate form used to calculate profit or loss from your business. The income (or loss) from Schedule C is then reported on the 1040 form. In regard to business expenses, the standard deduction does not come into play as it would for a hobbyist. The total of your business expenses need not exceed the standard deduction.

There is a shorter form called Schedule C-EZ for self-employed people in service industries. It can be applicable to illustrators and designers who have receipts of $25,000 or less and deductible expenses of $2,000 or less. Check with your accountant to see if you qualify.

Deductible expenses include advertising costs, brochures, business cards, professional group dues, subscriptions to trade journals and arts magazines, legal and professional services, leased office equipment, office supplies, business travel expenses, etc. Your accountant can give you a list of all 100 percent and 50 percent deductible expenses (such as entertainment).

As a self-employed "sole proprieter" there is no employer regularly taking tax out of your paycheck. Your accountant will help you put money away to meet your tax obligations and may advise you to estimate your tax and file quarterly returns.

Your accountant also will be knowledgeable about another annual tax called the Social Security Self-Employment tax. You must pay this tax if your net freelance income is $400 or more.

The fees of tax professionals are relatively low, and they are deductible. To find a good accountant, ask colleagues for recommendations, look for advertisements in trade publications or ask your local Small Business Association. And don't forget to deduct the cost of this book.

Whenever possible, retain your independent contractor status

Some clients automatically classify freelancers as employees and require them to file Form W-4. If you are placed on employee status, you may be entitled to certain benefits, but a portion

You may be eligible for a home office deduction

If you freelance fulltime from your home and devote a separate area to your business, you may qualify for a home office deduction. If eligible you can deduct a percentage of your rent and utilities, expenses such as office supplies and business-related telephone calls.

The IRS does not allow deductions if the space is used for reasons other than business. A studio or office in your home must meet three criteria:
- The space must be used exclusively for your business.
- The space must be used regularly as a place of business.
- The space must be your principle place of business.

The IRS might question a home office deduction if you are employed fulltime elsewhere and freelance from home. If you do claim a home office, the area must be clearly divided from your living area. A desk in your bedroom will not qualify. To figure out the percentage of your home used for business, divide the total square footage of your home by the total square footage of your office. This will give you a percentage to work with when figuring deductions. If the home office is ten percent of the square footage of your home, deduct ten percent of expenses such as rent, heat and air conditioning.

The total home office deduction cannot exceed the gross income you derive from its business use. You cannot take a net business loss resulting from a home office deduction. Your business must be profitable three out of five years. Otherwise, you will be classified as a hobbyist and will not be entitled to this deduction.

Consult a tax advisor before attempting to take this deduction, since its interpretations frequently change.

Refer to IRS Publication 587, Business Use of Your Home, for additional information. *Homemade Money*, by Barbara Brabec (Betterway Books), provides formulas for determining deductions and provides checklists of direct and indirect expenses.

of your earnings will be withheld by the client until the end of the tax year, and you could forfeit certain deductions. In short, you may end up taking home less than you would if you were classified as an independent contractor.

The IRS uses a list of 20 factors to determine whether a person should be classified as an independent contractor or an employee. This list can be found in the IRS Publication 937. Note, however, that your client will be the first to decide whether or not you will be so classified.

Report all income to Uncle Sam

Don't be tempted to sell artwork without reporting it on your income tax. You may think this saves money, but in the broader scheme it can do real damage to your career and credibility—even if you are never audited by the IRS. Unless you are reporting your income, the IRS will not categorize you as a professional, and you won't be able to deduct your expenses! And don't think you won't get caught if you neglect to report income from clients. If you bill any client in excess of $600, the IRS requires the client to provide you with a form 1099 at the end of the year. Your client must send one copy to the IRS and a copy to you to attach to your income tax return. Likewise, if you pay a freelancer over $600, you must issue a 1099 form. This procedure is one way the IRS cuts down on unreported income.

Register with the state sales tax department

Most states require a two to seven percent sales tax on artwork you sell directly from your studio or at art fairs or on work created for a client, such as art for a logo. You must register with the state sales tax department, which will issue you a sales permit or a resale number, and

send you appropriate forms and instructions for collecting the tax. Getting a sales permit usually involves filling out a form and paying a small fee. Reporting sales tax is a relatively simple procedure. Record all sales taxes on invoices and in your sales journal. Every three months, total the taxes collected and send it to the state sales tax department.

In most states, if you are selling to a customer outside of your sales tax area, you do not have to collect sales tax. However, this may not hold true for your state. You may also need a business license or permit. Call your state tax office to find out what is required.

Save money on art supply sales tax

As long as you have the above sales permit number, you can buy art supplies without paying sales tax. You will probably have to fill out a tax-exempt form with your permit number at the sales desk where you buy materials. The reason you do not have to pay sales tax on your art supplies is that sales tax is only charged on the final product. However, you must then add the cost of materials into the cost of your finished painting or the final artwork for your client. Keep all of your purchase receipts for these items in case of a tax audit. If the state discovers that you have not collected sales tax, you will be liable for tax and penalties.

If you sell all your work through galleries, they will charge sales tax, but you will still need a tax exempt number so you can get a tax exemption on supplies.

Some states claim "creativity" is a non-taxable service, while others view it as a product and therefore taxable. Be certain you understand the sales tax laws to avoid being held liable for uncollected money at tax time. Write to your state auditor for sales tax information.

For More Information

Most IRS offices have walk-in centers open year-round and offer over 90 free IRS publications to help taxpayers. Some helpful booklets include Publication 334—Tax Guide for Small Business; Publication 505—Tax Withholding and Estimated Tax; and Publication 533—Self Employment Tax. Order by phone at (800)829-3676. There's plenty of great advice on the Internet, too. Check out the official IRS website: http://www.irs.ustreas.gov/prod/cover.html. Fun graphics lead you to information, and you can even download tax forms.

If you don't have access to the Web, the booklet that comes with your tax return forms contains addresses of regional Forms Distribution Centers you can write to for information. The U.S. Small Business Administration offers seminars on taxes, and arts organizations hold many workshops covering business management, often including detailed tax information. Inquire at your local arts council, arts organization or university to see if a workshop is scheduled.

Save money on postage

If you are an illustrator or designer sending out samples, you can save big bucks by mailing bulk. Fine artists should send submissions via first class mail for quicker service and better handling. Package flat work between heavy cardboard or foam core, or roll it in a cardboard tube. Include your business card or a label with your name and address on the outside of the packaging material in case the outer wrapper becomes separated from the inner packing in transit.

Protect larger works—particularly those that are matted or framed—with a strong outer surface, such as laminated cardboard, masonite or light plywood. Wrap the work in polyfoam, heavy cloth or bubble wrap and cushion it against the outer container with spacers to keep from moving. Whenever possible, ship work before it is glassed. If the glass breaks en route, it may destroy your original image. If you are shipping large framed work, contact a museum in your area for more suggestions on packaging.

The U.S. Postal Service will not automatically insure your work, but you can purchase up to

$600 worth of coverage. Artworks exceeding this value should be sent by registered mail. Certified packages travel a little slower, but are easier to track.

Consider special services offered by the post office, such as Priority Mail, Express Mail Next Day Service and Special Delivery. For overnight delivery, check to see which air freight services are available in your area. Federal Express automatically insures packages for $100 and will ship art valued up to $500. Their 24-hour computer tracking system enables you to locate your package at any time.

UPS automatically insures work for $100, but you can purchase additional insurance for work valued as high as $25,000 for items shipped by air (there is no limit for items sent on the ground). UPS cannot guarantee arrival dates but will track lost packages. It also offers Two-Day Blue Label Air Service within the U.S. and Next Day Service in specific zip code zones.

Before sending any original work, make sure you have a copy (photostat, photocopy, slide or transparency) in your files. Always make a quick address check by phone before putting your package in the mail.

Send us your business tips!

If you are just starting out, it may be all you can handle to create and submit your work. But if you intend on making a living from your work, you must go beyond that and become an expert business person as well. If you've discovered a business strategy we've missed, please write to *Artist's & Graphic Designer's Market*, 4700 East Galbraith Road, Cincinnati OH 45236 or e-mail us at artdesign@fwpubs.com. A free copy of the 2004 edition goes to the best five suggestions.

Crash Course in Copyright

As creator of your artwork, you have certain inherent rights over your work and can control how each one of your artworks is used, until you sell your rights to someone else. The legal term for these rights is called **copyright**. Technically, any original artwork you produce is automatically copyrighted as soon as you put it in tangible form.

To be automatically copyrighted, your artwork must fall within these guidelines:

- **It must be your *original* creation.** It cannot be a *copy* of somebody else's work.
- **It must be "pictorial, graphic or sculptural."** Utilitarian objects, such as lamps or toasters, are not covered, although you can copyright an illustration featured on a lamp or toaster.
- **It must be fixed in "any tangible medium, now known or later developed."** Your work, or at least a representation of a planned work, must be created in or on a medium you can see or touch, such as paper, canvas, clay, a sketch pad, or even a website. It can't just be an idea in your head. An idea cannot be copyrighted.

Copyright lasts for your lifetime plus seventy years

Copyright is *exclusive*. When you create a work, the rights automatically belong to you and nobody else but you until you sell those rights to someone else.

In October 1998, Congress passed the Sonny Bono Copyright Term Extension Act, which extended the term of U.S. copyright protection. Works of art created on or after January 1978 are protected for your lifetime plus 70 years.

The artist's bundle of rights

One of the most important things you need to know about copyright is that it is not just a *singular* right. It is a *bundle* of rights you enjoy as creator of your artwork. Let's take a look at the five major categories in your bundle of rights and examine them individually:

- **Reproduction right.** You have the right to make copies of the original work.
- **Modification right.** You have the right to create derivative works based on the original work.
- **Distribution rights.** You have the right to sell, rent or lease copies of your work.
- **Public performance right.** The right to play, recite or otherwise perform a work. (This right is more applicable to written or musical art forms than visual art.)
- **Public display right.** You have the right to display your work in a public place.

This bundle of rights can be divided up in a number of ways, so that you can sell all or part of any of those exclusive rights to one or more parties. The system of selling parts of your copyright bundle is sometimes referred to as **"divisible" copyright**. Just as a land owner could divide up his property and sell it to many different people, the artist can divide up his rights to an artwork and sell portions of those rights to different buyers.

Divisible copyright: divide and conquer

Why is this so important? Because dividing up your bundle and selling parts of it to different buyers will help you get the most payment from each of your artworks. For any one of your artworks, you can sell your entire bundle of rights at one time (not advisable!) or divide and sell each bundle pertaining to that work into smaller portions and make more money as a result.

You can grant one party the right to use your work on a greeting card and sell another party the right to print that same work on T-shirts.

Clients tend to use legal jargon to specify the rights they want to buy. The terms below are commonly used in contracts to specify portions of your bundle of rights. Some terms are vague or general, such as "all rights;" others are more specific, such as "first North American rights." Make sure you know what each term means.

Divisible copyright terms

- **One-time rights.** Your client buys the right to use or publish your artwork or illustration on a one-time basis. One fee is paid for one use. Most magazine and bookcover assignments fall under this category.
- **First rights.** This is almost the same as purchase of one-time rights, except that the buyer is also paying for the privilege of being the first to use your image. He may use it only once unless the other rights are negotiated.
 Sometimes first rights can be further broken down geographically when a contract is drawn up. The buyer might ask to buy **first North American rights,** meaning he would have the right to be the first to publish the work in North America.
- **Exclusive rights.** This guarantees the buyer's exclusive right to use the artwork in his particular market or for a particular product. Exclusive rights are frequently negotiated by greeting card and gift companies. One company might purchase the exclusive right to use your work as a greeting card, leaving you free to sell the exclusive rights to produce the image on a mug to another company.
- **Promotion rights.** These rights allow a publisher to use an artwork for promotion of a publication in which the artwork appeared. For example, if *The New Yorker* bought promotional rights to your cartoon, they could also use it in a direct mail promotion.
- **Electronic rights.** These rights allow a buyer to place your work on electronic media such as websites. Often these rights are requested with print rights.
- **Work for hire.** Under the Copyright Act of 1976, section 101, a "work for hire" is defined as "(1) a work prepared by an employee within the scope of his or her employment; or (2) a work . . . specially ordered or commissioned for use as a contribution to a collective, as part of a motion picture or audiovisual work or as a supplementary work . . .if the parties expressly agree in a written instrument signed by them that the work shall be considered a work made for hire." When the agreement is "work for hire" you surrender all rights to the image and can never resell that particular image again. If you agree to the terms, make sure the money you receive makes it well worth the arrangement.
- **All rights.** Again, be very aware that this phrase means you will relinquish your right to a specific artwork. Before agreeing to the terms, make sure this is an arrangement you can live with. At the very least, arrange for the contract to expire after a specified date. Terms for all rights—including time period for usage and compensation—should be confirmed in a written agreement with the client.

Since legally, your artwork is your property, when you create an illustration for a magazine you are, in effect, temporarily "leasing" your work to the client for publication. Chances are you'll never hear an art director ask to lease or license your illustration, and he may not even realize he is leasing, not buying your work. But most art directors know that once the magazine is published, the art director has no further claims to your work and the rights revert back to you. If the art director wants to use your work a second or third time, he must ask permission and negotiate with you to determine any additional fees you want to charge. You are free to take that same artwork and sell it to another buyer.

However, had the art director bought "all rights," you could not legally offer that same image to another client. If you agreed to create the artwork as "work for hire," you relinquished your rights entirely.

What licensing agents know

The practice of leasing parts or groups of an artist's bundle of rights is often referred to as **"licensing,"** because (legally) the artist is granting someone a "license" to use his work for a limited time for a specific reason. As licensing agents have come to realize, it is the exclusivity of the rights and the ability to divide and sell them that make them valuable. Knowing exactly what rights you own, which you can sell, (and in what combinations) will help you negotiate with your clients.

Don't sell conflicting rights to different clients

You also have to make sure the rights you sell to one client don't conflict with any of the rights sold to other clients. For example, you can't sell the exclusive right to use your image on greeting cards to two separate greeting card companies. You *can* sell the exclusive greeting card rights to one card company and the exclusive rights to use your artwork on mugs to a separate gift company. It's always good to get such agreements in writing and to let both companies know your work will appear on other products.

When to use the Copyright © and credit lines

A copyright notice consists of the word "Copyright" or its symbol ©, the year the work was created or first published, and the full name of the copyright owner. It should be placed where it can easily be seen, on the front or back of an illustration or artwork. It's also common to print your copyright notice on slide mounts or onto labels on the back of photographs.

Under today's laws, placing the copyright symbol on your work isn't absolutely necessary to claim copyright infringement and take a plagiarist to court if he steals your work. If you browse through magazines, you will often see the illustrator's name in small print near the illustration, *without* the Copyright ©. This is common practice in the magazine industry. Even though the © is not printed, the illustrator still owns the copyright unless the magazine purchased all rights to the work. Just make sure the art director gives you a credit line near the illustration.

Usually you will not see the artist's name or credit line alongside advertisements for products. Advertising agencies often purchase all rights to the work for a specified time. They usually pay the artist generously for this privilege and spell out the terms clearly in the artist's contract.

How to register a copyright

To register your work with the U.S. Copyright Office, call the Copyright Form Hotline at (202) 707-9100 and ask for package 115 and circulars 40 and 40A. Cartoonists should ask for package 111 and circular 44. You can also write to the Copyright Office, Library of Congress, Washington DC 20559, Attn: Information Publications, Section LM0455.

You can also download forms from the Copyright Office website at http://loc.gov/copyright. Whether you call or write, they will send you a package containing Form VA (for visual artists). Registering your work costs $30.

After you fill out the form, return it to the Copyright Office with a check or money order for $30, a deposit copy or copies of the work and a cover letter explaining your request. For almost all artistic work, deposits consist of transparencies (33mm or $2\frac{1}{4} \times 2\frac{1}{4}$) or photographic prints (preferably 8×10). Send one copy for unpublished works; two copies for published works.

You can register an entire collection of your work rather than one work at a time. That way you will only have to pay one $30 fee for an unlimited number of works. For example if you have created a hundred works since 1998, you can send a copyright form VA to register "the collected work of Jane Smith, 1998-2002." But you will have to send either slides or photocopies of each of those works.

Why register?

It seems like a lot of time and trouble to send in the paperwork to register copyrights for all your artworks. It may not be necessary or worth it to you to register every artwork you create. After all, a work is copyrighted the moment it's created anyway, right?

The benefits of registering are basically to give you additional clout in case an infringement occurs and you decide to take the offender to court. Without a copyright registration, it probably wouldn't be economically feasible to file suit, because you'd be only entitled to your damages and the infringer's profits, which might not equal the cost of litigating the case. Had works been registered with the U.S. Copyright office it would be easier to prove your case and get reimbursed for your court costs.

Likewise, the big advantage of using the copyright © also comes when and if you ever have to take an infringer to court. Since the copyright © is the most clear warning to potential plagiarizers, it is easier to collect damages if the © was in plain sight.

Register works you fear are likely to be plagiarized with the U.S. Copyright Office before or shortly after they have been exhibited or published. That way, if anyone uses your work without permission, you can take action.

Deal swiftly with plagiarists

If you think your work has been plagiarized and you have not already registered it with the Copyright Office, register it immediately. You have to wait until it is registered before you can take legal action against the infringer.

Before taking the matter to court, however, your first course of action might be a well-phrased letter from your lawyer telling the offender to "cease and desist" using your work, because you have a registered copyright. Such a warning (especially if printed on your lawyer's letterhead) is often enough to get the offender to stop using your work.

Don't sell your rights too cheaply!

Recently a controversy has been raging about whether or not artists should sell the rights to their work to stock illustration agencies. Many illustrators strongly believe selling rights to stock agencies hurts the illustration profession. They say artists who deal with stock agencies, especially those who sell royalty free art, are giving up the rights to their work too cheaply.

Another pressing copyright concern is the issue of electronic rights. As technology makes it easier to download images, it is more important than ever for artists to protect their work against infringement.

Log on to www.theispot.com and discuss copyright issues with your fellow artists. Join organizations that crusade for artists' rights, such as the Graphic Artist's Guild (GAG) or The American Institute of Graphic Arts (AIGA). Volunteer Lawyers for the Arts is a national network of lawyers who volunteer free legal services to artists who can't afford legal advice. A quick search of the web will help you locate a branch in your state. Most branches offer workshops and consultations.

For More Information

Visit the U.S. Copyright Website (http://loc.gov/copyright) the official site of the U.S. Copyright Office. Another great site, called The Copyright Website, is located at http://benedict.com/visual/visual.htm.

A few great books on the subject are *Legal Guide for the Visual Artist*, by Tad Crawford (Allworth Press); *The Rights of Authors, Artists, and other Creative People*, by Kenneth P. Norwick and Jerry Simon Chasen (Southern Illinois University Press); and *Electronic Highway Robbery: An Artist's Guide to Copyrights in the Digital Era*, by Mary E. Carter (Peachpit Press).

Color Trends and the New Shade of Marketing

BY CANDI LACE

Does it really matter if you implement the traditional shade of aqua or "Aqueous #683" in your client's new logo? Absolutely, says Leatrice Eiseman, executive director of the Pantone Color Institute and founder of the Eiseman Center for Color Information and Training. While she often gives advice on diminutive matters such as this one, according to her, every detail counts in business graphics. "Whether you are designing a new line of greeting cards or a promotional insert for a toy company, color sensibility is very important, and it should play a key role in the initial stages of design planning," urges Eiseman.

Leatrice Eiseman

In a contemporary world, most everyone is a consumer, and this notion does not only incorporate moneymaking teens and adults. Eiseman points out that kids influence $165 million in spending each year just while they are crawling around in diapers. Since most children in diapers have not picked up enough language skills to develop extensive verbal meanings, they are most responsive to imagery. Therefore, the usage of color in products including clothing, CDs and tapes, giftware, food packaging, and decorative home art, for example, is considered more today than ever before.

"All these consumer products cross many industries with more and more increased demand, and that precisely means there are endless opportunities for artists and graphic designers," says Eiseman. "But not all of them are well educated and skilled enough to flourish."

The education Eiseman refers to is not a college degree or countless hours of personal studio time. Fine artists and graphic designers who desire a steady stream of lucrative work should be familiar with the latest color schemes, the difference between corporate colors and cultural colors, and how to identify salient features with proper color presentation, says Eiseman. Only after they have this basic knowledge, should designers focus on a client's identity, target audience, promotion, packaging, and any other factor that's crucial to the success of the presentation or product.

An allied member of the American Society of Interior Designers, the Fashion Group, and also a member of the American Trends Committee, Eiseman has been recognized internationally for her color expertise and sharp forecasts. But, how does one develop even an inkling of the knowledge she has acquired about color?

First off, designers should realize that colors are very personal and display attitude, asserts Eiseman. After all, right down to the very undergarment or the makeup tones someone chooses to wear on a given day, the need for color in personal expression is intrinsic in mundane decisions. "Color allows us to orchestrate creativity in any medium, and when it comes to business or personal expression, it is the number one cause for the negative or the positive way someone responds," says Eiseman. "If the color is misrepresented or simply does not fit the wearer—or product per se—it's noticeable, no matter how many other appropriate, eye-catching techniques are presented with it."

Once designers are attuned to the importance of color in everyday affairs, they should routinely examine a variety of industries—from the garment industry to the interior design industry—and make a note of the colors they see most frequently. While furniture does not directly relate to clothing, the trends are parallel, says Eiseman. Politics, entertainment (especially the film and music industries) and the rapidly increasing merge of cultures around the world also contribute to the latest color palette. Additionally, surveying contemporary art and lifestyle magazines (there are thousands to choose from today) and perusing the nearest lot of new cars is also helpful in learning what's hot and marketable before approaching a potential client.

In short, just what are the "hot and marketable" colors these days? Eiseman beams that the kelly green family from the '70s has made a comeback and is currently bursting through all design categories. The desirable, irresistible, highly energetic burgundy red also demands consumer attention in clothing, automobiles, food and paper products.

Want to know more? Read Leatrice Eiseman's five facts below!

Five Color Facts Every Artist, Illustrator and Graphic Designer Should Know

1. **Corporate colors are different than cultural colors.**
 Pay attention to national colors and sociological connotations. Appeal to the professional and cultural expectations of your audience. For example, choosy advertising executives may be interested in exuberant, futuristic tones that represent cutting edge global trends (violet, apricot, chartreuse) while a political association will prefer blue, gray and red.

2. **Color families are cyclically popular, and resurface every 20-30 years.**
 As noted above, the kelly green assembly has made a comeback in all realms of design-predominantly fashion. The chocolate brown family, as well as metallic colors, are equally popular today.

3. **The human eye grabs warm colors before cool colors.**
 Generally warm colors advance and cool colors recede; this should be noted for each assignment, as some clients want products and labels to excite, while others may desire a calming or serene effect.

4. **Sociological issues play an important role in color trends.**
 War or involvement in peacekeeping efforts will carry an assortment of colors associated with those events, such as tans and military greens. The colors of the flag, as seen more recently, become trendy during a patriotic surge or important celebration.

5. **The overuse of color may become a distraction.**
 It's important to restrain yourself and use color sparingly. In many cases, whether creating a greeting card or a CD cover, three colors are usually sufficient, and five is often too many. Avoid using color for mere decoration or to highlight special effects.

When Gruesome is Good: Your Complete Horror Roundtable

BY CANDI LACE

Titles such as *A Flock of Crows is Called a Murder, Are You Loathsome Tonight?* and *Dark Demons: Tales of Obsession, Possession and Unnatural Desire* demand attention, and publishers of the macabre increase their visibility by dressing these books in smashing covers.

Amazon.com claims over 800 recent horror and thriller releases in stock. With so many new books parading the shelves, it's difficult to judge why some tales of terror are more popular than others. Besides the author's name and the encouraging review quotes, readers are clearly enticed by imagery on the cover.

Are she-monsters and modern-day vampire figures overdone? Do haunted houses really conjure up fear? Are editors and art directors too swamped to download e-portfolios? Should freelancers send illustrations to their favorite magazines or book publishers first? Here, three key horror publishers discuss the realm of dark design, and offer tips every freelance artist and illustrator should store in her catacombs: **Keith Herber**, art director and managing partner, DarkTales Publications, who received Best Horror Publisher in 2000 from Jobs In Hell Excellence Awards; **Barry Hoffman**, president, Gauntlet Press, whose author list includes Ray Bradbury, Poppy Z. Brite and Jack Ketchum, among other industry favorites; and **Shane Ryan Staley**, editor-in-chief, Delirium Books, who specializes in limited edition hardcovers and online publishing of extreme fiction.

Why have you chosen eccentric, multimedia covers for many of your titles? Can you describe the mediums used in some of the art composition?

Keith Herber: For two recent titles, *Scary Rednecks* and *Six Inch Spikes*, we used a combination of licensed clip art, public domain images, reworked in Photoshop. We'll also use scanned bits, or shots from digital cameras, 3D objects, whatever can be found that fills the bill. Using graphic design as the actual cover art calls for a lot of symbolism, versus the more literal interpretations you can render via traditional art.

Barry Hoffman: Covers are essential, and uniqueness is important—after all, there are so many spines, blurbs and flaps in front of that potential buyer at a store. We really strive for our covers to stand out with striking images that won't be duplicated. For Poppy Z. Brite's hardcover version of *Are You Loathsome Tonight?*, for example, JK Potter altered photographs of Poppy with illustrations of unnatural elements of her physique.

Shane Staley: I've been looking at all sorts of artists lately, from digital-based artists to painters to pen and wash. I don't think it's as much the medium used, as what mood the artist conjures. With me, the fiction sets the stage for the artwork. When I have a portfolio for a certain artist, I really try to match the overall mood of his or her work to the mood of the fiction that will be

A fan of horror books since diapers, **CANDI LACE** *is the assistant editor of* AGDM *and* Children's Writer's & Illustrator's Market. *Also a freelance writer, Lace's work has been published in* Art Papers, Alternative Cinema, Clamor, *and* Sojourner: The Women's Forum, *among other venues.*

DarkTales Press promises to "bring horror to the world," and with books like *The Asylum*, this successful publisher fiercely defines the genre. Designed by Victor Heck and Keith Herber, this cover is originally accented in a glowing orange and firey pink, warmly inviting readers to explore inconceivable terrors including murderous cockroaches that talk.

"a terrifying literary journey into a reddish world of madness..."
Michael Rowe—*Fangoria Magazine*

The Asylum
Volume 1: The Psycho Ward

END OF LINE

Edited by
Victor Heck

presented in the book. Some of the more hardcore/extreme titles that are serious conjure a dark mood, like *Cage of Bones* and *Maternal Instinct*, and they have called for a digital photo artist.

Do you showcase books at many conferences? Do illustrators at conventions approach you for assignments, and are there any who have stood out?

KH: Yes, DarkTales does attend all the major horror conferences. We get queried at conventions, as well as through electronic and snail mail. A lot of prospects are younger artists looking for a break, but a surprising number are established pros with commercial careers looking for an opportunity to do something more creative and fun, and for a fee much less than they usually charge.

BH: Gauntlet has a presence at many functions, but we also have a strong relationship with distributors, chains, trade shows and independent bookstores. So many well-known illustrators such as Alan Clark have approached us. Consequently, we did choose him to do the cover of Nancy Collins' *Psycho* after that initial meeting, but we usually let the authors select the appropriate illustrator. This shouldn't discourage freelancers, however, because we have been known to suggest potential illustrators to the authors.

SS: Delirium is a fairly new press, and I've just begun getting into the convention planning. Other than conventions, Delirium has a file that keeps artists' portfolios for future reference and assignments. Once I sign an author for a new book, I pull out the portfolios and try to match the art style with the fiction. As for standouts, I'd have to say the artist GAK, who designed my company logo and two covers for recent Delirium releases, *Dark Testament* and *4×4*. Another

artist we've used is Chris Mars, who was the drummer for the now defunct alternative rock group *The Replacements*. Mars' artwork is very surreal and dark, and his first cover for us was *Guises*, by author Charlee Jacob.

If freelancers are simply writhing at their desks, shouting for an assignment from your press, what are things they should *not* do?

KH: I can only be sure of what they can do, but we have lots more artists on file than we have assignments. If we find a good match—a title and an artist—it's more luck than anything else. I would say to keep an online gallery and every few months, or when the site is significantly updated, drop an e-mail with a link to the site. It's not very intrusive, it's easy to access, and it keeps the artist on the publisher's radar.

BH: Do not approach any publisher blindly. I believe e-mail has made many artists lazy, as many are sending the same query letter to several publishers without addressing anyone specifically. Freelancers must search our website, and make sure queries are specific, mentioning books that we've published, at the very least. We do not publish dragons, for instance, but this theme comes up periodically because an artist has not researched our background. This is part of being professional and complete, taking all steps to get noticed within hundreds, sometimes thousands of competing artists. Lastly, they should not expect to get paid for everything they do. Each piece of work is a résumé builder.

SS: I don't care for e-mail links to websites. My workload doesn't allow me to surf the Internet for new artists. If the artist doesn't want to spend the time to send me an actual portfolio, then

Shaded in grays and metallic blue, this cover for Poppy Z. Brite's collection is a sure pleaser among horror fans. Digitally manipulated and painted by famous artist JK Potter, with layout and design by Buddy Martinez, *Are You Loathsome Tonight?* provides the evil Gauntlet Publications is unabashedly acclaimed for.

© Gauntlet Publications. Cover art: JK Potter; Layout/design: Buddy Martinez.

This short story collection published by Delirium is hardly about skeletons, and the seductively haunting cover introduces the alluring content within. Designed by Colleen Crary and Andrew Shorrock, *Cage of Bones: Tales of Obsession, Possession and Unnatural Desires* is a sophisticated example of tales Delirium Books has offered in their short, but prominent publishing endeavors.

I will not spend the time considering this artist for publication. And the portfolio doesn't have to be big—it can simply be a folder with four to five high-quality color samples of their work. A link on an e-mail will stay in my box for a few seconds, while several prints in a file will be there for good.

What images most appeal to readers of the macabre, and what images do you find overdone, outdated or way too campy for publication?

KH: I'm not sure what appeals to readers because there's such a variety. Most of the big publishers are rather conservative. The horror novels they publish seem to feature a lot of paintings of large trees, and a lot of small publishers tend to emulate the bigger publishers. DarkTales has gone its own way, using lots of splashy, saturated colors, and evocative imagery to catch the eye.

BH: In the early '90s, every horror book had a skull on it! Authors cringed. I don't really think that any element is necessarily overdone, but haunted houses may not evoke enough fright these days either, for example. A difference today is that we don't see much blood on cover art, and books like Stephen King's *Carrie* would have a different cover. No matter what the image is, it should mean foreboding and terror. Most importantly, the image has to make sense!

SS: Speaking solely about the horror genre, I'm really sick of seeing the rusty staple of a busty vampire on a cover or an interior piece. Although I like supernatural horror, I really don't care much for monsters on the cover. It has been said that the supernatural is a mirror reflection of our world—that is, the monsters that dwell in fiction can be related to the monsters inside of

humanity, as in the evil that man does. If an art piece mimics only the supernatural front, readers may be turned off by "just another monster tale."

Any explosive book covers out there today that come to mind?

KH: I think the cover of *Scary Rednecks and Other Inbred Horrors* caught people's eye, but it was also a combination of cover, content and title.

BH: I know I was impressed with Neal McPheeter's cover for *Right To Life* from Cemetery Dance, but as for mass market titles, most I just pass by without them garnering much interest.

SS: I'd have to tip my hat to the DarkTales release of *Scary Rednecks and Other Inbred Horrors*. It was such a fitting cover—one of my favorites in the past few years. It's a simple concept, but the rusted automobile with "JESUS SAVES" scrawled on it really set the tone for the book. I also like the design of many of Dave Barnett's Necro line, including the titles *Duet for the Devil* and the chapbook *Partners in Chyme*.

Based on your experience, is there enough work in the genre to be dispersed to illustrators, or should they search for a fulltime job instead?

KH: They should look for the good paying day job. There is room for a few people to make a living at it, but it's risky and insecure. Commercial work pays far better.

BH: Art can be a fulltime job. There are many open venues. Online and print publications may not have big budgets, but importance lies with getting work out there. Genre newsletters list hundreds of magazines accepting freelance work. Freelancers can start with specialty publishers, but note that these presses do not only rely on website portfolios. Again, the artists have to spend money attending conventions and compiling mailings, but authors, publishers, and art collectors are guaranteed to see the work.

SS: Honestly, I think that few can actually make a living at it. I would say you have to do it for the love of it, and hope that something comes along that allows you to create fulltime. Artists are in the same boat as authors and even small press publishers; almost all have a fulltime job outside of writing and publishing. The term "starving artist" comes to mind because it's a very true concept. All I can say is have faith in yourself and your abilities, and do it for the love of it. The rewards you receive will be far greater than any check.

THE ILLUSTRATORS OF HORROR

Alan M. Clark: Surrealistic storyteller

If horror buffs are tired of grinning pumpkins, starry-eyed witches and the standard vampire fare on magazine and book covers, popular illustrator Alan M. Clark is here to serve up the beautifully variant, savage imagery. Since the '80s, Clark has designed covers and spots for many renowned venues including Cemetery Dance Publications, *Weird Tales* magazine, Subterranean Press, Kitchen Sink Press, and *Asimov's Science Fiction* magazine. He is the founder of IFD Publishing, which is responsible for collaborating with other multimedia artists and distributing Clark's paintings. The famed illustrator says he is a surrealist at heart, and takes pride in all his disturbing works.

"One of my disappointments in dealing with the fine art market is that surrealism is considered a dead art form in that situation," says Clark. "I have rarely enjoyed my involvement with art galleries, so early on I looked to illustration as a way to make a living."

Clark received a Bachelor of Fine Arts degree from the San Francisco Art Institute, but

learned the business of illustrating professionally from other illustrators and editors. In the beginning of his career, Clark stampeded conferences including the World Fantasy Convention, made trips to New York each year to show a portfolio of new work, browsed bookstores for the latest selling horror titles, and formed mock book covers to send as promotional samples. Clark's first cover sales—to Tor Books—were generated from a mock-up cover featuring his painting of space ship images. Since, Clark has designed books by Nancy Collins, Jack Ketchum and Richard Laymon, among other horror favorites.

"I try to make my work distinctively different so I will not be so replaceable," says Clark. "I work to the satisfaction of my clients, and remind the industry of my existence as often as possible by sharing compelling images on a storytelling level with them."

The captivating "storytelling" images Clark is referring to, *must*: "pose more questions than answers; offer three out of five elements of a story, depending on the audience to fill in the rest; and visually serve as more than just a portrait, landscape or still-life."

Clark also urges freelancers to accept assignments they're not delighted by, work twice as hard on them for greater satisfaction, and don't walk away bitter. After all, that fantastic, dark dream assignment might be screaming furiously in the shadows.

Vincent Marcone: Caretaker of mY pEt sKeLeTOn

Vincent Marcone boasts of drawing bats, monsters and other strange creatures that nightmares are made of ever since he was two feet high, and he has thousands of illustrations to prove it. While Marcone is the creator of mY pEt sKeLeTOn, an award-winning art website, he is also a very successful illustrator for magazines. Having designed covers and produced inserts for publications such as *Wicked, Rue Morgue* and *Computer Arts*, among others, Marcone has always been intrigued by the ghastly side of things.

"There are many storytellers in my family, and to this day I listen to them wide-eyed," says Marcone. "Fairytales are the foundation for the horror genre we experience today, which is why I continue to look for all the things that go bump in the night."

Twisted fairytale or hellish nightmare, illustrator Vincent Marcone will masterfully convey it with lead, ink, gouache or any other instrument available. This cover for Canadian magazine *Rue Morgue* was one of Marcone's first assignments in the genre of horror. Consequence or factual sidenote, the editor denotes this particular issue was among the magazine's most spectacular.

While aspiring to be a biologist, Marcone studied fine art and graphic design at the University of Waterloo, as well as Conestoga College. After developing his own style of illustration combining traditional and digital techniques, he designed mY pEt sKeLeTOn for Net users. The site was swiftly met with praise by editors, art directors and flash media lovers all over the world. Consequently, Marcone acquired his first assignment for *Wicked* magazine, in which he created a cover featuring the *Blair Witch Project*.

Marcone's signature flash skeleton world recently won a nomination for "Best Art Site" from the Flash Forward Film Festival, a television spot on *Tech TV*, and is showcased in *Motion Graphics*, a book describing innovative creations on the Internet.

Hundreds of lucrative assignments later, illustrator Alan M. Clark insists that instances evoking horror are still limitless for him, and art is the necessary communicator. For the interior of *The Dark Comedy*, written by Peter Orullian, Clark clearly created a stable of fascinating, demented characters in the tradition of *Danse Macabre* and *Phantom of the Opera*. While the image shown above is a detail of the original painting, the piece in its entirety is a 45 × 13 acrylic on board, highlighted in brilliant blue, green and red tones.

From Psychedelic Sixties to Shabby Chic: Trend-tracking Boosts Sales

BY LINDA BUTLER

Whether you're illustrating a line of greeting cards, designing decorative frames for a giftware company, or a planning a series of fine art prints, knowing about the latest design and color trends will give you the leading edge in impressing potential buyers and clients. That goes for whatever design field you're in, regardless of the current economy. Trend tracking and implementation are even more important in times when consumers are less willing to part with their money. They will be more attracted to items that are different from those they've been shown before.

Try applying a trend in one industry to a different kind of product. For instance, think of applying a comfort food concept to a line of cards, using a 1950s kitchen theme. Think of a group of inspirational single-word captions and apply them to an antique lace giftwrap paper. Use the rustic hand-chiseled Americana styling combined with teddy bears in a family situation for a picture frame design.

Here's a list of the latest design and colors trends to help you brainstorm in new directions.

Textiles and Fashion

Toile—country pattern with classical, finely detailed motifs and pastoral scenes.
Floral prints—romantic in soft pastels
Vintage fabrics—brocades, antique lace, damasks and tapestry
Animal prints—leopard, cheetah, zebra and giraffe schemes, creating the neutral color group of brown, tan and black
Tropical prints—ginger blossoms, orchids, hibiscus, bamboo, banana leaves, palms and pineapples
Geometric patterns—black & white color schemes
Metallic gold thread accents—accent of exotic prints, reflective colors
European country prints—paisleys, small cameos and Jacobean florals
Feminine peasant blouses—lace, ruffles, cotton
Sheer chiffon skirts—solid colors, femininity, sensuality
Skin-tight ensembles—vinyl, polyster, leather

Home Decor

Supersizing—bigger furniture and accessories for open, high-ceilinged "McMansions"; dramatic European-style, oversized, highly decorated furniture
Antique furniture— white painted wood with worn edges
Flooring—tile, cork, area rugs; the linoleum and shag carpet of the '60s
Picture frames—three-dimensional pewter or resin, frames covered in vintage fabrics or lace
Accessories—items such as lampshades covered in pressed or faux silk flowers
Lighter colors—gentle pastel tints

LINDA BUTLER, *formerly a stylist at Gibson Greetings and Hallmark, is a freelance illustrator/designer and writer specializing in the social expression industry.*

Fine art prints—Gaugin's paintings of Tahitian women and exotic island life, cubist style still-life collages, black & white photography (a vintage look) often hand-colored in subtle pastels, square formats, decorative borders give the appearance of a matted or framed piece

Palms—create the illusion of a relaxing tropical vacation

Natural materials—grasses, bamboo and hemp for decorative add-ons; clay, wood, frosted glass, rattan, wicker, leather, semi-precious stones

Metals—brass, chrome, bronze for statues, small touches of copper for accents

Wood—light golden tan shades, fewer dark wood tones

Textures—matte finishes, frosted glass, subtle patterns replace strong textures

Exotic places and keepsakes

Global influences—African, Tuscan, "Gypsy exotic" (inspired by the Far East, Morocco, and India), beads, charms, colored glass, faux finishes, metallic threads in fabrics, fushia, peacock blue, orange, warm, reddish brown and black accents

Oriental minimalism—the Zen of design, the celebration of simplicity for those who wish to rise above the constant assault of consumerism and the saturation of too many things; clean empty spaces, linear furniture and sculpture, subtle textures, charcoal gray, black, and white with red accents

Neo nature—tropical and Latin elements, palm fronds, tropical lushness of banana leaves, sea grass and bamboo, natural materials with woven textures, exotic woods, chiseled ceramics, vivid aquatic greens and blues, with accents of orange, hot pink, red and magenta

Byzantine—lavish golden fretwork and spirals embellished with rich emerald green, sapphire blue, deep garnet red and topaz faux cabochon jewels; the influence of oriental design on the ancient art of Constantinople

Nostalgia: images of a rosier past

Shabby chic—weathered wood showing through scratched, crackled and worn white paint, button or shell-encrusted frames, old gilt, paper-mache, antique blown-glass Christmas ornaments, Victorian angels, a taste for comfort and well-used things; fabrics that look like they've been put out in the rain, sun and open air to fade and then steeped in tea to give it a well-worn look

British psychedelic '60s—Op art, apple green, turquoise, orange, rust and brown color schemes; Generation Y, born in the 80s, loves this style—(to them, it looks new)

The romantic look—feminine, magical, comforting, whimsical, frivolous, luxurious, softness, fanciful escapist qualities, ribbons, gauzy drapes, satin pillows

Farmhouse kitchen—Victorian American country, inspired by 19th-century whimsical naive paintings of chickens, ducks, sheep, cows, and pigs; rich, warm, vibrant colors, brass and copper jelly moulds, pots, pans and kettles

High mountain lodge—comfortable masculine rugged look, outdoor accents, natural woods

1950s mid-century modern design—Generation X; halcyon era of clean, bright colors, gingham prints and florals, kitchen kitsch, futuristic aluminum rocket-shaped technology, vintage cars (the PT Cruiser), greeting cards and giftware featuring advertisements of patio barbecues, favorite childhood comfort foods like Ovaltine and Milk Duds

Medieval—fair maidens, troubadours and courtly love, illuminated manuscripts, triptychs (a painting with two hinged folding side panels), romantic characters from the Arthurian legends, Mille-fleurs tapestries, the art of John William Waterhouse (1849-1917)

English cottage garden—soft, mid-toned pastels and floral patterns of roses or Gerber daisies, herbs and well-aged garden ornaments made of worn white-washed wood and metals, copper accessories with a green patina, a broad range of popular products including decorative flags, plant markers, thermometers, birdbaths, fountains, animal sculpture, matching garden tools

Formal French style—18th century provincial, Marie Antoinette's elegant Petit Trianon ceram-

ics, delicate rose trellis designs from Limoges and Sevres-style porcelain

Arts and Crafts style—the Glasgow School, C.R. Mackintosh silver geometric grids and stylized roses

Americana—warm, rustic, cozy traditional country look, rough-hewn primitive folk art, tin, the American flag motif with a sense of history, five-pointed stars, navy, maroon and cream as a subtle use of the traditional red, white and blue, old-fashioned handmade toys, American West cowboy styling for masculine products

The passion for contemporary crafts

Illustration, graphic design and the greeting card and giftware industries are strongly influenced by fine art rubber stampers, quilt makers, creative book artists, wearables artists, doll makers, ceramists, polymer clay artists, handmade card makers, mail artists, collage artists and jewelry makers. Book and magazine publishers, gift and novelty distributors, as well as greeting card businesses, collaborate periodically to produce contemporary craft projects. Do not limit yourself by thinking that craft can't be configured into your own insignia design.

Handmade papers—flower and leaf inclusions, layered irregular torn shapes, deckled edges

Beaded fringe and tassels—on sheer fabric gift bags, lampshades, pillows, jewelry, ornaments, clothing and accessories

Collage—classical architectural and fine art engravings, torn papers, unreadable script as background pattern, mottled muted colors

TREND SURVEILLANCE

While the fusion of vintage fabrics, metals and "neo nature" may be an unlikely success, it is clearly beneficial to examine all design trends with an open mind and a gigantic notebook.

Trend tracking is a necessary skill and may be practiced in any venue from the magazine aisle in your neighborhood bookstore to the nearest high-end appliance center.

(Information compiled from Giftware News, Giftware Business, *www.giftwarebusiness.com,* Decor Magazine, *www.decormagazine.com, The Trend Curve, Gift&Dec, www.GiftsandDec.com, Color Marketing Group, www.colormarketing.org, Pantone Color Institute, Color Association of the United States, http://www.colorassociation.com and The National Candle Association)*

LIKE A FREE COPY OF THE NEXT EDITION?
ENTER OUR DRAWING!

Artist's & Graphic Designer's Market **Reader Survey**

1. Is this your first edition of *Artist's & Graphic Designer's Market?*

_____ yes _____ no

2. How often do you purchase *Artist's & Graphic Designer's Market*

_____ every year

_____ every other year

_____ every three years

_____ other: _____

3. Please describe yourself and your artwork—and how you use *AGDM.*

Which articles did you like best?

1. _____

2. _____

3. _____

Name: _____

Address: _____

City _____ State _____ Zip _____

Phone: _____ e-mail _____

Website: _____

Mail to Mary Cox, *Artist's & Graphic Designer's Market*, 4700 East Galbraith Road, Cincinnati, OH 45236, or e-mail me at artdesign@fwpubs.com. Respond by March 30, 2003. **Twenty names will be drawn from respondents to receive free copies of the next edition**.

The Markets

Greeting Cards, Gifts & Products......... 48

Magazines .. 104

Posters & Prints 238

Book Publishers 282

Galleries .. 364

Syndicates & Cartoon Features 507

Stock Illustration & Clip Art Firms 517

Advertising Design & Related Markets ... 523

Record Labels 608

Greeting Cards, Gifts & Products

Perhaps the most purchased card of all is the birthday card. If you can come up with new twists to commemorate the ever-popular occasion, you just might win over a card company and get your designs published. Here's a great birthday card by artist Thorina Rose, that plays with an art deco theme. The card was published by Colors By Design, a Van Nuys, California greeting card company that publishes all kinds of cards from Baby Shower invitations to Graduation announcements, to Christmas, Hanukkah and Halloween cards—and of course, the ever-popular birthday card.

The businesses listed in this section need images for all kinds of products: greeting cards, shopping bags, T-shirts, school supplies, personal checks, mugs, calendars—you name it. If you haven't visited this section before, you'll be amazed to discover so many opportunities for your work!

WHAT TO SUBMIT

- Do NOT send originals. Companies want to see photographs, photocopies, printed samples, computer printouts, slides or tearsheets.
- Before you make copies of your sample, render the original artwork in watercolor or gouache in the standard industry size, $4\frac{5}{8} \times 7\frac{1}{2}$ inches.
- Artwork should be upbeat, brightly colored, and appropriate to one of the major categories or niches popular in the industry.
- When creating greeting card art, leave some space at the top or bottom of the artwork, because cards often feature lettering there. Check stores to see how much space to leave. It is not necessary to add lettering, because companies often prefer to use staff artists to create lettering.
- Have photographs, photocopies or slides made of your completed artwork.
- Make sure each sample is labeled with your name, address and phone number.
- Send three to five appropriate samples of your work to the contact person named in the listing. Include a brief (one to two paragraph) cover letter with your initial mailing.
- Enclose a self-addressed stamped envelope if you need your samples back.
- Within six months, follow up with another mailing to the same listings and additional companies you have researched.

Submitting to gift & product companies

Send samples similar to those you would send to greeting card companies, only don't be concerned with leaving room at the top of the artwork for a greeting. Some companies prefer you send postcard samples or color photocopies. Check the listings for specifics.

Payment and royalties

Most card and product companies have set fees or royalty rates that they pay for design and illustration. What has recently become negotiable, however, is rights. In the past, card companies almost always demanded full rights to work, but now some are willing to negotiate for other arrangements, such as greeting card rights only. If the company has ancillary plans in mind for your work (calendars, stationery, party supplies or toys), they will probably want to buy all rights. In such cases, you may be able to bargain for higher payment.

Don't overlook the collectibles market

Limited edition collectibles—everything from Dale Earnhardt collector plates to *Wizard of Oz* ornaments—appeal to a wide audience and are a lucrative niche for artists. To do well in this field, you have to be flexible enough to take suggestions. Companies test market to find out which images will sell the best, so they will guide you in the creative process. For a collectible plate, for example, your work must fit into a circular format or you'll be asked to extend the painting out to the edge of the plate.

Popular themes for collectibles include patriotic images, Native American, wildlife, animals (especially kittens and puppies), children, religious (including madonnas and angels), stuffed animals, dolls, TV nostalgia, gardening, culinary and sports images. You can submit slides to the creative director of companies specializing in collectibles. See our collectibles index on page 664. For special insight into the market, attend one of the industry's trade shows held yearly in South Bend, Indiana; Secaucus, New Jersey; and Anaheim, California.

Sell your designs as E-cards!

Electronic greetings are permeating the Internet. The range of e-card style and content is vast, ranging from static "postcards" to those with music, animation or interactive designs. Study e-card sites and familiarize yourself with the differences in these formats.

The nature of Internet content is quick-turnaround. New designs are always in demand. Now, due to the explosion of animated e-card content, there is a growing need for freelancers who can create simple animations using Flash animation. What is Flash? Flash is a software program that turns illustrations into animated, interactive content for websites.

Some other tips for maximizing your opportunities in the world of e-card design:

• Most companies hiring designers for e-greetings will want to see links to sites where your work is showcased. If you are just beginning and have no work yet published on a site, direct them to your on-line portfolio.

• Companies often post their design needs on their websites. Explore sites that feature e-cards and look for their guidelines.

• Visit www.shockwave.com and www.todaystoon.com, to see examples of Flash animation.

To look at the range in electronic greeting cards, visit:

www.amazon.com	www.egreetings.com
www.americangreetings.com	www.globalwarming.com
www.barnesandnoble.com	www.hallmark.com
www.bluemountain.com	www.ohmygoodness.com
www.ctw.org/Sesame/ecards	www.say-it-with-ease.com
www.dayspring.com	www.sparks.com
www.ecards.com	www.yahoo.com

—Terri See

ACME GRAPHICS, INC., 201 Third Ave. SW, Box 1348, Cedar Rapids IA 52406. (319)364-0233. Fax: (319)363-6437. E-mail: jeffs@acmegraphicsinc.com. **President:** Jeff Scherrman. Estab. 1913. Produces printed merchandise used by funeral directors, such as acknowledgments, register books and prayer cards. Art guidelines free for SASE.

• Acme Graphics manufactures a line of merchandise for funeral directors. Floral subjects, religious subjects, and scenes are their most popular products.

Needs: Approached by 30 freelancers/year. Considers pen & ink, watercolor and acrylic. "We will send a copy of our catalog to show type of work we do." Art guidelines available for SASE with first-class postage. Looking for religious, church window, floral and nature art. Also uses freelancers for calligraphy and lettering.

First Contact & Terms: Designers should send query letter with résumé, photocopies, photographs, slides and transparencies. Illustrators send postcard sample or query letter with brochure, photocopies, photographs, slides and tearsheets. Accepts submissions on disk. Samples are not filed and are returned by SASE. Responds in 10 days. Call or write for appointment to show portfolio of roughs. Originals are returned. Requests work on spec before assigning a job. Pays by the project, $50 minimum or flat fee. Buys all rights.

Tips: "Send samples or prints of work from other companies. No modern art or art with figures. Some designs are too expensive to print. Learn all you can about printing production."

✓ **KURT S. ADLER INC.**, 1107 Broadway, New York NY 10010. (212)924-0900. Fax: (212)807-0575. E-mail: Adlers@kurtadler.com. Website: Kurtadler.com. **President:** Howard Adler. Estab. 1946. Produces collectible figurines, decorations, gifts, ornaments. Manufacturer and importer of Christmas ornaments and giftware products.

Greeting Card Basics

- The Greeting Card Industry is also called the "Social Expressions" industry.
- Women buy 85 to 90 percent of all cards.
- The average person receives eight birthday cards a year.
- **Seasonal cards** express greetings for holidays, like Christmas, Easter or Valentine's Day.
- **Everyday cards** express non-holiday sentiments. The "everyday" category includes get well cards, thank you cards, sympathy cards, and a growing number of person-to-person greetings. There are cards of encouragement that say "Hang in there!" and cards to congratulate couples on staying together, or even getting divorced! There are cards from "the gang at the office" and cards to beloved pets. Check the rows and rows of cards in store racks to note the many "everyday" occasion.
- **Birthday cards** are the most popular everyday cards, accounting for 60% of sales of everyday cards.
- Categories are further broken down into the following areas: **traditional**, **humorous** and "**alternative**" cards. "Alternative" cards feature quirky, sophisticated or offbeat humor.
- According to the Greeting card association, the most popular card-sending holidays are, in order:

 1. Christmas
 2. Valentine's Day
 3. Mother's Day
 4. Father's Day
 5. Graduation
 6. Thanksgiving
 7. Halloween
 8. St. Patrick's Day
 9. Jewish New Year
 10. Hannukkah
 11. Grandparent's Day
 12. Sweetest Day
 13. Passover
 14. Secretary's Day
 15. National Boss's Day
 16. April Fool's Day
 17. Nurses' Day

 ## For More Information

Greetings Etc. www.greetingsmagazine.com is the official publication of the Greeting Card Association www.greetingcard.org. Subscriptions are reasonably priced. To subscribe call (973)252-0100.

Party & Paper is a trade magazine focusing on the party niche. Visit their website at http://www.partypaper.com for industry news and subscription information.

The National Stationery Show, the "main event" of the greeting card industry, is held each May at New York City's Jacob K. Javits Center. Log on to www.nationalstationeryshow.com to learn more about that important event. Other industry events are held across the country each year. For upcoming trade show dates, check *Greetings Etc.* or *Party & Paper*.

Needs: Prefers freelancers with experience in giftware. Considers all media. Will consider all styles appropriate for Christmas ornaments and giftware. Produces material for Christmas, Easter, Halloween.
First Contact & Terms: Send query letter with brochure, photocopies, photographs. Responds within 1 month. Will contact for portfolio review if interested. Payment negotiable.
Tips: "We rely on freelance designers to give our line a fresh, new approach and innovative new ideas."

ADVANCE CELLOCARD CO., INC., 2203 Lively Blvd., Elk Grove Village IL 60007-5209. (847)437-0220. **President:** Ron Ward. Estab. 1960. Produces greeting cards.
Needs: Considers watercolor, acrylic, oil and colored pencil. Art guidelines for SASE with first-class postage. Produces material for Valentine's Day, Mother's Day, Father's Day, Easter, graduation, birthdays and everyday.

First Contact & Terms: Send query letter with brochure and SASE. Accepts disk submissions compatible with Mac formated Illustrator 5.5, Photoshop 3.0 or Power Mac QuarkXPress 3.0. Samples not filed are returned by SASE. Responds in weeks. Originals are not returned. Pays average flat fee of $75-150/design. Buys all rights.

Tips: "Send letter of introduction, and samples or photostats of artwork."

ALASKA MOMMA, INC., 303 Fifth Ave., New York NY 10016. (212)679-4404. Fax: (212)696-1340. E-mail: licensing@alaskamomma.com. **President, licensing:** Shirley Henschel. "We are a licensing company representing artists, illustrators, designers and established characters. We ourselves do not buy artwork. We act as a licensing agent for the artist. We license artwork and design concepts such as wildlife, florals, art deco and tropical to toy, clothing, giftware, textiles, stationery and housewares manufacturers and publishers."

Needs: "We are looking for people whose work can be developed into dimensional products. An artist must have a distinctive and unique style that a manufacturer can't get from his own art department. We need art that can be applied to products such as posters, cards, puzzles, albums, bath accessories, figurines, calendars, etc. No cartoon art, no abstract art, no b&w art."

First Contact & Terms: "Artists may submit work in any form as long as it is a fair representation of their style." Prefers to see several multiple color samples in a mailable size. No originals. "We are interested in artists whose work is suitable for a licensing program. We do not want to see b&w art drawings. What we need to see are transparencies or color photographs or color photocopies of finished art. We need to see a consistent style in a fairly extensive package of art. Otherwise, we don't really have a feeling for what the artist can do. The artist should think about products and determine if the submitted material is suitable for licensed product. Please send SASE so the samples can be returned. We work on royalties that run from 5-10% from our licensees. We require an advance against royalties from all customers. Earned royalties depend on whether the products sell."

Tips: "Publishers of greeting cards and paper products have become interested in more traditional and conservative styles. There is less of a market for novelty and cartoon art. We need artists more than ever as we especially need fresh talent in a difficult market. Look at product! Know what companies are willing to license."

ALLPORT EDITIONS, 2337 NW York, Portland OR 97210-2112. (503)223-7268. Fax: (503)223-9182. E-mail: info@allport.com. Website: www.allport.com. **Contact:** Creative Director. Estab. 1983. Produces greeting cards and stationery. Specializes in greeting cards: fine art, humor, some photography, florals, animals and collage.

Needs: Approached by 100 freelancers/year. Works with 10 freelancers/year. Buys 40 freelance designs and illustrations/year. Art guidelines available on website. Uses freelancers mainly for art for cards. Also for final art. Prefers art scaleable to card size. Produces material for all holidays and seasons, birthdays and everyday. Submit seasonal material 1 year in advance.

First Contact & Terms: Illustrators and cartoonists send query letter with photocopies, photographs, photostats, tearsheets and SASE. Accepts submissions on disk compatible with PC-formatted EPS files with PC Preview or Quark document. Samples are filed or returned by SASE. Responds in 3 months. Portfolio review not required. Rights purchased vary according to project. Pays for illustration by the project. Finds freelancers through artists' submissions and stationery show in New York.

Tips: "Get my attention on the envelope."

AMBERLEY GREETING CARD CO., 11510 Goldcoast Dr., Cincinnati OH 45249-1695. (513)489-2775. Fax: (513)489-2857. Website: www.amberleygreeting.com. **Contact:** Art Director. Estab. 1966. Produces greeting cards. "We are a multi-line company directed toward all ages. We publish conventional as well as humorous cards."

Needs: Approached by 20 freelancers/year. Works with 10 freelancers/year. Buys 250 illustrations/year. Works on assignment only. Considers any media.

First Contact & Terms: Send query letter with nonreturnable sample or color photocopies. Calligraphers send photocopies of lettering styles. Samples are filed. Responds only if interested. Pays illustration flat fee $75-125; pays calligraphy flat fee $20-30. Buys all rights.

Tips: "Send appropriate materials. Go to a card store or supermarket and study the greeting cards. Look at what makes card art different than a lot of other illustration. Caption room, cliché scenes, "cute" animals, colors, etc. Research publishers and send appropriate art! I wish artists would not send a greeting card publisher art that looks unlike any card they've ever seen on display anywhere."

AMCAL INC., 2500 Bisso Lane, Bldg. 500, Concord CA 94520. (925)689-9930. Fax: (925)689-0108. Website: www.amcalart.com. Publishes calendars, notecards, Christmas cards and other book and stationery items. "Markets to a broad distribution channel, including better gifts, book and department stores through-

out U.S. Some sales to Europe, Canada and Japan. We look for illustration and design that can be used many ways—calendars, note cards, address books and more, so we can develop a collection. We license art that appeals to a widely female audience." No gag humor or cartoons.

Needs: Needs freelancers for design and production. Prefers work in horizontal format. Art guidelines for SASE with first-class postage, on our website or "you can call and request."

First Contact & Terms: Designers send query letter with brochure, résumé and SASE. Illustrators send query letter with brochure, résumé, photographs, SASE, slides, tearsheets and transparencies. Include a SASE for return of submission. Responds within 6 weeks. Will contact artist for portfolio review if interested. Pays for illustration by the project, advance against royalty.

Tips: "Research what is selling and what's not. Go to gift shows and visit lots of stationery stores. Read all the trade magazines. Talk to store owners."

▨ AMERICAN GREETINGS CORPORATION, One American Rd., Cleveland OH 44144. (216)252-7300. E-mail: jim.hicks@amgreetings.com. Website: www.amgreetings.com. **Director of Creative Recruitment:** James E. Hicks. Estab. 1906. Produces greeting cards, stationery, calendars, paper tableware products, giftwrap and ornaments—"a complete line of social expressions products."

Needs: Prefers artists with experience in illustration, decorative design and calligraphy. Usually works from a list of 100 active freelancers. Guidelines available for SASE.

First Contact & Terms: Send query letter with résumé. "Do not send samples." Pays $200 and up based on complexity of design. Does not offer royalties.

Tips: ''Get a BFA in Graphic Design with a strong emphasis on typography."

▨ AMERICAN TRADITIONAL STENCILS, 442 First New Hampshire Turnpike, Northwood NH 03261. (603)942-8100. Fax: (603)942-8919. E-mail: judy@americantraditional.com. Website: www.americ antraditional.com. **Owner:** Judith Barker. Estab. 1970. Manufacturer of brass, platinum and laser cut stencils. Clients: retail craft, art and gift shops. Current clients include Michael's Arts & Crafts, Old Sturbridge and Pfaltzgraph Co., JoAnn's Fabrics and some Ben Franklin stores.

Needs: Approached by 1-2 freelancers/year. Works with 1 freelance illustrator/year. Assigns 2 freelance jobs/year. Prefers freelancers with experience in graphics. Art guidelines not available. Works on assignment only. Uses freelancers mainly for stencils. Also for ad illustration and product design. Prefers b&w camera-ready art.

First Contact & Terms: Send query letter with brochure showing art style and photocopies. Samples are filed or are returned. Responds in 2 weeks. Call for appointment to show portfolio of roughs, original/final art and b&w tearsheets. Pays for design by the hour, $8.50-20; by the project, $15-150. Pays for illustration by the hour, $10-15. Rights purchased vary according to project.

Tips: "Join the Society of Craft Designers—great way to portfolio designs for the craft industry. Try juried art and craft shows—great way to see if your art sells."

☑ AMSCAN INC., 80 Grasslands Rd., Elmsford NY 10523. (914)345-2020. Fax: (914)345-8431. **Art Director:** Laurie Cole. Estab. 1954. Designs and manufactures paper party goods. Extensive line includes paper tableware, invitations, giftwrap and bags, decorations. Complete range of party themes for all ages, all seasons and all holidays. Features a gift line which includes baby hard and soft goods, wedding giftware, and home decorative and tabletop products. Seasonal giftware also included.

Needs: "Ever-expanding department with incredible appetite for fresh design and illustration. Subject matter varies from baby, juvenile, floral, type-driven and graphics. Designing is accomplished both in the traditional way by hand (i.e., painting) or on the computer using a variety of programs like FreeHand, Illustrator, Painter and Photoshop."

First Contact & Terms: "Send samples or copies of artwork to show us range of illustration styles. If artwork is appropriate, we will pursue." Pays by the project $300-3,500 for illustration and design.

☑ APPLEJACK LICENSING INTERNATIONAL, Box 1527, Historic Route 7A, Manchester Center VT 05255. (802)362-3662. Fax: (802)362-0370. E-mail: paul@applejackart.com. Website: www.applejack art.com. **Art Director:** Michael Katz. Vice President: Paul Wheeler. (Division Applejack Art Partners). Licenses art for balloons, bookmarks, calendars, CD-ROMs, collectible figurines, decorative housewares,

▨ MARKETS NEW TO THIS EDITION

decorations, games, giftbags, gifts, giftwrap, greeting cards, limited edition plates, mugs, ornaments, paper tableware, party supplies, personal checks, posters, prints, school supplies, stationery, T-shirts, textiles, toys, wallpaper, etc.

Needs: Approached by hundreds of freelancers/year. Works with 50-100 freelancers/year. Art guidelines free for SASE with first class postage. Considers all media and all styles. Prefers final art under 24×36, but not required. Produces material for all holidays. Submit seasonal material 6 months in advance.

First Contact & Terms: Designers send brochure, photocopies, photographs, slides, tearsheets, transparencies, CD ROM and SASE. Illustrators send query letter with photocopies, photographs, photostats, transparencies, tearsheets, résumé and SASE. Send follow-up postcard every 3 months. No e-mail submissions. Accepts disk submissions compatible with Photoshop, Quark or Illustrator. Samples are filed or returned by SASE. Responds in 1 month. Will contact artist for portfolio review if interested. Portfolio should include color final art, photographs, photostats, roughs, slides, tearsheets. Buys all rights.

AR-EN PARTY PRINTERS, INC., 3775 W. Arthur, Lincolnwood IL 60712. (847)673-7390. Fax: (847)673-7379. E-mail: ar-en@voyager.net. Website: ar-en.com. **Owner:** Gary Morrison. Estab. 1978. Produces stationery and paper tableware products. Makes personalized party accessories for weddings and all other affairs and special events.

Needs: Works with 2 freelancers/year. Buys 10 freelance designs and illustrations/year. Art guidelines not available. Works on assignment only. Uses freelancers mainly for new designs. Also for calligraphy. Looking for contemporary and stylish designs, especially b&w line art, no grey scale, to use for hot stamping dyes. Prefers small (2×2) format.

First Contact & Terms: Send query letter with brochure, résumé and SASE. Samples are filed or returned by SASE if requested by artist. Responds in 2 weeks. Company will contact artist for portfolio review if interested. Rights purchased vary according to project. Pays by the hour, $60 minimum; by the project, $1,000 minimum.

Tips: "My best new ideas always evolve from something I see that turns me on. Do you have an idea/ style that you love? Market it. Someone out there needs it."

ARTFUL GREETINGS, P.O. Box 52428, Durham NC 27717. (919)598-7599. Fax: (919)598-8909. E-mail: myw@artfulgreetings.com. Website: www.artfulgreetings.com. **Vice President of Operations:** Marian WhittedAlderman. Estab. 1990. Produces bookmarks, greeting cards, T-shirts and prints. Specializes in multicultural subject matter, all ages.

Needs: Approached by 75 freelancers/year. Works with 10 freelancers/year. Buys 20 freelance designs and illustrations/year. No b&w art. Pastel chalk media does not reproduce as bright enough color for us. Uses freelancers mainly for cards. Considers bright color art, no photographs. Looking for art depicting people of all races. Prefers a multiple of 2 sizes: 5×7 and 5½×8. Produces material for Christmas, Mother's Day, Father's Day, graduation, Kwanzaa, Valentine's Day, birthdays, everyday, sympathy, get well, romantic, thank you, woman-to-woman and multicultural. Submit seasonal material 1 year in advance.

First Contact & Terms: Designers send photocopies, SASE, transparencies (call first). Illustrators send photocopies (call first). Samples are filed. Artist should follow up with call or letter after initial query. Will contact for portfolio review of color slides and transparencies if interested. Negotiates rights purchased. Pays for illustration by the project $50-100. Finds freelancers through word of mouth, NY Stationery Show.

Tips: "Don't sell your one, recognizable style to all the multicultural card companies."

N: THE ASHTON-DRAKE GALLERIES, 9200 N. Maryland Ave., Niles IL 60714. (847)581-8107. E-mail: aship@bradfordexchange.com. Website: www.collectiblestoday.com. **Senior Manager of Artists' Relations and Recruitment:** Andrea Ship. Estab. 1985. Direct response marketer of collectible dolls, ornaments and figurines. Clients: consumers, mostly women of all age groups.

Needs: Approached by 300 freelance artists/year. Works with 250 freelance doll artists, sculptors, costume designers and illustrators/year. Works on assignment only. Uses freelancers for illustration, wigmaking, porcelain decorating, shoemaking, costuming and prop making. Prior experience in giftware design and doll design a plus. Subject matter includes babies, toddlers, children, brides and fashion. Prefers "cute, realistic and natural human features."

First Contact & Terms: Send or e-mail query letter with résumé and copies of samples to be kept on file. Prefers photographs, tearsheets or photostats as samples. Samples not filed are returned. Responds in 1 month. Compensation by project varies. Concept illustrations are done "on spec." Sculptors receive contract for length of series on royalty basis with guaranteed advances.

Tips: "Please make sure we're appropriate for you. Visit our website before sending samples!"

✓ FREDERICK BECK ORIGINALS, 27 E. Housatonic, Pittsfield MA 01201. (413)443-0973. Fax: (413)445-5014. **Art Director:** Mark Brown. Estab. 1953. Produces silk screen printed Christmas cards, traditional to contemporary.

• This company is under the same umbrella as Editions Limited and Gene Bliley Stationery. One submission will be seen by all companies, so there is no need to send three mailings. Frederick Beck and Editions Limited designs are a little more high end than Gene Bliley designs. The cards are sold through stationery and party stores, where the customer browses through thick binders to order cards, stationery or invitations imprinted with customer's name. Though some of the same cards are repeated or rotated each year, all companies are always looking for fresh images. Frederick Beck and Gene Bliley's sales offices are still in North Hollywood, CA, but art director works from Pittsfield office.

☑ **BEISTLE COMPANY**, 1 Beistle Plaza, Box 10, Shippensburg PA 17257-9623. (717)532-2131. Fax: (717)532-7789. E-mail: beistle@cvn.net; Website: www.beistle.com. **Product Manager:** C.M. Luhrs-Wiest. Art Director: Rick Buterbaugh. Estab. 1900. Manufacturer of paper and plastic decorations, party goods, gift items, tableware and greeting cards. Targets general public, home consumers through P-O-P displays, specialty advertising, school market and other party good suppliers.
Needs: Approached by 250-300 freelancers/year. Works with 50 freelancers/year. Prefers artists with experience in designer gouache illustration. Also needs digital art (Macintosh platform or compatible). Art guidelines available. Looks for full-color, camera-ready artwork for separation and offset reproduction. Works on assignment only. Uses freelance artists mainly for product rendering and brochure design and layout. Prefers designer gouache and airbrush technique for poster style artwork. 50% of freelance design and 50% of illustration demand knowledge of QuarkXPress, Illustrator, Photoshop or Painter. Also uses freelance sculptors.
First Contact & Terms: Send query letter with résumé and color reproductions with SASE. Samples are filed or returned by SASE. Art director will contact artist for portfolio review if interested. Sometimes requests work on spec before assigning a job. Pays by the project. Considers buying second rights (reprint rights) to previously published work. Finds artists through word of mouth, magazines, submissions/self-promotions, sourcebooks, agents, visiting artists' exhibitions, art fairs and artists' reps.
Tips: "Our primary interest is in illustration; often we receive freelance propositions for graphic design—brochures, logos, catalogs, etc. These are not of interest to us as we are manufacturers of printed decorations. Send color samples rather than b&w."

N: BEPUZZLED/UNIVERSITY GAMES, 2030 Harrison St., San Francisco CA 94110. (415)503-1600. Fax: (415)503-0085. **Creative Services Manager:** Susan King. Estab. 1986. Produces games and puzzles for children and adults. "Bepuzzled mystery jigsaw games challenge players to solve an original whodunit thriller by matching clues in the mystery with visual clues revealed in the puzzle."
Needs: Works with 20 freelance artists/year. Buys 20-40 designs and illustrations/year. Prefers local artists with experience in children's book and adult book illustration. Uses freelancers mainly for box cover art, puzzle images and character portraits. All illustrations are done to spec. Considers many media.
First Contact & Terms: Send query letter with brochure, résumé, tearsheets or other nonreturnable samples. Samples are filed. Art director will contact artist for portfolio review if interested. Portfolio should include original/final art and photographs. Original artwork is returned at the job's completion. Sometimes requests work on spec before assigning a job. Pays by the project, $300-3,000. Finds artists through word of mouth, magazines, submissions, sourcebooks, agents, galleries, reps, etc.

N: BERGQUIST IMPORTS, INC., 1412 Hwy. 33 S., Cloquet MN 55720. (218)879-3343. Fax: (218)879-0010. E-mail: bbergqu106@aol.com. Website: www.bergquistimports.com. **President:** Barry Bergquist. Estab. 1948. Produces paper napkins, mugs and tile. Wholesaler of mugs, decorator tile, plates and dinnerware.
Needs: Approached by 5 freelancers/year. Works with 5 freelancers/year. Buys 50 designs and illustrations/year. Prefers freelancers with experience in Scandinavian and wildlife designs. Works on assignment only. Also uses freelancers for calligraphy. Produces material for Christmas, Valentine's Day and everyday. Submit seasonal material 6-8 months in advance.
First Contact & Terms: Send query letter with brochure, tearsheets and photographs. Samples are not filed and are returned. Responds in 2 months. Request portfolio review in original query. Artist should follow up with a letter after initial query. Portfolio should include roughs, color tearsheets and photographs. Rights purchased vary according to project. Originals are returned at job's completion. Requests work on spec before assigning a job. Pays by the project, $50-300; average flat fee of $100 for illustration/design; or royalties of 5%. Finds artists through word of mouth, submissions/self-promotions and art fairs.

☑ **GENE BLILEY STATIONERY**, 27 E. Housatonic, Pittsfield MA 01201-0989. (413)443-0973. Fax: (413)445-5014. **Art Director:** Mark Brown. General Manager: Gary Lainer. Sales Manager: Ron Pardo. Estab. 1967. Produces stationery, family-oriented birth announcements and invitations for most events and Christmas cards.

● This company also owns Editions Limited and Frederick Beck Originals. One submission will be seen by both companies. See listing for Editions Limited/Frederick Beck.

BLOOMIN' FLOWER CARDS, 4734 Pearl St., Boulder CO 80301. (800)894-9185. Fax: (303)545-5273. **President:** Don Martin. Estab. 1995. Produces greeting cards, stationery and gift tags.
Needs: Approached by 50-100 freelancers/year. Works with 12-15 freelancers/year. Buys 20-30 freelance designs and illustrations/year. Art guidelines available. Uses freelancers mainly for card images. Considers all media. Looking for florals, garden scenes, herbs, peppers, vegetables, holiday florals, birds, and butterflies—bright colors, no photography. Produces material for Christmas, Easter, Mother's Day, Father's Day, Valentine's Day, Earth Day, birthdays, everyday, get well, romantic and thank you. Submit seasonal material 8 months in advance.
First Contact & Terms: Designers send query letter with slides, transparencies, photocopies, photographs and SASE. Illustrators send postcard sample of work, photocopies and photographs. Samples are filed or returned with letter if not interested. Responds if interested. Portfolio review not required. Rights purchased vary according to project. Pays royalties for design. Pays by the project or royalties for illustration. Finds freelancers through word of mouth, submissions, and local artists' guild.

N BLUE SKY PUBLISHING, 6395 Gunpark Dr., Suite M, Boulder CO 80301. (303)530-4654. Fax: (303)530-4627. **Contact:** Helen McRae. Estab. 1989. Produces greeting cards. "At Blue Sky Publishing, we are committed to producing contemporary fine art greeting cards that communicate reverence for nature and all creatures of the earth, that express the powerful life-affirming themes of love, nurturing and healing, and that share different cultural perspectives and traditions, while maintaining the integrity of our artists' work."
● Only considers submissions from January through first two weeks in April.
Needs: Approached by 500 freelancers/year. Works with 3 freelancers/year. Licenses 80 fine art pieces/year. Works with freelancers from all over US. Prefers freelancers with experience in fine art media: oils, oil pastels, acrylics, calligraphy, vibrant watercolor and fine art photography. Art guidelines available for SASE. "We primarily license existing pieces of art or photography. We rarely commission work." Looking for colorful, contemporary images with strong emotional impact. Art guidelines for SASE with first-class postage. Produces cards for all occasions. Submit seasonal material 1 year in advance.
First Contact & Terms: Send query letter with SASE, slides or transparencies. Samples are filed or returned if SASE is provided. Responds in 4 months if interested. Transparencies are returned at job's completion. Pays royalties of 3% with a $150 advance per image. Buys greeting-card rights for 5 years (standard contract; sometimes negotiated).
Tips: "We're interested in seeing artwork with strong emotional impact. Holiday cards are what we produce in biggest volume. We are looking for joyful images, cards dealing with relationships, especially between men and women, with pets, with Mother Nature and folk art. Vibrant colors are important."

N THE BRADFORD EXCHANGE, 9333 Milwaukee Ave., Niles IL 60714. (847)581-8015. Fax: (847)581-8770. **Department Product Development Manager:** Leslie Clay. Estab. 1973. Produces and markets collectible plates. "Bradford produces limited edition collectors plates featuring various artists' work which is reproduced on the porcelain surface. Each series of 6-8 plates is centered around a concept, rendered by one artist, and marketed internationally."
Needs: Approached by thousands of freelancers/year. Works with approximately 100 freelancers/year. Prefers artists with experience in rendering painterly, realistic, "finished" scenes; best mediums are oil and acrylic. Art guidelines by calling (847)581-8671. Uses freelancers for all work including border designs, sculpture. Considers oils, watercolor, acrylic and sculpture. Traditional representational style is best, depicting scenes of children, pets, wildlife, homes, religious subjects, fantasy art, florals or songbirds in idealized settings. Produces material for all occasions. Submit seasonal material 6-9 months in advance.
First Contact & Terms: Designers send brochure, transparencies, tearsheets, photographs, photocopies or slides. Illustrators and sculptors send query letter with photocopies, photographs, SASE, slides, tearsheets or transparencies. Samples are filed and are not returned. Art Director will contact artist only if interested. Originals are returned at job's completion. Pays by project. Pays royalties. Rights purchased vary according to project.

BRAZEN IMAGES, INC., 269 Chatterton Pkwy., White Plains NY 10606-2013. (914)949-2605. Fax: (914)683-7927. Website: www.brazenimages.com. **President/Art Director:** Kurt Abraham. Estab. 1981. Produces comedic adult greeting cards and postcards. "We produce cards that lean towards adult-oriented humorous/erotic art cartoons and photography. We buy stock and give assignments on occasions."
Needs: Approached by 500 freelancers/year. Works with 10 freelancers/year. Buys 10-30 freelance designs and illustrations/year. Considers any media "I don't want to limit the options." Looking for material for Christmas, Valentine's Day, Hanukkah, Halloween, birthdays, everyday and weddings.

First Contact & Terms: Send query letter with photographs, slides, SASE and transparencies. Samples are filed or returned by SASE if requested by artist. Material sent without SASE becomes the property of Brazen Images, Inc. Responds ASAP depending on workload. Company will contact artist for portfolio review if interested. Portfolio should include final art, photographs, slides and transparencies. Buys one-time rights. Originals are returned at job's completion. Pays royalties of 2%. Finds artists through artists' submissions.

Tips: "Pretend you are actually producing cards and create a Christmas card, Valentine's card, birthday and wedding card as your submissions."

BRILLIANT ENTERPRISES, 117 W. Valerio St., Santa Barbara CA 93101. **Art Director:** Ashleigh Brilliant. Publishes postcards.

Needs: Buys up to 300 designs/year. Freelancers may submit designs for word-and-picture postcards, illustrated with line drawings.

First Contact & Terms: Submit 5½×3½ horizontal b&w line drawings and SASE. Responds in 2 weeks. Buys all rights. "Since our approach is very offbeat, it is essential that freelancers first study our line. Ashleigh Brilliant's books include *I May Not Be Totally Perfect, But Parts of Me Are Excellent*; *Appreciate Me Now and Avoid the Rush*; and *I Want to Reach Your Mind, Where Is It Currently Located?* "We supply a catalog and sample set of cards for $2 plus SASE." Pays $60 minimum, depending on "the going rate" for camera-ready word-and-picture design.

Tips: "Since our product is highly unusual, familiarize yourself with it by sending for our catalog. Otherwise, you will just be wasting our time and yours."

BRISTOL GIFT CO., INC., P.O. Box 425, 6 North St., Washingtonville NY 10992. (914)496-2821. Fax: (914)496-2859. E-mail: bristol6@ny.frontiercomm.net. Website: www.bristolgift.com. **President:** Matt Ropiecki. Estab. 1988. Produces posters and framed pictures for inspiration and religious markets.

Needs: Approached by 5-10 freelancers/year. Art guidelines available for SASE. Works with 2 freelancers/year. Buys 15-30 freelance designs and illustrations/year. Works on assignment only. Uses freelancers mainly for design. Also for calligraphy, P-O-P displays, web design and mechanicals. Prefers 16×20 or smaller. 10% of design and 60% of illustration require knowledge of PageMaker or Illustrator. Produces material for Christmas, Mother's Day, Father's Day and graduation. Submit seasonal material 6 months in advance.

First Contact & Terms: Send query letter with brochure and photocopies. Samples are filed or are returned. Responds in 2 weeks. Company will contact artist for portfolio review if interested. Portfolio should include roughs. Requests work on spec before assigning a job. Originals are not returned. Pays by the project $30-50 or royalties of 5-10%. Rights purchased vary according to project. Interested in buying second rights (reprint rights) to previously published artwork.

BRUSH DANCE INC., 1 Simms St., San Rafael CA 94901. (800)531-7445, (415)259-0900. Fax: (415)259-0905. E-mail: jmalen@brushdance.com. Website: www.brushdance.com. **President:** Johanna Malen. Estab. 1989. Produces greeting cards, e-cards, calendars, postercards, candles, bookmarks, blank journal books and magnets. "Brush Dance creates products that help people express their deepest feelings and intentions. We combine humor, heartfelt sayings and inspirational writings with exceptional art."

Needs: Approached by 200 freelancers/year. Works with 5 freelancers/year. Art guidelines for 9×11 SASE with $1.50 postage. Uses freelancers mainly for illustration and calligraphy. Looking for non-traditional work conveying emotion or message. Prefers 5×7 or 7×5 originals or designs that can easily be reduced or enlarged to these proportions. Produces material for all occasions.

First Contact & Terms: Call or write for artist guidelines before submitting. Send query letter and hard copy samples of your work, 35mm slides, transparencies or color copies. *Never send originals.* Samples are filed or returned by SASE. Responds only if interested. Buys all rights. Originals are returned at job's completion. Pays royalty of 5-7.5% depending on product. Finds artists through word of mouth, submissions, art shows.

Tips: "Be sure to include self-addressed returned mailer with appropriate postage securely attached."

BURGOYNE, INC., 2030 E. Byberry Rd., Philadelphia PA 19116. (215)677-8000. Fax: (215)673-0828. E-mail: artists@burgoyne-cards.com. Website: burgoyne-cards.com. **Contact:** Art Dept. Estab. 1907. Produces greeting cards. Publishes Christmas greeting cards geared towards all age groups. Style ranges from traditional to contemporary to old masters' religious.

Needs: Approached by 150 freelancers/year. Works with 25 freelancers/year. Buys 50 designs and illustrations/year. Prefers freelancers with experience in all styles and techniques of greeting card design. Art guidelines available free for SASE with first-class postage. Uses freelancers mainly for Christmas illustrations. Also for lettering/typestyle work. Considers watercolor and pen & ink. Produces material for Christmas. Accepts work all year round.

First Contact & Terms: Send query letter with slides, tearsheets, transparencies, photographs, photocopies and SASE. Samples are filed. Creative director will contact artist for portfolio review if interested. Pays flat fee. Buys first rights or all rights. Sometimes requests work on spec before assigning a job. Interested in buying second rights (reprint rights) to previously published work, first rights or all rights.

Tips: "Send us fewer samples. Sometimes packages are too lengthy. It is better to send one style that is done very well than to send a lot of different styles that aren't as good. Also, please remember to send a SASE."

CAPE SHORE, INC., division of Downeast Concepts, 86 Downeast Dr., Yarmouth ME 04096. (207)846-3726. E-mail: capeshore@downeastconcepts.com. **Creative Director, licensing:** Melody Martin. Estab. 1947. "Cape Shore is concerned with seeking, manufacturing and distributing a quality line of gifts and stationery for the souvenir and gift market." Licenses art by noted illustrators with a track record for paper products and giftware.

Needs: Approached by 100 freelancers/year. Works with 50 freelancers/year. Buys 400 freelance designs and illustrations/year. Prefers artists and product designers with experience in gift product, hanging ornament and stationery markets. Art guidelines available free for SASE. Uses freelance illustration for boxed note cards, Christmas cards, ornaments, ceramics and other paper products. Considers all media. Looking for skilled wood carvers with a warm, endearing folk art style for holiday gift products.

First Contact & Terms: "Do not telephone; no exceptions." Send query letter with color copies and slides. Samples are filed or are returned by SASE. Art director will contact artist for portfolio review if interested. Portfolio should include slides, finished samples, printed samples. Pays for design by the project, advance on royalties or negotiable flat fee. Buys varying rights according to project.

Tips: "Cape Shore is looking for realistic detail, good technique, and traditional themes or very high quality contemporary looks for coastal as well as inland markets. We will sometimes buy art for a full line of products, or we may buy art for a single note or gift item. Proven success in the giftware field a plus, but will consider new talent and exceptional unpublished illustrators."

CARDMAKERS, Box 236, High Bridge Rd., Lyme NH 03768. Phone/fax: (603)795-4422. Fax: (603)795-4222. Website: www.cardmakers.com. **Principal:** Peter Diebold. Estab. 1978. Produces greeting cards. "We produce special cards for special interests and greeting cards for businesses—primarily Christmas. We have now expanded our Christmas line to include 'photo mount' designs, added designs to our everyday line for stockbrokers and have recently launched a new everyday line for boaters."

Needs: Approached by more than 300 freelancers/year. Works with 5-10 freelancers/year. Buys 20-40 designs and illustrations/year. Prefers professional-caliber artists. Art guidelines available on website or for SASE with first-class postage. Please do not e-mail us for same. Works on assignment only. Uses freelancers mainly for greeting card design, calligraphy and mechanicals. Also for paste-up. Considers all media. "We market 5×7 cards designed to appeal to individual's specific interest—boating, building, cycling, stocks and bonds, etc." Prefers an upscale look. Submit seasonal ideas 6-9 months in advance.

First Contact & Terms: Designers send query letter with SASE and brief sample of work. Illustrators send postcard sample or query letter with brief sample of work. "One good sample of work is enough for us. A return postcard with boxes to check off is wonderful. Phone calls are out; fax is a bad idea." Samples are filed or are returned by SASE. Responds only if interested unless with SASE. Portfolio review not required. Pays flat fee of $100-300 depending on many variables. Rights purchased vary according to project. Interested in buying second rights (reprint rights) to previously published work, if not previously used for greeting cards. Finds artists through word of mouth, exhibitions and *Artist's & Graphic Designer's Market* submissions.

Tips: "We like to see new work in the early part of the year. It's important that you show us samples *before* requesting submission requirements. Getting published and gaining experience should be the main objective of freelancers entering the field. We favor fresh talent (but do also feature seasoned talent). PLEASE be patient waiting to hear from us! Make sure your work is equal to or better than that which is commonly found in use presently. Go to a large greeting card store. If you think you're as good or better than the artists there, continue!"

CAROLE JOY CREATIONS, INC., 6 Production Dr., #1, Brookfield CT 06804. Fax: (203)740-4495. Website: www.carolejoy.com. **President:** Carole Gellineau. Estab. 1986. Produces greeting cards. Specializes in cards, notes and invitations by and for people who share an African heritage.

Needs: Approached by 200 freelancers/year. Works with 5-10 freelancers/year. Buys 100 freelance designs, illustrations and calligraphy/year. Prefers artists "who are thoroughly familiar with, educated in and sensitive to the African-American culture." Art guidelines available. Works on assignment only. Uses freelancers mainly for greeting card art. Also for calligraphy. Considers full color only. Looking for realistic, traditional, Afrocentric, colorful and upbeat style. Prefers 11×14. 20% freelance design work demands knowledge of Illustrator, Photoshop and QuarkXPress. Also produces material for Christmas, Easter, Moth-

In this greeting card depicting how fun and adventurous boating can be—even during Christmastime—illustrator Meg McLean proves that creativity is defined by the artist's unique vision, no matter how specific the assignment is. "Meg is particularly adept at translating our ideas," says Peter Diebold, co-owner of CardMakers. "She sketches them into very marketable greeting card designs with a minimum of direction from us."

er's Day, Father's Day, graduation, Kwanzaa, Valentine's Day, birthdays and everyday. Also for sympathy, get well, romantic, thank you, serious illness and multicultural cards. Submit seasonal material 1 year in advance.

First Contact & Terms: Send query letter with brochure, photocopies, photographs and SASE. No phone calls or slides. No e-mail addresses. Responds to street address only. Calligraphers send samples and compensation requirements. Samples are not filed and are returned with SASE only. Responds only if interested. Portfolio review not required. Buys all rights. Pays for illustration by the project.

Tips: "Excellent illustration skills are necessary and designs should be appropriate for African-American social expression. Writers should send verse that is appropriate for greeting cards and avoid lengthy, personal experiences. Verse and art should be uplifting."

CASE STATIONERY CO., INC., 179 Saw Mill River Rd., Yonkers NY 10701-6616. (914)965-5100. Fax: (914)965-2362. E-mail: case@casestationery.com. Website: www.casestationery.com. **President:** Jerome Sudnow. Vice President: Joyce Blackwood. Estab. 1954. Produces stationery, notes, memo pads and tins for mass merchandisers in stationery and housewares departments.

Needs: Approached by 10 freelancers/year. Buys 50 designs from freelancers/year. Works on assignment only. Buys design and/or illustration mainly for stationery products. Uses freelancers for mechanicals and ideas. Produces materials for Christmas; submit 6 months in advance. Likes to see youthful and traditional styles, as well as English and French country themes. 10% of freelance work requires computer skills.

First Contact & Terms: Send query letter with résumé and tearsheets, photostats, photocopies, slides and photographs. Samples not filed are returned. Responds ASAP. Call or write for appointment to show a portfolio. Original artwork is not returned. Pays by the project. Buys first rights or one-time rights.

Tips: "Find out what we do. Get to know us. We are creative and know how to sell a product."

☑ **H. GEORGE CASPARI, INC.**, 116 E. 27th St., New York NY 10016. (212)685-9798. **Contact:** Lucille Andriola. Publishes greeting cards, Christmas cards, invitations, giftwrap and paper napkins. "The line maintains a very traditional theme."

Needs: Buys 80-100 illustrations/year. Prefers watercolor and other color media. Produces seasonal material for Christmas, Mother's Day, Father's Day, Easter and Valentine's Day.

First Contact & Terms: Send samples to Lucille Andriola to review. Prefers unpublished original illustrations, slides or transparencies. Art director will contact artist for portfolio review if interested. **Pays on acceptance**; negotiable. Pays flat fee of $400 for design. Finds artists through word of mouth, magazines, submissions/self-promotions, sourcebooks, agents, visiting artist's exhibitions, art fairs and artists' reps.

Tips: "Caspari and many other small companies rely on freelance artists to give the line a fresh, overall style rather than relying on one artist. We feel this is a strong point of our company. Please do not send verses."

CATCH PUBLISHING, INC., 456 Penn St., Yeadon PA 19050. (610)626-7770. Fax: (610)626-2778. **Contact:** Michael Markowicz. Produces greeting cards, stationery, giftwrap, blank books, posters and calendars.

Needs: Approached by 200 freelancers/year. Works with 5-10 freelancers/year. Buys 25-50 freelance designs and illustrations/year. Art guidelines for SASE with first-class postage. Uses freelancers mainly for design. Considers all media. Produces material for Christmas, New Year and everyday. Submit seasonal material 1 year in advance.

First Contact & Terms: Send query letter with brochure, tearsheets, résumé, slides, computer disks and SASE. Samples are not filed and are returned by SASE if requested by artist. Responds in 6 months. Company will contact artist for portfolio review if interested. Portfolio should include final art, slides or large format transparencies. Rights purchased vary according to project. Originals are returned at job's completion. Pays royalties of 10-12% (may vary according to job).

⦂N⦂ CEDCO PUBLISHING CO., 100 Pelican Way., San Rafael CA 94901. E-mail: licensing@cedco.com. Website: www.cedco.com. **Contact:** Licensing Department. Estab. 1982. Produces 215 upscale calendars and books.

Needs: Approached by 500 freelancers/year. Art guidelines on website. "We never give assignment work." Uses freelancers mainly for stock material and ideas. "We use either 35mm slides or 4×5s of the work."

First Contact & Terms: "No phone calls accepted." Send query letter with nonreturnable photocopies and tearsheets. Samples are filed. Also send list of places where your work has been published. Responds only if interested. To show portfolio, mail thumbnails and b&w photostats, tearsheets and photographs. Original artwork is returned at the job's completion. Pays by the project. Buys one-time rights. Interested in buying second rights (reprint rights) to previously published work. Finds artists through art fairs and licensing agents.

Tips: "Full calendar ideas encouraged!"

■ CENTRIC CORP., 6712 Melrose Ave., Los Angeles CA 90038. (323)936-2100. Fax: (323)936-2101. E-mail: centric@juno.com. Website: www.centriccorp.com. **President:** Sammy Okdot. Estab. 1986. Produces fashion watches, clocks, mugs, frames, pens and T-shirts for ages 13-60.

Needs: Approached by 40 freelancers/year. Works with 6-7 freelancers/year. Buys approximately 100 designs and illustrations/year. Prefers local freelancers only. Works on assignment only. Uses freelancers mainly for watch and clock dials, frames and mug designs, T-shirts, pens and packaging. Also for mechanicals and web design. Considers mainly graphics, computer graphics, cartoons, pen & ink, photography. 95% of freelance work demands knowledge of QuarkXPress, Illustrator, Photoshop.

First Contact & Terms: Send postcard sample or query letter with appropriate samples. Accepts submissions on disk. Samples are filed if interested. Responds only if interested. Originals are returned at job's completion. Also needs package/product designers, pay rate negotiable. Requests work on spec before assigning a job. Pays by the project. Pays royalties of 1-10% for design. Rights purchased vary according to project. Finds artists through submissions/self-promotions, sourcebooks, agents and artists' reps.

Tips: "Show your range on a postcard addressed personally to the target person. Be flexible, easy to work with. The World Wide Web is making it easier to work with artists in other locations."

CLARKE AMERICAN, P.O. Box 460, San Antonio TX 78292-0460. (210)697-1377. Fax: (210)558-7045. E-mail: linda_m_roothame@clarkeamerican.com. Website: www.clarkeamerican.com. **Product Development Manager:** Linda Roothame. Estab. 1874. Produces checks and other products and services sold through financial institutions. "We're a national printer seeking original works for check series, consisting of five, three, or one scene. Looking for a variety of themes, media, and subjects for a wide market appeal."

Needs: Uses freelancers mainly for illustration and design of personal checks. Considers all media and a range of styles. Prefers art twice standard check size.

First Contact & Terms: Send postcard sample or query letter with brochure and résumé. "Indicate whether the work is available; do not send original art." Samples are filed and are not returned. Responds only if interested. Rights purchased vary according to project. Payment for illustration varies by the project.
Tips: "Keep red and black in the illustration to a minimum for image processing."

[N] CLAY ART, 239 Utah Ave., South San Francisco CA 94080-6802. (650)244-4970. Fax: (650)244-4979. **Art Director:** Jenny McClain Doores. Estab. 1979. Produces giftware and home accessory products: cookie jars, salt & peppers, mugs, pitchers, platters and canisters.
 • This company produces an Alfred E. Neuman cookie jar and other whimsical crockery.
Needs: Approached by 70 freelancers/year. Prefers freelancers with experience in 3-D design of giftware and home accessory items. Works on assignment only. Uses freelancers mainly for illustrations and 3-D design. Seeks humorous, whimsical, innovative work.
First Contact & Terms: Send query letter with résumé, SASE, tearsheets and photocopies. Samples are filed. Responds only if interested. Call for appointment to show portfolio of thumbnails, roughs and final art and color photostats, tearsheets, slides and dummies. Negotiates rights purchased. Originals are returned at job's completion. Pays by project.

[N] CLEO, INC., 4025 Viscount Ave., Memphis TN 38118. (901)369-6657. Fax: (901)369-6376. E-mail: cpatat@cleowrap.com. Website: www.cleowrap.com. **Senior Director of Creative Resources:** Claude Patat. Estab. 1953. Produces giftwrap and gift bags. "Cleo is the world's largest Christmas giftwrap manufacturer. Other product categories include some seasonal product. Mass market for all age groups."
Needs: Approached by 25 freelancers/year. Works with 40-50 freelancers/year. Buys more than 200 freelance designs and illustrations/year. Uses freelancers mainly for giftwrap and gift bags (designs). Also for calligraphy. Considers most any media. Looking for fresh, imaginative as well as classic quality designs for Christmas. 30″ repeat for giftwrap. Art guidelines available. Submit seasonal material at least a year in advance.
First Contact & Terms: Send query letter with slides, SASE, photocopies, transparencies and speculative art. Accepts submissions on disk. Samples are filed if interested or returned by SASE if requested by artist. Responds only if interested. Rights purchased vary according to project; usually buys all rights. Pays flat fee. Also needs package/product designers, pay rate negotiable. Finds artists through agents, sourcebooks, magazines, word of mouth and submissions.
Tips: "Understand the needs of the particular market to which you submit your work."

☑ COLORS BY DESIGN, 7723 Densmore Ave., VanNuys CA 91406. (818)376-1226. Fax: (818)376-1669. Website: www.colorsbydesign.com. **Creative Director:** Victoria Cole. Produces greeting cards, stationery, imprintables, invitations and notecards. "Our current products are bright, bold, whimsical watercolors using calligraphy and quotes. We are open to new lines, new looks."
Needs: Buys 100-200 freelance designs and illustrations/year. Considers all media. Cards are 5×7. Produces material for all holidays and seasons. "Anytime we welcome everyday submissions; in June, submit Mother's Day, Father's Day, Easter, graduation and Valentine's Day; in January, submit Christmas, New Year's, Hanukkah, Passover, Thanksgiving, Halloween, Rosh Hashanah."
First Contact & Terms: "Please write for our submission guidelines." Samples are returned by SASE. Responds in 6 weeks. Art director will contact artist for portfolio review if interested. Portfolio should include color roughs, final art and photographs. Originals are not returned. Buys all rights.
Tips: "Phone calls are discouraged. No photography, computer generated imagery or cartoons."

COMSTOCK CARDS, INC., 600 S. Rock Blvd., Suite 15, Reno NV 89502. (775)856-9400. Fax: (775)856-9406. E-mail: comstock@intercomm.com. Website: www.comstockcards.com. **Production Manager:** David Delacroix. Estab. 1987. Produces greeting cards, notepads and invitations. Styles include alternative and adult humor, outrageous, shocking and contemporary themes; specializes in fat, age and funny situations. No animals or landscapes. Target market predominately professional females, ages 25-55.
Needs: Approached by 250-350 freelancers/year. Works with 30-35 freelancers/year. "Especially seeking artists able to produce outrageous adult-oriented cartoons." Uses freelancers mainly for cartoon greeting cards. Art guidelines for SASE with first-class postage. No verse or prose. Gaglines must be brief. Prefers 5×7 final art. Produces material for all occasions. Submit holiday concepts 11 months in advance.
First Contact & Terms: Send query letter with SASE, tearsheets or photocopies. Samples are not usually filed and are returned by SASE if requested. Responds only if interested. Portfolio review not required. Originals are not returned. Pays royalties of 5%. Pays by project, $50-150 minimum; may negotiate other arrangements. Buys all rights.
Tips: "Make submissions outrageous and fun—no prose or poems. Outrageous humor is what we look for—risque OK, mild risque best."

⊞ CONCORD LITHO GROUP, 92 Old Turnpike Rd., Concord NH 03301. (603)225-3328. Fax: (603)225-6120. E-mail: mdagenais@concordlitho.com. Website: www.concordlitho.com. **Creative Director:** Mark Dagenais. Estab. 1958. Produces greeting cards, stationery, posters, giftwrap, specialty paper products for direct marketing. "We provide a range of print goods for commercial markets but also supply high-quality paper products used for fundraising purposes."

Needs: Buys 500 freelance designs and illustrations/year. Works on assignment only but will consider available work also. Uses freelancers mainly for greeting cards, wrap and calendars. Also for calligraphy and computer-generated art. Considers all media but prefers watercolor. Art guidelines available for SASE with first-class postage. "Our needs range from generic seasonal and holiday greeting cards to religious subjects, florals, nature, scenics, "cutesies," whimsical art and inspirational vignettes. We prefer more traditional designs with occasional contemporary needs. Always looking for traditional religious art." Prefers original art no larger than 10×14. Produces material for all holidays and seasons: Christmas, Valentine's Day, Mother's Day, Father's Day, Easter, Thanksgiving, New Year, birthdays, everyday and other religious dates. Submit seasonal material 6 months in advance.

First Contact & Terms: Send introductory letter with résumé or brochure, along with nonreturnable photographs, samples, or photocopies of work. Indicate whether work is for style only and if it is available. Accepts submissions on disk. Responds in 3 months. Portfolio review not required. Rights purchased vary according to project. Pays by the project, $200-800. "We will exceed this amount depending on project." No phone calls, please.

Tips: "Keep sending samples or color photocopies of work to update our reference library. Be patient. Send quality samples or copies."

⊞ COURAGE CENTER, 3915 Golden Valley Rd., Golden Valley MN 55422. (888)413-3323. E-mail: artsearch@courage.org. Website: www.couragecards.org. **Art and Production Manager:** Laura Brooks. Estab. 1970. "Courage Cards are holiday cards that are produced to support the programs of Courage Center, a nonprofit provider of rehabilitation services that helps people with disabilities live more independently."

Needs: In search of holiday art themes including: traditional, winter, nostalgic, religious, ethnic and world peace designs. Features artists with disabilities, but all artists are encouraged to enter the annual Courage Card Art Search. Art guidelines available on company's website.

First Contact & Terms: Call or e-mail name and address to receive Art Search guidelines, which are mailed March 1 for the May 31 entry deadline. Artist retains ownership of the art. Pays $350 licensing fee in addition to nationwide recognition through distribution of more than 500,000 catalogs and promotional pieces, Internet, TV, radio and print advertising.

Tips: "Do not send originals. We prefer that entries arrive as a result of the Art Search. The Selection Committee chooses art that will reproduce well as a card—colorful contemporary and traditional images for holiday greetings. Participation in the Courage Cards Art Search is a wonderful way to share your talents and help people live more independently."

CREATIF LICENSING, 31 Old Town Crossing, Mount Kisco NY 10549. (914)241-6211. E-mail: creatif @usa.net. Website: members@aol.com/creatiflic. **President and Licensing Manager:** Paul Cohen. Estab. 1975. "Creatif is a licensing agency that represents artists and concept people." Licenses art for commercial applications for consumer products in gift stationery and home furnishings industry.

Needs: Looking for unique art styles and/or concepts that are applicable to multiple products and categories.

First Contact & Terms: Send query letter with brochure, photocopies, photographs, SASE and tear-sheets. Does not accept e-mail attachments but will review website links. Responds in 2 months. Samples are returned with SASE. Creatif will obtain licensing agreements on behalf of the artists, negotiate and manage the licensing programs and pay royalties. Artists are responsible for filing all copyright and trademark. Requires exclusive representation of artists.

Tips: "We are looking to license talented and committed artists. Be aware of current trends and design with specific products in mind."

⊞ CROCKETT CARDS, P.O. Box 1543, 190 North St., Bennington VT 05201. (802)440-8079. Fax: (802)442-3184. Website: www.crockettstudios.com. **President:** Andrew Broskie. Estab. 1929. Publishes mostly traditional, some contemporary, humorous and whimsical silk screen Christmas and everyday greeting cards, postcards, notecards and bordered stationery. Christmas themes are geared to sophisticated, upscale audience.

Needs: Approached by 50 freelancers/year. Works with 20-30 freelancers/year. Buys 20-40 designs/year. Produces products by silk screen method exclusively. Considers cut and pasted paper designs and gouache. Prefers 5×7 or 4½×6½. Art guidelines on website. Produces material for Christmas and everyday.

First Contact & Terms: Submit nonreturnable, unpublished, original designs only. Art should be in finished form. Buys all rights. Pays flat fee of $100-200 for illustration/design. Finds artists through *Artist's & Graphic Designer's Market* submissions.

Tips: "Designs must be suitable for silkscreen process. Airbrush, watercolor techniques and pen & ink are not preferred. Bold, well-defined designs only. Our look is traditional, mostly realistic and graphic."

SUZANNE CRUISE CREATIVE SERVICES, INC., 7199 W. 98th Terrace, #110, Overland Park KS 66212. (913)648-2190. Fax: (913)648-2110. E-mail: artagent@cruisecreative.com. Website: www.cruisecr eative.com. **President:** Suzanne Cruise. Estab. 1990. "Sells and licenses art for calendars, craft papers, decorative housewares, giftbags, gifts, giftwrap, greeting cards, keychains, mugs, ornaments, prints, rubber stamps, stickers, tabletop, and textiles. "We are a full-service licensing agency, as well as a full-service creative agency representing licensed artists and freelance artists. Our services include, but are not limited to, screening manufacturers for quality and distribution, negotiating rights, overseeing contracts and payments, sending artists' samples to manufacturers for review, and exhibiting artists' work at major trade shows annually."

Needs: Seeks established and emerging artists with distinctive styles suitable for the ever-changing consumer market. Looking for artists that manufacturers cannot find in their own art staff or in the freelance market, or who have a style that has the potential to become a classic license. Works on assignment only. "We represent a wide variety of freelance artists, and a few select licensed artists, offering their work to manufacturers of goods such as gifts, textiles, home furnishings, clothing, book publishing, social expression (greeting cards, giftwrap, party goods, etc.), puzzles, rubber stamps, etc. We prefer to work with freelancers with experience in these markets. We look for art that has popular appeal. It can be traditional, whimsical, cute, humorous, seasonal or everyday, as long as it is not 'dated'."

First Contact & Terms: Send query letter with color photocopies, tearsheets or samples. No originals. Samples are returned by SASE. Responds only if interested. Portfolio required. Request portfolio review in original query.

Tips: "Walk a few trade shows and familiarize yourself with the industries you want your work to be in. Attend a few of the panel discussions that are put on during the shows to get to know the business a little better."

CRYSTAL CREATIVE PRODUCTS, INC., 3120 S. Verity Pkwy., Middletown OH 45044-7490. (513)423-0731. Fax: (513)423-0516. Website: www.crystalcreative.com. **Art Director:** Karen Wagers. Estab. 1894. Produces gift bags, printed giftwrapping tissues and decorative accessories. "Crystal produces a broad range of giftwrapping items for the mass market. We especially emphasize our upscale gift bags with coordinating specialty tissues and giftwrap. Our product line encompasses all age groups in both Christmas and all occasion themes."

Needs: Approached by 200 freelancers/year. Works with 500 freelancers/year. Buys over 200 freelance designs and illustrations/year. Prefers freelancers with experience in greeting cards or giftwrap markets. Works on assignment and "we also purchase reproduction rights to existing artwork." Uses freelancers mainly for gift bag and tissue repeat design. Also for calligraphy, mechanicals (computer only), b&w line illustration and local freelancers for design and production. 100% of design and 10% of illustration require knowledge of QuarkXPress, Illustrator, FreeHand, PageMaker and Photoshop. Produces seasonal material for Christmas, Valentine's Day, Easter, Hanukkah, Halloween, birthdays and everyday. "We need a variety of styles from contemporary to traditional—florals, geometric, country, whimsical, juvenile, upscale, etc."

First Contact & Terms: Send query letter with 10 or more color examples (not original art) and SASE. Submit samples anytime. Samples are filed or returned by SASE. Responds in 1 month. Company will contact artist for portfolio review if interested. Originals returned depending on rights purchased. Pays by project, $400-1,200. Negotiates rights purchased.

Tips: "Send a packet of samples of what you do best. We'll keep your work on file if it has potential for us, and return it if it doesn't. No phone calls please. Study the illustration work currently being applied to the product you are interested in (in the marketplace). Be sure your style and subjects are appropriate before sending. Pay attention to trends. Garden themes are still strong. Angels are still important—especially at Christmas and in non-traditional handlings. Old-fashioned roses are growing in popularity and there is an increasing interest in pets. Photographic images and typographic solutions are also increasing."

CURRENT, INC., 1005 E. Woodmen Rd., Colorado Springs CO 80920. (719)594-4100. Fax: (719)531-2564. Website: www.currentcatalog.com. **Creative Business Manager:** Dana Grignano. Estab. 1950. Produces bookmarks, calendars, collectible figurines, decorative housewares, decorations, games, giftbags, gifts, giftwrap, greeting cards, ornaments, party supplies, school supplies and stationery. Current is a leader in high quality direct mail social expressions products and unique home decor items.

Needs: Works with up to 400 freelancers/year. Buys 500 freelance designs and illustrations/year. Prefers freelancers with experience in greeting cards and surface design. Works on assignment and sometimes

accepts previously created designs. Uses freelancers mainly for cards, wraps, 3-D collectibles and home decor. Also for calligraphy. Considers all media. Looking for work that keeps abreast of trends in the industry in all categories and giving occasions. Styles vary from charming to sophisticated. 10% of freelance work demands knowledge of Photoshop, Illustrator and FreeHand. Produces material for all holidays and seasons and everyday. Submit seasonal material 1 year in advance.

First Contact & Terms: Designers send query letter with photocopies, tearsheets, transparencies and printed samples. Illustrators, calligraphers and 3-D designers send query letter with tearsheets and SASE. Send follow-up postcard sample every 4 months. Samples are filed if accepted or returned by SASE. Responds only if interested. Will contact artist for portfolio review if interested. Rights purchased vary according to project. Strongly prefer to purchase all rights rather than complicated agreements. Pays by the project; fees vary.

Tips: "Please research our catalogs prior to submitting. We prefer to work with artists who have worked in the social expressions/home decor industry. Please don't send slides or CDs. We need printed pieces or copies of pieces to display. Very interested in 3-dimensional designers for collectibles and home decor items."

☑ DECORCAL, INC., 2477 Merrick Rd., Bellmore NY 11710. (516)221-7200 or (800)645-9868. Fax: (516)221-7229. E-mail: decorcal1@aol.com. **President:** Walt Harris. Produces decorative, instant stained glass, sports and wildlife decals, as well as custom decals.

Needs: Buys 50 designs and illustrations from freelancers/year. Uses freelancers mainly for greeting cards and decals; also for P-O-P displays. Prefers watercolor.

First Contact & Terms: Send query letter with brochure showing art style or résumé and photographs. Samples not filed are returned. Art director will contact artist for portfolio review if interested. Portfolio should include final reproduction/product and photostats. Originals are not returned. Sometimes requests work on spec before assigning a job. Pays by project. Buys all rights. Finds artists through word of mouth, magazines, submissions/self-promotions, sourcebooks, agents, visiting artists' exhibitions, art fairs and artists' reps.

Tips: "We predict a steady market for the field."

DESIGN DESIGN, INC., P.O. Box 2266, Grand Rapids MI 49501. (616)774-2448. Fax: (616)774-4020. **Creative Director:** Tom Vituj. Produces humorous and traditional fine art greeting cards, stationery, magnets, sticky notes, giftwrap/tissue and paper plates/napkins.

Needs: Uses freelancers for all of the above products. Considers most media. Produces cards for everyday and all holidays. Submit seasonal material 1 year in advance.

First Contact & Terms: Send query letter with appropriate samples and SASE. Samples are not filed and are returned by SASE if requested by artist. To show portfolio, send color copies, photographs or slides. Do not send originals. Pays various royalties per product development.

DESIGNER GREETINGS, INC., Box 140729, Staten Island NY 10314. (718)981-7700. Fax: (718)981-0151. E-mail: dgreetings@aol.com. Website: www.designergreetings.com. **Art Director:** Fern Gimbelman. Produces all types of greeting cards. Produces alternative, general, informal, inspirational, contemporary, juvenile and studio cards and giftwrap.

Needs: Works with 16 freelancers/year. Buys 250-300 designs and illustrations/year. Art guidelines free for SAE with first-class postage or on website. Works on assignment only both traditionally and electronically. Also uses artists for airbrushing and pen & ink. No specific size required. Produces material for all seasons; submit seasonal material 6 months in advance. Also needs package/product design and web design.

First Contact & Terms: Send query letter with tearsheets, photocopies or other samples. Samples are filed or are returned only if requested. Responds in 2 months. Appointments to show portfolio are only made after seeing style of artwork. Originals are not returned. Pays flat fee. Buys all greeting card rights. Artist guidelines on website.

Tips: "We are willing to look at any work through traditional mail (photocopies, etc.). Appointments are given after I personally speak with the artist (by phone)."

DIMENSIONS, INC., 1801 N 12th St., Reading PA 19604. (610)939-9900. Fax: (610)939-9666. Website: www.dimensions-crafts.com. **Designer Relations Coordinator:** Pamela Keller. Produces craft kits and leaflets, including but not limited to needlework, stained glass, paint-by-number, iron-on transfer, printed felt projects. "We are a craft manufacturer with emphasis on sophisticated artwork and talented designers. Products include needlecraft kits and leaflets, wearable art crafts, baby products. Primary market is adult women but children's crafts also included."

Needs: Approached by 50-100 freelancers/year. Works with 200 freelancers/year. Develops more than 400 freelance designs and illustrations/year. Uses freelancers mainly for the original artwork for each product. Art guidelines for SASE with first-class postage. In-house art staff adapts for needlecraft. Consid-

ers all media. Looking for fine art, realistic representation, good composition, more complex designs than some greeting card art; fairly tight illustration with good definition; also whimsical, fun characters. Produces material for Christmas; Easter; Halloween; everyday; birth, wedding and anniversary records. Majority of products are everyday decorative designs for the home.

First Contact & Terms: Send cover letter with color brochure, tearsheets, photographs or photocopies. Samples are filed "if artwork has potential for our market." Samples are returned by SASE only if requested by artist. Responds in 1 month. Portfolio review not required. Originals are returned at job's completion. Pays by project, royalties of 2-5%; sometimes purchases outright. Finds artists through magazines, trade shows, word of mouth, licensors/reps.

Tips: "Current popular subjects in our industry: florals, country/folk art, garden themes, ocean themes, celestial, Southwest/Native American, Victorian, juvenile/baby and whimsical."

DLM STUDIO, 3158 Morley Rd., Shaker Heights OH 44122. (216)721-4444. Fax: (216)721-6878. E-mail: pat@dlmstudio.com. Website: www.dlmstudio.com. **Vice President:** Pat Walker. Estab. 1984. Produces fabrics/packaging/wallpaper. Specializes in wallcovering design, entire package with fabrics, also ultra-wide "mural" borders. Also licenses artwork for wall murals.

Needs: Approached by 40-80 freelancers/year. Works with 20-40 freelancers/year. Buys hundreds of freelance designs and illustrations/year. Art guidelines free for SASE with first-class postage. Works on assignment only. Uses freelancers mainly for designs, color work. Looking for traditional, floral, texture, woven, menswear, children's and novelty styles. 50% of freelance design work demands computer skills. Wallcovering CAD experience a plus. Produces material for everyday.

First Contact & Terms: Illustrators send query letter with photocopies, examples of work, résumé and SASE. Accepts disk submissions compatible with Illustrator or Photoshop files (Mac), SyQuest, Jaz or Zip. Samples are filed or returned by SASE on request. Responds in 1 month. Request portfolio review of color photographs and slides in original query, follow-up with letter after initial query. Rights purchased vary according to project. Pays by the project, $500-1,500, "but it varies." Finds freelancers through agents and local ads, word of mouth.

Tips: "Send great samples, especially traditional patterns. Novelty and special interest also strong, and digital files are very helpful. Study the market closely; do very detailed artwork."

EDITIONS LIMITED/FREDERICK BECK, 27 E. Housatonic, Pittsfield MA 01201. (413)443-0973. Fax: (413)445-5014. E-mail: mark@chatsworthcollection.com. Website: www.chatsworthcollection.com. **Art Director:** Mark Brown. Estab. 1958. Produces holiday greeting cards, personalized and box stock and stationery.

> ● Editions Limited joined forces with Frederick Beck Originals. The company also runs Gene Bliley Stationery. See editorial comment under Frederick Beck Originals for further information. Mark Brown is the art director for all three divisions.

Needs: Approached by 100 freelancers/year. Works with 20 freelancers/year. Buys 50-100 freelance designs and illustrations/year. Prefers freelancers with experience in silkscreen. Art guidelines available. Uses freelancers mainly for silkscreen greeting cards. Also for separations and design. Considers offset, silkscreen, thermography, foil stamp. Looking for traditional holiday, a little whimsy, contemporary designs. Size varies. Produces material for Christmas, graduation, Hannukkah, New Year, Rosh Hashanah and Valentine's Day. Submit seasonal material 15 months in advance.

First Contact & Terms: Designers send query letter with brochure, photocopies, photographs, résumé, tearsheets. Samples are filed. Responds in 1 month. Will contact artist for portfolio review of b&w, color, final art, photographs, photostats, roughs if interested. Buys all rights. Pays $150-300/design. Finds freelancers through word of mouth, past history.

☑ KRISTIN ELLIOTT, INC., 6 Opportunity Way, Newburyport MA 01950. (978)526-7126. Fax: (978)526-1013. E-mail: kedesignstudio@aol.com. Website: www.kristinelliott.com. **Creative Director:** Barbara Elliott. Publishes greeting cards and stationery products.

Needs: Works with 50 freelance artists/year. Uses freelancers mainly for illustration and graphic design. Prefers watercolor and gouache. Produces Christmas and everyday stationery products, including floral, music, tennis and golf images, imprintables and photo cards.

First Contact & Terms: Send published samples, color copies, slides, tearsheets or photos. Include SASE for return of materials. Payment negotiable.

Tips: Crisp, clean colors preferred. "Show prospective clients a full range of art styles in a professional presentation."

Note cards and stationery are big business, and as there are dozens of similar product lines on the shelves in bookstores, paper boutiques and greeting card outlets, being different is a challenging task for illustrators. The squiggly lines and wiry, playful action in this note card designed by Betty Silvar is characteristic of the images Kristin Elliott, Inc. licenses on modern stationery products.

☑ **ENESCO GROUP INC.**, (formerly Enesco Corporation), 225 Windsor Dr., Itasca IL 60143. (630)875-5300. Fax: (630)875-5349. Contact: New Submissions/Licensing. Producer and importer of fine gifts and collectibles, such as resin, porcelain bisque and earthenware figurines, plates, hanging ornaments, bells, picture frames, decorative housewares. Clients: gift stores, card shops and department stores.

Needs: Works with multiple freelance artists/year. Prefers artists with experience in gift product and packaging development. Uses freelancers for rendering, illustration and sculpture. 50% of freelance work demands knowledge of Photoshop, QuarkXPress or Illustrator.

First Contact & Terms: Send query letter with brochure, résumé, tearsheets, photostats and photographs. Samples are filed or are returned. Responds in 2 weeks. Pays by the project.

Tips: "Contact by mail only. It is better to send samples and/or photocopies of work instead of original art. All will be reviewed by Senior Creative Director, Executive Vice President and Licensing Director. If your talent is a good match to Enesco's product development, we will contact you to discuss further arrangements. Please do not send slides. Have a well thought-out concept that relates to gift products before mailing your submissions."

☑ **EPIC PRODUCTS INC.**, 17370 Mt. Herrmann, Fountain Valley CA 92708. (714)641-8194. Fax: (714)641-8217. **President:** Ardeen DuBow. Estab. 1978. Produces paper tableware products and wine and spirits accessories. "Epic Products manufactures products for the gourmet/housewares market; specifically products that are wine-related. Many have a design printed on them."

Needs: Approached by 50-75 freelance artists/year. Works with 10-15 freelancers/year. Buys 25-50 designs and illustrations/year. Prefers artists with experience in gourmet/housewares, wine and spirits, gift and stationery.

First Contact & Terms: Send query letter with résumé and photocopies. Samples are filed. Write for appointment to show portfolio. Portfolio should include thumbnails, roughs, final art, b&w and color. Buys all rights. Originals are not returned. Pays by the project.

☒ **EQUITY MARKETING, INC.**, 6330 San Vicente, Los Angeles CA 90048. (323)932-4300. **Studio Assistant:** Nanette Castillo. Specializes in design, development and production of promotional, toy and gift items, especially licensed properties from the entertainment industry. Clients include Tyco, Applause, Avanti and Ringling Bros. and worldwide licensing relationships with Disney, Warner Bros., 20th Century Fox and Lucas Film.

Needs: Needs product designers, sculptors, packaging and display designers, graphic designers and illustrators. Prefers whimsical and cartoon styles. Products are typically targeted at children. Works on assignment only.

First Contact & Terms: Send résumé and nonreturnable samples. Will contact for portfolio review if interested. Rights purchased vary according to project. Pays for design by the project, $50-1,200. Pays for illustration by the project, $75-3,000. Finds artists through word of mouth, network of design community, agents/reps.

Tips: "Gift items will need to be simply made, priced right and of quality design to compete with low prices at discount houses."

FANTAZIA MARKETING CORP., 65 N. Chicopee St., Chicopee MA 01020. (413)534-7323. Fax: (413)534-4572. **President:** Joel Nulman. Estab. 1979. Produces toys and high-end novelty products. Produces novelty, lamps, banks and stationery items in over-sized form.

Needs: Not limited. Will review anything. Prefers artists with experience in product development. "We're looking to increase our molded products." Uses freelancers for P-O-P displays, paste-up, mechanicals, product concepts. 50% of design requires computer skills.

First Contact & Terms: Send query letter with résumé. Samples are filed. Responds in 2 weeks. Call for appointment to show portfolio. Portfolio should include roughs and dummies. Rights purchased vary according to project. Originals not returned. Pays by project. Royalties negotiable.

FENTON ART GLASS COMPANY, 700 Elizabeth St., Williamstown WV 26187. (304)375 6122. Fax: (304)375-7833. E-mail: AskFenton@FentonArtGlass.com. Website: www.Fentonartglass.com. **Design Director:** Nancy Fenton. Estab. 1905. Produces collectible figurines, gifts. Largest manufacturer of handmade colored glass in the US.

• Design Director Nancy Fenton says this company rarely uses freelancers because they have their own staff of artisans. "Glass molds aren't very forgiving," says Fenton. Consequently it's a difficult medium to work with. There have been exceptions. "We were really taken with Linda Higdon's work," says Fenton, who worked with Higdon on a line of historical dresses.

Needs: Uses freelancers mainly for sculpture and ceramic projects that can be translated into glass collectibles. Considers clay, ceramics, porcelain figurines. Looking for traditional artwork appealing to collectibles market.

First Contact & Terms: Send query letter with brochure, photocopies, photographs, résumé and SASE. Samples are filed. Responds only if interested. Negotiates rights purchased. Pays for design by the project; negotiable.

N FIDDLER'S ELBOW, (formerly The Toy Works, Inc.), Fiddler's Elbow Rd., Middle Falls NY 12848. (518)692-9665. Fax: (518)692-9186. E-mail: info@thetoyworks.com. Website: www.fiddlerselbow.com. **Art and Licensing Coordinator:** Meredith Murdock. Estab. 1974. Produces decorative housewares, gifts, pillows, totes, soft sculpture, flags and doormats.

Needs: Works with 5 freelancers/year. Art guidelines available free for SASE. Buys 50 freelance designs and illustrations/year. Uses freelancers mainly for design and illustration. Looking for traditional, floral, adult contemporary. 50% of freelance design demands knowledge of Photoshop, Illustrator and QuarkXPress, however computer knowledge is not a must. Produces material for everyday home decor.

First Contact & Terms: Designers and illustrators send query letter with photostats, résumé, photocopies, photographs. Accepts disk submissions compatible with Postscript. Samples are filed or returned. Responds in 4 months. No phone calls! Portfolio review not required. Rights purchased vary according to project. Pays for design by the project; $400-1,000; pays for illustration by the project, $400-1,200.

Tips: When approaching a manufacturer, send color comps or prototypes with the type of art you create. It is much easier for manufacturers to understand your art if they see it on their product.

FINE ART PRODUCTIONS, RICHIE SURACI PICTURES, MULTIMEDIA, INTERACTIVE, 67 Maple St., Newburgh NY 12550-4034. Phone/fax: (845)561-5866. E-mail: rs7fap@idsi.net Websites: www.idsi.net/~rs7fap/OPPS5.html and www.idsi.net/~rs7fap/tentsales.htm. **Contact:** Richie Suraci. Estab. 1994. Produces stationery, calendars, posters, games/toys, paper tableware products, CD-ROMs, video/film backgrounds, magazine, newspaper print. "Our products are fantasy, New Age, sci-fi, outer space, environmental, adult erotica."

Needs: Prefers freelancers with experience in sci-fi, outer space, adult erotica, environmental, fantasy and mystical themes. Uses freelancers for calligraphy, P-O-P displays, paste-up and mechanicals. Art guidelines for SASE with first-class postage. Considers all media. 50% of freelance work demands knowledge of Illustrator, Photoshop, QuarkXPress, FreeHand, PageMaker, SGI and ImMix. Produces material for all holidays and seasons and Valentine's Day. Submit seasonal material 2 years in advance.

First Contact & Terms: Send postcard sample or query letter with brochure, tearsheets, résumé, photographs, slides, SASE, photocopies and transparencies. Accepts submissions on disk (PC/Macintosh). "If sending disks send 3½″ disks formatted for PC/Apple computers." Samples are filed or returned by SASE if requested by artist. Responds in 1 year if interested. Company will contact artist for portfolio review if interested. Portfolio should include thumbnails, roughs, final art, photostats, tearsheets, photographs, slides and transparencies. Rights purchased vary according to project. Originals are returned at job's completion. Pays by the project. Finds artists through agents, sourcebooks, magazines, word of mouth and submissions.

Tips: "Send unique material that is colorful. Send samples in genres we are looking for."

✔ FISHER-PRICE, 636 Girard Ave., E. Aurora NY 14052. (716)687-3983. Fax: (716)687-5281. Website: www.fisherprice.com. **Manager, Product Art:** Henry Schmidt. Estab. 1931. Manufacturer of toys and other children's products.

Needs: Approached by 10-15 freelance artists/year. Works with 25-30 freelance illustrators and sculptors and 15-20 freelance graphic designers/year. Assigns 100-150 jobs to freelancers/year. Prefers artists with experience in children's style illustration and graphics. Works on assignment only. Uses freelancers mainly for product decoration (label art). Prefers all media and styles except loose watercolor. Also uses sculptors. 25% of work demands knowledge of FreeHand, Illustrator, Photoshop.

● This company has two separate art departments: Advertising and Packaging, which does catalogs and promotional materials; and Product Art, which designs decorations for actual toys. Be sure to specify your intent when submitting material for consideration. Art director told *AGDM* he has been receiving more samples on disk or through the Internet. He says it's a convenient way for him or his staff to look at work.

First Contact & Terms: Send query letter with samples showing art style or slides, photographs and transparencies. Samples are filed. Responds only if interested. Call to schedule an appointment to show a portfolio. Portfolio should include original, final art and color photographs and transparencies. Pays for design and illustration by the hour, $25-50. Buys all rights.

 A CHECKMARK PRECEDING A LISTING indicates a change in either the address or contact information since the 2002 edition.

N FOTOFOLIO, INC., 561 Broadway, New York NY 10012. (212)226-0923. Fax: (212)226-0072. E-mail: submissions@fotofolio.com. Website: www.fotofolio.com. Estab. 1976. Produces greeting cards, calendars, posters, T-shirts, postcards and a line of products for children including a photographic book, Keith Haring coloring books and notecards.

Needs: Buys 5-60 freelance designs and illustrations/year. Reproduces existing works. Primarily interested in photography. Produces material for Christmas, Valentine's Day, birthday and everyday. Submit seasonal material 8 months in advance. Art guidelines for SASE with first-class postage.

First Contact & Terms: Send query letter with SASE c/o Editorial Dept. Samples are filed or are returned by SASE if requested by artist. Editorial Coordinator will contact artist for portfolio review if interested. Originals are returned at job's completion. Pays by the project, 7½-15% royalties. Rights purchased vary according to project. Finds artists through word of mouth, magazines, submissions/self-promotions, sourcebooks, agents, visiting artist's exhibitions, art fairs and artists' reps.

Tips: "When submitting materials, present a variety of your work (no more than 40 images) rather than one subject/genre."

N THE FRANKLIN MINT, Franklin Center PA 19091-0001. (610)459-6629. Fax:(610)459-7270. **Artist Relations Manager:** Heather Powers. Estab. 1964. Direct response marketing of high-quality collectibles. Produces collectible porcelain plates, prints, porcelain and coldcast sculpture, figurines, fashion and traditional jewelry, ornaments, precision diecast model cars, luxury board games, engineered products, heirloom dolls and plush, home decor items and unique gifts. Clients: general public worldwide, proprietary houselist of 8 million collectors and 55 owned-and-operated retail stores. Markets products in countries worldwide, including: USA, Canada, United Kingdom and Japan.

Needs: Approached by 3,000 freelance artists/year. Contracts 500 artists/sculptors per year to work on 7,000-8,000 projects. Uses freelancers mainly for illustration and sculpture. Considers all media. Considers all styles. 80% of freelance design and 50% of illustration demand knowledge of PageMaker, FreeHand, Photoshop, Illustrator, QuarkXPress and 3D Studio Eclipse (2D). Accepts work in SGI format. Produces material for Christmas and everyday.

First Contact & Terms: Send query letter, biography, SASE and samples (clear, professional full-color photographs, transparencies, slides, greeting cards and/or brochures and tearsheets). Sculptors send photographic portfolios. Do not send original artwork. Samples are filed or returned by SASE. Responds in 2 months. Portfolio review required for illustrators and sculptors. Company gives feedback on all portfolios submitted. Payment varies.

Tips: "In search of artists and sculptors capable of producing high quality work. Those willing to take art direction and to make revisions of their work are encouraged to submit their portfolios."

FRAVESSI GREETINGS, INC., P.O. Box 1800, Enfield CT 06083-1800. (800)223-0963. Website: www.fravessi.com. **Contact:** Art Director. Estab. 1930. Produces greeting cards, packaged goods, notes.

Needs: Approached by 25 freelancers/year. Works with 5 freelancers/year. Uses freelancers for greeting card design. Art guidelines available. Considers watercolor, gouache and pastel. Especially needs seasonal and everyday designs; prefers cute and whimsical imagery. Produces seasonal material for Christmas, Mother's Day, Father's Day, Thanksgiving, Easter, Valentine's Day, St. Patrick's Day, Halloween, graduation, Jewish New Year and Hanukkah. Submit seasonal art 1 year in advance.

First Contact & Terms: Send query letter and samples of work. Include SASE. Responds in 2-3 weeks. Provide samples to be kept on file for possible future assignments. Art Director will contact artist for portfolio review if interested. Originals are not returned. Requests work on spec before assigning a job. **Pays on acceptance**, flat fee of $125-250/illustration or design. Buys all rights. Finds artists through word of mouth and submissions.

Tips: Must now implement "tighter scheduling of seasonal work to adapt to changing tastes. There is an emphasis on lower-priced cards. Check the marketplace for type of designs we publish."

N GALISON BOOKS/MUDPUPPY PRESS, 28 W. 44th St., New York NY 10036. (212)354-8840. Fax: (212)391-4037. E-mail: jadams@galison.com. Website: www.galison.com. **Design Director:** Jennifer Adams. Estab. 1978. Produces boxed greeting cards, puzzles, address books and specialty journals. Many projects are done in collaboration with museums around the world.

Needs: Works with 10-15 freelancers/year. Buys 20 designs and illustrations/year. Works on assignment only. Uses freelancers mainly for illustration. Considers all media. Also produces material for Christmas and New Year. Submit seasonal material 1 year in advance. 100% of design and 5% of illustration demand knowledge of QuarkXPress.

First Contact & Terms: Send postcard sample, photocopies, résumé and tearsheets (no unsolicited original artwork) and SASE. Accepts submissions on disk compatible with Photoshop, Illustrator or QuarkXPress (but not preferred). Samples are filed. Responds only if interested. Request portfolio review in original query. Art Director will contact artist for portfolio review if interested. Portfolio should include

color photostats, slides, tearsheets and dummies. Originals are returned at job's completion. Pays by project. Rights purchased vary according to project. Finds artists through word of mouth, magazines and artists' reps.

Tips: "Looking for great presentation and artwork we think will sell and be competitive within the gift market."

N. GALLANT GREETINGS CORP., P.O. Box 308, Franklin Park IL 60131. (847)671-6500. Fax: (847)671-5900. E-mail: sales@gallantgreetings.com. Website: www.gallantgreetings.com. **Vice President Product Development:** Joan Lackouitz. Estab. 1966. Creator and publisher of seasonal and everyday greeting cards.

First Contact & Terms: Samples are not filed or returned. Responds only if interested.

GALLERY GRAPHICS, INC., P.O. Box 502, Noel MO 64854. (417)475-6191. Fax: (417)475-3542. E-mail: info@gallerygraphics. Website: gallerygraphics.com. **Art Director:** Laura Auffet. Estab. 1979. Produces bookmarks, calendars, gifts, greeting cards, stationery, prints, notepads, notecards. Gift company specializing primarily in nostalgic, country and other contemporary designs.

Needs: Approached by 100 freelancers/year. Works with 10 freelancers/year. Buys 100 freelance illustrations/year. Art guidelines free for SASE with first-class postage. Uses freelancers mainly for illustration. Considers any 2-dimensional media. Looking for country, teddy bears, florals, traditional. Prefers 16×20 maximum. Produces material for Christmas, Valentine's Day, birthdays, sympathy, get well, thank you. Submit seasonal material 8 months in advance.

First Contact & Terms: Accepts printed samples or Photoshop files. Send TIFF or EPS files. Samples are filed or returned by SASE. Will contact artist for portfolio review of color photographs, photostats, slides, tearsheets, transparencies if interested. Payment negotiable. Finds freelancers through submissions and word of mouth.

Tips: "Be flexible and open to suggestions."

C.R. GIBSON, CREATIVE PAPERS, (formerly Thomas Nelson Gifts, Inc., C.R. Gibson, Creative Papers, Kids Kollection by Creative Paper), 404 BNA Drive, Building 200, Suite 600, Nashville TN 37217. (615)724-2900. Fax: (615)391-3166. **Vice President of Cretive:** Ann Cummings. Producer of stationery and gift products, baby, kitchen and wedding collections. Specializes in baby, children, feminine, floral, wedding, sports and kitchen-related subjects. 85-90% require freelance illustration; 50% require freelance design. Gift catalog free by request.

Needs: Approached by 200-300 freelance artists/year. Works with 30-50 illustrators and 10-30 designers/year. Assigns 30-50 design and 30-50 illustration jobs/year. Uses freelancers mainly for covers, borders, giftwrap and cards. 50% of freelance work demands knowledge of QuarkXPress, FreeHand and Illustrator. Works on assignment only.

First Contact & Terms: Send query letter with brochure, résumé, tearsheets and photocopies. Samples are filed or are returned. Responds only if interested. Request portfolio review in original query. Portfolio should include thumbnails, finished art samples, color tearsheets and photographs. Return of original artwork contingent on contract. Sometimes requests work on spec before assigning a job. Interested in buying second rights (reprint rights) to previously published work. "Payment varies due to complexity and deadlines." Finds artists through word of mouth, magazines, artists' submissions/self-promotion, sourcebooks, agents, visiting artist's exhibitions, art fairs and artists' reps.

Tips: "The majority of our mechanical art is executed on the computer with discs and laser runouts given to the engraver. Please give a professional presentation of your work."

N. THE GIFTED LINE, 1003 West Cutting Blvd., Suite 130, Point Richmond CA 94804. (510)215-4777. Fax: (510)215-4789. **Art Director:** Jennifer Parker. Estab. 1988. Produces CD-ROMs, giftbags, greeting cards, stickers, wrap. "Currently our market is mostly middle-aged women, mid to upper education and income."

Needs: Approached by 20-30 freelancers/year. Works with 1-2 freelancers/year. Prefers local designers only. Prefers freelancers with experience in photoshop production. Art guidelines available. Works on assignment only. Uses freelancers mainly for production of products. Also for design. Looking for traditional, flora, sentimental, cute animals. 60% of freelance design work demands knowledge of Photoshop, Illustrator. Produces material for all holidays and seasons, everyday, get well, romantic, thank you.

First Contact & Terms: Send résumé/cover letter and appropriate samples. No e-mail materials. Samples are filed and not returned. Will contact artist for portfolio review if interested. Pays production artists $20-30/hour. Finds freelancers through Internet, local newspapers.

Tips: "Be proficient in computer skills."

☑ **GLITTERWRAP, INC.**, 701 Ford Rd., Rockaway NJ 07866. (973)625-4200, ext. 1265. Fax: (973)625-0399. **Creative Director:** Melissa Camacho. Estab. 1987. Produces giftwrap, gift totes and allied accessories. Also photo albums, diaries and stationery items for all ages—party and special occasion market.

Needs: Approached by 50-100 freelance artists/year. Works with 10-15 artists/year. Buys 10-30 designs and illustrations/year. Art guidelines available. Prefers artists with experience in textile design who are knowledgeable in repeat patterns or surface. Uses freelancers mainly for occasional on-site Mac production at hourly rate of $15-25. Freelance work demands knowledge of QuarkXPress, FreeHand, Illustrator and Photoshop. Considers many styles and mediums. Style varies with season and year. Consider trends and designs already in line, as well as up and coming motifs in gift market. Produces material for baby, wedding and shower, florals, masculine, Christmas, graduation, birthdays, Valentine's Day, Hanukkah and everyday. Submit seasonal material 6-8 months in advance.

First Contact & Terms: Send query letter with brochure, tearsheets, photographs, slides, transparencies or color copies of work. Do not send original art or oversized samples. Samples are filed or are returned by SASE if requested. Responds in 3 weeks. "To request our submission guidelines send SASE with request letter. To request catalogs send 11 × 14 SASE with $3.50 postage. Catalogs are given out on a limited basis." Rights purchased vary according to project.

Tips: "Giftwrap generally follows the fashion industry lead with respect to color and design. Adult birthday and baby shower/birth are fast-growing categories. There is a need for good/fresh/fun typographic birthday general designs in both adult and juvenile categories."

☑ **GRAHAM & BROWN**, 3 Corporate Dr., Cranbury NJ 08512. (609)395-9200. Fax: (609)395-9676. E-mail: atopper@grahambrownusa.com. Website: www.grahambrown.com. **President:** Bill Woods. Estab. 1946. Produces residential wallpaper and borders.

Needs: Prefers freelancers with experience in wallpaper. Uses freelancers mainly for designs. Also for artwork. Looking for traditional, floral and country styles. Produces material for everyday.

First Contact & Terms: Designers send query letter with photographs. Illustrators send postcard sample of work only to the attention of Andrea Topper. Samples are filed or returned. Responds only if interested. Buys all rights. For illustration pays a variable flat fee. Finds freelancers through shows (Surtex, etc.).

GREAT AMERICAN PUZZLE FACTORY INC., 16 S. Main St., S. Norwalk CT 06854. Fax: (203)838-2065. E-mail: Ashevlin@greatamericanpuzzle.com. Website: www.greatamericanpuzzle.com. **President:** Pat Duncan. Art Director: Frank DeStefano. Licensing: Patricia Duncan. Estab. 1975. Produces jigsaw puzzles and games for adults and children. Licenses wildlife, Americana and cats for puzzles (children's and adults).

Needs: Approached by 150 freelancers/year. Works with 15 freelancers/year. Buys 50 designs and illustrations/year. Uses freelancers mainly for puzzle material. Art guidelines for SASE with first-class postage. Looking for "fun, busy and colorful" work. 100% of graphic design requires knowledge of QuarkXPress, Illustrator or Photoshop.

First Contact & Terms: Send postcard sample or query letter with brochure, tearsheets and photocopies. Do not send originals or transparencies. Samples are filed or are returned. Art director will contact artist for portfolio review if interested. Original artwork is returned at job's completion. Pays flat fee of $800-1,000, work for hire. Royalties of 5-6% for licensed art (existing art only). Interested in buying second rights (reprint rights) to previously published work.

Tips: "All artwork should be *bright*, cheerful and eye-catching. 'Subtle' is not an appropriate look for our market. Go to a toy store and look at what is out there. Do your homework! Send a professional-looking package to appropriate potential clients. Presentation means a lot. We get a lot of totally inappropriate submissions."

GREAT ARROW GRAPHICS, 2495 Main St., Suite 457, Buffalo NY 14214. (716)836-0408. Fax: (716)836-0702. E-mail: design@greatarrow.com. Website: www.greatarrow.com. **Art Director:** Lisa Samar. Estab. 1981. Produces greeting cards and stationery. "We produce silkscreened greeting cards—seasonal and everyday—to a high-end design-conscious market."

Needs: Approached by 150 freelancers/year. Works with 75 freelancers/year. Buys 350-500 images/year. Send or call for art guidelines. Prefers freelancers with experience in hand-separated art. Uses freelancers mainly for greeting card design. Considers all 2-dimensional media. Looking for sophisticated, classic, contemporary or cutting edge styles. Requires knowledge of QuarkXPress, Illustrator or Photoshop. Produces material for all holidays and seasons. Submit seasonal material 1 year in advance.

First Contact & Terms: Send query letter with photocopies. Accepts submissions on disk compatible with QuarkXPress, Illustrator or Photoshop. Samples are filed or returned if requested. Responds in 1

month. Art director will contact artist for portfolio review if interested. Portfolio should include color roughs, final art, photographs and transparencies. Originals are returned at job's completion. Pays royalties of 5% of net sales. Rights purchased vary according to project.

Tips: "We are interested in artists familiar with the assets and limitations of screenprinting, but we are always looking for fun new ideas and are willing to give help and guidance in the silkscreen process. Be original—be complete with ideas—don't be afraid to be different . . . forget the trends . . . do what you want. Make your work as complete as possible at first submission. The National Stationery Show in New York City is a great place to make contacts."

HALLMARK CARDS, INC., P.O. Box 419580, Drop 216, Kansas City MO 64141-6580. Website: www.hallmark.com. Estab. 1931.

● Because of Hallmark's large creative staff of fulltime employees and their established base of freelance talent capable of fulfilling their product needs, they are not accepting freelance submissions.

HANNAH-PRESSLEY PUBLISHING, 1232 Schenectady Ave., Brooklyn NY 11203-5828. (718)451-1852. Fax: (718)629-2014. **President:** Melissa Pressley. Estab. 1993. Produces calendars, giftwrap, greeting cards, stationery, murals. "We offer design, illustration, writing and printing services for advertising, social and commercial purposes. We are greeting card specialists."

Needs: Approached by 10 freelancers/year. Works on assignment only. Uses freelancers mainly for pattern design, invitations, advertising, cards. Also for calligraphy, mechanicals, murals. Considers primarily acrylic and watercolor, but will consider others. Looking for upscale, classic; rich and brilliant colors; traditional or maybe Victorian; also adult humor. Produces material for Christmas, Mother's Day, Father's Day, graduation, Kwanzaa, Valentine's Day, birthdays, everyday, ethnic cards (black, hispanic, Caribbean), get well, thank you, sympathy, Secretary's Day.

First Contact & Terms: Send query letter with slides, color photocopies, résumé, SASE. Samples are filed or returned by SASE. Responds only if interested. Company will contact artist for portfolio review if interested. Portfolio should include b&w, color, final art, slides. Rights purchased vary according to project. Payment varies according to project. Finds freelancers through submissions, *Creative Black Book*.

Tips: "Please be honest about your expertise and experience."

HEART STEPS INC., E. 502 Highway 54, Waupaca WI 54981. (715)258-8141. Fax: (715)256-9170. President: Debra McCormick. Estab. 1993. Produces greeting cards and stationery. Specializes in all occasion greeting cards and stepfamily relationships cards.

Needs: Approached by 25+ freelancers/year. Works with 8+ freelancers/year. Buys 50 freelance designs and illustrations/year. Prefers freelancers with experience in watercolor. Works on assignment only. Uses freelancers mainly for completing the final watercolor images. Considers original art. Looking for watercolor fine art, floral, juvenile and still life. Prefers 10×14. Produces material for Christmas, Mother's Day, Father's Day, graduation, birthday, everyday, inspirational, encouragement, woman-to-woman. Submit seasonal material 8 months in advance.

First Contact & Terms: Designers send query letter with brochure, photocopies, photographs, résumé and SASE. Illustrators send query letter with photocopies and résumé. Samples are filed. Responds in 2 months. Request portfolio review in original query. Rights purchased vary according to project. Pays by the project for design; $100-300 for illustration. Finds freelancers through gift shows and word of mouth.

Tips: "Don't overlook opportunities with new, small companies!"

MARIAN HEATH GREETING CARDS, INC., 9 Kendrick Rd., Wareham MA 02571. (508)291-0766. Fax: (508)295-5992. Website: www.marianheath.com. **Art Director:** Molly DelMastro. Estab. 1950. Produces giftbags, giftwrap, greeting cards and stationery. Greeting card company supporting independent card and gift shop retailers. Product: greeting cards, notecards, stationery, ancillary products.

Needs: Approached by 100 freelancers/year. Works with 35-45 freelancers/year. Buys 1,200 freelance designs and illustrations/year. Prefers freelancers with experience in social expression. Art guidelines free for SASE with first-class postage. Uses freelancers mainly for greeting cards. Considers all media and styles. Generally 5¼×7¼ unless otherwise directed. Will accept various sizes due to digital production, manipulation. 30% of freelance design and illustration work demands knowledge of Photoshop, Illustrator, QuarkXPress. Produces material for all holidays and seasons and everyday. Submit seasonal material 1 year in advance.

First Contact & Terms: Designers send query letter with photocopies, résumé and SASE. OK to send slides, tearsheets and transparencies if necessary. Illustrators send query letter with photocopies, photostats, résumé, tearsheets and SASE. Accepts Mac-formatted EPS disk submissions. Samples are filed or returned

by SASE. Responds within 1 month. Will contact artist for portfolio review of color, final art, slides, tearsheets and transparencies. Pays for illustration by the project; flat fee; varies per project. Finds freelancers through agents, artist's rep, artist submission, licensing and design houses.

N ⚑ IGPC, 460 W. 34th St., 10th Floor, New York NY 10001. (212)629-7979. Fax: (212)629-3350. Website: www.igpc.net. **Contact:** Art Department. Agent to foreign governments. "We produce postage stamps and related items on behalf of 40 different foreign governments."

Needs: Approached by 50 freelance artists/year. Works with 75-100 freelance illustrators and designers/ year. Assigns several hundred jobs to freelancers/year. Prefers artists within metropolitan New York or tri-state area. Must have excellent design and composition skills and a working knowledge of graphic design (mechanicals). Artwork must be focused and alive (4-color) and reproducible to stamp size (usually 4 times up). Works on assignment only. Uses artists for postage stamp art. Prefers airbrush, acrylic and gouache (some watercolor and oil OK).

First Contact & Terms: Send samples. Responds in 5 weeks. Art Director will contact artist for portfolio review if interested. Portfolio should contain "4-color illustrations of realistic, tight flora, fauna, technical subjects, autos or ships. Also include reduced samples of original artwork." Sometimes requests work on spec before assigning a job. Pays by the project, $1,000-4,000. Consider government allowance per project when establishing payment.

Tips: "Artists considering working with IGPC must have excellent drawing abilities in general or specific topics, i.e., flora, fauna, transport, famous people, etc.; sufficient design skills to arrange for and position type; the ability to create artwork that will reduce to postage stamp size and still hold up with clarity and perfection. Must be familiar with printing process and print call-outs. Generally, the work we require is realistic art. In some cases, we supply the basic layout and reference material; however, we appreciate an artist who knows where to find references and can present new and interesting concepts. Initial contact should be made by phone for appointment."

THE IMAGINATION ASSOCIATION, P.O. Box 1780, Lake Dallas TX 75065-1780. (940)498-3308. Fax: (940)498-1596. E-mail: ellice@funnyaprons.com. Website: www.funnyaprons.com. **Creative Director:** Ellice Lovelady. Estab. 1992. Produces greeting cards, T-shirts, mugs, aprons and magnets. "We started as a freelance design firm and are established with several major greeting card and t-shirt companies that have produced our work. Our primary focus is now on our subdivision, The Funny Apron Company, that manufactures humorous culinary themed aprons and t-shirts for the gourmet marketplace."

Needs: Works with 12 freelancers/year. Artists must be fax accessible and able to work on fast turnaround. Guidelines free for SAE with first-class postage. Uses freelancers for everything. Considers all media. "We're open to a variety of styles." 100% of freelance work DEMANDS knowledge of Illustrator, Corel Draw, or programs with ability to electronically send vector-based artwork. (Photoshop alone is not sufficient.) Produces material for all holidays and seasons. Submit seasonal material 18 months in advance.

First Contact & Terms: Send query letter with brochure, photographs, SASE and photocopies. Samples are filed or returned by SASE if requested by artist. Company will contact artist for portfolio review if interested. Portfolio should include final art, photographs or any material to give indication of range of artist's style. Negotiates rights and payment terms. Originals are returned at job's completion. Finds artists via word of mouth from other freelancers or referrals from publishers.

Tips: Looking for artist "with a style we feel we can work with and a professional attitude. Understand that sometimes our publishers and manufacturers require several revisions before final art, and all under tight deadlines. Be persistent! Stay true to your creative vision and don't give up!"

⚑ INCOLAY STUDIOS INCORPORATED, 520 Library St., San Fernando CA 91344. Fax: (818)365-9599. **Art Director:** Shari Bright. Estab. 1966. Manufacturer. "Basically we reproduce antiques in Incolay Stone, all handcrafted here at the studio. There were marvelous sculptors in that era, but we believe we have the talent right here in the U.S. today and want to reproduce living American artists' work."

● Art director told *AGDM* that hummingbirds and cats are popular subjects in decorative art, as are angels, cherubs, endangered species and artwork featuring the family, including babies.

Needs: Prefers local artists with experience in carving bas relief. Uses freelance artists mainly for carvings. Also uses artists for product design and model making.

First Contact & Terms: Send query letter with résumé, or "call and discuss; 1-800-INCOLAY." Samples not filed are returned. Responds in 1 month. Call for appointment to show portfolio. Pays 5% of net. Negotiates rights purchased.

Tips: "Let people know that you are available and want work. Do the best you can Discuss the concept and see if it is right for 'your talent.'"

INKADINKADO, INC., 61 Holton St., Woburn MA 01801-5263. (781)938-6100. Fax:(781)938-5585. Website: www.sales@inkadinkado.com. **Director, Product Development, licensing:** Katey Franceschini. Estab. 1978. Produces craft kits and nature, country, landscapes and holiday designs for art for rubber stamps. Also offers licenses to illustrators depending upon number of designs interested in producing and range of style by artist. Distributes to craft, gift and toy stores and specialty catalogs.

Needs: Works with 12 illustrators and 6 designers/year. Uses freelancers mainly for illustration, lettering, line drawing, type design. Considers pen & ink. Themes include animals, education, holidays and nature. Prefers small; about 2×3. 50% of design and illustration work demands knowledge of Photoshop, QuarkX-Press, Illustrator. Produces material for all holidays and seasons. Submit seasonal material 6-8 months in advance.

First Contact & Terms: Designers and illustrators send query letter with 6 nonreturnable samples. Accepts submissions on disk. Samples are filed and not returned. Responds only if interested. Company will contact artist for portfolio review of b&w and final art if interested. Pays for illustration by the project, $100-250/piece. Rights purchased vary according to project. Also needs calligraphers for greeting cards and stamps, pays $50-100/project.

Tips: "Work small. The average size of an art rubber stamp is 3×3."

INSPIRATIONS UNLIMITED, P.O. Box 9097, Cedar Pines Park CA 92322. (909)338-6758 or (800)337-6758. Fax: (909)338-2907. **Owner:** John Wiedefeld. Estab. 1983. Produces greeting cards, gift enclosures, note cards and stationery.

Needs: Approached by 15 freelancers/year. Works with 4 freelancers/year. Buys 48 freelance designs and illustrations/year. Uses freelancers mainly for greeting cards. Will consider all media, all styles. Prefers 5×7 vertical only. Produces material for Christmas, Mother's Day, graduation, Valentine's Day, birthdays, everyday, sympathy, get well, romantic, thank you, serious illness. Submit seasonal material 1 year in advance.

First Contact & Terms: Designers and illustrators send photocopies and photographs. Samples are filed and are not returned. Responds in 1 week. Company will contact artist for portfolio review if interested. Buys reprint rights; rights purchased vary according to project. Pays $100/piece of art. Also needs calligraphers, pays $25/hour. Finds freelancers through artists' submissions, art galleries and shows.

Tips: "Send color copies of your artwork for review with a self-addressed envelope."

☑ **INTERCONTINENTAL GREETINGS LTD.**, 176 Madison Ave., New York NY 10016. (212)683-5830. Fax: (212)779-8564. Website: www.intercontinental-ltd.com. **Art Director:** Thea Groene. Estab. 1967. Sells reproduction rights of designs to publishers/manufacturers. Reps artists in 50 different countries, with clients specializing in greeting cards, giftware, giftwrap, greeting cards, calendars, postcards, prints, posters, stationery, paper goods, food tins and playing cards. Company guidelines free with SASE.

Needs: Approached by several hundred artists/year. Seeking creative decorative art in traditional and computer media (Photoshop preferred; some Illustrator work accepted). Graphics, sports, occasions (i.e., Christmas, baby, birthday, wedding), humorous, "soft touch," romantic themes, animals. Accepts seasonal/holiday material any time. Prefer: artists/designers experienced in greeting cards, paper products, giftware.

First Contact & Terms: Query with samples. Send unsolicited color copies or CDs by mail with return SASE for consideration. Upon request, submit portfolio for review. Provide résumé, business card, brochure, flier, tearsheets or slides to be kept on file for possible future assignments. Uses original color art; Photoshop files on disk, tiff, Mac, 300 dpi; 2¼×2¼, 4×5, 8×10 transparencies and 35mm slides. Pays on publication. Pays 20% royalties on sales. No credit line given. Offers advance when appropriate. Sells one-time rights and exclusive product rights. Simultaneous submissions and previously published work OK. Please state reserved rights if any.

Tips: Recommends the annual New York Stationery Show. In portfolio samples, wants to see "a neat presentation, thematic in arrangement, a series of interrelated images (at least six). In addition to having good drawing/painting/designing skills, artists should be aware of market needs."

THE INTERMARKETING GROUP, 29 Holt Rd., Amherst NH 03031. (603)672-0499. **President, licensing:** Linda L. Gerson. Estab. 1985. Licensing agent for all categories of consumer goods including greeting cards, stationery, calendars, posters, paper tableware products, tabletop, dinnerware, giftwrap, eurobags, giftware, toys, needle crafts. The Intermarketing Group is a full service merchandise licensing agency representing artists' works for licensing with companies in consumer goods products, including the home furnishings, paper product, greeting card, giftware, toy, housewares, needlecraft and apparel industries.

Needs: Approached by 100 freelancers/year. Works with 6 freelancers/year. Licenses work as developed by clients. Prefers freelancers with experience in full-color illustration. Uses freelancers mainly for tabletop, cards, giftware, calendars, paper tableware, toys, bookmarks, needlecraft, apparel, housewares. Will con-

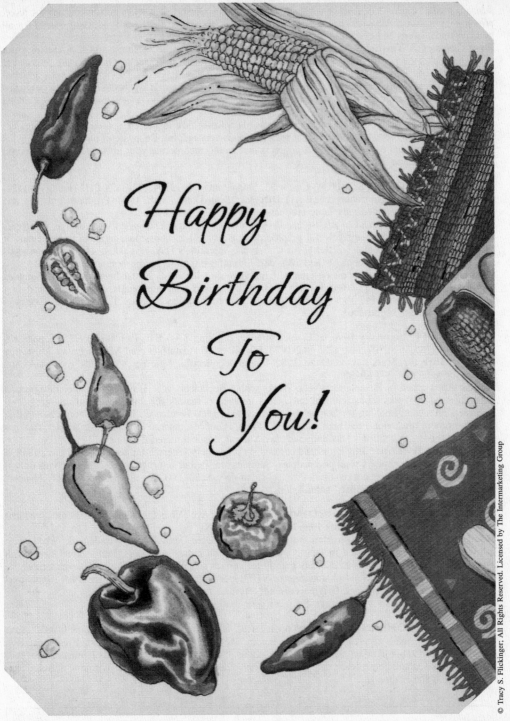

"Southwestern Quiche," a family recipe-inspired birthday card detailed in marker and colored pencil, is just one example among an assortment of consumer products The Intermarketing Group has licensed for illustrator Tracy S. Flickinger. Her exuberant designs have also popped up on paper tableware, needlecraft, book covers, ornaments, and holiday greeting cards.

sider all media forms. "My firm generally represents highly illustrated works and illustrations for direct product applications. All works are themed." Prefers 5×7 or 8×10 final art. Produces material for all holidays and seasons and everyday. Submit seasonal material 6 months in advance.

First Contact & Terms: Send query letter with brochure, tearsheets, résumé, slides, SASE or color copies. Samples are not filed and are returned by SASE. Responds in 3 weeks. Originals are returned at job's completion. Requests work on spec before assigning a job. Pays royalties of 2-7% plus advance against royalties. Buys all rights. Considers buying second rights (reprint rights) to previously published work. Finds new artists "mostly by referrals and via artist submissions. I do review trade magazines, attend art shows and other exhibits to locate suitable clients."

Tips: "Companies today seem to be leaning towards a fresh look in the art approach. Companies are selective in their licenses. A well-organized presentation is very helpful. Be aware of the market. See what is selling in stores and focus on specific products that would incorporate your art well. Get educated on market conditions and trends."

N JILLSON & ROBERTS, 3300 W. Castor St., Santa Anna CA 92704. (714)424-0111. Fax: (714)424-0054. Website: www.jillsonroberts.com. **Art Director:** Sean Dahl. Estab. 1974. Produces giftwrap and giftbags using more recycled/recyclable products.

Needs: Works with 10 freelance artists/year. Prefers artists with experience in giftwrap design. Considers all media. "We are looking for colorful graphic designs as well as humorous, sophisticated, elegant or contemporary styles." Produces material for Christmas, Valentine's Day, Hanukkah, Halloween, graduation, birthdays, baby announcements and everyday. Submit 3-6 months before holiday.

First Contact & Terms: Send query letter with brochure showing art style, tearsheets and slides. Samples are filed or are returned. Responds in 3 weeks. To show a portfolio, mail thumbnails, roughs, final reproduction/product, color slides and photographs. Originals not returned. Pays average flat fee of $250; or pays royalties (percentage negotiable).

N KID STUFF, University Blvd. at Essex Entrance, Building 2704 B-1, P.O. Box 19235, Topeka KS 66619-0235. (785)862-3707. Fax: (785)862-1424. E-mail: eric@kidstuffnet.com. Website: www.kidstuffnet.com. **Art Director:** Mark Larson. Estab. 1982. Produces collectible figurines, toys, kids' meal sacks and cartons for restaurants worldwide.

Needs: Approached by 8 freelancers/year. Works with 6 freelancers/year. Buys 10 freelance designs and illustrations/year. Works on assignment only. Uses freelancers mainly for illustration and sculpting toys. Considers all media. Looking for humorous, child-related styles. Freelance illustrators should be familiar with Photoshop, Illustrator, FreeHand and QuarkXPress. Produces material for Christmas, Easter, Halloween, Thanksgiving, Valentine's Day and everyday. Submit seasonal material 3 months in advance.

First Contact & Terms: Illustrators and cartoonists send query letter with photocopies or e-mail JPEG files. Sculptors, calligraphers send photocopies. Samples are filed or returned by SASE. Responds only if interested. Portfolio review not required. Pays by the project, $250-2,000 for illustration. Finds freelancers through word of mouth and artists' submissions.

N KIPLING'S CREATIVE DARE DEVILS, 830 Mimosa Ave., Vista CA 92083. E-mail: creativedaredevils@mail.com. **Creative Director:** John Kipling. Estab. 1981.

Needs: Approached by 75-150 freelancers/year. "Creative Dare Devils" is a ® trademark. Works with many freelancers/year. Interested in seeing and working with more freelancers. Prefers freelancers with experience in cartooning. Uses freelancers mainly for comics and illustrations. Prefers ink renderings.

First Contact & Terms: Send photocopies or VHS tapes for animation. Samples are filed. Rights purchased vary according to project. Originals are not returned. Artist will be given credit.

Tips: "Publish your own work to start. Establish a reputation."

☑ KOEHLER COMPANIES, 8758 Woodcliff Rd., Bloomington MN 55438. (952)830-9050. Fax: (952)830-9051. E-mail: bob@koehlercompanies.com. Website: koehlercompanies.com. **President:** Bob Koehler. Estab. 1988. Manufactures wall decor, plaques, clocks and mirrors; artprints laminated to wood. Clients: gift-based and home decor mail order catalog companies. Clients include: Wireless, Signals, Seasons, Paragon and Potpourri.

MARKET CONDITIONS are constantly changing! If you're still using this book and it is 2004 or later, buy the newest edition of *Artist's & Graphic Designer's Market* at your favorite bookstore or order directly from Writer's Digest Books (1-800-289-0963).

Needs: Works with 10 established artists; 8 mid-career artists and 10 emerging artist/year. Considers oil, acrylic, watercolor, mixed media, pastels and pen & ink. Preferred themes and styles: humorous, Celtic, inspirational, pet (cats and dogs), golf, fishing.

First Contact & Terms: Send query letter with brochure, photocopies or photographs, résumé and tearsheets. Samples are not filed and are returned by SASE. Company will contact artist for portfolio review if interested. Pays royalties or negotiates payment. Does not offer an advance. Rights purchased vary according to project. Also works with freelance designers. Finds artists through word of mouth.

THE LANG COMPANIES Lang Graphics; Main Street Press; Bookmark; R.A. Lang Card Co.; Lang Candles; Lang Books and Lang & Wise, 514 Wells St., Delafield WI 53018. (262)646-3399. Website: www.lang.com. **Product Development Coordinator:** Yvonne Groenevelt (product development and art submissions). Licensing: Robert Lang. Estab. 1982. Produces high quality linen-embossed greeting cards, stationery, calendars, candles, boxes, giftbags, and earthenware.

Needs: Approached by 300 freelance artists/year. Art guidelines available free for SASE. Works with 40 freelance artists/year. Uses freelancers mainly for card and calendar illustrations. Considers all media. Looking for traditional and non-abstract country, folk and fine art styles. Produces material for Christmas, birthdays and everyday. Submit seasonal material 6 months in advance.

First Contact & Terms: Send query letter with SASE and brochure, tearsheets, photostats, photographs, slides, photocopies or transparencies. Samples are filed or are returned by SASE if requested by artist. Responds in 6 weeks. Pays royalties based on net wholesale sales. Rights purchased vary according to project.

Tips: "Research the company and submit a compatible piece of art. Be patient awaiting a response. A phone call often rushes the review, and work may not be seriously considered."

LEADER PAPER PRODUCTS/PAPER ADVENTURES, 901 S. Fifth St., Milwaukee WI 53204. (414)383-0414. Fax: (414)383-0760. E-mail: shannadc@paperadventures.com. Website: www.paperadventures.com. Art Director: Shanna dela Cruz. Estab. 1901. Produces stationery, imprintables; scrapbook and paper crafting. Specializes in stationery, patterned papers and related paper products.

Needs: Approached by 50 freelancers/year. Works with 20 freelancers/year. Buys or licenses 150 freelance illustrations and design pieces/year. Prefers freelancers with experience in illustration/fine art, stationery design/surface design. Art guidelines available. Works on assignment only. Considers any medium that can be scanned. Also looking for designers for advertising and package design.

First Contact & Terms: Freelancers send or e-mail query letter with nonreturnable color samples and bio. Send follow-up postcard or call every 3 months. Accepts Mac-compatible disk and e-mail submissions. Samples are filed. Will contact artist for more samples and to discuss project. Pays for illustration by the project, $300 and up. Also considers licensing for complete product lines. Finds freelancers through trade-shows and *Artist's & Graphic Designer's Market*.

Tips: "Send lots of samples, showing your best neat and cleanest work with a clear concept. Be flexible."

☑ **LEGACY PUBLISHING GROUP**, P.O. Box 299, Clinton MA 01510. (800)322-3866 or (978)368-8711. Fax: (978)368-7867. Website: legacypublishinggroup.com. **Contact:** Art Department. Produces bookmarks, calendars, gifts, Christmas and seasonal cards and stationery pads. Specializes in journals, note cards, address and recipe books, coasters, placemats, magnets, book marks, albums, calendars and grocery pads.

Needs: Works with 8-10 freelancers/year. Buys 25-30 freelance designs and illustrations/year. Prefers traditional art. Art guidelines available. Works on assignment only. Uses freelancers mainly for original art for product line. Considers all color media. Looking for traditional, contemporary, garden themes and Christmas. Produces material for Christmas, everyday (note cards) and cards for teachers.

First Contact & Terms: Illustrators send query letter with photocopies, photographs, résumé, tearsheets, SASE and any good reproduction or color copy. We accept work compatible with Adobe or QuarkXPress plus color copies. Samples are filed. Responds in 2 weeks. Company will contact artist for portfolio review if interested. Portfolio should include color photographs, slides, tearsheets and printed reproductions. Buys all rights. Pays for illustration by the project, $600-1,000. Finds freelancers through word of mouth and artists' submissions.

Tips: "Get work out to as many potential buyers—*Artist's & Graphic Designer's Market* is a good source. Initially, plan on spending 80% of your time on self-promotion."

Ⓝ 🛈 THE LEMON TREE STATIONERY CORP., 95 Mahan St., West Babylon NY 11704. (800)229-3710. Fax: (800)229-3709. Website: www.lemontreestationery.com. Estab. 1969. Produces birth announcements, invitations and wedding invitations.

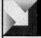 *insider* report

Capturing card company's 'look' is key to winning assignments

The best way to make it in the competitive greeting card niche is to study various companies' lines and determine what styles they sell. If your style matches theirs and you can provide similar designs, you stand a good chance of impressing them.

Most greeting card companies have a definite "look." A prime example of this is the greeting cards produced by The Lang Companies of Delafield, Wisconsin. Lang's cards and product lines are very recognizable. They are a little more high-end than other cards and gifts, and have a folk art feel to them. Alternative cartoons and the typical "mass market" greeting card illustrations you see on drugstore shelves are not the type of artwork they need. But get it right and the market will be welcoming.

Yvonne Groenevelt

Yvonne Groenevelt is the product development coordinator at Lang. As such, she gets to work with talented artists in acquiring the charming and beautiful illustrations that grace their calendars, cards and giftware. The company was founded by Robert Lang twenty years ago when his wife went shopping for a calendar and couldn't find one she liked. Since then, it has grown into a successful enterprise with eight divisions: Lang Graphics, Main Street Press, Bookmark, Lang & Wise, Old Glory, RA Lang Card Company, Lang Books and Lang Candles.

According to Groenevelt, Lang enjoys long-term relationships with many of its artists, who have made the Lang "look" a favorite with collectors around the country and the world. That look consists of classic landscapes, florals and animal portraits rendered in a nostalgic, folk-art style, designed to recapture a simpler way of life. Their products can be found in retail catalogs, gift shops, bookstores and fine shops everywhere. Or check their website, www.lang.com.

The fact that Lang has a group of well-established artists shouldn't discourage others from sending in their work. Says Groenevelt, "We are open to unsolicited submissions. What we look for is something that's different than what we already have in our line. But it must still be compatible with the Lang style."

For any artist hoping to break into the market, getting familiar with the company's style is of the utmost importance. For instance, Lang does not readily accept abstract or contemporary art. Nor do they use photographic art at this time. Keeping this in mind when submitting will be beneficial to all. "We look at everything that comes in, but please," Groenevelt advises, "don't send originals. Send transparencies, slides, photos or color copies instead. Yes, we do realize when looking at them that color copies aren't true, so that won't count against you. It's also equally important to include a cover letter and a self-addressed stamped envelope that will fit whatever you're sending so that it can be returned if you wish."

Once Groenevelt has found a submission that looks promising, she'll show it to a group of art directors to get their feedback. If the response is positive, the artist will be contacted to

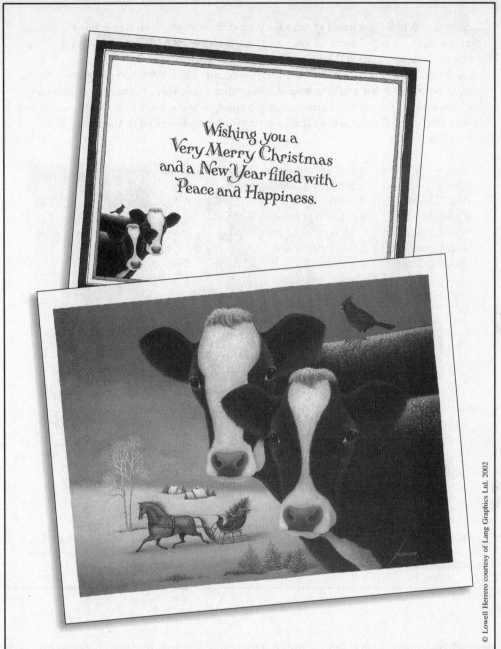

Boxed cards featuring captivating art are a specialty of Lang. The cow couple is from a painting by Lowell Herrero. Lang is also known for the special touches other companies might miss such as the "extra" illustration on the inside of the card. To view more works by this artist, check out his website, www.lowellherrero.com.

see what other work they can present and how it would relate to Lang products. Based on what comes out of that request, a proposal will be made. None of the artists for the company are in-house, so if the artist's style is the right fit, chances are good for further acceptances. Because Lang manufactures products in a variety of categories, art that was originally used on

a calendar will often find its way onto a greeting card or maybe even a mug. For this reason, they are open to submissions all year long, whether the subjectmatter is seasonal or not. Response to submissions is usually within four to six weeks.

Groenevelt, who has been with the Lang Companies since 1994, loves working with the people there, the artists and their beautiful illustrations. "It's very rewarding and heartwarming," she says. To those who are interested in breaking into the social expressions market and whose artistic style is compatible, Lang is certainly a wonderful place to start.

—Cindy Duesing

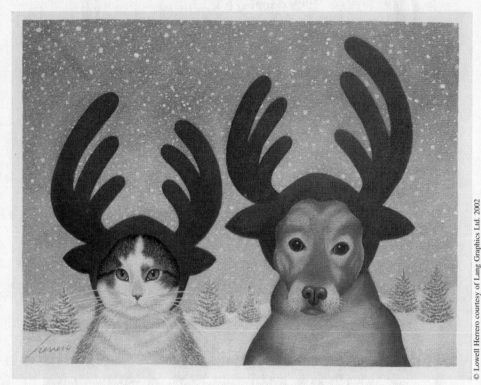

© Lowell Herrero courtesy of Lang Graphics Ltd. 2002

Squeaky Ashby and Lucy Zirble is the title of this work by Lowell Herrero. The original painting used for this card is for sale on Herrero's website at www.lowellherrero.com. The Lang Co. likes Herrero's paintings so much they've used them on everything from calendars to candles.

Needs: Buys 100-200 pieces of calligraphy/year. Prefers local designers. Works on assignment only. Uses Mac designers. Also for calligraphy, mechanicals, paste-up, P-O-P. Looking for traditional, contemporary. 50% of freelance work demands knowledge of Photoshop, QuarkXPress, Illustrator.

First Contact & Terms: Send query letter with résumé. Calligraphers send photocopies of work. Samples are not filed and are not returned. Responds only if interested. Company will contact artist for portfolio review of final art, photostats, thumbnails if interested. Pays for design by the project. Pays flat fee for calligraphy.

Tips: "Look around at competitors' work to get a feeling of the type of art they use."

N **LIFE GREETINGS**, P.O. Box 468, Little Compton RI 02837. (401)635-8535. **Editor:** Kathy Brennan. Estab. 1973. Produces greeting cards. Religious, inspirational greetings.

Inside Tips for Submitting Art to Greeting Card Companies

When art directors sit down and look at art submissions for their greeting card lines, they have certain parameters to consider that can influence the decision to accept or reject your work. Here are five tips to increase your chances of making a sale:

1. Most cards have a caption or some type of editorial on the front cover, so be sure to leave some uncluttered space where this could be dropped in. Since the top third of a greeting card is usually the only part that's visible to the customer when it's in the store's display rack, the caption is most often placed there.
2. Art directors often add special finishes, such as embossing, gold leaf, glitter or a high-gloss UV coating, to increase the value of the card. Check out how these finishes are applied and what style of artwork makes the best use of them.
3. The way you depict people in your artwork can affect the salability of a card. For example, a detailed illustration of a slim, blonde-haired young woman in a romantic pose with a brown-haired man might be suitable for an anniversary card. But customers probably wouldn't buy it if they were sending it to a couple who physically didn't resemble the pair, specifically an older couple or couples of Hispanic, Asian or African-American origins. Such a card would be more generally sendable if the pair were shown from afar in a nondescript manner. Another safer option is to use an illustration of a "couple" from the animal world, such as two birds, or what are known in the industry as "neuters." Neuters are androgynous human or animal figures, like teddy bears or cartoon characters that allow a card to be sent to or from a person of either sex.
4. Match the style of your technique with the occasion, the sender and recipient. Artwork that's intended for a teenager's birthday should not be too juvenile. If the recipient is male and over seven years old, skip the hearts, kittens and puppies. Regardless of the advances made concerning the equality between the sexes, customers are fairly traditional when it comes to choosing greeting cards.
5. Research the occasion before submitting the art, especially if you're dealing with a holiday from a religion or culture that is different from yours. Know the symbolism of a Catholic First Communion or Confirmation versus that of Protestant denominations. The menorah used for Rosh Hashanah has fewer branches than the one used for Hanukkah. These are subtle but important distinctions that will be noticed.
—Cindy Duesing

Needs: Approached by 25 freelancers/year. Works with 5 freelancers/year. Uses freelancers mainly for greeting card illustration. Also for calligraphy. Considers all media but prefers pen & ink and pencil. Prefers 4½×6¼—no bleeds. Produces material for Christmas, religious/liturgical events, baptism, first communion, confirmation, ordination.
First Contact & Terms: Send query letter with photocopies. Samples are filed or returned by SASE if requested by artist. Responds only if interested. Portfolio review not required. Originals are not returned. Pays by the project, $25 minimum. **"We pay on acceptance."** Finds artists through submissions.

THE LOLO COMPANY, 6755 Mira Mesa Blvd., Suite 123-410, San Diego, CA 92121. (800) 760-9930. Fax: (800)234-6540. E-mail: products@lolofun.com. Website: www.lolofun.com. **Creative Director:** Robert C. Paul. Estab. 1995. Publishes board games. Prefers humorous work. Uses freelancers mainly for product design and packaging. Recent games include "Don't Make Me Laugh," "Don't Make Me Laugh, Jr,." "Strange But True" and "Roh-Szam-Bo."
Needs: Approached by 1 illustrator and 1 designer/year. Works with 1 illustrator and 1 designer/year. Prefers local illustrators. 100% of freelance design and illustration demands knowledge of Illustrator, Photoshop and QuarkXPress.
First Contact & Terms: Preferred submission package is self-promotional postcard sample. Send 5 printed samples or photographs. Accepts disk submissions in Windows format; send via Zip as EPS.

Samples are filed. Will contact artist for portfolio review if interested. Portfolios should include artwork of characters in sequence, color photocopies, photographs, transparencies of final art and roughs. Rights purchased vary according to project. Finds freelancers through word of mouth and Internet.

N LOOKINGLASS, INC., 407 N. Paca St., Baltimore MD 21201. (410)547-0333. Fax: (410)547-0336. E-mail: lookinglass@erols.com. **President:** Louis Klaitman. Estab. 1972. Produces games/toys, trendy novelty items, party and Halloween. Also trade under Cabaret trademark. "We are product consultants and recommend new entrepeneurs to different resources for product graphics/3-D construction. We also represent many companies in novelty markets to retailers world wide (mainly in distribution)."
Needs: Approached by 2 freelance artists/year. Works with 2 freelancers/year. Prefers artists with experience in trendy novelty items. Works on assignment only. Uses freelancers mainly for logo design, illustration and concepts. Also for P-O-P displays, paste-up, mechanicals and graphics. Produces material for all holidays and seasons. Submit seasonal material 6 months (minimum) in advance.
First Contact & Terms: Send query letter with brochure, résumé, SASE and tearsheets. Samples are returned by SASE only if requested by artist. Responds only if interested. To show portfolio, mail tearsheets. Originals not returned. Payment negotiable. Rights purchased vary according to project.

LPG GREETINGS, INC., 4000 Porett Dr., Gurnee IL 60031. (847)244-4414. Fax: (847)244-0188. E-mail: judy@lpggreetings.com. Website: www.lpggreetings.com. **Creative Director:** Judy Cecchi. Estab. 1992. Produces greeting cards. Specializes in boxed Christmas cards.
Needs: Approached by 50-100 freelancers/year. Works with 20 freelancers/year. Buys 70 freelance designs and illustrations/year. Art guidelines free for SASE with first-class postage. Uses freelancers mainly for original artwork for Christmas cards. Considers any media. Looking for traditional and humorous Christmas. Usually prefers 5×7. Produces material for Christmas. Submit seasonal material 1 year in advance.
First Contact & Terms: Send query letter with photocopies. Samples are filed if interested or returned by SASE. Portfolio review not required. Will contact artist for portfolio if interested. Rights purchased vary according to project. Pays for design by the project. For illustration pays flat fee. Finds freelancers through word of mouth and artists' submissions. Please do not send unsolicited samples via e-mail; they will not be considered.
Tips: "Be creative with fresh new ideas."

N LUNT SILVERSMITHS, 298 Federal St., P.O. Box 1010, Greenfield MA 01302-1010. (413)774-2774. Fax: (413)774-4393. E-mail: design@lunt-silversmiths.com. Website: www.lunt-silversmiths.com. **Director of Design:** Carl F. Romboletti Jr. Estab. 1902. Produces collectible figurines, gifts, Christmas ornaments, flatware, babyware, tabletop products, sterling and steel flatware.
Needs: Approached by 1-2 freelancers/year. Works with 1-5 freelancers/year. Contracts 35 product models/year. Prefers freelancers with experience in tabletop product, model-making. Uses freelancers mainly for model-making and prototypes. Also for mechanicals. Considers clay, plastaline, resins, hard models. Looking for traditional, florals, sentimental, contemporary. 25% of freelance design work demands knowledge of Photoshop, Illustrator, AutoCad. Produces material for all holidays and seasons, Christmas, Valentine's Day, everyday.
First Contact & Terms: Designers and sculptors should send query letter with brochure, photocopies, photographs, résumé. Sculptors should also send résumé and photos. Accepts disk submissions created in Photoshop. Samples are filed or returned by SASE. Responds in 1 week only if interested. Will contact for portfolio review if interested. Portfolio should include photographs, photostats, slides. Rights purchased vary according to project. Pays for design, illustration and sculpture according to project.

N MADISON PARK GREETINGS, 1407 11th Ave., Seattle WA 98122-3901. (206)324-5711. Fax: (206)324-5822. E-mail: karinar@madpark.com. Website: www.madisonparkgreetings.com. **Art Director:** Karina Rostek. Estab. 1977. Produces greeting cards, stationery, notepads, frames.
Needs: Approached by 250 freelancers/year. Works with 15 freelancers/year. Buys 200 freelance designs and illustrations/year. Art guidelines available free for SASE. Works on assignment only. Uses freelancers mainly for greeting cards. Also for calligraphy, reflective art. Considers all paper-related media. Produces material for Christmas, Easter, Mother's Day, Father's Day, graduation, New Year, Valentine's Day, birthdays, everyday, sympathy, get well, anniversary, baby congratulations, wedding, thank you, expecting, friendship. "We are interested in floral and whimsical imagery, as well as humor." Submit seasonal material 10 months in advance.
First Contact & Terms: Designers send photocopies, slides, transparencies. Illustrators send postcard sample or photocopies. Accepts submissions on disk. Send EPS files. "Good samples are filed; rest are returned." Please enclose SASE. Company will contact artist for portfolio review of color, final art, roughs if interested. Rights purchased and royalty vary according to project.

FRANCES MEYER, INC., P.O. Box 3088, Savannah GA 31402-3088. (912)748-5252. Fax: (912)748-5339. E-mail: creative@francesmeyer.com. Website: www.francesmeyer.com. **Contact:** Creative Director. Estab. 1979. Produces scrapbooking products, stickers and stationery.
Needs: Works with 5-6 freelance artists/year. Art guidelines available free for SASE. Commissions 100 freelance illustrations and designs/year. Works on assignment only. "Most of our artists work in either watercolor or acrylic. We are open, however, to artists who work in other media." Looking for "everything from upscale and sophisticated adult theme-oriented paper items, to fun, youthful designs for birth announcements, baby and youth products. Diversity of style, originality of work, as well as technical skills are a few of our basic needs." Produces material for Christmas, graduation, Thanksgiving (fall), New Year's, Halloween, birthdays, everyday, weddings, showers, new baby, etc. Submit seasonal material 6-12 months in advance.
First Contact & Terms: Send query letter with tearsheets, slides, SASE, photocopies, transparencies (no originals) and "as much information as is necessary to show diversity of style and creativity." "No response or return of samples by Frances Meyer, Inc. *without SASE*!"Responds in 2-3 months. Company will contact artist for portfolio review if interested. Originals are returned at job's completion. Pays royalty (varies).
Tips: "Generally, we are looking to work with a few talented and committed artists for an extended period of time. We do not 'clean out' our line on an annual basis just to introduce new product. If an item sells, it will remain in the line. Punctuality concerning deadlines is a necessity."

MILLIMAC LICENSING CO., 188 Michael Way, Santa Clara CA 95051. (408)984-0700. Fax: (408)984-7456. E-mail: bruce@clamkinman.com. Website: www.clamkinman.com. **Owner:** Bruce Ingrassia. Estab. 1978. Produces collectible figurines, mugs, T-shirts and textiles. Produces a line of cartoon characters called the Clamkin® Family directed towards "children and adults young at heart."
Needs: Approached by 10 freelancers/year. Works with 2-3 freelancers/year. Buys 30-40 freelance designs and illustrations/year. Prefers freelancers with experience in cartooning. Works on assignment only. Uses freelancers mainly for line art, color separation, Mac computer assignments. Considers computer, pen & ink. Looking for humorous, clever, "off the wall," cute animals. 50% of freelance design/illustration demands knowledge of Photoshop, Illustrator, FreeHand (pencil roughs OK). "Computer must be Mac." Produces material for everyday.
First Contact & Terms: Designers/cartoonists send query letter with photocopies. Sculptors send photos of work. Accepts disk submissions compatible with Mac Illustrator files. Samples are filed. Will contact artist for portfolio review if interested. Rights purchased and pay rates vary according to project. Finds freelancers through submissions. "I also find a lot of talent around town—at fairs, art shows, carnivals, students—I'm always on the lookout."
Tips: "Get a computer—learn Illustrator, Photoshop. Be clever, creative, open minded and responsible."

☑ **MIXEDBLESSING**, P.O. Box 97212, Raleigh NC 27624-7212. (919)847-7944. E-mail: mixbless@aol.com. Website: www.mixedblessing.com. **President:** Elise Okrend. Licensing: Philip Okrend. Estab. 1990. Produces interfaith greeting cards combining Jewish and Christian as well as multicultural images for all ages. Licenses holiday artwork for wrapping paper, tote bags, clothing, paper goods.
Needs: Approached by 10 freelance artists/year. Works with 10 freelancers/year. Buys 20 designs and illustrations/year. Provides samples of preferred styles upon request. Works on assignment only. Uses freelancers mainly for card illustration. Considers watercolor, pen & ink and pastel. Prefers final art 5 × 7. Produces material for Christmas and Hanukkah. Submit seasonal material 10 months in advance.
First Contact & Terms: Send query letter with brochure, photocopies, photographs and SASE. Samples are filed. Responds only if interested. Artist should follow up with letter after initial query. Originals are returned at job's completion. Sometimes requests work on spec before assigning a job. Pays flat fee of $125-500 for illustration/design. Buys all rights. Finds artists through visiting art schools.
Tips: "I see growth ahead for the industry. Go to and participate in the National Stationery Show."

J.T. MURPHY CO., 200 W. Fisher Ave., Philadelphia PA 19120. (215)329-6655. Fax: (800)457-5838. **President:** Jack Murphy. Estab. 1937. Produces greeting cards and stationery. "We produce a line of packaged invitations, thank-you notes and place cards for retail."
Needs: Approached by 12 freelancers/year. Works with 4 freelancers/year. Buys 8 freelance designs and illustrations/year. Prefers local freelancers with experience in graphics and greeting cards. Uses freelancers mainly for concept, design and finished artwork for invitations and thank-yous. Looking for graphic, contemporary or traditional designs. Prefers 4 × 5⅛ but can work double size. Produces material for graduation, birthdays and everyday. Submit seasonal material 9 months in advance.
First Contact & Terms: Designers send query letter with brochure. Illustrators send query letter with photocopies. Samples are filed and returned with SASE. Responds in 1 month. Company will contact artist for portfolio review if interested. Rights purchased vary. Originals not returned. Payment negotiated.

NALPAC, LTD., 1111 E. Eight Mile Rd., Ferndale MI 48220. (248)541-1140. Fax: (248)544-9126. **President, licensing:** Ralph Caplan. Estab. 1971. Produces coffee mugs and T-shirts for gift and mass merchandise markets. Licenses all kinds of artwork for T-shirts, mugs and gifts.

Needs: Approached by 10-15 freelancers/year. Works with 2-3 freelancers/year. Buys 70 designs and illustrations/year. Works on assignment only. Considers all media. Needs computer-literate freelancers for design, illustration and production. 60% of freelance work demands computer skills.

First Contact & Terms: Send query letter with brochure, résumé, SASE, photographs, photocopies, slides and transparencies. Samples are filed or are returned by SASE if requested by artist. Responds in 1 month. Call for appointment to show portfolio. Usually buys all rights, but rights purchased may vary according to project. Also needs package/product designers, pay rate varies. Pays for design and illustration by the hour $10-25; or by the project $40-500, or offers royalties of 4-10%.

N NAPCO MARKETING, (formerly L.B.K. Marketing), 7800 Bayberry Rd., Jacksonville FL 32256-6893. (904)737-8500. Fax: (904)737-9526. E-mail: napco@leading.com. **Art Director:** John Skinner. Estab. 1940. NAPCO Marketing supplies floral, garden and home interior markets with middle to high-end products. Clients: wholesale.

● NAPCO Marketing has a higher-end look for their floral market products.

Needs: Works with 15 freelance illustrators and designers/year. 50% of work done on a freelance basis. No restrictions on artists for design and concept. Art guidelines available for SASE with first-class postage. Works on assignment only. Uses freelancers mainly for mechanicals and product design. "Need artists that are highly skilled in illustration for three-dimensional products.

First Contact & Terms: Designers send query letter with brochure, résumé, photocopies, photographs, SASE, tearsheets and "any samples we can keep on file." Illustrators send brochure, résumé, photocopies, photographs and SASE. If work is in clay, send photographs. Samples are filed or returned by SASE. Responds in 2 weeks. Artist should follow up with letter after initial query. Portfolio should include samples which show a full range of illustration style. Sometimes requests work on spec before assigning a job. Pays for design by the project, $50-500. Pays by the project for illustration, $50-2,000. Pays $15/hour for mechanicals. Buys all rights. Considers buying second rights (reprint rights) to previously published work. Finds artists through word of mouth and self-promotions.

Tips: "We are very selective in choosing new people. We need artists that are familiar with three-dimensional giftware and floral containers. We now produce dolls and seasonal giftware. Our market is expanding and so are our needs for qualified artists."

N ◈ NATIONAL DESIGN CORP., P.O. Box 509032, San Diego CA 92150-9032. (858)674-6040. Fax: (858)674-4120. Website: www.nationaldesign.com. **Creative Director:** Christopher Coats. Estab. 1985. Produces gifts, writing instruments and stationery accoutrements. Multi markets include gift/souvenir and premium markets.

Needs: Works with 3-4 freelancers/year. Buys 3 freelance designs and illustrations/year. Prefers local freelancers only. Must be Macintosh proficient. Works on assignment only. Uses freelancers mainly for design illustration. Also for prepress production on Mac. Considers computer renderings to mimic traditional medias. Prefers children's and contemporary styles. 100% of freelance work demands knowledge of QuarkXPress, Freehand and Photoshop. Produces material for Christmas and everyday.

First Contact & Terms: Send query letter with photocopies, résumé, SASE. Accepts submissions on disk. "Contact by phone for instructions." Samples are filed and are returned if requested. Company will contact artist for portfolio review of color, final art, tearsheets if interested. Rights purchased vary according to project. Payments depends on complexity, extent of project(s).

Tips: "Must be well traveled to identify with gift/souvenir markets internationally. Fresh ideas always of interest."

N NCE, New Creative Enterprises, Inc., 401 Milford Pkwy., Milford OH 45150. (513)248-1144 or (800)656-7787. Fax: (513)248-7520. Website: www.ncegifts.com. **Director of Design:** Terry Lee. Estab. 1979. Produces low-medium priced giftware and decorative accessories. "We sell a wide variety of items ranging from home decor to decorative flags. Our typical retail-level buyer is female, age 30-50."

Needs: Approached by 5-10 freelancers/year. Works with 2-5 freelancers/year. Buys 10-50 designs and illustrations/year. Prefers freelancers with experience in giftware/decorative accessory design, concept development and illustration and concept sketching. Most often needs ink or marker illustration. Seeks heartwarming and whimsical designs and illustrations using popular (Santa, Easter Bunny, etc.) or unique characters. Final art must be mailable size. Needs computer-literate freelancers for design, illustration and production. 50% of freelance work demands knowledge of Illustrator. Produces material for Christmas, Valentine's Day, Easter, Thanksgiving and Halloween. Submit seasonal material 1 year in advance.

First Contact & Terms: Send query letter with tearsheets, photographs, photocopies, photostats, slides and transparencies. Samples are filed and are returned by SASE if requested by artist. Responds in 5 weeks.

Director will contact artists for portfolio review if interested. Portfolio should include thumbnails, roughs, finished art samples, b&w and color tearsheets, photographs, slides and dummies. Originals are returned at job's completion. Rights purchased vary according to project.
Tips: "Familiarity and experience with the industry really helps, but is not imperative. Yard and garden decoration/accessories are very popular right now."

NEW DECO, INC., 23123 Sunfield Dr., Boca Raton FL 33433. (800)543-3326. E-mail: newdeco@minds pring.com. Website: newdeco.com. **President:** Brad Hugh Morris. Estab. 1984. Produces greeting cards, posters, fine art prints and original paintings.
● See also the listing for New Deco, Inc. in Posters & Prints section.
Needs: Approached by 50-100 artists/year. Works with 5-10 freelancers/year. Buys 8-10 designs and 5-10 illustrations/year. Uses artwork for original paintings, limited edition graphics, greeting cards, giftwrap, calendars, paper tableware, poster prints, etc. Licenses artwork for posters and prints.
First Contact & Terms: Send query letter with brochure, résumé, tearsheets, slides and SASE. Samples not filed are returned by SASE. Responds in 10 days only if interested. To show portfolio, mail color slides. Originals are returned at job's completion. Pays royalties of 5-10%. Negotiates rights purchased.
Tips: "Do not send original art at first."

☑ **NEW ENGLAND CARD CO.**, Box 228, West Ossipee NH 03890. (603)539-5095. E-mail: GLP@n hland.com. Website: www.nhland.com. **Owner:** Harold Cook. Estab. 1980. Produces greeting cards and prints of New England scenes which can be viewed on our website.
Needs: Approached by 75 freelancers/year. Works with 10 freelancers/year. Buys more than 24 designs and illustrations/year. Prefers freelancers with experience in New England art. Art guidelines available. Considers oil, acrylic and watercolor. Looking for realistic styles. Prefers art proportionate to 5×7. Produces material for all holidays and seasons. "Submit all year."
First Contact & Terms: Send query letter with SASE, photocopies, slides and transparencies. Samples are filed or are returned. Responds in 2 months. Artist should follow up after initial query. Pays by project. Rights purchased vary according to project, but "we prefer to purchase all rights."
Tips: "Once you have shown us samples, follow up with new art."

N ⚓ **N-M LETTERS, INC.**, 125 Esten Ave., Pawtucket RI 02860. (401)247-7651. Fax: (401)245-3182. E-mail: nmltrs@earthlink.net. **President:** Judy Mintzer. Estab. 1982. Produces announcements and invitations.
Needs: Approached by 2-5 freelancers/year. Works with 2 freelancers/year. Prefers local artists only. Works on assignment only. Produces material for births, weddings and Bar/Bat Mitzvahs. Submit seasonal material 6 months in advance.
First Contact & Terms: Send query letter with résumé. Responds in 1 month only if interested. Call for appointment to show portfolio of b&w roughs. Original artwork is not returned. Pays by the project.

☑ **NOBLE WORKS**, 123 Grand St., P.O. Box 1275, Hoboken NJ 07030. (201)420-0095. Fax: (201)420-0679. Website: www.nobleworks.com. **Contact:** Art Department. Estab. 1981. Produces bookmarks, greeting cards, magnets and gift products. Produces "modern cards for modern people." Trend oriented, hip urban greeting cards.
Needs: Approached by 100-200 freelancers/year. Works with 50 freelancers/year. Buys 250 freelance designs and illustrations/year. Prefers freelancers with experience in illustration. Art guidelines for SASE with first-class postage. We purchase "secondary rights" to illustration. Considers illustration, electronic art. Looking for humorous, "off-the-wall" adult contemporary and editorial illustration. Produces material for Christmas, Mother's Day, Father's Day, graduation, Halloween, Valentine's Day, birthdays, thank you, anniversary, get well, astrology, sympathy, etc. Submit seasonal material 18 months in advance.
First Contact & Terms: Designers send query letter with photocopies, SASE, slides, tearsheets, transparencies. Illustrators and cartoonists send query letter with photocopies, tearsheets, SASE. After introductory mailing send follow-up postcard sample every 8 months. Accepts submissions on Zip disk compatible with Mac QuarkXPress 4.0, Photoshop 5.0 or Illustrator 8.0. Samples are filed. Responds in 6 months. Buys reprint rights. Pays for design and illustration by the project. Finds freelancers through sourcebooks, illustration annuals, referrals.
Tips: "As a manufacturer must know the market niche its product falls into, so too must a freelancer."

N ⚓ **NORTHERN CARDS**, (formerly NCP Inc.), 5694 Ambler Dr., Mississauga, Ontario L4W 2K9 Canada. (905)625-4944. Fax: (905)625-5995. E-mail: ggarbacki@northerncards.com. Website: northerncar ds.com. **Product Coordinator:** Greg Garbacki. Estab. 1992. Produces 4 brands of greeting cards.
Needs: Approached by 200 freelancers/year. Works with 25 freelancers/year. Buys 75 freelance designs and illustrations/year. Uses freelancers for "camera-ready artwork and lettering." Art guidelines for SASE

with first-class postage. Looking for traditional, sentimental, floral and humorous styles. Prefers 5½ × 7¾ or 5 × 7. Produces material for Christmas, Easter, Mother's Day, Father's Day, graduation, Valentine's Day, birthdays and everyday. Also sympathy, get well, someone special, thank you, friendship, new baby, good-bye and sorry. Submit seasonal material 6 months in advance.

First Contact & Terms: Designers send query letter with brochure, photocopies, slides, résumé and SASE. Illustrators and cartoonists send photocopies, tearsheets, résumé and SASE. Lettering artists send samples. Samples are filed or returned by SASE. Responds only if interested. Pays flat fee, $200 (CDN). Finds freelancers through newspaper ads, gallery shows and Internet.

Tips: "Research your field and the company you're submitting to. Send appropriate work only."

N: NOTES & QUERIES, 9003A Yellow Brick Rd., Baltimore MD 21237. (410)682-6102. Fax: (410)682-5397. E-mail: vanessa@nandq.com. Website: www.nandq.com. **Sales Coordinator:** Vanessa Harnik. Estab. 1981. Produces greeting cards, stationery, journals, paper tableware products and giftwrap. Products feature contemporary art.

Needs: Approached by 30-50 freelancers/year. Works with 3-10 freelancers/year. Art guidelines available "pending our interest." Produces material for special projects only.

First Contact & Terms: Send query letter with photographs, slides, SASE, photocopies, transparencies, "whatever you prefer." Samples are filed or returned by SASE as requested by artist. Responds in 1 month. Artist should follow up with call and/or letter after initial query. Portfolio should include thumbnails, roughs, photostats or transparencies. Rights purchased or 5-7% royalties paid; varies according to project.

Tips: "Review what we do before submitting. Make sure we're appropriate for you."

✔ NOVO CARD PUBLISHERS INC., 3630 W. Pratt Ave., Lincolnwood IL 60712. (847)763-0077. Fax: (847)763-0022. E-mail: art@novocard.net. Website: www.novocard.net. Estab. 1927. Produces all categories of greeting cards.

Needs: Approached by 200 freelancers/year. Works with 30 freelancers/year. Buys 300 or 400 pieces/year from freelance artists. Art guidelines free for SASE with first-class postage. Uses freelancers mainly for illustration and text. Also for calligraphy. Considers all media. Prefers crop size: 5 × 7¾, bleed 5¼ × 8. Knowledge of Photoshop 4.0, Illustrator 6.0 and QuarkXPress helpful. Produces material for all holidays and seasons and everyday. Submit seasonal material 8 months in advance.

First Contact & Terms: Designers send brochure, photocopies, photographs and SASE. Illustrators and cartoonists send photocopies, photographs, tearsheets and SASE. Calligraphers send b&w copies. Accepts disk submissions compatible with Macintosh QuarkXPress 4.0 and Windows 95. Art samples are not filed and are returned by SASE only. Written samples retained on file for future assignment with writer's permission. Responds in 2 months. Pays for design and illustration by the project, $75-200.

N: NRN DESIGNS, INC., 5142 Argosy Dr., Huntington Beach CA 92649. (714)898-6363. Fax: (714)898-0015. Website: www.NRNDesigns.com. **Art Director:** Linda Braun. Estab. 1984. Produces calendars, high-end stationery and scrapbooking items including stickers.

• This company is no longer producing greeting cards.

Needs: Looking for freelance artists with innovative ideas and formats for invitations and scrapbooking products. Works on assignment only. Produces stickers and other material for Christmas, Easter, graduation, Halloween, Hanukkah, New Year, Thanksgiving, Valentine's Day, birthdays, everyday, (sympathy, get well, etc.). Submit seasonal material 1 year in advance.

First Contact & Terms: Send photocopies or other nonreturnable samples. Responds only if interested. Portfolios required from designers. Company will contact artist for portfolio review if interested. Rights purchased vary according to project. Pays for design by the project.

OATMEAL STUDIOS, Box 138, Rochester VT 05767. (802)767-3171. Fax: (802)767-9890. **Creative Director:** Helene Lehrer. Estab. 1979. Publishes humorous greeting cards and notepads, creative ideas for everyday cards and holidays.

Needs: Approached by approximately 300 freelancers/year. Buys 100-150 freelance designs and illustrations/year. Art guidelines for SASE with first-class postage. Considers all media. Produces seasonal material for Christmas, Mother's Day, Father's Day, Easter, Valentine's Day and Hanukkah. Submit art year round for all major holidays.

First Contact & Terms: Send query letter with slides, roughs, printed pieces or brochure/flyer to be kept on file; write for artists' guidelines. "If brochure/flyer is not available, we ask to keep one slide or printed piece; color or b&w photocopies also acceptable for our files." Samples returned by SASE. Responds in 6 weeks. No portfolio reviews. Sometimes requests work on spec before assigning a job. Negotiates payment.

Tips: "We're looking for exciting and creative, humorous (not cutesy) illustrations and single panel cartoons. If you can write copy and have a humorous cartoon style all your own, send us your ideas! We do accept work without copy too. Our seasonal card line includes traditional illustrations, so we do have a need for non-humorous illustrations as well."

N. OFFRAY, Rt. 24 Box 601, Chester NJ 07930. (908)879-4700. Fax: (908)879-8588. **Senior Design Director:** Joe Bahnken. Estab. 1900. Produces ribbons. "We're a ribbon company—for ribbon designs we look to the textile design studios and textile-oriented people; children's designs, craft motifs, fabric trend designs, floral designs, Christmas designs, bridal ideas, etc. Our range of needs is wide, so we need various looks."
Needs: Approached by 8-10 freelancers/year. Works with 5-6 freelancers/year. Buys 40-50 freelance designs and illustrations/year. Artists must be able to work from pencils to finish, various styles—work is small and tight. Works on assignment only. Uses freelancers mainly for printed artwork on ribbons. Looking for artists able to translate a trend or design idea into a 1½ to 2-inch space on a ribbon. Produces material for Christmas, everyday. Submit seasonal material 6 months in advance.
First Contact & Terms: Send postcard sample or query letter with résumé or call. Samples are filed. Responds only if interested. Portfolio should include color final art. Rights purchased vary according to project. Pays by the project, $200-300 for design.

ONTARIO FEDERATION OF ANGLERS AND HUNTERS, P.O. Box 2800, Peterborough, Ontario K9J 8L5 Canada. (705)748-6324. Fax: (705)748-9577. Website: www.ofah.org. **Graphic Designer:** Deborah Carew. Estab. 1928. Produces calendars, greeting cards, limited edition prints. "We are a nonprofit, conservation organization who publishes a high quality wildlife art calendar and a series of four Christmas cards each year. We also commission two paintings per year that we produce in limited edition prints."
Needs: Approached by 60 freelancers/year. Works with 6-12 freelancers/year. Buys 12 freelance designs and illustrations/year. Prefers wildlife artists. Art guidelines free for SAE with first-class postage, e-mail or on website. Uses freelancers mainly for calendar/cards. Considers any media that gives realistic style. "We find talent through a yearly wildlife art calendar contest. Our criteria is specific to the wildlife art market with a slant towards hunting and fishing activities. We can only consider North American species found in Ontario. We welcome scenes involving sportsmen and women in the outdoors. Also sporting dogs. All art must be fine art quality, realistic, full color, with backgrounds. Any medium that gives these results is acceptable. No illustrative or fantasy-type work please. Look to successful wildlife artists like Robert Bateman or Glen Loates for the style we're seeking." Prefers minimum 8½ × 11 final art. Produces material for Christmas, wildlife art cards, i.e. no wording required.
First Contact & Terms: Contact through contest only please. Samples are filed or returned. Responds following contest. Portfolio review not required. Buys one-time rights. Pays $150/calendar piece plus extras.

P.S. GREETINGS, INC., 5730 N. Tripp Ave., Chicago IL 60646. Fax: (773)267-6055. **Art Director:** Jennifer Dodson. Manufacturer of boxed greeting and counter cards.
Needs: Receives submissions from 300-400 freelance artists/year. Artists' guidelines are posted on website, or send SASE. Works with 20-30 artists/year on greeting card designs. Prefers illustrations be 5 × 7¾ with ⅛" bleeds cropped. Publishes greeting cards for everyday and holidays. 20% of work demands knowledge of QuarkXPress, Illustrator and Photoshop.
First Contact & Terms: All requests as well as submissions must be accompanied by SASE. Samples will *not* be returned without SASE! Responds in 1 month. Pays flat fee. Buys exclusive worldwide rights for greeting cards and stationery.
Tips: "Our line includes a whole spectrum: from everyday needs (florals, scenics, feminine, masculine, humorous, cute) to every major holiday (from New Year's to Thanksgiving) with an extensive Chrismas line as well. We continue to grow every year and are always looking for innovative talent."

N. PAINTED HEARTS & FRIENDS, 1222 N. Fair Oaks Ave., Pasadena CA 91103. (626)798-3633. Fax: (626)296-8890. E-mail: ines@paintedhearts.com. Website: www.paintedhearts.com. **Sales Manager:** Inez Duran. President: Susan Kinney. Estab. 1988. Produces greeting cards, stationery, invitations and notecards.
● This company also needs freelancers who can write verse. If you can wear this hat, you'll have an added edge.
Needs: Approached by 75 freelance artists/year. Works with 6 freelancers/year. Art guidelines free for SASE with first-class postage or by e-mail. Works on assignment only. Uses freelancers mainly for design. Produces material for all holidays and seasons, birthdays and everyday. Submit seasonal material 1 year in advance.

First Contact & Terms: Send art submissions Attn: David Mekelburg, send writer's submissions Attn: Inez Duran or use e-mail. Send query letter with résumé, SASE and color photocopies. Samples are returned with SASE. Responds only if interested. Write for appointment to show portfolio, which should include original and published work. Rights purchased vary according to project. Originals returned at job's completion. Pays flat fee of $150-300 for illustration. Pays royalties of 5%.

Tips: "Familiarize yourself with our card line." This company is seeking "young artists (in spirit!) looking to develop a line of cards. We're looking for work that is compatible but adds to our look, which is bright, clean watercolors. We need images that go beyond just florals to illustrate and express the occasion."

N PANDA INK, P.O. Box 5129, Woodland Hills CA 91308-5129. (818)340-8061. Fax: (818)883-6193. E-mail: ruthluvph@worldnet.att.net. **Art Director:** Ruth Ann Epstein. Estab. 1982. Produces greeting cards, stationery, calendars and magnets. Products are Judaic, general, everyday, anniversay, etc. Also has a metaphysical line of cards.

Needs: Approached by 8-10 freelancers/year. Works with 1-2 freelancers/year. Buys 3-4 freelance designs and illustrations/year. Uses freelancers mainly for design, card ideas. Considers all media. Looking for bright, colorful artwork, no risqué, more ethnic. Prefers 5×7. Produces material for all holidays and seasons, Christmas, Valentine's Day, Mother's Day, Father's Day, Easter, Hanukkah, Passover, Rosh Hashanah, graduation, Thanksgiving, New Year, Halloween, birthdays and everyday. Submit seasonal material 6 months in advance.

First Contact & Terms: Send query letter with résumé, SASE, tearsheets and photocopies. Samples are filed. Responds in 1 month. Portfolio review not required. Rights purchased vary according to project. Originals are returned at job's completion. Pay is negotiable; pays flat fee of $20; royalties of 2% (negotiable). Finds artists through word of mouth and submissions.

Tips: "Looking for bright colors and cute, whimsical art. Be professional. Always send SASE. Make sure art fits company format."

PAPEL GIFTWARE®, A Cast Art Comapny, 30 Engelhard Dr., Monroe Twsp. NJ 08831. (609)395-0022. Website: www.PapelGiftware.com. **Creative Director:** Tina Merola. Estab. 1955. Produces everyday and seasonal giftware items and home decor items: mugs, photo frames, magnets, figurines, plush collectible figurines, candles, novelty items and much more. No greeting cards or wrapping paper.

Needs: Works with over 500 illustrations/year. Use freelancers both for product design, and for adapting artwork to templates. Looking at all styles of artwork, original art, graphic, hand painted and computer art. Produces products for all seasons and everyday. Seasonal and everyday product lines include home accents, plush, figurines, seasonal decorations, expression gifts and occasion gifts.

First Contact & Terms: Designers send query letter with photocopies. Illustrators send samples or letter with photocopies and SASE to be kept on file. Samples not filed are returned by SASE. Will contact for portfolio review if interested. Portfolio should include final reproduction/product and b&w or color tearsheets, original artwork and photographs. Sometimes requests work on spec before assigning a job. Pays by project. Buys all rights.

Tips: "I look for strong basic drawing skills with a good color sense. I want an artist who is versatile and who can adapt their style to a specific product line with a decorative feeling. Please submit as many styles as you are capable of doing. Clean, accurate work is very important and mechanicals are important to specific jobs. New ideas and 'looks' are always welcome. Keep our files updated with your future work as developed. To shop the market, think in a forward way, because the giftware industry works one year ahead."

N PAPER MAGIC GROUP INC., 401 Adams Ave., Scranton PA 18510. (570)961-3863. Fax: (570)348-8389. **Creative Director for Winter Division:** Peg Cohan O'Connor. Estab. 1984. Produces greeting cards, stickers, vinyl wall decorations, 3-D paper decorations. "We are publishing seasonal cards and decorations for the mass market. We use a wide variety of design styles."

Needs: Works with 60 freelance artists/year. Prefers artists with experience in greeting cards. Work is by assignment or send submissions on spec. Designs products for Christmas and Valentine's Day. All submissions for Easter, Halloween and school market should be addressed to the Minneapolis office at 100 N. Sixth St., Suite 899C, Minneapolis MN 55403. (612)673-9202. Fax: (612)673-9120. Also uses freelancers for lettering and art direction.

First Contact & Terms: Send query letter with résumé, samples and SASE to the attention of Lisa Spencer. Color photocopies are acceptable samples. Samples are filed or are returned by SASE only if requested by artist. Responds in 2 months. Originals not returned. Pays by the project, $350-2,000 average. Buys all rights.

Tips: "Please, experienced illustrators only."

PAPER MOON GRAPHICS, INC., Box 34672, Los Angeles CA 90034. (310)287-3949. E-mail: moong uys@aol.com. **Contact:** Creative Director. Estab. 1977. Produces greeting cards and stationery. "We publish greeting cards with a friendly, humorous approach—dealing with contemporary issues."

- Paper Moon is a contemporary, alternative card company. Traditional art is not appropriate for this company.

Needs: Works with 40 artists/year. Buys 200 designs/illustrations/year. Buys illustrations mainly for greeting cards and stationery. Art guidelines for SASE with first-class postage. Produces material for everyday, holidays and birthdays. Submit seasonal material 6 months in advance.

First Contact & Terms: Send query letter with brochure, tearsheets, photostats, photocopies, slides and SASE. Samples are filed or are returned only if requested by artist and accompanied by SASE. Responds in 10 weeks. To show a portfolio, mail color roughs, slides and tearsheets. Original artwork is returned to the artist after job's completion. Pays average flat fee of $350/design; $350/illustration. Negotiates rights purchased.

Tips: "We're looking for bright, fun style with a contemporary look. Artwork should have a young 20s and 30s appeal." A mistake freelance artists make is that they "don't know our product. They send inappropriate submissions, not professionally presented and with no SASE."

█ PAPERPOTAMUS PAPER PRODUCTS INC., Box 310, Delta, British Columbia V4K 3Y3 Canada. Alternative address for small packages or envelopes only: Box 966, Point Roberts WA 98281. (604)940-3370. Fax: (604)940-3380. E-mail: artwork@paperpotamus.com. Website: www.paperpotamus.c om. **Director of Marketing:** George Jackson. Estab. 1988. Produces greeting cards for men and women ages 16-60.

Needs: Works with 8-10 freelancers/year. Buys 75-100 illustrations from freelancers/year. Also uses freelancers for P-O-P displays, paste-up and inside text. Prefers watercolor and computer colored, but will look at all color media. Especially seeks detailed humorous cartoons and classic style artwork. "Looking for a style which will work to create handmade or 3-dimensional greeting cards and higher end products such as scalloped and embossed notepads, address books, bookmarks and other stationery items." Will use some detailed nature drawings of items women are attracted to i.e. cats, flowers, teapots, horses, etc. especially in combination. Needs humorous color photos with captions and inside text. Also wants whales, eagles, tigers and other wildlife. Has both horse and wild bird card lines. Would like to see "cute" cats, Teddy bears, kids, etc. Produces t-shirts in both b&w and color. Produces material for Christmas. Submit seasonal work at least 18 months before holiday. Has worked with artists to produce entire lines of cards but is currently most interested in putting selected work into existing or future card lines. Prefers 5¼ × 7¼ finished artwork. Complete guidelines available on website.

First Contact & Terms: Send brochure, color photos, roughs, photocopies and SASE. No slides. Samples are not filed and are returned by SASE only if requested by artist. Responds in 3 months. Original artwork, including cartoons, is not returned if purchased. Pays average flat fee of $100-150/illustration or royalties of 5% on all goods artwork is used on. Prefers to buy all rights. Company has a 20-page catalog you may purchase by sending $4 with request for artist's guidelines. Please do not send IRCs in place of SASE. "Do not phone or fax to inquire about your artwork. It will be returned if you send an SASE with it. If sending samples from USA, put US postage on SASE. Your samples will be mailed back to you from USA post office. If you have a web page with your artwork online, send an e-mail giving web address, and it will be reviewed and e-mail will be sent in response."

Tips: "Know who your market is! Find out what type of images are selling well in the card market. Learn why people buy specific types of cards. Who would buy your card? Why? Who would they send it to? Why? Birthdays are the most popular occasions to send cards. Understand the time frame necessary to produce cards and do not expect your artwork to appear on a card in a store next month. Send only your best work, and we will show it to the world, with your name on it."

PAPERPRODUCTS DESIGN U.S. INC., 60 Galli Dr., Suite 1, Novato CA 94949. (415)883-1888. Fax: (415)883-1999. E-mail: carol@paperproductdesign.com. **President:** Carol Florsheim. Estab. 1990. Produces paper napkins, plates, designer tissue, giftbags and giftwrap. Specializes in high-end design, fashionable designs.

Needs: Approached by 20-30 freelancers/year. Buys multiple freelance designs and illustrations/year. Artists do not need to write for guidelines. They may send samples to the attention of Carol Florsheim at any time. Uses freelancers mainly for designer paper napkins. Looking for very stylized/clean designs and illustrations. Prefers 6½ × 6½. Produces seasonal and everyday material. Submit seasonal material 9 months in advance.

First Contact & Terms: Designers send brochure, photocopies, photographs, tearsheets. Samples are not filed and are returned if requested with SASE. Responds in 6 weeks. Request portfolio review of color, final art, photostats in original query. Rights purchased vary according to project. Pays for design and illustration by the project in advances and royalties. Finds freelancers through agents, *Workbook*.

Tips: "Shop the stores, study decorative accessories. Read European magazines."

PAPILLON INTERNATIONAL GIFTWARE INC., 40 Wilson Rd., Humble TX 77338. (281)446-9606. Fax: (281)446-1945. **President:** Michael King. Estab. 1987. Produces decorative accessories, home furnishings and Christmas ornaments. "Our product mix includes figurines, decorative accessories, Christmas ornaments and decor."

Needs: Approached by 20 freelance artists/year. Works with 4-6 freelancers/year. Buys 30-40 designs and illustrations/year. Prefers local artists only. Works on assignment only. "We are looking for illustrations appealing to classic and refined tastes for our Christmas decor." Prefers 10×14. Produces material for Christmas, Valentine's Day, Thanksgiving and Halloween. Submit seasonal material 1 year in advance.

First Contact & Terms: Send query letter with brochure, SASE, tearsheets, photographs, photocopies, photostats and slides. Samples are filed and are returned by SASE if requested by artist. Responds in 2 months. To show portfolio, mail roughs, color slides and tearsheets. Originals returned at job's completion. Pays by the project, $400 average. Negotiates rights purchased.

PARAMOUNT CARDS INC., 400 Pine St., Pawtucket RI 02860. (401)726-0800, ext. 2240. Fax: (401)727-3890. E-mail: cdesousa@paramountcards.com. Website: www.paramountcards.com. **Contact:** Art Coordinator. Estab. 1906. Publishes greeting cards. "We produce an extensive line of seasonal and everyday greeting cards which range from very traditional to whimsical to humorous. Almost all artwork is assigned."

Needs: Works with 50-80 freelancers/year. Uses freelancers mainly for finished art. Also for calligraphy. Considers watercolor, gouache, airbrush and acrylic. Prefers $5\frac{1}{2} \times 8\frac{5}{16}$. Produces material for all holidays and seasons. Submit seasonal holiday material 1 year in advance.

First Contact & Terms: Send query letter, résumé, SASE (important), photocopies and printed card samples. Samples are filed only if interested, or returned by SASE if requested by artist. Responds in 1 month if interested. Company will contact artist for portfolio review if interested. Portfolio should include photostats, tearsheets and card samples. Buys all rights. Originals are not returned. Pays by the project, $200-450. Finds artists through word of mouth and submissions.

Tips: "Send a complete, professional package. Only include your best work—you don't want us to remember you from one bad piece. Always include SASE with proper postage and *never* send original art—color photocopies are enough for us to see what you can do. No phone calls please."

PICKARD CHINA, 782 Pickard Ave., Antioch IL 60002. (847)395-3800. Website: www.pickardchin a.com. **President:** Eben C. Morgan, Jr.. Estab. 1893. Manufacturer of fine china dinnerware. Clients: upscale specialty stores and department stores. Current clients include Cartier, Marshall Field's and Gump's.

Needs: Assigns 2-3 jobs to freelance designers/year. Prefers designers for china pattern development with experience in home furnishings. Tabletop experience is a plus but not required.

First Contact & Terms: Send query letter with résumé and color photographs, tearsheets, slides or transparencies showing art styles. Samples are filed or are returned if requested. Art Director will contact artist for portfolio review if interested. Negotiates rights purchased. May purchase designs outright, work on royalty basis (usually 2%) or negotiate non-refundable advance against royalties.

MARC POLISH ASSOCIATES, P.O. Box 3434, Margate NJ 08402. (609)823-7661. E-mail: sedonamax @aol.com. **President:** Marc Polish. Estab. 1972. Produces T-shirts and sweatshirts. "We specialize in printed T-shirts and sweatshirts. Our market is the gift and mail order industry, resort shops and college bookstores."

Needs: Works with 6 freelancers/year. Designs must be convertible to screenprinting. Produces material for Christmas, Valentine's Day, Mother's Day, Father's Day, Hanukkah, graduation, Halloween, birthdays and everyday.

First Contact & Terms: Send query letter with brochure, tearsheets, photographs, photocopies, photostats and slides. Samples are filed or are returned. Responds in 2 weeks. To show portfolio, mail anything to show concept. Originals returned at job's completion. Pays royalties of 6-10%. Negotiates rights purchased.

Tips: "We like to laugh. Humor sells. See what is selling in the local mall or department store. Submit anything suitable for T-shirts. Do not give up. No idea is a bad idea. It sometimes might have to be changed slightly to fit into a marketplace."

THE POPCORN FACTORY, 13970 W. Laurel Dr., Lake Forest IL 60045. E-mail: abromley@thepopcor nfactory.com. Website: www.thepopcornfactory.com. **Director of Merchandising:** Ann Bromley. Estab. 1979. Manufacturer of popcorn packed in exclusive designed cans and other gift items sold via catalog for Christmas, Halloween, Valentine's Day, Easter and year-round gift giving needs.

Needs: Works with 6 freelance artists/year. Assigns up to 20 freelance jobs/year. Works on assignment only. Art guidelines available. Uses freelancers mainly for cover illustration and design. Occasionally uses artists for advertising, brochure and catalog design and illustration. 100% of freelance catalog work requires knowledge of QuarkXPress and Photoshop.

First Contact & Terms: Send query letter with photocopies, photographs or tearsheets. Samples are filed. Responds in 1 month. Write for appointment to show portfolio, or mail finished art samples and photographs. Pays for design by the hour, $50 minimum. Pays for catalog design by the page. Pays for illustration by project, $250-2,000. Considers complexity of project, skill and experience of artist, and turnaround time when establishing payment. Buys all rights.

Tips: "Send classic illustration, graphic designs or a mix of photography/illustration. We can work from b&w concepts—then develop to full 4-color when selected. *Do not send art samples via e-mail.*"

[N] PORTAL PUBLICATIONS, LTD., 201 Alameda del Prado, Suite 200, Novato CA 94949. (415)884-6200. E-mail: artsub@portalpub.com. Website: www.portalpub.com. **Vice President of Publishing:** Pamela Prince. Estab. 1954. Produces calendars, cards, stationery, posters and prints. "All Portal products are image-driven, with emphasis on unique styles of photography and illustration. All age groups are covered in each product category, although the prime market is female, ages 18 to 45."

Needs: Approached by 1,000+ freelancers (includes photographers and illustrators)/year. Freelance designs and illustrations purchased per year varies, 12+ calligraphy projects/year. Prefers freelancers with experience in "our product categories." Art guidelines free for SASE with first-class postage or via website. Works on assignment only. Uses freelancers mainly for primary image, photoshop work and calligraphy. Considers any media. Looking for "beautiful, charming, provocative, humorous images of all kinds." 90% of freelance design demands knowledge of the most recent versions of Illustrator and QuarkXPress. Submit seasonal material 12 months in advance.

First Contact & Terms: Send query letter with photocopies and SASE and follow-up postcard every 6 months. Prefers color copies to disk submissions. Samples are filed or returned by SASE. Responds only if interested. Will contact for portfolio review of b&w, color and final art if interested. Rights purchased vary according to project.

Tips: "Send color copies of your work that we can keep in our files—also, know our product lines."

PORTERFIELD'S FINE ART LICENSING, 5 Mountain Rd., Concord NH 03301-5479. (800)660-8345 or (603)228-1864. Fax: (603)228-1888. E-mail: porterfields@mediaone.net. Website: www.porterfieldsfineart.com. **President:** Lance J. Klass. Licenses representational, Americana, and most other subjects. "We're a full-service licensing agency." Estab. 1994. Functions as a full-service licensing representative for individual artists wishing to find publishers or licensees. "We have one of the fastest growing art licensing agencies in North America, as well as the largest and best-known art licensing site on the Internet at www.porterfieldsfineart.com. Stop by our site for more information about how to become a Porterfield's artist and have us represent you and your work for licenses in wall and home decor, collectibles, giftware and many other types of products."

Needs: Approached by 200 freelancers/year. Licenses many designs and illustrations/year. Prefers representational artists "who can create beautiful pieces of art that people want to look at and look at and look at." Art guidelines listed on its Internet site. Considers existing works first. Considers any media—oil, pastel, pencil, acrylics. "We want artists who have exceptional talent and who would like to have their art and their talents introduced to the broad public." Particularly seeking country folk Americana artists.

First Contact & Terms: Send query letter with tearsheets, photographs, slides, SASE, photocopies and transparencies. Samples are filed or returned by SASE. Responds in 2 weeks. Will contact for portfolio review if interested. Portfolio should include tearsheets or photographs. Rights purchased vary. Pays royalties for licensed works.

Tips: "We are impressed first and foremost by level of ability, even if the subject matter is not something we would use. Thus a demonstration of competence is the first step; hopefully the second would be that demonstration using subject matter that we feel would be marketable. We work with artists to help them with the composition of their pieces for particular media. We treat artists well, and actively represent them to potential licensees. Instead of trying to reinvent the wheel yourself and contact everyone 'cold,' get a licensing agent or rep whose particular abilities complement your art. We specialize in the application of art to collectibles, giftware, home decor and accessories, wall decor, and also to print media such as cards, stationery, calendars, prints, lithographs and even fabrics. Other licensing reps and companies specialize in cartoons, book illustrations, etc.—the trick is to find the right rep whom you feel you can work with, who really loves your art whatever it is, and whose specific contacts and abilities can help further your art in the marketplace."

N **PORTFOLIO GRAPHICS, INC.**, P.O. Box 17437, Salt Lake City UT 84117. (801)266-4844. Fax: (801)263-1076. E-mail: info@portfoliographics.com. Website: www.portfoliographics.com. **Creative Director:** Kent Barton. Estab. 1986. Produces greeting cards, fine art posters, prints, limited editions. Fine art publisher and distributor world-wide. Clients include frame shops, galleries, gift stores and distributors.

● Portfolio Graphics also has a listing in the Posters & Prints section of this book.

Needs: Approached by 200-300 freelancers/year. Works with 30 freelancers/year. Buys 50 freelance designs and illustrations/year. Art guidelines free for SASE with first-class postage. Considers all media. "Open to large variety of styles." Produces material for Christmas, everyday, birthday, sympathy, get well, anniversary, thank you and friendship.

First Contact & Terms: Illustrators send résumé, slides, tearsheets, SASE. "Slides are best. Do not send originals." Samples are filed "if interested" or returned by SASE. Responds in 2-3 weeks. Negotiates rights purchased. Pays 10% royalties. Finds artists through galleries, word of mouth, submissions, art shows and exhibits.

Tips: "Open to a variety of submissions, but most of our artists sell originals as fine art home or office decor. Keep fresh, unique, creative."

N **PRATT & AUSTIN COMPANY, INC.**, Dept. AGDM, 642 S. Summer St., Holyoke MA 01040. (413)532-1491. Fax: (413)536-2741. **President:** Bruce Pratt. Estab. 1931. Produces envelopes, children's items, stationery and calendars. Does not produce greeting cards. "Our market is the modern woman at all ages. Design must be bright, cute, busy and elicit a positive response."

Needs: Approached by 100-200 freelancers/year. Works with 20 freelancers/year. Buys 100-150 designs and illustrations/year. Art guidelines available. Uses freelancers mainly for concept and finished art. Also for calligraphy.

First Contact & Terms: Send nonreturnable samples, such as postcard or color copies. Samples are filed or are returned by SASE if requested. Will contact for portfolio review if interested. Portfolio should include thumbnails, roughs, color tearsheets and slides. Pays flat fee. Rights purchased vary. Interested in buying second rights (reprint rights) to previously published work. Finds artists through submissions and agents.

THE PRINTERY HOUSE OF CONCEPTION ABBEY, P.O. Box 12, 37112 State Hwy. VV, Conception MO 64433. (660)944-2632. Fax: (660)944-2582. E-mail: art@printeryhouse.org. Website: www.printeryhouse.org. **Art Director:** Brother Michael Marcotte, O.S.B. Estab. 1950. Publishes religious greeting cards. Licenses art for greeting cards and wall prints. Specializes in religious Christmas and all-occasion themes for people interested in religious, yet contemporary, expressions of faith. "Our card designs are meant to touch the heart. They feature strong graphics, calligraphy and other appropriate styles."

Needs: Approached by 75 freelancers/year. Works with 25 freelancers/year. Art guidelines available on website or for SASE with first-class postage. Uses freelancers for product illustration. Prefers acrylic, pastel, oil, watercolor, line drawings and classical and contemporary calligraphy. Looking for dignified styles and solid religious themes. Produces seasonal material for Christmas and Easter "as well as the usual birthday, get well, sympathy, thank you, etc. cards of a religious nature. Creative general message cards are also needed." Digital work is accepted in Photoshop or Illustrator format.

First Contact & Terms: Send query letter with résumé, photocopies, photographs, SASE, slides or tearsheets. Calligraphers send any printed or finished work. Non-returnable samples preferred—or else samples with SASE. Accepts disk submissions compatible with Photoshop or Illustrator. Send TIFF or EPS files. Responds usually within 3 weeks. To show portfolio, mail appropriate materials only after query has been answered. "In general, we continue to work with artists once we have accepted their work." Pays flat fee of $250-400 for illustration/design, and $50-150 for calligraphy. Usually buys exclusive reproduction rights for a specified format; occasionally buys complete reproduction rights.

Tips: "Remember our specific purpose of publishing greeting cards with a definite Christian/religious dimension but not piously religious. It must be good quality artwork. We sell mostly via catalogs so artwork has to reduce well for catalog."

PRISMATIX, INC., 333 Veterans Blvd., Carlstadt NJ 07072. (201)939-7700 or (800)222-9662. Fax: (201)939-2828. E-mail: irasalomon@att.net. **Vice President:** Miriam Salomon. Estab. 1977. Produces novelty humor programs. "We manufacture screen-printed novelties to be sold in the retail market."

Needs: Works with 3-4 freelancers/year. Buys 100 freelance designs and illustrations/year. Works on assignment only. 90% of freelance work demands computer skills.

First Contact & Terms: Send query letter with brochure, résumé. Samples are filed. Responds only if interested. Portfolio should include color thumbnails, roughs, final art. Payment negotiable.

PRIZM INC., P.O. Box 1106, Manhattan KS 66505-1106. (785)776-1613. Fax: (785)776-6550. E-mail: michele@pipka.com. **President of Product Development:** Michele Johnson. Produces collectible figurines, decorative housewares, gifts, limited edition plates, ornaments. Manufacturer of exclusive collectible figurine line.
Needs: Approached by 20 freelancers/year. Art guidelines free for SASE with first-class postage. Works on assignment only. Uses freelancers mainly for figurines, home decor items. Also for calligraphy. Considers all media. Looking for traditional, old world style, sentimental, folkart. Produces material for Christmas, Mother's Day, everyday. Submit seasonal material 1 year in advance.
First Contact & Terms: Send query letter with photocopies, résumé, SASE, slides, tearsheets. Samples are filed. Responds in 2 months if SASE is included. Will contact for portfolio review of color, final art, slides. Rights purchased vary according to project. Pays royalties of 7% plus payment advance; negotiable. Finds freelancers through artist submissions, decorative painting industry.
Tips: "People seem to be more family oriented—therefore more wholesome and positive images are important. We are interested in looking for new artists and lines to develop. Send a few copies of your work with a concept."

PRO IMAGE GREETINGS, INC., 215 Main St., Chatham NJ 07928-2408. (973)635-0014. Fax: (973)635-9299. E-mail: info@ProImageGreetingCards.com. **President:** Barry Rosner. Manufacturer/distributor primarily of premium quality photo greeting cards but also produces calendars, stationery, note cards, bookmarks, posters, photos, picture mattes and frames. Greeting cards are primarily for Christmas, Hannukah, New Years, engagement and wedding, graduation/seniors, birth announcements, christenings, baptisma and bar/bat mitzvahs, special anniversaries and birthdays and social announcements.
Needs: Buys 80-100 card designs and/or illustrations. Prefer to work with 6-8 freelancers to develop 2 product lines covering above occasions. Works on assignment only. Buys freelance full-cover and frame-border designs and illustrations for 5×7 and 3½×5, vertical and horizontal formats. Primarily interested in color designs and illustrations, but occasionally uses b&w and monochrome ones. Traditional, elegant, upscale and festive look and feel desired for the above occasions. Considers pencil, pen & ink, calligraphy and typography, charcoal, wtercolor, paintings, collage and mixed media for full-color, b&w, sepia-tone card printing with possible gold leaf and embossing, finishing. Will occasionally consider added bows, ribbons, lace, etc. for carriage trade prestige cards. Submit seasonal material 8 months in advance.
First Contact & Terms: Send query letter with tearsheets, color photocopies, photographs, photostats, inkjet prints, résumé (greeting card experience preferred but not required) and SASE. Responds initially within 3 weeks and finally within 3 months. Samples are filed or returned by SASE. Portfolio review not required. Sometimes requests spec work before assigning job. Originals returned at completion of job. Pays by project or $150-300 for full cover designs/art and $100-200 for simple border, thematic or element designs/art. Negotiates rights purchased.

☑ **PRUDENT PUBLISHING**, 65 Challenger Rd., Ridgefield Park NJ 07660. (201)641-7900. Fax: (201)641-9356. **Marketing:** Marian Francesco. Estab. 1928. Produces greeting cards. Specializes in business/corporate all-occasion and holiday cards.
Needs: Buys calligraphy. Art guidelines available. Uses freelancers mainly for card design, illustrations and calligraphy. Considers traditional media.. Prefers no cartoons or cute illustrations. Prefers 5½×7⅛ horizontal format (or proportionate to those numbers). Produces material for Christmas, Thanksgiving, birthdays, everyday, sympathy, get well and thank you.
First Contact & Terms: Designers, illustrators and calligraphers send query letter with brochure, photostats, photocopies, tearsheets. Samples are filed or returned by SASE if requested. Responds ASAP. Portfolio review not required. Buys all rights. No royalty or licensing arrangements. Pay is negotiable. Finds freelancers through artist's submissions, magazines, sourcebooks, agents and word of mouth.
Tips: "No cartoons."

RAINBOW CREATIONS, INC., 216 Industrial Dr., Ridgeland MS 39157. (601)856-2158. Fax: (601)856-5809. E-mail: walls@netdoor.com. Website: http://rainbowcreations.net. **President:** Steve Thomas. Estab. 1976. Produces wallpaper.
Needs: Approached by 10 freelancers/year. Works with 5 freelancers/year. Buys 45 freelance designs and illustrations/year. Prefers freelancers with experience in Illustrator, Photoshop. Art guidelines available on individual project basis. Works on assignment only. Uses freelancers mainly for new border designs. Also for setting designs in repeat. Considers Mac and hand-painted media. 50% of freelance design work demands knowledge of Photoshop and Illustrator. Produces material for everyday.
First Contact & Terms: Designers send query letter with photocopies, photographs and résumé. "We will accept disk submissions if compatible with Illustrator 5.0." Samples are returned. Responds in 7 days. Buys all rights. Pays for design and illustration by the project. Payment based on the complexity of design.
Tips: "If experienced in the field of textile/wallcovering call me directly."

☑ **RECO INTERNATIONAL CORPORATION**, Collector's Division, Box 951, 138 Haven Ave., Port Washington NY 11050. (516)767-2400. Fax: (516)767-2409. E-mail: hreich@reco.com. Website: www.reco.com. Manufacturer/distributor of limited editions, collector's plates, 3-dimensional plaques, lithographs and figurines. Sells through retail stores and direct marketing firms.
Needs: Works with freelance and contract artists. Uses freelancers under contract for plate and figurine design, home decor and giftware. Prefers romantic and realistic styles.
First Contact & Terms: Send query letter and brochure to be filed. Write for appointment to show portfolio. Art director will contact artist for portfolio review if interested. Negotiates payment. Considers buying second rights (reprint rights) to previously published work or royalties.
Tips: "Have several portfolios available. We are very interested in new artists. We go to shows and galleries, and receive recommendations from artists we work with."

RECYCLED PAPER GREETINGS INC., 3636 N. Broadway, Chicago IL 60613. (773)348-6410. Fax: (773)281-1697. Website: www.recycledpapergreetings.com. **Art Directors:** Gretchen Hoffman, John Le-Moine. Publishes greeting cards, adhesive notes and note pads.
Needs: Buys 1,000-2,000 freelance designs and illustrations. Considers b&w line art and color—"no real restrictions." Looking for "great ideas done in your own style with messages that reflect your own slant on the world." Prefers 5×7 vertical format for cards. "Our primary interest is greeting cards." Produces seasonal material for all major and minor holidays including Jewish holidays. Submit seasonal material 18 months in advance; everyday cards are reviewed throughout the year.
First Contact & Terms: Send SASE to the Art Department or view website for artist's guidelines. "Please do not send slides or tearsheets. We're looking for work done specifically for greeting cards." Responds in 2 months. Portfolio review not required. Originals returned at job's completion. Sometimes requests work on spec before assigning a job. Pays average flat fee of $250 for illustration/design with copy. Some royalty contracts. Buys card rights.
Tips: "Remember that a greeting card is primarily a message sent from one person to another. The art must catch the customer's attention, and the words must deliver what the front promises. We are looking for unique points of view and manners of expression. Our artists must be able to work with a minimum of direction and meet deadlines. There is a renewed interest in the use of recycled paper—we have been the industry leader in this for almost three decades."

RED FARM STUDIO, 1135 Roosevelt Ave., P.O. Box 347, Pawtucket RI 02862-0347. (401)728-9300. Fax: (401)728-0350. Contact: Creative Director. Estab. 1955. Produces greeting cards and stationery from original watercolor art. Also produces coloring books and paintable sets. Specializes in nautical and contemporary themes. Uses freelancers for greeting cards, notes, Christmas cards. Considers watercolor artwork for cards, notes and stationery; b&w linework and tonal pencil drawings for coloring books and paintable sets. Looking for accurate, detailed, realistic work, though some looser watercolor styles are also acceptable. Produces material for Christmas and everyday occasions. Also interested in traditional, realistic artwork for religious line: Christmas, Easter, Mother's and Father's Day and everyday subjects, including realistic portrait and figure work, such as the Madonna and Child.
First Contact & Terms: First send query letter and #10 SASE to request art guidelines. Submit printed samples, transparencies, color copies or photographs with a SASE. Samples not filed are returned by SASE. Art director will contact artist for portfolio review if interested. Pays flat fee of $250-350 for card or note illustration/design, or pays by project, $250-1000. Buys all rights. "No photography, please."
Tips: "We are interested in clean, bright and fun work. Our guidelines will help to explain our needs."

⟦N⟧ ⟦Y⟧ **REEDPRODUCTIONS**, 100 Ebbtide Ave., Suite 100, Sausalito CA 94965. (415)331-2694. Fax: (415)331-3690. E-mail: reedpro@earthlink.net. **Owner/Art Director:** Susie Reed. Estab. 1978. Produces general stationery and gift items including greeting cards, magnets and address books. Special emphasis on nature.
Needs: Approached by 20 freelancers/year. Works with few freelancers/year. Art guidelines are not available. Prefers local freelancers with experience. Works on assignment only. Artwork used for paper and gift novelty items. Also for computer graphics. Prefers color or b&w photo realist illustrations of nature images.
First Contact & Terms: Send query letter with brochure or résumé, tearsheets, photostats, photocopies or slides and SASE. Samples are filed or are returned by SASE. Art Director will contact artist for portfolio

NEED HELP? For tips on finding markets and understanding listings, see our Quick-Start Guide in the front of this book.

review if interested. Portfolio should include color or b&w final art, final reproduction/product, slides, tearsheets and photographs. Originals are returned at job's completion. Payment negotiated at time of purchase. Considers buying second rights (reprint rights) to previously published work.

RENAISSANCE GREETING CARDS, Box 845, Springvale ME 04083. (207)324-4153. Fax: (207)324-9564. **Art Director:** Jennifer Stockless. Estab. 1977. Publishes greeting cards; "current approaches" to all-occasion cards and seasonal cards. "We're an alternative card company with a unique variety of cards for all ages, situations and occasions."
Needs: Approached by 500-600 artists/year. Buys 300 illustrations/year. Occasionally buys calligraphy. Art guidelines available free for SASE with first-class postage. Full-color illustrations only. Produces materials for all holidays and seasons and everyday. Submit art 18 months in advance for fall and Christmas material; approximately 1 year in advance for other holidays.
First Contact & Terms: Send query letter with SASE. To show portfolio, mail color copies, tearsheets, slides or transparencies. Packaging with sufficient postage to return materials should be included in the submission. Responds in 2 months. Originals are returned to artist at job's completion. Sometimes requests work on spec before assigning a job. Pays for design by the project, $150-300 advance on royalties or flat fee, negotiable. Also needs calligraphers, pay rate negotiable. Finds artists mostly through submissions/self-promotions.
Tips: "Do some 'in store' research first to get familiar with a company's product/look in order to decide if your work is a good fit. It can take a lot of patience to find the right company or situation. Especially interested in trendy styles as well as humorous and whimsical illustration. Start by requesting guidelines, and then send a small (10-12) sampling of 'best' work, preferably color copies or slides (with SASE for return). Indicate if the work shown is available or only samples. We're doing more designs with special effects like die-cutting and embossing. We're also starting to use more computer-generated art and electronic images."

[N] RIGHTS INTERNATIONAL GROUP, 463 First St. #3C, Hoboken NJ 07030. (201)239-8118. Fax: (201)222-0694. E-mail: rhazaga@rightsinternational.com. Website: www.rightsinternational.com. **Contact:** Robert Hazaga. Estab. 1996. Agency for cross licensing. Licenses images for manufacturers of giftware, stationery, posters, home furnishing.
• This company also has a listing in the Posters & Prints section.
Needs: Approached by 50 freelancers/year. Uses freelancers mainly for creative, decorative art for the commercial and designer market. Also for textile art. Considers oil, acrylic, watercolor, mixed media, pastels and photography.
First Contact & Terms: Send brochure, photocopies, photographs, SASE, slides, tearsheets or transparencies. Accepts disk submissions compatible with PC format. Responds in 1 month. Will contact for portfolio review if interested. Negotiates rights purchased and payment.

[N] RITE LITE LTD./THE JACOB ROSENTHAL JUDAICA-COLLECTION, 333 Stanley Ave., Brooklyn NY 11207. (718)498-1700. Fax: (718)498-1251. E-mail: ritelite@aol.com. **President:** Alex Rosenthal. Estab. 1948. Manufacturer and distributor of a full range of Judaica ranging from mass-market commercial goods, such as decorative housewares, to exclusive numbered pieces, such as limited edition plates. Clients: department stores, galleries, gift shops, museum shops and jewelry stores.
• Company is looking for new menorah, mezuzah, children's Judaica, Passover and matza plate designs.
Needs: Approached by 15 freelancers/year. Works with 4 freelancers/year. Art guidelines not available. Works on assignment only. Uses freelancers mainly for new designs for Judaic giftware. Must be familiar with Jewish ceremonial objects or design. Prefers ceramic, brass and glass. Also uses artists for brochure and catalog design, illustration and layout mechanicals, P-O-P and product design. 25% of freelance work requires knowledge of Illustrator and Photoshop. Produces material for Hannukkah, Passover, Hasharah. Submit seasonal material 1 year in advance.
First Contact & Terms: Designers send query letter with brochure or résumé and photographs. Illustrators send photocopies. Do not send originals. Samples are filed. Responds in 1 month only if interested. Portfolio review not required. Art Director will contact for portfolio review if interested. Portfolio should include color tearsheets, photographs and slides. Pays flat fee of $500/design or royalties of 5-6%. Buys all rights. "Works on a royalty basis." Finds artists through word of mouth.
Tips: "Be open to the desires of the consumers. Don't force your preconceived notions on them through the manufacturers. Know that there is one retail price, one wholesale price and one distributor price."

ROCKSHOTS GREETING CARDS, 20 Vandam St., 4th Floor, New York NY 10013-1274. (212)243-9661. Fax: (212)604-9060. **Editor:** Bob Vesce. Estab. 1979. Produces calendars, giftbags, giftwrap, greet-

ing cards, mugs. "Rockshots is an outrageous, sometimes adult, always hilarious card company. Our themes are sex, birthdays, sex, holiday, sex, all occasion and sex. Our images are mainly photographic, but we also seek out cartoonists and illustrators."

Needs: Approached by 10-20 freelancers/year. Works with 5-6 freelancers/year. Buys 10 freelance designs and illustrations/year. Art guidelines free for SASE with first-class postage. "We like a line that has many different facets to it, encompassing a wide range of looks and styles. We are outrageous, adult, witty, off-the-wall, contemporary and sometimes shocking." Prefers any size that can be scaled on a greeting card size to 5 inches by 7 inches. 10% of freelance illustration demands computer skills. Produces material for Christmas, New Year, Valentine's Day, birthdays, everyday, get well, woman to woman ("some male bashing allowed") and all adult themes.

First Contact & Terms: Illustrators and/or cartoonists send photocopies, photographs and photostats. Samples are filed. Responds only if interested. Portfolio review not required. Buys first rights. Pays per image.

Tips: "As far as trends go in the greeting card industry, we've noticed that 'retro' refuses to die. Vintage looking cards and images still sell very well. People find comfort in the nostalgic look of yesterday. Sex also is a huge seller. Rockshots is looking for illustrators that can come up with something a little out of mainstream. Our look is outrageous, witty, adult and sometimes shocking. Our range of style starts at cute and whimsical and runs the gamut all the way to totally wacky and unbelievable. Rockshot cards definitely stand out from the competition. For our line of illustrations, we look for a style that can convey a message, whether through a detailed elaborate colorful piece of art or a simple 'gesture' drawing. Characters work well, such as the ever-present wisecracking granny to the nerdy 'everyman' guy. It's always good to mix sex and humor, as sex always sells. As you can guess, we do not shy away from much. Be creative, be imaginative, be funny, but most of all, be different."

N. ROMAN, INC., 555 Lawrence Ave., Roselle IL 60172. (630)529-3000. Fax: (630)529-1121. Website: www.roman.com. **Vice President:** Julie Puntch. Estab. 1963. Produces collectible figurines, decorative housewares, decorations, gifts, limited edition plates, ornaments. Specializes in collectibles and giftware to celebrate special occasions.

Needs: Approached by 25-30 freelancers/year. Works with 3-5 freelancers/year. Uses freelancers mainly for graphic packaging design, illustration. Also for a variety of services. Considers variety of media. Looking for traditional-based design. Roman also has an inspirational niche. 80% of freelance design and illustration demands knowledge of Photoshop, QuarkXPress, Illustrator. Produces material for Christmas, Mother's Day, graduation, Thanksgiving, birthdays, everyday. Submit seasonal material 1 year in advance.

First Contact & Terms: Send query letter with photocopies. Samples are filed or returned by SASE. Responds in 2 months if artist requests a reply. Portfolio review not required. Pays by the project, varies. Finds freelancers through word of mouth, artists' submissions.

N. RUBBERSTAMPEDE, 2550 Pellisier Place, Whittier CA 90601. (562)695-7969. Fax: (800)546-6888. **Senior Marketing Manager:** Olive Choa. Art Director: Deborah Tanaka. Estab. 1978. Produces art and novelty rubber stamps, kits, glitter pens, ink pads.

Needs: Approached by 30 freelance artists/year. Works with 10-20 freelance artists/year. Buys 200-300 freelance designs and illustrations/year. Uses freelance artists for calligraphy, P-O-P displays, and original art for rubber stamps. Considers pen & ink. Looks for cute, feminine style and fashion trends. Produces seasonal material: Christmas, Valentine's Day, Easter, Hanukkah, Thanskgiving, Halloween, birthdays and everyday. Submit seasonal material 6 months in advance.

First Contact & Terms: Send nonreturnable samples. Samples are filed. Responds only if interested. Pays by the hour, $15-50; by the project, $50-1,000. Rights purchased vary according to project. Originals are not returned.

N. ST. ARGOS CO., INC., 11040 W. Hondo Pkwy., Temple City CA 91780. (626)448-8886. Fax: (626)579-9133. **Manager:** Su-Chen Liang. Estab. 1987. Produces greeting cards, giftwrap, Christmas decorations, paper boxes, tin boxes, bags, puzzles, cards.
 • Also has listing in Posters & Prints.

Needs: Approached by 3 freelance artists/year. Works with 2 freelance artists/year. Buys 3 freelance designs and illustrations/year. Prefers artists with experience in Victorian or country style. Uses freelance artists mainly for design. Produces material for all holidays and seasons. Submit seasonal material 6 months in advance.

First Contact & Terms: Send query letter with résumé and slides. Samples are filed. Art Director will contact artist for portfolio review if interested. Portfolio should include color samples. Originals are not returned. Pays royalties of 7.5%. Negotiates rights purchased.

SANGHAVI ENTERPRISES PVT LTD., (formerly Greetwell), D-24, M.I.D.C., Satpur, Nasik 422 007 India. Fax: 91-253-351381. E-mail: seplnsk@vsnl.com. **Chief Executive:** H.L. Sanghavi. Produces greeting cards, calendars and posters.
Needs: Approached by 50-60 freelancers/year. Buys 50 designs/year. Free art guidelines available. Uses freelancers mainly for greeting cards and calendars. Prefers flowers, landscapes, wildlife and general themes.
First Contact & Terms: Send query letters and photocopies to be kept on file. Samples not filed are returned only if requested. Responds in 1 month. Originals are returned at job's completion. Pays flat fee of $25 for design. Buys reprint rights.
Tips: "Send color photos. Do not send originals. No SASE. Send two or three samples first. If this interests the buyer, then send more."

☑ **SANGRAY CORPORATION**, 2318 Lakeview Ave., Pueblo CO 81004. (719)564-3408. Fax: (719)564-0956. E-mail: von@sangray.com. Website: www.sangray.com. **Licensing:** Vern Estes. Licenses humor for gift and novelty. Estab. 1971. Produces refrigerator magnets, trivets, wall decor and other decorative accessories—all using full-color art. Art guidelines for SASE with first-class postage.
Needs: Approached by 30-40 freelancers/year. Works indirectly with 6-7 freelancers/year. Buys 25-30 freelance designs and illustrations/year. Prefers florals, scenics, small animals and birds. Uses freelancers mainly for fine art for products. Considers all media. Prefers 7×7. Submit seasonal material 10 months in advance.
First Contact & Terms: Send query letter with examples of work in any media. Samples are filed. Responds in 1 month. Company will contact artist for portfolio review if interested. Buys first rights. Originals are returned at job's completion. Pays by the project, $350-450. Finds artists through submissions and design studios.
Tips: "Try to get a catalog of the company products and send art that closely fits the style the company tends to use."

☑ **THE SARUT GROUP**, P.O. Box 110495, Brooklyn NY 11211. (718)387-7484. Fax: (718)387-7467. E-mail: far@sarut.com. Website: www.thesarutgroup.com. **Vice President Marketing:** Frederic Rambaud. Estab. 1979. Produces museum quality science and nature gifts. "Marketing firm with 20 employees. 36 trade shows a year. No reps. All products are exclusive. Medium- to high-end market."
Needs: Approached by 4-5 freelancers/year. Works with 4 freelancers/year. Uses freelancers mainly for new products. Seeks contemporary designs. Produces material for all holidays and seasons.
First Contact & Terms: Samples are returned. Responds in 2 weeks. Write for appointment to show portfolio. Rights purchased vary according to project.
Tips: "We are looking for concepts; products, not automatically graphics."

☑ **SEABRIGHT PRESS INC.**, (831)457-1568. E-mail: art@seabrightpress.com. Website: www.seabrightpress.com. **Editor, licensing:** Jim Thompson. Estab. 1990. Produces greeting cards and journals. Licenses contemporary artwork, greeting cards, blank journals.
Needs: Approached by 20-30 freelancers/year. Works with 5-10 freelancers/year. Licenses 10-20 freelance designs and illustrations/year. Uses freelancers mainly for notecard designs. Art guidelines available via website. Considers any media. Produces material for all holidays and seasons. Submit seasonal material 4-6 months in advance.
First Contact & Terms: E-mail query letter with brochure, tearsheets, photographs and photocopies (accepts e-mail material only). Samples are not filed. Responds in 2 months. Portfolio review not required. Negotiates rights purchased. Originals are returned at job's completion. Pays royalties of 5-7%.
Tips: "Be familiar with the notecard market before submitting work. Develop contemporary illustrations/designs that are related to traditional card themes. View our website for representative work."

☑ **SEABROOK WALLCOVERINGS, INC.**, 1325 Farmville Rd., Memphis TN 38122. (901)320-3500. Fax: (901)320-3675. **Director of Product Development:** Suzanne Ashley. Estab. 1910. Developer and distributor of wallcovering and coordinating fabric for all age groups and styles.
Needs: Approached by 10-15 freelancers/year. Works with approximately 6 freelancers/year. Buys approximately 200 freelance designs and illustrations/year. Prefers freelancers with experience in wall coverings. Works on assignment only. Uses freelancers mainly for designing and styling wallcovering collections. Considers gouache, oil, watercolor, etc. Prefers 20½×20½. Produces material for everyday, residential.
First Contact & Terms: Designers send query letter with color photocopies, photographs, résumé, slides, transparencies and sample of artists' "hand." Illustrators send query letter with color photocopies, photographs and résumé. Samples are filed or returned. Responds in 2 weeks. Company will contact artist for portfolio review of final art, roughs, transparencies and color copies if interested. Buys all rights. Pays for design by the project. Finds freelancers through word of mouth, submissions, trade shows.

Tips: "Attend trade shows pertaining to trends in wall covering. Be familiar with wallcovering design repeats."

✓ ⊕ ▣ SECOND NATURE, LTD., 10 Malton Rd., London, W105UP England. (020)8960-0212. Fax: (020)8960-8700. E-mail: rods@secondnature.co.uk. Website: www.secondnature.co.uk. **Contact:** Rod Schragger. Greeting card publisher specializing in unique 3-D/handmade cards and special finishes.
Needs: Prefers interesting new contemporary but commercial styles. Also calligraphy and web design. Art guidelines available. Produces material for Christmas, Valentine's Day, Mother's Day and Father's Day. Submit seasonal material 19 months in advance.
First Contact & Terms: Send query letter with samples showing art style. Samples not filed are returned only if requested by artist. Responds in 2 months. Originals are not returned at job's completion. Pays flat fee.
Tips: "We are interested in all forms of paper engineering or anything fresh and innovative."

Ⓝ SIGNED, SEALED, DELIVERED, P.O. Box 70007, Pasadena CA 91117. (626)796-9107. Fax: (626)564-1478. **Art Director:** Richard Adamson. Estab. 1998. Produces greeting cards, stationery. Specializes in Christmas cards and stationery featuring illustration, foil stamping and engraving. Supplier of all major department stores and fine card and gift stores.
Needs: Approached by 20 freelancers/year. Works with 3-5 freelancers/year. Buys 20-35 freelance designs and illustrations/year. Also buys some calligraphy. Use freelancers mainly for Christmas cards. Considers all media except sculpture. Looking for traditional, humorous, cute animals and graphic designs. Prefers multiple size range. 30% of freelance work demands knowledge of Photoshop, QuarkXPress. Produces material for Christmas, Hannukkah and Valentine's Day. Submit seasonal material 8-12 months in advance.
First Contact & Terms: Send query letter with photocopies. Samples are filed. Will contact artist for portfolio review of color photographs and slides if interested. Negotiates rights purchased. Pays flat fee by the project. Will also license with option to buy out after license is completed. Finds freelancers through word of mouth, submissions, Surtex show.

PAULA SKENE DESIGN, 1250 45th St., Suite 240, Emeryville CA 94608. (510)654-3510. Fax: (510)654-3496. **President:** Paula Skene. Designs, produces and markets greeting cards, stationery and corporate designs to meet specific client needs featuring foil stamping and embossing.
Needs: Works with 1-2 freelancers/year. Works on assignment only. Produces material for all holidays and seasons, everyday.
First Contact & Terms: Designers send tearsheets and photocopies. Illustrators send samples. Samples are returned. Responds in 3 days. Company will contact artist for portfolio review of b&w, color final art if interested. Buys all rights. Pays for design and illustration by the project.

✓ SPARROW & JACOBS, 6701 Concord Park Dr., Houston TX 77040. (713)744-7800. Fax: (713)744-8799. **Contact:** Merchandise Coordinator. (713)744-8796. Fax: (713)744-8799. E-mail: sparrow@gabp.com. Estab. 1986. Produces calendars, greeting cards, postcards. Publisher of greeting cards and other material for businesses to send for prospecting, retaining and informing real estate agents, insurance agents and chiropractors—themes not restricted to these catetories, however.
Needs: Approached by 60-80 freelancers/year. Works with 30 freelancers/year. Buys 50 freelance designs and illustrations/year. Uses freelancers mainly for illustrations for postcards and greeting cards and calligraphy. Considers all media. Looking for humorous, sophisticated cartoons and traditional homey and warm illustrations of sweet animals, client/business communications. Prefers 8×10 size. Produces material for Christmas, Easter, Mother's Day, Father's Day, graduation, Halloween, New Year, Thanksgiving, Valentine's Day, birthdays, everyday, "just listed/just sold," time change, doctor-to-patient reminders. Submit seasonal material 1 year in advance.
First Contact & Terms: Send query letter with color photocopies, photographs or tearsheets. We also accept e-mail submissions of low-resolution images. Accepts Mac-compatible disk submissions. If sending slides, do not send originals. We are not responsible for slides lost or damaged in the mail. Samples are filed or returned. Buys all rights. Pays for illustration by the project, $200-400.

SPENCER GIFTS, INC., subsidiary of Vivendi Universal, 6826 Black Horse Pike, Egg Harbor Twp. NJ 08234-4197. (609)645-5526. Fax: (609)645-5751. E-mail: james.stevenson@spencergifts.com. Website: wwwspencergifts.com. **Creative Director:** James Stevenson. Licensing: Carl Franke, new product art director. Estab. 1965. Retail gift chain located in approximately 750 stores in 43 states including Hawaii and Canada. Includes 120 new retail chain stores named "DAPY" (upscaled unique gift items), "GLOW" stores, SPIRIT Halloween stores and Universal Studio stores.

• Products offered by store chain include posters, T-shirts, games, mugs, novelty items, cards, 14k jewelry, neon art, novelty stationery. Art director says Spencer's is moving into a lot of different product lines, such as custom lava lights and Halloween costumes and products. Visit a store if you can to get a sense of what they offer.

Needs: Assigns 10-15 freelance jobs/year. Prefers artists with professional experience in advertising design. Uses artists for illustration (hard line art, fashion illustration, airbrush). Also needs product and fashion photography (primarily jewelry), as well as stock photography. Uses a lot of freelance computer art. 50% of freelance work demands knowledge of FreeHand, Illustrator, Photoshop and QuarkXPress. Also needs color separators, production and packaging people. "You don't necessarily have to be local for freelance production."

First Contact & Terms: Send postcard sample or query letter with *nonreturnable* brochure, résumé and photocopies, including phone number where you can be reached during business hours. Accepts submissions on disk. Art director will contact artist for portfolio review if interested. Will contact only upon job need. Considers buying second rights (reprint rights) to previously published work. Finds artists through sourcebooks.

Tips: "Become proficient in as many computer programs as possible."

STANDARD CELLULOSE & NOV CO., INC., 90-02 Atlantic Ave., Ozone Park NY 11416. (718)845-3939. Fax: (718)641-1170. **President:** Stewart Sloane. Estab. 1932. Produces giftwrap and seasonal novelties and decorations.

Needs: Approached by 10 freelance artists/year. Works with 1 freelance artist/year. Buys 3-4 freelance designs and illustrations/year. Prefers local artists only. Uses freelance artists mainly for design packaging. Also uses freelance artists for P-O-P displays, all media appropriate for display and P-O-P. Produces material for all holidays and seasons, Christmas, Easter, Halloween and everyday. Submit 6 months before holiday.

First Contact & Terms: Send query letter or call for appointment. Samples are not filed and are returned. Responds only if interested. Call to schedule an appointment to show a portfolio. "We will then advise artist what we want to see in portfolio." Original artwork is not returned at the job's completion. Payment negotiated at time of purchase. Rights purchased vary according to project.

STOTTER & NORSE, (formerly Stotter), 1000 Second St., Plainfield NJ 07063. (908)754-6330. Fax: (908)757-5241. E-mail: sales@stotternorse.com. Website: www.stotternorse.com. **V.P. Sales:** Larry Speichler. Estab. 1979. Produces barware, serveware, placemats and a broad range of tabletop products.

Needs: Buys 20 designs and illustrations/year. Art guidelines not available. Works on assignment only. Uses freelancers mainly for product design. Seeking trendy styles. Final art should be actual size. Produces material for all seasons. Submit seasonal material 6 months in advance.

First Contact and Terms: Send query letter with brochure and résumé. Samples are filed. Responds in 1 month or does not reply, in which case the artist should call. Call for appointment to show portfolio. Negotiates rights purchased. Originals returned at job's completion if requested. Pays flat fee and royalties; negotiable.

SUNRISE PUBLICATIONS INC., Box 4699, Bloomington IN 47402. (812)336-9900. Fax: (812)336-8712. E-mail: info@interact.com. Website: www.interart.com. **Contact:** Art Review Committee. Estab. 1974. Produces greeting cards, posters, writing papers, gift packaging and related products.

Needs: See art guidelines on website. Uses freelancers mainly for greeting card illustration. Also for calligraphy, lettering and product design. Considers any medium. Looking for "highly detailed, highly rendered illustration, but will consider a range of styles." Also looking for photography, humor concepts and surface design. Produces material for all holidays and seasons and everyday. Reviews seasonal material year-round.

First Contact & Terms: Send query letter with SASE, tearsheets, photographs, photocopies, photostats, slides and/or transparencies—maximum 20 images. Samples are not filed and are returned by SASE. Responds in 6 months. Art Director will contact artist for portfolio review if interested. Portfolio should include color tearsheets, photographs and/or slides (duplicate slides or transparencies, please; *not* originals). Originals are returned at job's completion. Negotiates rights purchased. Considers buying second rights (reprint rights) to previously published work.

Tips: Look carefully at the market/industry in which you want to market your work. Look at the competition!

SUNSHINE ART STUDIOS, INC., 51 Denslow Rd., E. Longmeadow MA 01028. (413)525-5599. Website: sunshinecards.com. **Creative Director:** Jeanna Lane. Estab. 1921. Produces greeting cards, stationery, calendars and giftwrap that are sold in own catalog, appealing to all age groups.

Needs: Works with 100-125 freelance artists/year. Buys 200-250 freelance designs and illustrations/year. Prefers artists with experience in greeting cards. Art guidelines available for SASE with first-class postage. Works on assignment only. Uses freelancers for greeting cards, giftwrap, stationery and gift items. Also for calligraphy. Considers all media. Looking for traditional or humorous look. Prefers art 4½×6½ or 5×7. Produces material for Christmas, Easter, birthdays and everyday. Submit seasonal material 6-8 months in advance.

First Contact & Terms: Send query letter with brochure, résumé, SASE, tearsheets and slides. Samples are filed or are returned by SASE if requested by artist. Responds only if interested. Portfolio should include finished art samples and color tearsheets and slides. Originals not returned. Pays by the project, $250-400. Pays $25-75/piece for calligraphy and lettering. Buys all rights.

N A SWITCH IN ART, Gerald F. Prenderville, Inc., P.O. Box 246, Monmouth Beach NJ 07750. (732)389-4912. Fax: (732)389-4913. E-mail: switchinart@aol.com. **President:** G.F. Prenderville. Estab. 1979. Produces decorative switch plates. "We produce decorative switch plates featuring all types of designs including cats, animals, flowers, kiddies/baby designs, birds, etc. We sell to better gift shops, museums, hospitals, specialty stores with large following in mail order catalogs."

Needs: Approached by 4-5 freelancers/year. Works with 2-3 freelancers/year. Buys 10-20 designs and illustrations/year. Prefers artists with experience in card industry and cat rendering. Seeks cats and wildlife art. Prefers 8×10 or 10×12. Submit seasonal material 6 months in advance.

First Contact & Terms: Send query letter with brochure, tearsheets and photostats. Samples are filed and are returned. Responds in 3-5 weeks. Pays by the project, $75-150. Interested in buying second rights (reprint rights) to previously published artwork. Finds artists mostly through word of mouth.

Tips: "Be willing to accept your work in a different and creative form that has been very successful. We seek to go vertical in our design offering to insure continuity. We are very easy to work with and flexible. Cats have a huge following among consumers but designs must be realistic."

SYRACUSE CULTURAL WORKERS, Box 6367, Syracuse NY 13217. (315)474-1132. Fax: (315)475-1277. E-mail: scwart@dreamscape.com. Website: www.syraculturalworkers.org. **Art Director:** Karen Kerney. Estab. 1982. Produces notecards, postcards, greeting cards, posters, T-shirts and calendars. "SCW is a nonprofit publisher of artwork that inspires and supports social change. Our *Tools for Change* catalog is distributed to individuals, stores, co-ops and groups in North America."

• SCW is specifically seeking artwork celebrating diverstiy, people's history and community building. Themes include environment, positive parenting, positive gay and lesbian images, multiculturalism and cross-cultural adoption.

Needs: Approached by many freelancers/year. Works with 50 freelancers/year. Buys 40-50 freelance fine art images and illustrations/year. Considers all media (in slide form). Art guidelines free for SASE with first-class postage. Looking for progressive, feminist, liberating, vital, people- and earth-centered themes. "December and January are major art selection months."

First Contact & Terms: Send query letter with slides, brochures, photocopies, photographs, SASE, tearsheets and transparencies. Samples are filed or returned by SASE. Responds in 1 month with SASE. Will contact for portfolio review if interested. Buys one-time rights. Pays by project, $85-400; royalties of 6% of gross sales. Finds artists through word of mouth, its own artist list and submissions.

Tips: "Please do NOT send original art or slides. Rather, send photocopies, printed samples or duplicate slides. Also, one postcard sample is not enough for us to judge whether your work is right for us. We'd like to see at least three or four different images. Include return postage if you would like your artwork/slides returned."

✓ ☒ TALICOR, INC., 14175 Telephone Ave., Suite A, Chino CA 91710. (909)517-0076. E-mail: webmaster@talicor.com. Website: www.talicor.com. **President:** Lew Herndon. Estab. 1971. Manufacturer and distributor of educational and entertainment games and toys. Clients: chain toy stores, department stores, specialty stores and Christian bookstores.

Needs: Works with 4-6 freelance illustrators and designers/year. Prefers local freelancers. Works on assignment only. Uses freelancers mainly for game design. Also for advertising, brochure and catalog design, illustration and layout; product design; illustration on product; P-O-P displays; posters and magazine design.

First Contact & Terms: Send query letter with brochure. Samples are not filed and are returned only if requested. Responds only if interested. Call or write for appointment to show portfolio. Pays for design and illustration by the project, $100-3,000. Negotiates rights purchased.

N ARTHUR THOMPSON & COMPANY, P.O. Box 8023, Saint Charles IL 60174-8023. (630)584-5235. **Contact:** Laurie Pena. Publishes greeting cards and letterheads; holiday (Christmas and Thanksgiving) and business-to-business cards. Business-to-business line includes thank you, congratulations, etc.

Needs: Approached by 300 or so artists/year. Uses artists for product illustration and photographers for photos. Accepts art in any media. Prefers clean, corporate-type designs or traditional work. Freelancers should be familiar with PageMaker, Illustrator, QuarkXPress or FreeHand.

First Contact & Terms: Send query letter, SASE and samples if possible. Prefers transparencies or slides. Do not send original art. Responds in 6 weeks. Provide samples and tearsheets to be kept on file for possible future assignments. Pays by the project, $200-350; negotiated. Considers product use and rights purchased when establishing payment. Art guidelines available upon request.

Tips: "We are a business-to-business greeting card company. We try to keep our cards oriented toward business themes."

☑ **TJ'S CHRISTMAS**, 13306 W. 99th St., Lenexa KS 66215. (913)888-8338. Fax: (913)888-8350. E-mail: mitch@imitchell.com. Website: www.imitchell.com. **Creative Coordinator:** Edward Mitchell. Estab. 1983. Produces figurines, decorative accessories, ornaments and other Christmas adornments. Primarily manufactures and imports Christmas ornaments, figurines and accessories. Also deals in some Halloween, Thanksgiving, gardening and everyday home decor items. Clients: higher-end floral, garden, gift and department stores.

Needs: Uses freelancers mainly for fun and creative designs. Considers most media. "Our products are often nostalgic, bringing back childhood memories. They also should bring a smile to your face. We are looking for fun designs that fit with our motto, 'Cherish the Memories.'" Produces material for Christmas, Halloween, Thanksgiving and everyday. Submit seasonal material 18 months in advance.

First Contact & Terms: Send query letter with résumé, SASE and photographs. Will accept work on disk. Portfolios may be dropped off Monday-Friday. Samples are not filed and are returned by SASE. Responds in 1 month. Negotiates rights purchased. Pays advance on royalties of 5%. Terms are negotiated. Finds freelancers through magazines, word of mouth and artist's reps.

Tips: "Continually search for new and creative ideas. Sometimes the craziest ideas turn into the best designs (i.e., a Santa figurine curiously holding up a Santa ornament that looks just like him.) Watch for trends (such as increasing number of baby boomers that are retiring.) Try to target the trends you see. Think from the viewpoint of a consumer walking around a small gift store."

☑ **UNITED DESIGN**, 1600 N. Main St., Noble OK 73068. (405)872-4433. Fax: (405)360-4442. E-mail: ghaynes@united-design.com. Website: www.united-design.com. **Product Development Assistant:** Gayle Haynes. Produces collectible figurines, decorative housewares, garden. Specializes in giftware: frames, animal sculpture, garden ornament, figurines.

Needs: Approached by 300 freelancers/year. Works with 70 freelancers/year. Buys 300 freelance designs and illustrations/year. Also 500-1,000 sculptures/year. Prefers freelancers with experience in sculpting and/or design for sampling. Considers sculpy, plastilene, wood. Please familiarize yourself with our subject matter before submitting portfolio. Produces material for seasonal and everyday home decor.

First Contact & Terms: Designers and sculptors send query letter with brochure, photocopies, photographs, résumé, SASE. No 3D samples or slides. Samples are filed (unless otherwise directed by submitter) or returned by SASE. Will contact within 3 weeks for portfolio review if interested. Rights purchased vary according to project. Pays by the project based on experience, expertise. Royalty arrangements vary. Finds freelancers through word of mouth, artists' submissions, websites.

Tips: "You must possess creativity, high technical ability while meeting deadlines."

VAGABOND CREATIONS INC., 2560 Lance Dr., Dayton OH 45409. (937)298-1124. **Art Director:** George F. Stanley, Jr. Publishes stationery and greeting cards with contemporary humor. 99% of artwork used in the line is provided by staff artists working with the company.

• Vagabond Creations Inc. now publishes a line of coloring books.

Needs: Works with 4 freelancers/year. Buys 30 finished illustrations/year. Prefers local freelancers. Seeking line drawings, washes and color separations. Material should fit in standard-size envelope.

First Contact & Terms: Query. Samples are returned by SASE. Responds in 2 weeks. Submit Christmas, Valentine's Day, everyday and graduation material at any time. Originals are returned only upon request. Payment negotiated.

Tips: "Important! Currently we are *not* looking for additional freelance artists because we are very satisfied with the work submitted by those individuals working directly with us. We do not in any way wish to offer false hope to anyone, but it would be foolish on our part not to give consideration. Our current artists are very experienced and have been associated with us in some cases for over 30 years."

N VERMONT T'S, Main St., Chester VT 05143. (802)875-2091. Fax: (802)875-4480. E-mail: vermontts @vermontel.net. **President:** Thomas Bock. Commercial screenprinter, specializing in T-shirts and sweat-shirts. Vermont T's produces custom as well as tourist-oriented silkscreened sportswear. Does promotional work for businesses, ski-resorts, tourist attractions and events.

Needs: Works with 5-10 freelance artists/year. Uses artists for graphic designs for T-shirt silkscreening. Prefers pen & ink, calligraphy and computer illustration.

First Contact & Terms: Send query letter with brochure. Samples are filed or are returned only if requested. Responds in 10 days. To show portfolio, mail photostats. Pays for design by the project, $75-250. Negotiates rights purchased. Finds most artists through portfolio reviews and samples.

Tips: "Have samples showing rough through completion. Understand the type of linework needed for silkscreening."

☑ **WANDA WALLACE ASSOCIATES**, 323 E. Plymouth, Suite 2, Inglewood CA 90302. (310)419-0376. Fax: (310)419-0382. Website: www.wandawallace.com. **President:** Wanda. Estab. 1980. Produces greeting cards and posters for general public appeal. "We produce black art prints, posters, originals and other media."

Needs: Approached by 10-12 freelance artists/year. Works with varying number of freelance artists/year. Buys varying number of designs and illustrations/year from freelance artists. Prefers artists with experience in black/ethnic art subjects. Uses freelance artists mainly for production of originals and some guest appearances. Considers all media. Produces material for Christmas. Submit seasonal material 4-6 months in advance.

First Contact & Terms: Send query letter with any visual aid. Some samples are filed. Policy varies regarding answering queries and submissions. Call or write to schedule an appointment to show a portfolio. Rights purchased vary according to project. Original artwork is returned at the job's completion. Pays by the project.

WARNER PRESS, INC., 1200 E. Fifth St., Anderson IN 46018. (765)644-7721. **Creative Director:** John Silvey. Estab. 1884. Produces church bulletins and church supplies such as postcards and children's materials. Warner Press is the publication board of the Church of God. "We produce products for the Christian market. Our main market is the Christian bookstore. We provide products for all ages."

Needs: Approached by 50 freelancers/year. Works with 35-40 freelancers/year. Buys 300 freelance designs and illustrations/year. Works on assignment only. Uses freelancers for all products, coloring books. Also for calligraphy. "We use local Macintosh artists with own equipment capable of handling 40 megabyte files in Photoshop, FreeHand and QuarkXPress." Considers all media and photography. Looking for bright florals, sensitive still lifes, landscapes, wildlife, birds, seascapes; all handled with bright or airy pastel colors. 100% of production work demands knowledge of QuarkXPress, Illustrator or Photoshop. Produces material for Father's Day, Mother's Day, Christmas, Easter, graduation and everyday. Submit seasonal material 18 months in advance.

First Contact & Terms: Send query letter with brochure, tearsheets and photocopies. Samples are filed and are returned if SASE included. Creative manager will contact artist for portfolio review if interested. Portfolio should include b&w and color final art, tearsheets, photographs and transparencies. Originals are not returned. Pays by the project, $250-350. Pays for calligraphy pieces by the project. Buys all rights (occasionally varies).

Tips: "Subject matter must be appropriate for Christian market. Most of our art purchases are for children's material. We prefer palettes of bright colors as well as clean, pretty pastels."

☒ **WHITEGATE FEATURES SYNDICATE**, 71 Faunce Dr., Providence RI 02906. (401)274-2149. **Contact:** Eve Green.
 • This syndicate is looking for fine artists and illustrators. See their listing in Syndicates for more information about their needs.

WHITNEY PINK, INC., P.O. Box 8244, Port OR 97207. (503)234-4100. Fax: (503)234-2500. **Director:** Larry Chusid. Estab. 1982. Produces calendars, greeting cards, mugs, t-shirts, humorous products and adult general market.

Needs: Approached by 24 freelancers/year. Works with 6 freelancers/year. Buys 36 freelance designs and illustrations/year. Art guidelines available. Uses freelancers mainly for copy and illustration. Considers all media. 20% of freelance design work demands knowledge of Illustrator and QuarkXPress. 20% of freelance illustration demands knowledge of Illustrator and QuarkXPress. Produces material for Christmas, birthdays and everyday. Submit seasonal material 8 months in advance.

First Contact & Terms: Designers send photocopies, SASE, slides and transparencies. Illustrators send photocopies, résumé, tearsheets and SASE. Samples are filed. Responds only if interested. Pays $350 plus royalties for art, $75 plus royalties for copy. Rights purchased vary according to project.

☒ **WILLITTS DESIGNS**, 1129 Industrial Ave., Petaluma CA 94952. (707)778-7211. Fax: (709)769-0304. E-mail: info@willitts.com. Website: http://willitts.com. **Marketing Coordinator:** Kameron Rankin.

Produces collectible figurines, decorative housewares, limited edition plates, mugs, ornaments, jewelry. Specializes in Just the Right Shoe—miniature shoe figurines; Ebony Products (Thomas Blackshear's ebony visions).

Needs: Approached by about 40 freelancers/year. Works with about 25 freelancers/year. Buys 6 freelance designs and illustrations/year. Uses freelancers mainly for mechanicals, P-O-P. Considers all media. 50% of freelance design work demands knowledge of Photoshop, QuarkXPress. Also needs graphics for catalog/collateral production. Produces material for Mother's Day, Father's Day. Submit seasonal material 6 months in advance.

First Contact & Terms: Designers send brochure, photocopies, photographs, résumé, slides, transparencies. Illustrators send query letter, photocopies, photographs, résumé. Sculptors send sample or photos with résumé/letter. Accepts disk submissions (PC, JPEG or Mac TIFF); Prefers Photoshop and QuarkXPress. Samples are filed. Wishes to see portfolios for designers, illustrators and sculptors. Will contact for portfolio review if interested. Artist should request portfolio review in original query and follow up with phone call. Negotiates rights purchased. Payment varies depending on project. Finds freelancers through word of mouth, artists' submissions.

Tips: "Attend collectible shows/subscribe to magazines. Be patient."

CAROL WILSON FINE ARTS, INC., Box 17394, Portland OR 97217. (503)261-1860. **Contact:** Gary Spector. Estab. 1983. Produces greeting cards and fine stationery products.

Needs: Romantic floral and nostalgic images. "We look for artists with high levels of training, creativity and ability."

First Contact & Terms: Send query letter with copies of artwork to be kept on file. No original artwork on initial inquiry. Samples not filed are returned by SASE. Responds in 2 months. Negotiates return of original art after reproduction. Payment ranges from flat fee to negotiated royalties.

Tips: "We are seeing an increased interest in romantic fine arts cards and very elegant products featuring foil, embossing and die-cuts."

● **SPECIAL COMMENTS** within listings by the editor of *Artist's & Graphic Designer's Market* are set off by a bullet.

Magazines

Popular weeklies are always on the lookout for new artistic talent. Compiled of liberal, assorted reviews, news stories and advertisements, most alternative newspapers may buy up to ten illustrations for each issue, as opposed to the one or two comic strips found in a daily newspaper. This eye-catching illustration designed by Andrew Spears for *Weekly Planet*'s annual fiction contest simply would not be ignored on the stands by most pedestrians.

Magazine art directors depend on freelance illustrators and photographers for most of the images in each edition. There are hundreds of magazines in need of freelance illustrators, but you have to know what kind of illustrations they need. Flip through a dozen magazines in your local drugstore and you will quickly see that each illustration conveys the tone and content of articles while fitting in with the magazine's "personality." Read the interview with Andy Cowles, art director of *Rolling Stone* on page 6 for more insights on how this works.

TARGET YOUR MARKETS

Read each listing carefully. Within each listing are valuable clues. Knowing how many artists approach each magazine will help you understand how stiff your competition is. (At first, you might do better submitting to art directors who aren't swamped with submissions.) Look at the preferred subject matter to make sure your artwork fits the magazine's needs. Note the submission requirements and develop a mailing list of markets you want to approach.

Visit newsstands and bookstores. Look for magazines not listed in *Artist's & Graphic Designer's Market*. Check the cover and interior. If illustrations are used, flip to the masthead (usually a box in one of the beginning pages) and note the art director's name. The circulation figure is relevant too. As a rule of thumb, the higher the circulation the higher the art director's budget. When art directors have a good budget, they tend to hire more illustrators and pay higher fees. Look at the illustrations and check the illustrator's name in the credit line in small print to the side of the illustration. Notice which illustrators are used often in the publications you wish to work with. You will notice that each illustrator they chose has a very definite style. After you have studied the illustrations in dozens of magazines, you will understand what types of illustrations are marketable.

CREATE A PROMO SAMPLE

Focus on one or two *consistent* styles to present to art directors in sample mailings. See if you can come up with a style that is different from every other illustrator's style, if only slightly. No matter how versatile you may be, limit styles you market to one or two. That way, you'll be more memorable to art directors. Pick a style or styles you enjoy and can work quickly in. Art directors don't like surprises. If your sample shows a line drawing, they expect you to work in that style when they give you an assignment. Look on pages 12-17 for some examples of good promotional pieces.

MORE MARKETING TIPS

- **Don't overlook trade magazines and regional publications.** While they may not be as glamorous as national consumer magazines, some trade and regional publications are just as lavishly produced. Most pay fairly well and the competition is not as fierce. Until you can get some of the higher circulation magazines to notice you, take assignments from smaller magazines, too. Alternative weeklies are great markets as well. Despite their modest payment, there are many advantages. You learn how to communicate with art directors, develop your signature style and learn how to work quickly to meet deadlines. Once the assignments are done, the tearsheets become valuable samples to send to other magazines.
- **Develop a spot illustration style in addition to your regular style.** "Spots"—illustrations that are half-page or smaller—are used in magazine layouts as interesting visual cues to lead readers through large articles, or to make filler articles more appealing. Though the fee for one spot is less than for a full layout, art directors often assign five or six spots within the same issue to the same artist. Because spots are small in size, they must be all the more compelling. So send art directors a sample showing several power-packed small pieces along with your regular style.
- **Invest in a fax machine, e-mail and graphics software.** Art directors like to work with

illustrators who own faxes, because they can quickly fax a layout with a suggestion. The artist can fax back a preliminary sketch or "rough" the art director can OK. Also they will appreciate it if you can e-mail TIFF, EPS or JPEG files of your work.

- **Get your work into competition annuals and sourcebooks.** The term "sourcebook" refers to the creative directories published annually showcasing the work of freelancers. Art directors consult these publications when looking for new styles. If an art director uses creative directories, we include that information in the listings to help you understand your competition. Some directories like *Black Book*, *The American Showcase* and *RSVP* carry paid advertisements costing several thousand dollars per page. Other annuals, like the *Print Regional Design Annual* or *Communication Art Illustration Annual* feature award winners of various competitions. An entry fee and some great work can put your work in a competition directory and in front of art directors across the country.
- **Consider hiring a rep.** If after working successfully on several assignments you decide to make magazine illustration your career, consider hiring an artists' representative to market your work for you. (See the Artists' Reps section, page 637.)

For More Information

- A great source for new leads is in the business section of your local library. Ask the librarian to point out the business and consumer editions of the *Standard Rate and Data Service (SRDS)* and *Bacon's Magazine Directory*. These huge directories list thousands of magazines and will give you an idea of the magnitude of magazines published today. Another good source is a yearly directory called *Samir Husni's Guide to New Consumer Magazines* also available in the business section of the public library. Also read *Folio* magazine to find out about new magazine launches and redesigns.

- Each year the Society of Publication Designers sponsors an annual juried competition called, appropriately, SPOTS. The winners are featured in a prestigious exhibition. For information about the annual competition, contact the Society of Publication Designers at (212)983-8585 or visit their website at www.spd.org.

- Networking with fellow artists and art directors will help you find additional success strategies. There are many great organizations out there—the Graphic Artist's Guild, The American Institute of Graphic Artists (AIGA), your city's Art Director's Club or branch of the Society of Illustrators, which hold monthly lectures and networking functions. Attend one event sponsored by each organization in your city to find a group you are comfortable with. Then join and become an active member.

N: A. & U. MAGAZINE, America's Aids Magazine, 25 Monroe St., Suite 205, Albany NY 12210-2729. (518)426-9010. Fax: (518)436-5354. E-mail: mailbox@aumag.org. Website: www.aumag.org. **Contact:** Edward Blakeborough, managing art director. Estab. 1991. Monthly 4-color literary magazine. *A. &. U.* is an AIDS publication—our audience is everyone affected by the AIDS crisis. Citc. 200,000. Art guidelines are free for #10 SASE with first-class postage.

Cartoons: Approached by 10 cartoonists/year. Buys 1 cartoon/year. Prefers work relating to HIV/AIDS disease. Prefers: single panel, double panel or multiple panel humorous, b&w washes, color washes or line drawings. Send querrrry letter with b&w photocopies, color photocopies, samples and SASE. Samples are not filed and are returned by SASE. Responds within a month only if interested. Buys first North American seriali rights. **Pays on acceptance;** $500 maximum.

Illustration: Approached by 15 illustrators/year. Buys 5 illustrations/issue. Features humorous illustration, realistic illustrations, charts & graphs, informational graphics, medical illustration, spot illustrations and computer illustration of all subjects affected by HIV/AIDS. Prefers all styles and media. Assigns 50% of illustrations to well-known or "name" illustrators; 25% to experienced, but not well-known illustrators;

25% to new and emerging illustrators. 50% of freelance illustration demands knowledge of Adobe Illustrator or Photoshop. Send query letter with printed samples, photocopies and SASE. Accepts Mac-compatible disk submissions. Samples are not filed and are returned by SASE. Responds within 1 month only if interested. Will contact artist for portfolio review if interested. Buys first North American serial rights. **Pays on acceptance,** $500 maximum. Finds freelancers through artists promotional samples.

Tips: We would like to get cutting-edge and unique illustrations or cartoons about the HIV/AIDS crisis, they can be humorous or nonhumorous.

[N] ⊕ ACTIVE LIFE, LexiCon, 1st Floor, 1-5 Clerkenwell, London EC1M 5PA United Kingdom. Phone: (0207)253 5775. Fax: (0207)253 5676. E-mail: activelife@lexicon-uk.com. Website: www.activelif emag.co.uk. **Managing Editor:** Helene Hodge. Editor's Assistant: Katy Morrison. Estab. 1990. Bimonthly lively lifestyle consumer magazine for the over 50s. Circ. 240,000.

Illustration: Approached by 200 illustrators/year. Buys 12 illustration/issue. Features humorous illustration. Preferred subject: families. Target group 50+. Prefers pastel and bright colors. Assigns 20% of illustration to well-known or "name" illustrators; 60% to experienced, but not well-known illustrators; 20% to new and emerging illustrators. Send nonreturnable samples. Accepts Mac-compatible disk submissions. Samples are filed. Responds within 1 month. Will contact artist for portfolio review if interested. Buys all rights. Pays on publication. Finds illustrators through promotional samples.

Tips: We use all styles, but more often "traditional" images.

☑ ADVENTURE CYCLIST, 150 E. Pine St, Missoula MT 59802. (406)721-1776. Fax: (406)721-8754. E-mail: gsiple@adventurecycling.org. Website: www.adventurecycling.org. **Art Director:** Greg Siple. Estab. 1974. Published 9 times/year. A journal of adventure travel by bicycle. Circ. 26,000. Originals returned at job's completion. Sample copies available.

Illustration: Buys 1 illustration/issue. Has featured illustrations by Margie Fullmer, Ludmilla Tomova and Kelly Sutherland. Works on assignment only. Send printed samples. Samples are filed. Publication will contact artist for portfolio review if interested. Pays on publication, $50-350. Buys one-time rights.

ADVOCATE, PKA'S PUBLICATION, 301A Rolling Hills Park, Prattsville NY 12468. (518)299-3103. **Art Editor:** C.J. Karlie. Estab. 1987. Bimonthly b&w literary tabloid. "*Advocate* provides aspiring artists, writers and photographers the opportunity to see their works published and to receive byline credit toward a professional portfolio so as to promote careers in the arts." Circ. 12,000. "Good quality photocopy or stat of work is acceptable as a submission." Sample copies available for $4. Art guidelines for SASE with first-class postage.

● The Gaited Horse Association Newsletter is published within the pages of *Advocate, PKA's Publication.*

Cartoons: Open to all formats except color washes. Send query letter with SASE and submissions for publication. Samples are not filed and are returned by SASE. Responds in 6 weeks. Buys first rights. Pays in contributor's copies.

Illustration: Buys 10-15 illustrations/issue. Considers pen & ink, charcoal, linoleum-cut, woodcut, lithograph, pencil or photos, "either b&w or color prints (no slides). We are especially looking for horse-related art and other animals." Also needs editorial and entertainment illustration. Send query letter with SASE and photos of artwork (b&w or color prints only). No simultaneous submissions. Samples are not filed and are returned by SASE. Portfolio review not required. Responds in 6 weeks. Buys first rights. Pays in contributor's copies. Finds artists through submissions and from knowing artists and their friends.

Tips: "No postcards are acceptable. Many artists send us postcards to review their work. They are not looked at. Artwork should be sent in an envelope with a SASE."

☑ THE ADVOCATE, 6922 Hollywood Blvd., Suite 1000, Los Angeles CA 90028. (323)871-1225. Fax: (323)467-6805. E-mail: cedwards@advocate.com. Website: www.advocate.com. **Creative Director:** Craig Edwards. Art Director: Mark Harvey. Estab. 1967. Frequency: biweekly. National gay and lesbian 4-color consumer news magazine.

● Also publishes *OUT Magazine*, which slightly focuses more on lifestyle. Send illustrations to Tom O'Quinn, art director at address above.

Illustration: Approached by 20 illustrators/year. Buys 1-2 illustrations/issue. Has featured illustrations by Alexander Munn, Sylvie Bourbonniere and Tom Nick Cocotos. Features caricatures of celebrities and politicians, computer illustration, realistic illustration and medical illustration. Preferred subjects: men, women, gay and lesbian topics. Considers all media. Assigns 90% of illustrations to experienced, but not well-known illustrators; 10% to new and emerging illustrators. Send postcard sample or nonreturnable samples. Accepts Mac-compatible disk submissions. Art guidelines available on website. Samples are filed. Responds only if interested. Portfolio review not required. Buys one-time rights. Pays on publication.

Tips: "We are happy to consider unsolicited illustration submissions to use as a reference for making possible assignments to you in the future. Before making any submissions to us, please familiarize yourself with our magazine. Keep in mind that *The Advocate* is a news magazine. As such, we publish items of interest to the gay and lesbian community based on their newsworthiness and timeliness. We do not publish unsolicited illustrations or portfolios of individual artists. Any illustration appearing in *The Advocate* was assigned by us to an artist to illustrate a specific article."

AGING TODAY, 833 Market St., San Francisco CA 94103. (415)974-9619. Fax: (415)974-0300. **Editor:** Paul Kleyman. Estab. 1979. "*Aging Today* is the bimonthly black & white newspaper of The American Society on Aging. It covers news, public policy issues, applied research and developments/trends in aging." Circ. 15,000. Accepts previously published artwork. Originals returned at job's completion if requested. Sample copies available for SASE with 77¢ postage.
Cartoons: Approached by 50 cartoonists/year. Buys 1-2 cartoons/issue. Prefers political and social satire cartoons; single, double or multiple panel with or without gagline, b&w line drawings. Send query letter with brochure and roughs. Samples returned by SASE. Responds only if interested. Buys one-time rights. Pays $15-25 for b&w.
Illustration: Approached by 50 illustrators/year. Buys 1 illustration/issue. Works on assignment only. Prefers b&w line drawings and some washes. Considers pen & ink. Needs editorial illustration. Send query letter with brochure, SASE and photocopies. Samples are not filed and are returned by SASE. Responds only if interested. To show portfolio, artist should follow up with call and/or letter after initial query. Buys one-time rights. Pays on publication; $25 for b&w cover; $25 for b&w inside.
Tips: "Send brief letter with two or three applicable samples. Don't send hackneyed cartoons that perpetuate ageist stereotypes."

THE AGUILAR EXPRESSION, 1329 Gilmore Ave., Donora PA 15033. (412)379-8019. **Editor/Publisher:** Xavier F. Aguilar. Estab. 1989. Biannual b&w literary magazine/newsletter. Circ. 150. Originals not returned. Sample copies available for $6. Art guidelines for SASE with first-class postage.
Illustration: Approached by 10-15 illustrators/year. Buys 1-2 illustrations/issue. Has featured illustrations by Barbara J. McPhail. Assigns 20% of illustrations to experienced, but not well-known illustrators; 80% to new and emerging illustrators. Considers pen & ink. "We need black line on white." Also needs creative illustrations with 1 line caption. Send query letter with SASE and photocopies. Samples are not filed and are not returned. Responds in 1 month. Portfolio review not required. Sometimes requests work on spec. Acquires one-time rights. Cash payment for cover art. Finds artists through submissions.
Design: Needs freelancers for multimedia design. Send query letter with photocopies and SASE.
Tips: "Study sample copy of publication before submitting artwork. Follow guidelines."

AIM, Box 1174, Maywod IL 60153. (312)874-6184. **Editor-in-Chief:** Ruth Apilado. Managing Editor: Dr. Myron Apilado. Estab. 1973. 8½×11 b&w quarterly with 2-color cover. Readers are those "wanting to eliminate bigotry and desiring a world without inequalities in education, housing, etc." Circ. 7,000. Responds in 3 weeks. Accepts previously published, photocopied and simultaneous submissions. Sample copy $5; artist's guidelines for SASE.
Cartoons: Approached by 12 cartoonists/week. Buys 10-15 cartoons/year. Uses 1-2 cartoons/issue. Prefers education, environment, family life, humor in youth, politics and retirement; single panel with gagline. Especially needs "cartoons about the stupidity of racism." Send samples with SASE. Responds in 3 weeks. Buys all rights on a work-for-hire basis. Pays on publication; $5-15 for b&w line drawings.
Illustration: Approached by 4 illustrators/week. Uses 4-5 illustrations/issue; half from freelancers. Prefers pen & ink. Prefers current events, education, environment, humor in youth, politics and retirement. Provide brochure to be kept on file for future assignments. Samples not returned. Responds in 1 month. Prefers b&w for cover and inside art. Buys all rights on a work-for-hire basis. Pays on publication; $25 for b&w cover illustrations.

FOR EXPLANATIONS OF THESE SYMBOLS,
SEE THE INSIDE FRONT AND BACK COVERS OF THIS BOOK.

Tips: "We could use more illustrations and cartoons with people from all ethnic and racial backgrounds in them. We also use material of general interest. Artists should show a representative sampling of their work and target the magazine's specific needs. Nothing on religion."

AKC GAZETTE, 260 Madison Ave., 4th Floor, New York NY 10016. (212)696-8370. Fax: (212)696-8299. Website: www.akc.org. **Creative Director:** Tilly Grassa. Estab. 1889. Monthly consumer magazine about "breeding, showing, and training pure-bred dogs." Circ. 58,000. Sample copy available for 9 × 12 SASE.
Illustration: Approached by 200-300 illustrators/year. Buys 6-12 illustrations/issue. Has featured illustrations by Pam Tanzey and Chet Jezierski. Assigns 10% of illustrations to well-known or "name" illustrators; 70% to experienced, but not well-known illustrators; 20% to new and emerging illustrators. Considers all media. 25% of freelance illustration demands knowledge of Photoshop, Illustrator, FreeHand and QuarkXPress. Send query letter with printed samples, photocopies and tearsheets. Send follow-up postcard every 6 months. Accepts Mac platform submissions—compatible with QuarkXPress (latest revision). Send EPS or TIFF files at a high resolution (300 dpi). Samples are filed. Responds only if interested. Rights purchased vary according to project. Pays on publication; $500-1,000 for color cover; $50-150 for b&w, $150-800 for color inside. Pays $75-300 for color spots. Finds illustrators through artist's submissions.
Design: Needs freelancers for design, production and multimedia projects. Prefers local designers with experience in QuarkXPress, Photoshop and Illustrator. 100% of freelance work demands knowledge of Photoshop, Illustrator and QuarkXPress. Send query letter with printed samples, photocopies, tearsheets and résumé.
Tips: "Although our magazine is dog-oriented and a knowledge of dogs is preferable, it is not required. Creativity is still key."

ALASKA BUSINESS MONTHLY, P.O. Box 241288, Anchorage AK 99524-1288. (907)276-4373. Fax: (907)279-2900. E-mail: info@akbizmag.com. **Editor:** Debbie Cutler. Estab. 1985. Monthly business magazine. "*Alaska Business Monthly* magazine is written, edited and published by Alaskans for Alaskans and other U.S. and international audiences interested in business affairs of the 49th state. Its goal is to promote economic growth in the state by providing thorough and objective discussion and analyses of the issues and trends affecting Alaska's business sector and by featuring stories on the individuals, organizations and companies that shape the Alaskan economy." Circ. 10,000. Accepts previously published artwork. Originals returned at job's completion if requested. Sample copies available for SASE with 3 first-class stamps.
Illustration: Rights purchased vary according to project. Pays on publication; $300-500 for color cover; $50-250 for b&w inside and $75-300 for color inside.
Tips: "Read the magazine before submitting anything."

N ALASKA MAGAZINE, 619 E. Shipcreek Ave., Suite 329, Anchorage AK 99501-1677. (907)272-6070. Fax: (907)258-5360. **Art Director:** Tim Blum. Production Assistant: Mischelle Kennedy. Estab. 1935. Monthly 4-color regional consumer magazine featuring Alaskan issues, stories and profiles exclusively. Circ. 250,000.
Cartoons: Approached by 500 cartoonists/year. Buys 2 cartoons/year. Prefers single panel, humorous color washes. Samples are filed and not returned. Does not report back. Buys first North American rights or rights purchased vary according to project. Pays on publication; $75-150 for b&w, $125-300 for color.
Illustration: Approached by 200 illustrators/year. Buys 1-4 illustration/issue. Has featured illustrations by James Havens, Lance Lekander, Victor Juhaz, Debra Dubac, Bob Parsons. Features humorous and realistic illustrations. Assigns 50% to experienced, but not well-known illustrators; 50% to new and emerging illustrators. 50% of freelance illustration demands knowledge of Illustrator, Photoshop and QuarkXPress. Send postcard or other nonreturnable samples. Accepts Mac-compatible disk submissions. Samples are not returned. Responds only if interested. Will contact artist for portfolio review if interested. Buys first North American serial rights or rights purchased vary according to project. Pays on publication; $125-300 for color inside; $400-600 for 2-page spreads; $125 for spots.
Tips: "We work with illustrators who grasp the visual in a story quickly and can create quality pieces on tight deadlines."

N ALL ANIMALS, 2100 L St. NW, Washington DC 20037-1525. (202)452-1100. E-mail: allanimals@h sus.org. Website: www.hsus.org. **Creative Director:** Paula Jaworski. Estab. 1954. Quarterly 4-color magazine focusing on The Humane Society news and animal protection issues. Circ. 450,000. Accepts previously published artwork. Originals are returned at job's completion. Art guidelines not available.
Illustration: Buys 1-2 illustrations/issue. Works on assignment only. Features natural history, realistic and spot illustration. Assigns 20% of illustrations to well-known or "name" illustrators; 80% to experienced, but not well-known illustrators. Themes vary. Send query letter with samples. Samples are filed or returned. Responds in 1 month. To show a portfolio, mail appropriate materials. Portfolio should include printed

samples, b&w and color tearsheets and slides. Buys one-time rights and reprint rights. **Pays on acceptance**; $250-500 for b&w cover; $250-500 for color cover; $300-500 for b&w inside; $300-500 for color inside; $300-600 for 2-page spreads; $75-150 for spots.

ALTERNATIVE THERAPIES IN HEALTH AND MEDICINE, 169 Saxony Rd., Suite 104, Encinitas CA 92024-6779. (760)633-3910. Fax: (760)633-3918. Website: www.alternativetherapies.com. **Creative Art Director:** Albert Bohorquez. Estab. 1995. Bimonthly trade journal. "*Alternative Therapies* is a peer-reviewed medical journal established to promote integration between alternative and cross-cultural medicine with conventional medical traditions." Circ. 20,000. Accepts previously published artwork. Originals returned at job's completion. Sample copies available.
Cartoons: Prefers alternative or conventional medicine themes. Prefers single panel, political and humorous, b&w washes and line drawings with gagline. Send query letter with roughs. Samples are filed. Responds in 10 days. Buys one-time rights.
Illustration: Buys 6 illustrations/year. "We purchase fine art for the covers, not graphic art." 50% of freelance work demands knowledge of Illustrator, QuarkXPress and Photoshop. Send query letter with slides. Samples are filed. Responds in 10 days. Publication will contact artist for portfolio review if interested. Portfolio should include photographs and slides. Buys one-time and reprint rights. Pays on publication; negotiable. Finds artists through agents, sourcebooks and word of mouth.

✓ AMERICA, 106 W. 56th St., New York NY 10019. (212)581-4640. Fax: (212)399-3596. E-mail: america@americapress.org. Website: www.americamagazine.org. **Associate Editor:** James Martin. Estab. 1904. Weekly Catholic national magazine sponsored by US Jesuits. Circ. 46,000. Sample copies for #10 SASE with first-class postage.
Illustration: Buys 3-5 illustrations/issue. Has featured illustrations by Michael O'Neill McGrath, William Hart McNichols, René Carson, Tim Foley, Stephanie Dalton Cowan. Features realistic illustration and spot illustration. Assigns 10% of illustrations to well-known or "name" illustrators; 45% of illustrations to experienced, but not well-known illustrators; 45% to new and emerging illustrators. Considers all media. Send query letter with printed samples and tearsheets. Buys first rights. Pays on publication; $300 for color cover; $150 for b&w cover; $75 for b&w inside.
Tips: "We look for illustrators who can do imaginative work for religious, educational or topical articles. We will discuss the article with the artist and usually need finished work in two to three weeks. A fast turnaround is extremely valuable."

AMERICA WEST AIRLINES MAGAZINE, 4636 E. Elwood St., Suite 5, Phoenix AZ 85040-1963. Estab. 1986. Monthly inflight magazine for national airline; 4-color, "conservative design. Appeals to an upscale audience of travelers reflecting a wide variety of interests and tastes." Circ. 130,000. Accepts previously published artwork. Original artwork is returned after publication. Sample copy $3. Art guidelines for SASE with first-class postage. Needs computer-literate illustrators familiar with Photoshop, Illustrator, QuarkXPress and FreeHand.
Illustration: Approached by 100 illustrators/year. Buys 5 illustrations/issue from freelancers. Has featured illustrations by Pepper Tharp, John Nelson, Shelly Bartek, Tim Yearington. Assigns 95% of illustrations to experienced, but not well-known illustrators. Buys illustrations mainly for spots, columns and feature spreads. Uses freelancers mainly for features and columns. Works on assignment only. Prefers editorial illustration in airbrush, mixed media, colored pencil, watercolor, acrylic, oil, pastel, collage and calligraphy. Send query letter with color brochure showing art style and tearsheets. Looks for the "ability to intelligently grasp idea behind story and illustrate it. Likes crisp, clean colorful styles." Accepts disk submissions. Send EPS files. Samples are filed. Does not report back. Will contact for portfolio review if interested. Sometimes requests work on spec. Buys one-time rights. Pays on publication. "Send lots of good-looking color tearsheets that we can keep on hand for reference. If your work interests us we will contact you."
Tips: "In your portfolio show examples of editorial illustration for other magazines, good conceptual illustrations and a variety of subject matter. Often artists don't send enough of a variety of illustrations; it's much easier to determine if an illustrator is right for an assignment if we have a complete grasp of the full range of abilities. Send high-quality illustrations and show specific interest in our publication."

THE AMERICAN ATHEIST, Box 5733, Parsippany NJ 07054-6733. (908)276-7300. Fax: (908)276-7402. Editorial office (to which art and communications should be sent): 1352 Hunter Ave., Columbus OH 43201-2733. Phone: (614)299-1036. Fax: (614)299-3712. Editor: Frank Zindler. Estab. 1958. Monthly for atheists, agnostics, materialists and realists. Circ. 10,000. Simultaneous submissions OK. Sample copy for self-addressed 9 × 12 envelope or label.
Cartoons: Buys 5 cartoons/issue. Pays $30 each.
Illustration: Buys 1 illustration/issue. Especially needs 4-seasons art for covers and greeting cards. "Send samples to be kept on file. We do commission artwork based on the samples received. All illustrations

must have bite from the atheist point of view and hit hard." Prefers pen & ink, then airbrush, charcoal/pencil and calligraphy. To show a portfolio, mail final reproduction/product and b&w photographs. **Pays on acceptance**; $75-100 for cover; $25 for inside.

Tips: "*American Atheist* looks for clean lines, directness and originality. We are not interested in side-stepping cartoons and esoteric illustrations. Our writing is hard-punching and we want artwork to match. The American Atheist Press (parent company) buys book cover designs and card designs. Nearly all our printing is in black & white, but several color designs (e.g. for covers and cards) are acceptable if they do not require highly precise registration of separations for printing."

AMERICAN BREWER MAGAZINE, 214 Muegel Rd., E. Amherst NY 14051. (716)689-5841. Fax: (716)689-5789. E-mail: bill@americanbrewer.com. Website: www.americanbrewer.com. **Publisher:** Bill Metzger. Estab. 1985. Published 6 times a year. Trade journal in color with 4-color cover focusing on the microbrewing and distilling. Circ. 18,000. Accepts previously published artwork. Original artwork returned after publication. Sample copies for $5; art guidelines not available.

Cartoons: Approached by 25-30 cartoonists/year. Occasionally buys cartoons. Prefers themes related to drinking or brewing handcrafted beer. Send query letter with roughs. Samples not filed are returned. Responds in 2 weeks. Buys reprint rights.

Illustration: Buys 2 illustrations/issue. Works on assignment only. Prefers themes relating to beer, brewing or drinking; various media. Send postcard sample or query letter with photocopies. Samples are filed and are not returned without SASE. Responds in 2 weeks. Pays $50-150 for b&w or color inside. Buys reprint rights.

Tips: "I prefer to work with San Francisco Bay Area artists. Work must be about microbrewing industry."

AMERICAN FITNESS, 15250 Ventura Blvd., Suite 200, Sherman Oaks CA 91403. (818)905-0040. Fax: (818)990-5468. Website: www.afaa.com. **Editor-at-Large:** Meg Jordan. Senior Editor: Rosibel Guzman. Bimonthly magazine emphasizing fitness, health and exercise "for sophisticated, college-educated, active lifestyles." Circ. 42,900. Accepts previously published material. Original artwork returned after publication. Sample copy $3.

Illustration: Approached by 12 illustrators/month. Assigns 2-4 illustrations/issue. Works on assignment only. Prefers "very sophisticated" 4-color line drawings. Send query letter with samples showing art style. Acquires one-time rights.

Tips: "Excellent source for never-before-published illustrators who are eager to supply full-page lead artwork."

THE AMERICAN GARDENER, 7931 E. Boulevard Dr., Alexandria VA 22308. (703)768-5700. E-mail: editor@ahs.org. Website: www.ahs.org. **Editor:** David J. Ellis. Managing Editor: Mary Yee. Estab. 1922. Consumer magazine for advanced and amateur gardeners and horticultural professionals who are members of the American Horticultural Society. Bimonthly, 4-color magazine, "very clean and open, fairly long features." Circ. 25,000. Accepts previously published artwork. Original artwork is returned at job's completion. Sample copies for $5.

Illustration: Buys 6-10 illustrations/year from freelancers. Works on assignment only. "Botanical accuracy is important for some assignments. All media used; digital media welcome." Send query letter with résumé, tearsheets, slides and photocopies. Samples are filed. "We will call artist if their style matches our need." To show a portfolio, mail b&w and color tearsheets and slides. Buys one-time rights. Pays $150-300 color, inside; on publication.

Tips: "As a nonprofit we have a low budget, but offer interesting subject matter, good display and welcome input from artists."

THE AMERICAN LEGION MAGAZINE, Box 1055, Indianapolis IN 46206. E-mail: Magazine@Legion.org. Website: www.legion.org. **Cartoon Editor:** Matt Grills. Emphasizes the development of the world at present and milestones of history; 4-color general-interest magazine for veterans and their families. Monthly. Original artwork not returned after publication.

Cartoons: Uses 4 freelance cartoons/issue. Receives 200 freelance submissions/month. "Experience level does not matter, and does not enter into selection process." Especially needs general humor in good taste. "Generally interested in cartoons with broad appeal. Those that attract the reader and lead us to read the caption rate the highest attention. Because of tight space, we're not in the market for spread or multipanel cartoons but use both vertical and horizontal single-panel cartoons. Themes should be home life, business, sports and everyday Americana. Cartoons that pertain only to one branch of the service may be too restricted for this magazine. Service-type gags should be recognized and appreciated by any ex-service man or woman. Cartoons that may offend the reader are not accepted. Liquor, sex, religion and racial differences are taboo. No roughs. Send final product for consideration." Usually reports within 1 month. Buys first rights. **Pays on acceptance**; $150.

Tips: "Artists should submit their work as we are always seeking new slant and more timely humor. Black & white submissions are acceptable, but we purchase only color cartoons. Want good, clean humor—something that might wind up on the refrigerator door. Consider the audience!"

N: AMERICAN LIBRARIES, 50 E. Huron St., Chicago IL 60611-2795. (312)280-4216. Fax: (312)440-0901. E-mail: americanlibraries@ala.org. Website: www.ala.org. **Editor:** Leonard Kniffel. Estab. 1907. Monthly professional 4-color journal of the American Library Association for its members, providing independent coverage of news and major developments in and related to the library field. Circ. 58,000. Original artwork returned at job's completion if requested. Sample copy $6. Art guidelines available with SASE and first-class postage.
Cartoons: Approached by 15 cartoonists/year. Buys no more than 1 cartoon/issue. Themes related to libraries only. Send query letter with brochure and finished cartoons. Samples are filed. Does not report on submissions. Buys first rights. Pays $35-50 for b&w.
Illustration: Approached by 20 illustrators/year. Buys 1-2 illustrations/issue. Assigns 75% of illustrations to experienced, but not well-known illustrators; 25% to new and emerging illustrators. Works on assignment only. Send query letter with brochure, tearsheets and résumé. Samples are filed. Does not report on submissions. To show a portfolio, mail tearsheets, photostats, photographs and photocopies. Portfolio should include broad sampling of typical work with tearsheets of both b&w and color. Buys first rights. **Pays on acceptance**; $75-150 for b&w and $250-300 for color, cover; $75-150 for b&w and $150-250 for color, inside.
Tips: "I suggest inquirer go to a library and take a look at the magazine first." Sees trend toward "more contemporary look, simpler, more classical, returning to fewer elements."

AMERICAN MEDICAL NEWS, 515 N. State, Chicago IL 60610. (312)464-4432. Fax: (312)464-5793. E-mail: Jef_Capaldi@ama-assn.org. Website: www.amednews.com. **Art Director:** Jef Capaldi. Estab. 1958. Weekly trade journal. "We're the nation's most widely circulated publication covering socioeconomic issues in medicine." Circ. 250,000. Originals returned at job's completion. Sample copies available. 10% of freelance work demands knowledge of Photoshop and FreeHand.
Illustration: Approached by 250 freelancers/year. Buys 2-3 illustrations/issue. Works on assignment only. Considers mixed media, collage, watercolor, acrylic and oil. Send postcard samples. Samples are filed. Will contact for portfolio review if interested. Buys first rights. **Pays on acceptance**. Pays $300-500 for b&w, $500-850 for color inside. Pays $200-400 for spots. Finds artists through illustration contest annuals, word of mouth and submissions.
Tips: "Illustrations need to convey a strong, clever concept."

AMERICAN MUSCLE MAGAZINE, Box 6100, Rosemead CA 91770. **Art Director:** Michael Harding. Monthly 4-color magazine emphasizing bodybuilding, exercise and professional fitness. Features general interest, historical, how-to, inspirational, interview/profile, personal experience, travel articles and experimental fiction (all sports-related). Circ. 431,156. Accepts previously published material. Original artwork returned after publication.
Illustration: Buys 5 illustrations/issue. Send query letter with résumé, tearsheets, slides and photographs. Samples are filed or are returned. Responds in 1 week. Buys first rights, one-time rights, reprint rights or all rights. **Pays on acceptance**.
Tips: "Be consistent in style and quality."

AMERICAN MUSIC TEACHER, 441 Vine St. Suite 505, Cincinnati OH 45202-2811. Website: www.mtna.org. **Art Director:** Bryan Pieper. Estab. 1951. Bimonthly 4-color trade journal emphasizing music teaching. Features historical and how-to articles. "*AMT* promotes excellence in music teaching and keeps music teachers informed. It is the official journal of the Music Teachers National Association, an organization which includes concert artists, independent music teachers and faculty members of educational institutions." Circ. 26,424. Accepts previously published material. Original artwork returned after publication. Sample copies available.
Illustration: Buys 1 illustration/issue. Uses freelancers mainly for diagrams and illustrations. Prefers musical theme. "No interest in cartoon illustration." Send query letter with brochure or résumé, tearsheets, slides and photographs. Samples are filed or are returned only if requested with SASE. Responds in 3 months. To show a portfolio, mail printed samples, color and b&w tearsheets, photographs and slides. Buys one-time rights. Pays on publication; $50-150 for b&w and color, cover and inside.

☑ AMERICAN SCHOOL BOARD JOURNAL, 1680 Duke St., Alexandria VA 22314. (703)838-6747. Fax: (703)549-6719. E-mail: msabatier@nsba.org. **Production Manager/Art Director:** Michele Sabatier. Estab. 1891. National monthly magazine for school board members and school administrators. Circ. 60,000. Sample copies available.

Illustration: Buys 40-50 illustrations/year. Considers all media. Send postcard sample. Send follow-up postcard sample every 3 months. Will not accept samples as e-mail attachment. Please send URL. Responds only if interested. Art director will contact artist for portfolio review of tearsheets if interested. Buys one-time rights. **Pays on acceptance.** Pays $1,200 maximum for color cover; $250-350 for b&w, $300-600 for color inside. Finds illustrators through agents, source books, on-line services, magazines, word of mouth and artist's submissions.

Tips: "We're looking for new ways of seeing old subjects: children, education, management. We also write a great deal about technology and love high-tech, very sophisticated mediums. We prefer concept over narrative styles."

N THE AMERICAN SPECTATOR, 291 A Main St., Great Barrington MA 01230-1608. (413)644-2100. Fax: (413)644-2122. Website: www.gilder.com/amspec/. **Contact:** Artwork Dept.. Monthly political, conservative, newsworthy literary magazine. "We cover political topics, human interest items and book reviews." Circ. 258,000. Original artwork returned after publication. Sample copies available; art guidelines not available.

Illustration: Uses 3-5 illustrations/issue. Interested in "realism with a comic twist." Works on assignment only. Has featured illustrations by Dan Adel, Jack Davis, Phillipe Weisbecker and Blair Drawson. Features caricatures of celebrities and politicians; humorous and realistic illustration; informational graphics; spot illustration. Prefers pen & ink, watercolor, acrylic, colored pencil, oil and pastel. Samples are filed or returned by SASE. Reports back on future assignment possibilities. Provide résumé, brochure and tearsheets to be kept on file for future assignments. No portfolio reviews. Responds in 2 weeks. Buys first North American serial rights. Pays on publication; $1,200-2,000 for color cover; $150-1,750 for color inside; $1,000-2,000 for 2-page spreads.

N AMERICAN WOMAN ROAD & TRAVEL, 2424 Coolidge Rd., Suite 203, Troy MI 48084. (310)260-0192. Fax: (310)260-0175. E-mail: courtney@awroadandtravel.com. Website: www.awroadandtravel.com. **Editor-in-Chief:** Courtney Caldwell. Estab. 1988. Biweekly automotive and travel online magazine for today's active women. Feature oriented for women of achievement. Hits: 500,000. Accepts previously published artwork. Originals returned at job's completion only if requested. Sample copies available for 9×12 SASE and 10 first-class stamps.

Cartoons: Approached by 3-5 cartoonists/year. Prefers women in automotive or travel—"classy, no bimbo stuff"; single/double panel humorous cartoons with gaglines. Send query letter with roughs and finished cartoons. Samples are filed. Responds in 1 month by SASE or if interested. Rights purchased vary. Pays $50 for b&w.

Illustration: Approached by 3-5 illustrators/year. Works on assignment only. Features humorous illustration. Assigns 50% of illustrations to experienced, but not well-known illustrators; 50% to new and emerging illustrators. Prefers women of achievement. Open/flexible to all media. Send query letter with résumé, SASE, tearsheets and photocopies. Samples are filed or are returned by SASE. Responds in 1 month by SASE. Will contact for portfolio review if interested. Portfolio should include b&w tearsheets, roughs, photocopies, final art and photographs. Rights purchased vary according to project. Pays on publication; $50 minimum for b&w inside. Finds artists through submissions, *Artist's & Graphic Designer's Market*.

Tips: "Must have knowledge of cars, travel safety, and how today's women think!"

ANALOG, 475 Park Ave. S., New York NY 10016. (212)686-7188. Fax: (212)686-7414. **Senior Art Director:** Victoria Green. Associate Art Director: June Levine. All submissions should be sent to June Levine, associate art director. Estab. 1930. Monthly consumer magazine. Circ. 80,000 Art guidelines free for #10 SASE with first-class postage.

Cartoons: Prefers single panel cartoons. Send query letter with photocopies and/or tearsheets and SASE. Samples are not filed and are returned by SASE. Responds only if interested. Buys one-time rights. **Pays on acceptance**; $35 minimum for b&w cartoons.

Illustration: Buys 8 illustrations/issue. Prefers science fiction, hardwre, robots, aliens and creatures. Considers all media. Send query letter with printed samples or tearsheets and SASE. Send follow-up postcard sample every 4 months. Accepts disk submissions compatible with QuarkXPress 7.5/version 3.3. Send EPS files. Files samples of interest, others are returned by SASE. Responds only if interested. "No phone calls." Portfolios may be dropped off every Tuesday and should include b&w and color tearsheets and transparencies. "No original art please, especially oversized." Buys one-time rights. **Pays on acceptance;** $1,200 for color cover; $125 minimum for b&w inside; $35-50 for spots. Finds illustrators through *Black Book*, *LA Workbook*, *American Showcase* and other reference books.

Ⓝ ANGELS ON EARTH MAGAZINE, 16 E. 34th St., New York NY 10016. (212)251-8127. Fax: (212)684-1311. Website: www.guideposts.org. **Director of Art & Design:** Kai-Ping Chao. Assistant Art Director: Robyn Kessler. Estab. 1995. Bimonthly magazine featuring true stories of angel encounters and angelic behavior. Circ. 1,000,000. Art guidelines free for SASE.

● Also publishes *Guideposts*, a monthly magazine. See listing in this section.

Illustration: Approached by 500 illustrators/year. Buys 5-10 illustrations/issue. Has featured illustrations by Kinuko Craft, Gary Kelley, Rafal Olbinski. Features computer, whimsical, reportorial, humorous, conceptual, realistic and spot illustration. Assigns 40% of illustrations to well-known or "name" illustrators; 40% to experienced but not well-known illustrators; 20% to new and emerging illustrators. Prefers conceptual/realistic, "soft" styles. Considers all media. Please send nonreturnable promotional materials, slides or tearsheets. Call for submission information. Accepts disk submissions compatible with Photoshop, Illustrator. Samples are filed or returned by SASE. Art director will contact artist for portfolio review if interested. Rights purchased vary. **Pays on acceptance**; $500-2,500 for color cover; $500-2,000 2-page spreads; $300-1,000 for spots. Finds artists through reps, *American Showcase*, *Society of Illustrators Annual*, submissions and artist's websites.

Tips: "Please study our magazine and be familiar with the content presented."

ANIMALS, 350 S. Huntington Ave., Boston MA 02130. (617)522-7400. Fax: (617)522-4885. **Contact:** Molly Lupica. Estab. 1868. "*Animals* is a national quarterly 4-color magazine published by the Massachusetts Society for the Prevention of Cruelty to Animals. We publish articles on and photographs of wildlife, domestic animals, conservation, controversies involving animals, animal-welfare issues, pet health and pet care." Circ. 90,000. Original artwork usually returned after publication. Sample copy $3.95 with SAE (8½×11); art guidelines not available.

Illustration: Approached by 1,000 illustrators/year. Works with 1 illustrator/year. Buys 1 illustration/year from freelancers. Uses artists mainly for spots. Prefers pets or wildlife illustrations relating to a particular article topic. Prefers pen & ink, then airbrush, charcoal/pencil, colored pencil, watercolor, acrylic, oil, pastel and mixed media. Needs editorial and medical illustration. Send query letter with brochure or tearsheets. Samples are filed or are returned by SASE. Responds in 1 month. Publication will contact artist for portfolio review if interested. Portfolio should include color roughs, original/final art, tearsheets and final reproduction/product. Negotiates rights purchased. **Pays on acceptance**.

Tips: "In your samples, include work showing animals, particularly dogs and cats or humans with cats or dogs. Show a representative sampling."

AOPA PILOT, 421 Aviation Way, Frederick MD 21701-4798. (301)695-2371. Fax: (301)695-2381. E-mail: mike.kline@aopa.org. Website: www.aopa.org. **Art Director:** Michael Kline. Associate Art Director: Adrienne Rosone. Estab. 1958. Monthly 4-color trade publication for the members of the Aircraft Owners and Pilots Association. The world's largest aviation magazine. Circ. 350,000. Sample copies free for 8½×11 SASE.

Illustration: Approached by 50 illustrators/year. Buys 3 illustrations/issue. Has featured illustrations by Jack Pardue, Byron Gin. Features charts & graphs, informational graphics, realistic, computer, aviation-related illustration. Prefers variety of styles ranging from technical to soft and moody. Assigns 75% of illustration to experienced, but not well-known illustrators; 25% to new and emerging illustrators. 10% of freelance illustration demands knowledge of Illustrator, Photoshop, FreeHand or 3-D programs. Send postcard or other nonreturnable samples, such as photocopies and tearsheets. Accepts Mac-compatible disk submissions. Send EPS files. Samples are filed and are not returned. Will contact artist for portfolio review if interested. Rights purchased vary according to project; negotiable. **Pays on acceptance.** Finds illustrators through agents, sourcebooks, online services and samples.

Tips: "We are looking to increase our stable of freelancers. Looking for a variety of styles and experience."

Ⓝ APPALACHIAN TRAILWAY NEWS, Box 807, Harpers Ferry WV 25425. (304)535-6331. Fax: (304)535-2667. **Editor:** Robert Rubin. Emphasizes the Appalachian Trail for members of the Appalachian Trail Conference. 5 issues/year. Circ. 26,000. Sometimes accepts previously published material. Returns original artwork after publication. Sample copy $3 (no SASE); art guidelines for SASE with first-class postage.

Illustration: Buys 2-5 illustrations/issue. Accepts all styles and media; computer generated or manual. Original artwork must be related to the Appalachian Trail. Send query letter with samples to be kept on file. Prefers nonreturnable postcards, photocopies or tearsheets as samples. Samples not filed are returned by SASE. Responds in 2 months. Negotiates rights purchased. **Pays on acceptance;** $25-200 for b&w, occasional color. Also buys 1-2 cartoons/year; pays $25 and up. Finds most artists through references, word of mouth and samples received through the mail.

N AQUARIUM FISH MAGAZINE, P.O. Box 6050, Mission Viejo CA 92690. (949)855-8822. Fax: (949)855-3045. E-mail: aquariumfish@fancypubs.com. Website: www.aquariumfish.com. **Editor:** Russ Case. Estab. 1988. Monthly magazine covering fresh and marine aquariums and garden ponds. Photo guidelines for SASE with first-class postage.

Cartoons: Approached by 30 cartoonists/year. Themes should relate to aquariums and ponds. Send query letter with finished cartoon samples. Samples are filed. Buys one-time rights. Pays $35 for b&w.

☑ AREA DEVELOPMENT MAGAZINE, 400 Post Ave., New York NY 11590-2267. (516)338-0900. Fax: (516)338-0100. Website: www.areadevelopment.com. **Art Director:** Marta Sivakoff. Estab. 1965. Monthly trade journal regarding economic development and site selection issues. Circ. 45,000.

Illustration: Approached by 60 illustrators/year. Buys 3-4 illustrations/year. Features charts & graphs; informational graphics; realistic, medical and computer illustration. Assigns 80% of illustrations to well-known or "name" illustrators; 20% to experienced, but not well-known illustrators. Prefers business/ corporate themes with strong conceptual ideas. Considers all media. 50% of freelance illustration demands knowledge of Photoshop, Illustrator and QuarkXPress. Send postcard sample. Accepts disk submissions compatible with QuarkXPress 3.31 for the Mac. Send EPS, TIFF files. Art director will contact artist for portfolio review of b&w, color tearsheets if interested. Rights purchased vary according to project. Pays on publication; $500-1,200 for color cover.

Tips: "Must have corporate understanding and strong conceptual ideas. We address the decision-makers' needs by presenting their perspectives. Create a varied amount of subjects (business, retail, money concepts). Mail color self-promotions with more than one illustration."

N ARMY MAGAZINE, 2425 Wilson Blvd., Arlington VA 22201. (703)841-4300. Website: www.ausa.o rg. **Art Director:** Patty Zukerowski. Estab. 1950. Monthly trade journal dealing with current and historical military affairs. Also covers military doctrine, theory, technology and current affairs from a military perspective. Circ. 115,000. Originals returned at job's completion. Sample copies available for $2.25. Art guidelines available.

Cartoons: Approached by 5 cartoonists/year. Buys 1 cartoon/issue. Prefers military, political and humorous cartoons; single or double panel, b&w washes and line drawings with gaglines. Send query letter with brochure and finished cartoons. Samples are filed or are returned by SASE if requested by artist. Responds to the artist only if interested. Buys one-time rights. Pays $50 for b&w.

Illustration: Approached by 1 illustrator/year. Buys 1-3 illustrations/issue. Works on assignment only. Prefers military, historical or political themes. Considers pen & ink, airbrush, acrylic, marker, charcoal and mixed media. "Can accept artwork done with Illustrator or Photoshop for Macintosh." Send query letter with brochure, résumé, tearsheets, photocopies and photostats. Samples are filed or are returned by SASE if requested by artist. Publication will contact artist for portfolio review if interested. Portfolio should include b&w and color tearsheets, photocopies and photographs. Buys one-time rights. Pays on publication; $300 minimum for b&w cover; $500 minimum for color cover; $50 for b&w inside; $75 for color inside; $35-50 for spots.

ARTHRITIS TODAY MAGAZINE, 1330 W. Peachtree St., Atlanta GA 30309-2858. (404)872-7100. Fax: (404)872-9559. E-mail: agraham@arthritis.org. **Creative Director:** Audrey Graham. Art Director, External Publishing: Susan Siracusa. Estab. 1987. Bimonthly consumer magazine. "*Arthritis Today* is the official magazine of the Arthritis Foundation. The award-winning publication is more than the most comprehensive and reliable source of information about arthritis research, care and treatment. It is a magazine for the whole person—from their lifestyles to their relationships. It is written both for people with arthritis and those who care about them." Circ. 700,000. Originals returned at job's completion. Sample copies available. 20% of freelance work demands knowledge of Illustrator, QuarkXPress or Photoshop.

Illustration: Approached by over 100 illustrators/year. Buys 5-10 illustrations/issue. Works on assignment only; stock images used in addition to original art. Send query letter with brochure, tearsheets, photostats, slides (optional) and transparencies (optional). Samples are filed. Publication will contact artist for portfolio review if interested. Portfolio should include color tearsheets, photostats, photocopies, final art and photographs. Buys first time North American serial rights. Other usage negotiated. **Pays on acceptance.** Finds artists through sourcebooks, Internet, other publications, word of mouth, submissions.

Tips: "No limits on areas of the magazine open to freelancers. Two-three departments, each issue use spot illustrations. Submit tearsheets for consideration. No cartoons."

☑ THE ARTIST'S MAGAZINE, 4700 E. Galbraith Rd., Cincinnati OH 45236. E-mail: tamedit@fwpub s.com. **Art Director:** Dan Pessell. Monthly 4-color magazine emphasizing the techniques of working artists

for the serious beginning, amateur and professional artist. Circ. 225,000. Occasionally accepts previously published material. Returns original artwork after publication. Sample copy $3.99 US, $4.50 Canadian or international; remit in US funds.

● Sponsors annual contest. Send SASE for more information. Also publishes a quarterly magazine called *Watercolor Magic*.

Cartoons: Contact: Cartoon Editor. Buys 3-4 cartoons/year. Must be related to art and artists. Pays $65 on acceptance for first-time rights.

Illustration: Buys 2-3 illustrations/year. Has featured illustrations by: Susan Blubaugh, Sean Kane, Jamie Hogan, Steve Dininno, Kathryn Adams. Features humorous and realistic illustration. Works on assignment only. Send query letter with brochure, photocopies, photographs and tearsheets to be kept on file. Prefers photostats or tearsheets as amples. Samples not filed are returned by SASE. Buys first rights. **Pays on acceptance**; $350-600 for color inside; $100-125 for spots.

Tips: "Research past issues of publication and send samples that fit the subject matter and style of target publication."

ART:MAG, P.O. Box 70896, Las Vegas NV 89170-0896. (702)734-8121. E-mail: magman@iopener.net. **Art Director:** Peter Magliocco. Contributing Artist-at-Large: Bill Chown. Art Editor: "The Mag Man." Estab. 1984. Quarterly b&w small press literary arts zine. Circ. 100. Art guidelines for #10 SASE with first-class postage.

Cartoons: Approached by 5-10 cartoonists/year. Buys 5 cartoons/year. Prefers single panel, political, humorous and satirical b&w line drawings. Send query letter with b&w photocopies, samples, tearsheets and SASE. Samples are filed. Responds in 3 months. Rights purchased vary according to project. Pays on publication. Pays 1 contributor's copy.

Illustration: Approached by 5-10 illustrators/year. Buys 3-5 illustrations/year. Has featured illustrations by Ed Fillmore, Ronit Glazer, Aaron Hawk, Stewart Gilbert, The Thomas Brothers, B. Chown. Features caricatures of celebrities and politicians and spot illustrations. Preferred subjects: art, literature and politics. Prefers realism, hip, culturally literate collages and b&w line drawings. Assigns 10% of illustrations to well-known or "name" illustrators; 60% of illustrations to experienced but not well-known illustrators; 30% to new and emerging illustrators. Send query letter with photocopies, SASE. Responds in 3 months. Portfolio review not required. Buys one-time rights. Pays on publication; 1 contributor's copy. Finds illustrators through magazines, word of mouth.

Tips: "*Art:Mag* is basically for new or amateur artists with unique vision and iconoclastic abilities whose work is unacceptable to slick mainstream magazines. Don't be conventional, be idea-oriented."

ISAAC ASIMOV'S SCIENCE FICTION MAGAZINE, 475 Park Ave. S., New York NY 10016. (212)686-7188. Fax: (212)686-7414. **Senior Art Director:** Victoria Green. Associate Art Director: June Levine. All submissions should be sent to June Levine, associate art director. Estab. 1977. Monthly b&w with 4-color cover magazine of science fiction and fantasy. Circ. 61,000. Accepts previously published artwork. Original artwork returned at job's completion. Art guidelines available for #10 SASE with first-class postage.

Cartoons: Approached by 20 cartoonists/year. Buys 1-2 cartoons/issue. Prefers science fiction and fantasy themes, humorous cartoons. Prefers single panel, b&w washes or line drawings with and without gagline. Send query letter with finished cartoons, photocopies and SASE. Samples are filed or returned by SASE. Responds only if interested. Buys one-time rights or reprint rights. **Pays on acceptance**; $35 minimum. Address cartoons to Brian Bieniowski, editor.

Illustration: Buys 4 illustrations/issue. Works on assignment only. Prefers photorealistic style. Considers all media. Send query letter with printed samples, photocopies and/or tearsheets and SASE. Accepts disk submissions compatible with QuarkXPress 7.5 version 3.3. Send EPS files. Accepts illustrations done with Illustrator and Photoshop. Responds only if interested. Portfolios may be dropped off every Tuesday and should include b&w and color tearsheets. Buys one-time and reprint rights. **Pays on acceptance**; $1,000-1,200 for color cover; $100-125 for b&w inside; $50 for spots.

Tips: No comic book artists. Realistic work only, with science fiction/fantasy themes. Show characters with a background environment.

✓ **ASSOCIATION OF BREWERS**, P.O. Box 1679, Boulder CO 80306. Website: www.beertown.org. **Magazine Art Director:** Dave Harford. Estab. 1978. "Our nonprofit organization hires illustrators for two

<div style="border:1px solid">

SASE MEANS SELF-ADDRESSED, STAMPED ENVELOPE. Send SASEs when requesting return of your samples.

</div>

magazines, *Zymurgy* and *The New Brewer*, each published bimonthly. *Zymurgy* is a journal of the American Homebrewers Association. The goal of the AHA division is to promote public awareness and appreciation of the quality and variety of beer through education, research and the collection and dissemination of information." Circ. 15,000 *"The New Brewer* is a journal of the Institute for Brewing Studies. The goal of the IBS division is to serve as a forum for the technical aspects of brewing and to seek ways to help maintain quality in the production and distribution of beer." Circ. 3,000.

Cartoons: Approached by 10 cartoonists/year. Buys 1-2 cartoons/year. Prefers humorous, b&w and color washes, b&w line drawings, with or without gagline. Send photographs, photocopies, tearsheets, any samples. No originals accepted; samples are filed. Buys one-time rights. **Pays on acceptance**, 60 day net; $75-300 for b&w cartoons; $150-350 for color cartoons.

Illustration: Approached by 50 illustrators/year. Buys 1-2 illustrations/issue. Prefers beer and homebrewing themes. Considers all media. Send postcard sample or query letter with printed samples, photocopies, tearsheets; follow-up sample every 3 months. Accepts disk submissions with EPS or TIFF files. "We prefer samples we can keep." No originals accepted. Responds only if interested. Art director will contact artist for portfolio review of b&w, color, final art, photographs, photostats, roughs, slides, tearsheets, thumbnails, transparencies; whatever media best represents art. Buys one-time rights. **Pays 60 day net on acceptance**; $600-800 for color cover; $200-300 for b&w inside; $200-400 for color. Pays $150-300 for spots. Finds artists through agents, sourcebooks (Society of Illustrators, *Graphis*, *Print*, *Colorado Creative*), mags, word of mouth, submissions.

Design: Prefers local design freelancers only with experience in Photoshop, QuarkXPress, Illustrator. Send query letter with printed samples, photocopies, tearsheets.

Tips: "Keep sending promotional material for our files. Anything beer-related for subject matter is a plus. We look at all styles."

N ATLANTA MAGAZINE, 1330 W. Peachtree St. NE, Suite 450, Atlanta GA 30309. (404)872-3100. Fax: (404)870-6219. E-mail: sbogle@atlantamag.emmis.com. Website: www/atlantamagazine.com. **Contact:** Susan L. Bogle, design director. Associate Art Director: Alice Lynn McMichael. Estab. 1961. Monthly 4-color consumer magazine. Circ: 64,000.

Illustration: Buys 3 illustrations/issue. Has featured illustrations by Fred Harper, Harry Campbell, Jane Sanders, various illustrators repped by Wanda Nowak, various illustrators repped by Gerald & Cullen Rapp, Inc. Features caricatures of celebrities, fashion illustration, humorous illustration and spot illustrations. Prefers a wide variety of subjects. Style and media depend on the story. Assignes 60% of illustrations to well-known or "name" illustrators; 30% to experienced, but not well-known illustrators; 10% to new and emerging illustrators. Send nonreturnable postcard sample. Samples are filed. Will contact artist for portfolio review if interested. Will contact artist for portfolio review if interested. Buys first rights. . **Pays on acceptance.** Finds freelancers through promotional samples, artists' reps, *The Alternative Pick*.

AUTHORSHIP, 3140 S. Peoria, #295, Aurora CO 80014. (303)841-0246. **Executive Director:** Sandy Whelchel. Estab. 1937. Bimonthly magazine. "Our publication is for our 3,000 members, and is cover-to-cover about writing."

Cartoons: Samples are returned. Responds in 4 months. Buys first North American serial and reprint rights. **Pays on acceptance**; $25 minimum for b&w.

Illustration: Accepts disk submissions. Send TIFF files.

Tips: "We only take cartoons slanted to writers."

N AUTOMOBILE MAGAZINE, Dept. AGDM, 120 E. Liberty, Ann Arbor MI 48104. (313)994-3500. Website: www.automobilemag.com. **Art Director:** Molly Jean. Estab. 1986. Monthly 4-color "automobile magazine for upscale lifestyles." Traditional, "imaginative" design. Circ. 650,000. Original artwork is returned after publication. *Art guidelines specific for each project.*

Illustration: Buys illustrations mainly for spots and feature spreads. Works with 5-10 illustrators/year. Buys 2-5 illustrations/issue. Works on assignment only. Considers airbrush, mixed media, colored pencil, watercolor, acrylic, oil, pastel and collage. Needs editorial and technical illustrations. Send query letter with brochure showing art style, résumé, tearsheets, slides, photographs or transparencies. Show automobiles in various styles and media. "This is a full-color magazine, illustrations of cars and people must be accurate." Samples are returned only if requested. "I would like to keep something in my file." Reports back about queries/submissions only if interested. Request portfolio review in original query. Portfolio should include final art, color tearsheets, slides and transparencies. Buys first rights and one-time rights. Pays $200 and up for color inside. Pays $2,000 maximum depending on size of illustration. Finds artists through mailed samples.

Tips: "Send samples that show cars drawn accurately with a unique style and imaginative use of medium."

AUTOMUNDO, 2960 SW Eighth St., 2nd Floor, Miami FL 33135-2827. (305)541-4198. Fax: (305)541-5138. E-mail: jorgek@automundo.com. Website: www.automundo.com. **Editor:** Jorge Koechlin. Estab. 1982. Monthly 4-color Spanish automotive magazine. Accepts previously published artwork. Originals returned at job's completion. Sample copies and art guidelines available.
Cartoons: Approached by 2 cartoonists/year. Buys 1 cartoon/issue. Prefers car motifs. Prefers cartoons without gagline. Send query letter with brochure and roughs. Accepts disk submissions. Samples are filed. Responds only if interested. Rights purchased vary. Pays $10 for b&w cartoons.
Illustration: Will contact for portfolio review if interested. Portfolios may be dropped off every Monday. Needs editorial illustrations.
Design: Needs freelancers for design with knowledge of Photoshop and Illustrator. Send brochure.

BABYBUG, 315 Fifth St., Peru IL 61354-0300. (815)223-2520. Fax: (815)224-6675. **Art Director:** Suzanne Beck. Estab. 1994. Magazine published every six weeks "for children six months to two years." Circ. 44,588. Sample copy for $4; art guidelines for SASE.
Illustration: Approached by about 85 illustrators/month. Buys 23 illustrations/issue. Considers all media. Send query letter with printed samples, photocopies and tearsheets. Samples are filed or returned if postage is sent. Responds in 45 days. Buys all rights. Pays 30 days after acceptance. Pays $500 minimum for color cover; $250 minimum per page inside. Finds illustrators through agents, *Creative Black Book*, magazines, word of mouth, artist's submissions and printed children's books.

☑ **BACKPACKER MAGAZINE**, Rodale, 33 E. Minor St., Emmaus PA 18098-0001. (610)967-5171. Fax: (610)967-8181. E-mail: bpeditor@rodalepress.com. Website: www.backpacker.com. **Art Director:** Chris Hercik. Estab. 1973. Consumer magazine covering non-motorized wilderness travel. Circ. 280,000.
Illustration: Approached by 200-300 illustrators/year. Buys 10 illustrations/issue. Considers all media. 60% of freelance illustration demands knowledge of FreeHand, Photoshop, Illustrator, QuarkXPress. Send query letter with printed samples, photocopies and/or tearsheets. Send follow-up postcard sample every 6 months. Accepts disk submissions compatible with QuarkXPress, Illustrator and Photoshop. Samples are filed and are not returned. Artist should follow up with call. Art director will contact artist for portfolio review of color photographs, slides, tearsheets and/or transparencies if interested. Buys first rights or reprint rights. Pays on publication. Finds artists through submissions and other printed media.
Tips: *Backpacker* does not buy cartoons. "Know the subject matter, and know *Backpacker Magazine*."

BALLOON LIFE MAGAZINE, 2336 47th Ave. SW, Seattle WA 98116-2331. (206)935-3649. Fax: (206)935-3326. E-mail: tom@balloonlife.com. Website: www.balloonlife.com. **Editor:** Tom Hamilton. Estab. 1985. Monthly 4-color magazine emphasizing the sport of ballooning. "Contains current news, feature articles, a calendar and more. Audience is sport balloon enthusiasts." Circ. 4,000. Accepts previously published material. Original artwork returned after publication. Sample copy for SASE with 8 first-class stamps. Art guidelines for SASE with first-class postage.
 ● Only cartoons and sketches directly related to gas balloons or hot air ballooning are considered by *Balloon Life*.
Cartoons: Approached by 20-30 cartoonists/year. Buys 1-2 cartoons/issue. Seeks gag, editorial or political cartoons, caricatures and humorous illustrations. Prefers single panel b&w line drawings with or without gaglines. Send query letter with samples, roughs and finished cartoons. Samples are filed or returned. Responds in 1 month. Buys all rights. Pays on publication; $25 for b&w and $25-40 for color.
Illustration: Approached by 10-20 illustrators/year. Buys 1-3 illustrations/year. Has featured illustrations by Charles Goll. Features humorous illustration; informational graphics; spot illustration. Needs computer-literate illustrators familiar with PageMaker, Illustrator, Photoshop, Colorit, Pixol Paint Professional and FreeHand. Send postcard sample or query letter with business card and samples. Accepts submissions on disk compatible with Macintosh files. Send EPS files. Samples are filed or returned. Responds in 1 month. Will contact for portfolio review if interested. Buys all rights. Pays on publication; $50 for b&w or color cover; $25 for b&w inside; $25-40 for color inside.
Tips: "Know what a modern hot air balloon looks like! Too many cartoons reach us that are technically unacceptable."

N **BALTIMORE JEWISH TIMES**, 1040 Park Ave., Suite 200, Baltimore MD 21218. (410)752-3504. Fax: (443)451-6029. E-mail: creativedirector@jewishtimes.com. Website: www.jewishtimes.com. **Art Director:** Robyn Katz. Weekly b&w tabloid with 4-color cover emphasizing special interests to the Jewish community for largely local readership. Circ. 20,000. Accepts previously published artwork. Returns original artwork after publication, if requested. Sample copy available.
 ● This publisher also publishes *Style Magazine*, a Baltimore lifestyle magazine, and *Chesapeake*, covering lifestyle topics in southern Maryland and the Eastern Shore.

Illustration: Approached by 50 illustrators/year. Buys 4-6 illustrations/issue. Works on assignment only. Prefers high-contrast, b&w illustrations. Send query letter with brochure showing art style or tearsheets and photocopies. Samples not filed are returned by SASE. Responds if interested. To show a portfolio, mail appropriate materials or write/call to schedule an appointment. Portfolio should include original/final art, final reproduction/product and color tearsheets and photostats. Buys first rights. Pays on publication; $200 for b&w, cover and $300 for color, cover; $50-100 for b&w, inside.

Tips: Finds artists through word of mouth, self-promotion and sourcebooks. Sees trend toward "more freedom of design integrating visual and verbal."

✓ BALTIMORE MAGAZINE, 1000 Lancaster St., Suite 400, Baltimore MD 21202-4382. (410)752-4200. Fax: (410)625-0280. E-mail: wamanda@baltimoremag.com. Website: www.baltimoremag.com. **Art Director:** Amanda Laine White. Production Assistant: Staci Caquelin. Estab. 1908. Monthly city magazine featuring news, profiles and service articles. Circ. 57,000. Originals returned at job's completion. Sample copies available for $2.05/copy. 10% of freelance work demands knowledge of QuarkXPress, FreeHand, Illustrator or Photoshop or any other program that is saved as a TIFF or PICT file.

Illustration: Approached by 60 illustrators/year. Buys 4 illustrations/issue. Works on assignment only. Considers all media, depending on assignment. Send postcard sample. Accepts disk submissions. Samples are filed. Will contact for portfolio review if interested. Buys one-time rights. Pays on publication; $100-400 for b&w, $150-600 for color insides; 60 days after invoice. Finds artists through sourcebooks, publications, word of mouth, submissions.

Tips: All art is freelance—humorous front pieces, feature illustrations, etc. Does not use cartoons.

✓ BARTENDER MAGAZINE, Box 158, Liberty Corner NJ 07938-0158. (908)766-6006. Fax: (908)766-6607. E-mail: barmag@aol.com. Website: www.bartender.com. **Editor:** Jackie Foley. Art Director: Lynn DeWitte. Estab. 1979. Quarterly 4-color trade journal emphasizing restaurants, taverns, bars, bartenders, bar managers, owners, etc. Circ. 150,000.

Cartoons: Approached by 10 cartoonists/year. Buys 3 cartoons/issue. Prefers bar themes; single panel. Send query letter with finished cartoons. Samples are filed. Buys first rights. Pays on publication; $50 for b&w and $100 for color cover; $50 for b&w and $100 for color inside.

Illustration: Approached by 5 illustrators/year. Buys 1 illustration/issue. Works on assignment only. Prefers bar themes. Considers any media. Send query letter with brochure. Samples are filed. Negotiates rights purchased. Pays on publication; $500 for color cover.

Design: Needs computer-literate designers familiar with QuarkXPress and Illustrator.

✓ 🔅 🎣 BC OUTDOORS, HUNTING AND SHOOTING, (formerly BC Outdoors), 1080 Howe St., Suite 900, Vancouver, British Columbia V6Z-2T1 Canada. (604)606-4644. Fax: (604)687-1925. 4-color magazine, emphasizing fishing, hunting, camping, wildlife/conservation in British Columbia. Published 8 times/year. Circ. 30,000. Original artwork returned after publication unless bought outright.

Illustration: Approached by more than 10 illustrators/year. Has featured illustrations by Ian Forbes and Brad Nickason. Buys 4-6 illustrations/year. Prefers local artists. Interested in outdoors, wildlife (BC species only) and activities as stories require. Format: b&w line drawings and washes for inside and color washes for inside. Works on assignment only. Samples returned by SAE (nonresidents include IRC). Reports back on future assignment possibilities. Arrange personal appointment to show portfolio or send samples of style. Subject matter and the art's quality must fit with publication. Buys first North American serial rights or all rights on a work-for-hire basis. Pays on publication; $40 minimum for spots.

Tips: "Send us material on fishing and hunting. We generally just send back non-related work."

N̄ THE BEAR DELUXE, P.O. Box 10342, Portland OR 97296. (503)242-1047. Fax: (503)243-2645. E-mail: bear@teleport.com. Website: www.orlo.org/beardeluxe. Contact: Lara Cuddy and Thomas Cobbname, art directors. Editor-in-Chief: Tom Webb. Estab. 1993. Quarterly 4-color, b&w consumer magazine emphasizing environmental writing and visual art. Circ. 19,000. Sample copies free for $3. Art guidelines for SASE with first-class postage.

Cartoons: Approached by 30 cartoonists/year. Buys 20 cartoons/issue. Prefers work related to environmental, outdoor, media, arts. Prefers single panel, political, humorous, b&w line drawings. Send query letter with b&w photocopies and SASE. Samples are filed or returned by SASE. Responds in 4 months. Buys first rights. Pays on publication; $10-50 for b&w.

Illustration: Approached by 20 illustrators/year. Has featured illustrations by Matt Wuerker, Ed Fella, Eunice Moyle and Ben Rosenberg. Caricature of politicians, charts & graphs, natural history and spot illustration. Assigns 20% of illustrations to well-known or "name" illustrators; 50% to well-known illustrators; 30% to new and emerging illustrators. 30% of freelance illustration demands knowledge of Illustrator, Photoshop and FreeHand. Send postcard sample and nonreturnable samples. Accepts Mac-compatible disk submissions. Send EPS or Tiff files. Samples are filed or returned by SASE. Responds only if interested.

Portfolios may be dropped off by appointment. Buys first rights. Pays on publication; $200 b&w or color cover; $15-75 for b&w or color inside; $15-75 for 2-page spreads; $20 for spots. Finds illustrators through word of mouth, gallery visits and promotional samples.

Tips: We are actively seeking new illustrators and visual artists, and really encourage people to send samples. Most of our work (besides cartoons) is assigned out as editorial illustration or independent art. Indicate whether an assignment is possible for you. Indicate your fastest turn-around time. We need people who can work with 2-3 week turn-around or faster.

BEVERAGE WORLD MAGAZINE, 770 Broadway, New York NY 10003-9522. (646)545-4500. Fax: (646)654-7727. E-mail: pkiefer@beverageworld.com. Website: www.beverageworld.com. **Art Director:** Patti Kiefer. Editor: M. Havis Dawson. Monthly magazine covering beverages (beers, wines, spirits, bottled waters, soft drinks, juices) for soft drink bottlers, breweries, bottled water/juice plants, wineries and distilleries. Circ. 33,000. Accepts simultaneous submissions. Original artwork returned after publication if requested. Sample copy $3.50. Art guidelines available.

Illustration: Buys 2-3 illustrations. Has featured illustrations by Craig M. Cannon, Steven Morrell and Rudy Guiterrez. Works on assignment only. Assigns 70% of illustrations to experienced, but not well-known illustrators; 30% to new and emerging illustrators. Send postcard sample, brochure, photocopies and photographs to be kept on file. Responds only if interested. Negotiates rights purchased. **Pays on acceptance**; $500 for color cover; $50-100 for b&w inside. Uses color illustration for cover, usually b&w for spots inside.

Design: Needs freelancers for design. 98% of design demands knowledge of Photoshop, Illustrator or QuarkXPress. Send query letter with brochure, résumé, photocopies and tearsheets. Pays by project.

[N] BITCH: FEMINIST RESPONSE TO POP CULTURE, 2765 16th St., San Francisco CA 94103. (415)864-6671. E-mail: crumb@bitchmagazine.com. Website: www.bitchmagazine.com. **Art Director:** Sarah Crumb. Estab. 1995. Four times yearly b&w magazine. "We examine popular culture in all its forms for women and feminists of all ages." Circ. 40,000.

Illustration: Approached by 300 illustrators/year. Buys 3-7 illustrations/issue. Has featured illustrations by Andi Zeisler, Hugh D'Andrade, Pamela Hobbs, Isabel Samaras and Pam Purser. Features caricatures of celebrities, conceptual, fashion and humorous illustration. Work on assignment only. Prefers b&w ink drawings and photo collage. Assigns 90% of illustrations to experienced, but not well-known, illustrators; 8% to new and emerging illustrators; 2% to well-known or "name" illustrators. Send postcard sample, nonreturnable samples. Accepts Mac-compatible disk submissions. Samples are filed and are not returned. Will contact artist for portfolio review if interested. "We now are able to pay, but not much at all." Finds illustrators through magazines and word of mouth.

Tips: "We have a couple of illustrators we work with generally, but are open to others. Our circulation has been doubling annually, and we are distributed internationally. Read our magazine and send something we might like."

[✓] [□] BLACK BEAR PUBLICATIONS/BLACK BEAR REVIEW, 1916 Lincoln St., Croydon PA 19021-8026. E-mail: bbreview@earthlink.net. Website: www.BlackBearReview.com. **Editor:** Ave Jeanne. Estab. 1984. Publishes award-winning, semiannual b&w magazine emphasizing social, political, ecological and environmental subjects "for mostly well-educated adults." Circ. 500. Also publishes chapbooks. Accepts previously published artwork. Art guidelines for SASE with first-class postage or visit our website. Current copy $6 postpaid in U.S., $9 overseas.

Illustration: Works with 20 illustrators/year. Buys 10 illustrations/issue. Has featured the illustrations of Marcus Gorenstein, Jessica Freeman, Hailey Parnell, Durlabh Singh, Amy Chace and Miles Histand. Prefers collage, woodcut, pen & ink. Send camera-ready pieces with SASE. Artwork sent on disk or via e-mail must be in one of the following Microsoft Windows formats: BMP, GIF or JPG. Samples not filed are returned by SASE. Portfolio review not required. Responds to e-mail submissions in 1 week. Acquires one-time rights or reprint rights. Pays on publication with sample copy for the magazine and $510-20 for cover illustration work. Pays cash on acceptance for chapbook illustrators. Chapbook illustrators are contacted for assignments. Average pay for chapbook illustrators is $20-50 for one-time rights. Does not use illustrations over 4 × 6. Finds artists through word of mouth, submissions and on the Internet. Seeks submissions for print format and for our website.

Tips: "Read our listing carefully. Be familiar with our needs and our tastes in previously published illustrations. We can't judge you by your résumé—send copies of b&w artwork. Include title and medium. Send pieces that reflect social concern. No humor please. If we are interested, we won't let you know without a SASE. Artwork may be sent via e-mail. Illustrations may be color for use on our website. If you direct us to see samples on your home page, give us time to visit and reply."

Citing *AGDM* as a top resource for compiling her mailing list and helping her search for the appropriate agent, Hailey Parnell is a rising illustrator. Her preferred tool is watercolor pencil, and her style humanistic and sensual, as praised by Ave Jeanne, the publisher of *Black Bear*. "Girl Contemplating" was quickly selected by Jeanne because of its "profound intensity to display both human emotion and artistic mastery."

N: BLACK ENTERPRISE, 130 Fifth Ave., 10th Floor, New York NY 10011-4306. (212)242-8000. Fax: (212)886-9610. Website: www.blackenterprise.com. Contact: Terence K. Saulsby, art director. Associate Art Director: Mary A. Brown. Designer: Aliatu Burke. Estab. 1970. Monthly 4-color consumer magazine covering business news, personal finance and wealth-building information to black business leaders, executives and entrepreneurs. Circ. 435,169.
Illustration: Approached by 1,000 illustrators/year. Buys 10 illustrations/issue. Has featured illustrations by D.L. Warfield, Peter Fasolino, Jerry Gonzalez and Stephen Schildbach. caricatures of business people, humorous and spot illustrations, informational graphics on business subjects, men and women, African-American professionals and entrepreneurs. Assigns 90% of illustrations to experienced, but not well-known illustrators; 10% to new and emerging illustrators. Send postcard sample. Samples are filed. Buys one-time rights. **Pays on acceptance**; $700-1,200 for full page spreads; $300 for spots. Finds illustrators through artist's mailings.
Tips: The illustrators we work with have been working for a long time and understand editorial illustration. I get a lot of solicitations from new illustrators who mistakenly send very Afrocentric work or abstract art. The subject matters we need to flush out our stories are very business oriented: taxes, wills, the stock market etc. You have to show me you can take an idea and illustrate it. When trying out an illustrator for the first time, I generally assign a spot illustration to see what the illustrator can do.

THE BLACK LILY, 8444 Cypress Circle, Sarasota FL 34243-2006. (941)351-4386. E-mail: gkuklews@ix. netcom.com. **Chief Editor:** Vincent Kuklewski. Estab. 1996. Quarterly b&w zine featuring fantasy and medieval short stories and poetry (pre-1600 world setting). Circ. 150.
Cartoons: Buys 2 cartoons/year. Prefers fantasy—elves, dragons, princesses, knights. Prefers: single or multiple panel, humorous, b&w line drawings. Send query letter with b&w photocopies and SASE. Samples are filed. Responds in 1 month. Rights purchased vary according to project. **Pays on acceptance.** Pays $5-25 for b&w and comic strips.
Illustration: Approached by 50 illustrators/year. Buys 15 illustrations/issue. Has featured illustrations by Bill Reames, Richard Dahlstrom, Virgil Barfield, Cathy Buburuz. Features humorous and realistic illustrations portraying high fantasy and pre-1600 historical subjects. Prefers pen & ink. Assigns 25% to experienced, but not well-known illustrators; 75% to new and emerging illustrators. Send query letter with photocopies, SASE. Accepts Windows-compatible disk submissions. Send TIFF files. Samples are filed. Responds in 1 month. Will contact artist for portfolio review if interested. Buys one-time rights or vary according to project. **Pays on acceptance.** Pays $25-50 for b&w cover; $5-50 for b&w inside. Pays $5 for spots.
Tips: Submit "crisp, clear black & white line drawings. Shading by stipiling preferred. Need more pre-1600 AD western Europe work, but also need Chinese/Japanese and Islamic designs. Especially interested in art with Northwoods Forest/animal/villagers/Lappland/fairy tale work. Commonly used size work is 'one-column' 3½×9. Always need cover art. We seek to never repeat the same artist on covers."

✓ THE B'NAI B'RITH IJM, B'nai B'rith International, (formerly The B'nai B'rith International Jewish Monthly), 1640 Rhode Island Ave. NW, Washington DC 20036. (202)857-6646. Fax: (202)296-1092. E-mail: erozenman@bnaibrith.org. Website: www.bnaibrith.org. **Editor:** Eric Rozenman. Estab. 1886. Specialized magazine published 4 times a year, focusing on matters of general Jewish interest. Circ. 100,000. Originals returned at job's completion. Sample copies available for $2; art guidelines for SASE with first-class postage.
Illustration: Approached by 100 illustrators/year. Buys 1-2 illustrations/issue. Works on assignment only. Considers pen & ink, airbrush, colored pencil, mixed media, watercolor, acrylic, oil, pastel, collage, marker, charcoal. Send query letter with brochure and SASE. Samples are filed. Responds only if interested. Request portfolio review in original query. Portfolio should include final art, color, tearsheets and published work. Buys one-time rights. Pays on publication; $50 for b&w cover; $400 maximum for color cover; $50 for b&w inside; $100 maximum for color inside. Finds artists through word of mouth and submissions.
Tips: "Have a strong and varied portfolio reflecting a high degree of professionalism. Illustrations should reflect a proficiency in conceptualizing art—not just rendering. Will not be held responsible for unsolicited material."

✓ BODY & SOUL, (formerly New Age Journal), 42 Pleasant St., Watertown MA 02472. (617)926-0200, ext. 338. Website: www.bodyandsoulmag.com. **Art Director:** Carolynn Decillo. Emphasizes alternative life-styles, holistic health, ecology, personal growth, human potential, planetary survival. Bimonthly. Circ. 190,000. Accepts previously published material and simultaneous submissions. Originals are returned after publication by request. Sample copy $3.
Illustration: Buys 60-90 illustrations/year. Works on assignment only. Send tearsheets, slides or promo pieces. Samples returned by SASE if not kept on file. Portfolio may be dropped off. Pays $1,000 for color cover; $400 for color inside.

Tips: Finds artists through sourcebooks and reps. "I prefer to see tearsheets or printed samples."

N BOOK, 252 W. 37th St., 5th Floor, New York NY 10018-6637. (212)659-7070. Fax: (212)736-4455. Website: www.bookmagazine.com. **Art Director:** Timothy Jones. Associate Art Director: Jenny Chung. Assistant Art Director: Thomas Keeton. Estab. 1999. Four-color consumer magazine published 10 times/ year for avid readers who are passionate about books. Features cover authors, readers, book groups and book stores. Circ. 525,000.
Illustration: Approached by 200 illustrators/year. Buys 6-7 illustrations/issue. Has featured illustrations by Gina Triplett, Michelle Chang, Michael Klein and Selcuk Demirel. Features caricatures of authors and celebrities, computer, humorous and spot illustrations. Features people in the publishing world. Prefers sophisticated color schemes. Assigns 10% of illustrations to well-known or "name" illustrators; 70% to experienced, but not well-known illustrators; 20% to new and emerging illustrators. Send postcard or photocopies and follow-up sample every 4-5 months. Samples are filed. Responds only if interested. Will contact artist for portfolio review if interested. Buys first rights. Pay varies. Finds illustrators through *American Illustration* and artist's promo samples.

✓ BOSTONIA MAGAZINE, 10 Lenox St., Brookline MA 02446-4042. (617)353-3081. Fax: (617)353-6488. Website: www.bu.edu. **Art Director:** Kim Han. Estab. 1900. Quarterly 4-color alumni magazine of Boston University. Audience is "highly educated." Circ. 230,000. Sample copies free for #10 SASE with first-class postage. Art guidelines not available.
Illustration: Approached by 500 illustrators/year. We buy 3 illustrations/issue. Features humorous and realistic illustration, medical, computer and spot illustration. Assigns 10% of illustrations to well-known or "name" illustrators; 50% experienced, but not well-known illustrators; 40% to new and emerging illustrators. Considers all media. Works on assignment only. Send query letter with photocopies, printed samples and tearsheets. Samples are filed and not returned. Responds within weeks only if interested. Will contact for portfolio review if interested. Portfolio should include color and b&w roughs, final art and tearsheets. Buys first North American serial rights. "Payment depends on final use and size." **Pays on acceptance**. Payment varies for cover and inside; pays $200-400 for spots. "Liberal number of tearsheets available at no cost." Finds artists through magazines, word of mouth and submissions.
Tips: "Portfolio should include plenty of tearsheets/photocopies as handouts. Don't phone; it disturbs flow of work in office. No sloppy presentations. Show intelligence and uniqueness of style."

✓ BOW & ARROW HUNTING MAGAZINE, 265 S. Anita Dr., #120, Orange CA 92868-3343. (714)939-9991. Fax: (714)939-9909. E-mail: editorial@bowandarrowhunting.com. Website: www.bowand arrowhunting.com. **Editor:** Joe Bell. Advertising Director: Kevin Kaiser. Emphasizes the sport of bowhunt-ing. Published 9 times per year. Art guidelines free for SASE with first-class postage. Original artwork returned after publication.
Cartoons: Buys occasional cartoon. Prefers single panel, with gag line; b&w line drawings. Send finished cartoons. Material not kept on file returned by SASE. Responds in 2 months. Buys first rights. Pays on publication.
Illustration: Buys 2-6 illustrations/issue; all from freelancers. Has featured illustrations by Tes Jolly and Cisco Monthay. Assigns 75% of illustrations to experienced but not well-known illustrators; 25% to new and emerging illustrators. Prefers live animals/game as themes. Send samples. Prefers photographs or original work as samples. Especially looks for perspective, unique or accurate use of color and shading, and an ability to clearly express a thought, emotion or event. Samples returned by SASE. Responds in 2 months. Portfolio review not required. Buys first rights. Pays on publication; $500 for color cover; $100 for color inside; $50-100 for b&w inside.

N ✦ BOXBOARD CONTAINERS INTERNATIONAL, 29 N. Wacker Dr., Chicago IL 60606-3203. (312)726-2802. Fax: (312)726-2574. Website: www.boxboard.com. **Contact:** Art Director. Estab. 1892. Monthly trade journal. Circ. 15,000.
Illustration: Approached by 10 illustrators/year. Buys 2 illustrations/year. Works on assignment only. 100% of freelance work demands knowledge of Illustrator. Send query letter with brochure and samples. Samples are filed. Responds only if interested. Rights purchased vary according to project. Pays $400 for color cover; $200 for b&w, $200 for color inside.
Tips: Prefers local artists. "Get lucky, and approach me at a good time. A follow-up call is fine, but pestering me will get you nowhere. Few people ever call after they send material. This may not be true of most art directors, but I prefer a somewhat casual, friendly approach. Also, being 'established' means nothing. I prefer to use new illustrators, as long as they are professional and friendly."

☑ **BRIDE'S MAGAZINE**, Condé-Nast Publications, 4 Times Square, 6th Floor, New York NY 10036-6522. (212)286-7528. Fax: (212)286-8331. Website: www.brides.weddingchannel.com. **Design Director:** Phyllis Cox. Art Department Assistant: Christian Drego. Estab. 1934. Bimonthly 4-color; "classic, clean, sophisticated design style." Circ. 440,511. Original artwork is returned after publication.

Illustration: Buys illustrations mainly for spots and feature spreads. Buys 5-10 illustrations/issue. Works on assignment only. Considers pen & ink, airbrush, mixed media, colored pencil, watercolor, acrylic, collage and calligraphy. Needs editorial illustrations. Send postcard sample. In samples or portfolio, looks for "graphic quality, conceptual skill, good 'people' style; lively, young, but sophisticated work." Samples are filed. Will contact for portfolio review if interested. Portfolios may be dropped off every Monday-Thursday and should include color and b&w final art, tearsheets, slides, photostats, photographs and transparencies. Buys one-time rights or negotiates rights purchased. Pays on publication; $250-350 for b&w or color inside; $250 minimum for spots. Finds artists through word of mouth, magazines, submissions/self-promotions, sourcebooks, artists' agents and reps, attending art exhibitions.

BUCKMASTERS WHITETAIL MAGAZINE, 10350 Hwy. 80 E., Montgomery AL 36117. (334)215-3337. Fax: (334)215-3535. Website: www.buckmasters.com. **Art Director:** Laura Unger. Vice President of Market Development & Design: Dockery Austin. Estab. 1987. Magazine covering whitetail deer hunting. Seasonal—6 times/year. Circ. 400,000. Accepts previously published artwork. Originals are not returned. Sample copies and art guidelines available. 80% of freelance work demands knowledge of Illustrator, QuarkXPress, Photoshop or FreeHand.

• Also publishes *Rack* and *Young Bucks Outdoors*. Tim Martin is art director for *Rack*; John Manfredi is art director for *Young Bucks Outdoors*

Cartoons: Approached by 5 cartoonists/year. Buys 1 cartoon/issue. Send query letter with brochure and photos of originals. Samples are filed or returned by SASE. Responds in 3 months. Rights purchased according to project. Pays $25 for b&w.

Illustration: Approached by 5 illustrators/year. Buys 1 illustration/issue. Works on assignment only. Considers all media. Send postcard sample. Accepts submissions on disk. Samples are filed. Call or write for appointment to show portfolio. Portfolio should include final art, slides and photographs. Rights purchased vary. Pays on publication; $500 for color cover; $150 for color inside.

Design: Needs freelance designers for multimedia. 100% of freelance work requires knowledge of Photoshop, QuarkXPress or Illustrator. Pays by project.

Tips: "Send samples related to whitetail deer or turkeys."

☑ **BUGLE—JOURNAL OF ELK AND THE HUNT**, 2291 W. Broadway, Missoula MT 59807-1813. (406)523-4570. Fax: (406)549-7710. E-mail: jpeters@rmef.org. Website: www.rmef.org. **Art Director:** Jodie Peters. Estab. 1984. Bimonthly 4-color outdoor conservation and hunting magazine for a nonprofit organization. Circ. 130,000.

Illustration: Approached by 30-40 illustrators/year. Buys 3-4 illustrations/issue. Has featured illustrations by Pat Daugherty, Cynthie Fisher, Joanna Yardley and Bill Gamradt. Features natural history illustration, humorous illustration, realistic illustrations and maps. Preferred subjects: wildlife and nature. "Open to all styles." Assigns 60% of illustrations to well-known or "name" illustrators; 20% to experienced, but not well-known illustrators; 20% to new and emerging illustrators. Send query letter with printed samples and tearsheets. Accepts Windows-compatible disk submissions. Send EPS or TIFF files. Samples are filed. Responds in 2 months. Will contact artist for portfolio review if interested. **Pays on acceptance**; $250-400 for b&w, $250-400 for color cover; $100-150 for b&w, $100-200 for color inside; $150-300 for 2-page spreads; $50 for spots. Finds illustrators through existing contacts and magazines.

Tips: "We are looking for a variety of styles and techniques with an attention to accuracy."

☒ ☑ **BUILDINGS MAGAZINE**, 615 Fifth St. SE, Cedar Rapids IA 52406-1888. (319)364-6167. Fax: (319)364-4278. E-mail: elisa-geneser@stamats.com. Website: www.buildings.com. **Art Director:** Elisa Geneser. Estab. 1906. Monthly trade magazine featuring "information related to current approaches, technologies and products involved in large commercial facilities." Circ. 57,000. Original artwork returned at job's completion.

Illustration: Works on assignment only. Has featured illustrations by Jonathan Macagba, Pamela Harden, James Henry and Jeffrey Scott. Features informational graphics; computer and spot illustration. Assigns 50% of illustrations to experienced, but not well-known illustrators; 50% to new and emerging illustrators. Considers all media, themes and styles. Send postcard sample. Accepts submissions on disk compatible with Macintosh, Photoshop 4.0 or Adobe Illustator 7.0. Samples are filed. Will contact for portfolio review if interested. Portfolio should include thumbnails, b&w/color tearsheets. Rights purchased vary. **Pays on acceptance**, $250-500 for b&w, $500-1,500 for color cover; $50-200 for b&w inside; $100-350 for color inside; $30-100 for spots. Finds artists through word of mouth and submissions.

Design: 60% of freelance work demands knowledge of Photoshop, Illustrator. Send query letter with brochure, photocopies and tearsheets. Pays by the project.

Tips: "Send postcards with samples of your work printed on them. Show us a variety of work (styles), if available. Send only artwork that follows our subject matter: commercial buildings and facility management."

BULLETIN OF THE ATOMIC SCIENTISTS, 6042 S. Kimbark Ave., Chicago IL 60637-2898. (773)702-2555. Fax: (773)702-0725. E-mail: thebulletin.org. Website: www.thebulletin.org. **Managing Editor:** Bret Lortie. Art Director: Thomas Lachemacher. Estab. 1945. Bimonthly magazine of international affairs and nuclear security. Circ. 15,000. Sample copies available.

Cartoons: Approached by 5-10 cartoonists/year. Buys 6-10 cartoons/issue. Prefers single panel, general humor, b&w/color washes and line drawings. Samples are not filed and are returned. Responds in 10 days. Buys one-time rights. **Pays on acceptance**; $50-150 for b&w.

Illustration: Approached by 20-25 illustrators/year. Buys 2-3 illustrations/issue. Send postcard sample and photocopies. Samples are filed. Responds only if interested. Buys first rights. **Pays on acceptance**; $300-500 for color cover; $100-300 for color inside. Publish illustrations with a variety of experience.

Tips: "We're eager to see cartoons that relate to our editorial content, so it's important to take a look at the magazine before submitting items."

☑ **BUSINESS LAW TODAY**, 750 N. Lake Shore Dr., 8th Floor, Chicago IL 60611-4403. (312)988-6122. Fax: (312)988-6081. E-mail: tedhamsj@staff.abanet.org. Website: www.abanet.org. **Art Director:** Jill Tedhams. Estab. 1992. Bimonthly magazine covering business law. Circ. 56,000. Art guidelines not available.

Cartoons: Buys 20-24 cartoons/year. Prefers business law and business lawyers themes. Prefers single panel, humorous, b&w line drawings with gaglines. Send photocopies and SASE. Samples are not filed and are returned by SASE. Responds in several days. Buys one-time rights. Pays on publication; $150 minimum for b&w. Please send cartoons to the attention of Ray DeLong.

Illustration: Buys 6-9 illustrations/issue. Has featured illustrations by Tim Lee, Henry Kosinski and Jim Starr. Features humorous, realistic and computer illustrations. Assigns 10% of illustrations to well-known or "name" illustrators; 80% to experienced, but not well-known illustrators; and 10% to new and emerging illustrators. Prefers editorial illustration. Considers all media. 10% of freelance illustration demands knowledge of Photoshop, Illustrator and QuarkXPress. "We will accept work compatible with QuarkXPress version 4.04. Send EPS or TIFF files." Samples are filed and are not returned. Responds only if interested. Buys one-time rights. Pays on pubication; $750 for color cover; $520 for b&w inside, $575 for color inside; $175 for b&w spots.

Tips: "Although our payment may not be the highest, accepting jobs from us could lead to other projects, since we produce many publications at the ABA. Sending samples (three to four pieces) works best to get a sense of your style; that way I can keep them on file."

◼ **BUSINESS LONDON MAGAZINE**, Box 7400, London Ontario N5Y 4X3 Canada. (519)472-7601. Fax: (519)473-7859. E-mail: businesslondon@bowesnet.com. **Art Director:** Rob Rodenhuis. Monthly magazine "covering London and area businesses; entrepreneurs; building better businesses." Circ. 14,000. Sample copies not available; art guidelines not available.

Cartoons: Approached by 2 cartoonists/year. Buys 1 cartoon/issue. Prefers business-related line art. Prefers single panel, humorous b&w washes and line drawings without gagline. Send query letter with roughs. Samples are filed and are not returned. Responds only if interested. Buys first rights. Pays on publication; $25-50 for b&w, $50-100 for color.

Illustration: Approached by 5 illustrators/year. Buys 2 illustrations/issue. Has featured illustrations by Nigel Lewis and Scott Finch. Features humorous and realistic illustration; informational graphics and spot illustration. Assigns 50% of illustrations to experienced, but not well-known illustrators; 50% to new and emerging illustrators. Prefers business issues. Considers all media. 10% of freelance illustration demands knowledge of Photoshop 3, Illustrator 5.5, QuarkXPress 3.2. Send query letter with printed samples. Accepts disk submissions compatible with QuarkXPress 7/version 3.3, Illustrator 5.5, Photoshop 3, (TIFFs of EPS files). Samples are filed and are not returned. Art director will contact artist for portfolio review of b&w, color, final art, photographs, slides and thumbnails if interested. Pays on publication; $125 maximum for cover; $25 minimum for b&w inside; $100 maximum for color inside. Finds illustrators through artist's submissions.

Tips: "Arrange personal meetings, provide vibrant, interesting samples, start out cheap! Quick turnaround is a must."

☑ **BUSINESS TRAVEL NEWS**, 770 Broadway, New York NY 10003. (646)654-4450. Fax: (646)654-4455. Website: www.btonline.com. **Design Director and Webmaster:** Teresa M. Carboni. Estab. 1984. Bimonthly 4-color trade publication focusing on business and corporate travel news/management. Circ. 50,000.

Illustration: Approached by 300 illustrators/year. Buys 4-8 illustrations/month. Features charts & graphs, computer illustration, conceptual art, informational graphics and spot illustrations. Preferred subjects: business concepts, electronic business and travel. Assigns 30% of illustrations to well-known, experienced and emerging illustrators. Send postcard or other nonreturnable samples. Samples are filed. Buys first rights. **Pays on acceptance**; $600-900 for color cover; $250-350 for color inside. Finds illustrators through artist's promotional material and sourcebooks.

Tips: "Send your best samples. We look for interesting concepts and print a variety of styles. Please note we serve a business market."

Ⓝ CALIFORNIA HOME & DESIGN, 618 Santa Cruz Ave., Menlo Park CA 94025. (650)324-1818. Fax: (415)324-1888. E-mail: gentrymag@aol.com. **Art Director:** Lisa Druri. Estab. 1994. Bimonthly magazine of Northern California lifestyle. Sample copy free for 9 × 10 SASE and first-class postage.

- Also publishes another bimonthly, *Gentry* and three annuals, *After Hours*, *One Source* and *Concepts*.

Cartoons: Approached by 200 cartoonists/year. Buys 4 cartoons/year. Prefers financial themes. Prefers single panel, humorous, color washes, without gagline. Send photocopies. Samples are filed and are not returned. Reports back if interested. Buys one-time rights. Pays on publication; $50-100 for b&w; $75-200 for color.

Illustration: Approached by 100 illustrators/year. Buys 6 illustrations/year. Prefers financial, fashion. Considers all media. 50% of freelance illustration demands knowledge of Photoshop, Illustrator, QuarkXPress. Send postcard sample, query letter with printed samples. Accepts disk submissions compatible with QuarkXPress (EPS files). Samples are filed. Responds only if interested. Buys one-time rights. Pays on publication. Pays $100-250 for spots. Finds illustrators through artist's submissions.

Design: Needs freelancers for design and production. Prefers local design freelancers. 100% of freelance work demands knowledge of Photoshop, Illustrator, QuarkXPress. Send printed samples.

Tips: "Read our magazine."

Ⓘ CALIFORNIA JOURNAL, 2101 K St., Sacramento CA 95816. (916)444-2840. Fax: (916)444-2339. Website: www.statenet.com. **Art Director:** Dagmar Thompson. Estab. 1970. Monthly magazine "covering politics, government and independent analysis of California issues." Circ. 15,000. Sample copies available. Art guidelines not available. Call.

Illustration: Approached by 10-30 illustrators/year. Buys 30-40 illustrations/year. Features caricatures of politicians; realistic, computer and spot illustration. Assigns 5% of illustrations to well-known or "name" illustrators; 25% to experienced, but not well-known illustrators; 70% to new and emerging illustrators. Prefers editorial. Considers all media. 10% of freelance illustration demands knowledge of Photoshop. Send postcard sample or query letter with photocopies. Send follow-up postcard sample every 4 months. Accepts disk submissions compatible with Mac Photoshop/Syquest on 3.5 or Zip disk. Samples are filed and not returned. Responds only if interested. Art director will contact artist for portfolio review if interested. Buys all rights. **Pays on acceptance**; $350 minimum for color cover; $150 minimum for b&w inside; $100 minimum for spots. Finds illustrators through magazines, word of mouth and artist's submissions.

Design: Prefers California design freelancers.

Tips: "We like to work with illustrators who understand editorial concepts and are politically current."

Ⓝ CAMPUS LIFE, 465 Gundersen Dr., Carol Stream IL 60188. Website: www.campuslife.net. **Designer:** Doug Fleener. Bimonthly 4-color publication for high school and college students. "Though our readership is largely Christian, *Campus Life* reflects the interests of all kids—music, activities, photography and sports." Circ. 100,000. Original artwork returned after publication. "No phone calls, please. Send mailers." Uses freelance artists mainly for editorial illustration.

Cartoons: Approached by 50 cartoonists/year. Buys 50 cartoons/year from freelancers. Uses 3 single-panel cartoons/issue plus cartoon features (assigned) on high school and college education, environment, family life, humor through youth and politics; applies to 13-18 age groups; both horizontal and vertical format. Prefers to receive finished cartoons. Responds in 1 month. **Pays on acceptance**; $50 for b&w, $75 for color.

Illustration: Approached by 175 illustrators/year. Works with 5 illustrators/year. Buys 2 illustrations/issue, 10/year from freelancers. Styles vary from "contemporary realism to very conceptual." Works on assignment only. 10% of freelance work demands knowledge of FreeHand and Illustrator. Send promos or

tearsheets. Please no original art transparencies or photographs. Samples returned by SASE. Publication will contact artist for portfolio review if interested. Buys first North American serial rights; also considers second rights. **Pays on acceptance**; $75-350 for b&w; $350-500 for color inside.

Tips: "I like to see a variety in styles and a flair for expressing the teen experience. Keep sending a mailer every couple of months."

[N] CANADIAN BUSINESS, 777 Bay St., 5th Floor, Toronto, Ontario M5W 1A7 Canada. (416)596-5100. Fax: (416)596-5155. Website: www.canadianbusiness.com. **Art Director:** Tim Davin. Associate Art Director: David Heath. Assistant Art Director: John Montgomery. Biweekly 4-color business magazine focusing on Canadian management and entrepreneurs. Circ. 85,000.

Illustration: Approached by 200 illustrators/year. Buys 5-10 illustrations/issue. Has featured illustrations by Blair Drawson, Jason Schneider, Seth, Simon Ng, Michael Cho. Features caricatures of celebrities and informational graphics of business subjects. Assigns 70% of illustrations to well-known or "name" illustrators; 30% to new and emerging illustrators (who are on staff as contract designer/illustrators). 30% of freelance illustration demands knowledge of Illustrator and Photoshop. Send postcard sample, printed samples and photocopies. Accepts Mac-compatible disk submissions. Responds only if interested. Will contact artist for portfolio review if interested. **Pays on acceptance**; $1,000-2,000 for color cover; $300-1,500 for color inside. Pays $300 for spots. Finds illustrators through magazines, word of mouth and samples.

[N] CANADIAN DIMENSION (CD), 91 Albert St., Room 2-B, Winnipeg, Manitoba R3R 1G5 Canada. (204)957-1519. Fax: (204)943-4617. E-mail: info@canadiandimension.mb.ca. Website: www.canadiandimension.mb.ca. **Office Manager:** Kevin Matthews. Estab. 1963. Bimonthly consumer magazine published "by, for and about activists in the struggle for a better world, covering women's issues, aboriginal issues, the enrivonment, labour, etc." Circ. 2,600. Accepts previously published artwork. Originals returned at job's completion. Sample copies available for $2. Art guidelines available for SASE with first-class postage.

Illustrators: Approached by 20 illustrators/year. Has featured illustrations by Kenneth Vincent, Darcy Muenchrath and Stephen King. Buys 10 illustrations/year. Send query letter with brochure and SASE. Samples are filed or returned by SASE if requested by artist. Publication will contact artist for portfolio review if interested. Buys one-time rights. Pays on publication; $100 for b&w cover; $50 for b&w inside and spots. Finds artists through word of mouth and artists' submissions. E-mail inquiries, samples or URLs welcome.

CAREER FOCUS, 7300 W. 110th St., 7th Floor, Overland Park KS 66210-2330. (913)317-2888. Website: www.neli.net/publications. **Contact:** Executive Editor. Estab. 1985. Bimonthly educational, career development magazine. "A motivational periodical designed for Black and Hispanic college graduates who seek career development information." Circ. 250,000. Accepts previously published artwork. Originals are returned at job's completion. Sample copies and art guidelines for SASE with first-class postage.

• *Career Focus* is published by CPG Communications Inc. (Career Publishing Group) which also publishes *Direct Aim*, *College Preview*, *Focus Kansas City* and *First Opportunity*. These magazines have similar needs for illustration as *Career Focus*.

Illustration: Buys 1 illustration/issue. Send query letter with SASE, photographs, slides and transparencies. Samples are filed. Responds only if interested. Buys one-time rights. Pays on publication; $20 for b&w, $25 for color.

CAREERS AND COLLEGES, 989 Sixth Ave., New York NY 10018. (212)563-4688. Fax: (212)967-2531. Website: www.careersandcolleges.com. **Art Director:** Barbara Hofrenning. Estab. 1980. Quarterly 4-color educational magazine published September-May. "Readers are college-bound high school juniors and seniors and college students. Besides our magazine, we produce educational material (posters, newsletters) for outside companies." Circ. 100,000. Accepts previously published artwork. Original artwork is returned at job's completion.

Illustration: "We're looking for contemporary, upbeat, sophisticated illustration. All techniques are welcome." Send query letter with samples. "Please do not call. Will call artist if interested in style." Buys one-time rights.

CAT FANCY, Fancy Publications, Inc., Box 6050, Mission Viejo CA 92690. (949)855-8822. Website: www.catfancy.com. Monthly 4-color magazine for cat owners, breeders and fanciers; contemporary, colorful and conservative. Readers are mainly women interested in all phases of cat ownership. Circ. 303,000. No simultaneous submissions. Sample copy $5.50; artist's guidelines for SASE.

Cartoons: Buys 12 cartoons/year. Seeks single, double and multipanel with gagline. Should be simple, upbeat and reflect love for and enjoyment of cats. Central character should be a cat. Send query letter with photostats or photocopies as samples and SASE. Responds in 3 months. Buys first rights. Pays on publication; $35 for b&w line drawings.

Illustration: Send query letter with brochure, high-quality photocopies (preferably color), SASE and tearsheets. Article illustrations assigned. Portfolio review not required. Pays $20-35 for spots; $20-100 for b&w; $50-300 for color insides; more for packages of multiple illustrations. Needs editorial, medical and technical illustration and images of cats.

Tips: "We need cartoons with an upbeat theme and realistic illustrations of purebred and mixed-breed cats. Please review a sample copy of the magazine before submitting your work to us."

✅ **CATHOLIC FORESTER**, Box 3012, Naperville IL 60566-7012. (630)983-4900. E-mail: cofpr@aol. com. Website: catholicforester.com. Fax: (800)811-2140. **Contact:** Art Director. Estab. 1883. Magazine. "We are a fraternal insurance company but use general-interest articles, art and photos. Audience is middle-class, many small town as well as big-city readers, patriotic, Catholic and traditionally conservative." National bimonthly 4-color magazine. Circ. under 100,000. Accepts previously published material. Sample copy for 9×12 SASE with 3 first-class stamps.

Cartoons: Buys less than 4 cartoons/year from freelancers. Considers "anything *funny* but it must be clean." Prefers single panel with gagline or strip; b&w line drawings. Material returned by SASE. Responds in about 2 months. Buys one-time rights, North American serial rights or reprint rights. Pays on publication; $30 for b&w.

Illustration: Buys and commissions editorial illustration. Will contact for portfolio review if interested. Requests work on spec before assigning job. Pays $30-100 for b&w, $75-300 for color inside.

Tips: "Know the audience you're drawing for—always read the article and don't be afraid to ask questions. Pick the art director's brain for ideas and be timely."

CED, P.O. Box 266007, Highlands Ranch CO 80163-6007. (303)470-4800. Fax: (303)470-4890. E-mail: druth@cahners.com. Website: cedmagazine.com. **Art Director:** Don Ruth. Estab. 1978. Monthly trade journal dealing with "the engineering aspects of the technology in Cable TV. We try to publish both views on subjects." Circ. 22,815. Accepts previously published work. Original artwork not returned at job's completion. Sample copies and art guidelines available.

Cartoons: Approached by 5-10 freelance illustrators/year. Perfers cable-industry-related themes; single panel, color washes without gagline "or b&w line drawing that we colorize." Contact only through artist rep. Samples are filed. Rights purchased vary according to project. Pays $200 for b&w; $400 for color.

Illustration: Buys 1 illustration/issue. Works on assignment only. Features caricatures of celebrities; realistic illustration; charts & graphs; informational graphics and computer illustrations. Assigns 10% of illustrations to well-known or "name" illustrators; 80% to experienced, but not well-known illustrators; 10% to new and emerging illustrators. Prefers cable TV-industry themes. Considers watercolor, airbrush, acrylic, colored pencil, oil, charcoal, mixed media, pastel, computer disk through Photoshop, Illustrator or FreeHand. Contact only through artist rep. Samples are filed. Call for appointment to show portfolio. Portfolio should include final art, b&w/color tearsheets, photostats, photographs and slides. Rights purchased vary according to project. **Pays on acceptance**; $400-800 for color cover; $125-400 for b&w and color inside; $250-500 for 2-page spreads; $75-175 for spots.

Tips: "Be persistent; come in person if possible. Be willing to change in mid course; be willing to have finished work rejected. Make sure you can draw and work fast."

◼ **CHARLESTON MAGAZINE**, 782 Johnnie Dodds Blvd., Suite C, Mt. Pleasant SC 29464. (843)971-9811. Fax: (843)971-0121. E-mail: gulfstream@awod.com. Website: www.charlestonmag.com. **Art Director:** Melinda Smith Monk. Editor: Darcy Shanklin. Estab. 1973. Quarterly 4-color consumer magazine. "Indispensible resource for information about modern-day Charleston SC, addresses issues of relevance and appeals to both visitors and residents." Circ. 20,000. Art guidelines are free for #10 SASE with first-class postage.

Illustration: Approached by 35 illustrators/year. Buys 3 illustrations/issue. Has featured illustrations by Tate Nation, Nancy Rodden, Paige Johnson, Emily Thompson and local artists. Features realistic illustrations, informational graphics, spot illustrations, computer illustration. Prefers business subjects, children, families, men, pets, women and teens. Assigns 10% of illustrations to well-known or "name" illustrators;

CARTOON markets are listed in the Cartoon Index located within the Niche Marketing Index at the back of this book.

30% to experienced, but not well-known illustrators; 60% to new and emerging illustrators. 35% of free-lance illustration demands knowledge of Illustrator, Photoshop, FreeHand, PageMaker, QuarkXPress. Send postcard sample and follow-up postcard every month. Send nonreturnable samples. Send query letter with printed samples. Accepts Mac-compatible disk submissions. Samples are filed or returned by SASE. Responds only if interested. Will contact artist for portfolio review if interested. Buys first rights, one-time rights or rights purchased vary according to project. Pays 30 days after publication; $175 for b&w, $200 for color cover; $100-400 for 2-page spreads; $50 for spots. Finds illustrators through sourcebooks, artists promo samples, word of mouth.

Tips: "Our magazine has won several design awards and is a good place for artists to showcase their talent in print. We welcome letters of interest from artists interested in semester-long, unpaid internships-at-large. If selected, artist would provide 4-5 illustrations for publication in return for masthead recognition and sample tearsheets. Staff internships (unpaid) also available on-site in Charleston S.C. Send letter of interest and samples of work to Art Director."

☑ **CHARLOTTE MAGAZINE**, 127 W. Worthington Ave., Suite 208, Charlotte NC 28203-4474. (704)335.7181. E-mail: cporter@abartapub.com. Website: www.charlottemag.com. **Art Director:** Carrie Porter. Associate Art Directors: Kristin Allen and Chris Goeller. Estab. 1995. Monthly 4-color, city-based consumer magazine for the Charlotte and surrounding areas. Circ. 28,000. Sample copies free for #10 SAE with first-class postage.

Illustration: Approached by many illustrators/year. Buys 1-5 illustrations/issue. Has featured illustrations by Jack Unruh, Sally Wern Conport, Vivienne Flesher, Stephen Verriest, Ishmael Roldan. Features carica-tures of celebrities and politicians; computer illustration; humorous illustration; natural history, realistic and spot illustration. Prefers wide range of media/conceptual styles. Assigns 40% of illustrations to well-known or "name" illustrators; 40% to experienced, but not well-known illustrators; 20% to new and emerging illustrators. Send postcard sample and follow-up postcard every 6 months. Send non-returnable samples. Accepts e-mail submissions. Send EPS or TIFF files. Samples are filed. Responds only if inter-ested. Portfolio review not required. Pays $150-400 for b&w inside; $300-800 for color inside; $800-1,000 for 2-page spreads; $150 for spots. Finds illustrators through artist promotional samples and sourcebooks.

Tips: "We are looking for diverse and unique approaches to illustration. Highly creative and conceptual styles are greatly needed. If you are trying to get your name out there we are a great avenue for you."

CHEMICAL SPECIALTIES, 110 William St., New York NY 10038. (212)621-4900. Fax: (212)621-4949. E-mail: msotolongo@chemweek.com. Website: www.chemweek.com. **Director:** Mario Sotolongo. Assistant Art Director: Gen Yee. Estab. 1998. Bimonthly, 4-color trade publication emphasizing commercial developments in specialty chemical markets. Circ. 40,000.

● This publisher also publishes other trade magazines, such as *Chemical Week, Modern Paints & Coatings, Adhesive Age* and *Soap and Cosmetics*, which have similar needs for illustration and are produced by the same staff. Check out their websites: www.modernpaintsandcoatings.com; www.adhesiveage.com. Art directors say these publications are open to submissions.

Illustration: Features charts and graphs, computer illustration, informational graphics, natural history illustration, realistic illustrations, medical illustration of business subjects. Prefers bright colors and clean look. Assigns 100% of illustrations to experienced, but not well-known illustrators. 100% of freelance illustration demands knowledge of Illustrator, Photoshop, QuarkXPress. Send non-returnable postcard sam-ple and follow-up postcard every 6 months. Accepts Mac-compatible disk submissions. Send EPS or TIFF files. Samples are filed and are not returned. Responds only if interested. Portfolio review not required. Rights purchased vary according to project. Pays on publication; $500-800, $500-800 for color cover.

Tips: "Freelancers should be reliable and produce quality work. Promptness and the ability to meet dead-lines are most important."

☑ **CHESAPEAKE BAY MAGAZINE**, 1819 Bay Ridge Ave., Annapolis MD 21403. (410)263-2662. Fax: (410)267-6924. E-mail: kashley@cbmmag.net. Website: www.cbmmag.net. **Art Director:** Karen Ash-ley. Estab. 1972. Monthly 4-color magazine focusing on the boating environment of the Chesapeake Bay—including its history, people, places and ecology. Circ. 45,000. Original artwork returned after publication upon request. Sample copies free for SASE with first-class postage. Art guidelines available. "Please call."

Cartoons: Approached by 12 cartoonists/year. Prefers single panel, b&w washes and line drawings with gagline. Cartoons or nautical and fishing humor are appropriate to the Chesapeake environment. Send query letter with finished cartoons. Samples are filed. Responds to the artist only if interested. Buys one-time rights. Pays $50 for b&w. Make sure to include contact information on each sample.

Illustration: Approached by 12 illustrators/year. Buys 2-3 technical and editorial illustrations/issue. Has featured illustrations by Jim Paterson, Rob Snyder, Tamziu Craig and Marcy Ramsey. Assigns 50% of illustrations to experienced, but not well-known illustrators; 50% to new and emerging illustrators. Consid-ers pen & ink, watercolor, collage, acrylic, marker, colored pencil, oil, charcoal, mixed media and pastel.

Usually prefers watercolor or oil for 4-color editorial illustration. "Style and tone are determined by the artist after he/she reads the story." Send query letter with résumé, tearsheets and photographs. Samples are filed. Responds only if interested. Publication will contact artist for portfolio review if interested. Portfolio should include "anything you've got." No b&w photocopies. Buys one-time rights. "Price decided when contracted." Pays $50-175 for b&w inside; $75-350 for color inside.

Tips: "Our magazine design is relaxed, fun, oriented toward people having fun on the water. Style seems to be loosening up. Boating interests remain the same. But for the Chesapeake Bay—water quality and the environment are more important to our readers than in the past. Colors brighter. We like to see samples that show the artist can draw boats and understands our market environment. Send tearsheets or call for an interview—we're always looking. Artist should have some familiarity with the appearance of different types of boats."

CHICKADEE, Bayard Press Canada, 49 Front St. E., 2nd Floor, 179 John St., Suite 500, Toronto, Ontario M5E 1B3 Canada. (416)340-2700. Fax: (416)340-9769. Website: www.owlkids.com. **Creative Director:** Barb Kelly. Estab. 1979. 9 issues/year. Children's discovery magazine. Chickadee is a "hands-on" science, nature and discovery publication designed to entertain and educate 6-9 year-olds. Each issue contains photos, illustrations, an easy-to-read animal story, a craft project, fiction, puzzles, a science experiment, and a pull-out poster. Circ. 150,000 in North America. Originals returned at job's completion. Sample copies available. Uses all types of conventional methods of illustration. Digital illustrators should be familiar with Illustrator or Photoshop.

- The same company that publishes *Chickadee* now also publishes *Chirp*, a science, nature and discovery magazine for pre-schoolers two to six years old, and *OWL*, a similar publication for children over eight years old.

Illustration: Approached by 500-750 illustrators/year. Buys 3-7 illustrations/issue. Works on assignment only. Prefers animals, children, situations and fiction. All styles, loaded with humor but not cartoons. Realistic depictions of animals and nature. Considers all media and computer art. No b&w illustrations. Send postcard sample, photocopies and tearsheets. Accepts disk submissions compatible with Illustrator 8.0. Send EPS files. Samples are filed or returned by SASE. Will contact for portfolio review if interested. Portfolio should include final art, tearsheets and photocopies. Buys all rights. Pays within 30 days of invoice; $500 for color cover; $100-750 for color/inside; $100-300 for spots. Finds artists through sourcebooks, word of mouth, submissions as well as looking in other magazines to see who's doing what.

Tips: "Please become familiar with the magazine before you submit. Ask yourself whether your style is appropriate before spending the money on your mailing. Magazines are ephemeral and topical. Ask yourself if your illustrations are: editorial and contemporary. Some styles suit books or other forms better than magazines." Impress this art director by being "fantastic, enthusiastic and unique."

CHILD LIFE, Children's Better Health Institute, 1100 Waterway Blvd., Box 567, Indianapolis IN 46206. (317)636-8881. Fax: (317)684-8094. Website: www.childlifemag.org. **Art Director:** Phyllis Lybarger. Editor: Susan Thompson. Estab. 1921. 4-color magazine for children 9-11. Monthly, except bimonthly January/February, April/May, July/August and October/November. Sample copy $1.25. Art guidelines for SASE with first-class postage.

- Art director reports *Child's Life* has gone through a format change from conventional to nostalgic. She is looking for freelancers whose styles lend themselves to a nostalgic look. This publisher also publishes *Children's Digest*, *Children's Playmate*, *Humpty Dumpty's Magazine*, *Jack and Jill*, *Turtle Magazine* and *U.S. Kids Weekly Reader Magazine*.

Illustration: Approached by 200 illustrators/year. Works with 15 illustrators/year. Buys approximately 20 illustrations/year on assigned themes. Features humorous, realistic, medical, computer and spot illustration. 50% of work is pick-up art; the remaining 50% is assigned to new and emerging illustrators. Especially needs health-related (exercise, safety, nutrition, etc.) themes, and stylized and realistic styles of children 9-11 years old. Uses freelance art mainly with stories and medical column and activities poems. Send postcard sample or query letter with tearsheets or photocopies. "Please send SASE and comment card with samples." Especially looks for an artist's ability to draw well consistently. Responds in 2 months. Buys all rights. Pays $275 for color cover; $35-90 for b&w inside; $70-155 for color inside; $210-310 for 2-page spreads; $35-80 for spots. Pays within 3 weeks prior to publication date. "All work is considered work for hire." Finds artists through submissions, occasionally through a sourcebook.

Tips: "Artists should obtain copies of current issues to become familiar with our needs. I look for the artist's ability to illustrate children in group situations and interacting with adults and animals, in realistic styles. Also use unique styles for occasional assignments—cut paper, collage or woodcut art. No cartoons, portraits of children or slick airbrushed advertising work."

☑ **CHILDREN'S DIGEST**, Children's Better Health Institute, 1100 Waterway Blvd., Box 567, Indianapolis IN 46202. (317)636-8881. Fax: (317)684-8094. Website: www.childrensdigestmag.org. **Art Director:** Penny Rasdall. 4-color magazine with special emphasis on book reviews, health, nutrition, safety and exercise for preteens. Published 8 times/year. Circ. 106,000. Sample copy $1.25; art guidelines for SASE.
 ● Also publishes *Child Life, Children's Playmate, Humpty Dumpty's Magazine, Jack and Jill, Turtle Magazine* and *U.S. Kids Weekly Reader Magazine*.
Illustration: Approached by 200 illustrators/year. Works with 2 illustrators/year. Buys 2 illustrations/year. Has featured illustrations by Len Ebert, Tim Ellis and Kathryn Mitter. Features humorous, realistic, medical, computer and spot illustrations. Assigns 90% of illustrations to experienced, but not well-known illustrators; 10% to new and emerging illustrators. Uses freelance art mainly with stories, articles, poems and recipes. Works on assignment only. Send query letter with brochure, résumé, samples and tearsheets to be kept on file. "Send samples with comment card and SASE." Portfolio review not required. Prefers photostats, slides and good photocopies as samples. Samples returned by SASE if not kept on file. Responds in 2 months. Buys all rights. Pays $275 for color cover; $35-90 for b&w inside; $60-120 for 2-color inside; $70-155 for 4-color inside; $35-70 for spots. Pays within 3 weeks prior to publication date. "All artwork is considered work for hire." Finds artists through submissions and sourcebooks.
Tips: Likes to see situation and storytelling illustrations with more than 1 figure. When reviewing samples, especially looks for artist's ability to bring a story to life with illustrations and to draw well consistently. No advertising work, cartoon styles or portraits of children. Needs realistic styles and animals.

☑ **CHILDREN'S PLAYMATE**, Children's Better Health Institute, 1100 Waterway Blvd., Box 567, Indianapolis IN 46206. (317)636-8881. Website: www.childrensplaymate.org. **Art Director:** Bart Rivers. 4-color magazine for ages 6-8. Special emphasis on entertaining fiction, games, activities, fitness, health, nutrition and sports. Published 8 times/year. Original art becomes property of the magazine and will not be returned. Sample copy $1.25.
 ● Also publishes *Child Life, Humpty Dumpty's Magazine, Jack and Jill* and *Turtle Magazine*.
Illustration: Uses 8-12 illustrations/issue; buys 6-8 from freelancers. Interested in editorial, medical, stylized, humorous or realistic themes; also food, nature and health. Considers pen & ink, airbrush, charcoal/pencil, colored pencil, watercolor, acrylic, oil, pastel, collage, multimedia and computer illustration. Works on assignment only. Send sample of style; include illustrations of children, families, animals—targeted to children. Provide brochure, tearsheet, stats or good photocopies of sample art to be kept on file. Samples returned by SASE if not filed. Artist should follow up with call or letter. Also considers b&w camera-ready art for puzzles, such as dot-to-dot, hidden pictures, crosswords, etc. Buys all rights on a work-for-hire basis. Payment varies. Pays $275 for color cover; up to $155 for color and $90 for b&w inside, per page. Finds artists through artists' submissions/self-promotions.
Tips: "Become familiar with our magazine before sending anything. Don't send just two or three samples. I need to see a minimum of eight pieces to determine that the artist fits our needs. Looking for samples displaying the artist's ability to interpret text, especially in fiction for ages 6-8. Illustrators must be able to do their own layout with a minimum of direction."

Ⓝ **CHILE PEPPER MAGAZINE**, River Plaza 1701 River Run #702, Ft. Worth TX 76102. (817)877-1048. Fax: (817)877-8870. **Creative Director:** Alan Glazener. Bimonthly magazine covering hot and spicy food/cuisine. Circ. 90,000.
Illustration: Approached by 6-12 illustrators/year. Buys 2-3 illustrations/issue. Prefers Southwestern art or just playful; colorful and classy. Considers all media. 90% of freelance illustration demands knowledge of Photoshop, Illustrator and QuarkXPress. Send postcard sample or printed samples. Accepts disk submissions compatible with Macintosh Photoshop 3, Illustrator 5, or other EPS or TIFF files. Samples are not filed and are not returned. Does not report back. Artist should follow-up in writing. Art director will contact artist for portfolio review of final art and tearsheets if interested. Rights purchased vary according to project. Pays $60-200. Finds illustrators through word of mouth, submissions.
Tips: "World travel is addressed often in *Chile Pepper*. Ethnic art and photography or just local color images are regular fare, but must have a hot & spicy bent to them. While often associated with hot & spicy, sexually suggestive images are not considered."

THE CHRISTIAN CENTURY, 104 S. Michigan, Chicago IL 60603-5901. (312)263-7510. Fax: (312)263-7540. Estab. 1888. Religious magazine; "a weekly ecumenical magazine with a liberal slant on issues of Christianity, culture and politics." Circ. 30,000. Accepts previously published artwork. Original artwork returned at job's completion. Art guidelines for SASE with first-class postage.
Cartoons: Send query letter with finished cartoons. Samples are filed or are returned by SASE if requested by artist. Responds in 3 weeks. Buys one-time rights. Fees negotiable.

Illustration: Usually works on assignment. Considers pen & ink, pastel, watercolor, acrylic and charcoal. Send query letter with tearsheets. Samples are filed or returned by SASE. Responds in 1 month. Buys one-time rights. Pays on publication. Fees negotiable.

CHRISTIAN HOME & SCHOOL, 3350 E. Paris Ave. SE, Grand Rapids MI 49512. (616)957-1070. Fax: (616)957-5022. E-mail: rogers@csionline.org. Website: www.CSIonline.org/csi/chs. **Senior Editor:** Roger W. Schmurr. Emphasizes current, crucial issues affecting the Christian home for parents who support Christian education. 4-color magazine; 4-color cover; published 6 times/year. Circ. 66,000. Sample copy for 9×12 SASE with 4 first-class stamps; art guidelines for SASE with first-class postage.
Cartoons: Prefers family and school themes. Pays $50 for b&w.
Illustration: Buys approximately 2 illustrations/issue. Has featured illustrations by Patrick Kelley, Rich Bishop and Pete Sutton. Features humorous, realistic, computer and spot illustration. Assigns 75% of illustrations to experienced, but not well-known illustrators; 25% to new and emerging illustrators. Prefers pen & ink, charcoal/pencil, colored pencil, watercolor, collage, marker and mixed media. Prefers family or school life themes. Works on assignment only. Send query letter with résumé, tearsheets, photocopies or photographs. Show a representative sampling of work. Samples returned by SASE, or "send one or two samples art director can keep on file." Will contact if interested in portfolio review. Buys first rights. Pays on publication; $250 for 4-color full-page inside; $75-125 for spots. Finds most artists through references, portfolio reviews, samples received through the mail and artist reps.

N CHRISTIAN PARENTING TODAY MAGAZINE, 465 Gunderson Dr., Carol Stream IL 60188-2498. (630)260-6200. Fax: (630)260-0114. E-mail: danacpt@aol.com. Website: www.christianparenting.com. **Art Director:** Doug Johnson. Estab. 1988. Bimonthly 2-color and 4-color consumer magazine featuring advice for Christian parents raising kids. Circ. 90,000.
Illustration: Approached by 100 illustrators/year. Buys 6 illustrations/issue (humorous and spot illustrations). Send postcard or other nonreturnable samples or tearsheets. Samples are filed. Will contact artist for portfolio review if interested. Buys first rights and one-time rights. Pays on publication. Pay varies. Finds illustrators through agents, self promos and directories.

✓ CHRISTIAN READER, Dept. AGDM, 465 Gundersen Dr., Carol Stream IL 60188. (630)260-6200. Fax: (630)260-0114. Website: www.christianitytoday.com. **Art Director:** John Aardema. Estab. 1963. Bi-monthly general interest magazine. "Stories of faith, hope and God's love." Circ. 175,000. Accepts previously published artwork. Originals returned at job's completion.
Illustration: Works on assignment only. Has featured illustrations by Rex Bohn, Ron Mazellan and Donna Kae Nelson. Features humorous, realistic and spot illustration. Prefers family, home and church life. Considers all media. Samples are filed. Responds only if interested. To show a portfolio, mail appropriate materials. Buys one-time rights.
Tips: "Send samples of your best work, in your best subject and best medium. We're interested in fresh and new approaches to traditional subjects and values."

N THE CHRONICLE OF THE HORSE, Box 46, Middleburg VA 20118. **Editor:** John Strassburger. Estab. 1937. Weekly magazine emphasizing horses and English horse sports for dedicated competitors who ride, show and enjoy horses. Circ. 23,500. Sample copy and guidelines available for $2.
Cartoons: Approached by 25 cartoonists/year. Buys 1-2 cartoons/issue. Considers anything about English riding and horses. Prefers single panel b&w line drawings or washes with or without gagline. Send query letter with finished cartoons to be kept on file if accepted for publication. Material not filed is returned. Responds in 6 weeks. Buys first rights. Pays on publication $20, b&w.
Illustration: Approached by 25 illustrators/year. "We use a work of art on our cover every week. The work must feature horses, but the medium is unimportant. We do not pay for this art, but we always publish a short blurb on the artist and his or her equestrian involvement, if any." Send query letter with samples to be kept on file until published. If accepted, insists on high-quality, b&w 8×10 photographs of the original artwork. Samples are returned. Responds in 6 weeks.
Tips: Does not want to see "current horse show champions or current breeding stallions."

CICADA, Box 300, Peru IL 61354. Website: www.cicadamag.com. **Senior Art Editor:** Ron McCutchan. Estab. 1998. Bimonthly literary magazine for young adults (senior high-early college). Limited illustration (spots and half-pages). Black & white interior with full-color cover. Circ. 12,500. Original artwork returned after publication. Sample copy $8.50; art guidelines available on website or for SASE with first-class postage.
Cartoons: Looking for ½ page (3×4½ dimension) cartoons "similar to *New Yorker* 'gags' but from a teen viewpoint—remember there's a difference between cartoons *for* teens and cartoons *about* teens, i.e. from an adult/parental viewpoint."

Illustration: Works with 30-40 illustrators a year. Buys 120 illustrations/year. Has featured illustrations by Erik Blegvad, Victor Ambrus, Ted Rall and Whitney Sherman. Has a strong need for good figurative art with teen appeal, but also uses looser/more graphic/conceptual styles. Works on assignment only (except for cartoons, which may be submitted on speculation). Send query letter and 4-6 samples to be kept on file "if I like it." Prefers photocopies and tearsheets as samples. Samples not kept on file are returned by SASE only. Response in 6 weeks. Pays 45 days from receipt of final art; $750 for color cover, $50-150 for b&w inside. Buys all rights.

☑ **CINCINNATI CITYBEAT**, 811 Race St., Cincinnati OH 45202. (513)665-4700. Fax: (513)665-4369. E-mail: shughes@citybeat.com. Website: www.citybeat.com. **Art Director:** Sean Hughes. Estab. 1994. Weekly alternative newspaper emphasizing issues, arts and events. Circ. 50,000. Sample copies and art guidelines for #10 SASE with first-class postage.
 ● Please research alternative weeklies before contacting this art director. He reports receiving far too many inappropriate submissions.
Cartoons: Approached by 30 cartoonists/year. Buys 1 cartoon/year. Send query letter with samples. Samples are filed. Responds in 2 weeks only if interested. Buys one-time rights. Pays on publication; $10-100 for b&w, $30-100 for cartoons, $10-35 for comic strips.
Illustration: Buys 1-3 illustrations/issue. Has featured illustrations by Christopher Witflee, Jerry Dowling, Woodrow J. Hinton III, Grady Roper and Steven Verriest. Features caricatures of celebrities and politicians, computer and humorous illustration. Prefers work with a lot of contrast. Assigns 10% of illustrations to well-known or "name" illustrators; 50% to experienced, but not well-known illustrators; 40% to new and emerging illustrators. 10% of freelance illustration demands knowledge of Illustrator, Photoshop, FreeHand, QuarkXPress. Send postcard sample or query letter with printed samples and follow-up postcard every 4 months. Accepts Mac-compatible disk submissions. Send EPS, TIFF or PDF files. Samples are filed. Responds in 2 weeks only if interested. Buys one-time rights. Pays on publication; $75-150 for b&w cover, $150-250 for color cover; $10-50 for b&w inside, $50-75 for color inside, $75-150 for 2-page spreads. Finds illustrators through word of mouth and artist samples.

Ⓝ **CINCINNATI MAGAZINE**, 705 Central Ave., Suite 370, Cincinnati OH 45202. (513)421-4300. E-mail: nancy@cintimag.emmis.com. **Art Director:** Nancy Stetler. Estab. 1960. Monthly 4-color lifestyle magazine for the city of Cincinnati. Circ. 30,000. Accepts previously published artwork. Original artwork returned at job's completion.
Illustration: Approached by 20 illustrators/year. Has featured illustrations by Rowan Barnes-Murphy and C.F. Payne. Works on assignment only. Send postcard samples. Samples are filed or returned by SASE. Responds only if interested. Buys one-time rights or reprint rights. Pays on publication; $200-800 for features; $40-150 for spots.
Tips: Prefers traditional media with an interpretive approach. No cartoons or mass-market computer art, please.

☑ **CIRCLE K MAGAZINE**, 3636 Woodview Trace, Indianapolis IN 46268. (317)875-8755. Fax: (317)879-0204. Website: www.circlek.org. **Art Director:** Laura Houser. Estab. 1968. Kiwanis International's youth magazine for college-age students emphasizing service, leadership, etc. Published 5 times/year. Circ. 12,000. Originals and sample copies returned to artist at job's completion.
 ● This organization also publishes *Kiwanis* magazine and *Keynoter*.
Illustration: Approached by more than 30 illustrators/year. Buys 1-2 illustrations/issue. Works on assignment only. Needs editorial illustration. "We look for variety." Send query letter with photocopies, photographs, tearsheets and SASE. Samples are filed. Will contact for portfolio review if interested. Portfolio should include tearsheets and slides. **Pays on acceptance**; $100 for b&w cover; $250 for color cover; $50 for b&w inside; $150 for color inside.

Ⓝ **CITY LIMITS**, 120 Wall St., 20th Floor, New York NY 10005. (212)479-3344. Fax: (212)344-6457. E-mail: citlim@aol.com. Website: www.citylimits.org. **Art Director:** Tracie McMillan. Estab. 1976. Monthly urban affairs magazine covering issues important to New York City's low- and moderate-income neighborhoods, including housing, community development, the urban environment, crime, public health and labor. Circ. 10,000. Originals returned at job's completion. Sample copies for 9×12 SASE and 4 first-class stamps.
Cartoons: Buys 5 cartoons/year. Prefers N.Y.C. urban affairs—social policy, health care, environment and economic development. Prefers political cartoons; single, double or multiple panel b&w washes and line drawings without gaglines. Send query letter with finished cartoons and tearsheets. Samples are filed. Responds in 1 month. Buys first rights and reprint rights. Pays $50 for b&w.
Illustration: Buys 2-3 illustrations/issue. Has featured illustrations by Noah Scalin. Must address urban affairs and social policy issues, affecting low- and moderate-income neighborhoods, primarily in New York

City. Considers pen & ink, watercolor, collage, airbrush, mixed media and anything that works in b&w. Send postcard sample or query letter with tearsheets, photocopies, photographs and SASE. Samples are filed. Responds in 1 month. Request portfolio review in original query. Buys first rights. Pays on publication; $50-100 for b&w cover; $50 for b&w inside; $25-50 for spots. "Our production schedule is tight, so publication is generally within two weeks of acceptance, as is payment." Finds artists through other publications, word of mouth and submissions.
Tips: "Our niche is fairly specific." Freelancers "are welcome to call and talk."

CLARETIAN PUBLICATIONS, 205 W. Monroe, Chicago IL 60606. (312)236-8682. Fax: (312)236-8207. **Art Director:** Tom Wright. Estab. 1960. Monthly magazine "covering the Catholic family experience and social justice." Circ. 40,000. Sample copies and art guidelines available.
Illustration: Approached by 20 illustrators/year. Buys 6 illustrations/issue. Considers all media. Send postcard sample or send query letter with printed samples and photocopies. Accepts disk submissions compatible with EPS or TIFF on 10 Mega Zip disks or CDs. Samples are filed. Responds only if interested. Art director will contact artist for portfolio review if interested. Negotiates rights purchased. **Pays on acceptance;** $100-400 for color inside.
Tips: "We like to employ humor in our illustrations and often use clichés with a twist."

CLEANING BUSINESS, Box 1273, Seattle WA 98111. (206)622-4241. Fax: (206)622-6876. E-mail: wgriffin@cleaningconsultants.com. Website: www.cleaningconsultants.com. **Publisher:** Bill Griffin. Submissions Editor: Jeff Warner. Monthly magazine with technical, management and human relations emphasis for self-employed cleaning and maintenance service contractors and workers. Circ. 6,000. Prefers to purchase all rights. Simultaneous submissions OK "if sent to noncompeting publications." Original artwork returned after publication if requested by SASE. Sample copy $3.
Cartoons: Buys 1-2 cartoons/issue. Must be relevant to magazine's readership. Prefers b&w line drawings.
Illustration: Buys approximately 12 illustrations/year including some humorous and cartoon-style illustrations. Send query letter with samples. "*Don't* send samples unless they relate specifically to our market." Samples returned by SASE. Buys first publication rights. Responds only if interested. Pays for illustration by project $3-15. Pays on publication.
Tips: "Our budget is extremely limited. Those who require high fees are really wasting their time. We are interested in people with talent and ability who seek exposure and publication. Our readership is people who work for and own businesses in the cleaning industry, such as maid services; janitorial contractors; carpet, upholstery and drapery cleaners; fire, odor and water damage restoration contractors; etc. If you have material relevant to this specific audience, we would definitely be interested in hearing from you. We are also looking for books games, videos, software, books, jokes and reports related to the cleaning industry."

THE CLERGY JOURNAL, 6160 Carmen Ave. E., Inver Grove Heights MN 55076-4420. (800)328-0200. Fax: (888)852-5524. Website: www.joinhands.com. **Assistant Editor:** Sharilyn Figuerola. Magazine for professional clergy and church business administrators; b&w with 4-color cover. Monthly (except June and December). Circ. 10,000. Original artwork returned after publication if requested.
 • This publication is one of many published by Logos Productions and Woodlake Books.
Cartoons: Buys 4 single panel cartoons/issue from freelancers on religious themes. Send SASE. Responds in 2 months. Pays $40-75; on publication.

CLEVELAND MAGAZINE, Dept. AGDM, 1422 Euclid Ave., Suite 730, Cleveland OH 44115. (216)771-2833. Fax: (216)781-6318. E-mail: sluzewski@clevelandmagazine.com. **Contact:** Gary Sluzewski. Monthly city magazine, b&w with 4-color cover, emphasizing local news and information. Circ. 45,000.
Illustration: Approached by 100 illustrators/year. Buys 3-4 editorial illustrations/issue on assigned themes. Sometimes uses humorous illustrations. 40% of freelance work demands knowledge of QuarkXPress, FreeHand or Photoshop. Send postcard sample with brochure or tearsheets. Accepts disk submissions. Please include application software. Call or write for appointment to show portfolio of printed samples, final reproduction/product, color tearsheets and photographs. Pays $300-700 for color cover; $75-200 for b&w inside; $150-400 for color inside; $75-150 for spots.
Tips: "Artists are used on the basis of talent. We use many talented college graduates just starting out in the field. We do not publish gag cartoons but do print editorial illustrations with a humorous twist. Full-page editorial illustrations usually deal with local politics, personalities and stories of general interest. Generally, we are seeing more intelligent solutions to illustration problems and better techniques. The economy has drastically affected our budgets; we pick up existing work as well as commissioning illustrations."

COBBLESTONE, DISCOVER AMERICAN HISTORY, Cobblestone Publishing, Inc., 30 Grove St., Suite C, Peterborough NH 03458. (603)924-7209. Fax: (603)924-7380. E-mail: anndillon@yahoo.com. Website: www.cobblestonepub.com. **Art Director:** Ann Dillon. Managing Editor: Lou Waryncia. Monthly magazine emphasizing American history; features nonfiction, supplemental nonfiction, fiction, biographies, plays, activities and poetry for children ages 8-14. Circ. 38,000. Accepts previously published material and simultaneous submissions. Sample copy $4.95 with 8×10 SASE; art guidelines on website. Material must relate to theme of issue; subjects and topics published in guidelines for SASE. Freelance work demands knowledge of Illustrator, Photoshop and QuarkXPress..

- Other magazines published by Cobblestone include *Appleseeds* (social studies), *Calliope* (world history), *Faces* (cultural anthropology), *Footsteps* (African American history), *Odyssey* (science), all for kids ages 8-15, and *Ladybug*, for ages 7-9.

Illustration: Buys 2-5 illustrations/issue. Prefers historical theme as it pertains to a specific feature. Works on assignment only. Has featured illustrations by Annette Cate, Beth Stover, David Kooharian, Barbara Knutson, Craig Spearing, Sheila Foley, Mark Mitchell, Mike Phillips, Tim Oliphant, Tim Foley, Richard Schlecht and Rich Harrington. Features caricatures of celebrities and politicians, humorous, realistic illustration, informational graphics, computer and spot illustration. Assigns 5% of illustrations to well-known or "name" illustrators; 80% to experienced, but not well-known illustrators; 15% to new and emerging illustrators. Send query letter with brochure, résumé, business card and b&w photocopies or tearsheets to be kept on file or returned by SASE. Write for appointment to show portfolio. Buys all rights. Pays on publication; $20-125 for b&w inside; $40-225 for color inside. Artists should request illustration guidelines.
Tips: "Study issues of the magazine for style used. Send samples and update samples once or twice a year to help keep your name and work fresh in our minds. Send nonreturnable samples we can keep on file—we're always interested in widening our horizons."

N: COMBAT AIRCRAFT: The International Journal of Military Aviation, P.O. Box 5074, Westport CT 06881-5074. (203)838-7979. Fax: (203)838-7344. E-mail: avmags@aol.com. Website: www.airpower.co.uk. **Art Director:** Zaur Eylanbekov. Managing Editor: Natalie Raccor. Estab. 1997. 4-color consumer magazine with 8 issues/year. Military aviation magazine with a focus on modern-day topics. Circ. 50,000.
Illustration: Approached by 25 illustrators/year. Buys 2 illustrations/issue. Has featured illustrations by Mark Styling, James Dietz, Ian Wyllie and Walter Wright. Features computer illustration and technical 3-views. Preferred subject: aviation. Prefers technical line drawings and accurate representations of aircraft. Assigns 33% of illustrations each to well-known or "name" illustrators; experienced, but not well-known, illustrators; and new and emerging illustrators. Send query letter with printed samples. Accepts Mac-compatible disk submissions. Send EPS or TIFF files. Samples are filed. Responds in 1 month. Will contact artist for portfolio review if interested. Buys one- time rights. Pays $40-100 for color cover; $20 for color inside. Finds illustrators through artists' promotional samples.
Tips: "Please do not call with descriptions of your work; send us the samples first."

COMMON GROUND, 3091 W. Broadway, Suite 201, Vancouver, British Columbia V6K 2G9 Canada. (604)733-2215. Fax: (604)733-4415. **Contact:** Art Director. Estab. 1982. 12 times/year consumer magazine and holistic personal resource directory. Accepts previously published artwork and cartoons. Original artwork is returned at job's completion. Sample copies for SASE with first-class Canadian postage or International Postage Certificate.
Illustration: Approached by 20-40 freelance illustrators/year. Buys 1-2 freelance illustrations/issue. Prefers all themes and styles. Considers cartoons, pen & ink, watercolor, collage and marker. Send query letter with brochure, photographs, SASE and photocopies. Samples are filed or are returned by SASE if requested by artist. Responds only if interested. Buys one-time rights. Payment varies; on publication.
Tips: "Send photocopies of your top one-three inspiring works in black & white or color. Can have all three on one sheet of $8\frac{1}{2} \times 11$ paper or all in one color copy. I can tell from that if I am interested."

COMMONWEAL, 475 Riverside Dr., Room 405, New York NY 10115. (212)662-4200. E-mail: tuna@commonwealmagazine.org. Website: www.commonwealmagazine.org. **Editor:** Margaret O'Brien Steinfels. Business Manager: Paul Q. Kane. Estab. 1924. Public affairs journal. "Journal of opinion edited by Catholic lay people concerning public affairs, religion, literature and all the arts"; b&w with 4-color cover. Biweekly. Circ. 20,000. Original artwork is returned at the job's completion. Sample copies for SASE with first-class postage. Guidelines for SASE with first-class postage.
Cartoons: Approached by 20-40 cartoonists/year. Buys 3-4 cartoons/issue from freelancers. Prefers simple lines and high-contrast styles. Prefers single panel, with or without gagline; b&w line drawings. Send query letter with finished cartoons. Samples are filed or are returned by SASE if requested by artist. Responds in 2 weeks. Buys non-exclusive rights. Pays $15 for b&w.

Illustration: Approached by 20 illustrators/year. Buys 3-4 illustrations/issue, 60/year from freelancers. Has featured illustrations by Baloo. Assigns 90% of illustrations to experienced, but not well-known illustrators; 10% to new and emerging illustrators. Prefers high-contrast illustrations that "speak for themselves." Prefers pen & ink and marker. Send query letter with tearsheets, photographs, SASE and photocopies. Samples are filed or returned by SASE if requested by artist. Responds in 2 weeks. To show a portfolio, mail b&w tearsheets, photographs and photocopies. Buys non-exclusive rights. Pays $15 for b&w inside on publication.
Tips: "Be familiar with publication before mailing submissions."

COMMUNITY BANKER, 900 19th St. NW, Washington DC 20006. (202)857-3100. Fax: (202)857-5581. E-mail: jbock@acbankers.org. Website: www.americascommunitybankers.com. **Art Director:** Jon C. Bock. Estab. 1993. Monthly trade journal targeting senior executives of high tech community banks. Circ. 12,000. Accepts previously published artwork. Originals returned at job's completion.
Illustration: Approached by 200 illustrators/year. Buys 2 illustrations/issue. Has featured illustrations by Kevin Rechin, Jay Montgomery, Michael Gibbs and Matthew Trueman. Features humorous illustration, informational graphics, spot illustrations, computer illustration. Preferred subjects: business subjects. Prefers pen & ink with color wash, bright colors, painterly. Works on assignment only. Send query letter, nonreturnable postcard samples and tearsheets. Accepts Mac-compatible disk submissions. Send TIFF files. Samples are filed. Responds only if interested. "Artists should be patient and continue to update our files with future mailings. We will contact artist when the right story comes along." Publication will contact artist for portfolio review if interested. Portfolio should include mostly finished work, some sketches. Buys first North American serial rights. Pays on publication; $1,200-2,000 for color cover; $800-1,200 for color inside; $250-300 for spots. Finds artists primarily through word of mouth and sourcebooks—*Directory of Illustration* and *Illustration Work Book*.
Tips: "Looking for: high tech/technology in banking; quick turnaround; and new approaches to illustration."

COMPUTERUSER, (formerly *Computer Currents*), 220 S. Sixth St., Suite 500, Minneapolis MN 55402-4501. (612)339-7571. Fax: (612)339-5806. E-mail: editorial@currents.net. Website: www.computeruser.com. **Art Director:** Kurt Guthmueller. National computing magazine that delivers how to buy, where to buy, and how to use editorial for PC and Mac business users. Emphasis is on reviews, how-tos, tutorials, investigative pieces, and more. Current slant is heavy on intranet, e-commerce, and Internet topics. Published in 32 regional editions. Considers previously published material. Original artwork is returned to the artist after publication. Art guidelines free for SASE with first-class postage and available on website.
Illustration: Buys 24 cover illustrations/year in both digital and traditional form. Has featured illustrations by Mel Lindstrom, David Bishop, Steven Campbell. Assigns 30% of illustrations to well-known or "name" illustrators; 60% to experienced but not well-known illustrators; 10% to new and emerging illustrators. Send query letter with samples, tearsheets, or color photocopies that we can keep on file. Responds if interested. Rights revert to artist. Pays $800-1,000 for covers.
Tips: "We're looking for experienced, professional artists that can work with editorial and deliver art to spec and on time. We're especially interested in artists with a distinct style who can work without constant supervision. Traditional layout and design experience a plus."

N CONDÉ NAST TRAVELER, 4 Times Square, 14th Floor, New York NY 10036-6522. (212)286-2860. Fax: (212)286-2190. Website: http://condenet.com/mags/trav. **Design Director:** Robert Best. Art Director: Kerry Robertson. Estab. 1987. Monthly travel magazine with emphasis on "truth in travel." Geared toward upper income 40-50 year olds with time to spare. Circ. 1 million. Originals are returned at job's completion. Freelance work demands knowledge of QuarkXPress, Illustrator and Photoshop.
Illustration: Approached by 5 illustrators/week. Buys 5 illustrations/issue. Works on assignment only. Considers pen & ink, collage, oil and mixed media. Send query letter with tearsheets. Samples are filed. Does not report back, in which case the artist should wait for assignment. To show a portfolio, mail b&w and color tearsheets. Buys first rights. Pays on publication; fees vary according to project.

CONFRONTATION: A LITERARY JOURNAL, English Department, C.W. Post, Long Island University, Brookville NY 11548. (516)299-2720. Fax: (516)299-2735. **Editor:** Martin Tucker. Estab. 1968. Semiannual literary magazine devoted to the short story and poem, for a literate audience open to all forms, new and traditional. Circ. 2,000. Sample copies available for $3. 20% of freelance work demands computer skills.
● *Confrontation* has won a long list of honors and awards from CCLM (now the Council of Literary Magazines and Presses) and NEA grants.
Illustration: Approached by 10-15 illustrators/year. Buys 2-3 illustrations/issue. Works on assignment only. Considers pen & ink and collage. Send query letter with SASE and photocopies. Samples are not

filed and are returned by SASE. Responds in 1-2 months only if interested. Rights purchased vary according to project. Pays on publication; $50-100 for b&w, $100-250 for color cover; $25-50 for b&w, $50-75 for color inside; $25-75 for spots.

CONSERVATORY OF AMERICAN LETTERS, Box 298, Thomaston ME 04861. (207)354-0753. **Editor:** Bob Olmsted. Estab. 1982. Quarterly Northwoods Journal emphasizing literature for literate and cultured adults. Original artwork returned after publication.
Cartoons: Pays $5 for b&w cartoons.
Illustration: Approached by 30-50 illustrators/year. "Very little illustration used. Find out what is coming up, then send something appropriate. Unsolicited 'blind' portfolios are of little help." Portfolio review not required. Buys first rights, one-time rights. **Pays on acceptance**; $5 for b&w cover; $30 for color cover; $5 for b&w inside; $30 for color inside.

N: CONSTRUCTION DIMENSIONS, 803 W. Broad St., Suite 600, Falls Church VA 22046. (703)534-8300. Fax: (703)534-8307. E-mail: info@awci.org. Website: www.awci.org. **Editor:** Laura M. Porinchak. Monthly magazine "for contractors, manufacturers, suppliers and allied trades in the wall and ceiling industry." Circ. 25,000. Sample copies available.
Cartoons: Would like to start buying cartoons. Prefers single panel b&w line drawings. Send query letter with tearsheets. Samples are not filed and are returned. Responds only if interested. Buys first North American serial rights. **Pays on acceptance**; negotiable. Has featured illustrations by Jim Patterson. Assigns 50% of illustrations to experienced, but not well-known illustrators; 50% to new and emerging illustrators.
Illustration: Buys 3-5 illustrations/year. Considers all media. Send query letter with tearsheets. Accepts disk submissions. Samples are not filed and are returned. Responds only if interested. Buys first North American serial rights. **Pays on acceptance**; $300-800 for b&w inside; $500-1,000 for color cover; $100-400 for b&w inside; $300-500 for color inside; $50-200 for spots. Finds illustrators through queries, word of mouth.
Tips: "We don't buy a lot of freelance artwork, but when we do, we usually need it fast. Prompt payment and extra copies are provided to the artist. Try to develop more than one style—be able to do cartoons as well as realistic drawings. Editors want different 'looks' for different articles. Keep sending samples (postcards), promotions, etc. to keep your name (and phone number) in front of the buyer as often as possible."

CONTRACT PROFESSIONAL, 125 Walnut St., Watertown MA 02472. (617)926-7077. Fax: (617)926-5818. Website: www.cpuniverse.com. **Contact:** Art Director. Estab. 1996. Published 12 times/year. 4-color consumer magazine for I.T. workers ("computer geeks") who work on a contract basis. Circ. 50,000.
● Also publishes *Purple Squirrel* for I.T. staffing companies, www.purplesquirrelmag.com.
Illustration: Approached by 10 illustrators/year. Buys 3-4 illustrations/issue. "Hoping to purchase more in future." Features charts & graphs, computer and humorous illustration, informational graphics and spot illustrations of business subjects. Send query letter with printed samples. Accepts Mac-compatible disk submissions. Samples are filed. Will contact artist for portfolio review if interested. Buys one-time rights. Pays on publication. Finds illustrators online and through promotional samples.
Tips: "Both magazines are fairly conservative. I find sometimes we like to stick with that approach, but often we need humor to affect it."

☑ COOK COMMUNICATIONS MINISTRIES, 4050 Lee Vance View, Colorado Springs CO 80918-7100. (719)536-0100. Website: www.cookministries.com. **Art Director:** Paul Segsworth. Publisher of teaching booklets, take home papers for Christian market, "all age groups." Art guidelines available for SASE with first-class postage only. No samples returned without SASE.
Illustration: Buys about 10 full-color illustrations/month. Has featured illustrations by Richard Williams, Chuck Hamrick, Ron Diciani. Assigns 20% of illustrations to well-known or "name" illustrators; 75% to experienced, but not well-known illustrators; 5% to new and emerging illustrators. Features realistic illustration; Bible illustration; computer and spot illustration. Send tearsheets, color photocopies of previously published work; include self-promo pieces. No samples returned unless requested and accompanied by SASE. Work on assignment only. **Pays on acceptance**; $400-700 for color cover; $150-250 for b&w inside; $250-400 for color inside; $500-800 for 2-page spreads; $10-50 for spots. Considers complexity of project, skill and experience of artist and turnaround time when establishing payment. Buys all rights.
Tips: "We do not buy illustrations or cartoons on speculation. Do *not* send book proposals. We welcome those just beginning their careers, but it helps if the samples are presented in a neat and professional manner. Our deadlines are generous but must be met. Fresh, dynamic, the highest of quality is our goal; art that appeals to preschoolers to senior citizens; realistic to humorous, all media."

[N] COSMO GIRL, 224 W. 57th St., 3rd Floor, New York NY 10019-3212. (212)649-3852. Fax: (212)489-9664. Website: www.cosmogirl.com. Contact: Art Department. Estab. 1996. Monthly 4-color consumer magazine designed as a cutting-edge lifestyle publication exclusively for teenage girls. Circ. 790,124.

Illustration: Approached by 350 illustrators/year. Buys 6-10 illustrations/issue. Has featured illustrations by Kirsten Ulve, Peter Stemmler, Yoki Ikeno, Deanne Cheuk, Chuck Gonzales and Chris Bellamy. Features caricatures of celebrities and music groups, fashion, humorous and spot illustration. Preferred subjects: teens. Assigns 10X% of illustrations to well-known or "name" illustrators; 80% to experienced, but not well-known illustrators; 10% to new and emerging illustrators. Send postcard sample and follow-up postcard every 6 months. Samples are filed. Responds only if interested. Buys first rights. **Pays on acceptance.** Pay varies. Finds illustrators through sourcebooks and samples.

[N] COSMOPOLITAN, The Hearst Corp., 224 W. 57th St., New York NY 10019-3299. (212)649-3570. Fax: (212)307-6563. Website: www.cosmopolitan.com. **Art Director:** John Lanuza. Designer: John Hansen. Estab. 1886. Monthly 4-color consumer magazine for contemporary women covering a broad range of topics including beauty, health, fitness, fashion, relationships and careers. Circ. 2,592,887

Illustration: Approached by 300 illustrators/year. Buys 6-7 illustrations/issue. Has featured illustrations by Marcin Baranski and Anna Palma. Features caricatures of celebrities, fashion, humorous and spot illustration. Preferred subjects: women. Prefers trendy fashion palette. Assigns 5% of illustrations to well-known or "name" illustrators; 90% to experienced, but not well-known illustrators; 5% to new and emerging illustrators. Send postcard sample and follow-up postcard every 4 months. Samples are filed. Responds only if interested. Buys first North American serial rights. **Pays on acceptance; $1,000 minimum for 2-page spreads; $350-500 for spots. Finds illustrators through sourcebooks and artists promotional samples.**

[✓] THE COVENANT COMPANION, 5101 N. Francisco Ave., Chicago IL 60625. (773)784-3000. E-mail: communication@covchurch.org. Website: www.covchurch.org. **Editor:** Donald Meyer. Managing Editor: Jane K. Swanson-Nystrom. Art Director: David Westerfield. Monthly b&w magazine with 4-color cover emphasizing Christian life and faith. Circ. 17,000. Art guidelines available free for SASE. Original artwork returned after publication if requested. Freelancers should be familiar with PageMaker and Corel-Draw. Art guidelines available.

Illustration: Uses b&w drawings or photos about Easter, Advent, Lent and Christmas. Works on submission only. Write or submit art 10 weeks in advance of season. Send query letter with brochure, photocopies, photographs, slides, transparencies and SASE. Responds "within a reasonable time." Pays 1 month after publication; $75 for color cover; $25 for b&w, $50 for color inside. More photos than illustrations.

Tips: "We usually have some rotating file, if we are interested, from which material may be selected. Submit copies/photos, etc. which we can hold on file."

CRAFTS 'N THINGS, 2400 Devon, Suite 375, Des Plaines IL 60018-4618. (847)635-5800. Fax: (847)635-6311. Website: www.craftideas.com. **President and Publisher:** Marie Clapper. Estab. 1975. General crafting magazine published 10 times yearly. Circ. 305,000. Originals returned at job's completion. Sample copies available. Art guidelines for SASE with first-class postage.

● *Crafts 'n Things* is a "how to" magazine for crafters. The magazine is open to crafters submitting designs and step-by-step instruction for projects such as Christmas ornaments, cross-stitched pillows, stuffed animals and quilts. They do not buy cartoons and illustrations. This publisher also publishes other craft titles including *Cross Stitcher* and *Pack-O-Fun*.

Design: Needs freelancers for design. Send query letter with photographs. Pays by project $50-300. Finds artists through submissions.

Tips: "Our designers work freelance. Send us photos of your *original* craft designs with clear instructions. Skill level should be beginning to intermediate. We concentrate on general crafts and needlework. Call or write for submission guidelines."

[N] THE CRAFTS REPORT, P.O. Box 1992, Wilmington DE 19899. (302)656-2209. Fax: (302)656-4894. E-mail: mricci@craftsreport.com. Website: www.craftsreport.com. **Art Director:** Mike Ricci. Estab. 1975. Monthly magazine "for people who earn a living or someday intend to earn a living as a craftsperson, retailer or show promoter." Circ. 20,000. Sample copies and art guidelines available.

Illustration: Buys about 12 illustrations/year. Considers all media. 75% of freelance illustration demands knowledge of Photoshop, Adobe Illustration and FreeHand. Send query letter with printed samples and photocopies. Accepts disk submissions compatible with Quark 3.3; TIFF or EPS. Samples are filed. Responds only if interested. Art director will contact artist for portfolio review of color and final art if interested. Buys first rights. Pays on publication; $50-150 for b&w, $100-300 for color inside. Pays $50 for spots. Finds illustrators through magazines, word of mouth, artist's submissions.

CRICKET, Box 300, Peru IL 61354-0300. Website: www.cricketmag.com. **Senior Art Director:** Ron McCutchan. Estab. 1973. Monthly magazine emphasizes children's literature for children ages 10-14. Design is fairly basic and illustration-driven; full-color with 2 basic text styles. Circ. 75,000. Original artwork returned after publication. Sample copy $5; art guidelines available on website or for SASE with first-class postage.

Cartoons: "We rarely run cartoons, but we are beginning to look at wordless ½ page (4½ × 6½ dimension) cartoons—1-3 panels; art styles should be more toward children's book illustration."

Illustration: Approached by 800-1,000 illustrators/year. Works with 75 illustrators/year. Buys 600 illustrations/year. Has featured illustrations by Alan Marks, Trina Schart Hyman, Kevin Hawkes and Deborah Nourse Lattimore. Assigns 25% of illustrations to well-known or "name" illustrators; 50% to experienced, but not well-known illustrators; 25% to new and emerging illustrators. Uses artists mainly for cover and interior illustration. Prefers realistic styles (animal or human figure), but "we're also looking for humorous and nontraditional styles." Works on assignment only. Send query letter with SASE and samples to be kept on file, "if I like it." Prefers photocopies and tearsheets as samples. Samples not kept on file are returned by SASE. Responds in 6 weeks. Does not want to see "overly slick, cute commercial art (i.e., licensed characters and overly sentimental greeting cards)." Buys all rights. Pays 45 days from receipt of final art; $750 for color cover; $50-150 for b&w inside; $75-250 for color inside; $250-350 for 2-page spreads; $50-75 for spots.

Tips: "We are trying to focus *Cricket* at a slightly older, preteen market. Therefore we are looking for art that is less sweet and more edgy and funky. Since a large proportion of the stories we publish involve people, particularly children, *please* try to include several samples with *faces* and full figures in an initial submission (that is, if you are an artist who can draw the human figure comfortably). It's also helpful to remember that most children's publishers need artists who can draw children from many different racial and ethnic backgrounds. Know how to draw the human figure from all angles, in every position. Send samples that tell a story (even if there is no story); art should be intriguing."

DAIRY GOAT JOURNAL, P.O. Box 10, 128 E. Lake St., Lake Mills WI 53551. (920)648-8285. Fax: (920)648-3770. Estab. 1923. Monthly trade publication covering dairy goats. Circ. 8,000. Accepts previously published work. Sample copies available.

Cartoons: Approached by 20 cartoonists/year. Buys 2-8 cartoons/issue. Will consider all styles and themes. Prefers single panel. Samples are returned. Responds in 3 weeks. **Pays on acceptance**; $15-25.

Illustration: Approached by 20 illustrators/year. Buys 10-30 illustrations/year. Works on assignment only. Send query letter with appropriate samples. Buys first rights or all rights. Pays $50-150 for color and b&w cover and inside.

Tips: "Please query first. We are eager to help beginners."

DAKOTA OUTDOORS, P.O. Box 669, Pierre SD 57501-0669. (605)224-7301. Fax: (605)224-9210. **Editor:** Kevin Hipple. Managing Editor: Rachel Engbrecht. Estab. 1978. Monthly outdoor magazine covering hunting, fishing and outdoor pursuits in the Dakotas. Circ. 7,500. Accepts previously published artwork. Original artwork is returned at job's completion. Sample copies and art guidelines for SASE with first-class postage.

Cartoons: Approached by 10 cartoonists/year. Buys 1-2 cartoons/issue. Prefers outdoor, hunting and fishing themes. Prefers cartoons with gagline. Send query letter with appropriate samples and SASE. Samples are not filed and are returned by SASE. Responds in 1-2 months. Rights purchased vary. Pays $5 for b&w.

Illustration: Approached by 2-10 illustrators/year. Buys 1 illustration/issue. Features spot illustration. Prefers outdoor, hunting/fishing themes, depictions of animals and fish native to the Dakotas. Prefers pen & ink. Accepts submissions on disk compatible with Macintosh in Illustrator, FreeHand and Photoshop. Send TIFF, EPS and PICT files. Send postcard sample or query letter with tearsheets, SASE and copies of line drawings. Responds in 2 months. To show a portfolio, mail "high-quality line art drawings." Rights purchased vary according to project. Pays on publication; $5-50 for b&w inside; $5-25 for spots.

Tips: "We especially need line-art renderings of fish, such as the walleye."

☑ **DANCING USA MAGAZINE**, 200 N. York Rd., Suite 205B, Elmhurst IL 60126-2750. (630)782-1260. Fax: (630)617-9950. E-mail: editor@dancingusa.com. Website: www.dancingusa.com **Art Director:** Sarah Beckley. Estab. 1983. Bimonthly, 4-color, consumer magazine spotlighting ballroom, latin and swing dance. Circ. 20,000. Samples copies free for 8 × 10 SAE and $1.20 first-class postage. Art guidelines free for #10 SASE with first-class postage.

Illustration: Approached by 3-5 illustrators/year. Buys 1-3 illustrations/issue. Has featured illustrations by Ty Wilson. Features ballroom, Latin and swing dance—style, technique, art and "science and couples dancing." Prefers any media—"Think newsstand 'pop' factor." Assigns 50% of illustrations to well-known or "name" illustrators; 25% to experienced, but not well-known illustrators; 25% to new and

emerging illustrators. Send postcard sample. Send nonreturnable samples. Accepts Windows-compatible disk submissions. Send TIFF and JPEG files. Samples are filed. Responds only if interested. Portfolio review not required. Buys one-time rights. Finds illustrators through word of mouth, Web.

Tips: "Our readers collect and save our issues because of their beautifiul covers. Create a moment that you would like to keep forever. Any media is acceptable—oils, pastels, watercolor. We are looking for a unique perspective on the joy of partner dancing. Any type of swing, Latin or ballroom (waltz, fox trot) dance is fine."

⚏ DC COMICS, AOL-Time Warner, Dept. AGDM, 1700 Broadway, 5th Floor, New York NY 10019. (212)636-5990. Fax: (212)636-5977. Website: www.dccomics.com. **Vice President Design and Retail Product Development:** Georg Brewer. Monthly 4-color comic books for ages 7-25. Circ. 6,000,000. Original artwork is returned after publication.

• See DC Comics's listing in Book Publishers section. *DC Comics* does not read or accept unsolicited submissions of ideas, stories or artwork.

DECORATIVE ARTIST'S WORKBOOK, 4700 E. Galbraith Rd., Cincinnati OH 45236. E-mail: cindyr @fwpubs.com. **Contact:** Art Director. Estab. 1987. "A step-by-step bimonthly decorative painting workbook. The audience is primarily female; slant is how-to." Circ. 89,000. Does not accept previously published artwork. Original artwork is returned at job's completion. Sample copy available for $4.65; art guidelines not available.

Illustration: Buys occasional illustration; 1/year. Works on assignment only. Has featured illustrations by Barbara Maslen and Annie Gusman. Features humorous, realistic and spot illustration. Assigns 50% of illustrations to experienced, but not well-known illustrators; 50% to new and emerging illustrators. Prefers realistic styles. Prefers pen & ink, watercolor, airbrush, acrylic, colored pencil, mixed media, pastel and digital art. Send postcard sample or query letter with tearsheets. Accepts disk submissions compatible with the major programs. Send EPS or TIFF files. Samples are filed. Responds only if interested. Buys first or one-time rights. Pays on publication; $50-100 for b&w inside; $100-350 for color inside.

DELAWARE TODAY MAGAZINE, 3301 Lancaster Pike, Suite 5C, Wilmington DE 19805-1436. Phone/fax: (302)656-1809. E-mail: kcarter@delawaretoday.com. Website: www.delawaretoday.com. **Creative Director:** Kelly Carter. Monthly 4-color magazine emphasizing regional interest in and around Delaware. Features general interest, historical, humorous, interview/profile, personal experience and travel articles. "The stories we have are about people and happenings in and around Delaware. Our audience is middle-aged (40-45) people with incomes around $79,000, mostly educated. We try to be trendy in a conservative state." Circ. 25,000. Original artwork returned after publication. Sample copy available. Needs computer-literate freelancers for illustration.

Cartoons: Works on assignment only. Do not send gaglines. Do not send folders of pre-drawn cartoons. Samples are filed. Responds only if interested. Buys first rights or one-time rights.

Illustration: Buys approximately 3-4 illustrations/issue. Has featured illustrations by Nancy Harrison, Charles Stubbs, Emily Thompson and Paine Proffit. "I'm looking for different styles and techniques of editorial illustration!" Works on assignment only. Open to all styles. Send postcard sample. "Will accept work compatible with QuarkXPress 7.5/version 4.0. Send EPS or TIFF files (CMYK, not RGB)." Send printed color promos. Publication will contact artist for portfolio review if interested. Portfolio should include printed samples, color or b&w tearsheets, and final reproduction/product. Pays on publication; $200-400 for cover; $100-150 for inside; $75 for spots. Finds artists through submissions and self-promotions.

Tips: "Be conceptual, consistent and flexible."

DELICIOUS! MAGAZINE, 1401 Pearl St., Boulder CO 80302. (303)939-8440. Fax: (303)440-8884. E-mail: delicious@newhope.com. Website: www.healthwell.com. **Art Director:** MVicki Hopewell. Designer: Julie Kruse. Estab. 1984. Monthly magazine distributed through natural food stores focusing on health, natural living, alternative healing. Circ. 400,000 guaranteed. Sample copies available.

Illustration: Approached by hundreds of illustrators/year. Buys approximately 1 illustration/issue. Prefers positive, healing-related and organic themes. Considers acrylic, collage, color washed, mixed media, pastel. 30% of illustration demands knowledge of Photoshop and Illustrator. Send postcard sample, query letter with printed samples, tearsheets. Send follow-up postcard sample every 6 months. Accepts disk submissions compatible with QuarkXPress 3.32 (EPS or TIFF files). Samples are filed and are not returned. Art director will contact artist for portfolio review of color, final art, photographs, photostats, tearsheets, transparencies, color copies. Rights purchased vary according to project. **Pays on acceptance**; $1,000 maximum for color cover; $250-700 for color inside; $250 for spots. Finds illustrators through *Showcase Illustration*, SIS, magazines and artist's submissions.

Design: Needs freelancers for design, production. Prefers local designers with experience in QuarkXPress, Illustrator, Photoshop and magazines/publishing. 100% of freelance work demands knowledge of Photoshop, Illustrator, QuarkXPress. Send query letter with printed samples, photocopies, tearsheets and résumé.
Tips: "We like our people and designs to have a positive and upbeat outlook. Illustrators must be able to illustrate complex health articles well and have great concepts with single focus images."

☑ **DERMASCOPE**, Geneva Corporation, 2611 N. Belt Line Rd., Suite 140, Sunnyvale TX 75182. (972)226-2309. Fax: (972)226-2339. Website: www.dermascope.com. **Graphic Artist:** Sandra Bedd. Estab. 1978. Bimonthly magazine/trade journal, 128-page magazine for dermatologists, plastic surgeons and stylists. Circ. 15,000. Sample copies and art guidelines available.
Illustration: Approached by 5 illustrators/year. Prefers illustrations of "how-to" demonstrations. Considers all media. 100% of freelance illustration demands knowledge of Photoshop, Illustrator, QuarkXPress, Fractil Painter. Accepts disk submissions. Samples are not filed. Responds only if interested. Rights purchased vary according to project. Pays on publication.

Ⓝ **DETROIT FREE PRESS MAGAZINE**, 600 W. Fort St., Detroit MI 48226. (313)222-6600. Fax: (313)222-5981. **Art Director:** Steve Dorsey. Weekly 4-color Sunday magazine of major metropolitan daily newspaper emphasizing general subjects. "The third largest newspaper magazine in the country." Circ. 1.1 million. Original artwork returned after publication. Sample copy available for SASE. 10% of freelance work demands knowledge of QuarkXPress, FreeHand or Illustrator.
Illustration: Buys 2-3 illustrations/issue. Uses a variety of themes and styles, "but we emphasize fine art over cartoons." Works on assignment only. Send query letter with samples to be kept on file unless not considered for assignment. Send "whatever samples best show artwork and can fit into 8½×11 file folder." Samples not filed are not returned. Responds only if interested. Buys first rights. Pays on publication; fees vary, depending on size.

Ⓝ **DISCOVER**, 114 Fifth Ave., 15th Floor, New York NY 10011-5604. (212)633-4400. Fax: (212)633-4817. Website: www.discover.com. **Art Director:** Richard Boddy. Estab. 1980. Monthly general interest science magazine. Circ. 1 million.
Illustration: Buys illustrations for covers, spots and feature spreads. Buys 10 illustrations/issue. Considers all media including electronic. Send query letter with brochure showing art style, or nonreturnable tearsheets. Samples are filed. Responds in 1 month. To show a portfolio, phone Art Director. Buys first rights. **Pays on acceptance**.

Ⓝ **DISCOVERIES**, 6401 The Paseo, Kansas City MO 64131. (816)333-7000. E-mail: khendrixson@nazarene.org. **Editor:** Virginia L. Folsom. Editorial Assistant: K Hendrixson. Estab. 1974. Weekly 4-color story paper; "for 8-10 year olds of the Church of the Nazarene and other holiness denominations. Material is based on everyday situations with Christian principles applied." Circ. 40,000. Originals are not returned at job's completion. Sample copies and guidelines for SASE with first-class postage.
Cartoons: Approached by 15 cartoonists/year. Buys 52 cartoons/year. "Cartoons need to be humor for children—not about them." Spot cartoons only. Prefers artwork with children and animals; single panel. Send finished cartoons. Samples not filed are returned by SASE. Responds in 2 months. Buys all rights. Pays $15 for b&w.
Tips: No "fantasy or science fiction situations or children in situations not normally associated with Christian attitudes or actions."

DIVERSION MAGAZINE, 1790 Broadway, 6th Floor, New York NY 10019-1412. (212)969-7500. Fax: (212)969-7557. Website: www.diversionmagazine.com. **Cartoon Editor:** Shari Hartford. Estab. 1976. Monthly travel and lifestyle magazine for physicians. Circ. 176,000. Art guidelines available free with SASE.
Cartoons: Approached by 50 cartoonists/year. Buys 50 cartoons/year. Prefers travel, food/wine, sports, lifestyle, family, animals, technology, art and design, performing arts, gardening. Prefers single panel, humorous, b&w line drawings, with or without gaglines. Send query letter with finished cartoons. "SASE must be included or cartoons will be discarded." Samples are not filed and are returned by SASE. Responds in 5 days. Buys first North American serial rights. **Pays on acceptance**; $100.

DOLPHIN LOG, The Cousteau Society, 3612 E. Tremont Ave., Bronx NY 10465-2022. (718)409-3370. Fax: (718)409-1677. E-mail: cousteauny@aol.com. **Editor:** Lisa Rao. Bimonthly 4-color educational magazine for children ages 7-13 covering "all areas of science, natural history, marine biology, ecology, and the environment as they relate to our global water system." 20-pages, 8×10 trim size. Circ. 80,000. Sample copy for $2.50 and 9×12 SASE with 3 first-class stamps; art guidelines for letter-sized SASE with first-class postage.

Illustration: Buys approximately 4 illustrations/year. Uses simple, biologically and technically accurate line drawings and scientific illustrations. "*Never* uses art that depicts animals dressed or acting like people. Subjects should be carefully researched." Prefers pen & ink, airbrush and watercolor. Send query letter with tearsheets and photocopies showing art style. "No portfolios. We review only tearsheets and/or photocopies. No original artwork, please." Buys one-time rights and worldwide translation rights for inclusion in other Cousteau Society publications and the right to grant reprints for use in other publications. Pays on publication; $25-200 for color inside.

Tips: "We usually find artists through their submissions/promotional materials and in sourcebooks. Artists should first request a sample copy to familiarize themselves with our style. Send only art that is both water-oriented and suitable for children."

N DREAMS OF DECADENCE, P.O. Box 2988, Radford VA 24143-2988. (540)763-2925. Fax: (540)763-2924. E-mail: dreamsofdecadence@dnapublications.com. Website: www.dnapublications.com/dreams. **Art Director:** Angela Kessler. Estab. 1995. Quarterly, 4-color b&w interior literary gothic fiction zine. Circ. 3,000. Sample copies and art guidelines available.

Illustration: Approached by 10 illustrators/year. Buys 15 illustrations/issue. Has featured illustrations by Lee Seed, Lori Albrech and Marianne Plumridge Eggleton. Features realistic and moody gothic illustrations for fiction pieces. Prefers bright colors for covers and pen & ink for interiors. Assigns 75% of illustrations to experienced, but not well-known illustrators; 25% to new and emerging illustrators. Send query letter with photocopies or tearsheets. Samples are filed. Will contact artist for portfolio review if interested. Buys first rights and reprint rights. Pays $100-300 for color cover; $10-50 for b&w inside; $5 for spots. Finds illustrators through samples.

Tips: "You are only as good as your weakest piece. We need quick turnaround and we do need new artists."

THE EAST BAY MONTHLY, 1301 59th St., Emeryville CA 94608. (510)658-9811. Fax: (510)658-9902. E-mail: artdirector@themonthly.com. **Art Director:** Andreas Jones. Estab. 1970. Consumer monthly tabloid; b&w with 4-color cover. Editorial features are general interests (art, entertainment, business owner profiles) for an upscale audience. Circ. 80,000. Accepts previously published artwork. Originals returned at job's completion. Art guidelines for SASE with first-class postage. Sample copy and guidelines for SASE with 5 oz. first-class postage. No nature or architectural illustrations. 100% of freelance design work demands knowledge of PageMaker, QuarkXPress, Macromedia FreeHand, Illustrator, Photoshop.

Cartoons: Approached by 75-100 cartoonists/year. Buys 3 cartoons/issue. Prefers single panel, b&w line drawings; "any style, extreme humor." Send query letter with finished cartoons. Samples are filed or returned by SASE. Responds only if interested. Buys one-time rights. Pays $35 for b&w.

Illustration: Approached by 150-200 illustrators/year. Buys 2 illustrations/issue. Prefers pen & ink, watercolor, acrylic, colored pencil, oil, charcoal, mixed media and pastel. Send postcard sample or query letter with tearsheets and photocopies. Accepts submissions on disk, Mac compatible with Macromedia FreeHand, Illustrator, Photoshop, PageMaker or QuarkXPress. Samples are filed or returned by SASE. Responds only if interested. Write for appointment to show portfolio of thumbnails, roughs, b&w tearsheets and slides. Buys one-time rights. Pays $100-200 for b&w inside; $25-50 for spots. Pays 15 days after publication.

Design: Needs freelancers for design and production. 100% of freelance design requires knowledge of PageMaker, Macromedia FreeHand, Photoshop, QuarkXPress and Illustrator. Send query letter with résumé, photocopies or tearsheets. Pays for design by project.

ELECTRICAL APPARATUS, Barks Publications, Inc., 400 N. Michigan Ave., Suite 900, Chicago IL 60611-4198. (312)321-9440. Fax: (312)321-1288. E-mail: eamagazine@aol.com. Website: www.eamagazine.com. **Senior Editor:** Kevin Jones. Estab. 1948. Monthly 4-color trade journal emphasizing industrial electrical/mechanical maintenance. Circ. 16,000. Art guidelines available free for SASE. Original artwork not returned at job's completion. Sample copy $4.

Cartoons: Approached by several cartoonists/year. Buys 3-4 cartoons/issue. Has featured illustrations by Joe Buresch, James Estes, Bernie White and Mark Ziemann. Assigns 75% of illustrations to experienced, but not well-known illustrators; 25% to new and emerging illustrators. Prefers themes relevant to magazine content; with gagline. "Captions are typeset in our style." Send query letter with roughs and finished cartoons. "Anything we don't use is returned." Responds in 3 weeks. Buys all rights. Pays $15-20 for b&w and color.

Illustration: "We have staff artists, so there is little opportunity for freelance illustrators, but we are always glad to hear from anyone who believes he or she has something relevant to contribute."

Tips: "Pay attention to the magazine's editorial focus."

[N] EMERGENCY MEDICINE MAGAZINE, 26 Main St., Chatham NJ 07928. Website: www.emedma g.com. **Art Director:** Diane Villarreal. Estab. 1969. Emphasizes emergency medicine for primary care physicians, emergency room personnel, medical students. Bimonthly. Circ. 140,000. Returns original artwork after publication. Art guidelines not available.

Illustration: Works with 10 illustrators/year. Buys 1-2 illustrations/issue. Has featured illustrations by Teri McDermott, Todd Buck and Kevin Somerville. Features realistic, medical and spot illustration. Assigns 70% of illustrations to well-known or "name" illustrators; 30% to experienced, but not well-known illustrators. Works on assignment only. Send postcard sample or query letter with brochure, photocopies, photographs, tearsheets to be kept on file. Samples not filed are not returned. Accepts disk submissions. To show a portfolio, mail appropriate materials. Responds only if interested. Buys first rights. **Pays on acceptance**; $1,000-1,500 for color cover; $200-500 for b&w inside; $500-1,000 for color inside; $250-600 for spots.

[✓] ENTREPRENEUR MAGAZINE, 2445 McCabe Way, Suite 400, Irvine CA 92614-6244. (949)261-2325. Fax: (949)261-0234. Website: www.entrepreneur.com. **Creative Director:** Mark Kozak. Design Director: Richard Olson. Estab. 1978. Monthly 4-color magazine offers how-to information for starting a business, plus ongoing information and support to those already in business. Circ. 525,000.

Illustration: Approached by 500 illustrators/year. Buys 10-20 illustrations/issue. Has featured illustrations by Peter Crowther, Adam McCauley, J.T. Morrow, Simone Tieber, Scott Menchin and Victor Gad. Features computer, humorous and spot illustration and charts and graphs. Themes are business, financial and legal. Needs editorial illustration, "some serious, some humorous depending on the article. Illustrations are used to grab readers' attention." Send nonreturnable postcard samples and followup postcard every 4 months or query letter with printed samples and tearsheets. Accepts Mac-compatible disk submissions. Send EPS files. Samples are filed and not returned. Will contact artist for portfolio review if interested. Buys one-time rights. **Pays on acceptance**; $700 for full-page spread; $425 for spots. Finds freelancers through samples, mailers, *Work Book*, SIS and artist reps.

Tips: "We want illustrators that are creative, clean and have knowledge of business concepts. We are always open to new talent."

ENVIRONMENT, 1319 18th St. NW, Washington DC 20036-1802. (202)296-6267, ext. 237. Fax: (202)296-5149. E-mail: env@heldref.org. Website: www.heldref.org. **Editorial Assistant:** Ellen Fast. Estab. 1958. Emphasizes national and international environmental and scientific issues. Readers range from "high school students and college undergrads to scientists, business, and government leaders and college and university professors." 4-color magazine with "relatively conservative" design. Published 10 times/year. Circ. 7,500. Original artwork returned after publication. Sample copy $8.50; art guidelines for SASE with first-class postage.

Cartoons: Buys 1-2 cartoons/issue. Receives 5 submissions/week. Interested in single panel line drawings or b&w washes with or without gagline. Send finished cartoons and SASE. Responds in 2 months. Buys first North American serial rights. Pays on publication; $50 for b&w cartoon.

Tips: "Regarding cartoons, we prefer witty or wry comments on the impact of humankind upon the environment. Stay away from slapstick humor." For illustrations, "we are looking for an ability to communicate complex environmental issues and ideas in an unbiased way."

[▼] ESQUIRE, 250 W. 55th St., 8th Floor, New York NY 10019. (212)649-4020. Fax: (212)977-3158. Website: www.esquire.com. **Design Director:** John Korpics. Assistant Art Directors: Tedd Albertson and Erin Whelan. Contemporary culture magazine for men ages 28-40 focusing on current events, living trends, career, politics and the media. Estab. 1933. Circ. 750,000.

Illustration: Send postcard mailers. Drop off portfolio on Wednesdays for review.

[N] [✦] EYE FOR THE FUTURE, 223 Glenhome Ave., Toronto, Ontario M6E 3G6 Canada. (416)654-5858. Fax: (416)654-5898. E-mail: eyefuture@eyefuture.com. Website: www.eyefuture.com. **Contact:** Peter Diplaros. Estab. 1995. Monthly b&w consumer magazine focusing on health and self development. Circ. 40,000.

Illustration: Features humorous, realistic and medical illustration. Open to all subjects except children, teens, pets. Send postcard or other nonreturnable samples. Accepts Mac-compatible disk submissions. Send EPS files. Responds only if interested. Portfolio review not required. Buys one-time rights. Pays on publication.

Tips: "Looking for art that can add emotional depth to entice a reader to read and article in its entirety. Our magazine is about personal growth and we do articles on psychology, image, health, New Age, humor and business. We are looking for emotional appeal—not intellect."

☑ **EYECARE BUSINESS/BOUCHER COMMUNICATIONS, INC.**, 1300 Virginia Dr., Suite 400, Fort Washington PA 19034. (215)643-8021. Fax: (215)643-1705. E-mail: murskogn@boucher1.com. **Art Director:** Greg Mursko. Estab. 1985. Monthly tabloid size trade magazine for opticians, optometrists and all others in the optical industry. Circ. 52,200. Sample copies available.
Illustration: Approached by many illustrators/year. Buys 4 illustrations/issue. Has featured illustrations by Dave Klug, David Merrel, Michael Dinges, Greg Hargreaves and Dan Mcgeehan. Assigns 50% of illustrations to experienced, but not well-known illustrators; 50% to new and emerging illustrators. Prefers business/editorial style. Considers acrylic, collage, color washed, mixed media, oil, pen & ink, watercolor. 30% of freelance illustration demands knowledge of Photoshop 3.05, Illustrator 6.0. Send query letter with printed samples, photocopies, tearsheets. Send follow-up postcard sample every 3 months. Accepts disk submissions compatible with QuarkXPress or Photoshop, EPS or JPEG or TIFF (low-res please), Zip 100 MB, or floppy. Samples are filed. Responds only if interested. Buys one-time rights. Pays on publication; $125-175 for b&w, $150-400 for color inside. Pays $200-400 for spots. Finds illustrators through *American Showcase*, consumer magazines, word of mouth, submissions, *Directory of Illustration*, *Black Book*.
Design: Needs freelancers for design and production. Prefers local design freelancers with experience in QuarkXPress, Photoshop and/or Illustrator. 100% of freelance work demands knowledge of Photoshop, Illustrator, QuarkXPress. Phone art director. "After initial call, a portfolio interview is required if interested or needed."
Tips: "We like work that follows current color trends in design and is a little edgy, yet freelancer should still be able to produce work for formatted pages. Should be fast and be familiar with magazine's style."

FAMILY CIRCLE, Dept. AGDM, 375 Lexington Ave., New York NY 10017-5514. (212)499-2000. Website: www.familycircle.com. **Art Director:** David Wolf. Circ. 7,000,000. Supermarket-distributed publication for women/homemakers covering areas of food, home, beauty, health, child care and careers. 17 issues/year. Does not accept previously published material. Original artwork returned after publication.
Illustration: Buys 2-3 illustrations/issue. Works on assignment only. Provide query letter with non-returnable samples or postcard sample to be kept on file for future assignments. Do not send original work. Prefers transparencies, postcards or tearsheets as samples. Responds only if interested. Prefers to see finished art in portfolio. Submit portfolio by appointment. All art is commissioned for specific magazine articles. Negotiates rights. **Pays on acceptance.**

FANTAGRAPHICS BOOKS, 7563 Lake City Way NE, Seattle WA 98115. (206)524-1967. Fax: (206)524-2104. **Contact:** Gary Groth or Kim Thompson. Monthly and bimonthly comic books and g:aphic novels. Titles include *Love and Rockets*, *Hate*, *Eightball*, *The Acme Novelty Library*, *Black Hole*, *Blab*, *Frank* and *Penny Century*. All genres except superheroes. Circ. 8,000-30,000. Sample copy $3; catalog $2.
Cartoons: Approached by 500 cartoonists/year. "Fantagraphics is looking for artists who can create an entire product or who can work as part of an established team." Most of the titles are b&w. Send query letter with photocopies which display storytelling capabilities, or submit a complete package. All artwork is creator-owned. Buys one-time rights usually. Payment terms vary. Creator receives an advance upon acceptance and then royalties after publication.
Tips: "We prefer not to see illustration work unless there is some accompanying comics work. We also do not want to see unillustrated scripts. Be sure to include basic information like name, address, phone number, etc. Also include SASE. In comics, I see a trend toward more personal styles. In illustration in general, I see more and more illustrators who got their starts in comics appearing in national magazines."

FASHION ACCESSORIES, P.O. BOX 859, Mahwah NJ 07430. (201)684-9222. Fax: (201)684-9228. **Publisher:** Sam Mendelson. Estab. 1951. Monthly trade journal; tabloid; emphasizing costume jewelry and accessories. Publishes both 4-color and b&w. Circ. 9,500. Accepts previously published artwork. Original artwork is returned to the artist at the job's completion. Sample copies for $3.
Illustration: Works on assignment only. Needs editorial illustration. Prefers mixed media. Freelance work demands knowledge of QuarkXPress. Send query letter with brochure and photocopies. Samples are filed.

FOR EXPLANATIONS OF THESE SYMBOLS,
SEE THE INSIDE FRONT AND BACK COVERS OF THIS BOOK.

Responds in 1 month. Portfolio review not required. Rights purchased vary according to project. **Pays on acceptance**; $50-100 for b&w cover; $100-150 for color cover; $50-100 for b&w inside; $100-150 for color inside.

FAST COMPANY, 77 N. Washington St., Boston MA 02114-1927. (617) 973-0350. Fax: (617)973-0373. E-mail: rrees@fastcompany.com. Website: www.fastcompany.com. **Design Director:** Patrick Mitchell. Deputy Art Director: Emily Crawford. Estab. 1996. Monthly cutting edge business publication supplying readers with tools and strategies for business today.
Illustration: Approached by "tons" of illustrators/year. Buys approximately 20 illustrations/issue. Has used illustrations by Bill Mayer, Ward Sutton and David Cowles. Considers all media. Send postcard sample or printed samples, photocopies. Accepts disk submissions compatible with QuarkXPress for Mac. Send EPS files. Send all samples to the attention of: Julia Moburg. Samples are filed and not returned. Responds only if interested. Rights purchased vary according to project. **Pays on acceptance**, $300-1,000 for color inside; $300-500 for spots. Finds illustrators through submissions, illustration annuals, *Workbook* and *Alternative Pick*.

☑ **FAULTLINE**, Department of English and Comparative Literature, UC Irvine, Irvine CA 92697-2650. E-mail: faultline@uci.edu. Website: www.humanities.uci.edu/faultline. **Creative Director:** Phoebe Hyde (2001-02 rotating director).
 • Even though this is not a paying market, this high-quality literary magazine would be an excellent place for fine artists to gain exposure. Postcard samples with a website address are the best way to show us your work.

FEDERAL COMPUTER WEEK, 3141 Fairview Park Dr., Suite 777, Falls Church VA 22042. (703)876-5131. Fax: (703)876-5126. E-mail: jeffrey_langkau@fcw.com. Website: www.fcw.com. **Art Director:** Jeff Langkau. Estab. 1987. Four-color trade publication for federal, state and local government information technology professionals. Circ. 120,000.
 • Also publishes *CIVIC.COM* and *Government Best Buys*.
Illustration: Approached by 50-75 illustrators/year. Buys 5-6 illustrations/month. Features charts & graphs, computer illustrations, informational graphics, spot illustrations of business subjects. Assigns 5% of illustrations to well-known or "name" illustrators; 85% to experienced, but not well-known illustrators; 10% to new and emerging illustrators. Send postcard or other nonreturnable samples. Accepts Mac-compatible disk submissions. Samples are filed. Will contact artist for portfolio review if interested. Buys one-time rights. Rights purchased vary according to project. Pays $800-1,200 for color cover; $600-800 for color inside; $200 for spots. Finds illustrators through samples and sourcebooks.
Tips: "We look for people who understand 'concept' covers and inside art, and very often have them talk directly to writers and editors."

FIFTY SOMETHING MAGAZINE, 1168 Beachview, Willoughby OH 44094. (216)951-2468. **Editor:** Linda L. Lindeman-DeCarlo. Estab. 1990. Quarterly magazine; 4-color. "We cater to the fifty-plus age group with upbeat information, feature stories, travel, romance, finance and nostalgia." Circ. 25,000. Accepts previously published artwork. Original artwork is returned at the job's completion. Sample copies for SASE, 10×12, with $1.37 postage.
Cartoons: Approached by 50 cartoonists/year. Buys 3 cartoons/issue. Prefers funny issues on aging. Prefers single panel b&w line drawings with gagline. Send query letter with brochure, roughs and finished cartoons. Samples are filed. Responds only if interested. Buys one-time rights. Pays $10, b&w and color.
Illustration: Approached by 50 illustrators/year. Buys 2 illustrations/issue. Prefers old-fashioned, nostalgia. Considers all media. Send query letter with brochure, photographs, photostats, slides and transparencies. Samples are filed. Responds only if interested. To show a portfolio, mail thumbnails, printed samples, b&w photographs, slides and photocopies. Buys one-time rights. Pays on publication; $25 for b&w, $100 for color cover; $25 for b&w, $75 for color inside.

☑ **FILIPINAS MAGAZINE**, 363 El Camino Real, Suite 100, South San Francisco CA 94080-5969. (650)872-8654. Fax: (650)872-8651. E-mail: r.virata@filipinasmag.com. Website: www.filipinasmag.com. **Art Director:** Raymond Virata. Estab. 1992. Monthly magazine "covering issues of interest to Filipino Americans and Filipino immigrants." Circ. 30,000. Sample copies free for 9×12 SASE and $1.70. Contact Art Director for information.
Cartoons: Buys 1 cartoon/issue. Prefers work related to Filipino/Filipino-American experience. Prefers single panel, humorous, b&w washes and line drawings with or without gagline. Send query letter with photocopies. Samples are filed. Responds only if interested. Buys all rights. Pays on publication; $25 minimum.

Illustration: Approached by 5 illustrators/year. Buys 1-3 illustrations/issue. Considers all media. Send query letter with photocopies. Accepts disk submissions compatible with Mac, QuarkXPress 4.1, Photoshop 6, Illustrator 7, include any attached image files (TIFF or EPS) or fonts. Responds only if interested. Pays on publication; $100 minimum for cover; $25 minimum for inside.

Tips: "Read our magazine."

THE FINAL EDITION, Box 294, Rhododendron OR 97049. (503)622-4798. **Publisher:** Michael P. Jones. Estab. 1985. Monthly b&w investigative journal that deals "with a variety of subjects—environment, wildlife, crime, etc. for professional and blue collar people who want in-depth reporting." Circ. 1,500. Accepts previously published material. Original artwork is returned after publication. Art guidelines for #10 SASE with 1 first-class stamp. 50% of freelance work demands computer skills.

Cartoons: Buys 1-18 cartoons/issue. Prefers single, double, multipanel, b&w line drawings, b&w or color washes with or without gagline. Send query letter with samples of style, roughs or finished cartoons. Samples are filed or returned by SASE. Responds in 2 weeks only if SASE is sent. Acquires one-time rights. Pays in copies.

Illustration: Buys 10 illustrations/issue. Works with 29 illustrators/year. Prefers editorial, technical and medical illustration in pen & ink, airbrush, pencil, marker, calligraphy and computer illustration. Send query letter with brochure showing art style or résumé and tearsheets, transparencies, photocopies, slides or photographs. Samples not filed are returned by SASE. Responds in 2 months, "depending upon work load." Cannot return phone calls because of large volume." Request portfolio review in original query. Portfolio should include thumbnails, roughs, printed samples, final reproduction/product, color or b&w tearsheets, photostats and photographs. Acquires one-time rights. Pays in copies. Finds artists primarily through sourcebooks and also through word of mouth.

Design: Needs freelancers for design and production. 50% of freelance work demands computer skills. Send brochure, résumé, photocopies, photographs, SASE, slides, tearsheets or transparencies.

Tips: "We are really looking for artists who can sketch covered wagons, pioneers, Native Americans and mountain men. Everything is acceptable just as long as it doesn't advocate sex and violence and destroying our environment. We are looking for illustrators who can illustrate in black & white. Pen and ink is a plus. We want to work with an illustrator who wants to be published. Due to the great many requests we are receiving each day, illustrators should include a SASE for a timely response."

FINESCALE MODELER, 21027 Crossroads Circle, Waukesha WI 53187. (262)796-8776. Fax: (262)796-1383. Website: www.finescale.com. **Art Director:** Mike Soliday. Estab. 1972. Magazine emphasizing plastic modeling. Circ. 73,000. Accepts previously published material. Original artwork is returned after publication. Sample copy and art guidelines available.
 ● Published by Kalmbach Publishing. Also publishes *Classic Toy Trains*, *Astronomy*, *Model Railroader*, *Model Retailer*, *Nutshell News* and *Trains*.

Illustration: Prefers technical illustration "with a flair." Send query letter with "samples, either postcard, 8 × 10 sheet, color copy or photographs. Currently running Illustrator 5.0. Accepts submissions on disk." Samples are filed or returned only if requested. Responds only if interested. Write for appointment to show portfolio or mail color and b&w tearsheets, final reproduction/product, photographs and slides. Negotiates rights purchased.

Tips: "Show black & white and color technical illustration. I want to see automotive, aircraft and tank illustrations."

FIRST FOR WOMEN, 270 Sylvan Ave., Englewood Cliffs NJ 07632. (201)569-6699. Fax: (201)569-6264. Website: www.ffwmarket.com. **Art Director:** Rosemarie Wyer. Estab. 1988. Mass market consumer magazine for the younger woman published every 3 weeks. Circ. 1.4 million. Originals returned at job's completion. Sample copies and art guidelines not available.

Cartoons: Buys 10 cartoons/issue. Prefers women's issues. Prefers humorous cartoons; single panel b&w washes and line drawings. Send query letter with photocopies. Samples are filed. Responds only if interested. Buys one-time rights. Pays $150 for b&w.

Illustration: Approached by 100 illustrators/year. Buys 1 illustration/issue. Works on assignment only. Preferred themes are humorous, sophisticated women's issues. Considers all media. Send query letter with any sample or promo we can keep. Publication will contact artist for portfolio review if interested. Buys one-time rights. **Pays on acceptance**; $200 for b&w, $300 for color inside. Finds artists through promo mailers and sourcebooks.

Tips: Uses humorous or conceptual illustration for articles where photography won't work. "Use the mail—no phone calls please."

N FIRST HAND MAGAZINE, P.O. Box 1314, Teaneck NJ 07666. (201)836-9177. Fax: (201)836-5055. Estab. 1980. Monthly consumer magazine emphasizing gay erotica. Circ. 60,000. Originals returned at job's completion at artist's request. Sample copies available for $5. Art guidelines for SASE with first-class postage.

Cartoons: Approached by 10 cartoonists/year. Buys 5 cartoons/issue. Prefers gay male themes—erotica; humorous; single panel b&w line drawings with gagline. Send query letter with finished cartoons. Samples are not filed and are returned by SASE. Responds in 6 weeks. Buys all rights. Pays $20 for b&w.

Illustration: Approached by 30 illustrators/year. Buys 12 illustrations/issue. Prefers gay male erotica. Considers pen & ink, airbrush, marker, colored pencil and charcoal. Send query letter with photostats. Samples are not filed and are returned by SASE. Responds in 6 weeks. Portfolio review not required. Buys all rights. Pays on publication; $50 for b&w inside.

FLORIDA LEADER MAGAZINE, Oxendine Publishing, P.O. Box 14081, Gainesville FL 32604-2081. (352)373-6907. Fax: (352)373-8120. E-mail: jeff@studentleader.com. Website: www.floridaleader.com. **Art Director:** Jeff Riemersma. Estab. 1983. 4-color magazine for college and high school students. Publishes 6 issues/year. Circ. 23,000. Sample copies for 8½×11 SASE and 4 first-class stamps. Art guidelines for #10 SASE with first-class postage.

• Oxendine Publishing also publishes *Student Leader Magazine* (www.studentleader.com); same art director.

Illustration: Approached by hundreds of illustrators/year. Buys 4 illustrations/issue. Has featured illustrations by Tim Foley, Jackie Pittman, Greta Buchart and Dan Miller. Assigns 33% of illustrations to well-known or "name" illustrators; 33% to experienced, but not well-known illustrators; 33% to new and emerging illustrators. Considers all media. 50% of freelance illustration demands computer skills. Send postcard sample. Disk submissions must be PC-based TIF or EPS images. Samples are filed and are not returned. Responds only if interested. Rights purchased vary according to project. Pays on publication; $100 for color inside. Finds illustrators through sourcebooks and artist's submissions.

Tips: "We need responsible artists who complete projects on time and have a great imagination. Also must work within budget."

FLY FISHERMAN MAGAZINE, Primedia Inc., 6405 Flank Dr., Harrisburg PA 17112. (717)657-9555. Fax: (717)657-9552. E-mail: ds@cowles.com. Website: www.flyshop.com. **Art Director:** David Siegfried. Estab. 1969. Bimonthly magazine covering all aspects of fly fishing including how to, where to, new products, wildlife and habitat conservation, and travel through top-of-the-line photography and artwork; 4-color. In-depth editorial. Readers are upper middle class subscribers. Circ. 150,000. Sample copies for SASE with first-class postage. Art guidelines for SASE with first-class postage.

Cartoons: Buys 1 cartoon/issue, 6-10 cartoons/year from freelancers. Prefers fly fishing related themes only. Prefers single panel with or without gagline; b&w line drawings and washes. Send query letter with samples of style. Samples are filed or returned by SASE. Reports back regarding queries/submissions within 3 weeks. Buys one-time rights. Pays on publication.

Illustration: Buys illustrations to illustrate fishing techniques and for spots. Buys 4-10 illustrations/issue, 50 illustrations/year. Buys 2-3 map illustrations/issue. Prefers digital or electronic files. Considers airbrush, mixed media, watercolor, acrylic, pastel, pen and ink and charcoal pencil. Needs computer-literate illustrators familiar with Adobe Illustrator, Photoshop and Macromedia FreeHand. Send query letter with brochure showing art style, résumé and appropriate samples, excluding originals. Samples are filed or returned by SASE. Call or write to schedule an appointment to show a portfolio or mail appropriate materials. Buys one-time rights and occasionally all rights. Pays on publication.

Tips: Spot art for front and back of magazine is most open to illustrators.

FOCUS ON THE FAMILY, 8605 Explorer Dr., Colorado Springs CO 80920-1051. (719)531-3400. Fax: (719)531-3499. Website: www.family.org. **Senior Art Director, Periodicals:** Tim Jones. Estab. 1977. Publishes magazines. Specializes in religious-Christian. Circ. 2,700,000. Publishes 9 titles/year.

Needs: Approached by 100 illustrators and 12 designers/year. Works with illustrators from around the US. Prefers designers experienced in Macintosh. Uses designers mainly for periodicals, publication design/production. 100% of design and 20% illustration demands knowledge of FreeHand, Photoshop, Illustrator, QuarkXPress.

First Contact & Terms: Send query letter with photocopies, printed samples, résumé, SASE and tearsheets portraying family themes. Send follow-up postcard every year. Samples are filed. Responds in 2 weeks. Will contact artist for portfolio review of photocopies of artwork portraying family themes if interested. Buys first, one-time or reprint rights. Finds freelancers through agents, sourcebooks and submissions.

Text Illustration: Assigns 150 illustration jobs/year. Pays by project. Prefers realistic, abstract, cartoony styles.

☑ **FOLIO: MAGAZINE**, Primedia, Inc., 11 Riverbend Dr. S., P.O. Box 4949, Stamford CT 06907-0949. (212)332-6300. Fax: (212)332-6435. Website: www.foliomag.com. **Contact:** Lee Steele. Trade magazine covering the magazine publishing industry. Sample copies for SASE with first-class postage.
Illustration: Approached by 200 illustrators/year. Buys 150-200 illustrations/year. Works on assignment only. Artists on-line galleries welcome in lieu of portfolio. Send postcard samples and/or photocopies or other appropriate samples. No originals. Samples are filed and returned by SASE if requested by artist. Responds only if interested. Call for appointment to show portfolio of tearsheets, slides, final art, photographs and transparencies. Buys one-time rights. Pays by the project.
Tips: "Art director likes to see printed 4-color and b&w sample illustrations. Do not send originals unless requested. Computer-generated illustrations are used but not always necessary. Charts and graphs must be Macintosh-generated."

☑ **FOODSERVICE AND HOSPITALITY**, Kostuch Publications Limited, 23 Lesmill Rd., #101, Don Mills, Ontario M3B 3P6 Canada. (416)447-0888. Fax: (416)447-5333. E-mail: mhewis@foodservice.ca. Website: www.foodserviceworld.com. **Senior Designer:** Michael Hewis. Estab. 1973. Monthly business magazine for foodservice industry/operators. Circ. 25,000. Sample copies available. Art guidelines available.
● Also publishes *Hotel Executive Magazine*.
Illustration: Approached by 30 illustrators/year. Buys 1 illustration/issue. Prefers serious/businessy/stylized art. Considers all media. Send query letter with printed samples and tearsheets. Samples are filed. Responds only if interested. Art director will contact artist for portfolio review of final art and tearsheets if interested. Portfolios may be dropped off every Monday and Tuesday. Buys one-time rights. Pays on publication; $500 minimum for color cover; $300 minimum for color inside. Finds illustrators through sourcebooks, word of mouth, artist's submissions.

FOODSERVICE DIRECTOR MAGAZINE, 770 Broadway, 4th Floor, New York NY 10003-1789. (646)654-7407. Fax: (646)654-7410. Website: www.fsdmag.com. **Contact:** Kathleen McCann. Estab. 1988. Monthly 4-color trade publication covering cafeteria-style food in colleges, schools, hospitals, prisons, airlines, business and industry. Circ. 45,000.
Illustration: Approached by 75 illustrators/year. Buys 1-2 illustrations/issue. Features humorous illustration, informational graphics, spot illustrations of food and kitchen art and business subjects. Prefers solid colors that reproduce well. No neon. Assigns 50% of illustration to experienced, but not well-known illustrators; 50% to new and emerging illustrators. 10% of freelance illustration demands knowledge of Illustrator, Photoshop, FreeHand, QuarkXPress. Send postcard or other nonreturnable samples or query letter with photocopies. Send follow-up postcard every 6 months. Accepts Mac-compatible disk submissions. Send EPS or TIFF files. Samples are filed. Will contact artist for portfolio review if interested. Pays on publication; $350-550 for color inside; $150 for spots. Finds illustrators through samples, sourcebooks.

FOUNDATION NEWS & COMMENTARY, Council on Foundations, 1828 L St. NW, Washington DC 20036. (202)466-6512. Fax: (202)785-3926. Website: www.foundationnews.org. **Executive Editor:** Jody Curtis. Estab. 1959. Bimonthly 4-color nonprofit association magazine that "covers news and trends in the nonprofit sector, with an emphasis on foundation grantmaking and grant-funded projects." Circ. 16,000. Accepts previously published artwork. Original artwork returned after publication. Sample copy available.
Illustration: Approached by 50 illustrators/year. Buys 3 illustrations/issue. Considers all formats. Send query letter with tearsheets, photostats, slides and photocopies. Samples are filed "if good"; none are returned. Buys first rights. **Pays on acceptance.**
Tips: The magazine is "clean, uncluttered, sophisticated, simple but attractive. It's high on concept and originality, and the content is somewhat abstract, not literal."

☒ ⊕ **FUTURE PUBLISHING LTD.**, 30 Monmouth St., Bath, England BA1 2BW. Phone: +44(0)442244. Fax: +44(0)732295. Website: www.netmag.co.uk. **Art Editor:** Martin Parfitt. Estab. 1984. Monthly 4-color computer magazines that cover many PC/Mac topics including the Internet.
● Future Publishing is Britain's fifth largest publisher of leisure computing and videogames magazines. They publish *.net*, *PC Format Gamesmaster* and about 50 other titles. They also publish woodworking, crafts, sports and music publications.
Cartoons: Approached by 30 cartoonists/year. Buys 3 cartoons/issue. Prefers business themes. Prefers humorous. Send color photocopies. Samples are filed or returned by SASE. Responds only if interested. Rights purchased vary according to project. Pays on publication.
Illustration: Approached by 50 illustrators/year. Buys 4 illustrations/issue. Has featured illustrations by John Bradley, Ed McLachlan, Estelle Corke, Oliver Burston, Garry Walton. Features humorous illustration, spot illustrations and computer illustrations of business subjects and computers in lifestyle. Prefers colorful,

strong, bright colors. Assigns 50% of illustrations to experienced, but not well-known illustrators; 50% to new and emerging illustrators. 50% of freelance illustration demands knowledge of Photoshop. Send postcard sample and follow-up postcard every 6 months. Send query letter, photocopies and SASE. Samples are filed or returned by SASE. Responds only if interested. Will contact artist for portfolio review if interested. Rights purchased vary according to project. Pays on publication. Finds illustrators through agents and originals book.

Tips: "Our current stable of four freelancers are reliable, affordable and can turn around jobs in good time. We are always open to new talent even if at first your portfolio doesn't apply to computer magazines."

THE FUTURIST, Dept. AGDM, 7910 Woodmont Ave., Suite 450, Bethesda MD 20814. Website: www.wfs.org. **Production Manager:** Lisa Mathias. Managing Editor: Cynthia Wagner. Emphasizes all aspects of the future for a well-educated, general audience. Bimonthly b&w and color magazine with 4-color cover; "fairly conservative design with lots of text." Circ. 30,000. Accepts simultaneous submissions and previously published work. Return of original artwork following publication depends on individual agreement.

Illustration: Approached by 50-100 illustrators/year. Buys fewer than 10 illustrations/year. Needs editorial illustration. Uses a variety of themes and styles "usually b&w drawings, often whimsical. We like an artist who can read an article and deal with the concepts and ideas." Works on assignment only. Send samples or tearsheets to be kept on file. Accepts disk submissions compatible with Illustrator, QuarkXPress or Photoshop on a Mac platform. Send EPS files. Will contact for portfolio review if interested. Rights purchased negotiable. **Pays on acceptance**; $500-750 for color cover; $75-350 for b&w, $200-400 for color inside; $100-125 for spots.

Tips: "Send samples that are strong conceptually with skilled execution. When a sample package is poorly organized, poorly presented—it says a lot about how the artists feel about their work." Sees trend of "moving away from realism; highly stylized illustration with more color." This publication does not use cartoons.

GALLERY MAGAZINE, Dept. AGDM, 401 Park Ave. S., New York NY 10016-8808. (212)779-8900. Fax: (212)725-7215. Website: www.gallerymagazine.com. **Creative Director:** Mark DeMaio. Emphasizes "sophisticated men's entertainment for the upper middle-class, collegiate male; monthly 4-color with flexible format, conceptual and sophisticated design." Circ. 375,000.

Cartoons: Approached by 100 cartoonists/year. Buys 3-8 cartoons/issue. Interested in sexy humor; single, double or multiple panel, color and b&w washes, b&w line drawings with or without gagline. Send finished cartoons. Enclose SASE. Contact: J. Linden. Responds in 1 month. Buys first rights.

Illustration: Approached by 300 illustrators/year. Buys 30 illustrations/year. Works on assignment only. Needs editorial illustrations. Interested in the "highest creative and technical styles." Especially needs slick, high-quality, 4-color work. 100% of freelance work demands knowledge of QuarkXPress and Illustrator. Send flier, samples or tearsheets to be kept on file for possible future assignments. Prefers prints over transparencies. Samples returned by SASE. Publication will contact artist for portfolio review if interested. Negotiates rights purchased. Pays on publication; $350 for b&w inside; $250-1,000 for color inside; $250-500 for spots. Finds artists through submissions and sourcebooks.

Design: Needs freelancers for design and production. 100% of freelance work demands knowledge of Photoshop, Illustrator, QuarkXPress. Prefers local freelancers only. Send query letter with résumé, SASE and tearsheets. Pays by the hour, $25.

Tips: A common mistake freelancers make is that "often there are too many samples of literal translations of the subject. There should also be some conceptual pieces."

GAME & FISH, 2250 Newmarket Pkwy., Suite 110, Marietta GA 30067. (770)953-9222. Fax: (770)933-9510. Website: www.gameandfish.about.com. **Graphic Artist:** Allen Hansen. Estab. 1975. Monthly b&w with 4-color cover. Circ. 575,000 for 30 state-specific magazines. Original artwork is returned after publication. Sample copies available.

Illustration: Approached by 50 illustrators/year. Buys illustrations mainly for spots and feature spreads. Buys 1-5 illustrations/issue. Considers pen & ink, watercolor, acrylic and oil. Send query letter with photocopies. "We look for an artist's ability to realistically depict North American game animals and game fish or hunting and fishing scenes." Samples are filed or returned only if requested. Responds only if interested. Portfolio review not required. Buys first rights. Pays 2½ months prior to publication; $25 minimum for b&w inside; $75-100 for color inside.

Tips: "We do not publish cartoons, but we do use some cartoon-like illustrations which we assign to artists to accompany specific humor stories. Send us some samples of your work, showing as broad a range as possible, and let us hold on to them for future reference. Being willing to complete an assigned illustration in a 4-6 week period and providing what we request will make you a candidate for working with us."

GARDEN GATE MAGAZINE, 2200 Grand Ave., Des Moines IA 50312. (515)282-7000. Fax: (515)283-2003. Website: www.gardengatemagazine.com. **Art Director:** Steven Nordmeyer. Estab. 1995. Bimonthly consumer magazine on how-to gardening for the novice and intermediate gardener. Circ. 300,000.

Illustration: 90% of illustration needs are conventional/watercolor illustrations. Other styles require knowledge of Photoshop 3.0, QuarkXPress 3.31 and Corel Draw 5.0. Send postcard sample, query letter with tearsheets. Accepts disk submissions compatible with QuarkXPress 7.5/version 3.31. Send EPS or TIF files. Samples are filed and are not returned. Responds only if interested. Art director will contact artist for portfolio review of slides, tearsheets if interested. Buys all rights. Finds illustrators through artist submissions, *Black Book*, word of mouth.

Design: Prefers designers with experience in publication design. 98% of freelance work demands knowledge of Photoshop 3.0, QuarkXPress 3.31, Corel Draw 5.0. Send query letter with printed samples and tearsheets.

Tips: "Become familiar with our magazine and offer an illustration style that is compatible."

GENTRY MAGAZINE, 618 Santa Cruz Ave., Menlo Park CA 94025-4503. (650)324-1818. Fax: (650)324-1888. E-mail: gentry@aol.com. Website: www.18media.com. **Art Director:** Lisa Duri. Estab. 1994. Monthly community publication for affluent audience of designers and interior designers. Circ. 35,000. Sample copies and art guidelines available for 9×10 SASE.

Cartoons: Approached by 200 cartoonists/year. Buys 4 cartoon/issue. Prefers political and humorous b&w line drawings without gaglines. Send query letter with tearsheets. Samples are filed. Responds only if interested. Buys first rights. Pays on publication; $50-100 for b&w; $75-200 for color.

Illustration: Approached by 100 illustrators/year. Buys 6 illustrations/issue. Features informational graphics and computer and spot illustration. Assigns 50% of illustrations to experienced, but not well-known illustrators; 50% to new and emerging illustrators. Prefers financial and fashion themes. Considers all media. Knowledge of Photoshop, Illustrator and QuarkXPress helpful. Send postcard sample. Accepts disk submissions if Mac compatible. Send EPS files. Samples are filed. Art director will contact artist for portfolio review if interested. Buys one-time rights. Pays on publication; $200-500 for color inside; $100-500 for spots. Finds illustrators through submissions.

Design: Needs freelancers for design and production. Prefers local designers. 100% of freelance work demands knowledge of Photoshop, Illustrator and QuarkXPress. Send query letter with printed samples, photocopies or tearsheets.

Tips: "Read our magazine. Regional magazines have limited resources but are a great vehicle for getting your work printed and getting tearsheets. Ask people and friends (honest friends) to review your portfolio."

GEORGIA MAGAZINE, P.O. Box 1707, Tucker GA 30085-1707. (770)270-6950. Fax: (770)270-6995. E-mail: ann.orowski@georgiaemc.com. **Editor:** Ann Orowski. Estab. 1945. Monthly consumer magazine promoting electric co-ops (largest read publication by Georgians for Georgians). Circ. 475,000 members.

Cartoons: Approached by 10 cartoonists/year. Buys 2 cartoons/year. Prefers electric industry theme. Prefers single panel, humorous, b&w washes and line drawings. Send query letter with photocopies. Samples are filed and not returned. Responds in 1 month if interested. Rights purchased vary according to project. **Pays on acceptance**; $50 for b&w, $50-100 for color.

Illustration: Approached by 10 illustrators/year. Prefers electric industry theme. Considers all media. 50% of freelance illustration demands knowledge of Illustrator and QuarkXPress. Send postcard sample or query letter with photocopies. Accepts disk submissions compatible with QuarkXPress 7.5. Samples are filed or returned by SASE. Responds in 1 month if interested. Rights purchased vary according to project. **Pays on acceptance**; $50-100 for b&w, $50-200 for color. Finds illustrators through word of mouth and artist's submissions.

Design: Uses freelancers for design and production. Prefers local designers with magazine experience. 80% of design demands knowledge of Photoshop, Illustrator and QuarkXPress. Send query letter with printed samples and photocopies.

GIFTWARE NEWS, 20 N. Wacker Dr., Suite 1865, Chicago IL 60606. (312)849-2220. Fax: (312)849-2174. Website: www.giftwarenews.net. **Art Director:** Bob Page. Monthly magazine "of gifts, collectibles, stationery, gift baskets, tabletop and home accessories." Circ. 33,500. Sample copies available.

Design: Needs freelancers for design, production, multimedia projects and Internet, possible CD production. Prefers designers with experience in magazine design. 100% of work demands knowledge of Photoshop 4.0, Illustrator 8.0 and QuarkXPress 4.0. Send query letter with printed samples.

GIFTWARE NEWS UK, 20 N. Wacker Dr., Suite 3230, Chicago IL 60606. (312)849-2220. Fax: (312)849-2174. E-mail: giftnews@aol.com. Website: www.giftwarenews.com. **Art Director:** Bob Page. Quarterly magazine "of gifts, collectibles, stationery, gift baskets, tabletop and home accessories in the UK." Circ. 10,000. Sample copy available.
Design: Needs freelancers for design, production and multimedia projects. Prefers freelancers with experience in magazine layout. 100% of design demands knowledge of Photoshop 3.0, Illustrator 6.0 and QuarkXPress 3.3. Send query letter with printed samples.

GIRLFRIENDS MAGAZINE, 3415 Cesar Chavez, #101, San Francisco CA 94110. (415)648-9464. Fax: (415)648-4705. E-mail: ethan@girlfriendsmag.com. Website: www.girlsfriendsmag.com. **Art Director:** Ethan Duran. Estab. 1994. Monthly lesbian magazine. Circ. 30,000. Sample copies available for $4.95. Art guidelines for #10 SASE with first-class postage.
Illustration: Approached by 50 illustrators/year. Buys 3-4 illustrations/issue. Features caricatures of celebrities and realistic, computer and spot illustration. Assigns 10% of illustrations to well-known or "name" illustrators; 50% to experienced, but not well-known illustrators; 40% to new and emerging illustrators. Prefers any style. Considers all media. 10% of freelance illustration demands knowledge of Illustrator, QuarkXPress. Send query letter with printed samples, tearsheets, résumé, SASE and color copies. Accepts disk submissions compatible with QuarkXPress (JPEG files). Samples are filed or returned by SASE on request. Responds in 2 months. To show portfolio, artist should follow-up with call and/or letter after initial query. Portfolio should include color, final art, tearsheets, transparencies. Rights purchased vary according to project. Pays on publication; $50-200 for color inside; $150-300 for 2-page spreads; $50-75 for spots. Finds illustrators through word of mouth and submissions.
Tips: "Read the magazine first; we like colorful work; ability to turn around in two weeks."

GIRLS' LIFE, 4517 Hartford Rd., Baltimore MD 21214-3122. (410)426-9600. Fax: (410)254-0991. Website: www.girlslife.com. **Art Director:** Chun Kim. Estab. 1994. Bimonthly consumer magazine for 8- to 15-year-old girls. Originals sometimes returned at job's completion. Sample copies available for $5 on back order or on newsstands. Art guidelines not available. Sometimes needs computer literate freelancers for illustration. 20% of freelance work demands computer knowledge of Illustrator, QuarkXPress or Photoshop. Circ. 315,905.
Illustration: Prefers anything pertaining to girls 8-15 years-old. Assigns 30% of illustrations to well-known or "name" illustrators; 60% to experienced, but not well-known illustrators; 10% to new and emerging illustrators. Considers pen & ink, watercolor, airbrush, acrylic and mixed media. Send query letter with SASE, tearsheets, photographs, photocopies, photostats, slides and transparencies. Samples are filed or are returned by SASE if requested by artist. Publication will contact artist for portfolio review if interested. Portfolio should include tearsheets, slides, photostats, photocopies, final art and photographs. Buys first rights. Pays on publication. Finds artists through artists' submissions.
Tips: "Send work pertaining to our market."

GLAMOUR, 4 Times Square, 16th Floor, New York NY 10036. **Art Director:** Henry Connell. Monthly magazine. Covers fashion and issues concerning working women (ages 20-35). Originals returned at job's completion. Sample copies available on request. 5% of freelance work demands knowledge of Illustrator, QuarkXPress, Photoshop and FreeHand.
Cartoons: Buys 1 cartoon/issue.
Illustration: Buys 1 illustrations/issue. Works on assignment only. Considers all media. Send postcard-size sample. Samples are filed and not returned. Publication will contact artist for portfolio review if interested. Rights purchased vary according to project. Pays on publication.

☑ **GOLF ILLUSTRATED**, 15115 S. 76th East Ave., Bixby OK 74008-4114. (918)366-6191. Fax: (918)366-5612. Website: www.Golfillustrated.com. **Managing Editor:** Jason Sowards. Art Director: Burt McCall. Estab. 1914. Bimonthly golf lifestyle magazine with instruction, travel, equipment reviews and more. Circ. 150,000. Sample copies free for 9×11 SASE and 6 first-class stamps. Art guidelines available for #10 SASE with first-class postage.
Cartoons: Approached by 25 cartoonists/year. Prefers golf. Prefers single panel, b&w washes or line drawings. Send photocopies. Samples are filed. Responds in 1 month. Buys first North American serial rights. **Pays on acceptance**; $50 minimum for b&w.
Illustration: Approached by 50 illustrators/year. Buys 10 illustrations/issue. Prefers instructional, detailed figures, course renderings. Considers all media. 30% of freelance illustration demands knowledge of Photoshop, Illustrator and QuarkXPress. Send query letter with photocopies, SASE and tearsheets. Accepts disk submissions. Samples are filed. Responds in 1 month. Portfolios may be dropped off Monday-Friday. Buys first North American serial and reprint rights. **Pays on acceptance**; $100-200 for b&w, $250-400 for color inside. Finds illustrators through sourcebooks, magazines, word of mouth and submissions.

Tips: "Read our magazine. We need fast workers with quick turnaround."

[N] GOLF JOURNAL, P.O. Box 708, Golf House, Far Hills NJ 07931-0708. (908)234-2300. Fax: (908)781-1112. E-mail: golfjournal@usga.org. Website: www.golfjournal.org. **Editor:** Brett Avery. Art Director: Donna Panagakos. Readers are "literate, professional, knowledgeable on the subject of golf." Published 9 times/year. Circ. 600,000. Original artwork not returned after publication. Free sample copy.
Cartoons: Buys 1-2 cartoons/issue. "The subject is golf. Golf must be central to the cartoon. Drawings should be professional and captions sharp, bright and literate, on a par with our generally sophisticated readership." Formats: single or multiple panel, color line drawings with gagline. Prefers to see finished cartoons. Send SASE. Responds in 1 month. Buys one-time rights. **Pays on acceptance**; $125-175, for color cartoons.
Illustration: Buys several illustrations/issue. "We maintain a file of samples from illustrators. Our needs for illustrations are based almost solely on assignments, illustrations to accompany specific stories. We need talent with a light artistic touch, and we would assign a job to an illustrator who is able to capture the feel and mood of a story. A sense of humor is a useful quality in the illustrator, but this sense shouldn't lapse into absurdity." Uses color washes. Send samples of style to be kept on file for future assignments. Responds in 1 month. Buys all rights on a work-for-hire basis. Payment varies, "usually $300 for page, $500 for color cover."
Tips: Wants to see "a light touch, identifiable, relevant, rather than nitwit stuff showing golfballs talking to each other." Does not want to see "willy-nilly submissions of everything from caricatures of past presidents to meaningless art. Know your market; we're a golf publication, not an art gazette."

GOLF TIPS MAGAZINE, 12121 Wilshire Blvd., Suite 1200, Los Angeles CA 90025-1123. (310)820-1500. Fax: (310)820-2793. Website: www.golftipsmag.com. **Art Director:** Warren Keating. Estab. 1986. Monthly 4-color consumer magazine featuring golf instruction articles. Circ. 300,000.
Illustration: Approached by 100 illustrators/year. Buys 3 illustrations/issue. Has featured illustrations by Phil Franké, Scott Matthews, Ed Wexler. Features charts & graphs, humorous illustration, informational graphics, realistic and medical illustration. Preferred subjects: men and women. Prefers realism or expressive, painterly editorial style or graphic humorous style. Assigns 30% of illustrations to well-known or "name" illustrators; 50% to experienced, but not well-known illustrators; 20% to new and emerging illustrators. 15% of freelance illustration demands knowledge of Illustrator, Photoshop and FreeHand. Send postcard or other nonreturnable samples. Accepts Mac-compatible disk submissions. Send EPS or TIFF files. Samples are filed. Will contact artist for portfolio review if interested. Rights purchased vary according to project. Pays on publication; $500-700 for color cover; $100-200 for b&w inside; $250-500 for color inside; $500-700 for 2-page spreads. Finds illustrators through *LA Workbook*, *Creative Black Book* and promotional samples.
Tips: "Look at our magazine and you will see straightforward, realistic illustration, but I am also open to semi-abstract, graphic humorous illustration, gritty, painterly, editorial style, or loose pen & ink and watercolor humorous style."

THE GOLFER, 21 E. 40th St., 13th Floor, New York NY 10016-0501. (212)696-2484. Fax: (212)696-1678. Website: www.emeraldtee.com. **Art Director:** Andrea Darif. Estab. 1994. 6 times/year "sophisticated golf magazine with an emphasis on travel and lifestyle. Circ. 254,865.
Illustration: Approached by 200 illustrators/year. Buys 6 illustrations/issue. Considers all media. Send postcard sample. "We will accept work compatible with QuarkXPress 3.3. Send EPS files." Samples are not filed and are not returned. Responds only if interested. Rights purchased vary according to project. Pays on publication. Payment to be negotiated.
Tips: "I like sophisticated, edgy, imaginative work. We're looking for people to interpret sport, not draw a picture of someone hitting a ball."

GOVERNING, 1100 Connecticut Ave. NW, Suite 1300, Washington DC 20036-4109. (202)862-8802. Fax: (202)862-0032. E-mail: rsteadham@governing.com. Website: www.governing.com. **Art Director:** Richard Steadham. Estab. 1987. Monthly magazine. "Our readers are executives of state and local governments nationwide. They include governors, mayors, state legislators, county executives, etc." Circ. 86,284.
Illustration: Approached by hundreds of illustrators/year. Buys 2-3 illustrations/issue. Prefers conceptual editorial illustration dealing with public policy issues. Considers all media. 10% of freelance illustration demands knowledge of Photoshop, Illustrator, FreeHand. Send postcard sample with printed samples, photocopies and tearsheets. Send follow-up postcard sample every 3 months. "No phone calls please. We work in QuarkXPress, so we accept any format that can be imported into that program." Samples are filed. Responds only if interested. Art director will contact artist for portfolio review if interested. Buys one-time rights. Pays on publication; $700-1,200 for cover; $350-700 for inside; $350 for spots. Finds illustrators through *Blackbook*, *LA Workbook*, online services, magazines, word of mouth, submissions.

Tips: "We are not interested in working with artists who can't take direction. If you can collaborate with us in communicating our words visually, then we can do business. Also, please don't call asking if we have any work for you. When I'm ready to use you, I'll call you."

GRAPHIC ARTS MONTHLY, 345 Hudson St., 4th Floor, New York NY 10014-4587. (212)519-7321. Fax: (212)519-7489. E-mail: rlevy@cahners.com. Website: www.gammag.com/. **Creative Director:** Rani Levy. Estab. 1930. Monthly 4-color trade magazine for management and production personnel in commercial and specialty printing plants and allied crafts. Design is "direct, crisp and modern." Circ. 70,000. Accepts previously published artwork. Originals returned at job's completion. Needs computer-literate freelancers for illustration.
Illustration: Approached by 150 illustrators/year. Buys 6 illustrations/issue. Works on assignment only. Considers all media, including computer. Send postcard-sized sample to be filed. Accepts disk submissions compatible with Photoshop, Illustrator or JPEG files. Will contact for portfolio review if interested. Portfolio should include final art, photographs, tearsheets. Buys one-time and reprint rights. **Pays on acceptance**; $750-1200 for color cover; $250-350 for color inside; $250 for spots. Finds artists through submissions.

☑ **GRAY AREAS**, P.O. Box 808, Broomall PA 19008-0808. E-mail: grayarea@mod.net. Website: www. grayarea.com/gray2.htm. **Publisher:** Netta Gilboa. Estab. 1991. Magazine examining gray areas of law and morality in the fields of music, law, technology and popular culture. Accepts previously published artwork. Originals not returned. Sample copies available for $8; art guidelines not available.
Cartoons: Approached by 15 cartoonists/year. Buys 2-5 cartoons/issue. Prefers "illegal subject matter" humorous cartoons; single, double or multiple panel b&w line drawings. Send query letter with brochure, roughs, photocopies or finished cartoons. Samples are filed. Responds in 1 week only if SASE provided. Buys one-time rights.
Illustration: Works on assignment only. Has featured illustrations by Dennis Preston, Jeff Wampler and Wes Wilson. Assigns 5% of illustrations to well-known or "name" illustrators; 35% to experienced, but not well-known illustrators; 60% to new and emerging illustrators. Features humorous and computer illustration. Assigns 50% of illustrations to experienced, but not well-known illustrators; 50% to new and emerging illustrators. Prefers "illegal subject matter like sex, drugs, computer criminals." Considers "any media that can be scanned by a computer, up to 8½×11 inches." 50% of freelance work demands knowledge of PageMaker 6.0 or CorelDraw 6.0. Send postcard sample or query letter with SASE and photocopies. Accepts disk submissions compatible with IBM/PC. Samples are filed. Responds in 1 week only if SASE enclosed. Portfolio review not required. Buys one-time rights. Pays on publication; $500 for color cover; negotiable b&w. Pays 5 copies of issue and masthead listing for spots.
Design: Needs freelancers for design. 50% of freelance work demands knowledge of PageMaker 6.0, FreeHand 5.0 or CorelDraw 6.0. Send query letter with photocopies. Pays by project.
Tips: "Most of the artists we use have approached us after seeing the magazine. All sections are open to artists. We are only interested in art which deals with our unique subject matter. Please do not submit without having seen the magazine. We have a strong 1960s style. Our favorite artists include Robert Crumb and Rick Griffin. We accept all points of view in art, but only if it addresses the subject we cover. Don't send us animals, statues or scenery."

GREENPRINTS, P.O. Box 1355, Fairview NC 28730. (828)628-1902. Website: www.greenprints.com. **Editor:** Pat Stone. Estab. 1990. Quarterly magazine "that covers the personal, not the how-to, side of gardening." Circ. 13,000. Sample copy for $5; art guidelines available on website or free for #10 SASE with first-class postage.
Illustration: Approached by 46 illustrators/year. Works with 15 illustrators/issue. Has featured illustrations by Claudia McGehee, P. Savage, Marilynne Roach and Jean Jenkins. Assigns 50% of illustrations to experienced, but not well-known illustrators; 50% to new and emerging illustrators. Prefers plants and people. Considers b&w only. Send query letter with photocopies, SASE and tearsheets. Samples accepted by US mail only. Accepts e-mail queries without attachments. Samples are filed or returned by SASE. Responds in 2 months. Buys first North American serial rights. Pays on publication; $250 maximum for color cover; $100-125 for b&w inside; $25 for spots. Finds illustrators through word of mouth, artist's submissions.
Tips: "Read our magazine and study the style of art we use. Can you do both plants and people? Can you interpret as well as illustrate a story?"

[N] **GROUP PUBLISHING—MAGAZINE DIVISION**, 1515 Cascade Ave, Loveland CO 80538-8681. (970)669-3836. Fax: (970)669-3269. Website: www.grouppublishing.com and www.onlinerev.com. Publishes *Group Magazine*, Art Director: Bill Fisher (6 issues/year; circ. 50,000; 4-color); *Children's Ministry Magazine*, Art Director: RoseAnne Buerge (6 issues/year; circ. 65,000; 4-color) for adult leaders who work with kids from birth to 6th grade; *Rev. Magazine*, Art Director: Bill Fisher (6 issues; 4-color)

an interdenominational magazine which provides innovative and practical ideas for pastors. Previously published, photocopied and simultaneous submissions OK. Original artwork returned after publication. Sample copy $2 with 9×12 SAE.

 ● This company also produces books. See listing in Book Publishers section.

Cartoons: Generally buys one spot cartoon per issue that deals with youth or children ministry. Pays $50 minimum.

Illustration: Buys 2-10 illustrations/issue. Has featured illustrations by Matt Wood, Chris Dean, Dave Klug and Otto Pfandschimdt. Send postcard samples, SASE, slides or tearsheets to be kept on file for future assignments. Accepts disk submissions compatible with Mac. Send EPS files. Responds only if interested. **Pays on acceptance**; $125-1,000, from b&w/spot illustrations (line drawings and washes) to full-page color illustrations inside. Buys first publication rights and occasional reprint rights.

Tips: "We prefer contemporary, nontraditional (not churchy), well-developed styles that are appropriate for our innovative, youth-oriented publications. We appreciate artists who can conceptualize well and approach difficult and sensitive subjects creatively."

GUIDEPOSTS FOR TEENS. 1050 Broadway, Chesterton IN 46304. (219) 929-4429. Fax: (219) 926-2397. E-mail: mlyons@guidepostos.org. Website: www.gp4teens.com. **Senior Designer:** David Lee. Art Director: Michael C. Lyons. Bimonthly magazine for teens 13-17 focusing on true teen stories, value centered. Estab. 1998. Circ: 200,000.

Illustration: Approached by 100 illustrators per year. Buys 10 illustrations per issue. Considers all media but prefers electronic. Has featured illustrations by Cliff Nielsen, Jaques Barby, Donna Nelson, Sally Comport. Assigns 40% of illustrations to well-known or "name" illustrators; 70% to experienced, but not well-known illustrators; 50% to new and emerging illustrators. Send postcard or tearsheets; "no large bundles, please. Disks welcome. Websites will be visited." Samples are filed or returned by SASE if requested by artist. Responds only if interested. Art director will contact if more information is desired. Buys mostly first and reprint rights. Pays on invoice, net 30 days. Pays $700-900 single page; $1,200-1,800 per spread; $150-400 per color spot. Finds illustrators through submissions, reps and Internet.

Tips: This art director loves "on the edge, funky, stylized nonadult, alternative styles. Traditional styles are sometimes used." Freelance graphic designers are used in 2 stories/issue.

✓ **GUIDEPOSTS MAGAZINE**, 16 E. 34th St., New York NY 10016. (212)251-8127. Fax: (212)684-1311. Website: www.guideposts.org. **Art Director:** Kai-Ping Chao. Estab. 1945. Monthly nonprofit inspirational, consumer magazine. *Guideposts* articles "present tested methods for developing courage, strength and positive attitudes through faith in God." Circ. 4 million. Sample copies and guidelines are available.

 ● Also publishes *Angels on Earth*, a bimonthly magazine buying 7-10 illustrations/issue. They feature more eclectic and conceptual art, as well as realism. Considers watercolor, collage, airbrush, acrylic, colored pencil, oil, mixed media and pastel. Both magazines have been redesigned.

Illustration: Buys 4-7 illustrations/issue. Works on assignment only. Features realistic, computer and spot illustration. Assigns 40% of illustrations to well-known or "name" illustrators; 40% to experienced, but not well-known illustrators; 20% to new and emerging illustrators. Prefers realistic, reportorial. Please send any promotional materials. Accepts disk submissions compatible with QuarkXPress, Illustrator, Photoshop (Mac based). Do not send non-returnable work. To arrange portfolio review artist should follow up with call after initial query. Buys one-time rights. **Pays on acceptance**; $1,000-2,500 for color cover; $1,000-2,000 for 2-page spreads; $300-1,000 for spots. Finds artists through sourcebooks, other publications, word of mouth, artists' submissions and Society of Illustrators' shows.

Tips: Sections most open to freelancers are illustrations for action/adventure stories. "Do your homework as to our needs and be familiar with the magazines. Tailor your portfolio or samples to each publication so our art director is not looking at one or two that fit her needs. Call me and tell me you've seen recent issues and how close your work is to some of the pieces in the magazine."

GUITAR PLAYER, 2800 Campus Dr., San Mateo CA 94403. (650)513-4400. Website: www.guitarplayer.com. **Art Director:** Richard Leeds. Estab. 1975. Monthly 4-color magazine focusing on technique, artist interviews, etc. Circ. 150,000. Original artwork is returned at job's completion. Sample copies and art guidelines not available.

Illustration: Approached by 15-20 illustrators/week. Buys 3 illustrations/issue. Works on assignment only. Features caricature of celebrities; realistic, computer and spot illustration. Assigns 33% of illustrations to well-known or "name" illustrators; 33% to experienced, but not well-known illustrators; 33% to new and emerging illustrators. Prefers conceptual, "outside, not safe" themes and styles. Considers pen & ink, watercolor, collage, airbrush, computer based, acrylic, mixed media and pastel. Send query letter with brochure, tearsheets, photographs, photocopies, photostats, slides and transparencies. Accepts disk submis-

sions compatible with Mac. Samples are filed. Responds only if interested. Will contact for portfolio review if interested. Buys first rights. Pays on publication; $200-400 for color inside; $400-600 for 2-page spreads; $200-300 for spots.

N GULF COAST MEDIA, 886 110th Ave. N., Suite 5, Naples FL 34108. (941)591-3431. Fax: (941)591-3938. **Art Director:** Traci Kiernan. Estab. 1989. Publishes chamber's annuals promoting area tourism as well as books; 4-color and b&w; design varies. Accepts previously published artwork. Originals are returned at job's completion.

Illustration: Works on assignment only; usage of illustration depends on client. Needs editorial illustration, maps and charts. Preferred themes depend on subject; watercolor, collage, airbrush, acrylic, marker, color pencil, mixed media. Send postcard or query letter with tearsheets, photographs and photocopies. Samples are filed. Responds only if interested. Publication will contact artist for portfolio review if interested. Portfolio should include roughs and original/final art. Buys first rights, one-time rights or reprint rights. **Pays on acceptance**; $250 for b&w, $250 for color, cover; $35 for b&w, $250 for color, inside; $50 for color spot art.

Tips: "Our magazine publishing is restricted to contract publications, such as Chamber of Commerce publications, playbills, collateral materials. All of our work is located in Florida, mostly southwest Florida, therefore everything we use will have a local theme."

GULFSHORE LIFE MAGAZINE, 9051 Tamiami Trail N., Suite 202, Naples FL 34108. (941)594-9980. Fax: (941)594-9986. Website: www.gulfshorelife.com. **Contact:** Creative Director. Estab. 1970. "Monthly 4-color magazine emphasizing life-style of southwest Florida for an affluent, sophisticated audience, traditional design." Circ. 30,000. Accepts previously published material. Original artwork returned after publication. Sample copy for $3.95. Art guidelines for SASE with first-class postage.

Illustration: Approached by 15-20 illustrators/year. Buys 1 illustration/issue. Prefers watercolor, collage, airbrush, acrylic, colored pencil, mixed media and pastel. Send postcard sample or query letter with brochure, résumé, tearsheets, photostats and photocopies. Accepts disk submissions compatible with Illustrator or QuarkXPress. Samples not filed are returned by SASE. Responds only if interested. Write to schedule appointment to show a portfolio, which should include thumbnails, printed samples, final/reproduction/ product and tearsheets. Negotiates rights purchased. Buys one-time rights. Pays on publication; $500-1000 for color cover; $100-350 for b&w inside; $150-500 for color inside. $50-150 for spots. Needs technical illustration. Needs freelancers familiar with Illustrator, Photoshop or QuarkXPress.

Design: Needs freelancers for design. Freelance work demands knowledge of Photoshop, QuarkXPress or Illustrator. Send query letter with résumé and tearsheets. Pays by the project or by the hour.

GULFSHORE LIFE'S HOME & CONDO MAGAZINE, 9051 N. Tamiami Trail, Suite 202, Naples FL 34108-2520. (941)594-9980. Fax: (941)594-9986. Website: www.gulfshorelifemag.com. **Art Director:** Tessa Tilden-Smith. "We are southwest Florida's resource for home and design." Published monthly. Circ. 30,000. Accepts previously published artwork. Originals returned at job's completion. Sample copies and art guidelines available.

Illustration: Approached by 40 illustrators/year. Buys 2-3 illustrations and 1 photographic work/issue. Has featured illustrations by Charles Stubbs, Mark James, Jeff Cline, Dale Anderson. Assigns 15% of illustrations to well-known or "name" illustrators; 70% to experienced but not well-known illustrators; 15% to new and emerging illustrators. Works on assignment only. Prefers digital, marker, colored pencil and pastel. Send query letter and price list with brochure, tearsheets and photocopies. "No phone calls please. Welcome illustrations created in Illustrator 5.0, FreeHand or Photoshop. OK to submit on disk." Samples are filed. Responds only if interested. Buys one-time rights. Pays on publication; average pay $350.

Tips: "If an artist will work with us and be sensitive to our constraints, we'll be willing to work with the artist to find a mutually beneficial arrangement. Look through copies of our magazine or call and request a copy before you show your portfolio. Your samples should be geared toward the particular needs and interests of our magazine, and should be in keeping with the unique architecture and environment of southwest Florida."

✓ HABITAT MAGAZINE, 928 Broadway, Suite 1105, New York NY 10010-6008. (212)505-2030. Fax: (212)254-6795. Website: habitatmag.com. **Editor-in-Chief:** Carol Ott. Art Director: Michael Gentile. Estab. 1982. "We are a how-to magazine for cooperative and condominium boards of directors and home owner associations in New York City." Published 11 times a year; 4-color and b&w pages; 4-color cover. Circ. 18,000. Original artwork is returned after publication. Sample copy $5.

Cartoons: Pays $75-125 for b&w.

Illustration: Works on assignment only. Send samples. Samples are filed. Pays $125-150; 4-color.

Tips: "Read our publication, understand the topic. Look at the 'Habitat Hotline' and 'Case Notes' sections."

HADASSAH MAGAZINE, 50 W. 58th St., New York NY 10019. (212)688-0227. Fax: (212)446-9521. E-mail: egoldberg@hadassah.org. Website: www.hadassah.org. **Art Director:** Jodie Rossi. Estab. 1914. Consumer magazine. *Hadassah Magazine* is a monthly magazine chiefly of and for Jewish interests—both here and in Israel. Circ. 340,000.
Cartoons: Buys 3-5 freelance cartoons/year. Preferred themes include the Middle East/Israel, domestic Jewish themes and issues. Send query letter with sample cartoons. Samples are filed or returned by SASE. Buys first rights. Pays $50, b&w; $100, color.
Illustration: Approached by 50 freelance illustrators/year. Works on assignment only. Features humorous, realistic, computer and spot illustration. Prefers themes of health, news, Jewish/family, Israeli issues, holidays. Send postcard sample or query letter with tearsheets. Samples are filed or are returned by SASE. Write for appointment to show portfolio of original/final art, tearsheets and slides. Buys first rights. Pays on publication; $400-600 for color cover; $100-200 for b&w inside; $200-250 for color inside; $75-100 for spots.

HARDWOOD MATTERS, National Hardwood Lumber Association, P.O. Box 34518, Memphis TN 38184-0518. (901)377-1818. Fax: (901)382-6419. Website: www.natlhardwood.org. **Editor:** Tim Bullard. Estab. 1989. Monthly magazine for trade association. Publication covers "forest products industry, government affairs and environmental issues. Audience is forest products members, Congress, natural resource users. Our magazine is pro-resource use, *no preservationist slant* (we fight to be able to use our private property and natural resources)." Accepts previously published artwork. Art guidelines not available.
• This publication buys one cartoon/issue at $20 (b&w). Send query letter with finished cartoons (single, double or multi-panel).
Illustration: Buys 6 illustrations/year. Prefers forestry, environment, legislative, legal themes. Considers pen & ink. Send query letter with résumé, photocopies of pen & ink work. Rights purchased vary according to project. Pays up to $200 for b&w inside.
Tips: "Our publication covers all aspects of the forest industry, and we consider ourselves good stewards of the land and manage our forestlands in a responsible, sustainable way—submissions should follow this guideline."

HARPER'S MAGAZINE, 666 Broadway, 11th Floor, New York NY 10012. (212)614-6500. Fax: (212)228-5889. **Art Director:** Angela Riechers. Estab. 1850. Monthly 4-color literary magazine covering fiction, criticism, essays, social commentary and humor.
Illustration: Approached by 250 illustrators/year. Buys 5-10 illustrations/issue. Has featured illustrations by Steve Brodner, Ralph Steadman, Polly Becker, Edmund Guy, Mark Ulriksen, Victoria Kann, Peter de Seve. Features intelligent concept-oriented illustration. Preferred subjects: literary, artistic, social, fiction-related. Prefers intelligent, original thought and imagery in any media. Assigns 50% of illustrations to well-known or "name" illustrators; 25% to experienced, but not well-known illustrators; 25% to new and emerging illustrators. 10% of freelance illustration demands knowledge of Photoshop. Send nonreturnable samples. Accepts Mac-compatible disk submissions. Samples are filed and are not returned. Will contact artist for portfolio review if interested. Portfolios may be dropped off for review; call first to schedule. Buys first North American serial rights. Pays on publication; $250-300 for b&w inside; $400-1,000 for color inside; $400 for spots. Finds illustrators through samples, annuals, reps, other publications.
Tips: "Intelligence, originality and beauty in execution are what we seek. A wide range of styles is appropriate; what counts most is content."

HEALTHCARE FINANCIAL MANAGEMENT, 2 Westbrook Corp. Center, Suite 700, Westchester IL 60154-5723. (708)531-9600. Fax: (708)531-0032. E-mail: cstachura@hfma.org. Website: www.hfma.org. **Publisher:** Cheryl Stachura. Estab. 1946. Monthly association magazine for chief financial officers in healthcare, managers of patient accounts, healthcare administrators. Circ. 33,220. Sample copies available; art guidelines not available.
Cartoons: Buys 1 cartoon/issue. Prefers single panel, humorous b&w line drawings with gaglines. Send query letter to the publisher with photocopies. Samples are filed or returned. Responds only if interested. Pays on publication.
Illustration: Considers acrylic, airbrush, color washed, colored pencil, marker, mixed media, oil, pastel, watercolor. Send query letter with printed samples, photocopies and tearsheets. Samples are filed. Will contact artist for portfolio review if interested.

HEARTLAND BOATING MAGAZINE, 319 N. 4th St., #650, St. Louis MO 63102. (314)241-4310. Fax: (314)241-4207. Website: www.Heartlandboating.com. **Art Director:** John R. Cassady II. Estab. 1989.

Specialty magazine published 9 times per year devoted to power (cruisers, houseboats) and sail boating enthusiasts throughout middle America. The content is both humorous and informative and reflects "the challenge, joy and excitement of boating on America's inland waterways." Circ. 16,000. Occasionally accepts previously published artwork. Originals are returned at job's completion. Sample copies available for $5. Art guidelines for SASE with first-class postage.

Cartoons: Approached by 10-12 cartoonists/year. Buys cartoons occasionally. Prefers boating; single panel without gaglines. Send query letter with roughs. Samples are filed or returned by SASE. Responds in 2 months. Negotiates rights purchased.

Illustration: Approached by 2-3 illustrators/year. Buys 1-2 illustrations/issue. Works on assignment only. Prefers boating-related themes. Considers pen & ink. Send postcard sample or query letter with SASE, photocopies and tearsheets. Accepts disk submissions compatible with Illustrator 5.0. Send EPS files. Samples are filed or returned by SASE. Responds in 2 months. Portfolio review not required. Negotiates rights purchased. Pays on publication. Pay is negotiated. Finds artists through submissions.

HEARTLAND USA, 100 W. Putnam Ave., Greenwich CT 06830-5342. (203)622-3456. Fax: (203)863-7296. E-mail: husaedit@ustnet.com. **Editor:** Brad Pearson. Creative Director: Elaine Mester. Estab. 1990. Bimonthly 4-color magazine. Audience is composed of blue-collar men with a passion for hunting, fishing and the great outdoors. Circ. 901,000. Accepts previously published artwork. Originals are returned at job's completion. Sample copies for SASE with first-class postage.

Cartoons: Approached by 60 cartoonists/year. Buys 3-6 cartoons/issue. Preferred themes are blue-collar life-style, "simple style, light humor, nothing political or controversial"; single panel, b&w line drawings and washes with or without gagline. Send query letter with roughs. Samples are filed. Responds in 2 weeks. Rights purchased vary according to project. Pays $150 for b&w.

Illustration: Approached by 36 illustrators/year. Buys 2 illustrations/issue. Preferred themes are blue-collar lifestyle. Prefers flexible board. Send query letter with tearsheets. Samples are filed. Responds in 2 weeks. Call for appointment to show portfolio of printed samples, tearsheets and slides. Rights purchased vary according to project. Pays on publication; $150 for b&w or color.

N: HEAVEN BONE, Box 486, Chester NY 10918. (914)469-9018. E-mail: heavenbone@aol.com. **Editor:** Steve Hirsch. Estab. 1987. Annual literary magazine emphasizing poetry, fiction reviews, and essays reflecting spiritual, surrealist and experimental literary concerns. Circ. 2,500. Accepts previously published artwork. Original artwork is returned after publication if requested. Sample copies $10; art guidelines for SASE with first-class postage.

Cartoons: Approached by 5-7 cartoonists/year. Cartoons appearing in magazine are "humorous, spiritual, esoteric, ecologically and politically astute." Pays in 2 copies of magazine, unless other arrangements made.

Illustration: Approached by 25-30 illustrators/year. Buys illustrations mainly for covers and feature spreads. Buys 2-7 illustrations/issue, 4-14/year from freelancers. Considers pen & ink, mixed media, watercolor, acrylic, oil, pastel, collage, markers, charcoal, pencil and calligraphy. Needs computer literate illustrators familiar with Illustrator, QuarkXPress, FreeHand and Photoshop. Send query letter with brochure showing art style, tearsheets, SASE, slides, transparencies, photostats, photocopies and photographs. "Send samples of your most esoteric and nontraditional work, inclusive of but not exclusively literary—be outrageous." Accepts disk submissions compatible with Illustrator 6.0, Photoshop 4.0 or any Mac-compatible format. Samples are returned by SASE. Responds in 6 months. To show a portfolio, mail b&w tearsheets, slides, photostats and photographs. Buys first rights. Pays in 2 copies of magazine.

Tips: "Please see sample issue before sending unsolicited portfolio."

N: HERBALGRAM, P.O. Box 144345, Austin TX 78714-4345. (512)926-4900. Fax: (512)926-2345. E-mail: sbarnes@herbalgram.org. Website: www.herbalgram.org. **Art Director:** Sean Barnes. Estab. 1983. Quarterly journal. "We're a non-commercial education and research journal with a mission to educate the public on the uses of beneficial herbs and plants. Fairly technical. For the general public, pharmacists, educators and medical professions." Circ. 33,000. Accepts previously published artwork. Originals are returned at job's completion.

Cartoons: Buys 3-4 cartoons/year. Prefers medical plant, general plant, plant regulation themes; single panel, political, humorous b&w line drawings with gaglines. Send query letter with brochure or roughs. Samples are filed. Buys one-time rights. Pays $50-100 for b&w.

Illustration: Approached by 20 illustrators/year. Buys 2 illustrations/year. Works on assignment only. Has featured illustrations by Regan Garrett and Michelle Vrentas. Features humorous, realistic and computer illustrations. Assigns 15% of illustrations to experienced, but not well-known illustrators; 85% to new and emerging illustrators. Prefers plant/drug themes. Considers acrylic, mixed media, collage or computer-generated images. 90% of freelance work demands knowledge of PageMaker, Photoshop, Freehand or Illustrator.Send query letter with photographs, tearsheets, photocopies and transparencies. Accepts disk

submissions compatible with PageMaker, QuarkXPress and Illustrator. Samples are filed. Will contact artist for portfolio review if interested. Portfolio should include final art, tearsheets and photocopies. Buys one-time rights. **Pays on acceptance**; $50-200 for b&w inside; $150-700 for color inside; $50-300 for spot illustrations. Finds artists through submissions, word of mouth and *Austin Creative Directory*.
Design: Needs freelancers for production and multimedia. 95% of design demands knowledge of Page-Maker, FreeHand, Photoshop, QuarkXPress or Illustrator. Send query letter with photocopies, photographs or transparencies. Pays $50-300 by project.
Tips: Have a "good knowledge of CMYK process, good knowledge of computer to service bureau process. We are nonprofit, any work donated is tax deductible. Please preview *HerbalGram* before submitting work. To get started, create a beautiful portfolio, create some hypothetical art for a publication or house you admire and use it as a tool to get in. Familiarize yourself with the companies you are soliciting. Try to know what their market and needs are. Send art that is relative to the recipient."

HIGH COUNTRY NEWS, 119 Grand Ave., P.O. Box 1090, Paonia CO 81428-1090. (970)527-4898. Fax: (970)527-4897. E-mail: editor@hcn.org. Website: www.hcn.org. **Editor:** Betsy Marston. Estab. 1970. Biweekly newspaper published by the nonprofit High Country Foundation. High Country News covers environmental, public lands and community issues in the 10 western states. Circ. 22,000. Art guidelines free for SASE with first-class postage.
Cartoons: Buys 1 cartoon/issue. Prefers issues affecting Western environment. Prefers single panel, political, humorous b&w washes and line drawings with or without gagline. Send query letter with finished cartoons and photocopies. "Samples are filed if they're appropriate for us or returned with SASE". Responds only if interested. Rights purchased vary according to project. Pays on publication; $35-100 for b&w. "Prefer attention to detail. Professional quality only."
Illustration: Considers all media if reproducible in b&w. Send query letter with printed samples and photocopies. Accepts disk submissions compatible with QuarkXPress and Photoshop. Samples are filed or returned by SASE. Responds only if interested. Rights purchsed vary according to project. Pays on publication; $50-100 for b&w cover; $35-75 for b&w inside. Finds illustrators through magazines, newspapers and artist's submissions.

✔ **HIGHLIGHTS FOR CHILDREN**, 803 Church St., Honesdale PA 18431. (570)253-1080. Fax: (570)251-7847. Website: www.highlights.com. **Art Director:** Janet Moir McCaffrey. Cartoon Editor: Rich Wallace. Monthly 4-color magazine for ages 2-12. Circ. 3 million. Art guidelines for SASE with first-class postage.
Cartoons: Receives 20 submissions/week. Buys 2-4 cartoons/issue. Interested in upbeat, positive cartoons involving children, family life or animals; single or multiple panel. Send roughs or finished cartoons and SASE. Responds in 6 weeks. Buys all rights. **Pays on acceptance**; $20-40 for line drawings. "One flaw in many submissions is that the concept or vocabulary is too adult, or that the experience necessary for its appreciation is beyond our readers. Frequently, a wordless self-explanatory cartoon is best."
Illustration: Buys 30 illustrations/issue. Works on assignment only. Prefers "realistic and stylized work; upbeat, fun, more graphic than cartoon." Pen & ink, colored pencil, watercolor, marker, cut paper and mixed media are all acceptable. Discourages work in fluorescent colors. Send query letter with photocopies, SASE and tearsheets. Samples to be kept on file. Buys all rights on a work-for-hire basis. **Pays on acceptance**; $1,025 for color front and back covers; $50-600 for color inside. "We are always looking for good hidden pictures. We require a picture that is interesting in itself and has the objects well-hidden. Usually an artist submits pencil sketches. In no case do we pay for any preliminaries to the final hidden pictures."
Tips: "We have a wide variety of needs, so I would prefer to see a representative sample of an illustrator's style."

Ⓝ HISPANIC MAGAZINE, 999 Ponce De Leon Blvd., Suite 600, Coral Gables FL 33134-3037. (305)442-2462. Fax: (305)774-3578. E-mail: minsua@hisp.com. Website: www.hispanicmagazine.com. **Creative Director:** Alberto Insua. Assistant Art Director: Devon Cox. Estab. 1987. Monthly 4-color consumer magazine for Hispanic Americans. Circ. 250,000.
Illustration: Approached by 100 illustrators/year. Buys 5 illustrations/issue. Has featured illustrations by Will Terry, A.J. Garces, Sonia Aguirre. Features caricatures of politicians, humorous illustration, realistic illustrations, charts & graphs, spot illustrations and computer illustration. Prefers business subjects, men and women. Prefers pastel and bright colors. Assigns 80% of illustrations to experienced, but not well-known illustrators; 20% to new and emerging illustrators. Send nonreturnable postcard samples. Accepts Mac-compatible disk submissions. Send EPS or TIFF files. Samples are filed. Responds only if interested. Will contact artist for portfolio review if interested. Buys one-time rights. Pays on publication; $500-1,000 for color cover; $300 maximum for b&w inside; $800 maximum for color inside; $250 for spots.
Tips: "Concept is very important, to take a idea or story and to be able to find a fresh perspective. I like to be surprised by the artist."

ALFRED HITCHCOCK MAGAZINE, 475 Park Ave. S., 11th Floor, New York NY 10016. (212)686-7188. Fax: (212)686-7414. **Senior Art Director:** Victoria Green. Associate Art Director: June Levine. All submissions should be sent to June Levine, associate art director. Estab. 1956. Monthly b&w magazine with 4-color cover emphasizing mystery fiction. Circ. 202,470. Accepts previously published artwork. Original artwork returned at job's completion. Art guidelines available for #10 SASE with first-class postage.
Illustration: Approached by 300 illustrators/year. Buys 8-10 illustrations/issue. Prefers semi-realistic, realistic style. Works on assignment only. Considers pen & ink. Send query letter with printed samples, photocopies and/or tearsheets and SASE. Send follow-up postcard sample every 3 months. Samples are filed or returned by SASE. Responds only if interested. "No phone calls." Portfolios may be dropped off every Tuesday and should include b&w and color tearsheets. "No original art please." Rights purchased vary according to project. **Pays on acceptance**; $1,000-1,200 for color cover; $100 for b&w inside; $35-50 for spots. Finds artists through submissions drop-offs, RSVP.
Tips: "No close-up or montages. Show characters within a background environment."

⟦N⟧ HOME BUSINESS MAGAZINE, PMB 368, 9582 Hamilton, Suite 368, Huntington Beach CA 92646. (714)968-0331. Fax: (714)962-7722. E-mail: henderso@ix.netcom.com. Website: www.homebusinessmag.com. **Contact:** Creative Director. Estab. 1992. Bimonthly consumer magazine. Circ. 84,000. Sample copies free for 10×13 SASE and $2.32 in first-class postage.
Illustration: Approached by 30 illustrators/year. Buys several illustrations/issue. Features natural history illustration, realistic illustrations, charts & graphs, informational graphics, spot illustrations and computer illustration of business subjects, families, men and women. Prefers pastel and bright colors. Assigns 85% of illustrations to well-known or "name" illustrators; 8% to experienced, but not well-known illustrators; 7% to new and emerging illustrators. 100% of freelance illustration demands knowledge of Illustrator and QuarkXPress. Send query letter with printed samples, photocopies and SASE. Send electronically as TIFF files. Samples are filed or returned if requested. Responds only if interested. Will contact artist for portfolio review if interested. Buys reprint rights. Negotiates rights purchased. Pays on publication. Finds illustrators through magazines, word of mouth or via Internet.

HOME EDUCATION MAGAZINE, P.O. Box 1083, Tonasket WA 98855. (509)486-1351. Fax: (509)486-2753. E-mail: hem-editor@home-ed-magazine.com. Website: www.home-ed-magazine.com. **Managing Editor:** Helen Hegener. Estab. 1983. "We publish one of the largest magazines available for homeschooling families." Desktop bimonthly published in 2-color; b&w with 4-color cover. Circ. 12,500. Original artwork is returned after publication upon request. Sample copy $6. Art guidelines for SASE with first-class postage.
Cartoons: Approached by 20-30 cartoonists/year. Buys 1-2/year. Style preferred is open, but theme must relate to home schooling. Prefers single, double or multiple panel b&w line drawings and washes with or without gagline. Send query letter with samples of style, roughs and finished cartoons, "any format is fine with us." Samples are filed or returned by SASE. Responds in 3 weeks. Buys reprint rights, one-time rights or negotiates rights purchased. **Pays on acceptance**; $10-20 for b&w.
Illustration: Approached by 100 illustrators/year. Buys illustrations mainly for spots and feature spreads. Considers pen & ink, mixed media, markers, charcoal pencil or any good sharp b&w or color media. Send postcard sample or query letter with brochure, résumé, slides, transparencies, tearsheets, photocopies or photographs. Accepts disk submissions. "We're looking for originality, clarity, warmth. Children, families and parent-child situations are what we need." Samples are filed or are returned by SASE. Will contact for portfolio review if interested. Buys one-time rights, reprint rights or negotiates rights purchased. **Pays on acceptance**; $50 for color cover; $10-50 for color inside; $5-20 for spots. Finds artists primarily through submissions and self-promotions.
Design: Needs freelancers for design. 100% of freelance work demands knowledge of Photoshop or QuarkXPress. Send query letter with any samples. Pays by project.
Tips: "Most of our artwork is produced by staff artists. We receive very few good cartoons. Study what we've done, suggest how we might improve it."

☑ HOME FURNISHINGS RETAILER, 305 W. High Ave., #400, High Point NC 27260. (336)801-6152. Fax: (336)801-6102. E-mail: mpierce@nhfa.org. **Director of Communications:** Mike Pierce. Art Director: Brooke McMurray. Estab. 1927. Monthly trade journal "of the National Home Furnishings Association. We provide in-depth coverage of trend, operational, marketing and advertising issues of interest to furniture retailers."
Illustration: Approached by 1-5 illustrators/issue. Has featured illustrations by Charles Stubbs. Features humorous and realistic illustration, charts & graphs, informational graphics and computer and spot illustration. Prefers furniture, consumers, human resources and merchandising. Considers all media. Send postcard sample or printed samples, photocopies and SASE. Accepts disk submissions. "We accept submissions

compatible with QuarkXPress. Send EPS or TIFF files." Samples are filed or are returned by SASE. Responds only if interested. Art director will contact artist for portfolio review, b&w, color, final art and tearsheets if interested. Rights purchased vary according to project. Pays on publication. Finds illustrators through submissions.

Tips: "We are only interested in work of relevance to home furnishings retailers. Do not call, send queries. Postcards showing work are great reminders of artists' work. Get samples of the magazine and read them. Submissions must be pertinent to our readers. We are a small trade publication—this means we have small art/photo budget."

HOPSCOTCH, The Magazine for Girls, Box 164, Bluffton OH 45817. (419)358-4610. Fax: (419)358-5027. Website: www.hopscotchmagazine.com. **Contact:** Marilyn Edwards. Estab. 1989. A bimonthly magazine for girls between the ages of 6 and 12; 2-color with 4-color cover; 52 pp.; 7×9 saddle-stapled. Circ. 15,000. Original artwork returned at job's completion. Sample copies available for $3. Art guidelines for SASE with first-class postage. 20% of freelance work demands computer skills.
 ● Also publishes *Boys' Quest*, www.boysquest.com.
Illustration: Approached by 200-300 illustrators/year. Buys 6-7 freelance illustrations/issue. Has featured illustrations by Chris Sabatino, Pamela Harden and Donna Catanese. Features humorous, realistic and spot illustration. Assigns 60% of illustrations to experienced, but not well-known illustrators; 40% to new and emerging illustrators. Artists work mostly on assignment. Needs story illustration. Prefers traditional and humor; pen & ink. Send query letter with photocopies of pen & ink samples. Samples are filed. Responds in 2 months. Buys first rights and reprint rights. **Pays on acceptance**; $200-250 for color cover; $25-35 for b&w inside; $50-70 for 2-page spreads; $10-25 for spots.
Tips: "Read our magazine. Send a few samples of work in pen and ink. Everything revolves around a theme. Our theme list is available with SASE."

HORSE ILLUSTRATED, P.O. Box 6050, Mission Viejo CA 92690. (949)855-8822. E-mail: horseillustrated@fancypubs.com. Website: www.horseillustratedmagazine.com. **Managing Editor:** Karen Keb Acevedo. Editor: Moira C. Harris. Estab. 1976. Monthly consumer magazine providing "information for responsible horse owners." Circ. 220,000. Originals are returned after job's completion. Art guidelines free for SASE with first-class postage.
Cartoons: Approached by 200 cartoonists/year. Buys 1 or 2 cartoons/issue. Prefers satire on horse ownership ("without the trite clichés"); single panel b&w line drawings with gagline. Send query letter with brochure, roughs and finished cartoons. Samples are not filed and are returned by SASE. Responds in 6 weeks. Buys first rights and one-time rights. Pays $40 for b&w.
Illustration: Approached by 60 illustrators/year. Buys 1 illustration/issue. Prefers realistic, mature line art, pen & ink spot illustrations of horses. Assigns 30% of illustrations to well-known or name illustrators; 60% to experienced, but not well-known illustrators; 10% to new and emerging illustrators. Considers pen & ink. Send query letter with SASE and photographs. Samples are not filed and are returned by SASE. Responds in 6 weeks. Portfolio review not required. Buys first rights or one-time rights. Pays on publication. Finds artists through submissions.
Tips: "We only use spot illustrations for breed directory and classified sections. We do not use much, but if your artwork is within our guidelines, we usually do repeat business. *Horse Illustrated* needs illustrators who know equine anatomy, as well as human anatomy with insight into the horse world."

Ⓝ HOUSE BEAUTIFUL, 1700 Broadway, 29th Floor, New York NY 10019. (212)903-5233. Fax: (212)765-8292. Website: www.housebeautiful.com. **Art Director:** Howard Greenberg. Estab. 1896. Monthly consumer magazine. *House Beautiful* is a magazine about interior decorating—emphasis is on classic and contemporary trends in decorating, architecture and gardening. The magazine is aimed at both the professional and non-professional interior decorator. Circ. 1.3 million. Originals returned at job's completion. Sample copies available.
Illustration: Approached by 75-100 illustrators/year. Buys 2-3 illustrations/issue. Works on assignment only. Prefers contemporary, conceptual, interesting use of media and styles. Considers all media. Send postcard-size sample. Samples are filed only if interested and are not returned. Portfolios may be dropped off every Monday-Friday. Publication will contact artist for portfolio review of final art, photographs, slides, tearsheets and good quality photocopies if interested. Buys one-time rights. Pays on publication; $600-700 for color inside; $600-700 for spots (99% of illustrations are done as spots).
Tips: "We find most of our artists through artist submissions of either portfolios or postcards. Sometimes we will contact an artist whose work we have seen in another publication. Some of our artists are found through artist reps and annuals."

HOUSE CALLS, Gulfstream Communications, P.O. Box 1794, Mt. Pleasant SC 29465. (843)971-9811. Fax: (843)971-0121. E-mail: gulfstream@awod.com. **Art Director:** Melinda Smith Monk. Quarterly controlled-circulation magazine from CareAlliance Health Services (several hospitals). "A fun and informative medical magazine." Circ. 80,000. Art guidelines for #10 SASE.

Illustration: Approached by 100 illustrators/year. Buys 35-60 illustrations/issue. Has featured illustrations by Paige Johnson, Melanie Freedman and Chris Curro. Features computer, humorous, medical and spot illustration and informational graphics—fun and colorful. Preferred subjects: children, families, men and women, teens. Considers all types of color schemes, styles and/or media. Assigns 35% of illustrations to experienced, but not well-known illustrators; 30% to well-known or "name" illustrators; 25% to new and emerging illustrators. 50% of freelance illustration demands knowledge of Illustrator, Photoshop, FreeHand, QuarkXPress and drawing or painting. Send postcard sample and follow-up postcard every month. Please send only non-returnable samples. Accepts Mac-compatible disk submissions. Samples are filed. Will contact artist for portfolio review if interested. Buys first rights or one-time rights; rights purchased vary according to project. Pays on publication, $65-850 for b&w and color inside; $450-2,000 for 2-page color spreads. Finds illustrators through sourcebooks, promotional samples and word of mouth.

Tips: "We like fun illustrations that will help draw the reader into the story. Although we're a medical magazine, we strive to be interesting and informative—never stuffy."

HOW, Design Ideas at Work, 4700 E. Galbraith Rd., Cincinnati OH 45236. E-mail: triciab@fwpubs.com. Website: www.howdesign.com. **Art Director:** Tricia Barlow. Estab. 1985. Bimonthly trade journal covering "how-to and business techniques for graphic design professionals." Circ. 40,000. Original artwork returned at job's completion. Sample copy $8.50.

• Sponsors annual conference for graphic artists. Send SASE for more information.

Illustration: Approached by 100 illustrators/year. Buys 4-8 illustrations/issue. Works on assignment only. Considers all media, including photography and computer illustration. Send nonreturnable samples. Accepts disk submissions. Responds only if interested. Buys first rights or reprint rights. Pays on publication; $350-1,000 for color inside.

Tips: "Send good samples that apply to the work I use. Be patient, art directors get a lot of samples."

HR MAGAZINE, 1800 Duke St., Alexandria VA 22314. (703)548-3440. Fax: (703)548-9140. E-mail: eabsher@shrm.org. Website: www.shrm.org. **Art Director:** Eva Absher. Estab. 1948. Monthly trade journal dedicated to the field of human resource management. Circ. 165,000.

Illustration: Approached by 70 illustrators/year. Buys 6-8 illustrations/issue. Prefers people, management and stylized art. Considers all media. Send query letter with printed samples. Accepts disk submissions. Illustrations can be attached to e-mails. *HR Magazine* is Macintosh based. Samples are filed. Art director will contact artist for portfolio review if interested. Rights purchased vary according to project. Requires artist to send invoice. Pays within 30 days. Pays $700-2,500 for color cover; $200-1,800 for color inside. Finds illustrators through sourcebooks, magazines, word of mouth and artist's submissions.

HUMPTY DUMPTY'S MAGAZINE, Children's Better Health Institute, Box 567, Indianapolis IN 46206. (317)636-8881. Fax: (317)684-8094. Website: www.humptydumptymag.org. **Art Director:** Rob Falco. A health-oriented children's magazine for ages 4-7; 4-color; simple and direct design. Published 8 times/year. Circ. 264,000. Originals are not returned at job's completion. Sample copies available for $1.25; art guidelines for SASE with first-class postage.

• Also publishes *Child Life, Children's Digest, Children's Playmate, Jack and Jill, Turtle Magazine* and *U.S. Kids, A Weekly Reader Magazine*.

Illustration: Approached by 300-400 illustrators/year. Buys 10-15 illustrations/issue. Has featured illustrations by John Nez, Kathryn Mitter, Alan MacBain, David Helton and Patti Goodnow. Features humorous, realistic, medical, computer and spot illustration. Assigns 90% of illustrations to experienced, but not well-known illustrators; 10% to new and emerging illustrators. Works on assignment only. Preferred styles are mostly cartoon and some realism. Considers any media as long as finish is done on scannable (bendable) surface. Send query letter with photocopies, tearsheets and SASE. Samples are filed and are not returned. Responds only if interested. To show a portfolio, mail color tearsheets, digital files (Mac), photostats, photographs and photocopies. Buys all rights. Pays on publication; $275 for color cover; $35-90 for b&w inside; $70-155 for color inside; $210-310 for 2-page spreads; $35-80 for spots; additional payment for digital pre-separated imagery: $35 full; $15 half; $10 spot.

Tips: "Please review our publications to see if your style is a match for our needs. Then you may send us very consistent styles of your abilities, along with a comment card and SASE for return."

HURRICANE ALICE: A FEMINIST QUARTERLY, Rhode Island College, Dept. of English, Providence RI 02908. (401)456-8377. Fax: (401)456-8379. E-mail: mreddy@ric.edu. **Submissions Manager:**

Joan Dagle. Estab. 1983. Quarterly literary magazine featuring nonfiction, fiction, poetry, reviews and artwork reflecting the diversity of women's lives. Sample copies for $2.50. Art guidelines for SASE with first-class postage.

Cartoons: Prefers woman-centered/feminist themes. Send query letter with photocopies. Samples are filed and returned by SASE when appropriate. Responds in 4 months. Pays in copies.

Illustration: Approached by 30 illustrators/year. Accepts 4-8 illustrations/issue. Has featured illustrations by Abigail Test, Kate Duhamel and Shawn Boyle. Prefers woman-centered/feminist themes. Considers all media. Send printed samples or photocopies and SASE when appropriate. Accepts disk submissions compatible with QuarkXPress 7.5/version 3.3, send EPS files, "but prefers photocopies." Samples are filed or returned by SASE if requested. Responds in 4 months. Pays in copies. Finds illustrators through word of mouth, submissions and previous contributors.

HUSTLER'S BARELY LEGAL, 8484 Wilshire Blvd., Suite 900, Beverly Hills CA 90211. (323)651-5400. **Art Director:** Jackie Osbeek. Estab. 1993. Monthy magazine "which contains fiction and nonfiction; sometimes serious, often humorous. Sex is the main topic but any sensational subject is possible." Circ. 90,000. Originals returned at job's completion. Sample copies available for $6.

Illustration: Approached by 15 illustrators/year. Buys 2 illustrations/issue. Works on assignment only. Prefers sex/eroticism as themes. Considers all media. Send query letter with tearsheets, photographs and photocopies. Samples are filed. Artist should follow up with call and/or letter after initial query. Publication will contact artist for portfolio review if interested. Porfolio should include b&w and color slides and final art. Buys all rights. **Pays on acceptance**; $500 for full page color inside. Finds artists through word of mouth, mailers and submissions.

Tips: "We use artists from all over the country, with diverse styles, from realistic to abstract. Must be able to deal with adult subject matter and have no reservations concerning explicit sexual images. We want to show these subjects in new and interesting ways."

N HUSTLER'S LEG WORLD, 8484 Wilshire Blvd., Suite 900, Beverly Hills CA 90211. (323)651-5400. **Art Director:** Usen Gandara. Estab. 1997. Monthy magazine "which contains fiction and nonfiction; sometimes serious, often humorous. Sex is the main topic but any sensational subject is possible." Circ. 90,000. Originals returned at job's completion. Sample copies available for $6.

Illustration: Approached by 15 illustrators/year. Buys 2 illustrations/issue. Works on assignment only. Prefers foot and leg fetishes as themes. Considers all media. Send query letter with tearsheets, photographs and photocopies. Samples are filed. Artist should follow up with call and/or letter after initial query. Publication will contact artist for portfolio review if interested. Porfolio should include b&w and color slides and final art. Buys all rights. **Pays on acceptance**; $500 for full page color inside. Finds artists through word of mouth, mailers and submissions.

Tips: "We use artists from all over the country, with diverse styles, from realistic to abstract. Must be able to deal with adult subject matter and have no reservations concerning explicit sexual images. We want to show these subjects in new and interesting ways."

HX MAGAZINE, 230 W. 17th St., 8th Floor, New York NY 10011. (212)352-3535. E-mail: hx@hx.com. Website: www.hx.com. **Art Director:** Chris Hawkins. Weekly magazine "covering gay and lesbian general interest, entertainment and nightlife in New York City." Circ. 40,000.

Cartoons: Approached by 5 cartoonists/year. Buys 1 cartoon/issue. Prefers gay and/or lesbian themes. Prefers multiple panel, humorous b&w line drawings with gagline. Send query letter with photocopies. Samples are filed and are not returned. Responds only if interested. Rights purchased vary according to project. Pays on publication. Payment varies.

Illustration: Approached by 10 illustrators/year. Number of illustrations purchased/issue varies. Prefers gay and/or lesbian themes. Considers all media. Send query letter with photocopies. Samples are filed and are not returned. Responds only if interested. Art director will contact artist for portfolio review of b&w and color if interested. Rights purchased vary according to project. Pays on publication. Finds illustrators through submissions.

Tips: "Read and be familiar with our magazine. Our style is very specific."

IDEALS MAGAZINE, a division of Guideposts, 535 Metroplex Dr., Suite 250, Nashville TN 37211. (615)333-0478. Fax: (615)781-1447. Website: www.idealspublications.com. **Editor:** Michelle Burke. Art Director: Eve DeGrie. Estab. 1944. 4-color bimonthly seasonal general interest magazine featuring poetry and family articles. Circ. 200,000. Accepts previously published material. Sample copy $4. Art guidelines free with #10 SASE with first-class postage.

Illustration: Approached by 100 freelancers/year. Buys 8 illustrations/issue. Features realistic and spot illustration of children, families and pets. Uses freelancers mainly for flowers, plant life, wildlife, realistic people illustrations and botanical (flower) spot art. Prefers seasonal themes. Prefers watercolors. Assigns

90% of illustrations to experienced, but not well-known illustrators; 10% to new and emerging illustrators. "We are not interested in computer generated art. Must *look* as hand-drawn as possible." Send nonreturnable samples or tearsheets. Samples are filed. Responds only if interested. Do not send originals. Prefers to buy artwork outright. Pays on publication; pay negotiable.

Tips: "In submissions, target our needs as far as style is concerned, but show representative subject matter. Artists should be familiar with our magazine before submitting samples of work."

IEEE SPECTRUM, 3 Park Ave., 17th Floor, New York NY 10016-5902. (212)419-7555. Fax: (212)419-7570. Website: www.spectrum.ieee.org. **Art Director:** Mark Montgomery. Estab. 1963. Monthly nonprofit trade magazine serving electrical and electronics engineers worldwide. Circ. 320,000.

Illustration: Buys 3 illustrations/issue. Has featured illustrations by John Hersey, J.D. King, Rob Magieri, Octavio Diaz, Dan Vasconcellos, M.E. Cohen, John Howard. Features natural history; realistic illustration; charts & graphs; informational graphics; medical, computer and spot illustration. Assigns 50% of illustrations to well-known or "name" illustrators; 25% to experienced, but not well-known illustrators; 25% to new and emerging illustrators. Considers all media. 50% of illustration demands knowledge of Photoshop and Illustrator. Send postcard sample or query letter with printed samples and tearsheets. Accepts disk submissions: 3.5 Mac disk; file compressed with STUFFIT. Send RGB, TIFF or EPS files. Samples are filed and are not returned. Responds only if interested. Art director will contact artist for portfolio review if interested. Portfolio should include color, final art and tearsheets. Buys first rights and one year's use on website. **Pays on acceptance**; $1,800 minimum for cover, negotiable if artwork is highly complex; $450 minimum for inside. Finds illustrators through Graphic Artist Guild book, *American Showcase*, *Workbook*.

Design: Needs freelancers for design and multimedia. Local design freelancers only. 100% of freelance work demands knowledge of Photoshop, Illustrator, QuarkXPress and Quark Publishing System. Send query letter with tearsheets.

Tips: "As our subject matter is varied, *Spectrum* uses a variety of illustrators. Read our magazine before sending samples. Prefer realism due to scientific subject matter."

IMPACT WEEKLY, 322 S. Patterson Blvd., Dayton OH 45202. (937)222-8855. Fax: (937)222-6113. E-mail: contactus@impactweekly.com. **Design Coordinator:** Suji Allen. Estab. 1993. Alternative weekly focusing on local news, arts and culture, and music. 50,000 readership. Circ. 25,000. Sample copies free for 8×10 SAE and 5 first-class stamps. Art guidelines are free for #10 SAE with first-class postage.

Illustration: Approached by 25 illustrators/year. Buys 30 illustrations/issue. Has featured illustrations by T.S. Hart and Steven Verriest. Features caricatures of celebrities, politicians; computer illustration; humorous, realistic and spot illustration. Preferred subjects: As needed for editorial assignments with strong concepts. Assigns 10% of illustrations to well-known or "name" illustrators; 60% to experienced, but not well-known illustrators; 30% to new and emerging illustrators. 50% of freelance illustration demands knowledge of Illustrator, Photoshop, QuarkXPress, and have scanning skills. Send postcard sample and follow-up postcard every 6 months. Send nonreturnable samples. Accepts Mac-compatible disk submissions. Samples are filed. Responds only if interested. Buys first rights, reprint rights. Negotiates rights purchased. Pays $75-150 for color cover; $35 for b&w inside; $35 for color inside; $35 for spots. Finds illustrators through readers, word-of-mouth, promos from artists.

Tips: "We're looking for freelancers with hip, edgy styles. Ability to meet or exceed deadlines is a *MUST*. Wired artists preferred. Strong conceptual skills required."

IN TOUCH FOR MEN, 13122 Saticoy St., North Hollywood CA 91605-3402. (818)764-2288. Fax: (818)764-2307. E-mail: alan@intouchformen.com. Website: http:/www.intouchformen.com. **Editor:** Michael Jimenez. Art Director: Glen Bassett. Estab. 1973. "*In Touch* is a monthly erotic magazine for gay men that explores all aspects of the gay community (sex, art, music, film, etc.)." Circ. 60,000. Accepts previously published work (very seldom). Originals returned after job's completion. Sample copies available. Art guidelines for SASE with first-class postage. Needs computer-literate freelancers for illustration.

● This magazine is open to working with illustrators who create work on computers and transfer it via modem. Final art must be saved in a Macintosh-readable format.

Cartoons: Approached by 10 cartoonists/year. Buys 1-2 cartoons/issue. Prefers humorous, gay lifestyle related (not necessarily sexually explicit in nature); single and multiple panel b&w washes and line drawings with gagline. Send query letter with finished cartoons. Samples are filed. Responds in 1 month. Buys one-time rights. Pays $50 for b&w, $100 for color.

Illustration: Approached by 10 illustrators/year. Buys 3-5 illustrations/issue. Assigns 95% of illustrations to well-known or "name" illustrators; 5% to new and emerging illustrators. Works on assignment only. Prefers open-minded, lighthearted style. Considers all types. Send query letter with photocopies and SASE.

Accepts disk submissions. Samples are filed. Responds in 2 weeks. Will contact for portfolio review if interested. Portfolio should include b&w and color final art. Rights vary. **Pays on acceptance**; $35-75 for b&w inside, $100 for color inside.

Tips: "Most artists in this genre will contact us directly, but we get some through word-of-mouth, and occasionally we will look up an artist whose work we've seen and interests us. Areas most open to freelancers are 4-color illustrations for erotic fiction stories, humorous illustrations and stand-alone comic strips/panels depicting segments of gay lifestyle. Querying is like applying for a job because artwork is commissioned. Review our publication and submit samples that suit our needs. It's pointless to send your best work if it doesn't look like what we use. Understanding of gay community and lifestyle a plus."

▓ THE INDEPENDENT WEEKLY, P.O. Box 2690, Durham NC 27715. (919)286-1972. Fax: (919)286-4274. E-mail: liz@indyweek.com. Website: www.indyweek.com. **Art Director:** Liz Holm. Estab. 1982. Weekly b&w with 4-color cover tabloid; general interest alternative. Circ. 50,000. Original artwork is returned if requested. Sample copies and art guidelines for SASE with first-class postage.

Illustration: Buys 10-15 illustrations/year. Prefers local (southeastern) illustrators. Has featured illustrations by Shelton Bryant, V. Cullum Rogers, David Terry. Works on assignment only. Considers pen & ink; b&w, computer generated art and color. Samples are filed or are returned by SASE if requested. Responds only if interested. Call for appointment to show portfolio or mail b&w tearsheets. Pays on publication; $100-250 for cover; $50 for b&w inside and spots.

Tips: "Have a political and alternative 'point of view.' Understand the peculiarities of newsprint. Be easy to work with and no prima donnas."

Ⓝ INFORMATION WEEK, CMP Media, 600 Community Dr., Manhasset NY 11030. (516)562-5000. Fax: (516)562-5036. E-mail: rbundi@cmp.com. Website: www.informationweek.com. **Art Director:** Mary Ellen Forte. Weekly 4-color trade publication for business and technology managers, combining business and technology issues. Circ. 400,000.

● CMP Media publishes more than 40 magazines.

Illustration: Approached by 200 illustrators/year. Buys 400 illustrations/year. Has featured illustrations by David Peters, Bill Mayer, Rapheal Lopez, Matsu, D.S. Stevens, Wendy Grossman. Features computer, humorous, realistic and spot illustrations of business subjects. Prefers many different media, styles. Assigns 33% of illustrations to well-known or "name" illustrators; 33% to experienced, but not well-known illustrators; 33% to new and emerging illustrators. 30% of freelance illustration demands knowledge of Illustrator, Photoshop. Send postcard sample or query letter with nonreturnable printed samples, tearsheets. Send follow-up postcard every 6 months. Accepts Mac-compatible disk submissions. Send EPS files. Samples are filed. Will contact artist for portfolio review if interested. Buys first rights, reprint rights or rights vary according to project. Pays on publication; $700-1,200 for color cover; $500-1,000 for color inside; $800-1,500 for 2-page spreads; $300 for spots. Finds illustrators through mailers, sourcebooks: *Showcase, Work Book, The Alternative Pick, Black Book, New Media Showcase*.

Tips: "We look for a variety of styles and media. To illustrate, sometimes very abstract concepts. Quick turnaround is very important for a weekly magazine."

INGRAMS MAGAZINE, 306 E. 12th, #1014, Kansas City MO 64106. (816)842-9994. Fax: (816)474-1111. E-mail: editorial@ingramsonline.com. Website: www.ingramsonline.com. **Contact:** Rob McLain. Monthly magazine covering business. Circ. 25,000. Sample copies free for #10 SASE with first-class postage; art guidelines not available.

Illustration: Buys 2 illustrations/issue. Features realistic illustration; charts & graphs and computer and spot illustration. Assigns 20% of illustrations to experienced, but not well-known illustrators; 80% to new and emerging illustrators. Considers all media. 50% of freelance illustration demands knowledge of Photoshop and QuarkXPress. Send query letter with printed samples. Samples are filed. Responds only if interested. Art director will contact artist for portfolio review of b&w and color photographs and tearsheets if interested. Rights purchased vary according to project. Pays $50-75 for b&w inside; $50-150 for color inside; $100-200 for 2-page spreads; $50-150 for spots. Finds illustrators through magazines and artist's submissions.

Tips: "Look through our magazine. If you're interested, send some samples or give me a call."

INSIDE, 2100 Arch St., Philadelphia PA 19103. (215)832-0745. **Editor:** Robert Leiter. Managing Editor: Martha Ledger. Estab. 1979. Quarterly. Circ. 60,000. Accepts previously published artwork. Interested in buying second rights (reprint rights) to previously published work. Original artwork returned after publication.

Illustration: Buys several illustrations/issue from freelancers. Has featured illustrations by: Sam Maitin, David Noyes, Robert Grossman. Assigns 25% of illustrations to well-known or "name" illustrators; 50% to experienced, but not well-known illustrators; 25% to new and emerging illustrators. Prefers color and

b&w drawings. Works on assignment only. Send samples and tearsheets to be kept on file. Samples not kept on file are not returned. Call for appointment to show portfolio. Responds only if interested. Buys first rights. Pays on publication; minimum $500 for color cover; minimum $250 for b&w and color inside. Prefers to see sketches.

Tips: Finds artists through artists' promotional pieces, attending art exhibitions, artists' requests to show portfolio. "We like illustrations that are bold, edgy and hip. We are currently redesigning the magazine for a younger market (25-40 year olds)."

ISLANDS, Dept. AM, 6309 Carpinteria Ave., Carpenteria CA 93140-4728. (805)745-7100. Fax: (805)745-7102. **Art Director:** Albert Chiang. Estab. 1981. Bimonthly magazine of "international travel exclusively about islands." 4-color with contemporary design. Circ. 225,000. Original artwork returned after publication. Sample copies available. Art guidelines for SASE with first-class postage. 100% of freelance work demands knowledge of QuarkXPress, FreeHand, Illustrator and Photoshop.

Illustration: Approached by 20-30 illustrators/year. Buys 3-4 illustrations/issue. Needs editorial illustration. No theme or style preferred. Considers all media. Send query letter with brochure, tearsheets, photographs and slides. "We prefer samples of previously published tearsheets." Samples are filed. Responds only if interested. Write for appointment to show portfolio or mail printed samples and color tearsheets. Buys first rights or one-time rights. **Pays on acceptance**; $500-750 for color cover; $100-400 per image inside.

Tips: A common mistake freelancers make is that "they show too much, not focused enough. Specialize!" Notices "no real stylistic trends, but desktop publishing is affecting everything in terms of how a magazine is produced."

JACK AND JILL, Children's Better Health Institute, Dept. AGDM, 1100 Waterway Blvd., Box 567, Indianapolis IN 46202. (317)636-8881. Fax: (317)684-8094. E-mail: danny885@aol.com. Website: www.ja ckandjillmag.org. **Art Director:** Mark Leslie. Emphasizes educational and entertaining articles focusing on health and fitness as well as developing the reading skills of the reader. For ages 7-10. Monthly except bimonthly January/February, April/May, July/August and October/November. Circ. 200,000. Magazine is 36 pages, 30 pages 4-color and 6 pages b&w. The editorial content is 50% artwork. Buys all rights. Original artwork not returned after publication (except in case where artist wishes to exhibit the art; art must be available to us on request). Sample copy $1.25; art guidelines for SASE with first-class postage.

• Also publishes *Child Life*, *Children's Digest*, *Children's Playmate*, *Humpty Dumpty's Magazine* and *Turtle*.

Illustration: Approached by more than 100 illustrators/year. Buys 25 illustrations/issue. Has featured illustrations by Alan MacBain, Phyllis Pollema-Cahill, George Sears and Mary Kurnick Maacs. Features humorous, realistic, medical, computer and spot illustration. Assigns 15% of illustrations to well-known or "name" illustrators; 70% to experienced, but not well-known illustrators; 15% to new and emerging illustrators. Uses freelance artists mainly for cover art, story illustrations and activity pages. Interested in "stylized, realistic, humorous illustrations for mystery, adventure, science fiction, historical and also nature and health subjects. Works on assignment only. "Freelancers can work in FreeHand, Photoshop or Quark programs." Send postcard sample to be kept on file. Accepts disk submissions. Publication will contact artist for portfolio review if interested. Portfolio should include printed samples, tearsheets, b&w and 2-color pre-separated art. Pays $275-335 for color cover; $90 maximum for b&w inside; $155-190 for color inside; $310-380 for 2-page spreads; $35-80 for spots. Company pays higher rates to artists who can provide color-separated art. Buys all rights on a work-for-hire basis. On publication date, each contributor is sent several copies of the issue containing his or her work. Finds artists through artists' submissions and self-promotion pieces.

Tips: Portfolio should include "illustrations composed in a situation or storytelling way, to enhance the text matter. Send samples of published story for which you did illustration work, samples of puzzles, hidden pictures, mazes and self-promotion art. Art should appeal to children first. Artwork should reflect the artist's skill regardless of techniques used. Fresh, inventive colors and characters a strong point. Research publications to find ones that produce the kind of work you can produce. Send several samples (published as well as self-promotion art). The style can vary if there is a consistent quality in the work."

JACKSONVILLE, 1032 Hendricks Ave., Jacksonville FL 32207. (904)396-8666. E-mail: info@jacksonvil lemag.com. Website: www.jacksonvillemag.com. **Creative Director:** Bronie Massey. Estab. 1983. City/ regional lifestyle magazine covering Florida's First Coast. 12 times/yearly with 3 supplements. Circ. 25,000. Originals returned at job's completion. Sample copies available for $5 (includes postage).

Illustration: Approached by 50 illustrators/year. Buys 1 illustration every other issue. Has featured illustrations by Robert McMullen, Jennifer Kalis and Liz Burns. Assigns 75% of illustrations to experienced but not well-known illustrators; 25% to new and emerging illustrators. Prefers editorial illustration with topical themes and sophisticated style. Send tearsheets. Will accept computer-generated illustrations compatible

with Macintosh programs: Illustrator and Photoshop. Samples are filed and are returned by SASE if requested. Publication will contact artist for portfolio review if interested. Portfolio should include b&w and color tearsheets and slides. Buys one-time rights. Pays on publication; $600 for color cover; $150-400 for inside depending on scope.

JAPANOPHILE, P.O. Box 7977, 415 N. Main St., Ann Arbor MI 48107. (734)930-1553. Fax: (734)930-9968. E-mail: japanophile@aol.com. Website: www.Japanophile.com. **Editor and Publisher:** Susan Aitken. Associate Editors: Madeleine Vala and Jason Bredle. Quarterly emphasizing bonsai, haiku, sports, cultural events, etc. for educated audience interested in Japanese culture. Circ. 1,000. Accepts previously published material. Original artwork returned at job's completion. Sample copy $4; art guidelines for SASE.

Cartoons: Approached by 7-8 cartoonists/year. Buys 1 cartoon/issue. Prefers single panel b&w line drawings with gagline. Send finished cartoons. Material returned only if requested. Responds only if interested. Buys first-time rights. Pays on publication; $20-50 for b&w.

Illustration: Buys 1-5 illustrations/issue. Has featured illustrations by Bob Rogers. Assigns 50% of illustrations to experienced but not well-known illustrators; 50% to new and emerging illustrators. Needs humorous editorial illustration. "Will publish 2-color designs, especially for cover." Prefers sumie or line drawings. Send postcard sample to be kept on file if interested. Samples returned only if requested with SASE. Responds only if interested. Buys first-time rights. Pays on publication; $20-50 for b&w cover, b&w inside and spots.

Design: Needs freelancers for design. Send query letter with brochure, photocopies, SASE, résumé. Pays by the project, $20-50.

Tips: Would like cartoon series on American foibles when confronted with Japanese culture. "Read the magazine. Tell us what you think it needs. Material that displays a unique insight into Japanese-American cultural relations draws our attention. We have redesigned our magazine and format and are looking for artists who can help us continue to improve our look."

N. JAZZIZ, 2650 N. Military Trail, Suite 140, Boca Raton FL 33431-6339. (561)893-6868. Fax: (561)893-6867. E-mail: mail@jazziz.com. Website: www.jazziz.com. **Art Director:** David Hogerty. Estab. 1982. Monthly magazine covering "all aspects of adult-oriented music with emphasis on instrumental and improvisatory styles: jazz, blues, classical, world beat, sophisticated pop; as well as audio and video." Circ. 120,000. Originals returned at job's completion with four sheets. Art guidelines available for SASE with first class postage.

Illustration: Approached by 100-200 illustrators/year. Buys 1-3 illustrations/issue. Works on assignment only. Send query letter with résumé, tearsheets and samples. Samples are filed or returned by SASE only if requested. Responds only if interested. Buys first North American serial rights.

Tips: "The old advice is the best advice. Be familiar with the magazine before querying."

JEMS, Journal of Emergency Medical Services, 1947 Camino Vida Roble, Suite 200, Carlsbad CA 92008. (800)266-5367. E-mail: keri.losavio@jems.com. Website: www.jems.com. **Editorial Director:** Lisa Dionne. Senior Editor: Keri Losavio. Estab. 1980. Monthly trade journal aimed at paramedics/paramedic instructors. Circ. 45,000. Accepts previously published artwork. Originals returned at job's completion. Sample copies available. Art guidelines for SASE. 95% of freelance work demands knowledge of QuarkXPress, Illustrator and Photoshop.

Illustration: Approached by 240 illustrators/year. Has featured illustrations by Brook Wainwright, Chris Murphy and Shayne Davidson. Buys 2-6 illustrations/issue. Works on assignment only. Prefers medical as well as general editorial illustration. Considers pen & ink, airbrush, colored pencil, mixed media, collage, watercolor, acrylic, oil and marker. Send postcard sample or query letter with photocopies. Accepts disk submissions compatible with most current versions of Illustrator or Photoshop. Samples are filed and are not returned. Portfolio review not required. Publication will contact artist for portfolio review of final art, tearsheets and printed samples if interested. Rights purchased vary according to project. Pays on publication. Pays $150-400 for color, $10-25 for b&w inside; $25 for spots. Finds artists through directories, agents, direct mail campaigns.

Tips: "Review magazine samples before submitting. We have had the most mutual success with illustrators who can complete work within one to two weeks and send finals in computer format. We use black & white and four-color medical illustrations on a regular basis."

JEWISH ACTION, 11 Broadway, New York NY 10004. (212)613-8146. Fax: (212)613-0646. E-mail: ja@ou.org. Website: www.ou.org. **Editor:** Nechama Carmel. Art Director: Ed Hamway. Estab. 1986. Quarterly magazine "published by Orthodox Union for members and subscribers. Orthodox Jewish contemporary issues." Circ. 25,000. Sample copies available for 9×12 SASE and $1.75 postage or can be seen on website.

Cartoons: Approached by 2 cartoonists/year. Prefers themes relevant to Jewish issues. Prefers single, double or multiple panel, political, humorous b&w washes and line drawings with or without gaglines. Send query letter with photocopies and SASE. Samples are not filed and are not returned. Responds only if interested. Buys one-time rights. Pays within 6 weeks of publication. Pays $20-50 for b&w.

Illustration: Approached by 4-5 illustrators. Considers all media. Assigns 50% of illustrations to experienced, but not well-known illustrators; 50% to new and emerging illustrators. Knowledge of Photoshop, Illustrator and QuarkXPress "not absolutely necessary, but preferred." Send query letter with photocopies and SASE. Accepts disk submissions. Prefer QuarkXPress TIFF or EPS files. Can send ZIP disk. Samples are not filed and are not returned. Responds only if interested. Art director will contact artist for portfolio review of photographs if interested. Buys one-time rights. Pays within 6 weeks of publication; $25-75 for b&w, $50-300 for color cover; $50-200 for b&w, $25-150 for color inside. Finds illustrators through submissions.

Design: Needs freelancers for design and production. Prefers local design freelancers only.

Tips: Looking for "sensitivity to Orthodox Jewish traditions and symbols."

JOURNAL OF ACCOUNTANCY, AICPA, Harborside 201 Plaza III, Jersey City NJ 07311. (201)938-3450. **Art Director:** Jeryl Ann Costello. Monthly 4-color magazine emphasizing accounting for certified public accountants; corporate/business format. Circ. 360,000. Accepts previously published artwork. Original artwork returned after publication.

Illustration: Approached by 200 illustrators/year. Buys 2-6 illustrations/issue. Prefers business, finance and law themes. Prefers mixed media, then pen & ink, airbrush, colored pencil, watercolor, acrylic, oil and pastel. Works on assignment only. 35% of freelance work demands knowledge of Illustrator, QuarkXPress and FreeHand. Send query letter with brochure showing art style. Samples not filed are returned by SASE. Portfolio should include printed samples, color and b&w tearsheets. Buys first rights. Pays on publication; $1,200 for color cover; $200-600 for color (depending on size) inside. Finds artists through submissions/self-promotions, sourcebooks and magazines.

Tips: "I look for indications that an artist can turn the ordinary into something extraordinary, whether it be through concept or style. In addition to illustrators, I also hire freelancers to do charts and graphs. In portfolios, I like to see tearsheets showing how the art and editorial worked together."

N JOURNAL OF HEALTH EDUCATION, 1900 Association Dr., Reston VA 20191. E-mail: johe@a ahperd.org. Website: www.aahperd.org/aahe/aahe.html. **Editor:** James H. Price, PhD, MPH. Estab. 1970. "Bimonthly trade journal for school and community health professionals, keeping them up-to-date on issues, trends, teaching methods, and curriculum developments in health." Conservative; b&w with 4-color cover. Circ. 10,000. Original artwork is returned after publication if requested. Sample copies available; art guidelines available on website.

Illustration: Approached by 50 illustrators/year. Buys 6 illustrations/year. Features realistic illustration; charts & graphs; informational graphics and computer illustrations. Uses artists mainly for covers. Wants health-related topics, any style; also editorial and technical illustrations. Prefers watercolor, pen & ink, airbrush, acrylic, oil and computer illustration. Works on assignment only. 70% of freelance work demands knowledge of PageMaker, Illustrator, QuarkXPress and FreeHand. Send postcard or query letter with photocopies. Samples are filed. Publication will contact artist for portfolio review if interested. Portfolio should include color and b&w thumbnails, roughs, printed samples, photostats, photographs and slides. Negotiates rights purchased. **Pays on acceptance**; $600 maximum for color cover.

Tips: "Send samples; follow up."

JUDICATURE, 180 N. Michigan Ave., Suite 600, Chicago IL 60601-7401. E-mail: drichert@ajs.org. Website: www.ajs.org. **Contact:** David Richert. Estab. 1917. Journal of the American Judicature Society. 4-color bimonthly publication. Circ. 8,000. Accepts previously published material and computer illustration. Original artwork returned after publication. Sample copy for SASE with $1.47 postage; art guidelines not available.

Cartoons: Approached by 10 cartoonists/year. Buys 1-2 cartoons/issue. Interested in "sophisticated humor revealing a familiarity with legal issues, the courts and the administration of justice." Send query letter with samples of style and SASE. Responds in 2 weeks. Buys one-time rights. Pays $35 for unsolicited b&w cartoons.

Illustration: Approached by 20 illustrators/year. Buys 1-2 illustrations/issue. Has featured illustrations by Estelle Carol, Mary Chaney, Jerry Warshaw and Richard Laurent. Features humorous and realistic illustration; charts & graphs; computer and spot illustration. Works on assignment only. Interested in styles from "realism to light humor." Prefers subjects related to court organization, operations and personnel. Freelance work demands knowledge of PageMaker and FreeHand. Send query letter, SASE, photocopies, tearsheets or brochure showing art style. Publication will contact artist for portfolio review if interested. Portfolio should include roughs and printed samples. Wants to see "black & white and color, along with the title

about state justices' workloads, interactions with other branches of state government, and their assessment of state supreme courts' needs for undertaking non-judicial duties with greater effectiveness. The chief justices were assured that they would be neither identified nor identifiable. Surveys were returned by chief justices from 39 states and this article presents the results. Not all chief justices answered every question so

In order to undertake a preliminary assessment of state supreme court justices' responsibilities other than traditional judicial decision making, a survey was sent to chief justices in all 50 states in 1998. The justices selected various responses offered by the survey and also had the opportunity to write their own comments. The survey asked chief justices to identify administrative and other responsibilities undertaken by their courts. Other questions asked

there were fewer than 39 responses for some survey items.

Workload

Chief justices were asked to estimate the percentage of time spent on activities other than traditional judicial decision making. As indicated by Table 1, many chief justices' working lives differ significantly from the stereotypical picture of judicial officers devoted to making considered judg-

Table 1	STATE SUPREME COURT CHIEF JUSTICES' ESTIMATES OF THEIR OWN TIME SPENT ON ACTIVITIES OTHER THAN TRADITIONAL JUDICIAL DECISION MAKING											
Percent of working hours	80	75	70	65	60	55	50	40	35	30	25	20
Number of chief justices reporting	2	2	5	1	3	1	10	5	1	2	2	4

Median percent of working hours on non-judicial activities: 50%
Mean percent of working hours on non-judicial activities: 49.6%

Note: If a chief justice supplied an estimated range, such as "10 to 20 percent," the midpoint of the range is used.

While *Judicature* is a scholarly journal, and the writing within is rather formidable, the editors are open to whimsical art from time to time. Created in ink and magic marker, Jerry Warshaw's "Bench Art" accompanied a numerical table charting the time Supreme Court justices spend on random court activities. The exaggerated labels on this judge's files clearly illustrated the writer's examples in a light, attractive manner.

and synopsis of editorial material the illustration accompanied." Buys one-time rights. Negotiates payment. Pays $250-375 for 2-, 3- or 4-color cover; $250 for b&w full page, $175 for b&w half page inside; $75-100 for spots.

Design: Needs freelancers for design. 100% of freelance work demands knowledge of PageMaker and FreeHand. Pays by the project.

Tips: "Show a variety of samples, including printed pieces and roughs."

KALEIDOSCOPE: Exploring the Experience of Disability through Literature and the Fine Arts, (formerly *Kaleidoscope: International Magazine of Literature, Fine Arts, and Disability*), 701 S. Main St., Akron OH 44311-1019. (330)762-9755. E-mail: mshiplett@udsakron.org. **Editor-in-Chief:** Dars han Perusek. Senior Editor: Gail Willmott. Estab. 1979. Black & white with 4-color cover. Semiannual. "Elegant, straightforward design. Explores the experiences of disability through lens of the creative arts. Specifically seeking work by artists with disabilities. Work by artists without disabilities must have a disability focus." Circ. 1,500. Accepts previously published artwork. Sample copy $5; art guidelines for SASE with first-class postage.

Illustration: Freelance art occasionally used with fiction pieces. More interested in publishing art that stands on its own as the focal point of an article. Approached by 15-20 artists/year. Has featured illustrations by Dennis J. Brizendine and Deborah Vidaver Cohen. Features humorous, realistic and spot illustration. Send query letter with résumé, photocopies, photographs, SASE and slides. Do not send originals. Prefers high contrast, b&w glossy photos, but will also review color photos or 35mm slides. Include sufficient postage for return of work. Samples are not filed. Publication will contact artist for portfolio review if interested. Acceptance or rejection may take up to a year. Pays $25-100 for color covers; $10-25 for b&w or color insides. Rights return to artist upon publication. Finds artists through submissions/self-promotions and word of mouth.

Tips: "Inquire about future themes of upcoming issues. Considers all mediums, from pastels to acrylics to sculpture. Must be high-quality art."

KALLIOPE, a journal of women's literature and art, 3939 Roosevelt Blvd., Jacksonville FL 32205. (904)381-3511. Website: www.fccj.org/kalliope. **Editor:** Mary Sue Koeppel. Estab. 1978. Literary b&w triannual which publishes an average of 27 pages of art by women in each issue. "Publishes poetry, fiction, reviews, and visual art by women and about women's concerns; high-quality art reproductions; visually interesting design." Circ. 1,600. Accepts previously published "fine" artwork. Original artwork is returned at the job's completion. Sample copy for $7. Art guidelines available for SASE with first-class postage.

Cartoons: Approached by 1 cartoonist/year. Has featured art by Joyce Tenneson, Aimee Young Jackson, Kathy Keler, Lise Metzger. Topics should relate to women's issues. Send query letter with roughs. Samples are not filed and are returned by SASE. Responds in 2 months. Rights acquired vary according to project. Pays 1 year subscription or 2 complimentary copies for b&w graphic.

Illustration: Approached by 35 fine artists/year. Buys 18 photos of fine art/issue. Looking for "excellence in fine visual art by women (nothing pornographic)." Send query letter with résumé, SASE, photographs (b&w glossies) and artist's statement (50-75 words). Samples are not filed and are returned by SASE. Responds in 2 months. Rights acquired vary according to project. Pays 1 year subscription or 2 complimentary copies for b&w cover or inside.

Tips: Seeking "excellence in theme and execution and submission of materials. We accept three to six works from a featured artist. We accept only black & white high quality photos of fine art."

KENTUCKY LIVING, Box 32170, Louisville KY 40232. (502)451-2430. Fax: (502)459-1611. Website: www.kentuckyliving.com. **Editor:** Paul Wesslund. 4-color monthly emphasizing Kentucky-related and general feature material for Kentuckians living outside metropolitan areas. Circ. 400,000. Accepts previously published material. Original artwork returned after publication if requested. Sample copy available.

Cartoons: Approached by 10-12 cartoonists/year. Pays $30 for b&w.

Illustration: Buys occasional illustrations/issue. Works on assignment only. Prefers b&w line art. Send query letter with résumé and samples. Samples not filed are returned only if requested. Buys one-time rights. **Pays on acceptance**; $50 for b&w inside.

☑ **THE KETC GUIDE**, 3655 Olive St., St. Louis MO 63108. (314)512-9000. Fax: (314)512-9005. Website: www.ketc.org. **Manager of Art & Design:** Jennifer Snyder. Estab. 1991. Company magazine of KETC/Channel 9. Monthly 4-color cover, 2-color inside program guide going to over 44,000 members of Channel 9, a PBS station. Age group of members is over 25, with a household income of $50,000 average. Circ. 44,000. Accepts previously published artwork. Originals returned at job's completion. Sample copies available. 100% of freelance work demands knowledge of Illustrator, QuarkXPress or Photoshop.

Tips: Send printed samples of work to art department manager. "There is no point in cold-calling if we have no visual reference of the work. We have a limited budget, but a high circulation. We offer longer deadlines, so we find many good illustrators will contribute."

☑ **KEYNOTER**, Kiwanis International, 3636 Woodview Trace, Indianapolis IN 46268. (317)875-8755. **Executive Editor:** Amy Wiser. Art Director: Laura Houser. Official publication of Key Club International, nonprofit high school service organization. 4-color; "contemporary design for mature teenage audience." Published 7 times/year. Circ. 170,000. Previously published, photocopied and simultaneous submissions OK. Original artwork returned after publication. Free sample copy with SASE and 65¢ postage.
Illustration: Buys 3 editorial illustrations/issue. Works on assignment only. Include SASE. Responds in 2 weeks. "Freelancers should call our Production and Art Department for interview." Buys first rights. **Pays on receipt of invoice**; $500 for b&w, $1,000 for color cover; $200 for b&w, $700 for color, inside.

KIPLINGER'S PERSONAL FINANCE, 1729 H St. NW, Washington DC 20006. (202)887-6416. Fax: (202)331-1206. E-mail: ccurrie@kiplinger.com. Website: www.kiplinger.com. **Art Director:** Cynthia L. Currie. Estab. 1947. A monthly 4-color magazine covering personal finance issues including investing, saving, housing, cars, health, retirement, taxes and insurance. Circ. 1 million. Originals are returned at job's completion.
Illustration: Approached by 350 illustrators/year. Buys 10-15 illustrations/issue. Works on assignment only. Has featured illustrations by Gregory Manchess, Tim Bower, Edwin Fotheringham, Michael Paraskevas, Joe Sorren. Features computer, humorous, conceptual editorial and spot illustration. Prefers business subjects. Assigns 80% of illustrations to well-known or "name" illustrators; 10% to experienced, but not well-known illustrators; 10% to new and emerging illustrators. Looking for original conceptual art. Interested in editorial illustration in new styles, including computer illustration. Send postcard samples. Accepts Mac-compatible disk submissions. Samples are filed or returned by SASE if requested by artist. Publication will contact artist for portfolio review if interested. Portfolio should include tearsheets. Buys one-time rights. Pays on publication; $400-1,200 for color inside; $250-500 for spots. Finds illustrators through reps, online, magazines, *Workbook* and award books.
Tips: "Send us high-caliber original work that shows creative solutions to common themes. Send postcards regularly. If they're good, they'll get noticed. A fresh technique, combined with a thought-out image will intrigue art directors and readers alike. We strive to have a balance of seriousness and wit throughout."

☑ **KIWANIS**, 3636 Woodview Trace, Indianapolis IN 46268. (317)875-8755. Fax: (317)879-0204. E-mail: kiwanismail@kiwanis.org. **Managing Editor:** Chuck Jonak. Art Director: Laura Houser. Estab. 1918. 4-color magazine emphasizing civic and social betterment, business, education and domestic affairs for business and professional persons. Published 10 times/year. Original artwork returned after publication by request. Art guidelines available for SASE with first-class postage.
Illustration: Works with 20 illustrators/year. Buys 3-6 illustrations/issue. Assigns themes that correspond to themes of articles. Works on assignment only. Keeps material on file after in-person contact with artist. Include SASE. Responds in 2 weeks. To show a portfolio, mail appropriate materials (out of town/state) or call or write for appointment. Portfolio should include roughs, printed samples, final reproduction/product, color and b&w tearsheets, photostats and photographs. Buys first rights. **Pays on acceptance**; $600-1,000 for cover; $400-800 for inside; $50-75 for spots. Finds artists through talent sourcebooks, references/word-of-mouth and portfolio reviews.
Tips: "We deal direct—no reps. Have plenty of samples, particularly those that can be left with us. Too many student or unassigned illustrations in many portfolios."

L.A. PARENT MAGAZINE, 443 E. Irving Dr., Suite D, Burbank CA 91504-2447. (818)846-0400. Fax: (818)841-4380. E-mail: laparent@compuserve.com. Website: www.parenthoodweb.com. **Editor:** Karen Lindell. Estab. 1979. Tabloid. A monthly city magazine for parents of young children, b&w with 4-color cover; "bold graphics and lots of photos of kids and families." Circ. 115,000. Accepts previously published artwork. Originals are returned at job's completion.
Illustration: Buys 2 freelance illustrations/issue. Assigns 50% of illustrations to experienced, but not well-known illustrators; 50% to new and emerging illustrators. Works on assignment only. Send postcard sample. Accepts disk submissions compatible with Illustrator 5.0 and Photoshop 3.0. Samples are filed or returned by SASE. Responds in 2 months. To show a portfolio, mail thumbnails, tearsheets and photostats. Buys one-time rights or reprint rights. **Pays on acceptance**; $300 color cover (may use only 1 color cover/year); $75 for b&w inside; $50 for spots.
Tips: "Show an understanding of our publication. Since we deal with parent/child relationships, we tend to use fairly straightforward work. Read our magazine and find out what we're all about."

☑ 🖳 **L.A. WEEKLY**, 6715 Sunset Blvd., Los Angeles CA 90028. (323)465-9909. Fax: (323)465-1550. E-mail: weeklyart@aol.com. Website: www.laweekly.com. **Art Director:** Bill Smith. Editorial Art Director: Dana Collins. Assistant Art Director: Laura Steele. Estab. 1978. Weekly alternative arts and news tabloid. Circ. 220,000. Art guidelines available.

Cartoons: Approached by over 100 cartoonists/year. "We contract about 1 new cartoonist per year." Prefers Los Angeles, alternative lifestyle themes. Prefers b&w line drawings without gagline. Send query letter with photocopies. Samples are filed or returned by SASE. Responds only if interested. Rights purchased vary according to project. Pays on publication; $120-200 for b&w.

Illustration: Approached by over 200 illustrators/year. Buys 4 illustrations/issue. Themes vary according to editorial needs. Considers all media. Send postcard sample or query letter with photocopies of cartoons to Dana Collins. "Can also e-mail final artwork." Samples are filed or returned by SASE. Responds only if interested. Portfolio may be dropped off Monday-Friday and should include any samples except original art. Artist should follow up with call and/or letter after initial query. Buys first rights. Pays on publication; $400-1,000 for cover; $120-400 for inside; $120-200 for spots. Prefers submissions but will also find illustrations through illustrators' websites, *Black Book*, *American Illustration*, various Los Angeles and New York publications.

Tips: Wants "less polish and more content. Gritty is good, quick turnaround and ease of contact a must."

LADYBUG, the Magazine for Young Children, Box 300, Peru IL 61354. **Art Director:** Suzanne Beck. Estab. 1990. Monthly 4-color magazine emphasizing children's literature and activities for children, ages 2-6. Design is "geared toward maximum legibility of text and basically art-driven." Circ. 140,000. Accepts previously published material. Original artwork returned after publication. Sample copy $4; art guidelines for SASE with first class postage.

Illustration: Approached by 600-700 illustrators/year. Works with 40 illustrators/year. Buys 200 illustrations/year. Has featured illustrations by Marc Brown, Cyndy Szekeres, Rosemary Wells, Tomie de Paola and Diane de Groat. Uses artists mainly for cover and interior illustration. Prefers realistic styles (animal, wildlife or human figure); occasionally accepts caricature. Works on assignment only. Send query letter with photocopies, photographs and tearsheets to be kept on file, "if I like it." Prefers photocopies and tearsheets as samples. Samples are returned by SASE if requested. Publication will contact artist for portfolio review if interested. Portfolio should show a strong personal style and include "several pieces that show an ability to tell a continuing story or narrative." Does not want to see "overly slick, cute commercial art (i.e., licensed characters and overly sentimental greeting cards)." Buys all rights. **Pays 45 days after acceptance**; $750 for color cover; $250 for color full page; $100 for color, $50 for b&w spots.

Tips: "Has a need for artists who can accurately and attractively illustrate the movements for finger-rhymes and songs and basic informative features on nature and 'the world around you.' Multi-ethnic portrayal is also a *very* important factor in the art for *Ladybug*."

LAW PRACTICE MANAGEMENT, 24476 N. Echo Lake Rd., Hawthorn Woods IL 60047-9039. (847)550-9790. Fax: (847)550-9794. Website: www.abanet.org/lpm. **Art Director:** Mark Feldman, Feldman Communications, Inc. E-mail: mark@feldcomm.com. 4-color trade journal for the practicing lawyer about "the business of practicing law." Estab. 1975. Published 8 times/year. Circ. 20,833.

Illustration: Uses cover and inside feature illustrations. Uses all media, including computer graphics. Mostly 4-color artwork. Send postcard sample or query letter with samples. Pays on publication. Very interested in high quality, previously published works. Pay rates: $200-350/illustration. Original works negotiable. Cartoons very rarely used.

Tips: "There's an increasing need for artwork to illustrate high-tech articles on technology in the law office. (We have two or more such articles each issue.) We're especially interested in computer graphics for such articles. Recently redesigned to use more illustration on covers and with features. Topics focus on management, marketing, communications and technology."

☑ **LISTEN MAGAZINE**, 55 W. Oak Ridge Dr., Hagerstown MD 21740. (301)393-4010. E-mail: listen @healthconnection.org. **Associate Editor:** Anita Jacobs. Monthly magazine (September-May) for teens with specific aim to educate against alcohol, tobacco and other drugs and to encourage positive life choices. Circ. 30,000. Accepts previously published artwork. Originals returned at job's completion. Sample copies available for $1. Art guidelines for SASE with first-class postage.

Cartoons: Buys occasional cartoons. Prefers single panel b&w washes and line drawings. Send query letter with brochure and roughs. Samples are filed. Responds only if interested. Buys reprint rights.

Illustration: Approached by 50 illustrators/year. Buys 6 illustrations/issue. Has featured illustrations by Perry Stewart and Rick Thomson. Works on assignment only. Considers all media. Send postcard sample or query letter with brochure, résumé and tearsheets. Accepts submissions on disk. Samples are filed or are returned by SASE. Publication will contact artist for portfolio review if interested. Buys reprint rights. **Pays on acceptance**. No longer uses illustrations for covers.

LOG HOME LIVING, 4200-T Lafayette Center Dr., Chantilly VA 20151. (800)826-3893 or (703)222-9411. Fax: (703)222-3209. Website: www.ksulmonetti@loghomeliving.com. **Art Director:** Karen Sulmonetti. Estab. 1989. Monthly 4-color magazine "dealing with the aspects of buying, building and living in a log home. We emphasize upscale living (decorating, furniture, etc.)." Circ. 108,000. Accepts previously published artwork. Sample copies not available. Art guidelines for SASE with first-class postage. 20% of freelance work demands knowledge of QuarkXPress, Illustrator and Photoshop.
Illustration: Buys 2-4 illustrations/issue. Works on assignment only. Prefers editoral illustration with "a strong style—ability to show creative flair with not-so-creative a subject." Considers watercolor, airbrush, colored pencil and pastel. Send postcard sample. Accepts disk submissions compatible with Illustrator, Photoshop and QuarkXPress. Samples are filed. Publication will contact artist for portfolio review if interested. Portfolio should include thumbnails, roughs, printed samples, or color tearsheets. Buys all rights. **Pays on acceptance**; $100-200 for b&w inside; $250-800 for color inside; $100-250 for spots. Finds artists through submissions/self-promotions, sourcebooks.
Design: Needs freelancers for design and production once a year in the summer. 80% of freelance work demands knowledge of Photoshop, Illustrator and QuarkXPress. Send query letter with brochure, résumé, photographs and slides. Pays by the project.

THE LOOKOUT, 8121 Hamilton Ave., Cincinnati OH 45231. (513)931-4050. Fax: (513)931-0950. E-mail: lookout@standardpub.com. Website: www.standardpub.com. **Administrative Assistant:** Sheryl Overstreet. Weekly 4-color magazine for conservative Christian adults and young adults. Circ. 100,000. Sample copy available for 75¢.
Cartoons: Prefers cartoons on family life and religious/church life; mostly single panel. Send photocopies of cartoons. Has featured illustrations by Dik Lapine, Steve Phelps and Jonny Hawkins. Pays $50 for b&w.
Illustration: Prefers humorous, stylish illustrations featuring christian families. Send postcard or other nonreturnable samples.
Tips: Do not send e-mail submissions.

N LOS ANGELES MAGAZINE, 5900 Wilshire Blvd., 10th Floor, Los Angeles CA 90036. (323)801-0075. Fax: (323)801-0105. Website: www.lamag.com. **Art Director:** Joe Kimberling. Monthly 4-color magazine with a contemporary, modern design, emphasizing life-styles, cultural attractions, pleasures, problems and personalities of Los Angeles and the surrounding area. Circ. 170,000. Especially needs very localized contributors—custom projects needing person-to-person concepting and implementation. Previously published work OK. Pays on publication. Sample copy $3. 10% of freelance work demands knowledge of QuarkXPress, Illustrator and Photoshop.
Illustration: Buys 10 illustrations/issue on assigned themes. Prefers general interest/life-style illustrations with urbane and contemporary tone. To show a portfolio, send or drop off samples showing art style (tearsheets, photostats, photocopies and dupe slides). Pays on publication; negotiable.
Tips: "Show work similar to that used in the magazine—a sophisticated style. Study a particular publication's content, style and format. Then proceed accordingly in submitting sample work. We initiate contact of new people per *Showcase* reference books or promo fliers sent to us. Portfolio viewing is all local."

THE LUTHERAN, 8765 W. Higgins Rd., Chicago IL 60631-4101. (773)380-2540. Fax: (773)380-2751. E-mail: lutheran@elca.org. Website: www.thelutheran.org. **Art Director:** Michael D. Watson. Estab. 1988. Monthly general interest magazine of the Evangelical Lutheran Church in America; 4-color, "contemporary" design. Circ. 650,000. Previously published work OK. Original artwork returned after publication on request. Free sample copy for 9×12 SASE and 5 first-class stamps. Freelancers should be familiar with Illustrator, QuarkXPress or Photoshop. Art guidelines available.
Cartoons: Approached by 100 cartoonists/year. Buys 2 cartoons/issue from freelancers. Interested in humorous or thought-provoking cartoons on religion or about issues of concern to Christians; single panel b&w washes and line drawings with gaglines. Prefers finished cartoons. Send query letter with photocopies of cartoons and SASE. Reports usually within 2 weeks. Buys one time rights. Pays on publication; $50-100 for b&w line drawings and washes.
Illustration: Buys 6 illustrations/year from freelancers. Has featured illustrations by Rich Nelson, Jimmy Holder, Michael D. Watson. Assigns 30% of illustrations to well-known or "name" illustrators; 70% to experienced, but not well-known illustrators. Works on assignment. Does not use spots. Send query letter with brochure and tearsheets to keep on file for future assignments. Buys one-time usage of art. Will return art if requested. Accepts disk submississions compatible with Illustrator 5.0. Samples returned by SASE if requested. Portfolio review not required. Pays on publication; $600 for color cover; $150-350 for b&w, $500 for color inside. Finds artists mainly through submissions.
Tips: "Include your phone number with submission. Send samples that can be retained for future reference. We are partial to computer illustrations. Would like to see samples of charts and graphs. Want professional looking work, contemporary, not too wild in style."

☑ **LYNX EYE**, 542 Mitchell Dr., Los Osos CA 93402. (805)528-8146. Fax: (805)528-7876. E-mail: pamccully@aol.com. **Co-Editor:** Pam McCully. Estab. 1994. Quarterly b&w literary magazine. Circ. 500.
Cartoons: Approached by 100 cartoonists/year. Buys 10 cartoons/year. Prefers sophisticated humor. Prefers single panel, political and humorous b&w washes or line drawings. Send b&w photocopies and SASE. Samples are not filed and are returned by SASE. Responds in 3 months. Buys first North American serial rights. **Pays on acceptance.** Pays $10 for b&w plus 3 copies.
Illustration: Approached by 100 illustrators/year. Buys 20 illustrations/issue. Has featured illustrations by Wayne Hogan, Greg Kidd and Michael Greenstein. Features humorous, natural history, realistic or spot illustrations. Prefers b&w work that stands alone as a piece of art—does not illustrate story/poem. Assigns 100% of illustrations to new and emerging illustrators, as well as to experienced, but not well-known illustrators. Send query letter with photocopies and SASE. Samples are not filed and are returned by SASE. Responds in 3 months. Will contact artist for portfolio review if interested. Buys first North American serial rights. **Pays on acceptance**. Pays $10 for b&w cover or inside plus 3 copies.
Tips: "We are always in need of artwork. Please note that your work is considered an individual piece of art and does not illustrate a story or poem."

MAD MAGAZINE, 1700 Broadway, New York NY 10019. (212)506-4850. Fax: (212)506-4848. Website: www.madmag.com. **Art Director:** Sam Viviano. Associate Art Director: Nadina Simon. Assistant Art Director: Patricia Dwyer. Monthly irreverent humor, parody and satire magazine. Estab. 1952. Circ. 250,000.
Illustration: Approached by 300 illustrators/year. Works with 100 illustrators/year. Has featured illustrations by Mort Drucker, Al Jaffee, Sergio Aragones, C.F. Payne, Roberto Parada, Drew Friedman, Peter Kuper, Dave Berg, Bill Wray, John Kascht, Paul Coker, Tom Bunk. Features humor, realism, caricature. Send query letter with photocopies and SASE. Samples are filed. Portfolios may be dropped off every Wednesday and can be picked up same day 4:30-5:00 p.m. Buys all rights. Pays $2,500-3,200 for color cover; $400-725 for inside. Finds illustrators through direct mail, sourcebooks (all).
Design: Also needs local freelancers for designs. Works with 2 freelance designers/year. 100% of freelance design demands knowledge of Illustrator, Photoshop and QuarkXPress. Send photocopies and résumé.
Tips: "Know what we do! *MAD* is very specific. Everyone wants to work for *MAD*, but few are right for what *MAD* needs! Understand reproduction process, as well as 'give-and-take' between artist and client."

Ⓝ **MADE TO MEASURE**, 600 Central Ave., Highland Park IL 60035. (874)433-1114. Fax: (847)433-6602. E-mail: toons@halper.com. Website: www.halper.com. **Publisher:** Rick Levine. Semiannual trade journal emphasizing uniforms and career clothes. Magazine distributed to retailers, manufacturers and uniform group purchasers. Circ. 25,000.
Cartoons: Buys 10 cartoons/issue. Requires themes relating to subject matter of magazine. Prefers single panel b&w line drawings with or without gagline. Send query letter with finished cartoons. Any cartoons not purchased are returned. Responds in 3 weeks. Buys first rights. **Pays on acceptance**; $50 for b&w.

☑ **MAGICAL BLEND**, 133½ Broadway, Chico CA 95928. (530)893-9037. E-mail: artdept@magicalblend.com. Website: www.magicalblend.com. **Art Director:** René Schmidt. Estab. 1980. Bimonthly 4-color magazine emphasizing spiritual exploration, transformation and visionary arts; eclectic design. Circ. 100,000. Original artwork returned after publication. Sample copy $5; art guidelines by SASE.
Illustration: Works with 20 illustrators/year. Uses 65 illustrations/year. Has featured illustrations by Gage Taylor and Alex Grey. Assigns 90% to experienced, but not well-known illustrators; 10% to new and emerging illustrators. Also publishes portfolios on individual or group of artists each issue. "We keep samples on file and work by editorial fit according to the artists style and content. We prefer eye-friendly and well executed color work. We look for pieces with a positive, inspiring, uplifting feeling." Send photographs, slides and SASE. Responds in 6 months if interested. Buys first North American serial rights. Pays in copies, subscriptions, and possibly ad space. Will print contact information with artwork if desired by artist.
Tips: "We want work that is energetic and thoughtful that has a hopeful outlook on the future. Our page size is 8 × 10¾. We like to print quality art by people who have talent, but don't fit into any category and are usually unpublished. Have technical skill, be unique, show a range of styles; don't expect to get rich from us, 'cuz we sure aren't! Be persistent."

MAIN LINE TODAY, 4699 W. Chester Pike, Newtown Business Center, Newtown Square PA 19703. (610)325-4630. Fax: (610)325-4636. **Art Director:** Ingrid Hansen-Lynch. Estab. 1996. Monthly consumer magazine providing quality information to the main line and western suburbs of Philadelphia. Sample copies for #10 SASE with first-class postage.
Illustration: Approached by 100 illustrators/year. Buys 3-5 illustrations/issue. Considers acrylic, charcoal, collage, color washed, mixed media, oil, pastel and watercolor. Send postcard sample or query letter with

FRIDAY
MARKET

Renowned for superb art and prose in spite of a modest circulation, *Lynx Eye* editors are rather selective about what goes from their in-box to the printer. David Holmes's "Friday Market" was one sketch from a series that exemplified a vacation in the British Isles. All of the images were eventually showcased in various issues of *Lynx Eye*.

printed samples and tearsheets. Send follow-up postcard sample every 3-4 months. Samples are filed and are not returned. Responds only if interested. Buys one-time and reprint rights. Pays on publication; $400 maximum for color cover; $125-250 for b&w inside; $125-250 for color inside. Pays $125 for spots. Finds illustrators by word of mouth and submissions.

☑ **MANAGED CARE**, 780 Township Line Rd., Yardley PA 19067. Phone/fax: (609)671-2100. Website: www.managedcaremag.com. **Art Director:** Philip Denlinger. Estab. 1992. Monthly trade publication for healthcare executives. Circ. 60,000.
Illustration: Approached by 50 illustrators/year. Buys 3 illustrations/issue. Has featured illustrations by Theo Rudnak, David Wilcox, Gary Overacre, Roger Hill. Features informational graphics, realistic and spot illustration. Prefers business subjects. Assignments for illustrations divided equally between well-known or name illustrators; experienced, but not well-known, illustrators; and new and emerging illustrators. Send postcard sample. Samples are filed. Will contact artist for portfolio review if interested. Rights purchased vary according to project. **Pays on acceptance**; $1,500-2,000 for color cover; $250-750 for color inside; $450 for spots. Finds illustrators through *American Showcase* and postcards.

☑ **MANY MOUNTAINS MOVING**, 420 22nd St., Boulder CO 80302-7909. (303)545-9942. Fax: (303)444-6510. E-mail: mmm@mmminc.org. Website: www.mmminc.org. **Art Directors:** Miho Shida and Naomi Horii. Estab. 1994. Quarterly literary magazine features poetry and invites fine art from artists from all walks of life. Circ. 3,000.
Illustration: Approached by 100 illustrators/year. Buys 8-10 illustrations/issue. Has featured illustrations by Tony Ortega, Laura Marshall. Features fine art and photography. Open to all subject matter and styles. Prefers b&w for inside art; b&w or color for cover. Assigns 30% of illustrations to well-known or "name" illustrators; 35% to experienced, but not well-known illustrators; 35% to new and emerging illustrators. Send query letter with SASE and photocopies. Responds in 2 months. Will contact artist for portfolio review if interested. Buys first North American serial rights. Pays on publication; $10 for b&w, $10 for color cover; $5 for b&w, $5 for color inside, $10 for 2-page spreads. Finds illustrators through artists' promotional samples, word of mouth, gallery exhibitions and magazine articles.

MASSAGE MAGAZINE, 200 7th Ave. #240, Santa Cruz CA 95062-4628. (831)477-1176. Fax: (831)477-2918. Website: www.massagemag.com. **Art Director:** Karen Menehan. Estab. 1986. Bimonthly trade magazine for practitioners and their clients in the therapeutic massage and allied healing arts and sciences (acupuncture, aromatherapy, chiropractic, etc.) Circ. 45,000. Art guidelines not available.
Illustration: Not approached by enough illustrators/year. Buys 6-10 illustrations/year. Features medical illustration representing mind/body/spirit healing. Assigns 100% of illustrations to experienced, but not well-known illustrators. Themes or style range from full color spiritually-moving to business-like line art. Considers all media. All art must be scanable. Send postcard sample and query letter with printed samples or photocopies. Accepts disk-submitted artwork done in Freehand or Photoshop for use in QuarkXPress 4.0. Responds only if interested. Rights purchased vary according to project. Pays on publication; $75-200 for inside color illustration. Finds illustrators through word of mouth and artist's submissions.
Tips: "I'm looking for quick, talented artists, with an interest in the healing arts and sciences."

N: MBUSINESS, 600 Harrison St., San Francisco CA 94107. (415)947-6212. Fax: (415)947-6029. E-mail: ptucker@cmp.com. Website: www.mbusinessdaily.com. Contact: Peter Tucker, art director. Estab. 2000. Monthly trade publication bringing cuttingedge mobile news, analysis and trends to the mobile phone and handheld computer industry.
Illustration: Has featured illustrations by Kieth Negley, Eldon Doty, A.I. Garces and Regan Dunnick. Features humorous illustration and informational graphics. Preferred subjects: business subjects, men and women. Assigns 90% to experienced, but not well-known illustrators; 10% to new and emerging illustrators. Send postcard sample and nonreturnable samples. Buys one-time rights. Pays $200-450 for color inside; $100-300 for spots. Finds illustrators through *Creative Black Book* and artists promotional samples.

☑ **THE MEETING PROFESSIONAL**, 4455 LBJ Freeway, Suite 1200, Dallas TX 75244-5903. (972)702-3000. Fax: (972)702-3096. E-mail: jott@mpiweb.org. Website: www.mpiweb.org. **Director of Creative Services:** Rockford Rudd. Estab. 1980. Monthly 4-color company magazine written for professional meeting managers responsible for meeting planners. Circ. 30,000 Art guidelines for #10 SASE.
Illustration: Approached by 10 illustrators/year. Buys 3 illustrations/issue. Has featured illustrations by Bart Forbes. Features computer illustrations on business subjects. Prefers bright, contemporary feel—slightly abstract. Assigns 50% of illustrations to new and emerging illustrators; 25% each to well-known or name illustrators and experienced, but not well-known, illustrators. 75% of freelance illustration demands knowledge of Photoshop. Send postcard sample; "only very polished or unique promos, please." Samples

are not returned. Responds only if interested. Portfolio review not required. Buys one-time rights. Pays $75-300 for color cover; $25-100 for color inside, $50-150 for 2-page color spread. Finds illustrators through sourcebooks, word of mouth.

Tips: "A unique style or technique and a friendly, down-to-earth attitude could get you a lot of work with us. Consistent, deadline-driven professional person would be an asset. You have to think globally in the meeting planning industry."

MEETINGS IN THE WEST, 550 Montgomery St., Suite 750, San Francisco CA 94111. (415)788-2005. Fax: (415)788-0301. Website: www.meeting411.com. **Art Director:** Scott Kambic. Graphic Artist: Mort Malison. Jr. Designer: Stephanie Groom. Monthly 4-color tabloid/trade publication for meeting planners covering the 14 western United States, plus western Canada and Mexico. Circ. 25,000.

Illustration: Approached by 5 illustrators/year. Buys more than 1 illustration/issue. Features computer illustration, humorous and spot illustration. Prefers subjects portraying business and business travel subjects. Prefers colorful, fun computer illustration. Assigns 20% of illustration to experienced, but not well-known illustrators; 80% to new and emerging illustrators. Send postcard sample. Accepts Mac-compatible disk submissions. Samples are filed or returned by SASE. Will contact artist for portfolio review if interested. Buys first rights. Pays on publication; $700-1,000 for color cover; $50-300 for color inside. Finds illustrators through word of mouth, recommendations by colleagues, promo samples.

Tips: "We are always open to new interpretations. All must be able to work fast and have a flexible style."

☑ **METRO PULSE**, 505 Market St., Suite 300, Knoxville TN 37902. (865)522-4922. Fax: (865)522-2955. E-mail: horstman@metropulse.com. Website: www.metropulse.com. **Art Director:** Lisa Horstman. Estab. 1985. Weekly, 4-color, b&w, alternative news magazine for Knoxville, TN. Circ. 30,000.

Cartoons: Approached by 20 cartoonists/year. Buys 40 cartoons/issue. Prefers humorous, b&w photocopies. Samples are filed and are not returned. Responds only if interested. Buys one-time rights. Pays on publication. Pays $15-25 for b&w; $15-25 for comic strips.

Illustration: Approached by 150. Buys 2 illustrations/issue. Has featured illustrations by Charlie Powell, Tim Winkler, Mark Andresen, Stan Shaw and Whitney Sherman. Features humorous, spot, computer and editorial illustrations. Subject matter varies. Assigns 10% of illustrations to well-known or "name" illustrators; 70% to experienced, but not well-known illustrators; 20% to new and emerging illustrators. 10% of freelance illustration demands knowledge of Photoshop. No real need for computer knowledge, but it's helpful to send work digitally. Send postcard sample or tearsheets. Accepts Mac-compatible disk submissions. Send TIFF files. Samples are filed and are not returned. Portfolio review not required. Will contact artist for portfolio review if interested. Buys first rights. Pays on publication; $200-400 for b&w cover; $200-400 for color cover; $50-150 for b&w inside; $50-150 for color inside; $100 for spots. Finds illustrators through magazines, the i-spot, promo samples.

Tips: "We look for editorial illustrators with a unique style; we don't often use realistic styles. I'm mostly looking for those who can interpret the text in an interesting way."

☑ **METROKIDS**, 1080 N. Delaware Ave., Suite 702, Philadelphia PA 19125-4330. (888)890-4668. Fax: (215)291-5563. Website: www.metrokids.com. **Art Director:** Tracy Rucker. Estab. 1990. Monthly parenting tabloid. Circ. 125,000. Accepts previously published artwork. Sample copy free for 3 first-class stamps. Art guidelines free for SASE with first-class postage. Needs computer-literate freelancers for illustration.

Cartoons: Approached by 12 cartoonists/year. Buys 1 cartoon/issue. Prefers parenting issues or kids' themes; single panel b&w line drawings. Samples are filed or returned by SASE if requested by artist. Responds in 3 months. Buys reprint rights. Pays $25 for b&w.

Illustration: Approached by 50 illustrators/year. Buys 100/year. Prefers parenting issues or kids' themes. Considers pen & ink. Send query letter with tearsheets, SASE and photocopies. Samples are filed or returned by SASE if requested by artist. Responds in 3 months. Portfolio review not required. Buys reprint rights. Pays on publication. Pays $50 for color cover; $25 for b&w inside.

METROSPORTS MAGAZINE, 1450 Randolph, Chicago IL 60607-1414. (312)421-1551. Fax: (312)421-1454. E-mail: Rsedge@windycitysportsmag.com. Website: www.metrosports.com. **Art Director:** Stacey Edge. Estab. 1986. Monthly tabloid, b&w with 4-color cover and center. Features multiple recreational sports coverage: New York metro, Boston, Washington, Philadelphia and Connecticut markets in separate editions. Circ. 200,000. Accepts previously published artwork. Originals are returned at job's completion. Art guidelines for SASE with first-class postage. Needs computer-literate freelancers for design.

Cartoons: Approached by 300 cartoonists/year. Preferred theme is recreational (not team) sports. Send query letter with brochure and roughs. Samples are filed. Responds only if interested. Negotiates rights purchased.

Illustration: Approached by 600 illustrators/year. Prefers line drawings, pen & ink and marker. Send query letter with photographs or photocopies. Samples are filed. To show portfolio, mail photocopies. Buys one-time rights. Pays on publication.
Tips: "We look for contemporary and original look."

N MICHIGAN LIVING, 2865 Waterloo, Troy MI 48084. (248)816-9265. Fax: (248)816-2251. E-mail: michliving@aol.com. **Editor:** Ron Garbinski. Estab. 1918. Monthly magazine emphasizing travel and lifestyle. Circ. 1.1 million. Sample copies and art guidelines for SASE with first-class postage.
Illustration: Approached by 20 illustrators/year. Features natural history illustrations; realistic illustration; charts & graphs; and informational graphics. Assigns 50% of illustrations to experienced, but not well-known illustrators; 50% to new and emerging illustrators. Prefers travel related illustrations. Considers all media. Send query letter with printed samples, photocopies, tearsheets and include e-mail address. Samples are not filed and are not returned. Art director will contact artist for portfolio review of b&w and color final art, photographs, photostats, roughs, slides, tearsheets, thumbnails, transparencies if interested. Buys first North American serial rights or reprint rights. Pays $450 maximum for cover and inside; $400 maximum for spots. Finds illustrators through sourcebooks, such as *Creative Black Book*, word of mouth, submissions.
Tips: "Read our magazine, we need fast workers with quick turnaround."

✓ MICHIGAN OUT OF DOORS, Box 30235, Lansing MI 48909. (517)371-1041. Fax: (517)371-1505. E-mail: magazine@mucc.org. Website: www.mucc.org. **Contact:** Dennis C. Knickerbocker. 4-color magazine emphasizing outdoor recreation, especially hunting and fishing, conservation and environmental affairs. Circ. 100,000. "Conventional" design. Art guidelines available free for SASE. Sample copy $3.50.
Illustration: "Following the various hunting and fishing seasons we have a limited need for illustration material; we consider submissions 6-8 months in advance." Has featured illustrations by Ed Sutton and Nick Van Frankenhuyzen. Assigns 90% of illustrations to experienced but not well-known illustrators; 10% to new and emerging illustrators. Reports as soon as possible. **Pays on acceptance**; $30 for pen & ink illustrations in a vertical treatment.

MICROSOFT CERTIFIED PROFESSIONAL MAGAZINE, 9121 Oakdale Ave., Suite 101, Chatsworth CA 91311. (818)734-1520. E-mail: mseibert@101com.com. Website: www.mcpmag.com. **Art Director:** Michele Seibert. Estab. 1993. Monthly 4-color trade publication for Windows NT/2000 professionals. Circ. 125,000.
Illustration: Approached by 1-2 illustrators/year. Features charts & graphs, informational graphics, spot illustrations and computer illustration of business subjects. Has featured illustrations by Bob Daly and Mark Betcher. Assigns 50% of illustrations to experienced, but not well-known illustrators; 50% to new and emerging illustrators. Accepts Mac-compatible disk submissions. Samples are filed. Responds in 1 month. Portfolio review not required. Buys all rights. Pays $500 for spots.
Tips: Art director looks for "something unique or different—the wierder, the better."

MID-AMERICAN REVIEW, English Dept., Bowling Green State University, Bowling Green OH 43403. (419)372-2725. Website: www.bgsu.edu/midamericanreview. **Contact:** Editor-in-Chief. Estab. 1980. Twice yearly literary magazine publishing "the best contemporary poetry, fiction, essays, and work in translation we can find. Each issue includes poems in their original language and in English." Circ. 700. Originals are returned at job's completion. Sample copies available for $5.
Illustration: Approached by 10-20 illustrators/year. Buys 1 illustration/issue. Considers pen & ink, watercolor, collage, charcoal and mixed media. Send query letter with brochure, SASE, tearsheets, photographs and photocopies. Samples are filed or are returned by SASE if requested by artist. Responds in 3 months. Buys first rights. Pays on publication. Pays $50 when funding permits. Also pays in copies, up to 20.
Tips: "*MAR* only publishes artwork on its cover. We like to use the same artist for one volume (two issues). We are looking for full-color artwork for a front-to-back, full bleed effect. Visit our website!"

MOBILE BEAT, P.O. Box 309, East Rochester NY 14445. (716)385-9920. Fax: (716)385-3637. E-mail: info@mobilebeat.com. Website: www.mobilebeat.com. **Editor:** Robert Lindquist. Estab. 1991. Bimonthly magazine "of professional sound, lighting and karaoke." Circ. 18,000.
Cartoons: Buys 1 cartoon/issue. Prefers single panel with gagline. Send query lettery with finished cartoons. Samples are filed. Responds in 1 month if interested. Buys one-time rights. Pays on publication; $100 minimum for b&w.
Illustration: Approached by 10-12 illustrators. Buys 0-1 illustrations/issue. Has featured illustrations by Robert Burger, Jeff Marinelli, Dan Sipple. Assigns 50% of illustrations to experienced but not well-known illustrators; 50% to new and emerging illustrators. 100% of freelance illustration demands knowledge of PageMaker, Photoshop, Illustrator and MacroMedia FreeHand. Send query letter with photocopies. Accepts

disk submissions compatible with PageMaker, Photoshop, Illustrator and MacroMedia FreeHand. Samples are filed. Responds in 1 month. Buys one-time rights. Pays on publication; $200-400 for b&w cover; $100 for b&w inside. Finds illustrators through agents, sourcebooks and submissions.
Tips: "Read our magazine."

N: MODEL RAILROADER, P.O. Box 1612, 21027 Crossroads Circle, Waukesha WI 53187. (414)786-8776. Fax: (414)796-1778. E-mail: tlund@kalmbach.com. Website: www.modelrailroader.com. **Art Director:** Thomas Danneman. Monthly magazine for hobbiests, rail fans. Circ. 230,000. Sample copies available for 9×12 SASE with first-class postage. Art guidelines available.
● Published by Kalmbach Publishing. Also publishes *Classic Toy Trains, Astronomy, Finescale Modeler, Model Retailer, Nutshell News* and *Trains*.
Cartoons: Prefers railroading themes. Prefers b&w line drawings with gagline. Send photocopies and tearsheets. Samples are filed and not returned. Responds only if interested. Buys one-time rights. **Pays on acceptance**; $30 for b&w cartoons.
Illustration: Prefers railroading, construction, how-to. Considers all media. 90% of freelance illustration demands knowledge of Photoshop 3.0, Illustrator 6.0, FreeHand 3.0, QuarkXPress 3.31 and Fractal Painter. Send query letter with printed samples, photocopies, SASE and tearsheets. Accepts disk submissions compatible with QuarkXPress 5.5. (Send EPS files.) Call first. Samples are filed and are not returned. Will contact for portfolio review of final art, photographs and thumbnails if interested. Buys all rights. Pays on publication; negotiable.

MODERN DRUMMER, 12 Old Bridge Rd., Cedar Grove NJ 07009. (201)239-4140. **Editor-in-Chief:** Ronald Spagnardi. Art Director: Scott Bienstock. Monthly magazine for drummers, "all ages and levels of playing ability with varied interests within the field of drumming." Circ. 103,000. Previously published work OK. Original artwork returned after publication. Sample copy for $4.99.
Cartoons: Buys 10-12 cartoons/year. Interested in drumming themes; single and double panel. Prefers finished cartoons or roughs. Include SASE. Responds in 3 weeks. Buys first North American serial rights. Pays on publication; $50.
Tips: "We want strictly drummer-oriented gags."

N: MODERN HEALTHCARE MAGAZINE, 360 N. Michigan, Chicago IL 60601. (312)649-5346. E-mail: khorist@crain.com. Website: www.modernhealthcare.com. **Assistant Managing Editor Graphics:** Keith Horist. Estab. 1976. Weekly 4-color trade magazine on healthcare topics, geared to CEO's, CFO's, COO's etc. Circ. 76,000.
Illustration: Approached by 50 illustrators/year. Features caricatures of politicians, humorous illustration, charts & graphs, informational graphics, medical illustration, spot illustrations and computer illustration. Assigns 60% of illustrations to well-known or "name" illustrators; 40% to experienced, but not well-known illustrators. 100% of freelance illustration demands knowledge of Illustrator, Photoshop, FreeHand. Send postcard sample and nonreturnable printed samples. Accepts Mac or Windows-compatible disk submissions. Samples are filed. Responds only if interested. Will contact artist for portfolio review if interested. Buys all rights. "Usually buy all rights for cover art. If it is a generic illustration not geared directly to our magazine, then we might buy only first rights in that case." **Pays on acceptance**; $400-450 for color cover; $50-150 for color inside. Finds illustrators through word of mouth and staff members.
Tips: "Keep sending out samples, someone will need your style. Don't give up!"

✓ MODERN MATURITY, Dept. AM, 601 E Street NW, Washington DC 20049. Website: www.modern maturity.org. **Design Director:** Eric Seidman. Estab. 1956. Bimonthly 4-color magazine emphasizing health, lifestyles, travel, sports, finance and contemporary activities for members 50 years and over. Circ. 20 million. Originals are returned after publication.
Illustration: Approached by 200 illustrators/year. Buys 30 freelance illustrations/issue. Assigns 60% of illustrations to well-known or "name" illustrators; 30% to experienced, but not well-known illustrators; 10% to new and emerging illustrators. Works on assignment only. Considers digital, watercolor, collage, oil, mixed media and pastel. Samples are filed "if I can use the work." Do not send portfolio unless requested. Portfolio can include original/final art, tearsheets, slides and photocopies and samples to keep. Buys first rights. Pays on completion of project; $700-3,500.
Tips: "We generally use people with strong conceptual abilities. I request samples when viewing portfolios."

MODERN PLASTICS, 110 William St., 11th Floor, New York NY 10138. (212)621-4653. Fax: (212)904-6111. Website: www.modplas.com. **Art Director:** Larry E. Matthews. Monthly trade journal

emphasizing technical articles for manufacturers of plastic parts and machinery; 4-color with contemporary design. Circ. 65,000 domestic, 35,000 international. 20% of freelance work demands knowledge of Illustrator, QuarkXPress or FreeHand.

Illustration: Works with 4 illustrators/year. Buys 6 illustrations/year. Prefers airbrush, computer and conceptual art. Works on assignment only. Send brochure. Samples are filed. Does not report back. Call for appointment to show a portfolio of tearsheets, photographs, slides, color and b&w. Buys all rights. **Pays on acceptance**; $800-1,200 for color cover; $200-250 for color inside.

Tips: "I get a lot of stuff that is way off track—aliens, guys with heads cut off, etc. We need technical and computer graphics that's appropriate."

☑ MODERN REFORMATION MAGAZINE, 1716 Spruce St., Philadelphia PA 19103. (215)546-3696. Fax: (215)735-5133. E-mail: modref@alliancenet.org. Website: www.modernreformation.org. **Design and Layout:** Lori Cook. Managing Editor: Eric Candry. Estab. 1991. Bimonthly b&w theological magazine from a reformational perspective. Circ. 10,000. Sample copies and art guidelines for 9×12 SASE and 5 first-class stamps.

Illustration: Buys 5 illustrations/issue. Has featured illustrations by Corey Wilkinson. Features charts & graphs, realistic, religious and spot illustration. Preferred subjects: religious. Prefers scratchboard, pen & ink, realism. Assigns 75% of illustrations to new and emerging illustrators; 25% to experienced, but not well-known illustrators. 25% of freelance illustration demands knowledge of Illustrator, Photoshop and QuarkXPress. Send query letter with photocopies. Accepts Mac-compatible disk submissions. Samples are filed. Will contact artist for portfolio review if interested. Buys one-time rights. **Pays on acceptance**; $150 minimum for b&w inside. Finds illustrators through artists' promo samples.

Tips: "Knowledge of theological issues helpful; quick turnaround and reliability a must."

MODERN SALON, Vance Publishing Corp., 400 Knightsbridge Pkwy., Lincolnshire IL 60069-3651. (847)634-2600. Fax: (847)634-4342. Website: www.modernsalon.com. **Art Director:** Natalie Cooper. Estab. 1913. Monthly trade publication that "highlights new hairstyles, products and gives how-to info." Circ. 136,000.

Illustration: Approached by "tons" of illustrators/year. Buys 1-2 illustrations/issue. Has featured illustrations by Roberta Polfus, Magué Calanche. Features fashion illustration, spot illustrations and computer illustration of families, women, teens and collage/conceptual illustrations. Prefers clean lines, bright colors, texture. Assigns 90% of illustrations to experienced, but not well-known illustrators; 10% to new and emerging illustrators. Send postcard sample. Samples are filed. Responds only if interested. Portfolio review not required. Buys one-time rights. Pays on publication; $300-700 for color inside. Pays $200 for spots. Finds illustrators through samples and word of mouth.

Tips: "I want an illustrator who is highly conceptual, easy to work with and get in touch with, and timely in regards to deadlines. We commission non-gritty, commercial-style illustrators with bright colors and highly stylized content."

MOMENT, 4710 41st St. NW, Washington DC 20016-1706. (202)364-3300. Fax: (202)364-2636. Website: www.momentmag.com. **Art Directors:** Ron Mele and Daryl Wakeley. Contact: Josh Rolnick, associate editor. Estab. 1973. Bimonthly Jewish magazine, featuring articles on religion, politics, culture and Israel. Circ. 65,000. Accepts previously published artwork. Originals returned at job's completion. Sample copies available for $4.50.

Cartoons: Uses reprints and originals. Prefers political themes relating to Middle East, Israel and contemporary Jewish life. Samples are filed. Responds only if interested. Rights purchased vary according to project. Pays minimum of $30 for ¼ page, b&w and color.

Illustration: Buys 5-10 illustrations/year. Works on assignment only. Send query letter. Samples are filed. Responds only if interested. Rights purchased vary according to project. Pays $30 for b&w, $225 for color cover; $30 for color inside (¼ page or less).

Tips: "We look for specific work or style to illustrate themes in our articles. Please know the magazine—read back issues!"

N MONEY, Time/Life Bldg. Rockefeller Cntr., New York NY 10020. (212)522-1212. Fax: (212)522-1796. Website: www.money.com. Contact: Syndi Becker, art director. Estab. 1972. Monthly 4-color consumer magazine. Circ. 1,000,000.

Illustration: Approached by tons of illustrators/year. Buys 34 illustrations/issue. Features caricatures of business people, CEOs of visible companies, charts & graphs, humorous and spot illustrations of men and women. Assigns 10% of illustrations to well-known or "name" illustrators; 90% to experienced, but not well-known illustrators. For first contact send query letter with 5 or 6 printed samples. Samples are not

returned. Responds only if interested. Will contact artist for portfolio review if interested. Buys one-time rights. Pays $250-750 for spots. Finds illustrators through *Creative Black Book*, *LA Workbook*, artists promotional samples.

Tips: Because our publication is photo-driven, we don't use as much illustration as we'd like—but we love illustration. The trouble with some beginning illustrtors is that they do not yet have the consistency of style that's so important in editorial work. I'll get a sample I love, ask to see more, and the illustrator shows the work that's all over the place in terms of style. And I'll think "Oh, this isn't anything I like the sample I liked," and won't hire that illustrator. Make sure your samples show that there is consistency in your work.

MONTANA MAGAZINE, P.O. Box 5630, Helena MT 59604. (406)443-2842. Fax: (406)443-5480. Website: www.montanamagazine.com. **Editor:** Beverly R. Magley. Estab. 1970. Bimonthly magazine covering Montana recreation, history, people, wildlife. Geared to Montanans. Circ. 40,000.
 ● Art director reports this magazine has rarely used illustration in the past, but would like to use more. Also, the magazine no longer accepts cartoons.
Illustration: Approached by 15-20 illustrators/year. Buys 1-2 illustrations/year. Prefers outdoors. Considers all media. Knowledge of Quark, Photoshop, Illustrator helpful but not required. Send query letter with photocopies. Accepts disk submissions combatible with Quark. Send EPS files. Samples are filed and are not returned. Buys one-time rights. Pays on publication; $35-50 for b&w; $50-125 for color. Pays $35-50 for spots. Finds illustrators through submissions, word of mouth.
Tips: "We work with local artists usually because of convenience and turnaround."

THE MORGAN HORSE, Box 960, Shelburne VT 05482. (802)985-4944. Fax: (802)985-8897. Website: www.morganhorse.com. **Art Director:** Sean Mitchell. Emphasizes all aspects of Morgan horse breed including educating Morgan owners, trainers and enthusiasts on breeding and training programs; the true type of the Morgan breed, techniques on promoting the breed, how-to articles, as well as preserving the history of the breed. Monthly. Circ. 8,500. Accepts previously published material, simultaneous submissions. Original artwork returned after publication. Sample copy $4.
Illustration: Approached by 10 illustrators/year. Buys 2-5 illustrations/year. Uses artists mainly for editorial illustration and mechanical production. "Line drawings are most useful for magazine work. We also purchase art for promotional projects dealing with the Morgan horse—horses must look like *Morgans*." Send query letter with samples and tearsheets. Accepts "anything that clearly shows the artist's style and craftsmanship" as samples. Samples are returned by SASE. Responds in 6-8 weeks. Call or write for appointment to show portfolio. Buys all rights or negotiates rights purchased. **Pays on acceptance**; $25-100 for b&w; $100-300 for color inside.
Tips: As trend sees "more of an effort on the part of art directors to use a broader style. Magazines seem to be moving toward more interesting graphic design. Our magazine design is a sophisticated blend of conservative and tasteful contemporary design. While style varies, the horses in our illustrations must be unmistakably Morgans."

MOTHER JONES, 731 Market St., Suite 600, San Francisco CA 94103. (415)665-6637. Fax: (415)665-6696. Webiste: www.motherjones.com. **Design Director:** Jane Palecek. Estab. 1976. Bimonthly magazine. Focuses on investigative journalism, progressive politics and exposés. Circ. 166,688. Accepts previously published artwork. Originals returned at job's completion. Sample copies available.
Cartoons: Approached by 25 cartoonists/year. Prints one cartoon/issue (6/year). Prefers full page, multiple-frame color drawings. Send query letter with postcard-size sample or finished cartoons. Samples are filed or returned by SASE if requested by artist. Responds only if interested. Buys first rights. Works on assignment only.
Illustration: Approached by hundreds of illustrators/year. Has featured illustrations by: Gary Baseman, Chris Ware, Juliette Borda and Gary Panter. Assigns 90% of illustrations to well-known or "name" illustrators; 5% to experienced, but not well-known illustrators; 5% to new and emerging illustrators. Works on assignment only. Considers all media. Send postcard-size sample or query letter with samples. Samples are filed and not returned. Responds to the artist only if interested. Portfolio should include photographs, slides and tearsheets. Buys first rights. Pays on publication; payment varies widely. Finds artists through illustration books; other magazines; word of mouth.

MOTHERING MAGAZINE, % Linda Johnson, 1532-A Paseo de Peralta, Santa Fe NM 87502. (505)989-8460. Website: www.mothering.com. **Contact:** Linda Johnson, designer. Estab. 1976. Consumer magazine focusing on natural family living, and natural/alternative practices in parenting. Circ. 75,000. Sample copies and art guidelines available.
 ● This magazine is art directed by Swell Design, an outside design firm.

Illustration: Knowledge of Photoshop 3.1, QuarkXPress 3.31 helpful, but not required. Send query letter and/or postcard sample. We will accept work compatible with QuarkXPress 3.31 for Power Mac. Send EPS files. Samples are filed. Responds only if interested. Buys first rights. Pays on publication; $500 maximum for cover; $275-450 for inside. Payment for spots depends on size. Finds illustrators through submissions, sourcebooks, magazines, word of mouth.
Tips: "Become familiar with tone and subject matter (mothers and babies) of our magazine."

MOTOR MAGAZINE, Dept. AGDM, 5600 Crooks Rd., Troy MI 48098. (248)828-0216, ext. 264. Fax: (248)879-8603. Website: www.motor.com. **Art Director:** Jennifer Herrmann. Estab. 1903. Emphasizes automotive technology, repair and maintenance for auto mechanics and technicians. Monthly. Circ. 145,463. Accepts previously published material. Original artwork returned after publication if requested. Never send unsolicited original art.
Illustration: Buys 5-15 illustrations/issue. Works on assignment only. Prefers realistic, technical line renderings of automotive parts and systems. Send query letter with résumé and photocopies to be kept on file. Will call for appointment to see further samples. Samples not filed are not returned. Responds only if interested. Buys unlimited rights. Write for appointment to show a portfolio of final reproduction/product and color tearsheets. **Pays on acceptance**; negotiable for cover, basically $300-1,500; $50-500 for b&w inside.
Tips: "*Motor* is an educational, technical magazine and is basically immune to illustration trends because our drawings *must* be realistic and technical. As design trends change, we try to incorporate these into our magazine (within reason). Though *Motor* is a trade publication, we approach it, design-wise, as if it were a consumer magazine. We make use of white space when possible and use creative, abstract and impact photographs and illustration for our opening pages and covers. But we must always retain a 'technical look' to reflect our editorial subject matter. Publication graphics is becoming like TV programming, more calculating and imitative and less creative."

MUSCLEMAG INTERNATIONAL, 5775 McLaughlin Rd., Mississauga, Ontario L5R 3P7 Canada. (905)507-3545. **Contact:** Robert Kennedy. Estab. 1974. Monthly consumer magazine. Magazine emphasizes bodybuilding for men and women. Circ. 300,000. Originals returned at job's completion. Sample copies available for $5; art guidelines not available.
Cartoons: "We are interested in acquiring a cartoonist to produce one full-page cartoon each month. Send photocopy of your work." Pays $1,000.
Illustration: Approached by 200 illustrators/year. Buys 130 illustrations/year. Has featured illustrations by Eric Blais and Gino Edwards. Features caricatures of celebrities; charts & graphs; humorous, medical and computer illustrations. Assigns 80% of illustrations to experienced, but not well-known illustrators; 20% to new and emerging illustrators. Prefers bodybuilding themes. Considers all media. Send query letter with photocopies. Samples are filed. Responds in 1 month. Portfolio review not required. Buys all rights.
Pays on acceptance; $100-150 for b&w inside; $250-500 for color inside. "Higher pay for high-quality work." Finds artists through "submissions from artists who see our magazine."
Tips: Needs line drawings of bodybuilders exercising. "Study the publication: work to improve by studying others. Don't send out poor quality stuff. It wastes editor's time."

MUSHING, P.O. Box 149, Ester AK 99725-0149. (907)479-0454. Fax: (907)479-3137. E-mail: editor@mushing.com. Website: www.mushing.com. **Publisher:** Todd Hoener. Estab. 1988. Bimonthly "year-round, international magazine for all dog-powered sports, from sledding to skijoring to weight pulling to carting to packing. We seek to educate and entertain." Circ. 10,000. Photo/art originals are returned at job's completion. Sample copies available for $5. Art guidelines available upon request.
Cartoons: Approached by 20 cartoonists/year. Buys up to 1 cartoon/issue. Prefers humorous cartoons; single panel b&w line drawings with gagline. Send query letter with roughs. Samples are not filed and are returned by SASE if requested by artist. Responds in 6 months. Buys first rights and reprint rights. Pays $25 for b&w and color.
Illustration: Approached by 20 illustrators/year. Buys 0-1 illustrations/issue. Prefers simple; healthy, happy sled dogs; some silhouettes. Considers pen & ink and charcoal. Send query letter with SASE and photocopies. Accepts disk submissions if Mac compatible. Send EPS or TIFF files with hardcopy. Samples are returned by SASE if requested by artist. Prefers to keep copies of possibilities on file and use as needed. Responds in 1-6 months. Portfolio review not required. Buys first rights. Pays on publication; $150 for color cover; $25 for b&w and color inside; $25 for spots. Finds artists through submissions.
Tips: "Be familiar with sled dogs and sled dog sports. We're most open to using freelance illustrations with articles on dog behavior, adventure stories, health and nutrition. Illustrations should be faithful and/or accurate to the sport. Cartoons should be faithful and tasteful (e.g., not inhumane to dogs)."

MUTUAL FUNDS MAGAZINE, Time Life Bldg., Rockefeller Center, New York NY 10020. (212)522-1212. Fax: (212)522-1549. Website: www. mfmag.com. **Art Director:** Anthony Kosner. Estab. 1994. Monthly consumer magazine covering mutual funds. Circ. 830,000.
Cartoons: Approached by 10 cartoonists/year. Buys 1 cartoon/issue. Prefers mutual fund themes. Prefers single panel, humorous, color washes, with gaglines. Send query with photocopies, tearsheets. Send nonreturnable samples only. Samples are filed. Responds only if interested. Buys first-time rights. Pays on publication; $150-400 for color.
Illustration: Approached by 100 illustrators/year. Assigns 50% of illustrations to well-known or "name" illustrators; 50% to experienced, but not well-known illustrators. Buys 10 illustrations/issue. Prefers detailed, colorful, pen & ink, wash. 20% of freelance illustration demands knowledge of any Mac based software. Send postcard sample or query letter with printed samples, photocopies and tearsheets. Send only nonreturnable samples. "No cold calls, please." Responds only if interested. Art director will contact artist for portfolio review of color final art, photographs, tearsheets, transparencies if interested. Buys one-time rights. Pays on publication; $400-1,500 for color cover; $350-2,000 for color inside; $150-250 for spots. Finds illustrators through sourcebooks, other magazines, direct mail.
Tips: "Look at *Mutual Funds* before you contact me. Know the product and see if you fit in. Be easy to communicate with, with quick turn around, flexible and traditional computer skills."

MY FRIEND, 50 St. Paul's Ave., Boston MA 02130-3491. (617)522-8911. Fax: (617)541-9805. E-mail: design@pauline.org. Website: www.pauline.org. **Graphic Design Dept. Director of Operations:** Sister Kathryn James Hermes, fsp. Designer, Art Director: Sister Helen Rita Lane, fsp. Estab. 1979. Monthly Catholic magazine for kids, 4-color cover, containing information, entertainment, and Christian information for young people ages 6-12. Circ. 11,000. Originals returned at job's completion. Sample copies free for 9 × 12 SASE with first-class postage; art guidelines available for SASE with first-class postage.
Illustration: Approached by 60 illustrators/year. Buys 6 illustrations/issue; 60/year. Works on assignment only. Has featured illustrations by Mary Rojas, Chris Ware, Larry Nolte, and Bob Berry. Features realistic illustration; informational graphics; spot illustration. Assigns 10% of illustrations to well-known or "name" illustrators; 80% to experienced, but not well-known illustrators; 10% to new and emerging illustrators. Prefers humorous, realistic portrayals of children. Considers pen & ink, watercolor, airbrush, acrylic, marker, colored pencil, oil, charcoal, mixed media and pastel. Send query letter with résumé, SASE, tearsheets, photocopies. Accepts disk submissions compatible with Windows/Mac OS (short for Operating System), PageMaker 6.5, Illustrator, Photoshop. Send TIFF or EPS files. Samples are filed or are returned by SASE if requested by artist. Responds within 2 months only if interested. Portfolio review not required. Rights purchased vary according to project. Pays on publication; $250 for color cover; $175 for color 2-page spread; $125 for color single page spread, $75 for color half page.
Design: Needs freelancers for design, production and multimedia projects. Design demands knowledge of PageMaker, Illustrator and Photoshop. Send query letter with résumé, photocopies and tearsheets. Pays by project.

☑ ☷ **THE MYSTERY REVIEW**, P.O. Box 233, Colborne, Ontario K0K 1S0 Canada. (613)475-4440. Fax: (613)475-3400. E-mail: mystrev@reach.net. Website: www:TheMysteryReview.com. **Editor:** Barbara Davey. Estab. 1992. Quarterly literary magazine "for mystery readers." Circ. 6,000.
Illustration: Send query letter with photocopies and SASE. Asks that disk submissions be compatible with PageMaker 6.0 version for Windows." Samples are filed. Responds only if interested. Negotiates rights purchased. Pays on publication; $50 maximum for b&w cover; $20 maximum for b&w inside. Finds illustrators through artist's submissions.
Tips: "Take a look at our magazine—it's in bookstores."

NA'AMAT WOMAN, 350 Fifth Ave., Suite 4700, New York NY 10118. (212)563-5222. Fax: (212)563-5710. E-mail: judith@naamat.org. **Editor:** Judith Sokoloff. Estab. 1926. Jewish women's magazine published 4 times yearly, covering a wide variety of topics that are of interest to the Jewish community, affiliated with NA'AMAT USA (a nonprofit organization). Originals are returned at job's completion. Sample copies available for $1.
Cartoons: Approached by 5 cartoonists/year. Buys 4-5 cartoons/year. Prefers political cartoons; single panel b&w line drawings. Send query letter with brochure and finished cartoons. Samples are filed or are returned by SASE if requested by artist. Responds to the artist only if interested. Rights purchased vary according to project. Pays $50 for b&w.
Illustration: Approached by 20 illustrators/year. Buys 1-3 illustrations/issue. Has featured illustrations by Julie Delton, Miriam Katin, Ilene Winn-Lederer and Lynne Feldman. Works on assignment only. Considers pen & ink, collage, marker and charcoal. Send query letter with tearsheets. Samples are filed or are returned by SASE if requested by artist. Responds to the artist only if interested. Publication will contact artist for

portfolio review if interested. Portfolio should include b&w tearsheets and final art. Rights purchased vary according to project. Pays on publication; $150-200 for b&w cover; $50-75 for b&w inside. Finds artists through sourcebooks, publications, word of mouth, submissions.

Tips: "Give us a try! We're small, but nice."

NAILPRO, 7628 Densmore Ave., Van Nuys CA 91406. (818)782-7328. Fax: (818)782-7340. E-mail: nailpro@nailpro.com. Website: www.nailpro.com. **Art Director:** Patty Quon-Sandberg. Monthly trade magazine for the nail and beauty industry audience: nail technicians. Circ. 50,000. Sample copies available.

Cartoons: Prefers subject matter related to nail industry. Prefers humorous color washes and b&w line drawings with or without gagline. Send query letter with samples. Responds only if interested. Rights purchased vary according to project. Payment varies with projects.

Illustration: Approached by tons of illustrators. Buys 3-4 illustrations/issue. Has featured illustrations by Kelley Kennedy, Nick Bruel and Kathryn Adams. Assigns 20% of illustrations to well-known or "name" illustrators; 70% to experienced, but not well-known illustrators; 10% to new and emerging illustrators. Prefers whimsical computer illustrations. Considers all media. 85% of freelance illustration demands knowledge of Photoshop 5.5, Illustrator 8.0 and QuarkXPress 4.04. Send postcard sample. Accepts disk submissions compatible with QuarkXPress 4.04, TIFFs, EPS files submitted on Zip, JAZ or CD (Mac format only). Send samples to attn: Art Director. Samples are filed. Responds only if interested. Art director will contact artist for portfolio review of b&w, color, final art and tearsheets if interested. Buys first rights. Pays on publication; $350-400 for 2-page, full-color feature spread; $300 for 1-page; $250 for ½ page. Pays $50 for spots. Finds illustrators through *Workbook*, samples sent in the mail, magazines.

Design: Needs freelancers for design, production and multimedia projects. Prefers local design freelancers only. 100% of freelance work demands knowledge of Photoshop 5.5, Illustrator 8.0 and QuarkXPress 4.04. Send query letter with printed samples and tearsheets.

Tips: "I like conceptual illustrators with a quick turnaround."

NAILS, 21061 S. Western Ave., Torrance CA 90501-1711. (310)533-2400. Fax: (310)533-2504. Website: www.nailsmag.com. **Art Director:** Liza Samala. Estab. 1983. Monthly 4-color trade journal; "seeks to educate readers on new techniques and products, nail anatomy and health, customer relations, chemical safety, salon sanitation and business." Circ. 57,000. Originals can be returned at job's completion. Sample copies available. Art guidelines vary. Needs computer-literate freelancers for design, illustration and production. 100% of freelance work demands knowledge of QuarkXPress, Illustrator or Photoshop.

Illustration: Buys 3 illustrations/issue. Works on assignment only. Needs editorial and technical illustration; charts and story art. Prefers "bright, upbeat styles." Interested in all media. Send query letter with brochure and tearsheets. Samples are filed. Responds in 1 month or artist should follow-up with call. Call for an appointment to show a portfolio of tearsheets and transparencies. Buys all rights. **Pays on acceptance;** $200-500 (depending on size of job) for b&w and color inside. Finds artists through self-promotion and word of mouth.

THE NATION, 33 Irving Pl., 8th Floor, New York NY 10003. (212)209-5400. Fax: (212)982-9000. Production-ext. 5421. Website: www.thenation.com. **Art Director:** Steven Brower. Estab. 1865. A weekly journal of "left/liberal political opinion, covering national and international affairs, literature and culture." Circ. 100,000. Originals are returned after publication upon request. Sample copies available. Art guidelines not available.

● *The Nation*'s art director works out of his design studio at Steven Brower Design. You can send samples to *The Nation* and they will be forwarded. Steven is also A.D. for *Print*.

Illustration: Approached by 50 illustrators/year. Buys 3-4 illustrations/issue. Works with 25 illustrators/year. Has featured illustrations by Robert Grossman, Luba Lukora, Igor Kopelnitsky and Karen Caldecott. Buys illustrations mainly for spots and feature spreads. Works on assignment only. Considers pen & ink, airbrush, mixed media and charcoal pencil; b&w only. Send query letter with tearsheets and photocopies. "On top of a defined style, artist must have a strong and original political sensibility." Samples are filed or are returned by SASE. Responds only if interested. Buys first rights. Pays $75-125 for b&w inside; $150 for color inside.

NATIONAL ENQUIRER, 5401 NW Broken Sound Blvd., Boca Raton FL 33487. (561)989-1355. E-mail: jcannathfox@nationalenquirer.com. **Editor:** Joan Cannata-Fox. A weekly tabloid. Circ. 3.8 million. Originals are returned at job's completion. Art guidelines available for SASE with first-class postage.

Cartoons: "We get 1,000-1,500 cartoons weekly." Buys 200 cartoons/year. Has featured cartoons by Edgar Argo, Norm Rockwell, Glenn Bernhardt, Earl Engelman, George Crenshaw, Goodard Sherman and Yahan Shirvanian. Prefers animal, family, husband/wife and general themes. Nothing political or off-color. Prefers single panel b&w line drawings and washes with or without gagline. Computer-generated cartoons

are not accepted. Prefers to do own coloration. Send query letter with finished cartoons and SASE. Samples are not filed and are returned only by SASE. Responds in 3 weeks. Buys first and one-time rights. Pays $300 for b&w plus $40 each additional panel.

Tips: "Study several issues to get a solid grasp of what we buy. Gear your work accordingly."

NATIONAL LAMPOON, 10850 Wilshire Blvd., Suite 1000, Los Angeles CA 90024. (310)474-5252. Fax: (310)474-1219. E-mail: srubin@nationallampoon.com. Website: www.nationallampoon.com. **Editor-in-Chief:** Scott Rubin. Art Director: Joe Oesterle. Estab. 1971. Online consumer magazine of humor and satire.

Cartoon: Approached by 50 cartoonists/year. Buys 6 cartoons/issue. Prefers satire. Prefers humorous, b&w line drawings. Send photocopies and SASE. Samples are filed. Responds only if interested. Negotiates rights purchased. Payment negotiable. E-mail submissions are preferred.

Illustration: Approached by 10 illustrators/year. Buys 30 illustrations/issue. Considers all media. Send e-mail with jpeg images or query letter with photocopies and SASE. Samples are filed. Responds only if interested. Rights purchased vary according to project. Payment negotiable.

Design: Needs freelancers for design and production. Prefers local designers. 100% of freelance work demands knowledge of Photoshop and QuarkXPress. Send query letter with photocopies.

Tips: "Since we are a web-based publication, I prefer artists who are experienced with jpeg images and who are familiar with e-mailing their work. I'm not going to discount some brilliant artist who sends traditional samples, but those who send e-mail samples have a better chance."

☑ **THE NATIONAL NOTARY**, 9350 De Soto Ave., Box 2402, Chatsworth CA 91313-2402. (818)739-4028. Fax: (818)700-1942 (Attn: Editorial Department). E-mail: publications@nationalnotary.org. Website: www.nationalnotary.org. **Senior Editor:** Armando Aguirre. Production Editor: Conny Israelson. Emphasizes "notaries public and notarization—goal is to impart knowledge, understanding, and unity among notaries nationwide and internationally." Readers are notaries of varying primary occupations (legal, government, real estate and financial), as well as state and federal officials and foreign notaries. Bimonthly. Circ. 180,000. Original artwork not returned after publication. Sample copy $5.

• Also publishes *Notary Bulletin*.

Cartoons: Approached by 5-8 cartoonists/year. Cartoons "must have a notarial angle"; single or multiple panel with gagline, b&w line drawings. Send samples of style. Samples not returned. Responds in 6 weeks. Call to schedule an appointment to show a portfolio. Buys all rights. Pays on publication; pay is negotiable.

Illustration: Approached by 3-4 illustrators/year. Uses about 3 illustrations/issue; buys all from local freelancers. Works on assignment only. Themes vary, depending on subjects of articles. 100% of freelance work demands knowledge of Illustrator, QuarkXPress or FreeHand. Send business card, samples and tearsheets to be kept on file. Samples not returned. Responds in 6 weeks. Call for appointment. Buys all rights. Negotiates pay; on publication.

Tips: "We are very interested in experimenting with various styles of art in illustrating the magazine. We generally work with Southern California artists, as we prefer face-to-face dealings."

Ⓝ **NATIONAL REVIEW**, 215 Lexington Ave., New York NY 10016. (212)679-7330. Website: www.nationalreview.com. **Art Director:** Luba Kolomytseva. Emphasizes world events from a conservative viewpoint; bimonthly b&w with 4-color cover, design is "straight forward—the creativity comes out in the illustrations used." Originals are returned after publication. Uses freelancers mainly for illustrations of articles and book reviews, also covers. Circ. 162,091.

Cartoons: Buys 10 cartoons/issue. Interested in "light political, social commentary on the conservative side." Send appropriate samples and SASE. Responds in 2 weeks. Buys first North American serial rights. Pays on publication; $50 for b&w.

Illustration: Buys 6-7 illustrations/issue. Especially needs b&w ink illustration, portraits of political figures and conceptual editorial art (b&w line plus halftone work). "I look for a strong graphic style; well-developed ideas and well-executed drawings." Style of Tim Bower, Jennifer Lawson, Janet Hamlin, Alan Nahigian. Works on assignment only. Send query letter with brochure showing art style or tearsheets and photocopies. No samples returned. Responds to future assignment possibilities. Call for an appointment to show portfolio of final art, final reproduction/product and b&w tearsheets. Include SASE. Buys first North American serial rights. Pays on publication; $100 for b&w inside; $750 for color cover.

Tips: "Tearsheets and mailers are helpful in remembering an artist's work. Artists ought to make sure their work is professional in quality, idea and execution. Recent printed samples alongside originals help. Changes in art and design in our field include fine art influence and use of more halftone illustration." A common mistake freelancers make in presenting their work is "not having a distinct style, i.e., they have a cross sample of too many different approaches to rendering their work. This leaves me questioning what kind of artwork I am going to get when I assign a piece."

NATION'S RESTAURANT NEWS, 425 Park Ave., 6th Floor, New York NY 10022-3506. (212)756-5000. Fax: (212)756-5215. E-mail: mvila@nrn.com. Website: www.nrn.com. **Senior Art Director:** Manny Vila. Assistant Art Director: Maureen Smith. Estab. 1967. Weekly 4-color trade publication/tabloid. Circ. 100,000.

Illustration: Approached by 35 illustrators/year. Buys 15 illustrations/issue. Has featured illustrations by Stephen Sweny, Daryl Stevens, Elvira Regince, Garrett Kallenbach, Elizabeth Brandt, Kerry Talbott and Cedric Hohnstadt. Features computer, humorous and spot illustrations of business subjects in the food service industry. Prefers pastel and bright colors. Assigns 5% of illustrations to well-known or "name" illustrators; 70% to experienced, but not well-known illustrators; 25% to new and emerging illustrators. 20% of freelance illustration demands knowledge of Illustrator or Photoshop. Send postcard sample or other nonreturnable samples, such as tearsheets. Accepts Windows-compatible disk submissions. Send EPS files. Samples are filed. Will contact artist for portfolio review if interested. Buys one-time rights. Pays on publication; $700-900 for b&w cover; $1,000-1,500 for color cover; $300-400 for b&w inside; $275-350 for color inside; $450-500 for spots. Finds illustrators through *Creative Black Book* and *LA Work Book*, *Directory of Illustration* and *Contact USA*.

Tips: "Great imagination and inspiration are essential for one's uniqueness in a field of such visual awareness."

N **NATURAL HISTORY**, American Museum of Natural History, Central Park West &79th St., New York NY 10024. (212)769-5500. Website: www.naturalhistory.com. **Editor:** Ellen Goldensohn. Designer: Tom Page. Emphasizes social and natural sciences. For well-educated professionals interested in the natural sciences. Monthly. Circ. 225,000.

Illustration: Buys 10-12 illustrations/year; 15-20 maps or diagrams/year. Works on assignment only. Query with samples. Samples returned by SASE. Provide "any pertinent information" to be kept on file for future assignments. Buys one-time rights. Pays on publication; $200 and up for color inside.

Tips: "Be familiar with the publication. Always looking for accurate and creative scientific illustrations, good diagrams and maps."

N **NATURAL LIFE**, P.O. Box 340, St. George, Ontario N0E 1N0 Canada. (519)442-1404. E-mail: natlife@life.ca. **Editor:** W. Priesnitz. Estab. 1976. Bimonthly magazine covering environment, sustainability, voluntary simplicity. Circ. 5,000. Sample copy for $5.

• *Natural Life* is not currently buying cartoons or other illustrations.

Tips: "Read us first!"

NATURALLY MAGAZINE, P.O. Box 317, Newfoundland NJ 07435. (973)697-8313. Fax: (973)697-8313. E-mail: naturally@internaturally.com. Website: www.internaturally.com. **Publisher/Editor:** Bernard Loibl. Director of Operations: Cheryl Hanenberg. Estab. 1981. Quarterly magazine covering family nudism/naturism and nudist resorts and travel. Circ. 35,000. Sample copies for $7.50 and $3.95 postage; art guidelines for #10 SASE with first-class postage.

Cartoons: Approached by 10 cartoonists/year. Buys 3 cartoons/issue. Prefers nudism/naturism. Send query letter with finished cartoons. Samples are filed. Responds only if interested. Buys one-time rights. Pays on publication. Pays $20-70.

Illustration: Approached by 10 illustrators/year. Buys 3 illustrations/issue. Prefers nudism/naturism. Considers all media. 20% of freelance illustration demands knowledge of Corel Draw. Contact only through artists' rep. Accepts all digital formats or hard copies. Samples are filed. Responds only if interested. Buys one-time rights. Pays on publication; $200 for cover; $70/page inside.

NATURE CONSERVANCY, 4245 N. Fairfax Dr., #100, Arlington VA 22203-1606. Fax: (703)841-9692. E-mail: mrowe@tnc.org. Website: www.tnc.org. **Art Director:** Miya Rowe. Estab. 1951. Bimonthly membership magazine of nonprofit conservation organization. "The intent of the magazine is to educate readers about broad conservation issues as well as to inform them about the Conservancy's specific accomplishments. The magazine is achievement-oriented without glossing over problems, creating a generally positive tone. The magazine is rooted in the Conservancy's work and should be lively, engaging and readable by a lay audience." Sample copies available.

Illustration: Approached by 100 illustrators/year. Buys 1-5 illustrations/issue. Considers all media. 10% of freelance illustration demands knowledge of Photoshop and/or Illustrator. Send query letter with photocopies and tearsheets. Samples are sometimes filed and are not returned. Responds only if interested. Rights purchased vary according to project. **Pays on acceptance**. Payment varies. Finds illustrators through sourcebooks, magazines and submissions.

NERVE COWBOY, P.O. Box 4973, Austin TX 78765-4973. **Editors:** Joseph Shields and Jerry Hagins. Art Director: Mary Gallo. Estab. 1995. Biannual b&w literary journal of poetry, short fiction and b&w artwork. Sample copies for $5 postpaid. Art guidelines free for #10 SASE with first-class postage.
Illustration: Approached by 200 illustrators/year. Buys work from 10 illustrators/issue. Has featured illustrations by Wayne Hogan, Stepan Chapman, Fred Berthoff, Christiane Gravert, Emmaline Shields, Jennifer Stanley, Sean Reeves, Bob Lavin and Albert Huffstickler. Features unusual illustration and creative b&w images. Prefers b&w. "Color will be considered if a b&w half-tone can reasonably be created from the piece." Assigns 10% of illustrations to well-known or "name" illustrators; 50% to experienced, but not well-known illustrators; 40% to new and emerging illustrators. Send printed samples, photocopies with a SASE. Samples are returned by SASE. Responds in 3 months. Portfolio review not required. Buys first North American serial rights. Pays on publication; 3 copies of issue in which art appears on cover; or 1 copy if art appears inside.
Tips: "We are always looking for new artists with an unusual view of the world."

NETWORK COMPUTING, 600 Community Dr., Manhasset NY 11030-3847. (516)562-5000. Fax: (516)562-7293. Website: www.networkcomputing.com. **Art Director:** David Yamada. Monthly trade magazine for those who professionally practice the art and business of networkology (a technology driver of networks). Circ. 220,000. Sample copies available.
Illustration: Approached by 30-50 illustrators/year. Buys 6-7 illustrations/issue. Considers all media. 60% of freelance illustration demands knowledge of FreeHand, Photoshop, Illustrator. Send postcard sample with follow-up sample every 3-6 months. Contact through artists' rep. Accepts disk submissions compatible with QuarkXPress 7.5/version 3.3. Send EPS files. Samples are returned. Responds only if interested. Art director will contact artist for portfolio review of tearsheets if interested. Buys one-time rights. **Pays on acceptance**: $700-1,000 for b&w, $1,500-2,000 for color cover; $300 minimum for b&w, $350-500 for color inside. Pays $350-500 for spots. Finds illustrators through agents, sourcebooks, word of mouth, submissions.

☑ **NETWORK MAGAZINE**, 600 Harrison St., San Francisco CA 94107-1387. (415)947-6000. Fax: (415)947-6022. Website: www.networkmagazine.com. **Contact:** Rob Kirby. Estab. 1986. Monthly magazine covers local and wide area computer networks. Circ. 200,000.
Illustration: Approached by 50 illustrators/year. Buys 5-7 illustrations/issue. "Half freelancers work electronically, half by hand. Themes are technology-oriented, but artwork doesn't have to be." Considers all media, color. 50% of freelance illustration demands knowledge of Photoshop. Send postcard sample. Accepts disk submissions compatible with Photoshop files on Mac-formatted disks; "would recommend saving as JPEG (compressed) if you're sending a disk." Samples are filed. Responds only if interested. "Will look at portfolios if artists are local (Bay area), but portfolio review is not necessary." **Pays on acceptance**; $400 minimum for inside. Finds illustrators through postcards in the mail, agencies, word of mouth, artist's submissions.
Tips: "Take a look at the magazine (on our website); all work is color; prefer contrast, not monochrome. Usually give freelancer a week to turn art around. The magazine's subject matter is highly technical, but the art doesn't have to be (we use a lot of collage and hand-done work in addition to computer-assisted art.)"

Ⓝ **NEVADA**, 401 N. Carson St., #100, Carson City NV 89701. (775)687-6158. Fax: (775)687-6159. Estab. 1936. Bimonthly magazine "founded to promote tourism in Nevada." Features Nevada artists, history, recreation, photography, gaming. Traditional, 3-column layout with large (coffee table type) 4-color photos. Circ. 80,000. Accepts previously published artwork. Originals are returned to artist at job's completion. Sample copies for $3.50. Art guidelines available.
Illustration: Approached by 25 illustrators/year. Buys 2 illustrations/issue. Works on assignment only. Send query letter with brochure, résumé and slides. Samples are filed. Responds in 2 months. To show portfolio, mail 20 slides and bio. Buys one-time rights. Pays $35 minimum for inside illustrations.

☑ **NEW HAMPSHIRE MAGAZINE**, 150 Dow St., Manchester NH 03101. (603)624-1442. Fax: (603)624-1310. E-mail: ssauer@nhmagazine.com. Website: www.nhmagazine.com. **Creative Director:** Susan Sauer. Estab. 1990. Monthly 4-color magazine emphasizing New Hampshire lifestyle. Circ. 20,000.

MARKET CONDITIONS are constantly changing! If you're still using this book and it is 2004 or later, buy the newest edition of *Artist's & Graphic Designer's Market* at your favorite bookstore or order directly from Writer's Digest Books (1-800-289-0963).

Cartoons: Approached by 2 cartoonists/year. NH related contest. Send query letter with b&w photocopies. Samples are filed. Rights purchased vary according to project. Pays on publication; $100-150 for b&w; $150-200 for color cartoons; $150-200 for comic strips.

Illustration: Approached by 12 illustrators/year. Has featured illustrations by Brad Wuorinen and Stephen Sauer. Features humorous illustration, charts & graphs and spot illustration. Prefers illustrating concept of story. Assigns 50% to experienced, but not well-known illustrators; 50% to new and emerging illustrators. 50% of freelance illustration demands knowledge of illustrator. Send postcard sample and follow-up postcard every 3 months. Accepts Mac-compatible disk submissions. Send EPS or TIFF files. Sample are filed. Responds in 1 week. Portfolio review not required. Negotiates rights purchased. Pays on publication; $75-200 for b&w inside; $75-250 for color inside; $150-250 for 2-page spreads; $75 for spots. Finds illustrators through word of mouth.

Tips: "Lifestyle magazines want 'uplifting' lifestyle messages, not dark or disturbing images."

NEW MOON: THE MAGAZINE FOR GIRLS AND THEIR DREAMS, P.O. Box 3620, Duluth MN 55803-3620. (218)728-5507. Fax: (218)728-0314. E-mail: girl@newmoon.org. Website: www.newmoon.org. **Managing Editor:** Deb Mylin. Estab. 1992. Bimonthly 4-color cover, 2-color inside consumer magazine. Circ. 25,000. Sample copies are $6.50.

Illustration: Buys 3-4 illustrations/issue. Has featured illustrations by Neverne Covington, Tricia Tusa, Julie Paschkis, Amanda Harvey. Features realistic illustrations, informational graphics and spot illustrations of children, women and girls. Prefers b&w, ink. Assigns 30% of illustrations to well-known or "name" illustrators; 30% to experienced, but not well-known illustrators; 30% to new and emerging illustrators. Send postcard sample or other nonreturnable samples. Final work can be submitted on disk or as original artwork. Send EPS files at 300 dpi or greater, hi-res. Samples are filed. Responds only if interested. Portfolio review not required. Buys one-time rights. Pays on publication; $400 maximum for color cover; $75 maximum for b&w inside. Finds illustrators through *Illustration Workbook*, samples and *Picture Book*.

Tips: "Be very familiar with the magazine and our mission. We are a magazine for girls ages 8-14 and look for illustrators who portray people of all different shapes, sizes, and ethnicities in their work. Women cover artists only. Men and women are welcome to submit black & white samples for inside. Send a 9×11 SASE for cover art guidelines."

NEW MYSTERY MAGAZINE, 101 W. 23rd St., Penthouse 1, New York NY 10011. (212)353-1582. E-mail: editorial@newmystery.com. Website: newmystery.com. **Art Director:** Dana Irwin. Estab. 1989. Quarterly literary magazine—a collection of mystery, crime and suspense stories with b&w drawings, prints and various graphics. Circ. 100,000. Accepts previously published artwork. Originals are returned at job's completion. Sample copies available for $7 plus $1.24 postage and SASE; art guidelines for SASE with first-class postage.

Cartoons: Approached by 100 cartoonists/year. Buys 1-3 cartoons/issue. Prefers themes relating to murder, heists, guns, knives, assault and various crimes; single or multiple panel, b&w line drawings. Send query letter with finished cartoon samples. Samples are filed and are returned by SASE if requested. Responds in 1-2 months. Rights purchased vary according to project. Pays $20-50 for b&w, $20-100 for color.

Illustration: Approached by 100 illustrators/year. Buys 12 illustrations/issue. Prefers themes surrounding crime, murder, suspense, noir. Considers pen & ink, watercolor and charcoal. Needs computer-literate freelancers for illustration. Send postcard sample with SASE. Accepts disk submissions compatible with IBM. Send TIFF and GIF files. Samples are filed. Responds in 1-2 months. To show a portfolio, mail appropriate materials: b&w photocopies and photographs. Rights purchased vary according to project. Pays on publication; $100-200 for covers; $25-50 for insides; $10-25 for spots.

Design: Needs freelancers for multimedia. Freelance work demands knowledge of Photoshop and QuarkX-Press. Send query letter with SASE and tearsheets. Pays by the project, $100-200.

Tips: "Study an issue and send right-on illustrations. Do not send originals. Keep copies of your work. *NMM* is not responsible for unsolicited materials."

the new renaissance, 26 Heath Rd., Apt. 11, Arlington MA 02174-3645. E-mail: umichaud@gwi.net. **Editor:** Louise T. Reynolds. Co-editor/Art Editor: Michal Anne Kuchauki. Estab. 1968. Biannual (spring and fall) magazine emphasizing literature, arts and opinion for "the general, literate public"; b&w with 4-color cover, 6×9. Circ. 1,400. Originals are only returned after publication if SASE is enclosed. Sample copy available for $6.50. Recent issue $11.50 add $1.50 foreign.

Cartoons: Approached by 35-45 freelance artists/year. Pays $15-30 for b&w plus copies of issue. Cartoons used only every 3-4 issues, not every issue.

Illustration: Buys 6-8 illustrations/issue from freelancers and "occasional supplementary artwork (2-4 pages)." Works mainly on assignment. Has featured illustrations by Alice Lane and Phoebe McKay. Features expressive, realistic illustrations and symbolism. Assigns 60-70% of illustrations to experienced, but

not well-known illustrators; 20-40% to new and emerging illustrators. Send résumé, samples, photos and SASE. Responds in 2-4 months. Publication will contact artist for portfolio review if interested, "but only if artist has enclosed SASE." Portfolio should include roughs, b&w photographs and SASE. Buys one-time rights. Pays after publication; $25-30 for b&w inside; $18-25 for spots.

Tips: "Buy a back issue to see if your kind of drawings fit in with our needs. We like realistic or symbolic, expressionistic interpretations, not literal ones. Only interested in b&w. We want artists who understand a 'quality' (or 'serious' or 'literary') piece of fiction (or, occasionally, a poem). Study our past illustrations. We are receiving work that is appropriate for a newsletter, newsprint or alternative-press magazines, but not for us *tnr* takes a classicist position in the arts—we want work that holds up and that adds another dimension to the writing—story or poem—rather than an illustration that simply echoes the storyline. We will only consider work that is submitted with a SASE. No postcards, please."

✔ ⌗ **NEW TIMES LA**, 1950 Sawtelle, #200, Los Angeles CA 90025. (310)477-0403. Fax: (310)478-9873. E-mail: eric.almendral@newtimesla.com. Website: www.newtimesla.com. **Art Director:** Eric Al-mendral. Layout Editor: Erika Ginter. Weekly alternative newspaper. Circ. 120,000. Sample copy and art guidelines available.

Cartoons: Approached by 15-20 cartoonists/year. Buys 2 cartoons/year. Prefers smart and unique styles. Prefers political, humorous b&w washes and line drawings with or without gaglines. Send query letter with finished cartoons and tearsheets. Samples are filed. Rights purchased vary according to project. **Pays on acceptance.**

Illustration: Approached by many illustrators/year. Has featured illustrations by Shane Rebenshied, Shag, Kalynn Campbell and Craig LaRotunda. Buys 1-3 illustrations/issue. Considers all media. Send postcard sample or query letter with printed samples and tearsheets. Prefers disk submissions of final art. Samples are filed. Portfolios may be dropped off the first Wednesday of the month. Rights purchased vary according to project. **Pays on acceptance.**

Design: Needs freelancers for design. Prefers local design freelancers only.

Tips: "We are looking for freelance illustrators who can quickly turn around finished work via digital means."

NEW WRITER'S MAGAZINE, Box 5976, Sarasota FL 34277. (941)953-7903. E-mail: newriters@aol.com. Website: www.newriters.com. **Editor/Publisher:** George J. Haborak. Estab. 1986. Bimonthly b&w magazine. Forum "where all writers can exchange thoughts, ideas and their own writing. It is focused on the needs of the aspiring or new writer." Rarely accepts previously published artwork. Original artwork returned after publication if requested. Sample copies for $3; art guidelines for SASE with first-class postage.

Cartoons: Approached by 15 cartoonists/year. Buys 1-3 cartoons/issue. Features spot illustration. Assigns 20% of illustrations to experienced, but not well-known illustrators; 80% to new and emerging illustrators. Prefers cartoons "that reflect the joys or frustrations of being a writer/author"; single panel b&w line drawings with gagline. Send query letter with samples of style. Samples are sometimes filed or returned if requested. Responds in 1 month. Buys first rights. Pays on publication; $10 for b&w.

Illustration: Buys 1 illustration/issue. Works on assignment only. Prefers line drawings. Considers water-color, mixed media, colored pencil and pastel. Send postcard sample. Samples are filed or returned if requested by SASE. Responds in 1 month. To show portfolio, mail tearsheets. Buys first rights or negotiates rights purchased. Pays $10 for spots. Payment negotiated.

THE NEW YORKER, 4 Times Square, New York NY 10036. (212)286-5400. E-mail (cartoons): bob@cartoonbank.com. Website: www.cartoonbank.com. Emphasizes news analysis and lifestyle features.

Cartoons: Buys b&w cartoons. Receives 3,000 cartoons/week. Cartoon editor is Bob Mankoff, who also runs Cartoon Bank, a stock cartoon agency that features *New Yorker* cartoons. Accepts unsolicited submissions only by mail. Reviews unsolicited submissions every 1-2 weeks. Photocopies only. Strict standards regarding style, technique, plausibility of drawing. Especially looks for originality. Pays $575 minimum for cartoons. Contact cartoon editor.

Illustration: All illustrations are commissioned. Portfolios may be dropped off Wednesdays between 10-6 and picked up on Thursdays. Mail samples, no originals. "Because of volume of submissions we are unable to respond to all submissions." No calls please. Emphasis on portraiture. Contact illustration department.

Tips: "Familiarize yourself with *The New Yorker*."

NEWSWEEK, 251 W. 57th St., 15th Floor, New York NY 10019. (212)445-4000. Website: www.newsweek.com. **Art Directors:** Amid Capeci and Alexander Ha. Assistant Managing Editor/Design: Lynn Staley. Weekly news magazine. Circ. 3,180,000. Has featured illustrations by Daniel Adel and Zohar Lozar.

Illustration: Send postcard samples or other nonreturnable samples. Prefers illustrations or situations in national and international news. Portfolios may be dropped off at front desk Tuesday or Wednesday from 9 to 5. Call ahead.

NIGHTLIFE MAGAZINE, 990 Motor Pkwy., Central Islip NY 11722. (631)435-8890. Fax: (631)435-8925. **Senior Vice President/Editor-in-Chief:** Fran Petito. Estab. 1979. Monthly consumer magazine covering events, entertainment and other consumer issues for general audience, ages 21-40, of New York area. Circ. 45,000. Originals are not returned.
Illustration: Approached by 25-30 illustrators/year. Buys 1 illustration/issue. Considers watercolor. Send postcard sample or query letter with tearsheets. Samples filed. Responds in 2 months. Portfolio review not required. Buys first rights. Pays on publication; $50-75 for color inside.

⫚ NORTH AMERICAN WHITETAIL MAGAZINE, 2250 Newmarket Pkwy., Suite 110, Marietta GA 30067. (770)953-9222. Fax: (770)933-9510. **Editorial Director:** Ken Dunwoody. Estab. 1982. Consumer magazine "designed for serious hunters who pursue whitetailed deer." 8 issues/year. Circ. 135,000. Accepts previously published artwork. Original artwork is returned at job's completion. Sample copies available for $3; art guidelines not available.
Illustration: Approached by 30 freelance illustrators/year. Buys 6-8 freelance illustrations/year. Works on assignment only. Considers pen & ink and watercolor. Send postcard sample and/or query letter with brochure and photocopies. Samples are filed or are returned by SASE if requested by artist. Responds only if interested. To show a portfolio, mail appropriate materials. Rights purchased vary according to project. Pays 10 weeks prior to publication; $25 minimum for b&w inside; $75 minimum for color inside.

NOTRE DAME MAGAZINE, 535 Grace Hall, Notre Dame IN 46556. (219)631-4630. Website: www.ND.EDU/~NDMAG. **Art Director:** Don Nelson. Estab. 1971. Quarterly 4-color university magazine that publishes essays on cultural, spiritual and ethical topics, as well as news of the university for Notre Dame alumni and friends. Circ. 140,000. Accepts previously published artwork. Original artwork returned after publication.
Illustration: Approached by 40 illustrators/year. Buys 5-8 illustrations/issue. Has featured illustrations by Steve Madson, Joe Ciardiello, Mark Fisher and Terry Lacy. Assigns 15% of illustrations to well-known or "name" illustrators; 75% to experienced, but not well-known illustrators; 10% to new and emerging illustrators. Works on assignment only. Tearsheets, photographs, slides, brochures and photocopies OK for samples. Samples are returned by SASE if requested. "Don't send submissions—only tearsheets or samples." Buys first rights. Pays $2,000 maximum for color covers; $150-400 for b&w inside; $200-700 for color inside; $75-150 for spots.
Tips: "Looking for noncommercial style editorial art by accomplished, experienced editorial artists. Conceptual imagery that reflects the artist's awareness of fine art ideas and methods is the kind of thing we use. Sports action illustrations not used. Cartoons not used. Create images that can communicate ideas."

NOVA EXPRESS, P.O. Box 27231, Austin TX 78755. E-mail: lawrenceperson@jump.net. Website: www. novaexpress.org. **Editor:** Lawrence Person. Estab. 1987. B&w literary zine featuring cutting-edge science fiction, fantasy, horror and slipstream. Circ. 550.
Illustration: Approached by 6 illustrators/year. Buys 10-15 illustrations/issue. Has featured illustrations by GAK, Tim Powers, Angela Mark, Steven Sanders, Michael Csontos, Cathy Burburuz, Bill D. Fountain, Phil Yeh, Keith Burdak. Features science fiction, fantasy, horror, spot illustrations. Prefers b&w. Assigns 50% of illustrations to experienced, but not well-known illustrators; 50% to new and emerging illustrators. Send nonreturnable samples. Accepts Mac-compatible disk submissions. Samples are filed. Responds in 3 months. Portfolio review not required. Buys one-time rights. Pays on publication in copies and subscription only. Finds illustrators online.
Tips: "We only publish artwork connected to the SF/F/H metagenre (though sometimes we find abstract or futuristic designs useable). However, we do not want clichéd SF/F themes (i.e., Gernsbackian rocket ships, unicorns, elves, or any other generic fantasy). Solid work and originality are always welcome. We only use b&w illustrations, so don't send color samples. Though not a paying market, *Nova Express* is widely read and well regarded by genre professionals."

☑ NOW AND THEN, Box 70556 ETSU, Johnson City TN 37614-1707. (423)439-5348. Fax: (423)439-6340. E-mail: fischman@etsu.edu. Website: cass.etsu.edu/n&t/. **Editor:** Jane Harris Woodside. Managing Editor: Nancy Fischman. Estab. 1984. Magazine covering Appalachian issues and arts, published 3 times a year. Circ. 1,000. Accepts previously published artwork. Originals are returned at job's completion. Sample copies available for $7. Art guidelines free for SASE with first class postage or on website.

Cartoons: Approached by 5 cartoonists/year. Prefers Appalachia issues, political and humorous cartoons; b&w washes and line drawings. Send query letter with brochure, roughs and finished cartoons. Samples are filed or will be returned by SASE if requested by artist. Responds in 4-6 months. Buys one-time rights. Pays $25 for b&w.

Illustration: Approached by 3 illustrators/year. Buys 1-2 illustrations/issue. Has featured illustrations by Nancy Jane Earnest, David M. Simon and Anthony Feathers. Features natural history; humorous, realistic, computer and spot illustration. Assigns 100% of illustrations to experienced, but not well-known illustrators. Prefers Appalachia, any style. Considers b&w or 2- or 4-color pen & ink, collage, airbrush, marker and charcoal. Freelancers should be familiar with FreeHand, PageMaker or Photoshop. Send query letter with brochure, SASE and photocopies. Samples are filed or will be returned by SASE if requested by artist. Responds in 6 months. Publication will contact artist for portfolio review if interested. Portfolio should include b&w tearsheets, slides, final art and photographs. Buys one-time rights. Pays on publication; $50-100 for color cover; $25 maximum for b&w inside.

Tips: "We have special theme issues. Illustrations have to have something to do with theme. Write for guidelines, see the website, enclose SASE."

NURSEWEEK, 1156-C Aster Ave., Sunnyvale CA 94086. (408)249-5877. Fax: (408)249-8204. E-mail: youngk@nurseweek.com. Website: www.nurseweek.com. **Creative Director:** Young Kim. "*Nurseweek* is a biweekly 4-color tabloid mailed free to registered nurses nationwide. Combined circulation of all publications is over 1 million. Biweekly to every RN nationwide. *Nurseweek* provides readers with nursing-related news and features that encourage and enable them to excel in their work and that enhance the profession's image by highlighting the many diverse contributions nurses make. In order to provide a complete and useful package, the publication's article mix includes late-breaking news stories, news features with analysis (including in-depth bimonthly special reports), interviews with industry leaders and achievers, continuing education articles, career option pieces (Spotlight, Entrepreneur) and reader dialogue (Letters, Commentary, First Person)." Sample copy $3. Art guidelines not available. Needs computer-literate freelancers for production. 90% of freelance work demands knowledge of Quark, PhotoShop, Illustrator, Adobe Acrobat, CorelDraw.

Illustration: Approached by 10 illustrators/year. Buys 1 illustration/year. Prefers pen & ink, watercolor, airbrush, marker, colored pencil, mixed media and pastel. Needs medical illustration. Send query letter with brochure, tearsheets, photographs, photocopies, photostats, slides and transparencies. Samples are not filed and are returned by SASE if requested by artist. Publication will contact artist for portfolio review if interested. Portfolio should include final art samples, photographs. Buys all rights. Pays on publication; $150 for b&w, $250 for color cover; $100 for b&w, $175 for color inside. Finds artists through sourcebooks.

Design: Needs freelancers for design. 90% of design demands knowledge of Photoshop 4.0, QuarkXPress 4.0. Prefers local freelancers. Send query letter with brochure, résumé, SASE and tearsheets. Pays for design by the project.

O&A MARKETING NEWS, Kal Publications, 559 S. Harbor Blvd., Suite A, Anaheim CA 92805-4525. (714)563-9300. Fax: (714)563-9310. Website: www.kalpub.com. **Editor:** Kathy Laderman. Estab. 1966. Bimonthly b&w trade publication about the service station/petroleum marketing industry. Circ. 8,000. Sample copies for 11×17 SASE with 10 first-class stamps.

● This publisher also published *Automotive Booster*.

Cartoons: Approached by 10 cartoonists/year. Buys 1-2 cartoons/issue. Prefers humor that relates to service station industry. Prefers single panel, humorous, b&w line drawings. Send b&w photocopies, roughs or samples and SASE. Samples are returned by SASE. Responds in 1 month. Buys one-time rights. **Pays on acceptance**; $12 for b&w.

Tips: "We run a cartoon (at least one) in each issue of our trade magazine. We're looking for a humorous take on business—specifically the service station/petroleum marketing/carwash/quick lube industry that we cover."

OFF OUR BACKS, a woman's journal, 2337B 18th St., Washington DC 20009. (202)234-8072. E-mail: offourbacks@compuserve.com. Website: www.igc.org/oob. **Office Coordinator:** Jennie Ruby. Collective Member: Karla Mantilla. Estab. 1970. Monthly feminist news journal; tabloid format; covers women's issues and the feminist movement. Circ. 10,000. Accepts previously published artwork. Original artwork is returned at the job's completion. Sample copies available; art guidelines free for SASE with first-class postage.

Cartoons: Approached by 6 freelance cartoonists/year. Buys 2 freelance cartoons/issue. Prefers political, feminist themes. Send query letter with roughs. Samples are filed. Responds to the artist if interested within 2 months.

Illustration: Approached by 20 freelance illustrators/year. Prefers feminist, political themes. Considers pen & ink. Send query letter with photocopies. Samples are filed. Responds to the artist only if interested. To show a portfolio, mail appropriate materials.

Tips: "Ask for a sample copy. Preference given to feminist, woman-centered, multicultural line drawings."

OFFICEPRO, 5501 Backlick Rd., Suite 240, Springfield VA 22151. (703)914-9200. Fax: (703)914-6777. E-mail: abrady@strattonpub.com. Website: www.iaap-hq.org. **Editor:** Angela Hickman Brady. Estab. 1945. Trade journal published 9 times/year. Publication directed to the office support professional. Emphasis is on workplace issues, trends and technology. Readership is 98% female. Circ. 40,000. Accepts previously published artwork. Originals returned at job's completion upon request only. Sample copies available (contact subscription office at (816)891-6600, ext. 235).

Illustration: Approached by 50 illustrators/year. Buys 20 or fewer illustrations/year. Works on assignment and purchases stock art. Prefers communication, travel, meetings and international business themes. Considers pen & ink, airbrush, colored pencil, mixed media, collage, charcoal, watercolor, acrylic, oil, pastel, marker and computer. Send postcard-size sample or send query letter with brochure, tearsheets and photocopies. Samples are filed. Responds to the artist only if interested. Publication will contact artist for portfolio review if interested. Portfolio should include final art and tearsheets. Buys one-time rights usually, but rights purchased vary according to project. **Pays on acceptance** (net 30 days); $500-600 for color cover; $60-150 for b&w, $200-400 for color inside; $60 for b&w spots. Finds artists through word of mouth and artists' samples.

OHIO MAGAZINE, 62 E. Broad St., 2nd Floor, Columbus OH 43215. (614)461-5083. Fax: (614)461-8505. Website: www.ohiomagazine.com. **Art Director:** Angie Packer. 12 issues/year emphasizing traveling in Ohio. Circ. 95,000. Previously published work OK. Original artwork returned after publication. Sample copy $2.50; art guidelines not available.

Illustration: Approached by 70 illustrators/year. Buys 2 illustrations/issue. Works on assignment only. Has featured illustrations by David and Amy Butler and Chris O'Leary. Features charts & graphs; informational graphics; spot illustrations. Assigns 10% of illustrations to well-known or "name" illustrators; 80% to experienced, but not well-known illustrators; 10% to new and emerging illustrators. Considers pen & ink, watercolor, collage, acrylic, marker, colored pencil, oil, mixed media and pastel. 20% of freelance work demands knowledge of Illustrator, QuarkXPress, Photoshop or FreeHand. Send postcard sample or brochure, SASE, tearsheets and slides. Accepts disk submissions. Send Mac EPS files. Samples are filed or are returned by SASE. Responds in 1 month. Request portfolio review in original query. Portfolio should include b&w and color tearsheets, slides, photostats, photocopies and final art. Buys one-time rights. **Pays on acceptance**; $250-500 for color cover; $50-400 for b&w inside; $50-500 for color inside; $100-800 for 2-page spreads; $50-125 for spots. Finds artists through submissions and gallery shows.

Design: Needs freelancers for design and production. 100% of freelance work demands knowledge of Photoshop and QuarkXPress. Send query letter with tearsheets and slides.

Tips: "Please take time to look at the magazine if possible before submitting."

OKLAHOMA TODAY MAGAZINE, 15 N. Robinson, Suite 100, Oklahoma City OK 73102-5403. (405)521-2496. Fax: (405)522-4588. Website: www.oklahomatoday.com. **Editor:** Louisa McCune. Estab. 1956. Bimonthly regional, upscale consumer magazine focusing on all things that define Oklahoma and interest Oklahomans. Circ. 50,000. Accepts previously published artwork. Originals are returned at job's completion. Sample copies available with a SASE.

Illustration: Approached by 24 illustrators/year. Buys 5-10 illustrations/year. Has featured illustrations by Rob Silvers, Tim Jossel, Steven Walker and Cecil Adams. Features caricatures of celebrities; natural history; realistic and spot illustration. Assigns 10% of illustrations to well-known illustrators; 80% to experienced, but not well-known illustrators; 10% to new and emerging illustrators. Considers pen & ink, watercolor, collage, airbrush, acrylic, marker, colored pencil, oil, charcoal and pastel. 20% of freelance work demands knowledge of PageMaker, Illustrator and Photoshop. Send query letter with brochure, résumé, SASE, tearsheets and slides. Samples are filed. Responds in days if interested; months if not. Portfolio review required if interested in artist's work. Portfolio should include b&w and color thumbnails, tearsheets and slides. Buys one-time rights. Pays $200-500 for b&w cover; $200-750 for color cover; $50-500 for b&w inside; $75-750 for color inside. Finds artists through sourcebooks, other publications, word of mouth, submissions and artist reps.

Tips: Illustrations to accompany short stories and features are most open to freelancers. "Read the magazine. Be willing to accept low fees at the beginning."

☑ **THE OPTIMIST**, 4494 Lindell Blvd., St. Louis MO 63108-2404. (314)371-6000. Fax: (314)371-6006. E-mail: rennera@optimist.org. Website: www.optimist.org. **Graphic Designer:** Andrea Walker. 4-color magazine with 4-color cover that emphasizes activities relating to Optimist clubs in US and Canada

(civic-service clubs). "Magazine is mailed to all members of Optimist clubs. Average age is 42; most are management level with some college education." Circ. 120,000. Sample copy for SASE; art guidelines not available.

Cartoons: Buys 2 or 3 cartoons/issue. Has featured cartoons by Martin Bucella, Randy Glasbergen, Randy Bisson. Assigns 75% of cartoons to experienced, but not well-known cartoonists; 25% to new and emerging cartoonists. Prefers themes of general interest: family-orientation, sports, kids, civic clubs. Prefers color single panel with gagline. No washes. Send query letter with samples. Send art on a disk if possible (Macintosh compatible). Submissions returned by SASE. Responds in 1 week. Buys one-time rights. **Pays on acceptance**; $30 for b&w or color.

Tips: "Send clear cartoon submissions, not poorly photocopied copies."

✓ **ORANGE COAST MAGAZINE**, 3701 Birch St., Suite 100, Newport Beach CA 92660. (949)862-1133. Fax: (949)862-0133. E-mail: ocmag@aol.com. Website: www.orangecoast.com. **Art Director:** Stacy Brockman. Estab. 1970. Monthly 4-color local consumer magazine with celebrity covers. Circ. 50,000.

Illustration: Approached by 100 illustrators/year. Has featured illustrations by Cathi Mingus, Gweyn Wong, Scott Lauman, Santiago Veeda, John Westmark, Robert Rose, Nancy Harrison. Features computer, fashion and editorial illustrations featuring children and families. Prefers serious subjects; some humorous subjects. Assigns 10% of illustrations to well-known or "name" illustrators; 40% to experienced, but not well-known illustrators; 50% to new and emerging illustrators. 40% of freelance illustration demands knowledge of Illustrator or Photoshop. Send postcard or other nonreturnable samples. Accepts Mac-compatible disk submissions. Send EPS files. Samples are filed. Responds in 1 month. Will contact artist for portfolio review if interested. **Pays on acceptance**; $175 for b&w or color inside; $75 for spots. Finds illustrators through artist promotional samples.

Tips: "Looking for fresh and unique styles. We feature approximately four illustrators per publication. I've developed great relationships with all of them."

OREGON CATHOLIC PRESS, 5536 NE Hassalo, Portland OR 97213-3638. (503)281-1191. Fax: (503)282-3486. E-mail: jeang@ocp.org. Website: www.ocp.org/. **Art Director:** Jean Germano. Estab. 1988. Quarterly liturgical music planner in both Spanish and English with articles, photos and illustrations specifically for but not exclusive to the Roman Catholic market.

● See *OCP*'s listing in the Book Publishers section to learn about this publisher's products and needs.

Illustration: Approached by 10 illustrators/year. Buys 20 illustrations/issue. Has featured illustrations by John August Swanson and Steve Erspamer. Assigns 50% of illustrations to experienced, but not well-known illustrators; 50% to new and emerging illustrators. Send query letter with printed samples, photocopies, SASE. Samples are filed or returned by SASE. Responds in 2 weeks. Portfolio review not required. Rights purchased vary according to project. **Pays on acceptance**; $100-250 for color cover; $30-50 for b&w spot art or photo.

OREGON RIVER WATCH, Box 294, Rhododendron OR 97049. (503)622-4798. **Editor:** Michael P. Jones. Estab. 1985. Quarterly b&w books published in volumes emphasizing "fisheries, fishing, camping, rafting, environment, wildlife, hiking, recreation, tourism, mountain and wilderness scenes and everything that can be related to Oregon's waterways. Down-home pleasant look, not polished, but practical—the '60s still live on." Circ. 2,000. Accepts previously published material. Original artwork returned after publication. Art guidelines for SASE with first-class postage.

Cartoons: Approached by 400 cartoonists/year. Buys 1-25 cartoons/issue. Cartoons need to be straightforward, about fish and wildlife/environmental/outdoor-related topics. Prefers single, double or multiple panel b&w line drawings, b&w or color washes with or without gagline. Send query letter with SASE, samples of style, roughs or finished cartoons. Samples are filed or are returned by SASE. Responds in 2 months "or sooner—depending upon work load." Buys one-time rights. Pays in copies.

Illustration: Approached by 600 illustrators/year. Works with 100 illustrators/year. Buys 225 illustrations/year. Needs editorial, humorous and technical illustration related to the environment. "We need b&w pen & ink sketches. We look for artists who are not afraid to be creative, rather than those who merely go along with trends." Send query letter with brochure, résumé, photocopies, SASE, slides, tearsheets and transparencies. "Include enough to show me your true style." Samples not filed are returned by SASE. Responds in 2 weeks. Buys one-time rights. Pays in copies. 20% of freelance work demands computer skills.

Design: Needs freelancers for design and production. Send brochure, photocopies, SASE, tearsheets, résumé, photographs, slides and transparencies. Pays in copies.

Tips: "Freelancers must be patient. We have a lot of projects going on at once but cannot always find an immediate need for a freelancer's talent. Being pushy doesn't help. I want to see examples of the artist's expanding horizons, as well as their limitations. Make it really easy for us to contact you. Remember, we get flooded with letters and will respond faster to those with a SASE."

ORGANIC GARDENING, 22 E. Second St., Emmaus PA 18098. (610)967-8065. Fax: (610)967-7846. E-mail: john.pepper@rodale.com. Website: www.organicgardening.com. **Art Director:** Brian Goddard. Magazine emphasizing gardening; 4-color; "uncluttered design." Published 3 times/year. Circ. 600,000. Usually buys first publication rights. Sample copies available only with SASE.
Illustration: Buys 10 illustrations/issue. Works on assignment only. Send query letter with samples, tearsheets, slides and photographs. Samples are filed or are returned by SASE only. Occasionally needs technical illustration. Buys first rights or one-time rights. Pays $100-1,500 for color depending on size.
Tips: "Our emphasis is 'how-to' gardening; therefore illustrators with experience in the field will have a greater chance of being published. Detailed and fine rendering quality is essential."

ORLANDO MAGAZINE, 225 S. Westmont Dr., Suite 1100, Altamonte Springs FL 32714. (407)767-8338. Fax: (407)767-8348. E-mail: orlandomag@aol.com. Website: www.orlandomagazine.com. **Art Director:** Jeanne Euker. Estab. 1946. "We are a 4-color monthly city/regional magazine covering the Central Florida area—local issues, sports, home and garden, business, entertainment and dining." Circ. 30,000. Accepts previously published artwork. Originals are returned at job's completion. Sample copies available.
Illustration: Buys 2-3 illustrations/issue. Has featured illustrations by T. Sirell, Rick Martin, Mike Wright, Jon Krause. Assigns 100% of illustrations to experienced, but not necessarily well-known illustrators. Works on assignment only. Needs editorial illustration. Send postcard, brochure or tearsheets. Samples are filed and are not returned. Responds only if interested with a specific job. Portfolio review not required. Buys first rights, one-time rights or all rights (rarely). Pays on publication; $400 for color cover; $200-250 for color inside.
Design: Needs freelancers for design and production. Pays for design by the project.
Tips: "Send appropriate samples. Most of my illustration hiring is via direct mail. The magazine field is still a great place for illustration. Have several ideas ready after reading editorial to add to or enhance our initial concept."

THE OTHER SIDE, 300 W. Apsley St., Philadelphia PA 19144. (215)849-2178. Fax: (215)849-3755. **Editors:** Dee Dee Risher and Doug Davidson. Art Director: Ellen Moore Osborne. "We are read by Christians with a radical commitment to social justice and a deep allegiance to biblical faith. We try to help readers put their faith into action." Publication is 80% 4-color with 4-color cover. Published 6 times/ year. Circ. 14,000. Art guidelines available free for SASE. Accepts previously published artwork. Sample copy available for $4.50.
Illustration: Approached by 40-50 artists/year. Especially interested in original artwork in color. Does not accept cartoons. Send query letter with tearsheets, photocopies, slides, photographs and SASE. Responds in 6 weeks. Simultaneous submissions OK. Publication will contact artist for portfolio review if interested. Pays within 1 month of publication; $50-100 for 4-color; $30-50 for b&w line drawings and spots.
Tips: "We're looking for artists whose work shares our perspective on social, economic and political issues."

☑ **OUR STATE: DOWN HOME IN NORTH CAROLINA**, 1915 Lendew St., Suite 200, Greensboro NC 27408. (336)286-0600. Fax: (336)286-0100. E-mail: croyston@ourstate.com. Website: www.ourstate.com. **Art Director:** Claudia Royston. Estab. 1933. Monthly 4-color consumer magazine featuring travel, history and culture of North Carolina. Circ. 71,500. Art guidelines are free for #10 SASE with first-class postage.
Illustration: Approached by 6 illustrators/year. Buys 12 illustrations/issue. Features "cartoon-y" maps. Preferred subjects: maps of towns in NC. "Prefers pastel and bright colors." Assigns 100% to new and emerging illustrators. 100% of freelance illustration demands knowledge of Illustrator. Send postcard sample or nonreturnable samples. Samples are not filed and are not returned. Portfolio review not required. Buys one-time rights. Pays on publication; $400-600 for color cover; $75-350 for b&w inside; $75-350 for color inside; $350 for 2-page spreads. Finds illustrators through word of mouth.

☑ **OUR SUNDAY VISITOR**, 200 Noll Plaza, Huntington IN 46750. (260)356-8400. Fax: (260)358-9117. Website: www.osv.com. **Art Director:** Eric Shoening. Estab. 1912. Weekly magazine which focuses on Catholicism. Audience is mostly older, conservative; adheres to the teachings of the magisterium of the church. Circ. 85,000. Accepts previously published artwork. Originals are returned at job's completion. Sample copies available. Art guidelines not available.

Illustration: Approached by 25-30 illustrators/year. Buys 100 illustrations/year. Works on assignment only. Preferred themes are religious and social issues. Considers pen & ink, watercolor, collage, airbrush, acrylic, marker, colored pencil, oil, charcoal, mixed media and pastel. Send query letter with photographs. Samples are filed. Portfolio review not required. Buys first rights. Pays on publication; $250 for b&w, $400 for color cover; $150 for b&w, $250 for color inside.

OUTDOOR CANADA MAGAZINE, 340 Ferrier St., Suite 210, Markham, Ontario L3R 2Z5 Canada. Website: www.outdoorcanada.ca. **Editor:** Patrick Walsh. 4-color magazine for Canadian anglers and hunters. enthusiasts and their families. Stories on fishing, hunting and wildlife. Readers are 81% male. Publishes 8 regular issues/year. Circ. 95,000. Art guidelines are available.
Illustration: Approached by 12-15 illustrators/year. Buys approximately 10 drawings/issue. Has featured illustrations by Malcolm Cullen, Stephen MacEachren and Jerzy Kolatch. Features humorous, computer and spot illustration. Assigns 90% to experienced, but not well-known illustrators; 10% to new and emerging illustrators. Uses freelancers mainly for illustrating features and columns. Uses pen & ink, acrylic, oil and pastel. Send postcard sample, brochure and tearsheets. Accepts disk submissions compatible with Illustrator 7.0. Send EPS, TIFF and PICT files. Buys first rights. Pays $150-300 for b&w inside, $100-500 for color inside; $500-700 for 2-page spreads; $150-300 for spots. Artists should show a representative sampling of their work. Finds most artists through references/word of mouth.
Design: Needs freelancers for multimedia. 20% of freelance work demands knowledge of Photoshop, Illustrator and QuarkXPress. Send brochure, tearsheets and postcards. Pays by the project.
Tips: "Meet our deadlines and our budget. Know our product. Fishing and hunting knowledge an asset."

OUTDOOR LIFE MAGAZINE, Dept. AGDM, 2 Park Ave., New York NY 10016-5604. (212)779-5000. Fax: (212)686-6877. Website: www.outdoorlife.com. **Art Director:** James M. Keleher. Assistant Art Directors: Margaret McKenna and Jason Beckstead. Estab. 1897. Monthly magazine geared toward hunting, fishing and outdoor activities. Circ. 1,351,394. Original artwork is returned at job's completion. Sample copies not available.
Illustration: Works on assignment only. Send nonreturnable postcard samples, tearsheets or brochures. Samples are filed. Rights purchased vary according to project. **Pays on acceptance**.

OUTER DARKNESS (Where Nightmares Roam Unleashed), 1312 N. Delaware Place, Tulsa OK 74110. (918)832-1246. E-mail: odmagazine@aol.com. **Editor:** Dennis Kirk. Estab. 1994. Quarterly digest/zine of horror and science fiction, poetry and art. Circ. 500. Sample copy for $3.95. Sample illustrations free for 6×9 SASE and 2 first-class stamps. Art guidelines free for #10 SASE with first-class postage.
Cartoons: Approached by 15-20 cartoonists/year. Buys 15 cartoons/year. Prefers horror/science fiction slant, but not necessary. Prefers single panel, humorous, b&w line drawings. Send query letter with b&w photocopies, samples, SASE. Samples are returned. Responds in 2 weeks. Buys one-time rights. Pays on publication in contributor's copies.
Illustration: Approached by 30-40 illustrators/year. Buys 5-7 illustrations/issue. Has featured illustrations by Allen Koszowski, Jeff Ward, Terry Campbell, Steve Rader. Features realistic science fiction and horror illustrations. Prefers b&w, pen & ink drawings. Assigns 30% of illustrations to well-known or "name" illustrators; 50% to experienced, but not well-known illustrators; 20% to new and emerging illustrators. Send query letter with photocopies, SASE. Responds in 2 weeks. Buys one-time rights. Pays on publication in contributor's copies. Finds illustrators through magazines and submissions.
Tips: "Send samples of your work, along with a cover letter. Let me know a little about yourself. I enjoy learning about artists interested in *Outer Darkness*. *Outer Darkness* is continuing to grow at an incredible rate. It's presently stocked in two out-of-state bookstores, and I'm working to get it into more. The latest issue of OD features a full color cover, and I hope to publish more such issues in the future. Outer darkness is quickly moving through the ranks."

OVER THE BACK FENCE, 14 S. Paint St., Suite 69, Chillicothe OH 45601. (740)772-2165. Fax: (740)773-7626. E-mail: backfencepub@centurytel.net. Website: www.backfence.com. **Creative Director:** Rocky Alten. Estab. 1994. Quarterly consumer magazine emphasizing southern Ohio topics. Circ. 15,000. Sample copies for $4; art guidelines free for #10 SASE with first-class postage.
Illustration: Features humorous and realistic illustration; informational graphics and spot illustration. Assigns 50% of illustration to experienced, but not well-known illustrators; 50% to new and emerging illustrators. Send query letter with photocopies, SASE and tearsheets. Ask for guidelines. Samples are occasionally filed or returned by SASE. Responds in 1-3 months. Creative director will contact artist for portfolio review if interested. Buys one-time rights. Pays on publication, net 15 days; $100 for b&w and color covers; $25-100 for b&w and color inside; $25-200 for 2-page spreads; $25-100 for spots. Finds illustrators through word of mouth and submissions.

Tips: "Our readership enjoys our warm, friendly approach. The artwork we select will possess the same qualities."

☑ **THE OXFORD AMERICAN**, P.O. Box 1156, Oxford MS 38655-1156. (662)236-1836. Fax: (662)236-3141. E-mail: oxam@watervalley.net. Website: www.oxfordamericanmag.com. **Art Director:** Lindsey Sipes. Estab. 1992. Bimonthly literary magazine. "The Southern magazine of good writing." Circ. 33,000.

Illustration: Approached by many artists/year. Uses a varying number of illustrations/year. Considers all media. Send postcard sample of work. Samples are filed. Responds only if interested. Art director will contact artist for portfolio review of final art and roughs if interested. Buys one-time rights. Pays on publication. Finds artists through word of mouth and submissions.

Tips: "See the magazine."

◼ **OXYGEN**, 5775 Mclaughlin Rd., Mississauga, Ontario L5R P37 Canada. (905)507-3545. Fax: (905)507-2372. Website: www.emusclemag.com. **Art Director:** Robert Kennedy. Estab. 1997. Bimonthly consumer magazine. "Oxygen is a new magazine devoted entirely to women's fitness, health and physique." Circ. 300,000.

Illustration: Buys 2 illustrations/issue. Has featured illustrations by Erik Blais, Ted Hammond and Lauren Sanders. Features caricatures of celebrities; charts & graphs; computer and realistic illustrations. Assigns 85% of illustrations to experienced, but not well-known illustrators; 15% to new and emerging illustrators. Prefers loose illustration, full color. Considers acrylic, airbrush, charcoal, collage, color washed, colored pencil, mixed media, pastel and watercolor. 50% of freelance illustration demands knowledge of Photoshop and QuarkXPress. Send query letter with photocopies and tearsheets. Samples are filed and are not returned. Responds in 21 days. Buys all rights. **Pays on acceptance**; $1,000-2,000 for b&w and color cover; $50-500 for b&w and color inside; $100-1,000 for 2-page spreads. Finds illustrators through word of mouth and submissions.

Tips: "Artists should have a working knowledge of women's fitness. Study the magazine. It is incredible the amount of work that is sent that doesn't begin to relate to the magazine."

☑ ◼ **PACIFIC YACHTING MAGAZINE**, 1080 Howe St., Suite 900, Vancouver, British Columbia V6Z 2T1 Canada. (604)606-4644. Fax: (604)687-1925. E-mail: editorial@pacificyachting.net. Website: www.pacificyachting.com. **Editor:** Simon Hill. Estab. 1968. Monthly 4-color magazine focused on boating on the West Coast of Canada. Power/sail cruising only. Circ. 25,000. Accepts previously published artwork. Original artwork returned at job's completion. Sample copies available for $4.95 cover price. Art guidelines not available.

Cartoons: Approached by 12-20 cartoonists/year. Buys 1 illustration or cartoon/issue. Boating themes only; single panel b&w line drawings. Send query letter with brochure and roughs. Samples are filed or are returned by SASE if requested by artist. Responds in 1 month. Buys one-time rights. Pays $25-50 for b&w.

Illustration: Approached by 25 illustrators/year. Buys 4-6 illustrations/year. Has featured illustrations by Dave Alavoine, Roger Jackson and Tom Shardlow. Boating themes only. Considers pen & ink, watercolor, airbrush, acrylic, colored pencil, oil and charcoal. Send query letter with brochure. Samples are filed or are returned by SASE if requested by artist. Responds in 2 weeks only if interested. Call for appointment to show portfolio of appropriate samples related to boating on the West Coast. Buys one-time rights. Pays on publication; $300 for color cover; $50-100 for b&w inside; $100-150 for color inside; $25-50 for spots.

Tips: "Know boats and how to draw them correctly. Know and love my magazine."

◼ **PAINT HORSE JOURNAL**, Box 961023, Fort Worth TX 76161-0023. (817)834-2742. Website: www.painthorsejournal.com. **Art Director:** Paul Zinn. Monthly 4-color official publication of breed registry of Paint horses for people who raise, breed and show Paint horses. Circ. 34,000. Original artwork returned after publication if requested. Sample copy for $3; artist's guidelines for SASE.

Illustration: Approached by 25-30 illustrators/year. Receives 4-5 illustrations/week. Buys a few illustrations each issue. Send business card and samples to be kept on file. Prefers snapshots of original art or photostats as samples. Samples returned by SASE if not filed. Responds in 1 month. Buys first rights on cover art, but would like to be able to use small, filler art many times. Pays on publication; $50 for b&w, $100-200 for color cover; $50 for b&w, $75-100 for color inside.

Tips: "No matter what style of art you use—you must include Paint horses with conformation acceptable (to the APHA). As horses are becoming more streamlined—as in race-bred Paints, the older style of horse seems outdated. Horses of Arabian-type conformation or with unnatural markings are incorrect. Action art and performance events are very nice to have."

N **PALO ALTO WEEKLY**, 703 High St., Palo Alto CA 94301. (415)326-8210. E-mail: chubenthal @paweekly.com. Website: www.paloaltoonline.com. **Design Director:** Carol Hubenthal. Estab. 1979. Semiweekly newspaper. Circ. 45,000. Accepts previously published artwork. Originals returned at job's completion. Sample copies available.

Illustration: Buys 20-30 illustrations/year. Works on assignment only. Considers all media. Send query letter with brochure, résumé, SASE, tearsheets, photographs, photocopies, photostats, slides and transparencies. Samples are filed. Publication will contact artist for portfolio review if interested. Pays on publication; $175 for b&w cover, $200 for color cover; $100 for b&w inside, $125 for color inside.

Tips: Most often uses freelance illustration for covers and cover story, especially special section covers such as restaurant guides. "We call for artists' work in our classified ad section when we need some fresh work to look at. We work exclusively with local artists."

PARABOLA MAGAZINE, 656 Broadway, New York NY 10012-2317. (212)505-9037. Fax: (212)979-7325. E-mail: parapola@panix.com. Website: www.parabola.org. **Managing Editor:** Natalie Baan. Estab. 1974. Quarterly magazine of world myth, religious traditions and arts/comparative religion. Circ. 40,000. Sample copies available. Art guidelines for #10 SASE with first-class postage.

Illustration: Approached by 20 illustrators/year. Buys 4-6 illustrations/issue. Prefers traditional b&w-high contrast. Considers all media. Send postcard or query letter with printed nonreturnable samples, photocopies and SASE. Send follow-up postcard sample every 3 months. Accepts disk submissions. Samples are filed. Responds only if interested. Buys one-time rights. Pays on publication (kill fee given for commissioned artwork only); $300 maximum for cover; $150 maximum for b&w inside. Pays $50-100 for spots. Finds illustrators through sourcebooks, magazines, word of mouth and artist's submissions.

Tips: "Familiarity with religious traditions and symbolism a plus. Timeless or classic look is preferred over 'trendy.' "

PARADE MAGAZINE, 711 Third Ave., New York NY 10017. (212)450-7000. E-mail: ira_yoffe@parad e.com. **Creative Director:** Ira Yoffe. Photo Editor: Miriam White-Lorentzen. Art Director: Natalie Pryor. Weekly emphasizing general interest subjects. Circ. 40 million (readership is 86 million). Original artwork returned after publication. Sample copy and art guidelines available. Art guidelines for SASE with first-class postage.

Illustration: Uses varied number of illustrations/issue. Works on assignment only. Send query letter with brochure, résumé, business card and tearsheets to be kept on file. Call or write for appointment to show portfolio. Responds only if interested. Buys first rights, occasionally all rights.

Design: Needs freelancers for design. 100% of freelance work demands knowledge of Photoshop, Illustrator, QuarkXPress. Prefers local freelancers. Send query letter with résumé. Pays for design by the project, by the day or by the hour depending on assignment.

Tips: "Provide a good balance of work."

N **PARENTS**, 375 Lexington Ave., 10th Floor, New York NY 10017-5514. (212)499-2000. Fax: (212)499-2083. E-mail: schristensen@parentsmagazine.com. Website: www.parents.com. Contact: Andrea Amadio, art director. Designer: Stephen Christensen. Deputy Art Director: Marian Fairweather. Creative Director: Jeffrey Saks. Estab. 1979. Monthly 4-color magazine withe features to help parents raise happy, healthy children. Circ. 2,153,221.

Illustration: Approached by 300 illustrators/year. Buys 5-6 illustrations/issue. Has featured illustrations by Bill Brown, Rob Blackhart, Katy Dockrill. Features humorous and spot illustrations of children, parents and babies. Assigns 80% of illustrations to experienced, but not well-known illustrators; 20% to new and emerging illustrators. Send postcard sample and follow-up postcard every 6 months or e-mail online portfolio. Samples are filed. Will contact artist for portfolio review if interested. Buys one-time rights for 1 year with option for more. Pay rates vary. Finds illustrators through sourcebooks, word of mouth, and artists promotional samples.

N **PARENTS' PRESS**, 1454 Sixth St., Berkeley CA 94710-1431. (510)524-1602. Fax: (510)524-0912. E-mail: parentsprs@aol.com. **Art Director:** Ann Skram. Estab. 1980. Monthly tabloid-size newspaper "for parents and children." Circ. 75,000. Sample copies and art guidelines available.

Illustration: Approached by 10-20 illustrators. Buys occasional illustrations. Prefers parenting and child related. Considers all media. Send postcard sample or query letter with printed samples, photocopies, SASE and tearsheets. Black & white illustrations needed. Send follow-up postcard sample every 3 months. Accepts disk submissions. "We will accept work compatible with QuarkXPress 4.1, Photoshop and Illustrator. Send EPS, TIF or JPEG files. Responds only if interested. Artists should write or phone. Art director will contact artist for portfolio review of b&w and color slides if interested. Buys one-time rights. Pays on publication; negotiable. Payment for spots negotiable.

N̄ PASSPORT, 6401 The Paseo, Kansas City MO 64131. (816)333-7000 ext. 2243. Fax: (816)333-4439. E-mail: khendrixson@nazarene.org. **Editor:** Emily Freeburg. Editorial Assistant Katherine Hendrixson. Estab. 1992. *"Passport* is a weekly 8 page, color story paper that focuses on the interests and concerns of the preteen (11- to 12-year-old). We try to connect what they learn in Sunday School with their daily lives." Circ. 40,000. Originals are not returned. Sample copies and art guidelines free for SASE with first-class postage.
Cartoons: Buys 1 cartoon/issue. Prefers humor for the preteen; single panel b&w line drawings with gagline. Send query letter with finished cartoon samples and SASE. Samples are filed or are returned by SASE if requested. Responds in 2 months. Buys multi-use rights. Pays $15 for b&w.

PC MAGAZINE, Ziff-Davis Media, 28 E. 28th St., 11th Floor, New York NY 10016. (212)503-3500. **Art Director:** Dean Markadakis. Deputy Art Director: Lisa Kocaurek. Associate Art Directors: Ann Greenfield and Cynthia Rhett. Estab. 1983. Bimonthly consumer magazine featuring comparative lab-based reviews of current PC hardware and software. Circ. 1.2 million. Sample copies available.
Illustration: Approached by 100 illustrators/year. Buys 10-20 illustrations/issue. Considers all media. 50% of freelance illustration demands knowledge of Photoshop, Illustrator. Send postcard sample and/or printed samples, photocopies, tearsheets. Accepts Zip disk submissions compatible with Photoshop, Illustrator or QuarkXPress 4.1. Samples are filed. Portfolios may be dropped on Wednesday and should include tearsheets and transparencies. **Pays on acceptance**. Payment negotiable for cover and inside; $300 for spots.

PEDIATRIC ANNALS, 6900 Grove Rd., Thorofare NJ 08086. (856)848-1000. Fax: (856)853-5991. Website: www.slackinc.com. **Managing Editor:** Shirley Strunk. Art Director: Linda Baker. Monthly 4-color magazine emphasizing pediatrics for practicing pediatricians. "Conservative/traditional design." Circ. 49,000. Considers previously published artwork. Original artwork returned after publication. Sample copies available; art guidelines available.
Illustration: Has featured illustrations by Peg Gerrity. Features realistic and medical illustration. Prefers "technical and conceptual medical illustration which relate to pediatrics." Considers watercolor, acrylic, oil, pastel and mixed media. Send query letter with brochure, tearsheets, slides and photographs to be kept on file. Publication will contact artist for portfolio review if interested. Buys one-time rights or reprint rights. Pays $250-700 for color cover. Finds artists through submissions/self-promotions and sourcebooks.
Tips: "Illustrators must be able to treat medical subjects with a high degree of accuracy. We need people who are experienced in medical illustration, who can develop ideas from manuscripts on a variety of topics, and who can work independently (with some direction) and meet deadlines. Non-medical illustration is also used occasionally. We deal with medical topics specifically related to children. Include color work, previous medical illustrations and cover designs in a portfolio. Show a representative sampling of work."

PENNSYLVANIA LAWYER, Pennsylvania Bar Association, 100 South St., Harrisburg PA 17108-0186. (717)238-6715. Website: www.pabar.org. **Editor:** Geoff Yuda. Bimonthly association magazine "featuring nuts and bolts articles and features of interest to lawyers." Circ. 30,000. Sample copies for #10 SASE with first-class postage. Art guidelines available.
Illustration: Approached by 30 illustrators/year. Buys 12 illustrations/year. Considers all media. Send query letter with samples. Samples are filed or returned by SASE. Art director will contact artist for portfolio review if interested. Negotiates rights purchased. **Pays on acceptance**; $185-600 for color cover; $100 for inside. Pays $25-50 for spots. Finds illustrators through word of mouth and artists' submissions.
Tips: "Artists must be able to interpret legal subjects. Art must have fresh, contemporary look. Read articles you are illustrating, provide three or more roughs in timely fashion."

◪ PERSIMMON HILL, Published by the National Cowboy and Western Heritage Museum, 1700 NE 63rd St., Oklahoma City OK 73111. (405)478-6404. Fax: (405)478-4714. E-mail: editor@nationalmuseum.org. Website: www.nationalcowboymuseum.org. **Director of Publications:** M.J. Van Deventer. Estab. 1970. Quarterly 4-color journal of western heritage "focusing on both historical and contemporary themes. It features nonfiction articles on notable persons connected with pioneering the American West; art, rodeo, cowboys, floral and animal life; or other phenomena of the West of today or yesterday. Lively articles, well written, for a popular audience. Contemporary design follows style of *Architectural Digest* and *European Travel and Life*." Circ. 15,000. Original artwork returned after publication. Sample copy for $10.50.
Needs: Send query letter with tearsheets, SASE, slides and transparencies. Samples are filed or returned by SASE if requested. Publication will contact artist for portfolio review if interested. Portfolio should include original/final art, photographs or slides. Buys first rights. Requests work on spec before assigning job. Pay varies. Finds artists through word of mouth and submissions. Does not publish illustrations—fine art only.

Tips: "We are a museum publication. Most illustrations are used to accompany articles. Work with our writers, or suggest illustrations to the editor that can be the basis for a freelance article or a companion story. More interest in the West means we have to provide more contemporary photographs and articles about what people in the West are doing today. Study the magazine first—at least four issues."

N: PET BUSINESS, 333 Seventh Ave., 11th Floor, New York NY 10001-5004. (212)979-4800. Fax: (646)674-0102. Website: www.petbusiness.com. **Art Director:** Jennifer Bumgardner. Managing Editor: Alison Netsel. A monthly 4-color news magazine for the pet industry (retailers, distributors, manufacturers, breeders, groomers). Circ. 24,500. Accepts previously published artwork.
Illustration: Occasionally needs illustration for business-oriented cover stories. Features realistic illustrations. Prefers watercolor, pen & ink, acrylics and color pencil. Accepts Windows-compatible disk submissions. Send EPS files, 266 dpi. Portfolio review not required. Pays on publication; $100.
Tips: "Send two or three samples and a brief bio, only."

PHI DELTA KAPPAN, Box 789, Bloomington IN 47402. (812)339-1156. Fax: (812)339-0018. Website: www.pdkintl.org/kappan/kappan.htm. **Design Director:** Carol Bucheri. Emphasizes issues, policy, research findings and opinions in the field of education. For members of the educational organization Phi Delta Kappa and subscribers. Black & white with 4-color cover and "conservative, classic design." Published 10 times/year. Circ. 130,000. Include SASE. Responds in 2 months. "We return illustrations and cartoons after publication." Sample copy for $5.50 plus $3 S&H. "The journal is available in most public and college libraries."
Cartoons: Approached by over 100 cartoonists/year. Looks for "finely drawn cartoons, with attention to the fact that we live in a multi-racial, multi-ethnic world."
Illustration: Approached by over 100 illustrators/year. Uses 1 4-color cover and spread/issue. Features serious conceptual art; humorous, realistic, computer and spot illustraion. Prefers style of John Berry, Brenda Grannan, Mario Noche and Jem Sullivan. Most illustrations depict some aspect of the education process (from pre-kindergarten to university level), often including human figures. Send postcard sample. Samples returned by SASE. "We can accept computer illustrations that are Mac formatted (EPS or TIFF files. Photoshop 5.0 or Illustrator 9.0)." Buys one-time rights. Payment varies.
Tips: "We look for artists who can create a finely crafted image that holds up when translated onto the printed page. Our journal is edited for readers with master's or doctoral degrees, so we look for illustrators who can take abstract concepts and make them visual, often through the use of metaphor."

PHILADELPHIA WEEKLY, 1701 Walnut St., Philadelphia PA 19103-5222. (215)563-7400. Fax: (215)563-0620. E-mail: jcox@philadelphiaweekly.com. Website: wwwphiladelphiaweekly.com. **Art Director:** Jeffrey Cox. Estab. 1971. Alternative, weekly, 4-color, b&w, tabloid focusing on news and opinion and arts and culture. Circ. 123,200.
Cartoons: Approached by 25 cartoonists/year. Buys 2-3 cartoons/issue. Prefers single panel, multiple panel, political, humorous, b&w washes, b&w line drawings. Send query letter with b&w photocopies. Samples are filed and are not returned. Responds only if interested. Buys one-time rights. Pays on publication.
Illustration: Approached by scores of illustrators/year. Buys 3-5 illustrations/issue. Has featured illustrations by Brian Biggs, Jay Bevenouv, James McHugh and Wayno. Features caricatures of celebrities and politicians; humorous, realistic and spot illustrations. Prefers realism but considers wide range of styles. Send postcard sample or query letter with printed samples and photocopies. Send non-returnable samples. Samples are filed and are not returned. Responds only if interested. Buys one-time rights. Pays on publication; $300-500 for color cover; $75-150 for b&w inside; $100-250 for color inside; $75 for spots. Finds illustrators through promotional samples.

PLANNING, American Planning Association, 122 S. Michigan Ave., Suite 1600, Chicago IL 60603. (312)431-9100. **Editor and Publisher:** Sylvia Lewis. Art Director: Richard Sessions. Monthly 4-color magazine for urban and regional planners interested in land use, housing, transportation and the environment. Circ. 30,000. Previously published work OK. Original artwork returned after publication, upon request. Free sample copy and artist's guidelines available. "Enclose $1 in postage for sample magazine—stamps only, no cash or checks, please."
Cartoons: Buys 2 cartoons/year on the environment, city/regional planning, energy, garbage, transportation, housing, power plants, agriculture and land use. Prefers single panel with gaglines ("provide outside of cartoon body if possible"). Include SASE. Responds in 2 weeks. Buys all rights. Pays on publication; $50 minimum for b&w line drawings.

Illustration: Buys 20 illustrations/year on the environment, city/regional planning, energy, garbage, transportation, housing, power plants, agriculture and land use. Send samples of style we can keep on file. If you want a response enclose SASE. Responds in 2 weeks. Buys all rights. Pays on publication; $250 maximum for b&w cover drawings; $100 minimum for b&w line drawings inside.

Tips: "Don't send portfolio. No corny cartoons. Don't try to figure out what's funny to planners. All attempts seen so far are way off base. Your best chance is to send samples of any type of illustration—cartoons or other—that we can keep on file. If we like your style we will commission work from you."

☑ **PLAY STATION MAGAZINE**, 150 North Hill Dr., #40, Brisbane CA 94005-1018. (415)656-8447. Fax: (415)468-4686. E-mail: dfitzpatrick@imaginemedia.com. Website: www.imaginemedia.com. **Art Director:** Dan Fitzpatrick. Editor-in-Chief: Chris Slate. Estab. 1997. Monthly 4-color consumer magazine focused on Play Station video game for preteens and up—"comic booky." Circ. 250,000. Free sample copies available.

Cartoons: Prefers multiple panel, humorous b&w line drawings; manga, comic book, image style. Send query letter with b&w and color photocopies and samples. Samples are filed. Responds only if interested. Buys all rights. Pays on publication.

Illustration: Approached by 20-30 illustrators/year. Buys 24 illustrations/issue. Has featured illustrations by Joe Madureira, Art Adams, Adam Warren, Hajeme Soroyana, Royo, J. Scott Campbell and Travis Charest. Features comic-book style, computer, humorous, realistic and spot illustration. Preferred subject: video game characters. Prefers liquid! BAD@$$ computer coloring. Assigns 80% of illustrations to well-known or "name" illustrators; 10% each to experienced, but not well-known, illustrators and new and emerging illustrators. 50% of freelance illustration demands knowledge of Illustrator and Photoshop. Send postcard sample or nonreturnable samples; send query letter with printed samples, photocopies and tearsheets. Accepts Mac-compatible disk submissions. Send TIFF files. Samples are filed. Will contact artist for portfolio review if interested. Buys all rights. Pays on publication. Finds illustrators through magazines and word of mouth.

Tips: "If you are an artist, confident that your vision is unique, your quality is the best, ever seeing anew, ever evolving, send us samples!"

☑ **PLAYBOY MAGAZINE**, 680 N. Lakeshore Dr., Chicago IL 60611. (312)751-8000. Website: www.playboy.com. **Managing Art Director:** Tom Staebler. Estab. 1952. Monthly magazine. Circ. 3.5 million. Originals returned at job's completion. Sample copies available.

Cartoons: Cartoonists should contact Michelle Urry, Playboy Enterprises Inc., Cartoon Dept., 730 Fifth Ave., New York NY 10019. "Please do not send cartoons to Kerig Pope!" Samples are filed or returned. Responds in 2 weeks. Buys all rights.

Illustration: Approached by 700 illustrators/year. Buys 30 illustrations/issue. Prefers "uncommercial looking" artwork. Considers all media. Send postcard sample or query letter with slides and photocopies or other appropriate sample. Does not accept originals. Samples are filed or returned. Responds in 2 weeks. Buys all rights. **Pays on acceptance**; $1,200/page; $2,000/spread; $250 for spots.

Tips: "No phone calls, only formal submissions of five pieces."

☑ **PLUS MAGAZINE**, 3565 S. Higuera, San Luis Obispo CA 93401. (805)544-8711. Fax: (805)544-4450. **Art Director:** Linda Loebs. Estab. 1981. Monthly tabloid-sized magazine for people ages 40 and up. Circ. 80,000. Accepts previously published work. Original artwork returned at job's completion. Sample copies for SASE with first-class postage; art guidelines available for SASE.

Cartoons: Buys 1-2 freelance cartoons/issue. Prefers single panel with gagline. Send query letter with finished cartoons. Samples are filed. Responds in 15 days. Pays $25 for b&w.

Illustration: Works on assignment only. "Would like drawings of famous people." Considers pen & ink. Send postcard, query letter with photocopies or tearsheets. Samples are filed. Responds in 15 days. Buys first rights or one-time rights. Pays on publication; $25 for b&w.

PN/PARAPLEGIA NEWS, 2111 E. Highland Ave., Suite 180, Phoenix AZ 85016-4702. (602)224-0500. Fax: (602)224-0507. E-mail: susan@pnnews.com. Website: www.pn-magazine.com. **Art Director:** Susan Robbins. Estab. 1947. Monthly 4-color magazine emphasizing wheelchair living for wheelchair users, rehabilitation specialists. Circ. 30,000. Accepts previously published artwork. Original artwork not returned after publication. Sample copy free for large-size SASE with $3 postage.

Cartoons: Buys 3 cartoons/issue. Prefers line art with wheelchair theme. Prefers single panel b&w line drawings with or without gagline. Send query letter with finished cartoons to be kept on file. Material not kept on file is returned by SASE. Responds only if interested. Buys all rights. **Pays on acceptance**; $10 for b&w.

Illustration: Prefers wheelchair living or medical and financial topics as themes. 50% of freelance work demands knowledge of QuarkXPress, Photoshop or Illustrator. Send postcard sample. Accepts disk submis-

sions compatible with Illustrator 9.0 or Photoshop 6.0. Send EPS as TIFF or JPEG files. Samples not filed are returned by SASE. Publication will contact artist for portfolio review if interested. Portfolio should include final reproduction/product, color and b&w tearsheets, photostats, photographs. Pays on publication; $250 for color cover; $10 for b&w inside, $25 for color inside.

Tips: "When sending samples, include something that shows a wheelchair user. We have not purchased an illustration or used a freelance designer for several years. We regularly purchase cartoons that depict wheelchair users."

POCKETS, Box 340004, 1908 Grand Ave., Nashville TN 37203-0004. (615)340-7333. E-mail: pockets@ upperroom.org. Website: www.upperroom.org. **Editor:** Janet R. Knight. Devotional magazine for children 6-12. 4-color with some 2-color. Monthly except January/February. Circ. 100,000. Accepts previously published material. Original artwork returned after publication. Sample copy for 9×12 or larger SASE with 4 first-class stamps.

Illustration: Approached by 50-60 illustrators/year. Features humorous, realistic, computer and spot illustration. Assigns 5% of illustrations to well-known or "name" illustrators; 80% to experienced, but not well-known illustrators; 15% to new and emerging illustrators. Uses variety of styles; 4-color, 2-color, flapped art appropriate for children. Realistic, fable and cartoon styles. Send postcard sample, brochure, photocopies, SASE and tearsheets. Also open to more unusual art forms: cut paper, embroidery, etc. Samples not filed are returned by SASE. "No response without SASE." Responds only if interested. Buys one-time or reprint rights. **Pays on acceptance**; $600 flat fee for 4-color covers; $50-250 for b&w inside, $75-350 for color inside.

Tips: "Decisions made in consultation with out-of-house designer. Send samples to our designer: Chris Schechner, 408 Inglewood Dr., Richardson, TX 75080."

N POLICY REVIEW, 818 Connecticut Ave. NW, Suite 601, Washington DC 20006. (202)466-6730. Fax: (202)466-6733. E-mail: polrev@heritage.org. Website: www.policyreview.org. Estab. 1977. Bi-monthly. Circ. 10,000. Sample copies free for #10 SASE with first-class postage.

Illustration: Approached by 40 illustrators/year. Buys 4-5 illustrations/issue. Has featured illustrations by Phil Foster, David Clark and Christopher Bing. Features caricatures of politicians, humorous, realistic, and conceptual spot illustration. Prefers b&w, conceptual work. Considers charcoal, collage and pen & ink. Send postcard sample. Accepts disk submissions compatible with QuarkXPress for PC; prefers TIFF or EPS files. Samples are filed. Responds only if interested. Art director will contact artist for portfolio review if interested. Rights purchased vary according to project. Pays on publication; negotiable. Pays $100-200 for spots.

N POPTRONICS, 275-G Marcus Blvd., Hauppange NY 11788. (631)592-6720. Fax: (631)592-6723. Website: www.poptronics.com. **Art Director:** Russell Truelson. Estab. 1939. Monthly magazine with 4-color emphasizing electronic and computer construction projects and tutorial articles; practical electronics for technical people including service technicians, engineers and experimenters in TV, hi-fi, computers, communications and industrial electronics. Circ. 133,000. Previously published work OK. Free sample copy. Art guidelines available. Needs computer-literate freelancers for illustration.

Cartoons: Approached by 20-25 cartoonists/year. Buys 70-80 cartoons/year on electronics, computers, communications, robots, lasers, stereo, video and service; single panel. Send query letter with finished cartoons. Samples are filed or returned by SASE. Responds in 1 week. Buys first or all rights. **Pays on acceptance**; $25 minimum for b&w washes.

Illustration: Approached by 10 illustrators/year. Buys 3 illustrations/year. Works on assignment only. Needs editorial and technical illustration. Preferred themes or styles depend on the story being illustrated. Considers airbrush, watercolor, acrylic and oil. Send postcard samples. Accepts disk submissions. Samples are filed or returned by SASE. Will contact for portfolio review if interested. Portfolio should include roughs, tearsheets, photographs and slides. Buys all rights. **Pays on acceptance**; $400 for color cover, $100 for b&w or color inside. Finds artists through submissions/self-promotions.

Tips: "Artists approaching *Poptronis* should have an innate interest in electronics and technology that shows through in their work."

N POPULAR SCIENCE, Time 4 Media, 2 Park Ave., New York NY 10016. (212)779-5000. Fax: (212)481-8062. E-mail: dick.barnett@popsci.com. Website: www.popsci.com. **Art Director:** Dick Barnett. "For the well-educated adult male, interested in science, technology, new products." Circ. 1,500,000. Original artwork returned after publication. Art guidelines available.

Illustration: Uses 30-40 illustrations/issue. Has featured illustrations by Don Foley, P.J. Loughron, Andrew Grirds and Bill Duke. Assigns 50% of illustrations to well-known or "name" illustrators; 40% to experienced but not well-known illustrators; 10% to new and emerging illustrators. Works on assignment only. Interested in technical 4-color art and 2-color line art dealing with automotive or architectural subjects.

Especially needs science and technological pieces as assigned per layout. Send postcard sample, photocopies or other nonreturnable samples. Responds only if interested. Samples kept on file for future assignments. "After seeing portfolios, I photocopy or photostat those samples I feel are indicative of the art we might use." Reports whenever appropriate job is available. Buys first publishing rights.

Tips: "More and more scientific magazines have entered the field. This has provided a larger base of technical artists for us. Be sure your samples relate to our subject matter, i.e., no rose etchings, and be sure to include a tearsheet for our files. I don't really need a high end, expensive sample. All I need is something that shows the type of work you do. Look at our magazine before you send samples. Our illustration style is very specific. If you think you fit into the look of our magazine, send a sample for our files."

POTPOURRI, A Magazine of the Literary Arts, P.O. Box 8278, Prairie Village KS 66208-0278. (913)642-1503. Fax: (913)642-3128. E-mail: potpourpub@aol.com. Website: www.potpourri.org. **Art Director:** Alberta J. Daw. Estab. 1989. Quarterly literary magazine featuring short stories, poetry, essays on arts, illustrations. Circ. 3,000. Art guidelines free for SASE with first-class postage. Sample copy for $4.95.
Illustration: Approached by 20 illustrators/year. Buys 10-12 illustrations/issue. Has featured illustrations by Wendy Born Hollender, M. Keating, E. Reeve, A. Olsen, T. Devine, D.J. Baker, D. Transue, S. Chapman, W. Philips, M. Larson, D. McMillion. Features caricatures of literary celebrities, computer and realistic illustrations. Prefers pen & ink. Assigns 20% of illustrations to new and emerging illustrators; 70% to experienced, but not well-known illustrators; 10% to well-known or "name" illustrators. Send query letter with printed samples, photocopies and SASE. Samples are filed. Responds in 3 months. Portfolio review not required. Buys one-time and reprint rights. Pays on publication, in copies. Finds illustrators through sourcebooks, artists' samples, word of mouth.
Tips: "*Potpourri* seeks original illustrations for its short stories. Also open to submissions for cover illustration of well-known literary persons. Prefer clean, crisp black & white illustrations and quick turnaround. *Potpourri* has completed its 14th year of publication and offers artists an opportunity for international circulation/exposure. The illustration should catch the reader's eye and imagination to make her stop and read the story."

POWDER MAGAZINE, 33046 Calle Aviador, San Juan Capistrano CA 92675. (949)496-5922. Fax: (949)496-7849. E-mail: frankr@emapUSA.com. Website: www.powdermag.com. **Art Director:** Bruce Scott. Estab. 1972. Monthly consumer magazine "for core skiers who live, eat and breathe skiing and the lifestyle that goes along with it." Circ. 106,000. Samples are available; art guidelines not available.
Illustration: Approached by 20-30 illustrators/year. Buys 5-10 illustrations/year. Has featured illustrations by Peter Spacek, Dan Ball and Santiago Uceda. Features humorous and spot illustration. Assigns 10% of illustrations to well-known or "name" illustrators; 70% to experienced, but not well-known illustrators; 20% to new and emerging illustrators. "Illustrators have to know a little about skiing." Considers all media. 10% of freelance illustration demands knowledge of Photoshop 3.0, Illustrator 5.0 and QuarkXPress 3.3. Send postcard sample or tearsheets. Accepts Macintosh EPS files compatible with QuarkXPress 3.3. Samples are filed. Responds only if interested. Buys one-time rights. **Pays on acceptance;** $100-300 for b&w inside; $200-400 for color inside; $400-1000 for 2-page spreads; 100-300 for spots.. Finds illustrators through sourcebooks and submissions.
Design: Needs freelancers for design and multimedia projects. Prefers local design freelancers. 100% of freelance work demands knowledge of Photoshop 3.0, Illustrator 5.0 and QuarkXPress 3.3. Send query letter with printed samples and photocopies.
Tips: "We like cutting-edge illustration, photography and design. We need it to be innovative and done quickly. We give illustrators a lot of freedom. Send sample or promo and do a follow-up call."

PRAIRIE JOURNAL TRUST, P.O. Box 61203 Brentwood P.O., Calgary, Alberta T2L 2K6 Canada. E-mail: prairiejournal@iname.com. Website: www.geocities.com/prairiejournal/. Estab. 1983. Biannual literary magazine. Circ. 600. Sample copies available for $8; art guidelines for SAE with IRCs only or on website.
Illustration: Approached by 25 illustrators/year. Buys 5 illustrations/issue. Has featured illustrations by C. Weiss, A. Peycha, B. Carlson, H. Spears, H. Love, John Howard and P. Wheatley. Considers b&w only. Send query letter with photocopies. Samples may be filed and are returned by SASE if requested by artist. Responds in 6 months. Portfolio review not required. Acquires first rights. Pays honorarium for b&w cover and inside drawings. Hig contrast line drawings preferred—submit only art you own the copyright to. Send samples with SAE and IRC for return. No originals.

PRAIRIE SCHOONER, 201 Andrews Hall, University of Nebraska, Lincoln NE 68588-0334. (402)472-0911. Fax: (402)472-9771. E-mail: eflanagan@unl.edu. Website: www.unl:edu/schooner/psmain.htm. **Editor:** Hilda Raz. Managing Editor: Erin Flanagan. Estab. 1927. Quarterly b&w literary magazine with 2-color cover. "*Prairie Schooner*, now in its 75th year of continuous publication, is called 'one of the top

literary magazines in America' by *Literary Magazine Review*. Each of the four issues contains short stories, poetry, book reviews, personal essays, interviews or some mix of these genres. Contributors are both established and beginning writers. Readers live in all states in the U.S. and in most countries outside the U.S." Circ. 3,200. Original artwork is returned after publication. "We rarely have the space or funds to reproduce artwork in the magazine but hope to do more in the future." Sample copies for $5.

Illustration: Approached by 1-5 illustrators/year. Uses freelancers mainly for cover art. "Before submitting, artist should be familiar with our cover and format, 6×9, black and one color or b&w, vertical images work best; artist should look at previous issues of *Prairie Schooner*. Portfolio review not required. We are rarely able to pay for artwork; have paid $50 to $100."

Tips: Finds artists through word of mouth. "We're trying for some four-color covers."

N PREMIERE MAGAZINE, 1633 Broadway, 41st Floor, New York NY 10019. (212)767-6000. Fax: (212)767-5450. Website: www.premiermag.com. **Art Director:** Richard Baker. Estab. 1987. "Monthly popular culture magazine about movies and the movie industry in the U.S. and the world. Of interest to both a general audience and people involved in the film business." Circ. 612,952. Original artwork is returned after publication.

Illustration: Approached by 250 illustrators/year. Works with 150 illustrators/year. Buys 5-10 illustrations/issue. Buys illustrations mainly for spots and feature spreads. Has featured illustrations by Dan Adel, Brian Briggs, Anita Kunz and Roberto Parada. Works on assignment only. Considers all styles depending on needs. Send query letter with tearsheets, photostats and photocopies. Samples are filed. Samples not filed are returned by SASE. Reports back about queries/submissions only if interested. Drop-offs Monday through Friday, and pick-ups the following day. Buys first rights or one-time rights. Pays $350 for b&w, $375-1,200 for color inside.

N ⚟ THE PRESBYTERIAN RECORD, 50 Wynford Dr., North York, Ontario M3C 1J7 Canada. (416)441-1111. E-mail: pcrecord@presbyterian.ca. Website: www.presbycan.ca/record. **Production and Design:** Tim Faller. Published 11 times/year. Deals with family-oriented religious themes. Circ. 60,000. Original artwork returned after publication. Simultaneous submissions and previously published work OK. Free sample copy and artists' guidelines for SASE with first-class postage.

Cartoons: Approached by 12 cartoonists/year. Buys 1-2 cartoons/issue. Interested in some theme or connection to religion. Send roughs and SAE (nonresidents include IRC). Responds in 1 month. Pays on publication; $25-50 for b&w.

Illustration: Approached by 6 illustrators/year. Buys 1 illustration/year on religion. Has featured illustrations by Ed Schnurr, Claudio Ghirardo and Chrissie Wysotski. Features humorous, realistic and spot illustration. Assigns 50% of illustrations to experienced, but not well-known illustrators; 50% to new and emerging illustrators. "We are interested in excellent color artwork for cover." Any line style acceptable—should reproduce well on newsprint. Works on assignment only. Send query letter with brochure showing art style or tearsheets, photocopies and photographs. Will accept computer illustrations compatible with QuarkXPress 4.1, Illustrator 8.0, Photoshop 5.0. Samples returned by SAE (nonresidents include IRC). Responds in 1 month. To show a portfolio, mail final art and color and b&w tearsheets. Buys all rights on a work-for-hire basis. Pays on publication; $50-100 for b&w cover; $100-300 for color cover; $25-80 for b&w inside; $25-60 for spots.

Tips: "We don't want any 'cute' samples (in cartoons). Prefer some theological insight in cartoons; some comment on religious trends and practices."

⚟ PRESBYTERIANS TODAY, 100 Witherspoon St., Louisville KY 40202. (502)569-5637. Fax: (502)569-8632. E-mail: today@pcusa.org. Website: www.pcusa.org/today. **Art Director:** Linda Crittenden. Estab. 1830. 4-color; official church magazine emphasizing Presbyterian news and informative and inspirational features. Publishes 10 issues year. Circ. 80,000. Originals are returned after publication if requested. Some feature illustrations may appear on website. Sample copies for SASE with first-class postage.

Cartoons: Approached by 20-30 cartoonists/year. Buys 1-2 freelance cartoons/issue. Prefers general religious material; single panel. Send roughs and/or finished cartoons. Samples are filed or are returned. Responds in 1 month. Rights purchased vary according to project. Pays $25, b&w.

Illustration: Approached by more than 50 illustrators/year. Buys 2-3 illustrations/issue, 30 illustrations/year from freelancers. Works on assignment only. Media varies according to need. Send query letter with tearsheets. Samples are filed and not returned. Responds only if interested. Buys one-time rights. Pays $150-350, cover; $80-250, inside.

N PRESIDENT & CEO, P.O. Box 197, Rockford IL 61105-0197. (815)963-4000. Fax: (815)963-7773. Website: www.presidentandceomag.com. Contact: Chuck Gregory, art director. Trade magazine published 8 times/year for senior executives in general management, finance, information technology, HR, sales and marketing. Circ. 50,000.

• Also publishes *Human Capital Strategies & News* and *Sales & Marketing Strategies & News*.

Cartoons: Approached by 1 cartoonist/year. Prefers single panel. Send b&w photocopies. Does not respond. Rights purchased vary according to project.

Illustration: Approached by 25 illustrators/year. Buys 1 illustration/issue. Features humorous illustration on business subjects. Send nonreturnable poscard samples. Samples are filed. Responds only if interested. No portfolio review required. Buys one-time rights. Pay varies. Finds illustrators through stock agencies.

Tips: Be persistent.

PREVENTION, 33 E. Minor St., Emmaus PA 18098. (610)967-7548. Fax: (610)967-7654. E-mail: ken.pa lumbo@rodale.com. Website: www.prevention.com. **Art Director:** Ken Palumbo. Estab. 1950. Monthly consumer magazine covering health and fitness, women readership. Circ. 3 million. Art guidelines available.

Illustration: Approached by 500-750 illustrators/year. Buys 1-2 spot illustrations/issue. Considers all media. Send postcard sample or query letter with photocopies, tearsheets. Accepts submissions on disk. Samples are filed or are returned. Responds only if interested. Art director will contact artist for portfolio review of b&w, color, photographs, tearsheets, transparencies if interested. Buys first North American serial rights. Finds illustrators through *Black Book*, *Workbook*, *Showcase*, magazines, submissions.

☑ **PRIME TIME SPORTS & FITNESS**, P.O. Box 6097, Evanston IL 60201. Phone/fax: (847)784-1194. E-mail: RoadRallye@aol.com. **Contact:** D. Dorner. Art Director: Diane Thomas. Estab. 1977. Magazine published 8 times/year "covering sports and fitness, women's sports and swimwear fashion." Circ. 63,000. Sample copies available; art guidelines for #10 SASE with first-class postage. (Best by e-mail.)

Cartoons: Approached by 50 cartoonists/year. Buys 11 cartoons/issue. Prefers sports-fitness theme. Prefers multiple panel, humorous, b&w washes. Send query letter with photocopies, "must see completed work (roughs by e-mail attachment OK)." Samples are filed and are not returned. Buys first North American serial rights, negotiates rights purchased. Pays on publication; $75-100 for b&w, $50-300 for color.

Illustration: Approached by over 200 illustrators/year. Buys 6-10 illustrations/issue. Has featured illustrations by Lynn Huntley, Nancy Thomas, Phil Greco and Larry Balsamo. Features caricatures of celebrities; fashion, humorous and realistic illustration; charts and graphs; informational graphics; medical, computer and spot illustration. Assigns 5% of illustrations to well-known or "name" illustrators; 25% to experienced, but not well-known illustrators; 60% to new and emerging illustrators. Prefers women in sports. Considers all media. 40% of freelance illustration demands knowledge of PageMaker, Draw, Microsoft Publisher. Send query letter with photocopies (e-mail OK too). Samples are not filed and are returned by SASE. Responds in 3 months. Buys all rights. Pays on publication; $10-200 for b&w cover; $20-200 for color cover; $10-25 for b&w inside; $10-100 for color inside; $25-100 for 2-page spreads; $5-25 for spots.

Design: Needs freelancers for design, production and multimedia projects. Prefers local design freelancers. 40% of freelance work demands knowledge of Microsoft Publisher. Send query letter with photocopies.

Tips: "Don't waste time giving us credits, work stands alone by itself. In fact we are turned off by experience and credits and turned on by good artwork. Find out what articles and features are planned then work art to fill."

PRINCETON ALUMNI WEEKLY, 194 Nassau St., Princeton NJ 08542. (609)258-4722. Fax: (609)258-2247. Website: www.princeton.edu/~paw. **Art Director:** Mary Ann Nelson. Estab. 1896. Biweekly alumni magazine, published independent of the university. Circ. 58,000. Sample copies available.

Illustration: Approached by 20-25 illustrators/year. Buys 25-30 illustrations/year. Considers all media. 5% of freelance illustration demands knowledge of PageMaker, Photoshop, Illustrator. Send postcard sample. After initial mailing, send follow-up postcard sample every 3 months. Samples are filed and are not returned. Responds only if interested. Art director will contact artist for portfolio review if interested. Portfolio should include "what artist feels will best show work. In phone call to set up appointment, artist will be told what art director is looking for." Buys first or one-time rights; varies according to project. **Pays on acceptance**. Finds illustrators through agents, submissions and *Graphic Artists Guild Directory of Illustration*.

Tips: "Artist must be able to take art direction."

Ⓝ **PRINT MAGAZINE**, 116 E. 27th St., 6th Floor, New York NY 10011-6901. (646)742-0800. Fax: (646)742-9211. Website: www.printmag.com. **Art Director:** Steven Brower. Estab. 1990. Bimonthly professional magazine for "art directors, designers and anybody else interested in graphic design." Circ. 55,000. Art guidelines available.

Illustration: Knowledge of Illustrator and QuarkXPress helpful but not required. Send postcard sample, printed samples and tearsheets. Sample are filed. Responds only if interested. Art director will contact

artist for portfolio review if interested. Portfolios may be dropped off every Monday, Tuesday, Wednesday, Thursday and Friday. Buys first rights. Pays on publication. Finds illustrators through agents, sourcebooks, word of mouth and artist's submissions.

Tips: "Read the magazine—we show art and design and don't buy and commission much, but it does happen."

☑ ✤ PRISM INTERNATIONAL, Department of Creative Writing, U.B.C., Buch E462—1866 Main Mall, Vancouver, British Columbia V6T 1Z1 Canada. (604)822-2514. Fax: (604)822-3616. E-mail: prism@interc hange.ubc.ca. Website: www.prism.arts.ubc.ca. Estab. 1959. Quarterly literary magazine. "We use cover art for each issue." Circ. 1,200. Original artwork is returned to the artist at the job's completion. Sample copies for $5, art guidelines for SASE with first-class postage.

Illustration: Approached by 20 illustrators/year. Buys 1 cover illustration/issue. Has featured illustrations by Annette Allwood, Maria Capolongo, Mark Korn, Scott Bakal, Chris Woods, Kate Collie and Angela Grossman. Features representational and non-representational fine art. Assigns 50% of illustrations to experienced, but not well-known illustrators; 50% to new and emerging illustrators. "Most of our covers are full color; however, we try to do at least one black & white cover/year." Send postcard sample. Accepts submissions on disk compatible with CorelDraw 5.0 (or lower) or other standard graphical formats. Most samples are filed. Those not filed are returned by SASE if requested by artist. Responds in 6 months. Portfolio review not required. Buys first rights. Pays on publication; $150 (Canadian) for b&w and color cover; $40 (Canadian) for b&w and color inside and 3 copies. Finds artists through word of mouth and going to local exhibits.

Tips: "We are looking for fine art suitable for the cover of a literary magazine. Your work should be polished, confident, cohesive and original. Send a postcard sample of your work. As with our literary contest, we will choose work which is exciting and which reflects the contemporary nature of the magazine."

🅽 PRIVATE PILOT, 265 S. Anita Dr., Suite 120, Orange CA 92868. (714)939-9991. Website: www.priv atepilotmag.com. **Editorial Director:** Bill Fedorko. Managing Editor: Michael Buckley. Art Director: Jerry Ford. Estab. 1965. Monthly magazine for owners/pilots of private aircraft, student pilots and others aspiring to attain additional ratings and experience. Circ. 105,000.
 • Also publishes *Custom Planes*, a monthly magazine for homebuilders and restorers. Same guidelines apply.

Illustration: Works with 2 illustrators/year. Buys 10 illustrations/year. Uses artists mainly for spot art. Send query letter with photocopies, tearsheets and SASE. Accepts submissions on disk (call first). Responds in 3 months. Pays $50-500 for color inside. "We also use spot illustrations as column fillers." Buys 1-2 spot illustrations/issue. Pays $35/spot.

Tips: "Know the field you wish to represent; we specialize in general aviation aircraft, not jets, military or spacecraft."

PROCEEDINGS, U.S. Naval Institute, 291 Wood Rd., Annapolis MD 21402-5035. (410)268-6110. Fax: (410)295-7940. Website: www.navalinstitute.org. **Art Director:** LeAnn Bauer. Monthly b&w magazine with 4-color cover emphasizing naval and maritime subjects. "*Proceedings* is an independent forum for the sea services." Design is clean, uncluttered layout, "sophisticated." Circ. 110,000. Accepts previously published material. Sample copies and art guidelines available.

Cartoons: Buys 23 cartoons/year from freelancers. Prefers cartoons assigned to tie in with editorial topics. Send query letter with samples of style to be kept on file. Responds only if interested. Negotiates rights purchased. Pays $25-50 for b&w, $50 for color.

Illustration: Buys 1 illustration/issue. Works on assignment only. Has featured illustrations by Tom Freeman, R.G. Smith and Eric Smith. Features humorous and realistic illustration; charts & graphs; informational graphics; computer and spot illustration. Needs editorial and technical illustration. "We like a variety of styles if possible. Do excellent illustrations and meet the requirement for military appeal." Prefers illustrations assigned to tie in with editorial topics. Send query letter with printed samples, tearsheets or photocopies. Accepts submissions on disk (call production manager for details). Samples are filed or are returned only if requested by artist. Publication will contact artist for portfolio review if interested. Negotiates rights purchased. Sometimes requests work on spec before assigning job. Pays $50 for b&w inside, $50-75 for color inside; $150-200 for color cover; $25 minimum for spots. "Contact us first to see what our needs are."

☑ PROFESSIONAL TOOL & EQUIPMENT NEWS AND BODYSHOP EXPO, 1233 Jamesville Ave., Fort Atkinson WI 53538-2738. (920)563-6388. Fax: (920)563-1699. Website: www.pten.com. **Publisher:** Rudy Wolf. Estab. 1990. Bimonthly trade journals. "*PTEN* covers tools and equipment used

in the automotive repair industry. *Bodyshop Expo* covers tools and equipment used in the automotive bodyshop industry." Circ. 110,000 for *Professional Tool*; 62,000 for *Bodyshop Expo*. Originals returned at job's completion. Art guidelines free for SASE with first-class postage.

Cartoons: Approached by 3 cartoonists/year. Buys 2 cartoons/issue. Prefers auto service and tool-related, single panel color washes with gaglines. Send query letter with finished cartoons. Samples are not filed and are returned by SASE if requested by artist. Responds in 1 month. Buys one-time rights. Pays $50 for b&w.

Illustration: Approached by 3 illustrators/year. Buys 2 illustrations/issue. Works on assignment only. Considers pen & ink and airbrush. Send query letter with brochure and tearsheets. Samples are not filed and returned by SASE. Buys one-time rights. **Pays on acceptance**; $100-200 for b&w, $200-500 for color inside.

PROFIT MAGAZINE, 777 Bay St., 5th Floor, Toronto, Ontario M5W 1A7 Canada. (416)596-5457. Fax: (416)596-5111. E-mail: jhull@profitmag.ca. Website: www.profitguide.com. **Art Director:** John Hull. Estab. 1982. 4-color business magazine for Canadian entrepreneurs published 8 times/year. Circ. 110,000.

Illustration: Buys 3-5 illustrations/issue. Has featured illustrations by Jerzy Kolacz, Jason Schneider, Ian Phillips. Features charts & graphs, computer, realistic and humorous illustration, informational graphics and spot illustrations of business subjects. Assigns 50% of illustrations to well-known or "name" illustrations; 50% to experienced, but not well-known illustrators. Send postcard or other nonreturnable samples. Accepts Mac-compatible disk submissions. Samples are not returned. Will contact artist for portfolio review if interested. Buys first rights. **Pays on acceptance**; $500-750 for color inside; $750-1,000 for 2-page spreads; $350 for spots. Pays in Canadian funds. Finds illustrators through promo pieces, other magazines.

PROGRESSIVE RENTALS, 1504 Robin Hood Trail, Austin TX 78703. (512)794-0095. Fax: (512)794-0097. E-mail: nferguson@apro-rto.com. Website: www.apro-rto.com. **Art Director:** Neil Ferguson. Estab. 1983. Bimonthly association publication for members of the Association of Progressive Rental Organizations, the national association of the rental-purchase industry. Circ. 5,000. Sample copies free for catalog-size SASE with first-class postage.

Illustration: Buys 3-4 illustrations/issue. Has featured illustrations by Barry Fitzgerald, Aletha Reppel, A.J. Garces, Edd Patton and Jane Marinsky. Features computer and conceptual illustration. Assigns 15% of illustrations to well-known or "name" illustrators; 70% to experienced, but not well-known illustrators; 15% to new and emerging illustrators. Prefers cutting edge; nothing realistic; strong editorial qualities. Considers all media. "Accepts computer-based illustrations (Photoshop, Illustrator). Send postcard sample, query letter with printed samples, photocopies or tearsheets. Accepts disk submissions. (Must be Photoshop-accessible EPS high-resolution [300 dpi] files or Illustrator files.) Samples are filed or returned by SASE. Responds in 1 month if interested. Rights purchased vary according to project. Pays on publication; $300-400 for color cover; $200-300 for b&w, $250-350 for color inside; $75-125 for spots. Finds illustrators mostly through artist's submissions; some from other magazines.

Tips: "Illustrators who work for us must have a strong conceptual ability—that is, they must be able to illustrate for editorial articles dealing with business/management issues. We are looking for cutting-edge styles and unique approaches to illustration. I am willing to work with new, lesser-known illustrators."

THE PROGRESSIVE, 409 E. Main St., Madison WI 53703. (608)257-4626. Website: www.progressive.org. **Art Director:** Nick Jehlen. Estab. 1909. Monthly b&w plus 4-color cover. Circ. 35,000. Originals returned at job's completion. Free sample copy and art guidelines.

Illustration: Works with 50 illustrators/year. Buys 10 b&w illustrations/issue. Features humorous and political illustration. Has featured illustrations by Eric Drooker, Peter Kuper, David Wheeler, David Klein and Johanna Goodman. Assigns 20% of illustrations to well-known or "name" illustrators; 50% to experienced, but not well-known illustrators; 30% to new and emerging illustrators. Needs editorial illustration that is "smart, bold, expressive." Works on assignment only. Send query letter with tearsheets and/or photocopies. Samples returned by SASE. Responds in 6 weeks. Portfolio review not required. Pays $700-800 for b&w and color cover; $250 for b&w line or tone drawings/paintings/collage inside. Buys first rights. Do not send original art. Send samples, postcards or photocopies and appropriate postage for materials to be returned.

PROTOONER, P.O. Box 2270, Daly City CA 94017-2270. (650)755-4827. E-mail: protooner@earthlink.net. Website: www.protooner.lookscool.com. **Editor:** Joyce Miller. Art Director: Ladd A. Miller. Estab. 1995. Monthly trade journal for the professional cartoonist and gagwriter. Circ. 925. Sample copy $6 U.S., $9 foreign. Art guidelines for #10 SASE with first-class postage.

Cartoons: Approached by tons of cartoonists/year. Buys 5 cartoons/issue. Prefers good visual humorous impact. Prefers single panel, humorous, b&w line drawings, with or without gaglines. Send query letter with roughs, SASE, tearsheets. "SASE a must!" Samples are filed. Responds in 1 month. Buys reprint rights. **Pays on acceptance**; $25-35 for b&w cartoons; $15 cover/spots.

Illustration: Approached by 6-12 illustrators/year. Buys 3 illustrations/issue. Has featured illustrations by Walt Klis, Chris Kemp, Art McCourt, Chris Patterson and Bob Votjko. Assigns 50% off illustrations to well-known or "name" illustrators; 30% to experienced, but not well-known illustrators; 20% to new and emerging illustrators. Features humorous illustration; informational graphics; spot illustration. Prefers humorous, original. Avoid vulgarity. Considers pen & ink. 50% of freelance illustration demands computer knowledge. Query for programs. Send query letter with printed samples and SASE. Samples are filed. Responds in 1 month. Buys reprint rights. **Pays on acceptance**; $20-30 for b&w cover. Pay for spots varies according to assignment.

Tips: "Pay attention to the magazine slant and SASE a must! Study sample copy before submitting. Request guidelines. Don't mail artwork not properly slanted!"

☑ **PSYCHOLOGY TODAY**, 49 E. 21st St., 11th Floor, New York NY 10010. (212)260-7210. Fax: (212)260-7445. Website: www.psychologytoday.com. **Art Director:** Philippe Garnier. Estab. 1991. Bi-monthly consumer magazine for professionals and academics, men and women. Circ. 350,000. Accepts previously published artwork. Originals returned at job's completion.

Illustration: Approached by 250 illustrators/year. Buys 5 illustrations/issue. Works on assignment only. Prefers psychological, humorous, interpersonal studies. Considers all media. Needs editorial, technical and medical illustration. 20% of freelance work demands knowledge of QuarkXPress or Photoshop. Send query letter with brochure, photostats and photocopies. Samples are filed and are not returned. Responds only if interested. Buys one-time rights. Pays on publication; $200-500 for color inside; $50-350 for spots; cover negotiable.

🅽 **PUBLIC CITIZEN NEWS**, 1600 20th St., NW, Washington DC 20009. (202)588-1000. E-mail: jvinson@citizen.org. Website: www.citizen.org. **Editor:** Jeff Vinson. Bimonthly magazine emphasizing consumer issues for the membership of Public Citizen, a group founded by Ralph Nader in 1971. Circ. 100,000. Accepts previously published material. Sample copy available for 9×12 SASE with first-class postage.

Illustration: Buys up to 2 illustrations/issue. Assigns 33% of illustrations to well-known or "r.ame" illustrators; 33% to experienced, but not well-known illustrators; 33% to new and emerging illustrators. Prefers contemporary styles in pen & ink. Send query letter with samples to be kept on file. Samples not filed are returned by SASE. Buys first rights or one-time rights. Pays on publication. Payment negotiable.

Tips: "Send several keepable samples that show a range of styles and the ability to conceptualize. Want cartoons that lampoon policies and politicians, especially on the far right of the political spectrum. Magazine was redesigned into a newspaper format in 1998."

☑ **PUBLISHERS WEEKLY**, 245 W. 17th St., 6th Floor, New York NY 10011. (212)645-9700. Fax: (212)463-6631. Website: www.publishersweekly.reviewnews.com. **Art Director:** Clive Chiu. Weekly magazine emphasizing book publishing for "people involved in the creative or the technical side of publishing." Circ. 50,000. Original artwork is returned to the artist after publication.

Illustration: Buys 75 illustrations/year. Works on assignment only. "Open to all styles." Send postcard sample or query letter with brochure, tearsheets, photocopies. Samples are not returned. Responds only if interested. **Pays on acceptance**; $350-500 for color inside.

☑ **QECE (QUESTION EVERYTHING CHALLENGE EVERYTHING)**, P.O. Box 122, Royersford PA 19468-0122. E-mail: qece@yahoo.com. Website: www.geocities.com/qece/. **Creative Director:** Larry Nocella. Estab. 1996. Twice yearly b&w zine "encouraging a more questioning mentality." Circ. 450. Sample copies available for $3. Please send only well-hidden cash or money orders made out to "Larry Nocella." Art guidelines free for #10 SASE with first class postage. "Please order sample copy before requesting guidelines to see the type of art we publish."

Cartoons: Buys 10 cartoons/year. Prefers subversive and bizarre single, double or multiple panel humorous, b&w line drawings. Send query letter with b&w photocopies and SASE. Samples are not filed; returned by SASE. Responds in 1 month. Buys one-time rights. Pays on publication.

Illustration: Approached by 12 illustrators/year. Buys 4 illustrations/issue. Has featured illustrations by Walter M. Rivera, Linda Chido, Colin Develin. Features charts & graphs, humorous and realistic illustrations; "anything that jolts the imagination." Prefers "intelligent rebellion." Prefers b&w line art. Assigns 100% of illustrations to new and emerging illustrators. Send query letter with bio (25 words or less),

photocopies, SASE. Samples are not filed; returned by SASE. Responds in 1 month. Portfolio review not required. Buys one-time rights. Pays on publication; 2 contributor copies for b&w cover. Finds illustrators through Internet, word of mouth.

Tips: "*QECE* offers you the artistic freedom you've always wanted. Send your most unique black & white creations—our 'gallery' centerfold has no theme other than printing the coolest (in our opinion) art we can get. Throw off your shackles and create what you want. Cartoonists, be subversive, but avoid common subjects, such as latest political scandal, etc. Be pro-activist, pro-action. Be free and Question Everything. Challenge Everything."

■ **QUEEN OF ALL HEARTS**, Monfort Missionaries, 26 S. Saxon Ave., Bay Shore NY 11706-8993. (631)665-0726. Fax: (631)665-4349. E-mail: pretre@worldnet.att.net. Website: www.montfortmissionaries .com. **Managing Editor:** Rev. Roger Charest. Estab. 1950. Bimonthly Roman Catholic magazine on Marian theology and spirituality. Circ. 2,500. Accepts previously published artwork. Sample copy available.

Illustration: Buys 1 or 2 illustrations/issue. Works on assignment only. Prefers religious. Considers pen & ink and charcoal. Send postcard samples. Samples are not filed and are returned by SASE if requested by artist. Buys one-time rights. **Pays on acceptance**; $50 minimum for b&w inside.

Tips: Area most open to freelancers is illustration for short stories. "Be familiar with our publication."

ELLERY QUEEN'S MYSTERY MAGAZINE, 475 Park Ave. S., New York NY 10016. (212)686-7188. Fax: (212)686-7414. **Senior Art Director:** Victoria Green. Associate Art Director: June Levine. All submissions should be sent to June Levine, associate art director. Emphasizes mystery stories and reviews of mystery books. Art guidelines for SASE with first-class postage.

• Also publishes *Alfred Hitchcock Mystery Magazine*, *Analog* and Isaac Asimov's *Science Fiction Magazine*.

Cartoons: "We are looking for cartoons with an emphasis on mystery, crime and suspense." Cartoons should be addressed to Lauren Kuczala, editor.

Illustration: Prefers line drawings. All other artwork is done inhouse. Send SASE and tearsheets or transparencies. Accepts disk submissions. Responds in 3 months. **Pays on acceptance**; $1,200 for color covers; $125 for b&w interior art. Considers all media in b&w and halftones. Send SASE with tearsheets or photocopies and printed samples. Accepts finished art on disc.

Tips: "Please see our magazine before submitting samples."

N ■ **QUILL & QUIRE**, 70 The Esplanade, #210, Toronto, Ontario M5E 1R2 Canada. (416)360-0044. Fax: (416)955-0794. E-mail: quill@idirect.com. Website: www.quillandquire.com. **Editor:** Scott Anderson. Estab. 1935. Monthly trade journal of book news and reviews for booksellers, librarians, publishers, writers and educators. Circ. 7,000. Art guidelines not available.

Illustration: Approached by 25 illustrators/year. Buys 3 illustrations/issue. Has featured illustrations by Barbara Spurll, Chum McLeod and Carl Wiens. Assigns 100% of illustrations to experienced, but not well-known illustrators. Considers pen & ink and collage. 10% of freelance illustration requires knowledge of Photoshop, Illustrator and QuarkXPress. Send postcard sample. Accepts disk submissions. Samples are filed. Responds only if interested. Negotiates rights purchased. **Pays on acceptance;** $200-300 for b&w and color cover; $100-200 for b&w and color inside. Finds illustrators through word of mouth, artist's submissions.

Tips: "Read our magazine."

N **RACQUETBALL MAGAZINE**, 1685 W. Uintah, Colorado Springs CO 80904-2906. (719)635-5396. Fax: (719)635-0685. E-mail: lmojer@racqmag.com. Websites: www.racqmag.com and www.usra.o rg. **Director of Communications/Editor:** Linda Mojer. Bimonthly publication of The United States Racquetball Association. "Distributed to members of USRA and industry leaders in racquetball. Focuses on both amateur and professional athletes." Circ. 50,000. Accepts previously published artwork. Originals returned at job's completion. Sample copies and art guidelines available.

Cartoons: Needs editorial illustration. Prefers racquetball themes. Send query letter with roughs. Samples are filed. Publication will contact artist for portfolio review if interested. Negotiates rights purchased. Pays $50 for b&w, $50 for color (payment negotiable).

Illustration: Approached by 5-10 illustrators/year. Usually works on assignment. Prefers racquetball themes. Freelancers should be familiar with PageMaker. Send postcard samples. Accepts disk submissions. Samples are filed. Publication will contact artist for portfolio review if interested. Negotiates rights purchased. Pays on publication; $200 for color cover; $50 for b&w, $50 for color inside (all fees negotiable).

RANGER RICK, 1100 Wildlife Center Dr., Reston VA 20190. (703)438-6000. Website: www.nwf.org. **Art Director:** Donna D. Miller. Monthly 4-color children's magazine focusing on wildlife and conversation. Circ. 500,000. Art guidelines are free for #10 SASE with first-class postage.

Illustration: Approached by 100-200 illustrators/year. Buys 4-6 illustrations/issue. Has featured illustrations by Danielle Jones, Jack Desrocher, John Dawson and Dave Clegg. Features computer, humorous, natural science and realistic illustrations. Preferred subjects: children, wildlife and natural world. Assigns 4% of illustrations to well-known or "name" illustrators; 95% to experienced, but not well-known illustrators; 1% to new and emerging illustrators. 50% of freelance illustration demands knowledge of Illustrator, Photoshop. Send query letter with printed samples, photocopies and SASE. Accepts Mac-compatible disk submissions. Samples are filed or returned by SASE. Responds in 3 months. Will contact artist for portfolio review if interested. Buys one-time rights. Pays on publication; $50-250 for b&w inside; $150-800 for color inside; $1,000-2,000 for 2-page spreads; $350-450 for spots. Finds illustrators through promotional samples, books and other magazines.

Tips: "Looking for new artists to draw animals using Illustrator, Photoshop and other computer drawing programs. Submit an original game idea—hidden picture, maze, what's wrong here etc. Please read our magazine before submitting."

N RAPPORT, 5265 Fountain Ave., Los Angeles CA 90029. (323)660-0433. **Art Director:** Crane Jackson. Estab. 1974. Bimonthly entertainment magazine featuring book and CD reviews; music focus is on jazz, some popular music. Circ. 52,000. Originals not returned.

Illustration: Buys 6 illustrations/issue. Works on assignment only. Prefers airbrush and acrylic. Digital art OK. Send postcard sample and brochure. Samples are filed. Responds in 2 months. Pays $100 for cover illustration; $50-100 for b&w inside; $100 for color inside.

Tips: "As a small publication, we try to pay the best we can. We do not want artists who have a fixed amount for payment when they see us. We give good exposure for artists who will illustrate our articles. If we find good artists, they'll get a lot of work, payment on receipt and plenty of copies of the magazine to fill their portfolios. Several artists have been recruited by book publishers who have seen their work in our magazine, which reviews more than 100 books from all publishers. We do not want artists who demand to be paid more. We are open to newcomers as well as established artists. Art for art's sake is disappearing from magazines. We'll suggest art to illustrate articles, or will supply article. Publication will contact artist when the proper article arises."

☑ RDH, 1421 S. Sheridan, Tulsa OK 74112-6619. (918)831-9742. Fax: (918)831-9804. E-mail: mark@pennwell.com. Website: www.pennwell.com. **Editor:** Mark Hartley. Estab. 1980. Monthly trade journal for dental hygienists. Circ. 66,388.

Illustration: Buys 6-8 illustrations/year. Considers all media. Knowledge of Photoshop, Illustrator and QuarkXPress "nice to have but not necessary." Send postcard sample. Accepts disk submissions. "Can be Quark document, but we can obtain EPS image from Illustrator." Samples are filed. Responds only if interested. Art director will contact artist for portfolio review of photographs and thumbnails if interested. Buys first rights. **Pays on acceptance;** $800 minimum for cover; $100 minimum for b&w and $250 minimum for inside. "Currently, we work with artists based locally. Would consider different styles."

Design: Needs freelancers for design. Prefers designers with experience in media kits, brochures, etc. Freelance work demands knowledge of Photoshop, Illustrator and QuarkXPress.

Tips: "Audience is 99% female. Work should 'speak' to women."

N READER'S DIGEST, Reader's Digest Rd., Pleasantville NY 10570-7000. (914)238-1000. Fax: (914)238-4559. Website: www.readersdigest.com. **Art Directors:** Hanu Laakso and Dean Abatemarco. Estab. 1922. Monthly consumer magazine for the general interest reader. Content features articles from various sources on a wide range of topics published in 19 languages in more than 60 countries. Circ. 13,368,327 (U.S.) 25,000,000 worldwide.

Cartoons: Approached by 500 cartoonists/year. Buys 30 cartoons/issue. Prefers single panel, b&w line drawings with or without color wash. Send b&w or color photocopies. Samples are filed. Responds only if interested. Buys one-time world rights for one year.

Illustration: Approached by 500 illustrators/year. Buys 7-8 illustrations/issue. Has featured illustrations by Christoph Niemann, David Roth, Mirko Ilic, Natalie Ascencios, Ingo Fast and Andrea Ventura. Assigns 80% of illustrations to well-known or "name" illustrators; 15% to experienced, but not well-known illustrators; 5% to new and emerging illustrators. Send postcard sample, or small packet of 4-5 samples. Samples are filed. Will contact artist for portfolio review if interested. Buys one-time world rights for 1 year. **Pays on acceptance; $750 minimum for color inside; $750 for spots. Finds illustrators through American Illustration, Society of Illustrators,** *Workbook*, reps' internet sites.

Tips: More than anything else we're looking for a certain level of sophistication, whether that's in cartoon illustration or a Brad Holland-type illustration. That means excellence in concept and execution. There are a lot of artists who send samples but we look for that undefinable element that makes them stand out. Talent is talent. When you see someone with it, it's undeniable. Our job is to spot that talent, encourage it and use it.

☑ **REDBOOK MAGAZINE**, Redbook Art Dept., 224 W. 57th St., 6th Floor, New York NY 10019-3212. (212)649-2000. Fax: (212)581-8114. Website: www.redbookmag.com. **Creative Director:** Marilou Lopez. Art Director: David Huang. Monthly magazine "geared to married women ages 24-39 with young children and busy lives interested in fashion, food, beauty, health, etc." Circ. 7 million. Accepts previously published artwork. Original artwork returned after publication with additional tearsheet if requested.

 • Send illustrations to the attention of Francois Baron, associate art director.

Illustration: Buys 3-7 illustrations/issue. Illustrations can be in any medium. Portfolio drop off any day, pick up 2 days later. To show a portfolio, mail work samples that will represent the artist and do not have to be returned. This way the sample can remain on file, and the artist will be called if the appropriate job comes up." Accepts fashion illustrations for fashion page. Buys reprint rights or negotiates rights.

Tips: "Look at the magazine before you send anything, we might not be right for you. Generally, illustrations should look new, of the moment, intelligent and feminine."

REFORM JUDAISM, 633 Third Ave., 6th Floor, New York NY 10017-6778. (212)650-4240. **Managing Editor:** Joy Weinberg. Estab. 1972. Quarterly magazine. "The official magazine of the Reform Jewish movement. It covers developments within the movement and interprets world events and Jewish tradition from a Reform perspective." Circ. 310,000. Accepts previously published artwork. Originals returned at job's completion. Sample copies available for $3.50.

Cartoons: Prefers political themes tying into editorial coverage. Send query letter with finished cartoons. Samples are filed. Responds in 1 month. Buys first rights, one-time rights and reprint rights.

Illustration: Buys 8-10 illustrations/issue. Works on assignment. 10% of freelance work demands computer skills. Send query letter with brochure, résumé, SASE and tearsheets. Samples are filed. Responds in 1 month. Publication will contact artist for portfolio review if interested. Portfolio should include tearsheets, slides and final art. Rights purchased vary according to project. **Pays on acceptance**; varies according to project. Finds artists through sourcebooks and artists' submissions.

THE REPORTER, Women's American ORT, 315 Park Ave. S., New York NY 10010. (212)505-7700. Fax: (212)674-3057. Website: www.waort.org. **Contact:** Editor. Estab. 1966. Quarterly organization magazine for Jewish women emphasizing Jewish and women's issues, lifestyle, education. *The Reporter* is the magazine of Women's American ORT, a membership organization supporting a worldwide network of technical and vocational schools. Circ. 60,000. Original artwork returned at job's completion. Sample copies for SASE with first-class postage.

Illustration: Buys 1-5 illustrations/issue. Works on assignment only. Prefers contemporary art. Considers pen & ink, mixed media, watercolor, acrylic, oil, charcoal, airbrush, collage and marker. Send postcard sample or query letter with brochure, SASE and photographs. Samples are filed. Responds to the artist only if interested. Rights purchased vary according to project. Pays on publication; $150 and up, depending on work.

REPRO REPORT, 800 Enterprise Dr., #202, Oak Brook IL 60523-1929. (630)571-4685. Fax: (630)571-4731. E-mail: seanmc@irga.com. Website: www.irga.com. **Production Coordinator:** Sean McDonald. Estab. 1928. Trade journal of the International Reprographic Association. Circ. 1,000. Art guidelines not available.

Illustration: Features informational graphics; computer illustration. Assigns 100% of illustrations to new and emerging illustrators. Send postcard sample or query letter with printed samples and tearsheets. Art director will contact artist for portfolio review if interested. Negotiates rights purchased. **Pays on acceptance.** Pays $400-500 for color cover. Finds illustrators through word of mouth, computer users groups, direct mail.

Design: Needs freelancers for design. 80% of freelance design demands knowledge of PageMaker, Photoshop, Illustrator and CorelDraw. Send query letter with brochure, photocopies, photographs and tearsheets. Pays by the project, $400-500. Prefers local freelancers only.

Tips: "We demand a fast turnaround and prefer art utilizing the computer."

RESIDENT AND STAFF PHYSICIAN, 241 Forsgate Dr., Jamesburg NJ 08831-1385. (732)656-1140. Fax: (732)656-1955. E-mail: jcullen@mwc.com. Website: www.mwc.com. **Editor:** Julie Cullen. Monthly publication emphasizing hospital medical practice from clinical, educational, economic and human standpoints. For hospital physicians, interns and residents. Circ. 100,000.

Illustration: "We commission qualified freelance medical illustrators to do covers and inside material. Artists should send sample work." Send query letter with brochure showing art style or résumé, tearsheets, photostats, photocopies, slides and photographs. Call or write for appointment to show portfolio of color and b&w final reproduction/product and tearsheets. **Pays on acceptance**; $800 for color cover; payment varies for inside work.

Tips: "We like to look at previous work to give us an idea of the artist's style. Since our publication is clinical, we require highly qualified technical artists who are very familiar with medical illustration. Sometimes we have use for nontechnical work. We like to look at everything. We need material from the *doctor's* point of view, *not* the patient's."

RESTAURANT HOSPITALITY, 1300 E. Ninth St., Cleveland OH 44114. (216)931-9942. Fax: (216)696-0836. E-mail: croberto@penton.com. **Art Director:** Christopher Roberto. Circ. 123,000. Estab. 1919. Monthly trade publication emphasizing restaurant management ideas and business strategies. Readers are restaurant operators, chefs and food service chain executives.

Illustration: Approached by 150 illustrators/year. Buys 5-10 illustrations per issue (combined assigned and stock illustration.) Prefers food and business related illustration in a variety of styles. Illustrations should tie-in with the restaurant industry. Has featured illustrations by Mark Shaver, Paul Watson and Brian Raszka. Assigns 10% of illustrations to well-known or "name" illustrators; 60% to experienced, but not well-known illustrators; and 30% to new and emerging illustrators. Welcomes stock submissions. Send postcard samples and follow-up card every 3-6 months. Buys one-time rights. **Pays on acceptance**; $400-500 full page; $300-350 quarter-page; $250-350 for spots.

Tips: "I like to work with illustrators who are trying new techniques. I particularly enjoy contemporary styles and themes that are exciting and relevant to our industry. If you have a website, please include your URL on your sample so I can view more of your work online."

RHODE ISLAND MONTHLY, 280 Kinsley Ave., Providence RI 02903-4161. (401)421-2552. Fax: (401)277-8080. **Art Director:** Ellen Dessloch. Estab. 1988. Monthly 4-color magazine which focuses on life in Rhode Island. Provides the reader with in-depth reporting, service and entertainment features and dining and calendar listings. Circ. 40,000. Accepts previously published artwork. Art guidelines not available.

• Also publishes a bride magazine and tourism-related publications.

Illustration: Approached by 20 freelance illustrators/year. Buys 1-2 illustrations/issue. Works on assignment and sometimes on spec. Considers all media. Send query letter with SASE, tearsheets, photographs and slides. Samples are filed. Request portfolio review in original query. Publication will contact artist for portfolio review if interested. Portfolio should include b&w and color tearsheets. Buys one-time rights. Sometimes requests work on spec before assigning job. Pays on publication; $150 for b&w, $250 minimum for color inside, depending on the job. Finds artists through word of mouth, submissions/self-promotions and sourcebooks.

Tips: "Ninety-five percent of our visual work is done by photographers. That's what works for us. We are glad to file illustration samples and hire people with appropriate styles at the appropriate time. I need to look at portfolios quickly. I like to know the illustrator knows a little bit about *RI Monthly* and has therefore edited his/her work down to a manageable amount to view in a short time."

☑ **RICHMOND MAGAZINE**, 2100 W. Broad St., Suite 105, Richmond VA 23220. (804)355-0111. Fax: (804)355-5442. E-mail: gwenrd@richmag.com. Website: www.richmag.com. **Art Director:** Steve Hedberg. Estab. 1980. Monthly 4-color regional consumer magazine focusing on Richmond lifestyles. Circ. 25,000. Art guidelines free for #10 SASE with first-class postage.

Cartoons: Approached by 20 cartoonists/year. Buys 5-10 cartoons/year. Prefers humorous, witty, Richmond-related, single panel, humorous color washes. Send query letter with color photocopies. Samples are filed and not returned. Responds only if interested. Buys one-time rights. Pays on publication; $75-150 for b&w; $75-200 for color cartoons.

Illustration: Approached by 30 illustrators/year Buys 1-2 illustrations/issue. Has featured illustrations by Kelly Alder, Kerry Talbott, Joel Priddy. Features humorous, realistic, conceptional, medical and spot illustrations. Assigns 75% of illustrations to experienced, but not well-known illustrators; 25% to new and emerging illustrators. Send postcard sample or query letter with photocopies, tearsheets or other nonreturnable samples and SASE. Send follow-up postcard every 2 months. Accepts Mac-compatible disk submissions. Send EPS files. Samples are filed or returned by SASE. Will contact artist for portfolio review if interested. Pays $150-200 for b&w cover; $200-500 for color cover; $50-100 for b&w inside; $150-300 for color inside; $200-400 for 2-page spreads; $75 for spots. Finds illustrators through promo samples, word of mouth, regional sourcebooks.

Tips: "Be dependable, on time and have strong concepts."

☑ **ROLLING STONE MAGAZINE**, 1290 Avenue of the Americas, 2nd Floor, New York NY 10104-0298. (212)484-1616. Fax: (212)484-1664. Website: www.rollingstone.com. **Art Director:** Andy Cowles. Senior Art Director: Gail Anderson. Deputy Art Director: Siung Tjia. Estab. 1967. Bimonthly magazine. Circ. 1.4 million. Originals returned at job's completion. 100% of freelance design work demands knowledge of Illustrator, QuarkXPress and Photoshop. (Computer skills not necessary for illustrators).

Illustration: Approached by "tons" of illustrators/year. Buys approximately 4 illustrations/issue. Works on assignment only. Considers all media. Send postcard sample and/or query letter with tearsheets, photocopies or any appropriate sample. Samples are filed. Does not reply. Portfolios may be dropped off every Tuesday before noon and should include final art and tearsheets. Portfolios may be picked back up on Wednesday afternoon. Publication will contact artist for portfolio review if interested. Buys first and one-time rights. **Pays on acceptance**; payment for cover and inside illustration varies; pays $300-500 for spots. Finds artists through word of mouth, *American Illustration*, *Communication Arts*, mailed samples and drop-offs.

☑ **THE ROTARIAN**, 1560 Sherman Ave., Evanston IL 60201-4818. (847)866-3000. Fax: (847)866-9732. E-mail: pratt@rotaryintl.org. Website: www.rotary.org. **Editor:** Cary Silver. Art Director: F. Sanchez. Estab. 1911. Monthly 4-color publication emphasizing general interest, business and management articles. The official magazine of the Rotary Club, a service organization for business and professional men and women, their families and other subscribers. Circ. 510,000. Accepts previously published artwork. Sample copy and editorial fact sheet available.
Cartoons: Approached by 14 cartoonists/year. Buys 5-8 cartoons/issue. Interested in general themes with emphasis on business, sports and animals. Avoid topics of sex, national origin, politics. Send query letter to Cartoon Editor, Charles Pratt, with brochure showing art style. Responds in 1-2 weeks. Buys all rights. **Pays on acceptance**; $100.
Illustration: Approached by 8 illustrators/year. Buys 10-20 illustrations/year; 7-8 humorous illustrations/year from freelancers. Uses freelance artwork mainly for covers and feature illustrations. Most editorial illustrations are commissioned. Send query letter to art director with photocopies or brochure showing art style. To show portfolio, artist should follow-up with a call or letter after initial query. Portfolio should include original/final art, final reproduction/product, color and photographs. Sometimes requests work on spec before assigning job. Buys all rights. **Pays on acceptance**; payment negotiable, depending on size, medium, etc.; $800-1,000 for color cover; $75-150 for b&w inside; $200-700 for color inside.
Tips: "Preference given to area talent. We're looking for a wide range of styles, although our subject matter might be considered somewhat conservative by those steeped in the avant-garde."

RUNNER'S WORLD, 33 E. Minor St., Emmaus PA 18098. (610)967-5171. Fax: (610)967-8883. Website: www.RUNNERSWORLD.com. **Art Director:** Ken Kleppert. Associate Director: Erin Douglas. Estab. 1965. Monthly 4-color with a "contemporary, clean" design emphasizing serious, recreational running. Circ. 470,000. Accepts previously published artwork "if appropriate." Returns original artwork after publication. Art guidelines not available.
Illustration: Approached by hundreds of illustrators/year. Works with 50 illustrators/year. Buys average of 10 illustrations/issue. Has featured illustrations by Sam Hundley, Gil Eisner, Randall Enos and Katherine Adams. Features humorous and realistic illustration; charts & graphics; informational graphics; computer and spot illustration. Assigns 40% of illustrations to well-known or "name" illustrators; 40% to experienced, but not well-known illustrators; 20% to new and emerging illustrators. Needs editorial, technical and medical illustrations. "Styles include tightly rendered human athletes, graphic and cerebral interpretations of running themes. Also, *RW* uses medical illustration for features on biomechanics." No special preference regarding media, but appreciates electronic transmission. "No cartoons or originals larger than 11×14." Works on assignment only. 30% of freelance work demands knowledge of Illustrator, Photoshop or FreeHand. Send postcard samples to be kept on file. Accepts submissions on disk compatible with Illustrator 5.0. Send EPS files. Publication will contact artist for portfolio review if interested. Buys one-time international rights. Pays $1,800 maximum for 2-page spreads; $400 maximum for spots. Finds artists through word of mouth, magazines, submissions/self-promotions, sourcebooks, artists' agents and reps, and attending art exhibitions.
Tips: Portfolio should include "a maximum of 12 images. Show a clean presentation, lots of ideas and few samples. Don't show disorganized thinking. Portfolio samples should be uniform in size. Be patient!"

Ⓝ **RUNNING TIMES**, 213 Danbury Rd., Wilton CT 06897. (203)761-1113. Fax: (203)761-9933. Website: www.runningtimes.com. **Art Director:** Troy Santi. Estab. 1977. Monthly consumer magazine covers sports, running. Circ. 70,000. Originals returned at job's completion. Sample copies available; art guidelines available.
Cartoons: Used occasionally.
Illustration: Buys 3-4 illustrations/issue. Works on assignment only. Has featured illustrations by Ben Fishman, Peter Hoex and Paul Cox. Features humorous, medical, computer and spot illustration. Considers pen & ink, colored pencil, mixed media, collage, charcoal, acrylic, oil. 100% of freelance work demands knowledge of QuarkXPress, Photoshop, FreeHand and Illustrator. Send postcard sample or query letter with tearsheets. Accepts disk submissions compatible with Photoshop, FreeHand or Illustrator. Samples are filed. Publication will contact artist for portfolio review of roughs, final art and tearsheets if interested.

Buys one-time rights. Pays on publication; $400-600 for color inside; $250 maximum for b&w inside; $350 maximum for color inside; $500 maximum for 2-page spreads; $300 maximum for spots. Finds artists through illustration annuals, mailed samples, published work in other magazines.

Design: Needs freelancers for design and production. 100% of design demands knowledge of FreeHand 4.0, Photoshop 3.1, QuarkXPress 3.3 and Illustrator 5.0. Send query letter with résumé and tearsheets. Pays by the hour, $20. Finds artists through illustration annuals, mailed samples, published work in other magazines.

Tips: "Look at previous issues to see that your style is appropriate. Send multiple samples and send samples regularly. I don't usually give an assignment based on one sample. Send out cards to as many publications as you can and make phone calls to set up appointments with the ones you are close enough to get to."

RURAL HERITAGE, Dept AGDM, 281 Dean Ridge Lane, Gainesboro TN 38562-5039. (931)268-0655. E-mail: editor@ruralheritage.com. Website: www.ruralheritage.com. **Editor:** Gail Damerow. Estab. 1976. Bimonthly farm magazine "published in support of modern-day farming and logging with draft animals (horses, mules, oxen)." Circ. 4,500. Sample copy for $8 postpaid; art guidelines not available.

• Editor stresses the importance of submitting cartoons that deal only with farming and logging using draft animals.

Cartoons: Approached by "not nearly enough" cartoonists who understand our subject/year. Buys 2 or more cartoons/issue. Prefers bold, clean, minimalistic draft animals and their relationship with the teamster. "No unrelated cartoons!" Prefers single panel, humorous, b&w line drawings with or without gagline. Send query letter with finished cartoons and SASE. Samples accepted by US mail only. Samples are not filed (unless we plan to use them—then we keep them on file until used) and are returned by SASE. Responds in 2 months. Buys first North American serial rights or all rights rarely. Pays on publication; $10 for one-time rights; $20 for all rights.

Tips: "Know draft animals (horses, mules, oxen, etc.) well enough to recognize humorous situations intrinsic to their use or that arise in their relationship to the teamster. Our best contributors read *Rural Heritage* and get their ideas from the publication's content."

✔ **SACRAMENTO MAGAZINE**, 4471 D Street, Sacramento CA 95819. (916)452-6200. Fax: (916)498-6061. Website: www.sacmag.com. **Art Director:** Debbie Hurst. Estab. 1975. Monthly consumer lifestyle magazine with emphasis on home and garden, women, health features and stories of local interest. Circ. 20,000. Accepts previously published artwork. Originals returned to artist at job's completion. Sample copies available.

Illustration: Approached by 100 illustrators/year. Buys 5 illustrations/year. Works on assignment only. Considers pen & ink, collage, airbrush, acrylic, colored pencil, oil, marker and pastel. Send postcard sample. Accepts disk submissions. Send EPS files. Samples are filed and are not returned. Publication will contact artist for portfolio review if interested. Portfolio should include b&w and color tearsheets and final art. Buys one-time rights. Pays on publication; $300-400 for color cover; $200-500 for b&w or color inside; $100-200 for spots. Finds artists through submissions.

Tips: Sections most open to freelancers are departments and some feature stories.

✔ **SAILING MAGAZINE**, 125 E. Main St., Port Washington WI 53074-0249. (262)284-3494. Fax: (262)284-7764. E-mail: sailingmag@ameritech.net. Website: www.sailingonline.com. **Editor:** Greta Schanen. Estab. 1966. Monthly 4-color literary magazine featuring sailing with a photography-oriented large format. Circ. 43,223.

Illustration: Has featured illustrations by Marc Castelli. Features realistic illustrations, spot illustrations, map art and technical illustrations (sailboat plans). Preferred subjects: nautical. Prefers pen & ink with color wash. Send query letter with photocopies. Accepts Mac-compatible disk submissions. Send EPS or TIFF files. Samples are filed or returned by SASE. Responds within 1 month. Will contact artist for portfolio review if interested. Buys first rights, first North American serial rights. Rights purchased vary according to project. Pays on publication; $25-100 for b&w inside, $25-100 for color inside, $200-500 for 2-page spreads, $25 for spots. "Freelancers find us—we have no need to look for them."

Tips: "Freelance art very rarely used.."

✔ **SALES & MARKETING MANAGEMENT MAGAZINE**, 770 Broadway., New York NY 10003-9595. (646)654-4500. Fax: (646)654-7616. Website: www.salesandmarketing.com. **Art Director:** Brandon Palcaio. Estab. 1918. Monthly 4-color trade magazine for sales and marketing executives. Circ. 65,000.

Illustration: Approached by 250-350 illustrators/year. Buys 1-10 illustrations/issue. Has featured illustrations by Philip Burke, Robert Risko, William Duke, Richard Downs, Amanda Duffy, Harry Campbell, Brian Raszka, Tim Hussey, Katherine Streeter. Features caricatures of celebrities, charts & graphs, computer, humorous, realistic and spot illustrations. Prefers business subjects, men and women. Prefers hip,

fresh styles—all media. Avoid standard "business-looking" work in favor of more current approaches. Assigns 25% of illustrations to well-known or "name" illustrators; 50% to experienced, but not well-known illustrators; 25% to new and emerging illustrators. 50% of freelance illustration demands knowledge of Illustrator or Photoshop. "Use illustrators that work in all media, so computer skills only necessary if that's how artist works." Send postcard, printed samples, photocopies or tearsheets. Accepts Mac-compatible disk submissions (Prefers printed samples). Samples are filed or returned by SASE. Will contact artist for portfolio review if interested. Buys first North American serial rights. Pays on publication; $800-1,100 for color cover; $650-1,000 full page color inside; $800-1,100 for 2-page spreads; $150-250 for spots. Finds illustrators through all sources, but prefers artist's promo samples.

SALT WATER SPORTSMAN, 263 Summer St., Boston MA 02210. (617)303-3660. Fax: (617)303-3661. Website: www.saltwatersportsman.com. **Art Director:** Chris Powers. Estab. 1939. Monthly consumer magazine describing the how-to and where-to of salt water sport fishing in the US, Caribbean and Central America. Circ. 140,000. Accepts previously published artwork. Originals returned at job's completion. Sample copies for 8½×11 SASE and 6 first-class stamps. Art guidelines available for SASE with first-class postage.
Illustration: Buys 4-5 illustrations/issue. Works on assignment only. Considers pen & ink, watercolor, acrylic, charcoal and electronic art files. Send query letter with tearsheets, photocopies, SASE and transparencies. Samples are not filed and are returned by SASE if requested by artist. Publication will contact artist for portfolio review if interested. Portfolio should include b&w and color tearsheets and final art. Buys first rights. **Pays on acceptance**; $500-1,000 for color cover; $50 for b&w inside; $100 for color inside. Finds artists mostly through submissions.
Design: Needs freelancers for design. 10% of freelance work demands knowledge of Photoshop, Illustrator, QuarkXPress. Send query letter with photocopies, SASE, tearsheets, transparencies. Pays by the project.
Tips: Areas most open to freelancers are how-to, semi-technical drawings for instructional features and columns; occasional artwork to represent fishing action or scenes. "Look the magazine over carefully to see the kind of art we run—focus on these styles."

N! SAN FRANCISCO BAY GUARDIAN, 520 Hampshire St., San Francisco CA 94110. (415)255-3100. Website: www.sfbg.com. **Art Director:** Victor Krummenacher. For "a young, liberal, well-educated audience." Circ. 157,000. Weekly newspaper; tabloid format, b&w with 4-color cover, "progressive design." Art guidelines not available.
Illustration: Has featured illustrations by Mark Matcho, John Veland, Barbara Pollack, Gabrielle Drinard and Gus D'Angelo. Features caricatures of politicans; humorous, realistic and spot illustration. Assigns 10% of illustrations to well-known or "name" illustrators; 60% to experienced, but not well-known illustrators; 30% to new and emerging illustrators. Weekly assignments given to local artists. Subjects include political and feature subjects. Preferred styles include contemporary, painterly and graphic line—pen and woodcut. "We like intense and we like fun." Artists who exemplify desired style include Tom Tommorow and George Rieman. Pays on publication; $300-315 for b&w and color cover; $34-100 for b&w inside; $75-150 for color inside; $100-250 for 2-page spreads; $34-100 for spots.
Design: 100% of freelance work demands knowledge of Photoshop, Illustrator, QuarkXPress. Prefers diversified talent. Send query letter with photocopies, photographs and tearsheets. Pays for design by the project.
Tips: "Please submit samples and letter before calling. Turnaround time is generally short, so long-distance artists generally will not work out." Advises freelancers to "have awesome work—but be modest."

N! SANTA BARBARA MAGAZINE, 25 E. De La Guerra St., Santa Barbara CA 93101-2217. (805)965-5999. **Art Director:** Alisa Baur. Estab. 1975. Quarterly 4-color magazine with classic design emphasizing Santa Barbara culture and community. Circ. 25,000. Original artwork returned after publication if requested. Sample copy for $3.50.
Illustration: Approached by 20 illustrators/year. Works with 2-3 illustrators/year. Buys about 1-3 illustrations/year. Uses freelance artwork mainly for departments. Works on assignment only. Send query letter with brochure, résumé, tearsheets and photocopies. Responds in 6 weeks. To show a portfolio, mail b&w and color art, final reproduction/product and tearsheets; will contact if interested. Buys first rights. **Pays on acceptance**; approximately $275 for color cover; $175 for color inside. "Payment varies."
Tips: "Be familiar with our magazines."

THE SATURDAY EVENING POST, Box 567, Indianapolis IN 46206-0567. (317)634-1100. Fax: (317)637-0126. E-mail: Satevepst@aol.com. Website: www.satevepost.org. Estab. 1728. Preventative health magazine with a general interest slant. Published 6 times/year. Circ. 500,000. Sample copy $5.
Cartoons: Cartoon Editor: Steven Pettinga. Buys about 30 cartoons/issue. Uses freelance artwork mainly for humorous fiction. Prefers single panel with gaglines. Receives 100 batches of cartoons/week. "We

look for cartoons with neat line or tone art. The content should be in good taste, suitable for a general-interest, family magazine. It must not be offensive while remaining entertaining. Review our guidelines online and then review recent issues. Political, violent or sexist cartoons are not used. Need all topics, but particularly medical, health, travel and financial." SASE. Responds in 2 months. Pays on publication; $125 for b&w line drawings and washes, no pre-screened art.

Illustration: Art Director: Chris Wilhoite. Uses average of 3 illustrations/issue. Send query letter with brochure showing art style or résumé and samples. To show a portfolio, mail final art. Buys all rights, "generally. All ideas, sketchwork and illustrative art are handled through commissions only and thereby controlled by art direction. Do not send original material (drawings, paintings, etc.) or 'facsimiles of' that you wish returned." Cannot assume any responsibility for loss or damage. "If you wish to show your artistic capabilities, please send nonreturnable, expendable/sampler material (slides, tearsheets, photocopies, etc.)." Pays $1,000 for color cover; $175 for b&w, $450 for color inside.

Tips: "Send samples of work published in other publications. Do not send racy or too new wave looks. Have a look at the magazine. It's clear that 50 percent of the new artists submitting material have not looked at the magazine."

THE SCHOOL ADMINISTRATOR, %American Association of School Administrators, 1801 N. Moore St., Arlington VA 22209. (703)875-0753. Fax: (703)528-2146. E-mail: lgriffin@aasa.org. Website: www@aasa.org. **Managing Editor:** Liz Griffin. Monthly association magazine focusing on education. Circ. 25,000.

Cartoons: Approached by 75 editorial cartoonists/year. Buys 11 cartoons/year. Prefers editorial/humorous, b&w/color washes or b&w line drawings. "Humor should be appropriate to a CEO of a school system, not a classroom teacher." Send photocopies and SASE. Responds only if interested. Buys one-time rights. **Pays on acceptance**.

Illustration: Approached by 60 illustrators/year. Buys 1-2 illustrations/issue. Has featured illustrations by Michael Gibbs, Ralph Butler, Paul Zwolak, Heidi Younger and Claudia Newell. Features spot and computer illustrations. Preferred subjects: education K-12. Assigns 50% of illustrations to experienced, but not well-known illustrators; 50% to well-known or "name" illustrators. Considers all media. "Prefers illustrators who can take a concept and translate it into a simple powerful image and who can deliver art in digital form." Send nonreturnable samples. Samples are filed and not returned. Responds only if interested. Rights purchased vary according to project. Pays on publication; $650 for color cover. Finds illustrators through word of mouth, stock illustration source and Creative Sourcebook.

Tips: "Read our magazine. I like work that takes a concept and translates it into a simple, powerful image. Check out our website."

☑ **SCHOOL BUSINESS AFFAIRS**, 11401 N. Shore Dr., Reston VA 20190-4200. (703)478-0405. Fax: (703)478-0205. Website: www.asbointl.org. **Publications Coordinator:** Kari Baer. Monthly trade publication for school business officials. Circ. 6,000. Accepts previously published artwork. Originals are returned at job's completion. Sample copies available; art guidelines not available.

Illustration: Buys 2 illustrations/issue. Prefers business-related themes. Send query letter with tearsheets. Accepts disk submissions compatible with IBM format; Illustrator 4.0. Samples are filed. Responds to the artist only if interested. Portfolio review not required. Rights purchased vary according to project.

Tips: "Tell me your specialties, your style—do you prefer realistic, surrealistic, etc. Include range of works with samples."

N SCIENCE NEWS, 1719 N St. NW, Washington DC 20036. (202)785-2255. Website: wwwsciencene ws.org. **Art Director:** Eric Roell. Weekly magazine emphasizing all sciences for teachers, students and scientists. Circ. 220,000. Accepts previously published material. Original artwork returned after publication. Sample copy for SASE with 42¢ postage.

Illustration: Buys 6 illustrations/year. Prefers realistic style, scientific themes; uses some cartoon-style illustrations. Works on assignment only. Send query letter with photostats or photocopies to be kept on file. Samples returned by SASE. Responds only if interested. Buys one-time rights. Write for appointment to show portfolio of original/final art. **Pays on acceptance**; $50-200; $50 for spots.

THE SCIENCE TEACHER, 1840 Wilson Blvd., Arlington VA 22201-3000. (703)243-7100. Fax: (703) 243-7177. Website: www.nsta.org. **Managing Editor:** Michelle Chovan. Art Director: Linda Oliver. Estab. 1958. Monthly education association magazine; 4-color with straightforward design. "A journal for high school science teachers, science educators and secondary school curriculum specialists." Circ. 27,000. Accepts previously published work. Original artwork returned at job's completion. Sample copies and art guidelines available with SASE.

Illustration: Approached by 75 illustrators/year. Buys 2 illustrations/issue. Works on assignment only. Has featured illustrations by Charles Beyl, Leila Cabib and Michael Teel. Features humorous and realistic

illustration. Assigns most work to experienced, but not well-known illustrators. Considers pen & ink, airbrush, collage and charcoal. Needs conceptual pieces to fit specific articles. Send query letter with tearsheets and photocopies. Samples are filed. Publication will contact artist for portfolio review if interested. Buys one-time rights. Pays on publication; budget limited.

Tips: Prefers experienced freelancers with knowledge of the publication. "I have found a very talented artist through his own self-promotion, yet I also use a local sourcebook to determine artists' styles before calling them in to see their portfolios. Feel free to send samples, but keep in mind that we're busy, too. Please understand we don't have time to return samples or take calls."

SCIENTIFIC AMERICAN, 415 Madison Ave., New York NY 10017-1111. (212)754-0550. Fax: (212)755-1976. Website: www.sciam.com. Contact: Jana Brenning, senior associate art director. Monthly 4-color consumer magazine emphasizing scientific information for educated readers, covering geology, astronomy, medicine, technology and innovations. Circ. 650,000.

Illustration: Approached by 100 illustrators/year. Buys 5-6 illustrations/issue. Has featured illustrations by John McFaul, Dave Cutler, Jo Sloan, George Retseck, Matt Mahurin, Brian Cronin and Roz Chast. Features science related charts & graphs, natural history and spot illustrations humorous spot illustration. Assigns 100% of illustrations to experienced, but not well-known illustrators. Send postcard sample and follow-up postcard every 3-4 months. Samples are filed. Responds only if interested. Will contact artist for portfolio review if interested. Buys one-time rights. **Pays on acceptance; $750-1,000 for color inside; $350-750 for spots.**

Tips: Illustrators should look at target markets more closely. Don't assume what a magazine wants, in terms of illustration, by its title. We're *Scientific American*, and we do use science illustration but we use a lot of other types of illustration as well, such as work by Roz Chast which you might not think would fit with out publication. Many not-so well-known publications have large budgets for illustration.

SCRAP, 1325 G St. N.W., Suite 1000, Washington DC 20005-3104. (202)662-8547. Fax: (202)626-0947. E-mail: kentkiser@scrap.org. Website: www.scrap.org. **Editor:** Kent Kiser. Estab. 1987. Bimonthly 4-color trade publication that covers all aspects of the scrap recycling industry. Circ. 7,000.

Cartoons: "We run single-panel cartoons that focus on the recycling theme/business."

Illustration: Approached by 40 illustrators/year. Buys 3-4 illustrations/issue. Features realistic illustrations, business/industrial/corporate illustrations and international/financial illustrations. Prefered subjects: business subjects. Assigns 90% of illustrations to experienced, but not well-known illustrators; 10% to new and emerging illustrators. Send postcard sample. Samples are filed. Responds in 2 weeks. Portfolio review not required. Buys first North American serial rights. **Pays on acceptance;** $1,200-2,000 for color cover; $300-1,000 for color inside. Finds illustrators through creative sourcebook, mailed submissions, referrals from other editors, and "direct calls to artists whose work I see and like."

Tips: "We're always open to new talent and different styles. Our main requirement is the ability and willingness to take direction and make changes if necessary. No prima donnas, please. Send a postcard to let us see what you can do."

SEA MAGAZINE, Box 17782 Cowan, Irvine CA 92614. **Art Director:** Julie Hogan. Estab. 1908. Monthly 4-color magazine emphasizing recreational boating for owners or users of recreational powerboats, primarily for cruising and general recreation; some interest in boating competition; regionally oriented to 13 Western states. Circ. 55,000. Accepts previously published artwork. Return of original artwork depends upon terms of purchase. Sample copy for SASE with first-class postage.

• Also needs freelancers fluent in Quark and Photoshop for production.

Illustration: Approached by 20 illustators/year. Buys 10 illustrations/year mainly for editorial. Considers airbrush, watercolor, acrylic and calligraphy. Send query letter with brochure showing art style. Samples are returned only if requested. Publication will contact artist for portfolio review if interested. Portfolio should include tearsheets and cover letter indicating price range. Negotiates rights purchased. Pays on publication; $50 for b&w; $250 for color inside (negotiable).

Tips: "We will accept students for portfolio review with an eye to obtaining quality art at a reasonable price. We will help start career for illustrators and hope that they will remain loyal to our publication."

SEATTLE MAGAZINE, 423 Third Ave. W., Seattle WA 98119-4001. (206)284-1750. Fax: (206)284-2550. E-mail: lou@seattlemag.com. Website: www.seattlemag.com. **Art Director:** Lou Maxor. Estab. 1992. Monthly urban lifestyle magazine covering Seattle. Circ. 48,000. Call art director directly for art guidelines.

Illustration: Approached by hundreds of illustrators/year. Buys 2 illustrations/issue. Considers all media. "We can scan any type of illustration." Send postcard sample. Accepts e-mail submissions. Samples are filed. Responds only if interested. Art director will contact artist for portfolio review of color, final art and transparencies if interested. Buys one-time rights. Sends payment on 15th of month of publication. Pays

on publication; $150-1,100 for color cover; $50-400 for b&w; $50-1,100 for color inside; $50-400 for spots. Finds illustrators through agents, sourcebooks such as *Creative Black Book*, *LA Workbook*, online services, magazines, word of mouth, artist's submissions, etc.

Tips: "Good conceptual skills are the most important quality that I look for in an illustrator as well as unique skills."

SEATTLE WEEKLY, 1008 Western Ave., Suite 300, Seattle WA 98104. (206)623-0500. Fax: (206)467-4338. E-mail: ksteichen@seattleweekly.com. Website: www.seattleweekly.com. **Contact:** Art Director. Estab. 1975. Weekly consumer magazine; tabloid format; news with emphasis on local issues and arts events. Circ. 35,000. Accepts previously published artwork. Original artwork is not returned at job's completion; "but you can come and get them if you're local." Sample copies available for SASE with first-class postage. Art guidelines not available.

Illustration: Approached by 30-50 freelance illustrators/year. Buys 3 freelance illustrations/issue. Works on assignment only. Prefers "sophisticated themes and styles, usually b&w." Considers pen & ink, charcoal, mixed media and scratchboard. Send query letter with tearsheets and photocopies. Samples are filed and are not returned. Does not report back, in which case the artists should "revise work and try again." To show a portfolio, mail b&w and color photocopies; "always leave us something to file." Buys first rights. Pays on publication; $200-250 for color cover; $60-75 for b&w inside.

Tips: "Give us a sample we won't forget. A really beautiful mailer might even end up on our wall, and when we assign an illustration, you won't be forgotten."

SEEK, 8121 Hamilton Ave., Cincinnati OH 45231. (513)931-4050, ext. 365. **Editor:** Eileen H. Wilmoth. Emphasizes religion/faith. Readers are young adult to middle-aged adults who attend church and Bible classes. Quarterly in weekly issues. Circ. 45,000. Sample copy and art guidelines for SASE with first-class postage.

Cartoons: Approached by 6 cartoonists/year. Buys 8-10 cartoons/year. Buys "church or Bible themes—contemporary situations of applied Christianity." Prefers single panel b&w line drawings with gagline. Has featured illustrations by Chuck Perry and Julie Riley. Send finished cartoons, photocopies and photographs. Include SASE. Responds in 4 months. Buys first North American serial rights. **Pays on acceptance**; $30.

Illustration: Send b&w 8×10 glossy photographs.

N: SELF EMPLOYED AMERICA, 2121 Precinct Line Rd., Hurst TX 76054-3136. (817)428-4243. Fax: (817)428-4210. Website: www.nase.org. Contact: Patty Harkins, art director. Bimonthly 4-color trade publication for owners of small businesses. Circ. 180,000.

Illustration: Approached by 200 illustrators/year. Buys 2 illustrations/issue. Features men's and women's home business or small business-related illustrations. Send postcard sample. Samples are filed. Buys one-time rights. Pay varies.

✓ SERVER/WORKSTATION EXPERT, 1340 Centre St., Newton Center MA 02459-2499. (617)641-9101. Fax: (617)641-9102. E-mail: bdillman@cpg.com. Website: www.cpg.com. **Art Director:** Brad Dillman. Estab. 1989. Monthly 4-color trade publication for the server/workstation market and related products and services. Circ. 95,000.

Illustration: Approached by 20-30 illustrators/year. Buys 10 illustrations/issue. Has featured illustrations by Paul Anderson, Chris Butler, Lynne Cannoy, Daniel C. O'Connor, Paul Zwolak and Tom Barrett. Features computer illustration, informational graphics and spot illustrations. Assigns 33.3% of illustration to well-known or "name" illustrators; 33.3% to experienced, but not well-known illustrators; 33.3% to new and emerging illustrators. Send postcard or other nonreturnable samples and follow-up samples every 2 months. Accepts Mac-compatible disk submissions. Send EPS or TIFF files. Samples are filed. Will contact artist for portfolio review if interested. Pays on publication; $325-1,200 for color inside; $250 for spots.

Tips: "We like to give new artists a shot, those who are conceptual are looked at closely. Work should be conceptual because we deal in the high-tech arena. We alternate the talent every 4-6 months."

SHEEP! MAGAZINE, 128 E. Lake St., W., P.O. Box 10, Lake Mills WI 53551. (920)648-8285. Fax: (920)648-3770. Estab. 1980. A monthly publication covering sheep, wool and woolcrafts. Circ. 15,000. Accepts previously published work. Original artwork returned at job's completion.

Cartoons: Approached by 30 cartoonists/year. Buys 6-8 cartoons/issue. Considers all themes and styles. Prefers single panel with gagline. Send query letter with brochure and finished cartoons. Samples are returned. Responds in 3 weeks. Buys first rights or all rights. Pays $15-25 for b&w; $50-100 for color.

Illustration: Approached by 10 illustrators/year. Buys 5 illustrations/year. Works on assignment only. Considers pen & ink, colored pencil, watercolor. Send query letter with brochure, SASE and tearsheets.

Samples are filed or returned. Responds in 3 weeks. To show a portfolio, mail thumbnails and b&w tearsheets. Buys first rights or all rights. **Pays on acceptance**; $45-75 for b&w, $75-150 for color cover; $45-75 for b&w, $50-125 for color inside.
Tips: "Demonstrate creativity and quality work."

N SHEPHERD EXPRESS, 413 N. Second St., Suite 150, Milwaukee WI 53203. (414)276-2222. Fax: (414)276-3312. Website: www.shepherd-express.com. **Production Manager:** Jill Rosenmerkel. Estab. 1982. "A free weekly newspaper that covers news, entertainment and opinions that don't get covered in our daily paper. We are an alternative paper in the same genre as *LA Weekly* or New York's *Village Voice*." Circ. 58,000. Accepts previously published artwork. Sample copies free for SASE with first-class postage. Art guidelines not available.
Cartoons: Approached by 130 cartoonists/year. Buys 2-3 cartoons/issue. Prefers single panel, b&w line drawings. Send query letter with finished cartoon samples. Samples are filed. Responds only if interested. Buys one-time rights. Pays $15 for b&w.
Illustration: Approached by 25 illustrators/year. Buys 1-2 illustrations/month. Works on assignment only. Considers pen & ink, watercolor, airbrush, acrylic, marker, colored pencil, oil, charcoal and pastel. Send nonreturnable postcard samples. Samples are not filed and are returned by SASE if requested by artist. Buys one-time rights. Pays on publication; $35 for b&w cover; $50 for color cover; $30 for b&w inside.
Tips: "Freelance artists must be good and fast, work on tight deadlines and have a real grasp at illustrating articles that complement the print. Please schedule an *appointment* to show your portfolio."

SIGNS OF THE TIMES, 1350 N. King's Rd., Nampa ID 83687. (208)465-2592. Fax: (208)465-2531. E-mail: merste@pacificpress.com. Website: www.pacificpress.com. **Art Director:** Merwin Stewart. A monthly Seventh-day Adventist 4-color publication that examines contemporary issues such as health, finances, diet, family issues, exercise, child development, spiritual growth and end-time events. "We attempt to show that Biblical principles are relevant to everyone." Circ. 200,000. Original artwork returned to artist after publication. Art guidelines available for SASE with first-class postage.
● They accept illustrations in electronic form on a Zip disk provided to their ftp site by prior arrangement, or sent as e-mail attachments.
Illustration: Buys 6-10 illustrations/issue. Works on assignment only. Has featured illustrations by Ron Bell, Darren Thompson, Consuelo Udave and Lars Justinen. Features realistic illustration. Assigns 10% of illustrations to well-known or "name" illustrators; 80% to experienced, but not well-known illustrators; 10% to new and emerging illustrators. Prefers contemporary "realistic, stylistic, or humorous styles (but not cartoons)." Considers any media. Send postcard sample, brochure, photographs, slides, tearsheets or transparencies. Samples are not returned. "Tearsheets or color photos (prints) are best, although color slides are acceptable." Samples are filed for future consideration and are not returned. Publication will contact artist for more samples of work if interested. Buys first-time North American publication rights.
Pays on acceptance (30 days); $600-800 for color cover; $100-300 for b&w inside; $300-700 for color inside. Fees negotiable depending on needs and placement, size, etc. in magazine. Finds artists through submissions, sourcebooks, and sometimes by referral from other art directors.
Tips: "Most of the magazine illustrations feature people. Approximately 20 visual images (photography as well as artwork) are acquired for the production of each issue, half in black & white, half in color, and the customary working time frame is 3 weeks. Quality artwork and timely delivery are mandatory for continued assignments. It is customary for us to work with highly skilled and dependable illustrators for many years." Advice for artists: "Invest in a good art school education, learn from working professionals within an internship, and draw from your surroundings at every opportunity. Get to know lots of people in the field where you want to market your work, and consistently provide samples of your work so they'll remember you. Then relax and enjoy the adventure of being creative."

✓ SINISTER WISDOM, Box 3252, Berkeley CA 94703. E-mail: sw@aalexander.org. Website: sinister wisdom.org. **Contact:** Art Director. Estab. 1976. Literary magazine. Triannual multicultural lesbian feminist journal of arts and politics, international distribution; b&w with 2-color cover. Design is "tasteful with room to experiment. Easy access to text is first priority." Circ. 3,500. Accepts previously published artwork. Original artwork returned at job's completion. Sample copies available for $6.50. Art guidelines for SASE with first-class postage.
Cartoons: Approached by 15 cartoonists/year. Buys 0-2 cartoons/issue. Prefers lesbian/feminist themes, any style. Prefers single panel, b&w line drawings. Send query letter with roughs. Samples are filed or returned by SASE. Responds in 9 months. Buys one-time rights. Pays 2 copies upon publication.
Illustration: Approached by 30-75 illustrators/year. Buys 6-15 illustrations/issue. Features caricatures of lesbian celebrities; women's fashion illustration; humorous, realistic and spot illustration. Prefers lesbian themes, images of women, abstraction and fine art. Considers any media for b&w reproduction. 20% of

freelance work demands computer skills in PageMaker, Illustrator or FreeHand. Send postcard sample, photographs and slides. Accepts disk submissions. Samples are filed or returned by SASE. Responds in 9 months. Does not review portfolios. Buys one-time rights. Pays on publication; 2 copies.

Tips: "Read it and note the guidelines and themes of upcoming issues. We accept work by lesbians only."

SKILLSUSA PROFESSIONAL, 14001 James Monroe Hwy., Box 3000, Leesburg VA 20177. (703)777-8810. Fax: (703)777-8999. E-mail: tomhall@skillsusa. Website: www.skillsusa.org. **Editor:** Tom Hall. Estab. 1965. Four-color quarterly newsletter. "*SkillsUSA Professional* helps high school instructors teach about careers, educational opportunities and activities of local SkillsUSA chapters. SkillsUSA-VICA is an organization of 240,000 students and teachers in technical, skilled and service careers. Circ. 13,000. Accepts previously published artwork. Originals returned at job's completion (if requested). Sample copies available.

Illustration: Approached by 4 illustrators/year. Works on assignment only. Prefers positive, youthful, innovative, action-oriented images. Considers pen & ink, watercolor, collage, airbrush and acrylic. Send postcard sample. Accepts disks compatible with FreeHand 5.0, Illustrator 8 and PageMaker 6.5. Send FreeHand and EPS files. Samples are filed. Portfolio should include printed samples, b&w and color tearsheets and photographs. Rights purchased vary according to project. **Pays on acceptance**; $200-300 for color; $100-300 for spots.

Design: Needs freelancers for design. 100% freelance work demands knowledge of PageMaker 6.5 and FreeHand 5.0. Send query letter with brochure. Pays by the project.

Tips: "Send samples or a brochure. These will be kept on file until illustrations are needed. Don't call! Fast turnaround helpful. Due to the unique nature of our audience, most illustrations are not re-usable; we prefer to keep art."

SKIPPING STONES, P.O. Box 3939, Eugene OR 97403-0939. (541)342-4956. E-mail: skipping@efn.org. Website: www.efn.org/~skipping. **Editor:** Arun Toké. Estab. 1988. Bimonthly b&w (with 4-color cover) consumer magazine. International nonprofit multicultural and nature education magazine for today's youth. Circ. 2,500. Art guidelines are free for SASE with first-class postage. Sample copy available for $5.

Cartoons: Prefers multicultural, social issues, nature/ecology themes. Requests b&w washes and line drawings. Send b&w photocopies and SASE. Samples are filed or returned by SASE. Responds in 3 months only if interested. Buys first rights and reprint rights. Pays on publication in copies. Featured cartoons by Lindy Wojcicki of Florida. Prefers cartoons by youth under age 19.

Illustration: Approached by 100 illustrators/year. Buys 20-30 illustrations/year. Has featured illustrations by Vidushi Avrati Bhatnagar, India; Inna Svjatova, Russia; Jon Bush, US. Features humorous illustration, informational graphics, natural history and realistic, authentic, illustrations. Preferred subjects: children and teens. Prefers pen & ink. Assigns 20% of illustrations to experienced, but not well-known illustrators; 80% to new and emerging illustrators. Send nonreturnable photocopies and SASE. Samples are filed or returned by SASE. Responds in 3 months if interested. Portfolio review not required. Buys first rights, reprint rights. Pays on publication 1-5 copies. Finds illustrators through word of mouth, artists promo samples.

Tips: "We are a gentle, non-glossy, ad-free magazine not afraid to tackle hard issues. We are looking for work that challenges the mind, charms the spirit, warms the heart; handmade, non-violent, global, for youth 8-15 with multicultural/nature content. Please, no aliens or unicorns. We are especially seeking work by young artists under 19 years of age! People of color and international artists are especially encouraged."

SKYDIVING MAGAZINE, 1725 N. Lexington Ave., DeLand FL 32724. (904)736-4793. Fax: (904)736-9786. E-mail: editor@skydivingmagazine.com. Website: www.skydivingmagazine.com. **Designer:** Sue Clifton. Estab. 1979. "Monthly magazine on the equipment, techniques, people, places and events of sport parachuting." Circ. 14,200. Originals returned at job's completion. Sample copies available; art guidelines not available.

Cartoons: Approached by 10 cartoonists/year. Buys 2 cartoons/issue. Has featured cartoons by Craig Robinson. Prefers skydiving themes; single panel, with gagline. Send query letter with roughs. Samples are filed. Responds in 2 weeks. Buys one-time rights. Pays $25 for b&w.

SLACK PUBLICATIONS, 6900 Grove Rd., Thorofare NJ 08086. (609)848-1000. Fax: (609)853-5991. E-mail: lbaker@slackinc.com. **Creative Director:** Linda Baker. Estab. 1960. Publishes 22 medical publications dealing with clinical and lifestyle issues for people in the medical professions. Accepts previously published artwork. Originals returned at job's completion. Art guidelines not available.

Illustration: Approached by 50 illustrators/year. Buys 2 illustrations/issue. Works on assignment only. Features humorous and realistic illustration; charts & graphs; infomational graphics; medical, computer and spot illustration. "No cartoons." Assigns 5% of illustrations to well-known or "name" illustrators; 90% to experienced, but not well-known illustrators; 5% to new and emerging illustrators. Prefers water-

color, airbrush, acrylic, oil and mixed media. Send query letter with tearsheets, photographs, photocopies, slides and transparencies. Samples are filed and are returned by SASE if requested by artist. Responds to the artist only if interested. To show a portfolio, mail b&w and color tearsheets, slides, photostats, photocopies and photographs. Negotiates rights purchased. Pays on publication; $200-400 for b&w cover; $400-600 for color cover; $100-200 for b&w inside; $100-350 for color inside; $50-150 for spots.
Tips: "Send samples."

☑ **SMALL BUSINESS TIMES AND EMPLOYMENT TIMES**, 1123 N. Water St., Milwaukee WI 53202. (414)277-8181. Fax: (414)277-8191. Website: www.biztimes.com. **Art Director:** Anne Baesemann. Estab. 1995. Bimonthly b&w with 4-color cover and inside spread, regional publication for business owners. We also publish a weekly employment paper which requires illustration.
Illustration: Approached by 80 illustrators/year. Buys 3-5 illustrations/issue. Has featured illustrations by Brad Hamann, Fedrico Jordan, Michael Waraska. Features computer, humorous, realistic and b&w spot illustrations. Prefers business subjects in simpler styles that reproduce well on newsprint. Assigns 5% of illustrations to well-known or "name" illustrators; 20% to experienced, but not well-known illustrators; 75% to new and emerging illustrators. Send postcard sample and follow-up postcard every year. Accepts Mac-compatible disk submissions. Send EPS or TIFF files. Will contact artist for portfolio review if interested. Buys one-time rights. **Pays on acceptance**; $150-250 for color cover; $50-100 for b&w inside. Finds illustrators through word-of-mouth, *Black Book*, *Workbook*.
Tips: "Conceptual illustrators wanted! We're looking for simpler black & white illustrations that communicate quickly. Due to deadlines, expect approximately one to two week turnaround time."

THE SMALL POND MAGAZINE OF LITERATURE, Box 664, Stratford CT 06615. **Editor:** Napoleon St. Cyr. Estab. 1964. Emphasizes poetry and short prose. Readers are people who enjoy literature—primarily college-educated. Usually b&w or 2-color cover with "simple, clean design." Published 3 times/year. Circ. 300. Sample copy for $4; art guidelines for SASE.
Illustration: Receives 50-75 illustrations/year. Acquires 1-3 illustrations/issue. Assigns 20% of illustrations to experienced, but not well-known illustrators; 80% to new and emerging illustrators. Has featured illustrations by Syd Weedon, Mal Gormley, Matthew Morgaine, Tom Herzberg and Jackie Peterson. Features spot illustrations. Uses freelance artwork mainly for covers, centerfolds and spots. Prefers "line drawings (inside and on cover) which generally relate to natural settings, but have used abstract work completely unrelated. Fewer wildlife drawings and more unrelated-to-wildlife material." Send query letter with finished art or production-quality photocopies, 2×3 minimum, 8×11 maximum. Include SASE. Publication will contact artist for portfolio review if interested. Pays 2 copies of issue in which work appears. Buys copyright in copyright convention countries. Finds artists through submissions.
Tips: "Need cover artwork, but inquire first or send for sample copy." Especially looks for "smooth clean lines, original movements, an overall impact. Don't send a heavy portfolio, but rather four to six black & white representative samples with SASE. Don't send your life history and/or a long sheet of credits. DO NOT send a postcard with a beautiful work in full color. Black & white and 3-5 pieces, no postcards. Work samples are worth a thousand words." Advice to artists: "Peruse listings in *Artist's & Graphic Designer's Market* for wants and needs of various publications."

SMART MONEY, 1755 Broadway, 2nd Floor, New York NY 10019. (212)830-9200. Fax: (212)830-9245. Website: www.smartmoney.com. **Art Director:** Joan Yu. Estab. 1992. Monthly consumer magazine. Circ. 760,369. Originals returned at job's completion. Sample copies available.
Illustration: Approached by 200-300 illustrators/year. Buys 10 illustrations/issue. Works on assignment only. Considers pen & ink, airbrush, colored pencil, mixed media, collage, charcoal, watercolor, acrylic, oil, pastel and digital. Send postcard-size sample. Samples are filed. Publication will contact artist for portfolio review if interested. Portfolio should include tearsheets and photocopies. Buys first and one-time rights. Pays 30 days from invoice; $1,500 for color cover; $400-700 for spots. Finds artists through sourcebooks and submissions.

Ⓝ **SMITHSONIAN MAGAZINE**, 750 Ninth St. NW, Suite 7100, Washington DC 20560-0001. (202)275-2000. Fax: (202)275-1986. Website: www.smithsonianmag.com. Contact: Edgar Rich, art director. Assistant Art Director: Tippi Nicole Thole. Monthly consumer magazine exploring lifestyles, cultures, environment, travel and the arts. Circ. 2,088,000.
Illustration: Approached by hundreds of illustrators/year. Buys 1-3 illustrations/issue. Has featured illustrations by Elizabeth Wolf. Features charts & graphs, informational graphics, humorous, natural history, realistic and spot illustration. Samples are filed. Responds only if interested. Will contact artist for portfolio review if interested. Buys first rights. **Pays on acceptance**; $200-1,000 for color inside. Finds illustrators through agents and word of mouth.

N̈ SOAP OPERA UPDATE MAGAZINE, 270 Sylvan Ave., Englewood Cliffs NJ 07632. (201)569-6699, ext. 226. Fax: (201)569-2510. **Art Director:** Eric Savage. Estab. 1988. Biweekly consumer magazine geared toward fans of soap operas and the actors who work in soaps. It is "the only full-size, all color soap magazine in the industry." Circ. 700,000. Originals are not returned.
Illustration: Approached by 100 illustrators/year. Works on assignment only. Prefers illustrations showing a likeness of an actor/actress in soap operas. Considers any and all media. Send postcard sample. Samples are filed. Publication will contact artist for portfolio review if interested. Portfolio should include color tearsheets and final art. Buys all rights usually. Pays on publication; $50-200 maximum for color inside and/or spots. Finds artists through promo pieces.
Tips: Needs caricatures of actors in storyline-related illustration. "Please send self-promotion cards along with a letter if you feel your work is consistent with what we publish."

SOLDIERS MAGAZINE, 9325 Gunston Rd., Suite S108, Ft. Belvoir VA 22060-5548. (703)806-4486. Fax: (703)806-4566. Website: www.dtic.mil/soldiers. **Editor-in-Chief:** John E. Suttle. Art Director: Helen Hall Van Hoose. Monthly 4-color magazine that provides "timely and factual information on topics of interest to members of the Active Army, Army National Guard, Army Reserve and Department of Army civilian employees and Army family members." Circ. 225,000. Previously published material and simultaneous submissions OK. Samples available upon request.
Illustration: Buys 5-10 illustrations/year. Considers all media. Send query letter with photocopies of samples. Responds only if interested. Illustrations should have a military or general interest theme. No portfolio review necessary. Buys all rights. **Pays on acceptance.** Pay varies by project.
Tips: "We are actively seeking new ideas and fresh humor, and are looking for new contributors. However, we require professional-quality material, professionally presented. We will not use anti-Army, sexist or racist material. We suggest you review recent back issues before submitting."

SOLIDARITY MAGAZINE, Published by United Auto Workers, 8000 E. Jefferson, Detroit MI 48214. (313)926-5291. E-mail: uawsolidarity@uaw.net. Website: http:/www.uaw.org. **Editor:** Dick Olson. Four-color magazine for "1.3 million member trade union representing U.S. workers in auto, aerospace, agricultural-implement, public employment and other areas." Contemporary design.
Cartoons: Carries "labor/political" cartoons. Pay varies.
Illustration: Works with 10-12 illustrators/year for posters and magazine illustrations. Interested in graphic designs of publications, topical art for magazine covers with liberal-labor political slant. Looks for "ability to grasp our editorial slant." Send postcard sample or tearsheets and SASE. Samples are filed. Pays $500-600 for color cover; $200-300 for b&w inside; $300-450 for color inside. Graphic Artists Guild members only.

SOUTHERN ACCENTS MAGAZINE, 2100 Lakeshore Dr., Birmingham AL 35209. (205)877-6000. Fax: (205)877-6990. Webskite: www.southernaccents.com. **Art Director:** Ann M. Carothers. Estab. 1977. Bimonthly consumer magazine emphasizing fine Southern interiors and gardens. Circ. 350,000.
Illustration: Buys 25 illustrations/year. Considers color washes, colored pencil and watercolor. Send postcard sample. Accepts disk submissions. Samples are returned. Responds only if interested. Art director will contact artist for portfolio of final art, photographs, slides and tearsheets if interested. Rights purchased vary according to project. **Pays on acceptance** or pays on publication; $100-800 for color inside. Finds artists through magazines and sourcebook submissions.

SPIDER, P.O. Box 300, Peru IL 61354. **Art Director:** Anthony Jacobson. Estab. 1994. Monthly magazine "for children 6 to 9 years old. Literary emphasis, but also include activities, crafts, recipes and games." Circ. 95,000. Samples copies available; art guidelines for SASE with first-class postage.
Illustration: Approached by 800-1,000 illustrators/year. Buys 30-35 illustrations/issue. Has featured illustrations by Floyd Cooper, Jon Goodell and David Small. Features humorous and realistic illustration. Assigns 25% of illustrations to well-known or "name" illustrations; 50% to experienced, but not well-known illustrators; 25% to new and emerging illustrators. Prefers art featuring children and animals, both realistic and whimsical styles. Considers all media. Send query letter with printed samples, photocopies, SASE and tearsheets. Send follow-up every 4 months. Samples are filed or are returned by SASE. Responds

N̈ MARKETS NEW TO THIS EDITION

in 6 weeks. Buys all rights. **Pays on acceptance**; $750 minimum for cover; $150-250 for color inside. Pays $50-150 for spots. Finds illustrators through artists who've published work in the children's field (books/magazines); artist's submissions.

Tips: "Read our magazine, include samples showing children and animals and put your name, address and phone number on every sample. It's helpful to include pieces that take the same character(s) through several actions/emotional states. It's also helpful to remember that most children's publishers need artists who can draw children from many different racial and ethnic backgrounds."

[N] SPITBALL, The Literary Baseball Magazine, 5560 Fox Rd., Cincinnati OH 45239. (513)385-2268. **Editor:** Mike Shannon. Quarterly 2-color magazine emphasizing baseball exclusively, for "well-educated, literate baseball fans." Sometimes prints color material in b&w on cover. Returns original artwork after publication if the work is donated; does not return if purchases work. Sample copy for $6.
 • *Spitball* has a regular column called "Brushes with Baseball" that features one artist and his work. Chooses artists for whom baseball is a major theme/subject. Prefers to buy at least one work from the artist to keep in its collection.

Cartoons: Prefers single panel b&w line drawings with or without gagline. Prefers "old fashioned *Sport Magazine/New Yorker* type. Please, cartoonists . . . make them funny, or what's the point!" Query with samples of style, roughs and finished cartoons. Samples not filed are returned by SASE. Responds in 1 week. Negotiates rights purchased. Pays $10, minimum.

Illustration: "We need two types of art: illustration (for a story, essay or poem) and filler. All work must be baseball-related; prefers pen & ink, airbrush, charcoal/pencil and collage. Interested artists should write to find out needs for specific illustration." Buys 3 or 4 illustrations/issue. Send query letter with b&w illustrations or slides. Target samples to magazine's needs. Samples not filed are returned by SASE. Responds in 1 week. Negotiates rights purchased. **Pays on acceptance**; $20-40 b&w inside. Needs short story illustration.

Tips: "Usually artists contact us and if we hit it off, we form a long-lasting mutual admiration society. Please, you cartoonists out there, drag your bats up to the *Spitball* plate! We like to use a variety of artists."

[N] SPORTS AFIELD, Hearst Magazines, 11650 Riverside Dr., North Hollywood CA 91602-1066. (818)763-9221. Fax: (818)763-9238. Website: www.sportsafield.com. **Art Director:** Michael Vannatter. Estab. 1887. Monthly magazine. "*SA* is edited for outdoor enthusiasts with special interests in fishing and hunting. We are the oldest outdoor magazine and continue as the authority on all traditional sporting activities including camping, boating, hiking, fishing, mountain biking, rock climbing, canoeing, kayaking, rafting, shooting and wilderness travel." Circ. 459,396.

Illustration: Buys 2-3 illustrations/issue. Prefers outdoor themes. Considers all media. Freelancers should be familiar with Photoshop, Illustrator, QuarkXPress. Send postcard sample or query letter with photocopies and tearsheets. Accepts disk submissions. Samples are filed. Responds only if interested. Will contact for portfolio of b&w or color photographs, slides, tearsheets and transparencies if interested. Buys first North American serial rights. Pays on publication; negotiable. Finds illustrators through *Black Book*, magazines, submissions.

SPORTS 'N SPOKES, 2111 E. Highland Ave., Suite 180, Phoenix AZ 85016-4702. (602)224-0500. Fax: (602)224-0507. E-mail: susan@pnnews.com. Website: www.sportsnspokes.com. **Art and Production Director:** Susan Robbins. Published 8 times a year. Consumer magazine with emphasis on sports and recreation for the wheelchair user. Circ. 15,000. Accepts previously published artwork. Sample copies for 11×14 SASE and 6 first-class stamps.

Cartoons: Approached by 10 cartoonists/year. Buys 3-5 cartoons/issue. Prefers humorous cartoons; single panel b&w line drawings with or without gagline. Send query letter with finished cartoons. Samples are filed or returned by SASE if requested by artist. Responds in 3 months. Buys all rights. **Pays on acceptance**; $10 for b&w.

Illustration: Approached by 10 illustrators/year. Works on assignment only. Considers pen & ink, watercolor and computer-generated art. 50% of freelance work demands knowledge of Illustrator, QuarkXPress or Photoshop. Send postcard sample or query letter with résumé and tearsheets. Accepts disk submissions compatible with Illustrator 9.0 or Photoshop 6.0. Send EPS, TIFF or JPEG files. Samples are filed or returned by SASE if requested by artist. Responds to the artist only if interested. Publication will contact artist for portfolio review if interested. Portfolio should include color tearsheets. Buys one-time rights and reprint rights. Pays on publication; $250 for color cover; $10 for b&w inside; $25 for color inside.

Tips: "We have not purchased an illustration or used a freelance designer for many years. We regularly purchase cartoons with wheelchair sports/recreation theme."

N: STEREOPHILE, 110 Fifth Ave., 5th Floor, New York NY 10011-5601. (212)229-4896. Fax: (212)886-2809. Website: www.stereophile.com. **Art Director:** Natalie Baca. Estab. 1962. "We're the oldest and largest subject review high-end audio magazine in the country, approximately 220 pages/monthly." Circ. 80,000. Accepts previously published artwork.

Illustration: Approached by 50 illustrators/year. Buys 3-5 illustrations/issue. Works on assignment only. Features realistic illustration; charts & graphs; computer and spot illustration. Assigns 75% of illustrations to experienced, but not well-known illustrators; 25% to new and emerging illustrators. Interested in all media. Send query letter with brochure and tearsheets. Samples are filed. Responds only if interested. Portfolio should include original/final art, tearsheets or other appropriate samples. Rights purchased vary according to project. Pays on publication; $150-1000 for color inside.

Tips: "Be able to turn a job in three to five days and have it look professional. Letters from previous clients to this effect help. Some knowledge of consumer electronics is helpful. Prefer electronic submissions, on disks or via e-mail/web."

STONE SOUP, The Magazine by Young Writers and Artists, P.O. Box 83, Santa Cruz CA 95063. (831)426-5557. E-mail: editor@stonesoup.com. Website: www.stonesoup.com. **Editor:** Gerry Mandel. Bi-monthly 4-color magazine with "simple and conservative design" emphasizing writing and art by children. Features adventure, ethnic, experimental, fantasy, humorous and science fiction articles. "We only publish writing and art by children through age 13. We look for artwork that reveals that the artist is closely observing his or her world." Circ. 20,000. Sample copies available for $4. Art guidelines for SASE with first-class postage.

Illustration: Buys 12 illustrations/issue. Prefers complete and detailed scenes from real life. All art must be by children ages 8-13. Send query letter with photocopies. Samples are filed or are returned by SASE. Responds in 1 month. Buys all rights. Pays on publication; $100 for color cover; $20-25 for color inside; $20 for spots.

THE STRAIN, 11702 Webercrest, Houston TX 77048. (713)733-0338. **Articles Editor:** Alicia Adler. Estab. 1987. Monthly literary magazine and interactive arts publication. "The purpose of our publication is to encourage the interaction between diverse fields in the arts and (in some cases) science." Circ. 1,000. Accepts previously published artwork. Original artwork is returned to the artist at the job's completion. Sample copy for $5 plus 9×12 SAE and 7 first-class stamps.

Cartoons: Send photocopies of finished cartoons with SASE. Samples not filed are returned by SASE. Responds in 2 years on submissions. Buys one-time rights or negotiates rights purchased.

Illustration: Buys 2-10 illustrations/issue. "We look for works that inspire creation in other arts." Send work that is complete in any format. Samples are filed "if we think there's a chance we'll use them." Those not filed are returned by SASE. Publication will contact artist for portfolio review if interested. Portfolio should include final art or photographs. Negotiates rights purchased. Pays on publication; $10 for b&w, $5 for color cover; $10 for b&w inside; $5 for color inside.

N: STRATEGIC FINANCE, 10 Paragon Dr., Montvale NJ 07645. (800)638-4427. Website: www.imane t.org and www.strategicfinancemag.com. **Editorial Director:** Kathy Williams. **Art Director:** Mary Zisk. Production Manager: Lisa Nasuta. Estab. 1919. Monthly 4-color with a 3-column design emphasizing management accounting for management accountants, controllers, chief financial officers, chief accountants and treasurers. Circ. 80,000. Accepts simultaneous submissions. Originals are returned after publication.

● This magazine has a new title, new design and broadened coverage.

Illustration: Approached by 6 illustrators/year. Buys 10 illustrations/issue. Send nonreturnable postcard samples. Prefers financial accounting themes.

STRATTON MAGAZINE, P.O. Box 85, Dorset VT 05251. (802)362-7200. Fax: (802)362-7222. Website: www.strattonmagazine.com. **Art Director:** Irene Cole. Estab. 1964. Quarterly 4-color free lifestyle magazine for the Southern Vermont resort area. Circ. 25,000.

Illustration: Approached by 2-4 illustrators/year. Buys 0-6 illustrations/issue. Has featured illustrations by Matthew Perry, John D'Alliard. Features humorous illustration, natural history illustration and realistic illustrations. Preferred subjects: nature. Assigns 85% to experienced, but not well-known illustrators; 15% to new and emerging illustrators. "We will do traditional separations from reflective art but if supplied electronically, should be in Illustrator or Photoshop. Send postcard samples. Send nonreturnable samples. Accepts Mac-compatible disk submissions. Send EPS or TIFF files. Samples are filed. Responds only if interested. Will contact artist for portfolio review if interested. Buys one-time rights. Rights purchased vary according to project. Pays on publication; $250-500 for color cover; $25-100 for b&w, $100-250 for color inside.

Tips: "We have an outstanding nationally known staff photographer who provides most of our visuals, but we turn to illustration when the subject requires it and budget allows. I would like to have more artists available who are willing to accept our small payment in order to build their books! We are fairly traditional so please do not send way-out samples."

STUDENT LAWYER, 750 N. Lake Shore Dr., Chicago IL 60611. (312)988-6042. E-mail: kulcm@staff.a banet.org. **Art Director:** Mary Anne Kulchawik. Estab. 1972. Trade journal, 4-color, emphasizing legal education and social/legal issues. *"Student Lawyer* is a legal affairs magazine published by the Law Student Division of the American Bar Association. It is not a legal journal. It is a features magazine, competing for a share of law students' limited spare time—so the articles we publish must be informative, lively, good reads. We have no interest whatsoever in anything that resembles a footnote, academic article. We are interested in professional and legal education issues, sociolegal phenomena, legal career features, and profiles of lawyers who are making an impact on the profession." Monthly (September-May). Circ. 35,000. Original artwork is returned to the artist after publication.
Illustration: Approached by 20 illustrators/year. Buys 8 illustrations/issue. Has featured illustrations by Sean Kane, Jim Starr, Slug Signorino, Ken Wilson and Charles Stubbs. Features realistic, computer and spot illustration. Assigns 50% of illustrations to experienced, but not well-known illustrators; 50% to new and emerging illustrators. Needs editorial illustration with an "innovative, intelligent style." Works on assignment only. Needs computer-literate freelancers for illustration. Send postcard sample, brochure, tearsheets and printed sheet with a variety of art images (include name and phone number). Samples are filed. Call for appointment to show portfolio of final art and tearsheets. Buys one-time rights. **Pays on acceptance**; $500-800 for color cover; $450-600 for color inside; $300-450 for b&w inside; $150-300 for spots.
Tips: "In your portfolio, show a variety of color and black & white, plus editorial work."

STUDENT LEADER MAGAZINE, P.O. Box 14081, Gainesville FL 32604-2081. (352)373-6907. Fax: (352)373-8120. E-mail: jeff@studentleader.com. Website: www.studentleader.com. **Art Director:** Jeff Riemersma. Estab. 1993. National college leadership magazine published 3 times/year. Circ. 100,000. Sample copies for 8½×11 SASE and 4 first-class stamps. Art guidelines for #10 SASE with 1 first-class stamp.
• Oxendine Publishing also publishes *Florida Leader Magazine* and *Florida Leader Magazine for High School Students.*
Illustration: Approached by hundreds of illustrators/year. Buys 6 illustrations/issue. Has featured illustrations by Tim Foley, Jackie Pittman, Greta Buchart, Dan Miller. Assigns 33% of illustrations to well-known or "name" illustrators; 33% to experienced, but not well-known illustrators; 33% to new and emerging illustrators. Considers all media. 50% of freelance illustration demands computer skills. Disk submissions must be PC-based, TIFF or EPS files. Samples are filed and are not returned. Responds only if interested. Rights purchased vary according to project. Pays on publication; $150 for color inside. Finds illustrators through sourcebook and artist's submissions.
Tips: "We need responsible artists who complete projects on time and have a great imagination. Also must work within budget."

☑ **SUN VALLEY MAGAZINE**, 12 E. Bullion St., Suite B, Hailey ID 83333-8409. (208)788-0770. Fax: (208)788-3881. E-mail: svmag@micron.net. Website: www.sunvalleymag.com. **Art Director:** Drew Furlong. Estab. 1971. Consumer magazine published 3 times/year "highlighting the activities and lifestyles of people of the Wood River Valley." Circ. 15,000. Sample copies available. Art guidelines free for #10 SASE with first-class postage.
Illustration: Approached by 10 illustrators/year. Buys 3 illustrations/issue. Prefers forward, cutting edge styles. Considers all media. 50% of freelance illustration demands knowledge of QuarkXPress. Send query letter with SASE. Accepts disk submissions compatible with Macintosh, QuarkXPress 3.3. Send EPS files. Samples are filed. Does not report back. Artist should call. Art director will contact artist for portfolio review of b&w, color, final art, photostats, roughs, slides, tearsheets and thumbnails if interested. Buys first rights. Pays on publication; $100-200 for b&w, $250-500 for color cover; $35-100 for b&w, $50-100 for color inside.
Tips: "Read our magazine. Send ideas for illustrations and examples."

Ⓝ TAMPA BAY MAGAZINE, 2531 Landmark Dr., Clearwater FL 34621. (727)791-4800. **Editor:** Aaron Fodiman. Estab. 1986. Bimonthly local lifestyle magazine with upscale readership. Circ. 40,000. Accepts previously published artwork. Sample copy available for $4.50. Art guidelines not available.
Cartoons: Approached by 30 cartoonists/year. Buys 6 cartoons/issue. Prefers single panel color washes with gagline. Send query letter with finished cartoon samples. Samples are not filed and are returned by SASE if requested. Buys one-time rights. Pays $15 for b&w, $20 for color.

Illustration: Approached by 100 illustrators/year. Buys 5 illustrations/issue. Prefers happy, stylish themes. Considers watercolor, collage, airbrush, acrylic, marker, colored pencil, oil and mixed media. Send query letter with photographs and transparencies. Samples are not filed and are returned by SASE if requested. To show a portfolio, mail color tearsheets, slides, photocopies, finished samples and photographs. Buys one-time rights. Pays on publication; $150 for color cover; $75 for color inside.

TECHLINKS, 3630 Stonewall Dr. SE, Atlanta GA 30339. (770)436-6789. Fax: (770)276-4486. Website: www.techlinks.net. **Art Director:** Renee Solomon. Estab. 1998. Bimonthly 4-color publication for end users and corporate buyers in the Georgia technology community. Circ. 35,000.
Illustration: Approached by 50 illustrators/year. Has featured illustrations by Basil Berry. Prefers business subjects. Assigns 20% of illustrations to experienced, but not well-known illustrators; 80% to new and emerging illustrators. 100% of freelance illustration demands knowledge of Photoshop, PageMaker, Quark XPress. Send postcard sample and follow-up postcard every 4 months. Accepts Mac-or Windows-compatible disk submissions. Samples are not filed and not returned. Will contact artist for portfolio review if interested. Buys first rights. Pays on publication. Payment negotiable. Finds illustrators through our sister company; America's Performance Group.

✍ TECHNICAL ANALYSIS OF STOCKS & COMMODITIES, 4757 California Ave. SW, Seattle WA 98116-4499. (206)938-0570. E-mail: cmorrison@traders.com. Website: www.Traders.com. **Art Director:** Christine Morrison. Estab. 1982. Monthly traders' magazine for stocks, bonds, futures, commodities, options, mutual funds. Circ. 52,000. Accepts previously published artwork. Sample copies available for $5. Art guidelines on website.
> • This magazine has received several awards including the Step by Step Design Annual, American Illustration IX, Society of American Illustration New York. They also publish *Working Money*, a general interest financial magazine (has similar cartoon and illustration needs).

Cartoons: Approached by 10 cartoonists/year. Buys 1 cartoon/issue. Prefers humorous cartoons, single panel b&w line drawings with gagline. Send query letter with finished cartoons. Samples are filed. Buys one-time rights and reprint rights. Pays $35 for b&w.
Illustration: Approached by 100 illustrators/year. Buys 6 illustrations/issue. Works on assignment only. Features humorous, realistic, computer (occasionally) and spot illustrations. Send brochure, tearsheets, photographs, photocopies, photostats, slides. Accepts disk submissions compatible with any Adobe products on TIFF or EPS files. Samples are filed and are not returned. Publication will contact artist for portfolio review if interested. Portfolio should include b&w and color tearsheets, slides, photostats, photocopies, final art and photographs. Buys one-time rights and reprint rights. Pays on publication; $135-350 for color cover; $165-213 for color inside; $105-133 for b&w inside.
Tips: "Looking for creative, imaginative and conceptual types of illustration that relate to the article's concepts. Also caricatures with market charts and computers. Send a few copies of black & white and color work with cover letter—if I'm interested I will call."

☑ TECHNIQUES, 1410 King St., Alexandria VA 22314-2749. (703)683-3111. Fax: (703)683-7424. E-mail: mjones@acteonline.org or jwelch@acteonline.org. Website: www.acteonline.org. **Art Director:** Mitchell Jones. Estab. 1924. Monthly 4-color technical and career education magazine. Circ. 45,000. Accepts previously published artwork. Originals returned at job's completion. Sample copies with 9×11 SASE and first-class postage. Art guidelines not available.
Illustration: Approached by 50 illustrators/year. Buys 8 illustrations/year. Works on assignment only. Has featured illustrations by John Berry, Valerie Spain, Eric Westbrook, Becky Heavner and Bryan Leister. Features informational graphics; computer and spot illustrations. Assigns 60% of illustrations to well-known or "name" illustrators; 20% to experienced, but not well-known illustrators; 20% to new and emerging illustrators. Considers pen & ink, watercolor, colored pencil, oil and pastel. Needs computer-literate freelancers for illustration. Send query letter with samples. Samples are filed. Portfolio review not required. Rights purchased vary according to project. Sometimes requests work on spec before assigning job. Pays on publication; $600-1,000 for color cover; $275-500 for color inside.

TENNIS, 810 7th Ave., 4th Floor, New York NY 10019-5918. (212)636-2700. Fax: (212)636-2730. Website: www.tennis.com. **Art Director:** Gary Stewart. For affluent tennis players. Monthly. Circ. 800,000. **Illustration:** Works with 15-20 illustrators/year. Buys 50 illustrations/year. Uses artists mainly for spots and openers. Works on assignment only. Send postcard sample or query letter with tearsheets. Mail printed samples of work. **Pays on acceptance**; $400-800 for color.

N. TEXAS MEDICINE, 401 W. 15th St., Austin TX 78701. (512)476-7733. Fax: (512)370-1629. Website: www.texmed.org. **Art Director:** Laura Levi. Monthly trade journal published by Texas Medical Association for the statewide Texas medical profession. Circ. 35,000. Sample copies and art guidelines available.
Illustrations: Approached by 30-40 illustrators/year. Buys 4-6 illustrations/issue. Prefers medical themes. Considers all media. Send postcard sample or query letter with photocopies. Accepts disk submissions of EPS or TIFF files for QuarkXPress 3.32. Samples are filed and are not returned. Responds only if interested. Art director will contact artist for portfolio review of b&w, color, final art, photographs, photostats, tearsheets or transparencies if interested. Rights purchased vary according to project. Pays on publication. Payment varies; $350 for spots. Finds artists through agents, magazines and submissions.

N. THE TEXAS OBSERVER, 307 W. Seventh, Austin TX 78701. (512)477-0746. Fax: (512)474-1175. E-mail: editors@texasobserver.org. **Contact:** Editor. Estab. 1954. Biweekly b&w magazine emphasizing Texas political, social and literary topics. Circ. 10,000. Accepts previously published material. Returns original artwork after publication. Sample copy for SASE with postage for 2 ounces; art guidelines for SASE with first-class postage.
• This magazine likes to feature Texas illustrators exclusively.
Cartoons: "Our style varies; content is political/satirical or feature illustrations." Also uses caricatures.
Illustration: Buys 4 illustrations/issue. Has featured illustrations by: Matt Weurker and Sam Hurt. Assigns 15% of illustrations to well-known or "name" illustrators; 75% to experienced, but not well-known illustrators; 10% to new and emerging illustrators. Needs editorial illustration with political content. "We only print b&w, so pen & ink is best; washes are fine." Send photostats, tearsheets, photocopies, slides or photographs to be kept on file. Samples not filed are returned by SASE. Responds in 1 month. Request portfolio review in original query. Buys one-time rights. Pays on publication; $50 for b&w cover; $25 for inside.
Tips: "No color. We use mainly local artists usually to illustrate features. We also require a fast turnaround. Humor scores points with us."

✓ TEXAS PARKS & WILDLIFE, 3000 S. IH 35, Suite 120, Austin TX 78704-6536. (512)912-7000. Fax: (512)707-1913. Website: www.tpwmagazine.com. **Art Director:** Mark Mahorsky. Estab. 1942. Monthly magazine "containing information on state parks, wildlife conservation, hunting and fishing, environmental awareness." Circ. 180,000. Sample copies for #10 SASE with first-class postage.
Illustration: 100% of freelance illustration demands knowledge of QuarkXPress. Send postcard sample. Samples are not filed and are not returned. Responds only if interested. Buys one-time rights. Pays on publication; negotiable. Finds illustrators through magazines, word of mouth, artist's submissions.
Tips: "Read our magazine."

N. THOMSON MEDICAL ECONOMICS, Five Paragon Dr., Montvale NJ 07645. (201)358-7695. **Art Coordinator:** Sindi Price. Estab. 1909. Publishes 22 health related publications and several annuals. Interested in all media, including electronic and traditional illustrations. Accepts previously published material. Originals are returned at job's completion. Uses freelance artists for "all editorial illustration in the magazines." 25% illustration and 100% freelance production work demand knowledge of QuarkXPress, Illustrator and Photoshop.
Cartoons: Prefers editorial illustration with medically related themes. Prefers single panel b&w line drawings and washes with gagline. Send query letter with finished cartoons. Material not filed is returned by SASE. Responds in 2 months. Buys all rights.
Illustration: Prefers all media including 3-D illustration. Needs editorial and medical illustration that varies, "but is mostly on the conservative side." Works on assignment only. Send query letter with résumé and samples. Samples are filed. Responds only if interested. Publication will contact artist for portfolio review if interested. Buys one-time rights. **Pays on acceptance**; $1,000-1,500 for color cover; $200-600 for b&w, $250-800 for color inside.

THRASHER, 1303 Underwood Ave., San Francisco CA 94124-3308. (415)822-3083. Fax: (415)822-8359. Website: www.thrashermagazine.com. **Managing Editor:** Ryan Henry. Estab. 1981. Monthly 4-color magazine. "*Thrasher* is the dominant publication devoted to the latest in extreme youth lifestyle, focusing on skateboarding, snowboarding, new music, videogames, etc." Circ. 200,000. Accepts previously

published artwork. Originals returned at job's completion. Sample copies for SASE with first-class postage. Art guidelines not available. Needs computer-literate freelancers for illustration. Freelancers should be familiar with Illustrator or Photoshop.

Cartoons: Approached by 100 cartoonists/year. Buys 2-5 cartoons/issue. Has featured illustrations by Mark Gonzales. Prefers skateboard, snowboard, music, youth-oriented themes. Assigns 100% of illustrations to new and emerging illustrators. Send query letter with brochure and roughs. Samples are filed and are not returned. Responds to the artist only if interested. Rights purchased vary according to project. Pays $50 for b&w, $75 for color.

Illustrations: Approached by 100 illustrators/year. Buys 2-3 illustrations/issue. Prefers themes surrounding skateboarding/skateboarders, snowboard/music (rap, hip hop, metal) and characters and commentary of an extreme nature. Prefers pen & ink, collage, airbrush, marker, charcoal, mixed media and computer media (Mac format). Send query letter with brochure, résumé, SASE, tearsheets, photographs and photocopies. Samples are filed. Publication will contact artist for portfolio review if interested. Portfolio should include b&w and color tearsheets, photocopies and photographs. Rights purchased vary according to project. Negotiates payment for covers. Sometimes requests work on spec before assigning job. Pays on publication; $75 for b&w, $100 for color inside.

Tips: "Send finished quality examples of relevant work with a bio/intro/résumé that we can keep on file and update contact info. Artists sometimes make the mistake of submitting examples of work inappropriate to the content of the magazine. Buy/borrow/steal an issue and do a little research. Read it. Desktop publishing is now sophisticated enough to replace all high-end prepress systems. Buy a Mac. Use it. Live it."

☑ **TIKKUN MAGAZINE**, 2107 Van Ness Ave., Suite 302, San Francisco CA 94109. (415)575-1200. Fax: (415)575-1434. E-mail: magazine@tikkun.org. Website: www.tikkun.org. Editor: Michael Lerner. **Managing Editor:** Deborah Kory. Estab. 1986. "A bimonthly Jewish critique of politics, culture and society. Includes articles regarding Jewish and non-Jewish issues, left-of-center politically." Circ. 70,000. Accepts previously published material. Original artwork returned after publication. Sample copies for $6 plus $2 postage.

Illustration: Approached by 50-100 illustrators/year. Buys 10-12 illustrations/issue. Has featured illustrations by Julie Delton, David Ball, Jim Flynn. Features symbolic and realistic illustration. Assigns 90% of illustrations to experienced, but not well-known illustrators; 10% to new and emerging illustrators. Prefers line drawings. Send brochure, résumé, tearsheets, photostats, photocopies. Slides and photographs for color artwork only. Buys one-time rights. Do not send originals; unsolicited artwork will not be returned. "Often we hold onto line drawings for last-minute use." Pays on publication; $150 for color cover; $50 for b&w inside.

Tips: No "sculpture, heavy religious content. Read the magazine—send us a sample illustration of an article we've printed, showing how you would have illustrated it."

☑ **TIME**, 1271 Avenue of the Americas, Rockefeller Center, New York NY 10020-1393. (212)522-1212. Fax: (212)522-0323. Website: www.time.com. **Art Director:** Arthur Hochstein. Deputy Art Directors: Cynthia Hoffman and D.W. Pine. Estab. 1923. Weekly magazine covering breaking news, national and world affairs, business news, societal and lifestyle issues, culture and entertainment. Circ. 4,096,000.

Illustration: Considers all media. Send postcard sample, printed samples, photocopies or other appropriate samples. Accepts disk submissions. Samples are filed. Responds only if interested. Portfolios may be dropped off every Tuesday between 11 and 1. They may be picked up the following day, Wednesday, between 11 and 1. Buys first North American serial rights. Pay is negotiable. Finds artists through sourcebooks and illustration annuals.

☑ **THE TOASTMASTER**, 23182 Arroyo Vista, Rancho Santa Margarita CA 92688-2699. (949)858-8255. Fax: (949)858-1207. Website: www.toastmasters.com. **Art Director:** Susan Campbell. Estab. 1924. Monthly trade journal for association members. "Language, public speaking, communication are our topics." Circ. 170,000. Accepts previously published artwork. Originals returned at job's completion. Sample copies available.

Illustration: Buys 6 illustrations/issue. Works on assignment only. Prefers communications themes. Considers watercolor and collage. Send postcard sample. Accepts disk submissions. Samples are filed or

THE MULTIMEDIA INDEX preceding the General Index in the back of this book lists markets seeking freelancers with multimedia, animation and CD-ROM skills.

returned by SASE if requested by artist. Responds to the artist only if interested. Portfolio should include tearsheets and photocopies. Negotiates rights purchased. **Pays on acceptance**; $500 for color cover; $50-200 for b&w, $100-250 for color inside.

TODAY'S CHRISTIAN WOMAN, 465 Gundersen Dr., Carol Stream IL 60188. (630)260-6200. Fax: (630)260-0114. **Art Director:** Kay Chin Bishop. Estab. 1978. Bimonthly consumer magazine "for Christian women, covering all aspects of family, faith, church, marriage, friendship, career and physical, mental and emotional development from a Christian perspective." Circ. 250,000.
• This magazine is published by Christianity Today, Intl. which also publishes 11 other magazines..
Illustration: Buys 6 illustrations/issue. Considers all media. Send postcard sample or query letter with printed samples, photocopies, SASE and tearsheets. Samples are filed. Responds only if interested. Buys first rights. Pays $200-650 for color inside. Pays $250-350 for spots.

TODAY'S PARENT, 269 Richmond St. West, Toronto, Ontario M5V 1X1, Canada. (416)596-8680. Fax: (416)596-1991. Website: www.todaysparent.com. **Art Director:** Penny Argue. Monthly parenting magazine. Circ. 175,000. Sample copies available.
Illustration: Send query letter with printed samples, photocopies or tearsheets. Send follow-up postcard sample every year. Portfolios may be dropped off on Mondays and picked up on Tuesdays. Accepts disk submissions. Art director will contact artist for portfolio review of b&w and color photographs, slides, tearsheets and transparencies if interested. Buys first rights. **Pays on acceptance**, $100-300 for b&w and $250-800 for color inside. Pays $400 for spots. Finds illustrators through magazines, submissions and word of mouth.
Tips: Looks for "good conceptual skills and skill at sketching children and parents."

TOLE WORLD, 1041 Shary Circle, Concord CA 94518-2407. (925)671-9852. Fax: (925)671-0692. E-mail: syarmolich@egw.com. Website: www.toleworld.com. **Editor:** Sandra Yarmolich. Estab. 1977. Bimonthly 4-color magazine with creative designs for decorative painters. "*Tole* incorporates all forms of craft painting including folk art. Manuscripts on techniques encouraged." Circ. 90,000. Accepts previously published artwork. Original artwork returned after publication. Sample copies available; art guidelines available for SASE with first-class postage.
Illustrations: Buys illustrations mainly for step-by-step project articles. Buys 8-10 illustrations/issue. Prefers acrylics and oils. Considers alkyds, pen & ink, mixed media, colored pencil, watercolor and pastels. Needs editorial and technical illustration. Send query letter with photographs. Samples are not filed and are returned. Responds within 2 months. Pay is negotiable.
Tips: "Submissions should be neat, evocative and well-balanced in color scheme with traditional themes, though style can be modern."

TRAINING & DEVELOPMENT MAGAZINE, 1640 King St., Box 1443, Alexandria VA 22313-2043. (703)683-8146. Fax: (703)548-2383. E-mail: ljones@astd.org. **Art Director:** Elizabeth Z. Jones. Estab. 1945. Monthly trade journal that covers training and development in all fields of business. Circ. 40,000. Accepts previously published artwork. Original artwork is returned at job's completion. Art guidelines not available.
Illustration: Approached by 20 freelance illustrators/year. Buys 5-7 freelance illustrations/issue. Works on assignment only. Has featured illustrations by Alison Seiffer, James Yang and Riccardo Stampatori. Features humorous, realistic, computer and spot illustration. Assigns 35% of illustrations to well-known or "name" illustrators; 55% to experienced, but not well-known illustrators; 10% to new and emerging illustrators. Prefers sophisticated business style. Considers collage, pen & ink, airbrush, acrylic, oil, mixed media, pastel. Send postcard sample. Accepts disks compatible with Illustrator 9, FreeHand 5.0, Photoshop 5. Send EPS, JPEG or TIFF files. Use 4-color (process) settings only. Samples are filed. Responds to the artist only if interested. Write for appointment to show portfolio of tearsheets, slides. Buys one-time rights or reprint rights. Pays on publication; $700-1,200 for color cover; $350 for b&w inside; $350-800 for color inside; $800-1,000 for 2-page spreads; $100-300 for spots.
Tips: "Send more than one image if possible. Do not keep sending the same image. Try to tailor your samples to the art director's needs if possible."

TRAINING MAGAZINE, Helping People and Business Succeed, 50 S. Ninth St., Minneapolis MN 55402-3118. (612)333-0471. Fax: (612)333-6526. Website: www.trainingmag.com. **Art Director:** Michele Schmidt. Estab. 1964. Monthly 4-color trade journal covering job-related training and education in business and industry, both theory and practice. Audience: training directors, personnel managers, sales and data processing managers, general managers, etc. Circ. 51,000. Sample copies for SASE with first-class postage.

Cartoons: Approached by 20-25 cartoonists/year. Buys 1-2 cartoons/issue. "We buy a wide variety of styles. The themes relate directly to our editorial content, which is training in the workplace." Prefers single panel, b&w line drawings or washes with and without gagline. Send query letter with brochure and finished cartoons. Samples are filed or are returned by SASE if requested by artist. Responds in 1 month. Buys first rights or one-time rights. Pays $100 for b&w.

Illustration: Buys 6-8 illustrations/issue. Works on assignment only. Prefers themes that relate directly to business and training. Styles are varied. Considers pen & ink, airbrush, mixed media, watercolor, acrylic, oil, pastel and collage. Send postcard sample, tearsheets or photocopies. Accepts disk submissions. Samples are filed. Responds to the artist only if interested. Buys first rights or one-time rights. **Pays on acceptance;** $1,500-2,000 for color cover; $800-1,200 for color inside; $100 for spots.

Tips: "Show a wide variety of work in different media and with different subject matter. Good renditions of people are extremely important."

N **TRAINS**, P.O. Box 1612, 21027 Crossroads Circle, Waukesha WI 53187. (262)796-8776. Fax: (262)796-1778. E-mail: tdanneman@kalmbach.com. Website: www.trains.com. **Art Director:** Thomas G. Danneman. Estab. 1940. Monthly magazine about trains, train companies, tourist RR, latest railroad news. Circ. 133,000. Art guidelines available.
 • Published by Kalmbach Publishing. Also publishes *Classic Toy Trains*, *Astronomy*, *Finescale Modeler*, *Model Railroader*, *Model Retailer*, *Classic Trains*, *Bead and Button*, *Birder's World*.

Illustration: 100% of freelance illustration demands knowledge of Photoshop 5.0, Illustrator 8.0. Send query letter with printed samples, photocopies and tearsheets. Accepts disk submissions (opticals) or CDs, using programs above. Samples are filed. Art director will contact artist for portfolio review of color tearsheets if interested. Buys one-time rights. Pays on publication.

Tips: "Quick turnaround and accurately built files are a must."

☑ **TRAVEL & LEISURE**, Dept. AM, 1120 Sixth Ave., 10th Floor, New York NY 10036-6700. (212)382-5600. Fax: (212)382-5877. Website: www.travelandleisure.com. **Art Director:** Laura Gharrity. Associate Art Directors: Stephanie Acher and Jae Han. Monthly magazine emphasizing travel, resorts, dining and entertainment. Circ. 1 million. Original artwork returned after publication. Art guidelines for SASE.

Illustration: Approached by 250-350 illustrators/year. Buys 1-15 illustrations/issue. Interested in travel and leisure-related themes. Prefers pen & ink, airbrush, colored pencil, watercolor, acrylic, oil, pastel, collage, mixed media and calligraphy. Does not use b&w work. "Illustrators are selected by excellence and relevance to the subject." Works on assignment only. Provide samples and business card to be kept on file for future assignment. Responds only if interested. Buys world serial rights. Pays on publication; $800-1,500 maximum for color inside; $1,500 for color cover.

Tips: No cartoons.

☑ **▢** **TROIKA MAGAZINE**, P.O. Box 1006, Weston CT 06883-0006. (203)319-0873. Fax: (203)319-0755. E-mail: submit@troikamagazine.com. Website: www.troikamagazine.com. **Art Director:** Tim Hussey. Estab. 1994. Quarterly literary magazine. *TROIKA* encourages readers to reflect on topics such as culture, science, the arts, parenting, the environment, business and politics. Circ. 120,000. Sample copies available.

Cartoons: Approached by 1,000 cartoonists/year. Buys 3 cartoons/issue. Prefers, single, double and multiple panel, political, humorous, b&w and color washes, b&w line drawings with gagline. Send query letter with photocopies. Samples are filed and are not returned. Responds only if interested. Buys first North American serial rights. Pays on publication; $250.

Illustration: Approached by 10,000 illustrators/year. Buys 40 illustrations/issue. Has featured illustrations by Philippe Weisbecker, Tim Hussey, Christian Clayton, David Miller, Christoph Niemann, Joel Nakamura, Ingo Fast, Paul Lange, David Goldin, Tavis Coburn, Chris Shasp, Katherine Streeter, John Boyer, Gary Taxali, Christian Northeast. Assigns 50% of illustrations to well-known or "name" illustrators; 25% to experienced, but not well-known illustrators; 25% to new and emerging illustrators. Considers all media. Send postcard sample. Samples are filed and are not returned. Responds only if interested. Art director will contact artist for portfolio review if interested. Buys first North American serial rights. Pays on publication; $1,000 for cover; $250-750 for inside. Pays $300-400 for spots. Finds illustrators through *Creative Black Book*, *LA Workbook*, on-line services, magazines, word of mouth, artist's submissions.

Design: Needs freelancers for design, production and multimedia projects. 100% of design demands knowledge of QuarkXPress. Send query letter with photocopies.

Tips: "We encourage freelancers to send in their work."

N **TRUE WEST MAGAZINE**, P.O. Box 8008, Cave Creek AZ 85327. (480)575-1881. Fax: (480)575-1903. E-mail: editor@truewestmagazine.com. Website: www.truewestmagazine.com. **Editor:** Bob Boze Bell. Monthly b&w magazine with 4-color cover emphasizing American Western history from 1830 to

1910. For a primarily rural and suburban audience, middle-age and older, interested in Old West history, horses, cowboys, art, clothing and all things Western. Circ. 65,000. Accepts previously published material and considers some simultaneous submissions. Original artwork returned after publication. Sample copy for $2; art guidelines for SASE and on website.

- Editor Bob Boze Bell says he would like to include more cartoons—be sure to send samples with a Western theme.

Cartoons: Approached by 10-20 cartoonists/year. Buys 2-3 cartoon/issue. Prefers western history theme. Prefers humorous cartoons, single or multiple panel. Send query letter with photocopies. Samples are filed or returned. Responds in 2 weeks if interested. Buys first rights. Pays $25-75 for b&w cartoons.

Illustration: Approached by 100 illustrators/year. Buys 5-10 illustrations/issue (2 or 3 humorous). Has featured illustrations by Gary Zaboly, Bob Bose Bell, Sparky Moore and Jack Jackson. Assigns 80% of illustrations to well-known or "name" illustrators; 10% to experienced, but not well-known illustrators; 10% to new and emerging illustrators. "Inside illustrations are usually, but not always, pen & ink line drawings; covers are Western paintings." 10% of freelance illustration demands knowledge of Photoshop, Illustrator and QuarkXPress. Send query letter with photocopies to be kept on file; "We return anything on request. For inside illustrations, we want samples of artist's line drawings. For covers, we need to see full-color transparencies." Responds in 2 weeks. Publication will contact artist for portfolio review if interested. Buys one-time rights. **"Pays on acceptance for new artists, on assignment for established contributors."** Pays $500-1,000 for color cover; $50-150 for b&w inside; and $50-250 for spots.

☑ **TURTLE MAGAZINE, For Preschool Kids**, Children's Better Health Institute, 1100 Waterway Blvd., Box 567, Indianapolis IN 46202. (317)636-8881. Website: www.turtlemag.org. **Art Director:** Bart Rivers. Estab. 1979. Emphasizes health, nutrition, exercise and safety for children 2-5 years. Published 8 times/year; 4-color. Circ. 343,923. Original artwork not returned after publication. Sample copy for $1.75; art guidelines for SASE with first-class postage. Needs computer-literate freelancers familiar with Macromedia FreeHand and Photoshop for illustrations.

- Also publishes *Child Life*, *Children's Digest*, *Children's Playmate*, *US Kids*, *Humpty Dumpty's Magazine* and *Jack and Jill*.

Illustration: Approached by 100 illustrators/year. Works with 20 illustrators/year. Buys 15-30 illustrations/ issue. Interested in "stylized, humorous, realistic and cartooned themes; also nature and health." Works on assignment only. Send query letter with good photocopies and tearsheets. Accepts disk submissions. Samples are filed or are returned by SASE. Responds only if interested. Portfolio review not required. Buys all rights. Pays on publication; $275 for color cover; $35-90 for b&w inside; $70-155 for color inside; $35-70 for spots. Finds most artists through samples received in mail.

Tips: "Familiarize yourself with our magazine and other children's publications before you submit any samples. The samples you send should demonstrate your ability to support a story with illustration."

🅽 **TV GUIDE**, 1211 Sixth Ave., New York NY 10036. (212)852-7500. Fax: (212)852-7470. Website: www.tvguide.com. **Art Director:** Theresa Griggs. Estab. 1953. Weekly consumer magazine for television viewers. Circ. 11,000,000. Has featured illustrations by Mike Tofanelli and Toni Persiani.

Illustration: Approached by 200 illustrators/year. Buys 50 illustrations/year. Considers all media. Send postcard sample. Samples are filed. Art director will contact artist for portfolio review of color tearsheets if interested. Negotiates rights purchased. **Pays on acceptance**; $1,500-4,000 for color cover; $1,000-2,000 for full page color inside; $200-500 for spots. Finds artists through sourcebooks, magazines, word of mouth, submissions.

🅽 ☑ **U. THE NATIONAL COLLEGE MAGAZINE**, 12707 High Bluff Dr., Suite 2000, San Diego CA 92130. (858)677-9449. Fax: (310)551-1659. E-mail: tcarrier@collegeus.com. Website: www.umagazin e.com. **Creative Art Director:** Tony Carrieri. Estab. 1986. Monthly consumer magazine of news, lifestyle and entertainment geared to college students. Magazine is for college students by college students. Circ. 1.5 million. Sample copies and art guidelines available for SASE with first-class postage or on website. Do not submit unless you are a college student.

Cartoons: Approached by 25 cartoonists/year. Buys 2 cartoons/issue. Prefers college-related themes. Prefers humorous color washes, single or multiple panel with gagline. Send query letter with photocopies. Samples are filed and not returned. Responds only if interested. Pays on publication; $25 for color.

Illustration: Approached by 100 illustrators/year. Buys 10-20 illustrations/issue. Features caricatures of celebrities; humorous illustration; informational graphics; computer and spot illustration. Assigns 100% of illustrations to new and emerging illustrators. Prefers bright, light, college-related, humorous, color only, no b&w. Considers collage, color washed, colored pencil, marker, mixed media, pastel, pen & ink or watercolor. 20% of freelance illustration demands knowledge of Photoshop, Illustrator and QuarkXPress.

Send query letter with photocopies and tearsheets. Samples are filed and are not returned. Responds only if interested. Pays on publication; $100 for color cover; $25 for color inside; $25 for spots. Finds illustrators through college campus newspapers and magazines.

Tips: "We need light, bright, colorful art. We accept art from college students only."

UNMUZZLED OX, 105 Hudson St., New York NY 10013. (212)226-7170. E-mail: MAndreOX@aol.c om. **Editor:** Michael Andre. Emphasizes poetry, stories, some visual arts (graphics, drawings, photos) for poets, writers, artists, musicians and interested others; b&w with 2-color cover and "classy" design. Circ. varies depending on format (5,000-20,000). Return of original artwork after publication "depends on work—artist should send SASE." Sample copy for $14 (book quality paperback form).

Cartoons: Send query letter with copies. Responds in 10 weeks. No payment for cartoons.

Illustration: Uses "several" illustrations/issue. Themes vary according to issue. Send query letter and "anything you care to send" to be kept on file for possible future assignments. Responds in 10 weeks.

Tips: Magazine readers and contributors are "highly sophisticated and educated"; artwork should be geared to this market. "Really, *Ox* is part of New York art world. We publish art, not 'illustration.'"

⟨N⟩ UPSIDE, 731 Market St., 2nd Floor, San Francisco CA 94103-2005. (415)489-5600. Fax: (415)589-4400. E-mail: gserrano@upside.com. Website: www.upside.com. **Creative Director:** Gerry Serrano. Estab. 1990. Monthly trade publication covering the business aspects of the technology industry from an executive perspective. *Upside* interprets, examines and tracks emerging technology trends in a sophisticated, entertaining fashion. Circ. 308,035.

Humorous Illustrations: Approached by 100 cartoonists/year. Buys 12 cartoons/year. Prefers sophisticated business and technology themes. Send query letter with photocopies. Samples are filed. **Pays on acceptance**. Payment negotiable.

Illustration: Approached by 500 illustrators/year. Buys 25-30 illustrations/issue. Has featured illustrations by Vivienne Flesher, Jose Cruz, Ismael Roldan and Brian Raska. Features caricatures and portraiture of influential hi-tech business personalities, like Bill Gates, Andy Grove, Ted Turner, Larry Ellison; humorous illustration; realistic or stylistic illustrations of controversial hi-tech business subjects. "We tend to hit below the belt within reason." Prefers all styles and media. Art director chooses style to go with the varying tone and content of each article. Assigns 5% of illustrations to well-known or "name" illustrators; 55% to experienced, but not well-known illustrators; 40% to new and emerging illustrators. Send postcard sample and follow-up postcard every 3 months. Accepts Mac-compatible disk submissions of digital-generated images. Samples are filed. Responds only if interested. Will review portfolios. Call to arrange drop-off. Buys first rights. Pays 30 days after acceptance; $1,200-1,500 for color cover (uses mostly photography for covers); $800-1,000 for color inside; $200-300 for spots. Finds illustrators through samples and source books.

U.S. LACROSSE MAGAZINE, 113 W. University Pkwy., Baltimore MD 21210-3300. (410)235-6882. Fax: (410)366-6735. E-mail: dblack@lacrosse.org.. Website: www.lacrosse.org. **Art Director:** Deb Black. Estab. 1978. "*Lacrosse Magazine* includes opinions, news, features, student pages, 'how-to's' for fans, players, coaches, etc. of all ages." Published 8 times/year. Circ. 80,000. Accepts previously published work. Sample copies available.

Cartoons: Prefers ideas and issues related to lacrosse. Prefers single panel, b&w washes or b&w line drawings. Send query letter with finished cartoon samples. Samples are filed or returned by SASE if requested. Rights purchased vary according to project. Pays $40 for b&w.

Illustration: Approached by 12 freelance illustrators/year. Buys 3-4 illustrations/year. Works on assignment only. Prefers ideas and issues related to lacrosse. Considers pen & ink, collage, marker and charcoal. Freelancers should be familiar with Illustrator, FreeHand or QuarkXPress. Send postcard sample or query letter with tearsheets or photocopies. Accepts disk submissions compatible with Mac. Samples are filed. Call for appointment to show portfolio of final art, b&w and color photocopies. Rights purchased vary according to project. Pays on publication; $100 for b&w cover, $150 for color cover; $75 for b&w inside, $100 for color inside.

Tips: "Learn/know as much as possible about the sport."

☑ US KIDS: A WEEKLY READER MAGAZINE, 1100 Waterway Blvd., Indianapolis IN 46202. (317)636-8881. Fax: (317)684-8094. Website: www.uskidsmag.org. **Art Director:** Timothy LaBelle. Estab. 1987. Magazine published 8 times/year focusing on health and fitness for kids 5-12 years old. Marketed through school systems. Circ. 250,000. Sample copy for $2.50. Art guidelines free for SASE with first-class postage.

• Also publishes *Children's Digest*, *Humpty Dumpty*, *Turtle Magazine* and *Jack & Jill*.

Illustration: Approached by 120 illustrators/year. Buys 2-5 illustrations/issue. Use same artist on a series. Has featured illustrations by: George Sears, John Lupton, Ron Wheeler, John Blackford and Geoffrey

Brittingham. Assigns 10% of illustrations to well-known or "name" illustrators; 70% to experienced but not well-known illustrators; 20% to new and emerging illustrators. Prefers health, fitness, fun for kids, simple styles. Considers all media. Send postcard sample or query letter with printed samples, photocopies, tearsheets. Send follow-up postcard sample every 4-6 months. Samples are filed. Responds only if interested. Art director will contact artist for portfolio review of color, final art, tearsheets, transparencies. Include a sample with name and address to leave with art director. Buys all rights. Pays on publication; $70-190 for color inside. Pays $70-80 for spots. Finds illustrators through sourcebooks and submissions. Pays slightly more for electronic versions of illustrations (on disk and formatted for magazine use).

Tips: "Work should be colorful and on the traditional side rather than wild and wacky. We center much of our magazine toward good health and educational themes. You must be geared to children, positive in nature. Timing and need are biggest factors! Most illustration is 'middle of road.' Do not use much that is too avant-garde. Need for activity pages and/or pieces. We also are gearing our magazine down to a younger audience. Though we will use other info, our thrust will be toward second and third grade age groups."

☑ **UTNE READER**, 1624 Harmon Place, Suite 330, Minneapolis MN 55403. (612)338-5040. Fax: (612)338-6043. Website: www.utne.com. **Art Director:** Kristi Anderson. Assistant Art Director: Jessica Coulter. Estab. 1984. Bimonthly digest featuring articles and reviews from the best of alternative media; independently published magazines, newsletters, books, journals and websites. Topics covered include national and international news, history, art, music, literature, science, education, economics and psychology. Circ. 250,000.

● *Utne Reader* seeks to present a lively diversity of illustration and photography "voices." We welcome artistic samples which exhibit a talent for interpreting editorial content.

Illustration: Buys 15-20 illustrations per issue. Buys 60-day North American rights. Finds artists through submissions, annuals and sourcebooks. Send single-sided postcards, color or b&w photocopies, printed agency/rep samples, or small posters. We are unlikely to give an assignment based on only one sample, and we strongly prefer that you send several samples in one package rather than single pieces in separate mailings. Clearly mark your full name, address, phone number, fax number, and e-mail address on everything you send. Do not send electronic disks, e-mails with attachments or references to websites. Do not send original artwork of any kind. Samples cannot be returned.

☑ **VANCOUVER MAGAZINE**, 555 W. 12th Ave., Suite 300, Vancouver, British Columbia V5Z 4L4 Canada. (604)877-7732. Fax: (604)877-4823. E-mail: dcheung@vancouvermagazine.com. Website: www.vancouvermagazine.com. **Art Director:** Doris Cheung. Monthly 4-color city magazine. Circ. 65,000.

Illustration: Approached by 25 illustrators/year. Buys 8 illustrations/issue. Has featured illustrations by Maurice Vellecoup, Seth, Ken Steacy, Amanda Duffy. Features editorial and spot illustrations. Prefers conceptual, alternative, bright and graphic use of color and style. Assigns 70% of illustrations to well-known or "name" illustrators; 20% to experienced, but not well-known illustrators; 10% to new and emerging illustrators. Send postcard or other nonreturnable samples and follow-up samples every 3 months. Samples are filed. Responds only if interested. Portfolio may be dropped off every Tuesday and picked up the following day. Buys one-time and WWW rights. **Pays on acceptance**; negotiable. Finds illustrators through magazines, agents, *Showcase*.

Tips: "We stick to tight deadlines. Aggressive, creative, alternative solutions encouraged. No phone calls please."

☑ **VANITY FAIR**, 4 Times Square, 22nd Floor, New York NY 10036. (212)286-8180. Fax: (212)286-6707. E-mail: vfmail@vf.com. Website: www.condenet.com. **Deputy Art Director:** Julie Weiss. Design Director: David Harris. Estab. 1983. Monthly consumer magazine. Circ. 1.1 million. Does not use previously published artwork. Original artwork returned at job's completion. 100% of freelance design work demands knowledge of QuarkXPress and Photoshop.

Illustration: Approached by "hundreds" of illustrators/year. Buys 3-4 illustrations/issue. Works on assignment only. "Mostly uses artists under contract."

VEGETARIAN JOURNAL, P.O. Box 1463, Baltimore MD 21203-1463. (410)366-8343. E-mail: vrg@vrg.org. Website: www.vrg.org. **Editor:** Debra Wasserman. Estab. 1982. Bimonthly nonprofit vegetarian magazine that examines the health, ecological and ethical aspects of vegetarianism. "Highly educated audience including health professionals." Circ. 27,000. Accepts previously published artwork. Originals returned at job's completion upon request. Sample copies available for $3.

Cartoons: Approached by 4 cartoonists/year. Buys 1 cartoon/issue. Prefers humorous cartoons with an obvious vegetarian theme; single panel b&w line drawings. Send query letter with roughs. Samples are not filed and are returned by SASE if requested by artist. Responds in 2 weeks. Rights purchased vary according to project. Pays $25 for b&w.

Illustration: Approached by 20 illustrators/year. Buys 6 illustrations/issue. Works on assignment only. Prefers strict vegetarian food scenes (no animal products). Considers pen & ink, watercolor, collage, charcoal and mixed media. Send query letter with photostats. Samples are not filed and are returned by SASE if requested by artist. Responds in 2 weeks. Portfolio review not required. Rights purchased vary according to project. **Pays on acceptance**; $25-50 for b&w/color inside. Finds artists through word of mouth and job listings in art schools.

Tips: Areas most open to freelancers are recipe section and feature articles. "Review magazine first to learn our style. Send query letter with photocopy sample of line drawings of food."

VIBE, 215 Lexington Ave., 6th Floor, New York NY 10016. (212)448-7300. Fax: (212)448-7430. E-mail: fbachleda@vibe.com. Website: www.vibe.com. **Design Director:** Florian Bachleda. Estab. 1993. Monthly consumer magazine focused on music, urban culture. Circ. 800,000. Accepts previously published artwork. Originals returned at job's completion. Sample copies available.

Cartoons: Send postcard-size sample or query letter with brochure and finished cartoons. Samples are filed. Responds to the artist only if interested. Buys one-time rights.

Illustration: Works on assignment only. Send postcard-size sample or query letter with photocopies. Samples are filed. Publication will contact artist for portfolio review of roughs, final art and photocopies if interested. Buys one-time or all rights.

VIDEOMAKER MAGAZINE, Box 4591, Chico CA 95927. (530)891-8410. Fax: (530)891-8443. E-mail: spiper@videomaker.com. Website: www.videomaker.com. **Art Director:** Samuel Piper. Monthly 4-color magazine for camcorder users with "contemporary, stylish yet technical design." Circ. 200,000. Accepts previously published artwork. 75% of freelance work demands knowledge of QuarkXPress, Illustrator, FreeHand and Photoshop.

Cartoons: Prefers technical illustrations. Pays $30-200 for b&w, $200-800 for color.

Illustration: Approached by 30 illustrators/year. Buys 3 illustrations/issue. Assigns 80% of illustrations to experienced, but not well-known illustrators; 20% to new and emerging illustrators. Works on assignment only. Considers pen & ink, airbrush, colored pencil, mixed media, watercolor, acrylic, oil, pastel, collage, marker and charcoal. Needs editorial and technical illustration. Send postcard sample and/or query letter with photocopies, brochure, SASE and tearsheets. Samples are filed. Publication will contact artist for portfolio review. Portfolio should include thumbnails, tearsheets and photographs. Negotiates rights purchased. Sometimes requests work on spec before assigning job. Pays on publication; $30-800 for b&w inside; $50-1,000 for color inside; $30-50 for spots. Finds artists through submissions/self-promotions.

Design: Needs freelancers for design. Freelance work demands knowledge of QuarkXPress, Photoshop and FreeHand. Send query letter with brochure, photocopies, SASE, tearsheets. Pays by the project, $30-1,000.

Tips: "Read a previous article from the magazine and show how it could have been illustrated. The idea is to take highly technical and esoteric material and translate that into something the layman can understand. Since our magazine is mostly designed on desktop, we are increasingly more inclined to use computer illustrations along with conventional art. We constantly need people who can interpret our information accurately for the satisfaction of our readership. Want artists with quick turnaround (21 days maximum). Magazine was redesigned in October 2000 with a digital emphasis."

N **VIM & VIGOR**, 1010 E. Missouri Ave., Phoenix AZ 85014. (602)395-5850. Fax: (602)395-5853. **Senior Art Director:** Susan Knight. Creative Director: Randi Karabin. Estab. 1985. Quarterly consumer magazine focusing on health. Circ. 1.2 million Originals returned at job's completion. Sample copies available. Art guidelines available.

● The company publishes 16 other titles as well.

Illustration: Approached by 100 illustrators/year. Buys 10 illustrations/issue. Works on assignment only. Considers mixed media, collage, charcoal, acrylic, oil, pastel and computer. Send postcard sample with tearsheets and online portfolio/website information. Accepts disk submissions. Samples are filed. Rights purchased vary according to project. **Pays on acceptance**; $700-1,100 for color inside; $300 for spots. Finds artists through agents, web sourcebooks, word of mouth and submissions.

WASHINGTON CITY PAPER, 2390 Champlain St. N.W., Washington DC 20009. (202)332-2100. E-mail: mail@washcp.com. Website: www.washingtoncitypaper.com. **Art Director:** Jandos Rothstein. Estab. 1980. Weekly tabloid "distributed free in D.C. and vicinity. We focus on investigative reportage, arts, and general interest stories with a local slant." Circ. 95,000. Art guidelines not available.

Cartoons: Only accepts weekly features, no spots or op-ed style work. Pays $25 minimum for b&w.

Illustration: Approached by 100-200 illustrators/year. Buys 2-8 illustrations/issue. Has featured illustrations by Michael Kupperman, Peter Kuper, Greg Heuston, Joe Rocco, Marcos Sorensen and Robert Meganck. Features caricatures of politicians; humorous illustration; informational graphics; computer and spot

illustration. Considers all media, if the results do well in b&w. Send query letter with printed samples, photocopies or tearsheets. We occasionally accept Mac-compatible files. Art director will contact artist for portfolio review of b&w, final art, tearsheets if interested. Buys first-rights. Pays on publication which is usually pretty quick; $150 minimum for b&w cover; $220 minimum for color cover; $85 minimum for inside. Finds illustrators mostly through submissions.

Tips: "We are a good place for freelance illustrators, we use a wide variety of styles, and we're willing to work with beginning illustrators. We like illustrators who are good on concept and can work fast if needed. We don't use over polished 'clip art' styles. We also avoid cliché DC imagery such as the capitol and monuments. We strongly recommend that interested illustrators send samples by mail rather than e-mail or URLs."

N **WATERCOLOR MAGIC**, 4700 E. Galbraith Rd., Cincinnati OH 45236. (513)531-2690. Fax: (513)531-2902. E-mail: wcmedit@aol.com. **Art Director:** Brian Schroeder. Editor: Ann Abbott. Estab. 1995. Quarterly 4-color consumer magazine to "help artists explore and master watermedia." Circ: 92.000. Art guidelines free for #10 SASE with first-class postage.

Illustration: Pays on publication. Finds illustrators through word of mouth, visiting art exhibitions, unsolicited queries, reading books.

Tips: "We are looking for watermedia artists who are willing to teach special aspects of their work and their techniques to our readers."

WEEKLY PLANET, 1310 E. Ninth Ave., Tampa FL 33605. (813)248-8888. Fax: (813)248-9999. E-mail: todd@weeklyplanet.com. Website: www.weeklyplanet.com. **Art Director:** Todd Bates. Estab. 1989. 4-color, alternative newsweekly magazine. Circ. 80,000.

Illustration: Approached by 300 illustrators/year. Buys 1-5 illustrations/week. Has featured illustrations by Art Chantry, Ismael Roldan, Pat Moriarty and Winston Smith. Features humorous and spot illustrations. Themes vary based on editorial. Assigns 10% of illustrations to well-known or "name" illustrators; 80% to experienced, but not well-known illustrators; 10% to new and emerging illustrators. Send non-returnable postcard samples. Samples are filed and are not returned. Will contact artist for portfolio review if interested. Buys first rights. Pays on publication; $100-200 for color inside, $200-600 for color cover; $75 for spots. Finds freelancers through artists' samples, magazines, other alternative weeklies and sourcebooks such as *Alternative Pick*, *Showcase* and *Workbook*.

Tips: "We are always open to new talent. Know your market—we are an alternative weekly and generally prefer cutting edge, gritty art that reproduces well on newsprint. No phone calls please."

WESTERN DAIRY BUSINESS, (formerly The Dairyman), 6437 Collamer Rd., E. Syracuse NY 13057. (315)703-7979. Fax: (315)703-7988. E-mail: mdbise@aol.com. Website: www.dairybusiness.com. **Art Director:** Maria Bise. Estab. 1922. Monthly trade journal with audience comprised of "Western-based milk producers, herd size 100 and larger, all breeds of cows, covering the 13 Western states." Circ. 23,000. Accepts previously published artwork. Samples copies and art guidelines available.

Illustration: Approached by 5 illustrators/year. Buys 1-4 illustrations/issue. Works on assignment only. Preferred themes "depend on editorial need." Considers 3-D and computer illustration. Send query letter with brochure, tearsheets and résumé. Samples are filed or are returned by SASE if requested by artist. Responds in 2 weeks. Write for appointment to show portfolio of thumbnails, tearsheets and photographs. Buys all rights. Pays on publication; $100 for b&w, $200 for color cover; $50 for b&w, $100 for color inside.

Tips: "We have a small staff. Be patient if we don't get back immediately. A follow-up letter helps. Being familiar with dairies doesn't hurt. Quick turnaround will put you on the 'A' list."

WESTWAYS, 3333 Fairview Rd., Costa Mesa CA 92808. (714)885-2396. Fax: (714)885-2335. **Design:** Eric Van Eyke. Estab. 1918. A bimonthly lifestyle and travel magazine. Circ. 3,000,000. Original artwork returned at job's completion. Sample copies and art guidelines available for SASE.

Illustration: Approached by 20 illustrators/year. Buys 2-6 illustrations/issue. Works on assignment only. Preferred style is arty-tasteful, colorful. Considers pen & ink, watercolor, collage, airbrush, acrylic, colored pencil, oil, mixed media and pastel. Send query letter with brochure, tearsheets and samples. Samples are filed. Responds in 1-2 weeks only if interested. To show a portfolio, mail appropriate materials. Portfolio should include thumbnails, final art, b&w and color tearsheets. Buys first rights. Pays on publication; $250 minimum for color inside.

WISCONSIN REVIEW, 800 Algoma Blvd., University of Wisconsin-Oshkosh, Oshkosh WI 54901. (920)424-2267. E-mail: wireview@yahoo.com. **Contact:** Art Editor. Triquarterly review emphasizing liter-

ature (poetry, short fiction, reviews). Black & white with 4-color cover. Circ. 2,000. Accepts previously published artwork. Original artwork returned after publication "if requested." Sample copy for $4; art guidelines available; for SASE with first-class postage.

Illustration: Uses 5-10 illustrations/issue. Has featured illustrations by Kurt Zivelonghi and Simone Bonde. Assigns 75% of illustrations to new and emerging illustrators. "Cover submissions can be color, size 5½×8½ or smaller or slides. Submissions for inside must be b&w, size 5½×8½ or smaller unless artist allows reduction of a larger size submission. Send postcard sample, SASE and slides with updated address and phone number to be kept on file for possible future assignments. Send query letter with roughs, finished art or samples of style. Samples returned by SASE. Responds in 5 months. Pays in 2 contributor's copies.

WISCONSIN TRAILS, P.O. Box 317, BlackEarth WI 53515. (608)767-8000. **Creative Director:** Kathie Campbell. 4-color publication concerning travel, recreation, history, industry and personalities in Wisconsin. Published 6 times/year. Circ. 35,000. Previously published and photocopied submissions OK. Art guidelines for SASE.

Illustration: Buys 6 illustrations/issue. "Art work is done on assignment, to illustrate specific articles. All articles deal with Wisconsin. We allow artists considerable stylistic latitude." Send postcard samples or query letter with brochure, photocopies, SASE, tearsheets, résumé, photographs, slides and transparencies. Samples kept on file for future assignments. Indicate artist's favorite topics; name, address and phone number. Include SASE. Publication will contact artist for portfolio review if interested. Buys one-time rights on a work-for-hire basis. Pays on publication; $50-150 for b&w inside; $50-400 color inside. Finds artists through magazines, submissions/self-promotions, artists' agents and reps and attending art exhibitions.

Tips: "Keep samples coming of new work."

N WOODENBOAT MAGAZINE, Box 78, Brooklin ME 04616-0078. (207)359-4651. Fax: (207)359-8920. E-mail: dickg@woodenboat.com. Website: www.woodenboat.com. **Art Director:** Olga Lange. Estab. 1974. Bimonthly magazine for wooden boat owners, builders and designers. Circ. 106,000. Previously published work OK. Sample copy for $4. Art guidelines free for SASE with first-class postage.

Illustration: Approached by 10-20 illustrators/year. Buys 2-10 illustrations/issue on wooden boats or related items. Has featured illustrations by Sam Manning and Kathy Bray. Assigns 10% of illustrations to well-known or "name" illustrators; 80% to experienced but not well-known illustrators; 10% to new and emerging illustrators. Send postcard sample or query letter with printed samples and tearsheets. Samples are filed. Does not report back. Artist should follow up with call. Pays on publication. "Rates vary, but usually $50-400 for spots."

Design: Needs freelancers for design and production. 100% of freelance work demands knowledge of Photoshop, Illustrator, QuarkXPress. Send query letter with tearsheets, résumé and slides. Pays by project.

Tips: "We work with several professionals on an assignment basis, but most of the illustrative material that we use in the magazine is submitted with a feature article. When we need additional material, however, we will try to contact a good freelancer in the appropriate geographic area."

WORCESTER MAGAZINE, 172 Shrewsbury St., Worcester MA 01604. (508)755-8004. Fax: (508)755-8860. E-mail: nangelo@wpltd.com. **Production Director:** Nick Angelo. Estab. 1976. A weekly alternative newspaper serving the Worcester community with news, investigative reports, arts, music and other cultural events. Circ. 40,000. Sample copies available.

Cartoons: Approached by 12 cartoonists/year. Buys 2 cartoons/issue. Prefers satire, parody, cutting-edge humor. Prefers b&w line drawings. Send query letter with photocopies and tearsheets. Samples are filed. Responds only if interested. Negotiates rights purchased. Pays on publication; $200-300 for b&w.

Illustration: Approached by 50 illustrators/year. Buys 12 illustrations/year. Prefers seasonal, arts and political themes. Only accepts digital art. 100% of freelance illustration demands knowledge of Photoshop, Illustrator and QuarkXPress. Send query letter with photocopies. Accepts disk submissions compatible with Macintosh computer platform—EPS files, QuarkXPress 4.0, Illustrator 7.0, Photoshop 5.0, Postscript Type II fonts. Samples are filed. Responds only if interested. Art director will contact artist for portfolio review of b&w, color, final art, photographs, roughs and tearsheets if interested. Buys all rights. Pays on publication; $75-400 for color cover; $75-100 for spots. Finds illustrators through word of mouth.

Design: Needs freelancers for design and production. Prefers local design freelancers only. 100% of freelance work demands knowledge of Photoshop, Illustrator and QuarkXPress. Send query letter with photocopies.

N WORKBENCH, August Home Publishing, Inc., 2200 Grand Ave., Des Moines IA 50312. (515)282-7000. Website: www.workbenchmagazine.com. **Art Director:** Robert Foss. Estab. 1957. Bimonthly 4-color magazine for woodworking and home improvement enthusiasts. Circ. 550,000. 100% of freelance work demands knowledge of Illustrator or QuarkXPress on PC or Macintosh.

Illustration: Works with 10 illustrators/year. Buys 100 illustrations/year. Artists with experience in the area of technical drawings, especially house plans, exploded views of furniture construction, power tool and appliance cutaways, should send SASE for sample copy and art guidelines. Style of Eugene Thompson, Don Mannes and Mario Ferro. Send query letter with nonreturnable samples. Publication will contact artist for portfolio review if interested. Sometimes requests work on spec before assigning job. Pays $50-1,200 for full color.

WORKFORCE, 245 Fischer Ave., B-2, Costa Mesa CA 92626-4537. (714)751-1883. Fax: (714)751-4106. Website: www.workforce.com. **Art Director:** Douglas R. Deay. Production Director: Laura Brunell. Estab. 1922. Monthly trade journal for human resource business executives. Circ. 36,000. Sample copies available in libraries.

Illustration: Approached by 100 illustrators/year. Buys 10 illustrations/issue. Prefers business themes. Considers all media. 40% of freelance illustration demands knowledge of Photoshop, QuarkXPress and Illustrator. Send postcard sample. Send follow-up postcard sample every 3 months. Samples are filed and are not returned. Does not report back, artist should call. Art director will contact for portfolio review if interested. Rights purchased vary according to project. **Pays on acceptance**; $350-500 for color cover; $100-400 for b&w and/or color inside; $75-150 for spots. Finds artists through agents, sourcebooks such as *LA Workbook*, magazines, word of mouth and submissions.

Tips: "Read our magazine."

WORKING MOTHER MAGAZINE, 135 W. 50th St., 16th Floor, New York NY 10020-1201. (212)351-6400. Fax: (212)445-6174. Website: www.workingmother.com. **Creative Director:** Alberto Orta. Estab. 1979. "A monthly service magazine for working mothers focusing on work, money, children, food and fashion." Circ. 930,000. Original artwork is returned at job's completion. Sample copies and art guidelines available.

Illustration: Approached by 100 illustrators/year. Buys 3-5 illustrations/issue. Works on assignment only. Prefers light humor and child/parent, work themes. Considers watercolor, collage, airbrush, acrylic, colored pencil, oil, mixed media and pastel. Send query letter with printed samples of tearsheets. Samples are filed and are not returned. Does not report back, in which case the artist should call or drop off portfolio. Portfolio should include tearsheets, slides and photographs. Buys first rights. **Pays on acceptance**; $150-2,000 for color inside.

N WORLD TRADE, 23211 S. Pointe Dr., Suite 101, Laguna Hills CA 92653-1478. (949)234-1700. Fax: (949)234-1701. Website: www.worldtrademag.com. **Art Director:** Mike Powell. Estab. 1988. Monthly 4-color consumer journal; "read by upper management, presidents and CEOs of companies with international sales." Circ. 83,000. Accepts previously published artwork. Original artwork is returned to artist at job's completion. Sample copies and art guidelines not available.

Cartoons: Prefers business/social issues. Samples are filed. Responds only if interested. Buys first rights or reprint rights.

Illustration: Approached by 15-20 illustrators/year. Buys 1-2 illustrations/issue. Works on assignment only. "We are open to all kinds of themes and styles." Considers pen & ink, colored pencil, mixed media and watercolor. Send query letter with brochure and tearsheets. Samples are filed. Responds only if interested. Portfolio review not required. Buys first rights or reprint rights. Pays on publication; $800 for color cover; $275 for color inside.

Tips: "Send an example of your work. We prefer previous work to be in business publications. Artists need to understand we work from a budget to produce the magazine, and budget controls and deadlines are closely watched."

N WRITER'S DIGEST, 4700 E. Galbraith Rd. Cincinnati OH 45236. E-mail: writersdig@fwpubs.com. Website: www.writersdigest.com. Art Director: Tari Zumbaugh. Editor: Melanie Rigney. Monthly magazine emphasizing freelance writing for freelance writers. Circ. 200,000. Original artwork returned after publication. Sample copy for $3. Art guidelines free for SASE with first-class postage.

● Submissions are also considered for inclusion in annual *Writer's Yearbook* and other one-shot publications.

Illustration: Buys 1-2 feature illustrations per month. Theme: the writing life. Prefers b&w line art. Works on assignment only. Send postcard or any printed/copied samples to be kept on file (limit size to 8½×11).

Accepts Mac-formatted disk submissions. "EPS, PICT, TIFF or JPEG OK for viewing—for reproduction we need EPS." Buys one-time rights. **Pays on acceptance**; $500-1,000 for color cover; $100-500 for inside b&w.
Tips: "We're also looking for black & white spots of writing-related subjects. We buy all rights; $15-25/spot. I like having several samples to look at. Online portfolios are great."

WRITER'S YEARBOOK, 4700 E. Galbraith Rd., Cincinnati OH 45236. **Art Director:** Tari Zumbaugh. Annual publication featuring "the best writing on writing." Topics include writing and marketing techniques, business issues for writers and writing opportunities for freelance writers and people getting started in writing. Original artwork returned with 1 copy of the issue in which it appears. Sample copy $6.25. Affiliated with *Writer's Digest*. Cartoons submitted to either publication are considered for both.
Illustrations: Uses 1-2 illustrations/issue. Theme: the writing life. Prefers b&w line art. Works on assignment only. Send postcard or any printed/copied samples to be kept on file (limit size to 8½×11). Accepts Mac-formatted disk submissions. "EPS, PICT, TIFF or JPEG OK for viewing—for reproduction we need EPS." Buys first North American serial rights for one-time use. **Pays on acceptance**; $100-500 inside b&w, $500-1,000 for color cover.
Tips: Send finished, not rough art.

WY'EAST HISTORICAL JOURNAL, P.O. Box 294, Rhododendron OR 97049. (503)622-4798. Fax: (503)622-4798. **Publisher:** Michael P. Jones. Estab. 1994. Quarterly historical journal. "Our readers love history and nature, and this is what we are about. Subjects include America, Indians, fur trade, Oregon Trail, etc., with a focus on the Pacific Northwest." Circ. 2,500. Accepts previously published artwork. Originals returned at job's completion if accompanied by SASE. Sample copies $10. Art guidelines for SASE with first-class postage. 50% of freelance work demands computer skills.
Cartoons: Approached by 50 cartoonists/year. Buys 6 cartoons/issue. Prefers Northwest Indians, Oregon Trail, wildlife; single panel. Send query letter with brochure, roughs and finished cartoons. Samples are filed or are returned by SASE. Responds in 2 weeks. Buys reprint rights. Pays in copies.
Illustration: Approached by 100 illustrators/year. Buys 10 illustrations/issue. Prefers Northwest Indians, Oregon Trail, fur trade, wildlife. Considers pen & ink, airbrush and charcoal. Send query letter with brochure, résumé, SASE, tearsheets, photographs, photocopies, slides and transparencies. Samples are filed or are returned by SASE if requested by artist. Responds in 2 weeks. Publication will contact artist for portfolio review if interested. Portfolio should include b&w and color thumbnails, tearsheets, slides, roughs, photostats, photocopies, final art and photographs. Buys first rights. Pays in copies. Finds artists th.ough submissions, sourcebooks and word of mouth.
Design: Needs freelancers for design and production. 50% of freelance work demands computer skills. Send brochure, photocopies, SASE, tearsheets, résumé, photographs, slides, transparencies. Pays in published copies.
Tips: Uses freelancers for "feature articles in need of illustrations. However, we will consider doing a feature on the artist's work. Artists find us. Send us a good selection of your samples, even if they are not what we are looking for. Once we see what you can do, we will give an assignment. We are specifically seeking illustrators who know how to make black & white illustrations come alive."

YACHTING MAGAZINE, 18 Marshall St., Suite 114, Norwalk CT 06854-2237. (203)299-5900. Fax: (203)625-4481. Website: www.yachtingnet.com. **Art Director:** Rana Bernhardt. Estab. 1907. Monthly magazine "with emphasis on high-end power and sail vessels. Gear and how-to also included." Circ. 132,000. Art guidelines not available.
Illustration: Approached by 75 illustrators/year. Buys 4-5 illustrations/issue. Features humorous illustration; charts & graphs; informational graphics; computer and spot illustration. Assigns 100% of illustrations to experienced, but not well-known illustrators. Prefers tech drawings. Considers all media. 30% of freelance illustration demands knowledge of Photoshop, Illustrator and QuarkXPress, all late versions. Send postcard sample. Send follow-up postcard samle every 3 months. Accepts disk submissions compatible with QuarkXPress 7.5/version 3.3 send EPS files. Files accepted on CD and ZIP. Samples are filed and

**FOR EXPLANATIONS OF THESE SYMBOLS,
SEE THE INSIDE FRONT AND BACK COVERS OF THIS BOOK.**

are not returned. Responds only if interested. Art director will contact artist for portfolio review of b&w, color tearsheets if interested. Buys first rights. Pays on publication; $250-450 for color inside; $450-600 for 2-page spreads; $150-350 for spots.

Design: Needs freelancers for design, production and multimedia projects, rarely. Prefers designers with experience in production. 100% of freelance work demands knowledge of Photoshop, Illustrator and Quark-XPress. Send query letter with printed samples and tearsheets.

Tips: "Read the magazine. I like clean, professional work done quickly and with little supervision. Have a presentable portfolio. Our subject is pretty slim, but we can see potential."

N: YM, Dept. AM, 375 Lexington Ave., New York NY 10017-5514. (646)758-0555. Fax: (646)758-0808. **Art Director:** Amy Demas. Deputy Art Director: Anton Ioukhnovets. A fashion magazine for teen girls between the ages of 14-21. Ten issues (monthly and 2 joint issues—June-July and December-January.) Circ. 2,276,939. Original artwork returned at job's completion. Sample copies available.

Illustration: Buys 1-2 illustrations/issue. Buys 12-36 illustrations/year. Prefers funny, whimsical illustrations related to girl/guy problems, horoscopes and dreams. Considers watercolor, collage, acrylic, colored pencil, oil, charcoal, mixed media, pastel. Samples are filed or not filed (depending on quality). Samples are not returned. Responds to the artist only if interested. Buys one-time rights. **Pays on acceptance** or publication. Offers one half of original fee as kill fee.

YOGA JOURNAL, 2054 University Ave., Suite 600, Berkeley CA 94704-1059. (510)841-9200. Fax: (510)644-3101. Website: www.yogajournal.com. **Art Director:** Jonathan Wieder. Estab. 1975. Bimonthly consumer magazine emphasizing health, consciousness, yoga, holistic healing, transpersonal psychology, body work and massage, martial arts, meditation and Eastern spirituality. Circ. 135,000. Originals returned at job's completion.

Illustration: Approached by 150 illustrators/year. Buys 8 illustrations/issue. Works on assignment only. Considers all media, including electronic (Mac). Send query letter with nonreturnable samples. Accepts disk submissions compatible with Illustrator 5.5. Send EPS files. Samples are filed. Publication will contact artist for portfolio review if interested. Buys one-time rights. **Pays on acceptance**; $800-1,500 for color cover; $500-1,000 for b&w, $800-1,200 for color inside; $150-400 for spots.

Tips: "Send plenty of samples in a convenient form (i.e. 8½×11 color photocopies with name and phone number on each sample) that don't need to be returned. Tearsheets are always desirable."

Posters & Prints

Inspired by a local dance troupe, artist Anna Oneglia created "Red Dress Dancing (#3)" from an intricate combination of watercolor and woodblock on panel. Helen Carter of the Syracuse Cultural Workers, a distributor of "gifts with a social and activist purpose," says the subject's brightness, energy and vitality swept over selection committee members instantly. "Red Dress Dancing (#3)" was also published as a poster featuring a quote from author Anne Lamott.

The benefit of working with a publisher/distributor is that they take on the expense and duties of printing and marketing. Find out how they plan to market your work and what outlets it will be sold to before you sign a contract.

This section lists art publishers and distributors who can publish and market your work as prints. It is important to understand the difference between the terms "publisher" and "distributor" before you start looking for markets within this section. Art *publishers* work with you to publish a piece of your work in print form. Art *distributors* assist you in marketing a pre-existing poster or print to poster and print galleries, department stores and other outlets. Some companies function as both publisher and distributor. Be sure to look in the first paragraph of each listing to determine if the company is a publisher, distributor or both.

TARGET YOUR MARKETS

Some listings in this section are **fine art presses**, others are more commercial. Read the listings carefully to determine if they create editions for the fine art market or for the **decorative market**.

Once you select a list of potential publishers, send for each publisher's catalog. Some publishers will not send their catalogs because they are too expensive, but you can often ask to see one at a local poster shop, print gallery, upscale furniture store or frame shop. Examine the colors in the catalogs to make sure the quality is high.

What to send

To approach a publisher, send a brief query letter, a short bio, a list of galleries that represent your work and five to ten slides or whatever samples they specify in their listing. It helps to send printed pieces or tearsheets as samples, as these show publishers that your work reproduces well and that you have some understanding of the publication process. Some publishers will accept digital submissions via e-mail or CD.

Signing and numbering your editions

Before you enter the print arena, you will need to know the proper method of signing and numbering your editions. You can observe how this is done by visiting galleries and museums and talking to fellow artists.

If you are creating a limited edition, with a specific set number of prints, all prints are numbered, such as 35/100. The largest number is the total number of prints in the edition; the smaller number is the number of the print. Some artists hold out 10% as artist's proofs and number them separately with AP after the number (such as 5/100 AP). Many artists sign and number their prints in pencil.

Original prints. Original prints may be woodcuts, engravings, linocuts, mezzotints, etchings, lithographs or serigraphs. What distinguishes them is that they are produced by hand by the artist (and consequently often referred to as hand-pulled prints). In a true original print the work is created specifically to be a print. Each print is considered an original because the artist creates the artwork directly on the plate, woodblock, etching stone or screen. Original prints are sold through specialized print galleries, frame shops and high-end decorating outlets, as well as fine art galleries.

Offset reproductions and posters. Offset reproductions, also known as posters and image prints, are reproduced by photochemical means. Since plates used in offset reproductions do not wear out, there are no physical limits on the number of prints made. Quantities, however, may still be limited by the publisher in order to add value to the edition.

Giclée prints. As the new color-copier technology matures, inkjet fine art prints, also called giclée prints, are gaining respectability. Iris prints, images that are scanned into a computer and output on oversized printers, are even showing up in museum collections.

EXPLORE YOUR PRINTING OPTIONS

1. Working with a commercial poster manufacturer or art publisher. If you don't mind creating commercial images, and following current trends, the decorative market can be quite lucrative. On the other hand, if you should decide to work with a fine art publisher, you will have more control over the final image.

2. Working with a fine art press. Fine art presses differ from commercial presses in that press operators (usually artists themselves) work side by side with you to create the edition every step of the way, sharing their experience and knowledge of the printing process. You may be charged a fee for the time your work is on the press and for the expert advice of the printer.

3. Working at a co-op press. Instead of approaching an art publisher you can learn to make your own hand-pulled original prints—such as lithographs, monoprints, etchings or silk-screens. If there is a co-op press in your city, you can rent time on a printing press and create your own editions. It is rewarding to learn printing skills and have the hands-on experience. You also gain total control of your work. The drawback is you have to market your images yourself, by approaching galleries, distributors and other clients.

4. Self-publishing with a printing company. Several national printing concerns advertise heavily in artists' magazines, encouraging artists to publish their own work. If you are a savvy marketer, who understands the ins and outs of trade shows and direct marketing, this is a viable option. However it takes a large investment up front. You could end up with a thousand prints taking up space in your basement, or if you are a good marketer you could end up selling them all and making a much larger profit from your work than if you had gone through an art publisher or poster company.

5. Marketing through distributors. If you choose the self-publishing route, but don't have the resources to market your prints, distributors will market your work to outlets around the country in exchange for a percentage of sales. Distributors have connections with all kinds of outlets like retail stores, print galleries, framers, college bookstores and museum shops.

Canvas transfers. Canvas transfers are becoming increasingly popular. Instead of, and often in addition to, printing an image on paper, the publisher transfers your image onto canvas so the work has the look and feel of a painting. Some publishers market limited editions of 750 prints on paper, along with a smaller edition of 100 of the same work on canvas. The edition on paper might sell for $150 per print, while the canvas transfer would be priced higher, perhaps selling for $395.

PRICING CRITERIA FOR LIMITED EDITIONS AND POSTERS

Because original prints are always sold in limited editions, they command higher prices than posters (which usually are not numbered). Since plates for original prints are made by hand, and as a result can only withstand a certain amount of use, the number of prints pulled is limited by the number of impressions that can be made before the plate wears out. Some publishers impose their own limits on the number of impressions to increase a print's value. These limits may be set as high as 700 to 1,000 impressions, but some prints are limited to just 250 to 500, making them highly prized by collectors.

A few publishers buy work outright for a flat fee, but most pay on a royalty basis. Royalties for handpulled prints are usually based on retail price and range from 5 to 20 percent, while percentages for posters and offset reproductions are lower (from 2½ to 5 percent) and are based on the wholesale price. Be aware that some publishers may hold back royalties to cover promotion and production costs. This is not uncommon.

Prices for reproductions vary widely depending on the quantity available; the artist's reputation; the popularity of the image; the quality of the paper, ink and printing process. Since prices are lower than for original prints, publishers tend to select images with high-volume sales potential.

Negotiating your contract

As in other business transactions, ask for a contract and make sure you understand and agree to all the terms before you sign. Make sure you approve the size, printing method, paper, number of images to be produced and royalties. Other things to watch for include insurance terms, marketing plans, and a guarantee of a credit line or copyright notice.

Always retain ownership of your original work. Work out an arrangement in which you're selling publication rights only. You'll also want to sell rights only for a limited period of time. That way you can sell the image later as a reprint, or license it for other use (for example as a calendar or note card). If you are a perfectionist about color, make sure your contract gives you final approval of your print. Stipulate that you'd like to inspect a press proof prior to the print run.

MORE INDUSTRY TIPS

Research print outlets. Visit galleries, frame shops, furniture stores and other retail outlets that carry prints to see where your art fits in. You may also want to visit designer showrooms and interior decoration outlets.

Find a niche. Many artists do well in small, specialized niches. Limited edition prints with Civil War themes, for example, are avidly collected by Civil War enthusiasts. But to appeal to Civil War buffs, artists must do extensive research. Every detail, from weapons and foliage in battlefields, to the buttons on soldiers' uniforms, must be historically accurate. Signed limited editions are usually created in a print run of 950 or so and can average about $175-200; artist's proofs sell from between $195-250, with canvas transfers selling for $400-500. The original paintings from which images are taken often sell for thousands of dollars to avid collectors.

Sport art is another lucrative niche. There's a growing trend toward portraying sports figures from golf, tennis, football, basketball, racing (both sports car and horse racing) in prints which include both the artist's and the athlete's signatures. Movie stars from the 1940s and 50s (such as Humphrey Bogart, James Dean, Marilyn Monroe and Elvis) are also cult favorites.

Work in a series. It is often easier to market a series of small prints exploring a single theme or idea than to market single images. A series of similar prints works well in long hospital corridors, office meeting rooms or restaurants. Also marketable are "paired" images. Hotels often purchase two similar prints for each of their rooms.

Study trends. If you hope to get published by a commercial art publisher or poster company, your work will have a greater chance of acceptance if you use popular colors and themes. See our trend report on page 43.

Attend trade shows. Many artists say it's the best way to research the market and make contacts. Increasingly it has become an important venue for self-published artists to market their work. Decor Expo (formerly Art Buyers Caravan) is held each year in four cities, Atlanta, New Yor, Orlando and Los Angeles. For more information call (888)608-5300.

Don't overlook the collectibles market. If your artwork has wide appeal, and you are flexible, another option for you is the lucrative plates and collectibles market. You will be asked to adjust your work to fit into a circular format if it is chosen for a collectible plate, so be prepared to work with the company's creative staff to develop the final image. Consult the Greeting Cards, Gifts & Products section for companies specializing in collectibles.

 For More Information

☑ Read industry publications, such as *Decor* magazine and *Art Business News* to get a sense of what sells in both markets.

☑ To find out what trade shows are coming up in your area, check the event calendars in industry trade publications. Many shows, such as the Art Buyers Caravan, are scheduled to coincide with annual stationery or gift shows, so if you work in both the print and greeting card markets, be sure to take that into consideration. Remember, traveling to trade shows is considered a deductible business expense, so don't forget to save your receipts!

☑ Consult *Business and Legal Forms for Fine Artists* by Tad Crawford (Allworth Press) for sample contracts.

AARON ASHLEY, INC., Bentley Publishing Group, 1410 Lesnick Lane, Walnut Creek CA 94596. (925)935-3186. Fax: (925)935-0213. E-mail: bentley@bentleypublishinggroup.com. Website: www.bentleypublishinggroup.com. **President:** Robert Sher. Produces unlimited edition, offset reproduction fine art prints for distributors, decorators, frame shops, corporate curators, giftshops, museums and galleries. Clients: Freer Museum and Amon Carter.

Needs: Seeking decorative art for the designer and commercial markets. Considers oil, acrylic and watercolor paintings, mixed media and pastel. Prefers realistic or representational works. Artists represented include French-American Impressionists, Bierstadt, Russell, Remington, Jacqueline Penney, Ron McKee, Carolyn Blish and Urania Christy Tarbot. Editions created by working from an existing painting or transparency or by collaborating with the artists. Approached by 150 artists/year. Publishes the work of 12 emerging, 12 mid-career and 50 established artists/year.

First Contact & Terms: Query with SASE and slides or photos. "Do not send originals." Samples are returned. Responds in 6 weeks. Company will contact artist for portfolio review of color photographs and transparencies if interested. Pays royalties. Buys reprint rights. Requires exclusive representation for unlimited editions. Provides advertising and promotion.

Tips: Advises artists to attend Art Expo (industry trade show) held yearly in May in New York City.

ACTION IMAGES INC., 7101 N. Ridgeway, Lincolnwood IL 60712. (847)763-9700. Fax: (847)763-9701. E-mail: actionim@aol.com. Website: www.actionimagesinc.com. **President:** Tom Green. Estab. 1989. Art publisher of sport art. Publishes limited edition prints, open edition posters as well as direct printing on canvas. Specializes in sport art prints for events such as the Super Bowl, World Series, Final Four, Indy 500 and NASCAR. Clients include galleries, distributors, sales promotion agencies. Current clients include E&J Gallo Winery, Duracell Battery, Coca Cola, AllSport.

Needs: Seeking sport art for posters and as promotional material for sporting events. Considers all media. Artists represented include Ken Call, Konrad Hack, George Gaadt and Alan Studt. Approached by approximately 25 artists/year. Publishes the work of 1 emerging, 6 mid-career and 6 established artists/year.

First Contact & Terms: Send query letter with slides or color prints and SASE. Accepts submissions on disk compatible with Mac. Send EPS files. Samples are filed. Responds only if interested. If interested in samples, will ask to see more of artist's work. Pays flat fee: $1,000-2,000. Buys exclusive reproduction rights. Often acquires original painting. Provides insurance while work is at firm and outbound in-transit insurance. Promotional services vary depending on project. Also needs designers. Prefers designers who own Macs. Designers send query letter and samples. Finds artists through recommendations from other artists, word of mouth and submissions.

Tips: "The trend seems to be moving away from superrealism toward more Impressionistic work. We like to work with artists who are knowledgable about the pre-press process. Sometimes artists don't understand that the colors they create in their studios will not reproduce the exact way they envision them. Greens are tough to reproduce accurately. When you finish an artwork, have a photographer shoot it and get a color print. You'll be surprised how the colors come out. For example, if you use dayglow colors, they will not show up well in the cromalin. When we hire an artist to create a piece, we need to know the cromalin print will come back with accurate colors. This can only occur when the artist understands how colors reproduce and plans his colors so the final version shows the intended color."

AEROPRINT, (AKA SPOFFORD HOUSE), South Shore Rd., Box 154, Spofford NH 03462. (603)363-4713. **Owner:** H. Westervelt. Estab. 1972. Art publisher/distributor handling limited editions and open editions of offset reproductions for galleries and collectors. Clients: aviation art collectors and history buffs.

Needs: Artists represented include Merv Corning, Jo Kotula, Terry Ryan, Gil Cohen, James Deitz, Nixon Galloway, John Willis, Harley Copic, Robert Taylor, Nicholas Trudgian, Keith Ferris, William Phillips, John Shaw and Robert Bailey. Publishes the work of 8 established artists. Distributes the work of 32 established artists.

ALEXANDRE ENTERPRISES, P.O. Box 34, Upper Marlboro MD 20773. (301)627-5170. Fax: (301)627-5106. **Artistic Director:** Walter Mussienko. Estab. 1972. Art publisher and distributor. Publishes and distributes handpulled originals, limited editions and originals. Clients: retail art galleries, collectors and corporate accounts.

Needs: Seeking creative and decorative art for the serious collector and designer market. Considers oil, watercolor, acrylic, pastel, ink, mixed media, original etchings and colored pencil. Prefers landscapes, wildlife, abstraction, realism and impressionism. Artists represented include Cantin and Gantner. Editions created by collaborating with the artist. Approached by 30 artists/year. Publishes the work of 2 emerging, 2 mid-career and 3-4 established artists/year. Distributes the work of 2-4 emerging, 2 mid-career and 12 established artists/year.

First Contact & Terms: Send query letter with résumé, tearsheets and photographs. Samples are filed. Responds in 4-6 weeks only if interested. Call to schedule an appointment to show a portfolio or mail photographs and original pencil sketches. Payment method is negotiated: consignment and/or direct purchase. Offers an advance when appropriate. Negotiates rights purchased. Provides promotion, a written contract and shipping from firm.

Tips: "Artist must be properly trained in the basic and fundamental principles of art and have knowledge of art history. Have work examined by art instructors before attempting to market your work."

N AMCAL FINE ART, 2500 Bisso Lane, Bldg. 500, Concord CA 94520. (925)689-9930. Fax: (925)689-0108. Website: www.amcalart.com. **Development Manager:** Julianna Ross. Licensing: Valerie Weeks. Estab. 1993. Art publisher. Publishes limited and unlimited editions, canvas transfers and offset reproductions. Clients: print galleries.

● Also has listing in Greeting Cards, Gifts & Products section. This company's licensing division licenses images for tabletop, textile, collectibles, gift and stationery products.

Needs: Seeking high quality art for the serious collector. Also needs designers. Considers all media. Prefers representational work. Artist represented include Charles Wysocki. Editions created by collaborating with the artist or by working from an existing painting. Approached by 50 artists/year. Publishes the work of 1 mid-career and 1 established artist/year.

First Contact & Terms: Send postcard size sample of work or query letter with brochure, slides, transparencies, tearsheets and photographs. Samples are not filed and are returned by SASE if requested by artist. Responds in 2 months. Publisher will contact artist for portfolio review if interested. Portfolio should include color slides, tearsheets, transparencies, final art and photographs. Pays royalties. Offers advance when appropriate. Provides advertising, in-transit insurance, insurance while work is at firm, promotion, shipping from firm and written contract. Finds artists through researching trade, art magazines, attending shows, visiting galleries.

Tips: Suggest artists read *US Art* magazine, *Art Business News*, *GSB*, also home decor magazines.

✔ APPLEJACK LIMITED EDITIONS, P.O. Box 1527, Historic Rt. 7A, Manchester Center VT 05255. (802)362-3662. E-mail: gladys@applajackart.com. Website: www.applejackart.com. **Administrative Assistant:** Valerie Martin. Major publisher of limited edition prints.

Needs: Seeking fine art for the serious collector and the commercial market. Artists represented include Mort Künstler.

First Contact & Terms: Send query letter with slides and SASE to Submissions. Publisher will contact artist for portfolio review if interested.

ARNOLD ART STORE & GALLERY, 210 Thames St., Newport RI 02840. (401)847-2273. (800)352-2234. Fax: (401)848-0156. E-mail: info@arnoldart.com. Website: arnoldart.com. **Owner:** Bill Rommel. Estab. 1870. Poster company, art publisher, distributor, gallery specializing in marine art. Publishes/distributes limited and unlimited edition, fine art prints, offset reproduction and posters.

Needs: Seeking creative, fashionable, decorative art for the serious collector, commercial and designer markets. Considers oil, acrylic, watercolor, mixed media, pastel, pen & ink, sculpture. Prefers sailing

images—Americas Cup or other racing images. Artists represented include Willard Bond, Lucia deLieris, John Mecray. Editions created by working from an existing painting. Approached by 100 artists/year. Publishes/distributes the work of 10-15 established artists/year.

First Contact & Terms: Send query letter with 4-5 photographs. Samples are filed or returned by SASE. Call to arrange portfolio review. Pays flat fee, royalties or consignment. Negotiates rights purchased; rights purchased vary according to project. Provides advertising and promotion. Finds artists through word of mouth.

☑ **HERBERT ARNOT, INC.**, 250 W. 57th St., New York NY 10107. (212)245-8287. Website: www.arn otart.com. **President:** Peter Arnot. Vice President: Vicki Arnot. Art dealer of original oil paintings. Clients: galleries, design firms.

Needs: Seeking creative and decorative art for the serious collector and designer market. Considers oil and acrylic paintings. Has wide range of themes and styles—"mostly traditional/impressionistic, not abstract." Artists represented include An He, Malva, Willi Bauer, Gordon, Jereczek and Lucien Delarue. Distributes the work of 250 artists/year.

First Contact & Terms: Send query letter with brochure, résumé, business card, slides or photographs to be kept on file. Samples are filed or are returned by SASE. Responds in 1 month. Portfolios may be dropped off every Monday-Friday or mailed. Provides promotion.

Tips: "Artist should be professional."

ART BEATS, INC., 129 Glover Ave., Norwalk CT 06850-1311. (800)677-6947. Fax: (203)846-2105. Website: www.nygs.com. Estab. 1983. Art publisher. Publishes and distributes open edition posters and gift/fine art cards. Clients: framers, galleries, gift shops. Current clients include Prints Plus, Intercontinental Art. Member of New York Graphic Society Publishing Group.

Needs: Seeking creative, fashionable and decorative art for the commercial and designer markets. Considers oil, watercolor, mixed media, pastel and acrylic. Art guidelines free for SASE with first-class postage. Approached by 1,000 artists/year. Publishes the work of 45 established artists/year.

First Contact & Terms: Send query letter with résumé, color correct photographs, transparencies and tearsheets. Samples are not filed and are returned by SASE if requested by artist. Responds in 3 months. Publisher will contact artist for portfolio review if interested. Portfolio should include photostats, slides, tearsheets, photographs and transparencies; "no originals please." Pays royalties of 10% gross sales. No advance. Buys first rights, one-time rights or reprint rights. Provides promotion and written contract. Finds artists through art shows, exhibits, word of mouth and submissions.

ℕ ART BROKERS OF COLORADO, 2419 W. Colorado Ave., Colorado Springs CO 80904. (719)520-9177. Fax: (719)633-5747. Website: www.artbrokers.com. **Contact:** Nancy Anderson. Estab. 1991. Art publisher. Publishes limited and unlimited editions, posters and offset reproductions. Clients: galleries, decorators, frame shops.

Needs: Seeking decorative art by established artists for the serious collector. Prefers oil, watercolor and acrylic. Prefers western theme. Editions created by collaborating with the artist. Approached by 20-40 artists/year. Publishes the work of 1-2 established artists/year.

First Contact & Terms: Send query letter with photographs. Samples are not filed and are returned by SASE. Responds in 4-6 weeks. Company will contact artist for portfolio review of final art if interested. Pays royalties. Rights purchased vary according to project. Provides insurance while work is at firm.

Tips: Advises artists to attend all the trade shows and to participate as often as possible.

ℕ ART EMOTION CORP., 1758 S. Edgar, Palatine IL 60067. (847)397-9300. E-mail: gperez@artcom. com. **President:** Gerard V. Perez. Estab. 1977. Art publisher and distributor. Publishes and distributes limited editions. Clients: corporate/residential designers, consultants and retail galleries.

Needs: Seeking decorative art. Considers oil, watercolor, acrylic, pastel and mixed media. Prefers representational, traditional and impressionistic styles. Artists represented include Garcia, Johnson and Sullivan. Editions created by working from an existing painting. Approached by 50-75 artists/year. Publishes and distributes the work of 2-5 artists/year.

First Contact & Terms: Send query letter with slides or photographs. "Supply a SASE if you want materials returned to you." Samples are filed. Does not necessarily report back. Pays royalties of 10%.

Tips: "Send visuals first."

ℕ ART IMPRESSIONS, INC., 9035-A Eton Ave., Canoga Park CA 91304-1616. (818)700-8541. Fax: (818)718-5722. **Contact:** Jennifer Vincioni. Estab. 1990. Licensing agent. Clients: major manufacturers worldwide. Current clients include: Hasbro, Spring Industries, Lexington Furniture, American Greetings, Portal Publications and Mead.

Needs: Seeking art for the commercial market. Considers oil, acrylic, mixed media, pastel and photography. Prefers proven themes like children, domestic animals, fantasy/fairies, nostalgia, no abstract, nudes or "dark" themes. Artists represented include Schim Schimmel, Valerie Tabor-Smith, Susan Branch, Josephine Wall and Dana Simson. Approached by over 70 artists/year.

First Contact & Terms: Send query letter with photocopies, photographs, slides, transparencies or tearsheets and SASE. Accepts disk submissions. Samples are not filed and are returned by SASE. Responds in 2 months. Company will contact artist for portfolio review if interested. Artists are paid percentage of licensing revenues generated by their work. No advance. Requires exclusive representation of artist. Provides advertising, promotion, written contract and legal services. Finds artists through attending art exhibitions, word of mouth, publications and artists' submissions.

Tips: "Artists should have at least 25 images available and be able to reproduce an equal number annually. Artwork must be available on disc or transparency, and be of reproduction quality."

N: ARTEFFECTS DESIGNS & LICENSING INC., P.O. Box 1090, Dewey AZ 86327. (928)632-0530. Fax: (928)632-9052. **Manager:** William F. Cupp. Product development, art licensing and representation of European publishers.

Needs: Seeking creative, decorative art for the commercial and designer markets. Considers oil, acrylic, mixed media. Interested in all types of design. Artists represented include James Demmick, Judy Kaufman, Wendy Stevenson, Timothy Easton, Gideon and Christian Baron. Editions created by working from an existing painting.

First Contact & Terms: Send brochure, photographs, SASE, slides. "Must have SASE or will not return." Responds only if interested. Company will contact artist for portfolio review of transparencies if interested. Pays flat fee or royalties. No advance. Rights purchased vary according to project. Provides advertising and representation at international trade shows.

✔ ARTS UNIQ' INC., 1710 S. Jefferson Ave., Box 3085, Cookeville TN 38502. (615)526-3491. Fax: (615)528-8904. E-mail: art@artsuniq.com. Website: www.artsuniq.com. **Contact:** Carrie Wallen. Licensing: Carol White. Estab. 1985. Art publisher. Publishes limited and open editions. Licenses a variety of artwork for cards, throws, figurines, etc. Clients: art galleries, gift shops, furniture stores and department stores.

Needs: Seeking creative and decorative art for the designer market. Considers all media. Artists represented include D. Morgan, Jack Terry, Judy Gibson and Carolyn Wright. Editions created by collaborating with the artist or by working from an existing painting.

First Contact & Terms: Send query letter with slides or photographs. Samples are filed or are returned by request. Responds in 1-2 months. Pays royalties monthly. Requires exclusive representation rights. Provides promotion, framing and shipping from firm.

✔ ARTVISIONS, 12117 SE 26th St., Suite 202A, Bellevue WA 98005-4118. (425)746-2201. E-mail: mkt.art@artvisions.com. Website: www.artvisions.com. **President:** Neil Miller. Estab. 1993. Markets include publishers, manufacturers and others who may require fine art. Fine art licensing of posters and prints. See complete listing in Artists' Reps section.

✔ BENTLEY PUBLISHING GROUP, (formerly Bentley House Fine Art Publishers), Box 5551, 1410-J Lesnick Lane, Walnut Creek CA 94596. (925)935-3186. Fax: (925)935-0213. E-mail: alp@bentleyp ublishinggroup.com. Website: www.bentleypublishinggroup.com. **Director:** Mary Sher. Art Acquisitions: Jan Weiss. Estab. 1986. Art publisher of open and limited editions of offset reproductions and canvas replicas; also agency for licensing of artists' images worldwide. License florals, teddy bear, landscapes, wildlife and Christmas images to appear on puzzles, tapestry products, doormats, stitchery kits, giftbags, greeting cards, mugs, tiles, wall coverings, resin and porcelain figurines, waterglobes and various other gift items. Clients: framers, galleries, distributors and framed picture manufacturers.

Needs: Seeking decorative fine art for the designer, residential and commercial markets. Considers oil, watercolor, acrylic, pastel, mixed media and photography. Artists represented include Barbara Mock, Carl Valente, Peggy Abrams, Howard Behrens, Nenad Mirkovich, Raymond Knaub, Janet Kruskamp, Viktor Shvaiko, Klaus Strubel, Asoma and S. Sam Park. Editions created by collaborating with the artist or by working from an existing painting. Approached by 1,000 artists/year.

First Contact & Terms: Submit jpeg images via e-mail or send query letter with brochure showing art style or résumé, advertisements, slides and photographs. Samples are filed or are returned by SASE if requested by artist. Responds in 6 weeks. Pays royalties of 10% net sales for prints monthly plus 50 artist proofs of each edition. Pays 50% monies received from licensing. Obtains all reproduction rights. Usually requires exclusive representation of artist. Provides national trade magazine promotion, a written contract, worldwide agent representation, 5 annual trade show presentations, insurance while work is at firm and shipping from firm.

Tips: "Feel free to call and request guidelines. Bentley House is looking for experienced artists, with images of universal appeal."

BERGQUIST IMPORTS INC., 1412 Hwy. 33 S., Cloquet MN 55720. (218)879-3343. Fax: (218)879-0010. E-mail: bbergqu106@aol.com. **President:** Barry Bergquist. Estab. 1948. Distributor. Distributes unlimited editions. Clients: gift shops.
Needs: Seeking creative and decorative art for the commercial market. Considers oil, watercolor, mixed media and acrylic. Prefers Scandinavian or European styles. Artists represented include Jacky Briggs, Dona Douma and Suzanne Tostey. Editions created by collaborating with the artist or by working from an existing painting. Approached by 20 artists/year. Publishes the work of 2-3 emerging, 2-3 mid-career and 2 established artists/year. Distributes the work of 2-3 emerging, 2-3 mid-career and 2 established artists/year.
First Contact & Terms: Send brochure, résumé and tearsheets. Samples are not filed and are returned. Responds in 2 months. Artist should follow up. Portfolio should include color thumbnails, final art, photostats, tearsheets and photographs. Pays flat fee: $50-300, royalties of 5%. Offers advance when appropriate. Negotiates rights purchased. Provides advertising, promotion, shipping from firm and written contract. Finds artists through art fairs. Do not send art attached to e-mail. Will not download from unknown sources.
Tips: Suggests artists read *Giftware News Magazine*.

BERKSHIRE ORIGINALS, 2 Prospect Hill, Stockbridge MA 01263. (413)298-3691. Fax: (413)298-1293. E-mail: trumbull@marian.org. Website: www.marian.org. **Program Planner:** Alice Trumbull. Estab. 1991. Art publisher and distributor of offset reproductions and greeting cards.
Needs: Seeking creative art for the commercial market. Considers oil, watercolor, acrylic, pastel and pen & ink. Prefers religious themes, but also considers florals, holiday and nature scenes, line art and border art.
First Contact & Terms: Send query letter with brochure showing art style or other art samples. Samples are filed or are returned by SASE if requested by artist. Responds in 1 month. Write for appointment to show portfolio of slides, color tearsheets, transparencies, original/final art and photographs. Pays flat fee; $50-500. Buys all rights.
Tips: "Good draftsmanship is a must, particularly with figures and faces. Colors must be harmonious and clearly executed."

BERNARD FINE ART, P.O. Box 1528, Historic Rt. 7A, Manchester Center VT 05255. (802)362-0373. Fax: (802)362-1082. E-mail: Michael@applejackart.com. Website: www.applejackart.com. **Managing Director:** Michael Katz. Art publisher. Publishes open edition prints and posters. Clients: picture frame manufacturers, distributors, manufacturers, galleries and frame shops.
 ● This company is a division of Applejack Art Partners, along with the high-end poster lines Hope Street Editions and Rose Selavy of Vermont, as well as Pineapple Publishing, which features over 75 Norman Rockwell images.
Needs: Seeking creative, fashionable and decorative art for commercial and designer markets. Considers oil, watercolor, acrylic, pastel, mixed media and printmaking (all forms). Art guidelines free for SASE with first-class postage. Editions created by collaborating with the artist or by working from an existing painting. Artists represented include Erin Dertner, Sue Dreamer, Rusty Rust, Bill Bell, Shelly Rasche, Steven Klein and Michael Harrison. Approached by hundreds of artists/year. Publishes the work of 8-10 emerging, 10-15 mid-career and 100-200 established artists.
First Contact and Terms: Send query letter with brochure showing art style and/or résumé, tearsheets, photostats, photocopies, slides, photographs or transparencies. Samples are returned by SASE. Responds only if interested. Call or write for appointment to show portfolio of thumbnails, roughs, original/final art, b&w and color photostats, tearsheets, photographs, slides and transparencies. Pays royalty. Offers an advance when appropriate. Buys all rights. Usually requires exclusive representation of artist. Provides in-transit insurance, insurance while work is at firm, promotion, shipping from firm and a written contract. Finds artists through submissions, sourcebooks, agents, art shows, galleries and word of mouth.
Tips: "We look for subjects with a universal appeal. Some subjects that would be appropriate are landscapes, still lifes, wildlife, religious themes and florals. Please send enough examples of your work so we can see a true representation of style and technique."

N: THE BILLIARD LIBRARY CO., 1570 Seabright Ave., Long Beach CA 90813. (562)437-5413. Fax: (562)436-8817. E-mail: info@billiardlibrary.com. **Creative Director:** Darian Baskin. Estab. 1973. Art publisher. Publishes unlimited and limited editions and offset reproductions. Clients: galleries, frame shops, decorators. Current clients include Deck the Walls, Prints Plus, Adventure Shops.
Needs: Seeking creative, fashionable and decorative art for the commercial and designer markets. Considers oil, watercolor, mixed media, pastel, sculpture and acrylic. Artists represented include George Bloom-

field, Dave Harrington and Lance Slaton. Approached by 100 artists/year. Publishes and distributes the work of 1-3 emerging, 1-3 mid-career and 1-2 established artists/year. Also uses freelancers for design. Prefers local designers only.
First Contact & Terms: Send query letter with slides, photocopies, résumé, photostats, transparencies, tearsheets and photographs. Samples are filed and not returned. Responds only if interested. Publisher/Distributor will contact artists for portfolio review if interested. Pays royalties of 10%. Negotiates rights purchased. Provides promotion, advertising and a written contract. Finds artists through submissions, word of mouth and sourcebooks.
Tips: "The Billiard Library Co. publishes and distributes artwork of all media relating to the sport of pool and billiards. Themes and styles of any type are reviewed with an eye towards how the image will appeal to a general audience of enthusiasts. We are experiencing an increasing interest in nostalgic pieces, especially oils. Will also review any image relating to bowling or darts."

☑ **THE BLACKMAR COLLECTION**, P.O. Box 537, Chester CT 06412. (860)526-9303. E-mail: carser@mindspring.com. Estab. 1992. Art publisher. Publishes offset reproduction and giclée prints. Clients: individual buyers.
Needs: Seeking creative art. "We are not actively recruiting at this time." Artists represented include DeLos Blackmar, Blair Hammond, Gladys Bates and Keith Murphey. Editions created by working from an existing painting. Approached by 24 artists/year. Publishes the work of 3 established artists/year. Provides advertising, in-transit insurance, insurance while work is at firm. Finds artists through personal contact.

☑ **BRINTON LAKE EDITIONS**, Box 888, Brinton Lake Rd., Concordville PA 19331-0888. (610)459-5252. Fax: (610)459-2180. E-mail: galleryone@mindspring.com. **President:** Lannette Badel. Estab. 1991. Art publisher, distributor, gallery. Publishes/distributes limited editions and canvas transfers. Clients: independent galleries and frame shops. Current clients include: over 100 galleries, mostly East Coast.
Needs: Seeking fashionable art. Considers oil, acrylic, watercolor, mixed media and pastel. Prefers realistic landscape and florals. Artists represented include Gary Armstrong and Lani Badel. Editions created by collaborating with the artist. Approached by 20 artists/year. Publishes/distributes the work of 1 emerging and 1 established artist/year.
First Contact & Terms: Send query letter with samples. Samples are not filed and are returned. Responds in 2 months. Company will contact artist for portfolio review of final art, photographs, slides, tearsheets and transparencies if interested. Negotiates payment. Rights purchased vary according to project. Requires exclusive representation of artist.
Tips: "Artists submitting must have good drawing skills no matter what medium used."

◪ **BUSCHLEN MOWATT GALLERY**, 1445 W. Georgia St., Vancouver, British Columbia V6G 2T3 Canada. (604)682-1234 or (800)663-8071. Fax: (604)682-6004. **Gallery Director:** Sherri Kajiwara. Assistant Director: David Chaperon Estab. 1979 (gallery opened 1987). Art publisher, distributor and gallery. Publishes and distributes handpulled originals and limited editions. Clients are beginning to advanced international collectors and dealers.
Needs: Seeking creative art for the serious collector and the designer market. Considers all media. Artists represented include Cathelin, Brasilier, Moore, Motherwel, Frankenthaler, Olitski, Cassigneu, Bill Reid, Fenwick Lansdowne, Bernard Gantner. Editions created by collaborating with the artist. Approached by 1,000 artists/year. Publishes the work of 2 emerging and 5 established artists/year. Distributes the work of 4 emerging and 5-10 established artists/year.
First Contact & Terms: Send query letter with résumé and photographs. Do not contact through agent. Samples returned only with SASE if requested by artist. Responds in 3 months. Publisher/distributor will contact artist for portfolio review if interested. Portfolio should include color tearsheets and photographs. Negotiates payment. Buys all rights. Requires exclusive representation of artist. Provides advertising, insurance while work is at firm, promotion and written contract. Finds artists through art exhibitions, art fairs, word of mouth, sourcebooks, publications, and submissions.

◪ **CANADIAN ART PRINTS INC.**, 110-6311 Westminster Hwy., Richmond, British Columbia V7C 4V4 Canada. (604)276-4551. Fax: (604)276-4552. E-mail: sales@canadianartprints.com. Website: www.canadianartprints.com. **Art Director:** Niki Krieger. Assistant to Art Director: Tammy Cripps. General Manager: Lisa Krieger. Estab. 1965. Art publisher/distributor. Publishes or distributes unlimited edition, fine art prints, posters and art cards. Clients: galleries, decorators, frame shops, distributors, corporate curators, museum shops, giftshops and manufacturing framers. Licenses all subjects of open editions for wallpaper, writing paper, placemats, books, etc.
Needs: Seeking fashionable and decorative art for the commercial and designer markets. Considers oil, acrylic, watercolor, mixed media, pastel. Prefers representational florals, landscapes, marine, decorative, and street scenes. Artists represented include Linda Thompson, Jae Dougall, Philip Craig, Joyce Kamikura,

Kiff Holland, Victor Santos, Dubravko Raos, Don Li-Leger, Michael O'Toole and Will Rafuse. Editions created by collaborating with the artist and working from an existing painting. Approached by 300-400 artists/year. Publishes/distributes 10-15 emerging, 10 mid-career and 20 established artists/year.

First Contact & Terms: Send query letter with photographs, SASE, slides, tearsheets, transparencies. Samples are not filed and are returned by SASE. Responds in 1 month. Will contact artist for portfolio review of photographs, slides or transparencies if interested. Pays range of royalties. Buys reprint rights or negotiates rights purchased. Provides advertising, in-transit insurance, insurance while work is at firm, promotion, shipping and contract. Finds artists through art exhibitions, art fairs, word of mouth, art reps, submissions.

Tips: "Keep up with trends by following decorating magazines."

☑ **CARMEL FINE ART PRODUCTIONS, LTD.**, 21 Stocker Rd., Verona NJ 07044. (800)951-1950. Fax: (973)571-1768. E-mail: carmelfineart@comcast.net. Website: carmelprod.com. **Vice President Sales:** Louise Perrin. Estab. 1995. Art publisher/distributor. Publishes/distributes handpulled originals, limited and unlimited edition fine art prints and offset reproduction. Clients: galleries, corporate curators, distributors, frame shops, decorators.

Needs: Seeking creative art for the serious collector, commercial and designer markets. Considers oil, acrylic, pastel. Prefers family-friendly abstract and figurative images. Artists represented include Nico, Melvin King, Jenik Cook, Laura Cooper, Adam Hicks, William Carter, G.L. Smothers, William Ward, William Calhoun, Jon Jones and Anthony Armstrong. Editions created by collaborating with the artist and working from an existing painting. Approached by 10-20 artists/year. Publishes the work of 2-3 emerging, 1 mid-career and 2-3 established artists/year.

First Contact & Terms: Send query letter with brochure, photographs. Samples are filed. Responds in 1 month. Will contact artist for portfolio review of final art, roughs if interested. Rights purchased vary according to project. Provides advertising, promotion, shipping from firm and contract. Finds artists through established networks.

Tips: "Be true to your creative callings. Abstracts are being accepted by a wider audience. Be prepared to work hard."

☑ **CHALK & VERMILION FINE ARTS**, 55 Old Post Rd., #2, Greenwich CT 06831. (203)869-9500. Fax: (203)869-9520. E-mail: mail@chalk-vermilion.com. **Contact:** Pam Rerrano. Estab. 1976. Art publisher. Publishes original paintings, handpulled serigraphs and lithographs, posters, limited editions and offset reproductions. Clients: 4,000 galleries worldwide.

Needs: Publishes decorative art for the serious collector and the commercial market. Considers oil, mixed media, acrylic and sculpture. Artists represented include Erte, Thomas McKnight, Alex Katz, Liudmila Kondakova, Kerry Hallam, John Kiraly, Sally Caldwell Fisher and Fanny Brennan. Editions created by collaboration. Approached by 350 artists/year.

First Contact & Terms: Send query letter with résumé and slides or photographs. Samples are filed or are returned by SASE if requested by artist. Responds in 3 months. Publisher will contact artist for portfolio review if interested. Pay "varies with artist, generally fees and royalties." Offers advance. Negotiates rights purchased. Prefers exclusive representation of artist. Provides advertising, in-transit insurance, promotion, shipping to and from firm, insurance while work is at firm and written contract. Finds artists through exhibitions, trade publications, catalogs, submissions.

☒ **CIRRUS EDITIONS**, 542 S. Alameda St., Los Angeles CA 90013. (213)680-3473. Fax: (213)680-0930. E-mail: cirrus@cirrusgallery.com. Website: www.cirrusgallery.com. **President:** Jean R. Milant. Produces limited edition handpulled originals. Clients: museums, galleries and private collectors.

Needs: Seeking contemporary paintings and sculpture. Prefers abstract, conceptual work. Artists represented include Lari Pittman, Joan Nelson, John Millei, Charles C. Hill and Bruce Nauman. Publishes and distributes the work of 6 emerging, 2 mid-career and 1 established artists/year.

First Contact & Terms: Prefers slides as samples. Samples are returned by SASE.

CLASSIC COLLECTIONS FINE ART, 1 Bridge St., Irvington NY 10533. (914)591-4500. Fax: (914)591-4828. **Acquisition Manager:** Larry Tolchin. Estab. 1990. Art publisher. Publishes unlimited editions and offset reproductions. Clients: galleries, interior designers, hotels. Licenses florals, landscapes, animals for kitchen/bathroom.

Needs: Seeking decorative art for the commercial and designer markets. Considers oil, acrylic, watercolor, mixed media and pastel. Prefers landscapes, still lifes, florals. Artists represented include Harrison Rucker, Henrietta Milan, Sid Willis, Charles Zhan and Henry Peeters. Editions created by collaborating with the artist and by working with existing painting. Approached by 100 artists/year. Publishes the work of 6 emerging, 6 mid-career and 6 established artists/year.

First Contact & Terms: Send slides and transparencies. Samples are filed. Responds in 3 months. Company will contact artist for portfolio review if interested. Offers advance when appropriate. Buys first and reprint rights. Provides advertising, insurance while work is at firm and written contract. Finds artists through art exhibitions, fairs and competitions.

THE COLONIAL ART CO., 1336 NW First St., Oklahoma City OK 73106. (405)232-5233. E-mail: colonialart@aol.com. **Owner:** Willard Johnson. Estab. 1919. Publisher and distributor of offset reproductions for galleries. Clients: retail and wholesale. Current clients include Osburns, Grayhorse and Burlington.
Needs: Artists represented include Felix Cole, Dennis Martin, John Walch and Leonard McMurry. Publishes the work of 2-3 emerging, 2-3 mid-career and 3-4 established artists/year. Distributes the work of 10-20 emerging, 30-40 mid-career and hundreds of established artists/year. Prefers realism and expressionism—emotional work.
First Contact & Terms: Send sample prints. Samples not filed are returned only if requested by artist. Publisher/distributor will contact artist for portfolio review if interested. Pays negotiated flat fee or royalties, or on a consignment basis (firm receives 33% commission). Offers an advance when appropriate. Does not require exclusive representation of the artist. Considers buying second rights (reprint rights) to previously published work.
Tips: "The current trend in art publishing is an emphasis on quality."

N. CRAZY HORSE PRINTS, 23026 N. Main St., Prairie View IL 60069. (847)634-0963. **Owner:** Margaret Becker. Estab. 1976. Art publisher and gallery. Publishes limited editions, offset reproductions and greeting cards. Clients: Native American art collectors.
Needs: "We publish only Indian authored subjects." Considers oil, pen & ink and acrylic. Prefers and nature themes. Editions created by working from an existing painting. Approached by 10 artists/year. Publishes the work of 2 and distributes the work of 20 established artists/year.
First Contact & Terms: Send résumé and photographs. Samples are filed. Reports back to the artist only if interested. Portfolio review not required. Publisher will contact artist for portfolio review if interested. Portfolio should include photographs and bio. Pays flat fee: $250-1,500 or royalties of 5%. Offers advance when appropriate. Buys all rights. Provides promotion and written contract. Finds artists through art shows and submissions.

N. CREATIF LICENSING CORP., 31 Old Town Crossing, Mount Kisco NY 10549-4030. (914)241-6211. E-mail: creatiflic@aol.com. Website: members.aol.com/creatiflic. Estab. 1975. Art licensing agency. Clients: manufacturers of gifts, stationery, toys and home furnishings.
 • Creatif posts submission guidelines on its web page. The company is also listed in the Greeting Cards, Gifts and Products section.
Needs: Considers oil, acrylic, watercolor, mixed media and pastel. Artists represented include Roger La Borde. Approached by hundreds of artists/year.
First Contact & Terms: Send query letter with 8½×11 color copies. Accepts disk submissions if compatible with Mac Photoshop 2.5. Samples are filed and are returned by SASE. Responds in 1 month. Company will contact artist for portfolio review of color and photographs if interested. Pays royalties; varies depending on the experience and marketablity of the artist. Also varies advance structure depending on if the artwork is existing vs. new. Offers advance when appropriate. Negotiates licensing rights. "Artist retains all rights, we license rights to clients." Provides advertising, promotion, written contract, sales marketing and negotiating contracts. Finds artists through art fairs, word of mouth, art reps, sourcebooks and referrals.
Tips: "Be aware of current color trends and design with specific products in mind."

☑ DARE TO MOVE, Dept. AGDM, 12932 SE Kent-Kangley Rd. #007, Kent WA 98031. (253)639-4493. Fax: (253)630-1865. E-mail: daretomove@aol.com. Website: www.daretomove.com. **President:** Steve W. Sherman. Estab. 1987. Art publisher, distributor. Publishes/distributes limited editions, unlimited editions, canvas transfers, fine art prints, offset reproductions. Licenses aviation and marine art for puzzles, note cards, book marks, coasters etc. Clients: art galleries, aviation museums, frame shops and interior decorators.
 • This company has expanded from aviation-related artwork to work encompassing most civil service areas. Steve Sherman likes to work with artists who have been painting for 10-20 years. He usually starts off distributing self-published prints. If prints sell well, he will work with artist to publish new editions.
Needs: Seeking naval, marine, firefighter, civil service and aviation-related art for the serious collector and commercial market. Considers oil and acrylic. Artists represented include John Young, Ross Buckland, Mike Machat, James Dietz, Jack Fellows, William Ryan, Patrick Haskett. Editions created by collaborating

with the artist or working from an existing painting. Approached by 15-20 artists/year. Publishes the work of 1 emerging, 2-3 mid-career and established artists/year. Distributes the work of 9 emerging and 2-3 established artists/year.

First Contact & Terms: Send query letter with photographs, slides, tearsheets and transparencies. Samples are filed or sometimes returned by SASE. Artist should follow up with call. Portfolio should include color photographs, transparencies and final art. Pays royalties of 20% commission of wholesale price. Buys one-time or reprint rights. Provides advertising, in-transit insurance, insurance while work is at firm, promotion, shipping from firm and written contract.

Tips: "Present your best work—professionally."

☑ 🛉 **DAUPHIN ISLAND ART CENTER**, 1406 Cadillac Ave., Box 699, Dauphin Island AL 36528. Phone/fax: (251)861-5701. E-mail: photography@dauphinislandartcenter.com. Websites: www.dauphinislandartcenter.com and/or www.nickcolquitt.com. **Owner:** Nick Colquitt. Estab. 1984. Wholesale producer and distributor of marine and nautical decorative art. Clients: West, Gulf and eastern coastline retailers.

Needs: Approached by 12-14 freelance artists/year. Works with 8-10 freelance artists/year. Prefers local artists with experience in marine and nautical themes. Uses freelancers mainly for wholesale items to be retailed. Also for advertising, brochure and catalog illustration, and design. 1% of projects require freelance design.

First Contact & Terms: Send query letter with brochure and samples. Samples not filed are returned only if requested by artist. Responds in 3 weeks. To show portfolio, mail final reproduction/product. Pays for design and illustration by the finished piece. Considers skill and experience of artist and "retailability" when establishing payment. Negotiates rights purchased.

Tips: Advises artists to attend any of the Art Expo events, especially those held in Atlanta Merchandise Mart. Dauphin Island Art Center offers weekend seminar/workshops year-round on subject of making and marketing any graphic art. Every inquiry is answered promptly.

DECORATIVE EXPRESSIONS, INC., 3595 Clearview Place, Atlanta GA 30340. (770)457-8008. Fax: (770)457-8018. **President:** Robert Harris. Estab. 1984. Distributor. Distributes original oils. Clients: galleries, designers, antique dealers.

Needs: Seeking creative and decorative art for the designer market. Styles range from traditional to contemporary to impressionistic. Artists represented include Javier Mulio and Giner Bueno. Approached by 6 artists/year. Distributes the work of 2-6 emerging, 2-4 mid-career and 10-20 established artists/year.

First Contact & Terms: Send photographs. Samples are returned by SASE if requested by artist. Reports back to the artist only if interested. Portfolios may be dropped off every Monday. Portfolio should include final art and photographs. Negotiates payment. Offers advance when appropriate. Negotiates rights purchased. Requires exclusive representation of artist. Provides advertising, in-transit insurance, promotion and distribution through sale force and trade shows. Finds artists through word of mouth, exhibitions, travel.

Tips: "The design market is major source for placing art. We seek art that appeals to designers."

🔃 **DENVER ART COMPANY, INC.**, 7009 S. Fillmore Court, Littleton CO 80122. (303)773-6250. Fax: (303)773-6199. **President:** Debbrah Courtney. Estab. 1984. Publishes/distributes handpulled originals, monoprints, monotypes, original acrylic on canvas/paper. Clients: galleries, designers, architects, distributors, corporate curators.

Needs: Seeking creative art for the serious collector, commercial and designer markets. Considers oil, acrylic, watercolor, mixed media, pastel, pen & ink. Prefers abstract-contemporary, figurative styles. Artists represented include Olivia Grace, Chris Welsh, Phillip Jaeger and Anne Wallace. Editions created by collaborating with the artist or by working from an existing painting. Publishes work by 2 emerging, 2 mid-career, 10 established artist/year. Distributes work by 7 emerging, 1 mid-career, 1 established artist/year.

First Contact & Terms: Send photographs, résumé, tearsheets. Samples are filed or returned. Responds in 2 weeks. Company will contact artist for portfolio review of color photographs if interested. Pays on consignment basis: firm receives 50% commission. Negotiates rights purchased. Representation negotiable. Provides advertising, in-transit insurance, insurance while work is at firm, promotion, shipping from firm, written contract. Finds artists through trade shows, Art Expo-New York, Maison et object-Paris, art publications.

Tips: "Study—read trade publications and attend trade shows."

☑ **DIRECTIONAL PUBLISHING, INC.**, 2812 Commerce Square E., Birmingham AL 35210. (205)951-1965. Fax: (205)951-3250. E-mail: custsvc@directionalart.com. Website: directionalart.com.

President: David Nichols. Account Executive: Tony Murray. Estab. 1986. Art publisher. Publishes limited and unlimited editions and offset reproductions. Clients: galleries, frame shops and picture manufacturers. Licenses: decorative stationery, rugs, home products.

Needs: Seeking decorative art for the designer market. Considers oil, watercolor, acrylic and pastel. Prefers casual designs in keeping with today's interiors. Artists represented include A. Kamelhair, H. Brown, R. Lewis, L. Brewer, S. Cairns, N. Strailey, D. Swartzendruber, D. Nichols, M.B. Zeitz and N. Raborn. Editions created by working from an existing painting. Approached by 50 artists/year. Publishes and distributes the work of 5-10 emerging, 5-10 mid-career and 3-5 established artists/year.

First Contact & Terms: Send query letter with slides and photographs or digital disc. Samples are not filed and are returned by SASE. Responds in 3 months. Pays royalties. Buys all rights. Provides in-transit insurance, insurance while work is at firm, promotion, shipping from firm and written contract.

Tips: "Always include SASE. Do not follow up with phone calls. All work published is first of all *decorative*. The application of artist designed borders to artwork can sometimes greatly improve the decorative presentation. We follow trends in the furniture/accessories market. Aged and antiqued looks are currently popular—be creative! Check out what's being sold in home stores for trends and colors."

DODO GRAPHICS, INC., 145 Cornelia St., P.O. Box 585, Plattsburgh NY 12901. (518)561-7294. Fax: (518)561-6720. **Manager:** Frank How. Art publisher of offset reproductions, posters and etchings for galleries and frame shops.

Needs: Considers pastel, watercolor, tempera, mixed media, airbrush and photographs. Prefers contemporary themes and styles. Prefers individual works of art, 16×20 maximum. Publishes the work of 5 artists/year.

First Contact & Terms: Send query letter with brochure showing art style or photographs and slides. Samples are filed or are returned by SASE. Responds in 3 months. Write for appointment to show portfolio of original/final art and slides. Payment method is negotiated. Offers an advance when appropriate. Buys all rights. Requires exclusive representation of the artist. Provides written contract.

Tips: "Do not send any originals unless agreed upon by publisher."

☑ **EDITIONS LIMITED GALLERIES, INC.**, 4090 Halleck St., Emeryville CA 94608. (510)923-9770. Fax: (510)923-9777. **Director:** Todd Haile. Art publisher and distributor of limited edition graphics and fine art posters. Clients: galleries, framing stores, art consultants and interior designers.

Needs: Seeking art for the designer market. Considers oil, acrylic and watercolor painting, monoprint, monotype, photography and mixed media. Prefers landscape, floral and abstract imagery. Editions created by collaborating with the artist or by working from an existing work.

First Contact & Terms: Send query letter with résumé, slides and photographs. Samples are filed or are returned by SASE. Responds in 2 months. Publisher/distributor will contact artist for portfolio review if interested. Payment method is negotiated. Negotiates rights purchased.

Tips: "We deal both nationally and internationally, so we need art with wide appeal. No figurative please. When sending slides or photos, send at least six so we can get an overview of your work. We publish artists, not just images."

ENCORE GRAPHICS & FINE ART, P.O. Box 812, Madison AL 35758. (800)248-9240. E-mail: encore @randenterprises.com. Website: www.egart.com. **President:** J. Rand, Jr. Estab. 1995. Poster company, art publisher, distributor. Publishes/distributes limited edition, unlimited edition, fine art prints, offset reproduction, posters. Clients: galleries, frame shops, distributors.

Needs: Creative art for the serious collector. Considers all media. Prefers African American and abstract. Art guidelines available on company's website. Artists represented include Greg Gamble, Buck Brown, Mario Robinson, Lori Goodwin, Wyndall Coleman, T.H. Waldman, John Will Davis, Burl Washington, Henry Battle, Cisco Davis, Delbert Iron-Cloud and John Moore. Editions created by working from an existing painting. Approached by 15 artists/year. Publishes the work of 3 emerging artists, 1 mid-career artist/year. Distributes the work of 3 emerging, 2 mid-career and 3 established artists/year.

First Contact & Terms: Send photocopies, photographs, résumé, tearsheets. Samples are filed. Responds only if interested. Company will contact artist for portfolio review of color, photographs, tearsheets if interested. Negotiates payment. Offers advance when appropriate. Requires exclusive representation of artist. Provides advertising, in-transit insurance, insurance while work is at firm, promotion, shipping from firm, written contract. Finds artists through the World Wide Web and art exhibits.

Tips: "Prints of African-Americans with religious themes or children are popular now. Paint from the heart."

N FAIRFIELD ART PUBLISHING, (formerly American Vision Gallery), 625 Broadway, 4th Floor, New York NY 10012. (212)677-2559. Fax: (212)677-2253. **Vice President:** Peter Lowenkron. Estab. 1974.

Art publisher and distributor. Publishes and distributes posters, fine art prints, unlimited editions and offset reproductions. Clients: galleries, frame shops, museum shops, decorators, corporate curators, giftshops. Current clients include Museum of Modern Art, The Studio Museum.

Needs: African-American and decorative art for the designer and commercial markets. Considers collage, oil, watercolor, pastel, pen & ink, acrylic. Prefers depictions of African-Americans, Carribean scenes or African themes. Artists represented include Daniel Pollera, Roger Vilarchao, Yves Poinsot, William Merritt Chase.

First Contact & Terms: Send query letter with slides and brochure. Samples are returned by SASE if requested by artist. Responds only if interested. Pays flat fee, $400-2,500 maximum, or royalties of 7-15%. Offers advance when appropriate. Rights purchased vary according to project. Interested in buying second rights (reprint rights) to previously published artwork.

Tips: "If you don't think you're excellent, wait until you have something excellent. Posters are a utility, they go somewhere specific, so images I use fit somewhere—over the couch, kitchen, etc."

FUNDORA ART GALLERY, 103400 Overseas Hwy., Key Largo FL 33037. (305)451-2200. Fax: (305)453-1153. E-mail: thomasfund@aol.com. **Director:** Manny Fundora. President: Thomas Fundora. Estab. 1987. Art publisher/distributor/gallery. Publishes limited edition fine art prints. Clients: galleries, decorators, frameshops. Current clients include: Ocean Reef Club, Paul S. Ellison.

Needs: Seeking creative and decorative art for the serious collector. Considers oil, watercolor, mixed media. Prefers nautical, maritime, tropical. Artists represented include Tomas Fundora, Gaspel, Juan A. Carballo, Carlos Sierra. Editions created by collaborating with the artist and working from an existing painting. Approached by 15 artists/year. Publishes/distributes the work of 2 emerging, 1 mid-career and 3 established artists/year.

First Contact & Terms: Send query letter with brochure, photographs, slides or printed samples. Samples are filed. Will contact artist for portfolio review if interested. Pays royalties. Buys first rights. Requires exclusive representation of artist in US. Provides advertising and promotion. Also works with freelance designers.

Tips: "Trends to watch: tropical sea and landscapes."

☑ **G.C.W.A.P. INC.**, 12075 Marina Loop, W. Yellowstone MT 59758. (406)646-9551. Fax: (406)646-9552. E-mail: GCWAP@wyellowstone.com. **Executive Vice President:** Jack Carter. Estab. 1980. Publishes limited edition art. Clients: galleries and individuals.

Needs: Seeking art for the serious collector and commercial market. Considers oil and pastel. Prefers western, wildlife and train themes. Artists represented include Gary Carter, Arlene Hooker Fay, Jim Norton. Editions created by collaborating with the artist. Approached by 10-20 artists/year. Publishes/distributes the work of 3 established artists/year.

First Contact & Terms: Send query letter with photographs, résumé and transparencies. Samples are returned. Responds in 1 month. Company will contact artists for portfolio review if interested. Negotiates payment. Buys reprint rights. Requires exclusive representation of artist. Provides advertising.

GALAXY OF GRAPHICS, LTD., 460 W. 34th St., New York NY 10001. (212)947-8989. E-mail: aakgog@aol.com. **Art Directors:** Colleen Buchweitz and Christine Pratti. Estab. 1983. Art publisher and distributor of unlimited editions. Licensing handled by Colleen Buchweitz. Clients: galleries, distributors, and picture frame manufacturers.

• Since our last edition, this publisher added a new size of 11×28 panels to its line.

Needs: Seeking creative, fashionable and decorative art for the commerical market. Artists represented include Richard Henson, Betsy Brown, John Butler, Charlene Olson, Ros Oesterle, Joyce Combs, Christa Kieffer, Ruane Manning and Carol Robinson. Editions created by collaborating with the artist or by working from an existing painting. Considers any media. "Any currently popular and generally accepted themes." Art guidelines free for SASE with first-class postage. Approached by several hundred artists/year. Publishes and distributes the work of 20 emerging and 20 mid-career and established artists/year.

First Contact & Terms: Send query letter with résumé, tearsheets, slides, photographs and transparencies. Samples are not filed and are returned by SASE. Responds in 2 weeks. Call for appointment to show portfolio. Pays royalties of 10%. Offers advance. Buys rights only for prints and posters. Provides insurance while material is in-house and while in transit from publisher to artist/photographer. Provides written contract to each artist.

Tips: "There is a trend of strong jewel-tone colors and spice-tone colors. African-American art very needed."

ROBERT GALITZ FINE ART, 166 Hilltop Court, Sleepy Hollow IL 60118. (847)426-8842. Fax: (847)426-8846. **Owner:** Robert Galitz. Estab. 1986. Distributor of handpulled originals, limited editions and watercolors. Clients: designers, architects, consultants and galleries—in major cities of seven states.

Needs: Seeking creative, fashionable and decorative art for the serious collector and commercial and designer markets. Considers all media. Prefers contemporary and representational imagery. Art guidelines free for SASE with first-class postage. Editions created by collaborating with the artist. Publishes the work of 1-2 established artists/year. Distributes the work of 100 established artists/year.

First Contact & Terms: Send query letter with slides and photographs. Samples are filed or are returned by SASE. Responds in 1 month. Call for appointment to show portfolio of original/final art. Pays flat fee of $200 minimum, or pays on consignment basis (25-40% commission). No advance. Buys all rights. Provides a written contract.

Tips: Advises artists to attend an Art Expo event in New York City, Las Vegas, Miami or Chicago. Finds artists through galleries, sourcebooks, word of mouth, art fairs. "Be professional. I've been an art broker or gallery agent for 26 years and very much enjoy bringing artist and client together!"

☑ **GANGO EDITIONS**, 351 NW 12th, Portland OR 97209. (503)223-9694. E-mail: jackie@gangoeditions.com. Website: www.gangoeditions.com. **Contact:** Jackie Gango, Licensing. CEO: Debi Gango. Estab. 1982. Publishes posters. Licenses work already published in poster form. Clients: poster galleries, art galleries, contract framers and major distributors.

Needs: Seeking creative art for the commercial and designer markets. Considers oil, watercolor, acrylic, pastel, mixed media and Polaroid transfers. Prefers still life, floral, abstract, landscape, folk art, animals, nature themed and some photography. Artists represented include Diane Pederson, Amy Melious, Michael Palmer, Randal Painter, Pamela Gladding, Alan Stephenson, Dave Avazino, Gregg Robinson, Paul Hargittai and Maureen Love. Editions created by working from an existing painting or work. Publishes and distributes the work of emerging and established artists.

First Contact & Terms: Send query letter with slides and/or photographs. Samples returned by SASE. Artist is contacted by mail. Responds in 6 weeks. Pays royalties of 10%. Requires exclusive representation of artist on posters only. Provides written contract.

Tips: "We are currently looking for new images and are always actively seeking new artists. We are eager to work with fresh ideas, colors and presentations. We like to see images in sets of four if possible. We also like to see classical, traditional works done in a unique style. Be aware of market trends."

GEME ART INC., 209 W. Sixth St., Vancouver WA 98660. (360)693-7772. Fax: (360)695-9795. **Art Director:** Merilee Will. Estab. 1966. Art publisher. Publishes fine art prints and reproductions in unlimited and limited editions. Clients: galleries, frame shops, art museums. Licenses designs.

Needs: Considers oil, acrylic, pastel, watercolor and mixed media. "We use a variety of styles from realistic to whimsical, catering to "Mid-America art market." Artists represented include Lois Thayer, Crystal Skelley, Steve Nelson, Lary McKee, Charles Freeman, Jeanné Flevotomas and Lael Nelson (plus many other artists).

First Contact & Terms: Send color slides, photos or brochure. Include SASE. Publisher will contact artist for portfolio review if interested. Simultaneous submissions OK. Payment on a royalty basis. Purchases all rights. Provides promotion, shipping from publisher and contract.

Tips: "We have added new sizes and more artists to our lines since last year."

◰ **GHAWACO INTERNATIONAL INC.**, P.O. Box 8365, Station T, Ottawa K1G 3H8 Canada. (613)293-1011 or (888)769-ARTS. Fax: (613)824-0842 or (888)769-5505. E-mail: buyart@ghawaco.com. Website: www.ghawaco.com. **Product Development:** Dr. Kwasi Nyarko. Estab. 1994. Art publisher and distributor. Publishes/distributes limited edition, unlimited edition, canvas transfers and offset reproduction. Clients: museum shops, galleries, gift shops, frame shops, distributors, bookstores and other buyers.

Needs: Seeking contemporary ethnic art. Considers oil and acrylic. Prefers artwork telling the stories of peoples of the world. Emphasis on under-represented groups such as African and Aboriginal. Artists represented include Wisdom Kudowor, Ablade Glover, Kofi Agorsor, A.K. Duah, Oumarou Traoré. Editions created working from an existing painting. Publishes work of 1 emerging, 1 mid-career and 1 established artist/year. Also needs freelancers for design.

First Contact & Terms: Send query letter with brochure, photographs, résumé and SASE. Samples are filed. Responds only if interested. Request portfolio review in original query. Company will contact artist for portfolio review if interested. Portfolio should include final art, photographs and slides. Pays royalties of up to 30% (net). Consignment basis: firm receives 50% commission or negotiates payment. Offers no advance. Negotiates rights purchased. Requires exclusive representation of artist. Provides advertising, insurance while work is at firm, promotion, shipping from our firm and written contract. Finds artists through referrals, word of mouth and art fairs.

Tips: "To create good works that are always trendy, do theme-based compositions. Artists should know what they want to achieve in both the long and short term. Overall theme of artist must contribute to the global melting pot of styles."

☑ **THE GOLTZ GROUP/CHICAGO ART SOURCE**, (formerly The Goltz Group), 1871 N. Clyburn Ave., Chicago IL 60614. (773)248-3100. Fax: (773)248-3926. E-mail: allison@chicagoartsource.com. **Director Art Division:** Allison DiJohn. Estab. 1978. Gallery and designer showroom. Distributes handpulled originals, limited and unlimited editions, fine art and monoprints, offset reproductions, posters, photography, drawings, collage, etc. Clients: corporations, interior designers, restaurants and chain stores. Current clients include: Andersen Consulting, Lettuce Entertain You restaurants and Northwestern Memorial Hospital.

Needs: Seeking creative and decorative art for corporate and residential markets. Represents the work of emerging, mid-career and established artists—all media.

First Contact & Terms: Send brochure, photocopies, photographs, tearsheets, slides and SASE. Samples are filed "if we like them, returned by SASE if not." Responds in 6 weeks. Company will contact artist for portfolio review of color final art and photographs if interested. Negotiates payment. Rights purchased vary according to project. Services are negotiated on a per project basis. Finds artists through art exhibitions and fairs, reps, sourcebooks, *Art Business News, Decor, Art in America, Art News, US Art* and sculpture and textile magazines.

Tips: "We need art appropriate in color, subject matter and design for an urban, Midwestern business. No ducks, no glitter. Getting work in on time is essential. Don't try to surprise us with some new color not previously agreed to in commissioned work. Be objective and try not to be defensive about your artwork."

N **GRAPHIQUE DE FRANCE**, 9 State St., Woburn MA 01801. (781)935-3405. Fax: (781)935-5145. E-mail: artworksubmissions@graphiquedefrance.com. Website: www.graphiquedefrance.com. **Contact:** Acquisitions Department. Estab. 1979. Art publisher and distributor handling offset reproductions, posters, notecards, gift and stationery products, calendars and silkscreens. Clients: galleries, foreign distributors, museum shops, high end retailers. Art guidelines available via voicemail recording.

First Contact & Terms: Artwork may be submitted in the form of slides, transparencies or high-quality photocopies. Please do not send original artwork. Please allow 2 months for response. SASE is required for any submitted material to be returned.

Tips: "It's best not to insist on speaking with someone at a targeted company prior to submitting work. Let the art speak for itself and follow up a few weeks after submitting."

☑ **RAYMOND L. GREENBERG ART PUBLISHING**, 42 Leone Lane, Chester NY 10918. (914)469-6699. Fax: (914)469-5955. E-mail: art@raymondlgreenberg.com. Website: raymondlgreenberg.com. **Owner:** Ray Greenberg. Licensing: Ray Greenberg. Estab. 1995. Art publisher. Publishes unlimited edition fine art prints for major framers and plaque manufacturers. Licenses inspirational, ethnic, Victorian, kitchen and bath artwork for prints for wall decor. Clients include Crystal Art Galleries, North American Art.

Needs: Seeking decorative artwork in popular styles for the commercial and mass markets. Considers oil, acrylic, watercolor, mixed media, pastel and pen & ink. Prefers inspirational, ethnic, Victorian, nostalgic, country, floral and religious themes. Art guidelines free for SASE with first-class postage. Artists represented include Barbara Lanza, David Tobey, Diane Viera, Robert Daley and Marilyn Rea. Editions created by collaborating with the artist and/or working from an existing painting. Approached by 35 artists/year. Publishes 7 emerging, 13 mid-career and 5 established artists/year.

First Contact & Terms: Send query letter with photographs, slides, SASE; "any good, accurate representation of your work." Samples are filed or returned by SASE. Responds in 6 weeks. Company will contact artist for portfolio review if interested. Pays flat fee: $50-200 or royalties of 5-7%. Offers advance against royalties when appropriate. Buys all rights. Prefers exclusive representation. Provides insurance, promotion, shipping from firm and contract. Finds artists through word-of-mouth.

Tips: "Versatile artists who are willing to paint for the market can do very well with us. Be flexible and patient."

N **THE GREENWICH WORKSHOP, INC.**, One Greenwich Place, Shelton CT 06484. Website: www.greenwichworkshop.com. **Contact:** Artist Selection Committee. Art publisher and gallery. Publishes limited and open editions, offset productions, fine art lithographs, serigraphs, canvas reproductions and fine art porcelains and books. Clients: independent galleries in US, Canada and United Kingdom.

Needs: Seeking creative, fashionable and decorative art for the serious collector, commercial and designer markets. Considers oil, watercolor, mixed media, pastel and acrylic. Considers all but abstract. Artists represented include James C. Christensen, Howard Terpning, James Reynolds, James Bama, Bev Doolittle, Scott Gustafson, Braldt Bralds. Editions created by collaborating with the artist or by working from an existing painting. Approached by 100 artists/year. Publishes the work of 4-5 emerging, 15 mid-career and 25 established artists. Distributes the work of 4-5 emerging, 15 mid-career and 25 established artists/year.

First Contact & Terms: Send query letter with brochure, slides, photographs, SASE and transparencies. Samples are not filed and are returned by SASE. Responds in 3 months. Publisher will contact artist for portfolio review if interested. Portfolio should include final art, tearsheets, photographs, slides and

transparencies. Pays royalties. No advance. Rights purchased vary according to project. Requires exclusive representation of artist. Provides advertising, insurance while work is at firm, promotion, shipping to and from firm, and written contract. Finds artists through art exhibits, submissions and word of mouth.

N GREGORY EDITIONS, 12919 Southwest Freeway, Suite 170, Stafford TX 77477. (800)288-2724. Fax: (281)494-4755. E-mail: mleace@aol.com. **President:** Mark Eaker. Estab. 1988. Art publisher and distributor of originals, limited editions, serigraphs and bronze sculptures. Licenses variety art for Texture Touch™ canvas reproduction. Clients: Retail art galleries.

Needs: Seeking contemporary, creative artwork. Considers oil and acrylic. Open to all subjects and styles. Artists represented include G. Harvey, JD Challenger, Stan Solomon, James Talmadge, Denis Paul Noyer, Liliana Frasca, Michael Young, James Christensen, Gary Ernest Smith, Douglas Hofmann, Alan Hunt, Joy Kirton-Smith, BH Brody, Nel Whatmore, Larry Dyke, Tom DuBois, Michael Jackson, Robert Heindel and sculptures by Ting Shao Kuang and JD Challenger. Editions created by working from an existing painting. Publishes and distributes the work of 5 emerging, 2 mid-career and 2 established artists/year.

First Contact & Terms: Send query letter with brochure or slides showing art style. Call for appointment to show portfolio of photographs and transparencies. Purchases paintings outright; pays percentage of sales. Negotiates payment on artist-by-artist basis based on flat negotiated fee per visit. Requires exclusive representation of artist. Provides in-transit insurance, insurance while work is at firm, promotion, shipping from firm and written contract.

N GUILDHALL, INC., Dept. AM, P.O. Box 136550, Fort Worth TX 76136. (800)356-6733. Fax: (817)236-1948. E-mail: westart@guildhall.com. Website: www.guildhall.com/artprints. **President:** John M. Thompson III. Art publisher/distributor of limited and unlimited editions, offset reproductions and handpulled originals for galleries, decorators, offices and department stores. Current clients include over 500 galleries and collectors nationwide.

Needs: Seeking creative art for the serious and commercial collector and designer market. Considers pen & ink, oil, acrylic, watercolor, and bronze and stone sculptures. Prefers historical Native American, Western, equine, wildlife, landscapes and religious themes. Prefers individual works of art. Artists represented include Wayne Baize, Jack Hines, Ralph Wall, John Potocschnik and Jessica Zemski. Editions created by collaborating with the artist and by working from an existing painting. Approached by 150 artists/year. Also for design. 15% of projects require freelance design.

First Contact & Terms: Send query letter with résumé, tearsheets, photographs, slides and 4×5 transparencies, preferably cowboy art in photos or printouts. Samples are not filed and are returned only if requested. Responds in 1 month. Call or write for appointment to show portfolio, or mail thumbnails, color and b&w tearsheets, slides and 4×5 transparencies. Pays $200-15,000 flat fee; 10-20% royalties; 35% commission on consignment; or payment method is negotiated. Negotiates rights purchased. Requires exclusive representation for contract artists. Provides insurance while work is at firm, promotion, shipping from firm and written contract.

Tips: "The new technologies in printing are changing the nature of publishing. Self-publishing artists have flooded the print market. Many artists are being told to print themselves. Most of them, in order to sell their work, have to price it very low. In many markets this has caused a glut. Some art would be best served if it was only one of a kind. There is no substitute for scarcity and quality."

N HADDAD'S FINE ARTS INC., 3855 E. Miraloma Ave., Anaheim CA 92806. (714)996-2100. Website: www.haddadsfinearts.com. **President:** Paula Haddad. Art Director: Beth Hedstrom. Estab. 1953. Art publisher and distributor. Produces unlimited edition offset reproductions and posters. Clients: galleries, art stores, museum stores and manufacturers. Sells to the trade only—no retail.

Needs: Seeking creative and decorative art for the commercial and designer markets. Prefers traditional, realism with contemporary flair; unframed individual works and pairs; all media including photography. Editions created by collaborating with the artist or by working from an existing painting. Approached by 200-300 artists/year. Publishes the work of 10-15 emerging artists/year. Also uses freelancers for design. 20% of projects require freelance design. Design demands knowledge of QuarkXPress and Illustrator.

First Contact & Terms: Illustrators should send query letter with brochure, transparencies, slides, photos representative of work for publication consideration. Include SASE. Designers send query letter explaining skills. Responds in 3 months. Publisher/distributor will contact artist for portfolio review if interested. Portfolio should include slides, roughs, final art, transparencies. Pays royalties quarterly, 10% of base net price. Rights purchased vary according to project. Provides advertising and written contract.

HADLEY HOUSE PUBLISHING, 11300 Hampshire Ave. S., Bloomington MN 55438. (952)943-8474. Fax: (952)943-8098. Website: www.Hadleylicensing.com. **Director of Art Publishing:** Lisa Laliberte

Belak. Licensing: Gary Schmidt Estab. 1974. Art publisher, distributor and 30 retail galleries. Publishes and distributes giclees, limited and unlimited editions and offset reproductions. Licenses all types of flat art. Clients: wholesale and retail.

Needs: Seeking artwork with creative artistic expression and decorative appeal for the serious collector. Considers oil, watercolor, acrylic, pastel and mixed media. Prefers wildlife, florals, landscapes, figurative and nostalgic Americana themes and styles. Art guidelines free for SASE with first-class postage. Artists represented include Charles Wysocki, Charles White, James A. Meger, Olaf Wieghorst, Steve Hanks, Les Didier, Al Agnew, Darrell Bush, Dave Barnhouse, Michael Capser, Nancy Howe, Steve Hamrick, Terry Redlin, Bryan Moon, Lynn Kaatz, John Ebner, Cha Ilyong, Sueellen Ross, Lindsey Foggett, Larry Chandler, Collin Bogle, Lee Bogle, Adele Earnshaw and Bruce Miller. Editions created by collaborating with artist and by working from an existing painting. Approached by 200-300 artists/year. Publishes the work of 3-4 emerging, 15 mid-career and 8 established artists/year. Distributes the work of 1 emerging and 4 mid-career artists/year.

First Contact & Terms: Send query letter with brochure showing art style or résumé and tearsheets, slides, photographs and transparencies. Samples are filed or are returned. Responds in 2 months. Call for appointment to show portfolio of slides, original final art and transparencies. Pays royalties. Requires exclusive representation of artist and/or art. Provides insurance while work is at firm, promotion, shipping from firm, a written contract and advertising through dealer showcase.

Tips: "Build a market for your originals by affiliating with an art gallery or two. Never give away your copyrights! When you can no longer satisfy the overwhelming demand for your originals . . . *that* is when you can hope for success in the reproduction market."

IMAGE CONNECTION, 456 Penn St., Yeadon PA 19050. (610)626-7770. Fax: (610)626-2778. **Art Coordinator:** Helen Casale. Estab. 1981. Publishes and distributes posters and cards. Represents several European publishers.

Needs: Seeking creative, fashionable and decorative art for the commercial and designer markets. Considers oil, watercolor, acrylic, pastel, mixed media and photography. Prefers contemporary and popular themes, realistic and abstract.

First Contact & Terms: Send query letter with brochure showing art style or résumé, slides, photographs and transparencies. Samples are not filed and are returned by SASE. Responds in 1 month. Write for appointment to show portfolio or mail finished art samples, photographs, slides and disks. Payment method is negotiated. Offers advance when appropriate. Negotiates rights purchased. Requires exclusive representation of artist. Provides in-transit insurance, insurance while work is at firm, promotion, shipping to and from firm and a written contract.

N IMAGE CONSCIOUS, 147 Tenth St., San Francisco CA 94103. (415)626-1555. Fax: (415)626-2481. E-mail: cbardy@imageconscious.com. Website: www.imageconscious.com. **Creative Director:** Cindy Bardy. Estab. 1980. Art publisher and domestic and international distributor of offset and poster reproductions. Clients: poster galleries, frame shops, department stores, design consultants, interior designers and gift stores. Current clients include Z Gallerie, Deck the Walls and Pier 1.

Needs: Seeking creative and decorative art for the designer market. Considers oil, acrylic, pastel, watercolor, tempera, mixed media and photography. Prefers individual works of art, pairs or unframed series. Artists represented include Bill Brauer, Aleah Koury, Susan Jokelson, Laurie Eastwood. Editions created by collaborating with the artist and by working from an existing painting or photograph. Approached by hundreds of artists/year. Publishes the work of 2-3 emerging, 2-3 mid-career and 4-5 established artists/year. Distributes the work of 50 emerging, 200 mid-career and 700 established artists/year.

First Contact & Terms: Send query letter with brochure, résumé, tearsheets, photographs, slides and/or transparencies. Samples are filed or are returned by SASE. Responds in 1 month. Publisher/distributor will contact artist for portfolio review if interested. No original art. Payment method is negotiated. Negotiates rights purchased. Provides promotion, shipping from firm and a written contract.

Tips: "Research the type of product currently in poster shops. Note colors, sizes and subject matter trends."

N IMAGES OF AMERICA PUBLISHING COMPANY, P.O. Box 608, Jackson WY 83001. (800)451-2211. Fax: (307)739-1199. E-mail: artsforthepark@bcissnet.com. Website: www.artfortheparks.com. **Executive Director:** Christopher Moran. Estab. 1990. Art publisher. Publishes limited editions, posters. Clients: galleries, frame shops, distributors, gift shops, national parks, natural history associations.

● This company publishes the winning images in the Art for the Parks competition which was created in 1986 by the National Park Academy of the Arts in cooperation with the National Park Foundation. The program's purpose is to celebrate representative artists and to enhance public awareness of the park system. The top 100 paintings tour the country and receive cash awards. Over $100,000 in prizes in all.

Needs: Seeking national park images. Considers oil, acrylic, watercolor, mixed media, pastel, pen & ink. Prefers nature and wildlife images from one of the sites administered by the National Park Service. Art guidelines available on company's website. Artists represented include Jim Wilcox, Linda Tippetts, Howard Hanson, Dean Mitchell, Steve Hanks. Editions created by collaborating with the artist. Approached by over 2,000 artists/year.

First Contact & Terms: Submit by entering the Arts for the Parks contest for a $40 entry fee. Entry form and slides must be postmarked by June 1 each year. Send for prospectus before April 1st. Samples are filed. Portfolio review not required. Pays flat fee of $50-50,000. Buy one-time rights. Provides advertising.

Tips: "All artwork selected must be representational of a National Park site."

IMCON, 68 Greene St., Oxford NY 13830. (607)843-5130. E-mail: imcon@mkl.com. **President:** Fred Dankert. Estab. 1986. Fine art printer of handpulled originals. "We invented the waterless litho plate, and we make our own inks." Clients: galleries, distributors.

Needs: Seeking creative art for the serious collector. Editions created by collaborating with the artist "who must produce image on my plate. Artist given proper instruction."

First Contact & Terms: Call or send query letter with résumé, photographs and transparencies.

Tips: "Artists should be willing to work with me to produce original prints. We do *not* reproduce; we create new images. Artists should have market experience."

IMPACT IMAGES, 4919 Windplay Dr., El Dorado Hills CA 95762. (916)933-4700. Fax: (916)933-4717. **Owner:** Benny Wilkins. Estab. 1975. Publishes unlimited edition posters. Clients: frame shops, museum and gift shops. Current clients inlcude Impulse Designs, Image Conscious, Prints Plus, Summit Art Inc. and Deck the Walls. Licences art posters.

Needs: Seeking traditional and contemporary artwork. Considers oils, acrylics, pastels, watercolors, mixed media. Prefers contemporary, original themes, humor, fantasy, autos, animals, children, western, country, floral, golf, angels, inspirational, aviation, ethnic, wildlife and suitable poster subject matter. Prefers individual works of art. "Interested in licensed subject matter." Artists represented include Jonnie Chardon, Dan McMannis and Beatrix Potter. Publishes the work of 5 emerging, 25 mid-career and 15 established artists/year.

First Contact & Terms: Send query letter with brochure, tearsheets, photographs, slides and transparencies. Samples are not filed and are returned by SASE. Responds in 1 month. Payment method is negotiated. Offers an advance when appropriate. Negotiates rights purchased. Does not require exclusive representation of the aritst. Provides written contract. Finds artists through art fairs, word of mouth and submissions.

Tips: "We usually publish 16×20 and 8×10 formats so we need artwork that can be cropped to these dimensions. We do not require exclusive rights to an image so the artist is free to sell images for other uses."

☑ **INTERCONTINENTAL GREETINGS LTD.**, 176 Madison Ave., New York NY 10016. (212)683-5380. Fax: (212)779-8564. Website: www.intercontinental-ltd.com. **Art Director:** Thea Groene. Estab. 1967. Sells reproduction rights of design to publisher/manufacturers. Handles offset reproductions, greeting cards, stationery and gift items. Clients: paper product, gift tin, ceramic and textile manufacturers. Current clients include: Franklin Mint, Scandecor, Verkerke, Simon Elvin, others in Europe, Latin America, Japan and Asia.

Needs: Seeking creative, fashionable and decorative art for the commercial and designer markets. Considers oil, watercolor, mixed media, pastel, acrylic, computer and photos. Approached by several hundred artists/year. Publishes the work of 30 emerging, 100 mid-career and 100 established artists/year. Also needs freelance design (not necessarily designers). 100% of freelance design demands knowledge of Photoshop, Illustrator and Painter. Prefers designers experienced in greeting cards, paper products and giftware.

First Contact & Terms: Send query letter with brochure, tearsheets, slides, photographs, photocopies and transparencies or CDs. Samples are filed or returned by SASE if requested by artist. Artist should follow-up with call. Portfolio should include color final art, photographs and slides. Pays flat fee, $30-500, or royalties of 20%. Offers advance when appropriate. Rights purchased vary according to project. Requires exclusive representation of artist, "but only on the artwork we represent." Provides promotion, shipping to firm and written contract. Finds artists through attending art exhibitions, word of mouth, sourcebooks or other publications and submissions. Company guidelines are free with SASE.

Tips: Recommends New York Stationery Show held annually. "In addition to having good painting/designing skills, artists should be aware of market needs."

☑ 🌐 **INTERNATIONAL GRAPHICS GMBH.**, Dieselstr. 7, 76344, Eggenstein Germany. 011(49)721-978-0688. Fax: (49)721-978-0678. E-mail: LW@ig-team.de. Website: www.international-graphics.de. **President:** Lawrence Walmsley. **Publishing Assistant:** Evelyne Dennler. Estab. 1983. Poster com-

pany/art publisher/distributor. Publishes/distributes limited edition monoprints, monotypes, offset reproduction, posters, original paintings and silkscreens. Clients: galleries, framers, department stores, gift shops, card shops and distributors. Current clients include: Windsor Art and Balangier.

Needs: Seeking creative, fashionable and decorative art for the commercial and designer markets. Also seeking Americana art for our gallery clients. Considers oil, acrylic, watercolor, mixed media, pastel. Prefers landscapes, florals, still lifes. Art guidelines free for SASE with first-class postage. Artists represented include Ida, Janssen, Lilita, Bähr-Clemens, McCulloch, Barth, Mayer, Hecht. Editions created by working from an existing painting. Approached by 20-30 artists/year. Publishes the work of 4-5 emerging, 1-5 mid-career and 1-2 established artists/year. Distributes the work of 40-50 emerging, 10 mid-career, 2-3 established artists/year.

First Contact & Terms: Send query letter with brochure, photocopies, photographs, photostats, résumé, slides, tearsheets. Accepts disk submissions in Mac or Windows. Samples are filed and returned. Responds in 1-2 months. Will contact artist for portfolio review if interested. Negotiates payment on basis of per piece sold arrangement. Offers advance when appropriate. Buys first rights. Provides advertising, promotion, shipping from our firm and contract. Also work with freelance designers. Prefers local designers only. Finds artists through exhibitions, word of mouth, submissions.

Tips: "Bright landscapes and still life pictures are good at the moment. Blues are popular—especially darker shades."

N ARTHUR A. KAPLAN CO. INC., 460 W. 34th St., New York NY 10001. (212)947-8989. Fax: (212)629-4317. E-mail: christine.pratti@kapgog.com. **Art Directors:** Colleen Buchweitz and Christine Pratti. Estab. 1956. Art publisher of unlimited editions of offset reproduction prints. Clients: galleries and framers.

Needs: Seeking creative and decorative art for the designer market. Considers all media. Artists represented include Lena Liu, Vivian Flasch and Marco Bronzini. Editions created by collaborating with artist or by working from an existing painting. Approached by 1,550 artists/year. Publishes and distributes the work of "as many good artists as we can find."

First Contact & Terms: Send résumé, tearsheets, slides and photographs to be kept on file. Material not filed is returned by SASE. Responds in 2-3 weeks. Call for appointment to show portfolio, or mail appropriate materials. Portfolio should include final reproduction/product, color tearsheets and photographs. Pays a royalty of 5-10%. Offers advance. Buys rights for prints and posters only. Provides insurance while work is at firm and in transit from plant to artist.

Tips: "We cater to a mass market and require fine quality art with decorative and appealing subject matter. Don't be afraid to submit work—we'll consider anything and everything."

LESLI ART, INC., Box 6693, Woodland Hills CA 91365. (818)999-9228. E-mail: artlesli@aol.com. **President:** Stan Shevrin. Estab. 1965. Artist agent handling paintings for art galleries and the trade.

Needs Considers oil paintings and acrylic paintings. Prefers realism and impressionism—figures costumed with narrative content, landscapes, still lifes and florals. Works with 20 artists/year.

First Contact & Terms: To show portfolio, mail slides or color photographs. Samples not filed are returned by SASE. Responds in 1 month. Payment method is negotiated. Offers an advance. Provides national distribution, promotion and written contract.

Tips: "Considers only those artists who are serious about having their work exhibited in important galleries throughout the United States and Europe."

N LESLIE LEVY FINE ART PUBLISHING, INC., 7131 Main St., Scottsdale AZ 85251. (480)947-2925. Fax: (480)945-1518. E-mail: leslevy@ix.netcom.com. Website: www.leslielevy.com. **President:** Leslie Levy. Estab. 1976. Art publisher of posters. "Our publishing customers are mainly frame shops, galleries, designers, framed art manufacturers, distributors and department stores. Currently works with over 10,000 clients."

Needs Seeking creative and decorative art for the residential, hospitality, health care, commercial and designer markets. Artists represented include: Steve Hanks, Doug Oliver, Robert Striffolino, Kent Wallis, Cyrus Afsary, Raymond Knaub, Terry Isaac, June Carey, Peter Van Dusen, Mary DeLoyht-Arendt, and many others. Considers oil, acrylic, pastel, watercolor, tempera, mixed media and photography. Prefers art depicting florals, landscapes, wildlife, semiabstract, Americana and figurative works. Approached by hundreds of artists/year.

N MARKETS NEW TO THIS EDITION

First Contact & Terms: Send query letter with résumé, slides or photos and SASE. Samples are returned by SASE. Responds in 6 weeks. "Portfolio will not be seen unless interest is generated by the materials sent in advance." Please do not send limited editions, transparencies or original works. Pays royalties quarterly based on wholesale price. Insists on acquiring reprint rights for posters. Requires exclusive representation of the artist. Provides advertising, promotion, written contract and insurance while work is at firm. "Please, don't call us. After we review your materials, we will contact you or return materials within 6-8 weeks.

Tips: "We are looking for floral, figurative, landscapes, wildlife, semiabstract art, and any art of exceptional quality. Please, if you are a beginner, do not go through the time and expense of sending materials. Also we publish no copycat art."

LIPMAN PUBLISHING, 76 Roxborough St. W., Toronto, Ontario M5R 1T8 Canada. (800)561-4260. E-mail: lipman@passport.ca. **Owner:** Louise Lipman. Estab. 1976. Art publisher. Publishes unlimited editions, offset reproductions and posters. Clients: wholesale framers, distributors, hospitality. Current clients include: Pier One, Bombay, Spiegel.

Needs: Seeking decorative art for the commercial and designer markets. Considers all 2-dimensional media. Prefers garden, kitchen, landscape, floral themes. Art guidelines available. Artists represented include William Buffett, Jim Harrington, Anna Pugh and Donald Farnsworth. Editions created by collaborating with the artist or by working from an existing painting.

First Contact & Terms: Send slides, photographs, photocopies or any low-cost facsimile. Samples are filed and not returned. Responds in a few weeks. Publisher will contact artist for portfolio review if interested. Portfolio should include color thumbnails, photographs and slides. Pays royalties of 10%. Negotiates rights purchased. Requires exclusive representation of artist. Provides advertising, promotion and written contract.

Tips: "There's a trend to small pictures of garden-, kitchen-, and bathroom-related material. Be willing to take direction."

LOLA LTD./LT'EE, 1817 Egret St. SW, S. Brunswick Islands, Ocean Isle Beach NC 28470. (910)754-8002. **Owner:** Lola Jackson. Distributor of limited editions, offset reproductions, unlimited editions, hand-pulled originals, antique prints and etchings. Clients: art galleries, architects, picture frame shops, interior designers, major furniture and department stores, industry and antique gallery dealers.

• This distributor also carries antique prints, etchings and original art on paper and is interested in buying/selling to trade.

Needs: Seeking creative and decorative art for the commercial and designer markets. "Handpulled graphics are our main area." Also considers oil, acrylic, pastel, watercolor, tempera or mixed media. Prefers unframed series, 30×40 maximum. Artists represented include Buffet, White, Brent, Jackson, Mohn, Baily, Carlson, Coleman. Approached by 100 artists/year. Publishes the work of 5 emerging, 5 mid-career and 5 established artists/year. Distributes the work of 40 emerging, 40 mid-career and 5 established artists/year.

First Contact & Terms: Send query letter with sample. Samples are filed or are returned only if requested. Responds in 2 weeks. Payment method is negotiated. "Our standard commission is 50% less 50% off retail." Offers an advance when appropriate. Provides insurance while work is at firm, shipping from firm and written contract.

Tips: "We find we cannot sell b&w only; red, orange and yellow are also hard to sell unless included in abstract subjects. Best colors: emerald, mauve, pastels, blues. Leave wide margins on prints. Send all samples before end of May each year as our main sales are targeted for summer. We do a lot of business with birds, botanicals, boats and shells—anything nautical."

LONDON CONTEMPORARY ART, 6950 Phillips Hwy., Suite 51, Jacksonville FL 32216. (904)296-4982. Fax: (904)296-4943. Website: www.lcausa.com. Estab. 1978. Art publisher. Publishes limited editions. Clients: art galleries.

Needs: Seeking art for the commercial market. Prefers figurative, landscapes, some abstract expressionism. Artists represented include Roy Fairchild, David Dodsworth, Janet Treby, Peter Nixon, Bolan, Gary Benfield, Felix Mas and Miguel Avataneo. Editions created by working from an existing painting. Approached by hundreds of artists/year. Publishes the work of 1-10 emerging, 1-10 mid-career and 20 established artists/year. Distributes the work of 1-10 emerging, 1-10 mid-career, 20-50 established artists/year.

First Contact & Terms: Send brochure, résumé, tearsheets, photographs and photocopies. Samples are returned by SASE. Publisher/distributor will contact artist for portfolio review if interested. Portfolio should include final art, tearsheets and photographs. Negotiates payment. Rights purchased vary according to project. Provides advertising, in-transit insurance, insurance while work is at firm, promotion, shipping from firm and written contract. Finds artists through attending art exhibitions and art fairs, word of mouth and submissions.

Tips: Recommends artists read *Art Business News* and *U.S. Art*. "Pay attention to color trends and interior design trends. Artists need discipline and business sense and must be productive."

LYNESE OCTOBRE, INC., P.O. Box 5002, Clearwater FL 33758. (727)724-8800. Fax: (727)724-8352. E-mail: jerry@lyneseoctobre.com. Website: www.lyneseoctobre.com. **President:** Jerry Emmons. Estab. 1982. Distributor. Distributes unlimited editions, offset reproductions and posters. Clients: picture framers and gift shops.
Needs: Seeking fashionable and decorative art for the commercial and designer markets. Considers oil, watercolor, mixed media, pastel, pen & ink and acrylic. Artists represented include Neil Adamson, AWS, NWS, FWS; Roger Isphording, Betsy Monroe, Paul Brendt, Sherry Vintson, Jean Grastorf. Approached by 50 artists/year.
First Contact & Terms: Send brochure, tearsheets, photographs and photocopies. Samples are sometimes filed or are returned. Responds in 1 month. Distributor will contact artist for portfolio review if interested. Portfolio should include final art, photographs and transparencies. Negotiates payment. No advance. Rights purchased vary according to project. Provides written contract.
Tips: Recommends artists attend decor expo shows. "The trend is toward quality, color-oriented regional works."

MAIN FLOOR EDITIONS, 4943 McConnell Ave., Los Angeles CA 90066. (310)823-5686. Fax: (310)823-4399. **Art Director:** Allen Cathey. Estab. 1996. Poster company, art publisher and distributor. Publishes/distributes limited edition, unlimited edition and posters. Clients: distributors, retail chain stores, galleries, frame shops, O.E.M. framers.
Needs: Seeking creative, fashionable and decorative art for the commercial and designer markets. Considers oil, acrylic, watercolor, mixed media, pastel and photography. Artists represented include Allayn Stevens, Inka Zlin and Peter Colvin. Editions created by collaborating with the artist or by working from an existing painting. Approached by 100 artists/year. Publishes work of 30 emerging, 15 mid-career and 10 established artists/year. Distributes the work of 5 emerging, 3 mid-career and 2 established artists/year.
First Contact & Terms: Send query letter with brochure, photocopies, photographs and tearsheets. Samples are filed and are not returned. Responds in 6 months only if interested. Company will contact artist for portfolio review if interested. Portfolio should include photographs, slides and tearsheets. Pays flat fee $300-700; royalties of 10%. Offers advance when appropriate. Negotiates rights purchased. Requires exclusive representation of artist. Finds artists through art fairs, sourcebooks and word of mouth.
Tips: "Follow catalog companies—colors/motifs."

SEYMOUR MANN, INC., 230 Fifth Ave., Suite 910, New York NY 10001. (212)683-7262. Fax: (212)213-4920. E-mail: smanninc@aol.com. Website: www.seymourmann.com. Manufacturer.
Needs: Seeking fashionable and decorative art for the serious collector and the commercial and designer markets. Also needs freelancers for design. 15% of products require freelance design. Considers watercolor, mixed media, pastel, pen & ink and 3-D forms. Editions created by collaborating with the artist. Approached by "many" artists/year. Publishes the work of 2-3 emerging, 2-3 mid-career and 4-5 established artists/year.
Tips: "Focus on commercial end purpose of art."

MANOR ART ENTERPRISES, LTD., 555 E. Boston Post Rd., Mamaroneck NY 10543. (914)738-8569. Fax: (914)738-8581. **President:** Greg Croston. Estab. 1992. Art publisher of unlimited editions and offset reproductions. Clients: framing, manufacturing, world-wide distributors.
Needs: Seeking artwork with creative expression, fashionableness and decorative appeal for the commercial market. Considers oil, watercolor, acrylic, mixed media. Prefers traditional and realistic. Artists represented include Anton Pieck, Reina, Ruth Morehead, Bill Morehead, Kim Jacobs, Joan Elliot and Brian Paterson, creator of the Foxwood Tales. Editions created by collaborating with the artist. Approached by 100 artists/year. Publishes the work of 2-4 emerging, 2-4 mid-career and 2-4 established artists/year.
First Contact & Terms: Send query letter with brochure showing art style or résumé and tearsheets, slides and photographs. Samples are not filed and are returned. Responds in 2 weeks. Write for appointment to show portfolio, which should include slides, tearsheets, transparencies, original/final art and photographs. Pays flat fee or royalties of 7-10%. Offers advance. Negotiates rights purchased. Requires exclusive representation. Provides in-transit insurance and insurance while work is at firm.
Tips: "The focus of our publishing is towards traditional with worldwide appeal—tight and realistic."

N **MARCO FINE ARTS**, 201 Nevada St., El Segundo CA 90245. (310)615-1818. Fax: (310)615-1850. E-mail: info@marcofinearts.com. Website: www.marcofinearts.com. Publishes/distributes limited edition, fine art prints and posters. Clients: galleries, decorators and frame shops.

Needs: Seeking creative and decorative art for the serious collector and design market. Considers oil, acrylic and mixed media. Prefers landscapes, florals, figurative, Southwest, contemporary, impressionist, antique posters. Accepts outside serigraph production work. Artists represented include John Nieto, Aldo Luongo, John Axton, Guy Buffet, Linda Kyser Smith and Sergei Ossovsky. Editions created by collaborating with the artist or working from an existing painting. Approached by 80-100 artists/year. Publishes the work of 3 emerging, 3 mid-career and 3-5 established artist/year.

First Contact & Terms: Send query letter with brochure, photocopies, photographs, photostats, résumé, SASE, slides, tearsheets and transparencies. Accepts disk submissions. Samples are filed and are returned by SASE. Responds only if interested. Company will contact artist for portfolio review or original artwork (show range of ability) if interested. Payment to be discussed. Requires exclusive representation of artist.

MARLBORO FINE ART & PUBL., LTD., 10 Gristmill Rd., Howell NJ 07731. Phone/fax: (732)901-5732. E-mail: charlin15@aol.com. Website: www.art-smart.com/mfa. Estab. 1996. Art publisher/distributor. Publishes/distributes limited and unlimited edition offset reproductions and posters. Clients: galleries, decorators, frame shops, distributors, architects, corporate curators, museum shops, giftshops. Current clients include: Charray Art, Creative Energies, James Lawrence, Inc.

Needs: Publishes/distributes creative, fashionable and decorative art for the commercial market. Considers acrylic, watercolor, mixed media, pastel, pen & ink. Prefers multicultural themes; specializes in African-American themes. Artists represented include Anthony Armstrong, Khalil Bey, Hosa Anderson, Harry Davis, William Buffett, Alex Corbbrey, Mario A. Robinson, Ophie Lawrence, James Ghetters, Jr. and Ruth Williams. Editions created by collaborating with the artist and working from an existing painting. Approached by 15-20 artists/year. Publishes 1-2 emerging, 2 established artists/year. Distributes the work of 5-10 emerging, 5 mid-career artists/year.

First Contact & Terms: Send query letter with brochure, photocopies, photographs, photostats, slides, transparencies. Samples are not filed and are returned. Responds in days. Will contact artist for portfolio review if interested. Royalties paid monthly. Offers advance when appropriate. Rights purchased vary according to project. Provides advertising, promotion, shipping from firm and contract. Finds artists through the web, trade publications.

Tips: "Do your own thing—if it feels right—go for it! You could be the next trendsetter."

BRUCE MCGAW GRAPHICS, INC., 389 W. Nyack Rd., West Nyack NY 10994. (845)353-8600. Fax: (845)353-3155. E-mail: acquisitions@bmcgawmail.com. Website: www.bmcgaw.com. **Acquisitions:** Martin Lawlor. Clients: poster shops, galleries, I.D., frame shops.
* Bruce McGraw publishes nearly 300 images per year.

Needs: Artists represented include Diane Romanello, Romero Britto, David Doss, Ray Hendershot, Jacques Lamy, Bob Timberlake, Robert Bateman, Michael Kahn, Albert Swayhoover, Barbara Culp, William Mangum and P.G. Gravele. Other important fine art poster licenses include Disney, Andy Warhol, MOMA, New York and others. Publishes the work of 30 emerging and 30 established artists/year.

First Contact & Terms: Send slides, transparencies or any other visual material that shows the work in the best light. "We review all types of 2-dimensional art with no limitation on media or subject. Review period is 1 month, after which time we will contact you with our decision. If you wish the material to be returned, enclose a SASE. Contractual terms are discussed if work is accepted for publication." Forward 20-60 examples—we look for a body of work from which to publish.

Tips: "Simplicity is very important in today's market (yet there still needs to be 'a story' to the image). Form and palette are critical to our decision process. We have a tremendous need for decorative pieces, especially new abstracts, landscapes, and florals. Decorative still life images are very popular, whether painted or photographed, and much needed as well. There are a lot of prints and posters being published into the marketplace these days. Market your best material! There are a number of important shows—the largest American shows being Art Expo, New York (March), Galeria, New York (March), and the Atlanta A.B.C. Show (September). Review our catalog at your neighborhood gallery or poster shop or visit our website before submitting."

MILL POND PRESS COMPANIES, 310 Center Court, Venice FL 34292-3500. (800)535-0331. Fax: (941)497-6026. E-mail: millpondPD@worldnet.att.net. **Public Relations Director:** Ellen Collard. Licensing: Angela Sauro. Estab. 1973. Publishes limited editions, unlimited edition, offset reproduction and giclees. Divisions include Mill Pond Press, Loren Editions, Visions of Faith and Mill Pond Licensing. Clients: galleries, frameshops and specialty shops, Christian book stores, licensees. Licenses various genre on a range of products.

Needs: Seeking creative, fashionable, decorative art. Open to all styles. Considers oil, acrylic, watercolor and mixed media. Prefers wildlife, spiritual, figurative and nostalgic. Artists represented include Robert

Bateman, Carl Brenders, Peter Ellenshaw, Nita Engle, Luke Buck, Paco Young and Maynard Reece. Editions created by collaborating with the artist or by working from an existing painting. Approached by 400-500 artists/year. Publishes the work of 4-5 emerging, 5-10 mid-career and 15-20 established artists/year.

First Contact & Terms: Send query letter with photographs, résumé, SASE, slides, transparencies and description of artwork. Samples are not filed and are returned by SASE. Responds in 1 year. Company will contact artist for portfolio review if interested. Pays royalties. Rights purchased vary according to project. Requires exclusive representation of artist. Provides advertising, in-transit insurance, insurance while work is at firm, promotion, shipping to and from firm and written contract. Finds artists through art exhibitions, submissions and word of mouth.

Tips: "We continue to expand the genre published. Inspirational art has been part of expansion. Realism is our base but we are open to looking at all art."

N MODARES ART PUBLISHING, 2305 Louisiana Ave. N, Golden Valley MN 55427. (800)896-0965. Fax: (612)513-1357. **President:** Mike Modares. Estab. 1993. Art publisher, distributor. Publishes/distributes limited edition, unlimited edition, canvas transfers, monoprints, monotypes, offset reproduction and posters. Clients: galleries, decorators, frame shops, distributors, architects, corporate curators, museum shops and giftshops.

Needs: Seeking creative and decorative art for the commercial and designer market. Considers oil, acrylic, watercolor mixed media and pastel. Prefers realism and impressionism. Artists represented include Jim Hansel, Derk Hansen and Michael Schofield. Editions created by collaborating with the artist or working from an existing painting. Approached by 10-50 artists/year. Distributes the work of 10-30 emerging artists/year. Also needs freelancers for design.

First Contact & Terms: Send query letter with brochure, photographs, photostats, slides and transparencies. Samples are not filed and are returned. Responds in 5 days. Portfolio may be dropped off every Monday, Tuesday and Wednesday. Artist should follow up with a call. Portfolio should include color, final art, photographs, photostats, thumbnails. Payment negotiated. Offers advance when appropriate. Buys one-time rights and all rights. Sometimes requires exclusive representation of artist. Provide advertising, in-transit insurance, insurance while work is at firm, promotion, shipping from our firm and written contract. Finds artists through attending art exhibitions, art fairs and word of mouth.

☑ MODERNART EDITIONS, 276 Fifth Ave., Suite 205, New York NY 10001. (212)779-0700, ext. 251. Fax: (253)550-2148. E-mail: marymize@aol.com. Website: www.modernarteditions.com. **Contact:** Mary Mizerany. Estab. 1973. Art publisher and distributor of "top of the line" open edition posters and offset reproductions. Clients: galleries and custom frame shops worldwide.

Needs: Seeking decorative art for the commercial and designer markets. Considers oil, watercolor, mixed media, pastel and acrylic. Prefers fine art landscapes, floral, abstracts, representational, still life, decorative, collage, mixed media. Size: 16×20. Artists represented include Carol Ann Curran, Diane Romanello, Pat Woodworth, Chuck Huddleston, Penny Feder and Neil Faulkner. Editions created by collaboration with the artist or by working from an existing painting. Approached by 200 artists/year. Publishes the work of 10-15 emerging artists/year. Distributes the work of 100 emerging artists/year.

First Contact & Terms: Send postcard size sample of work, contact through artist rep, or send query letter with slides, photographs, brochure, photocopies, résumé, photostats, transparencies. Submissions via e-mail are preferred. Responds in 6 weeks. Request portfolio review in original query. Publisher/distributor will contact artist for portfolio review if interested. Portfolio should include color photostats, photographs, slides and transparencies. Pays flat fee of $200-300 or royalties of 10%. Offers advance against royalties. Provides insurance while work is at firm, shipping to firm and written contract.

Tips: Advises artists to attend Art Expo New York City and Atlanta ABC.

N MORIAH PUBLISHING, INC., 23500 Mercantile Rd., Unit B, Beechwood OH 44122. (216)595-3131. Fax: (216)595-3140. E-mail: rouven@moriahpublishing.com. Website: www.moriahpublishing.com. **Contact:** Rouven R. Cyncynatus. Estab. 1989. Art publisher and distributor of limited editions. Licenses wildlife and nature on all formats. Clients: wildlife art galleries.

Needs: Seeking artwork for the serious collector. Editions created by working from an existing painting. Approached by 100 artists/year. Publishes the work of 6 and distributes the work of 15 emerging artists/year. Publishes and distributes the work of 10 mid-career artists/year. Publishes the work of 30 and distributes the work of 10 established artists/year.

First Contact & Terms: Send query letter with brochure showing art style, slides, photocopies, résumé, photostats, transparencies, tearsheets and photographs. Responds in 2 months. Write for appointment to show portfolio or mail appropriate materials: rough, b&w, color photostats, slides, tearsheets, transparencies and photographs. Pays royalties. No advance. Buys reprint rights. Requires exclusive representation of artist. Provides in-transit insurance, promotion, shipping to and from firm, insurance while work is at firm, and a written contract.

Tips: "Artists should be honest, patient, courteous, be themselves, and make good art."

MUNSON GRAPHICS, 2754 Aquafria, Suite E, Santa Fe NM 87505. (505)424-4112. Fax: (505)424-6338. E-mail: michael@munsongraphics.com. Website: www.munsongraphics.com. **President:** Michael Munson. Estab. 1997. Poster company, art publisher and distributor. Publishes/distributes limited edition, fine art prints and posters. Clients: galleries, museum shops, gift shops and frame shops.
Needs: Seeking creative art for the serious collector and commercial market. Considers oil, acrylic, watercolor and pastel. Artists represented include O'Keeffe, Baumann, Nieto, Abeyta. Editions created by working from an existing painting. Approached by 75 artists/year. Publishes work of 3-5 emerging, 3-5 mid-career and 3-5 established artists/year. Distributes the work of 5-10 emerging, 5-10 mid-career and 5-10 established artists/year.
First Contact & Terms: Send query letter with slides, SASE and transparencies. Samples are not filed and are returned by SASE. Responds in 1 month. Company will contact artist for portfolio review if interested. Negotiates payment. Offers advance. Rights purchased vary according to project. Provides written contract. Finds artists through art exhibitions, art fairs, word of mouth and artists' submissions.

NATIONAL WILDLIFE GALLERIES/artfinders.com, 11000-31 Metro Parkway, Fort Myers FL 33912. (941)939-2425, Fax (941)936-2788. E-mail: art@artfinders.net. Website: www.artlithos.com and www.artfinders.net. **Contact:** David H. Boshart. Publisher/distributor of wildlife art.
 • This publisher also owns National Art Publishing Corp. but the two are separate entities. National Wildlife Galleries was established in 1990, when National Art Publishing Corp. acquired Peterson Prints.
Needs: Seeking paintings, graphics, posters for the fine art and commercial markets. Specializes in wildlife art. Artists represented include Larry Barton, Bill Burkett and Guy Coheleach.
First Contact & Terms: Send query letter, slides and SASE. Publisher will contact for portfolio review if interested.

NEW DECO, INC., 23123 Sunfield Dr., Boca Raton FL 33433. (561)488-8041 or (800)543-3326. Fax: (561)488-9743. **President:** Brad Morris. Estab. 1984. Art publisher and distributor of limited editions using lithography and silkscreen for galleries. Also publishes/distributes unlimited editions and pool and billiard images for posters and prints. Clients: art galleries and designers.
 • Also has listing in Greeting Cards, Gifts & Products section.
Needs: Interested in contemporary work. Artists represented are Robin Morris, Nico Vrielink and Lee Bomhoff. Needs new designs for reproduction. Publishes and distributes the work of 1-2 emerging, 1-2 mid-career and 1-2 established artists/year.
First Contact & Terms: Send brochure, résumé and tearsheets, photostats or photographs to be kept on file. Samples not filed are returned. Responds only if interested. Portfolio review not required. Publisher/distributor will contact artist for portfolio review if interested. Pays flat fee or royalties of 7%. Also accepts work on consignment (firm receives 50% commission). Offers advance. Negotiates rights purchased. Provides promotion, shipping and a written contract. Negotiates ownership of original art. "We find most of our artists through *Artist's & Graphic Designer's Market* listing, advertising, trade shows and referrals."
Tips: Advises artists to attend the New York Art Expo.

■ **NEW YORK GRAPHIC SOCIETY**, 129 Glover Ave., Norwalk CT 06850. (203)661-2400. Website: www.nygs.com. **Publisher:** Richard Fleischmann. President: Owen Hickey. Estab. 1925. Publisher of offset reproductions, posters. Clients: galleries, frame shops and museums shops. Current clients include Deck The Walls, Ben Franklin, Prints Plus.
Needs: Considers oil, acrylic, pastel, watercolor, mixed media and colored pencil drawings. Publishes reproductions, posters. Publishes and distributes the work of numerous emerging artists/year. Art guidelines free with SASE. Response to submissions in 90 days.
First Contact & Terms: Send query letter with transparencies or photographs. All submissions returned to artists by SASE after review. Pays flat fee or royalty. Offers advance. Buys all print reproduction rights. Provides in-transit insurance from firm to artist, insurance while work is at firm, promotion, shipping from firm and a written contract; provides insurance for art if requested. Finds artists through submissions/self promotions, magazines, visiting art galleries, art fairs and shows.
Tips: "We publish a broad variety of styles and themes. We actively seek all sorts of fine decorative art."

■ **NEXTMONET**, (formerly Visualize), 444 Townsend St., 2nd Floor, San Francisco CA 94107. (888)914-5050. Fax: (415)977-6905. E-mail: jobs@nextmonet.com. Website: www.nextmonet.com. **Contact:** Artwork Submissions. Estab. 1998. Art publisher, distributor. Publishes/distributes limited edition and fine art prints as well as originals. Clients: decorators, corporate curators and private consumers.

Needs: Seeking creative, decorative art for the serious collector, commercial and designer markets. Considers oil, acrylic, watercolor, mixed media, pastel, pen & ink and photography. Prefers all styles. Artists represented include James Stagg, Susan Friedman and Eric Zener. Editions created by collaborating with the artist and working from an existing painting. Approached by 1,000 artists/year.

First Contact & Terms: Send query letter with résumé, SASE and slides. Accepts disk submissions in JPEG or BITMAP format compatible with Photoshop 5.5. Samples are filed, kept on disk or returned by SASE. Portfolio review not required. Finds artists through World Wide Web, sourcebooks, art exhibitions, art fairs, artists' submissions, publications and word of mouth.

N NORTHLAND POSTER COLLECTIVE, Dept. AM, 1613 E. Lake St., Minneapolis MN 55407. (612)721-2273. Website: www.northlandposter.com. **Manager:** Ricardo Levins Morales. Estab. 1979. Art publisher and distributor of handpulled originals, unlimited editions, posters and offset reproductions. Clients: mail order customers, teachers, bookstores, galleries, unions.

Needs: "Our posters reflect themes of social justice and cultural affirmation, history, peace." Artists represented include Ralph Fasanella, Karin Jacobson, Betty La Duke, Ricardo Levins Morales and Lee Hoover. Editions created by collaborating with the artist or by working from an existing painting.

First Contact & Terms: Send query letter with tearsheets, slides and photographs. Samples are filed or are returned by SASE. Responds in months; if does not report back, the artist should write or call to inquire. Write for appointment to show portfolio. Payment method is negotiated. Offers an advance when appropriate. Negotiates rights purchased. Contracts vary but artist always retains ownership of artwork. Provides promotion and a written contract.

Tips: "We distribute a work that we publish as well as pieces already printed. We print screen prints inhouse and publish one to four offset posters per year."

☑ NORTHWEST PUBLISHING & SUN DANCE GRAPHICS, 9580 Delegates Dr., Orlando FL 32837. (407)240-1091. Fax: (407)240-1951. E-mail: sales@northwestpublishing.com and sales@sundance graphics.com. Website: northwestpublishing.com. **Art Director:** Kathy Anish. Estab. 1996. Publishes art prints.

Needs: Approached by 300 freelancers/year. Works with 50 freelancers/year. Buys 200 freelance designs and illustrations/year. Art guidelines free for SASE with first-class postage. Works on assignment only. Looking for high-end art. 20% of freelance design work demands knowledge of Photoshop, Illustrator and QuarkXPress.

First Contact & Terms: Designers send brochure photocopies, photographs, photostats, tearsheets and SASE. "No original art please." Samples are filed or returned by SASE. Responds in 6 weeks. Company will contact artists for portfolio review if interested. Portfolio should include color final art, slides, tearsheets and transparencies. Rights purchased vary according to project. Pays "either royalties or a flat fee. The artist may choose." Finds freelancers through SURTEX, word of mouth and art societies.

Tips: "Read the trade magazines, *GSB*, *G&D*, *GN*, *Decor* and *Greetings Today*."

☑ NOTTINGHAM FINE ART, P.O. Box 309, Chester NH 03036-0309. (603)887-7089. E-mail: robert @artandgift.com. Website: www.artandgift.com. **President:** Robert R. Lemelin. Estab. 1992. Art publisher, distributor. Publishes/distributes handpulled originals, limited editions, fine art prints, monoprints, monotypes, offset and digital reproductions. Clients: galleries, frame shops, architects.

Needs: Seeking creative, fashionable, decorative art for the serious collector. Considers oil, acrylic, watercolor, mixed media, pastel. Prefers sporting, landscape, floral, creative, musical and lifestyle themes. Artists represented include Roger Blum, Barbie Tidwell, Cristina Martuccelli, Monique Parry and Ronald Parry. Editions created by collaborating with the artist or by working from an existing painting. Approached by 60 artists/year.

First Contact & Terms: Send query letter with brochure, photographs, slides. Samples are filed or returned by SASE. Responds in 2 months. Company will contact artist for portfolio review of color photographs, slides and transparencies if interested. Pays in royalties. Rights purchased vary according to project. Requires exclusive representation of artist. Provides advertising, insurance while work is at firm, promotion, shipping from firm, written contract. Finds artists through art fairs, submissions and referrals from existing customers.

Tips: "If you don't have a marketing plan developed or $5,000 you don't need, don't self-publish. We look for artists with consistent quality and a feeling to their work."

☑ NOUVELLES IMAGES INC., 28 Boulevard de la Bastille, 75012 Paris France. (011)331-56 95 06 05. Fax: (011)331-56 95 06 17. E-mail: fr@nouvellesimages.com. Website: www.nouvellesimages.com. **Contact:** Art Director. Estab. 1987. Publishes open edition, fine art prints and posters. Also publishes greeting cards, note cards, postcards and calendars. Clients: galleries, decorators, frame shops, etc.

• This company's headquarters are in Paris, France and publishing decisions are made out of that office. So do not send your slides to U.S. address or they will be returned unopened. When shipping your submission note that in Paris the postal code comes before the city name.

Needs: Seeking creative and decorative art for the commercial and designer markets. Considers oil. Prefers classic to contemporary. For art guidelines, call, e-mail or write. Artists represented include Haring, Hopper, Kandinsky, Matisse, Dufy, Klee and Feininger. Edition created by collaborating with the artist or by working from an existing artwork. Approached by 50 artists/year. Publishes the work of emerging and established artists. Also needs freelancers for design.

First Contact & Terms: Send query letter with photographs, résumé, slides or transparencies to Paris office. See above. Include SASE. Samples are returned when requested. Responds in 6 months. Company will contact artist for portfolio review of b&w and color if interested. Pays royalties. Offers advance when appropriate. Rights purchased vary according to project. Provides advertising, promotion and written contract. Finds artists through connections, research and artists' circles.

Tips: "Please do not send anything that is original or irreplaceable, and please include a self-addressed envelope for all material that you would like to have returned you."

NOVA MEDIA INC., 1724 N. State, Big Rapids MI 49307. (231)796-4637. E-mail: trund@nov.com. Website: www.nov.com. **Editor:** Tom Rundquist. Licensing: Arne Flores. Estab. 1981. Poster company, art publisher, distributor. Publishes/distributes limited editions, unlimited editions, fine art prints, posters, e-prints. Current clients: various galleries. Licenses e-prints.

Needs: Seeking creative art for the serious collector. Considers oil, acrylic. Prefers expressionism, impressionism, abstract. Editions created by collaborating with the artist or by working from an existing painting. Approached by 14 artists/year. Publishes/distributes the work of 2 emerging, 2 mid-career and 1 established artists/year. Artists represented include Jill Everest Fonner. Also needs freelancers for design. Prefers local designers.

First Contact & Terms: Send query letter with photographs, résumé, SASE, slides, tearsheets. Samples are returned by SASE. Responds in 2 weeks. Request portfolio review in original query. Company will contact artist for portfolio review of color photographs, slides, tearsheets if interested. Pays royalties of 10% or negotiates payment. No advance. Rights purchased vary according to project. Provides promotion.

Tips: Predicts colors will be brighter in the industry. "Focus on companies that sell your style."

OLD GRANGE GRAPHICS, 40 Scitico Rd., Somersville CT 06072. (800)282-7776. Fax: (800)437-3329. E-mail: ogg@denunzio.com. Website: www.oldgrangegraphics.com. **President:** Gregory Panjian. Estab. 1976. Distributor/canvas transfer studio. Publishes/distributes canvas transfers, posters. Clients: galleries, frame shops, museum shops, publishers, artists.

Needs: Seeking decorative art for the commercial and designer markets. Considers lithographs. Prefers prints of artworks that were originally oil paintings. Editions created by working from an existing painting. Approached by 100 artists/year.

First Contact & Terms: Send query letter with brochure. Samples are not filed and are returned. Responds in 1 month. Will contact artist for portfolio review of tearsheets if interested. Negotiates payment. Rights purchased vary according to project. Provides promotion and shipping from firm. Finds artists through art publications.

Tips: Recommends Galeria, Artorama and ArtExpo shows in New York and *Decor, Art Trends, Art Business News* and *Picture Framing* as tools for learning the current market.

OLD WORLD PRINTS, LTD., 2601 Floyd Ave., Richmond VA 23220-4305. (804)213-0600. Fax: (804)213-0700. E-mail: kwurdeman@yahoo.com. Website: oldworldprintsltd.com. **President:** John Wurdeman. Vice President Art Acceptance: Kathy Wurdeman. Licensing: John Wurdeman. Estab. 1973. Art publisher and distributor of open-edition, hand-printed reproductions of antique engravings as well as all subject matter of color printed art. Clients: retail galleries, frame shops and manufacturers, hotels, and fund raisers.

• Old World Prints reports the top-selling art in their 10,000-piece collection includes botanical and decorative prints.

Needs: Seeking traditional and decorative art for the commercial and designer markets. Specializes in handpainted prints. Considers "b&w (pen & ink or engraved) art which can stand by itself or be hand painted by our artists or originating artist." Prefers traditional, representational, decorative work. Editions created by collaborating with the artist. Distributes the work of more than 1,000 artists. "Also seeking golf, coffee, tea, and exotic floral images."

First Contact & Terms: Send query letter with brochure showing art style or résumé and tearsheets and slides. Samples are filed. Responds in 6 weeks. Write for appointment to show portfolio of photographs,

slides and transparencies. Pays flat fee of $100/piece and royalties of 10% of profit. Offers an advance when appropriate. Negotiates rights purchased. Provides in-transit insurance, insurance while work is at firm, promotion, shipping from firm and a written contract. Finds artists through word of mouth.

Tips: "We are a specialty art publisher, the largest of our kind in the world. We are actively seeking artists to publish and will consider all forms of art."

[N] OPUS ONE PUBLISHING, P.O. Box 1469, Greenwich CT 06836-1469. (203)661-2400. Fax: (203)661-2480. **Publishing Director:** Owen F. Hickey. Estab. 1970. Art Publisher. Publishes open editions, offset reproductions, posters.

Needs: Seeking creative, fashionable and decorative art for the commercial and designer markets. Considers all media. Art guidelines free for SASE with first-class postage. Artists represented include Kate Frieman, Jack Roberts, Jean Richardson, Richard Franklin, Lee White. Approached by 100 artists/year. Publishes the work of 20% emerging, 20% mid-career and 60% established artists.

First Contact & Terms: Send brochure, tearsheets, slides, photographs, photocopies, transparencies. Samples are not filed and are returned. Responds in 1 month. Artist should follow up with call after initial query. Portfolio should include final art, slides, transparencies. Negotiates payment. Offers advance when appropriate. Rights purchased vary according to project.

Tips: "Please attend the Art Expo New York City trade show."

[N] PALATINO EDITIONS, 341 Sutter St., San Francisco CA 94108. (415)392-7237. Fax: (415)392-4609. Website: www.palatino.com. **Contact:** Acquisitions Director. Estab. 1983. Art publisher of hand-pulled originals, limited editions, fine art prints, monoprints, monotypes, posters and originals. Clients: galleries, decorators, frame shops and corporate curators.

Needs: Seeking decorative art for serious collectors and the commercial market; original, interesting art for art galleries. Considers oil, acrylic, watercolor and mixed media. Prefers landscapes, figuratives, some abstract and realism. Artists represented include Thomas Pradzynski, Manel Anoro and Regina Saura. Editions created by collaborating with the artist and by working from an existing painting. Approached by 500-2,500 artists/year. Publishes/distributes the work of 1 emerging artist and 2 mid-career artists/year.

First Contact & Terms: Send query letter with brochure, photographs, résumé, slides, transparencies, tearsheets and SASE; send only visual material including exhibition catalog. Samples are not filed and are returned by SASE. Responds in 3-4 weeks. Company will contact artist for portfolio review of final art if interested. Payment to be determined. Rights purchased vary according to project. Requires exclusive representation of artist. Provides advertising, in-transit insurance/return, insurance while work is at firm, promotion, shipping from our firm, written contract and marketing and public relations efforts, established gallery network for distribution. Finds artists through art exhibitions, art fairs, word of mouth, art reps, sourcebooks, artists' submissions and watching art competitions.

Tips: "We prefer to set trends. We are looking for innovation and original thought and aesthetic. Know your market and be familiar with printing techniques and what works best for your work."

[N] PANACHE EDITIONS LTD, 234 Dennis Lane, Glencoe IL 60022. (847)835-1574. Website: www.artofrunning.com. **President:** Donna MacLeod. Estab. 1981. Art publisher and distributor of offset reproductions and posters. Clients: galleries, frame shops, domestic and international distributors. Current clients are mostly individual collectors.

Needs: Considers acrylic, pastel, watercolor and mixed media. "Looking for contemporary compositions in soft pastel color palettes; also renderings of children on beach, in park, etc." Artists represented include Bart Forbes, Peter Eastwood and Carolyn Anderson. Prefers individual works of art and unframed series. Publishes and distrubutes work of 1-2 emerging, 2-3 mid-career and 1-2 established artists/year.

First Contact & Terms: Send query letter with brochure showing art style or photographs, photocopies and transparencies. Samples are filed. Responds only if interested. To show portfolio, mail roughs and final reproduction/product. Pays royalties of 10%. Negotiates rights purchased. Requires exclusive representation of artist. Provides in-transit insurance, insurance while work is at firm, promotion, shipping to and from firm and written contract.

Tips: "We are looking for artists who have not previously been published [in the poster market] with a strong sense of current color palettes. We want to see a range of style and coloration. Looking for a unique and fine art approach to collegiate type events, i.e., Saturday afternoon football games, Founders Day celebrations, homecomings, etc. We do not want illustrative work but rather an impressionistic style that captures the tradition and heritage of one's university. We are very interested in artists who can render figures."

☑ PENNY LANE PUBLISHING INC., 1791 Dalton Dr., New Carlisle OH 45344. (937)849-1101. Fax: (937)849-9666. E-mail: info@PennyLanePublishing.com. Website: www.PennyLanePublishing.com.

Art Coordinators: Kathy Benton and Beth Schenck. Licensing: Renee Franck and Laura Parr. Estab. 1993. Art publisher. Publishes limited editions, unlimited editions, offset reproductions. Clients: galleries, frame shops, distributors, decorators.

Needs: Seeking creative, decorative art for the commercial market. Considers oil, acrylic, watercolor, mixed media, pastel. Artists represented include Linda Spivey, Becca Barton, Cindy Sampson, Annie LaPoint, Fiddlestix, Mary Ann June. Editions created by collaborating with the artist or working from an existing painting. Approached by 40 artists/year. Publishes the work of 3-4 emerging, 15 mid-career and 6 established artists/year.

First Contact & Terms: Send query letter with brochure, résumé, photographs, slides, tearsheets. Samples are filed or returned by SASE. Responds in 2 months. Company will contact artist for portfolio review of color, final art, photographs, slides, tearsheets if interested. Pays royalties. Buys first rights. Requires exclusive representation of artist. Provides advertising, shipping from firm, promotion, written contract. Finds artists through art exhibitions, art fairs, submissions, decorating magazines.

Tips: Advises artists to be aware of current color trends and work in a series. "**Please review our website to see the style of artwork we publish.**"

N: ☧ THE PICTURE CO., 497 Edison Court, Unit H, Cordelia CA 94585. (707)863-8334. Fax: (707)864-3830. Poster company, art publisher, distributor, gallery and custom framer. Publishes/distributes limited edition, unlimited edition, canvas transfers, fine art prints, offset reproduction and posters. Clients: galleries, decorators, frame shops and corporations.

Needs: Seeking creative, fashionable and decorative art for the commercial market. Considers oil, acrylic, watercolor, mixed media, pastel, pen & ink and sculpture. Artists represented include Guan and Kohler. Editions created by collaborating with the artist and by working from an existing painting. Approached by 10 artists/year. Publishes work of 1 emerging, 3 mid-career and 2 established artists/year. Also needs freelancers for design. Prefers local designers only.

First Contact & Terms: Send query letter with brochure, photocopies, photographs, résumé and tearsheets. Samples are filed and not returned. Responds in 2 weeks only if interested. Company will contact artist for portfolio review if interested. Portfolio should include b&w, color, final art, photostats, photographs and tearsheets. Pays on consignment basis: firm receives 40% commission. No advance. Buys first rights. Provides advertising, promotion and framing. Finds artists through art fairs.

N: PORTAL PUBLICATIONS, LTD., 201 Alameda del Prado, Suite 200, Novato CA 94949. (415)884-6200. **Vice President, Publishing:** Pamela Prince. Estab. 1954. Poster company and art publisher. Publishes art prints, posters, blank and greeted cards, stationery and calendars.
• See listing in Greeting Cards, Gifts & Products section.

⊕ PORTER DESIGN—EDITIONS PORTER, The Old Estate Yard, Newton St. Loe, Bath, Somerset BA2 9BR, England. (01144)1225-874250. Fax: (01144)1225-874251. E-mail: Mary@porter-design.com. Website: www.porter-design.com. US Address: 38 Anacapa St., Santa Barbara CA 93101. (805)568-5433. (805)568-5435. **Partners:** Henry Porter, Mary Porter. Estab. 1985. Publishes limited and unlimited editions and offset productions and hand-colored reproductions. Clients: international distributors, interior designers and hotel contract art suppliers. Current clients include Devon Editions, Top Art, Harrods and Bruce McGaw.

Needs: Seeking fashionable and decorative art for the designer market. Considers watercolor. Prefers 16th-19th century traditional styles. Artists represented include Elizabeth Blackadder, Alexandra Churchill, Caroline Anderton, Victor Postolle, Joseph Hooker and Adrien Chancel. Editions created by working from an existing painting. Approached by 10 artists/year. Publishes and distributes the work of 10-20 established artists/year.

First Contact & Terms: Send query letter with brochure showing art style or résumé and photographs. Accepts disk submissions compatible with QuarkXPress on Mac. Samples are filed or are returned. Responds only if interested. To show portfolio, mail photographs. Pays flat fee or royalties. Offers an advance when appropriate. Negotiates rights purchased.

PORTFOLIO GRAPHICS, INC., P.O. Box 17437, Salt Lake City UT 84117. (801)266-4844. E-mail: info@portfoliographics.com. Website: www.portfoliographics.com. **Creative Director:** Kent Barton. Estab. 1986. Publishes and distributes unlimited editions and posters. Clients: galleries, designers, poster distributors (worldwide) and framers. Licensing: All artwork is available for license for large variety of products. Portfolio Graphics works with a large licensing firm who represents all of their imagery.

Needs: Seeking creative, fashionable and decorative art for commercial and designer markets. Considers oil, watercolor, acrylic, pastel, mixed media and photography. Publishes 80-100 new works/year. Art guidelines free for SASE with first-class postage. Editions created by working from an existing painting or transparency.

First Contact & Terms: Send query letter with résumé, biography, slides and photographs. Samples are not filed. Responds in 1 month. To show portfolio, mail slides, transparencies, tearsheets, and photographs with SASE. (Material will not be returned without an enclosed SASE.) Pays royalties of 10%. Provides promotion and a written contract.

Tips: "We find artists through galleries, magazines, art exhibits, submissions. We're looking for a variety of artists and styles/subjects."

✓ **POSNER FINE ART**, 13234 Fiji Way, Suite G, Marina Del Rey CA 90292. (310)318-8622. Fax: (310)578-8501. E-mail: posart1@aol.net. Website: posnergallery.com. **Director:** Judith Posner. Associate Director: Roberta Kerr. Estab. 1994. Art distributor and gallery. Distributes fine art prints, monoprints, sculpture and paintings. Clients: galleries, frame shops, distributors, architects, corporate curators, museum shops. Current clients include: Rennaisance Hollywood Hotel, United Airlines, Adler Realty.

Needs: Seeking creative art for the serious collector and commercial market. Considers oil, acrylic, watercolor, mixed media, sculpture. Prefers very contemporary style. Artists represented include Jae Hahn, Soja Kim, David Hockney, Robert Indiana, Greg Gummersall and Susan Veneable. Editions created by collaborating with the artist. Approached by hundreds of artists/year. Distributes the work of 5-10 emerging, 5 mid-career and 200 established artists/year. Art guidelines free for SASE with first-class postage.

First Contact & Terms: Send slides. "Must enclose self-addressed stamped return envelope." Samples are filed or returned. Responds in a few weeks. Pays on consignment basis: firm receives 50% commission. Buys one-time rights. Provides advertising, promotion, insurance while work is at firm. Finds artists through art fairs, word of mouth, submissions, attending exhibitions, art reps.

Tips: "Know color trends of design market. Look for dealer with same style in gallery." Send consistent work.

✓ **POSTER PORTERS**, P.O. Box 9241, Seattle WA 98109-9241. (206)286-0818. Fax: (206)286-0820. E-mail: posterporters@compuserve.com. Website: www.posterporters.com. **Marketing Director:** Mark Simard. Art rep/publisher/distributor/gift wholesaler. Publishes/distributes limited and unlimited edition, posters and art T-shirts. Clients: galleries, decorators, frame shops, distributors, corporate curators, museum shops, giftshops. Current clients include: Prints Plus, W.H. Smith, Smithsonian, Nordstrom.

Needs: Publishes/distributes creative art for regional commercial and designer markets. Considers oil, watercolor, pastel. Prefers regional, art. Artists represented include Beth Logan, Carolin Oltman, Jean Casterline, M.J. Johnson. Art guidelines free for SASE with first-class postage. Editions created by collaborating with the artist, working from an existing painting. Approached by 144 artists/year. Publishes the work of 2 emerging, 2 mid-career and 1 established artist/year. or Distributes the work of 50 emerging, 25 mid-career, 20 established artists/year.

First Contact & Terms: Send photocopies, SASE, tearsheets. Accepts disk submissions. Samples are filed or returned by SASE. Will contact artist for Friday portfolio drop off. Pays flat fee: $225-500; royalties of 5%. Offers advance when appropriate. Buys all rights. Provides advertising, promotion, contract. Also works with freelance designers. Prefers local designers only. Finds artists through exhibition, art fairs, art reps, submissions.

Tips: "Be aware of what is going on in the interior design sector. Be able to take criticism. Be more flexible."

✓ ⊠ **POSTERS INTERNATIONAL**, 1200 Castlefield Ave., Toronto, Ontario M6B 1G2 Canada. (416)789-7156. Fax: (416)789-7159. E-mail: karen@postersinternational.net. Website: www.postersinternational.net. **President:** Esther Cohen. Artist submissions to: Creative Director Karen McElroy. Licensing: Richie Cohen. Estab. 1976. Poster company, art publisher. Publishes fine art posters. Licenses any kind of painting or photography for notecards, wrapping paper and gift bags. Clients: galleries, decorators, distributors, hotels, restaurants etc., in U.S., Canada and International. Current clients include: Holiday Inn and Bank of Nova Scotia.

Needs: Seeking creative, fashionable art for the commercial market. Considers oil, acrylic, watercolor, mixed media, b&w and color photography. Prefers landscapes, florals, collage, architecturals, classical (no figurative). Artists represented include Joe Anna Arnett, Patricia George and Scott Steele. Editions created by collaborating with the artist or by working from an existing painting. Approached by 100 artists/year. Art guidelines free for SASE with first-class postage or IRC.

 A CHECKMARK PRECEDING A LISTING indicates a change in either the address or contact information since the 2002 edition.

First Contact & Terms: Send query letter with brochure, photographs, slides, transparencies. "No originals please!" Samples are filed or returned by SASE. Responds in 2 months. Company will contact artist for portfolio review of photographs, photostats, slides, tearsheets, thumbnails, transparencies if interested. Pays flat fee or royalties of 10%. Offers advance when appropriate. Rights purchased vary according to project. Provides advertising, promotion, shipping from firm, written contract. Finds artists through art fairs, art reps, submissions.

Tips: "Be aware of current color trends and always work in a series of two or more. Visit poster shops to see what's popular before submitting artwork."

N **PRESTIGE ART INC.**, 3909 W. Howard St., Skokie IL 60076. (847)679-2555. E-mail: prestige@prestigeart.com. Website: www.prestigeart.com. **President:** Louis Schutz. Estab. 1960. Publisher/distributor/art gallery. Represents a combination of 18th and 19th century work and contemporary material. Publishes and distributes handpulled originals, limited and unlimited editions, canvas transfers, fine art prints, offset reproductions, posters, sculpture. Licenses artwork for note cards, puzzles, album covers and posters. Clients: galleries, decorators, architects, corporate curators.

 • Company president Louis Shutz now does consultation to new artists on publishing and licensing their art in various mediums.

Needs: Seeking creative and decorative art. Considers oil, acrylic, mixed media, sculpture, glass. Prefers figurative art, impressionism, surrealism/fantasy, photo realism. Artists represented include Jean-Paul Avisse. Editions created by collaborating with the artist or by working from an existing painting. Approached by 15 artists/year. Publishes the work of 2 emerging and 2 established artists/year. Distributes the work of 5 emerging and 100 established artists/year.

First Contact & Terms: Send query letter with résumé and tearsheets, photostats, slides, photographs and transparencies. Accepts IBM compatible disk submissions. Samples are not filed and are returned by SASE. Responds only if interested. Company will contact artist for portfolio review of tearsheets if interested. Pays flat fee. Offers an advance when appropriate. Rights purchased vary according to project. Provides insurance in-transit and while work is at firm, advertising, promotion, shipping from firm and written contract.

Tips: "Be professional. People are seeking better quality, lower-sized editions, less numbers per edition—1/100 instead of 1/750."

N **PRIME ART PRODUCTS**, 5772 N. Ocean Shore Blvd., Palm Coast FL 32137. Phone/fax: (386)445-6057. **Owner:** Dee Abraham. Estab. 1990. Art publisher, distributor. Publishes/distributes limited editions, unlimited editions, fine art prints, offset reproductions. Clients include: galleries, specialty giftshops, interior design and home accessory stores.

Needs: Seeking art for the commercial and designer markets. Considers oil, acrylic, watercolor. Prefers realistic shore birds and beach scenes. Artists represented include Robert Binks, James Harris, Keith Martin Johns, Christi Mathews, Art LaMay and Barbara Klein Craig. Editions created by collaborating with the artist or by working from an existing painting. Approached by 30 artists/year. Publishes the work of 1-2 emerging artists/year. Distributes the work of many emerging and 4 established artists/year.

First Contact & Terms: Send photographs, SASE and tearsheets. Samples are filed or returned by SASE. Responds in 5 days. Company will contact artist for portfolio review if interested. Negotiates payment per signature. Offers advance when appropriate. Rights purchased vary according to project. Finds artists through submissions and small art shows.

THE PRINTS AND THE PAPER, 106 Walnut St., Montclair NJ 07042. (973)746-6800. Fax: (973)746-6801. Estab. 1996. Distributor of handpulled originals, limited and unlimited edition antiques and reproduced illustration, prints, hand colored etchings and offset reproduction. Clients: galleries, decorators, frame shops, giftshops.

Needs: Seeking decorative art. Considers watercolor, pen & ink. Prefers illustration geared toward children; also florals. Artists represented include Helga Hislap, Raymond Hughes, Dorothy Wheeler, Arthur Rackham, Richard Doyle. Editions created by working from an existing painting or print.

First Contact & Terms: Send query letter with SASE, slides. Samples are filed or returned by SASE. Will contact artist for portfolio review of slides if interested. Negotiates payment. Offers advance when appropriate. Rights purchased vary according to project. Finds artists through art exhibitions, word of mouth.

Tips: "We are a young company (6 years). We have not established all guidelines. We are attempting to establish a reputation for having quality illustration which covers a broad range."

✓ **PROGRESSIVE EDITIONS**, 37 Sherbourne St., Toronto, Ontario M5A 2P6 Canada. (416)860-0983. Fax: (416)367-2724. E-mail: info@progressiveeditions.com. Website: www.progressiveeditions.c

om. **President:** Mike Havers. General Manager: Tom Shacklady. Estab. 1982. Art publisher. Publishes handpulled originals, limited edition fine art prints and monoprints. Clients: galleries, decorators, frame shops, distributors.

Needs: Seeking creative and decorative art for the serious collector and designer market. Considers oil, acrylic, watercolor, mixed media, pastel. Prefers figurative, abstract, landscape and still lifes. Artists represented include Eric Waugh, Emilija Pasagic, Doug Edwards, Marsha Hammel. Editions created by working from an existing painting. Approached by 100 artists/year. Publishes the work of 4 emerging, 10 mid-career, 10 established artists/year. Distributes the work of 10 emerging, 20 mid-career, 20 established artists/year.

First Contact & Terms: Send query letter with photographs, slides. Samples are not filed and are returned. Responds in 1 month. Will contact artist for portfolio review if interested. Negotiates payment. Offers advance when appropriate. Negotiates rights purchased. Requires exclusive representation of artist. Provides advertising, in-transit insurance, insurance while work is at firm, promotion, shipping and contract. Finds artists through exhibition, art fairs, word of mouth, art reps, sourcebooks, submissions, competitions.

Tips: "Develop organizational skills."

☑ **RIGHTS INTERNATIONAL GROUP**, 463 First St., #3C, Hoboken NJ 07030. (201)239-8118. Fax: (201)222-0694. E-mail: info@rightsinternational.com. Website: www.rightsinternational.com. **Contact:** Robert Hazaga. Estab. 1996. Agency for cross licensing. Represents artists for licensing into publishing, stationery, giftware, home furnishing. Clients: giftware, stationery, posters, prints, calendars, wallcoverings and home decor publishers. Clients include: Scandecor, Nobleworks, Studio Oz, Editions Ltd.

• This company is also listed in the Greeting Card, Gifts & Products section.

Needs: Seeking creative, decorative art for the commercial and designer markets. Also looking for country/Americana with a new fresh interpretation of country with more of a cottage influence. Think Martha Stewart, *Country Living* magazine; globaly-inspired artwork such as safari animals, Hemingwayesque inspired pieces (exploration travel themes, images bordered with rattan motifs) and Zen florals. Considers oil, acrylic, watercolor, mixed media, pastel. Prefers commercial style. Artists represented include Julliane Marcoux, Ashley Arden, Dan Kime, John Kime, Sara Jacobs, Mari Gidding, Raymond Clearwater, Rosanne Olson, Raymond Woods, Vivien Rhyan, Elli Milan, John Milan, and Chris Hill. Approached by 50 artists/year.

First Contact & Terms: Send brochure, photocopies, photographs, SASE, slides, tearsheets, transparencies, jpgs, CD-ROM. Accepts disk submissions compatible with PC Platform. Samples are not filed and are returned by SASE. Responds in 2 weeks. Company will contact artist for portfolio review if interested. Negotiates payment.

Tips: "Check our website for trend, color and style forecasts!"

☑ **RINEHART FINE ARTS, INC.**, a member of Bentley Publishing Group, 250 W. 57th St., Suite 2202A, New York NY 10107. (212)399-8958. Fax: (212)399-8964. E-mail: hwrinehart@earthlink.net. Website: www.rinehartfinearts.com. Poster publisher. President: Harriet Rinehart. Licenses 2D artwork for posters. Clients include galleries, decorators, frame shops, corporate curators, museum shops, gift shops and substantial overseas distribution.

• This publisher represents established artists such as Howard Behrens, Linnea Pergola, Victor Shvaiko, Sally Caldwell Fisher and Thomas McKnight.

Needs: Seeking creative, fashionable and decorative art. Considers oil, acrylic, watercolor, mixed media, pastel and pen & ink. Artists represented include Howard Behrens, Thomas McKnight, Tadashi Asoma, André Bourrié. Editions created by collaborating with the artist or working from an existing painting. Approached by 30-40 artists/year. Publishes the work of 10 emerging, 10 mid-career, 5 established artists/year.

First Contact & Terms: Send query letter with photographs, SASE, slides, tearsheets, transparencies or "whatever the artist has which represents artist." Samples are not filed. Responds in 3 months. Portfolio review not required. Pays royalties of 8-10%. Rights purchased vary according to project. Provides advertising, promotion, written contract and substantial overseas exposure.

Tips: "Read *Home Furnishings News*. Work in a series. Attend trade shows."

Ⓝ ☑ **RIVER HEIGHTS PUBLISHING INC.**, 82 Walmer Rd., Toronto, Ontario M5R 2X7 Canada. (416)922-0500. Fax: (416)929-7326. E-mail: riverhpublishing@aol.com. **Publisher:** Paul Swartz. Art publisher. Publishes limited editions, unlimited editions, fine art prints, offset reproductions, sculpture. Clients: galleries, frame shops, marketing companies, corporations, mail order, chain stores, barter exchanges.

Needs: Seeking decorative art for the commercial market. Considers oil, acrylic and watercolor. Prefers wildlife, Southwestern, American Indian, impressionism, nostalgia and Victorian (architecture). Artists represented include A.J. Casson, Paul Rankin, George McLean, Rose Marie Condon. Editions created by

collaborating with the artist. Approached by 50 artists/year. Publishes the work of 1 emerging, 2 mid-career, 1 established artists/year. Distributes the work of 3 emerging, 2 mid-career and 3 established artists/year.

First Contact & Terms: Send photographs, résumé, SAE (nonresidents include IRC), slides, tearsheets. Samples are not filed and are returned by SAE. Responds in 3 weeks. Company will contact artist for portfolio review of final art if interested. Pays flat fee, royalties and/or consignment basis. Rights purchased vary according to project. Requires exclusive representation of artist. Provides advertising, insurance, promotion, shipping from firm, written contract and samples on greeting cards, calendars.

N ROMM ART CREATIONS, LTD., 112 Maple Lane, P.O. Box 1426, Bridgehampton NY 11932. (631)537-1827. Fax: (631)537-1752. Website: www.rommart.com. **Contact:** Steven Romm. Estab. 1987. Art publisher. Publishes unlimited editions, posters and offset reproductions. Clients: distributors, galleries, frame shops.

Needs: Seeking decorative art for the commercial and designer markets. Considers oil, watercolor, mixed media, pastel, acrylic and photography. Prefers traditional and contemporary. Artists represented include Tarkay, Wohlfelder, Switzer. Editions created by collaborating with the artist or by working from an existing painting. Publishes the work of 10 emerging, 10 mid-career and 10 established artists/year.

First Contact & Terms: Send query letter with slides and photographs. Samples are not filed and are returned by SASE if requested by artist. Reports back to the artist only if interested. Publisher will contact artist for portfolio review if interested. Pays royalties of 10%. Offers advance. Rights purchased vary according to project. Requires exclusive representation of artist for posters only. Provides promotion and written contract.

Tips: Advises artists to attend Art Expo and to visit poster galleries to study trends. Finds artists through attending art exhibitions, agents, sourcebooks, publications, submissions.

⊕ FELIX ROSENSTIEL'S WIDOW & SON LTD., 33-35 Markham St., London SW3 3NR England. (44)207-352-3551. Fax: (44)207-351-5300. E-mail: sales@felixr.com. Webwite: felixr.com. **Contact:** Mrs. Lucy McDowell. Licensing: Miss Caroline Dyas. Estab. 1880. Publishes handpulled originals, limited edition, canvas transfers, fine art prints and offset reproductions. Licenses all subjects on any quality product.

Needs: Seeking decorative art for the serious collector and the commercial market. Considers oil, acrylic, watercolor, mixed media and pastel. Prefers art suitable for homes or offices. Artists represented include Spencer Hodge, Barbara Olsen, Ray Campbell and Richard Akerman. Editions created by collaborating with the artist or by working from an existing painting. Approached by 200-500 artists/year.

First Contact & Terms: Send query letter with photographs. Samples are not filed and are returned by SAE. Responds in 2 weeks. Company will contact artist for portfolio review of final art and transparencies if interested. Negotiates payment. Offers advance when appropriate. Rights purchased vary according to project.

Tips: "We don't view artwork sent digitally via e-mail or CD-Rom."

☑ SAGEBRUSH FINE ART, 3065 South West Temple, Salt Lake City UT 84115. (801)466-5136. Fax: (801)466-5048. E-mail: cher@sagebrushfineart.com. **Art Review Coordinator:** Cher Cobus. Vice President: Susan Singleton. Licensing: Mike Singleton. Estab. 1991. Art publisher. Publishes fine art prints and offset reproductions. Clients: frame shops, distributors, corporate curators and chain stores.

Needs: Seeking decorative art for the commercial and designer markets. Considers oil, acrylic, watercolor and photography. Prefers traditional themes and styles. Current clients include: Mark Arian, Michael Humphries, Jo Moulton, Susan Seals. Editions created by collaborating with the artist or by working from an existing painting. Approached by 200 artists/year. Publishes the work of 20 emerging artists/year.

First Contact & Terms: Send SASE, slides and transparencies. Samples are not filed and are returned by SASE. Responds in 3 weeks. Company will contact artist for portfolio review if interested. Pays royalties of 10% or negotiates payment. Offers advance when appropriate. Rights purchased vary according to project. Provides advertising, promotion, shipping from firm and written contract.

PAUL SAWYIER ART COLLECTION, INC., (formerly The Sawyier Art Collection, Inc.), 101 Woodhill Lane, Suite 2, Frankfort KY 40601. (800)456-1390. Fax: (502)226-6207. **President:** Connie Johnson. Distributor. Distributes limited and unlimited editions, posters and offset reproductions. Clients: retail art print and framing galleries.

Needs: Seeking fashionable and decorative art. Prefers floral and landscape. Artists represented include Robert Conely, Lena Liu, Bobby Sikes, Sandy Clough, James Crow, Donny Finley, Steve Hockensmith, Sandra Kuck, Doug Prather and Steve White. Distributes prints for 24 art publishers, including Art In

Motion, Bentley House, Classic Collection, Galaxy of Graphics, Modern Art, New York Graphics and Winn Devon. Approached by 100 artists/year. Distributes the work of 10 emerging, 50 mid-career and 10 established artists/year.

First Contact & Terms: Send query letter with tearsheets. Samples are not filed and are not returned. Reports back to the artist only if interested. Distributor will contact artist for portfolio review if interested. Portfolio should include color tearsheets. Buys work outright. No advance. Finds artists through publications (*Decor*, *Art Business News*), retail outlets.

☑ **SCAFA ART PUBLISHING CO. INC.**, 165 Chubb Ave., Lyndhurst NJ 07070. Website: www.scafa art.com. **Art Coordinator and licensing:** Elaine Citron. Produces open edition offset reproductions. Clients: framers, commercial art trade and manufacturers worldwide. Licenses florals, still lifes, landscapes, animals, religious, etc. for placemats, puzzles, textiles, furniture, cassette/CD covers.

Needs: Seeking decorative art for the wall decor market. Considers unframed decorative paintings, posters, photos and drawings. Prefers pairs and series. Artists represented include T.C. Chiu, Jack Sorenson, Kay Lamb Shannon and Marianne Caroselli. Editions created by collaborating with the artist and by working from a pre-determined subject. Approached by 100 artists/year. Publishes and distributes the work of dozens of artists/year. "We work constantly with our established artists, but are always on the lookout for something new."

First Contact & Terms: Send query letter first with slides or photos and SASE. Responds in about 3-4 weeks. Pays $200-350 flat fee for some accepted pieces. Royalty arrangements with advance against 5-10% royalty is standard. Buys only reproduction rights. Provides written contract. Artist maintains ownership of original art. Requires exclusive publication rights to all accepted work.

Tips: "Do not limit your submission. We are interested in seeing your full potential. Please be patient. All inquiries will be answered."

N ⊕ **SCANDECOR MARKETING AB**, Box 656, S-751, Uppsala Sweden. E-mail: mariekadestam @scandecor-marketing.sc. Website: www.scandecor-marketing.sc. **Contact:** Marie Kadestam. Poster company, art publisher/distributor. Publishes/distributes fine art prints and posters. Clients include gift and stationery stores, craft stores and frame shops.

● See listing for Scandecor in Greeting Cards, Gifts and Products section for editorial comment regarding new address.

Needs: Seeking fashionable, decorative art. Considers acrylic, watercolor and pastel. Themes and styles vary according to current trends. Editions created by working from existing painting. Approached by 150 artists/year. Publishes the work of 5 emerging, 10 mid-career and 10 established artists/year. Also uses freelance designers. 25% of products require freelance design.

First Contact & Terms: Send query letter with brochure, photocopies, photographs, slides, tearsheets, CDs, transparencies and SASE. Responds in 2 months. Company will contact artist for portfolio review if interested. Portfolio should include color photographs, slides, tearsheets and/or transparencies. Pays flat fee, $250-1,000. Rights vary according to project. Provides written contract. Finds artists through art exhibitions, art and craft fairs, art reps, submissions and looking at art already in the marketplace in other forms (e.g., collectibles, greeting cards, puzzles).

SCHIFTAN INC., 1300 Steel Rd. W, Suite 4, Morrisville PA 19067. (215)428-2900 or (800)255-5004. Fax: (215)295-2345. E-mail: schiftan@erols.com. Website: www.schiftan.com. **President:** Harvey S. Cohen. Estab. 1903. Art publisher, distributor. Publishes/distributes unlimited editions, fine art prints, offset reproductions, posters and hand-colored prints. Clients: galleries, decorators, frame shops, architects, wholesale framers to the furniture industry.

Needs: Seeking fashionable, decorative art for the commercial market. Considers watercolor, mixed media. Prefers traditional, landscapes, botanicals, wild life, Victorian. Editions created by collaborating with the artist. Approached by 15-20 artists/year. Also needs freelancers for design.

First Contact & Terms: Send query letter with transparencies. Samples are not filed and are returned. Responds in 1 week. Company will contact artist for portfolio review of final art, roughs, transparencies if interested. Pays flat fee or royalties. Offers advance when appropriate. Negotiates rights purchased. Provides advertising, written contract. Finds artists through art exhibitions, art fairs, submissions.

N **SCHLUMBERGER GALLERY**, P.O. Box 2864, Santa Rosa CA 95405. (707)544-8356. Fax: (707)538-1953. E-mail: sande@schlumberger.org. **Owner:** Sande Schlumberger. Estab. 1986. Art publisher, distributor and gallery. Publishes and distributes limited editions, posters, original paintings and sculpture. Clients: collectors, designers, distributors, museums, galleries, film and television set designers. Current clients include: Bank of America Collection, Fairmont Hotel, Editions Ltd., Sonoma Cutter Vineyards, Dr. Robert Jarvis Collection and Sparks Collection.

Needs: Seeking decorative art for the serious collector and the designer market. Prefers trompe l'oeil, realist, architectural, figure, portrait. Artists represented include Charles Giulioli, Deborah Deichler, Susan Van Camden, Aurore Carnero, Borislav Satijnac, Robert Hughes, Fletcher Smith and Tom Palmore. Editions created by collaborating with the artist or by working from an existing painting. Approached by 50 artists/year.

First Contact & Terms: Send query letter with tearsheets and photographs. Samples are not filed and are returned by SASE if requested by artist. Publisher/Distributor will contact artist for portfolio review if interested. Portfolio should include color photographs and transparencies. Negotiates payment. Offers advance when appropriate. Rights purchased vary according to project. Provides advertising, in-transit insurance, insurance while work is at firm, promotion, shipping to and from firm, written contract and shows. Finds artists through exhibits, referrals, submissions and "pure blind luck."

Tips: "Strive for quality, clarity, clean lines and light, even if the style is impressionistic. Bring spirit into your images. It translates!"

N SEGAL FINE ART, 594 S. Arthur Ave., Louisville CO 80027. (800)999-1297. (303)926-6800. Fax: (303)926-0340. E-mail: sfa@segalfineart.com. Website: www.segalfineart.com. **Artist Liason:** Greg Segal. Estab. 1986. Art publisher. Publishes limited editions. Clients: galleries and H-D dealerships.

Needs: Seeking creative and fashionable art for the serious collector and commercial market. Considers oil, watercolor, mixed media and pastel. Artists represented include David Uhl, Scott Jacobs and Tom Fritz. Publishes limited edition serigraphs, mixed media pieces and posters.

First Contact & Terms: Send query letter with slides or résumé, bio and photographs. Samples are not filed and are returned by SASE. Responds in 2 months. To show portfolio, mail slides, color photographs, bio and résumé. Offers advance when appropriate. Negotiates payment method and rights purchased. Requires exclusive representation of artist. Provides promotion.

Tips: Advises artists to "remain connected to their source of inspiration."

✓ ROSE SELAVY OF VERMONT, Division of Applejack Art Partners, P.O. Box 1528, Historic Rt. 7A, Manchester Center VT 05255. (802)362-0373. Fax: (802)362-1082. E-mail: michael@applejackart.com. Website: www.applejackart.com. Publishes/distributes unlimited edition fine art prints. Clients: galleries, decorators, frame shops, distributors, architects, corporate curators, museum shops and giftshops.

Needs: Seeking decorative art for the serious collector, commercial and designer markets. Considers oil, acrylic, watercolor, mixed media, pastel and pen & ink. Prefers folk art, antique, traditional and Botanical. Artists represented include Susan Clickner and Valorie Evers Wenk. Editions created by collaborating with the artist or by working from an existing painting.

First Contact & Terms: Send query letter with brochure, photocopies, photographs, slides and tearsheets. Samples are not filed and are returned by SASE. Responds only if interested. Company will contact artist for portfolio review if interested. Negotiates payment. Offers advance when appropriate. Rights purchased vary according to project. Usually requires exclusive representation of artist. Provides promotion and written contract. Also needs freelancers for design. Finds artists through art exhibitions and art fairs.

N SIDE ROADS PUBLICATIONS, 177 NE 39th St., Miami FL 33137. (305)438-8828. Fax: (305)576-0551. E-mail: sideropub@aol.com. Website: www.sideroadspub.com. Estab. 1998. Art publisher and distributor of originals and handpulled limited edition serigraphs. Clients: galleries, decorators and frame shops.

Needs: Seeking creative art for the commercial market. Considers oil, acrylic, mixed media and sculpture. Open to all themes and styles. Artists represented include Clemens Briels. Editions created by working from an existing painting. Also needs freelancers for design.

First Contact & Terms: Send query letter with brochure, photographs, résumé, slides and SASE. Samples are filed or returned by SASE. Company will contact artist for portfolio review if interested. Payment on consignment basis. Rights purchased vary according to project. Requires exclusive representation of artist. Provides advertising and promotion. Finds artists through art exhibitions and artists' submissions.

SIPAN LLC, 300 Glenwood Ave., Raleigh NC 27603. Phone/fax: (919)833-2535. **Member:** Owen Walker III. Estab. 1994. Art publisher. Publishes handpulled originals. Clients: galleries and frame shops.

Needs: Seeking art for the serious collector and the commercial market. Considers oil, acrylic, watercolor. Prefers traditional themes. Artists represented include Altino Villasante. Editions created by collaborating with the artist. Approached by 5 artists/year. Publishes/distributes the work of 1 emerging artist/year.

First Contact & Terms: Send photographs, SASE and transparencies. Samples are not filed and are returned by SASE. Responds in 2 weeks. Company will contact artist for portfolio review of color final art if interested. Negotiates payment. Offers advance when appropriate. Buys all rights. Requires exclusive representation of artist. Provides advertising, in-transit insurance, insurance while work is at firm, promotion, written contract.

[N] [globe] SJATIN BV, P.O. Box 4028, 5950 AA Belfeld/Holland. 3177 475 1998. Fax: 31774 475 1965. E-mail: art@sjatin.nl. Website: www.sjatin.nl. **President:** Inge Colbers. Estab. 1977. Art publisher. Publishes handpulled originals, limited editions, fine art prints. Licenses romantic art to appear on placemats, notecards, stationery, photo albums, posters, puzzles and gifts. Clients: furniture stores, department stores. Current clients include: Karstadt (Germany), Prints Plus (USA).
 ● Sjatin actively promotes worldwide distribution for artists they sign.
Needs: Seeking decorative art for the commercial market. Considers oil, acrylic, watercolor, mixed media, pastel. Prefers romantic themes, florals, landscapes/garden scenes, women. Artists represented include Willem Haenraets, Peter Motz, Reint Withaar. Editions created by collaborating with the artist or by working from an existing painting. Approached by 50 artists/year. "We work with 20 artists only, but publish a very wide range from cards to oversized prints and we sell copyrights."
First Contact & Terms: Send brochure and photographs. Responds only if interested. Company will contact artist for portfolio review of color photographs (slides) if interested. Negotiates payment. Offers advance when appropriate. Buys all rights. Provides advertising, promotion, shipping from firm and written contract (if requested).
Tips: "Follow the trends in interior decoration; look at the furniture and colors. I receive so many artworks that are beautiful and very artistic, but are not commercial enough for reproduction. I need designs which appeal to many many people, worldwide such as flowers, gardens, interiors and kitchen scenes. I do not wish to receive graphic art. Artists entering the poster/print field should attend the I.S.F. Show in Birmingham, Great Britain or the ABC show in Atlanta."

[N] SOHO GRAPHIC ARTS WORKSHOP, 433 W. Broadway, Suite 5, New York NY 10012. (212)966-7292. **Director:** Xavier H. Rivera. Estab. 1977. Art publisher, distributor and gallery. Publishes and distributes limited editions.
Needs: Seeking art for the serious collector. Considers prints. Editions created by collaborating with the artist or working from an existing painting. Approached by 10-15 artists/year.
First Contact & Terms: Send résumé. Responds in 2 weeks. Artist should follow-up with letter after initial query. Portfolio should include slides and 35mm transparencies. Negotiates payment. No advance. Buys first rights. Provides written contract.

[✓] SOMERSET HOUSE PUBLISHING, 10688 Haddington Dr., Houston TX 77043. (800)444-2540. Fax: (713)465-6062. E-mail: sallen@somersethouse.com or dklepper@somersethouse.com. Website: www. somersethouse.com. **Executive Vice President:** Stephanie Allen. Licensing: Daniel Klepper. Estab. 1972. Art publisher of fine art limited and open editions, handpulled original graphics, offset reproductions, giclees and canvas transfers. Clients include independent galleries in U.S., Canada, Australia.
Needs: Seeking fine art for the serious collector and decorative art for the designer market. Considers oil, acrylic, watercolor, mixed media, pastel. Also prefer religious art. Artists represented include G. Harvey, Larry Dyke, Nancy Glazier, Martin Grelle, Tom du Bois, Christa Kieffer and J.D. Challenger. Editions created by collaborating with the artist or by working from an existing painting. Approached by 1,500 artists/year. Publishes the work of 7 emerging, 4 mid-career and 7 established artists/year.
First Contact & Terms: Send query letter accompanied by 10-12 slides or photos representative of work with SASE. Samples are filed for future projects unless return is requested. Samples are not filed and are returned. Responds in 2 months. Publisher will contact artist for portfolio review if interested. Pays royalties. Rights purchased vary according to project. Provides advertising, insurance in-transit and while work is at firm, promotion, shipping from firm, written contract.
Tips: "Considers mature, full-time artists. Special consideration given to artists with originals selling above $5,000. Be open to direction."

[globe] JACQUES SOUSSANA GRAPHICS, 37 Pierre Koenig St., Jerusalem 91041 Israel. Phone: 972-2-6782678. Fax: 972-2-6782426. E-mail: jsgraphics@soussanart.com. Website: www.soussanart.com. Estab. 1973. Art publisher. Publishes handpulled originals, limited editions, sculpture. Clients: galleries, decorators, frame shops, distributors, architects. Current clients include: Royal Beach Hotel, Moriah Gallery, London Contemporary Art.
Needs: Seeking decorative art for the serious collector and designer market. Considers oil, watercolor and sculpture. Artists represented include Calman Shemi, Gregory Kohelet, Zina Rothman, Lea Avizedek, Adriana Naveh, Sami Briss, Edwin Salomon, and Hoshe Castel. Editions created by collaborating with the artist. Approached by 20 artists/year. Publishes/distributes the work of 5 emerging, 3 mid-career and 2 established artists/year.
First Contact & Terms: Send query letter with brochure, slides. To show portfolio, artist should follow-up with letter after initial query. Portfolio should include color photographs.

N SPORT'EN ART, R.R. #3, Box 17, Sullivan IL 61951-1058. (217)797-6770. E-mail: sportart@moultr ie.com. Large publisher/distributor of limited edition prints and posters featuring outdoor wildlife sports (i.e. hunting and fishing) images. **Contact:** Dan Harshman.

First Contact & Terms: Send query letter with slides and SASE. Publisher will contact for portfolio review if interested.

N SPORTS ART INC, Dept. AM, N. 1675 Powers Lake Rd., Powers Lake WI 53159. (800)552-4430. Fax: (262)279-9830. E-mail: ggg-golfgifts@elknet.net. Website: www.golfgiftsandart.com. **President:** Dean Chudy. Estab. 1989. Art publisher and distributor of limited and unlimited editions, offset reproductions and posters. Clients: over 2,000 active art galleries, frame shops and specialty markets.

Needs: Seeking artwork with creative artistic expression for the serious collector and the designer market. Considers oil, watercolor, acrylic, pastel, pen & ink and mixed media. Prefers sports themes. Artists represented include Ken Call and Brent Hayes. Editions created by collaborating with the artist or working from an existing painting. Approached by 150 artists/year. Distributes the work of 30 emerging, 60 mid-career and 30 established artists/year.

First Contact & Terms: Send query letter with brochure showing art style or résumé, tearsheets, SASE, slides and photographs. Accepts submissions on disk. Samples are filed or returned by SASE if requested by artist. To show a portfolio, mail thumbnails, slides and photographs. Pays royalties of 10%. Offers an advance when appropriate. Negotiates rights purchased. Sometimes requires exclusive representation of the artist. Provides promotion and shipping from firm.

Tips: "We are interested in generic sports art that captures the essence of the sport as opposed to specific personalities."

SULIER ART PUBLISHING AND DESIGN RESOURCE NETWORK, 111 Conn Terrace, Lexington KY 40508-3205. (859)259-1688. Fax: (859)296-0650. E-mail: info@NeilSuliershopmall.com. Website: www.Homeplaceproducts.com. Estab. 1969. **Art Director:** Neil Sulier. Art publisher and distributor. Publishes and distributes handpulled originals, limited and unlimited editions, posters, offset reproductions and originals. Clients: designers.

Needs: Seeking creative, fashionable and decorative art for the serious collector and the commercial and designer markets. Considers oil, watercolor, mixed media, pastel and acrylic. Prefers impressionist. Artists represented include Judith Webb, Neil Sulier, Eva Macie, Neil Davidson, William Zappone, Zoltan Szabo, Henry Faulconer, Mariana McDonald. Editions created by collaborating with the artist or by working from an existing painting. Approached by 20 artists/year. Publishes the work of 5 emerging, 30 mid-career and 6 established artists/year. Distributes the work of 5 emerging artists/year.

First Contact & Terms: Send query letter with brochure, slides, photocopies, résumé, photostats, transparencies, tearsheets and photographs. Samples are filed or are returned. Responds only if interested. Request portfolio review in original query. Artist should follow up with call. Publisher will contact artist for portfolio review if interested. Portfolio should include slides, tearsheets, final art and photographs. Pays royalties of 10%, on consignment basis or negotiates payment. Offers advance when appropriate. Negotiates rights purchased (usually one-time or all rights). Provides in-transit insurance, promotion, shipping to and from firm, insurance while work is at firm and written contract.

N SUMMIT PUBLISHING, 746 Higuera, Suite 4, San Luis Obispo CA 93401. (805)549-9700. Fax: (805)549-9710. E-mail: summit@summitart.com. Website: www.summitart.com. **Owner:** Ralph Gorton. Estab. 1987. Art publisher, distributor and gallery. Publishes and distributes handpulled originals and limited editions.

Needs: Seeking creative, fashionable and decorative art for the serious collector. Considers oil, watercolor, mixed media and acrylic. Prefers fashion, contemporary work. Artists represented include Manuel Nunez, Catherine Abel and Tim Huhn. Editions created by collaborating with the artist or by working from an existing painting. Approached by 20 artists/year. Publishes and distributes the work of emerging, mid-career and established artists.

First Contact & Terms: Send postcard size sample of work or send query letter with brochure, résumé, tearsheets, slides, photographs and transparencies. Samples are filed. Responds in 5 days. Artist should follow-up with call. Publisher/Distributor will contact artist for portfolio review if interested. Portfolio should include color thumbnails, roughs, final art, tearsheets and transparencies. Pays royalties of 10-15%, 60% commission or negotiates payment. Offers advance when appropriate. Buys first rights or all rights. Requires exclusive representation of artist. Provides advertising, in-transit insurance, insurance while work is at firm, promotion, shipping to and from firm and written contract. Finds artists through attending art exhibitions, art fairs, word of mouth and submissions. Looks for artists at Los Angeles Expo and New York Expo.

Tips: Recommends artists attend New York Art Expo, ABC Shows.

Creating images in a series such as the "Tropical Atrium" duo by Carol Hallock may increase your visibility to all kinds of poster and print distributors, mass market licensers and giftware companies. Their target markets are expansive, and venues such as restaurants, hotels, recreation centers, and even city visitor bureaus usually purchase bright, inviting images in pairs. Hallock's "Tropical Atrium" is an example of dozens of landscape-oriented wall art creations promoted by Sunset Marketing.

SUNSET MARKETING, 5908 Thomas Dr., Panama City Beach FL 32408. (850)233-6261. Fax: (850)233-9169. E-mail: info@sunsetartprints.com. Website: www.sunsetartprints.com. **Product Development:** Leah Moseley. Estab. 1986. Art publisher and distributor of unlimited editions, canvas transfers and fine art prints. Clients: galleries, decorators, frame shops, distributors and corporate curators. Current clients include: Paragon, Propac, Uttermost, Lieberman's and Bruce McGaw.
Needs: Seeking fashionable and decorative art for the commercial and designer market. Considers oil, acrylic and watercolor art and home decor furnishings. Artists represented include Steve Butler, Merri Paltinian, Van Martin, Kimberly Hudson, Carol Flallock and Barbara Shipman. Editions created by collaborating with the artist.
First Contact & Terms: Send query letter with brochure, photocopies and photographs. Samples are filed. Company will contact artist for portfolio review of color final art, roughs and photographs if interested. Requires exclusive representation of artist.

SYRACUSE CULTURAL WORKERS, P.O. Box 6367, Syracuse NY 13217. (315)474-1132. Fax (315)475-1277. E-mail: scwart@dreamscape.com. Website: www.syrculturalworkers.org. **Art Director:** Karen Kerney. Produces posters, notecards, postcards, greeting cards, T-shirts and calendars that are feminist, multicultural, lesbian/gay allied, racially inclusive and honor elders and children.
Needs: Art guidelines free for SASE with first-class postage and also available on company's website.
First Contact & Terms: Pays flat fee, $85-400; royalties of 6% of gross sales.

JOHN SZOKE EDITIONS, 591 Broadway, 3rd Floor, New York NY 10012-3232. (212)219-8300. E-mail: info@johnszokeeditions.com. Website: www.johnszokeeditions.com or www.jamesrizzi.com. **Director:** John Szoke. Produces limited edition handpulled originals for galleries, museums and private collectors.
● This prestigious publisher works with many of the biggest names in contemporary art. He is constantly offering new editions, but is not considering new artists at the present time. See his website for a look at limited edition prints by well-known artists.

Needs: Artists represented include James Rizzi, Janet Fish, Peter Milton, Burton Morris, Richard Haas and others.

[N] TAHARAA FINE ART, P.O. Box 1810 Koloa HI 96756. (808)742-8882. Toll Free: (888)828-7311. Fax: (808)742-1348. E-mail: info@taharaafineart.com. Website: Taharaafineart.com. **Owner:** Neil Stein. Estab. 1998. Art publisher of handpulled originals, limited editions and giclees. Clients: all wholesale—galleries, decorators, etc. Current clients include: Pacific Fine Art, Atlantis S/B, Volcano Art Center and Polynesian Culturl Center.
Needs: Seeking creative and decorative art for the serious collector and the commercial and designer markets. Considers oil, acrylic, watercolor, mixed media and pastel. "We prefer tropical themes or styles but will accept any wonderful art." Artists represented include Marian Berger, Raoul Vitale and Anastasia. Editions created by collaborating with the artist and by working from an existing painting. Approached by 150 artists/year. Publishes 2 established artists/year.
First Contact & Terms: Send query letter with brochure, photographs, résumé, slides and transparencies. Artist should follow up with call after initial query. Samples are filed or returned. Company will contact artist for portfolio review of color photographs if interested. Negotiates payment and rights purchased. Usually requires exclusive representation of artist. Provides advertising, in-transit insurance, insurance while work is at firm, promotion, shipping and written contract.

TAKU GRAPHICS, 5763 Glacier Hwy., Juneau AK 99801. (907)780-6310. Fax: (907)780-6314. E-mail: amhamey@ptialaska.net. Website: www.takugraphics.com. **Owner:** Adele Hamey. Estab. 1991. Distributor. Distributes handpulled originals, limited edition, unlimited edition, fine art prints, offset reproduction, posters, hand-painted silk ties, paper cast, bead jewelry and note cards. Clients: galleries and gift shops.
Needs: Seeking art from Alaska and the Pacific Northwest exclusively. Considers oil, acrylic, watercolor, mixed media, pastel and pen & ink. Prefers regional styles and themes. Artists represented include JoAnn George, Ann Miletich, Brenda Schwartz and Barry Herem. Editions created by working from an existing painting. Approached by 30-50 artists/year. Distributes the work of 20 emerging, 6 mid-career and 6 established artists/year.
First Contact & Terms: Send query letter with brochure, photographs and tearsheets. Samples are not filed and are returned. Responds in 1 month. Company will contact artist for portfolio review if interested. Pays on consignment basis: firm receives 35% commission. No advance. Requires exclusive representation of artist. Provides advertising, insurance while work is at firm, promotion, sales reps, trade shows and mailings. Finds artists through word of mouth.

[N] BRUCE TELEKY INC., 625 Broadway, 4th Floor, New York, NY 10012. (800)835-3539 or (212)677-2559. Fax: (212)677-2253. Publisher/Distributor. **President:** Bruce Teleky. Clients include galleries, manufacturers and other distributors.
Needs: Works from existing art to create open edition posters or works with artist to create limited editions. Artists represented include Romare Bearden, Faith Ringgold, Joseph Reboli, Barbara Appleyard, Norman Rockwell, Gigi Boldon and Daniel Pollera.
First Contact & Terms: Send query letter with slides, transparencies, postcard or other appropriate samples and SASE. Publisher will contact artist for portfolio review if interested. Payment negotiable.

[N] THINGS GRAPHICS & FINE ART, 1522 14th St. NW, Washington DC 20005. (202)667-4028. Fax: (202)328-2258. E-mail: sales@thingsgraphics.com. Website: www.thingsgraphics.com. **Special Assistant—New Acquisitions:** Edward Robertson. Estab. 1984. Art publisher and distributor. Publishes/distributes limited and unlimited editions, offset reproductions and posters. Clients: gallery owners. Current clients include Savacou Gallery and Deck the Walls.
Needs: Seeking artwork with creative expression for the commercial market. Considers oil, watercolor, acrylic, pen & ink, mixed media and serigraphs. Prefers Afro-American, Caribbean and "positive themes." Artists represented include Charles Bibbs, John Holyfield, James Denmark and Leroy Campbell. Editions created by working from an existing painting. Approached by 60-100 artists/year. Publishes the work of 1-5 emerging, 1-5 mid-career and 1-5 established artists/year. Distributes the work of 10-20 emerging, 10-20 mid-career and 60-100 established artists/year.
First Contact & Terms: Send query letter with résumé, tearsheets, photostats, photocopies, slides, photographs, transparencies and full-size print samples. Samples are filed. Responds in 3-4 weeks. To show a portfolio, mail thumbnails, tearsheets, photographs, slides and transparencies. Payment method is negotiated. Does not offer an advance. Negotiates rights purchased. Provides promotion and a written contract.
Tips: "Continue to create new works; if we don't use the art the first time, keep trying us."

Ⓝ TRIAD ART GROUP, 73 Wynnewood Lane, Stamford CT 06903. (203)329-3895. Fax: (203)329-3896. E-mail: triadart@optonline.net. Website: www.royoart.com. **President:** Greg Bloch. Art publisher/distributor of handpulled originals, limited editions and sculpture. Clients: galleries.
Needs: Seeking artwork for the serious collector and the commercial market. Considers oil, acrylic, watercolor, mixed media and pastel. Prefers representational themes and styles. Artists represented include Royo and Vila Nova. Editions created by collaborating with the artist and by working from an existing painting. Approached by 50 artists/year. Publishes/distributes the work of 1 emerging artist, 1 mid-career artist and 1 established artist/year.
First Contact & Terms: Send query letter with brochure, photographs, slides, transparencies and SASE. Samples are not filed and are returned by SASE. Company will contact artist for portfolio review of photographs and transparencies if interested. Pays royalties or pays on consignment basis. Offers advance when appropriate. Rights purchased vary according to project. Requires exclusive representation of artist. Provides advertising, in-transit insurance, insurance while work is at firm, promotion, shipping and written contract. Finds artists through art exhibitions and fairs, word of mouth, World Wide Web, art reps, sourcebooks and other publications, artists' submissions and watching art competitions.

Ⓝ UMOJA FINE ARTS, 16250 Northland Dr., Suite 104, Southfield MI 48075. (800)469-8701. E-mail: info@umojafinearts.com. Website: www.umojafinearts.com. Estab. 1995. Art publisher and distributor specializing in African-American posters, graphics, painting and sculpture. **President:** Ian Grant.
Needs: Seeking fine art and decorative images and sculpture for the serious collector as well as the commercial market. Artists include Lazarus Bain, Jeff Clark, Joe Dobbins, Marcus Glenn, David Haygood, Annie Lee, Jimi Claybrooks, Joe Dobbins Sr., Ivan Stewart. Editions created by collaborating with the artist. Approached by 40-50 artists/year. Publishes the work of 1-2 emerging, 1-2 mid-career and 1 established artists/year. Distributes the work of 2-3 emerging, 2-3 mid-career and 2 established artists/year.
First Contact & Terms: Send query letter with slides and SASE. Samples are filed. Responds only if interested in 1 month. Publisher will contact for portfolio review if interested. Buys all rights. Requires exclusive representation of artist. Provides advertising, insurance while work is at firm and written contract.

Ⓝ UNIVERSAL PUBLISHING, 821 E. Ojai Ave., Ojai CA 93023. (805)640-0057. Fax: (805)640-0059. E-mail: milgallery@aol.com. Website: www.militarygallery.com. **Vice President:** Andrew Wilkey. Estab. 1967. Art publisher and distributor. Publishes/distributes limited edition, unlimited edition, canvas transfers, fine art prints, offset reproduction and posters. Clients: galleries and mail order. Current clients include: The Soldier Factory and Virginia Bader Fine Art.
Needs: Seeking creative, fashionable and decorative art. Considers oil, acrylic, watercolor and pen & ink. Prefers aviation and maritime. Artists represented include Robert Taylor and Nicolas Trudgian. Editions created by collaborating with the artist or by working from an existing painting. Approached by 10 artists/year. Publishes work of 1 emerging, 1 mid-career and 1 established artist/year. Distributes the work of 1 emerging, 1 mid-career and 1 established artist/year.
First Contact & Terms: Send query letter with photographs, slides, tearsheets and transparencies. Samples are not filed and are returned. Responds in 2 days. Company will contact artist for portfolio review if interested. Portfolio should include photographs, tearsheets and transparencies. Payment negotiable. Buys all rights. Requires exclusive representation of artist. Provides advertising, promotion and written contract. Finds artists through word of mouth.
Tips: "Get to know us via our catalogs."

☑ VARGAS FINE ART PUBLISHING, INC., Southgate at Washington Business Park. 9700 Martin Luther King, Jr. Hwy., Suite D, Lanham MD 20706. (301)731-5175. Fax: (301)731-5712. E-mail: vargasfineart@aol.com. Website: www.vargasfineart.com. **President:** Elba Vargas-Colbert. Estab. 1987. Art publisher and worldwide distributor of serigraphs, limited and open edition offset reproductions, etchings, sculpture, music boxes, keepsake boxes, ceramic art tiles, art magnets, art mugs, collector plates, calendars, canvas transfers and figurines. Clients: galleries, frame shops, museums, decorators, movie sets and TV.
Needs: Seeking creative art for the serious collector and commercial market. Considers oil, watercolor, acrylic, pastel pen & ink and mixed media. Prefers ethnic themes. Artists represented include Joseph Holston, Kenneth Gatewood, Tod Haskin Fredericks, Betty Biggs, Charles Bibbs, Sylvia Walker, Ted Ellis, Leroy Campbell, William Tolliver, Sylvia Walker, Paul Goodnight, Wayne Still and Paul Awuzie. Approached by 100 artists/year. Publishes/distributes the work of about 80 artists.
First Contact & Terms: Send query letter with résumé, slides and/or photographs. Samples are filed. Responds only if interested. To show portfolio, mail photographs. Payment method is negotiated. Requires exclusive representation of the artist.
Tips: "Continue to hone your craft with an eye towards being professional in your industry dealings."

N VERNON FINE ART AND EDITIONS, 1738 Treble Dr., 504, Humble TX 77338. (281)446-4340. Fax: (413)446-4657. E-mail: vern.muenz.art@prodigy.net. Website: www.kvernon.com. **Owner:** Karen Vernon. Estab. 1978. Art publisher and distributor. Publishes and distributes handpulled originals, limited and unlimited editions, offset reproductions and posters. Clients: galleries, frame shops, designers, hotels. Current clients include: Hospitality Galleries (Orlando), Artcorp (Taiwan), Baldwin Art (Highpoint, Ashton-Houston, Atlanta, Dallas, Highpoint).

Needs: Seeking creative art for the serious collector, commercial and designer markets. Considers oil, watercolor, pastel and acrylic. Prefers realism ("color is important"). Artists represented include Vernon, Archer, Muenzemayer, Spann, Eckard, Jackson, Johnson, Stanford. Editions created by working from an existing painting. Approached by 50 artists/year. Publishes the work of 5 mid-career and 2 established artists/year. Distributes the work of 10 established artist/year.

First Contact & Terms: Send query letter with résumé, slides, photographs and photocopies. Samples are not filed and are returned by SASE if requested by artist. Responds in 2 weeks. Publisher/Distributor will contact artist for portfolio review if interested. Portfolio should include b&w and color photographs and slides. Pays royalties. Offers advance when appropriate. Rights purchased vary according to project. Provides advertising, in-transit insurance, insurance while work is at firm, promotion, shipping from firm and written contract. Finds artists through submissions, art fairs and trade shows.

Tips: Recommends artists attend ABC Show and Art Expo and read *Decor* and *Art Business News*.

✓ N VIBRANT FINE ART, 3941 W. Jefferson Blvd., Los Angeles CA 90016. (323)766-0818. Fax: (323)737-4025. E-mail: vibrant2@earthlink.net. **Art Director:** Phyliss Stevens. Licensing: Tom Nolen. Design Coordinator: Jackie Stevens. Estab. 1990. Art publisher and distributor. Publishes and distributes fine art prints, limited and unlimited editions and offset reproductions. Licenses ethnic art to appear on ceramics, gifts, textiles, miniature art, stationery and note cards. Clients: galleries, designers, giftshops, furniture stores and film production companies.

Needs: Seeking decorative and ethnic art for the commercial and designer markets. Considers oil, watercolor, mixed media and acrylic. Prefers African-American, Native-American, Latino themes. Artists represented include Sonya A. Spears, Van Johnson, Momodou Ceesay, William Crite and Darryl Daniels. Editions created by collaborating with the artist or by working from an existing painting. Approached by 40 artists/year. Publishes the work of 5 emerging, 5 mid-career and 2 established artists/year. Distributes the work of 5 emerging, 5 mid-career and 2 established artists/year. Also needs freelancers for design. 20% of products require design work. Designers should be familiar with Illustrator and Mac applications. Prefers local designers only.

First Contact & Terms: Send query letter with brochure, tearsheets and slides. Samples are filed or are returned by SASE. Publisher/distributor will contact artist for portfolio review if interested. Portfolio should include color tearsheets, photographs, slides and biographical sketch. Pays royalties of 10%. Rights purchased vary according to project. Provides advertising, insurance while work is at firm, promotion, written contract and shipping from firm. Finds artists through art exhibitions, referrals, sourcebooks, art reps, submissions.

Tips: "Ethnic art is hot. The African-American art market is expanding. I would like to see more submissions from artists that include slides of ethnic imagery, particularly African-American, Latino and Native American. We desire contemporary cutting edge, fresh and innovative art. Artists should familiarize themselves with the technology involved in the printing process. They should possess a commitment to excellence and understand how the business side of the art industry operates."

N SHAWN VINSON FINE ART, 119 E. Court St., Suite 100, Decatur GA 30030. (404)370-1720. Fax: (404)370-1845. E-mail: shawnvinson@mindspring.com. Website: www.shawnvinsongallery.com. **Owner:** Shawn Vinson. Fine arts gallery, dealer and consultant, specializing in contemporary paintings and works on paper. Clients: galleries, designers and collectors. Current clients include: Gallery 71, New York City, Universal Studios Florida, Naomi Judd.

Needs: Seeking fine art originals for the serious collector. Considers oil, acrylic, mixed media and pastel. Prefers contemporary and painterly styles. Represents American, English and Dutch artists. Approached by 6-12 artists/year. Publishes the work of 1-2 emerging, 1-2 mid-career and 1-2 established artists/year. Distributes the work of 8-10 emerging, 8-10 mid-career and 8-10 established artists/year.

First Contact & Terms: Send query letter with photographs, résumé, SASE, slides and tearsheets. Accepts disk submissions compatible with Microsoft applications. Samples are filed. Responds only if interested. Company will contact artist for portfolio review if interested. Pays on consignment basis or negotiates payment. Rights purchased vary according to project. Provides advertising, in-transit insurance, insurance while work is at firm and promotion.

Tips: "Maintain integrity in your work. Limit number of dealers."

N VLADIMIR ARTS USA INC., 2504 Sprinkle Rd., Kalamazoo MI 49001. (616)383-0032. Fax: (616)383-1840. E-mail: vladimir@vladimirarts.com. Website: www.vladimirarts.com. Art publisher, distributor and gallery. Publishes/distributes handpulled originals, limited edition, unlimited edition, canvas transfers, fine art prints, monoprints, monotypes, offset reproduction, posters and giclee. Clients: galleries, decorators, frame shops, distributors, architects, corporate curators, museum shops, giftshops and West Point military market.

Needs: Seeking creative, fashionable and decorative art for the serious collector, commercial market and designer market. Considers oil, acrylic, watercolor, mixed media, pastel, pen & ink and sculpture. Artists represented include Hongmin Zou, Ben Maile, Bev Doolittle, Charles Wysocki and Paul Steucke. Editions created by collaborating with the artist. Approached by 30 artists/year. Publishes work of 10 emerging, 10 mid-career and 10 established artists/year. Distributes work of 1-2 emerging, 1 mid-career and 1-2 established artists/year.

First Contact & Terms: Send query letter with brochure, photocopies, photographs and tearsheets. Accepts disk submissions compatible with Illustrator 5.0 for Windows 95 and later. Samples are filed or returned with SASE. Responds only if interested. Company will contact artist for portfolio review if interested. Portfolio should include b&w, color, fine art, photographs and roughs. Negotiates payment. No advance. Provides advertising, promotion and shipping from our firm. Finds artists through attending art exhibitions, art fairs, word of mouth, World Wide Web, art reps, sourcebooks, artists' submissions and watching art competitions.

Tips: "The industry is growing in diversity of color. There are no limits."

N WANDA WALLACE ASSOCIATES, 323 E. Plymouth, Suite #2, Inglewood CA 90306-0436. (310)419-0376. Fax: (310)419-0382. Website: www.wandawallace.com. **President:** Wanda Wallace. Estab. 1980. Art publisher, distributor, gallery and consultant for corporations, businesses and residential. Publishes handpulled originals, limited and unlimited editions, canvas transfers, fine art prints, monotypes, posters and sculpture. Clients: decorators, galleries, distributors.

● This company operates a nonprofit organization called Wanda Wallace Foundation that educates children through utilizing art and creative focus.

Needs: Seeking art by and depicting African-Americans. Considers oil, acrylic, watercolor, mixed media, pastel, pen & ink and sculpture. Prefers traditional, modern and abstract styles. Artists represented include Alex Beaujour, Dexter, Aziz, Momogu Ceesay, Charles Bibbs, Betty Biggs, Tina Allen, Adrian Won Shue. Editions created by collaborating with the artist or by working from an existing painting. Approached by 100 artists/year. Publishes/distributes the work of 10 emerging, 7 mid-career and 3 established artists/year.

First Contact & Terms: Send query letter with brochure, photocopies, photographs, tearsheets and transparencies. Samples are filed and are not returned. Responds only if interested. Company will contact artist for portfolio review of color, final art, photographs and transparencies. Pays on consignment basis: firm receives 50% commission or negotiates payment. Offers advance when appropriate. Buys all rights. Requires exclusive representation of artist. Provides advertising, promotion, shipping from firm and written contract.

Tips: "African-American art is very well received. Depictions that sell best are art by black artists. Be creative, it shows in your art. Have no restraints."

N WEBSTER FINE ART LTD., 1185 Tall Tree Rd., Clemmons NC 27012. (336)712-0900. Fax: (336)712-0974. E-mail: ctm@triad.rr.com. Website: www.websterfineart.com. **Design Director/Artist/Computer Specialist:** Cecilia T. Myrick. Art publisher/distributor. Estab. 1987. Publishes unlimited editions and fine art prints. Clients: galleries, frame shops, distributors, giftshops.

Needs: Considers oil, acrylic, watercolor, pastel, pen & ink, mixed media. "Seeking creative artists that can take directions; decorative, classic, traditional, fashionable, realistic, impressionistic, landscape, artists who know the latest trends." Artists represented include Janice Brooks, Lorraine Rossi, Fiona Butler. Editions created by collaborating with the artist.

First Contact & Terms: Send query letter with brochure, photocopies, photographs, slides, tearsheets, transparencies and SASE. Samples are filed or returned by SASE. Responds in 1 month. Company will contact artist for portfolio review if interested. Negotiates payment. Offers advance when appropriate. Buys all or reprint rights. Finds artists by word of mouth, attending art exhibitions and fairs, submissions and watching art competitions.

Tips: "Check decorative home magazines—*Southern Accents, Architectural Digest, House Beautiful*, etc.—for trends. Understand the decorative art market."

N WHITEGATE FEATURES SYNDICATE, 71 Faunce Dr., Providence RI 02906. (401)274-2149. Website: www.whitegatefeatures.com. **Talent Manager:** Eve Green.

● This syndicate is looking for fine artists and illustrators. See listing in Syndicates section for information on their needs.

First Contact & Terms: "Please send (nonreturnable) slides or photostats of fine arts works. We will call if a project suits your work." Pays royalties of 50% if used to illustrate for newspaper or books.
Tips: "We also work with collectors of fine art and we are starting a division that will represent artists to galleries."

☑ **WILD APPLE GRAPHICS, LTD.**, 526 Woodstock Rd., Woodstock VT 05091. (802)457-3003. Fax: (802)457-5891. E-mail: wildapple@aol.com. Website: www.wildapple.com. **Artist Relations:** Patty Hasson and Nancy Bacon. Director of Licensing: Deborah Legget. Estab. 1990. Art publisher and distributor of open edition prints. Licenses fine art representing over 15 artists for paper products, decorative accessories, kitchen textiles, floor coverings and many others. Clients: frame shops, interior designers, furniture companies and framed picture manufacturers. Current clients include Pier 1, Bombay, Neiman Marcus and stores selling decorative accessories.
Needs: Seeking decorative art for the commercial and designer markets. Considers all 2D media. Artists represented include Warren Kimble, Nancy Pallan, Deborah Schenck, David Carter Brown, Isabelle de Borchgrave, Cheri Blum, Alberta Hristova, Michael Clark, Carol Rowan and Chris Paschke. Fine art prints created by working from an existing painting or by collaborating with the artist. Approached by 2,000 artists/year. Publishes the work of 75 artists/year.
First Contact & Terms: Send query letter with résumé and slides, photographs or transparencies that represent a broad range of artwork. Samples are returned by SASE. Responds in 2 months. Negotiates payment method and rights purchased. Provides in-transit insurance, insurance while work is at firm, promotion, shipping to and from firm and a written contract. Finds artists through art fairs, museums, galleries and submissions.
Tips: "Don't be trendy. We seek decorative images that will have broad appeal and can stay on walls for a long time. Frightening/destructive, full nudity or deeply religious images are not suitable for our markets. Be aware that techniques have to be tight enough to reproduce well."

▓ **WILD WINGS INC.**, S. Highway 61, Lake City MN 55041. (651)345-5355. Fax: (651)345-2981. Website: www.wildwings.com. **Vice President:** Sara Koller. Estab. 1968. Art publisher, distributor and gallery. Publishes and distributes limited editions and offset reproductions. Clients: retail and wholesale.
Needs: Seeking artwork for the commercial market. Considers oil, watercolor, mixed media, pastel and acrylic. Prefers wildlife. Artists represented include David Maass, Lee Kromschroeder, Ron Van Gilder, Robert Abbett, Michael Sieve and Persis Clayton Weirs. Editions created by working from an existing painting. Approached by 300 artists/year. Publishes the work of 36 artists/year. Distributes the work of numerous emerging artists/year.
First Contact & Terms: Send query letter with slides and résumé. Samples are filed and held for 6 months then returned. Responds in 3 weeks if uninterested or 6 months if interested. Publisher will contact artist for portfolio review if interested. Pays royalties for prints. Accepts original art on consignment and takes 40% commission. No advance. Buys first-rights or reprint rights. Requires exclusive representation of artist. Provides in-transit insurance, promotion, shipping to and from firm, insurance while work is at firm and a written contract.

WINN DEVON ART GROUP, 6015 Sixth Ave. S., Seattle WA 98108. (206)763-9544. Fax: (206)762-1389. **Vice President Product Development:** Karen Schweitzer. Estab. 1976. Art publisher. Publishes open and limited editions, offset reproductions, giclees and serigraphs. Clients: mostly trade, designer, decorators, galleries, retail frame shops. Current clients include: Pier 1, Z Gallerie, Intercontinental Art, Chamton International, Bombay Co.
Needs: Seeking decorative art for the designer market. Considers oil, watercolor, mixed media, pastel, pen & ink and acrylic. Artists represented include Buffet, Gunn, Hayslette, Horning, Hall, Singley, Schaar. Current clients include: Lourenco, Romeu, Shrack, Bernsen/Tunick, Tomao. Editions created by working from an existing painting. Approached by 300-400 artists/year. Publishes and distributes the work of 0-3 emerging, 3-8 mid-career and 8-10 established artists/year.
First Contact & Terms: Send query letter with brochure, slides, photocopies, résumé, photostats, transparencies, tearsheets or photographs. Samples are returned by SASE if requested by artist. Responds in 4-6 weeks. Publisher will contact artist for portfolio review if interested. Portfolio should include "whatever is appropriate to communicate the artist's talents." Pay varies. Rights purchased vary according to project. Provides written contract. Finds artists through attending art exhibitions, agents, sourcebooks, publications, submissions.
Tips: Advises artists to attend Art Expo New York City, ABC Atlanta. "I would advise artists to attend just to see what is selling and being shown, but keep in mind that this is not a good time to approach publishers/exhibitors with your artwork."

Book Publishers

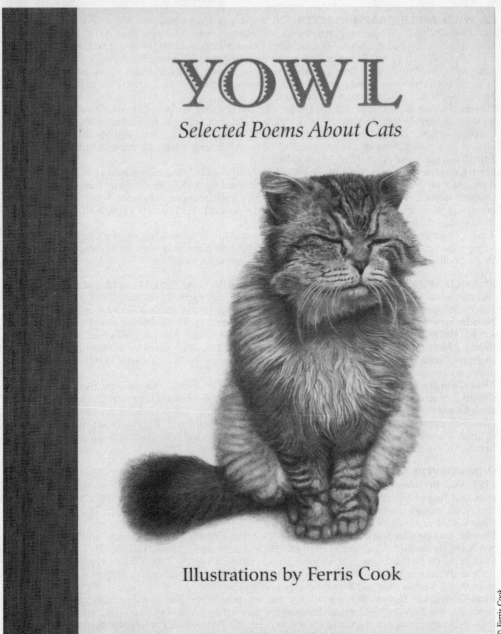

YOWL

Selected Poems About Cats

Illustrations by Ferris Cook

Bulfinch Press, an imprint of Little, Brown and Company published this small volume of poems about cats, illustrated by Ferris Cook. Cook has illustrated six other books of poetry. To illustrate the project, Cook sketched thirty-three different cats. (The cat on the cover, according to Cook's acknowledgements is named "Mr. Bean.")

Artwork for book covers must grab readers' attention and make them want to pick up the book. Secondly, it must show at a glance what type of book it is and who it is meant to appeal to. In addition, the cover has to include basic information such as title, the author's name, the publisher's name, blurbs and price.

The interior of a book is important, too. Designers create the page layouts that direct us through the text and illustrators create artwork to complement the story. This is particularly important in children's books and textbooks. Many publishing companies hire freelance designers with computer skills to design interiors on a contract basis. Look within each listing for the subheading Book Design, to find the number of jobs assigned each year, and how much is paid per project.

Finding your best markets

Within the first paragraph of each listing, we describe the type of books each publisher specializes in. This may seem obvious, but submit only to publishers who specialize in the type of book you want to illustrate or design. There's no use submitting to a publisher of literary fiction if you want to illustrate for children's picture books.

The publishers in this section are just the tip of the iceberg. You can find additional publishers by visiting bookstores and libraries and looking at covers and interior art. When you find covers you admire, write down the name of the books' publishers in a notebook. If the publisher is not listed in *Artist's & Graphic Designer's Market*, go to your public library and ask to look at a copy of *Literary Market Place*, also called *LMP*, published annually by Bowker. The cost of this large directory is prohibitive to most freelancers, but you should become familiar with it if you plan to work in the industry. Though it won't tell you how to submit to each publisher, it does give art directors' names. The book also has a section featuring the winners of the year's book awards, including awards for book design.

How to submit

Send one to five nonreturnable samples along with a brief letter. Never send originals. Most art directors prefer samples 8½ × 11 or smaller that can fit in file drawers. Bulky submissions are considered a nuisance. After sending your initial introductory mailing, you should follow-up with postcard samples every few months to keep your name in front of art directors. If you have an e-mail account and can send TIFF or JPEG files, check the publishers' preferences and see if they will accept submission via e-mail.

PUBLISHING TERMS TO KNOW

Mass market books are sold in supermarkets, newsstands, drugstores, etc. They include paperbacks by popular authors like Stephen King.

Trade books are the hardcovers and paperbacks found only in bookstores and libraries. The paperbacks are larger than those on the mass market racks. They are printed on higher quality paper, and feature matte-paper jackets.

Textbooks feature plenty of illustrations, photographs, and charts to explain their subjects. They are also more likely to need freelance designers.

Small press books are books produced by a small, independent publisher. Many are literary or scholarly in theme, and often feature fine art on the cover.

Backlist titles or **reprints** refer to publishers' titles from past seasons that continue to sell year after year. These books are often updated and republished with freshly designed covers to make them more attractive to readers.

Getting paid

Payment for design and illustration varies depending on the size of the publisher, the type of project and the rights bought. Most publishers pay on a per-project basis, although some publishers of highly illustrated books (such as children's books) pay an advance plus royalties. A few very small presses may only pay in copies.

Illustrating for children's books

Working in children's books requires a specific set of skills. You must be able to draw the same characters in a variety of action poses and situations. Like other publishers, many children's publishers are expanding their product lines to include multimedia projects (CD-ROM and software). A number of children's publishers are listed in this book, but *Children's Writer's & Illustrator's Market*, published by Writer's Digest Books (800)289-0963, is a valuable resource if you enter this field. You can order this essential book on www.writersdigest.com/catalog.

For More Information

If you decide to focus on book publishing, you'll need to become familiar with *Publishers Weekly*, the trade magazine of the industry and its website, www.publishe rsweekly.com. It will keep you abreast of new imprints, publishers that plan to increase their title selection, and the names of new art directors. You should also look for articles on book illustration and design in *HOW* and other graphic design magazines. Book designers like Lorraine Louie, Lucille Tenazas and Chip Kidd are regularly featured, as are cover illustrators like Gary Kelley. To find out about one of the innovators of book design, read *Wendell Minor: Art for the Written Word* edited by Wendell Minor and Florence Friedman Minor (Harvest Books). Other great books to browse through are *Jackets Required: An Illustrated History of American Book Jacket Design, 1920-1950*, by Steven Heller and Seymour Chwast (Chronicle Books), which offers nearly 300 examples of book jackets, and *Covers & Jackets! What the Best-Dressed Books & Magazines are Wearing*, by Steven Heller and Anne Fink (PCB Intl. Inc.).

AAIMS PUBLISHERS, 11000 Wilshire Blvd., P.O. Box 241777, Los Angeles CA 90024-9577. (213)968-1195. E-mail: aaimspub@aol.com. **Director of Art:** Nancy Freeman. Estab. 1969. Publishes hardcover, trade and mass market paperback originals, textbooks. Publishes all types of fiction and nonfiction. Publishes 17 titles/year. Recent titles include: *A Message from Elvis*, by Harry McKinzie; and *USMC Force Recon: A Black Hero's Story*, by Amankwa Adeduro. Book catalog for SASE.
Needs: Uses freelancers for jacket/cover design and illustration. Also for text illustration, multimedia projects and direct mail and book catalog design. Works on assignment only. 80% of freelance work requires knowledge of Microsoft Word and WordPerfect. 7% of titles require freelance art direction.
First Contact & Terms: Send query letter with SASE, photographs and photocopies. Samples are filed or are returned by SASE. Portfolio should include thumbnails and roughs. Sometimes requests work on spec before assigning a job. Buys all rights. Originals are not returned. Pays by the project, negotiated.
Book Design: Assigns 5 freelance design jobs/year and 5 freelance art direction projects/year. Pay varies for design.
Jackets/Cover: Assigns 17 freelance design and 7 freelance illustration jobs/year. Pay varies for design.
Tips: "Looking for design and illustration that is appropriate for the general public. Book design is becoming smoother, softer and more down to nature with expression of love of all—humanity, animals and earth."

A&B PUBLISHERS GROUP, 1000 Atlantic Ave., Brooklyn NY 11238. (718)783-7808. Fax: (718)783-7267. **Production Manager:** Maxwell Taylor. Estab. 1992. Publishes trade paperback originals, calendars and reprints. Types of books include comic books, history, juvenile, preschool and young adult.

Specializes in history. Publishes 15 titles/year. Recent titles include: *Nutrition Made Simple* and *What They Never Told You in History Class, Vol. I and II*. 70% require freelance illustration; 25% require freelance design. Catalog available.

Needs: Approached by 60 illustrators and 32 designers/year. Works with 12 illustrators and 4 designers/year. Prefers local illustrators experienced in airbrush and computer graphics. Uses freelancers mainly for "book covers and insides." 85% of freelance design demands knowledge of Photoshop, Illustrator and QuarkXPress. 60% of freelance design demands knowledge of Photoshop, Illustrator, QuarkXPress and Painter. 20% of titles require freelance art direction.

First Contact & Terms: Designers send query letter with photocopies. Illustrators send postcard sample, photocopies, printed samples or tearsheets. Send follow-up postcard sample every 4 months. Accepts disk submissions from designers compatible with QuarkXPress, Photoshop and Illustrator. Send EPS and TIFF files. Samples are filed. Portfolio review required. Portfolio should include artwork portraying children, animals, perspective, anatomy and transparencies. Rights purchased vary according to project.

Book Design: Assigns 14 freelance design jobs/year. Pays by the hour, $15-65 and also a flat fee.

Jackets/Covers: Assigns 14 freelance design jobs and 21 illustration jobs/year. Pays by the project, $250-1,200. Prefers "computer generated titles, pen & ink and watercolor or airbrush for finish."

Text Illustration: Assigns 12-25 freelance illustration jobs/year. Pays by the hour, $8-25 or by the project $800-2,400 maximum. Prefers "airbrush or watercolor that is realistic or childlike, appealing to young school-age children." Finds freelancers through word of mouth, submissions, NYC school of design.

Tips: "I look for artists who are knowledgeable about press and printing systems—from how color reproduces to how best to utilize color for different presses."

✓ ADAMS MEDIA CORPORATION 57 Littlefield St., Avon MA 02322. (508)427-7100. Fax: (508)427-6790. E-mail: pbeatrice@adamsmedia.com. Website: www.adamsmedia.com. **Art Director:** Paul Beatrice. Estab. 1980. Company publishes hardcover originals, trade paperback originals and reprints. Types of books include biography, business, gardening, pet care, cookbooks, history, humor, instructional, New Age, nonfiction, reference, self-help and travel. Specializes in business and careers. Publishes 100 titles/year. 15% require freelance illustration. Recent titles include: *The Postage Stamp Garden Book*; *Test Your Cat's Psychic Powers*; and *The Everything Cover Letter Book*. Book catalog free by request.

Needs: Works with 8 freelance illustrators and 7-10 designers/year. Buys less than 100 freelance illustrations/year. Uses freelancers mainly for jacket/cover illustration, text illustration and jacket/cover design. 100% of freelance work demands computer skills. Freelancers should be familiar with QuarkXPress 4.1 and Photoshop.

First Contact & Terms: Send postcard sample of work. Samples are filed. Art director will contact artist for portfolio review if interested. Portfolio should include tearsheets. Rights purchased vary according to project, but usually buys all rights.

Jackets/Covers: Assigns 50 freelance design jobs/year. Pays by the project, $700-1,500.

Text Illustration: Assigns 30 freelance illustration jobs/year.

ℕ ADVANTAGE PUBLISHERS' GROUP, 5880 Oberlin Dr., Suite 400, San Diego CA 92121-4794. (858)457-2500. Fax: (858)452-2167. E-mail: joannp@advmkt.com. Website: www.advpubgrp.com. **Managing Editor:** JoAnn Padgett. Imprints include Laurel Glen Publishing (adult trade), Silver Dolphin Books (juvenile trade), Thunder Bay Press (adult promotional). Publishes hardcover originals and reprints, trade paperback originals and reprints and books with craft items. Types of books include coffee table, cookbooks, history, instructional, juvenile, new age, nonfiction, preschool, reference, self help and travel. Specializes in interactive educational titles (books with components) geared to juveniles and families. Publishes 150 titles/year. Recent titles include: *Let's Start Modeling* (Craft Series); *Then & Now Series*. 25% require freelance illustration and design. Book catalog free for 8½×11 SAE with 5 first-class stamps.

Needs: Seeking artists who own rights to large, thematic collections of color art appropriate for juvenile audience. Works with 12 illustrators and 6 designers/year. Prefers freelancers experienced in QuarkXPress for Mac. Uses freelancers mainly for book design and page layout and composition. 100% of freelance design work demands knowledge of Photoshop, Illustrator and QuarkXPress.

First Contact & Terms: Designers send query letter with brochure, photocopies, tearsheets and résumé. Illustrators send postcard sample. Accepts disk submissions. Send EPS files. Samples are filed or returned by SASE. Responds only if interested. Art director will contact artist for portfolio review if interested. Rights purchased vary according to project; negotiable.

Book Design: Assigns 6 freelance design jobs/year. Pays by the hour or by the project.

Jackets/Covers: Assigns 6 freelance design and 6 freelance illustration jobs/year. Pays by the project.

Text Illustration: Assigns 6 freelance illustration jobs/year. Pays by the piece.

ALFRED PUBLISHING CO., INC., 16320 Roscoe Blvd., Box 10003, Van Nuys CA 91410-0003. (818)891-5999. Fax: (818)891-2182. Website: www.alfredpub.com. **Art Director:** Ted Engelbart. Estab.

1922. Book publisher. Publishes trade paperback originals. Types of books include instructional, juvenile, young adult, reference and music. Specializes in music books. Publishes approximately 300 titles/year. Recent titles include: *Blues Guitar for Beginners*, *Anthology of Baroque Keyboard Music* and *Music for Little Mozarts*.

Needs: Approached by 40-50 freelancers/year. Works with 10 freelance illustrators and 5 designers/year. "We prefer to work directly with artist—local, if possible." Uses freelancers mainly for cover art, marketing material, book design and production. Also for jacket/cover and text illustration. Works on assignment only.

First Contact & Terms: Send résumé, SASE and tearsheets. "Photocopies are fine for line art." Samples are filed. Responds only if interested. "I appreciate paid reply cards." To show portfolio, include "whatever shows off your work and is easily viewed." Originals are returned at job's completion.

Jackets/Covers: Assigns 20 freelance design and 25 illustration jobs/year. Pays by the project, $300-800. "We generally prefer fairly representational styles for covers, but anything upbeat in nature is considered."

Text Illustration: Assigns 15 freelance illustration jobs/year. Pays by the project, $350-2,500. "We use a lot of line art for b&w text, watercolor or gouache for 4-color text."

☑ **ALLYN AND BACON, INC.,** 75 Arlington St., Suite 300, Boston MA 02116. (617)848-6000. Fax: (617)455-1378. E-mail: Linda_Knowles@ablongman.com. Website: www.ablongman.com. **Art Director:** Linda Knowles. Publishes more than 300 hardcover and paperback textbooks/year. 60% require freelance cover designs. Subject areas include education, psychology and sociology, political science, theater, music and public speaking. Recent titles include: *Indigenous People, Ethnic Groups and the State.*

Needs: Designers must be strong in book cover design and contemporary type treatment. 50% of freelance work demands knowledge of Illustrator, Photoshop and FreeHand.

Jackets/Covers: Assigns 100 design jobs and 2-3 illustration jobs/year. Pays for design by the project, $300-750. Pays for illustration by the project, $150-500. Prefers sophisticated, abstract style in pen & ink, airbrush, charcoal/pencil, watercolor, acrylic, oil, collage and calligraphy.

Tips: "Keep stylistically and technically up to date. Learn *not* to over-design: read instructions and ask questions. Introductory letter must state experience and include at least photocopies of your work. If I like what I see, and you can stay on budget, you'll probably get an assignment. Being pushy closes the door. We primarily use designers based in the Boston area."

⊞ THE AMERICAN BIBLE SOCIETY, 1865 Broadway, New York NY 10023. (212)408-1200. Fax: (212)408-1259. E-mail: cmurphy@americanbible.org. Website: www.americanbible.org. **Associate Director, Product Development:** Christina Murphy. Estab. 1868. Company publishes religious products including Bibles/New Testaments, portions, leaflets, calendars and bookmarks. Additional products include religious children's books, posters, seasonal items, teaching aids, audio casettes, videos and CD-ROMs. Specializes in contemporary applications to the Bible. Publishes 80 titles/year. Recent titles include: *Contemporary English Children's Illustrated Bible.* 25% requires freelance illustration; 90% requires freelance design. Book catalog on website.

Needs: Approached by 50-100 freelancers/month. Works with 10 freelance illustrators and 20 designers/year. Uses freelancers for jacket/cover illustration and design, text illustration, book design and children's activity books. 90% of freelance work demands knowledge of Illustrator, QuarkXPress, Photoshop. Works on assignment only. 5% of titles require freelance art direction.

First Contact & Terms: Send postcard samples of work or send query letter with brochure and tearsheets. Samples are filed and/or returned. **Please do not call.** Responds in 2 months. Product design will contact artist for portfolio review if additional samples are needed. Portfolio should include final art and tearsheets. Buys all rights. Finds artists through artists' submissions, *The Workbook* (by Scott & Daughters Publishing) and *RSVP Illustrator.*

Book Design: Assigns 3-5 freelance interior book design jobs/year. Pays by the project, $350-1,000 depending on work involved.

Jackets/Covers: Assigns 60-80 freelance design and 20 freelance illustration jobs/year. Pays by the project, $350-2,000.

Text Illustration: Assigns several freelance illustration jobs/year. Pays by the project.

Tips: "Looking for contemporary, multicultural artwork/designs and good graphic designers familiar with commercial publishing standards and procedures. Have a polished and professional-looking portfolio or be prepared to show polished and professional-looking samples."

AMERICAN BIOGRAPHICAL INSTITUTE, 5126 Bur Oak Circle, Raleigh NC 27612. (919)781-8710. Fax: (919)781-8712. **President:** Janet Evans. Estab. 1967. Publishes hardcover reference books and biography. Publishes 5 titles/year. Recent titles include: *2,000 Notable American Women; Five Hundred Leaders of Influence.* 75% require freelance illustration and design. Books are "mostly graphic text." Book catalog not available.

Needs: Approached by 4-5 freelance artists/year. Works with 2 illustrators and 2 designers/year. Buys 10 illustrations/year. Prefers artists with experience in graphics and copy design. Uses freelancers mainly for brochures (direct mail pieces). Also uses freelancers for book and direct mail design and jacket/cover illustration. 95% of freelance work demands knowledge of QuarkXPress or Photoshop. Works on assignment only.

First Contact & Terms: Send query letter with résumé, photocopies or printed samples. Samples are filed. Art director will contact artists for portfolio review if interested. Portfolio should include art samples, b&w and color dummies and photographs. Sometimes requests work on spec before assigning job. Originals are not returned. Finds artists mostly through word of mouth.

Book Design: Pays by the hour, $35-50; or by the project, $250-500.

AMERICAN JUDICATURE SOCIETY, 180 N. Michigan, Suite 600, Chicago IL 60601-7401. (312)558-6900, ext. 119. Fax: (312)558-9175. E-mail: drichert@ajs.org. Website: www.ajs.org. **Editor:** David Richert. Estab. 1913. Publishes journals and books. Specializes in courts, judges and administration of justice. Publishes 5 titles/year. 75% requires freelance illustration. Catalog available free for SASE.

Needs: Approached by 20 illustrators and 6 designers/year. Works with 3-4 illustrators and 1 designer/year. Prefers local designers. Uses freelancers mainly for illustration. 100% of freelance design demands knowledge of PageMaker, FreeHand, Photoshop and Illustrator. 10% of freelance illustration demands knowledge of PageMaker, FreeHand, Photoshop and Illustrator.

First Contact & Terms: Designers send query letter with photocopies. Illustrators send query letter with photocopies and tearsheets. Send follow-up postcard every 3 months. Samples are not filed and are returned by SASE. Responds in 1 month. Will contact artist for portfolio review of photocopies, roughs and tearsheets if interested. Buys one-time rights.

Book Design: Assigns 1-2 freelance design jobs/year. Pays by the project, $500-1,000.

Text Illustration: Assigns 10 freelance illustration jobs/year. Pays by the project, $75-375.

AMHERST MEDIA, INC., P.O. Box 586, Amherst NY 14226. (716)874-4450. Fax: (716)874-4508. Website: www.AmherstMedia.com. **Publisher:** Craig Alesse. Estab. 1974. Company publishes trade paperback originals. Types of books include instructional and reference. Specializes in photography, how-to. Publishes 30 titles/year. Recent titles include: *Portrait Photographer's Handbook* and *Creating World Class Photography*. 20% require freelance illustration; 80% require freelance design. Book catalog free for 9 × 12 SAE with 3 first-class stamps.

Needs: Approached by 12 freelancers/year. Works with 3 freelance illustrators and 3 designers/year. Uses freelance artists mainly for illustration and cover design. Also for jacket/cover illustration and design and book design. 80% of freelance work demands knowledge of QuarkXPress or Photoshop. Works on assignment only.

First Contact & Terms: Send brochure, résumé and photographs. Samples are filed. Responds only if interested. Art director will contact artist for portfolio review if interested. Portfolio should include slides. Rights purchased vary according to project. Originals are returned at job's completion. Finds artists through word of mouth.

Book Design: Assigns 12 freelance design jobs/year. Pays for design by the hour $25 minimum; by the project $1,650.

Jackets/Covers: Assigns 12 freelance design and 4 illustration jobs/year. Pays $200-1200. Prefers computer illustration (QuarkXPress/Photoshop).

Text Illustration: Assigns 12 freelance illustration jobs/year. Pays by the project. Prefers computer illustration (QuarkXPress).

ANDREWS McMEEL PUBLISHING, 4520 Main, Kansas City MO 64111-7701. (816)932-6600. Fax: (816)932-6781. E-mail: tlynch@amuniversal.com. Website: www.amuniversal.com/amp. **Art Director:** Tim Lynch. Estab. 1972. Publishes hardcover originals and reprints; trade paperback originals and reprints. Types of books include humor, instructional, nonfiction, reference, self help. Specializes in cartoon/humor books. Publishes 200 titles/year. Recent titles include: *Blue Day Book*, *The Millionaire Mind* and *The Last Editor*. 10% requires freelance illustration; 80% requires freelance design.

Needs: Approached by 100 illustrators and 10 designers/year. Works with 15 illustrators and 25 designers/year. Prefers freelancers experienced in book jacket design. 100% of freelance design demands knowledge of Illustrator, Photoshop, QuarkXPress. 100% of freelance illustration demands knowledge of traditional art skills: printing, watercolor, etc.

First Contact & Terms: Designers send query letter with printed samples. Illustrators send query letter with printed samples or contact through artists' rep. Samples are filed and not returned. Responds only if interested. Portfolio review not required. Rights purchased vary according to project. Finds freelancers mostly through sourcebooks and samples sent in by freelancers.

Book Design: Assigns 60 freelance design jobs/year. Pays by the project, $600-3,000.

Jackets/Covers: Assigns 60 freelance design jobs and 20 illustration jobs/year. Pays for design $600-3,000.

Tips: "We want designers who can read a manuscript and design a concept for the best possible cover. Communicate well and be flexible with design."

[N] APPALACHIAN MOUNTAIN CLUB BOOKS, 5 Joy St., Boston MA 02108. (617)523-0636. Fax: (617)523-0722. E-mail: amcbooks@amcinfo.org. Website: www.outdoors.org. **Production:** Elisabeth L. Brady. Estab. 1876. Publishes trade paperback originals and reprints. Types of books include adventure, instructional, nonfiction, travel and children's nature books. Specializes in hiking guidebooks. Publishes 7-10 titles/year. Recent titles include: *The Conservation Book* and *Seashells in My Pocket.* 5% requires freelance illustration; 100% requires freelance design. Book catalog free for #10 SAE with 1 first-class stamp.

Needs: Approached by 5 illustrators and 2 designers/year. Works with 1 illustrator and 2 designers/year. Prefers local freelancers experienced in book design. 100% of freelance design demands knowledge of FreeHand, Photoshop, QuarkXPress. 100% of freelance illustration demands knowledge of FreeHand, Illustrator.

First Contact & Terms: Designers send postcard sample or query letter with photocopies. Illustrators send postcard sample. Accepts Mac-compatible disk submissions. Samples are not filed and are not returned. Will contact artist for portfolio review of book dummy, photocopies, photographs, tearsheets, thumbnails if interested. Negotiates rights purchased. Finds freelancers through professional recommendation (word of mouth).

Book Design: Assigns 10-12 freelance design jobs/year. Pays for design by the project, $1,200-1,500.

Jackets/Covers: Assigns 10-12 freelance design jobs and 1 illustration job/year. Pays for design by the project.

[✓] ARJUNA LIBRARY PRESS, 1025 Garner St., D, Space 18, Colorado Springs CO 80905-1774. **Executive Director:** Count Prof. Joseph A. Uphoff, Jr. Estab. 1979. Company publishes trade paperback originals and monographs. Types of books include experimental fiction, fantasy, horror, nonfiction and science fiction. Specializes in surrealism and metamathematics. Publishes 1 or more titles/year. Recent titles include: *The Promethean and Epimethean Continuum of Art*, by Professor Shlomo Giora Shoham. 100% require freelance illustration. Book catalog available for $1.

Needs: Approached by 1-2 freelancers/year. Works with 1-2 freelance illustrators/year. Buys 1-2 freelance illustrations/year. Uses freelancers for jacket/cover and text illustration.

First Contact & Terms: Send query letter with brochure, résumé, SASE, tearsheets, slides, photographs and photocopies. Samples are filed. Responds if interested. Portfolio review not required. Originals are not returned.

Book Design: Pays contributor's copy and "royalties by agreement if work becomes profitable."

Jackets/Covers: Pays contributor's copy and "royalties by agreement if work becomes profitable."

Text Illustration: Pays contributor's copy and "royalties by agreement if work becomes profitable."

Tips: "Although color illustrations are needed for dust jackets and paperback covers, because of the printing cost, most interior book illustrations are black and white. It is a valuable skill to be able to make a color image with strong values of contrast that will transcribe positively into black and white. In terms of publishing and computer processing, art has become information. There is yet an art that presents the manifestation of the object as being a quality. This applies to sculpture, ancient relics, and anything with similar material value. These things should be treated with respect; curatorial values will always be important. Also, the proliferation of design that has become the Internet is often very confusing to look at or read. A good design can be very complex if its elegance includes a lucid way to focus on information content."

ART DIRECTION BOOK CO. INC., 456 Glenbrook Rd., Glenbrook CT 06906. (203)353-1441. Fax: (203)353-1371. **Art Director:** Doris Gordon. Publishes hardcover and paperback originals on advertising design and photography. Publishes 10-12 titles/year. Titles include disks of *Scan This Book* and *Most Happy Clip Art*; book and disk of *101 Absolutely Superb Icons* and *American Corporate Identity #11*. Book catalog free on request.

Needs: Works with 2-4 freelance designers/year. Uses freelancers mainly for graphic design.

First Contact & Terms: Send query letter to be filed and arrange to show portfolio of 4-10 tearsheets. Portfolios may be dropped off Monday-Friday. Samples returned by SASE. Buys first rights. Originals are returned to artist at job's completion. Advertising design must be contemporary. Finds artists through word of mouth.

Book Design: Assigns 8 freelance design jobs/year. Pays $350 maximum.

Jackets/Covers: Assigns 8 freelance design jobs/year. Pays $350 maximum.

N ARTEMIS CREATIONS, 3395-2J Nostrand Ave., Brooklyn NY 11229. (718)648-8215. E-mail: artemispub@sysmatrix.net. Website: members.aol.com/femdombook. **President:** Shirley Oliveira. Estab. 1992. Publishes trade paperback originals, audio tapes and periodicals. Types of books include erotica, experimental fiction, fantasy, horror, humor, new age, nonfiction and religious. Specializes in powerful women. Publishes 2-4 books, 4 journals and novellas/year. 10% require freelance illustration and design.
Needs: Black & white line art, fantasy, fetishism.
First Contact & Terms: Designers send query letter with photocopies, photographs, résumé and tearsheets. Illustrators send photocopies, résumé, SASE and tearsheets. Accepts disk submissions compatible with PC only. Samples are filed and are returned by SASE. Responds in 1 day. Rights purchased vary according to project.
Book Design: Pays by the project.
Jackets/Covers: Pays for design by the project $200 maximum. Pays for illustration by the project $8 maximum for b&w line art.
Text Illustration: Finds freelancers through magazines and word of mouth.
Tips: "Artists should follow instructions."

☑ ARTIST'S & GRAPHIC DESIGNER'S MARKET, Writer's Digest Books, 4700 East Galbraith Rd., Cincinnati OH 45236. E-mail: artdesign@fwpubs.com. **Editor:** Mary Cox. Annual directory of markets for designers, illustrators and fine artists. Buys one-time rights.
Needs: Buys 35-45 illustrations/year. "I need examples of art that have been sold to the listings in *Artist's & Graphic Designer's Market*. Look through this book for examples. The art must have been freelanced; it cannot have been done as staff work. Include the name of the listing that purchased or exhibited the work, what the art was used for and, if possible, the payment you received. Bear in mind that interior art is reproduced in black and white, so the higher the contrast, the better. I also need to see promo cards, business cards and tearsheets."
First Contact & Terms: Send printed piece, photographs or tearsheets. "Since *Artist's & Graphic Designer's Market* is published only once a year, submissions are kept on file for the upcoming edition until selections are made. Material is then returned by SASE if requested." Pays $75 to holder of reproduction rights and free copy of *Artist's & Graphic Designer's Market* when published.

N ATHENEUM BOOKS FOR YOUNG READERS, 1230 Avenue of the Americas, New York NY 10020. (212)698-4381. Website: www.simonsayskids.com. **Contact:** Art Director. Imprint of Simon & Schuster Children's Publishing Division. Imprint publishes hardcover originals, picture books for young kids, nonfiction for ages 8-12 and novels for middle-grade and young adults. Types of books include biography, historical fiction, history, nonfiction. Publishes 60 titles/year. Recent titles include: *Olivia Saves the Circus*, by Flaconer; and *Zeely*, by Virginia Hamilton. 100% requires freelance illustration. Book catalog free by request.
Needs: Approached by hundreds of freelance artists/year. Works with 40-60 freelance illustrators/year. Buys 40 freelance illustrations/year. "We are interested in artists of varying media and are trying to cultivate those with a fresh look appropriate to each title."
First Contact & Terms: Send postcard sample of work or send query letter with tearsheets, résumé and photocopies. Samples are filed. Portfolios may be dropped off every Thursday between 9 a.m. and noon. Art Director will contact artist for portfolio review if interested. Portfolio should include final art if appropriate, tearsheets, and folded and gathered sheets from any picture books you've had published. Rights purchased vary according to project. Originals are returned at job's completion. Finds artists through submissions, magazines ("I look for interesting editorial illustrators"), word of mouth.
Jackets/Covers: Assigns 20 freelance illustration jobs/year. Pays by the project, $1,200-1,800. "I am not interested in generic young adult illustrators."
Text Illustration: Pays by the project, $500-2,000.

N ATLAS GAMES, P.O. Box 131233, Roseville MN 55113-1233. (651)638-0077. Fax: (651)638-0084. E-mail: info@atlas-games.com. Website: www.atlas-games.com. **Art Director:** Scott Reeves. Publishes roleplaying game books, game/trading cards and board games. Main style/genre of games: fantasy, horror, historical (medieval). Uses freelance artists mainly for b&w interior illustrations. Publishes 12 titles or products/year. Game/product lines include: *Unknown Armies* and *Feng Shui*. 100% requires freelance illustration; 5% requires freelance design. Request art guidelines by mail or on website.

SASE MEANS SELF-ADDRESSED, STAMPED ENVELOPE. Send SASEs when requesting return of your samples.

Needs: Approached by 100 illustrators and 10 designers/year. Works with 6 illustrators and 1 designer/year. 100% of freelance design demands knowledge of Photoshop and QuarkXPress.

First Contact & Terms: Illustrators send 6-12 printed samples, photocopies, photographs or tearsheets. Samples are filed. Responds in 2 months. Will contact artist for portfolio review if interested. Negotiates rights purchased. Finds freelancers through submissions and referrals.

Visual Design: Assigns 1 freelance design job/year.

Book Covers/Posters/Cards: Assigns 4 illustration jobs/year. Pays $200-300 for cover art. Pays for design by the project, $100-300.

Text Illustration: Assigns 20 freelance text illustration jobs/year. Pays by the full page, $40-50. Pays by the half page, $20-25.

Tips: "Please include a SASE."

N AUGSBURG FORTRESS PUBLISHERS, Box 1209, 100 S. Fifth St., Suite 700, Minneapolis MN 55402. (612)330-3300. **Contact:** Director of Design, Marketing Services. Publishes hard cover and paperback Protestant/Lutheran books (90 titles/year), religious education materials, audiovisual resources, periodicals. Recent titles include: *Ecotheraphy*, by Howard Clinebell; and *Thistle*, by Walter Wangerin.

Needs: Uses freelancers for advertising layout, design, illustration and circulars and catalog cover design. Freelancers should be familiar with QuarkXPress 4.1, Photoshop 5.5 and Illustrator 8.01.

First Contact & Terms: "Majority, but not all, of our freelancers are local." Works on assignment only. Responds on future assignment possibilities in 2 months. Call, write or send brochure, disk, flier, tearsheet, good photocopies and 35mm transparencies; if artist is not willing to have samples filed, they are returned by SASE. Buys all rights on a work-for-hire basis. May require designers to supply overlays on color work.

Jackets/Covers: Uses designers primarily for cover design. Pays by the project, $600-900. Prefers covers on disk using QuarkXPress.

Text Illustration: Negotiates pay for 1-, 2- and 4-color. Generally pays by the project, $25-500.

Tips: Be knowledgeable "of company product and the somewhat conservative contemporary Christian market."

N AVALANCHE PRESS, LTD., P.O. Box 100852, Birmingham AL 35210-0852. (205)957-0017. Fax: (205)957-0016. E-mail: avlchpress@aol.com. Website: www.avalanchepress.com. **Production Manager:** Peggy Gordon. Estab. 1993. Publishes roleplaying game books, game/trading cards, posters/calendars and board games. Main style/genre of games: science fiction, fantasy, humor, Victorian, historical, military and mythology. Uses freelance artists for "most everything." Publishes 40 titles or products/year. Game/product lines include: The *Epic* line of historical role playing games. 70% requires freelance illustration; 10% requires freelance design; 20% requires freelance art direction.

Needs: Approached by 50 illustrators and 150 designers/year. Works with 4 illustrators and 1 designer/year. Prefers local illustrators. Prefers freelancers experienced in professional publishing. 90% of freelance design demands knowledge of Illustrator. 30% of freelance illustration demands knowledge of PageMaker and QuarkXPress.

First Contact & Terms: Send query letter with résumé and SASE. Send printed samples. Do not send electronic submissions. Samples are not filed and are not returned. Will contact artist for portfolio review if interested. Buys all rights.

Visual Design: Assigns 8-12 freelance design and 1-4 art direction projects/year. Pays by the project.

Book Covers/Posters/Cards: Assigns 10-12 illustration jobs/year. Pays by the project.

Tips: "We need people who want to work with us and have done their homework. Study our product lines and do not send us blanket, mass-mailed queries. We really mean this—mail-merge inquiries land in the circular file."

N AVALON PUBLISHING GROUP, 161 Williams St., 16th Floor, New York NY 10038. (646)375-2570. Fax: (646)375-2571. Website: www.avalonpub.com. **Art Director:** Linda Kosarin. Estab. 1953. Company publishes hardcover originals. Types of books include romance, western and mystery. Publishes 100 titles/year. 100% require freelance illustration. Recent titles include: *Endurance*.

Needs: Prefers local freelancers only. Uses freelancers for jacket/cover illustration. Works on assignment only.

First Contact & Terms: Send postcard sample of work. Samples are not filed and are not returned. Responds only if interested. Portfolio review not required. Rights purchased vary according to project. Originals are returned at job's completion. Finds artists through submissions.

Jackets/Covers: Assigns 60 freelance design jobs/year.

N AVON BOOKS, 1350 Avenue of the Americas, New York NY 10019. (212)261-6665. Fax: (212)261-6925. Website: www.avonromance.com. **Art Director:** Cathleen Flanagan. Estab. 1941. Publishes hard-

cover, trade and mass market paperback originals and reprints. Types of books include adventure, biography, cookbooks, fantasy, history, horror, humor, juvenile, mainstream fiction, New Age, nonfiction, romance, science fiction, self-help, travel, young adult. Specializes in romance, mystery, upscale fiction. Publishes 400-450 titles/year. Recent titles include: *A Touch So Wicked* and *Queen*, by Faye Kellerman. 85% requires freelance illustration; 10% requires freelance design.

Needs: Approached by 150 illustrators and 25 designers/year. Works with 125 illustrators and 5-10 designers/year. Prefers freelancers experienced in illustration. Uses freelancers mainly for illustration. 80% of freelance design and 5% of freelance illustration demands knowledge of Photoshop, Illustrator and QuarkXPress.

First Contact & Terms: Designers send query letter with tearsheets or other printed samples. Illustrators send postcard sample and/or query letter with printed samples, slides, tearsheets and transparencies. Accepts disk submissions from designers, not illustrators, compatible with QuarkXPress 7.5, version 3.3. Send EPS files. Samples are filed or returned. Responds in days if interested. Portfolios may be dropped off every Thursday. Will contact for portfolio review of slides and transparencies of work in all genres if interested. Rights purchsed vary according to project.

Book Design: Assigns 25 freelance design jobs/year. Pays by the project, $700-1,500.

Jackets/Covers: Assigns 25 freelance design jobs and 325 illustration jobs/year. Pays for design by the project, $700-1,500. Pays for illustration by the project, $1,000-5,000. Prefers all mediums.

BAEN BOOKS, P.O. Box 1188, Wake Forest NC 27588. (919)570-1640. Fax: (919)570-1644. Website: www.baen.com. **Publisher:** Jim Baen. Editor: Toni Weisskopf. Estab. 1983. Publishes science fiction and fantasy. Publishes 60-70 titles/year. Titles include: *The Shiva Option* and *Pandora's Regions*. 75% requires freelance illustration; 80% requires freelance design. Book catalog free on request.

First Contact & Terms: Approached by 500 freelancers/year. Works with 10 freelance illustrators and 3 designers/year. 50% of work demands computer skills. Designers send query letter with résumé, color photocopies, tearsheets (color only) and SASE. Illustrators send query letter with color photocopies, SASE, slides and tearsheets. Samples are filed. Originals are returned to artist at job's completion. Buys exclusive North American book rights.

Jackets/Covers: Assigns 64 freelance design and 64 illustration jobs/year. Pays by the project—$200 minimum, design; $1,000 minimum, illustration.

Tips: Wants to see samples within science fiction, fantasy genre only. "Do not send black & white illustrations or surreal art. Please do not waste our time and your postage with postcards. Serious submissions only."

BARBOUR PUBLISHING, 1810 Barbour Dr., P.O. Box 719, Uhrichsville OH 44683. (740)922-6045, ext. 125. Fax: (740)922-5948. E-mail: rmartins@barbourbooks.com. Website: www.barbourbooks.com. **Creative Director:** Robyn Martins. Estab. 1981. Publishes hardcover, trade paperback and mass market paperback originals and reprints. Types of books include general Christian contemporary and Christian romance, self help, young adult, reference and Christian children's books. Specializes in short, easy-to-read Christian bargain books. Publishes 150 titles/year. 60% require freelance illustration.

Needs: Prefers freelancers with experience in people illustration and photorealistic styles. Uses freelancers mainly for fiction romance jacket/cover illustration. Works on assignment only.

First Contact & Terms: Send query letter with photocopies or tearsheets and SASE. Accepts Mac disk submissions compatible with Illustrator 6.0 and Photoshop. Buys all rights. Originals are returned. Finds artists through word of mouth, recommendations, sample submissions and placing ads.

Jackets/Covers: Assigns 10 freelance design and 90 illustration jobs/year. Pays by the project, $450-750.

Tips: "Submit a great illustration of people suitable for a romance cover or youth cover in a photorealistic style. I am also looking for great background illustrations, such as florals and textures. As a publisher of bargain books, I am looking for top-quality art on a tight budget."

BAY BOOKS & TAPES, 555 De Haro St., Suite 220, San Francisco CA 94107. (415)252-4350. Fax: (415)252-4352. E-mail: info@baybooks.com. Website: www.baybooks.com. **Art Director:** Amy Armstrong. Estab. 1990. Imprints include Bay Books, KQED Video and Soma Books. Publishes hardcover and trade paperback originals and reprints, audio tapes and videos. Types of books include biography, coffee table books, cookbooks, travel and television related. Specializes in public television related. Publishes 12 titles/year. Recent titles include: *Orchids, A Splendid Obsession*. 5% require freelance illustration; 90% require freelance design. Catalog free.

Needs: Approached by 5 illustrators and 30 designers/year. Works with illustrators and 10 designers/year. Prefers local freelancers with experience in book design and production. Uses freelancers mainly for design. 100% of freelance design demands knowledge of Photoshop, Illustrator and QuarkXPress. 75% of freelance illustration demands knowledge of Photoshop, Illustrator and QuarkXPress.

First Contact & Terms: Designers send query letter with résumé and tearsheets. Illustrators send postcard sample, query letter with printed samples, résumé, SASE and follow-up postcard samples every 2 months. Accepts disk submissions compatible with Quark, Illustrator and Photoshop. Samples are filed or returned by SASE. Responds only if interested. Artist should follow up with call and/or letter after initial query or art director will contact artist for portfolio review of line art, book dummy and tearsheets if interested. Rights purchased vary according to project.

Book Design: Assigns 10 freelance design jobs/year. Pays for design by the project.

Jackets/Covers: Pays for design by the project. Pays for illustration by the project. Prefers Quark, illustrations in digital format OK.

Text Illustration: Assigns 2 freelance illustration jobs/year. Pays by the project. Prefers illustrations in digital format. Finds freelancers through agents, word of mouth and submissions.

Tips: "We work primarily with cookbook illustrations."

[N] BEAVER POND PUBLISHING, P.O. Box 224, Greenville PA 16125. (724)588-3492. Fax: (724)588-2486. E-mail: beaverpond@pathway.net. Website: www.bookblender.com. **Owner:** Rich Faler. Estab. 1988. Subsidy publisher and publisher of trade paperback originals and reprints and how-to booklets. Types of books include instructional and adventure. Specializes in outdoor topics. Publishes 20 titles/year. Recent titles include: *How to Catch More Trout*, by Charles Meck. 20% require freelance illustration. Book catalog free by request.

Needs: Approached by 6 freelance artists/year. Works with 3 illustrators/year. Buys 50 illustrations/year. Prefers artists with experience in outdoor activities and animals. Uses freelancers mainly for book covers and text illustration. Works on assignment only.

First Contact & Terms: Send query letter with tearsheets and/or photocopies. Samples are filed. Responds only if interested. To show portfolio, mail appropriate materials: thumbnails, b&w photocopies. Rights purchased vary according to project. Originals are returned at job's completion (if all rights not purchased).

Jackets/Covers: Assigns 3-4 illustration jobs/year. Pays for covers as package with text art. Prefers pen & ink line art.

Text Illustration: Assigns 3-4 jobs/year. Pays by the project, $100 (booklets)-$1,600 (books). Prefers pen & ink line art.

Tips: "Show an understanding of animal anatomy. We want accurate work."

[N] BEDFORD/ST. MARTIN'S, 75 Arlington St., Boston MA 02116. (617)426-7440. Fax: (617)350-7544. Website: www.bedfordstmartins.com. **Advertising Manager:** Terry Govan. Promotions Manager: Thomas Macy. Creative Supervisors: Hope Tompkins and Pelle Cass. Estab. 1981. Publishes college textbooks in English, history and communications. Publishes 40 titles/year. Recent titles include: *A Writer's Reference*, Fourth Edition; *The Bedford Handbook*, Sixth Edition; *The American Promise* Second Edition; and *The Bedford Introduction to Literature*, Sixth Edition; and *A Speaker's Guidebook: Text and Reference*. Books have "contemporary, classic design." 5% require freelance illustration; 90% require freelance design.

Needs: Approached by 25 freelance artists/year. Works with 2-4 illustrators and 6-8 designers/year. Buys 2-4 illustrations/year. Prefers artists with experience in book publishing. Uses freelancers mainly for cover and brochure design. Also for jacket/cover and text illustration and book and catalog design. 75% of design work demands knowledge of Adobe Illustrator, QuarkXPress and Adobe Photoshop.

First Contact & Terms: Send query letter with brochure, tearsheets and SASE. Samples are filed or are returned by SASE if requested by artist. Responds only if interested. Request portfolio review in original query. Art director or promotions manager will contact artists for portfolio review if interested. Portfolio should include roughs, original/final art, color photostats and tearsheets. Interested in buying second rights (reprint rights) to previously published work. Originals are returned at job's completion.

Jackets/Covers: Assigns 40 design jobs and 2-4 illustration jobs/year. Pays by the project. Finds artists through magazines, self-promotion and sourcebooks. Contact: Donna Dennison.

Tips: "Regarding book cover illustrations, we're usually interested in buying reprint rights for artistic abstracts or contemporary, multicultural scenes and images of writers and writing-related scenes (i.e. desks with typewriters, paper, open books, people reading, etc.)."

BEHRMAN HOUSE, INC., 11 Edison Place, Springfield NJ 07081. (973)379-7200. Fax: (973)379-7280. Website: www.behrmanhouse.com. **Executive Editor:** Gila Gavirtz. Director of Education: Terry Kaye. Estab. 1921. Book publisher. Publishes textbooks. Types of books include preschool, juvenile, young adult, history (all of Jewish subject matter) and Jewish texts. Specializes in Jewish books for children and adults. Publishes 12 titles/year. Recent titles include: *Let's Discover Mitzvot*. "Books are contemporary with lots of photographs and artwork; colorful and lively. Design of textbooks is very complicated." 50% require freelance illustration; 100% require freelance design. Book catalog free by request.

Needs: Approached by 50 freelancers/year. Works with 6 freelance illustrators and 6 designers/year. Prefers freelancers with experience in illustrating for children; "Jewish background helpful." Uses freelancers for textbook illustration and book design. 25% of freelance work demands knowledge of QuarkXPress. Works on assignment only.

First Contact & Terms: Send postcard samples or query letter with résumé and tearsheets. Samples are filed. Responds only if interested. Buys reprint rights. Sometimes requests work on spec before assigning a job.

Book Design: Assigns 8 freelance design and 3 illustration jobs/year. Pays by project, $4,000-20,000.

Jackets/Covers: Assigns 8 freelance design and 4 illustration jobs/year. Pays by the project, $500-1,000.

Text Illustration: Assigns 6 freelance design and 4 illustration jobs/year. Pays by the project.

☑ **THE BENEFACTORY, INC.,** P.O. Box 128, Cohasset MA 02025. (970)229-9194. E-mail: benefactory@aol.com. Website: www.readplay.com. **Creative Director:** Cynthia A. Germain. Estab. 1990. Publishes audio tapes, hardcover and trade paperback originals. Types of books include children's picture books. Specializes in true stories about real animals. Publishes 9 titles/year. Recent titles include: *Free Fall* and *Caesar: On Deaf Ears*. 100% requires freelance illustration. Book catalog free for 8½×11 SAE with 3 first-class stamps.

- A number of The Benefactory's illustrators have won prestigious awards, including: Paula Bartlett: 1997 National Association of Parenting Publications Honors Award; Kerry Maguire: 1993 John Burrough's Outstanding Nature Book for Children Award.

Needs: Approached by 5 illustrators/year. Works with 9 illustrators/year.

First Contact & Terms: Send nonreturnable postcard samples. Samples are filed. Will contact artist for portfolio review of artwork portraying animals, children, nature if interested. Rights purchased very according to project.

Tips: "We look for realistic portrayal of children and animals with great expression. We bring our characters and stories to life for children."

ROBERT BENTLEY PUBLISHERS, 1734 Massachusetts Ave., Cambridge MA 02138-1804. (617)547-4170. E-mail: Sales@BentleyPublishers.com. Website: www.bentleypublishers.com. **Publisher:** Michael Bentley. Publishes hardcover originals and reprints and trade paperback originals—reference books. Specializes in automotive technology and automotive how-to. Publishes 20 titles/year. Recent titles include: *Jeep Owner's Bible, Unbeatable BMW* and *Zora Arkus-Duntov: The Legend Behind Corvette*. 50% require freelance illustration; 50% require freelance design and layout. Book catalog for 9×12 SAE.

Needs: Works with 5-10 illustrators and 15-20 designers/year. Buys 1,000 illustrations/year. Prefers artists with "technical illustration background, although a down-to-earth, user-friendly style is welcome." Uses freelancers for jacket/cover illustration and design, text illustration, book design, page layout, direct mail and catalog design. Also for multimedia projects. 100% of design work requires computer skills. Works on assignment only.

First Contact & Terms: Send query letter with résumé, SASE, tearsheets and photocopies. Accepts disk submissions. Samples are filed. Responds in 5 weeks. To show portfolio, mail thumbnails, roughs and b&w tearsheets and photographs. Buys all rights. Originals are not returned.

Book Design: Assigns 10-15 freelance design and 20-25 illustration jobs/year. Pays by the project.

Jackets/Covers: Pays by the project.

Text Illustration: Prefers Illustrator files.

Tips: "Send us photocopies of your line artwork and résumé."

BETHLEHEM BOOKS, 10194 Garfield St., S, Bathgate ND 58216. (701)265-3725. Fax: (701)265-3716. E-mail: peter@bethlehembooks.com. Website: www.bethlehembooks.com. **Assistant Editor:** Peter Sharpe. Estab. 1993. Publishes hardcover originals, trade paperback originals and reprints. Types of books include adventure, biography, history, juvenile and young adult. Specializes in children's books. Publishes 5-10 titles/year. Recent titles include: *Pamela Walks the Dog*. Catalog available.

Needs: Approached by 25 illustrators/year. Works with 4 illustrators/year. Prefers freelancers experienced in b&w line drawings. Uses freelancers mainly for covers and book illustrations.

First Contact & Terms: Illustrators send postcard sample or query letter with photocopies. Accepts disk submissions from illustrators compatible with IBM, prefers TIFFs or QuarkXPress 3.32 files. Samples are filed. Responds in 1 month. Will contact artist for portfolio review if interested. Portfolio should include artwork portraying people in action. Negotiates rights purchased.

Jackets/Covers: Assigns 2 freelance illustration jobs/year. Pays by the project, $800-1,000. Prefers oil or watercolor.

Text Illustration: Assigns 2 freelance illustration jobs/year. Pays by the project, $100-2,000. Prefers pen and ink. Finds freelancers through books and word of mouth.

Tips: "Artists should be able to produce life-like characters that fit the story line."

BINARY ARTS CORP., 1321 Cameron St., Alexandria VA 22314. (703)549-4999. Fax: (703)549-6210. E-mail: swagner@puzzles.com. Website: http://www.puzzles.com. **Director of Product Design and Development:** Steve Wagner. Estab. 1985. Publishes board games, grid games and puzzles. Main style/genre of games: humor and education. Uses freelance artists mainly for illustration. Publishes 7-15 titles or products/year. Game/product lines include: *Grid Games, Kinetics, Peg Puzzles* and *Thinking Games*. 100% requires freelance illustration; 50% requires freelance design.
Needs: Approached by 20 illustrators and 20 designers/year. Works with 5 illustrators and 3 designers/year. Sometimes prefers local illustrators. Prefers freelancers experienced in Illustrator, Quark. 100% of freelance design demands knowledge of Illustrator, Photoshop and QuarkXPress. 100% of freelance illustration demands knowledge of Illustrator.
First Contact & Terms: Send self-promotion postcard sample and follow-up postcard. Illustrators send 10-20 printed samples and tearsheet. Samples are filed. Responds only if interested. Will contact artist for portfolio review if interested. Buys all rights. Finds freelancers through referrals, *Black Book*, etc.
Visual Design: Assigns 20 freelance design jobs/year.
Posters/Cards: Assigns 5 freelance design jobs and 5 illustration jobs/year. Pays for illustration by the project.

BONUS BOOKS, INC., 160 E. Illinois St., Chicago IL 60611. (312)467-0580. Fax: (312)467-9271. E-mail: devon@bonus-books.com. Website: www.bonus-books.com. **Managing Editor:** Devon Freeny. Imprints include Precept Press. Company publishes textbooks and hardcover and trade paperback originals. Specializes in sports/gambling, broadcasting, biography, medical, fundraising. Publishes 30 titles/year. Recent titles include: *Get the Edge at Roulette* and *Baseball Chicago Style*. 1% require freelance illustration; 40% require freelance design.
Needs: Approached by 100 freelancers/year. Works with 0-1 freelance illustrator and 5 designers/year. Prefers local freelancers with experience in designing on the computer. Uses freelancers for jacket/cover illustration and design and direct mail design. Also for multimedia projects. 100% of design and 90% of illustration demand knowledge of Photoshop, Illustrator and QuarkXPress. Works on assignment only.
First Contact & Terms: Designers send brochure, résumé and tearsheets. Illustrators send postcard sample or query letter with brochure, résumé. Samples are filed. Responds only if interested. Artist should not follow up with call. Portfolio should include color final art. Rights purchased vary according to project. Finds artists through artists' submissions and authors' contacts.
Book Design: Assigns 4 freelance design jobs/year.
Jackets/Covers: Assigns 10 freelance design and 0-1 illustration job/year. Pays by the project, $250-1,000.
Tips: First-time assignments are usually regional, paperback book covers; book jackets for national books are given to "proven" freelancers.

BOOK DESIGN, Box 193, Moose WY 83012. **Art Director:** Robin Graham. Specializes in high quality hardcover and paperback originals. Publishes more than 12 titles/year. Recent titles include: *Tales of the Wolf, Wildflowers of the Rocky Mountains, Mattie: A Woman's Journey West, Cubby in Wonderland* and *Windswept*.
Needs: Works with 20 freelance illustrators and 10 designers/year. Works on assignment only. "We are looking for top-notch quality only." 90% of freelance work demands knowledge of PageMaker and FreeHand.
First Contact & Terms: Send query letter with "examples of past work and one piece of original artwork which can be returned." Samples not filed are returned by SASE if requested. Responds in 20 days. Originals are not returned. Write for appointment to show portfolio. Negotiates rights purchased.
Book Design: Assigns 6 freelance design jobs/year. Pays by the project, $50-3,500.
Jackets/Covers: Assigns 2 freelance design and 4 illustration jobs/year. Pays by the project, $50-3,500.
Text Illustration: Assigns 26 freelance jobs/year. Prefers technical pen illustration, maps (using airbrush, overlays etc.), watercolor illustration for children's books, calligraphy and lettering for titles and headings. Pays by the hour, $5-20, or by the project, $50-3,500.

THOMAS BOUREGY & CO., INC. (AVALON BOOKS), 160 Madison Ave., 5th Floor, New York NY 10016-5412. (212)598-0222. Fax: (212)979-1862. Website: www.avalonbooks.com. **Contact:** Art Director. Estab. 1950. Book publisher. Publishes hardcover originals. Types of books include romance, mysteries and Westerns. Publishes 60 titles/year. Recent titles include: *Two Cupids Too Many* and *The Tomoka Mystery*. 100% require freelance illustration and design. Prefers local artists and artists with experience in dust jackets. Works on assignment only.
 • Avalon Books is an imprint of Thomas Bouregy & Co. Check their website to see a variety of covers, all executed by freelancers.
First Contact & Terms: Send samples. Samples are filed if appropriate. Responds if interested.

N: BOYDS MILLS PRESS, 815 Church St., Honesdale PA 18431. (570)253-1164. Fax: (570)253-0179. Website: www.boydsmillpress.com. **Art Director:** Tim Gillner. Estab. 1990. A division of Highlights for Children, Inc. Imprint publishes hardcover originals and reprints. Types of books include fiction, nonfiction, picture books and poetry. Publishes 50 titles/year. Recent titles include: *By the Hanukkah Light*, by Sheldon Oberman (illustrated by Neil Waldman); *Year Goes Round*, by Karen B. Winnick; *O Christmas Tree*, by Vashanti Rahaman (illustrated by Frané Lessac); and *Bingleman's Midway*, by Karen Ackerman (illustrated by Barry Moser).

Needs: Approached by hundreds of freelancers/year. Works with 25-30 freelance illustrators and 5 designers/year. Prefers freelancers with experience in book publishing. Uses freelancers mainly for picture books. Also for jacket/cover design and illustration, text illustration and book design. 25% of freelance work demands knowledge of QuarkXPress. Works on assignment only.

First Contact & Terms: Send query letter with tearsheets or photocopies. Samples are filed and not returned. Artist should follow up with call. Portfolio should include b&w and color final art, photostats, tearsheets and photographs. Rights purchased vary according to project. Originals are returned at job's completion. Finds artists through agents, sourcebooks, submissions, other publications.

Book Design: Assigns 10 freelance design jobs/year. Pays by the project.

Jackets/Covers: Assigns 6 freelance design/illustration jobs/year. Pays by the project.

Text Illustration: Pays by the project.

Tips: First-time assignments are usually poetry books (b&w illustrations); picture books are given to "proven" freelancers.

N: BROADMAN & HOLMAN PUBLISHERS 127 Ninth Ave. N., Nashville TN 37234. (615)251-2520. Website: www.broadmanholman.com. **Vice President Marketing:** John Thompson. Estab. 1891. Religious publishing house. Publishes 104 titles/year. 20% of titles require freelance illustration. Recent titles include: *Spiritual Readership*, *My Happy Heart* and *Summer With a Smile*. Books have contemporary look. Book catalog free on request.

Needs: Works with 15 freelance illustrators and 20 freelance designers/year. Artist must be experienced, professional. Works on assignment only. 100% of titles require freelance art direction.

First Contact & Terms: Send query letter and samples to be kept on file. Bio is helpful. Call or write for appointment to show portfolio. Send slides, tearsheets, postcards or photocopies; "samples *cannot* be returned." Responds only if interested. Pays for illustration by the project, $250-1,500. Negotiates rights purchased.

Book Design: Pays by the project, $500-1,000.

Jackets/Covers: "100% of our cover designs are now done on computer." Pays by the project, $1,500-2,000

Text Illustration: Pays by the project, $150-300.

Tips: "We are looking for computer-literate experienced book designers with extensive knowledge of biblical themes." Looks for "the ability to illustrate scenes with multiple figures, to accurately illustrate people of all ages, including young children and babies, and to illustrate detailed scenes described in text."

THE BUREAU FOR AT-RISK YOUTH, A Guidance Channel Company, 135 Dupont St., P.O. Box 760, Plainview NY 11803-0760. (800)999-6884. Fax: (516)262-1886. E-mail: info@at-risk.com. Website: www.at-risk.com. **Editor-in-Chief:** Sally Germain. Estab. 1991. Publishes CD-ROMs, booklets, pamphlets, posters, video programs, curriculum and educational resources for educators, counselors, children, parents and others who work with youth. Publishes 20-50 titles/year. Recent titles include: *Express Yourself Poster Series*, by Kathleen Bishop; *YouthLink Mentoring Program* and *You're the Boss Lifeskills & Entrepreneurship Program*. 30% requires freelance illustrations; 75% requires freelance design. Free Catalog of Resources available with $1.70 in stamps.

Needs: Works with 4 illustrators/year and 6 designers/year. Prefers local designers/illustrators, but not required. Prefers freelancers experienced in educational/youth materials. Freelance design demands knowledge of Photoshop and QuarkXPress. Illustration demands knowledge of Illustrator, Photoshop and QuarkXPress.

First Contact & Terms: Send query letter with photocopies and SASE. Accepts Mac-compatible disk submissions. Send EPS files. Samples are filed. Responds only if interested; will return materials if SASE sent and requested. Portfolio review not required intially. Rights purchased vary according to project. Finds freelancers through word of mouth and networking.

THE MULTIMEDIA INDEX preceding the General Index in the back of this book lists markets seeking freelancers with multimedia, animation and CD-ROM skills.

Jackets/Covers: Payment either by hour or by project, but depends on specific project.

■ **CACTUS GAME DESIGN, INC.**, 751 Tusquittee St., Hayesville, NC 28904. (828)389-1536. Fax: (828)389-1534. E-mail: cactusrob@aol.com. Website: www.cactusgamedesign.com. **Art Director:** Doug Gray. Estab. 1995. Publishes comic books, game/trading cards, posters/calendars, CD-ROM/online games and board games. Main style/genre of games: science fiction, fantasy and Biblical. Uses freelance artists mainly for illustration. Publishes 2-3 titles or products/year. *Outburst: Bible Edition*, *Redemption 2nd Edition*, *Gil's Bible Jumble*. 100% requires freelance illustration; 25% requires freelance design.
Needs: Approached by 50 illustrators and 5 designers/year. Works with 20 illustrators and 1 designer/year. Prefers freelancers experienced in fantasy and Biblical art. 100% of freelance design demands knowledge of Corel Draw, Photoshop and QuarkXPress.
First Contact & Terms: Send query letter with résumé and photocopies. Accepts disk submissions in Windows or Mac format. Send via CD, floppy disk, Zip as TIFF, GIF or JPEG files. Samples are filed. Responds only if interested. Portfolio review not required. Rights purchased vary according to project. Finds freelancers through submission packets and word of mouth.
Visual Design: Assigns 100-150 freelance design jobs/year. Pays for design by the hour, $20.
Book Covers/Posters/Cards: Pays for illustration by the project, $25-250. "Artist must be aware of special art needs associated with Christian retail environment."
Tips: "We like colorful action shots."

CANDY CANE PRESS, Ideals Publications, a division of Guideposts, 535 Metroplex Dr., Suite 250, Nashville TN 37211. (615)333-0478. Fax: (615)781-1447. Website: www.idealspublications.com. **Art Director:** Eve DeGrie. Publisher: Patricia Pingry. Estab. 1996. Publishes hardcover and trade paperback originals. Types of books include children's picture books, juvenile and preschool. Publishes 10 titles/year. Recent titles include: *Meet George Washington* and *The Story of Jesus*. 100% requires freelance illustration.
Needs: Works with 10 illustrators/year.
First Contact & Terms: Designers and illustrators send postcard sample or query letter with photocopies and SASE. Portfolio review not required. Negotiates rights purchased; rights purchased vary according to project. Finds freelancers through networking events sponsored by graphic arts organizations, sourcebooks and illustration annuals, design magazines and word of mouth.
Tips: "We are looking for traditional, somewhat humorous illustrations including multicultural children. Please make sure samples are appropriate for our publication."

▮ **CARTWHEEL BOOKS**, Imprint of Scholastic, Inc., 555 Broadway, New York NY 10012-3999. (212)343-6100. Fax: (212)343-4444. Website: www.scholastic.com. **Art Director:** Edith T. Weinberg. Estab. 1990. Publishes mass market and trade paperback originals. Types of books include children's picture books, instructional, juvenile, preschool, novelty books. Specializes in books for very young children. Publishes 100 titles/year. Recent titles include: *I Spy*, by Jean Marzollo and Walter Wick. 100% requires freelance illustration; 25% requires freelance design; 5% requires freelance art direction. Book catalog available for SASE with first-class stamps.
Needs: Approached by 500 illustrators and 50 designers/year. Works with 75 illustrators, 5 designers and 3 art directors/year. Prefers local designers. 100% of freelance design demands knowledge of QuarkXPress.
First Contact & Terms: Designers send query letter with printed samples, photocopies, SASE. Illustrators send postcard sample or query letter with printed samples, photocopies and follow-up postcard every 2 months. Samples are filed. Responds in 1 month. Will contact artist for portfolio review of artwork portraying children and animals, artwork of characters in sequence, tearsheets if interested. Rights purchased vary according to project. Finds freelancers through submissions on file, reps.
Book Design: Assigns 10 freelance design and 2 art direction projects/year. Pays for design by the hour, $30-50; art direction by the hour, $35-50.
Text Illustration: Assigns 200 freelance illustration jobs/year. Pays by the project, $500-10,000.
Tips: "I need to see cute fuzzy animals, young, lively kids, and/or clear depictions of objects, vehicles and machinery."

▧ **MARSHALL CAVENDISH**, 99 White Plains Rd., Tarrytown NY 10591. (914)332-8888. Fax: (914)332-1888. Website: www.marshallcavendish.com. **Art Director:** Jean Krulis. Imprints include Benchmark Books and Cavendish Children's Books. Publishes hardcover originals. Types of books include children's picture books and teen novels. Publishes 24 titles/year. Recent titles include: *A Place to Sleep*, *Jack Quack*, *The Boy Who Was Generous With Salt* and *Borderlands*. 80% requires freelance illustration.
Needs: Uses freelancers mainly for illustration.
First Contact & Terms: Send photocopies and/or printed samples. Samples are filed. Will contact artist for portfolio review of artwork portraying children, adults, animals, artwork of characters in sequence, book dummy, photocopies. Negotiates rights purchased. Finds freelancers mostly through agents.

Jacket/Covers: Assigns 5 illustration jobs/year. Pays by the project; negotiable.
Text Illustration: Assigns 10 freelance jobs/year. Pays by the project; offers royalty.

CCC PUBLICATIONS, 9725 Lurline Ave., Chatsworth Park CA 91311. (818)718-0507. Fax: (818)718-0655. **Editorial Director:** Cliff Carle. Estab. 1984. Company publishes trade paperback originals and manufactures accessories (T-shirts, mugs, caps). Types of books include self-help and humor. Specializes in humor. Publishes 30 titles/year. Recent titles include: *The Better Half*, by Randy Glasbergen; and *Golfaholics*, by Bob Zahn. 90% require freelance illustration; 90% require freelance design. Book catalog free for SAE with $1 postage.
Needs: Approached by 200 freelancers/year. Works with 20-30 freelance illustrators and 10-20 designers/year. Buys 100 freelance illustrations/year. Prefers artists with experience in humorous or cartoon illustration. Uses freelancers mainly for color covers and b&w interior drawings. Also for jacket/cover and book design. 80% of design and 50% of illustration demands computer skills.
First Contact & Terms: Send postcard sample or query letter with samples, résumé, SASE. Samples are filed or are returned by SASE if requested by artist. Responds only if interested. Art director will contact artist for portfolio review if interested. Portfolio should include b&w and color samples. Rights purchased vary according to project. Finds artists through agents and unsolicited submissions.
Book Design: Assigns 30 freelance design jobs/year. Pay negotiated based on artist's experience and notoriety.
Jackets/Covers: Assigns 30 freelance design and 30 illustration jobs/year. Pay negotiated on project by project basis.
Text Illustration: Assigns 30 freelance illustration jobs/year. Pay negotiated.
Tips: First-time assignments are usually b&w text illustration; cover illustration is given to "proven" freelancers. "Sometimes we offer royalty points and partial advance. Also, cartoon characters should have 'hip' today look. Be original."

■ **THE CENTER FOR WESTERN STUDIES**, Box 727, Augustana College, Sioux Falls SD 57197. (605)274-4007. Website: http://inst.augie.edu/CWS/. **Publications Director:** Harry F. Thompson. Estab. 1970. Publishes hardcover originals and trade paperback originals and reprints. Types of books include western history. Specializes in history and cultures of the Northern Plains, especially Plains Indians, such as the Sioux and Cheyenne. Publishes 2-3 titles/year. Recent titles include: *Soldier, Settler, Sioux: Fort Ridgeley and the Minnesota River Valley*; and *The Lizard Speaks: Essays on the Writings of Frederick Manfred*. 25% require freelance design. Books are conservative, scholarly and documentary. Book catalog free by request.
Needs: Approached by 1-2 freelancers/year. Works with 1-2 freelance designers and 1-2 illustrators/year. Uses freelancers mainly for cover design. Also for book design and text illustration. Works on assignment only.
First Contact & Terms: Send query letter with résumé, SASE and photocopies. Request portfolio review in original query. Responds only if interested. Portfolio should include roughs and final art. Sometimes requests work on spec before assigning a job. Rights purchased vary according to project. Originals are not returned. Finds illustrators and designers through word of mouth and submissions/self promotion.
Book Design: Assigns 1-2 freelance design jobs/year. Pays by the project, $500-750.
Jackets/Covers: Assigns 1-2 freelance design jobs/year. Pays by the project, $250-500.
Text Illustration: Pays by the project, $100-500.
Tips: "We are a small house, and publishing is only one of our functions, so we usually rely on the work of graphic artists with whom we have contracted previously. Send samples."

CENTERSTREAM PUBLISHING, P.O. Box 17878, Anaheim Hills CA 92807. (714)779-9390. E-mail: centerstrm@aol.com. **Production:** Ron Middlebrook. Estab. 1978. Publishes audio tapes and hardcover originals. Types of books include history, self-help, music history and instruction. Publishes 10-20 titles/year. Recent titles include: *Essential Blues Guitar*, *300 Fiddle Tunes*, *Irish and American Fiddle Tunes for Harmonica*, *Jazz Saxophone* (video) and *Hawaiian Ukulele, The Early Methods*. 100% requires freelance illustration. Book catalog free for 6×9 SAE with 2 first-class stamps.
Needs: Approached by 12 illustrators/year. Works with 3 illustrators/year.
First Contact & Terms: Illustrators send postcard sample or tearsheets. Accepts Mac-compatible disk submissions. Samples are not filed and are returned by SASE. Responds only if interested. Buys all rights, or rights purchased vary according to project.
Tips: "Publishing is a quick way to make a slow buck."

Ⓝ CHARIOT VICTOR PUBLISHING, Cook Communication Ministries, 4050 Lee Vance View, Colorado Springs CO 80918-7100. (719)536-0100. **Creative Director:** Jeff Barnes. Estab. late 1800s. Imprints include Chariot Publishing, Victor Publishing, Lion Publishing and Rainfall Educational Toys. Imprint

publishes hardcover and trade paperback originals and mass market paperback originals. Also toys. Types of books include contemporary and historical fiction, mystery, self-help, religious, juvenile, some teen and preschool. Publishes 100-150 titles/year. Recent titles include: *Gifts from God* and *Kids Hope*. 100% require freelance illustration; 20% require freelance design.

Needs: Approached by dozens of freelance artists/year. Works with 50 freelance illustrators and 10 free-lance designers/year. Buys 350-400 freelance illustrations/year. Prefers artists with experience in children's publishing and/or packaging. Uses freelance artists mainly for covers, educational products and picture books. Also uses freelance artists for and text illustration, jacket/cover and book design. 50% of design work demands knowledge of Illustrator, QuarkXPress, Photoshop or FreeHand. Works on assignment only.

First Contact & Terms: Send postcard sample or query letter with résumé, tearsheets and photocopies. "Only send samples you want me to keep." Samples are not returned. Responds only if interested. Artist should follow up with call. Rights purchased vary according to project. Originals are "usually" returned at the job's completion. Finds artists through submissions and word of mouth.

Book Design: Assigns 10 freelance design jobs/year.

Jackets/Covers: Assigns 100 freelance design/illustration jobs/year. Pays by the project, $300-2,000. Prefers computer design for comps, realistic illustration for fiction, cartoon or simplified styles for children's.

Text Illustration: Assigns 75 freelance illustration jobs/year. Pays by the project, $2,000-5,000 buyout for 32-page picture books. "Sometimes we offer royalty agreement." Prefers from simplistic, children's styles to realistic.

Tips: "First-time assignments are frequently available as we are always looking for a fresh look. However, our larger 'A' projects usually are assigned to those who we've worked with in the past."

N ☷ CHATHAM PRESS, INC., P.O. Box A, Old Greenwich CT 06870. (203)531-7755. **Art Director:** Arthur G.D. Mark. Estab. 1971. Publishes hardcover originals and reprints, trade paperback originals and reprints. Types of books include coffee table books, cookbooks, history, nonfiction, self-help, travel, western, political, Irish and photographic. Publishes 12 titles/year. Recent titles include: *Exploring Old Cape Cod* and *Photographers of New England*. 5% requires freelance illustration; 5% requires freelance design; 5% requires freelance art direction. Book catalog free for 7×10 SASE with 4 first-class stamps.

Needs: Approached by 16 illustrators and 16 designers/year. Works with 2 illustrators, 2 designers and 2 art directors/year. Prefers local illustrators and designers. Seeks b&w photographs of maritime and New England-oriented coastal scenes.

First Contact & Terms: Send query letter with photocopies and SASE. Samples are not filed and are returned by SASE. Responds in 2 months. Will contact artist for portfolio review if interested. Negotiates rights purchased. Finds freelancers through word of mouth and individual contacts.

Jackets/Covers: Assigns 4 freelance design jobs and 1 illustration job/year. Pays for design by the project. Pays for illustration by the project.

Tips: "We accept and look for contrast (black & whites rather than grays), simplicity in execution, and immediate comprehension (i.e., not cerebral, difficult-to-quickly-understand) illustrations and design. We have one tenth of a second to capture our potential customer's eyes—book jacket—art must help us do that."

N CHELSEA HOUSE PUBLISHERS, 1974 Sproul Rd., Suite 204, Broomall PA 19008-0914. (610)353-5166, ext. 188. Fax: (610)353-5191. **Contact:** Art Director. Estab. 1973. Publishes hardcover originals and reprints. Types of books include biography, history, juvenile, reference, young adult. Specializes in young adult literary books. Publishes 150 titles/year. Recent titles include: *Coretta Scott King*, by Lisa Renee Rhodes. 85% requires freelance illustration; 30% requires freelance design; 10% requires freelance art direction. Book catalog not available.

Needs: Approached by 100 illustrators and 50 designers/year. Works with 25 illustrators, 10 designers, 5 art directors/year. Prefers freelancers experienced in Macintosh computer for design. 100% of freelance design demands knowledge of Photoshop, QuarkXPress. 20% of freelance illustration demands knowledge of Illustrator, Photoshop, QuarkXPress.

First Contact & Terms: Designers send query letter with nonreturnable printed samples, photocopies. Illustrators send postcard sample and follow-up postcard every 3 months. Accepts Mac-compatible disk submissions. Samples are filed and are not returned. Will contact artist for portfolio review if interested. Buys first rights. Finds freelancers through networking, submissions, agents and *American Showcase*.

Book Design: Assigns 25 freelance design and 5 art direction projects/year. Pays for design by the hour, $15-35; for art direction by the hour, $25-45.

Jackets/Covers: Assigns 50 freelance design jobs and 150 illustration jobs/year. Prefers oil, acrylic. Pays for design by the hour, $25-35. Pays for illustration by the project, $650-850. Prefers portraits that capture close likeness of a person.

Tips: "Most of the illustrations we purchase involve capturing an exact likeness of a famous or historical person. Full color only, no black & white line art. Please send nonreturnable samples only."

CHILDREN'S BOOK PRESS, 2211 Mission St.,San Francisco CA 94110. (415)821-3080. Fax: (415)821-3081. E-mail: cbookpress@cbookpress.org. Website: www.cbookpress.org. Estab. 1975. Publishes hardcover originals and trade paperback reprints. Types of books: juvenile picture books only. Specializes in multicultural. Publishes 3 titles/year. Recent titles include: *My Very Own Room/Mi propio cuartito*, *Iguanas in the Snow/Iguanas en la nievo* and *Grandma and Me at the Flea/Los meros moros remateros*. 100% requires freelance illustration and design. Catalog free for 9×6 SASE with 57¢ first-class stamps.
Needs: Approached by 1,000 illustrators and 20 designers/year. Works with 2 illustrators and 2 designers/year. Prefers local designers experienced in QuarkXPress (designers) and previous children's picture book experience (illustrators). Uses freelancers for 32-page picture book design. 100% of freelance design demands knowledge of Photoshop, Illustrator and QuarkXPress.
First Contact & Terms: Designers send query letter with brochure, photocopies, photostats, résumé, bio, SASE and tearsheets. Illustrators send postcard sample or query letter with photocopies, photographs, printed samples, résumé, SASE and tearsheets. Responds in 6 months if interested or if SASE is included. Will contact artist for portfolio review if interested. Buys all rights.
Book Design: Assigns 2 freelance design jobs/year. Pays by the project.
Text Illustration: Assigns 2 freelance illustration jobs/year. Pays royalty.
Tips: "We look for a multicultural experience. We are especially interested in the use of bright colors and non-traditional instructive approach."

CHILDREN'S PRESS, Imprint of Scholastic Inc. Publishes children's nonfiction for the school and library market. Books are closely related to the elementary and middle-school curriculum.
- See listing for Franklin Watts for address and submission on requirements. Art Director is same for both imprints.

CHILDSWORK/CHILDSPLAY, LLC, The Guidance Channel, 135 Dupont St., Plainview NY 11803-0760. (516)349-5520, ext. 351. Fax: (516)349-5521. E-mail: karens@guidancechannel.com. Website: http://childswork.com. **New Product Development Editor:** Karen Schader. Estab. 1985. Types of books include children's picture books, instructional, juvenile, nonfiction, psychological/therapeutic books, games and counseling tools. Publishes 12-15 titles/year. Recent titles include: *The Penguin Who Lost Her Cool*, *The Lion Who Lost His Roar*, *The Hyena Who Lost Her Laugh*; *Stop Being So Mean!*. 100% requires freelance illustration; 100% requires freelance design. Product catalog for 4 first-class stamps.
Needs: Works with 6-8 illustrators and 2-4 designers/year. Prefers local illustrators. Prefers local designers. Freelance design demands knowledge of Illustrator, Photoshop, QuarkXPress. Freelance illustrations demands knowledge of Illustrator, Photoshop, QuarkXPress.
First Contact & Terms: Designer send query letter with photocopies, SASE. Illustrators send query letter with photocopies, SASE. Send EPS or TIFF files. Samples are filed or returned by SASE. Responds only if interested. Portfolio review not required. Will contact artist for portfolio review if interested. Buys all rights. Finds freelancers through referral, recommendations, submission packets.
Book Design: Assigns 12-15 freelance design jobs/year.
Jackets/Covers: Assigns 6-8 freelance design jobs and 6-8 illustration jobs/year. Pays for design by the project.
Text Illustration: Prefers freelancers experienced in children's educational/psychological materials.
Tips: "Freelancers should be flexible and responsive to our needs, with commitment to meet deadlines and, if needed, be available during business hours. We use a wide range of styles, from cartoonish to realistic."

CHINA BOOKS & PERIODICALS, 2929 24th St., San Francisco CA 94110. (415)282-2994. Fax: (415)282-0994. Website: www.chinabooks.com. **Art Director:** Linda Revel. Estab. 1960. Publishes hardcover and trade paperback originals. Types of books include contemporary fiction, instrumental, biography, juvenile, reference, history and travel. Specializes in China-related books. Publishes 10 titles/year. Recent titles include: *Chinese Folk Art* and *Be a Cat*, by Tsai Chih Chung. 10% require freelance illustration; 75% require freelance design. Books are "tastefully designed for the general book trade." Free book catalog.
Needs: Approached by 50 freelancers/year. Works with 5 freelance illustrators and 3 designers/year. Prefers freelancers with experience in Chinese topics. Uses freelancers mainly for illustration, graphs and maps. 50% of freelance work demands knowledge of QuarkXPress.

First Contact & Terms: Send postcard sample or query letter with résumé, samples and SASE. Samples are filed. Responds in 1 month. Write for appointment to show portfolio of thumbnails, b&w slides and photographs. Originals are returned at job's completion.

Book Design: Assigns 4 freelance jobs/year. Pays by the project, $500-3,000.

Jackets/Covers: Assigns 4 freelance design and 2 illustration jobs/year. Pays by the project, $700-2,000.

Text Illustration: Assigns 2 freelance jobs/year. Pays by the hour, $15-30; or by the project, $100-2,000. Prefers line drawings, computer graphics and photos.

Ⓝ CHRISTIAN SCHOOL INTERNATIONAL, 3350 E. Paris SE, Grand Rapids MI 49512-3054. (616)957-1070. Fax: (616)957-5022. E-mail: csi@csionline.org. Website: www.gospelcom.net/csi. **Production:** Judy Bandstra. Publishes textbooks. Types of books include juvenile, preschool, religious, young adult and teacher guides. Specializes in religious textbooks. Publishes 6-10 titles/year. Recent titles include: *Library Materials Guide*, *Science K-6* and *Literature 3-6*, Bible R-8. 20% requires freelance illustration. Book catalog free for 9×12 SAE with 3 first-class stamps.

Needs: Approached by 30-40 illustrators/year. Works with no more than 5 illustrators/year. Prefers freelancers experienced in 4-color illustration for textbooks. 90% of freelance design and 50% of freelance illustration demands knowledge of QuarkXPress.

First Contact & Terms: Send query letter with printed samples, photocopies. Samples are filed and are not returned. Will contact artist for portfolio review if interested. Buys first rights or rights purchased vary according to project. Finds freelancers through word of mouth, submission packets.

Text Illustration: Assigns 5-10 freelance illustration jobs/year. Pays by the project.

Ⓝ CHRONICLE BOOKS, 85 Second St., 6th Floor, San Francisco CA 94105. Website: www.chronicle books.com. **Creative Director:** Michael Carabetta. Estab. 1979. Company publishes high quality, affordably priced hardcover and trade paperback originals and reprints. Types of books include cookbooks, art, design, architecture, contemporary fiction, travel guides, gardening and humor. Publishes approximately 150 titles/year. Recent best-selling titles include the *Griffin & Sabine* trilogy, by Nick Bantock, *What a Way To Go* and *Extreme Dinosaurs*. Book catalog free on request (call 1-800-722-6657).

● Chronicle has a separate children's book division, and a gift division, which produces blank greeting cards, address books, journals and the like.

Needs: Approached by hundreds of freelancer/year. Works with 15-20 illustrators and 30-40 designers/year. Uses artists for cover and interior design and illustration. 99% of design work demands knowledge of PageMaker, QuarkXPress, FreeHand, Illustrator or Photoshop; "mostly QuarkXPress—software is up to discretion of designer." Works on assignment only.

First Contact & Terms: Send query letter with tearsheets, color photocopies or printed samples no larger than 8½×11. Samples are filed or are returned by SASE. Responds only if interested. Art Director will contact artist for portfolio review if interested. Portfolio should include thumbnails, roughs, final art, photostats, tearsheets, slides, tearsheets and transparencies. Buys all rights. Originals are returned at job's completion. Finds artists through submissions, *Communication Arts* and sourcebooks.

Book Design: Assigns 30-50 freelance design jobs/year. Pays by the project; $750-1200 for covers; varying rates for book design depending on page count.

Jackets/Covers: Assigns 30 freelance design and 30 illustration jobs/year. Pays by the project.

Text Illustration: Assigns 25 freelance illustration jobs/year. Pays by the project.

Tips: "Please write instead of calling; don't send original material."

CIRCLET PRESS, INC., 1770 Massachusetts Ave., #278, Cambridge MA 02140. (617)864-0492. Fax: (617)864-0663. E-mail: circlet-info@circlet.com. Website: www.circlet.com. **Publisher:** Cecilia Tan. Estab. 1992. Company publishes trade paperback originals. Types of books include erotica, erotic science fiction and fantasy. Publishes 8-10 titles/year. Recent titles include: *Nymph*, by Francesca Lia Block; *Through A Brazen Mirror*, by Delia Sherman; and *Stars Inside Her*, by Cecilia Tan. 100% require freelance illustration. Book catalog free for business size SAE with 1 first-class stamp.

Needs: Approached by 50-100 freelancers/year. Works with 4-5 freelance illustrators/year. Uses freelancers for cover art. Needs computer-literate freelancers for illustration. 100% of freelance work demands knowledge of QuarkXPress or Photoshop. Works on assignment only. 10% of titles require freelance art direction.

First Contact & Terms: Send query letter with color photocopies or e-mail with attachments, pitching an idea for specific upcoming books. List of upcoming books available for 34¢ SASE or on website. Ask for "Artists Guidelines." Samples are filed. Responds only if interested. Portfolio review not required. Buys one-time rights or reprint rights. Originals are returned at job's completion. Finds artists through art shows at science fiction conventions and submission samples. "I need to see human figures well-executed with sensual emotion. No tentacles or gore! Photographs, painting, computer composites all welcomed. We use much more photography these days."

Book Design: Assigns 2-4 freelance design jobs/year. Pays by the project, $15-100.

Jackets/Covers: Assigns 2-4 freelance illustration jobs/year. Pays by the project, $100-200. Now using 4-color and halftones.

Tips: "Follow the instructions in this listing: Don't send me color samples on slides. I have no way to view them. Any jacket and book design experience is also helpful. I prefer to see a pitch idea for a cover aimed at a specific title, a way we can use an image that is already available to fit a theme. The artists I have hired in the past 3 years have come to me through the Internet by e-mailing JPEG or GIF files of samples in response to the guidelines on our website. The style that works best for us is photographic collage and post-modern."

N. CLARION BOOKS, 215 Park Ave., 10th Floor, New York NY 10003. (212)420-5800. Website: www.houghtonmifflinbooks.com. **Art Director:** Joann Hill. Imprint of Houghton Mifflin Company. Imprint publishes hardcover originals and trade paperback reprints. Specializes in picture books, chapter books, middle grade novels and nonfiction, including historical and animal behavior. Publishes 60 titles/year. Recent titles include: *The Hobbit*, by J.R.R. Tolkien. 90% requires freelance illustration. Book catalog free for SASE.

• *The Three Pigs*, by David Weisner was awarded the 2002 Caldecott Medal. *A Single Shard*, by Linda Sue Park was awarded the 2002 Newbery Medal.

Needs: Approached by "countless" freelancers. Works with 48 freelance illustrators/year. Uses freelancers mainly for picture books and novel jackets. Also for jacket/cover and text illustration.

First Contact & Terms: Send query letter with tearsheets and photocopies. Samples are filed "if suitable to our needs." Responds only if interested. Portfolios may be dropped off every Monday. Art Director will contact artist for portfolio review if interested. Rights purchased vary according to project. Originals are returned at job's completion.

Text Illustration: Assigns 48 freelance illustration jobs/year. Pays by the project.

Tips: "Be familiar with the type of books we publish before submitting. Send a SASE for a catalog or look at our books in the bookstore. Send us children's book-related samples."

N. COFFEE HOUSE PRESS, 27 N. Fourth St., Minneapolis MN 55401-1718. (612)338-0125. Fax: (612)338-4004. Website: www.coffeehousepress.org. **Contact:** Design & Production Manager. Publishes hardcover and trade paperback originals. Types of books include experimental and mainstream fiction and poetry. Publishes 14 titles/year. Recent titles include: *Glory Goes and Gets Some* and *The Man Who Swam With Beavers*. 15% requires freelance illustration. Book catalog free for SASE.

Needs: Approached by 20 illustrators and 10 designers/year. Works with 4 illustrators/year. Prefers freelancers experienced in book covers.

First Contact & Terms: Designers send query letter with photocopies. Illustrators send postcard sample and/or photocopies and printed samples. After introductory mailing send follow-up postcard samples every 6 months. Samples are filed. Will contact artist for portfolio review if interested. Rights purchased vary according to project.

Jackets/Covers: Assigns 5 freelance illustration jobs/year. Pays for illustration by the project, $200-550.

Text Illustration: Finds illustrators through sourcebooks, word of mouth, self promos.

Tips: "We are nonprofit and may not be able to provide full market value for artwork and design. However, we can provide national exposure and excellent portfolio pieces, and allow for generous creative license."

N. CONARI PRESS, 2550 9th St., Suite 101, Berkeley CA 94710-2551. (510)649-7175. Fax: (510)649-7190. **Editor:** Leslie Berriman. Art Director: Claudia Swelser. Estab. 1987. Publishes hardcover and trade paperback originals. Types of books include self help, women's issues and general non-fiction. Publishes 30 titles/year. Titles include *True Love* and *Random Acts of Kindness*. 10% require freelance illustration. Book catalog free.

Needs: Approached by 100 freelancers/year. Uses freelancers for jacket/cover illustration and design. Works on assignment only.

First Contact & Terms: Send query letter with samples. Samples are filed. Responds to the artist only if interested. Rights purchased vary according to project. Originals returned at job's completion.

Book Design: Assigns 25 freelance design jobs/year. Pays for design: by the hour, $25 minimum; by the project, $1,100 minimum.

Jackets/Covers: Assigns 25 freelance design and 10 illustration jobs/year. Pays for design by the project, $1,100 minimum. Pays for illustration by the project, $300-500.

Text Illustration: Assigns 1-3 freelance jobs/year. Pays by the project, $100-1,000; pays for design $1,100 minimum.

Tips: "To get an assignment with me you need dynamic designs, flexibility and reasonable prices."

⛿ COUNCIL FOR EXCEPTIONAL CHILDREN, 1110 N. Glebe Rd., Suite 300, Arlington VA 22201-5704. (703)620-3660. Fax: (703)620-2521. E-mail: cecpubs@cec.sped.org. Website: www.cec.sped. org. **Senior Director for Publications:** Kathleen McLane. Estab. 1922. Publishes audio and videotapes, CD-ROMs, paperback originals. Specializes in professional development/instruction. Recent titles include: *IEP Team Guide* and *Adapting Instructional Material for the Inclusive Classroom*. Publishes 10 titles/year. Book catalog available.
Needs: Prefers local illustrators, designers and art directors. Prefers freelancers experienced in education. Some freelance illustration demands knowledge of PageMaker, QuarkXPress.
First Contact & Terms: Send query letter with printed samples, SASE. Accepts Windows-compatible disk submissions or TIFF files. Samples are not filed and are returned by SASE. Will contact artist for portfolio review showing book dummy and roughs if interested. Buys all rights.

Ⓝ THE COUNTRYMAN PRESS (Division of W.W. Norton & Co., Inc.), Box 748, Woodstock VT 05091. (802)457-4826. Fax: (802)457-1678. E-mail: countrymanpress@wwnorton.com. Website: www.cou ntrymanpress.com. **Prepress Manager:** Fred Lee. Estab. 1976. Book publisher. Publishes hardcover originals and reprints, and trade paperback originals and reprints. Types of books include history, travel, nature and recreational guides. Specializes in recreational (biking/hiking) guides. Publishes 35 titles/year. Recent titles include: *Reading the Forested Landscape* and *Connecticut, An Explorer's Guide*. 10% require freelance illustration; 60% require freelance cover design. Book catalog free by request.
Needs: Works with 4 freelance illustrators and 7 designers/year. Uses freelancers for jacket/cover and book design. Works on assignment only. Prefers working with computer-literate artists/designers within New England/New York with knowledge of PageMaker, Photoshop, Illustrator, QuarkXPress or FreeHand.
First Contact & Terms: Send query letter with appropriate samples. Samples are filed. Responds to the artist only if interested. To show portfolio, mail best representations of style and subjects. Negotiates rights purchased.
Book Design: Assigns 10 freelance design jobs/year. Pays for design by the project, $500-1,200.
Jackets/Covers: Assigns 10 freelance design jobs/year. Pays for design $400-1,000.
Text Illustration: Assigns 2 freelance illustration jobs/year.

CRC PRODUCT SERVICES, 2850 Kalamazoo Ave. SE, Grand Rapids MI 49560. (616)224-0780. Fax: (616)224-0834. Website: www.crcna.org/cr/crop/croparte.htm. **Art Director:** Dean Heetderks. Estab. 1866. Publishes hardcover and trade paperback originals and magazines. Types of books include instructional, religious, young adult, reference, juvenile and preschool. Specializes in religious educational materials. Publishes 8-12 titles/year. 85% requires freelance illustration.
Needs: Approached by 30-45 freelancers/year. Works with 12-16 freelance illustrators/year. Prefers freelancers with religious education, cross-cultural sensitivities. Uses freelancers for jacket/cover and text illustration. Works on assignment only. 5% requires freelance art direction.
First Contact & Terms: Send query letter with brochure, résumé, tearsheets, photographs, photocopies, photostats, slides and transparencies. Illustration guidelines are available on website. Samples are filed. Portfolio should include thumbnails, roughs, finished samples, color slides, tearsheets, transparencies and photographs. Buys one-time rights. Originals are returned at job's completion.
Jackets/Covers: Assigns 2-3 freelance illustration jobs/year. Pays by the project, $200-1,000.
Text Illustration: Assigns 50-100 freelance illustration jobs/year. Pays by the project, $75-100. "This is high-volume work. We publish many pieces by the same artist."
Tips: "Be absolutely professional. Know how people learn and be able to communicate a concept clearly in your art."

CREATIVE WITH WORDS PUBLICATION, P.O. Box 223226, Carmel CA 93922. E-mail: cwwpub @usa.net. Website: members.tripod.com/CreateWithWords. **Editor-in-Chief:** Brigitta Geltrich. Nature Editor: Bert Hower. Estab. 1975. Publishes mass market paperback originals. Types of anthologies include adventure, children's picture books, history, humor, juvenile, preschool, travel, young adult and folklore. Specializes in anthologies. Publishes 12-14 titles/year. Recent titles include: *Folkhumor* and *We are Writers, Too!* Books are listed on website.
Needs: Approached by 5 illustrators/month. Works with 6-12 illustrators/year. Prefers freelancers experienced in b&w drawings. Does not want computer art.
First Contact & Terms: Send postcard sample and follow-up postcard every 3 months, or query letter with printed samples, photocopies, SASE. Samples are filed or returned by SASE. Responds in 2 weeks if SASE was enclosed. Will contact artist for portfolio review if interested. Buys one-time rights and sometimes negotiates rights purchased.
Book Design: Assigns 12-14 freelance design jobs/year. Pays for design by the project, $2-20 a sketch.
Jackets/Covers: Assigns 12-14 illustration jobs/year. Pays for illustration by the project, $2-20 a sketch. Prefers folkloristic themes, general-public appeal.

Text Illustration: Assigns 12-14 freelance illustration jobs/year. Pays by the project, $2-20. Prefers b&w sketches.

Tips: "We aim for a folkloristic slant in all of our publications. Therefore, we always welcome artists who weave this slant into our daily lives for a general (family) public. We also like to have the meanings of a poem or prose expressed in the sketch."

CROSS CULTURAL PUBLICATIONS, INC., P.O. Box 506, Notre Dame IN 46556. (219)272-0889. Fax: (219)273-5973. E-mail: crosscult@aol.com. Website: www.crossculturalpub.com. **Marketing Manager:** Anand Pullapilly. Director of Graphic Art: Christine English. Business Manager: Kavita Pullapilly. Estab. 1980. Imprint is Cross Roads Books. Company publishes hardcover and trade paperback originals and textbooks. Types of books include biography, religious and history. Specializes in scholarly books on cross-cultural topics. Publishes 30 titles/year. Recent titles include: *She is With the Angels*, by August Swanenberg; *I Became a Fly*, by Donald McKnight; *Human Consciousness* and *The Material Soul*, by John Dedek.

Needs: Approached by 25 freelancers/year. Works with 2 freelance illustrators/year. Prefers local artists only. Uses freelance artists mainly for jacket/cover illustration.

First Contact & Terms: Send query letter with résumé and photocopies. Samples are not filed and are not returned. Responds only if interested. Art director will contact artist for portfolio review if interested. Portfolio should include b&w samples. Rights purchased vary according to project. Originals are not returned. Finds artists through word of mouth.

Jackets/Covers: Assigns 4-5 freelance illustration jobs/year. Pays by the project.

Tips: "First-time assignments are usually book jackets. We publish books that push the boundaries of knowledge."

THE CROSSING PRESS, 1201 Shaffer Rd., Suite B, Santa Cruz CA 95060. (831)420-1110. Fax: (831)420-1114. E-mail: knarita@crossingpress.com. Website: www.crossingpress.com. **Art Director:** Karen Narita. Estab. 1966. Publishes audio tapes, trade paperback originals and reprints. Types of books include nonfiction and self-help. Specializes in natural healing, New Age spirituality, cookbooks. Publishes 50 titles/year. Recent titles include: *Reliance on the Light*, *Zen Judaism* and *Psycho Kitty*. Art guidelines on website.

Needs: Freelance illustrators, photographers, artists and designers welcome to submit samples. Prefers designers experienced in Quark, Photoshop and book text design.

First Contact & Terms: Send query letter with printed samples, photocopies or 3-5 slides, SASE if materials are to be returned. Accepts Mac-compatible disk submissions. Samples are filed or returned by SASE. Will contact artist for portfolio review if interested. Rights purchased vary according to project. Finds freelancers through submissions, promo mailings, *Directory of Illustration*, *California Image*, *Creative Black Book*.

Tips: "We look for artwork that is expressive, imaginative, colorful, textural—abstract or representational—appropriate as cover art for books on natural healing or New Age spirituality. We also are interested in artists/photographers of prepared food for cookbooks."

CROWN PUBLISHERS, INC., 201 E. 50th St., 5th Floor, New York NY 10022. (212)572-2600. **Art Director:** Whitney Cookman. Art Directors: Mary Schuck and Mary Sarah Quinn. Specializes in fiction, nonfiction and illustrated nonfiction. Publishes 250 titles/year. Recent titles include: *The Provocateur* and *The Myth of Excellence*.

• Crown is an imprint of Random House. Within that parent company several imprints, including Clarkson Potter; Crown Arts & Letters; and Harmony maintain separate art departments.

Needs: Approached by several hundred freelancers/year. Works with 15-20 illustrators and 25 designers/year. Prefers local artists. 100% of design demands knowledge of QuarkXPress and Illustrator. Works on assignment only.

First Contact & Terms: Send query letter with samples showing art style. Responds only if interested. Originals are not returned. Rights purchased vary according to project.

Jackets/Covers: Assigns 15-20 design and/or illustration jobs/year. Pays by the project.

Tips: "There is no single style. We use different styles depending on nature of the book and its perceived market. Become familiar with the types of books we publish. For example, don't send juvenile, sci-fi or romance. Book design has changed to Mac-generated layout."

CRUMB ELBOW PUBLISHING, P.O. Box 294, Rhododendron OR 97049. (503)622-4798. **Publisher:** Michael P. Jones. Estab. 1982. Imprints include Oregon Fever Books, Tyee Press, Research Centrex, Read'n Run Books. Silhouette Imprints, Wildlife Research Group. Company publishes hardcover, trade paperback and mass market originals and reprints, textbooks, coloring books, poetry, cards, calendars, prints and maps. Types of books include adventure, biography, coffee table books, cookbooks, experimental

fiction, fantasy, historical fiction, history, horror, humor, instructional, juvenile, mainstream fiction, New Age, nonfiction, preschool, reference, religious, romance, science fiction, self-help, textbooks, travel, western, and young adult. Specializes in historical and wildlife books. Publishes 40 titles/year. Recent titles include: *Phantom Coach*, by Amelia B. Edwards; and *Dickon the Devil*, by J.S. Lefanu. 75% require freelance illustration; 75% require freelance design. Book catalog available for $3.

Needs: Approached by 250 freelancers/year. Works with 50 freelancers and 35 designers/year. Uses freelancers for jacket/cover design and illustration, text illustration, book and catalog design, calendars, prints, note cards. 50% of freelance work demands computer skills. Works on assignment only.

First Contact & Terms: Send query letter with brochure, SASE, tearsheets and photocopies. Samples are filed or returned by SASE if requested by artist. Responds in 1 month. Request portfolio review in original query. Portfolio should include book dummy, final art, photographs, roughs, slides and tearsheets. Buys one-time rights. Originals are returned at job's completion.

Book Design: Assigns 35 freelance design jobs/year. Pays by the project, $50-250 or in published copies.

Jackets/Covers: Assigns 35 freelance design and 60 illustration jobs/year. Pays by the project, $50-250 or in published copies.

Text Illustration: Assigns 60 freelance illustration jobs/year. Pays by the project, $50-250 or in published copies. Prefers pen & ink.

Tips: "We find talented individuals to illustrate our projects any way we can. Generally artists hear about us and want to work with us. We are a very small company who gives beginners a chance to showcase their talents in a book project; and yet, more established artists are in touch with us because our projects are interesting (like American Indian mythology, The Oregon Trail, wildlife, etc.) and we do not art-direct anyone to death."

N DARKTALES PUBLICATIONS, 21 S. Emerson, Mount Prospect IL 60056. (847)259-3418. E-mail: doc@darktales.com. Website: www.darktales.com. **Contact:** Keith Herber, art director. Estab. 1998. Publishes trade paperback originals. Types of books include fantasy, horror and science fiction. Publishes 12 titles/year. Recent titles include: *The Charm*, by Adam Niswander; *Harlan*, by David Whitman; and *The Asylum: Volume 2*, edited by Victor Heck. 75% requires freelance illustration. Book catalog not available.

Needs: Approached by 20 illustrators. Works with 5 illustrators/year. Prefers freelancers experienced in graphic design.

First Contact & Terms: Designers send postcard sample and follow-up postcard every 3 months. Illustrators send postcard sample and follow-up postcard every 3 months. Accepts Mac-compatible disk submissions as EPS or TIFF files. Responds in 6 weeks. Will contact artist for portfolio review if interested. Portfolio should include photographs. Buys first North American serial rights. "Illustrators find us!"

Jackets/Covers: Assigns 8 freelance design jobs and 2 illustration jobs/year. Pays for design by the project, $100-150. Pays for illustration by the project, $100-250. Prefers bold, strong designs.

Text Illustration: Assigns 0 freelance illustration jobs/year.

Tips: "We look for strong designs and expect the artist to make their own statement about the book."

JONATHAN DAVID PUBLISHERS, 68-22 Eliot Ave., Middle Village NY 11379. (718)456-8611. Fax: (718)894-2818. E-mail: info@jdbooks.com. Website: www.jdbooks.com. **Production Coordinator:** Fiorella de Lima. Estab. 1948. Company publishes hardcover and paperback originals. Types of books include biography, religious, young adult, reference, juvenile and cookbooks. Specializes in Judaica. Publishes 25 titles/year. Recent titles include: *Drawing a Crowd* and *The Presidents of the United States & the Jews*. 50% require freelance illustration; 75% require freelance design.

Needs: Approached by numerous freelancers/year. Works with 5 freelance illustrators and 5 designers/year. Prefers freelancers with experience in book jacket design and jacket/cover illustration. 100% of design and 5% of illustration demand computer literacy. Works on assignment only.

First Contact & Terms: Designers send query letter with résumé and photocopies. Illustrators send postcard sample and/or query letter with photocopies, résumé. Samples are filed. Production coordinator will contact artist for portfolio review if interested. Portfolio should include color final art and photographs. Buys all rights. Originals are not returned. Finds artists through submissions.

Book Design: Assigns 15-20 freelance design jobs/year. Pays by the project.

Jackets/Covers: Assigns 15-20 freelance design and 4-5 illustration jobs/year. Pays by the project.

Tips: First-time assignments are usually book jackets, mechanicals and artwork.

✓ ALDINE DE GRUYTER, NEW YORK, 200 Saw Mill R. Rd., Hawthorne NY 10532. (914)747-0110. Website: www.degruyterny.com. **Production Manager:** Anne Obuck. Estab. 1978. Imprint of Walter de Gruyter Inc. Publishes scholarly books and graduate level textbooks (cloth and paper dual editions). Specializes in sociology. Publishes 15-20 titles/year. 0% requires illustration; 100% requires freelance design of paperback cover only (no interior design needed). Book catalog free on request.

Needs: Works with 2 designers/year. Prefers local freelancers experienced in scholarly covers and jackets. Design demands knowledge of Illustrator and QuarkXPress, "or subject to prior discussion. Strong typographic skills essential."

First Contact & Terms: Designers send photocopies, résumé. Samples are filed. Will contact artist for portfolio review of printed samples if interested.

Jackets/Covers: Assigns 15-20 design jobs/year. Pays by the project; negotiable.

Tips: "Looking for somewhat witty, but always intelligent approach to dealing with sometimes nonexciting sociology titles. Adaptation to 2-color discipline. Good use of color."

N **DELIRIUM BOOKS**, P.O. Box 338, N. Webster IN 46555. (574)594-1607. E-mail: deliriumbooks@k conline.com. Website: www.deliriumbooks.com **Contact:** Shane Ryan Staley, editor-in-chief. Estab. 1999. Publishes hardcover and trade paperback originals. Types of books include horror. Specializes in limited edition small press titles. Publishes 8 titles/eyar. Recent titles include: *Cobwebs and Whispers*, by Scott Thomas; *Heretics*, by Greg F. Gifune; *Dark Testament*, edited by Shane Ryan Staley. 100% requires freelance illustration; 100% requires freelance design. Book catalog free on request for 1 first-class stamp.

Needs: Approached by 50 illustrators and 20 designers/year. Works with 10 illustrators and 8 designers/year. Prefers freelancers experienced in cover art and horror design/typography. 100% of freelance design demands knowledge of Adobe Photoshop. 100% of freelance illustrations demands knowledge of Adobe Photoshop.

First Contact & Terms: Designer send query letter with printed samples. Illustrators send query letter with printed samples Accepts Mac-compatible disk submissions as TIFF files. Samples are filed or returned by SASE. Responds only if interested. Will contact artist for Portfolio review if interested. Portfolio should include horror elements and photocopies. Buys first North American serial rights. Finds freelancers through submission packets placed on file.

Book Design: Assigns 1 freelance design job/year. Assigns 1 freelance art direction project/year. Pays for design by the project, $100-800.

Jackets/Covers: Assigns 1-2 freelance design jobs and 8-12 illustration jobs/year. Prefers digital format. Pays for design by the project, $100-800. Pays for illustration by the project, $100-800. Prefers experienced horror cover illustration.

Text Illustration: Assigns 8-12 freelance illustration jobs/year. Pays by the project, $50-400. Prefers freelancers who can match mood and atmosphere of specific horror titles.

Tips: Artists should be equipped to send high resolution digital files (CMTK) as TIFF format. Often times, the artist is assigned to do both the cover art and text illustrations. We prefer the usage of Adobe Photoshop.

⛏ **DOMINIE PRESS, INC.**, 1949 Kellogg Ave., Carlsbad CA 92008-6582. (760)431-8000. Fax: (760)431-8777. E-mail: info@dominie.com. Website: www.dominie.com. **C.E.O.:** Raymond Yuen. Editors: Bob Rowland and Carlos Byfield. Estab. 1975. Publishes textbooks. Types of books include children's picture books, juvenile, nonfiction, preschool, textbooks and young adult. Specializes in educational textbooks. Publishes 180 titles/year. Recent titles include: *The Day Miss Francine Got Skunked* and *Marine Life Series*. 90% requires freelance illustration; 50% requires freelance design; 30% requires freelance art direction. Book catalog free for 9×12 SASE with $2 postage.

Needs: Approached by 50 illustrators and 50 designers/year. Works with 35 illustrators, 10 designers and 2 art directors/year. Prefers local designers and art directors. Prefers freelancers experienced in children's books and elementary textbooks. 100% of freelance design demands knowledge of Illustrator, Photoshop, FreeHand, PageMaker and QuarkXPress.

First Contact & Terms: Designers send printed samples and tearsheets. Illustrators send query letter with printed samples and tearsheets. Samples are not filed and are returned by SASE. Responds in 6 months only if interested. Will contact artist for portfolio review if interested. Portfolio should include book dummy, photocopies, photographs, roughs, tearsheets, thumbnails, transparencies. Buys all rights.

Book Design: Assigns 25 freelance designs and 5 freelance art direction projects/year. Pays by the project.

Jackets/Covers: Assigns 30 freelance design jobs and 150 illustration jobs/year.

Text Illustration: Assigns 150 freelance illustration jobs/year. Pays by the project.

N **DUTTON CHILDREN'S BOOKS**, Penguin Putnam Inc., 375 Hudson St., New York NY 10014. **Art Director:** Sara Reynolds. Publishes hardcover originals. Types of books include children's picture books, juvenile, preschool, young adult. Publishes 100-120 titles/year. 75% require freelance illustration.

First Contact & Terms: Send postcard sample, printed samples, tearsheets. Samples are filed or returned by SASE. Will contact artist for portfolio review if interested. Portfolios may be dropped off every Tuesday and picked up by end of the day. Do not send samples via e-mail.

Jackets/Covers: Pays for illustration by the project $1,500-2,000.

☑ **THE ECCO PRESS**, HarperCollins, 10 E. 53rd, New York NY 10022. (212)207-7000. Fax: (212)702-2460. E-mail: eccopress@snip.net. Website: www.harpercollins.com. **Art Director:** Roberto DeVicq. Estab. 1972. Publishes hardcover and trade paperback originals and reprints. Types of books include biography, cookbooks, experimental and mainstream fiction, poetry, nonfiction and travel. Specializes in literary fiction, poetry and cookbooks. Publishes 60 titles/year. Recent titles include: *Blonde* by Joyce Carol Oates, and *Dirty Havana Trilogy*, by Pedro Juan Couitterez. 10% requires freelance illustration; 100% requires freelance design.

● Ecco Press is one of the world's most prestigious literary publishers. The press was acquired by HarperCollins in 1999.

Needs: Approached by 40 illustrators and 60 designers/year. Works with 2 illustrators and 20 designers/year. Prefers freelancers experienced in book jacket design and interior book design. 100% of freelance design demands knowledge of QuarkXPress. 80% of freelance illustration demands knowledge of Photoshop.

First Contact & Terms: Designers and illustrators send postcard sample or query letter with photocopies and tearsheets. Accepts Mac-compatible disk submissions. Some samples filed, most not kept and not returned. Will contact artist for portfolio review if interested. You may also drop off portfolio on Wednesday and pick up Friday afternoon. Rights purchased vary according to project. Finds freelancers through word of mouth, sourcebooks, design magazines and browsing bookstores.

Book Design: Pays for design by the project.

Jackets/Covers: Assigns 60 freelance design jobs and 1 illustration job/year. Pays by the project, $500-1,000 for design, $200-500 for illustration. "We prefer sophisticated and hip experienced designers."

Tips: "The best designers read the manuscript or part of the manuscript. Artwork should reflect the content of the book and be original and eye-catching. Submit designs in QuarkXPress for Mac on Zip disks. Ask questions. Jacket font should be readable."

EDUCATIONAL IMPRESSIONS, INC., 116 Washington Ave., Hawthorne NJ 07506. (973)423-4666. Fax: (973)423-5569. E-mail: awpeller@worldnet.att.net. Website: www.awpeller.com. **Art Director:** Karen Birchak. Estab. 1983. Publishes original workbooks with 2-4 color covers and b&w text. Types of books include instructional, juvenile, young adult, reference, history and educational. Specializes in all educational topics. Publishes 4-12 titles/year. Recent titles include: *September, October and November*, by Rebecca Stark; *Tuck Everlasting*; and *Walk Two Moons Lit Guides*. Books are bright and bold with eye-catching, juvenile designs/illustrations.

Needs: Works with 1-5 freelance illustrators/year. Prefers freelancers who specialize in children's book illustration. Uses freelancers for jacket/cover and text illustration. Also for jacket/cover design. 50% of illustration demands knowledge of QuarkXPress, FreeHand and Photoshop. Works on assignment only.

First Contact & Terms: Send query letter with tearsheets, SASE, résumé and photocopies. Samples are filed. Art director will contact artist for portfolio review if interested. Buys all rights. Interested in buying second rights (reprint rights) to previously published work. Originals are not returned. Prefers line art for the juvenile market. Sometimes requests work on spec before assigning a job.

Book Design: Pays by the project, $20 minimum.

Jackets/Covers: Pays by the project, $20 minimum.

Text Illustration: Pays by the project, $20 minimum.

Tips: "Send juvenile-oriented illustrations as samples."

EDWARD ELGAR PUBLISHING INC., 136 West St., Suite 202, Northampton MA 01060. (413)584-5551. Fax: (413)584-9933. E-mail: kwight@e-elgar.com. Website: www.e-elgar.com. **Promotions Manager:** Katy Wight. Promotions Assistant: Candace Bradbury-Carlin. Estab. 1986. Publishes hardcover originals and textbooks. Types of books include instructional, nonfiction, reference, textbooks, academic monographs and references in economics. Publishes 200 titles/year. Recent titles include: *Who's Who in Economics, Third Edition* and *Teaching Economics to Undergraduates*.

● This publisher uses only freelance designers. Its academic books are produced in the United Kingdom. Direct Marketing material is done in U.S. There is no call for illustration.

Needs: Approached by 2-4 designers/year. Works with 2 designers/year. Prefers local designers. Prefers freelancers experienced in direct mail and academic publishing. 100% of freelance design demands knowledge of Photoshop, QuarkXPress.

First Contact & Terms: Designers send query letter with printed samples. Accepts Mac-compatible disk submissions. Samples are filed. Will contact artist for portfolio review if interested. Buys one-time rights or rights purchased vary according to project. Finds freelancers through word of mouth, local sources i.e. phone book, newspaper, etc.

☑ **ELTON-WOLF PUBLISHING**, 2505 Second Ave., Suite #515, Seattle WA 98121. (206)748-0345. Fax: (206)748-0343. E-mail: info@elton-wolf.com. Website: www.elton-wolf.com. **President:** Beth Far-

rell. Administrative Assistant: Kylee Krida. Production Coordinator: Sheila Hackler. Estab. 1972. Book publisher. Publishes 100 titles/year. 100% require freelance illustration. Titles include *The Blood Remembers*, *Silent Partners*, *Gift of the Rainbow Serpent* and *Owosso Rain*.

Needs: Approached by 70 freelance artists/year. Needs freelancers for multimedia projects. 95% of design demands computer skills.

First Contact & Terms: Works on assignment only. Send résumé and brochure showing art style or tearsheets, photostats and photocopies. Accepts disk submissions. Samples not filed are returned only if requested. Responds only if interested. To show portfolio, mail appropriate materials. Payment negotiable.

Tips: Books contain pen & ink and 4-color photos. "Don't act as if you know more about the work than we do. Do exactly what is assigned to you. Quality, service, and timeliness are our bywords. Our goal is to exceed our authors' expectations both in our production services, as well as, post-production services."

☑ EMC/PARADIGM PUBLISHING, a division of EMC Corp., 875 Montreal Way, St. Paul MN 55102. (651)290-2800. Fax: (651)290-2899. E-mail: donofrio@emcp.com. Website: www.emcp.com. **Art Director:** Joan D'Onofrio. Estab. 1989. Book publisher. Publishes textbooks, audio books, CD-ROMs. Types of books include business and office, communications, software-specific manuals. Specializes in basic computer skills. Publishes 50 titles/year. Recent titles include: *Medical Assisting* and *Word Perfect 6.0*, by Nita Rutkosky. 100% require freelance illustration and design. Books have very modern high-tech design, mostly computer-generated. Book catalog free by request.

Needs: Approached by 50-75 freelancers/year. Works with 14 freelance illustrators and 20 designers/year. Uses freelance artists mainly for covers. Works on assignment only.

First Contact & Terms: Send brochure and slides. Samples are filed. Slides are returned. Art director will contact artist for portfolio review if interested. Portfolio should include b&w and color transparencies. Rights purchased vary according to project. Interested in buying second rights (reprint rights) to previously published work. Finds artists through submissions, agents and recommendations.

Book Design: Assigns 10 freelance design jobs and 30 illustration jobs/year. Pays by the project, $500-1,500.

Jackets/Covers: Assigns 20 freelance design jobs and 20 illustration jobs/year. Pays by the project, $400-1,500.

Text Illustration: Pays $25-100/illustration.

Tips: "All work is being generated by the computer. I don't use any art that is done by hand, however, I am not interested in computer techies who think they are now designers. I'm looking for excellent designers who are highly competent on the computer."

☑ ⚓ M. EVANS AND COMPANY, INC., 216 E. 49th St., New York NY 10016-1502. (212)688-2810. Fax: (212)486-4544. **Contact:** George DeKay. Estab. 1956. Publishes hardcover and trade paperback originals. Types of books include contemporary fiction, biography, health and fitness, history, self-help and cookbooks. Specializes in general nonfiction. Publishes 40 titles/year. Recent titles include: *Dr. Atkins' New Diet Revolution*, by Robert C. Atkins; and *New Encyclopedia of Vitamins and Minerals*. 5% requires freelance illustration and design.

Needs: Approached by hundreds of freelancers/year. Works with approximately 3 freelance illustrators and designers/year. Prefers local artists. Uses freelance artists mainly for jacket/cover illustration. Also for text illustration and jacket/cover design. Works on assignment only.

First Contact & Terms: Send query letter with brochure and résumé. Samples are filed. Art Director will contact artist for portfolio review if interested. Portfolio should include original/final art and photographs. Rights purchased vary according to project. Originals are returned at job's completion upon request.

Book Design: Assigns 10 freelance jobs/year. Pays by project, $200-500.

Jackets/Covers: Assigns 20 freelance design jobs/year. Pays by the project, $600-1,200.

Text Illustration: Pays by the project, $50-500.

EXCELSIOR CEE PUBLISHING, P.O. Box 5861, Norman OK 73070. (405)329-3909. Fax: (405)329-6886. E-mail: ecp@oecadvantage.net. Website: excelsiorcee.com. Estab. 1989. Publishes trade paperback originals. Types of books include how-to, instruction, nonfiction and self help. Specializes in how-to and writing. Publishes 6 titles/year. Recent titles include: *When I Want Your Opinion I'll Tell it to You*.

Needs: Uses freelancers mainly for jacket and cover design.

First Contact & Terms: Designers send query letter with SASE. Illustrators send query letter with résumé and SASE. Accepts disk submissions from designers. Samples returned by SASE. Negotiates rights purchased.

Book Design: Assigns 2 freelance design jobs/year. Pays by the project.

Jackets/Covers: Assigns 6 freelance illustration jobs/year. Pays by the project; negotiable.

Text Illustration: Pays by the project. Finds freelancers through word of mouth and submissions.

Ⓝ FABER & FABER, INC., Division of Farrar, Straus and Giroux, 19 Union Square W., New York NY 10003-3304. (212)741-6900. Fax: (212)633-9385. **Managing Editor:** Carolyn McGuire. Estab. 1976. Publishes hardcover originals, trade paperback originals and reprints. Types of books include biography, cookbooks, history, mainstream fiction, nonfiction, self help and travel. Publishes 35 titles/year. 30% require freelance design.

Needs: Approached by 60 illustrators and 40 designers/year. Works with 2 illustrators and 5 designers/year. Uses freelancers mainly for book jacket design. 80% of freelance design demands knowledge of Photoshop and QuarkXPress.

First Contact & Terms: Designers send query letter with photocopies. Illustrators send postcard sample or photocopies. Samples are filed or returned by SASE. Will contact artist for portfolio review if interested. Rights purchased vary according to project.

Jackets/Covers: Assigns 20 freelance design and 4 illustration jobs/year. Pays by project.

FACTS ON FILE, 11 Penn Plaza, New York NY 10001-2006. (212)967-8800. Fax: (212)967-9196. Website: www.factsonfile.com. **Art Director:** Cathy Rincon. Creative Director: Zina Scar-pulla. Estab. 1940. Publisher of school, library and trade books, CD-ROMs and OnFiles. Types of reference and trade books include science, history, biography, language/literature/writing, pop culture, biography, self-help. Specializes in general reference. Publishes 150 titles/year. Recent titles include: *The New Complete Book of Food*, *The Book of Rules* and *Encyclopedia of American Crime*. 10% require freelance illustration. Book catalog free by request.

Needs: Approached by 100 freelance artists/year. Works with 5 illustrators and 25 designers/year. Uses freelancers mainly for jacket and direct mail design. Needs computer-literate freelancers for design and illustration. Demands knowledge of Macintosh and IBM programs. Works on assignment only.

First Contact & Terms: Send query letter with SASE, tearsheets and photocopies. Samples are filed. Responds only if interested. Call to show a portfolio, which should include thumbnails, roughs, color tearsheets, photographs and comps. Rights purchased vary. Originals returned at job's completion.

Jackets/Covers: Assigns 50 freelance design jobs/year. Pays by the project, $500-1,000.

Tips: "Our books range from straight black and white to coffee-table type four-color. We're using more freelancers for technical, computer generated line art—charts, graphs, maps. We're beginning to market some of our titles in CD-Rom and online format; making fuller use of desktop publishing technology in our production department."

☑ FANJOY & BELL, LTD., P.O. Box 370, Chester NH 03036-0370. (800)984-9798. Fax: (603)887-8556. E-mail: edhewson@att.net. **Publisher:** Ed Hewson. Estab. 1996. Publishes hardcover originals, trade paperback originals and reprints. Types of books include history, instruction, nonfiction and western. Publishes 3 titles/year. Recent titles include: *Apache Sundown*. 100% require freelance illustration. Catalog available.

Needs: Approached by 5-10 illustrators/year. Works with 2-3 illustrators/year. Prefers local illustrators experienced in western art and political cartoons. Uses freelancers mainly for covers and interior art. Freelance design demands knowledge of PageMaker.

First Contact & Terms: Designers send query letter with brochure and photographs. Illustrators send query letter with photocopies, photographs and printed samples or simply a postcard sample on color copy. Accepts disk submissions compatible with PageMaker 6.5, "but can view most images." Samples are filed or are returned if requested. Responds in 2 weeks. Portfolio review required from designers. Artists should follow up with letter after initial query for a portfolio review of photocopies and photographs. Rights purchased vary according to project.

Jackets/Covers: Assigns 3-4 illustration jobs/year. Pays by the project or royalty per copy.

Text Illustration: Assigns 3-4 freelance illustration jobs/year. Pays by the project or royalty per copy. Prefers b&w pen and ink drawings and pastel watercolors. Finds freelancers through magazines.

Ⓝ FANTAGRAPHICS BOOKS, INC., 7563 Lake City Way, Seattle WA 98115. (206)524-1967. Fax: (206)524-2104. E-mail: fbicomix@fantagraphics.com. Website: www.fantagraphics.com. **Contact:** Submissions Editor. Estab. 1976. Publishes hardcover and trade paperback originals and reprints. Types of books include contemporary, experimental, mainstream, historical, humor and erotic. "All our books are comic books or graphic stories." Publishes 100 titles/year. Recent titles include: *Love & Rockets*, *Hate*, *Eightball*, *Acme Novelty Library*, *JIM* and *Naughty Bits*. 10% requires freelance illustration. Book catalog free by request.

Needs: Approached by 500 freelancers/year. Works with 25 freelance illustrators/year. Must be interested in and willing to do comics. Uses freelancers for comic book interiors and covers.

First Contact & Terms: Send query letter addressed to submissions editor with résumé, SASE, photocopies and finished comics work. Samples are not filed and are returned by SASE. Responds to the artist only if interested. Call or write for appointment to show portfolio of original/final art and b&w samples. Buys one-time rights or negotiates rights purchased. Originals are returned at job's completion. Pays royalties.
Tips: "We want to see completed comics stories. We don't make assignments, but instead look for interesting material to publish that is pre-existing. We want cartoonists who have an individual style, who create stories that are personal expressions."

[N] FARRAR, STRAUS & GIROUX, INC., 19 Union Square W., New York NY 10003. (212)741-6900. Fax: (212)741-6973. **Art Director:** Susan Mitchell. Book publisher. Estab. 1946. Publishes hardcover and trade paperback originals and trade paperback reprints. Publishes nonfiction and juvenile fiction. Publishes 200 titles/year. 20% require freelance illustration; 40% freelance design.
Needs: Works with 12 freelance designers and 3-5 illustrators/year. Uses artists for jacket/cover and book design.
First Contact & Terms: Send postcards, tearsheets, photocopies or other nonreturnable samples. Samples are filed and are not returned. Responds only if interested. Originals are returned at job's completion. Call or write for appointment to show portfolio of photostats and final reproduction/product. Portfolios may be dropped off every Wednesday before 2 p.m. Considers complexity of project and budget when establishing payment. Buys one-time rights.
Book Design: Assigns 40 freelance design jobs/year. Pays by the project, $300-450.
Jackets/Covers: Assigns 20 freelance design jobs/year and 10-15 freelance illustration jobs/year. Pays by the project, $750-1,500.
Tips: The best way for a freelance illustrator to get an assignment is "to have a great portfolio."

[✓] FILMS FOR CHRIST, P.O. Box 200, Gilbert AZ 85299. E-mail: mail@eden.org. Website: www.eden. org. **Contact:** Paul S. Taylor. Number of employees: 4. Motion picture producer and book publisher. Audience: educational, religious and secular. Produces and distributes motion pictures, videos and books.
• Design and computer work are done inhouse. Will work with out-of-town illustrators.
Needs: Works with 1-5 freelance illustrators/year. Works on assignment only. Uses illustrators for books, catalogs and motion pictures. Also for storyboards, animation, cartoons, slide illustration and ads.
First Contact & Terms: Send query letter with résumé, photocopies, slides, tearsheets or snapshots. Samples are filed or are returned by SASE. Responds in 1 month. All assignments are on a work-for-hire basis. Originals are not returned. Considers complexity of project and skill and experience of artist when establishing payment.

[✓] FIRST BOOKS, 6750 SW Franklin St., Suite A, Portland OR 97223. (503)968-6777. Fax: (503)968-6779. Website: www.firstbooks.com. **President:** Jeremy Solomon. Estab. 1988. Publishes trade paperback originals. Publishes 10 titles/year. Recent titles include: *Gay USA*, by George Hobica and *Newcomers Handbook*. 100% require freelance illustration.
Needs: Uses freelance designers not illustrators mainly for interiors and covers.
First Contact & Terms: Designers send "any samples you want to send and SASE but no original art, please!" Illustrators send query letter with a few photocopies or slides. Samples are filed or returned by SASE. Responds in 1 month. Rights purchased vary according to project.
Book Design: Payment varies per assignment.
Tips: "We're a small outfit—keep that in mind when sending in samples. Also, we're only interested in designers, not pure illustrators. Small samples get looked at more than anything bulky and confusing. Little samples are better than large packets and binders. Postcards are easy. Save a tree!"

[N] FOCUS PUBLISHING, 502 Third St. NW, Bemidji MN 56601. (218)759-9817. Fax: (218)751-7210. E-mail: focus@paulbunyan.net. Website: www.paulbunyan.net/Focus. **President:** Jan Haley. Estab. 1993. Publishes hardcover originals, trade paperback originals and reprints. Types of books include juvenile, religious and young adult. Specializes in Christian, Bible studies. Publishes 3-4 titles/year. Recent titles include: *Keeper of the Light* and *J. Rooker, Manatee*. 25% requires freelance illustration. Catalog available.
Needs: Prefers in-house designers. Uses freelancers mainly for children's titles.
First Contact & Terms: Illustrators send query letter with photocopies, résumé, SASE and tearsheets. Samples are filed and are returned by SASE. Responds in 2 months. Will contact artist for portfolio review of photocopies, roughs and tearsheets if interested. Negotiates rights purchased.
Text Illustration: Assigns 1-2 freelance illustration jobs/year. Pays negotiable. Finds freelancers through sourcebooks—NY Artist Guild and submissions on file.

FORT ROSS INC., 26 Arthur Place, Yonkers NY 10701. (914)375-6448. Fax: (914)375-6439. E-mail: ftross@ix.netcom.com. Website: www.fortross.net. **Executive Director:** Dr. Vladimir P. Kartsev. Repre-

sents leading Russian publishing companies in the US and Canada. Estab. 1992. Hardcover originals, mass market paperback originals and reprints, and trade paperback reprints. Works with adventure, children's picture books, fantasy, horror, romance, science fiction and western. Specializes in romance, science fiction, mystery. Represents 1,000 titles/year. Recent titles include: translations of *Kissot Midas*, by George Vainer; *Harem's Routine*, by Valery Popov; and *The Redemption*, by Howard Fast. 100% requires freelance illustration. Book catalog not available.

- "Since 1996 we have introduced a new generation of outstanding Russian book illustrators and designers to the American and Canadian publishing world. At the same time we have drastically changed the exterior of books published in Central and Eastern Europe using classical American illustrations and covers."

Needs: Approached by 100 illustrators/year. Works with 40 illustrators/year. Prefers freelancers experienced in romance, science fiction, fantasy, mystery cover art.

First Contact & Terms: Illustrators send query letter with printed samples, photocopies, SASE, tearsheets. Accepts Windows-compatible disk submissions. Send EPS files. Samples are filed. Will contact artist for portfolio review if interested. Buys secondary rights. Finds freelancers through agents, networking events, sourcebooks, *Black Book*, *RSVP*, *Spectrum*.

Book Design: Assigns 5 freelance design and 5 freelance art direction projects/year. Pays by the project, $300-500.

Jackets/Covers: Buys 1,000 illustrations/year. Pays for illustration by the project, $50-150 for secondary rights (for each country). Prefers experienced romance, mystery, science fiction, fantasy cover illustrators.

Tips: "Fort Ross is the best place for experienced cover artists to sell secondary rights for their images in Russia, Spain, Netherlands, Poland, Czech Republic, countries of the former USSR, Central and Eastern Europe. We prefer realistic, thoughtfully executed expressive images on our covers."

FORWARD MOVEMENT PUBLICATIONS, 412 Sycamore St., Cincinnati OH 45202. (513)721-6659. Fax: (513)721-0729. E-mail: forward.movement@msn.com. Website: www.forwardmovement.org. **Director/Editor:** Edward S. Gleason. Estab. 1934. Publishes trade paperback originals. Types of books include religious. Publishes 24 titles/year. Recent titles include: *Downsized*, by Leland Davis; and *Alcoholism: A Family Affair*. 17% require freelance illustration.

Needs: Works with 2-4 freelance illustrators and 1-2 designers/year. Uses freelancers mainly for illustrations required by designer. "We also keep original clip art-type drawings on file to be paid for as used."

First Contact & Terms: Send query letter with tearsheets, photocopies or postcard samples. Samples are sometimes filed. Art director will contact artist for portfolio review if interested. Sometimes requests work on spec before assigning a job. Interested in buying second rights (reprint rights) to previously published work. Rights purchased vary according to project. Originals sometimes returned at job's completion. Finds artists mainly through word of mouth.

Jackets/Covers: Assigns 1-4 freelance design and 6 illustration jobs/year. Pays by the project, $25-175.

Text Illustration: Assigns 1-4 freelance jobs/year. Pays by the project, $10-200; pays $5-25/picture. Prefers pen & ink.

Tips: "We need clip art. If you send clip art, include fee you charge for use."

ℕ WALTER FOSTER PUBLISHING, 23062 La Cadena, Laguna Hills CA 92653. (949)380-7510. Fax: (949)380-7575. E-mail: info@walterfoster.com. Website: www.walterfoster.com. **Creative Director:** Sydney Sprague. Estab. 1922. Publishes hardcover, trade paperback and mass market paperback originals and reprints. Types of books include instructional, juvenile, young adult, "all art related." Specializes in art & craft. Publishes 80-100 titles/year. 80% require freelance illustration; 20% require freelance design. Catalog free for 6×9 SASE with 6 first-class stamps.

Needs: Approached by 50-100 illustrators and 50-100 designers/year. Works with 25-30 illustrators and 5-10 designers/year. 100% of freelance design demands knowledge of Photoshop, Illustrator and QuarkXPress.

First Contact & Terms: Designers send query letter with brochure. Illustrators send postcard sample or query letter with color photocopies. Accepts disk submissions. "If samples suit us they are filed," or they are returned by SASE. Responds only if interested. Art director will contact artist for portfolio review of photocopies, photographs, photostats, slides and transparencies if interested. Buys all rights.

NICHE MARKETING INDEX, identifying Cartoons, Children's Illustration, Licensing, Medical Illustration, Mugs, Religious Art, Science Fiction/Fantasy Art, Sport Art, T-Shirts, Textiles, Wildlife Art and other categories is located in the back of this book.

Book Design: Assigns 10-25 freelance design jobs/year. Pays by the project.
Jackets/Covers: Assigns 10-25 freelance design jobs and 25-30 illustration jobs/year. Pays by the project. Finds freelancers through agents, sourcebooks, magazines, word of mouth and submissions.

N GALISON BOOKS/MUDPUPPY PRESS, 28 W. 44th St., New York NY 10036. (212)354-8840. Fax: (212)391-4037. Website: www.gallison.com. **Design Director:** Gina Manola. Publishes coffee table books. Specializes fine art, botanicals. Publishes 120 titles/year. 50% requires design.
 • Also has listing in greeting cards, gifts and products section.
Needs: Approached by 10 illustrators/year. Works with 50 illustrators and 20 designers/year. Some freelance design demands knowledge of Photoshop, Illustrator and QuarkXPress.
First Contact & Terms: Designers send brochure, photocopies, SASE, tearsheets. Illustrators send photocopies, printed samples, tearsheets. Samples are filed or returned SASE. Will contact artist for portfolio review if interested. Rights purchased vary according to project.

N GALLOPADE INTERNATIONAL/CAROLE MARSH FAMILY CD-ROM, 665 Hwy. 74S, Suite 600, Peachtree City GA 30269. (770)631-4222 or (800)536-2438. Fax: (770)631-4810. Website: www.gallopade.com. **Art Director:** Steven St. Laurent. Estab. 1979. Publishes hardcover and trade paperback originals, textbooks and interactive multimedia. Types of books include contemporary fiction, western, instructional, mystery, biography, young adult, reference, history, humor, juvenile and sex education. Publishes 1,000 titles/year. Titles include: *Alabama Jeopardy* and *A Trip to the Beach* (CD-ROM). 20% requires freelance illustration; 20% requires freelance design.
Needs: Works almost exclusively with paid or unpaid interns. Company selects interns from applicants who send nonreturnable samples, résumé and internship availability. Interns work on an initial unpaid project, anything from packaging and book covers to multimedia and book design. Students can receive credit and add commercial work to their portfolio. Prefers artists with Macintosh experience.
First Contact & Terms: Send nonreturnable samples only. Usually buys all rights.

N GAUNTLET PRESS, 309 Powell Rd., Springfield PA 19064-3028. (610)328-5476. Fax: (610)328-9949. E-mail: info@gauntletpress.com. Website: www.gauntletpress.com. **Contact:** Barry Hoffman, president. Estab. 1991. Publishes hardcover originals and reprints, trade paperback originals and reprints. Types of books include horror, science fiction and young adult. Specializes in signed limited collectibles. Publishes 8 titles/eyar. Recent titles include: *Judas Eyes*, *Dark Carnival* and *The Shrinking Man*.
 • See Barry Hoffman's tips on the dark design industry in "When Gruesome is Good" (page 36). Currently Gauntlet Press is not accepting submissions, as they are solidly booked for the next two years.

GAYOT PUBLICATIONS, 5900 Wilshire Blvd., Los Angeles CA 90036. (323)965-3529. Fax: (323)936-2883. E-mail: gayots@aol.com. Website: www.gayot.com. **Publisher:** Alain Gayot. Estab. 1986. Publishes trade paperback originals. Types of books include travel and restaurant guides. Publishes 8 titles/year. Recent titles include: *The Best of London*, *The Best of Las Vegas*, *The Best of New York* and *The Best of Hawaii*. 50% requires freelance design. Catalog available.
Needs: Approached by 30 illustrators and 2 designers/year. Works with 2 designers/year. Prefers local designers. 50% of freelance design demands knowledge of Dreamweaver, Flash, Photoshop, Illustrator and QuarkXPress.
First Contact & Terms: Designers send query letter with brochure, photocopies and résumé. Send follow-up postcard every 6 months. Accepts disk submissions compatible with Mac, any program. Samples are filed. Responds only if interested. Will contact artist for portfolio review if interested. Rights purchased vary according to project.
Book Design: Pays by the hour or by the project.
Jackets/Covers: Assigns 40 freelance design jobs/year. Pays for design by the hour. Pays for illustration by the project, $800-1,200.
Tips: "We look for rapidity, flexibility, eclecticism and an understanding of the travel guide business."

GEM GUIDES BOOK CO., 315 Cloverleaf Dr., Suite F, Baldwin Park CA 91706. (626)855-1611. Fax: (626)855-1610. E-mail: gembooks@aol.com. Website: www.gemguidesbooks.com. **Editor:** Kathy Mayerski. Assistant Editor: Janet Francisco. Estab. 1964. Book publisher and wholesaler of trade paperback originals and reprints. Types of books include earth sciences, western, instructional, travel, history and regional (western US). Specializes in travel and local interest (western Americana). Publishes 7 titles/year. Recent titles include: *Arizona Roadside Discoveries*, by Terry Hutchins; and *Gem Trails of Texas*, by Brad L. Cross. 75% requires freelance illustration and design. Book catalog free for SASE.
Needs: Approached by 24 freelancers/year. Works with 3 designers/year. Uses freelancers mainly for covers. 100% of freelance work demands knowledge of PageMaker 6.5. Works on assignment only.

First Contact & Terms: Send query letter with brochure, résumé and SASE. Samples are filed. Editor will contact artist for portfolio review if interested. Requests work on spec before assigning a job. Buys all rights. Originals are not returned. Finds artists through word of mouth and "our files."
Jackets/Covers: Pays by the project.

GIBBS SMITH, PUBLISHER, P.O. Box 667, Layton UT 84041. (801)544-9800. Fax: (801)544-5582. E-mail: info@gibbs-smith.com. Website: www.gibbs-smith.com. **Vice Presicent Editorial:** Madge Baird. Senior Editor: Suzanne Taylor. Estab. 1969. Imprints include Peregrine Smith Books. Company publishes hardcover and trade paperback originals and textbooks. Types of books include children's picture books, coffee table books, cookbooks, humor, juvenile, nonfiction textbooks, western. Specializes in interior design. Publishes 50 titles/year. Recent titles include: *French by Design*, *Inside Log Homes* and *Fuzzy Red Bathrobe*. 10% requires freelance illustration; 100% requires freelance design. Book catalog free for 8½ × 11 SASE with $1.24 postage.
Needs: Approached by 250 freelance illustrators and 50 freelance designers/year. Works with 5 freelance illustrators and 15 designers/year. Prefers local art directors. Prefers freelancers experienced in layout of photographic nonfiction. Uses freelancers mainly for cover design and book layout, cartoon illustration, children's book illustration. 100% of freelance design demands knowledge of QuarkXPress. 70% of freelance illustration demands knowledge of Photoshop, Illustrator and FreeHand.
First Contact & Terms: Designers send samples for file. Illustrators send printed samples and photocopies. Samples are filed. Responds only if interested. Finds freelancers through submission packets and illustration annuals.
Book Design: Assigns 50 freelance design jobs/year. Pays by the project, $10-15/page.
Jackets/Covers: Assigns 50-60 freelance design jobs and 5 illustration jobs/year. Pays for design by the project, $500-800. Pays for illustration by the project.
Text Illustration: Assigns 1 freelance illustration job/year. Pays by the project.

GOLDEN BOOKS, 888 Seventh Ave., New York NY 10106. (212)547-6700. Fax: (212)547-6788. Website: www.goldenbooks.com. **Creative Director:** Cathy Goldsmith. Senior Art Directors: Robert Ludlow and Tracy Tyler. Art Director: Anita Lambrinos (leveled readers). Printing company and publisher. Imprint is Golden Books. Publishes preschool and juvenile. Specializes in picture books themed for infant to 8-year-olds. Publishes 250 titles/year. Titles include *Cartoon Network*, *Nickelodeon*, *Mattel*, *Metro Cat*, *Beans Baker Number Five*, *Miami Makes the Play*.
Needs: Approached by several hundred artists/year. Works with approximately 100 illustrators/year. Very little freelance design work. Most design is done in-house. Buys enough illustration for over 200 new titles, approximately 70% being licensed character books. Artists must have picture book experience; illustrations are generally full color but b&w art is required for coloring and activity books. Uses freelancers for picture books, storybooks and leveled readers. Traditional illustration, as well as digital illustration is accepted, although digital is preferred.
First Contact & Terms: Send query letter with SASE and tearsheets. Samples are filed or are returned by SASE if requested by artist. Portfolio drop-off Monday through Friday, 10 am to 4 pm. Call ahead and ask for Cicelee Padilla, senior art coordinator. Will look at original artwork and/or color representations in portfolios, but please do not send original art through the mail. Royalties or work-for-hire limited according to project.
Jackets/Covers: All design done in-house. Makes outright purchase of cover illustrations.
Text Illustration: Assigns approximately 250 freelance illustration jobs/year. Payment varies.
Tips: "We are open to a wide variety of styles. Contemporary illustrations that have strong bright colors and mass market appeal featuring appealing multicultural children will get strongest consideration."

GOOSE LANE EDITIONS LTD., 469 King St., Fredericton, New Brunswick E3B 1E5 Canada. (506)450-4251. E-mail: gooselane@nb.aibn.com. **Art Director:** Julie Scriver. Estab. 1958. Publishes trade paperback originals of poetry, fiction and nonfiction. Types of books include biography, cookbooks, fiction, reference and history. Publishes 10-15 titles/year. 10% requires freelance illustration. Titles include: *A Guide to Animal Behavior* and *Pete Luckett's Complete Guide to Fresh Fruit and Vegetables*. Books are "high quality, elegant, generally with full-color fine art reproduction on cover." Book catalog free for SAE with Canadian first-class stamp or IRC.
Needs: Approached by 3 freelancers/year. Works with 1-2 illustrators/year. Only works with freelancers in the region. Works on assignment only.
First Contact & Terms: Send web portfolio address. Illustrators may send postcard samples. Samples are filed or are returned by SASE. Responds in 2 months.
Book Design: Pays by the project, $400-1,200.
Jackets/Covers: Assigns 1 freelance design job and 2-3 illustration jobs/year. Pays by the project, $200-500.

Text Illustration: Assigns 1 freelance illustration job/year. Pays by the project, $300-1,500.

THE GRADUATE GROUP, P.O. Box 370351, W. Hartford CT 06137-0351. (860)233-2330. E-mail: graduategroup@hotmail.com. Website: www.graduategroup.com. **President:** Mara Whitman. Estab. 1967. Publishes trade paperback originals. Types of books include instructional and reference. Specializes in internships and career planning. Publishes 35 titles/year. Recent titles include: *Create Your Ultimate Resume, Portfolio and Writing Samples: An Employment Guide for the Technical Communicator*, by Mara W. Cohen Ioannides. 10% require freelance illustration and design. Book catalog free by request.
Needs: Approached by 20 freelancers/year. Works with 1 freelance illustrator and 1 designer/year. Prefers local freelancers only. Uses freelancers for jacket/cover illustration and design; direct mail, book and catalog design. 5% of freelance work demands computer skills. Works on assignment only.
First Contact & Terms: Send query letter with brochure and résumé. Samples are not filed. Responds only if interested. Write for appointment to show portfolio.

GRAYWOLF PRESS, 2402 University Ave., St. Paul MN 55114. (651)641-0077. Fax: (651)641-0036. E-mail: czarniec@graywolfpress.org. Website: www.graywolfpress.org. **Executive Editor:** Anne Czarniecki. Estab. 1974. Publishes hardcover originals, trade paperback originals and reprints. Specializes in novels, nonfiction, memoir, poetry, essays and short stories. Publishes 16 titles/year. Recent titles include: *Heart-Side Up*, by Barbara Dinorick; *Bellocq's Ophelia*, by Natasha Trethewey; and *The Half-Finished Heaven*, by Tomas Tranströmer, translation by Robert Bly. 100% require freelance design. Books use solid typography, strikingly beautiful and well-integrated artwork. Book catalog free by request.
● Graywolf is recognized as one of the finest small presses in the nation.
Needs: Approached by 50 freelance artists/year. Works with 5 designers/year. Buys 20 illustrations/year (existing art only). Prefers artists with experience in literary titles. Uses freelancers mainly for cover design. Works on assignment only.
First Contact & Terms: Send query letter with résumé and photocopies. Samples are returned by SASE if requested by artist. Executive editor will contact artist for portfolio review if interested. Portfolio should include b&w, color photostats and tearsheets. Negotiates rights purchased. Interested in buying second rights (reprint rights) to previously published work. Originals are returned at job's completion. Pays by the project. Finds artists through submissions and word of mouth.
Jackets/Covers: Assigns 16 design jobs/year. Pays by the project, $800-1,200. "We use existing art—both contemporary and classical—and emphasize fine typography."
Tips: "Have a strong portfolio of literary (fine press) design."

N **[icon]** **GREAT QUOTATIONS PUBLISHING**, 8102 Lemont Rd., #300, Woodridge IL 60517. (630)268-9900. Fax: (630)269-9500. **Design Editor:** Cheryl Henderson. Estab. 1985. Imprint of Greatime Offset Printing. Company publishes hardcover, trade paperback and mass market paperback originals. Types of books include humor, inspiration, motivation and books for children. Specializes in gift books. Publishes 50 titles/year. Recent titles include: *Only a Sister Could Be Such a Good Friend* and *Words From the Coach*. 50% requires freelance illustration and design. Book catalog available for $2 with SASE.
Needs: Approached by 100 freelancers/year. Prefers local artists. Uses freelancers to illustrate and/or design books and catalogs. 50% of freelance work demands knowledge of QuarkXPress and Photoshop. Works on assignment only.
First Contact & Terms: Send letter of introduction and a maximum of 3 samples. Only samples measuring 8½×11 will be considered. Name, address and telephone number should be clearly displayed on the front of the sample. All appropriate samples will be placed in publisher's library. Design Editor will contact artist under consideration, as prospective projects become available. Rights purchased vary according to project.
Book Design: Assigns 35 freelance design jobs/year. Pays by the project, $300-3,000.
Jackets/Covers: Assigns 15 freelance design jobs/year and 15 illustration jobs/year. Pays by the project, $300-3,000.
Text Illustration: Assigns 20 freelance illustration jobs/year. Pays by the project, $100-1,000.
Tips: "We're looking for bright, colorful cover design on a small size book cover (around 6×6). Outstanding humor or motivational titles will be most in demand."

[icon] **GROSSET & DUNLAP**, Penguin Putnam Inc., 345 Hudson St., New York NY 10014-3657. (212)366-2000. Fax: (212)532-3693. www.penguinputnam.com. **Contact:** Art Director. Publishes hardcover, trade paperback and mass market paperback originals and board books for preschool and juvenile audience (ages 1-10). Specializes in "very young mass market children's books." Publishes 175 titles/year. Recent titles include: *Thanksgiving Is for Giving Thanks*; *Corduroy's Christmas Surprise*, by Dan Greenberg. 100% require freelance illustration; 10% require freelance design.

• Grosset & Dunlap publishes children's books that examine new ways of looking at the world of children. Many books by this publisher feature unique design components such as acetate overlays, 3-D pop-up pages, or actual projects/toys that can be cut out of the book.

Needs: Works with 50 freelance illustrators and 1-2 freelance designers/year. Buys 80 books' worth of illustrations/year. "Be sure your work is appropriate for our list." Uses freelance artists mainly for book illustration. Also for jacket/cover and text illustration and design. 50% of design and 10% of illustration demand knowledge of Illustrator 5.5, QuarkXPress 3.3, and Photoshop 2.5.

First Contact & Terms: Designers send query letter with résumé and tearsheets. Illustrators send postcard sample and/or query letter with résumé, photocopies, SASE, and tearsheets. Samples are filed. Responds to the artist only if interested. Call for appointment to show portfolio, or mail slides, color tearsheets, transparencies and dummies. Rights purchased vary according to project. Originals are returned at job's completion.

Book Design: Assigns 20 design jobs/year. Pays by the hour, $15-22 for mechanicals.

Jackets/Covers: Assigns approximately 10 cover illustration jobs/year. Pays by the project, $1,500-2,500.

Text Illustration: Assigns approximately 80 projects/year. Pays by the project, $4,000-10,000.

Tips: "We are always looking for people who can illustrate wonderful babies and children. We are looking for good strong art."

🅝 GROUP PUBLISHING BOOK PRODUCT, (formerly Group Publishing—Book & Curriculum Division), 1515 Cascade Ave., Loveland CO 80539. (970)669-3836. Fax: (970)669-1994. Website: www.groupublishing.com. **Art Directors (for interiors):** Jeff Spencer, Jean Bruns, Kari Monson and Randy Kady. Webmaster: Fred Schuth. Company publishes books, Bible curriculum products (including puzzles, posters, etc.), clip art resources and audiovisual materials for use in Christian education for children, youth and adults. Publishes 35-40 titles/year. Recent titles include: *The Dirt on Learning*, *Group's Hands-On Bible Curriculum*, *Real Life Bible Curriculum*, *Group's Treasure Hunt Bible Adventure Vacation Bible School* and *Faith Weaver Bible Curriculum*.

• This company also produces magazines. See listing in Magazines section for more information.

Needs: Uses freelancers for cover illustration and design. 100% of design and 50% of illustration demand knowledge of QuarkXPress 3.32-4.0, Macromedia Freehand 8.0, Photoshop 5.0, Illustrator 7.0. Occasionally uses cartoons in books and teacher's guides. Uses b&w and color illustration on covers and in product interiors.

First Contact & Terms: Contact Jeff Storm, Marketing Art Director, if interested in cover design or illustration. Contact Jeff Spencer if interested in book and curriculum interior illustration and design. Send query letter with nonreturnable b&w or color photocopies, slides, tearsheets or other samples. Accepts disk submissions. Samples are filed, additional samples may be requested prior to assignment. Responds only if interested. Rights purchased vary according to project.

Jackets/Covers: Assigns minimum 15 freelance design and 10 freelance illustration jobs/year. Pays for design, $250-1,200; pays for illustration, $250-1,200.

Text Illustration: Assigns minimum 30 freelance illustration jobs/year. **Pays on acceptance**: $40-200 for b&w (from small spot illustrations to full page). Fees for color illustration and design work vary and are negotiable. Prefers b&w line or line and wash illustrations to accompany lesson activities.

Tips: "We prefer contemporary, nontraditional styles appropriate for our innovative and upbeat products and the creative Christian teachers and students who use them. We seek experienced designers and artists who can help us achieve our goal of presenting biblical material in fresh, new and engaging ways. Submit design/illustration on disk. Self promotion pieces help get you noticed. Have book covers/jackets, brochure design, newsletter or catalog design in your portfolio. Include samples of Bible or church-related illustration."

GRYPHON PUBLICATIONS, P.O. Box 209, Brooklyn NY 11228. **Publisher:** Gary Lovisi. Assistant Editor: Lucille Cali. Website: www.gryphonbooks.com. Estab. 1983. Book and magazine publisher of hardcover originals, trade paperback originals and reprints, reference and magazines. Types of books include science fiction, mystery and reference. Specializes in crime fiction and bibliography. Publishes 10 titles/year. Titles include *Difficult Lives*, by James Salli; and *Vampire Junkies*, by Norman Spinrad. 40% require freelance illustration; 10% require freelance design. Book catalog free for #10 SASE.

• Also publishes *Hardboiled*, a quarterly magazine of noir fiction, and *Paperback Parade* on collectible paperbacks.

Needs: Approached by 50-100 freelancers/year. Works with 5 freelance illustrators and 1 designer/year. Prefers freelancers with "professional attitude." Uses freelancers mainly for book and magazine cover and interior illustrations. Also for jacket/cover, book and catalog design. Works on assignment only.

First Contact & Terms: Send query letter with résumé, SASE, tearsheets or photocopies. Samples are filed. Responds in 2 weeks only if interested. Buys one-time rights. "I will look at reprints if they are of high quality and cost effective." Originals are returned at job's completion if requested. Send b&w samples only.

Jackets/Covers: Assigns 2 freelance design and 5-6 illustration jobs/year. Pays by the project, $25-150.

Text Illustration: Assigns 2 freelance jobs/year. Pays by the project, $10-100. Prefers b&w line drawings.

Tips: "It is best to send photocopies of your work with an SASE and query letter. Then we will contact on a freelance basis."

GUARDIANS OF ORDER, 176 Speedvale West, Unit #2, Guelph, Ontario N1H 1C2 Canada. (519)821-7174. Fax: (519)821-7635. E-mail: info@guardiansorder.on.co. Website: www.guardiansorder.on.ca. **Art Director:** Jeff Mackintosh. Estab. 1997. Publishes roleplaying game books. Main style/genre of games: Japanimation. Uses freelance artists mainly for books and posters. Publishes 18 titles or products/year. Game/product lines include: *Big Eyes, Small Mouth* game line, and *Silver Age Sentinels* super hero game line.

Needs: Approached by 10 illustrators and 5 designers/year. Works with 5 illustrators and 2 designers/year. Prefers local illustrators. Prefers local designers and freelancers. Prefers freelancers experienced in color, CG and line art. 100% of freelance design demands knowledge of Illustrator, Photoshop and QuarkXPress. 50% of freelance illustration demands knowledge of Photoshop.

First Contact & Terms: Send query letter with résumé, business card. Illustrators send printed samples, photocopies and disk submissions. Send 10 samples. "We require 95% b&w, 5% color." Accepts disk submissions in Mac format. Send via CD. "Please do not e-mail digital samples." Samples are filed. Responds by e-mail only if interested. "Samples returned only by request and if accompanied by SAE and international postage coupons (*no* US stamps)." Portfolio review not required. Buys first or reprint rights. Finds freelancers through submission packets and conventions.

Visual Design: Pays for design by the project, 50% 14 days after delivery of work and 50% 60 days after publication of project.

Text Illustration: Assigns 6-10 freelance illustration jobs/year. Pays by the project. Prefers characters with backgrounds, scenic art, and/or technical illustrations.

Tips: "We need fast, reliable workers who know what a role playing game is, with quick turnaround."

GUERNICA EDITIONS, P.O. Box 117, Station P, Toronto, Ontario M5S 2S6 Canada. (416)658-9888. Fax: (416)657-8885. E-mail: guernicaeditions@cs.com. Website: www.guernicaeditions.com. **Publisher/Editor:** Antonio D'Alfonso. Editor: Joseph Pivato. Estab. 1978. Book publisher and literary press specializing in translation. Publishes trade paperback originals and reprints. Types of books include contemporary and experimental fiction, biography and history. Specializes in ethnic/multicultural writing and translation of European and Quebecois writers into English. Publishes 20-25 titles/year. Recent titles include: *Us Fools Believing*, by Miriam Packer (artist: Hono Lulu); *Molisan Poems*, by Eugenio Cirese (art: Vince Mancuso); *Winters in Montreal*, by Pietro Corsi (art: Nick Palazzo). 40-50% require freelance illustration. Book catalog available for SAE; nonresidents send IRC.

Needs: Approached by 6 freelancers/year. Works with 6 freelance illustrators/year. Uses freelancers mainly for jacket/cover illustration.

First Contact & Terms: Send query letter with résumé, SASE (or SAE with IRC), tearsheets, photographs and photocopies. Samples are filed or are returned by SASE if requested by artist. Responds only if interested. To show portfolio, mail photostats, tearsheets and dummies. Buys one-time rights. Originals are not returned at job completion.

Jackets/Covers: Assigns 10 freelance illustration jobs/year. Pays by the project, $150-200.

Tips: "We really believe that the author should be aware of the press they work with. Try to see what a press does and offer your own view of that look. We are looking for strong designers. We have three new series of books, so there is a lot of place for art work."

HARLAN DAVIDSON, INC., 773 Glenn Ave., Wheeling IL 60090-6000. (847)541-9720. Fax: (847)541-9830. E-mail: harlandavidson@harlandavidson.com. Website: www.harlandavidson.com. **Production Manager:** Lucy Herz. Imprints include Forum Press and Crofts Classics. Publishes textbooks. Types of books include biography, classics in literature, drama, political science and history. Specializes in US and European history. Publishes 6-15 titles/year. Recent titles include: *Women in Antibellum Reform*. 20% requires freelance illustration; 20% requires freelance design. Catalog available.

Needs: Approached by 2 designers/year. Works with 1-2 designers/year. 100% of freelance design demands knowledge of Photoshop.

First Contact & Terms: Designers send query letter with brochure and résumé. Samples are filed or are returned by SASE. Responds in 2 weeks. Portfolio review required from designers. Will contact artist for portfolio review of book dummy if interested. Buys all rights.

Book Design: Assigns 3 freelance design jobs/year. Pays by the project, $500-1,000.
Jackets/Covers: Assigns 3 freelance design jobs/year. Pays by the project, $500-1,000. Finds freelancers through networking.
Tips: "Have knowledge of file preparation for electronic prepress."

HARMONY HOUSE PUBLISHERS—LOUISVILLE, P.O. Box 90, Prospect KY 40059. (502)228-4446. Fax: (502)228-2010. **Art Director:** William Strode. Estab. 1980. Publishes hardcover books. Specializes in general books, cookbooks and education. Publishes 20 titles/year. Titles include *Sojourn in the Wilderness* and *Christmas Collections*. 10% require freelance illustration.
Needs: Approached by 10 freelancers/year. Works with 2-3 freelance illustrators/year. Prefers freelancers with experience in each specific book's topic. Uses freelancers mainly for text illustration. Also for jacket/cover illustration. Usually works on assignment basis.
First Contact & Terms: Send query letter with brochure, résumé, SASE and appropriate samples. Samples are filed or are returned. Responds only if interested. "We don't usually review portfolios, but we will contact the artist if the query interests us." Buys one-time rights. Returns originals at job's completion. Assigns several freelance design and 2 illustration jobs/year. Pays by the project.

☒ HARPERCOLLINS PUBLISHERS, LTD. (CANADA), 55 Avenue Rd., Suite 2900, Hazelton Lanes, Toronto, Ontario M5R 3L2 Canada. (416)975-9334. Fax: (416)975-9884. Website: www.harpercanada.com. **Contact:** Vice President Production. Publishes hardcover, trade paperback and mass market paperback originals and reprints. Types of books include adventure, biography, coffee table books, fantasy, history, humor, juvenile, mainstream fiction, New Age, nonfiction, preschool, reference, religious, self-help, travel, true crime, western and young adult. Publishes 100 titles/year. 50% require freelance illustration; 25% require freelance design.
Needs: Prefers freelancers experienced in mixed media. Uses freelancers mainly for illustration, maps, cover design. 100% of freelance design demands knowledge of Photoshop, Illustrator, QuarkXPress. 25% of freelance illustration demands knowledge of Photoshop and Illustrator.
First Contact & Terms: Designers send query letter with brochure, photocopies, tearsheets. Illustrators send postcard sample and/or query letter with photocopies, tearsheets. Accepts disk submissions compatible with QuarkXPress. Send EPS or TIFF files. Samples are filed. Will contact artist for portfolio review "only after review of samples if I have a project they might be right for." Portfolio should include book dummy, photocopies, photographs, slides, tearsheets, transparencies. Rights purchased vary according to project.
Book Design: Assigns 5 freelance design jobs/year. Pays by the project.
Jackets/Covers: Assigns 20 freelance design and 50 illustration jobs/year. Pays by the project.
Text Illustration: Assigns 10 freelance illustration jobs/year. Pays by the project.

☑ HARVEST HOUSE PUBLISHERS, 990 Owen Loop N., Eugene OR 97402. (541)343-0123. Fax: (541)242-8819. **Cover Coordinator:** Barbara Sherrill. Specializes in hardcover and paperback editions of Christian evangelical adult fiction and nonfiction, children's books, gift books and youth material. Publishes 100-125 titles/year. Recent titles include: *The Proposal*, *Let's Have Tea Together*, *I'll Wait Right Here* and *The Unrandom Universe*. Books are of contemporary designs which compete with the current book market.
Needs: Works with 4-5 freelance illustrators and 7-8 freelance designers/year. Uses freelance artists mainly for cover art. Also uses freelance artists for text illustration. Works on assignment only.
First Contact & Terms: Send query letter with brochure, résumé, tearsheets and photographs. Art director will contact artist for portfolio review if interested. Requests work on spec before assigning a job. Originals may be returned at job's completion. Buys all rights. Finds artists through word of mouth and submissions/self-promotions.
Book Design: Pays by the project.
Jackets/Covers: Assigns 100-125 design and less than 10 illustration jobs/year. Pays by the project.
Text Illustration: Assigns 5 jobs/year. Pays by the project.

☑ ▣ HAY HOUSE, INC., P.O. Box 5100, Carlsbad CA 92018-5100. (800)431-7695. **Art Director:** Christy Salinas. Publishes hardcover originals and reprints, trade paperback originals and reprints, audio tapes, CD-ROM. Types of books include New Age, astrology, metaphysics, psychology and gift books. Specializes in self-help. Publishes 100 titles/year. Recent titles include: *You Can Heal Your Life*, *The Western Guide to Feng Shui*, *Heal Your Body A-Z* and *New York Times* bestseller *Adventures of a Psychic*. 40% require freelance illustration; 30% require freelance design.
• Hay House is also looking for people who design for the gift market.
Needs: Approached by 50 freelance illustrators and 5 freelance designers/year. Works with 20 freelance illustrators and 2-5 freelance designers/year. Uses freelancers mainly for cover design and illustration. 80% of freelance design demands knowledge of Photoshop, Illustrator, QuarkXPress. 20% of titles require freelance art direction.

First Contact & Terms: Designers send photocopies (color), résumé, SASE "if you want your samples back." Illustrators send photocopies. "We accept TIFF and EPS images compatible with the latest versions of QuarkXPress, Photoshop and Illustrator. Samples are filed or are returned by SASE. Art director will contact artist for portfolio review of printed samples or original artwork if interested. Buys all rights. Finds freelancers through word of mouth, submissions.
Book Design: Assigns 20 freelance design jobs/year; 10 freelance art direction projects/year.
Jacket/Covers: Assigns 50 freelance design jobs and 25 illustration jobs/year. Pays for design by the project, $800-1,000. Payment for illustration varies for covers.
Text Illustration: Assigns 10 freelance illustration jobs/year.
Tips: "We look for freelancers with experience in graphic design, desktop publishing, printing processes, production and illustrators with strong ability to conceptualize."

HEAVEN BONE PRESS, Box 486, Chester NY 10918. (914)469-9018. E-mail: heavenbone@aol.com. **President/Editor:** Steve Hirsch. Estab. 1987. Book and magazine publisher of trade paperback originals. Types of books include poetry and contemporary and experimental fiction. Publishes 4-6 titles/year. Recent titles include: *Fountains of Gold*, by Wendy Vig and Jon Anderson. Design of books is "off-beat, eclectic and stimulating." 80% require freelance illustration. Book catalog available for SASE.
● This publisher often pays in copies. Approach this market if you're seeking to build your portfolio and are not concerned with payment. The press also publishes *Heaven Bone* magazine for which illustrations are needed.
Needs: Approached by 10-12 freelancers/year. Works with 3-4 freelance illustrators. Uses freelancers mainly for illustrations. Needs computer-literate freelancers for illustration. 5% of work demands knowledge of QuarkXPress, FreeHand, Illustrator or Photoshop.
First Contact & Terms: Send query letter with brochure, tearsheets, photostats, photographs and slides. Samples are filed or returned by SASE. Responds in 3 months. To show portfolio, mail finished art, photostats, tearsheets, photographs and slides. Rights purchased vary according to project. Originals are returned at job's completion.
Book Design: Assigns 1-2 freelance design jobs/year. Prefers to pay in copies, but has made exceptions.
Jackets/Covers: Prefers to pay in copies, but has made exceptions. Enjoys pen & ink, woodcuts, b&w drawings and front and back outside covers in 4-color process.
Text Illustration: Assigns 1-2 freelance design jobs/year.
Tips: "Know our specific needs, know our magazine and be patient."

✔ 🌐 **HEMKUNT PUBLISHERS LTD.**, A-78 Naraina Indl. Area Ph.I, New Delhi 110028 India. Phone: 011-91-11 579-2083, 579-0032 or 579-5079. Fax: 611-3705. E-mail: hemkunt@ndf.vsnl.net.in. Website: www.hemkuntpublishers.com (in process). **Chief Executive:** Mr. G.P. Singh. Director Marketing: Arvinder Singh. Director Production: Deepinder Singh. Specializes in educational text books, illustrated general books for children and also books for adults on different subjects. Subjects include religion and history. Publishes 30-50 new titles/year. Recent titles include: *More Tales of Birbal and Akbar*, *Social Studies for classes 3, 4, 5*, and *Benaras—Visions of a Living Ancient Tradition*.
Needs: Works with 30-40 freelance illustrators and 3-5 designers/year. Uses freelancers mainly for illustration and cover design. Also for jacket/cover illustration. Works on assignment only.
First Contact & Terms: Send query letter with résumé and samples to be kept on file. Prefers photographs and tearsheets as samples. Samples not filed are not returned. Art director will contact artist for portfolio review if interested. Requests work on spec before assigning a job. Originals are not returned. Considers complexity of project, skill and experience of artist and project's budget when establishing payment. Buys all rights. Interested in buying second rights (reprint rights) to previously published artwork.
Book Design: Assigns 40-50 freelance design jobs/year. Payment varies.
Jackets/Covers: Assigns 30-40 freelance design jobs/year. Pays $20-50.
Text Illustration: Assigns 30-40 freelance jobs/year. Pays by the project.

HILL AND WANG, 19 Union Square W., New York NY 10003. (212)741-6900. Fax: (212)741-6973. **Art Director:** Susan Mitchell. Imprint of Farrar, Straus & Giroux. Imprint publishes hardcover, trade and mass market paperback originals and hardcover reprints. Types of books include biography, coffee table books, cookbooks, experimental fiction, historical fiction, history, humor, mainstream fiction, New Age, nonfiction and self-help. Specializes in literary fiction and nonfiction. Publishes 120 titles/year. Recent titles include: *Love Artist, Grace Paley Collected Stories*. 20% require freelance illustration; 10% require freelance design.
Needs: Approached by hundreds of freelancers/year. Works with 10-20 freelance illustrators and 10-20 designers/year. Prefer artist without rep with a strong portfolio. Uses freelancers for jacket/cover illustration and design. Works on assignment only.

First Contact & Terms: Send postcard sample of work or query letter with portfolio samples. Samples are filed and are not returned. Responds only if interested. Artist should continue to send new samples. Portfolios may be dropped off every Wednesday and should include printed jackets. Rights purchased vary according to project. Originals are returned at job's completion. Finds artists through word of mouth and submissions.

Book Design: Pays by the project.

Jackets/Covers: Assign 10-20 freelance design and 10-20 illustration jobs/year. Pays by the project, $500-1,500.

Text Illustration: Assigns 10-20 freelance illustration jobs/year. Pays by the project, $500-1,500.

☑ ⊞ **HIPPOCRENE BOOKS INC.**, 171 Madison Ave., Suite 1602, New York NY 10016. (212)685-4371. Fax: (212)779-9338. Website: www.hippocrenebooks.com. **Associate Editor:** Anne McBride. Estab. 1971. Publishes hardcover originals and trade paperback reprints. Types of books include biography, cookbooks, history, nonfiction, reference, travel, dictionaries, foreign language, bilingual. Specializes in dictionaries, cookbooks, love poetry. Publishes 60 titles/year. Recent titles include: *Hippocrene Children's Illustrated Foreign Language Dictionaries*, *St Patrick's Secrets* and *American Proverbs*. 10% requires freelance illustration. Book catalog free for 9×12 SAE with 4 first-class stamps.

Needs: Approached by 150 illustrators and 50 designers/year. Works with 2 illustrators and 3 designers/year. Prefers local freelancers experienced in line drawings.

First Contact & Terms: Designers send query letter with photocopies, SASE, tearsheets. Illustrators send postcard sample and follow-up postcard every 6 months. No disk submissions. Samples are filed. Will contact artist for portfolio review if interested. Portfolio should include photocopies of artwork portraying "love" poetry and food subjects. Buys one-time rights. Finds freelancers through promotional postcards and suggestion of authors.

Jackets/Covers: Assigns 2 freelance design and 4 freelance illustration jobs/year. Pays by the project, $200-500.

Text Illustration: Assigns 4 freelance illustration jobs/year. Pays by the project, $250-1,700. Prefers freelancers who create drawings/sketches for love or poetry books.

Tips: "We prefer traditional illustrations appropriate for gift books and cookbooks."

⊞ **HOLCOMB HATHAWAY, PUBLISHERS**, 6207 N. Cattletrack Rd., Scottsdale AZ 85250. (480)991-7881. Fax: (480)991-4770. Website: www.hhppub.com. E-mail: sales@hh-pub.com. **Production Director:** Gay Pauley. Estab. 1997. Publishes textbooks. Specializes in education, communication. Publishes 10 titles/year. Recent titles include: *Creating Independent Readers*. 50% requires freelance cover illustration; 10% requires freelance design. Book catalog not available.

Needs: Approached by 15 illustrators and 15 designers/year. Works with 3 illustrators and 10 designers/year. Prefers freelancers experienced in cover design, typography, graphics. 100% of freelance design and 50% of freelance illustration demands knowledge of Photoshop, Illustrator, QuarkXPress.

First Contact & Terms: Send query letter with brochure. Illustrators send postcard sample. Will contact artist for portfolio review of photocopies and tearsheets if interested. Rights purchased vary according to project.

Book Design: Assigns 3 freelance design jobs/year. Pays for design by the project, $500-1,500.

Jackets/Covers: Assigns 10 design jobs/year. Pays by the project, $750-1,000. Pays for cover illustration by the project.

Text Illustration: Assigns 2 freelance illustration jobs/year. Pays by the piece. Prefers computer illustration. Finds freelancers through word of mouth, submissions.

Tips: "It is helpful if designer has experience with college textbook design and good typography skills."

☑ **HOLLOW EARTH PUBLISHING**, P.O. Box 51480, Boston MA 02205. (617)865-0306. Fax: (617)249-0161. E-mail: hep2@aol.com. **Publisher:** Helian Yvette Grimes. Estab. 1983. Company publishes hardcover, trade paperback and mass market paperback originals and reprints, textbooks, electronic books and CD-ROMs. Types of books include contemporary, experimental, mainstream, historical and science fiction, instruction, fantasy, travel and reference. Specializes in mythology, photography, computers (Macintosh). Publishes 5 titles/year. Titles include *Norse Mythology*, *Legend of the Niebelungenlied*. 50% require freelance illustration; 50% require freelance design. Book catalog free for #10 SAE with 1 first-class stamp.

Needs: Approached by 250 freelancers/year. Prefers freelancers with experience in computer graphics. Uses freelancers mainly for graphics. Also for jacket/cover design and illustration, text illustration, book design and multimedia projects. 100% of freelance work demands knowledge of Illustrator, QuarkXPress, Photoshop, FreeHand, Director or rendering programs. Works on assignment only.

First Contact & Terms: Send e-mail queries only. Responds in 1 month. Art director will contact artist for portfolio review if interested. Portfolio should include color thumbnails, roughs, tearsheets and photographs. Buys all rights. Originals are returned at job's completion. Finds artists through submissions and word of mouth.
Book Design: Assigns 12 book and magazine covers/year. Pays by the project, $100 minimum.
Jackets/Covers: Assigns 12 freelance design and 12 illustration jobs/year. Pays by the project, $100 minimum.
Text Illustration: Assigns 12 freelance illustration jobs/year. Pays by the project, $100 minimum.
Tips: Recommends being able to draw well. First-time assignments are usually article illustrations; covers are given to "proven" freelancers.

☑ **HENRY HOLT BOOKS FOR YOUNG READERS**, 115 W. 18th St., 6th Floor, New York NY 10011. (212)886-9200. Fax: (212)645-5832. Website: www.henryholt.com. **Art Director:** Martha Rago. Estab. 1866. Imprint of Henry Holt and Company, Inc. Imprint publishes hardcover and trade paperback originals and reprints. Types of books include juvenile, preschool and young adult. Specializes in picture books and young adult nonfiction and fiction. Publishes 225 titles/year. 100% requires freelance illustration. Book catalog free by request.
Needs: Approached by 1,300 freelancers/year. Works with 30-50 freelance illustrators and designers/year. Uses freelancers for jacket/cover and text illustration. Works on assignment only.
First Contact & Terms: Send postcard sample of work or query letter with tearsheets and SASE. Samples are filed or returned by SASE if requested by artist. Responds in 3 months if interested. Portfolios may be dropped off every Monday by 9 a.m. for 5 p.m. pickup. Art director will contact artist for portfolio review if interested. Portfolio should include photostats, final art, roughs and tearsheets. "Anything artist feels represents style, ability and interests." Rights purchased vary according to project. Originals are returned at job's completion. Finds artists through word of mouth, artists' submissions and attending art exhibitions.
Jackets/Covers: Assigns 20-30 freelance illustration jobs/year. Pays $1,200 and up.
Text Illustration: Assigns 30-50 freelance illustration jobs/year. Pays $5,000 minimum.

▦ **HOMESTEAD PUBLISHING**, Box 193, Moose WY 83012. Phone/fax: (307)733-6248. **Contact:** Art Director. Estab. 1980. Publishes hardcover and paperback originals. Types of books include art, biography, history, guides, photography, nonfiction, natural history, and general books of interest. Publishes more than 30 titles/year. Recent titles include: *Cubby in Wonderland*, *Windswept* and *Banff-Jasper Explorer's Guide*. 75% requires freelance illustration. Book catalog free for SAE with 4 first-class stamps.
Needs: Works with 20 freelance illustrators and 10 designers/year. Prefers pen & ink, airbrush, pencil and watercolor. 25% of freelance work demands knowledge of PageMaker or FreeHand. Works on assignment only.
First Contact & Terms: Send query letter with printed samples to be kept on file or write for appointment to show portfolio. For color work, slides are suitable; for b&w, technical pen, photostats. "Include one piece of original artwork to be returned." Samples not filed are returned by SASE only if requested. Responds in 10 days. Rights purchased vary according to project. Originals are not returned.
Book Design: Assigns 6 freelance design jobs/year. Pays by the project, $50-3,500.
Jackets/Covers: Assigns 2 freelance design and 4 illustration jobs/year. Pays by the project, $50-3,500.
Text Illustration: Assigns 50 freelance illustration jobs/year. Prefers technical pen illustration, maps (using airbrush, overlays, etc.), watercolor illustrations for children's books, calligraphy and lettering for titles and headings. Pays by the hour, $5-20 or by the project, $50-3,500.
Tips: "We are using more graphic, contemporary designs and looking for the best quality."

HONOR BOOKS, 2448 E. 81 St., Suite 4800, Tulsa OK 74137-1222. (918)496-9007. Fax: (918)496-3588. E-mail: info@honorbooks.com. Website: www.honorbooks.com. **Contact:** Creative Director. Estab. 1991. Publishes hardcover originals, trade paperback originals, mass market paperback originals and gift books. Types of books include biography, coffee table books, humor, juvenile, motivational, religious and self help. Specializes in inspirational and motivational. Publishes 60-70 titles/year. Recent titles include: *Love Letters from God* and *Snickers from the Front Pew*. 40% require freelance illustration; 90% require freelance design.
Needs: Works with 4 illustrators and 10 designers/year. Prefers illustrators experienced in line art; designers experienced in book design. Uses freelancers mainly for design and illustration. 100% of freelance design demands knowledge of FreeHand, Photoshop, Illustrator and QuarkXPress. 20% of freelance illustration demands knowledge of FreeHand, Photoshop and Illustrator. 15% of titles rquire freelance art direction.
First Contact & Terms: Designers send query with photocopies and tearsheets. Illustrators send query letter with printed samples and tearsheets. Send follow-up postcard every 3 months. Accepts disk submis-

sions compatible with QuarkXPress or EPS files. Samples are filed. Responds in 3 weeks. Request portfolio review in original query. Will contact artist for portfolio review of book dummy, photographs, roughs and tearsheets if interested. Rights purchased vary according to project.

Book Design: Assigns 60 freelance design jobs/year. Pays by the project, $300-1,800.

Jackets/Covers: Assigns 60 freelance design jobs and 30 illustration jobs/year. Pays for design by the project, $700-2,400. Pays for illustration by the project, $400-1,500.

Text Illustration: Pays by the project. Finds freelancers through *Creative Black Book*, word of mouth, conventions and submissions.

✅ **HOUGHTON MIFFLIN COMPANY**, Children's Book Department, 222 Berkeley St., Boston MA 02116. (617)351-5000. Fax: (617)351-1125. Website: www.hmco.com. **Art Director:** Bob Kosturko. Estab. 1880. Company publishes hardcover originals. Types of books include juvenile, preschool and young adult. Publishes 60-70 titles/year. 100% requires freelance illustration; 10% requires freelance design. Recent titles include: *Henry Builds a Cabin*; and *Hotel Honolulu*, by Paul Theroux.

Needs: Approached by 400 freelancers/year. Works with 50 freelance illustrators and 10 designers/year. Prefers artists with interest in or experience with children's books. Uses freelance illustrators mainly for jackets, picture books. Uses freelance designers primarily for photo essay books. 100% of freelance design work demands knowledge of QuarkXPress, Photoshop and Illustrator.

First Contact & Terms: Send postcard sample of work or send query letter with tearsheets and photocopies. Do not send originals! Samples are filed or returned by SASE. Art director will contact artist for portfolio review if interested. Portfolio should include printed books, book dummy, slides, transparencies, roughs and tearsheets. Rights purchased vary according to project. Works on assignment only. Finds artists through sourcebooks, word of mouth, submissions.

Book Design: Assigns 10-20 freelance design jobs/year. Pays by the project.

Jackets/Covers: Assigns 12 freelance illustration jobs/year. Pays by the project.

Text Illustration: Assigns up to 50 freelance illustration jobs/year. Pays by the project.

HOWELL PRESS, INC., 1713-2D Allied Lane, Charlottesville VA 22903. (434)977-4006. Fax: (434)971-7204. E-mail: howellpres@aol.com. Website: www.howellpress.com. **President:** Ross Howell. Estab. 1985. Company publishes hardcover and trade paperback originals. Types of books include history, coffee table books, cookbooks, gardening, quilts and crafts, aviation, transportation and titles of regional interest. Publishes 12 titles/year. Recent titles include: *Godfather's Pasta*, by Olinda Chiocca; *Complete Guide to Stock Car Racing*, by Keith Buchanan; and *Swear Like a Trooper*, by William Priest. 50% require freelance illustration and design. Book catalog free by request.

Needs: Approached by 15-20 freelancers/year. Works with 0-1 freelance illustrator and 3-5 designers/year. "It's most convenient for us to work with local freelance designers." Uses freelancers overwhelmingly for graphic design. Also for jacket/cover, direct mail, book and catalog design. 100% of freelance work demands knowledge of PageMaker, Illustrator, Photoshop or QuarkXPress.

First Contact & Terms: Designers send query letter with résumé, SASE and tearsheets. Illustrators send query letter with résumé, photocopies, SASE and tearsheets. Samples are filed and are returned by SASE if requested by artist. Production manager will contact artist for portfolio review if interested. Portfolio should include color tearsheets and slides. Negotiates rights purchased. Originals are returned at job's completion. Finds artists through submissions.

Book Design: Assigns 9-10 freelance design jobs/year. Pays for design by the hour, $15-25; by the project, $500-5,000.

HUMANICS PUBLISHING GROUP, P.O. Box 7400, Atlanta GA 30357. (404)874-2176. Fax: (404)874-1976. E-mail: humanics@mindspring.com. Website: www.humanicspub.com. **Acquisitions Editor:** W. Arthur Bligh. Art Director: Hart Paul. Estab. 1976. Publishes college textbooks, paperback trade, New Age and educational activity books. Publishes 30 titles/year. Recent titles include: *Learning: Before and After School Activities*, *Homespun Curriculum* and *Learning Through Art*. Learning books are workbooks with 4-color covers and line art within; trade paperbacks are 6×9 with 4-color covers. Book catalog for 9×12 SASE. Specify which imprint when requesting catalog: Learning or trade paperbacks.

● No longer publishes children's fiction or picture books.

First Contact & Terms: Send query letter with résumé, SASE and photocopies. Samples are filed or are returned by SASE if requested by artist. Rights purchased vary according to project. Originals are not returned.

Book Design: Pays by the project.

Jackets/Covers: Pays by the project.

Text Illustration: Pays by the project.

Tips: "We use 4-color covers, and our illustrations are line art with no halftones."

N HUNTINGTON HOUSE PUBLISHERS, P.O. Box 53788, Lafayette LA 70505. (337)237-7049. Fax: (337)237-7060. Website: www.huntinghousebooks.com. Art Director: Kathy Doyle. Publisher: Mark Anthony. Marketing Director: Theresa Tresclair. Estab. 1979. Book publisher. Publishes hardcover, trade paperback and mass market paperback originals. Types of books include contemporary fiction, juvenile, religious and political issues. Specializes in politics, exposés and religion. Publishes 30 titles/year. Recent titles include: *The Heavenly Odyssey* and *Jericho Syndrome*. 5% require freelance illustration. Book catalog free upon request.

Needs: Approached by 15 freelancers/year. Works with 2 freelance illustrators/year. Uses freelancers for jacket/cover illustration and design and text illustration. Works on assignment only.

First Contact & Terms: Send query letter with résumé and photocopies. Samples are filed. Responds to artist only if interested. To show a portfolio, mail thumbnails, roughs and dummies. Buys all rights. Originals are returned at job's completion.

Text Illustration: Assigns 1 freelance design and 1 illustration job/year. Payment "is arranged through author."

Tips: "We do not publish children's fiction or picture books any longer."

N IGNATIUS PRESS, Guadalupe Associates, 2515 McAllister St., San Francisco CA 94118. (415)387-2324. Fax: (415)387-0896. Website: www.ignatius.com. **Production Editor:** Carolyn Lemon. Art Editor: Roxanne Lum. Estab. 1978. Company publishes Catholic theology and devotional books for lay people, priests and religious readers. Publishes 30 titles/year. Recent titles include: *Father Elijah: An Apocalypse* and *Tolkien: A Celebration*.

Needs: Works with 2-3 freelance illustrators/year. Works on assignment only.

First Contact & Terms: Will send art guidelines "if we are interested in the artist's work." Accepts previously published material. Send brochure showing art style or résumé and photocopies. Samples not filed and not returned. Responds only if interested. To show a portfolio, mail appropriate materials; "we will contact you if interested." **Pays on acceptance.**

Jackets/Covers: Buys cover art from freelance artists. Prefers Christian symbols/calligraphy and religious illustrations of Jesus, saints, etc. (used on cover or in text). "Simplicity, clarity, and elegance are the rule. We like calligraphy, occasionally incorporated with Christian symbols. We also do covers with type and photography." Pays by the project.

Text Illustration: Pays by the project.

Tips: "I do not want to see any schmaltzy religious art. Since we are a nonprofit Catholic press, we cannot always afford to pay the going rate for freelance art, so we are always appreciative when artists can give us a break on prices and work *ad maiorem Dei gloriam*."

☑ INCENTIVE PUBLICATIONS, INC., 3835 Cleghorn Ave., Nashville TN 37215. (615)385-2934. E-mail: info@incentivepublications.com. Website: www.incentivepublications.com. **Art Director:** Marta Johnson Drayton. Specializes in supplemental teacher resource material, workbooks and arts and crafts books for children K-8. Publishes 15-30 titles/year. Recent titles include: *If You Don't Feed the Teachers They Eat the Students*, *Basic Not Boring Book of Tests*, and *Can We Eat the Art*. 40% require freelance illustration. Books are "cheerful, warm, colorful, uncomplicated and spontaneous."

Needs: Works with 3-6 freelance illustrators/year. Uses freelancers for covers and text illustraion. Also for promo items (occasionally). Works on assignment only, primarily with local artists.

First Contact & Terms: Illustrators send query letter with photocopies, SASE and tearsheets. Samples are filed. Samples not filed are returned by SASE. Art director will contact artist for portfolio review if interested. Portfolio should include original/final art, photostats, tearsheets and final reproduction/product. Sometimes requests work on spec before assigning a job. Considers complexity of project, project's budget and rights purchased when establishing payment. Buys all rights. Originals are not returned.

Jackets/Covers: Assigns 4-6 freelance illustration jobs/year. Prefers 4-color covers in any medium. Pays by the project, $350-450.

Text Illustration: Assigns 4-6 freelance jobs/year. Black & white line art only. Pays by the project, $175-1,250.

Tips: "We look for a warm and whimsical style of art that respects the integrity of the child. We sell to parents and teachers. Art needs to reflect specific age children/topics for immediate association of parents and teachers to appropriate books."

INNER TRADITIONS INTERNATIONAL/BEAR & COMPANY, (formerly Inner Traditions International), One Park St., Rochester VT 05767. (802)767-3174. Fax: (802)767-3726. E-mail: peri@InnerTraditions.com. Website: www.InnerTraditions.com. **Art Director:** Peri Champine. Estab. 1975. Publishes hardcover originals and trade paperback originals and reprints. Types of books include self-help, psychology,

esoteric philosophy, alternative medicine and art books. Publishes 60 titles/year. Recent titles include: *Planting the Future*, *Pagan Fleshworks* and *Sun Dancing*. 50% requires freelance illustration; 50% requires freelance design. Book catalog free by request.

Needs: Works with 8-9 freelance illustrators and 10-15 freelance designers/year. 100% of freelance design demands knowledge of QuarkXPress, Illustrator, FreeHand and Photoshop. Buys 30 illustrations/year. Uses freelancers for jacket/cover illustration and design. Works on assignment only.

First Contact & Terms: Send query letter with résumé, SASE, tearsheets, photocopies, photographs and slides. Accepts disk submissions. Samples filed if interested or are returned by SASE if requested by artist. Responds to the artist only if interested. To show portfolio, mail tearsheets, photographs, slides and transparencies. Rights purchased vary according to project. Originals returned at job's completion. Pays by the project.

Jackets/Covers: Assigns approximately 32 design and 26 illustration jobs/year. Pays by the project.

INTERCULTURAL PRESS, INC., 374 U.S. Route 1, Yarmouth ME 04096. (207)846-5168. Fax: (207)846-5181. E-mail: books@interculturalpress.com. Website: www.interculturalpress.com. **Production Manager:** Patty Topel. Estab. 1982. Company publishes paperback originals. Types of books include text and reference. Specializes in intercultural and multicultural. Publishes 12 titles/year. Recent titles include: *Wimmin, Wimps & Wallflowers*, by Philip Herbst; and *Germany: Unravelling an Enigma*, by Greg Nees. 10% require freelance illustration. Book catalog free by request.

Needs: Approached by 20 freelancers/year. Works with 2-3 freelance illustrators/year. Prefers freelancers with experience in trade books, multicultural field. Uses freelancers mainly for jacket/cover design and illustration. 80% of freelance work demands knowledge of PageMaker or Illustrator. "If a freelancer is conventional (i.e., not computer driven) they should understand production and pre-press."

First Contact & Terms: Send query letter with brochure, tearsheets, résumé and photocopies. Samples are filed or are returned by SASE if requested by artist. Does not report back. Will contact artist for portfolio review if interested. Portfolio should include b&w final art. Buys all rights. Originals are not returned. Finds artists through submissions and word of mouth.

Jackets/Covers: Assigns 6 freelance illustration jobs/year. Pays by the project, $300-500.

Text Illustration: Assigns 1 freelance illustration job/year. Pays "by the piece depending on complexity." Prefers b&w line art.

Tips: First-time assignments are usually book jackets only; book jackets with interiors (complete projects) are given to "proven" freelancers. "We look for artists who have flexibility with schedule and changes to artwork. We appreciate an artist who will provide artwork that doesn't need special attention by pre-press in order for it to print properly. For black & white illustrations keep your lines crisp and bold. For color illustrations keep your colors pure and saturated to keep them from reproducing 'muddy.' "

☑ **INTERNATIONAL MARINE/RAGGED MOUNTAIN PRESS**, McGraw-Hill, Box 220, Camden ME 04843-0220. (207)236-4838. Fax: (207)236-6314. Website: www.books.mcgraw-hill.com/im. **Director of Editing, Design and Production:** Molly Mulhern Gross. Estab. 1969. Imprint of McGraw-Hill. Specializes in hardcovers and paperbacks on marine (nautical) and outdoor recreation topics. Publishes 50 titles/year. Recent titles include: *Sailing to Simplicity*, by Dave Gerr; and *Cruising Cuisine*, by Kay Pastorins. 50% require freelance illustration. Book catalog free by request.

Needs: Works with 20 freelance illustrators and 20 designers/year. Uses freelancers mainly for interior illustration. Prefers local freelancers. Works on assignment only.

First Contact & Terms: Send résumé and tearsheets. Samples are filed. Responds in 1 month. Considers project's budget when establishing payment. Buys one-time rights. Originals are not returned.

Book Design: Assigns 20 freelance design jobs/year. Pays by the project, $150-550; or by the hour, $12-30.

Jackets/Covers: Assigns 20 freelance design and 3 illustration jobs/year. Pays by the project, $100-500; or by the hour, $12-30.

Text Illustration: Assigns 20 jobs/year. Prefers technical drawings. Pays by the hour, $12-30; or by the project, $30-80/piece.

Tips: "Do your research. See if your work fits with what we publish. Write with a résumé and sample; then follow with a call; then come by to visit."

JAIN PUBLISHING CO., Box 3523, Fremont CA 94539. (510)659-8272. Fax: (510)659-0501. E-mail: mail@jainpub.com Website: www.jainpub.com. **Publisher:** M.K. Jain. Estab. 1989. Publishes hardcover originals, trade paperback originals and reprints and textbooks. Types of books include business, health, self help, religious and philosophies (Eastern). Publishes 10 titles/year. Recent titles include: *Introduction to the Lotus Sutra* and *Classical Korean Publishing*. Books are "uncluttered, elegant, using simple yet refined art." 100% require freelance jacket/cover design.

Needs: Approached by 50 freelancers/year. Works with 4 freelance illustrators and designers/year. Prefers freelancers with experience in book cover design. Uses freelancers mainly for jacket/cover design. Also for jacket/cover illustration. 100% of freelance work demands knowledge of Illustrator, Photoshop and QuarkXPress.

First Contact & Terms: Send postcard sample or query letter tearsheets. Accepts disk submissions. Samples are filed. Responds to the artist only if interested. Rights purchased vary according to project. Originals are not returned.

Jackets/Covers: Assigns 10 freelance design and 10 illustration jobs/year. Prefers "color separated disk submissions." Pays by the project, $300-500.

Tips: Expects "a demonstrable knowledge of art suitable to use with health and religious (Eastern) books."

JALMAR PRESS/INNERCHOICE PUBLISHING, 24426 S. Main St., Suite 702, Carson CA 90745. (310)816-3085. Fax: (310)816-3092. E-mail: blwjalmar@worldnet.att.net. Website: www.jalmarpress.com. **President:** Bradley L. Winch. Operations Manager: Cathy Winch. Estab. 1971. Publishes books emphasizing healthy self-esteem, character building, emotional intelligence, nonviolent communication, peaceful conflict resolution, stress management and whole brain learning. Publishes 6-10 titles/year. Recent titles include: *How to Handle a Bully*, *The Anger Workout for Teens*, and *Positive Attitudes and Peacemaking*. Books are contemporary, yet simple and activity-driven.

- Jalmar has developed a new line of books to help counselors, teachers and other caregivers deal with the 'tough stuff' including violence, abuse, divorce, AIDS, low self-esteem, the death of a loved one, etc.

Needs: Works with 3-5 freelance illustrators and 3 designers/year. Uses freelancers mainly for cover design and illustration. Also for direct mail and book design. Works on assignment only.

First Contact & Terms: Send query letter with brochure showing art style. Samples not filed are returned by SASE. 80% of freelance work demands knowledge of Photoshop, Illustrator, QuarkXPress and PDF. Buys all rights. Considers reprints but prefers original works. Considers complexity of project, budget and turnaround time when establishing payment.

Book Design: Pays by the project, $200 minimum.

Jackets/Covers: Pay by the project, $200 minimum.

Text Illustration: Pays by the project, $15 minimum.

Tips: "Portfolio should include samples that show experience. Don't include 27 pages of 'stuff.' Stay away from the 'cartoonish' look. If you don't have any computer design and/or illustration knowledge— get some! If you can't work on computers, at least understand the process of using traditional artwork with computer generated electronic files. For us to economically get more of our product out (with fast turnaround and a minimum of rough drafts), we've gone exclusively to computers for total book design; when working with traditional artists, their artwork will be placed within the computer-generated document."

☑ JEWISH LIGHTS PUBLISHING, Sunset Farm Offices, Rt. 4, P.O. Box 237, Woodstock VT 05091. (802)457-4000. Fax: (802)457-5032. E-mail: production@jewishlights.com. Website: www.jewishlights.com. **Production Manager:** Tim Holtz. Estab. 1990. Publishes hardcover originals, trade paperback originals and reprints. Types of books include children's picture books, history, juvenile, nonfiction, reference, religious, self help, spirituality, life cycle, theology and philosophy, wellness. Specializes in adult nonfiction and children's picture books. Publishes 50 titles/year. Recent titles include: *The Dance of the Dolphin*; *Cain & Abel*; *The Jewish Lights Spirituality Handbook*. 10% requires freelance illustration; 90% requires freelance design. Book catalog free on request.

Needs: Approached by 75 illustrators and 20 designers/year. Works with 5 illustrators and 20 designers/year. Prefers freelancers experienced in fine arts, children's book illustration, typesetting and design. 100% of freelance design demands knowledge of PageMaker, QuarkXPress.

First Contact & Terms: Designers send postcard sample, query letter with printed samples, tearsheets. Illustrators send postcard sample or other printed samples. Samples are filed and are not returned. Portfolio review not required. Buys all rights. Finds freelancers through submission packets, websites, searching local galleries and shows, Graphic Artists' Guild's *Directory of Illustrators* and *Picture Book*.

Book Design: Assigns 40 freelance design jobs/year. Pays for design by the project.

Jackets/Covers: Assigns 40 freelance design jobs and 10 illustration jobs/year. Pays for design by the project.

Tips: "We prefer a painterly, fine-art approach to our children's book illustration to achieve a quality that would intrigue both kids and adults. We do not consider cartoonish, cariacature-ish art for our children's book illustration."

☑ JUDSON PRESS, Imprint of American Baptist Board of Education & Publication, P.O. Box 851, Valley Forge PA 19482-0851. Fax: (610)768-2223. E-mail: wendy.ronga@abc-usa.org. Website: www.juds

onpress.com. **Creative Director:** Wendy Ronga. Estab. 1824. Publishes hardcover originals and reprints, trade paperback originals and reprints. Types of books: religious, New Age and African-American titles. Specializes in pastoral aid, church school curriculum. Publishes 30 titles/year.

First Contact & Terms: Send printed samples. Samples are filed and not returned. Responds only if interested. "We are looking for talented designers with a book-publishing background to design book interiors, plus some covers. The type of illustrator we use depends on the project—the majority of work involves drawing people. I am open to a variety of styles—from realistic to abstract or very loose. We are also looking for African-American illustrators for our African-American books, both childrens and adults."

Jackets/Covers: Assigns 30 freelance design jobs and 20 illustration jobs/year.

Text Illustration: Varies between 18-30 books/year. Assigns 35 book interior design jobs/year.

Tips: "I look closely at type treatment. It should be well thought out, clean and simple. The choice of font should convey the feeling of the book in a headline. With illustrators I look for good ideas as well as a pleasing style. I want the illustrators to come up with concepts on their own for the manuscript."

✓ KAEDEN BOOKS, P.O. Box 16190, Rocky River OH 44116. (440)356-0030. Fax: (440)356-5081. E-mail: curmston@kaeden.com. Website: www.kaeden.com. **Publisher:** Craig Urmston. Estab. 1989. Publishes children's books and picture books. Types of books include preschool, picture books and early juvenile. Specializes in educational elementary content. Publishes 8-16 titles/year. 90% require freelance illustration; 10% require freelance design. Book catalog available upon request. Recent new titles include *When I Go to Grandma's House*, *Sammy's Hamburger Caper*, and *Moose's Loose Tooth*.

● Kaeden Books is now providing content for Thinkbox.com and the TAE Kindlepark Electronic Book Program.

Needs: Approached by 100-200 illustrators/year. Works with 5-10 illustrators/year. Prefers freelancers experienced in juvenile/humorous illustration and children's picture books. Uses freelancers mainly for story illustration. 10% of freelance illustrations demands knowledge of Illustrator, QuarkXPress, CorelDraw 9, Pagemaker or Freehand.

First Contact & Terms: Designers send query letter with brochure and résumé. Illustrators send postcard sample or query letter with photocopies, photographs, printed samples, tearsheets and résumé. Samples are filed and not returned. Responds only if interested. Art director will contact artist for portfolio review if interested. Buys all rights.

Jackets/Covers: Assigns 10-25 illustration jobs/year. Pays by the project. Looks for a variety of styles.

Text Illustration: Assigns 10-25 jobs/year. Pays by the project. "We accept all media, though most of our books are watermedia."

Tips: "We look for professional-level drawing and rendering skills, plus the ability to interpret a juvenile story. There is a tight correlation between text and visual in our books, plus a need for attention to detail. Please send only samples that pertain to our market."

N KALMBACH PUBLISHING CO., 21027 Crossroads Circle, P.O. Box 1612, Waukesha WI 53187. (262)796-8776. Fax: (262)796-1142. E-mail: kludwig@kalmbach.com. Website: www.kalmbach.com. **Books Art Director:** Kristi L. Ludwig. Estab. 1934. Imprints include Greenberg Books. Company publishes hardcover and trade paperback originals. Types of books include instruction, reference and history. Specializes in hobby books. Publishes 35 titles/year. Recent titles include: *Atlas of the Moon*, *Bead Art* and *Model Railroad Wiring*. 10-20% require freelance illustration; 10-20% require freelance design. Book catalog free by request.

Needs: Approached by 10 freelancers/year. Works with 2 freelance illustrators and 2 designers/year. Prefers freelancers with experience in the hobby field. Uses freelance artists mainly for book layout, line art illustrations. Also for book design. 90% of freelance work demands knowledge of Illustrator, QuarkXPress or Photoshop. "Freelancers should have most updated versions." Works on assignment only.

First Contact & Terms: Send query letter with résumé, tearsheets and photocopies. Samples are filed. Art Director will contact artist for portfolio review if interested. Portfolio should include slides and final art. Rights purchased vary according to project. Originals are returned at job's completion. Finds artists through word of mouth, submissions.

Book Design: Assigns 10-12 freelance design jobs/year. Pays by the project, $1,000-3,000.

Text Illustration: Assigns 5 freelance illustration jobs/year. Pays by the project, $250-2,000.

Tips: First-time assignments are usually text illustration, simple book layout; complex track plans, etc., are given to "proven" freelancers. Admires freelancers who "present an organized and visually strong portfolio; meet deadlines (especially when first working with them) and listen to instructions."

✓ KAMEHAMEHA SCHOOLS PRESS, 1887 Makuakane St., Honolulu HI 96817-1887. Fax: (808)842-8895. E-mail: kspress@ksbe.edu. Website: www.ksbe.edu/pubs/KSPress/catalog.html. **Contact:** Henry Bennett. Publishes hardcover originals and reprints, trade paperback originals and reprints and textbooks. Types of books include biography, Hawaiian culture and history, instruction, juvenile, nonfiction,

preschool, reference, textbooks and young adult. Publishes 3-5 titles/year. Recent titles include: *From the Mountains to the Sea* and *Kamehameha IV: Alexander Liholiho*. 25% require freelance illustration; 5% require freelance design. Catalog available.

Needs: Approached by 3-5 illustrators and 5-10 designers/year. Works with 2-3 illustrators and 1-2 designers/year. Prefers local freelancers knowledgeable in Hawaiian culture. Uses freelancers mainly for b&w line illustration. 100% of freelance design demands knowledge of QuarkXPress.

First Contact & Terms: Designers send query letter with photocopies of book design. Illustrators send query letter with photocopies. Samples are filed. Responds only if interested. Will contact artist for portfolio review of roughs and tearsheets if interested. Portfolio should include artwork portraying Hawaiian cultural material. Buys all rights.

Book Design: Assigns 1-3 freelance design jobs/year. Pays by the project.

Jackets/Covers: Assigns 1-3 freelance design jobs and 1-3 illustration jobs/year. Pays for design and illustration by the project.

Text Illustration: Assigns 1-3 freelance illustration jobs/year. Pays by the project. Finds freelancers through word of mouth and submissions.

Tips: "We require our freelancers to be extremely knowledgeable in accurate and authentic presentation of Hawaiian-culture images."

☑ **KAR-BEN COPIES, INC.**, 6800 Tildenwood Lane, Rockville MD 20852. (301)984-8733. Fax: (301)881-9195. E-mail: karben@aol.com. Website: www.karben.com. **Editor:** Madeline Wikler. Estab. 1975. Company publishes hardcovers and paperbacks on juvenile Judaica. Publishes 6-8 titles/year. Recent titles include: *Baby's Bris*, by Susan Wilkowski; and *Sammy Spider's Passover Fun Book*, by Judge Groner and Madeline Wikler. Books contain "colorful illustrations to appeal to young readers." 100% require freelance illustration. Book catalog free on request.

Needs: Uses 10-12 freelance illustrators/year. Uses freelancers mainly for book illustration. Also for jacket/cover design and illustration, book design and text illustration.

First Contact & Terms: Send query letter with samples or tearsheets showing skill in children's book illustration to be kept on file. Samples not filed are returned by SASE. Responds in 2 weeks only if SASE included. Originals are returned at job's completion. Sometimes requests work on spec before assigning a job. Considers skill and experience of artist and turnaround time when establishing payment. Pays by the project, $500-3,000 average, or advance plus royalty. Buys all rights. Considers buying second rights (reprint rights) to previously published artwork.

Tips: Send samples showing active children, not animals or still life. Don't send original art. "Look at our books and see what we do. We are using more full-color as color separation costs have gone down."

🅽 **KENDALL/HUNT PUBLISHING CO.**, 4050 Westmark Dr., Dubuque IA 52004-1840. (563)589-1040. Fax: (563)589-1160. Website: www.kendallhunt.com. **Senior Production Technology Coordinator:** Sara Eisbach. Estab. 1940. Publishes hardcover and trade paperback originals and reprints, textbooks, audio tapes and CD-ROM. Types of books include adventure, biography, coffee table books, history, instructional, nonfiction, self-help and K-12 and college textbooks. Publishes 1,800 titles/year. 5% require freelance illustration. Recent titles include: *Prime Science* and *Math Trailblazers*.

Needs: Approached by 8-10 illustrators and 8-10 designers/year. Works with 4 illustrators and 3 designers/year. 100% of freelance design demands knowledge of PageMaker, FreeHand, Photoshop and Illustrator. 95% of freelance illustration demands knowledge of FreeHand, Photoshop, Illustrator and Corel Draw.

First Contact & Terms: Designers send query letter with brochure. Illustrators send query letter with printed samples and résumé. Samples are filed. Responds only if interested. Buys all rights.

Book Design: Assigns 25-50 freelance design jobs/year. Pays by the project.

Jackets/Covers: Pays by the project, $125-250. Media and style varies.

Text Illustration: Assigns 10-15 freelance illustration jobs/year. Payment negotiable. Finds freelancers through artist's submissions.

☑ **KIRKBRIDE BIBLE CO. INC.**, Kirkbride Bible & Technology, 335 W. 9th St., Indianapolis IN 46202-0606. (317)633-1900. Fax: (317)633-1444. E-mail: sales@kirkbride.com. Website: www.kirkbride.com. **Director of Production and Technical Services:** Michael B. Gage. Estab. 1915. Publishes hardcover originals, CD-ROM and many styles and translations of the Bible. Types of books include reference and religious. Specializes in reference and study material. Publishes 6 main titles/year. Recent titles include: *NIV Thompson Student Bible*. 5% require freelance illustration; 20% require freelance design. Catalog available.

Needs: Approached by 1-2 designers/year. Works with 1-2 designers/year. Prefers freelancers experienced in layout and cover design. Uses freelancers mainly for artwork and design. 100% of freelance design and most illustration demands knowledge of PageMaker, FreeHand, Photoshop, Illustrator and QuarkXPress. 5-10% of titles require freelance art direction.

First Contact & Terms: Designers send query letter with photostats, printed samples and résumé. Illustrators send query letter with photostats, printed samples and résumé. Accepts disk submissions compatible with QuarkXPress or Photoshop files—4.0 or 3.1. Samples are filed. Responds only if interested. Rights purchased vary according to project.
Book Design: Assigns 1 freelance design job/year. Pays by the hour $100 minimum.
Jackets/Covers: Assigns 1-2 freelance design jobs and 1-2 illustration jobs/year. Pays for design by the project, $100-1,000. Pays for illustration by the project, $100-1,000. Prefers modern with traditional text.
Text Illustration: Assigns 1 freelance illustration/year. Pays by the project, $100-1,000. Prefers traditional. Finds freelancers through sourcebooks and references.
Tips: "Quality craftsmanship is our top concern, and it should be yours also!"

B. KLEIN PUBLICATIONS INC., P.O. Box 6578, Delray Beach FL 33482. (561)496-3316. Fax: (561)496-5546. **Editor:** Bernard Klein. Estab. 1955. Publishes reference books, such as the *Guide to American Directories*. Publishes approximately 15-20 titles/year. 25% require freelance illustration. Book catalog free on request.
Needs: Works with 1-3 freelance illustrators and 1-3 designers/year. Uses freelancers for jacket design and direct mail brochures. 25% of titles require freelance art direction.
First Contact & Terms: Submit résumé and samples. Pays $50-300.

ALFRED A. KNOPF, INC., subsidiary of Random House Inc., 299 Park Ave., New York NY 10171. (212)751-2600. Fax: (212)572-2593. Website: www.aaknopf.com. **Art Director:** Carol Carson. Publishes hardcover originals for adult trade. Specializes in history, fiction, art and cookbooks. Publishes 200 titles/year. Recent titles include: *Prophecy* and *Me Times Three*.
Needs: Works with 3-5 freelance illustrators and 3-5 freelance designers/year. Prefers artists with experience in b&w. Uses freelancers mainly for cookbooks and biographies. Also for text illustration and book design.
First Contact & Terms: Send query letter with SASE. Request portfolio review in original query. Artist should follow up. Sometimes requests work on spec before assigning a job. Originals are returned at job's completion.
Book Design: Pays by the hour, $15-30; by the project, $450 minimum.
Text Illustration: Pays by the project, $100-5,000; $50-150/illustration; $300-800/maps.
Tips: Finds artists through submissions, agents and sourcebooks. "Freelancers should be aware that Macintosh/Quark is a must for design and becoming a must for maps and illustration."

☑ ☀ **PETER LANG PUBLISHING, INC.**, 275 Seventh Ave., 28th Floor, New York NY 10001. Website: www.peterlangusa.com. **Production Manager:** Lisa Dillon. Publishes humanities textbooks and monographs. Publishes 300 titles/year. Book catalog not available, "but visit website."
Needs: Works with a small pool of designers/year. Prefers local freelance designers experienced in scholarly book covers. Most covers will be 2 colors and black. 100% of freelance design demands knowledge of Illustrator, Photoshop and QuarkXPress.
First Contact & Terms: Send query letter with printed samples, photocopies and SASE. Accepts Windows-compatible and Mac-compatible disk submissions. Samples are filed. Responds only if interested. Will contact artist for portfolio review if interested. Finds freelancers through referrals.
Jackets/Covers: Assigns 100 freelance design jobs/year. Only accepts Quark electronic files. Pays for design by the project; $175 for comp; $175 for cover mechanical.

☑ **LAREDO PUBLISHING CO./RENAISSANCE HOUSE**, (formerly Laredo Publishing Co.), 8907 Wilshire Blvd. 102, Beverly Hills CA 90211. (310)358-5288. Fax: (310)358-5282. E-mail: laredo@renaissancehouse.net. Website: renaissancehouse.net. **Art Director:** Pablo Torrecilla. Estab. 1991. Publishes juvenile, preschool textbooks. Specializes in Spanish texts, educational/readers. Publishes 16 titles/year. Recent titles include: *Legends of America* (series of 21 titles), *Extraordinary People* (series of 6 titles), *Breast Health with Nutribionics*.
Needs: Approached by 10 freelance illustrators and 2 freelance designers/year. Works with 2 freelance designers/year. Uses freelancers mainly for book development. 100% of freelance design demands knowledge of Photoshop, Illustrator, QuarkXPress. 20% of titles require freelance art direction.
First Contact & Terms: Designers send query letter with brochure, photocopies. Illustrators send photocopies, photographs, résumé, slides, tearsheets. Samples are not filed and are returned by SASE. Responds only if interested. Portfolio review required for illustrators. Art director will contact artist for portfolio review if interested. Portfolio should include book dummy, photocopies, photographs, tearsheets and artwork portraying children. Buys all rights or negotiates rights purchased.
Book Design: Assigns 5 freelance design jobs/year. Pays for design by the project.
Jacket/Covers: Pays for illustration by the project, page.

Text Illustration: Pays by the project, page.

LEE & LOW BOOKS, 95 Madison Ave., New York NY 10016-7801. (212)779-4400. E-mail: info@leean dlow.com. Website: www.leeandlow.com. **Executive Editor:** Louise May. Editor: Jennifer Hunt. Publisher: Philip Lee. Estab. 1991. Book publisher. Publishes hardcover originals and reprints for the juvenile market. Specializes in multicultural children's books. Publishes 12-15 titles/year. First list published in spring 1993. Recent titles include: *Rent Party Jazz*, by William Miller; *Where On Earth Is My Bagel?*, by Frances Park and Ginger Park; and *Love to Mamá*, edited by Pat Mora. 100% requires freelance illustration and design. Book catalog available.

Needs: Approached by 100 freelancers/year. Works with 12-15 freelance illustrators and 4-5 designers/year. Uses freelancers mainly for illustration of children's picture books. 100% of design work demands computer skills. Works on assignment only.

First Contact & Terms: Contact through artist rep or send query letter with brochure, résumé, SASE, tearsheets or photocopies. Samples of interest are filed. Art director will contact artist for portfolio review if interested. Portfolio should include color tearsheets and dummies. Rights purchased vary according to project. Originals are returned at job's completion.

Book Design: Pays by the project.

Text Illustration: Pays by the project.

How would an artist ever depict something as unusual as a Korean boy searching for an evasive breakfast bagel? Although the book plot was strange, fulltime illustrator Grace Lin was easily chosen for the assignment since she had previously designed covers for award-winning publisher Lee & Low Books. Utilizing expert gouache painting skills, Lin often designs a slew of colorful characters for children's books and novelties.

Tips: "We want an artist who can tell a story through pictures and is familiar with the children's book genre. We are now also developing materials for younger children, ages 2-5, so we are interested in seeing work for this age group, too. Lee & Low Books makes a special effort to work with writers and artists of color and encourages new talent. We prefer filing samples that feature children, particularly from diverse backgrounds."

☑ **LEISURE BOOKS/LOVE SPELL**, Divisions of Dorchester Publishing Co., Inc., 276 Fifth Ave., Suite 1008, New York NY 10001-0112. (212)725-8811. Fax: (212)532-1054. Website: www.dorchesterpub. com. **Director of Art & Production:** Katy Steinhilber. Estab. 1970. Specializes in paperback, originals and reprints, especially mass market category fiction—realistic historical romance, western, adventure, horror. Publishes 170 titles/year. Recent titles include: *Chase the Lightning*, by Madeline Baker; *Eden*, by Bobbi Smith; *Spirit*, by Graham Masterton; and *A Long Deep*, by Tom Piccirilli. 90% requires freelance illustration.
Needs: Works with 24 freelance illustrators and 6 designers/year for covers. We need highly realistic, paperback illustration; digital, oil or acrylic. By assignment only.
First Contact & Terms: Send samples by mail. Accepts submissions from illustrators on CD but nonreturnable tearsheets preferred. No samples will be returned without SASE. Will respond only if samples are appropriate and if SASE is enclosed. Portfolios may be dropped off Monday-Thursday. Complexity of project will determine payment. Usually buys first rights, but rights purchased vary according to project. Interested in buying second rights (reprint rights) to previously published work "for romances and westerns only." Originals returned at job's completion.
Jackets/Covers: Pays by the project.
Tips: "Talented new artists welcome. Be familiar with the kind of artwork we use on our covers. If it's not your style, don't waste your time and ours."

LIBRARIES UNLIMITED/TEACHER IDEAS PRESS, Box 6633 Englewood CO 80155-6633. (303)770-1220. Fax: (303)220-8843. E-mail: lu-booksg@lu.com. Website: www.lu.com. **Contact:** Publicity Department. Estab. 1964. Specializes in hardcover and paperback original reference books concerning library science and school media for librarians, educators and researchers. Also publishes in resource and activity books for teachers. Publishes more than 60 titles/year. Recent titles include: *Best Books for Children*. Book catalog free by request.
Needs: Works with 4-5 freelance artists/year.
First Contact & Terms: Designers send query letter with résumé and photocopies. Illustrators send query letter with photocopies. Samples not filed are returned only if requested. Responds in 2 weeks. Considers complexity of project, skill and experience of artist, and project's budget when establishing payment. Buys all rights. Originals not returned.
Text Illustration: Assigns 2-4 illustration jobs/year. Pays by the project.
Jackets/Covers: Assigns 4-6 design jobs/year. Pays by the project, $500 minimum.
Tips: "We look for the ability to draw or illustrate without overly loud cartoon techniques. Freelancers should have the ability to use two-color effectively, with screens and screen builds. We ignore anything sent to us that is in four-color. We also need freelancers with a good feel for typefaces."

🄽 **LIPPINCOTT WILLIAMS & WILKINS**, Parent company: Wolters Kluwer. 351 W. Camden St., Baltimore MD 21201-2436. (410)528-4000. Fax: (410)528-8596. E-mail: mfernand@lww.com. Website: www.lww.com. **Senior Design Coordinator:** Mario Fernandez. Estab. 1890. Publishes audio tapes, CD-ROMs, hardcover originals and reprints, textbooks, trade paperbook originals and reprints. Types of books include instructional and textbooks. Specializes in medical publishing. Publishes 400 titles/year. Recent titles include: *Principles of Medical Genetics-2nd Edition* and *Communication Development: Foundations Processes and Clinical Applications*. 100% requires freelance design.
Needs: Approached by 20 illustrators and 20 designers/year. Works with 10 illustrators and 30 designers/year. Prefers freelancers experienced in medical publishing. 100% of freelance design demands knowledge of Illustrator, Photoshop, QuarkXPress.
First Contact & Terms: Send query letter with printed samples and tearsheets. Accepts Mac-compatible disk submissions. Send EPS or TIFF files. Responds only if interested. Will contact artist for portfolio review if interested. Buys all rights. Finds freelancers through submission packets, word of mouth.
Book Design: Assigns 150 freelance design jobs/year. Pays by the project, $350-5,000.
Jackets/Covers: Assigns 150 freelance design jobs/year. Pays for design by the project, $350-5,000. Prefers medical publishing experience.
Text Illustration: Assigns 150 freelance illustration jobs/year. Pays by the project, $350-500. Prefers freelancers with medical publishing experience.

Tips: "We're looking for freelancers who are flexible and have extensive clinical and textbook medical publishing experience. Designers must be proficient in Quark, Illustrator and Photoshop and completely understand how design affects the printing (CMYK 4-color) process."

⊞ LITURGY TRAINING PUBLICATIONS, An agency of the Roman Catholic Archdiocese of Chicago, 1800 N. Hermitage, Chicago IL 60622. (773)486-8970. Fax: (773)486-7094. **Contact:** Design Manager. Estab. 1964. Publishes hardcover originals and trade paperback originals and reprints. Types of books include religious instructional books for adults and children. Publishes 50 titles/year. Recent titles include: *A Prayer Book for Remembering the Women*, *The Weekday Lectionary* and *Confirmation, a Parish Celebration*. 60% requires freelance illustration; 3-5% requires freelance design. Book catalog free by request.
Needs: Approached by 30-50 illustrators and 10-20 designers/year. Works with 10-15 illustrators and 1-2 designers/year. Prefers local designers. 90% of freelance design demands knowledge of Illustrator, Photoshop and QuarkXPress. 10% of freelance illustration demands knowledge of Photoshop.
First Contact & Terms: Designers and illustrators send postcard sample or send query letter with printed samples, photocopies and tearsheets. Accepts Mac-compatible disk submissions. Send EPS or TIFF files. Samples are filed and are not returned. Will contact artist for portfolio review if interested. Rights purchased vary according to project.
Book Design: Assigns 1-2 freelance design jobs/year.
Jackets/Covers: Assigns 1-2 freelance design jobs and 20-30 illustration jobs/year. Pays for design by the hour.
Text Illustration: Assigns 15-20 freelance illustration jobs/year. Pays by the project. "There is more opportunity for illustrators who are good in b&w or 2-color, but illustrators who work exclusively in 4-color are also utilized."
Tips: "Two of our books were in the AIGA 50 Best Books of the Year show in recent years and we win numerous awards. Sometimes illustrators who have done religious topics for others have a hard time working with us because we do not use sentimental or traditional religious art. We look for sophisticated, daring, fine art-oriented illustrators and artists. Those who work in a more naturalistic manner need to be able to portray various nationalities well. We never use cartoons."

Ⓝ LLEWELLYN PUBLICATIONS, Box 64383, St. Paul MN 55164-0383. (651)291-1970. Fax: (651)291-1908. Website: www.llewellyn.com. **Contact:** Art Director. Estab. 1909. Book publisher. Publishes trade paperback and mass market originals and reprints, tarot kits and calendars. Types of books include reference, self-help, metaphysical, occult, mythology, health, women's spirituality and New Age. Publishes 80 titles/year. Books have photography, realistic painting and computer generated graphics. 60% require freelance illustration. Book catalog available for large SASE and 5 first-class stamps.
Needs: Approached by 100 freelancers/year. Buys 30-50 freelance illustrations/year. Prefers freelancers with experience in book covers, New Age material and realism. Uses freelancers mainly for realistic paintings and drawings. Works on assignment only.
First Contact & Terms: Send query letter with printed samples, tearsheets, photographs, photocopies or slides (preferred). Samples are filed or are returned by SASE. Art Director will contact artist for portfolio review if interested. Sometimes requests work on spec before assigning a job. Negotiates rights purchased.
Jackets/Covers: Assigns 40 freelance illustration jobs/year. Pays by the illustration, $150-700. Media and style preferred "are usually realistic, well-researched, airbrush, watercolor, acrylic, oil, colored pencil. Artist should know our subjects."
Text Illustration: Assigns 25 freelance illustration jobs/year. Pays by the project, or $30-100/illustration. Media and style preferred are pencil and pen & ink, "usually very realistic; there are usually people in the illustrations."
Tips: "I need artists who are aware of occult themes, knowledgeable in the areas of metaphysics, divination, alternative religions, women's spirituality, and who are professional and able to present very refined and polished finished pieces. Knowledge of history, mythology and ancient civilization is a big plus."

LOOMPANICS UNLIMITED, P.O. Box 1197, Port Townsend WA 98368. (360)385-2230. Fax: (360)385-7785. E-mail: publicity@loompanics.com. Website: www.loompanics.com. **Editorial Liaison:** Gia Cosindas. Estab. 1973. Publishes mass market paperback originals and reprints, trade paperback originals and reprints. Types of books include nonfiction, crime, police science, illegal drug manufacture, self-sufficiency and survival. Specializes in how-to with an edge. Publishes 25 titles/year. Recent titles include: *Surviving on the Streets: How to Go Down Without Going Out*, *Build Your Own Catapult in Your Backyard*, and *Divining Ecstasy: The Magical and Mystical Essence of Salvia Divinorum*. 75% requires freelance illustration. Book catalog available for $5.
Needs: Works with 10 illustrators and 2 designers/year. Prefers freelancers experienced in action drawing, cartoons, precision/botany.

First Contact & Terms: Send query letter with printed samples, photocopies and SASE. Samples are returned by SASE. Responds only if interested. Will contact artist for portfolio review if interested. Buys one-time rights. Usually works with freelancers publisher has worked with in the past.

Book Design: Assigns 1 freelance design job/year. Pays for design by the project.

Jackets/Covers: Assigns 10 freelance design jobs and 15 illustration jobs/year. Pays for design and illustration by the project. Prefers creative illustrators willing to work with controversial and unusual material.

Text Illustration: Assigns 50 freelance illustration jobs/year.

Tips: "Please do not call us. We develop good, long-lasting relationships with our illustrators, who are used to our 'we're-not-sure-what-we-want-but-we'll-know-it when-we-see-it' approach."

N **LUGUS PUBLICATIONS**, 48 Falcon St., Toronto, Ontario M4S 2P5 Canada. (416)322-5113. Fax: (416)484-9512. E-mail: lugust@tvo.org. **President:** Gethin James. Estab. 1981. Publishes hardcover, trade paperback and mass market paperback originals and reprints and textbooks. Types of books include coffee table books, cookbooks, fantasy, history, humor, instructional, juvenile, mainstream fiction, nonfiction, preschool, romance, science fiction, self help, textbooks, travel and young adult. Specializes in school guidance. Publishes 20 titles/year. Recent titles include: *Children as Storytellers*. 10% require freelance illustration; 10% require freelance design. Book catalog free.

Needs: Approached by 5 illustrators and 2 designers/year. Works with 2 illustrators and 1 designer/year. Prefers freelancers experienced in educational publishing. Uses freelancers mainly for covers and illustration. 100% of freelance work demands knowledge of Photoshop, QuarkXPress and Color It.

First Contact & Terms: Designers send query letter with brochure. Illustrators send postcard sample. Accept disk submissions compatible with Ready Set Go! Samples are not filed and are not returned. Responds only if interested. Buys all rights or rights purchased vary according to project. Finds freelancers through submissions.

Book Design: Assigns 2 freelance design jobs/year. Pays by the project.

Jackets/Covers: Assigns 5 freelance design and 5 illustration jobs/year. Pays by the project. Prefers complete artwork on disk or SyQuest cartridge.

Text Illustration: Assigns 5 freelance illustration jobs/year. Pays by the project. Prefers artwork stored on disk or SyQuest cartridge.

Tips: "It is helpful if artist has familiarity with Docutech and high speed color copying."

N **THE LYONS PRESS**, 123 W. 18th St., New York NY 10011. (212)620-9580. Fax: (212)929-1836. Website: www.lyonspress.com. **Art Director:** Liz Driesbach. Estab. 1980. Publishes hardcover and trade paperback originals and reprints. Types of books include adventure, cookbooks, instructional, nonfiction, gardening, sports, martial arts, outdoors. Publishes 180 titles/year. Recent titles include: *Quotable New York* and *The Way of the River*. 50% requires freelance illustration; 40% requires freelance design. Book catalog available.

Needs: Approached by 20 illustrators and 10 designers/year. Works with 15-20 illustrators and 10-15 designers/year. Prefers freelancers experienced in designing books and covers. 100% of freelance design and 20% of freelance illustration demands knowledge of Illustrator, Photoshop, QuarkXPress.

First Contact & Terms: Designers send query letter with printed samples, photocopies, tearsheets. Illustrators send postcard sample or query letter with tearsheets. Accepts Mac-compatible disk submissions. Samples are filed and are not returned. Will contact artist for portfolio review if interested. Portfolio showing book dummy and tearsheets may be dropped off every Wednesday and can be picked up the following day. Rights purchased vary according to project. Finds freelancers through *Workbook*, *RSVP*.

Book Design: Assigns 25 freelance design jobs/year. Pays by the project.

Jackets/Covers: Assigns 25 freelance design and 30 illustration jobs/year. Pays for design by the project, $400 maximum. Pays for illustration by the project, $300-450.

Text Illustration: Assigns 35 freelance illustration jobs/year. Pays by the project, $200-700 depending on job.

N **MADISON BOOKS**, Dept. AGDM, 4720 Boston Way, Lanham MD 20706. (301)731-9534. Fax: (301)459-3464. **Vice President, Design:** Gisele Byrd Henry. Estab. 1984. Publishes hardcover and trade paperback originals. Specializes in biography, history and popular culture. Publishes 16 titles/year. Titles include *The Mystified Fortune Teller*, *Love and Limerence*, *Three Golden Ages*. 40% require freelance illustration; 100% require freelance jacket design. Book catalog free by request.

● Madison Books is just one imprint of Rowman & Littlefield Publishing Group, which has eight imprints. Look for expanded listing next year.

Needs: Approached by 20 freelancers/year. Works with 4 freelance illustrators and 12 designers/year. Prefers freelancers with experience in book jacket design. Uses freelancers mainly for book jackets. Also for catalog design. 80% of freelance work demands knowledge of Illustrator, QuarkXPress, Photoshop or FreeHand. Works on assignment only.

First Contact & Terms: Send query letter with tearsheets, photocopies and photostats. Samples are filed or are returned by SASE if requested by artist. Responds to the artist only if interested. Call for appointment to show portfolio of roughs, original/final art, tearsheets, photographs, slides and dummies. Buys all rights. Interested in buying second rights (reprint rights) to previously published work.

Jackets/Covers: Assigns 16 freelance design and 2 illustration jobs/year. Pays by the project, $400-1,000. Prefers typographic design, photography and line art.

Text Illustration: Pays by project, $100 minimum.

Tips: "We are looking to produce trade-quality designs within a limited budget. Covers have large type, clean lines; they 'breathe.' If you have not designed jackets for a publishing house but want to break into that area, have at least five 'fake' titles designed to show ability. I would like to see more Eastern European style incorporated into American design. It seems that typography on jackets is becoming more assertive, as it competes for attention on bookstore shelf. Also, trends are richer colors, use of metallics."

✓ 🏛 **MAPEASY, INC.**, P.O. Box 80, 54 Industrial Rd., Wainscott NY 11975-0080. (631)537-6213. Fax: (631)537-4541. E-mail: charris@mapeasy.com. Website: mapeasy.com. **Production:** Chris Harris. Estab. 1990. Publishes maps. 100% requires freelance illustration; 25% requires freelance design. Book catalog not available.

Needs: Approached by 15 illustrators and 10 designers/year. Works with 3 illustrators and 1 designer/year. Prefers local freelancers. 100% of freelance design and illustration demands knowledge of Illustrator, Photoshop, QuarkXPress and Painter.

First Contact & Terms: Send query letter with photocopies. Accepts Mac-compatible disk submissions. Samples are filed. Responds only if interested. Will contact artist for portfolio review if interested. Portfolio should include photocopies. Finds freelancers through ads and referrals.

Text Illustration: Pays by the hour, $45 maximum.

✓ **MEADOWBROOK PRESS**, 5451 Smetana Dr., Minnetonka MN 55343. (612)930-1100. Fax: (612)930-1940. E-mail: pwoods@meadowbrookpress.com. Website: www.meadowbrookpress.com and www.production.meadowbrookpress.com. **Production Manager:** Paul Woods. Company publishes hardcover and trade paperback originals. Types of books include instruction, humor, juvenile, preschool and parenting. Specializes in parenting, humor. Publishes 20 titles/year. Titles include *When You Were One*, *What's Your Baby's Name*, *Slumber Parties*, *52 Romantic Evenings* and *1440 Reasons to Quit Smoking*. 80% require freelance illustration; 10% require freelance design.

Needs: Uses freelancers mainly for humor, activity books, spot art. Also for jacket/cover and text illustration. 100% of design work demands knowledge of QuarkXPress, Photoshop or Illustrator. Works on assignment only.

First Contact & Terms: Designers send query letter with résumé and photocopies. Illustrators send query letter with photocopies. Samples are filed and are not returned. Responds only if interested. Art director will contact artist for portfolio review if interested. Portfolio should include b&w and color final art and transparencies. Originals are returned at job's completion. Finds artists through agents, sourcebooks and submissions.

Book Design: Assigns 2 freelance design jobs/year. "Pay varies with complexity of project."

Jackets/Covers: Assigns 18 freelance design and 6 freelance illustration jobs/year. Pays by the project, $500-1,500.

Text Illustration: Assigns 18 freelance illustration jobs/year. Pays by the project, $50-100/illustration.

Tips: "We want hardcopy samples to keep on file for review, not on disk or via e-mail, but do appreciate ability to illustrate digitally."

🆕 **R.S. MEANS CO., INC.**, Parent company: CMDG, 63 Smiths Lane, Kingston MA 02364-0800. (781)585-7880. Fax: (781)585-8814. E-mail: hmarcella@rsmeans.com. Website: www.rsmeans.com. **Sr. Marketing Specialist:** Helen Marcella. Estab. 1942. Publishes CD-ROMs, hardcover originals and re-prints; textbooks; trade paperback originals and reprints. Types of books include instructional, reference, construction. Specializes in construction cost books. Publishes 25-30 titles/year. Recent titles include: *Illustrated Construction Dictionary*. 50% requires freelance illustration; 100% requires freelance design.

Needs: Prefers local freelancers.

First Contact & Terms: Send query letter with printed samples, photocopies. Samples are filed. Will contact artist for portfolio review if interested. Buys all rights. Finds freelancers through word of mouth.

Tips: "We are looking for an updated look, but still professional. It is helpful if you have some background or familiarity with construction."

MENNONITE PUBLISHING HOUSE/HERALD PRESS, 616 Walnut Ave., Scottdale PA 15683. (724)887-8500, ext. 244. Fax: (724)887-3111. E-mail: jim@mph.org. Website: www.mph.org. **Art Director:** James M. Butti. Estab. 1918. Publishes hardcover and paperback originals and reprints; textbooks and church curriculum. Specializes in religious, inspirational, historical, juvenile, theological, biographical, fiction and nonfiction books. Publishes 24 titles/year. Recent titles include: *The Amish in Their Own Words* and *Yonie Wondernose*. Books are "fresh and well illustrated." 30% require freelance illustration. Catalog available free by request.

Needs: Approached by 150 freelancers each year. Works with 8-10 illustrators/year. Prefers oil, pen & ink, colored pencil, watercolor, and acrylic in realistic style. "Prefer artists with experience in publishing guidelines who are able to draw faces and people well." Uses freelancers mainly for book covers. 10% of freelance work demands knowledge of Illustrator, QuarkXPress or CorelDraw. Works on assignment only.

First Contact & Terms: Send query letter with résumé, tearsheets, photostats, slides, photocopies, photographs and SASE. Samples are filed ("if we feel freelancer is qualified") and are returned by SASE if requested by artist. Responds only if interested. Art director will contact artist for portfolio review of final art, photographs, roughs and tearsheets. Buys one-time or reprint rights. Originals are not returned at job's completion "except in special arrangements." To show portfolio, mail photostats, tearsheets, final reproduction/product, photographs and slides and also approximate time required for each project. Considers complexity of project, skill and experience of artist and project's budget when establishing payment. Buys all rights.

Jackets/Covers: Assigns 8-10 illustration jobs/year. Pays by the project, $200 minimum. "Any medium except layered paper illustration will be considered."

Text Illustration: Assigns 6 jobs/year. Pays by the project. Prefers b&w, pen & ink or pencil.

Tips: "Design we use is colorful, realistic and religious. When sending samples, show a wide range of styles and subject matter—otherwise you limit yourself."

MILKWEED EDITIONS, 1011 Washington Ave. S., Suite 300, Minneapolis MN 55415. (612)332-3192. Fax: (612)215-2550. Website: www.milkweed.org. **Production Editor:** Laurie Buss. Production Assistant: Ben Barnhart. Art and Design Coordinator: Dale Cooney. Estab. 1979. Publishes hardcover and trade paperback originals and trade paperback reprints of contemporary fiction, poetry, essays and children's novels (ages 8-13). Publishes 16-18 titles/year. Recent titles include: *Eccentric Islands*, by Bill Holm; *Stories from Where We Live*, edited by Sara St. Antoine; *The Barn at the End of the World*, by Mary Rose O'Reilly. Books have "colorful quality" look. Book catalog available for SASE with $1.50.

Needs: Approached by 150 illustrators/year. Works with 7 illustrators and designers/year. Buys 100 illustrations/year. Prefers artists with experience in book illustration. Prefers freelancers experienced in color and b&w. Uses freelancers mainly for 4-color jacket/cover illustration and b&w text illustration. 100% of freelance design demands knowledge of Illustrator, Photoshop and QuarkXPress. Works on assignment only.

First Contact & Terms: Send query letter with résumé, SASE and tearsheets. Samples are filed. Editor will contact artists for portfolio review if interested. Portfolio should include best possible samples. Rights purchased vary according to project. Interested in buying second rights (reprint rights) to previously published work. Originals are returned at job's completion. Finds artists through word of mouth, submissions and "seeing their work in already published books."

Jackets/Covers: Assigns 7-10 illustration jobs and 2 design jobs/year. Pays by the project, $250-800 for design. "Prefer a range of different media—according to the needs of each book."

Text Illustration: Assigns 3 jobs/year. Pays by the project. Prefers various media and styles.

Tips: "Show quality drawing ability, narrative imaging and interest—call back. Design and production are completely computer-based. Budgets have been cut, so any jobs tend to necessitate experience. We use a variety of styles. For adult nonfiction books we are especially interested in artists who depict the natural environment. For children's fiction, ability to depict people accurately is mandatory."

☑ MITCHELL LANE PUBLISHERS, INC., 34 Decidedly Lane, Bear DE 19701. (302)834-9646. Fax: (302)834-4164. E-mail: eclipsetel.com. Website: www.angelfire.com/biz/mitchelllane. **Publisher:** Barbara Mitchell. Estab. 1993. Publishes hardcover and trade paperback originals. Types of books include biography. Specializes in multicultural biography for young adults. Publishes 35-40 titles/year. Recent titles include: *Unlocking the Secrets of Science*. 50% requires freelance illustration; 10% requires freelance design.

Needs: Approached by 20 illustrators and 5 designers/year. Works with 2 illustrators/year. Prefers freelancers experienced in illustrations of people.

First Contact & Terms: Send query letter with printed samples, photocopies. Interesting samples are filed and are not returned. Will contact artist for portfolio review if interested. Buys all rights.

Jackets/Covers: Prefers realistic portrayal of people.

MODERN LANGUAGE ASSOCIATION, 26 Broadway, 3rd Floor, New York NY 10004. (646)576-5000. Fax: (646)458-0030. Website: www.mla.org. **Marketing Coordinator:** Kathleen Hansen. Estab. 1883. Non-profit educational association. Publishes hardcover and trade paperback originals, trade paperback reprints and textbooks. Types of books include instructional, reference and literary criticism. Specializes in language and literature studies. Publishes 10-15 titles/year. Recent titles include: *The MLA Style Manual*, 2nd edition, by Joseph Gibaldi; and *Descent*, by David Bergelson. 5-10% require freelance design for covers only. Book catalog free by request.

Needs: Approached by 5-10 freelancers/year. Works with 2-3 freelance designers/year. We do not work with illustrators. Prefers freelancers with experience in academic book publishing and textbook promotion. Uses freelancers for jackets and book design. 100% of freelance work demands knowledge of QuarkXPress. Works on assignment only.

First Contact & Terms: Send query letter with brochure. Responds to the artist only if interested. To show portfolio, mail finished art samples and tearsheets. Originals returned at job's completion if requested.

Book Design: Assigns 1-2 freelance design jobs/year. Payment "depends upon complexity and length."

Jackets/Covers: Assigns 3-4 freelance design jobs/year. Pays by the project, $750-1,500.

Tips: "We do not use illustrations for any of our publications. Please do not send illustration samples! Most freelance designers with whom we work produce our marketing jackets rather than our books. We are interested in seeing samples only of pieces related to publishing."

N MODERN PUBLISHING, Dept. AGDM, 155 E. 55th St., New York NY 10022. (212)826-0850. Fax: (212)759-9069. Website: www.modernpublishing.com. **Editorial Director:** Kathy O'Hehir. Specializes in children's hardcovers, paperbacks, coloring books and novelty books. Publishes approximately 200 titles/year. Recent titles include: *Treasury of Illustrated Classics: Treasure Island*, Fisher Price books and Disney books.

Needs: Approached by 10-30 freelancers/year. Works with 25-30 freelancers/year. Works on assignment and royalty.

First Contact & Terms: Send query letter with résumé and samples. Samples are not filed and are returned by SASE only if requested. Responds only if interested. Originals are not returned. Considers turnaround time and rights purchased when establishing payment.

Jackets/Covers: Pays by the project, $150-250/cover, "usually four books/series."

Text Illustration: Pays by the project, $15-25/page; line art, "24-382 pages per book, always four books in series." Pays $50-125/page; full color art.

Tips: "Do not show samples that don't reflect the techniques and styles we use. Research our books and bookstores to know our product line better."

MONDO PUBLISHING, 980 Avenue of the Americas, New York NY 10018. Website: www.mondopub.com. **Executive Editor:** Don Curry. Estab. 1992. Publishes hardcover and trade paperback originals and reprints and audio tapes. Types of books include juvenile. Specializes in fiction, nonfiction. Publishes 75 titles/year. Recent titles include: *You Don't Look Like Your Mother*, by Aileen Fisher; *Right Outside My Window*, by Mary Ann Hoberman; and *Who Likes It Hot*, by May Garelick. Book catalog for 9×12 SASE with $3.20 postage.

Needs: Works with 40 illustrators and 10 designers/year. Prefers freelancers experienced in children's hardcovers and paperbacks, plus import reprints. Uses freelancers mainly for illustration, design. 100% of freelance design demands knowledge of Photoshop, Illustrator, QuarkXPress.

First Contact & Terms: Send query letter with photocopies, printed samples and tearsheets. Samples are filed. Will contact for portfolio review if interested. Portfolio should include artist's areas of expertise, photocopies, tearsheets. Rights purchased vary according to project. Finds freelancers through agents, sourcebooks, illustrator shows, submissions, recommendations of designers and authors.

Book Design: Assigns 40 jobs/year. Pays by project.

Text Illustration: Assigns 45-50 freelance illustration jobs/year. Pays by project.

✓ MOREHOUSE PUBLISHING GROUP, 4475 Linglestown Rd., Harrisburg PA 17112. (717)541-8130. Fax: (717)541-8136. E-mail: morehouse@morehouse.com. Website: www.morehousegroup.com. **Editorial Director:** Debra Farrington. Estab. 1884. Company publishes trade paperback and hardcover originals and reprints. Books are religious. Specializes in spirituality, Christianity/contemporary issues. Publishes 50 titles/year. Recent titles include: *Jenny's Prayer*, by Annette Griessman, illustrated by Mary Anne Lard; and *God of the Sparrow*, by Jaroslau Vajda, illustrated by Preston McDaniels. Book catalog free by request.

Needs: Works with 3-4 illustrators/year. Prefers freelancers with experience in religious (particularly Christian) topics. Also uses original art—all media. Works on assignment only.

First Contact & Terms: Send query letter with résumé and photocopies. Samples are filed. Portfolio review not required. Usually buys one-time rights. Finds artists through freelance submissions, *Literary Market Place* and mostly word of mouth.

Text Illustration: Assigns 3-4 freelance illustration jobs/year for children's books.

Tips: "Prefer using freelancers who are located in central Pennsylvania and are available for meetings when necessary."

MORGAN KAUFMANN PUBLISHERS, INC., Academic Press, A Harcourt Science and Technology Company, 340 Pine St., Sixth Floor, San Francisco CA 94104. (415)392-2665. Fax: (415)982-2665. E-mail: design@mkp.com. Website: www.mkp.com. **Director of Production and Manufacturing:** Scott Norton. Estab. 1984. Company publishes computer science books for academic and professional audiences in both paperback, hardback, and book/CD-ROM packages. Publishes 40-50 titles/year. Recent titles include: *GUI Bloopers*, by Jeff Johnson. 75% require freelance interior illustration; 100% require freelance text and cover design; 15% require freelance design and production of 4-color inserts.

Needs: Approached by 150-200 freelancers/year. Works with 10-15 freelance illustrators and 10-15 designers/year. Uses freelancers for covers, text design and technical and editorial illustration, design and production of 4-color inserts. 100% of freelance work demands knowledge of either Illustrator, QuarkXPress, Photoshop, Ventura, Framemaker, or laTEX (multiple software platform). Works on assignment only.

First Contact & Terms: Send query letter with samples. Samples must be nonreturnable or with SASE. "No calls, please." Samples are filed. Production editor will contact artist for portfolio review if interested. Portfolio should include final printed pieces. Buys interior illustration on a work-for-hire basis. Buys first printing and reprint rights for text and cover design. Finds artists primarily through word of mouth and submissions.

Book Design: Assigns freelance design jobs for 40-50 books/year. Pays by the project. Prefers Illustrator and Photoshop for interior illustration and QuarkXPress for 4-color inserts.

Jackets/Covers: Assigns 40-50 freelance design; 3-5 illustration jobs/year. Pays by the project. Uses primarily stock photos. Prefers designers take cover design through production to film and MatchPrint. "We're interested in a look that is different from the typical technical publication." For covers, prefers modern, clean, spare design, with emphasis on typography and high-impact imagery.

Tips: "Although experience with book design is an advantage, sometimes artists from another field bring a fresh approach, especially to cover design. Currently the tough find is an affordable Photoshop artist for manipulation of images and collage work for covers."

N WILLIAM MORROW & CO. INC., (Harper Collins Publishers), 10 E. 53rd St., New York NY 10022. (212)261-6695. Fax: (212)207-6968. Website: www.harpercollins.com. **Art Director:** Richard Acquan. Specializes in hardcover originals and reprint children's books, adult trade, fiction and nonfiction. Publishes 70 titles/year. Recent titles include: *The Dream Room* and *Acid Tongues and Tranquil Dreams*. 100% require freelance illustration. Book catalog free for 8½×11" SASE with 3 first-class stamps.

First Contact & Terms: Works with 30 freelance artists/year. Uses artists mainly for picture books and jackets. Works on assignment only. Send query letter with résumé and samples, "followed by call." Samples are filed. Responds in 1 month. Originals returned to artist at job's completion. Portfolio should include original/final art and dummies. Considers complexity of project and project's budget when establishing payment. Negotiates rights purchased.

Book Design: "Most design is done on staff." Assigns 1 or 2 freelance design jobs/year. Pays by the project.

Jackets/Covers: Assigns 1 or 2 freelance design jobs/year. Pays by the project.

Text illustration: Assigns 70 freelance jobs/year. Pays by the project.

Tips: "Be familiar with our publications."

MOUNTAIN PRESS PUBLISHING CO., P.O. Box 2399, Missoula MT 59806. (406)728-1900. Fax: (406)728-1635. E-mail: mtnpress@montana.com. Website: www.mtnpress.com. **Editor:** Kathleen Ort. Production Design: Jean Nuckolls. Estab. 1960s. Company publishes trade paperback originals and reprints; some hardcover originals and reprints. Types of books include western history, geology, natural history/nature. Specializes in geology, natural history, history, horses, western topics. Publishes 20 titles/year. Recent titles include: *From Angels to Hellcats: Legendary Texas Women*, regional photographic field guides. Book catalog free by request.

Needs: Approached by 100 freelance artists/year. Works with 5-10 freelance illustrators/year. Buys 5-10 freelance illustrations/year. Prefers artists with experience in book illustration and design, book cover illustration. Uses freelance artists for jacket/cover illustration, text illustration and maps. 100% of design work demands knowledge of PageMaker, FreeHand or Illustrator. Works on assignment only.

First Contact & Terms: Send query letter with résumé, SASE and any samples. Samples are filed or are returned by SASE. Responds only if interested. Project editor will contact artist for portfolio review if interested. Buys one-time rights or reprint rights depending on project. Originals are returned at job's completion. Finds artists through submissions, word of mouth, sourcebooks and other publications.
Book Design: Pays by the project.
Jackets/Covers: Assigns 0-1 freelance design and 3-6 freelance illustration jobs/year. Pays by the project.
Text Illustration: Assigns 0-1 freelance illustration jobs/year. Pays by the project. Prefers b&w: pen & ink, scratchboard, ink wash, pencil.
Tips: First-time assignments are usually book cover/jacket illustration or map drafting; text illustration projects are given to "proven" freelancers.

☑ MOYER BELL, 54 Phillips St., Wickford RI 02852-5126. (401)294-0106. Fax: (401)294-1076. E-mail: britt@moyerbell.com. Website: moyerbell.com. **Contact:** Britt Bell. Estab. 1984. Imprints include Asphodel Press. Publishes hardcover originals, trade paperback originals and reprints. Types of books include biography, coffee table books, history, instructional, mainstream fiction, nonfiction, reference, religious, self-help. Publishes 20 titles/year. 25% require freelance illustration; 25% require freelance design. Book catalog free.
Needs: Works with 5 illustrators and 5 designers/year. Prefers electronic media. Uses freelancers mainly for illustrated books and book jackets. 100% of design and illustration demand knowledge of Photoshop, Illustrator, QuarkXPress and Postscript.
First Contact & Terms: Designers send query letter with photocopies. Illustrators send postcard sample and/or photocopies. Accepts disk submissions. Samples are filed or returned by SASE. Rights purchased vary according to project.
Book Design: Assigns 5 freelance design jobs/year. Pays by project; rates vary.
Jackets/Covers: Assigns 5 design jobs and 5 illustration jobs/year. Pays by project; rates vary. Prefers Postscript.
Text Illustration: Assigns 5 freelance illustration jobs/year. Payment varies. Prefers Postscript.

Ⓝ NBM PUBLISHING CO., 555 Eighth Ave., Suite 1202, New York NY 10018. (212)643-5407. Fax: (212)643-1545. Website: www.nbmpub.com. **Publisher:** Terry Nantier. Publishes graphic novels for an audience of 18-34 year olds. Types of books include adventure, fantasy, mystery, science fiction, horror and social parodies. Recent titles include: *A Treasury of Victorian Murder* and *Boneyard*. Circ. 5,000-10,000.
 • Not accepting submissions unless for graphic novels. Publisher reports too many inappropriate submissions from artists who "don't pay attention."

THE NEW ENGLAND PRESS, Box 575, Shelburne VT 05482. (802) 863-2520. Fax: (802)863-1510. E-mail: nep@together.net. Website: www.nepress.com. **Managing Editor:** Mark Wanner. Specializes in paperback originals on regional New England subjects and nature. Publishes 6-8 titles/year. Recent titles include: *Green Mountain Boys of Summer: Vermonters in the Big Leagues* and *Spanning Time: Vermont's Covered Bridges*. 50% require freelance illustration. Books have "traditional, New England flavor."
First Contact & Terms: Approached by 50 freelance artists/year. Works with 3-6 illustrators and 1-2 designers/year. Northern New England artists only. Send query letter with photocopies and tearsheets. Samples are filed. Responds only if interested. Considers complexity of project, skill and experience of artist, project's budget and turnaround time when establishing payment. Negotiates rights purchased. Originals not usually returned to artist at job's completion, but negotiable.
Book Design: Assigns 6-8 jobs/year. Payment varies.
Jackets/Covers: Assigns 2-4 illustration jobs/year. Payment varies.
Text Illustration: Assigns 2-4 jobs/year. Payment varies.
Tips: Send a query letter with your work, which should be "more folksy than impressionistic."

☑ NORTHLAND PUBLISHING, Box 1389, Flagstaff AZ 86002-1389. (928)774-5251. Fax: (928)774-0592. E-mail: lois@northlandpub.com. Website: www.northlandpub.com. **Art Director:** Lois Rainwater. Estab. 1958. Company publishes hardcover and trade paperback originals. Types of books include western, natural history, Native American art, cookbooks and children's picture books. Publishes 25 titles/year. Recent children's titles include: *Fiesta Mexicali* and *Arizona's Greatest Golf Courses*. 50% requires freelance illustration; 25% requires freelance design. Art guidelines on website.
 • Rising Moon is Northland's children's imprint.
Needs: Approached by 1,000 freelancers/year. Works with 5-12 freelance illustrators and 2-4 book designers/year. Prefers freelancers with experience in illustrating children's titles. Uses freelancers mainly for children's books. 100% of freelance design work demands knowledge of Illustrator, QuarkXPress or Photoshop. Works on assignment only.

First Contact & Terms: Send query letter with résumé, SASE, tearsheets, slides and transparencies. Samples are filed or are returned by SASE if requested by artist. Will contact artist for portfolio review if interested. Portfolio should include color tearsheets and transparencies. Rights purchased vary according to project. Originals are returned at job's completion. Finds artists mostly through submissions.

Book Design: Assigns 2-4 freelance design jobs/year. Pays by the project, $500-4,500.

Jackets/Covers: No jacket/cover art needed.

Text Illustration: Assigns 5-12 freelance illustration jobs/year. Pays by the project, $1,000-10,000. Royalties are preferred—gives cash advances against royalties.

Tips: "Creative presentation and promotional pieces filed."

☑ NORTHWESTERN PRODUCTS, INC., 2855 Anthony Lane S, Suite 225, Minneapolis MN 55413. (612)617-1600. Fax: (612)617-1691. **Creative Director:** Tonya Gunn. Types of products include framed art and inspirational gifts. Produces 50 products/year. 100% requires freelance illustration and design.

Needs: Approached by 8 freelancers/year. Works with 20 freelance illustrators/year. Prefers freelancers with experience in the gift and card market. Uses freelancers for illustrations of landscape and still lifes.

First Contact & Terms: Send query letter with brochure, tearsheets, photographs and photocopies. Samples are filed by artist. Art director will contact artist for portfolio review if interested. Portfolio should include 4-color photographs and dummies. Sometimes requests work on spec before assigning a job. Rights purchased vary according to project.

Product Design: Assigns 30 freelance design jobs/year. Pays by the project. Any medium may be used.

Ⓝ NORTHWOODS PRESS, P.O. Box 298, Thomaston ME 04561. Division of the Conservatory of American Letters. **Editor:** Robert Olmsted. Estab. 1972. Specializes in hardcover and paperback originals of poetry. Publishes approximately 6 titles/year. Titles include *Dan River Anthology, 1991*, *Broken Dreams* and *Bound*. 10% require freelance illustration. Book catalog for SASE.

● The Conservatory of American Letters now publishes the *Northwoods Journal*, a quarterly literary magazine. They're seeking cartoons and line art and pay cash on acceptance. Send SASE for complete submission guidelines.

Needs: Approached by 40-50 freelance artists/year. Works with 1-2 illustrators/year. Uses freelance artists mainly for cover illustration. Also uses freelance artists for text illustration.

First Contact & Terms: Send query letter to be kept on file. Art Director will contact artist for portfolio review if interested. Sometimes requests work on spec before assigning a job. Considers complexity of project, skill and experience of artist, project's budget, turnaround time and rights purchased when establishing payment. Buys one-time rights and occasionally all rights. Originals are returned at job's completion.

Book Design: Pays by the project, $10-100.

Jackets/Covers: Assigns 2-3 design jobs and 4-5 illustration jobs/year. Pays by the project, $10-100.

Text Illustration: Pays by the project, $5-20.

Tips: Portfolio should include "art suitable for book covers—contemporary, usually realistic."

▧ NOVALIS PUBLISHING, INC., 49 Front St. E., 2nd Floor, Toronto, Ontario M53 1B3 Canada. (416)363-3303. Fax: (416)363-9409. E-mail: novalis@interlog.com. Website: www.novalis.ca. **Managing Editor:** Anne Louise Mahone. Estab. 1936. Publishes hardcover, mass market and trade paperback originals and textbooks. Primarily religious. Publishes 30 titles/year. Recent titles include: *Fergie the Frog* series and *On Our Way With Jesus* (sacramental preparation textbook). 100% requires freelance illustration; 25% requires freelance design; and 25% require freelance art direction. Free book catalog available.

Needs: Approached by 4 illustrators and 4 designers/year. Works with 3-5 illustrators and 2-4 designers/year. Prefers local freelancers experienced in graphic design and production. 100% of freelance work demands knowledge of Illustrator, Photoshop, PageMaker, PageMaker, QuarkXPress.

First Contact & Terms: Send postcard sample or query letter with printed samples, photocopies, tearsheets. Samples are filed or returned on request. Will contact artist for portfolio review if interested. Rights purchased vary according to project; negotiable.

Book Design: Assigns 10-20 freelance design and 2-5 art direction projects/year. Pays for design by the hour, $25-40.

Jackets/Covers: Assigns 5-10 freelance design and 2-5 illustration jobs/year. Prefers b&w, ink, woodcuts, linocuts, varied styles. Pays for design by the project, $100-800, depending on project. Pays for illustration by the project, $100-800, depending on project. Pays for illustration by the project, $100-600.

Text Illustration: Assigns 2-10 freelance illustration jobs/year. Pays by the project, $100 minimum, depending on project.

Tips: "We look for dynamic design incorporating art and traditional, non-traditional, folk etc. with spiritual, religious, Gospel, biblical themes—mostly Judaeo-Christian."

OCTAMERON PRESS, 1900 Mount Vernon Ave., Alexandria VA 22301. Website: www.octameron.com. **Editorial Director:** Karen Stokstod. Estab. 1976. Specializes in paperbacks—college financial and college admission guides. Publishes 10-15 titles/year. Titles include *College Match* and *The Winning Edge*.
Needs: Approached by 25 freelancers/year. Works with 1-2 freelancers/year. Works on assignment only.
First Contact & Terms: Send query letter with brochure showing art style or résumé and photocopies. Samples not filed are returned if SASE included. Considers complexity of project and project's budget when establishing payment. Rights purchased vary according to project.
Jackets/Covers: Works with 1-2 designers and illustators/year on 15 different projects. Pays by the project, $500-1,000.
Text Illustration: Works with variable number of artists/year. Pays by the project, $35-75. Prefers line drawings to photographs.
Tips: "The look of the books we publish is friendly! We prefer humorous illustrations."

☑ **ORCHARD BOOKS**, Scholastic, 557 Broadway, New York NY 10012. (212)951-2600. Fax: (212)213-6435. Website: www.scholastic.com. Book publisher. **Art Director:** David Saylor. Estab. 1987. Publishes hardcover and paperback children's books. Specializes in picture books and novels for children and young adults. Publishes 20-30 titles/year. Recent titles include: *Giraffe Can't Dance*, by Giles Andrede, illustrated by Guy Parker Rees. 100% require freelance illustration; 25% require freelance design. Book catalog free for SAE with 2 first-class stamps.
Needs: Works with 50 illustrators/year. Works on assignment only. 5% of titles require freelance art direction.
First Contact & Terms: Designers send brochure and/or photocopies. Illustrators send brochure, photocopies and/or tearsheets. Samples are filed or are returned by SASE only if requested. Responds to queries/submissions only if interested. Originals returned to artist at job's completion. Call or write for appointment to show portfolio or mail appropriate materials. Portfolio should include thumbnails, tearsheets, final reproduction/product, slides and dummies or whatever artist prefers. Considers complexity of project, skill and experience of artist and project's budget when establishing payment. Buys all rights.
Book Design: Assigns 15 freelance design jobs/year. Pays by the project, $650 minimum.
Jackets/Covers: Assigns 20 freelance design jobs/year. Pays by the project, $650 minimum.
Text Illustration: Assigns 5 freelance jobs/year. Pays by the project, minimum $2,000 advance against royalties.
Tips: "Send a great portfolio."

OREGON CATHOLIC PRESS, 5536 NE Hassalo, Portland OR 97213-3638. (503)281-1191. Fax: (503)282-3486. E-mail: jeang@ocp.org. Website: ocp.org/. **Art Director:** Jean Germano. Division estab. 1997. Types of books include religious and liturgical books specifically for, but not exclusively to, the Roman Catholic market. Publishes 2-5 titles/year. 30% requires freelance illustration. Book catalog available for 9×12 SAE with first-class stamps.
 ● Oregon Catholic Press (OCP Publications) is a nonprofit publishing company, producing music and liturgical publications used in parishes throughout the United States, Canada, England and Australia. This publisher also has listings in the Magazine and Record Labels sections.
Tips: "I am always looking for appropriate art for our projects. We tend to use work already created on a one-time-use basis, as opposed to commissioned pieces. I look for tasteful, not overtly religious art."

Ⓝ **OREGON HISTORICAL SOCIETY PRESS**, 1200 SW Park Ave., Portland OR 97205. (503)222-1741. Fax: (503)221-2035. **Managing Editor:** Adair Law. Estab. 1898. Imprints include Eager Beaver Books. Company publishes hardcover originals, trade paperback originals and reprints, mars, posters, plans, postcards. Types of books include biography, travel, reference, history, reprint juvenile and fiction. Specializes in Pacific Northwest history, geography, natural history. Publishes 10-12 biography titles/year. Recent titles include: *So Far From Home: An Army Bride on the Western Frontier, Hail, Columbia, Journal of Travels* and *Oregon Geographic Names*, Sixth Edition. 25% require freelance illustration; 50% require freelance design. Book catalog free by request.
Needs: Approached by 10-50 freelance artists. Works with 8-10 freelance illustrators and 2-5 freelance designers/year. Buys 0-50 freelance illustrations/year. Prefers local artists only. Uses freelance artists mainly for illustrations and maps. Also uses freelance artists for jacket/cover and text illustration, book design. 20% of freelance work demands knowledge of PageMaker. Works on assignment only.
First Contact & Terms: Send query letter with résumé, tearsheets and photocopies. Samples are filed or are returned by SASE. Responds in 10 days. Art Director will contact artist for portfolio review if interested. Portfolio should include b&w thumbnails, roughs, final art, slides and photographs. Buys onetime rights or rights purchased vary according to project. Originals are returned at job's completion.
Book Design: Assigns 2-5 freelance design jobs/year. Pays by the project.
Jackets/Covers: Assigns 2-5 freelance design and 2-5 freelance illustration jobs/year. Pays by the project.

Text Illustration: Assigns 8-10 freelance illustration jobs/year. Pays by the hour or by the project.

OREGON STATE UNIVERSITY PRESS, 101 Waldo Hall, Corvallis OR 97331-6407. (541)737-3166. Fax: (541)737-3170. Website: www.osu.orst.edu/dept/press. **Managing Editor:** Jo Alexander. Estab. 1961. Publishes hardcover and trade paperback originals and reprints and textbooks. Types of books include biography, history, nonfiction, reference, textbooks and western. Specializes in scholarly and regional trade. Publishes 15 titles/year. Recent titles include: *Frigid Embrace: Politics, Economics and Environment in Alaska*, *Crater Lake National Park: A History*; and *Exploring the Tualatin River Basin: A Nature and Recreation Guide*. Publishes 15-20 titles/year. 5% requires freelance illustration; 90% requires freelance design of cover, jacket. Book catalog for 8×11 SASE with 2 first-class stamps.
Needs: Approached by 20 illustrators and 20 designers/year. Works with 2 illustrators and 5 designers/year. Prefers freelancers experienced in computer skills. 100% of freelance design demands knowledge of one or more: Illustrator, Photoshop, FreeHand, PageMaker, PageMaker and QuarkXPress.
First Contact & Terms: Designers send query letter with printed samples or reference to website where we can view work. Accepts Mac-compatible disk submissions. Send TIFF files. Samples are filed. Responds only if interested. Portfolio review not required. Rights purchased vary according to project. Finds freelancers through submission packets and personal referrals.
Book Design: Assigns 15 freelance design jobs/year. Pays by the project, $500-1,000.
Jackets/Covers: Assigns 15 freelance design jobs/year. Computer design essential. Pays by the project, $500 minimum.

☑ **THE OVERLOOK PRESS**, 141 Wooster St., New York NY 10012. (212)673-2210. Fax: (212)673-2296. Website: www.overlookpress.com. **Contact:** Art Director. Estab. 1970. Book publisher. Publishes hardcover originals. Types of books include contemporary and experimental fiction, health/fitness, history, fine art and children's books. Publishes 90 titles/year. Recent titles include: *The Company*, by Robert Littel; and *Wilson*, by David Mamet. 60% require freelance illustration; 40% require freelance design. Book catalog for SASE.
Needs: Approached by 10 freelance artists/year. Works with 4 freelance illustrators and 4 freelance designers/year. Buys 5 freelance illustrations/year. Prefers local artists only. Uses freelance artists mainly for jackets. Works on assignment only.
First Contact & Terms: Send query letter with printed samples or other non-returnable material. Samples are filed. To show a portfolio, mail tearsheets and slides. Buys one-time rights. Originals returned to artist at job's completion.
Jackets/Covers: Assigns 10 freelance design jobs/year. Pays by the project, $250-350.

N ☑ **THE OVERMOUNTAIN PRESS**, Sabre Industries, Inc., P.O. Box 1261, Johnson City TN 37605. (423)926-2691. Fax: (423)929-2464. E-mail: beth@overmtn.com. Website: www.overmtn.com. **Senior Editor:** Elizabeth L. Wright. Estab. 1970. Publishes hardcover and trade paperback originals and reprints. Types of books include biography, children's picture books, cookbooks, history and nonfiction. Specializes in regional nonfiction (Appalachian). Publishes 40 titles/year. Recent titles include: *Toto in Candyland*, *Lost Heritage*, *Our Living Heritage*, *Ten Friends* and *The Book of Kings: A History of Bristol TN/VA's Founding Family*. 20% requires freelance illustration. Book catalog free for 3 first-class stamps.
 ● The Overmountain Press has recently begun publishing southern mysteries under a new imprint—Silver Dagger Mysteries.
Needs: Approached by 10 illustrators/year. Works with 3 illustrators/year. Prefers local illustrators, designers and art directors. Prefers freelancers experienced in children's picture books. 100% of freelance design and illustration demands knowledge of Photoshop and QuarkXPress.
First Contact & Terms: Illustrators send query letter with printed samples. Samples are filed. Will contact artist for portfolio review including artwork and photocopies portraying children/kids' subjects if interested. Rights purchased vary according to project.
Jackets/Covers: Assigns 5-10 illustration jobs/year. Considers any medium and/or style. Pays by the project, royalty only, no advance. Prefers children's book illustrators.
Text Illustration: Assigns 2 freelance illustration jobs/year. Pays by the project, royalty only. Considers any style, medium, color scheme or type of work.
Tips: "We are starting a file of children's book illustrators. At this time we are not 'hiring' freelance illustrators. We are collecting names, addresses, numbers and samples of those who would be interested in having an author contact them about illustration."

RICHARD C. OWEN PUBLICATIONS INC., P.O. Box 585, Katonah NY 10536. (914)232-3903. Fax: (914)232-3977. Website: www.rcowen.com. **Art Director:** Janice Boland. Estab. 1986. Company publishes children's books. Types of books include juvenile fiction and nonfiction. Specializes in books

for 5-, 6- and 7-year-olds. Publishes 15-20 titles/year. Recent titles include: *I Went to the Beach*, *Cool*, *So Sleepy*, *Bedtime*, *Sea Lights*, *Mama Cut My Hair* and *The Author on My Street* and *My Little Brother Ben*. 100% require freelance illustration.

● "We are building a new collection of anthologies and continue to seek quality art."

Needs: Approached by 200 freelancers/year. Works with 20-40 freelance illustrators/year. Prefers freelancers with focus on children's books who can create consistency of character from page to page in an appealing setting. Uses freelancers for jacket/cover and text illustration. Works on assignment only.

First Contact & Terms: First request guidelines. Send samples of work (color brochure, tearsheets and photocopies). Samples are filed. Art director will contact artist if interested. Buys all rights. Original illustrations are returned at job's completion.

Text Illustration: Assigns 20-40 freelance illustration jobs/year. Pays by the project, $1,000-3,000 for a full book; $25-100 for spot illustrations.

Tips: "Show adequate number and only best samples of work. Send work in full color, but target the needs of the individual publisher. Send color copies of work—no slides. Be persistent—keep file updated. Be willing to work with the art director. All our books have a trade book look. No odd, distorted figures. Our readers are 5-8 years old. Try to create worlds that will captivate them."

OXFORD UNIVERSITY PRESS, English as a Second Language (ESL), 198 Madison Ave., 9th Floor, New York NY 10016. E-mail: jun@oup-usa.org. Website: www.oup-usa.org. **Art Buyers:** Jodi Waxman, Elizabeth Blomster, Andrea Suffredini and Donatella Accardi. Chartered by Oxford University. Estab. 1478. Specializes in fully illustrated, not-for-profit, contemporary textbooks emphasizing English as a second language for children and adults. Also produces wall charts, picture cards, CDs and cassettes. Recent titles include: *American Headway, English Time* and various Oxford Picture Dictionaries.

Needs: Approached by 1,000 freelance artists/year. Works with 100 illustrators and 8 designers/year. Uses freelancers mainly for interior illustrations of exercises. Also uses freelance artists for jacket/cover illustration and design. Some need for computer-literate freelancers for illustration. 20% of freelance work demands knowledge of QuarkXPress or Illustrator. Works on assignment only.

First Contact & Terms: Send query letter with brochure, tearsheets, photostats, slides or photographs. Samples are filed. Art Buyer will contact artist for portfolio review if interested. Artists work from detailed specs. Considers complexity of project, skill and experience of artist and project's budget when establishing payment. Artist retains copyright. Originals are returned at job's completion. Finds artists through submissions, artist catalogs such as *Showcase*, *Guild Book*, etc. occasionally from work seen in magazines and newspapers, other illustrators.

Jackets/Covers: Pays by the project.

Text Illustration: Assigns 500 jobs/year. Uses black line, half-tone and 4-color work in styles ranging from cartoon to realistic. Greatest need is for natural, contemporary figures from all ethnic groups, in action and interaction. Pays for text illustration by the project, $45/spot, $2,500 maximum/full page.

Tips: "Please wait for us to call you. You may send new samples to update your file at any time. We would like to see more natural, contemporary, nonwhite people from freelance artists. Art needs to be fairly realistic and cheerful."

PAULINE BOOKS & MEDIA, 50 St. Pauls Ave., Boston MA 02130-3491. (617)522-8911. Fax: (617)541-9805. E-mail: design@pauline.org. Website: www.pauline.org. **Art Director:** Sr. Helen Rita Lane. Estab. 1932. Book publisher. "We also publish a children's magazine and produce audio and video cassettes." Publishes hardcover and trade paperback originals and reprints and textbooks. Also electronic books and software. Types of books include instructional, biography, preschool, juvenile, young adult, reference, history, self-help, prayer and religious. Specializes in religious topics. Publishes 20 titles/year. Art guidelines available. Sample copies for SASE with first-class postage.

Needs: Approached by 50 freelancers/year. Works with 10-20 freelance illustrators/year. Also needs freelancers for multimedia projects. 65% of freelance work demands knowledge of PageMaker, Illustrator, Photoshop, etc.

First Contact & Terms: Send query letter with résumé, SASE, tearsheets and photocopies. Accepts disk submissions compatible with Windows 95, Mac. Send EPS, TIFF, GIF or TARGA files. Samples are filed or are returned by SASE. Responds in 1-3 months only if interested. Rights purchased vary according to project. Originals are returned at job's completion.

Jackets/Covers: Assigns 1-2 freelance illustration jobs/year. Pays by the project.

Text Illustration: Assigns 3-10 freelance illustration jobs/year. Pays by the project.

PAULIST PRESS, 997 Macarthur Blvd., Mahwah NJ 07430. (201)825-7300. Fax: (201)825-8345. Website: www.paulistpress.com. **Managing Editor:** Paul McMahon. Children's Editor: Susan Heyboer O'Keefe. Estab. 1869. Company publishes hardcover and trade paperback originals and textbooks.

Types of books include biography, juvenile and religious. Specializes in academic and pastoral theology. Publishes 95 titles/year. Recent titles include: *The Voice, The Myth of More, The Forgotten Desert Mothers.* 5% requires freelance illustration; 5% requires freelance design.

- Paulist Press recently began to distribute a general trade imprint Hidden Spring. Books in this imprint "help readers seek the spiritual."

Needs: Works with 10-12 freelance illustrators and 15-20 designers/year. Prefers local freelancers. Uses freelancers for juvenile titles, jacket/cover and text illustration. 10% of freelance work demands knowledge of QuarkXPress. Works on assignment only.

First Contact & Terms: Send query letter with brochure, résumé and tearsheets. Samples are filed. Responds only if interested. Portfolio review not required. Negotiates rights purchased. Originals are returned at job's completion if requested.

Book Design: Assigns 10-12 freelance design jobs/year.

Jackets/Covers: Assigns 90 freelance design jobs/year. Pays by the project, $400-800.

Text Illustration: Assigns 3-4 freelance illustration jobs/year. Pays by the project.

N PEACHPIT PRESS, INC., Division of Addison Wesley, 1249 Eighth St., Berkeley CA 94710. (510)524-2178. Fax: (510)524-2221. Website: www.peachpit.com. Estab. 1986. Book publisher. Types of books include instruction and computer. Specializes in graphics and design. Publishes 50-60 titles/year. Recent titles include: *HTML 4: Visual Quickstart Guide, Flash 4 Creative Web Animation* and *The Little iMac Book.* 20% requires freelance design. Book catalog free by request.

Needs: Approached by 50-75 artists/year. Works with 4 freelance designers/year. Prefers artists with experience in computer book cover design. Uses freelance artists mainly for covers, fliers and brochures. Also uses freelance artists for direct mail and catalog design. Works on assignment only.

First Contact & Terms: Send query letter with résumé, photographs and photostats. Samples are filed. Responds to the artist only if interested. Call for appointment to show a portfolio of original/final art and color samples. Buys all rights. Originals are not returned at job's completion.

Book Design: Pays by the project, $500-2,000.

Jackets/Covers: Assigns 40-50 freelance design jobs/year. Pays by the project, $1,000-5,000.

✓ ☀ PEACHTREE PUBLISHERS, 1700 Chattahoochee Ave., Atlanta GA 30318. (404)876-8761. Fax: (404)875-2578. E-mail: hello@peachtree-online.com. Website: www.peachtree-online.com. **Art Director:** Loraine Balcsik. Production Manager: Melanie McMahon. Estab. 1977. Publishes hardcover and trade paperback originals. Types of books include children's picture books, history for young adults, humor, juvenile, preschool, self-help, travel, young adult. Specializes in children's and young adult titles. Publishes 20-24 titles/year. Recent titles include: *The Yellow Star, The Monster Who Ate My Peas, What's the Time Grandma Wolf,* and *Anna Casey's Place in the World.* 90-100% requires freelance illustration; 5% requires freelance design. Call for catalog.

Needs: Approached by 750 illustrators and 200 designers/year. Works with 4-5 illustrators and 1-2 designers/year. Prefers local designers. Prefers fine art painterly style in children's and young adult books. "If possible, send samples that show your ability to depict subjects or characters in a consistent manner." Freelance design demands knowledge of QuarkXPress, Adobe Photoshop and Adobe Illustrator.

First Contact & Terms: Illustrators send query letter with photocopies, SASE, tearsheets. "Prefer not to receive samples from designers at this time since most is done in-house." Accepts Mac-compatible disk submissions but not preferred. Samples are filed and are returned by SASE. Responds only if interested. Will contact artist for portfolio review if interested. Rights purchased vary according to project. Finds freelancers through submission packets, agents and sourcebooks, including *Directory of Illustration* and *Picturebook.*

Jackets/Covers: Assigns 18-20 illustration jobs/year. Prefers acrylic, watercolor, or a mixed media on flexible material. Pays for design by the project.

Text Illustration: Assigns 4-6 freelance illustration jobs/year. Pays by the project.

Tips: "We are an independent, high-quality house with a limited number of new titles per season, therefore each book must be a jewel. We expect the illustrator to bring creative insights which expand the readers' understanding of the storyline through visual clues not necessarily expressed within the text itself."

N PEARSON TECHNOLOGY GROUP, 201 W. 103rd St., Indianapolis IN 46290. (317)581-3500. Website: www.pearsonptg.com. **Operations Specialist:** Phyllis Gault. Imprints include Que, New Riders, Sams, Alpha and Brady Games. Company publishes instructional computer books. Publishes 500 titles/year. 5-10% requires freelance illustration; 3-5% requires freelance design.

Needs: Approached by 100 freelancers/year. Works with 10+ freelance illustrators and 10 designers/year. Buys 50 freelance illustrations/year. Uses freelancers for jacket/cover illustration and design, text

illustration, direct mail and book design. 50% of freelance work demands knowledge of QuarkXPress, Illustrator and Photoshop. Finds artists through agents, sourcebooks, word of mouth, submissions and attending art exhibitions.

First Contact & Terms: Send query letter with brochure, tearsheets, photostats, résumé, photographs, slides, photocopies or transparencies. Samples are filed or returned by SASE if requested by artist. Art Director will contact artist for portfolio review if interested. Portfolio should include final art, photographs, photostats, roughs, slides, tearsheets and transparencies. Rights purchased vary according to project.

Book Design: Assigns 10 freelance design jobs/year. Pays by the project, $1,000-4,000.

Jackets/Covers: Assigns 10 freelance design and 10+ illustration jobs/year. Pays by the project, $1,000-3,000.

Text Illustration: Pays by the project.

PELICAN PUBLISHING CO., Box 3110, Gretna LA 70054. (504)368-1175. Fax: (504)368-1195. E-mail: production@pelicanpub.com. Website: www.pelicanpub.com. **Contact:** Production Manager. Publishes hardcover and paperback originals and reprints. Publishes 70 titles/year. Types of books include travel guides, cookbooks, business/motivational, architecture, golfing, history and children's books. Books have a "high-quality, conservative and detail-oriented" look. Recent titles include: *Della Ray, Majesty of St. Charles*, by Shawn O'Hisser.

Needs: Approached by 200 freelancers/year. Works with 20 freelance illustrators/year. Uses freelancers for illustration and multimedia projects. Works on assignment only. 100% of design and 50% of illustration demand knowledge of QuarkXPress, Photoshop 4.0, Illustrator 4.0.

First Contact & Terms: Designers send photocopies, photographs, SASE, slides and tearsheets. Illustrators send postcard sample or query letter with photocopies, SASE, slides and tearsheets. Samples are not returned. Responds on future assignment possibilities. Buys all rights. Originals are not returned.

Book Design: Pays by the project, $500 minimum.

Jackets/Covers: Pays by the project, $150-500.

Text Illustration: Pays by the project, $50-250.

Tips: "Show your versatility. We want to see realistic detail and color samples."

N PEN NOTES, INC., 61 Bennington Ave., Freeport NY 11520-3913. (516)868-5753. Fax: (516)868-8441. E-mail: pennotes@worldnet.att.net. Website: www.PenNotes.com. **President:** Lorette Konezny. Produces learning books for children ages 3 and up. Clients: Bookstores, toy stores and parents.

Needs: Prefers artists with book or advertising experience. Works on assignment only. Each year assigns 1-2 books (with 24 pages of art) to freelancers. Uses freelancers for children's illustration, P-O-P display and design and mechanicals for catalog sheets for children's books. 100% of freelance design and up to 50% of illustration demands computer skills. Prefers knowledge of press proofs on first printing. Prefers imaginative, realistic style with true perspective and color. 100% of titles require freelance art direction.

First Contact & Terms: Designers send brochure, résumé, SASE, tearsheets and photocopies. No e-mails. Illustrators send sample with tearsheets. Samples are filed. Call or write for appointment to show portfolio or mail final reproduction/product, color and b&w tearsheets and photostats. Pays for design by the hour, $15-36; by the project, $60-125. Pays for illustration by the project, $60-500/page. Buys all rights.

Tips: "Everything should be provided digitally. The style must be geared for children's toys. Looking for realistic/cartoon outline with flat color. You must work on deadline schedule set by printing needs. Must have full range of professional and technical experience for press proof. All work is property of Pen Notes, copyright property of Pen Notes."

N PENGUIN BOOKS, 375 Hudson St., New York NY 10014. (212)366-2000. Website: www.penguinp utnam.com. **Art Director:** Paul Buckley. Publishes hardcover and trade paperback originals. Recent titles include: *The Cat Who Went Up the Creek*, by Lillian Jackson Braun.

Needs: Works with 10-20 freelance illustrators and 10-20 freelance designers/year. Uses freelancers mainly for jackets, catalogs, etc.

First Contact & Terms: Send query letter with tearsheets, photocopies and SASE. Rights purchased vary according to project.

Book Design: Pays by the project; amount varies.

Jackets/Covers: Pays by the project; amount varies.

N ⬛ PEREGRINE, 40 Seymour Ave., Toronto, Ontario M4J 3T4 Canada. (416)461-9884. Fax: (416)461-4031. E-mail: peregrine@peregrine-net.com. Website: www.peregrine-net.com. **Creative Director:** Kevin Davies. Estab. 1993. Publishes roleplaying game books, audio music, and produces miniatures supplements. Main style/genre of games: science fiction, cyberpunk, mythology, fantasy, military, horror and humor. Uses freelance artists mainly for interior art (b&w, greyscale) and covers (color). Publishes 1-

4 titles or products/year. Game/product lines include: *Murphy's World* (roleplaying game), *Bob*, *Lord of Evil* (roleplaying game), *Adventure Areas* (miniatures supplements), *Adventure Audio*. 90% requires freelance illustration; 10% requires freelance design. Art guidelines available on website.

Needs: Approached by 20 illustrators and 2 designers/year. Works with 5 illustrators/year. Prefers freelancers experienced in anatomy, structure, realism, cartoon and greyscale. 100% of freelance design demands knowledge of Illustrator, Photoshop and QuarkXPress.

First Contact & Terms: Send self-promotion photocopy and follow-up postcard every 6-9 months. Send query letter with résumé, business card. Illustrators send photocopies and tearsheets. Send 5-10 samples. Accepts disk submissions in Mac format. Send via CD, floppy disk, Zip, e-mail or website as EPS, TIFF or JPEG files at 72-100 dpi (samples), finished work at 300 dpi. Only use Jaz or CD for finished work, not samples. Samples are filed and are not returned. Responds only if interested. Portfolio review not required. Rights purchased vary according to project. Finds freelancers through conventions, internet and word of mouth.

Book Covers/Posters/Cards: Assigns 1-2 illustration jobs/year. Pays for illustration by the project.

Text Illustration: Assigns 5-10 illustration jobs/year (greyscale/b&w). Pays by the full page, $50-100. Pays by the half page $10-25. "Price varies with detail of image required and artist's reputation."

Tips: "Check out our existing products. Make sure at least half of the samples submitted reflect the art styles we're currently publishing. Other images can be provided to demonstrate your range of capability."

PERFECTION LEARNING CORPORATION, COVER-TO-COVER, 10520 New York Ave., Des Moines IA 50322-3775. (515)278-0133, ext. 209. Fax: (515)278-2980. E-mail: rmesser@plconline.c om. Website: www.perfectionlearning.com. **Art Director:** Randy Messer. Senior Designer: Deb Bell. Estab. 1927. Publishes hardcover originals and reprints, mass market paperback originals and reprints, educational resources, trade paperback originals and reprints, high general interest/low reading level, multicultural, nature, science, social issues, sports. Specializes in high general interest/low reading level and Lit-based teacher resources. Publishes 100 titles/year. Recent titles: *American Justice II*, *The Secret Room*, *the Message, the Promise, and How Pigs Figure in*, *River of Ice*, *Orcas—High Seas Supermen*. All 5 titles have been nominated for ALA Quick Picks. 50% requires freelance illustration.

● Perfection Learning Corporation has had several books nominated for awards including *Iditarod*, nominated for a Golden Kite award and *Don't Bug Me*, nominated for an ALA-YALSA award.

Needs: Approached by 70 illustrators and 10-20 designers/year. Works with 30-40 illustrators/year. Prefers local designers and art directors. Prefers freelancers experienced in cover illustration and interior spot— 4-color and b&w. 100% of freelance design demands knowledge of QuarkXPress.

First Contact & Terms: Illustrators send postcard or query letter with printed samples, photocopies, SASE, tearsheets. Accepts Mac-compatible disk submissions. Send EPS. Samples are filed or returned by SASE. Responds only if interested. Portfolio review not required. Rights purchased vary according to project. Finds freelancers through tearsheet submissions, illustration annuals, phone calls, artists' reps.

Jackets/Covers: Assigns 40-50 freelance illustration jobs/year. Pays for illustration by the project, $750-1,750, depending on project. Prefers illustrators with conceptual ability.

Text Illustration: Assigns 40-50 freelance illustration jobs/year. Pays by the project. Prefers freelancers who are able to draw multicultural children and good human anatomy.

Tips: "We look for good conceptual skills, good anatomy, good use of color. Our materials are sold through schools for classroom use—they need to meet educational standards."

PETER PAUPER PRESS, INC., 202 Mamaroneck Ave., White Plains NY 10601-5387. (914)681-0144. Fax: (914)681-0389. E-mail: pauperp@aol.com. **Contact:** Creative Director. Estab. 1928. Company publishes hardcover small format illustrated gift books and photo albums. Specializes in friendship, love, celebrations, holidays. Publishes 40-50 titles/year. Recent titles include: *Love Is a Beautiful Thing* and *A Friend for All Seasons*. 100% require freelance illustration; 100% require freelance design.

Needs: Approached by 75-100 freelancers/year. Works with 15-20 freelance illustrators and 3-5 designers/ year. Uses freelancers for jacket/cover and text illustration. 100% of freelance design demands knowledge of QuarkXPress. Works on assignment only.

First Contact & Terms: Send query letter with brochure, résumé, SASE, photographs, tearsheets or photocopies. Samples are filed or are returned by SASE. Responds in 1 month with SASE. Art Director will contact artist for portfolio review if interested. Portfolio should include book dummy, final art, photographs and photostats. Rights purchased vary according to project. Originals are returned at job's completion. Finds artists through submissions, gift and card shows.

Book Design: Assigns 65 freelance design jobs/year. Pays by the project, $500-2,500.

Jackets/Covers: Assigns 65 freelance design and 40 illustration jobs/year. Pays by the project, $800-1,200.

Text Illustration: Assigns 65 freelance illustration jobs/year. Pays by the project, $1,000-2,800.

Tips: "Knowledge of the type of product we publish is extremely helpful in sorting out artists whose work will click for us. We are most likely to have a need for up-beat works."

☑ **THE PILGRIM PRESS/UNITED CHURCH PRESS**, 700 Prospect Ave. E., Cleveland OH 44115-1100. (216)736-3715. Fax: (216)736-2207. Website: www.pilgrimpress.com. **Art Director:** Martha Clark. Production: Janice Brown. Estab. 1957. Company publishes hardcover originals and trade paperback originals and reprints. Types of books environmental ethics, human sexuality, devotion, women's studies, justice, African-American studies, world religions, Christian education, curriculum, reference and social and ethical philosophical issues. Specializes in religion. Publishes 60 titles/year. Recent titles include: *In Good Company: A Woman's Journal for Spiritual Reflection* and *Still Groovin'*. 75% require freelance illustration; 50% require freelance design. Books are progressive, classic, exciting, sophisticated—conceptually looking for "high design." Book catalog free by request.
Needs: Approached by 50 freelancers/year. Works with 20 freelance illustrators and 10 designers/year. Buys 50 illustrations/year. Prefers freelancers with experience in book publishing. Uses freelancers mainly for covers, catalogs and illustration. Also for book design. Works on assignment only.
First Contact & Terms: Send query letter with résumé, tearsheets and photocopies. Samples are filed and are not returned. Art Director will contact artist for portfolio review if interested. Negotiates rights purchased. Interested in buying second rights (reprint rights) to previously published work based on need, style and concept/subject of art and cost. "I like to see samples." Originals are returned at job's completion. Finds artists through agents and stock houses.
Book Design: Assigns 50 freelance design jobs/year. Pays by the project, $500.
Jackets/Covers: Assigns 125 freelance design jobs/year. Prefers contemporary styles. Pays by the project, $500-700.
Text Illustration: Assigns 15-20 design and 15-20 illustration jobs/year. Pays by the project, $200-500; negotiable, based on artist estimate of job, number of pieces and style.
Tips: "I also network with other art directors/designers for their qualified suppliers/freelancers. If interested in curriculum illustration, show familiarity with illustrating biblical art and diverse races and ages."

PINCUSHION PRESS, 4277 NW 27th Ave., Boca Raton FL 33434. (561)989-9706. Fax: (561)989-0216. **Art Director:** Max Golden. Estab. 1990. Publishes hardcover and trade paperback originals. Types of books include coffee table books and nonfiction. Specializes in antiques and collectibles. Publishes 8 titles/year. Recent titles include: *Collecting Tin Toys*. 10% require freelance illustration; 90% require freelance design. Book catalog free for $1.01 postage.
Needs: Approached by 10 illustrators and 10 designers/year. Works with 1 freelance illustrator and 3 designers/year. Uses freelancers mainly for book jacket and book interior design. 75% of freelance design and 50% of illustration demands knowledge of PageMaker, FreeHand, Photoshop, Illustrator, QuarkXPress.
First Contact & Terms: Designers send query letter with photocopies or Web addresses. Illustrators send printed samples. Samples are not filed and are returned by SASE. Portfolio review required from designers. Request portfolio review in original query. Portfolio should include book dummy, photocopies, photographs. Negotiates rights purchased, rights purchased vary according to project. Finds freelancers through word of mouth and artists' submissions.
Book Design: Assigns 5 freelance design jobs/year. Pays by project.
Jackets/Covers: Pays by project. Prefers fully rendered art.
Text Illustration: Pays by project.

PLAYERS PRESS, Box 1132, Studio City CA 91614. **Associate Editor:** Jean Sommers. Specializes in plays and performing arts books. Recent titles include: *Principles of Stage Combat*, *Theater Management* and *The American Musical Theatre*.
Needs: Works with 3-15 freelance illustrators and 1-3 designers/year. Uses freelancers mainly for play covers. Also for text illustration. Works on assignment only.
First Contact & Terms: Send query letter with brochure showing art style or résumé and samples. Samples are filed or are returned by SASE. Request portfolio review in original query. Art director will contact artist for portfolio review if interested. Portfolio should include thumbnails, final reproduction/product, tearsheets, photographs and "as much information as possible." Sometimes requests work on spec before assigning a job. Buys all rights. Considers buying second rights (reprint rights) to previously published work, depending on usage. "For costume books this is possible."
Book Design: Pays by the project, rate varies.
Jackets/Covers: Pays by the project, rate varies.
Text Illustration: Pays by the project, rate varies.
Tips: "Supply what is asked for in the listing and don't waste our time with calls and unnecessary cards. We usually select from those who submit samples of their work which we keep on file. Keep a permanent address so you can be reached."

PRAKKEN PUBLICATIONS, INC., 3970 Varsity Dr., Box 8623, Ann Arbor MI 48107. (734)975-2800. Fax: (734)975-2787. Website: www.techdirections.com or www.eddigest.com. **Production and Design Manager:** Sharon Miller. Estab. 1934. Imprints include The Education Digest, Tech Directions. Company publishes textbooks, educator magazines and reference books. Specializes in vocational, technical, technology and general education. Publishes 2 magazines and 2 new book titles/year. Titles include: *High School-to-Employment Transition, Exploring Solar Energy, II: Projects in Solar Electricity, Technology's Past, Workforce Preparation: An International Perspective* and *More Technology Projects for the Classroom.* Book catalog free by request.

Needs: Rarely uses freelancers. 50% of freelance work demands knowledge of PageMaker. Works on assignment only.

First Contact & Terms: Send samples. Samples are filed or are returned by SASE if requested by artist. Responds only if interested. Art director will contact artist for portfolio review if interested. Portfolio should include b&w and color final art, photostats and tearsheets.

N PRENTICE HALL, Pearson Publishing, School Division Art Dept., One Lake St., Room 1K24, Upper Saddle River NJ 07458. (201)236-7000. Fax: (201)236-7755. Website: www.phschool.com. Imprint publishes textbooks. "Will be getting into consumer market." Specializes in history, science, language arts, multimedia. 50% require freelance illustration; 75% require design.

Needs: Buys 15 covers and hundreds of interior illustrations/year. Uses freelancers for jacket/cover design and illustration, text illustration and book design. Needs computer-literate freelancers for design, illustration, production and presentation. Freelancers should be familiar with Illustrator, QuarkXPress and Photoshop. Works on assignment only.

First Contact & Terms: Send postcard sample of work or send query letter with samples. Samples are filed. Art Director will contact artist for portfolio review if interested. Portfolio should include book dummy, final art, photographs and tearsheets. Buys all rights. Originals are not returned.

Tips: Finds artists through agents, sourcebooks, word of mouth, artist's submissions, attending art exhibitions.

PRENTICE HALL COLLEGE DIVISION, Pearson Education, 445 Hutchinson Ave., 4th Floor, Columbus OH 43235. (614)841-3700. Fax: (614)841-3645. Website: www.prenhall.com. **Design Coordinator:** Diane Lorenzo. Specializes in college textbooks in education and technology. Publishes 300 titles/year. Recent titles include: *Exceptional Children*, by Heward; and *Electronics Fundamentals*, by Floyd.

Needs: Approached by 25-40 freelancers/year. Works with 30 freelance illustrators/year. Uses freelancers mainly for interior textbook design and media (Web/database) production. 100% of freelance design and 70% of illustration demand knowledge of QuarkXPress 4.0, Illustrator 9.0 or Photoshop 6.0, Director 6.0.

First Contact & Terms: Send query letter with résumé and tearsheets; sample text designs on CD in Mac format. Accepts submissions on CD in Mac files only (not PC) in software versions stated above. Samples are filed and portfolios are returned. Responds in 30 days. Rights purchased vary according to project. Originals are returned at job's completion.

Book Design: Pays by the project, $500-2,500.

Text Illustration: Assigns 20 text designs/year.

Tips: "Send a style that works well with our particular disciplines. All text designs are produced electronically, but the textbook should be appealing to the student-reader whether 1-color, 2-color or 4-color."

PRICE STERN SLOAN, The Penguin Putnam Group, 375 Hudson, New York NY 10014. (212)414-3610. Fax: (212)414-3396. **Contact:** Submissions Editor. Estab. 1971. Book publisher. Publishes juvenile only—hardcover, trade paperback and mass market originals and reprints. Types of books include picture books, middle-grade and young adult fiction, games, crafts, and occasional novelty titles. Publishes 100 titles/year. R75% require freelance illustration; 10% require freelance design. Books vary from edgy to quirky to illustrative, "but always unique!"

Needs: Approached by 300 freelancers/year. Works with 20-30 freelance illustrators and 10-20 designers/year. Prefers freelancers with experience in book or advertising art. Uses freelancers mainly for illustration. Also for jacket/cover and book design. Needs computer-literate freelancers for production.

First Contact & Terms: Send query letter with brochure, résumé and photocopies. Samples are filed or are returned by SASE if requested by artist. Art Director will contact artist for portfolio review if interested. "Please don't call." Portfolio should include b&w and color tearsheets. Rights purchased vary according to project. Finds artists through word of mouth, magazines, submissions/self-promotion, sourcebooks and agents.

Book Design: Assigns 5-10 freelance design jobs and 20-30 illustration jobs/year. Pays by the project.

Jackets/Covers: Assigns 5-10 freelance design jobs and 10-20 illustration jobs/year. Pays by the project, rate varies.

Text Illustration: Pays by the project and occasionally by participation.

Tips: "Do not send original art. Become familiar with the types of books we publish. We are extremely selective when it comes to children's books, so please send only your best work."

PROLINGUA ASSOCIATES, P.O. Box 1348, Brattleboro VT 05302-1348. (802)257-7779. Fax: (802)257-5117. E-mail: prolingu@sover.net. Website: www.prolinguaAssociates.com. **President:** Arthur A. Burrows. Estab. 1980. Company publishes textbooks. Specializes in language textbooks. Publishes 3-8 titles/year. Recent titles include: *Living in South Korea* and *Pronunciation Activities*. Most require freelance illustration. Book catalog free by request.

Needs: Approached by 10 freelance artists/year. Works with 2-3 freelance illustrators/year. Uses freelance artists mainly for pedagogical illustrations of various kinds. Also uses freelance artists for jacket/cover and text illustration. Works on assignment only.

First Contact & Terms: Send postcard sample and/or query letter with brochure, photocopies and photographs. Samples are filed. Responds in 1 month. Portfolio review not required. Buys all rights. Originals are returned at job's completion if requested. Finds artists through word of mouth and submissions.

Text Illustration: Assigns 5 freelance illustration jobs/year. Pays by the project, $200-1,200.

PUFFIN BOOKS, Penguin Putnam Inc., Dept. AM, 345 Hudson St., New York NY 10014-3657. (212)366-2000. Fax: (212)366-2040. E-mail: webmaster@penguin.com. Website: www.penguinputnam.com. **Art Director:** Deborah Kaplan. Division estab. 1941. Book publisher. Division publishes trade paperback originals and reprints and mass market paperback originals. Types of books include contemporary, mainstream, historical fiction, adventure, mystery, biography, preschool, juvenile and young adult. Specializes in juvenile novels. Publishes 175-200 titles/year. Titles include *Why Do Dogs Bark?* (easy-to-read series) and *Outlaws of Sherwood*. 50% require freelance illustration; 5% require freelance design.
• Puffin recently launched a new imprint, Firebird Books, featuring fantasy books for the young adult to adult audience.

Needs: Approached by 20 artists/year. Works with 35 illustrators/year. Buys 60 illustrations/year. Prefers artists with experience in realistic juvenile renderings. Uses freelancers mainly for paperback cover 4-color art. Also for text illustration. Works on assignment only.

First Contact & Terms: Send query letter with tearsheets and transparencies. Samples are filed or are returned by SASE if requested by artist. Responds to the artist only if interested. Call for appointment to show portfolio. Portfolio should include color tearsheets and transparencies. Rights purchased vary according to project. Originals returned to artist at job's completion.

Book Design: Assigns 5 illustration jobs/year.

Jackets/Covers: Assigns 60 illustration jobs/year. Prefers oil, acrylic, watercolor and 4-color. Pays by the project, $900-2,000.

Text Illustration: Assigns 5 illustration jobs/year. Prefers b&w line drawings. Pays by the project, $500-1,500.

Tips: "I need you to show that you have experience in painting tight, realistic, lively renderings of kids ages 6-18."

PULSAR GAMES, INC., 12839 Patrick Court, Fishers IN 46038. (317)841-8992. Fax: (317)585-8106. E-mail: info@pulsargamesinc.com. Website: www.pulsargamesinc.com. **Art Director:** Ray Hedman. Estab. 1997. Publishes roleplaying game books, posters/calendars, newsletter. Main style/genre of games: science fiction, fantasy and comic book. Uses freelance artists mainly for illustration. Publishes 6 titles or products/year. Game/product lines include: *Blood of Heroes* and *Project Pulsar*. 100% requires freelance illustration. Art guidelines available on website.

Needs: Approached by 30 illustrators and 10 designers/year. Works with 10 illustrators and 3 designers/year. Prefers freelancers experienced in comic book style and sci-fi genre. 100% of freelance design demands knowledge of Photoshop, QuarkXPress, PageMaker and Acrobat. 20% of freelance illustration demands knowledge of Illustrator, Photoshop, FreeHand, QuarkXPress and PageMaker.

First Contact & Terms: Send self-promotion postcard sample and follow-up postcard every 3 months. Send query letter with résumé, business card, SASE and product release form. Illustrators send printed samples, photocopies, photographs and slides. Send 8-10 samples. Accepts disk submissions in Windows or Mac format. Send via CD, floppy disk, Zip or e-mail as EPS, TIFF, GIF or JPEG files at 150 dpi. Samples are filed and are not returned. Responds only if interested. Will contact artist for portfolio review if interested. Portfolio should include artwork portraying comic book and sci-fi characters and settings, b&w, color, photocopies, final art and roughs. Negotiates rights purchased and rights purchased vary according to project. Finds freelancers through submission packets, promotional postcards, conventions, word of mouth and referrals.

Visual Design: Assigns 3-5 freelance design jobs/year. Pays for design by the project.

Book Covers/Posters/Cards: Assigns 5-10 illustration jobs/year. Prefers pencils, pen & ink, colored inks, watercolor and oils. Pays for illustration by the project or royalties.

Text Illustration: Assigns 3-5 illustration jobs/year. Pays by the project.

Tips: "Be fast, but slow enough to be detail oriented. Be persistant and show all your favored media. We would rather receive a real portfolio than pictures on a web page."

PULSE-FINGER PRESS, Box 488, Yellow Springs OH 45387. **Contact:** Orion Roche or Raphaello Farnese. Publishes hardbound and paperback fiction, poetry and drama. Publishes 5-10 titles/year.

Needs: Prefers local freelancers. Works on assignment only. Uses freelancers for advertising design and illustration. Pays $25 minimum for direct mail promos.

First Contact & Terms: Send query letter. "We can't use unsolicited material. Inquiries without SASE will not be acknowledged." Responds in 6 weeks; responds on future assignment possibilities. Samples returned by SASE. Send résumé to be kept on file. Artist supplies overlays for all color artwork. Buys first serial and reprint rights. Originals are returned at job's completion.

Jackets/Covers: "Must be suitable to the book involved; artist must familiarize himself with text. We tend to use modernist/abstract designs. Try to keep it simple, emphasizing the thematic material of the book." **Pays on acceptance**; $25-100 for b&w jackets.

Tips: "We do most of our work in-house; otherwise, we recruit from the rich array of talent in the colleges and universities in our area. We've used the same people—as necessary—for years; so it's very difficult to break into our line-ups. We're receptive, but our needs are so limited as to preclude much of a market."

✔ **G.P. PUTNAM'S SONS, PHILOMEL BOOKS**, 345 Hudson St., New York NY 10014-3657. (212)366-2000. Website: www.penguin.com. **Art Director, Children's Books:** Cecilia Yung. Publishes hardcover juvenile books. Publishes 60 titles/year. Free catalog available.

Needs: Illustration on assignment only.

First Contact & Terms: Provide flier, tearsheet, brochure and photocopy or stat to be kept on file for possible future assignments. Samples are returned by SASE. "We take drop-offs on Tuesday mornings. Please call Carolyn Fucibe (212)366-2000) in advance with the date you want to drop of your portfolio. Do not send samples via e-mail."

Jackets/Covers: "Uses full-color paintings, realistic painterly style."

Text Illustration: "Uses a wide cross section of styles for story and picture books."

✔ **QUITE SPECIFIC MEDIA GROUP LTD.**, 7373 Pyramid Place, Hollywood CA 90046. (323)851-5797. Fax: (323)851-5798. Website: www.quitespecificmedia.com. **Contact:** Ralph Pine. Estab. 1967. Publishes hardcover originals and reprints, trade paperback reprints and textbooks. Specializes in costume, fashion, theater and performing arts books. Publishes 12 titles/year. Recent titles include: *The Medieval Tailor's Assistant*. 10% requires freelance illustration; 60% requires freelance design.

● Imprints of Quite Specific Media Group Ltd. include Drama Publishers, Costume & Fashion Press, By Design Press, Entertainment Pro and Jade Rabbit.

Needs: Works with 2-3 freelance designers/year. Uses freelancers mainly for jackets/covers. Also for book, direct mail and catalog design and text illustration. Works on assignment only.

First Contact & Terms: Send query letter with brochure and tearsheets. Samples are filed. Responds to the artist only if interested. Rights purchased vary according to project. Originals not returned. Pays by the project.

RAINBOW BOOKS, INC., P.O. Box 430, Highland City FL 33846-0430. (863)648-4420. Fax: (863)648-4420. E-mail: RBIbooks@aol.com. **Media Buyer:** Betsy A. Lampe. Estab. 1979. Company publishes hardcover and trade paperback originals. Types of books include instruction, adventure, biography, travel, self-help, religious, mystery, reference, history and cookbooks. Specializes in nonfiction, self help and how-to. Publishes 20 titles/year. Recent titles include: *You Can Be All That! A Guide to Beauty and Success* and *Medical School Is Murder*.

Needs: Approached by hundreds of freelance artists/year. Works with 5 illustrators/year. Prefers freelancers with experience in book-cover design and line illustration. Uses freelancers for jacket/cover illustration and design and text illustration. Needs computer-literate freelancers for design, illustration and production. 90% of freelance work demands knowledge of draw or design programs. Works on assignment only.

First Contact & Terms: Send brief query, tearsheets, photographs and book covers or jackets. Samples are not returned. Responds in 2 weeks. Art director will contact artist for portfolio review if interested. Portfolio should include b&w and color tearsheets, photographs and book covers or jackets. Rights purchased vary according to project. Originals are returned at job's completion.

Jackets/Covers: Assigns 10 freelance illustration jobs/year. Pays by the project, $250-1,000.

Text Illustration: Pays by the project. Prefers pen & ink or electronic illustration.

Tips: "Nothing Betsy Lampe receives goes to waste. After consideration for Rainbow Books, Inc., artists/designers are listed free in her newsletter (Publisher's Report), which goes out to over 500 independent presses (weekly). Then, samples are taken to the art department of a local school to show students how professional artists/designers market their work. Send samples (never originals), be truthful about the amount of time needed to complete a project, learn to use the computer. Study the competition (when doing book covers), don't try to write cover copy, learn the publishing business (attend small press seminars, read books, go online, make friends with the local sales reps of major book manufacturers). Pass along what you learn. Do not query via e-mail attachment."

☑ **RANDOM HOUSE CHILDREN'S BOOK GROUP**, 1540 Broadway, New York NY 10036. (212)782-9000. Fax: (212)782-9452. Website: www.randomhouse.com/kids. **Art Director:** Jan Gerardi. Specializes in hardcover and mass market paperback originals and reprints. Publishes 200 titles/year. Recent titles include: *Wiggle Waggle Fun* and *Junie B. First Grader (at last!)*. 100% require freelance illustration.
Needs: Works with 100-150 freelancers/year. Works on assignment only.
First Contact & Terms: Send query letter with résumé, tearsheets and printed samples, photostats; no originals. Samples are filed. Negotiates rights purchased.
Book Design: Assigns 5 freelance design jobs/year. Pays by the project.
Text Illustration: Assigns 150 illustration jobs/year. Pays by the project.

RANDOM HOUSE VALUE PUBLISHING, 280 Park Ave., New York NY 10017. (212)751-2600. Fax: (212)940-7805. **Contact:** Art Director. Imprint of Random House, Inc. Other imprints include Wings, Gramercy and Crescent. Imprint publishes hardcover, trade paperback and reprints, and trade paperback originals. Types of books include adventure, coffee table books, cookbooks, children's books, fantasy, historical fiction, history, horror, humor, instructional, mainstream fiction, New Age, nonfiction, reference, religious, romance, science fiction, self-help, travel and western. Specializes in contemporary authors' work. Recent titles include: *Aesop's Fables Illustrated Stories for Children* and *The Wizardry of Oz* and work by John Saul, Mary Higgins Clark, Tom Wolfe, Dave Barry and Michael Chrichton (all omnibuses). 80% requires freelance illustration; 50% requires freelance design.
Needs: Approached by 50 freelancers/year. Works with 30-40 freelance illustrators and 15-20 designers/year. Uses freelancers mainly for jacket/cover illustration and design for fiction and romance titles. 100% of design and 50% of illustration demands knowledge of Illustrator, QuarkXPress, Photoshop and Free-Hand. Works on assignment only.
First Contact & Terms: Designers send résumé and tearsheets. Illustrators send postcard sample, brochure, résumé and tearsheets. Samples are filed. Request portfolio review in original query. Art Director will contact artist for portfolio review if interested. Portfolio should include tearsheets. Buys first rights. Originals are returned at job's completion. Finds artists through *American Showcase, Workbook, The Creative Illustration Book*, artist's reps.
Book Design: Pays by the project.
Jackets/Covers: Assigns 20-30 freelance design and 40 illustration jobs/year. Pays by the project, $500-1,500.
Tips: "Study the product to make sure styles are similar to what we have done: new, fresh, etc."

☒ **READ'N RUN BOOKS**, imprint of Crumb Elbow, Box 294, Rhododendron OR 97049. (503)622-4798. **Publisher:** Michael P. Jones. Estab. 1985. Specializes in fiction, history, environment and wildlife books for children through adults. "Books for people who do not have time to read lengthy books." Publishes 60 titles/year. Recent titles include: *Nikki, Rooster & Chick-a-Biddy*, by Naomi Russell; and *Sir Dominick's Bargain*, by J. Sheridan LeFanu. "Our books, printed in b&w or sepia, are both hardbound and softbound, and are not slick looking. They are home-grown-looking books that people love." Accepts previously published material. Art guidelines for #10 SASE.
• Read 'N Run is an imprint of Crumb Elbow publishing. See listing for other imprints.
Needs: Works with 55 freelance illustrators and 10 designers/year. Prefers pen & ink, airbrush, charcoal/pencil, markers, calligraphy and computer illustration. Uses freelancers mainly for illustrating books. Also for jacket/cover, direct mail, book and catalog design. 50% of freelance work demands computer skills.
First Contact & Terms: Send query letter with brochure, tearsheets, photocopies and SASE. Samples not filed are returned by SASE. Request portfolio review in original query. Art Director will contact artist for portfolio review if interested. Artist should follow up after initial query. Portfolio should include thumbnails, roughs, final reproduction/product, color and b&w tearsheets, photostats and photographs. Will not respond to postcards. Buys one-time rights. Interested in buying second rights (reprint rights) to previously published work. Originals are returned at job's completion. Pays in copies, on publication.
Book Design: Assigns 20 freelance design jobs/year.
Jackets/Covers: Assigns 20 freelance design and 30 illustration jobs/year. Pays $75-250 or in published copies.

Text Illustration: Assigns 70 freelance illustration jobs/year. Pays by the project, $75-250.

Tips: "Generally, the artists find us by submitting samples—lots of them, I hope. Artists may call us, but we will not return calls. We will be publishing short-length cookbooks. I want to see a lot of illustrations showing a variety of styles. There is little that I actually don't want to see. We have a tremendous need for illustrations on the Oregon Trail (i.e., oxen-drawn covered wagons, pioneers, mountain men, fur trappers, etc.) and illustrations depicting the traditional way of life of Plains Indians and those of the North Pacific Coast and Columbia River with emphasis on mythology and legends. Pen & ink is coming back stronger than ever! Don't overlook this. Be versatile with your work. We will also evaluate your style and may utilize your work through another imprint that is under us, or even through our 'Wy-East Historical Journal.' "

☑ ♥ **RED DEER PRESS**, Room 813, MacKimmie Library Tower, 2500 University Dr., NW, Calgary, Alberta T2N 1N4 Canada. (403)220-4334. Fax: (403)210-8191. E-mail: rdp@ucalgary.ca. **Managing Editor:** Dennis Johnson. Estab. 1975. Book publisher. Publishes hardcover and trade paperback originals. Types of books include contemporary and mainstream fiction, fantasy, biography, preschool, juvenile, young adult, humor and cookbooks. Specializes in contemporary adult and juvenile fiction, picture books and natural history for children. Recent titles include: *The Saturday Appaloosa* and *Waiting for the Sun*. 100% require freelance illustration; 30% require freelance design. Book catalog available for SASE with Canadian postage.

Needs: Approached by 50-75 freelance artists/year. Works with 10-12 freelance illustrators and 2-3 freelance designers/year. Buys 50 freelance illustrations/year. Prefers artists with experience in book and cover illustration. Also uses freelance artists for jacket/cover and book design and text illustration. Works on assignment only.

First Contact & Terms: Send query letter with résumé, tearsheets, photographs and slides. Samples are filed. To show a portfolio, mail b&w slides and dummies. Rights purchased vary according to project. Originals returned at job's completion.

Book Design: Assigns 3-4 design and 6-8 illustration jobs/year. Pays by the project.

Jackets/Covers: Assigns 6-8 design and 10-12 illustration jobs/year. Pays by the project, $300-1,000 CDN.

Text Illustration: Assigns 3-4 design and 4-6 illustration jobs/year. Pays by the project. May pay advance on royalties.

Tips: Looks for freelancers with a proven track record and knowledge of Red Deer Press. "Send a quality portfolio, preferably with samples of book projects completed."

☑ **RED WHEEL/WEISER**, (formerly Samuel Weiser Inc.), 368 Congress St., 4th Floor, Boston MA 02210. (617)542-1324. Fax: (617)482-9676. E-mail: kfivel@redwheelweiser.com. Website: www.redwheel weiser.com. **Contact:** Kathleen Wilson Fivel. Specializes in hardcover and paperback originals, reprints and trade publications on metaphysics/oriental philosophy/esoterica. Publishes 24 titles/year. "We use visionary art or nature scenes." Catalog available for SASE.

Needs: Approached by approximately 25 artists/year. Works with 10-15 illustrators and 2-3 designers/year. Uses freelancers for jacket/cover design and illustration. 80% of design and 40% of illustration demand knowledge of Illustrator, Photoshop and QuarkXPress.

First Contact & Terms: Designers send query letter with résumé, photocopies and tearsheets. Illustrators send query letter with photocopies, photographs, SASE and tearsheets. "We can use art or photos. I want to see samples I can keep." Samples are filed or are returned by SASE only if requested by artist. Responds in 1 month only if interested. Originals are returned to artist at job's completion. To show portfolio, mail tearsheets, color photocopies or slides. Considers complexity of project, skill and experience of artist, project's budget, turnaround time and rights purchased when establishing payment. Buys one-time nonexclusive rights. Finds most artists through references/word-of-mouth, portfolio reviews and samples received through the mail.

Jackets/Covers: Assigns 20 design jobs/year. Prefers airbrush, watercolor, acrylic and oil. Pays by the project, $100-500.

Tips: "Send me color copies of work—something we can keep in our files. Stay in touch with phone numbers. Sometimes we get good material but then can't use it because we can't find the photographer or artist! We're interested in buying art that we use to create a cover, or in artists with professional experience with cover film—who can work from inception of design to researching/creating image to type design; we work with old-fashioned mechanicals, film and disk. Don't send us drawings of witches, goblins and demons, for that is not what our field is about. You should know something about us before you send materials."

☑ ▣ **REGNERY PUBLISHING INC.**, Parent company: Eagle Publishing Inc., One Massachusetts Ave. NW, Washington DC 20001. (202)216-0601. Fax: (202)216-0612. Website: www.regnery.com. **Con-**

tact: Art Director. Estab. 1947. Publishes hardcover originals and reprints, trade paperback originals and reprints. Types of books include biography, health, exercize, diet, coffee table books, cookbooks, history, humor, instructional, nonfiction and self help. Specializes in nonfiction. Publishes 30 titles/year. Recent titles include: *God, Guns and Rock & Roll*, by Ted Nugent; and *The Diet Trap*. 20-50% requires freelance design. Book catalog available for SASE.

Needs: Approached by 20 illustrators and 20 designers/year. Works with 6 designers/year. Prefers local illustrators and designers. Prefers freelancers experienced in Mac, QuarkXPress and Photoshop. 100% of freelance design demands knowledge of QuarkXPress. 50% of freelance illustration demands knowledge of Photoshop, QuarkXPress.

First Contact & Terms: Send postcard sample and follow-up postcard every 6 months. Accepts Mac-compatible disk submissions. Send TIFF files. Samples are filed. Will contact artist for portfolio review if interested. Finds freelancers through *Workbook*, networking and submissions.

Book Design: Assigns 5-10 freelance design jobs/year. Pays for design by the project; negotiable.

Jackets/Covers: Assigns 5-10 freelance design and 1-5 illustration jobs/year. Pays by the project; negotiable.

Tips: "We welcome designers with knowledge of Mac platforms . . . and the ability to design 'bestsellers' under extremely tight guidelines and deadlines!"

N: ROWMAN & LITTLEFIELD PUBLISHERS, INC., Parent company: University Press of America, 4720 Boston Way, Suite A, Lanham MD 20706. (301)731-9534. Fax: (301)459-3464. E-mail: ghenry@univ press.com. Website: www.rowmanlittlefield.com. **Art Director:** Giséle Byrd Henry. Estab. 1975. Publishes hardcover originals and reprints, textbooks, trade paperback originals and reprints. Types of books include biography, history, nonfiction, reference, self help, textbooks. Specializes in nonfiction trade. Publishes 250 titles/year. Recent titles include: *Orphans of Islam*. 100% of titles require freelance design. Does not use freelance illustrations. Book catalog not available.

Needs: Approached by 10 designers/year. Works with 20 designers/year. Prefers freelancers experienced in typographic design, Photoshop special effects. 100% of freelance design demands knowledge of Photoshop and QuarkXPress.

First Contact & Terms: Designers send query letter with printed samples, photocopies, tearsheets, SASE. Accepts Mac-compatible disk submissions. Send TIFF files. Samples are filed or returned by SASE. Responds only if interested. Portfolio review not required. Buys all rights. Finds freelancers through submission packets and word of mouth.

Jackets/Covers: Assigns 150 freelance design jobs/year. Prefers postmodern, cutting-edge design and layering, filters and special Photoshop effects. Pays for design by the project $500-1,100. Prefers interesting "on the edge" typography. Must be experienced book jacket designer.

Tips: "All our designers must work on a Mac platform, and all files imported into Quark. Proper file set up is essential. Looking for cutting edge trade nonfiction designers who are creative and fluent in all special effect software."

✓ SCHOLARLY RESOURCES INC., 104 Greenhill Ave., Wilmington DE 19805-1897. (302)654-7713. Fax: (302)654-3871. E-mail: market@scholarly.com. Website: www.scholarly.com. **Marketing Manager:** Toni Moyer. Managing Editor: Carolyn J. Travers. Estab. 1972. Publishes textbooks and trade paperback originals. Types of books include American history, Latin American studies, women's studies and reference books. Publishes 40 titles/year. Recent titles include: *The Civil War on the Web: A Guide to the Very Best Sites*, *Aces Wild: The Race for Machl*, *Viva Mexico!Viva la Independencia!*, *American Census Handbook* 60% requires freelance illustration; 80% requires freelance design. Book catalog free.

Needs: Works with 3 illustrators and 8 designers/year. Prefers freelancers experienced in book design. 100% of freelance design demands knowledge of PageMaker and QuarkXPress.

First Contact & Terms: Designers and illustrators send query letter with printed samples, photocopies, tearsheets and SASE. Accepts Mac-compatible disk submissions. Samples are filed. Responds only if interested. Will contact artist for portfolio review if interested. Buys all rights. Finds freelancers through submission packets and networking events.

Book Design: Assigns 12 freelance design jobs/year. Pays by the project, $400-800.

Jackets/Covers: Assigns 30 freelance design jobs/year. Pays by the project, $1,000-1,500.

N: SCHOLASTIC INC., 555 Broadway, New York NY 10012. Website: www.scholastic.com. **Creative Directors:** David Saylor and Nathaniel Bisson. Specializes in paperback originals of young adult, biography, classics, historical and contemporary teen. Publishes 500 titles/year. Recent titles include: *Good Night Gorilla* and *What Grandmas Do Best*. 80% require freelance illustration. Books have "a mass-market look for kids."

Needs: Approached by 100 freelancers/year. Works with 75 freelance illustrators and 2 designers/year. Prefers local freelancers with experience. Uses freelancers mainly for mechanicals. Also for jacket/cover illustration and design and book design. 40% of illustration demand knowledge of QuarkXPress, Illustrator, Photoshop.

First Contact & Terms: Designers send query letter with résumé and tearsheets. Illustrators send postcard sample and tearsheets. Accepts disk submissions compatible with Mac. Samples are filed or are returned only if requested, with SASE. Art Director will contact artist for portfolio review if interested. Considers complexity of project and skill and experience of artist when establishing payment. Originals are returned at job's completion. Finds artists through word of mouth, *American Showcase*, *RSVP* and Society of Illustrators.

Book Design: Pays by the project, $2,000 and up.

Jackets/Covers: Assigns 200 freelance illustration jobs/year. Pays by the project, $2,000-5,000.

Text Illustration: Pays by the project, $1,500-2,500.

Tips: "In your portfolio, show tearsheets or proofs only of printed covers. Illustrators should research the publisher. Go into a bookstore and look at the books. Gear what you send according to what you see is being used."

☑ ⚑ **SEAL PRESS**, 300 Queen Anne Ave. N. #375, Seattle WA 98109. (206)283-7844. Fax: (206)285-9410. Website: www.sealpress.com. **Contact:** Faith Conlon. Estab. 1976. Publishes hardcover originals, trade paperback originals and reprints. Types of books include multicultural nonfiction, outdoor writing, popular culture, self-help and women's studies. Specializes in writing by women authors only. Publishes 15 titles/year. Recent titles include: *Bruised Hibiscus* and *Real Girl/Real World: Tools for Finding Your True Self.* 100% requires freelance design. Book catalog free upon request.

Needs: Works with 10 designers/year. Prefers local designers. Prefers freelancers experienced in book cover design. 100% of freelance design demands knowledge of Photoshop, PageMaker or QuarkXPress.

First Contact & Terms: Designers send query letter with printed samples. "We like to view portfolios on designer's website." Samples are filed. Responds only if interested. Portfolio review not required if available online. Buys first rights. Finds freelancers through recommendations, other presses and submissions.

Book Design: Assigns 15 freelance design projects/year. Pays for design by the project, $600-800.

Tips: "Please review our website or catalog before submitting samples or querying."

Ⓝ **17TH STREET PRODUCTIONS**, Division of Alloy, 151 W. 26th St., 11th Floor, New York NY 10001. (212)244-4307. **Contact:** Art Director. Independent book producer/packager. Publishes mass market paperback originals. Publishes mainstream fiction, juvenile, young adult, self-help and humor. Publishes 125 titles/year. Recent titles include: *Roswell High*, *Sweet Valley High*, *Sweet Valley Twins* series, *Summer* series and *Bonechillers* series. 80% require freelance illustration; 25% require freelance design. Book catalog not available.

Needs: Approached by 50 freelance artists/year. Works with 20 freelance illustrators and 5 freelance designers/year. Only uses artists with experience in mass market illustration or design. Uses freelance artists mainly for jacket/cover illustration and design. Also uses freelance artists for book design. Works on assignment only.

First Contact & Terms: Send query letter with résumé, SASE, tearsheets, photographs and photocopies. Samples are filed or returned by SASE if requested by artist. Responds to the artist only if interested. To show portfolio, mail original/final art, slides dummies, tearsheets and transparencies. Sometimes requests work on spec before assigning a job. Rights purchased vary according to project. Originals are returned at job's completion.

Jackets/Covers: Assigns 10 freelance design and 50-75 freelance illustration jobs/year. Only criteria for media and style is that they reproduce well.

Tips: "Know the market and have the professional skills to deliver what is requested on time. Book publishing is becoming very competitive. Everyone seems to place a great deal of importance on the cover design as that affects a book's sell through in the book stores."

Ⓝ **SIMON & SCHUSTER**, Division of Viacom, 1230 Avenue of the Americas, New York NY 10020. (212)698-7000. Fax: (212)698-7007. Website: www.simonsays.com. **Contact:** Art Director. Imprints include Pocket Books, Minstrel and Archway. Company publishes hardcover, trade paperback and mass market paperback originals, reprints and textbooks. Types of books include juvenile, preschool, romance, self-help, young adult and many others. Specializes in young adult, romance and self help. 95% require freelance illustration; 80% require freelance design.

Needs: Works with 50 freelance illustrators and 5 designers/year. Prefers freelancers with experience working with models and taking direction well. Uses freelancers for hand lettering, jacket/cover illustration and design and book design. 100% of design and 75% of illustration demand knowledge of Illustrator and Photoshop. Works on assignment only.

First Contact & Terms: Send query letter with tearsheets. Accepts disk submissions. Samples are filed and are not returned. Responds only if interested. Portfolios may be dropped off every Monday and Wednesday and should include tearsheets. Buys all rights. Originals are returned at job's completion.

Text Illustration: Assigns 50 freelance illustration jobs/year.

SOUNDPRINTS, 353 Main Ave., Norwalk CT 06851-1552. (203)846-2274. Fax: (203)846-1776. Website: www.soundprints.com. **Art Director:** Martin Pilchowski. Associate Publisher: Ashley Andersen. Assistant Editor: Chelsea Shriver. Estab. 1989. Company publishes hardcover originals. Types of books include juvenile. Specializes in wildlife, worldwide habitats, social studies and history. Publishes 12-14 titles/year. Recent titles include: *Screech Owl at Midnight Hollow*, by Drew Lamm; *Koala Country*, by Deborah Dennand; and *Box Turtle At Silver Pond Lane*, by Susan Korman. 100% require freelance illustration. Book catalog free for 9×12 SAE with $1.21 postage.

Needs: Works with 8-10 freelance illustrators/year. Prefers freelancers with experience in realistic wildlife illustration and children's books. Heavy visual research required of artists. Uses freelancers for illustrating children's books (cover and interior).

First Contact & Terms: Send query letter with samples, tearsheets, résumé and SASE. Samples are filed or returned by SASE if requested by artist. Responds in 1 month. Art director will contact artist for portfolio review if interested. Portfolio should include color final art and tearsheets. Rights purchased vary according to project. Originals are returned at job's completion. Finds artists through agents, sourcebooks, reference, unsolicited submissions.

Text Illustration: Assigns 12-14 freelance illustration jobs/year.

Tips: "Wants realism, not cartoons. Animals illustrated are not anthropomorphic. Artists who love to produce realistic, well-researched wildlife and habitat illustrations, and who care deeply about the environment, are most welcome."

SOURCEBOOKS, INC., 1935 Brookdale Rd., Suite 139, Naperville IL 60563. (630)961-3900. Fax: (630)961-2168. Estab. 1987. Company publishes hardcover and trade paperback originals and ancillary items. Types of books include humor, New Age, nonfiction, fiction, preschool, reference, self-help and gift books. Specializes in business books and gift books. Publishes 150 titles/year. Recent titles include: *Poetry Speaks*; *Echoes of Notre Dame Football*, by Joe Garner; *First Lady*, by Michael Malone. Book catalog free for SAE with $2.86 postage.

Needs: Uses freelancers mainly for ancillary items, journals, jacket/cover design and illustration, text illustration, direct mail, book and catalog design. 100% of design and 25% of illustration demand knowledge of QuarkXPress 4.0, Photoshop 5.0 and Illustrator 8.0. Works on assignment only.

First Contact & Terms: Designers send query letter with photocopies. Illustrators send postcard sample. Accepts disk submissions compatible with Illustrator 8.0, Photoshop 5.0. Send EPS files. Responds only if interested. Request portfolio review in original query. Negotiates rights purchased.

Book Design: Pays by the project.

Jackets/Covers: Pays by the project.

Text Illustration: Pays by the project.

Tips: "We have expanded our list tremendously and are, thus, looking for a lot more artwork. We have terrific distribution in retail outlets and are looking to provide more great-looking material."

✔ **SPARTACUS PUBLISHING, LLC**, (formerly Death's Edge Games), 3906 Grace Ellen Dr., Columbia MO 65202-1739. E-mail: cclark@spartacuspublishing.com. **Art Director:** Thomas Thurman. Senior Editor: Casey Clark. Estab. 2001. Publishes role-playing game books and comedy books. Main style/genre of games: mythology and fantasy. Uses freelance artists mainly for interior art. Publishes 2-3 titles or products/year. Game/product lines include: *Inferno*, *Out of the Abyss*, *Gods of Hell*, *Battle Dragons*, *Arcanum*, *Bestiary* and *Lexicon*. 50% requires freelance illustration.

Needs: Approached by 6-10 illustrators and 0-1 designer/year. Works with 1-2 illustrators/year. Prefers freelancers experienced in b&w line art with good comic book background.

First Contact & Terms: Send query letter with résumé and photocopies. Send 1 sample. Samples are filed. Responds in weeks. Will contact artist for portfolio review if interested. Rights purchased vary according to project. Finds freelancers through conventions and word of mouth.

Visual Design: Assigns 1-2 freelance design jobs/year. Pays for design by the project, $20-600.

✔ **THE SPEECH BIN, INC.**, 1965 25th Ave., Vero Beach FL 32960. (561)770-0007. Fax: (561)770-0006. Website: www.speechbin.com. **Senior Editor:** Jan J. Binney. Estab. 1984. Publishes textbooks and

educational games and workbooks for children and adults. Specializes in tests and materials for treatment of individuals with all communication disorders. Publishes 20-25 titles/year. Recent titles include: *My First Phonics Book* and *American Sign Language Dictionary*, by Julie Buxton and Kelly Godfrey. 50% require freelance illustration; 50% require freelance design. Book catalog available for 8½×11 SAE with $1.48 postage.

Needs: Works with 8-10 freelance illustrators and 2-4 designers/year. Buys 1,000 illustrations/year. Work must be suitable for handicapped children and adults. Uses freelancers mainly for instructional materials, cover designs, gameboards, stickers. Also for jacket/cover and text illustration. Occasionally uses freelancers for catalog design projects. Works on assignment only.

First Contact & Terms: Send query letter with SASE, tearsheets and photocopies. Samples are filed or are returned by SASE if requested by artist. Responds to the artist only if interested. Do not send portfolio; query only. Usually buys all rights. Considers buying second rights (reprint rights) to previously published work. Finds artists through "word of mouth, our authors and submissions by artists."

Book Design: Pays by the project.

Jackets/Covers: Assigns 10-12 freelance design jobs and 10-12 illustration jobs/year. Pays by the project.

Text Illustration: Assigns 6-10 freelance illustration jobs/year. Prefers b&w line drawings. Pays by the project.

SPINSTERS INK BOOKS, P.O. Box 22005, Denver CO 80222. (303)762-7284. Fax: (303)761-5284. E-mail: spinster@spinsters-ink.com. Website: www.spinsters-ink.com. **Production Manager:** Tracy Gilsvik. Corporate Communications Manager: Nina Miranda. Estab. 1978. Company publishes trade paperback originals and reprints. Types of books include contemporary fiction, mystery, biography, young women, reference, history of women, humor and feminist. Specializes in "fiction and nonfiction that deals with significant issues in women's lives from a feminist perspective." Publishes 14 titles/year. Recent titles include: *Voices of the Soft-Bellied Warrior*, by Mary Saracind (memoir); *Look Me in the Eye: Old Women, Aging, & Ageism (nonfiction new expanded edition)*. 50% require freelance illustration; 100% require freelance design. Book catalog free by request.

Needs: Approached by 24 freelancers/year. Works with 6-8 freelance illustrators and 6-8 freelance designers/year. Buys 10-14 freelance illustrations/year. Prefers artists with experience in "portraying positive images of women's diversity." Uses freelance artists for jacket/cover illustration and design, book and catalog design. 100% of freelance work demands knowledge of Illustrator, Photoshop, QuarkXPress or PageMaker. Works on assignment only.

First Contact & Terms: Designers send query letter with résumé. Illustrators send postcard sample with photocopies and SASE. Accepts submissions on disk compatible with QuarkXPress. Samples are filed or are returned by SASE if requested by artist. Responds in 6 weeks. Art Director will contact artist for portfolio review if interested. Portfolio should include b&w and color thumbnails, final art and photographs. Buys first rights. Originals are returned at job's completion. Finds artists through word of mouth and submissions.

Jackets/Covers: Assigns 14 freelance design and 14 freelance illustration jobs/year. Pays by the project, $200-1,000. Prefers "original art with appropriate type treatment, b&w to 4-color. Often the entire cover is computer-generated, with scanned image. Our production department produces the entire book, including cover, electronically."

Text Illustration: Assigns 0-6 freelance illustrations/year. Pays by the project, $75-150. Prefers "b&w line drawings or type treatment that can be converted electronically. We create the interior of books completely using desktop publishing technology on the Macintosh."

Tips: "We're always looking for freelancers who have experience portraying images of diverse women, and who have current technological experience on the computer."

STARBURST PUBLISHERS, P.O. Box 4123, Lancaster PA 17604. (800)441-1456. Fax: (717)293-0939. E-mail: editorial@starburstpublishers.com. Website: www.starburstpublishers.com. **Publisher:** David Robie. Senior Editor: Chad Allen. Estab. 1982. Publishes hardcover originals and trade paperback originals and reprints. Types of books include contemporary and historical fiction, celebrity biography, self help, cookbooks and other nonfiction. Specializes in inspirational and general nonfiction. Publishes 15-20 titles/year. Recent titles include: *Acts: God's Word for the Biblically Inept*. 50% require freelance design; 50% require freelance illustration. Books contain strong, vibrant graphics or artwork. Book catalog available for SAE with 4 first-class stamps.

Needs: Works with 5 freelance illustrators and designers/year. Buys 10 illustrations/year. Prefers artists with experience in publishing and knowledge of mechanical layout. Uses freelancers mainly for jacket/cover design and illustration. Works on assignment only.

First Contact & Terms: Send query letter with tearsheets or samples. Samples are filed or are returned by SASE. Art Director will contact artist for portfolio review if interested. Sometimes requests work on spec before assigning a job. Buys all rights. Considers buying second rights (reprint rights) to previously published artwork. Originals are not returned.

Book Design: Assigns 5-7 freelance design jobs/year. Pays by the project, $200 minimum.

Jackets/Cover: Assigns 10-15 freelance jobs/year. Pays by the project, $200 minimum.

Text Illustration: Assigns 15 illustration jobs/year. Pays by the project, $200 minimum.

STEMMER HOUSE PUBLISHERS, INC., 2627 Caves Rd., Owings Mills MD 21117. (410)363-3690. Fax: (410)363-8459. E-mail: stemmerhouse@home.com. Website: www.stemmer.com. **President:** Barbara Holdridge. Specializes in hardcover and paperback nonfiction, art books, gardening books, juvenile and design resource originals. Publishes 10 titles/year. Recent titles include: *Will You Sting Me? Will You Bite?* and *My Ocean Liner*. Books are "well illustrated." 10% requires freelance design; 75% requires freelance illustration.

Needs: Approached by more than 200 freelancers/year. Works with 4 freelance illustrators and 1 designer/year. Works on assignment only.

First Contact & Terms: Designers send query letter with brochure, tearsheets, SASE, photocopies. Illustrators send postcard sample or query letter with brochure, photocopies, photographs, SASE, slides and tearsheets. Do not send original work. Material not filed is returned by SASE. Call or write for appointment to show portfolio. Responds in 6 weeks. Works on assignment only. Originals are returned to artist at job's completion on request. Negotiates rights purchased.

Book Design: Assigns 1 freelance design and 2 illustration projects/year. Pays by the project, $300-2,000.

Jackets/Covers: Assigns 4 freelance design jobs/year. Prefers paintings. Pays by the project, $300-1,000.

Text Illustration: Assigns 3 freelance jobs/year. Prefers full-color artwork for text illustrations. Pays by the project on a royalty basis.

Tips: Looks for "draftmanship, flexibility, realism, understanding of the printing process." Books are "rich in design quality and color, stylized while retaining realism; not airbrushed. We prefer non-computer. Review our books. Propose a strong picture-book manuscript with your illustrations."

SWAMP PRESS, 15 Warwick Ave., Northfield MA 01360. **Owner:** Ed Rayher. Estab. 1977. Publishes trade paperback originals. Types of books include poetry. Specializes in limited letterpress editions. Publishes 2 titles/year. Recent titles include: *Scripture of Venus* and *Tightrope*. 75% requires freelance illustration. Book catalog not available.

Needs: Approached by 10 illustrators/year. Works with 2 illustrators/year. Prefers freelancers experienced in single and 2-color woodblock/linocut illustration.

First Contact & Terms: Illustrators send query letter with photocopies and SASE. Accepts Mac-compatible disk submissions. Samples are filed or returned by SASE. Responds in 2 months. Rights purchased vary according to project.

Jackets/Covers: Pays for illustration by the project, $20-50.

Text Illustration: Assigns 2 freelance illustration jobs/year. Pays by the project, $20-50 plus copies. Prefers knowledge of letterpress.

Tips: "We are a small publisher of limited edition letterpress printed and hand-bound poetry books. We use fine papers, archival materials and original art."

N JEREMY P. TARCHER, INC., 375 Hudson St., New York NY 10014. (212)366-2000. **Art Director:** David Walker. Estab. 1970s. Imprint of G.P. Penguin Putnam Co. Imprint publishes hardcover and trade paperback originals and trade paperback reprints. Types of books include instructional, New Age, adult contemporary and self-help. Publishes 25-30 titles/year. Recent titles include: *The End of Work*, *The Artist's Way*, *Executive Orders* by Tom Clancy; and *The Temple in the House*. 30% require freelance illustration; 30% require freelance design.

Needs: Approached by 10 freelancers/year. Works with 10-12 freelance illustrators and 4-5 designers/year. Works only with artist reps. Uses jacket/cover illustration. 50% of freelance work demands knowledge of QuarkXPress. Works on assignment only.

First Contact & Terms: Send postcard sample of work or send query letter with brochure, tearsheets and photocopies. Samples are filed. Art Director will contact artist for portfolio review if interested. Portfolio should include book dummy, final art, photographs, roughs, tearsheets and transparencies. Buys first rights or one-time rights. Originals are returned at job's completion. Finds artists through sourcebooks, *Communication Arts*, word of mouth, submissions.

Book Design: Assigns 4-5 freelance design jobs/year. Pays by the project, $800-1,000.

Jackets/Covers: Assigns 4-5 freelance design and 10-12 freelance illustration jobs/year. Pays by the project, $950-1,100.

Text Illustration: Assigns 1 freelance illustration job/year. Pays by the project, $100-500.

⯀ TECHNICAL ANALYSIS, INC., 4757 California Ave. SW, Seattle WA 98116-4499. (206)938-0570. Fax: (206)938-1307. Website: www.traders.com. **Art Director:** Christine Morrison. Estab. 1982. Magazine, books and software producer. Publishes trade paperback reprints and magazines. Types of books include instruction, reference, self-help and financial. Specializes in stocks, options, futures and mutual funds. Publishes 3 titles/year. Recent titles include: *Charting the Stock Market*. Books look "technical, but creative; original graphics are used to illustrate the main ideas." 100% requires freelance illustration; 10% requires freelance design.

Needs: Approached by 100 freelance artists/year. Works with 20 freelance illustrators/year. Buys 100 freelance illustrations/year. Uses freelance artists for magazine illustration. Also uses freelance artists for text illustration and direct mail design. Works on assignment only.

First Contact & Terms: Send query letter with résumé, SASE, tearsheets, photographs and photocopies. Samples are filed. Responds in 2 months. Write to schedule an appointment to show a portfolio. Buys first rights or reprint rights. Most originals are returned to artist at job's completion.

Book Design: Assigns 5 freelance design, 100 freelance illustration jobs/year. Pays by project, $30-230.

Jackets/Covers: Assigns 1 freelance design, 15 freelance illustration jobs/year. Pays by project $30-230.

Text Illustration: Assigns 5 freelance design and 100 freelance illustration jobs/year. Pays by the hour, $50-90; by the project, $100-140.

☑ TEHABI BOOKS, INC., 4920 Carroll Canyon Rd., Suite 200, San Diego CA 92121. (858)450-9100. Fax: (858)450-9146. E-mail: nancy@tehabi.com. Website: www.tehabi.com. **Editorial Director:** Nancy Cash. Art Director: Curt Boyer. Senior Art Director: Josie Delker. Estab. 1992. Publishes softcover, hardcover, trade. Specializes in design and production of large-format, visual books. Works hand-in-hand with publishers, corporations, institutions and nonprofit organizations to identify, develop, produce and market high-quality visual books for the international market place. Produces lifestyle/gift books; institutional books; corporate-sponsored books and CD-ROMs. Publishes 12 titles/year. Recent titles include: *Titanic, Legacy of the World's Greatest Ocean Liner*, by Susan Wels; *Hooked: America's Passion for Bass Fishing*; and *Cleopatra's Palace*.

Needs: Approached by 50 freelancers/year. Works with 75-100 freelance photographers and illustrators/year. Freelancers should be familiar with PageMaker, Illustrator, QuarkXPress, Photoshop, FreeHand and 3-D programs. Works on assignment only. 3% of titles require freelance art direction.

First Contact & Terms: Send query letter with résumé, samples. "Give a follow-up call." Rights purchased vary according to project. Finds artists through sourcebooks, publications and submissions.

Text Illustration: Pays by the project, $100-10,000.

⯀ ⯀ ⯀ THISTLEDOWN PRESS LTD., 633 Main St., Saskatoon, Saskatchewan S7H 0J8 Canada. (306)244-1722. Fax: (306)244-1762. E-mail: tdpress@shaw.ca. Website: www.thistledown.sk.ca. **Director, Production:** Allan Forrie. Estab. 1975. Publishes trade and mass market paperback originals. Types of books include contemporary and experimental fiction, juvenile, young adult and poetry. Specializes in poetry creative and young adult fiction. Publishes 10-12 titles/year. Titles include *Ariadne's Dream*, by Tess Gragoulis; *Prisoner in a Red-Rose Chain*, by Jeffrey Moore. Book catalog for SASE.

Needs: Approached by 25 freelancers/year. Works with 8-10 freelance illustrators/year. Prefers local, Canadian freelancers. Uses freelancers for jacket/cover illustration. Uses only Canadian artists and illustrators for its title covers. Works on assignment only.

First Contact & Terms: Designers send query letter with résumé and photocopies. Illustrators send postcard samples. Samples are filed or are returned by SASE. Responds to the artist only if interested. Call for appointment to show portfolio of original/final art, tearsheets, photographs, slides and transparencies. Buys one-time rights.

Jackets/Covers: Assigns 10-12 illustration jobs/year. Prefers painting or drawing, "but we have used tapestry—abstract or expressionist to representational." Also uses 10% computer illustration. Pays by the project, $250-600.

Tips: "Look at our books and send appropriate material. More young adult and adolescent titles are being published, requiring original cover illustration and cover design. New technology (Illustrator, Photoshop) has slightly altered our cover design concepts."

TORAH AURA PRODUCTIONS/ALEF DESIGN GROUP, 4423 Fruitland Ave., Los Angeles CA 90058. (213)585-7312. Fax: (213)585-0327. E-mail: jane@torahaura.com. Website: www.torahaura.com. **Art Director:** Jane Golub. Estab. 1981. Publishes hardcover and trade paperback originals, textbooks. Types of books include children's picture books, cookbooks, juvenile, nonfiction and young adult. Specializes in Judaica titles. Publishes 15 titles/year. Recent titles include: *S'fatai Tiftan (Open My Lips)* and *I Have Some Questions About God*. 85% requires freelance illustration. Book catalog free for 9×12 SAE with 10 first-class stamps.

Needs: Approached by 50 illustrators and 20 designers/year. Works with 5 illustrators/year.

First Contact & Terms: Illustrators send postcard sample and follow-up postcard every 6 months, printed samples, photocopies. Accepts Windows-compatible disk submissions. Samples are filed. Will contact artist for portfolio review if interested. Rights purchased vary according to project. Finds freelancers through submission packets.

Jackets/Covers: Assigns 6-24 illustration jobs/year. Pays by the project.

■ **TREEHAUS COMMUNICATIONS, INC.,** 906 W. Loveland Ave., P.O. Box 249, Loveland OH 45140. (513)683-5716. Fax: (513)683-2882. E-mail: treehaus1@earthlink.net. Website: www.treehaus1.c om. **President:** Gerard Pottebaum. Estab. 1973. Publisher. Specializes in books, periodicals, texts, TV productions. Product specialties are social studies and religious education. Recent titles include: *The Stray* and *Rosanna The Rainbow Angel* for children ages 4-8.

Needs: Approached by 12-24 freelancers/year. Works with 2 or 3 freelance illustrators/year. Prefers freelancers with experience in illustrations for children. Works on assignment only. Uses freelancers for all work. Also for illustrations and designs for books and periodicals. 5% of work is with print ads. Needs computer-literate freelancers for illustration.

First Contact & Terms: Send query letter with résumé, transparencies, photocopies and SASE. Samples sometimes filed or are returned by SASE if requested by artist. Responds in 1 month. Art director will contact artist for portfolio review if interested. Portfolio should include final art, tearsheets, slides, photostats and transparencies. Pays for design and illustration by the project. Rights purchased vary according to project. Finds artists through word of mouth, submissions and other publisher's materials.

Tips: "We are looking for original style that is developed and refined. Whimsy helps."

TROLL COMMUNICATIONS, Publishing Division, 100 Corporate Dr., Mahwah NJ 07430. (201)529-4000. Fax: (201)529-4237. Website: www.troll.com. **Art Director:** Tom Westburgh. Specializes in hardcovers and paperbacks for juveniles (6- to 14-year-olds). Publishes more than 100 titles/year. Recent titles include: *I Love You, Stinky Face, The Blobheads* and *Neeny Coming, Neeny Going*. 30% require freelance design and illustrations.

Needs: Works with 10 freelancers/year. Prefers freelancers with 2-3 years of experience. Works on assignment only.

First Contact & Terms: Send query letter with brochure/flier, résumé and tearsheets or photostats. Don't send original art. Samples returned by SASE only if requested. Responds in 1 month. Considers complexity of project, skill and experience of artist, budget and rights purchased when establishing payment. Buys all rights or negotiates rights purchased. Originals usually not returned at job's completion.

☑ **TSR, INC.,** a subsidiary of Wizards of the Coast, P.O. Box 707, Renton WA 98057-0707. (425)204-9289. Fax: (425)204-5869. Website: www.wizards.com. **Contact:** Art Submissions. Estab. 1975. Produces games, books and calendars. "We produce the *Dungeons & Dragons*® roleplaying game and the game worlds and fiction books that support it."

Needs: Art guidelines free with SASE or on website. Works on assignment only. Uses freelancers for book and game covers and interiors and trading card game art. Considers any media. "Artists interested in cover work should show us tight, action-oriented 'realistic' renderings of fantasy or science fiction subjects in oils or acrylics."

First Contact & Terms: "Send cover letter with contact information and 6-10 pieces, color copies or copies of black & white work. Do not send originals—they will be returned without review. If you wish to have your portfolio returned, send a SASE."

Tips: Finds artists through submissions, reference from other artists and by viewing art on display at the annual Gencon® Game Fair in Milwaukee, Wisconsin. "Be familiar with the adventure game industry in general and our products in particular. Make sure pieces in portfolio are tight, have good color and technique."

TWENTY-FIRST CENTURY BOOKS/A DIVISION OF MILLBROOK PRESS, INC., 2 Old New Milford Rd., Brookfield CT 06804. (203)740-2220. Fax: (203)775-5643. Website: www.millbrookpress.c om. **Art Director:** Judie Mills. Estab. 1986. Publishes hardcover originals. Types of books include juvenile, young adult and nonfiction for school and library market. Specializes in biography, social studies, drug education and science. Publishes 25-38 titles/year. Recent titles include: *The Glass Ceiling* and *Confederate Ladies of Richmond. 60% requires freelance illustration.*

Needs: Approached by up to 10 freelance artists/year. Works with 3-10 freelance illustrators/year. Buys 100-200 freelance illustrations/year. Prefers artists with experience in realistic narrative illustration. Uses freelance artists mainly for jacket/cover and text illustration. Works on assignment only.

First Contact & Terms: Send query letter with tearsheets and any nonreturnable samples. Samples are filed. Responds only if interested. Write to schedule an appointment to show portfolio or mail tearsheets. Rights purchased vary according to project. Originals returned at job's completion.

Book Design: Assigns 5-20 freelance illustration jobs/year.

Jackets/Covers: Assigns 10-15 freelance illustration jobs/year. Pays by the project.

Text Illustration: Assigns 10-20 freelance illustration jobs/year. Pays by the project.

Tips: "Be competent, with a professional manner and a style that fits the project."

TYNDALE HOUSE PUBLISHERS, INC., 351 Executive Dr., Carol Stream IL 60189. (630)668-8300. E-mail: talinda_laubach@tyndale.com. Website: www.tyndale.com. **Art Buyer:** Talinda M. Laubach. Vice President, Production: Joan Major. Specializes in hardcover and paperback originals as well as children's books on "Christian beliefs and their effect on everyday life." Publishes 200 titles/year. 50% require freelance illustration. Books have "high quality innovative design and illustration." Recent titles include: *Desecration* and *Bringing Up Boys.*

Needs: Approached by 50-75 freelance artists/year. Works with 30-40 illustrators and cartoonists/year.

First Contact & Terms: Send query letter, tearsheets and/or slides. Samples are filed or are returned by SASE. Responds only if interested. Considers complexity of project, skill and experience of artist, project's budget and rights purchased when establishing payment. Negotiates rights purchased. Originals are returned at job's completion except for series logos.

Jackets/Covers: Assigns 40 illustration jobs/year. Prefers progressive but friendly style. Pays by the project.

Text Illustration: Assigns 10 jobs/year. Prefers progressive but friendly style. Pays by the project.

Tips: "Only show your best work. We are looking for illustrators who can tell a story with their work and who can draw the human figure in action when appropriate." A common mistake is "neglecting to make follow-up calls. Be able to leave sample(s). Be available; by friendly phone reminders, sending occasional samples. Schedule yourself wisely, rather than missing a deadline."

UAHC PRESS, 633 Third Ave., New York NY 10017. (212)249-0100. E-mail: SBenick@UAHC.org. **Managing Director:** Stuart L. Benick. Produces books and magazines for Jewish school children and adult education. Recent titles include: *Good Morning Good Night*, by Michelle Shapiro Abraham.

Needs: Approached by 20 freelancers/year.

First Contact & Terms: Send samples or write for interview. Include SASE.

Jackets/Covers: Pays by the project, $250-600.

Text Illustration: Pays by the project, $150-200.

Tips: Seeking "clean and catchy" design and illustration.

N⃞ UNIVELT INC., Box 28130, San Diego CA 92198. (760)746-4005. Fax: (760)746-3139. Website: www.univelt.com. **Manager:** R.H. Jacobs. Publishes hardcover and paperback originals on astronautics and related fields for the American Astronautical Society. Specializes in space. Publishes 10 titles/year; all have illustrations. Titles include *Spaceflight Mechanics, Guidance and Control, Space Programs and Fiscal Reality.* Books have "glossy covers with illustrations." Book catalog free by request.

Needs: Prefers local freelancers. Sometimes uses freelancers for covers, title sheets, dividers, occasionally a few illustrations.

First Contact & Terms: Please call before making any submissions. "We have been only using local sources." Responds in 1 month to unsolicited submissions. Buys one-time rights. Originals are returned at job's completion.

Jackets/Covers: Assigns 10 freelance design and 10 illustration jobs/year. Pays $50-100 for front cover illustration or frontispiece.

Text Illustration: Pays by the project, $50-100.

Tips: "Books usually include a front cover illustration and frontispiece. Illustrations have to be space-related. We obtain most of our illustrations from authors and from NASA. We usually do not use freelance sources."

N⃞ THE UNIVERSITY OF ALABAMA PRESS, Box 870380, Tuscaloosa AL 35487-0380. (205)348-5180 or (205)348-1571. Fax: (205)348-9201. E-mail: rcook@uapress.ua.edu. Website: www.uapress.ua.edu. **Production Manager:** Rick Cook. Designer: Michelle Myatt Quinn. Specializes in hardcover and paperback originals and reprints of academic titles. Publishes 55 titles/year. Recent titles include: *Whiskey Man*, by Howell Raines; *Traces of Gold*, by Nicolas S. Witschi; and *Mark Twain in the Margins*, by Joe B. Fulton. 5% requires freelance design.

Needs: Works with 1-2 freelancers/year. Requires book design experience, preferably with university press work. Works on assignment only. 100% of freelance design demands knowledge of PageMaker 6.5, Photoshop 5.0, QuarkXPress and Illustrator.

First Contact & Terms: Send query letter with résumé, tearsheets and slides. Accepts disk submissions if compatible with Macintosh versions of above programs, provided that a hard copy that is color accurate

is also included. Samples not filed are returned only if requested. Responds in a few days. To show portfolio, mail tearsheets, final reproduction/product and slides. Considers project's budget when establishing payment. Buys all rights. Originals are not returned.

Book Design: Assigns several freelance jobs/year. Pays by the project, $600 minimum.

Jackets/Covers: Assigns 5-6 freelance design jobs/year. Pays by the project, $600 minimum.

Tips: Has a limited freelance budget. "We often need artwork that is abstract or vague rather than very pointed or focused on an obvious idea. For book design, our requirements are that they be classy and, for the most part, conservative."

THE UNIVERSITY OF NEBRASKA PRESS, 233 N. Eighth St., Lincoln NE 68588-0255. (402)472-3581. Fax: (402)472-0308. Website: www.unl.edu/UP/home.htm. **Production Manager:** Debra K. Turner. Estab. 1941. Publishes hardcover originals and trade paperback originals and reprints. Types of books include history, musicology, translations. Specializes in Western history, American Indian ethnohistory, Judaica, nature, Civil War, sports history, women's studies. Publishes 150 titles/year. Recent titles include: *Phantom Limb*, by Sternburg; *Turtle Lung*, by Red Shirt; *Grant's Secret Service*, by Feis. 5-10% require freelance illustration; 20% require freelance design. Book catalog free by request and available online.

Needs: Approached by 10 freelancers/year. Works with 2-3 freelance illustrators/year. Prefers freelancers experienced in 4-color, action in Civil War, basketball or Western topics. "We must use Native American artists for books on that subject." Uses freelancers for jacket/cover illustration. Works on assignment only.

First Contact & Terms: Send query letter with photocopies. Samples are filed. Responds to the artist only if interested. Buys one-time rights. Originals are returned at job's completion.

Jackets/Covers: Assigns 2-3 illustration jobs/year. Usually prefers realistic, western, action styles. Pays by the project, $200-500.

UNIVERSITY OF OKLAHOMA PRESS, 1005 Asp Ave., Norman OK 73019. (405)325-2000. Fax: (405)325-4000. E-mail: gcarter@ou.edu. Website: www.oupress.com. **Design Manager:** Gail Carter. Estab. 1927. Company publishes hardcover and trade paperback originals, reprints and textbooks. Types of books include biography, coffee table books, history, nonfiction, reference, textbooks, western. Specializes in western/Indian nonfiction. Publishes 100 titles/year. 75% requires freelance illustration (for jacket/cover). 5% requires freelance design. Book catalog free by request.

Needs: Approached by 50-100 freelancers/year. Works with 40-50 freelance illustrators and 10-15 designers/year. "We cannot commission work, must find existing art." Uses freelancers mainly for jacket/cover illustrations. Also for jacket/cover and book design. 25% of freelance work demands knowledge of PageMaker, Illustrator, QuarkXPress, Photoshop, FreeHand, CorelDraw and Ventura.

First Contact & Terms: Send query letter with brochure, résumé and photocopies. Samples are filed. Does not reply. Design Manager will contact artist for portfolio review if interested. Portfolio should include book dummy and photostats. Buys reprint rights. Originals are returned at job's completion. Finds artists through submissions, attending exhibits, art shows and word of mouth.

Book Design: Assigns 5-10 freelance design jobs/year. Pays by the project.

Jackets/Covers: Assigns 15-20 freelance design jobs/year. Pays by the project.

UNIVERSITY OF PENNSYLVANIA PRESS, 4200 Pine St., Philadelphia PA 19104-4011. (215)898-6261. Fax: (215)898-0404. E-mail: cgross@pobox.upenn.edu. Website: www.upenn.edu/pennpress/. **Design Director:** John Hubbard. Estab. 1920. Publishes audio tapes, CD-ROMs and hardcover originals. Types of books include biography, history, nonfiction, landscape architecture, art history, anthropology, literature and regional history. Publishes 70 titles/year. Recent titles include: *Bootleggers and Smuthounds* and *Red Planet*. 90% requires freelance design. Book catalog free for 8½ × 11 SASE with 5 first-class stamps.

Needs: Works with 7 designers/year. 100% of freelance work demands knowledge of Illustrator, Photoshop, FreeHand and QuarkXPress.

First Contact & Terms: Designers send query letter with photocopies. Illustrators send postcard sample. Accepts Mac-compatible disk submissions. Samples are not filed and are returned. Will contact artist for portfolio review if interested. Portfolio should include book dummy and photocopies. Rights purchased vary according to project. Finds freelancers through submission packets and word of mouth.

Book Design: Assigns 10 freelance design jobs/year. Pays by the project, $600-1,000.

Jackets/Covers: Assigns 60 freelance design jobs/year. Pays by the project, $500-1,000.

VAN DER PLAS PUBLICATIONS, INC., 1282 Seventh Ave., San Francisco CA 94112-2526. (415)665-8214. Fax: (415)753-8572. E-mail: rob@vanderplas.net. Website: www.vanderplas.net. **Editor:** Rob Van der Plas. Estab. 1985. Book publisher. Publishes trade paperback originals. Types of books include

instructional and travel. Specializes in subjects relating to cycling and bicycles. Publishes 6 titles/year. Recent titles include: *Baseball's Hitting Secrets*, *Play Golf in the Zone* and *Bicycle Collectibles*. 20% require freelance illustration. Book catalog for SASE with first-class postage.

Needs: Approached by 5 freelance artists/year. Works with 2 freelance illustrators/year. Buys 100 freelance illustrations/year. Uses freelance artists mainly for technical (perspective) and instructions (anatomically correct hands, posture). Also uses freelance artists for text illustration; line drawings only. Also for design. 50% of freelance work demands knowledge of CorelDraw and FreeHand. Works on assignment only.

First Contact & Terms: Send query letter with tearsheets. Accepts disk submissions. Please include print-out with EPS files. Samples are filed. Call "but only after we have responded to query." Portfolio should include photostats. Rights purchased vary according to project. Originals are not returned to the artist at the job's completion.

Book Design: Pays by the project.

Text Illustration: Assigns 5 freelance illustration jobs/year. Pays by the project.

Tips: "Show competence in line drawings of technical subjects and 2-color maps."

⧉ VIDA PUBLISHERS, Division of Zondervan/HarperCollins, 8325 NW 53rd St., Suite 100, Miami FL 33166. (305)463-8432. Fax: (305)463-0278. Website: www.editorialvida.com. **Art Director:** Nahum Saez. Estab. 1946. Publishes trade paperback originals and reprints, mass market paperback originals, textbooks, music, audio tapes. Types of book include religious, bibles. Publishes 75 Spanish, 30 French titles/year Recent titles include: *El Caso de Cristo*, by Lee Strobel; and *Dios es Relevante*, by Luis Palau. 25% require freelance design.

Needs: Approached by 13 freelance illustrators and 10 freelance designers/year. Works with 3 freelance illustrators and 5 freelance designers/year. Prefers freelancers experienced in Macintosh environment. Uses freelancers mainly for book cover and promotional material such as catalogs, brochures, ads, posters, etc. 100% of freelance design and 50% of illustration demand knowledge of Photoshop, Illustrator, QuarkX-Press.

First Contact & Terms: Designers should send query letter with photographs, résumé, tearsheets. Illustrators should send postcard sample and/or query letter with résumé, photographs, slides, tearsheets and/or transparencies. Accepts disk submissions compatible with above programs. Samples are filed or are returned. Responds only if interested. Art director will contact artist for portfolio review if interested. Portfolio should include photographs, tearsheets, transparencies. Buys all rights.

Jacket/Covers: Pays for design by the project, $400-1,000. Pays for illustration by the project, $200-500.

Tips: "It is helpful if artist has knowledge of producing a finished electronic mechanical, creating special effects in Photoshop and, most importantly, has knowledge of good design."

VOYAGEUR PRESS, 123 N. Second St., Stillwater MN 55082-5002. (651)430-2210. Fax: (651)430-2211. E-mail: books@voyageurpress.com. Website: www.voyageurpress.com. **Editorial Director:** Michael Dregni. Pre-Press Director: Andrea Rud. Estab. 1973. Book publisher. Publishes hardcover and trade paperback originals. Types of books include Americana, collectibles, travel, cookbooks, natural history and regional. Specializes in natural history, travel and regional subjects. Publishes 50 titles/year. Recent titles include: *Global Warming* and *The Big Book of Caterpillar*. 10% require freelance illustration; 10% require freelance design. Book catalog free by request.

Needs: Approached by 100 freelance artists/year. Works with 2-5 freelance illustrators and 2-5 freelance designers/year. Prefers artists with experience in maps and book and cover design. Uses freelance artists mainly for cover and book design. Also uses freelance artists for jacket/cover illustration and direct mail and catalog design. 100% of design requires computer skills. Works on assignment only.

First Contact & Terms: Send postcard sample and/or query letter with brochure, photocopies, SASE and tearsheets, list of credits and nonreturnable samples of work that need not be returned. Samples are filed. Responds to the artist only if interested. "We do not review portfolios unless we have a specific project in mind. In that case, we'll contact artists for a portfolio review." Usually buys first rights. Originals returned at job's completion.

Book Design: Assigns 2-5 freelance design jobs and 2-5 freelance illustration jobs/year.

Jackets/Covers: Assigns 2-5 freelance design and 2-5 freelance illustration jobs/year.

Text Illustration: Assigns 2-5 freelance design and 2-5 design illustration jobs/year.

Tips: "We use more book designers than artists or illustrators, since most of our books are illustrated with photographs."

▣ W PUBLISHING GROUP, (formerly Word Publishing), 545 Marriott Dr., Suite 750, Nashville TN 37214. Fax: (615)902-3206. E-mail: twilliams@wpublishinggroup.com. Website: www.wpublishing.com. **Executive Art Director:** Tom Williams. Estab. 1951. Imprints include Word Bibles. Company publishes hardcover, trade paperback and mass market paperback originals and reprints; audio and video. Types of books include biography, fiction, nonfiction, religious, self-help and sports biography. "All books have a

strong Christian content—including fiction." Publishes 65 titles/year. Recent titles include: *Stories of the Heart and Home*, by James Dobson; *He Chose the Nails*, by Max Lucado and *The Wounded Spirit*, by Frank Peretti. 30-35% require freelance illustration; 100% require freelance design.

Needs: Approached by 700 freelancers/year. Works with 20 freelance illustrators and 30 designers/year. Buys 20-30 freelance illustrations/year. Uses freelancers mainly for book cover and packaging design. Also for jacket/cover illustration and design and text illustration. 100% of design and 10% of illustration demand knowledge of Illustrator, QuarkXPress and Photoshop. Works on assignment only.

First Contact & Terms: Prefer e-mail with link to website. Send query letter with SASE, tearsheets, photographs, photocopies, photostats, "whatever shows artist's work best." Accepts disk submissions, but not preferred. Samples are returned by SASE. Art director will contact artist for portfolio review if interested. Portfolio should include tearsheets and transparencies. Purchases all rights. Originals are returned at job's completion. Finds artists through agents, *Creative Illustration Book*, *American Showcase*, *Workbook*, *Directory of Illustration*.

Jacket/Covers: Assigns 65 freelance design and 20-30 freelance illustration jobs/year. Pays by the project $2,000-5,000. Considers all media—oil, acrylic, pastel, watercolor, mixed.

Text Illustration: Assigns 10 freelance illustration jobs/year. Pays by the project $75-250. Prefers line art.

Tips: "Please do not phone. I'll choose artists who work with me easily and accept direction and changes gracefully. Meeting deadlines is also extremely important. I regret to say that we are not a good place for newcomers to start. Experience and success in jacket design is a must for our needs and expectations. I hate that. How does a newcomer start? Probably with smaller companies. Beauty is still a factor with us. Our books must not only have shelf-appeal in bookstores, but coffee-table appeal in homes."

N **□** **J. WESTON WALCH PUBLISHING**, 321 Valley St., Portland ME 04102. (207)772-2846. Fax: (207)774-7167. Website: www.walch.com. **Art Director:** David Sullivan. Estab. 1927. Company publishes supplementary educational books and other material (video, software, audio, posters, cards, games, etc.). Types of books include instructional and young adult. Specializes in all middle and high school subject areas. Recent titles include: Graphic Organizers for: English classes, science classes, and social studies classes, *Portrait of American Music: Great Twentieth Century Musicians*. Publishes 100 titles/year. 15-25% require freelance illustration. Book catalog free by request.

Needs: Approached by 70-100 freelancers/year. Works with 10-20 freelance illustrators and 5-10 designers/year. Prefers local freelancers only. Uses freelancers mainly for text and/or cover illustrations. Also for jacket/cover design, interior design, typography and typesetting.

First Contact & Terms: Send tearsheets, SASE and photocopies. Samples are filed or returned by SASE. Accepts disk submissions compatible with Photoshop, QuarkXPress, FreeHand or Framemaker. Art Director will contact artist for portfolio review if interested. Portfolio should include final art, roughs and tearsheets. Buys one-time rights. Originals are returned at job's completion. Finds artists through submissions, reviewing with other art directors in the local area.

Jackets/Covers: Assigns 10-15 freelance design and 10-20 illustration jobs/year. Pays by the project, $300-1,500.

Text & Poster Illustration: Pays by the project, $300-4,000.

Tips: "Show a facility with taking subject matter appropriate for middle and high school curriculums and presenting it in a new way."

WARNER BOOKS INC., imprint of AOL Time Warner Book Group, 1271 Avenue of the Americas, New York NY 10020. (212)522-7200. Website: www.twbookmark.com. **Vice President and Creative Director of Warner Books:** Jackie Meyer. Publishes mass market paperbacks and adult trade hardcovers and paperbacks. Publishes 300 titles/year. Recent titles include: *Find Me*, by Rosie O'Donnell; *The Millionaires*, by Brad Meltzer; and *Cancer Schmancer*, by Fran Drescher. 20% requires freelance design; 80% requires freelance illustration.

• Others in the department are Diane Luger, Chris Standish, Carolyn Lechter and Rachel McClain. Send them mailers for their files as well.

Needs: Approached by 500 freelancers/year. Works with 75 freelance illustrators and photographers/year. Uses freelancers mainly for illustration and handlettering. Works on assignment only.

First Contact & Terms: Do not call for appointment or portfolio review. Mail samples only. Send non-returnable brochure or tearsheets and photocopies. Samples are filed. Art Director will contact artist for portfolio review if interested. Negotiates rights purchased. Considers buying second rights (reprint rights) to previously published work. Originals are returned at job's completion (artist must pick up). "Check for most recent titles in bookstores." Finds artists through books, mailers, parties, lectures, judging and colleagues.

Jackets/Covers: Pays for design and illustration by the project. Uses all styles of jacket illustrations.

Tips: Industry trends include "graphic photography and stylized art." Looks for "photorealistic style with imaginative and original design and use of eye-catching color variations. Artists shouldn't talk too much. Good design and art should speak for themselves."

N WHALESBACK BOOKS, Box 9546, Washington DC 20016. (202)333-2182. Fax: (202)333-2184. **Publisher:** W.D. Howells. Estab. 1988. Imprint of Howells House. Company publishes hardcover and trade paperback originals and reprints. Types of books include biography, history, art, architecture, social and human sciences. Publishes 2-4 titles/year. 80% require freelance illustration; 80% require freelance design.
Needs: Approached by 6-8 freelance artists/year. Works with 1-2 freelance illustrators and 1-3 freelance designers/year. Buys 10-20 freelance illustrations/job. Prefers local artists with experience in color and desktop. Uses freelance artists mainly for illustration and book/jacket designs. Also uses freelance artists for jacket/cover illustration and design; text, direct mail, book and catalog design. 20-40% of freelance work demands knowledge of PageMaker, Illustrator or QuarkXPress. Works on assignment only.
First Contact & Terms: Send query letter with brochure, SASE and photocopies. Samples are not filed and are returned by SASE if requested by artist. Responds only if interested. Art Director will contact artist for portfolio review if interested. Portfolio should include b&w roughs and photostats. Rights purchased vary according to project.
Book Design: Assigns 2-4 freelance design jobs/year. Pays by the project.
Jackets/Covers: Assigns 2-4 freelance design jobs/year. Pays by the project.
Text Illustration: Assigns 6-8 freelance illustration jobs/year. Pays by the project.

N WHITE MANE PUBLISHING COMPANY, INC., 63 W. Burd St., P.O. Box 708, Shippensburg PA 17257. (717)532-2237. Fax: (717)532-6110. **Vice President:** Harold Collier. Estab. 1987. Publishes hardcover originals and reprints, trade paperback originals and reprints. Types of books include biography, history, juvenile, nonfiction, religious, self-help and young adult. Publishes 70 titles/year. 10% requires freelance illustration; 50% requires freelance design. Book catalog free with SASE.
Needs: Works with 2-8 illustrators and 2 designers/year.
First Contact & Terms: Illustrators and designers send query letter with printed samples. Samples are filed. Responds only if interested. Will contact artist for portfolio review if interested. Rights purchased vary according to project. Finds freelancers through submission packets and postcards.
Jackets/Covers: Assigns 10 freelance design jobs and 2 illustration jobs/year. Pays for design by the project.

N WHITE WOLF PUBLISHING, 735 Park N. Blvd., Suite 128, Clarkston GA 30021. (404)292-1819. Fax: (404)292-9426. Website: www.white-wolf.com. Estab. 1986. Imprints include Borealis, World of Darkness. Publishes hardcover originals, trade and mass market paperback originals and reprints. Types of books include experimental fiction, fantasy, horror, science fiction. Specializes in alternative horror and dark fantasy. Publishes 24 titles/year. Recent titles include: *Lankhmar Series*, by Fritz Leiber; *The Eternal Champion Series*, by Michael Moorcock. 65% require freelance illustration. Book catalog free.
Needs: Approached by 50 illustrators/year. Works with 20 illustrators/year. Prefers freelancers experienced in 4-color, b&w, and photo collage. Uses freelancers mainly for book covers and some interior illustration.
First Contact & Terms: Send photocopies, photographs, photostats and/or printed samples. Send follow-up postcard every year. Accepts disk submissions from illustrators. Samples are filed or returned by SASE. Responds only if interested. Buys all rights.
Jackets/Covers: Assigns 20 freelance illustration jobs/year. Pays for illustration by project, $500-2,000. Prefers collage, figurative, painterly, and/or experimental work.
Text Illustration: Assigns 2 freelance illustration jobs/year. Pays by project, $50-100. Prefers line art and figurative work. Finds freelancers through submissions, conventions and word of mouth.
Tips: "We are looking for work that is experimental and unusual."

N ALBERT WHITMAN & COMPANY, 6340 Oakton, Morton Grove IL 60053-2723. **Editor:** Kathleen Tucker. Art Director: Scott Piehl. Specializes in hardcover original juvenile fiction and nonfiction—many picture books for young children. Publishes 25 titles/year. Recent titles include: *Mabella the Clever*, by Margaret Read MacDonal; and *Bravery Soup*, by Maryann Cocca-Leffle. 100% requires freelance illustration. Books need "a young look—we market to preschoolers and children in grades 1-3."
Needs: Prefers working with artists who have experience illustrating juvenile trade books. Works on assignment only.
First Contact & Terms: Illustrators send postcard sample and tearsheets. "One sample is not enough. We need at least three. Do *not* send original art through the mail." Accepts disk submissions. Samples are

not returned. Responds "if we have a project that seems right for the artist. We like to see evidence that an artist can show the same children and adults in a variety of moods, poses and environments." Rights purchased vary. Original work returned at job's completion.

Cover/Text Illustration: Cover assignment is usually part of text illustration assignment. Assigns 2-3 covers per year. Prefers realistic and semi-realistic art. Pays by flat fee for covers; royalties for picture books.

Tips: Especially looks for "an artist's ability to draw people, especially children and the ability to set an appropriate mood for the story."

WILLIAMSON PUBLISHING, P.O. Box 185, Charlotte VT 05445. (802)425-2102. E-mail: jean@willi amsonbooks.com. Website: www.williamsonbooks.com. **Editorial Director:** Susan Williamson. Production Manager: Dana Pierson. Estab. 1983. Publishes trade paperback originals. Types of books include children's nonfiction (science, history, the arts), creative play, early learning, preschool and educational. Specializes in children's active hands-on learning. Publishes 15 titles/year. Recent titles include: *Paper-Folding Fun*, *All Around Town*, *Scrapbooks & Photo Albums*, *Garden Fun*, *40 Knots to Know* and *Fun Frames*. Book catalog free for 8½ × 11 SASE with 5 first-class stamps.

Needs: Approached by 400 illustrators and 10 designers/year. Works with 25 illustrators and 15 designers/year. 100% of freelance design demands computer skills. "We especially need illustrators with a vibrant black & white style—and with a sense of humor evident in illustrations." All illustrations must be provided in scanned, electronic form.

First Contact & Terms: Designers send query letter with brochure, photocopies, résumé, SASE. Illustrators send postcard sample and/or query letter with photocopies, résumé and SASE. Samples are filed. Responds only if interested.

Book Design: Pays for design and illustration by the project.

Tips: "We are actively seeking freelance illustrators and book designers to support our growing team. We are looking for mostly black & white and some 2-color illustration—step-by-step how-to (always done with personality as opposed to technical drawings). Go to the library and look up several of our books in our four series. You'll immediately see what we're all about. Then do a few samples for us. If we're excited about your work, you'll definitely hear from us. We always need designers who are interested in a non-traditional approach to kids' book design. Our books are award-winners and design and illustration are key elements to our books' phenomenal success."

WILSHIRE BOOK CO., 12015 Sherman Rd., North Hollywood CA 91605. (818)765-8579. E-mail: mpowers@mpowers.com. Website: www.mpowers.com. **President:** Melvin Powers. Company publishes trade paperback originals and reprints. Types of books include biography, humor, instructional, New Age, psychology, self-help, inspirational and other types of nonfiction. Publishes 25 titles/year. Recent titles include: *Think Like a Winner!*, *The Princess Who Believed in Fairy Tales* and *The Knight in Rusty Armor*. 100% require freelance design. Catalog for SASE with first-class stamps.

Needs: Uses freelancers mainly for book covers, to design cover plus type. Also for direct mail design. "We need graphic design ready to give to printer. Computer cover designs are fine."

First Contact & Terms: Send query letter with fee schedule, tearsheets, photostats, photocopies (copies of previous book covers). Portfolio may be dropped off every Monday-Friday. Portfolio should include book dummy, slides, tearsheets, transparencies. Buys first, reprint or one-time rights. Interested in buying second rights (reprint rights) to previously published work. Negotiates payment.

Book Design: Assigns 25 freelance design jobs/year.

Jackets/Covers: Assigns 25 cover jobs/year.

WINDSTORM CREATIVE, (formerly Pride & Imprints), 7419 Ebbert Dr. SE, Port Orchard WA 98367. (360)769-7174. Website: www.windstormcreative.com. **Senior Editor:** Ms. Cris Newport. Publishes books, CD-ROMs, internet guides. Trade paperback. Children's books as well as illustrated novels for adults. Genre work as well as general fiction. Recent titles: *Queen's Champion*, *The Legend of Lancelot Retold*, *The Best Thing*, *Caruso the Mouse*, *Levi: The Smartest Boy in the World* and *Roses & Thorns: Beauty & the Beast Retold*.

Needs: Prefers freelancers. Must provide references and résumé.

First Contact & Terms: See webpage for guidelines. Portfolios submitted without SASE are not reviewed. Does not respond to postcards without return postage. Keep portfolios on file. After receiving guidelines, artists should respond within 30 days with portfolio sample and SASE as well as agreement to guidelines in writing. MUST be able to work on a schedule and meet deadlines. Must be willing to revise and work closely with art director. Artists paid on royalty and retain originals of their own work.

WIZARDS OF THE COAST, P.O. Box 707, Renton WA 98057-0707. (425)204-7289. Website: www.wi zards.com. **Attn:** Artist Submissions. Estab. 1990.

• Because of large stable of artists, very few new artists are being given assignments.

Needs: Prefers freelancers with with experience in fantasy art. Art guidelines available for SASE or on website. Works on assignment only. Uses freelancers mainly for cards, posters, books. Considers all media. Looking for fantasy, science fiction portraiture art. 100% of design demands knowledge of Photoshop, Illustrator, FreeHand, QuarkXPress. 30% of illustration demands computer skills.

First Contact & Terms: Illustrators send query letter with 6-10 non-returnable full color or b&w pieces. Accepts submissions on disk. "We do not accept original artwork." Will contact for portfolio review if interested. Portfolios should include color, finished art or b&w pieces, photographs and tearsheets. Rights purchased vary according to project. Pays for design by the project, $300 minimum. Payment for illustration and sculpture depends on project. Finds freelancers through conventions, submissions and referrals.

Tips: "Remember who your audience is. Not everyone does 'babe' art."

WRIGHT GROUP-McGRAW HILL, Parent company: The Chicago Tribune, 19201 120th Ave. NE, Bothell WA 98011. (425)486-8011. Website: www.wrightgroup.com. **Art Directors:** Debra Lee and Patty Andrews. Publishes educational children's books. Types of books include children's picture books, history, nonfiction, preschool, educational reading materials. Specializes in education pre K-8. Publishes 150 titles/ year. 100% requires freelance illustration; 5% requires freelance design.

Needs: Approached by 100 illustrators and 10 designers/year. Works with 50 illustrators and 2 designers/ year. Prefers local designers and art directors. Prefers freelancers experienced in children's book production. 100% of freelance design demands knowledge of Photoshop, FreeHand, QuarkXPress.

First Contact & Terms: Send query letter with printed samples, color photocopies and follow-up post-card every 6 months. Samples are filed or returned. Will contact artist for portfolio review if interested. Buys all rights. Finds freelancers through submission packets, agents, sourcebooks, word of mouth.

Book Design: Assigns 2 freelance design and 2 freelance art direction projects/year. Pays for design by the hour, $30-35.

Text Illustration: Assigns 150 freelance illustration jobs/year. Pays by the project, $3,000-3,800.

Tips: "Illustrators will have fun and enjoy working on our books, knowing the end result will help children learn to love to read."

XICAT INTERACTIVE INC., 800 E. Broward, Suite 700, Ft. Lauderdale FL 33301. (954)522-3900, ext. 206. Fax: (954)522-0280. E-mail: jlinn@xicat.com. Website: www.xicat.com. **Art Director:** John Linn. Estab. 1990. Produces software and games for all major platforms. Produces flight sims, action, adventure and strategy titles. Recent releases: *Gothic* (PC CD-Rom), *Top Angler* (Playstation 2), *Invader* (Gameboy Advance); and *Janes Attack Squadron* (PC/CD-ROM).

Needs: Produces 30 releases/year. Works with 2 freelancers/year. Prefers local or national freelancers who own Mac/IBM computers with experience in packaging and high-end design. "Interns are welcome as well." Uses freelancers for packaging design for software i.e. game boxes. 90% of freelance design and illustration demands knowledge of Illustrator, QuarkXPress, Photoshop, FreeHand, 3D Studio Max and Adobe Premier.

First Contact & Terms: Send or e-mail postcard sample and/or query letter with résumé. Accepts disk submissions in IBM format (Zip, 3.5″, CD). Samples are filed. Responds in 30 days. Will contact for portfolio review if interested. Portfolio should include b&w, color, final art, slides, thumbnails, transparencies or CD-ROM. Pays by the hour, $100-150 depending on complexity. Buys all rights. Finds artists through local art college like International Fine Arts College in Miami or the Art Institute of Fort Lauderdale.

Tips: "Don't stop; continue networking yourself, your ideas. Don't take no for an answer! I look for flawless work, with a not-so-conservative style. Prefer wild, flashy, distorted, fun designs."

YE GALLEON PRESS, Box 287, Fairfield WA 99012. (509)283-2422. Estab. 1937. Publishes hard-cover and paperback originals and reprints. Types of books include rare Western history, Indian material, antiquarian shipwreck and old whaling accounts, and town and area histories. Publishes 20 titles/year. 10% requires freelance illustration. Book catalog on request.

First Contact & Terms: Works with 2 freelance illustrators/year. Query with samples and SASE. No advance. Pays promised fee for unused assigned work. Buys book rights.

ZAPP STUDIO, 338 St. Antoine St. E., 3rd Floor, Montreal, Quebec H2Y 1A3 Canada. (514)954-1441. Fax: (514)954-1443. E-mail: helenec@zapp.ca. **Art Director:** Hélène Cousineau. Estab. 1986. Company publishes hardcover originals and reprints. Specializes in children's books. Publishes 40 titles/year. Recent titles include: *Human Body Puzzle Book* (boxed set with 16 blocks, poster, stickers, activity book and trivia cards); *Fun World Atlas*; flash-card sets; *Math in a Flash* and *Preschool Fun!*. 50% requires freelance illustration; 30% requires freelance design.

Needs: Approached by 60 freelance illustrators/year. Works with 15 freelance illustrators and 3 designers/year. Prefers freelancers with experience in children's publications. Uses freelancers for illustration and book design. 50% of freelance work demands knowledge of Illustrator, QuarkXPress and Photoshop. Works on assignment only.

First Contact & Terms: Send postcard sample or query letter with brochure, résumé, photographs, SASE, tearsheets and photocopies. Accepts disk submissions compatible with Illustrator 8.0 and Photoshop 5.5. Send EPS files. Samples are filed and are not returned. Responds in 1 month. Art Director will contact artist for portfolio review if interested. Portfolio should include book dummy, final art or transparencies. Buys first rights. Does not pay royalties. Originals are not returned. Finds artists through sourcebooks, word of mouth, submissions and attending art exhibitions.

Tips: "Our studio's major publications are children's books focusing on 3-7 year age group."

NEED HELP? For tips on finding markets and understanding listings, see our Quick-Start Guide in the front of this book.

Galleries

Artist Martha Gannon stops at nothing to produce museum-quality art similar to this piece entitled *Lila*. For her solo show, Wistful Intentions, at the Women & Their Work Gallery in Austin, Gannon presented large wall panels of photography, digital manipulations and bronze, among other media. The Women & Their Work collective was the first organization in Texas to receive a grant in visual art from the National Endowment for the Arts, and they have brought national attention to over 1,600 artists.

You don't have to move to New York City to find a gallery. Whether you live in a small town or a big city, the easiest galleries to try first are the ones closest to you. It's much easier to begin developing a reputation within a defined region. New artists rarely burst onto the scene on a national level.

The majority of galleries will be happy to take a look at your slides if you make an appointment or mail your slides to them. If they feel your artwork doesn't fit their gallery, most will gently let you know, often steering you toward a more appropriate one. Whenever you meet rejection (and you will), tell yourself it's all part of being an artist.

FOLLOW THE RULES

- **Never walk into a gallery without an appointment, expecting to show your work to the gallery director.** When we ask gallery directors for pet peeves they always discuss the talented newcomer walking into the gallery with paintings in hand. Send a polished package of about 8 to 12 neatly labeled, mounted duplicate slides of your work submitted in plastic slide sheet format (refer to the listings for more specific information on each gallery's preferred submission method). Do not send original slides, as you will need them to reproduce later. Send an SASE, but realize you may not get your packet returned.
- **Seek out galleries that show the type of work you create.** Each gallery has a specific "slant" or mission. Read the interview with gallery dealer Michael Ingbar in this section to learn how to scope out galleries to find the right one for you.
- **Visit as many galleries as you can.** Browse for a while and see what type of work they sell. Do you like the work? Is it similar to yours in quality and style? What about the staff? Are they friendly and professional? Do they seem to know about the artists the gallery handles? Do they have convenient hours? When submitting to galleries outside your city, if you can't manage a personal visit before you submit, read the listing carefully to make sure you understand what type of work is shown in that gallery and get a feel for what the space is like. Ask a friend or relative who lives in that city to check out the gallery for you.
- **Attend openings.** You'll have a chance to network and observe how the best galleries promote their artists. Sign each gallery's guest book or ask to be placed on galleries' mailing lists. That's also one good way to make sure the gallery sends out professional mailings to prospective collectors.

Showing in multiple galleries

Most successful artists show in several galleries. Once you have achieved representation on a local level, you are ready to broaden your scope by querying galleries in other cities. You may decide to concentrate on galleries in surrounding states, becoming a "regional" artist. Some artists like to have an East Coast and a West Coast gallery.

Pricing your fine art

A common question of beginning artists is "What do I charge for my paintings?" There are no hard and fast rules. The better known you become, the more people will pay for your work. Though you should never underprice your work, you must take into consideration what people are willing to pay. Also keep in mind that you must charge the same amount for a painting sold in a gallery as you would for work sold from your studio. If you plan to sell work from your studio, or from a website or other galleries, be upfront with your gallery. Work out a commission arrangement that feels fair to both of you and everybody wins.

All Galleries Are Not Alike

As you search for the perfect gallery, it's important to understand the different types of spaces and how they operate. The route you choose depends on your needs, the type of work you do, your long term goals, and the audience you're trying to reach.

Retail or commercial galleries. The goal of the retail gallery is to sell and promote artists while turning a profit. Retail galleries take a commission of 40 to 50 percent of all sales.

Co-op galleries. Co-ops exist to sell and promote artists' work, but they are run by artists. Members exhibit their own work in exchange for a fee, which covers the gallery's overhead. Some co-ops also take a small commission of 20 to 30 percent to cover expenses. Members share the responsibilities of gallery-sitting, sales, housekeeping and maintenance.

Rental galleries. The gallery makes its profit primarily through renting space to artists and consequently may not take a commission on sales (or will take only a very small commission). Some rental spaces provide publicity for artists, while others do not. Showing in this type of gallery is risky. Rental galleries are sometimes thought of as "vanity galleries" and, consequently they do not have the credibility other galleries enjoy.

Nonprofit galleries. Nonprofit spaces will provide you with an opportunity to sell work and gain publicity, but will not market your work aggressively, because their goals are not necessarily sales-oriented. Nonprofits normally take a small commission of 20 to 30 percent.

Museums. Though major museums generally show work by established artists, many small museums are open to emerging artists.

Art consultancies. Generally, art consultants act as liasions between fine artists and buyers. Most take a commission on sales (as would a gallery). Some maintain small gallery spaces and show work to clients by appointment.

Juried shows, competitions and other outlets

As you submit your work and get feedback you might find out your style hasn't developed enough to grab a gallery's interest. It may take months, maybe years, before you find a gallery to represent you. But don't worry, there are plenty of other venues to show in until you are accepted in a commercial gallery. If you get involved with your local art community, attend openings, read the arts section of your local paper, you'll see there are hundreds of opportunities right in your city.

Enter group shows and competitions every chance you get. Go to the art department of your local library and check out the bulletin board, then ask the librarian to steer you to regional arts magazines like *Art Calendar* (www.artcalendar.com), that list "calls to artists" and other opportunities to exhibit your work. Subscribe to the *Art Deadlines List*, available in hard copy or online versions (www.artdeadlineslist.com). Join a co-op gallery and show your work in a space run by artists for artists.

Another opportunity to show your work is through local restaurants and retail shops that show the work of local artists. Ask the manager how you can show your work. Become an active member in an arts group. It's important to get to know your fellow artists. And since art groups often mount exhibitions of their members' work you'll have a way to show your work until you find a gallery to represent you.

Alabama

CORPORATE ART SOURCE, 2960-F Zelda Rd., Montgomery AL 36106. (334)271-3772. E-mail: casjb@mindspring.com. Website: casgallery.com. **Owner:** Jean Belt. Consultant: Keven Belt. Retail gallery and art consultancy. Estab. 1985. Interested in mid-career and established artists. "I don't represent artists,

For More Information

To develop a sense of various galleries and how to approach them, look to the myriad of art publications that contain reviews and articles. A few such publications are *ARTnews, Art in America, The New Art Examiner* and regional publications such as *ARTweek* (West Coast), *Southwest Art, Dialogue* and *Art New England.* Lists of galleries can be found in *Art in America's Guide to Galleries, Museums and Artists* and *Art Now, U.S.A.'s National Art Museum and Gallery Guide. The Artist's Magazine, Art Papers* and *Art Calendar* are invaluable resources for artists and feature dozens of helpful articles about dealing with galleries.

but keep a slide bank to draw from as resources." Exhibited artists include: Beau Redmond and Dale Kenington. Open Monday-Friday, 10-5. Located in exclusive shopping center; 1,000 sq. ft. Clientele: corporate upscale, local. 25% private collectors, 75% corporate collectors. Overall price range: $100-50,000. Most work sold at $2,500.

Media: Considers all media and all types of prints. Most frequently exhibits oil/acrylic paintings on canvas, glass, prints, pastel and watercolor. Also interested in sculpture.

Style: Exhibits expressionism, neo-expressionism, pattern painting, color field, geometric, abstraction, postmodernism, painterly abstraction, impressionism and realism. Genres include landscapes, abstract and architectural work.

Terms: Artwork is accepted on consignment (50% commission). Retail price set by artist. Gallery provides insurance. Prefers artwork unframed.

Submissions: Send query letter with résumé, slides or photographs and SASE. Call for appointment to show portfolio of slides and photographs. Responds in 6 weeks.

Tips: "Always send several photos (or slides) of your work. An artist who sends a letter and one photo and says 'write for more info' gets trashed. We don't have time to respond unless we feel strongly about the work—and that takes more than one sample."

N **GALLERY 54, INC.**, 54 Upham, Mobile AL 36607. (334)473-7995. **Owner:** Leila Hollowell. Retail gallery. Estab. 1992. Represents 35 established artists/year. May be interested in seeing the work of emerging artists in the future. Exhibited artists inlcude Charles Smith and Lee Hoffman. Sponsors 5 shows/year. Average display time 1 month. Open all year; Tuesday-Saturday, 11-4:30. Located in midtown, about 560 sq. ft. Clientele: local. 70% private collectors, 30% corporate collectors. Overall price range: $20-6,000; most work sold at $200-1,500.

Media: Considers oil, acrylic, watercolor, pastel, pen & ink, drawing, mixed media, collage, sculpture, ceramics, glass, photography, woodcuts, serigraphs and etchings. Most frequently exhibits acrylic/abstracts, watercolor and pottery.

Style: Exhibits expressionism, painterly abstraction, impressionism and realism. Prefers realism, abstract and Impressionism.

Terms: Accepts work on consignment (40% commission) or buys outright for 50% of retail price (net 30 days). Retail price set by the artist. Gallery provides contract. Artist pays shipping costs. Prefers artwork framed.

Submissions: Southern artists preferred (mostly Mobile area). It's easier to work with artist's work on consignment. Send query letter with slides and photographs. Write for appointment to show portfolio of photographs and slides. Responds in 2 weeks. Files information on artist. Finds artists through art fairs, referrals by other artists and information in mail.

Tips: "Don't show up with work without calling and making an appointment."

LEON LOARD GALLERY OF FINE ARTS, 2781 Zelda Rd., Montgomery AL 36106. (800)270-9017. Fax: (334)270-0150. E-mail: leonloardgallery@usa.com. **Gallery Director:** Barbara Reed. Retail gallery. Estab. 1989. Represents about 70 emerging, mid-career and established artists/year. Exhibited artists include Paige Harvey, Barbara Reed, Cheryl McClure, McCreery Jordan and Pete Beckman. Sponsors 4 shows/year. Average display time 3 months. Open all year; Monday-Friday, 9-4:30; weekends by appointment. Located in upscale suburb; cloth walls. 45% of space for special exhibitions; 45% of space for gallery artists. Clientele: local community—many return clients. 80% private collectors, 20% corporate collectors. Overall price range: $100-75,000; most work sold at $500-5,000.

Media: Considers oil, acrylic, watercolor, pastel, pen & ink, drawing, mixed media, collage, paper, sculpture, ceramics, fiber and glass. Most frequently exhibits oil on canvas, acrylic on canvas and watercolor on paper.

Style: Exhibits all styles and all genres. Prefers impressionism, realism and abstract.

Terms: Accepts work on consignment. Retail price set by the gallery and the artist. Gallery provides insurance, promotion and contract. Shipping costs are shared. Prefers artwork unframed.

Submissions: Send query letter with résumé, slides, bio and photographs. Portfolio should include photographs and slides. Responds in 2 weeks. Files bios and slides.

Alaska

N BUNNELL STREET GALLERY, 106 W. Bunnell, Suite A, Homer AK 99603. (907)235-2662. Fax: (907)235-9427. E-mail: bunnell@xyz.net. Website: www.xyz.net/~bunnell/. **Director:** Asia Freeman. Nonprofit gallery. Estab. 1990. Approached by 50 artists/year. Represents 35 emerging, mid-career and established artists. Sponsors 12 exhibits/year. Average display 1 month. Open Monday-Saturday, 10-6; Sunday, 12-4 (summer only). Closed January. Located on corner of Main and Bunnell Streets, Old Town, Homer; 30×25 exhibition space; good lighting, hardwood floors. Clients include local community and tourists. 10% of sales are to corporate collectors. Overall price range: $50-2,500; most work sold at $500.

Media: Considers all media. Most frequently exhibits painting, ceramics and installation. No prints/originals only.

Style: Considers all styles and genres. Most frequently exhibits painterly abstraction, impressionism, conceptualism.

Terms: Artwork is accepted on consignment and there is a 35% commission. A donation of time is requested. Gallery provides insurance, promotion and contract. Accepted work should be framed. Does not require exclusive representation locally.

Submissions: Call or write to arrange a personal interview to show portfolio of slides or mail portfolio for review. Returns material with SASE. Responds in 1 month. Finds artists through word of mouth, submissions, art exhibits and referrals by other artists.

N DECKER/MORRIS GALLERY, 621 W. Sixth Ave., Anchorage AK 99501-2127. (907)272-1489. Fax: (907)272-5395. **Managers:** Don Decker and Julie Decker. Retail gallery. Estab. 1994. Interested in emerging, mid-career and established artists. Represents 50 artists. Sponsors 15 solo and group shows/year. Average display time 4 weeks. Clientele: 90% private collectors, 10% corporate clients. Overall price range: $100-5,000; most work sold at $500-1,000.

Media: Considers oil, acrylic, watercolor, pastel, mixed media, collage, works on paper, sculpture, ceramic, craft, fiber, glass and all original handpulled prints. Most frequently exhibits oil, mixed media and all types of craft.

Style: Exhibits all styles. "We have no pre-conceived notions as to what an artist should produce." Specializes in original works by artists from Alaska and the Pacific Northwest. "We are a primary source of high-quality crafts in the state of Alaska. We continue to generate a high percentage of our sales from jewelry and ceramics, small wood boxes and bowls and paper/fiber pieces. We push the edge to avante garde."

Terms: Accepts work on consignment (50% commission). Retail price set by artist. Exclusive area representation preferred. Gallery provides insurance, promotion.

Submissions: Send letter of introduction with résumé, slides, bio and SASE.

Tips: Impressed by "high quality ideas/craftsmanship—good slides."

Arizona

N ARTISIMO ARTSPACE, 4333 N. Scottsdale Rd., Scottsdale AZ 85251. (480)949-0433. Fax: (480)994-0959. E-mail: artisimo@earthlink.net. Website: www.artisimogallery.com. Contact: Amy Wenk, director. For-profit gallery. Estab. 1991. Approached by 30 artists/year. Represents 20 emerging, mid-career and established artists. Exhibited artists include: Carolyn Gareis (mixed media), Scott R. Smith (airbrush on canvas). Sponsors 3 exhibits/year. Average display time 5 weeks. Open all year; Thursday-Saturday, 10-4. Closed August. Clients include local community, upscale, designers, corporations, restaurants. Overall price range: $200-4,000; most work sold at $1,500.

Media: Considers all media and all types of prints.

Style: Exhibits: geometric abstraction and painterly abstraction. Genres include figurative work, florals, landscapes and abstract.

Terms: Artwork is accepted on consignment and there is a 50% commission. Retail price set by the artist. Gallery provides insurance and promotion. Requires exclusive representation locally.
Submissions: Send query letter with artist's statement, bio, photographs, résumé and SASE. Returns material with SASE. Responds in 3 weeks. Files slides and bios. Finds artists through word of mouth, submissions, portfolio reviews, art exhibits, art fairs and referrals by other artists.
Tips: Good quality slides or photos.

ELEVEN EAST ASHLAND INDEPENDENT ART SPACE, 11 E. Ashland, Phoenix AZ 85004. (602)257-8543. **Director:** David Eugene Cook. Estab. 1986. Represents emerging, mid-career and established artists. Exhibited artists include Erastes Cinaedi, Frank Mell, David Cook, Vernita N. Cognita, Ron Crawford and Mark Dolce. Sponsors 1 juried, 1 invitational and 6 solo and mixed group shows/year. Average display time 2 months. Located in "two-story old farm house in central Phoenix, off Central Ave." Overall price range: $100-5,000; most artwork sold at $100-800.
• An anniversary exhibition is held every year in April and is open to national artists. Work must be submitted by the end of February. Work will be for sale, and considered for permanent collection and traveling exhibition.
Media: Considers all media. Most frequently exhibits photography, painting, mixed media and sculpture.
Style: Exhibits all styles, preferably contemporary. "This is a non-traditional proposal exhibition space open to all artists excluding Western and Southwest styles (unless contemporary style)."
Terms: Accepts work on consignment (25% commission); rental fee for space covers 2 months. Retail price set by artist. Artist pays for shipping.
Submissions: Accepts proposal in person or by mail to schedule shows 6 months in advance. Send query letter with résumé, brochure, business card, 3-5 slides, photographs, bio and SASE. Call or write for appointment to show portfolio of slides and photographs. Be sure to follow through with proposal format. Responds only if interested within 1 month. Samples are filed or returned if not accepted or under consideration.
Tips: "Be yourself, avoid hype and commercial glitz. Be ready to show, be sincere and have a positive attitude. Our space is somewhat unique, as I deal with mostly new and emerging artists. The main things I look for are confidence, workmanship and presentation. Don't be afraid to approach exhibition opportunities. Avoid trade/craft type shows. Be willing to be involved with exhibiting and promoting your work. Avoid gaudy presentation."

N ETHERTON GALLERY, 135 S. Sixth Ave., Tucson AZ 85701. (520)624-7370. Fax: (520)792-4569. Second location: 4419 N. Campbell Ave., Tucson AZ 85701. (520)615-1441. Fax: (520)615.1151. E-mail: ethertongallery@mindspring.com. **Contact:** Terry Etherton. Retail gallery and art consultancy. Estab. 1981. Represents 50 + emerging, mid-career and established artists. Exhibited artists include Holly Roberts, Fritz Scholder, James G. Davis and Mark Klett. Sponsors 12 shows/year. Average display time 5 weeks. Open from September to June. Located "downtown; 3,000 sq. ft.; in historic building—wood floors, 16' ceilings." 75% of space for special exhibitions; 10% of space for gallery artists. Clientele: 50% private collectors, 25% corporate collectors, 25% museums. Overall price range: $100-50,000; most work sold at $500-2,000.
Media: Considers oil, acrylic, drawing, mixed media, collage, sculpture, ceramic, all types of photography, original handpulled prints, woodcuts, wood engravings, linocuts, engravings, mezzotints, etchings and lithographs. Most frequently exhibits photography, painting and sculpture.
Style: Exhibits expressionism, neo-expressionism, primitivism, postmodern works. Genres include landscapes, portraits and figurative work. Prefers expressionism, primitive/folk and post-modern. Interested in seeing work that is "cutting-edge, contemporary, issue-oriented, political."
Terms: Accepts work on consignment (50% commission). Buys outright for 50% of retail price (net 30 days). Retail price set by gallery and artist. Gallery provides insurance and promotion; shipping costs are shared. Prefers framed artwork.
Submissions: Only "cutting-edge contemporary—no decorator art." No "unprepared, incomplete works or too wide a range—not specific enough." Send résumé, brochure, slides, photographs, reviews, bio and SASE. Call or write to schedule an appointment to show a portfolio, which should include slides. Responds in 6 weeks only if interested. Files slides, résumés and reviews.
Tips: "Become familiar with the style of our gallery and with contemporary art scene in general."

N MESA CONTEMPORARY ARTS, 155 N. Center, Box 1466, Mesa AZ 85211-1466. (480)644-2056. Fax: (480)644-2901. E-mail: patty_haberman@ci.mesa.az.us. Website: www.mesaarts.com. Owned and operated by the City of Mesa. Estab. 1981. Exhibits the work of emerging, mid-career and established artists. "We only do national juried shows and curated invitationals. We are an exhibition gallery, NOT a commercial sales gallery." Sponsors 6 shows/year. Average display time 4-6 weeks. Located downtown; 1,300 sq. ft., "wood floors, 14' ceilings and monitored security." 100% of space for special exhibitions.

Clientele: "cross section of Phoenix metropolitan area." 95% private collectors, 5% gallery owners. "Artists selected only through national juried exhibitions." Overall price range: $100-10,000; most artwork sold at $200-400.

Media: Considers all media including sculpture, painting, printmaking, photography, fibers, glass, wood, metal, video, ceramics, installation and mixed.

Style: Exhibits all styles and genres. Interested in seeing contemporary work.

Terms: Charges 25% commission. Retail price set by artist. Gallery provides insurance, promotion and contract; pays for shipping costs from gallery. Requires framed artwork.

Submissions: Send a query letter or postcard with a request for a prospectus. After you have reviewed prospectus, send slides of up to 4 works (may include details if appropriate.) "We do not offer portfolio review. Artwork is selected through national juried exhibitions." Files slides and résumés. Finds artists through gallery's placement of classified ads in various art publications, mailing news releases and word of mouth.

Tips: "Scout galleries to determine their preferences before you approach them. Have professional quality slides. Present only your very best work in a professional manner."

N **SCHERER GALLERY**, Hillside, 671 Hwy. 179, Sedona AZ 86336. (928)203-9000. Fax: (928)203-0643. **Owners:** Tess Scherer and Marty Scherer. Retail gallery. Estab. 1968. Represents over 30 mid-career and established artists. Interested in seeing the work of emerging artists. Exhibited artists include Tamayo, Hundertwasser, Friedlaender, Delaunay, Calder and Barnet. Sponsors 4 solo and 3 group shows/year. Average display time 2 months. Open daily 10-6. 3,000 sq. ft.; 25% of space for special exhibitions; 75% for gallery artists. Clientele: upscale, local community and international collectors. 90% private collectors, 10% corporate clients. Overall price range: $1,000-20,000; most artwork sold at $5,000-10,000.

• This gallery moved from New Jersey to Arizona in 1997. Owners say "after 30 years in New Jersey we headed for a warmer climate. So far, we love it here."

Media: Considers non-functional glass sculpture; paintings and other works on paper including hand-pulled prints in all mediums; and kaleidoscopes.

Style: Exhibits color field, minimalism, surrealism, expressionism, modern and post modern works. Looking for artists "with a vision. Work that shows creative handling of the medium(s) and uniqueness to the style—'innovation,' 'enthusiasm.' " Specializes in handpulled graphics, art-glass and kaleidoscopes.

Terms: Accepts work on consignment (50% commission). Retail price set by artist. Exclusive area representation required. Gallery provides insurance, promotion and contract; shipping costs are shared.

Submissions: Send query letter, résumé, bio, at least 12 slides (no more than 30), photographs and SASE. Follow up with a call for appointment to show portfolio. Responds in 1 month.

Tips: "Persevere! Don't give up!" Considers "originality and quality of the work."

TEMPLE BETH ISRAEL SYLVIA PLOTKIN JUDAICA MUSEUM/CONTEMPORARY ARTS GALLERY, 10460 N. 56th St., Scottsdale AZ 85253. (480)951-0323. Fax: (480)951-7150. E-mail: museum@templebethisrael.org. **Director:** Pamela S. Levin. Museum. Estab. 1997. Represents 75 emerging, mid-career and established artists. Exhibited artists include Robert Lipnich and Elizabeth Mears. Clients include local community, tourists and upscale. Overall price range: $50-5,000; most work sold at $500.

Media: Considers all media. Most frequently exhibits craft, glass and ceramics. Considers all types of prints.

Styles: Considers all styles. Genre: Judaica.

Making Contact & Terms: Artwork is accepted on consignment and there is a 40% commission. Retail price set by the artist. Gallery provides insurance and promotion. Accepted work should be framed. Prefers only Judaica.

Submissions: Call to arrange a personal interview to show portfolio. Send query letter with bio, brochure, photocopies, photographs, résumé, reviews, slides. Returns material with SASE. Responds in 1 month.

Arkansas

THE ARKANSAS ARTS CENTER, P.O. Box 2137, Little Rock AR 72203. (501)372-4000. Fax: (501)375-8053. **Curator of Art:** Brian Young. Curator of Decorative Arts: Alan DuBois. Museum art school, children's theater and traveling exhibition service. Estab. 1930s. Exhibits the work of emerging, mid-career and established artists. Sponsors 25 shows/year. Average display time 6 weeks. Open all year. Located downtown; 10,000 sq. ft.; 60% of space for special exhibitions.

Media: Most frequently exhibits drawings and crafts.

Style: Exhibits all styles and all genres.

Terms: Retail price set by the artist. "Work in the competitive exhibitions (open to artists in Arkansas and six surrounding states) is for sale; we usually charge 10% commission."

Submissions: Send query letter with samples, such as photos or slides.

Tips: "Write for information about exhibitions for emerging and regional artists, and various themed exhibitions."

☑ **DUCK CLUB GALLERY**, 2333 N. College, Fayetteville AR 72703. (501)443-7262. Website: www.d uckclubgallery.com. **President:** Charlie Sego. Vice President: Ted B. Sego. Secretary-Treasurer: Frances Sego. Retail gallery. Estab. 1980. Represents mid-career and established artists. May be interested in seeing the work of emerging artists in the future. Exhibited artists include Terry Redlin, Jane Garrison and Linda Cullers. Displays work "until it sells." Open all year; Monday-Friday, 10-5:30; Saturday, 10-4. Located midtown; 1,200 sq. ft. 100% of space for gallery artists. Clientele: tourists, local community, students; "we are a university community." 80% private collectors, 20% corporate collectors. Overall price range: $50-400; most work sold at $50-200.

Media: Considers all media including wood carved decoys. Considers engravings, lithographs, serigraphs, etchings, posters. Most frequently exhibits limited edition and open edition prints and poster art.

Style: Exhibits all styles and genres. Prefers: wildlife, local art and landscapes.

Terms: Buys outright for 50% of retail price (net 30 days). Retail price set by the artist. Gallery provides insurance and promotion; artist pays for shipping. Prefers artwork unframed.

Submissions: Send query letter with brochure, photographs and business card. Write for appointment to show portfolio. Finds artists through word of mouth, referrals by other artists, visiting art fairs and exhibitions, submissions, referrals from customers.

Tips: "Please call for an appointment. Don't just stop in. For a period of time, give exclusively to the gallery representing you. Permit a gallery to purchase one or two items, not large minimums."

N WALTON ARTS CENTER, P.O. Box 3547, 495 N. Dickson St., Fayetteville AR 72702. (479)443-9216. Fax: (479)443-9784. Website: www.waltonartscenter.org. **Contact:** Michele McGuire, curator of exhibits. Nonprofit gallery. Estab. 1990. Approached by 50 artists/year. Represents 10 emerging, mid-career and established artists. Exhibited artists include: E. Fay Jones, Phil Joanou (oil on canvas). Sponsors 2 exhibits/year.Average display time X2 months. Open all year; Monday-Friday, 10-6; weekends 12-4. Closed Thanksgiving, Christmas, July 4. Joy Pratt Markham Gallery is 2,500 sq. ft. with approximately 200 running wall feet. McCoy Gallery also has 200 running wall feet in the Education Building. Clients include local communitiy and upscale. Overall price range: $100-10,000. "Walton Arts Center serves as a resource to showcase a variety of thought-provoking visual media that will challenge new and traditional insights and encourage new dialogue in a museum level environment."

Media: Considers all media and all types of prints. Most frequently exhibits oil, installation, paper.

Style: Considers all styles and genres.

Terms: Artwork is accepted on consignment and there is a 30% commission. Retail price set by the artist. Gallery provides insurance and contract. Accepted work should be framed. Requires exclusive representation locally.

Submissions: Mail portfolio for review. Send query letter with artist's statement, bio, business card, résumé, reviews, SASE and slides. Returns material with SASE. Responds in 3 months. Finds artists through submissions, art exhibits, referrals by other artists and travelling exhibition companies.

California

N THE ART COLLECTOR, 4151 Taylor St., San Diego CA 92110. (619)299-3232. Fax: (619)299-8709. **Contact:** Janet Disraeli. Retail gallery and art consultancy. Estab. 1972. Represents emerging, mid-career and established artists. Exhibited artists include Dan Sayles and Reed Cardwell. Sponsors 2 shows/year. Average display time 1 month. Open all year; Monday-Friday. 1,000 sq. ft.; 100% of space for gallery artists. Clientele: upscale, business, decorators. 50% private collectors, 50% corporate collectors. Overall price range: $175-10,000; most work sold at $450-1,000.

Media: Considers all media and all types of prints. Most frequently exhibits paintings, sculpture, monoprints.

Style: Exhibits all styles. Genres include all genres, especially florals, landscapes and figurative work. Prefers abstract, semi-realistic and realistic.

Terms: Artwork is accepted on consignment and there is a 50% commission. Retail price set by the artist. Gallery provides insurance. Gallery pays for shipping from gallery. Artist pays for shipping to gallery. Prefers artwork framed.

Submissions: Accepts artists from United States only. Send query letter with résumé and slides. Call for appointment to show portfolio of slides. Responds in 2 weeks. Files slides, biographies, information about artist's work.

Tips: Finds artists through artist's submissions and referrals.

◼ ART SOURCE LA INC., 2801 Ocean Park Blvd., PMB 7, Santa Monica CA 90405. (310)452-4411. Fax: (310)452-0300. E-mail: pattye@artsourcela.com. Website: www.artsourcela.com. **Artist Liaison:** Patty Evert. Art consultancy. Estab. 1980. Approached by 500 artists/year; represents 150 emerging, mid-career and established artists. Open Monday-Thursday, 9-6; Friday, 9-1. Clients include interior designers, architects, hospitality and entertainment industries and corporate. Overall price range: $400-10,000; most work sold at $500-2,500.

Media: Considers acrylic, ceramics, collage, craft, drawing, fiber, glass, works on canvas, mixed media, oil, paper, pen & ink, sculpture and watercolor. Also sells photography, works on paper and sculpture. Considers all types of prints.

Style: Considers all styles. Genres include Americana, figurative work, florals, landscapes, Southwestern, Western and abstract.

Making Contact & Terms: Artwork is accepted on consignment, and there is a 50% commission. Retail price set by the gallery and the client. Gallery provides insurance and promotion. Accepts artists worldwide.

Submissions: Send query letter with artist's statement, bio, brochure, photographs or slides, résumé and SASE. Returns materials with SASE. Responds in 6 weeks. Finds artists through word of mouth, submissions, art exhibits, art fairs and referrals by other artists.

Tips: Make sure work is labeled and information is legible and concise.

CHOZEN GALLERY, 276 E. Granvia Valmonte, Palm Springs CA 92262. (760)320-5707. Fax: (760)320-0288. E-mail: chozenpsca@aol.com. **Director:** David Smith. Alternative space, for profit gallery. Estab. 1998. Approached by 8-10 artists/year; represents 10-12 emerging artists. Exhibited artists include Downs, Benjamin, Figueredo, Moiseyev, Soto-Diaz, David Smith. Sponsors 10 exhibits/year. Average display time 3-4 weeks. Open by appointment. Clients include local community and upscale. 5% of sales are to corporate collectors.

Media: Considers acrylic, oil, paper and sculpture. Most frequently exhibits oil, acrylic and metal. Considers lithographs, serigraphs and giclee.

Style: Exhibits: geometric abstraction, minimalism, postmodernism, surrealism and painterly abstraction. Most frequently exhibits minimalism, abstract and surrealism. Considers all genres.

Making Contact & Terms: Artwork is accepted on consignment, and there is a 50% commission. Retail price set by the gallery and the artist (mutual agreement). Gallery provides insurance and promotion. Requires exclusive representation locally.

Submissions: Call or e-mail to arrange a personal interview to show portfolio. Mail portfolio for review or send query letter with artist's statement, bio, photographs, résumé, reviews and SASE. Returns material with SASE. Responds in 2 months. Files entire packet if interested. Finds artists through word of mouth, submissions, portfolio reviews, art exhibits and referrals by other artists.

◼ CONTEMPORARY CENTER, 2630 W. Sepulveda Blvd., Torrance CA 90505. (310)539-1933. **Director:** Sharon Fowler. Retail gallery. Estab. 1953. Represents 150 emerging, mid-career and established artists. Exhibited artists include Steve Main, Cheryl Williams. Open all year; Tuesday-Saturday, 10-6; Sunday 12-5; closed Monday. Space is 5,000 sq. ft. "We sell contemporary American crafts along with contemporary production and handmade furniture." Clientele: private collectors, gift seekers, many repeat customers. Overall price range: $20-800; most work sold at $20-200.

Media: Considers paper, sculpture, ceramics, fiber and glass.

Terms: Retail price set by the gallery and the artist.

Submissions: Send query letter with brochure, slides and photographs. Call for appointment to show portfolio of photographs and slides. Responds in 2 weeks. Finds artists through word of mouth and attending craft shows.

Tips: "Be organized with price, product and realistic ship dates."

CUESTA COLLEGE ART GALLERY, P.O. Box 8106, San Luis Obispo CA 93403-8106. (805)546-3202. Fax: (805)546-3904. E-mail: mpeluso@bass.cuesta.cc.ca.us. Website: http://academic.cuesta.cc.ca.us/finearts/gallery.htm. **Director:** Marta Peluso. Nonprofit gallery. Estab. 1965. Exhibits the work of emerging, mid-career and established artists. Exhibited artists include Italo Scanga and JoAnn Callis. Sponsors 5 shows/year. Average display time 4½ weeks. Open all year. Space is 1,300 sq. ft.; 100% of space for special exhibitions. Overall price range: $250-5,000; most work sold at $400-1,200.

Media: Considers all media and all types of prints. Most frequently exhibits painting, sculpture and photography.

As the director of the Cuesta College Art Gallery in San Luis Obispo, California stated, this untitled ceramic teacup by Kristen Morgin is "unfired and filled with raw energy." The detailed teacup, which also encompasses wire, paper and assorted paints, was one of many artworks in Morgin's exhibition devoted to "musical instruments, natural history, tea sets, table settings, and parasitic books and collages." Morgin is an Assistant Professor of Art in Ceramics at California State University.

Style: Exhibits all styles, mostly contemporary.
Terms: Accepts work on consignment (20% commission). Retail price set by artist. Customer payment by installment available. Gallery provides insurance, promotion and contract; shipping costs are shared. Prefers artwork framed.

Submissions: Send query letter with résumé, slides, bio, brochure, SASE and reviews. Call for appointment to show portfolio. Responds in 6 months. Finds artists mostly by reputation and referrals, sometimes through slides.

Tips: "We have a medium budget, thus cannot pay for extensive installations or shipping. Present your work legibly and simply. Include reviews and/or a coherent statement about the work. Don't be too slick or too sloppy."

N DELPHINE GALLERY, 1324 State St., Santa Barbara CA 93101. **Director:** Michael Lepere. Retail gallery and custom frame shop. Estab. 1979. Represents/exhibits 10 mid-career artists/year. Exhibited artists include Jim Leonard, Edwin Brewer and Steve Vessels. Sponsors 8 shows/year. Average display time 4-6 weeks. Open all year; Tuesday-Friday, 10-5; Saturday, 10-3. Located downtown Santa Barbara; 300 sq. ft.; natural light (4th wall is glass). 33% of space for special exhibitions. Clientele: upscale, local community. 40% private collectors, 20% corporate collectors. Overall price range: $1,000-4,500; most work sold at $1,000-3,000.

Media: Considers all media except photography, installation and craft. Considers serigraphs. Most frequently exhibits oil on canvas, acrylic on paper and pastel.

Style: Exhibits conceptualism and painterly abstraction. Includes all genres and landscapes.

Terms: Artwork is accepted on consignment (50% commission). Retail price set by the gallery. Gallery provides insurance and promotion; shipping costs are shared.

Submissions: Prefers artists from Santa Barbara/Northern California. Send query letter with résumé, slides and SASE. Write for appointment to show portfolio of slides. Responds in 1 month.

N SOLOMON DUBNICK GALLERY, 2131 Northrop Ave., Sacramento CA 95825. (916)920-4547. Fax: (916)923-6356. Website: www.sdgallery.com. **Director:** Shirley Dubnick. Retail gallery and art consultancy. Estab. 1981. Represents/exhibits 20 emerging, mid-career and established artists/year. "Must have strong emerging record of exhibits." Exhibited artists include Jian Wang and Gary Pruner. Sponsors 11-12 shows/year. Average display time 1 month. Open all year; Tuesday-Saturday, 11-6 or by appointment. Located in suburban area on north side of Sacramento; 7,000 sq. ft.; large space with outside sculpture space for large scale, continued exhibition space for our stable of artists, besides exhibition space on 1st floor. Movable walls for unique artist presentations. 75% of space for special exhibitions; 25% of space for gallery artists. Clientele: upscale, local, students, national and international clients due to wide advertising of gallery. 80% private collectors, 20% corporate collectors. Overall price range: $500-50,000; most work sold at $2,000-10,000.

Media: Considers oil, pen & ink, paper, acrylic, drawing, sculpture, watercolor, mixed media, ceramics, pastel and photography. Considers original prints produced only by artists already represented by gallery. Most frequently exhibits painting, sculpture and works on paper.

Style: Exhibits all styles (exhibits very little abtract paintings unless used in landscape). Genres include landscapes, figurative and contemporary still life. Prefers figurative, realism and color field.

Terms: Accepts work on consignment (50% commission). Commission may differ on certain sculpture. Retail price set by the gallery with artist concerns. Gallery provides insurance, promotion and contract; shipping costs are shared (large scale delivery to and from gallery is paid for by artist). Prefers artwork framed.

Submissions: Accepts only artists from Northern California with invited artists outside state. Send query letter with résumé, slides, photographs, reviews, bio and SASE. Call for appointment to show portfolio of photographs, transparencies and slides. Responds only if interested within 1 month. Files all pertinent materials. Finds artists through word of mouth, referrals by other artists, art fairs, advertising in major art magazines and artists' submissions.

Tips: "Be professional. Do not bring work into gallery without appointment with Director or Assistant Director. Do not approach staff with photographs of work. Be patient."

N Y FALKIRK CULTURAL CENTER, 1408 Mission Ave., P.O. Box 151560, San Rafael CA 94915-1560. (415)485-3328. Fax: (415)485-3404. Website: www.falkirkculturalcenter.org. Nonprofit gallery. Estab. 1974. Approached by 500 artists/year. Exhibits 350 emerging, mid-career and established artists. Sponsors 8 exhibits/year. Average display time 2 months. Open Monday-Friday, 10-5; weekends 10-1; Thursday til 9. Three galleries located on second floor with lots of natural light (UV filtered). National historic site (1888 Victorian) converted to multi-use cultural center. Clients include local community, students, tourists and upscale.

Media: Considers all media and all types of prints. Most frequently exhibits painting, sculpture and works on paper.

Making Contact & Terms: Artwork is accepted on consignment, and there is a 30% commission. Retail price set by the artist. Gallery provides insurance. Prefers only Marin County artists.

Submissions: Marin County and San Francisco Bay Area artists only send artist's statement, bio, résumé and slides. Returns material with SASE. Responds within 3 months.

GALLERY EIGHT, 7464 Girard Ave., La Jolla CA 92037. (858)454-9781. **Director:** Ruth Newmark. Retail gallery with focus on contemporary crafts. Estab. 1978. Represents 100 emerging and mid-career artists. Interested in seeing the work of emerging artists. Exhibited artists include Philip Moulthrop, Yoshiro Ikeda and Ken Loeber. Sponsors 6 shows/year. Average display time 6-8 weeks. Open all year; Monday-Saturday, 10-5. Located downtown; 1,200 sq. ft. 25% of space for special exhibitions; 100% of space for gallery artists. Clientele: upper middle class, mostly 35-60 in age. Overall price range: $5-5,000; most work sold at $25-150.
Media: Considers ceramics, metal, wood, craft, fiber and glass. Most frequently exhibits ceramics, jewelry, other crafts.
Terms: Accepts work on consignment (50% commission) or buys outright for 50% of retail price (net 30 days). Retail price set by the gallery and the artist. Gallery provides insurance, promotion and shipping costs from gallery; artist pays shipping costs to gallery.
Submissions: Send query letter with résumé, slides, photographs, reviews and SASE. Call or write for appointment to show portfolio of photographs and slides. Responds in 3 weeks. Files "generally only material relating to work by artists shown at gallery." Finds artists by visiting exhibitions, word of mouth, various art publications and sourcebooks, submissions, through agents, and juried fairs.
Tips: "Make appointments. Do not just walk in and expect us to drop what we are doing to see work."

N GREENLEAF GALLERY, 20315 Orchard Rd., Saratoga CA 95070. (408)867-3277. **Owner:** Janet Greenleaf. Director: Chris Douglas. Collection and art consultancy and advisory. Estab. 1979. Represents 45 to 60 emerging, mid-career and established artists. By appointment only. "Features a great variety of work in diverse styles and media. We have become a resource center for designers and architects, as we will search to find specific work for all clients." Clientele: professionals, collectors and new collectors. 50% private collectors, 50% corporate clients. Prefers "very talented emerging or professional full-time artists—already established." Overall price range: $400-15,000; most artwork sold at $500-8,000.
Media: Considers oil, acrylic, watercolor, pastel, mixed media, collage, works on paper, sculpture, glass, original handpulled prints, lithographs, serigraphs, etchings and monoprints.
Style: Deals in expressionism, neo-expressionism, minimalism, impressionism, realism, abstract work or "whatever I think my clients want—it keeps changing." Traditional, landscapes, florals, wildlife, figurative and still lifes.
Terms: Artwork is accepted on consignment. "The commission varies." Artist pays for shipping or shipping costs are shared.
Submissions: Send query letter, résumé, 6-12 photographs (but slides OK), bio, SASE, reviews and "any other information you wish." Call or write to schedule an appointment for a portfolio review, which should include originals. If does not reply, the artist should call. Files "everything that is not returned. Usually throw out anything over two years old." Finds artists through visiting exhibits, referrals from clients, or artists, submissions and self promotions.
Tips: "Send good photographs with résumé and ask for an appointment. Send to many galleries in different areas. It's not that important to have a large volume of work. I would prefer to know if you are full time working artist and have representation in other galleries."

N JUDITH HALE GALLERY, 2890 Grand Ave., P.O. Box 884, Los Olivos CA 93441-0884. (805)688-1222. Fax: (805)688-2342. **Owner:** Judy Hale. Retail gallery. Estab. 1987. Represents 70 mid-career and established artists. Exhibited artists include Neil Boyle, Susan Kliewer, Karl Dempwolt, Alice Nathan, Larry Bees and Ted Goerschner. Sponsors 4 shows/year. Average display time 6 months. Open all year. Located downtown; 2,100 sq. ft.; "the gallery is eclectic and inviting, an old building with six rooms." 20% of space for special exhibitions which are regularly rotated and rehung. Clientele: homeowners, tourists, decorators, collectors. Overall price range: $100-5,000; most work sold at $500-2,000.
 • This gallery opened a second location next door at 2884 Grand Ave. and connecting sculpture garden. Representing nationally recognized artists. This old building once housed the blacksmith's shop.
Media: Considers oil, acrylic, watercolor, pastel, sculpture, engravings and etchings. Most frequently exhibits watercolor, oil, acrylic and sculpture.
Style: Exhibits impressionism and realism. Genres include landscapes, florals, western and figurative work. Prefers figurative work, western, florals, landscapes, structure. No abstract or expressionistic.
Terms: Accepts work on consignment (40% commission). Retail price set by artist. Offers payment by installments. Gallery arranges reception and promotion; artist pays for shipping. Prefers artwork framed.

Submissions: Send query letter with 10-12 slides, bio, brochure, photographs, business card and reviews. Call for appointment to show portfolio of photographs. Responds in 2 weeks. Files bio, brochure and business card.

Tips: "Create a nice portfolio. See if your work is comparable to what the gallery exhibits. Do not plan your visit when a show is on; make an appointment for future time. I like 'genuine' people who present quality with fair pricing. Rotate artwork in a reasonable time, if unsold. Bring in your best work, not the 'seconds' after the show circuit."

N HEARST ART GALLERY, SAINT MARY'S COLLEGE, P.O. Box 5110, Moraga CA 94575. (925)631-4379. Fax: (925)376-5128. Website: http://gallery.stmarys-ca.edu. College gallery. Estab. 1931. Exhibits mid-career and established artists. Exhibited artists include: William Keith (painting). Sponsors 6 exhibits/year. Average display time 5-6 weeks. Open Wednesday-Sunday, 11-4:30; weekends from 11-4:30. Closed major holidays, installation periods. Located on college campus, 1,650 square feet exhibition space. Clients include local community, students and tourists.

Media: Considers all media. Most frequently exhibits paintings, works on paper and sculpture. Considers all types of prints.

Submissions: Send query letter with artist's statement, bio, résumé, SASE and slides. Returns material with SASE. Finds artists through submissions, art exhibits, art fairs, referrals by other artists.

N LEARSI GALLERY, 73655 El Paseo Dr. #K, Palm Desert CA 92260. (760)773-5035. Fax: (760)773-0545. E-mail: beyondtheveil@msn.com. **Owner:** Mr. Katz. Commercial gallery. Estab. 1997. Approached by 60 artists/year. Represents 12 emerging, mid-career and established artists. Sponsors 5 exhibits/year. Average display time 2 weeks. Clients include local community, tourists and upscale.

Media: Considers acrylic, ceramics, collage, drawing, glass, installation, mixed media, oil, paper, pen & ink and sculpture. Most frequently exhibits oil, mixed media, ceramic and wood.

Style: Considers all styles.

Making Contact & Terms: Artwork is accepted on consignment, and there is a 50% commission. Retail price set by the gallery. Gallery provides insurance, promotion and contract. Requires exclusive representation locally.

Submissions: Write to arrange a personal interview to show portfolio of photographs, slides and transparencies. Send query letter with artist's statement, bio, brochure, photographs, résumé, reviews and slides. Returns material with SASE. Responds in 1 week. Finds artists through word of mouth, submissions, art exhibits, referrals by other artists.

Tips: "It is up to each artist to decide what to include in submission packet. The choices you make could mean the difference between getting in or not. Archival quality materials are very important to collectors. Create a cohesive body of work, using only one solid style. Good slides are very important as well."

LIZARDI/HARP GALLERY, P.O. Box 91895, Pasadena CA 91109. (626)791-8123. Fax: (626)791-8887. E-mail: lizardiharp@earthlink.net. Director: Grady Harp. Retail gallery and art consultancy. Estab. 1981. Represents 15 emerging, mid-career and established artists/year. Exhibited artists include Christopher James, John Nava, Craig Attebery, Miguel Condé, Wes Hempe, Gerard Huber, Wade Reynolds, Robert Peters, Erik Olson, Anita Janosova and Trevor Southey. Sponsors 9 shows/year. Average display time 1 month. Open all year; Tuesday-Saturday. 80% private collectors, 20% corporate collectors. Overall price range: $900-80,000; most work sold at $2,000-15,000.

Media: Considers oil, acrylic, watercolor, pastel, pen & ink, drawing, mixed media, sculpture, installation, photography, lithographs, and etchings. Most frequently exhibits works on paper and canvas, sculpture, photography.

Style: Exhibits representational art. Genres include landscapes, figurative work—both portraiture and narrative and still life. Prefers figurative, landscapes and experimental.

Terms: Accepts work on consignment (50% commission). Retail price set by the gallery and the artist. Gallery provides insurance, promotion, contract; artist pays shipping costs.

Submissions: Send query letter with artist's statement, résumé, 20 slides, bio, photographs, SASE and reviews. Write for appointment to show portfolio of photographs, slides and transparencies. Responds in 1 month. Files "all interesting applications." Finds artists through studio visits, group shows, submissions.

N MARKETS NEW TO THIS EDITION

Tips: "Timelessness of message is a plus (rather than trendy). Our emphasis is on quality or craftsmanship, evidence of originality . . . and maturity of business relationship concept." Artists are encouraged to send an "artist's statement with application and at least one 4×5 or print along with 20 slides. Whenever possible, send images over the Internet via e-mail."

☑ **MALTZ GALLERY**, (formerly Otis Gallery, Otis College of Art And Design Gallery), 9045 Lincoln Blvd., Westchester CA 90045. (310)665-6905. Fax: (310)665-6908. E-mail: galleryinfo@otisart.edu. Director: Dr. Anne Ayres. Nonprofit college gallery. Represents/exhibits 10-50 emerging and mid-career artists/year. Sponsors 4 shows/year. Average display time 2 months. Open fall, winter, spring—sometimes summer; Tuesday-Saturday, 10-5. Located just north of Lax-Los Angeles International Airport; 3,500 sq. ft. 100% of space devoted to special exhibitions by gallery artists. Clientele: all types. Work is exhibited, not sold.
Media: Considers all media and all types of prints. Most frequently exhibits painting, sculpture and media.
Style: Exhibits conceptualism all styles. Prefers contemporary.
Terms: Gallery provides insurance, promotion, contract and shipping costs.
Submissions: Send query letter with résumé, up to twenty 35mm slides and SASE. Finds artists through word of mouth, studio visits and attending other exhibitions.

N **MONTEZUMA BOOKS & GALLERY**, 289 Third Ave., Chula Vista CA 91910-2721. (619)426-1283. Fax: (619)426-0212. E-mail: lisamoctezuma@hotmail.com. Website: www.moctezumaart.com. **Contact:** Lisa Moctezuma, owner. For-profit gallery. Estab. 1999. Approached by 20 artists/year. Represents 12 emerging, mid-career and established artists. Exhibited artists include: Alberto Blanco (painting, Chinese ink drawings, collage, mixed media) and Norma Michel (painting, mixed media and boxes). Sponsors 8 exhibits/year. Average display time 6 weeks. Open all year; Monday-Saturday, 10-5. Located just south of San Diego, in downtown Chula Vista. The gallery space is approximately 1,000 sq. ft. and is coupled with a bookstore. Clients include local community and upscale. 10% of sales are to corporate collectors. Overall price range: $200-2,000; most work sold at $400.
Media: Considers all media and all types of prints. Most frequently exhibits paper, watercolor and acrylic.
Style: Considers all styles and genres. Most frequently exhibits painterly abstraction, primitivism realism and conceptualism.
Terms: Artwork is accepted on consignment and there is a 40% commission. Retail price set by the gallery. Gallery provides promotion and contract. Accepted work should be framed. Does not require exclusive representation locally. We focus on established and emerging artists from the San Diego/Tijuana border area, Mexico and the Californias.
Submissions: Mail poftfolio for review. Send query letter with artist's statement, bio, photocopies, photographs, résumé, reviews, SASE and slides. Responds in 2 months. Finds artists through word of mouth and referrals by other artists.

☑ **A NEW LEAF GALLERY**, 1286 Gilman St., Berkeley CA 94706. (510)525-7621. Fax: (510)234-6092. E-mail: inquiries@anewleafgallery.com. Website: www.anewleafgallery.com. **Owners:** John Denning, Brigitte Micmacker. Retail gallery. Estab. 1990. Represents 80 mid-career and established artists. Exhibited artists include William Wareham and Ed Haddaway. Sponsors 4-6 shows/year. Average display time 2 months. Open all year. Located in North Berkeley; 10,000 sq. ft.; "all contemporary outdoor sculptures shown in a garden setting." 30-50% of space for special exhibitions. Clientele: 80% private collectors. Overall price range: $500-100,000; most work sold at $1,000-5,000. "We are actively looking for more work in the $800-3,000 range for our gallery and e-commerce-ready website."
Media: Considers sculpture, ceramic and glass. Most frequently exhibits sculpture, fountains and art furniture (must be suitable for outdoors). "No paintings or works on paper, please."
Style: Exhibits abstract and abstract figurative work.
Terms: Accepts artwork on consignment (50% commission). Exclusive area representation required. Retail price set by artist in cooperation with gallery. Gallery provides insurance, promotion and contract; artist pays for shipping.
Submissions: Send query letter with résumé, slides, bio and SASE—digital images are OK as well. Responds in 6 weeks. Files slides and bio.
Tips: "We suggest artists visit us if possible—this is a unique setting. Sculpturesite.com, our new website, shows a wider range of sculpture than our outdoor gallery can."

N **ORANGE COUNTY CENTER FOR CONTEMPORARY ART**, 117 N. Sycamore St., Santa Ana CA 92701. (714)667-1517. Website: www.occca.net. **Acting Executive Director:** Barbara Thompson. Cooperative, nonprofit gallery. Exhibits emerging and mid-career artists. 20 members. Sponsors 12 shows/year. Average display time 1 month. Open all year; Wednesday-Sunday 11-4. 3,000 sq. ft. 25% of time for special exhibitions; 75% of time for gallery artists.

Media: Considers all media.

Terms: Co-op membership fee plus a donation of time. Retail price set by artist.

Submissions: Accepts artists generally in and within 50 miles of Orange County. Send query letter with SASE. Responds in 1 week.

Tips: "This is an artist-run nonprofit. Send SASE for application prospectus. Membership means 24 to 30 hours monthly working in and for the gallery and programs; educational outreach; specific theme special exhibitions; hands-on gallery operations and professional career development."

ORLANDO GALLERY, 18376 Ventura Blvd., Tarzana CA 91356. (818)705-5368. E-mail: orlando2@ear thlink.com. Website: http://venturablvd.com/orlando/. **Co-Directors:** Robert Gino and Don Grant. Retail gallery. Estab. 1958. Represents 30 emerging, mid-career and established artists. Sponsors 22 solo shows/ year. Average display time is 1 month. Accepts only California artists. Overall price range: up to $35,000; most artwork sold at $2,500.

Media: Considers oil, acrylic, watercolor, pastel, pen & ink, drawings, mixed media, collage, works on paper, sculpture, ceramic and photography. Most frequently exhibits oil, watercolor and acrylic.

Style: Exhibits painterly abstraction, conceptualism, primitivism, impressionism, photorealism, expressionism, neo-expressionism, realism and surrealism. Genres include landscapes, florals, Americana, figurative work and fantasy illustration. Prefers impressionism, surrealism and realism. Interested in seeing work that is contemporary. Does not want to see decorative art.

Terms: Accepts work on consignment. Retail price set by artist. Offers customer discounts and payment by installments. Exclusive area representation required. Gallery provides insurance and promotion; artist pays for shipping.

Submissions: Send query letter, résumé and 12 or more slides. Portfolio should include slides and transparencies. Finds artists through submissions.

Tips: "Be inventive, creative and be yourself."

N THE MARY PORTER SESNON GALLERY, Porter College, UCSC, Santa Cruz CA 95064. (831)459-3606. Fax: (831)459-3535. E-mail: lfellows@cats.ucsc.edu. Website: www.arts.ucsc.edu/sesnon. **Director:** Shelby Graham. Associate Director: Bridget Barnes. University gallery, nonprofit. Estab. 1971. Features new and established artists. Sponsors 4-6 shows/year. Average display time 4-6 weeks. Open September-June; Tuesday-Saturday, noon-5. Located on campus; 1,000 sq. ft. 100% of space for changing exhibitions. Clientele: academic and community-based. "We are not a commercial gallery. Visitors interested in purchasing work are put in direct contact with artists."

Media: Considers all media.

Style: Exhibits experimental, conceptually-based work.

Terms: Gallery provides insurance, promotion, shipping costs to and from gallery and occasional publications.

Submissions: Send query letter with résumé, slides, statement, SASE and reviews. Responds only if interested within 6 months. "Material is retained for committee review and returned in SASE."

N POSNER FINE ART, 13234 Fuji Way #G, Marina del Rey CA 90292. (310)822-2600. Fax: (310)578-8501. E-mail: posartl@aol.com. Website: www.artla.com. **Director:** Judith Posner. Retail gallery and art publisher. Estab. 1994. Represents 200 emerging, mid-career and established artists. Sponsors 5 shows/ year. Average display time 6 weeks. Open all year, Tuesday-Saturday, 10-6; Sunday, 12-5 or by appointment. Clientele: upscale and collectors. 50% private collectors, 50% corporate collectors. Overall price range: $25-50,000; most work sold at $500-10,000.

Media: Considers oil, acrylic, watercolor, pastel, mixed media, collage, works on paper, sculpture, ceramics, original handpulled prints, engravings, etchings, lithographs, posters and serigraphs. Most frequently exhibits paintings, sculpture and original prints.

Style: Exhibits painterly abstraction, minimalism, impressionism, realism, photorealism, pattern painting and hard-edge geometric abstraction. Genres include florals and landscapes. Prefers abstract, trompe l'oeil, realistic.

Terms: Accepts work on consignment (50% commission). Retail price set by the gallery. Customer discount and payment by installments. Gallery provides insurance and promotion; shipping costs are shared. Prefers artwork unframed.

Submissions: Send query letter with résumé, slides and SASE. Portfolio should include slides. Responds only if interested in 2 weeks. Finds artists through submissions and art collectors' referrals.

Tips: "We are looking for artists for corporate collections."

SANTA BARBARA CONTEMPORARY ARTS FORUM, 653 Paseo Nuevo, Santa Barbara CA 93101. (805)966-5373. Fax: (805)962-1421. E-mail: sbcaf@sbcaf.org. Website: www.sbcaf.org. **Contact:** Program Committee. Nonprofit gallery. Estab. 1976. Approached by 200 artists/year. Exhibited artists

include Tom Knechtel and Elizabeth Olbert. Sponsors 16 exhibits/year. Does not represent artists' work. Average display time 6-8 weeks. Open Tuesday-Saturday, 11-5; Sunday, 12-5. Located in 2,800 sq. ft. of exhibition space. Clients include local community, students, tourists and upscale.
Media: Considers all media and all types of prints.
Style: Considers all styles. Genres include anything other than traditional genres.
Submissions: Mail portfolio of slides for review. Returns material with SASE. Responds in 6 months. Files all materials except slides. Finds artists through word of mouth, submissions, portfolio review, art exhibits, referrals by other artists and studio visits.

N SHAMWARI GALLERY, 4176 Piedmont Ave., Oakland CA 94611. (510)923-1222. Fax: ((510)923-1104. E-mail: lwhite7738@aol.com. **Director:** Lillian White. For-profit gallery. Estab. 1997. Approached by 100 artists/year. Represents 7 emerging, mid-career and established artists. Sponsors 4 exhibits/year. Average display time 3 months. Open all year; Tuesday-Sunday, 11-6. Shamwari Gallery specializes in contemporary stone sculpture from Zimbabwe. Original paintings from around the world are exhibited as well as fine South African artifacts. Clients include local community, some tourists and upscale. Overall price range: $200-15,000; most work sold at $2,000.
Media: Considers acrylic, ceramics, drawing, mixed media, oil, paper, sculpture, watercolor.
Style: Exhibits: painterly abstraction. Most frequently exhibits abstract.
Terms: Charges 50% commission. Retail price set by gallery and the artist. Gallery provides insurance, promotion and contract. Accepted work should be framed. Requires exclusive representation locally.
Submissions: Call or write to arrange a personal interview to show portfolio of photographs, slides and transparencies. Send query letter with artist's statement, bio, brochure, business card, photographs, résumé, reviews, SASE, slides. Returns material with SASE. Reponds in 2 months. Files résumé and bio. Finds artists through word of mouth and referrals by other artists.

STUDIO 7 FINE ARTS, 77 West Angela St., Pleasanton CA 94566. (925)846-4322. E-mail: terry4arts@hotmail.com. Website: www.studio7arts.com. **Owner:** Terry Dowel. Retail gallery. Estab. 1981. Represents/exhibits 40-60 emergina and established artists/year. Sponsors 4-6 shows/year. Average display time 3 weeks. Open all year. Located in historic downtown Pleasanton; 1,800 sq. ft.; excellent lighting from natural and halogen sources. 70% of space for special exhibitions; 70% of space for gallery artists. Clientele: "wonderful, return customers." 99% private collectors, 1% corporate collectors. Overall price range: $100-10,000; most work sold at under $2,000.
Media: Considers oil, acrylic, watercolor, pastel, drawing, mixed media, collage, paper, sculpture, ceramics, fine craft, glass, woodcuts, engravings, lithographs, mezzotints, serigraphs and etchings. Most frequently exhibits oil, acrylic, etching, watercolor, handblown glass, jewelry and ceramics.
Style: Exhibits painterly abstraction and impressionism. Genres include landscapes and figurative work. Prefers landscapes, figurative and abstract.
Terms: Prefers work on consignment. Retail price set by the artist. Gallery provides promotion and contract and shares in shipping costs.
Submissions: Prefers artists from the Bay Area. Send query letter with résumé, 20-30 slides representing current style and SASE. Call for appointment to show portfolio of originals, slides and transparencies. Responds only if interested within 1 month. Files only accepted artists' slides and résumés (others returned). Finds artists through word of mouth and "my own canvassing."
Tips: "Be prepared! Please come to your appointment with an artist statement, an inventory listing including prices, a résumé, and artwork that is ready for display."

N NATALIE AND JAMES THOMPSON ART GALLERY, School of Art Design, San José State University, San José CA 95192-0089. (408)924-4723. Fax: (408)924-4326. E-mail: jfh@cruzio.com. Website: www.sjsu.edu. **Contact:** Jo Farb Hernandez, director. Nonprofit gallery. Approached by 100 artists/year. Represents 6 emerging, mid-career and established artists. Sponsors 6 exhibits/year. Average display time 1 month. Open all year; Tuesday-Friday, 11-4. Closed semester breaks, summer and weekends. Clients include local community, students and upscale.
Media: Considers all media and all types of prints.
Style: Considers all styles and genres.
Terms: Retail price set by the artist. Gallery provides insurance and promotion. Accepted work should be framed. Does not require exclusive representation locally.
Submissions: Send query letter with artist's statement, bio, résumé, reviews, SASE and slides. Returns material with SASE.

EDWARD WESTON FINE ART, 10511 Andora Ave., P.O. Box 3098, Chatsworth CA 91313. (818)885-1044. Fax: (818)885-1021. **Vice President:** Ann Weston. Art consultancy, for profit gallery, rental and wholesale gallery. Estab. 1960. Approached by 50 artists/year. Represents 100 emerging, mid-career and

established artists. Exhibited artists include George Barris, George Hurrell, C.S. Bull, Milton Greene and Laszlo Willinger. Sponsors 16 exhibits/year. Average display time 4-6 weeks. Open 7 days a week by appointment. Located in a 2-story 30×60 showroom gallery, office and storage facility. Clients include local community, tourists, upscale and dealers. 5% of sales are to corporate collectors. Overall price range: $50-75,000; most work sold at $1,000.

Media: Considers all media and all types of prints. Most frequently exhibits photography, paintings and sculpture.

Style: Considers all styles. Most frequently exhibits figurative work, landscapes. Considers all genres.

Making Contact & Terms: Artwork is accepted on consignment, and there is a 50% commission. Artwork is bought outright for 10-20% of the retail price; net 30 days. Retail price set by the gallery. Gallery provides contract. Accepted work should be framed and matted. Requires exclusive representation locally.

Submissions: Write to arrange a personal interview to show portfolio of photographs and transparencies. Mail portfolio for review. Send query letter with bio, brochure, business card, photocopies, photographs and reviews. Cannot return material. Responds in 1 month. Files materials if interesting. Finds artists through word of mouth, art exhibits and art fairs.

Tips: "Be thorough and complete."

SYLVIA WHITE CONTEMPORARY ARTISTS' SERVICES, 2022 Broadway, Suite B, Santa Monica CA 90404. (310)828-6200. E-mail: artadvice@aol.com. Website: www.artadvice.com. **Owner:** Sylvia White. Retail gallery, art consultancy and artist's career development services. Estab. 1979. Represents 25 emerging, mid-career and established artists. Interested in seeing work of emerging artists. Exhibited artists include Martin Mull, John White. Sponsors 12 shows/year. Average display time 1 month. Open all year; Tuesday-Friday, 10-5. Located in downtown Santa Monica; 2,000 sq. ft.; 100% of space for special exhibitions. Clientele: upscale. 50% private collectors, 50% corporate collectors. Overall price range: $1,000-10,000; most work sold at $3,000.

 ● Sylvia White also has representatives in Chicago, San Francisco and New York.

Media: Considers all media, including photography. Most frequently exhibits painting and sculpture.

Style: Exhibits all styles, including painterly abstraction and conceptualism.

Terms: Retail price set by gallery and artist. Gallery provides insurance, promotion and contract. Artist pays for shipping costs.

Submissions: Send query letter with résumé, slides, bio and SASE. Portfolio should include slides.

N WOMEN'S CENTER ART GALLERY, UCSB, Bldg. 434, Santa Barbara CA 93106. (805)893-3778. Fax: (805)893-3289. E-mail: artforwomen@mail2museum.com. Website: www.sa.ucsb.edu/women'scenter. **Contact:** Nicole DeGuzman, curator. Nonprofit gallery. Estab. 1973. Approached by 200 artists/year. Represents 50 emerging, mid-career and established artists. Exhibited artists include: Bobbi Bennett (photography) and Christa Reyes-Gonzales (acrylic on canvas). Sponsors 4 exhibits/year. Average display time 11 weeks. Open all year; Monday-Friday, 10-5. Closed UCSB campus holidays and weekends. Located in the Women's Center, on the campus of University of California at Santa Barbara. Exhibition space is roughly 4,000 sq. ft. Clients include local community and students. Overall price range: $100-1,000; most work sold at $300.

Media: Considers all media and all types of prints. Most frequently exhibits acrylic, mixed media and photography.

Style: Considers all styles and genres. Most frequently exhibits post modernism, feminist art and abstraction.

Terms: Retail price set by the artist. Gallery provides insurance and promotion. Accepted work should be framed. Does not require exclusive representation locally. Preference given to residents of Santa Barbara County.

Submissions: Mail portfolio for review. Send query letter with artist's statement, bio, photocopies, photographs, résumé, SASE and slides. Returns material with SASE. Responds only if interested within 3 months. Files complete submission material. Finds artists through word of mouth, submissions, portfolio reviews, art exhibits, referrals by other artists, e-mail and promotional calls to artists.

Tips: "Complete your submission thoroughly and include a relevent statement pertaining to the specific exhibit." Emphasize feminist subjects in imagery chosen.

N LEE YOUNGMAN GALLERIES, 1316 Lincoln Ave., Calistoga CA 94515. (707)942-0585. Fax: (707)942-6657. E-mail: leeyg@earthlink.net. Website: home.earthlink.net/~leeyg. **Owner:** Ms. Lee Love Youngman. Retail gallery. Estab. 1985. Represents 40 established artists. Exhibited artists include Ralph Love and Paul Youngman. Sponsors 3 shows/year. Average display time 2 months. Open all year. Located downtown; 3,000 sq. ft.; "warm Southwest decor, somewhat rustic." Clientele: 100% private collectors. Overall price range: $500-24,000; most artwork sold at $1,000-3,500.

Media: Considers oil, acrylic, watercolor and sculpture. Most frequently exhibits oils, bronzes and alabaster.

Style: Exhibits impressionism and realism. Genres include landscapes, Southwestern, Western and wildlife. Interested in seeing American realism. No abstract art.

Terms: Accepts work on consignment (50% commission). Retail price set by gallery. Customer discounts and payment by installment are available. Gallery provides insurance and promotion. Artist pays for shipping to and from gallery. Prefers framed artwork.

Submissions: Accepts only artists from Western states. "No unsolicited portfolios." Portfolio review requested if interested in artist's work. "The most common mistake artists make is coming on weekends, the busiest time, and expecting full attention." Finds artists through publication, submissions and owner's knowledge.

Tips: "Don't just drop in—make an appointment. No agents."

Los Angeles

Ⓝ ACADEMY GALLERY, 8949 Wilshire Blvd., Beverly Hills CA 90211. (310)247-3000. Fax: (310)247-3610. E-mail: gallerywoscars.org. Website: www.oscars.org. Nonprofit gallery. Estab. 1992. Represents established artists. Sponsors 9 exhibits/year. Average display time 2 months. Open all year; Tuesday-Friday, 10-5; weekends 12-6. Gallery begins in building's Grand Lobby and continues on the 4th floor. Total square footage is approx. 2,000. Clients include students and tourists,

Style: Considers all styles.

Submissions: Call or write to arrange a personal interview to show portfolio of photographs, slides and transparencies. Mail portfolio for review. Send query letter with brochure, photographs, résumé and slides. Returns material with SASE. Responds in 2 weeks. Finds artists through referrals by other artists.

☑ ⚎ CITY OF LOS ANGELES' CULTURAL AFFAIRS DEPARTMENT SLIDE REGISTRY, 514 S. Sprint St., 5th Floor, Los Angeles CA 90013. (213)485-8665. Fax: (213)485-8417. E-mail: cadslr@e arthlink.net. **Slide Registrar:** Mary E. Oliver. Registry for California artists. Estab. 1985. Represents 1,300 emerging, mid-career and established artists. Permanent resource for artists and consultants.

Media: Considers all media.

Style: Considers all styles and genres.

Terms: Accepts only artists from California. All artists must fill out application to be registered.

Submissions: Call, send query letter or e-mail for application.

Ⓝ DEVORZON GALLERY, 2720 Ellison Dr., Beverly Hills CA 90210-1208. (310)888-0111. Website: www.devorzon@mac.com. **Owner:** Barbara DeVorzon. Private gallery. "We also work in the design trade." Represents emerging and mid-career artists. Exhibited artists include Vasa, John Kennedy, Zdenek Sorf, Fulvia Levi-Bianchi, Enrique Senis Oliver. Average display time varies. Open all year. Located in Beverly Hills; 2,000 sq. ft. 100% of space for special exhibitions. 25% private collectors; 25% corporate collectors; 50% designers. Overall price range: $500-10,000.

Media: Considers oil, acrylic, watercolor, pastel, mixed media and sculpture. Most frequently exhibits oil or acrylic canvases, mixed media or three dimensional sculpture.

Style: Exhibits neo-expressionism, painterly abstraction, conceptualism, color field, realism, photorealism and neo-renaissance. "Original work only!"

Terms: Accepts work on consignment. Retail price set by the gallery. Gallery provides insurance. Artist pays for shipping. Prefers artwork unframed.

Submissions: Call for appointment to show portfolio.

Ⓝ DIRT GALLERY, 7906 Santa Monica Blvd., #218, Hollywood CA 90046. (323)822-9359. E-mail: dirtgallery@earthlink.net. Website: www.dirtgalleryla.com. **Contact:** Curator. Alternative space, for profit gallery. Estab. 1996. Approached by more than 400 artists/year. Represents 100s of emerging, mid-career and established artists. Average display time 6 weeks. Open all year; Thursday-Saturday, 12-5. Closed early March and late summer. DIRT Gallery is 5 rooms, approximately 12×12 each, in an old 1930s hotel. Clients include local community, students and upscale. Overall price range: $$50-7,000; most work sold at $300.

Media: Considers all media linocuts and woodcuts.

Style: Considers all styles. Most frequently exhibits contemporary, graffitti influence and urban. Genres include alternative, edgy.

Terms: Artwork is accepted on consignment and there is a 50% commission. Retail price set by the gallery and the artist. Gallery provides promotion. Does not require exclusive representation locally.

Submissions: Write to arrange a personal interview to show portfolio of slides. E-mail JPEGs. Returns material with SASE. Finds artists through word of mouth, submissions, portfolio reviews and referrals by other artists.

■ GALLERY 825, LA Art Association, 825 N. La Cienega Blvd., Los Angeles CA 90069. (310)652-8272. Fax: (310)652-9251. **Director:** Ashley Emenegger. Gallery Coordinator: Sinéad Finnerty. Nonprofit gallery. Estab. 1925. Exhibits emerging and established artists. "Artists must be Southern California-based." Interested in seeing the work of emerging artists. Approximately 300 members. Sponsors 11 juried shows/year. Average display time 3-4 weeks. Open all year; Tuesday-Saturday, 12-5. Located in Beverly Hills/West Hollywood. 25% of space for special exhibitions (2 rooms); 75% for gallery artists (2 large main galleries). Clientele: set decorators, interior decorators, general public. 90% private collectors.
Media: Considers all media and original handpulled prints. "Fine art only. No crafts." Most frequently exhibits mixed media, oil/acrylic and watercolor.
Style: All styles.
Terms: Requires $150 annual membership fee plus entry fees or 12 hours volunteer time for artists. Retail price set by artist (33% commission). Gallery provides promotion. "No shipping allowed." "Artists must apply via jury process held at the gallery 2 times per year in February and August." Phone for information.
Tips: "No commercial work (e.g. portraits/advertisements)."

■ LOS ANGELES MUNICIPAL ART GALLERY, Barnsdall Art Park, 4804 Hollywood Blvd., Los Angeles CA 90027. **Curators:** Noel Korten and Scott Canty. Nonprofit gallery. Estab. 1971. Interested in emerging, mid-career and established artists. Sponsors 5 solo and group shows/year. Average display time 2 months. 10,000 sq. ft. Accepts primarily Southern California artists.
Media: Considers oil, acrylic, watercolor, pastel, pen & ink, drawings, contemporary sculpture, ceramic, fiber, photography, craft, mixed media, performance art, video, collage, glass, installation and original handpulled prints.
Style: Exhibits contemporary works only. "We organize and present exhibitions which primarily illustrate the significant developments and achievements of living Southern California artists. The gallery strives to present works of the highest quality in a broad range of media and styles. Programs reflect the diversity of cultural activities in the visual arts in Los Angeles."
Terms: Gallery provides insurance, promotion and contract. This is a curated exhibition space, not a sales gallery.
Submissions: Send query letter, résumé, brochure, slides and photographs. Slides and résumés are filed. Submit slides to Scott Canty or Noel Korten.
Tips: "No limits—contemporary only."

LOUIS STERN FINE ARTS, 9002 Melrose Ave., W. Hollywood CA 90069. (310)276-0147. Fax: (310)276-7740. E-mail: gallery@louisstern.com. Estab. 1982. Approached by 50 artists/year. Represents or exhibits 15-20 established artists. Exhibited artists include: Cecilia Miguez (sculpture), Ana Mercedes Hoyos (painting), Judith Foosaner (painting) and Les Biller (painting). Sponsors 6-8 exhibits/year. Average display time 6 weeks. Open all year; Tuesday-Friday, 10-6; Saturday 11-5. Closed Christmas. Space is located in West Hollywood. Three galleries, high ceilings, wood flooring, sky lights. Can accommodate large scale paintings and sculpture as well as installations. Clients include local community and students. Overall price range: $3,000-300,000.
Media: Considers all media and all types of prints. Most frequently exhibits oil, mixed media and sculpture. Considers all types of prints.
Style: Considers all styles.
Terms: Artwork is accepted on consignment. Retail price set by the gallery and the artist.
Submissions: Send query letter with slides. Responds in 1 month. Finds artists through word of mouth, portfolio reviews, and referrals by other artists.

San Francisco

N EBERT GALLERY, 49 Geart St., San Francisco CA 94108. (415)296-8405. E-mail: dickebert@sprynet.com. Website: www.ebertgallery.com. **Owner:** Dick Ebert. Retail gallery. Estab. 1989. Represents 24 established artists "from this area." Interested in seeing the work of emerging artists. Sponsors 11-12 shows/year. Average display time 1 month. Open all year; Tuesday-Friday, 10:30-5:30; Saturday, 11-5. Located downtown near bay area; 200 sq. ft.; one room. Clientele: collectors, tourists, art students. 80% private collectors. Overall price range: $500-20,000; most work sold at $500-8,000.

Media: Considers oil, acrylic, watercolor, pastel, pen & ink, drawing, mixed media, collage, paper, sculpture, glass, photography, woodcuts, engravings, mezzotints, etchings and encostic. Most frequently exhibits acrylic, oils and pastels.

Style: Exhibits expressionism, painterly abstraction, impressionism and realism. Genres include landscapes, figurative work, all genres. Prefers landscapes, abstract, realism. "Smaller work to 4×5—no larger."

Terms: Accepts work on consignment (50% commission). Retail price set by the artist. Gallery provides promotion. Shipping costs are shared. Prefers artwork framed.

Submissions: San Francisco Bay Area artists only. Send query letter with résumé and slides. Finds artists through referral by professors or stable artists.

Tips: "You should have several years of practice as an artist before approaching galleries. Enter as many juried shows as possible."

[N] INTERSECTION FOR THE ARTS, 446 Valencia, San Francisco CA 94103. (415)626-2787. E-mail: info@theintersection.org. Website: www.theintersection.org **Program Director:** Kevin B. Chen. Alternative space and nonprofit gallery. Estab. 1965. Exhibits the work of 10 emerging and mid-career artists/year. Sponsors 8 shows/year. Average display time 6 weeks. Open all year. Located in the Mission District of San Francisco; 1,000 sq. ft.; gallery has windows at one end and cement pillars betwen exhibition panels. 100% of space for special exhibitions. Clientele: 100% private collectors.

• This gallery supports emerging and mid-career artists who explore experimental ideas and processes. Interdisciplinary, new genre, video performance and installation is encouraged.

Media: Considers oil, pen & ink, acrylic, drawings, watercolor, mixed media, installation, collage, photography, site-specific installation, video installation, original handpulled prints, woodcuts, lithographs, posters, wood engravings, mezzotints, linocuts and etchings.

Style: Exhibits all styles and genres.

Terms: Retail price set by artist. Customer discounts and payment by installment are available. Gallery provides promotion; shipping costs are shared.

Submissions: Send query letter with résumé, 20 slides, reviews, bio, clippings and SASE. Portfolio review not required. Responds within 6 months only if interested and SASE has been included. Files slides.

Tips: "Create proposals which consider the unique circumstances of this location, utilizing the availability of the theater and literary program/resources/audience."

MUSEO ITALOAMERICANO, Fort Mason Center Bldg. C, San Francisco CA 94123. (415)673-2200. Fax: (415)673-2292. E-mail: museo@firstworld.net. Website: www.museoitaloamericano.org. Museum. Estab. 1978. Approached by 80 artists/year. Exhibits 15 emerging, mid-career and established artists/year. Exhibited artists include: Sam Provenzano. Sponsors 7 exhibits/year. Average display time 2-3 months. Open all year; Wednesday-Sunday, 12-5; weekends 12-5. Closed major holidays. Located in the San Francisco Marina District with beautiful view of the Golden Gate Bridge, Saulsalito, Tiburon and Alcatraz. 3,500 sq. ft. of exhibition space. Clients include local community, students, tourists, upscale and members.

Media: Considers all media and all types of prints. Most frequently exhibits mixed media, paper, photography and oil.

Style: Considers all styles and genres. Most frequently exhibits primitivism realism, geometric abstraction, figurative and conceptualism.

Terms: The museum rarely sells pieces. If it does, it takes 20% of the sale. Gallery provides insurance and promotion. Accepted work should be framed, mounted and matted. Accepts only Italian or Italian-American artists.

Submissions: Call or write to arrange a personal interview to show portfolio of photographs, slides and catalogues. Send query letter with artist's statement, bio, brochure, photography, résumé, reviews, SASE and slides. Returns material with SASE. Responds in 2 months. Files 2 slides and biography and artist's statement for each artist. Finds artists through word of mouth and submissions.

Tips: Looks for good quality slides; and clarity in writing statements and résumés. "Be concise."

OCTAVIA'S HAZE GALLERY, 498 Hayes St., San Francisco CA 94102. (415)255-6818. Fax: (415)255-6827. E-mail: octaviashaze@mindspring.com. Website: www.octaviashaze.com. **Director:** Sky Alsgaard. For profit gallery. Estab. 1999. Approached by 60 artists/year. Represents 10 emerging and mid-career artists. Exhibited artists include: Tsuchida Yasuhiko and Steven Starfas. Sponsors 10 exhibits/year. Average display time 45 days. Open all year; Wednesday-Sunday, 12-6; Sunday, 11-5. Closed Christmas through New Years. Clients include local community, tourists and upscale. 13% of sales are to corporate collectors. Overall price range: $200-6,000; most work sold at $600.

Media: Most frequently exhibits glass, paintings (all media) and photography. Considers all types of prints.

Style: Considers all styles. Most frequently exhibits abstract, surrealism and expressionism. Genres include figurative work and landscapes.

Terms: Artwork is accepted on consignment and there is a 50% commission. Retail price set by the gallery. Gallery provides promotion and contract. Accepted work should be framed and matted.
Submissions: Send query letter with artist's statement, résumé, SASE and slides. Returns material with SASE. Responds in 4 months. Finds artists through word of mouth, submissions and art exhibits.

SAN FRANCISCO ARTS COMMISSION GALLERY, 401 Van Ness Ave., San Francisco CA 94102. (415)554-6080. Fax: (415)252-2595. E-mail: natasha_garcia-lomas@ci.sf.ca.us. Website: http://sfac.sfsu.edu/. **Director:** Rupert Jenkins. Gallery Manager: Natasha Garcia-Lomas. Nonprofit municipal gallery; alternative space. Estab. 1983. Exhibits work of approximately 150 emerging and mid-career artists/year; 400-500 in Slide Registry. Sponsors 7 indoor group shows/year. Average display time 5 weeks (indoor); 3 months (outdoor installations). Open all year. Located at the Civic Center; 1,000 sq. ft. across the street from City Hall and in the heart of the city's performing arts complex. 100% of space for special exhibitions. Clientele: cross section of San Francisco/Bay Area including tourists, upscale, local and students. Sales are minimal.
Media: Considers all media. Most frequently exhibits installation, mixed media, sculpture/3-D, painting, photography.
Style: Exhibits all styles. Prefers cutting-edge, contemporary works.
Terms: Accepts artwork on consignment (25% commission). Retail price set by artist. Gallery provides insurance, promotion and contract; artist pays for shipping.
Submissions: Accepts only artists residing in one of nine Bay Area counties. Write for guidelines to join the slide registry to automatically receive calls for proposals and other exhibition information. Do not send unsolicited slides.
Tips: "The Art Commission Gallery serves as a forum for exhibitions which reflect the aesthetic and cultural diversity of contemporary art in the Bay Area. Temporary installations in the outdoor lot adjacent to the gallery explore alternatives to traditional modes of public art. Gallery does not promote sale of art, as such, but will handle sale of available work if a visitor wishes to purchase it. Exhibit themes, artists, and selected works are recommended by the gallery director to the San Francisco Art Commission for approval. Gallery operates for the benefit of the public as well as the artists. It is not a commercial venue for art."

Colorado

THE BOULDER MUSEUM OF CONTEMPORARY ART, 1750 13th St., Boulder CO 80302. (303)443-2122. Fax: (303)447-1633. E-mail: info@bmoca.org. Website: www.bmoca.org. **Contact:** Exhibitions Committee. Nonprofit museum. Estab. 1972. Exhibits contemporary art and performance. Programs regional, national and international emerging and established artists. 10,000 sq. ft. of exhibition and performance spaces. "Located in a historically landmarked two-story, red-brick building in heart of downtown Boulder."
Media: Considers all media.
Style: Exhibits new art forms in the work of emerging and established artists.
Submissions: Accepts work by invitation only, after materials have been reviewed by Exhibitions Committee. Send query letter, artist statement, résumé, approximately 20 high-quality slides and SASE. Portfolio review requested if interested in artist's work. Submission review in January and June. Responds in 6 months. Submissions are filed. Additional materials appropriate to submission are accepted.

BUSINESS OF ART CENTER, 513 Manitou Ave., Colorado Springs CO 80928. (719)685-1861. Website: businessofartcenter.org. Nonprofit gallery. Estab. 1988. Approached by 200 emerging, mid-career and established artists/year. Sponsors 40 exhibits/year. Average display time 1 month. Open all year; Monday-Sunday, 10-6. Shorter winter hours, please call. Clients include local community, students and upscale. 10% of sales are to corporate collectors.
Media: Considers all media and all types of prints. Most frequently exhibits painting, photography and ceramic.
Style: Considers all styles and genres.
Terms: Artwork is accepted on consignment and there is a 40% commission. Retail price set by the artist. Gallery provides insurance, promotion and contract. Accepted work should be framed. Requires exclusive representation locally. Accepts only artists from Colorado.
Submissions: Write to arrange a personal interview to show portfolio. Send query letter with artist's statement, bio and slides. Returns material with SASE. Finds artists through word of mouth, submissions, portfolio reviews, art exhibits and referrals by other artists.
Tips: Archival quality materials are mandatory to the extent possible in the medium.

N: GALLERY M, 2830 E. Third Ave., Denver CO 80206. (303)331-8400. Fax: (303)331-8522. E-mail: mhayutnegallerym.com. Website: www.gallery.com. **Contact:** Managing Partner. For-profit gallery. Estab. 1996. Represents emerging, mid-career and established artists. Exhibited artists include: Alfred Elsenstaedt (photography). Average display time 6-12 weeks. Clients include local community, tourists and upscale. Overall price range: $265-??; most work sold at $1,000-5,000.

Media: Considers acrylic, collage, drawing, glass, installation, mixed media, oil, paper, pastel, pen & ink, sculpture,watercolor, engravings, etchings, linocuts, lithographs, mezzotints, serigraphs and woodcuts.

Style: Exhibits: color field, expressionism, geometric abstraction, neo-expressionism, postmodernism, primitivism realism and surrealism. Considers all genres.

Terms: Retail price set by the gallery and the artist. Gallery provides insurance and promotion. Requires exclusive representation locally.

Submissions: Write to arrange a personal interview to show portfolio of photographs, slides and transparencies. Mail portfolio for review. Returns materials with SASE. Finds artists through word of mouth, submissions, portfolio reviews, art exhibits, art fairs and referrals by other artists.

N: WILLIAM HAVU GALLERY, 1040 Cherokee St., Denver CO 80204 (303)893-2360. Fax: (303)893-2813. E-mail: bhavu@mho.net. Website: www.oneoverone.com. **Owner:** Bill Havu. Gallery Administrator: Julia Rymer. For-profit gallery. Estab. 1998. Approached by 120 emerging, mid-career and established artists. Exhibits 50 artists. Exhibited artists include: Emilio Lobato, painter and printmaker; Amy Metier, painter. Sponsors 7-8 exhibits/year. Average display time 6-8 weeks. Open all year; Tuesday-Friday, 10-6; Saturday, 11-5. Closed Sundays, Christmas and New Year's Day. Located in the Golden Triangle Arts District of downtown Denver. The only gallery in Denver designed as a gallery; 3,000 square feet, 18 foot high ceilings, 2 floors of exhibition space; sculpture garden. Clients include local community, students, tourists, upscale, interior designers and art consultants. Overall price range: $250-15,000; most work sold at $1,000-4,000.

Media: Considers acrylic, ceramics, collage, drawing, mixed media, oil, paper, pastel, pen & ink, sculpture and watercolor. Most frequently exhibits painting, prints and ceramic sculpture. Considers etchings, linocuts, lithographs, mezzotints, woodcuts, monotypes, monoprints and silkscreens.

Style: Exhibits: expressionism, geometric abstraction, impressionism, minimalism, postmodernism, surrealism and painterly abstraction. Most frequently exhibits painterly abstraction, impressionism and expressionism.

Terms: Artwork is accepted on consignment and there is a 50% commission. Retail price set by the gallery and the artist. Gallery provides insurance, promotion and contract. Accepted work should be framed. Accepts only artists from Rocky Mountain, Southwestern region.

Submissions: Mail portfolio for review. Send query letter with artist's statement, bio, brochure, résumé, SASE and slides. Returns material with SASE. Responds only if interested within 1 month. Files slides and résumé, if we are interested in the artist. Finds artists through word of mouth, submissions and referrals by other artists.

Tips: Always mail a portfolio packet. We do not accept walk-ins or phone calls to review work. Explore website or visit gallery to make sure work would fit with the gallery's objective. Archival-quality materials play a major role in selling fine art to collectors. We only frame work with archival-quality materials and feel its inclusion in work can "make" the sale.

E.S. LAWRENCE GALLERY, 516 E. Hyman Ave., Aspen CO 81611. (970)920-2922. Fax: (970)920-4072. E-mail: esl@eslawrence.com. Website: www.eslawrence.com. **Director:** Kert Koski. Retail gallery. Estab. 1988. Represents emerging, mid-career and established artists. Exhibited artists include Zvonimir Mihanovic, Graciela Rodo Boulanger, Pino, Steve Hanks and Chiu Tak Hak. Sponsors 2 shows/year. Open all year; daily 10-10. Located downtown. 100% of space for gallery artists. 95% private collectors, 5% corporate collectors.

● This gallery also has a location in Charleston SC.

Media: Considers oil, acrylic, watercolor, pastel, mixed media, sculpture, glass, lithograph and serigraphs. Most frequently exhibits oil, acrylic, watercolor and bronzes.

Style: Exhibits expressionism, impressionism, photorealism and realism. Genres include landscapes, florals, Americana, figurative work. Prefers photorealism, impressionism, expressionism.

Terms: Accepts artwork on consignment. Retail price set by the gallery and the artist. Gallery provides insurance, promotion and contract; artist pays shipping costs to and from gallery "if not sold." Prefers artwork framed.

Submissions: Send query letter with résumé, slides and photographs. Write for appointment to show portfolio of photographs, slides and reviews. Responds in 1 month. Finds artists through agents, visiting exhibitions, word of mouth, art publications and artists' submissions.

Tips: "We are always willing to look at submissions. We are only interested in originals above $5,000 retail price range. Not interested in graphics."

N. MERRILL JOHNSON GALLERY, 315 Detroit St., Denver CO 80211. (303)333-1566. Fax: (303)333-1564. E-mail: info@merrillgallery.com. Website: www.merrillgallery.com. **Director:** Reneé Rowe. For-profit gallery. Estab. 1986. Approached by 350 artists/year. Exhibits 24 emerging, mid-career and established artists. Exhibited artists include: Daniel Sprick, oil; Ray Knaub, oil. Sponsors 11 original paintings and sculpture exhibits/year. Average display time 2 weeks. Open all year; Monday-Friday, 10-6; Saturday, 11-5. Closed Sundays. Located in the heart of Cherry Creek North's upscale shopping district. Clients include local community, tourists, upscale. Overall price range: $650-60,000; most work sold at $5,000.
Media: Considers acrylic, ceramics, mixed media, oil, pastel, pen & ink, sculpture and watercolor. Most frequently exhibits oil, pastel and watercolor.
Style: Exhibits: expressionism and impressionism. Most frequently exhibits representational contemporary figurative, still life and landscape. Genres include figurative work, florals, landscapes, portraits and still lifes.
Terms: Artwork is accepted on consignment and there is a 50% commission. Retail price set by the artist. Gallery provides insurance and promotion. Accepted work should be framed. Requires exclusive representation locally.
Submissions: Write to arrange a personal interview to show portfolio of photographs, transparencies and slides. Mail portfolio for review. Send artist's statement, bio, photographs, SASE and slides. Returns material with SASE. Responds in 1 month. Files artist's statement and bio. Finds artists through submissions, art exhibits and art publications.
Tips: "We expect materials to be archival."

SANGRE DE CRISTO ARTS CENTER AND BUELL CHILDREN'S MUSEUM, 210 N. Santa Fe Ave., Pueblo CO 81003. (719)543-0130. Fax: (719)543-0134. E-mail: artctr@ris.net. **Curator of Visual Arts:** Jina Pierce. Nonprofit gallery and museum. Estab. 1972. Exhibits emerging, mid-career and established artists. Sponsors 20 shows/year. Average display time 10 weeks. Open all year. Admission free. Located "downtown, right off Interstate I-25"; 16,000 sq. ft.; six galleries, one showing a permanent collection of western art; changing exhibits in the other five. Also a new 10,000 sq. ft. children's museum with changing, interactive exhibits. Clientele: "We serve a 19-county region and attract 200,000 visitors yearly." Overall price range for artwork: $50-100,000; most work sold at $50-2,500.
Media: Considers all media.
Style: Exhibits all styles. Genres include southwestern, regional and contemporary.
Terms: Accepts work on consignment (40% commission). Retail price set by artist. Gallery provides insurance, promotion, contract and shipping costs. Prefers artwork framed.
Submissions: "There are no restrictions, but our exhibits are booked into 2001 right now." Send query letter with slides. Write or call for appointment to show portfolio of slides. Responds in 2 months.

PHILIP J. STEELE GALLERY AT ROCKY MOUNTAIN COLLEGE OF ART & DESIGN, 6875 E. Evans Ave., Denver CO 80224. (303)753-6046. Fax: (303)759-4970. E-mail: lspivak@rmcad.edu. Website: wwwrmcad.edu. **Gallery Director:** Lisa Spivak. Nonprofit college gallery. Estab. 1962. Represents emerging, mid-career and established artists. Sponsors 10-12 shows/year. Exhibited artists include Christo, Jenny Holzer. Average display time 1 month. Open all year; Monday-Friday, 8-6; Saturday, 9-4. Located in southeast Denver; 1,500 sq. ft.; in very prominent location (art college with 450 students enrolled). 100% of space for gallery artists. Clientele: local community, students, faculty.
Media: Considers all media and all types of prints. Most frequently exhibits mixed media, oil/acrylic and work on paper.
Style: Exhibits all styles.
Terms: Artists sell directly to buyer; gallery takes no commission. Retail price set by the artist. Gallery provides insurance and promotion; artist pays shipping costs to and from gallery.
Submissions: Send query letter with résumé, slides, bio, SASE and reviews by April 15 for review for exhibit the following year.
Tips: Impressed by "professional presentation of materials, good-quality slides or catalog."

Connecticut

N. ALVA GALLERY, 311 State St., New London CT 06320. (860)437-8664. Fax: (860)437-8665. E-mail: gimgreen@aol.com. Website: www.alvagallery.com. For-profit gallery. Estab. 1999. Approached by 50 artists/year. Represents 30 emerging, mid-career and established artists. Exhibited artists include: Mau-

reen McCabe (assemblage) and Gigi Linerant (pastel). Average display time 6 weeks. Open all year; Tuesday-Saturday, 11-5. Closed between Christmas and New Year and last 2 weeks of August. Clients include local community, tourists and upscale. 5% of sales are to corporate collectors. Overall price range: $250-10,000; most work sold at $1,500.

Media: Considers acrylic, collage, drawing, fiber, glass, mixed media, oil, paper, pastel, pen & ink, sculpture and watercolor. Most frequently exhibits oil, photography and mixed media. Considers all types of prints.

Style: Considers all styles and genres.

Terms: Artwork is accepted on consignment and there is a 50% commission. Retail price set by the artist. Gallery provides insurance and promotion. Does not require exclusive representation locally.

Submissions: Mail portfolio for review. Responds in 2 months. Finds artists through word of mouth, portfolio reviews and referrals by other artists.

MONA BERMAN FINE ARTS, 78 Lyon St., New Haven CT 06511. (203)562-4720. Fax: (203)787-6855. E-mail: mbfineart@snet.net. **Director:** Mona Berman. Art consultant. Estab. 1979. Represents 100 emerging and mid-career artists. Exhibited artists include Tom Hricko, David Dunlop, Pierre Dardignac and S. Wind-Greenbain. Sponsors 1 show/year. Open all year by appointment. Located near downtown; 1,400 sq. ft. Clientele: 5% private collectors, 95% corporate collectors. Overall price range: $200-20,000; most artwork sold at $500-5,000.

Media: Considers all media except installation. Shows very little sculpture. Considers all limited edition prints except posters and photolithography. Most frequently exhibits works on paper, painting, relief and ethnographic arts.

Style: Exhibits most styles. Prefers abstract, landscape and transitional. No figurative, little still life.

Terms: Accepts work on consignment (50% commission; net 30 days). Retail price is set by gallery and artist. Customer discounts and payment by installment are available. Gallery provides insurance; artist pays for shipping. Prefers artwork unframed.

Submissions: Send query letter, résumé, CD or "about 20 slides," bio, SASE, reviews and "price list—retail only at stated commission." Portfolios are reviewed only after CD or slide submission. Responds in 1 month. Slides and reply returned only if SASE is included. Finds artists through word of mouth, art publications and sourcebooks, submissions and self-promotions and other professionals' recommendations.

Tips: "Please understand that we are not a gallery, although we do a few exhibits. We are primarily art consultants. We continue to be busy selling high-quality art and related services to the corporate, architectural and design sectors. Read our listings, then you don't have to call first. A follow-up call is certainly acceptable after you have sent your package."

MARTIN CHASIN FINE ARTS L.L.C., 1125 Church Hill Rd., Fairfield CT 06432. (203)374-5987. Fax: (203)372-3419. **Owner:** Martin Chasin. Retail gallery. Estab. 1985. Represents 40 mid-career and established artists. Interested in seeing the work of emerging artists. Exhibited artists include Katherine Ace and David Rickert. Sponsors 8 shows/year. Average display time 3 weeks. Open all year. Located downtown; 1,000-1,500 sq. ft. 50% of space for special exhibitions. Clientele: "sophisticated." 40% private collectors; 30% corporate collectors. Overall price range: $1,500-10,000; most work sold at $3,000-5,000.

Media: Considers oil, acrylic, watercolor, pastel, pen & ink, drawings, paper, woodcuts, wood engravings, engravings, mezzotints, etchings, lithographs, pochoir and serigraphs. "No sculpture." Most frequently exhibits oil on canvas, etchings/engravings and pastel.

Style: Exhibits expressionism, neo-expressionism, color field, impressionism and realism. Genres include landscapes, Americana, portraits. Prefers landscapes, seascapes, ships/boating scenes and sporting action. Particularly interested in realistic art.

Terms: Accepts work on consignment (30-50% commission). Retail price set by artist. Offers payment by installments. Gallery provides insurance, promotion and shipping costs from gallery. Prefers artwork unframed.

Submissions: Send query letter with résumé, slides, bio, price list and SASE. Call or write for appointment to show portfolio of slides and photographs. Responds in 3 weeks. Files future sales material. Finds artists through exhibitions, "by artists who write to me and send good slides or transparencies. Send at least 10-15 slides showing all genres of art you produce. Omit publicity sheets and sending too much material."

Tips: "The art scene is less far-out, fewer avant-garde works are being sold. Clients want artists with a solid reputation."

N BILL GOFF, INC., 5 Bridge St., P.O. Box 977, Kent CT 06757-0977. (860)927-1411. Fax: (860)927-1987. **President:** Bill Goff. Estab. 1977. Exhibits, publishes and markets baseball art. 95% private collectors, 5% corporate collectors.

Needs: Baseball subjects for prints. Realism and photorealism. Represents 10 artists; emerging, mid-career and established. Exhibited artists include Andy Jurinko and William Feldman, Bill Purdom, Bill Williams.

First Contact & Terms: Send query letter with bio and photographs. Write to schedule an appointment to show a portfolio, which should include photographs. Responds only if interested within 2 months. Files photos and bios. Accepts work on consignment (50% commission) or buys outright for 50% of retail price. Overall price range: $95-30,000; most work sold at $125-220 (published lithographs). Retail price set by the gallery. Gallery provides insurance and promotion; shipping costs are shared. Prefers artwork unframed.

Tips: "Do not waste our time or your own by sending non-baseball items."

SILVERMINE GUILD GALLERY, 1037 Silvermine Rd., New Canaan CT 06840. (203)966-5617. Fax: (203)972-7236. **Director:** Helen Klisser During. Nonprofit gallery. Estab. 1922. Represents 300 emerging, mid-career and established artists/year. Sponsors 24 shows/year. Average display time 1 month. Open all year; Tuesday-Saturday, 11-5; Sunday, 1-5. 5,000 sq. ft. 95% of space for gallery artists. Clientele: private collectors, corporate collectors. Overall price range: $250-10,000; most work sold at $1,000-2,000.

Media: Considers all media and all types of prints. Most frequently exhibits paintings, sculpture and ceramics.

Style: Exhibits all styles.

Terms: Accepts guild member work on consignment (50% commission). Co-op membership fee plus donation of time (50% commission.) Retail price set by the gallery and the artist. Gallery provides insurance, promotion and contract. Prefers artwork framed.

Submissions: Send query letter.

✓ 🎨 **SMALL SPACE GALLERY**, Arts Council of Greater New Haven, 70 Audubon St., New Haven CT 06510. (203)772-2788. Fax: (203)772-2262. E-mail: arts.council@snet.net. Website: www.artscouncil-newhaven.org. **Director:** Lisa Ronello. Alternative space. Estab. 1985. Interested in emerging artists. Sponsors 10 solo and group shows/year. Average display time: 1 month. Open to Arts Council artists only (Greater New Haven). Arts Council membership costs $35. Artwork price range: $35-3,000.

Media: Considers all media.

Style: Exhibits all styles and genres. "The Small Space Gallery was established to provide our artist members with an opportunity to show their work. Particularly those who were just starting their careers. We're not a traditional gallery, but an alternative art space." Shows are promoted through greater New Haven's only comprehensive arts and entertainment events magazine.

Terms: Arts Council requests 10% donation on sale of each piece. Retail price set by artist. Exclusive area representation not required. Gallery provides insurance (up to $10,000) and promotion.

Submissions: Send query letter with résumé, brochure, slides, photographs and bio. Call or write for appointment to show portfolio of originals, slides, transparencies and photographs. Will reply to all mailings and phone calls. Files publicity, price lists and bio.

Delaware

CARSPECKEN SCOTT GALLERY, 1707 N. Lincoln St., Wilmington DE 19806. (302)655-7173. E-mail: carspecken-Scott@aol.com. **Gallery Director:** Toni Vandergrift. Art consultancy, for profit gallery. Also provides museum quality framing. Estab. 1973. Approached by 100 artists/year. Represents 25 mid-career and established artists. Exhibited artists include: Greg Bennett and Mary Page Evans (oil canvas). Sponsors 8 exhibits/year. Average display time 1 month. Open all year; Monday-Friday, 9-5:30; Saturday, 10-3. Clients include local community and upscale. Overall price range: $500-8,000; most work sold at $2,800.

Media: Considers drawing, oil, sculpture and watercolor. Most frequently exhibits oil, acrylic and drawing. Considers engravings, etchings and lithographs.

Style: Exhibits: expressionism, impressionism and painterly abstraction. Most frequently exhibits florals, stilllifes and landscapes.

Terms: Artwork is accepted on consignment and there is a 40% commission. Retail price set by the artist. Gallery provides promotion. Accepted work should be framed. Requires exclusive representation locally.

Submissions: Mail portfolio for review. Send query letter with artist's statement, bio, photographs, résumé, SASE and slides. Returns material with SASE. Responds in 1 month. Finds artists through portfolio reviews, and referrals by other artists.

N **DELAWARE ART MUSEUM ART SALES & RENTAL GALLERY**, 2301 Kentmere Parkway, Wilmington DE 19806. (302)571-9590 ext. 550. Fax: (302)571-0220. **Director, Art Sales & Rental:** Alice

B. Hupfel. Nonprofit retail gallery, art consultancy and rental gallery. Estab. 1975. Represents 50-100 emerging artists. Open all year; Tuesday-Saturday, 9-4 and Sunday 10-4. Located seven minutes from the center of Wilmington; 1,200 sq. ft.; "state-of-the-art gallery and sliding racks." Clientele: 40% private collectors; 60% corporate collectors. Overall price range: $500-12,000; most work sold at $1,500-2,500.
Media: Considers all media and all types of prints except posters and reproductions.
Style: Exhibits all styles.
Terms: Accepts artwork on consignment (40% commission). Rental fee for artwork covers 2 months. Retail price set by artist. Gallery provides insurance while on premises and contract. Artist pays shipping costs. Artwork must be framed.
Submissions: Artist must be able to pick up and deliver.

N: DELAWARE CENTER FOR THE CONTEMPORARY ARTS, 200 S. Madison St., Wilmington DE 19801. (302)656-6466. Fax: (302)656-6944. Website: www.thedca.org. **Director:** Steve Lanier. Nonprofit gallery. Estab. 1979. Exhibits the work of emerging, mid-career and established artists. Sponsors 30 solo/group shows/year of both national and regional artists. Average display time is 1 month. 3,000 sq. ft. Overall price range: $50-10,000; most artwork sold at $500-1,000.
Media: Considers all media, including contemporary crafts.
Style: Exhibits contemporary, abstract, figurative, conceptual, representational and non-representational, painting, sculpture, installation and contemporary crafts.
Terms: Accepts work on consignment (35% commission). Retail price is set by the gallery and the artist. Exclusive area representation not required. Gallery provides insurance and promotion; shipping costs are shared.
Submissions: Send query letter, résumé, slides and/or photographs and SASE. Write for appointment to show portfolio. Seeking consistency within work as well as in presentation. Slides are filed. Submit up to 20 slides with a corresponding slide sheet describing the work (i.e. media, height by width by depth), artist's name and address on top of sheet and title of each piece in the order in which you would like them reviewed.
Tips: "Before submitting slides, call and inquire about an organization's review schedule so your slides won't be tied up for an extended period. Submit at least ten slides that represent a cohesive body of work."

MICHELLE'S OF DELAWARE, 831 North Market St., Wilmington DE 19801. (302)655-3650. Fax: (302)661-ARTS. **Art Director:** Raymond Bullock. Retail gallery. Estab. 1991. Represents 18 mid-career and established artists/year. May be interested in seeing the work of emerging artists in the future. Exhibited artists include: William Tolliver and Joseph Holston. Sponsors 8 shows/year. Average display time 1-2 weeks. Open all year; Saturday-Sunday, 11-5 and 1-5 respectively. Located in Market Street Mall (downtown); 2,500 sq. ft. 50% of space for special exhibitions. Clientele: local community. 97% private collectors; 3% corporate collectors. Overall price range: $300-20,000; most work sold at $1,300-1,500.
Media: Considers oil, acrylic, watercolor, pastel, pen & ink, mixed media, collage and sculpture; types of prints include woodcuts, lithographs, mezzotints, serigraphs, linocuts and etchings. Most frequently exhibits acrylic, watercolor, pastel and oil.
Style: Exhibits all genres. Prefers: jazz, landscapes and portraits.
Terms: Retail price set by the artist. Gallery provides insurance and contract; shipping costs are shared. Prefers artwork framed.
Submissions: Send slides. Write for appointment to show portfolio of artwork samples. Responds only if interested within 1 month. Files bio. Finds artists through art trade shows and exhibitions.
Tips: "Use conservation materials to frame work."

District of Columbia

ADDISON/RIPLEY FINE ART, 1670 Wisconsin Ave., NW, Washington DC 20007. (202)338-5180. Fax: (202)338-2341. E-mail: addisonrip@aol.com. Website: artnet.com. **Owner:** Christopher Addison. For profit gallery and art consultancy. Estab. 1981. Approached by 100 artists/year. Represents 25 emerging, mid-career and established artists. Exhibited artists include: Wolf Kahn (paintings, pastels). Sponsors 13 exhibits/year. Average display time 6 weeks. Open all year; Tuesday-Saturday, 11-6. Closed end of summer. Upper Georgetown, large, open gallery space that is light filled. Clients include local community, tourists and upscale. 20% of sales are to corporate collectors. Overall price range: $500-80,000; most work sold at $2,500-5,000.
Media: Considers acrylic, ceramics, collage, drawing, fiber, glass, installation, mixed media, oil, paper, pastel, sculpture and watercolor. Most frequently exhibits oil and acrylic. Considers etchings, linocuts, lithographs, mezzotints, photography and woodcuts.

Style: Considers all styles. Most frequently exhibits painterly abstraction, color field and expressionism. Considers all genres.

Terms: Terms depend on the circumstances. Retail price set by the gallery and the artist. Gallery provides insurance, promotion and contract. Accepted work should be framed, mounted and matted. No restrictions regarding art or artists.

Submissions: Mail portfolio for review. Send query letter with artist's statement, bio, photocopies, résumé and SASE. Returns material with SASE. Responds in 1 month. Call. "Files ones we like." Finds artists through word of mouth, submissions, and referrals by other artists.

Tips: "Submit organized, professional-looking materials."

☑ ATLANTIC GALLERY OF GEORGETOWN, 1055 Thomas Jefferson St. NW, Washington DC 20007. (202)337-2299. Fax: (202)333-4467. E-mail: gallerydc@aol.com. **Director:** Virginia Smith. Retail gallery. Estab. 1976. Represents 10 mid-career and established artists. Exhibited artists include John Stobart, Tim Thompson, John Gable, Frits Goosen and Robert Johnson. Sponsors 5 solo shows/year. Average display time is 2 weeks. Open all year. Located downtown; 700 sq. ft. Clientele: 70% private collectors, 30% corporate clients. Overall price range: $100-20,000; most artwork sold at $300-5,000.

Media: Considers oil, watercolor and limited edition prints.

Style: Exhibits realism and impressionism. Prefers realistic marine art, florals, landscapes and historic narrative leads.

Terms: Accepts work on consignment (40% commission). Retail price set by gallery and artist. Exclusive area representation required. Gallery provides insurance, promotion and contract; artist pays for shipping.

Submissions: Send query letter, résumé and slides. Portfolio should include originals and slides.

BIRD-IN-HAND BOOKSTORE & GALLERY, 323 7th St. SE, Box 15258, Washington DC 20003. (202)543-0744. Fax: (202)547-6424. E-mail: chrisbih@aol.com. **Director:** Christopher Ackerman. Retail gallery. Estab. 1987. Represents 30 emerging artists. Exhibited artists include Dario Scholis, Karen Whitman, Janet Dowling, Darien Payne. Sponsors 6 shows/year. Average display time 6-8 weeks. Located on Capitol Hill at Eastern Market Metro; 300 sq. ft.; space includes small bookstore, art and architecture. "Most of our customers live in the neighborhood." Clientele: 100% private collectors. Overall price range: $75-1,650; most work sold at $75-350.

Media: Considers original handpulled prints, woodcuts, wood engravings, artists' books, linocuts, engravings, etchings. Also considers small paintings. Prefers small prints, works on paper and fabric.

Terms: Accepts work on consignment (40% commission). Retail price set by gallery. Gallery provides insurance, promotion and contract; shipping costs are shared.

Submissions: Send query letter with résumé, 10-12 slides and SASE. Write for appointment to show portfolio of originals and slides. Interested in seeing tasteful work. Responds in 1 month. Files résumé; slides of accepted artists.

Tips: "The most common mistake artists make in presenting their work is dropping off slides/samples without SASE and without querying first. We suggest a visit to the gallery before submitting slides. We show framed and unframed work of our artists throughout the year as well as at time of individual exhibition. Also, portfolio/slides of work should have a professional presentation, including media, size, mounting, suggested price, and copyright date."

Ⓝ DADIAN GALLERY, 4500 Massachusetts Ave. NW, Washington DC 20016. (202)885-8674. Fax: (202)885-8605. E-mail: dsokolove@wesleysem.edu. Website: www.wesleysem.edu/car/dadian.htm. **Curator:** Deborah Sokolove. Nonprofit gallery. Estab. 1989. Approached by 50 artists a year. Exhibits 7-10 emerging, mid-career and established artists. Sponsors 7 exhibits/year. Average display time 2 months. Open Monday-Friday, 11-5. Closed August, December 24-January 1. Gallery is within classroom building of Methodist seminary; 550 sq. ft.; glass front open to foyer, moveable walls for exhibition and design flexibility.

Media: Considers all media and all types of prints. Most frequently exhibits painting, drawing and sculpture.

Style: Considers all styles and genres.

Terms: Artists are requested to make a donation to the Henry Luce III Center for the Arts and Religion at Wesley Theological Seminary from any sales. Gallery provides insurance. Accepted work should be framed. "We look for strong work with a spiritual or religious intention."

Submissions: Send query letter with artist's statement, SASE and slides. Returns material with SASE. Responds only if interested within 1 year. Finds artists through word of mouth, submissions, art exhibits and referrals by other artists.

FOXHALL GALLERY, 3301 New Mexico Ave. NW, Washington DC 20016. (202)966-7144. E-mail: foxhallgallery@foxhallgallery.com. Website: www.foxhallgallery.com. **Director:** Jerry Eisley. Retail gallery. Represents emerging and established artists. Sponsors 6 solo and 6 group shows/year. Average display time 3 months. Overall price range: $500-20,000; most artwork sold at $1,500-6,000.
Media: Considers oil, acrylic, watercolor, pastel, sculpture, mixed media, collage and original handpulled prints (small editions).
Style: Exhibits contemporary, abstract, impressionistic, figurative, photorealistic and realistic works and landscapes.
Terms: Accepts work on consignment (50% commission). Retail price set by gallery and artist. Customer discounts and payment by installment are available. Exclusive area representation required. Gallery provides insurance.
Submissions: Send résumé, brochure, slides, photographs and SASE. Call or write for appointment to show portfolio. Finds artists through agents, by visiting exhibitions, word of mouth, various art publications and sourcebooks, artists' submissions, self promotions and art collectors' referrals.
Tips: To show in a gallery artists must have "a complete body of work—at least 30 pieces, participation in a juried show and commitment to their art as a profession."

THE FRASER GALLERY, 1054 31st St., NW, Washington DC 20007. (202)298-6450. Fax: (202)298-6450. E-mail: frasergallery@hotmail.com. Website: thefrasergallery.com. **Director:** Catriona Fraser. For profit gallery. Estab. 1996. Approached by 100 artists/year. Represents 40 emerging, mid-career and established artists. Exhibited artists include: Maxwell Mackenzie (b&w infrared photography) and David FeBland (oil painting). Sponsors 12 exhibits/year. Average display time 1 month. Open all year; Tuesday-Friday, 12-3; weekends, 12-6. 400 sq. ft. Located in the center of Georgetown, Ind—courtyard with 4 other galleries. Clients include local community, tourists, internet browsers and upscale. Overall price range: $200-15,000; most work sold at under $5,000. The Fraser Gallery is associate dealer for Southebys.com and member of Art Dealers of Greater Washington.
Media: Considers acrylic, drawing, mixed media, oil, paper, pastel, pen & ink, sculpture and watercolor. Most frequently exhibits oil, photography and drawing. Considers engravings, etchings, linocuts, mezzotints and woodcuts.
Style: Most frequently exhibits contemporary realism. Genres include figurative work and surrealism.
Terms: Artwork is accepted on consignment and there is a 50% commission. Retail price set by the artist. Gallery provides insurance, promotion and contract. Accepted work should be framed. Requires exclusive representation locally.
Submissions: Write to arrange a personal interview to show portfolio of photographs and slides. Send query letter with bio, photographs, résumé, reviews, SASE and slides. Returns material with SASE. Responds in 1 week. Finds artists through submissions, portfolio reviews, art exhibits and art fairs. Also accepts CD-ROM with images and digital résumés.
Tips: "Research the background of the gallery and apply to galleries that show your style of work. All work should be framed or matted to full museum standards."

N HEMPHILL FINE ARTS, 1027 33rd St. NW, Washington DC 20007. (202)342-5610. Fax: (202)289-0013. Website: www.hemphillfinearts.com. Art consultancy and for-profit gallery. Estab. 1993. Approached by 80-150 artists/year. Represents 30 emerging, mid-career and established artists. Exhibited artists include: Jacob Kainen (painter) and Wade Hoefer (painter). Sponsors 8 exhibits/year. Average display time 6-8 weeks. Open all year; Tuesday-Saturday, 10-5; weekends, 10-5. Closed December 24-January 1. Clients include upscale. 40% of sales are to corporate collectors. Overall price range: $800-200,000; most work sold at $3,000.
Media: Most frequently exhibits painting, sculpture, prints and photography.
Style: Considers all styles. Most frequently exhibits contemporary artists.
Terms: Artwork is accepted on consignment and there is 1 50% commission.
Submissions: Send query letter with artist's statement, bio, brochure, photographs, reviews, SASE and slides. Returns material with SASE. Responds in 2 months. Files slides and contact information. Finds artists through word of mouth.

Florida

ALEXANDER FINE ARTS, 3211 W. Swann Ave., #605, Tampa FL 33609. (813)348-9885. E-mail: gallery@yborart.com. Website: yborart.com. **Owner:** C. Alexander. Art consultancy. Estab. 1993. Represents more than 10 established artists. Exhibited artists include: James Michalopoulos (oil), Victoria Martinez Rodgers (oil) and Daniel Watts (oil). Sponsors 7 exhibits/year. Average display time 6 weeks. Clients include local community and upscale. 30% of sales are to corporate collectors.

Media: Considers original contemporary art—oil, watercolor acrylic, sculpture, mixed media and glass. Most frequently exhibits oil, sculpture and acrylic.

Style: Considers all styles.

Terms: Artwork is accepted on consignment and there is a 50% commission. Retail price set by the gallery. Gallery provides insurance. Accepted work should be in good condition. Requires exclusive representation locally.

Submissions: Contact by e-mail. Returns material with SASE. Files résumé and photos. Finds artists through word of mouth, submissions, art fairs, and referrals by other artists.

Tips: "Be professional."

⚑ ART CENTER/SOUTH FLORIDA, 800 Lincoln Rd., Miami Beach FL 33139. (305)674-8278. Fax: (305)674-8772. E-mail: info@artcentersf.org. Website: www.artcentersf.org. Nonprofit gallery. Estab. 1985. Exhibits emerging artists. Average display time 1 month. Open all year; Monday-Wednesday, 1-10; Thursday-Sunday, 1-11. Clients include local community, students, tourists and upscale. Overall price range: $500-5,000.

Media: Considers all media except craft. Most frequently exhibits sculpture, painting and installation. Considers all types of prints.

Style: Exhibits: conceptualism, minimalism and painterly abstraction,

Terms: Retail price set by the artist. Gallery provides insurance and promotion. Accepted work should be ready to install. Does not require exclusive representation locally.

Submissions: Artist sends SASE—See send application which will be reviewed by a panel. Send query letter with SASE. Returns material with SASE. Artists apply with a proposal for an exhaibition. It is then reviewed by a panel.

☑ ARTS ON DOUGLAS, 123 Douglas, New Smyrna Beach FL 32168. (386)428-1133. Fax: (386)428-5008. E-mail: aod@ucnsb.net. Website: www.douglas.com. **Gallery Manager:** Meghan F. Martin. For profit gallery. Estab. 1996. Approached by many artists/year. We represent 56 professional Florida artists and exhibit 12 established artists/year. Average display time 1 month. Open all year; Tuesday-Friday, 11-6; Saturday, 10-2. 5,000 sq. ft. of exhibition space. Clients include local community, tourists and upscale. Overall price range varies.

Media: Considers all media except installation.

Style: Considers all styles and genres. Exhibits vary.

Terms: Artwork is accepted on consignment and there is a 50% commission. Retail price set by the artist. Gallery provides insurance and promotion. Accepted work should be framed. Requires exclusive representation locally. Accepts only professional artists from Florida.

Submissions: Send query letter with artist's statement, bio, brochure, résumé, reviews, SASE and slides. Returns material with SASE. Responds in 1 month. Files slides, bio and résumé. Artists may want to call gallery prior to sending submission package—not always accepting new artists.

Tips: "We want current bodies of work—please send slides of what you're presently working on."

⚑ ATLANTIC CENTER FOR THE ARTS, INC., 1414 Arts Center Ave., New Smyrna Beach FL 32168. (386)427-6975. Website: www.atlanticcenterforthearts.org. Nonprofit interdisciplinary artists-in-residence program. Estab. 1979. Sponsors 5-6 residencies/year. Located on secluded bayfront—3½ miles from downtown.

● This location accepts applications for residencies only, but they also run Harris House of Atlantic Center for the Arts, which accepts Florida artists only for exhibition opportunities. Harris House is located at 214 S. Riverside Dr., New Smyrna Beach FL 32168. (386)423-1753.

Media: Most frequently exhibits paintings/drawings/prints, video installations, sculpture, photographs.

Style: Contemporary.

Terms: Call Harris House for more information.

Submissions: Call Harris House for more information.

⚑ BLUE DOLPHIN GALLERY, 29 S. Palafox Place, Pensacola FL 32501. (850)435-7646. E-mail: artboys.com. **Art Director:** Chris Tuggle. For-profit gallery. Estab. 1992. Approached by 50 artists/year. Exhibits 100 emerging and mid-career artists. Exhibited artists include: Fabrice Jean, watercolor; and D.B. Dennis, acrylic. Sponsors 7 exhibits/year. Average display time 1 month to exhibit—up to 4 months on floor. Open all year; Monday-Saturday, 10-5:30; weekends, 10-4. Located in historic downtown, main street; 6,000 sq. ft.; lite pedestals for glasswork and sculpture; moveable walls for paintings; glass shelves set in 2 walls. 20% of sales are to corporate collectors. Overall price range: $50-15,000; most work sold at $600.

Media: Considers all media and all types of prints. Most frequently exhibits glass, watercolor and acrylic.

Style: Most frequently exhibits impressionism, surrealism and painterly abstraction. Considers all genres.

Terms: Artwork is accepted on consignment and there is a 50% commission. Retail price set by the gallery, gallery provides insurance, promotion and contract. Accepted work should be framed and matted. Requires exclusive representation locally.

Submissions: Call or write to arrange a personal interview to show portfolio of photographs, slides and transparencies. Send query letter with artist's statement, bio, photocopies, photographs, SASE and slides. Returns material with SASE. Responds in 1 week. Files bio and artist's statement. Finds artists through submissions, portfolio reviews, art exhibits, art fairs, referrals by other artists and select art magazines.

Tips: Make appointment, make sure to send slides, bio and statement; if local, also bring at least 5 pieces to inspect.

ℕ BOCA RATON MUSEUM OF ART, 501 Plaza Real, Mizner Park, Boca Raton FL 33432. (561)392-2500. Fax: (561)391-6410. E-mail: info@bocamuseum.org. Website: www.BocaMuseum.org. **Executive Director:** George S. Bolge. Museum. Estab. 1950. Represents established artists. 5,500 members. Exhibits change every 2 months. Open all year; Tuesday, Thursday-Saturday, 10-5; Wednesday and Friday, 10-9; Sunday, 12-5. Located one mile east of I-95 in Mizner Park in Boca Raton; 44,,000 sq. ft.; national and international temporary exhibitions and impressive second-floor permanent collection galleries. three galleries—one shows permanent collection, two are for changing exhibitions. 66% of space for special exhibitions.

Media: Considers all media. Exhibits modern masters including Braque, Degas, Demuth, Glackens, Klee, Matisse, Picasso and Seurat; 19th and 20th century photographers; Pre-Columbian and African art.

Submissions: "Contact executive director, in writing."

Tips: "Photographs of work of art should be professionally done if possible. Before approaching museums, an artist should be well-represented in solo exhibitions and museum collections. Their acceptance into a particular museum collection, however, still depends on how well their work fits into that collection's narrative and how well it fits with the goals and collecting policies of that museum."

☑ ALEXANDER BREST MUSEUM/GALLERY, 2800 University Blvd., Jacksonville University, Jacksonville FL 32211. (904)745-7371. Fax: (904)745-7375. E-mail: dlauder@ju.edu. Website: www.dept.j u.edu/art/. **Director:** David Lauderdale. Museum. Estab. 1970. Sponsors group shows of various number of artists. Average display time 6 weeks. Open all year; Monday-Friday, 9-4:30; Saturday, 12-5. "We close 2 weeks at Christmas and University holidays." Located in Jacksonville University, near downtown; 1,600 sq. ft.; 11½ foot ceilings. 50% of space for special exhibitions. "As an educational museum we have few if any sales. We do not purchase work—our collection is through donations."

Media: "We rotate style and media to reflect the curriculum offered at the institution. We only exhibit media that reflect and enhance our teaching curriculum. (As an example we do not teach bronze casting, so we do not seek such artists.)."

Style: Exhibits expressionism, neo-expressionism, primitivism, painterly abstraction, surrealism, all styles, primarily contemporary.

Terms: Retail price set by the artist. Gallery provides insurance and promotion; artist pays shipping costs to and from gallery. "The art work needs to be ready for exhibition in a professional manner."

Submissions: Send query letter with résumé, slides, brochure, business card and reviews. Write for appointment to show portfolio of slides. "Responds fast when not interested. Yes takes longer." Finds artists through visiting exhibitions and submissions.

Tips: "Being professional impresses us. But circumstances also prevent us from exhibiting all artists we are impressed with."

FLORIDA STATE UNIVERSITY MUSEUM OF FINE ARTS, Copeland & W. Tennessee St., Tallahassee FL 32306-1140. (850)644-6836. E-mail: apcraig@mailer.fsu.edu. Website: www.mailer.fsu.edu/ ~svad/FSUMuseum/FSU_Museum.html. **Director:** Allys Palladino-Craig. Estab. 1970. Shows work by over 100 artists/year; emerging, mid-career and established. Sponsors 12-22 shows/year. Average display time 3-4 weeks. Located on the university campus; 16,000 sq. ft. 50% of space for special exhibitions.

Media: Considers all media, including electronic imaging and performance art. Most frequently exhibits painting, sculpture and photography.

Style: Exhibits all styles. Prefers contemporary figurative and non-objective painting, sculpture, printmaking, photography.

Terms: "Sales are almost unheard of; the museum takes no commission." Retail price set by the artist. Museum provides insurance, promotion and shipping costs to and from the museum for invited artists.

Submissions: Send query letter or call for Artist's Proposal Form.

Tips: "The museum offers a yearly competition with an accompanying exhibit and catalog. Artists' slides are kept on file from this competition as a resource for possible inclusion in other shows. Write for prospectus, available late December through January."

KENDALL CAMPUS ART GALLERY, MIAMI-DADE COMMUNITY COLLEGE, 11011 SW 104 St., Miami FL 33176-3393. (305)237-2322. Fax: (305)237-2901. E-mail: Lfontana@MDCC.edu. **Interim Director:** Lilia Fontana. College gallery. Estab. 1970. Represents emerging, mid-career and established artists. Exhibited artists include Komar and Melamid. Sponsors 8 shows/year. Average display time 5 weeks. Open all year except for 2 weeks at Christmas and 3 weeks in August. Located in suburban area, southwest of Miami; 3,000 sq. ft.; "space is totally adaptable to any exhibition." 100% of space for special exhibitions. Clientele: students, faculty, community and tourists. "Gallery is not primarily for sales, but sales have frequently resulted."
Media: Considers all media, all types of original prints. "No preferred style or media. Selections are made on merit only."
Style: Exhibits all styles and genres.
Terms: "Purchases are made for permanent collection; buyers are directed to artist." Retail price set by artist. Gallery provides insurance and promotion; arrangements for shipping costs vary. Prefers artwork framed.
Submissions: Send query letter with résumé, slides, bio, brochure, SASE, and reviews. Write for appointment to show portfolio of slides. "Artists commonly make the mistake of ignoring this procedure." Files résumés and slides (if required for future review).
Tips: "Present good-quality slides of works which are representative of what will be available for exhibition."

MIAMI ART MUSEUM, 101 W. Flagler St., Miami FL 33130. (305)375-3000. Fax: (305)375-1725. Website: www.miamiartmuseum.org. **Director:** Suzanne Delehanty. Museum. Estab. 1996. Represents emerging, mid-career and established artists. Average display time 3 months. Open all year; Tuesday-Friday, 10-5; Saturday and Sunday, noon-5 pm. Located downtown; cultural complex designed by Philip Johnson. 16,000 sq. ft. for exhibitions.
Media: Considers all media.
Style: Exhibits international art with a particular emphasis on the art of the Western Hemisphere 1940s to the present; large scale traveling exhibitions, retrospective of internationally known artists.
Submissions: Accepts only artists nationally and internationally recognized. Send query letter with résumé, slides, bio, brochure, photographs, SASE and reviews. Responds in 3 months. Finds artists through visiting exhibitions, word of mouth, art publications and artists' submissions.

☑ **NUANCE GALLERIES**, 804 S. Dale Mabry, Tampa FL 33609. (813)875-0511. **Owner:** Robert A. Rowen. Retail gallery. Estab. 1981. Represents 70 emerging, mid-career and established artists. Sponsors 3 shows/year. Open all year. 3,000 sq. ft. "We've reduced the size of our gallery to give the client a more personal touch. We have a large extensive front window area."
Media: Specializing in watercolor, original mediums including sculpture.
Style: "Majority of the work we like to see are realistic landscapes, escapism pieces, bold images, bright colors and semitropical subject matter. Our gallery handles quite a selection, and it's hard to put us into any one class."
Terms: Accepts work on consignment (50% commission). Retail price set by gallery and artist. Offers customer discounts and payment by installments. Gallery provides insurance and contract; shipping costs are shared.
Submissions: Send query letter with slides and bio. SASE if want slides/photos returned. Portfolio review requested if interested in artist's work.
Tips: "Be professional; set prices (retail) and stick with them. There are still some artists out there that are not using conservation methods of framing. As far as submissions we would like local artists to come by to see our gallery and get the idea what we represent. Tampa has a healthy growing art scene, and the work has been getting better and better. But as this town gets more educated, it is going to be much harder for up-and-coming artists to emerge."

☑ **OPUS 71 GALLERIES, HEADQUARTERS**, (formerly Authors/Opus 71 Guesthouse), 1301 Petronia St., Key West FL 33040. (305)294-7381 or (305)295-7454. E-mail: lionxsx@aol.com. **Co-Directors:** Charles Z. Candler III and Gary R. Johnson. Retail and wholesale gallery, alternative space, art consultancy and salon style organization. Estab. 1969. Represents 40 (25-30 on regular basis) emerging, mid-career and established artists/year. By appointment only. Clientele: upscale, local, international and regional. 75% private collectors; 25% corporate collectors. Overall price range: $200-85,000; most work sold at $500-5,000

● This gallery is a division of The Leandros Corporation. Other divisions include The Alexander Project and Opus 71 Art Bank.

Media: Considers oil, acrylic, pastel, pen & ink, drawing, mixed media, collage, sculpture and ceramics; types of prints include woodcuts and wood engravings. Most frequently exhibits oils or acrylic, bronze and marble sculpture and pen & ink or pastel drawings.

Style: Exhibits: expressionism, neo-expressionism, primitivism, painterly abstraction, surrealism, conceptualism, minimalism, color field, postmodern works, impressionism, photorealism, hard-edge geometric abstraction (paintings), realism and imagism. Exhibits all genres. Prefers: figural, objective and nonobjective abstraction and realistic bronzes (sculpture).

Terms: Accepts work on consignment or buys outright. Retail price set by "consulting with the artist initially." Gallery provides insurance (with limitations), promotion and contract; artist pays for shipping to gallery and for any return of work. Prefers artwork framed, unless frame is not appropriate.

Submissions: Telephone call is important. Call for appointment to show portfolio of photographs and actual samples. "We will not look at slides." Responds in 2 weeks. Files résumés, press clippings and some photographs. "Artists approach us from a far flung area. We currently have artists from about 12 states and 4 foreign countries. Most come to us. We approach only a handful of artists annually."

Tips: "Know yourself . . . be yourself . . . ditch the jargon. Quantity of work available not as important as quality and the fact that the presenter is a working artist. We don't want hobbyists."

PALM AVENUE GALLERY, (formerly The Hang-Up, Inc.), 45 S. Palm Ave., Sarasota FL 34236. (941)953-5757. E-mail: palmavenue.gallery@verizon.net. Website: www.palmavenuegallery.com. **President:** Brent Manor. Vice President: Sandra Manor. Retail gallery. Represents 20 emerging and mid-career artists. Sponsors 6 shows/year. Average display time 1 month. Open all year. Located in arts and theater district downtown; 1,700 sq. ft.; "high tech, 10 ft. ceilings with street exposure in restored hotel." 50% of space for special exhibitions. Clientele: 75% private collectors, 25% corporate collectors. Overall price range: $500-5,000; most artwork sold at $500-2,000.

Media: Considers oil, acrylic, watercolor, mixed media, collage, works on paper, sculpture, glass and pottery. Most frequently exhibits painting, graphics and sculpture.

Style: Exhibits expressionism, painterly abstraction, surrealism, impressionism, realism and hard-edge geometric abstraction. All genres. Prefers impressionism, surrealism.

Terms: Accepts artwork on consignment (50% commission). Retail price set by artist. Sometimes offers customer discounts. Gallery provides insurance, promotion and contract. Prefers framed work. Exhibition costs shared 50/50.

Submissions: Send résumé, brochure, slides, bio and SASE. Write for appointment to show portfolio of originals and photographs. "Be organized and professional. Come in with more than slides; bring P.R. materials, too!" Responds in 1 week.

PENSACOLA MUSEUM OF ART, 407 S. Jefferson, Pensacola FL 32501. (850)432-6247. Website: www.poensacolamuseumofart.org. **Director:** Maria V. Butler. Nonprofit museum. Estab. 1954. Interested in emerging, mid-career and established artists. Sponsors 18 exhibitions/year. Average display time: 6-8 weeks. Open all year. Located in the historic district; renovated 1906 city jail. Clientele: 90% private collectors; 10% corporate clients. Overall price range: $200-20,000; most work sold at $500-3,000.

• This museum has guidelines for submitting work. Write to Curator of Exhibitions for "Unsolicited Exhibition Policy" guidelines.

Media: Considers all media. Most frequently exhibits painting, sculpture, photography, glass and newtech (i.e. holography, video art, computer art etc.).

Style: Exhibits neo-expressionism, realism, photorealism, surrealism, minimalism, primitivism, color field, postmodern works, imagism; all styles and genres.

Terms: Retail price set by museum and artist. Exclusive area representation not required. Museum provides insurance and promotion costs.

Submissions: Send query letter with résumé, at least 3 slides, SASE and/or videotape. "A common mistake of artists is making impromptu drop-ins." Files guides and résumé.

Tips: Looks for "skill and expertise and a broad selection of definitive works."

POLK MUSEUM OF ART, 800 E. Palmetto St., Lakeland FL 33801-5529. (863)688-7743. Website: www.PolkMuseumofArt.org. **Assistant Curator:** Todd Behrens. Museum. Estab. 1966. Approached by

 SPECIAL COMMENTS within listings by the editor of *Artist's & Graphic Designer's Market* are set off by a bullet.

© Virginia beth Shields

Acclaimed for its spacious, elegant exhibition rooms, The Polk Museum of Art in Lakeland, Florida also receives widespread attention for showcasing enormous installation works such as this one devised by artist Virginia beth Shields. *Traces: A Visible Mark, a Route or a Path, a Vestige* chronicles "explored, questioned, and disturbed historical, social, gender, and cultural boundaries," according to Assistant Curator and Registrar, Todd Behrens. Shields has exhibited at over 20 galleries, and designed several books and catalogues during her art career.

75 artists/year. Sponsors 19 exhibits/year. Open all year; Monday-Friday, 9-5; Saturday, 10-5; Sunday, 1-5. Closed major holidays. Four different galleries of various sizes and configurations. Visitors include local community, students and tourists.

Media: Considers all media. Most frequently exhibits prints, photos and paintings. Considers all types of prints except posters.

Style: Considers all styles. Considers all genres, provided the artistic quality is very high.

Terms: Gallery provides insurance, promotion and contract. Accepted work should be framed.

Submissions: Mail portfolio for review. Send query letter with artist's statement, bio, résumé and SASE. Returns material with SASE. Reviews 2-3 times/year and responds shortly after each review. Files slides and résumé.

☑ **RENNER STUDIOS**, (formerly Ron Renner Gallery), 4268 SE Rainbows End, Stuart FL 34997, (561)287-1855. Fax: (561)287-0398. E-mail: ronrenner@adelphia.net. Website: www.cidinternational.com.

Gallery Director/Owner: Ron Renner. Exhibited artists include Simbari and Ron Renner. Private gallery and interior design studios. Clientele: upscale. 90% private collectors, 10% corporate collectors. Overall price range: $750-250,000; most work sold at $7,500-10,000.

Media: Considers oil, pen & ink, acrylic, drawing, watercolor, mixed media, pastel, collage, photography, engravings, etchings, lithographs and serigraphs. Most frequently exhibits oil on canvas/linen, acrylic on canvas, serigraphs.

Style: Exhibits expressionism, impressionism, action painting. Genres include Mediterranean seascapes. Prefers abstract expressionism, impressionism and drawings.

Terms: Artwork is accepted on consignment (50% commission). Retail price set by the gallery. Gallery provides insurance, promotion, contract; shipping costs are shared. Prefers artwork framed.

Submissions: Send query letter with résumé, slides, bio and SASE. Responds only if interested within 3 weeks. Files bio, résumé, photos and slides. Finds artists through submissions and visits to exhibits.

Tips: "Keep producing, develop your style, take good pictures for slides of your work."

☑ **STETSON UNIVERSITY DUNCAN GALLERY OF ART**, 421 N. Woodland Blvd., Unit 8252, Deland FL 32720-3756. (386)822-7266. Fax: (386)822-7268. E-mail: cnelson@stetson.edu. Website: stetson.edu/departments/art. **Gallery Director:** Dan Gunderson. Nonprofit university gallery. Approached by 20 artists/year. Represents 8-12 emerging and established artists. Exhibited artists include: Jack Earl (ceramics). Sponsors 7-8 exhibits/year. Average display time 6 weeks. Open Sept.-April; Monday-Friday, 10-4; weekends 1-4. Duncan Gallery occasionally sponsors summer exhibitions; call for details. Approximately 2,400 sq. ft. located in a building (Sampson Hall) which houses the Art Department, American Studies Department, and the Modern Language Department at Stetson University. Clients include local community, students, tourists, school groups and elder hostelers.

Media: Considers acrylic, ceramics, drawing, installation, mixed media, oil, pen & ink, sculpture installation and watercolor. Most frequently exhibits oil/acrylic, sculpture and ceramics. Considers all types of prints.

Style: Considers all styles. Most frequently exhibits contemporary.

Terms: 30% of price is returned to gallery. Retail price set by the artist. Gallery provides insurance. Accepted work should be framed, mounted and matted. Does not require exclusive representation locally.

Submissions: Send query letter with artist's statement, bio, letter of proposal, résumé, reviews, SASE and 20 slides. Returns material with SASE. May respond, but artist should contact by phone. Files "whatever is found worthy of an exhibition—even if for future year." Finds artists through word of mouth, submissions, art exhibits, and referrals by other artists.

Tips: Looks for "professional-quality slides. Good letter of proposal."

N TERRACE GALLERY, 400 S. Orange Ave., Orlando FL 32801. (407)246-4279. Fax; (407)246-4329. E-mail: cityoforlandoart@mindspring.com. **Contact:** Frank Holt, director. Estab. 1996. Approached by 50 artists/year. Represents 4 emerging, mid-career and established artists. Average display time 3 months. Open all year; Monday-Friday, 8-9; weekends, 12-5. Closed major holidays. Terrace Gallery does not sell art; they showcase various exhibits to the community.

Submissions: Mail portfolio for review. Send query letter with artist's statement, bio, brochure, business card, photocopies, photographs, résumé, reviews, slides, and images that don't have to be sent back. Responds in 1 month. Finds artists through word of mouth, submissions, portfolio reviews, art exhibits, art fairs and referrals by other artists.

N VISUAL ARTS CENTER OF NORTHWEST FLORIDA, 19 E. Fourth St., Panama City FL 32401. (850)769-4451. Fax: (850)785-9248. E-mail: vac@visualartscenter.org. Website: www.visualartscenter.org. **Exhibition Coordinator:** Dolores Dickey. Museum. Estab. 1988. Approached by 20 artists/year. Exhibits 2 mid-career and established artists. Exhibited artists include: Don Taylor, watercolor; Judy Rivere, acrylic. Sponsors 10 exhibits/year. Average display time 6 weeks. Open all year; Monday, Wednesday and Friday, 10-4; Tuesday and Thursday, 10-8; Saturday, 1-5. Closed major holidays and Sundays. The center is located in dowtown Panama City in a historic building. The center features a large gallery (200 running feet) upstairs and smaller gallery downstairs (80 funning feet). And we have a unique stairwell and Artist Guild Gallery available as needed. Clients include local community and tourists. Overall price range: $50-750; most work sold at $200.

Media: Considers all media and all types of prints. Most frequently exhibits oil, watercolor and acrylic.

Style: Considers all styles and genres. Most frequently exhibits impressionism, primitivism realism and postmodernism.

Terms: Artwork is accepted on consignment and there is a 30% commission. Retail price set by the artist. Gallery provides promotion and contract. Accepted work should be framed, mounted and matted. Does not require exclusive representation locally.

Submissions: Send query letter with artist's statement, bio, résumé, SASE and slides. Returns material with SASE. Responds only if interested within 4 months. Files artist's statement, bio and résumé. Finds artists through word of mouth, submissions and art exhibits..

Georgia

N ABSTEIN GALLERY, 558 14th St. NW, Atlanta GA 30318. (404)872-8020. Fax: (404)872-2518. **Gallery Director:** Paul E. Abstein. Retail gallery. Estab. 1973. Represents/exhibits 40 emerging, mid-career and established artists/year. Exhibited artists include Eva Carter and Elsie Dresch. Sponsors 3 shows/year. Average display time 1-2 months. Open all year; Tuesday-Friday, 9-5; Saturday, 10-5; Sunday, 1-5. Located midtown; 15,000 sq. ft.; 2 story glass block window and interior glass wall. 100% of space for gallery artists. Clientele: interior designers, Atlanta and surrounding city homeowners. 50% private collectors, 50% corporate collectors. Overall price range: $100-12,000; most work sold at $1,000-5,000.

Media: Considers all media and all types of prints. Most frequently exhibits oil on canvas, pastel and watercolor, ceramics.

Style: Exhibits expressionism, conceptualism, photorealism, minimalism, color field, hard-edge geometric abstraction, painterly abstraction, postmodern works, realism, surrealism, impressionism and imagism. All genres. Prefers abstract figurative, landscapes and abstraction.

Terms: Artwork is accepted on consignment and there is a 50% commission. Retail price set by the artist. Gallery provides insurance, promotion and contract. Artist pays for shipping costs. Prefers artwork un-framed (paper art acetate-wrapped).

Submissions: Send query letter with résumé, slides, price list, photographs, bio and SASE. "We will contact them once we see slides." Responds in 2 weeks. Files artist bio.

Tips: "Try to visit galleries where you wish to submit to see if the work would be suitable."

N BRENAU UNIVERSITY GALLERIES, One Centennial Circle, Gainesville GA 30501. (770)534-6263. Fax: (770)538-4599. **Gallery Director:** Jean Westmacott. Nonprofit gallery. Estab. 1980s. Exhibits emerging, mid-career and established artists. Sponsors 7-9 shows/year. Average display time 6-8 weeks. Open all year; Monday-Friday, 10-4; Sunday, 2-5 during exhibit dates. Summer hours are Monday-Thursday, 1-4 only. Located near downtown; 3,958 sq. ft., two galleries—the main one in a renovated 1914 neoclassic building, the other in an adjacent renovated Victorian building dating from the 1890s. 100% of space for special exhibitions. Clientele: tourists, upscale, local community, students. "Although sales do occur as a result of our exhibits, we do not currently take any percentage, except in our invitational exhibitions. Our purpose is primarily educational."

Media: Considers all media.

Style: Exhibits wide range of styles. "We intentionally try to plan a balanced variety of media and styles."

Terms: Retail price set by the artist. Gallery provides insurance and promotion; shipping costs are shared, depending on funding for exhibits. Prefers artwork framed. "Artwork must be framed or otherwise ready to exhibit."

Submissions: Send query letter with résumé, 10-20 slides, photographs and bio. Write for appointment to show portfolio of slides and transparencies. Responds within months if possible. Artist should call to follow up. Files one or two slides or photos with a short résumé or bio if interested. Remaining material returned. Finds artists through referrals, direct viewing of work and inquiries.

Tips: "Be persistent, keep working, be organized and patient. Take good slides and develop a body of work. Galleries are limited by a variety of constraints—time, budgets, location, taste and rejection does not mean your work may not be good; it may not 'fit' for other reasons at the time of your inquiry."

N GALERIE TIMOTHY TEW, 309 E. Paces Ferry, #130, Atlanta GA 30305. (404)869-0511. Fax: (404)869-0512. For-profit gallery. Estab. 1987. Approached by 2-10 artists/year. Exhibits 27 emerging and established artists. Exhibited artists include: Isabelle Melchior and Kimo Minton. Sponsors 6 exhibits/year. Average display time 4-6 weeks. Open all year; Tuesday-Saturday, 11-5. Clients include local community, upscale and international. 20% of sales are to corporate collectors. Overall price range: $4,000-20,000; most work sold at $4,000-10,000.

Media: Considers drawing, oil and sculpture. Considers etchings.

Style: Exhibits: conceptualism, expressionism and painterly abstraction. Genres include figurative work, florals and portraits.

Terms: Artwork is accepted on consignment and there is a 50% commission. Retail price set by the gallery. Gallery provides insurance and promotion. Accepted work should be mounted. Requires exclusive representation locally.

Submissions: Portfolio should include slides. Mail portfolio for review. Returns material with SASE. Responds in 1 week. Finds artists through word of mouth.

N HEAVEN BLUE ROSE CONTEMPORARY GALLERY, 934 Canton St., Roswell GA 30075. (770)642-7380. Fax: (770)640-7335. E-mail: inquiries@heavenbluerose.com. Website: www.heavenbluerose.com. **Contact:** Catherine Moore or Nan Griffith, partners/owners. Cooperative, for-profit gallery. Estab. 1991. Approached by 8 artists/year. Represents 13 emerging, mid-career and established artists. Exhibited artists include: Ford Smith (mixed media and acrylic), Ronald Pircio (oils and pastels). Average display time 6 weeks. Open all year; Tuesday-Satuday, 11-5:30; Sunday, 1-4. "Located in the Historic District of Roswell GA. Space is small but fantastic energy! Beautifully curated to an overall gallery look. Open, white spaces. Two levels; great reputation." 10% of sales are to corporate collectors. Overall price range: $200-3,000; most work sold at $1,000.

Media: Considers acrylic, collage, drawing, fiber, glass, mixed media, oil, paper, pastel, sculpture, watercolor gicleé. Only of works whose originals were shown in gallery first. Also digital art. Most frequently exhibits oils, mixed media and pastel.

Style: Exhibits: color field, conceptualism, expressionism, geometric abstraction, minimalism, neo-expressionism, primitivism realism, surrealism and painterly abstraction. Most frequently exhibits geometric abstraction, neo-expressionism and conceptualism. Considers all genres.

Terms: Artwork is accepted on consignment and there is a 50% commission—3D only. There is a co-op membership fee plus a donation of time. There is a 20% commission. Retail price set by the gallery and the artist. Gallery provides contract. Accepted work should be framed. Requires exclusive representation locally or Does not require exclusive representation locally. Accepts only artists from metro Atlanta and local to Roswell GA. We want to promote our local artists. We are all well recognized and/or awarded and/or collected.

Submissions: Call or write to arrange a personal interview to show portfolio of photographs, slides, transparencies or framed work. Send query letter with artist's statement, bio, photographs, résumé and SASE. Returns material with SASE. Responds in 1 month. Files contact information. Finds artists through word of mouth, submissions and referrals by other artists.

Tips: "Framing is very important. Our clients want framed pieces. Consistency of work, available inventory, quality and integrity of artist and work are imperative."

ANN JACOB GALLERY, 3261 Roswell Rd. NE, Atlanta GA 30305. (404)262-3399. E-mail: gallery@annjacob.com. **Director:** Yvonne J. Spiotta. Co-Director: Ellen Bauman. Retail gallery. Estab. 1968. Represents 35 emerging, mid-career and established artists/year. Sponsors 4 shows/year. Open all year; Tuesday-Saturday 10-5. Located in Buckhead; 1,600 sq. ft. 100% of space for special exhibitions; 100% of space for gallery artists. Clientele: private and corporate. 80% private collectors, 20% corporate collectors.

Media: Considers oil, acrylic, watercolor, sculpture, ceramics, craft and glass. Most frequently exhibits paintings, sculpture and glass.

Style: Exhibits all styles, all genres.

Terms: Accepts work on consignment (50% commission). Retail price set by the gallery and the artist. Gallery provides promotion; artist pays shipping costs.

Submissions: Send query letter with résumé, slides, bio, brochure, photographs and SASE. Write for appointment. Responds in 2 weeks.

N. THE LOWE GALLERY, 75 Bennett St., Space A-2, Atlanta GA 30309. (404)352-8114. Fax: (404)352-0564. E-mail: info@lowegallery.com. **Director:** Anne Archer Dennington. Retail gallery. Estab. 1989. Exhibits contemporary emerging, mid-career, and internationally recognized artists from the United States, Europe and South America. Hosts 10-12 exhibits/year. Average display time 4-6 weeks. Open all year; Tuesday-Friday, 10:30-5:30; Saturday, 11-5 and Sunday by appointment. Located uptown (Buckhead); 12,000 sq. ft.; 4 exhibition rooms with a dramatic split level Grand Salon with 30 ft. ceilings and 18 ft. walls. 100% of space for gallery artists. 75% private collectors, 25% corporate collectors. Overall price range: $1,200-100,000; most work sold at $2,000-15,000.

Media: Considers any 2- or 3-dimensional medium. Most frequently exhibits painting, drawing and sculpture.

Style: Exhibits a wide range of aesthetics from figurative realism to painterly abstraction. Prefers postmodern works with a humanistic/spiritual content.

Terms: Artwork is accepted on consignment (50% commission). Retail price set by the gallery. Gallery provides promotion and contract; shipping costs are shared. Prefers artwork framed.

Submissions: Send query letter with résumé, 10-20 slides and SASE. Write for appointment to show portfolio of slides. Responds only if interested within 6 weeks. Finds artists through submissions.

Tips: "Put together an organized, logical submission. Do not bring actual pieces into the gallery. Be sure to include a SASE. Show galleries at least one cohesive body of work, could be anywhere between 10-40 pieces."

N. NŌVUS, INC., 439 Hampton Green, Peachtree City GA 30269. (770)487-0706. Fax: (770)487-2112. E-mail: novusus@bellsouth.net. **Vice President:** Pamela Marshall. Art dealer. Estab. 1987. Represents 200 emerging, mid-career and established artists. Clientele: corporate, hospitality, healthcare. 5% private collectors, 95% corporate collectors. Overall price range: $500-20,000; most work sold at $800-5,000.

Media: Considers oil, acrylic, watercolor, pastel, mixed media, collage, paper, sculpture, ceramics, craft, fiber, glass, photography, and all types of prints.

Style: Exhibits all styles. Genres include landscapes, abstracts, florals and figurative work. Prefers landscapes, abstract and figurative.

Terms: Accepts work on consignment (50% commission). Retail price set by the artist. Gallery provides promotion and contract; shipping costs are shared. Prefers artwork unframed.

Submissions: Send query letter with résumé, slides, brochure and reviews. Write for appointment to show portfolio of originals, photographs and slides. Responds only if interested within 1 month. Files slides and bio. Finds artists through agents, visiting exhibitions, word of mouth, art publications and sourcebooks, submissions.

Tips: "Send complete information and pricing. Do not expect slides and information back. Keep the dealer updated with current work and materials."

N. VESPERMANN GLASS GALLERY, 309 E. Paces Ferry Rd., Atlanta GA 30305. (404)266-0102. Fax: (404)266-0190. Website: www.vespermann.com. **Owner:** Seranda Vesperman. Managers: Tracey Lofton. Assistant Gallery Manager: Maureen Ryan. Retail gallery. Estab. 1984. Represents 200 emerging, mid-career and established artists/year. Sponsors 4-5 shows/year. Average display time 1 month. Open all year; Tuesday-Friday, 11-5 and Saturday 12-5. 2,500 sq. ft.; features contemporary art glass. Overall price range: $100-10,000; most work sold at $200-2,000.

Media: Considers glass.

Style: Exhibits contemporary.

Terms: Accepts work on consignment (50% commission). Buys outright for 50% of retail price (net 30 days). Retail price set by the gallery and the artist. Gallery provides insurance, promotion and contract; shipping costs are shared.

Submissions: Send query letter with résumé, slides, bio. Write for appointment to show portfolio of photographs, transparencies and slides. Responds only if interested within 2 weeks. Files slides, résumé, bio.

Hawaii

N. CEDAR STREET GALLERIES, 817 Cedar St., Honolulu HI 96814. (808)589-1580. E-mail: info@CedarStreetGalleries.com. Website: www.cedarstreetgalleries.com. **Contact:** Michael C. Schnack. Art consultancy, for-profit and wholesale gallery. Estab. 1999. Represents 150 emerging, mid-career and established artists. Sponsors 3 exhibits/year. Open all year; Monday-Saturday, 10-5; weekends 10-4. Clients include local community, students, tourists and upscale. Overall price range: $100-50,000.

Media: Considers all media; types of prints include engravings, etchings, linocuts, lithographs, mezzotints, serigraphs and woodcuts.

Style: Considers all styles. Genres include florals, landscapes and figurative.

Terms: Artwork is accepted on consignment and there is 1 50% commission. Retail price set by the artist. Accepted work should be framed, mounted and matted. Does not require exclusive representation locally. Accepts only artists from Hawaii.

Submissions: Call or write to arrange a personal interview to show portfolio of photographs.

HANA COAST GALLERY, Hotel Hana-Maui, P.O. Box 565, Hana Maui HI 96713. (808)248-8636. Fax: (808)248-7332. E-mail: director@hanacoast.com Website: www.hanacoast.com. **Managing Director:** Patrick Robinson. Retail gallery and art consultancy. Estab. 1990. Represents 84 established artists. Sponsors 12 group shows/year. Average display time 1 month. Open all year. Located in the Hotel Hana-Maui at Hana Ranch; 3,000 sq. ft.; "an elegant ocean-view setting in one of the top small luxury resorts in the world." 20% of space for special exhibitions. Clientele: ranges from very upscale to highway traffic walk-ins. 85% private collectors, 15% corporate collectors. Overall price range: $150-50,000; most work sold at $1,500-9,500.

Media: Considers oil, acrylic, watercolor, pastel, mixed media, collage, works on paper, sculpture, ceramic, craft, fiber, glass, photography, original handpulled prints, engravings, lithographs, pochoir, wood engravings, mezzotints, serigraphs and etchings. Most frequently exhibits oil, watercolor and Japanese woodblock/old master etchings.

Style: Exhibits expressionism, primitivism, impressionism and realism. Genres include landscapes, florals, portraits, figurative work and Hawaiiana. Prefers landscapes, florals and figurative work. "We display very painterly Hawaiian landscapes. Master-level craftwork, particularly turned-wood bowls and smaller jewelry chests. We are *the* major gallery featuring Hawaiian crafts/furniture."

Terms: Accepts artwork on consignment (60% commission). Retail price set by gallery and artist. Gallery provides insurance, promotion and shipping costs from gallery. Framed artwork only.

Submissions: Accepts only full-time Hawaii resident artists. Send query letter with résumé, slides, bio, brochure, photographs, SASE and reviews. Write for appointment to show portfolio after query and samples submitted. Portfolio should include originals, photographs, slides and reviews. Responds only if interested within 1 week. If not accepted at time of submission, all materials returned.

Tips: "Know the quality level of art in our gallery and know that your own art would be companionable with what's being currently shown. Be able to substantiate the prices you ask for your work. We do not offer discounts, so the agreed upon price/value must stand the test of the market."

N HONOLULU ACADEMY OF ARTS, 900 S. Beretania St., Honolulu HI 96814. (808)532-8700. Fax: (808)532-8787. E-mail: academypr@honoluluacademy.org. Website: www.honoluluacademy.org. **Director:** George R. Ellis. Nonprofit museum. Estab. 1927. Exhibits emerging, mid-career and established Hawaiian artists. Interested in seeing the work of emerging artists. Sponsors 40-50 shows/year. Average display time 6-8 weeks. Open all year; Tuesday-Saturday 10-4:30, Sunday 1-5. Located just outside of downtown area; 40,489 sq. ft. 30% of space for special exhibition. Clientele: general public and art community.
Media: Considers all media. Most frequently exhibits painting, works on paper, sculpture.
Style: Exhibits all styles and genres. Prefers traditional, contemporary and ethnic.
Terms: "On occasion, artwork is for sale." Retail price set by artist. Museum provides insurance and promotion; museum pays for shipping costs. Prefers artwork framed.
Submissions: Exhibits artists of Hawaii. Send query letter with résumé, slides and bio directly to curator(s) of Western and/or Asian art. Curators are: Jennifer Saville, Western art; Julia White, Asian art. Write for appointment to show portfolio of slides, photographs and transparencies. Responds in 3-4 weeks. Files résumés, bio.
Tips: "Be persistent but not obnoxious." Artists should have completed a body of work of 50-100 works before approaching galleries.

☑ MAYOR'S OFFICE OF CULTURE AND THE ARTS, 530 S. King, #404, Honolulu HI 96813. (808)523-4674. Fax: (808)527-5445. E-mail: pradulovic@co.honolulu.hi.us. Website: www.co.honolulu.hi .us/moca. **Executive Director:** Peter Radulovic. Local government/city hall exhibition areas. Estab. 1965. Exhibits group shows coordinated by local residents. Sponsors 50 shows/year. Average display time 3 weeks. Open all year; Monday-Friday, 7:45-4:30. Located at the civic center in downtown Honolulu; 3 galleries—courtyard (3,850 sq. ft.), lane gallery (873 sq. ft.), 3rd floor (536 sq. ft.); Mediterranean-style building, open interior courtyard. "City does not participate in sales. Artists make arrangements directly with purchaser."
Media: Considers all media and all types of prints. Most frequently exhibits oil/acrylic, photo/print and clay.
Terms: Gallery provides promotion; local artists deliver work to site. Prefers artwork framed.
Submissions: "Local artists are given preference." Send query letter with résumé, slides and bio. Write for appointment to show portfolio of slides. "We maintain an artists' registry for acquisition review for the art in City Buildings Program."
Tips: "Selections of exhibitions are made through an annual application process. Have a theme or vision for exhibit. Plan show at least one year in advance."

N ⚑ RAMSAY MUSEUM, 1128 Smith St., Honolulu HI 96817. (808)537-ARTS. Fax: (808)531-MUSE. E-mail: ramsay@lava.net. Website: www.ramsaymuseum.org. **CEO:** Ramsay. Gallery, museum shop, permanent exhibits and artists' archive documenting over 200 exhibitions including 500 artists of Hawaii. Estab. 1981. Open all year; Monday-Friday, 10-5; Saturday, 10-4. Located in downtown historic district; 5,000 sq. ft.; historic building with courtyard. 25% of space for special exhibitions; 25% of space for gallery artists. 50% of space for permanent collection of Ramsay Quill and Ink originals spanning 50 years. Clientele: 50% tourist, 50% local. 60% private collectors, 40% corporate collectors.
Media: Especially interested in ink.
Style: Exhibits all styles and genres. Currently focusing on the art of tattoo.
Terms: Accepts work on consignment. Retail price set by the artist.
Submissions: Send query letter with résumé, 20 slides, bio, SASE. Write for appointment to show portfolio of original art. Responds only if interested within 1 month. Files all material that may be of future interest. Finds artists through submissions and judging.
Tips: "Keep a record of all artistic endeavors for future book use, and to show your range to prospective commissioners and galleries. Prepare your gallery presentation packet with the same care that you give to your art creations. Quality counts more than quantity. Show samples of current work with an exhibit concept in writing."

N VOLCANO ART CENTER GALLERY, P.O. Box 104, Hawaii National Park HI 96718. (808)967-7511. Fax: (808)967-8512. **Gallery Manager:** Fia Mattice. Nonprofit gallery to benefit arts education; nonprofit organization. Estab. 1974. Represents 200 emerging, mid-career and established artists/year. 1,400 member organization. Exhibited artists include Dietrich Varez and Brad Lewis. Sponsors 11 shows/year. Average display time 1 month. Open all year; daily 9-5 except Christmas. Located Hawaii Volcanoes

National Park; 3,000 sq. ft.; in the historic 1877 Volcano House Hotel. 15% of space for special exhibitions; 85% of space for gallery artists. Clientele: affluent travelers from all over the world. 95% private collectors, 5% corporate collectors. Overall price range: $20-28,000; most work sold at $50-400.
Media: Considers all media, all types of prints. Most frequently exhibits wood, mixed media, ceramics and glass.
Style: Prefers traditional Hawaiian, contemporary Hawaiian and contemporary fine crafts.
Terms: "Artists must become Volcano Art Center members." Accepts work on consignment (50% commission). Retail price set by the gallery. Gallery provides promotion and contract; artist pays shipping costs to gallery.
Submissions: Prefers only work relating to the area or by Hawaiian artists. Call for appointment to show portfolio. Responds only if interested within 1 month. Files "information on artists we represent."

Idaho

BROWN'S GALLERIES, 1022 Main St., Boise ID 83702. (208)342-6661. Fax: (208)342-6677. E-mail: brownsgallery@micron.net. Website: www.brownsgallery.com. **Director:** Randall Brown. Retail gallery featuring appraisal and restoration services. Estab. 1968. Represents 50 emerging, mid-career and established artists. Exhibited artists include Robert Moore and John Horejs. Sponsors 12 shows/year. Average display time 1 month. Open all year. Located downtown; 2,500 sq. ft. Up to 50% of space for special exhibitions. Clientele: mid-to above average income, some tourists. 50% private collectors, 50% corporate collectors. Overall price range: $10-200,000; most work sold at $1,000-5,000.
Media: Considers oil, acrylic, watercolor, pastel, pen & ink, drawings, mixed media, collage, works on paper, sculpture, ceramic, fiber, glass. Most frequently exhibits painting, sculpture and glass.
Style: Exhibits all styles, including expressionism, neo-expressionism, painterly abstraction, imagism, conceptualism, color field, postmodern works, impressionism, realism, photorealism, pattern painting and hard-edge geometric abstraction. All genres. Prefers impressionism and realism.
Terms: Accepts artwork on consignment (50% commission). Retail price set by artist. "We also do some 'wholesale' purchasing." Sometimes offers customer discounts and payment by installment. Gallery provides insurance, promotion and contract; artist pays for shipping. Prefers artwork framed.
Submissions: Send query letter with all available information. Portfolio review requested if interested in artist's work. Files all materials.
Tips: "We deal only with professionals. Amateurs frequently don't focus enough on the finish, framing, display, presentation or marketability of their work. We have a second gallery, Brown's Gallery McCall, located in the heart of a popular summer and winter resort town. We carry an eclectic group of work focusing slightly more on tourists than our first location."

N. DEVIN GALLERIES, 507 Sherman Ave., Coeur d'Alene ID 83814. Phone/fax: (208)667-2898. E-mail: info@devingalleries.com. Website: www.devingalleries.com. **Owners:** Skip and Debbie Peterson. Retail gallery. Estab. 1982. Represents 100 established artists. Exhibited artists include Chester Fields, Oranes Berberian, J. Nelson. Sponsors 4 shows/year. Average display time 3 months. Open all year. Located "in main business district downtown;" 5,000 sq. ft.; antique and rustic. 30% of space for special exhibitions. Clientele: middle to upper income. 82% private collectors, 18% corporate collectors. Overall price range: $1,000-25,000; most work sold at $1,500.
Media: Considers all media.
Style: Exhibits all styles. Genres include landscapes, florals, Western, wildlife and portraits. Prefers contemporary styles.
Terms: Accepts artwork on consignment (50% commission). Retail price set by gallery and artist. Gallery provides insurance, promotion and contract; artist pays for shipping. Prefers artwork framed.
Submissions: Send query letter with bio, photographs, SASE and business card. Write for appointment to show portfolio of originals and photographs. Responds within 2 weeks only if interested. Files all material for 6 months.
Tips: "Devin Galleries now has a complete custom frame shop with 23 years experience in framing."

KNEELAND GALLERY, P.O. Box 2070, Sun Valley ID 83353. (208)726-5512. Fax: (208)726-3490. (800)338-0480. E-mail: art@kneelandgallery.com. **Director:** Carey Molter. Retail gallery, art consultancy. Estab. 1981. Represents 40 emerging, mid-career and established artists/year. Artists include: Ovanes Berberian, Steven Lee Adams, Scott Christensen, Glenna Goodacre, Donna Howell-Sickles, Robert Moore. Sponsors 9 shows/year. Average display time 3 weeks. Open all year; Monday-Saturday, 10-5. Located

downtown; 2,500 sq. ft.; features a range of artists in several exhibition rooms. 50% of space for special exhibitions; 50% of space for gallery artists. Clientele: tourist, seasonal, local, upscale. 95% private collectors, 5% corporate collectors. Overall price range: $200-25,000; most work sold at $1,000-6,000.
Media: Considers all media and all types of prints. Most frequently exhibits oil, acrylic, watercolor.
Style: Genres include landscapes, florals, figurative work. Prefers traditional landscapes-realism, expressionism.
Terms: Accepts work on consignment (50% commission). Retail price set by the artist. Gallery provides insurance, promotion and contract; shipping costs are shared. Prefers artwork framed.
Submissions: Send query letter with résumé, slides, photographs, artists' statement, bio, SASE. Write for appointment to show portfolio of photographs and slides. Responds in 1-2 months. Files photo samples/business cards. Finds artists through submissions and referrals.

THE POTTER'S CENTER, 110 Ellen, Boise ID 83714. (208)378-1112. Fax: (208)378-8881. **Owner:** Scott Brown. Retail gallery. Estab. 1976. Represents 25 mid-career artists/year. Interested in seeing the work of emerging artists. Exhibited artists include: Liz James and Julie Wawirka. Sponsors 6 shows/year. Average display time 6 weeks. Open all year; Tuesday-Friday, 10-5:30; Saturday, 12-4. 800 sq. ft. exhibition space. Clientele: tourists and local community. Overall price range: $10-200; most work sold at $50-75.
Media: Considers ceramics. Most frequently exhibits ceramics.
Terms: Accepts work on consignment (40% commission). Retail price set by the artist. Gallery provides promotion; shipping costs are shared.
Submissions: Accepts only artists from Idaho. Prefers only ceramics. Send query letter with slides or photographs. Call for appointment to show portfolio of photographs. Responds in 1-2 weeks. Finds artists through word of mouth.
Tips: An artist is ready for gallery representation when they have "a body of work over time that shows control of medium and a personal approach to create their style."

ANNE REED GALLERY, P.O. Box 597, Ketchum ID 83340. (208)726-3036. Fax: (208)726-9630. E-mail: gallery@annereedgallery.com. Website: www.annereedgallery.com. **Director:** L'Anne Gilman. Retail Gallery. Estab. 1980. Represents mid-career and established artists. Exhibited artists include Robert Kelly, Deborah Butterfield, Kenro Izu and Andrew Young. Sponsors 10 exhibitions/year. Average display time 1 month. Open all year. Located at 391 First Avenue North. 10% of space for special exhibitions; 90% of space for gallery artists. Clientele: 80% private collectors, 20% corporate collectors.
Media: Most frequently exhibits sculpture, wall art and photography.
Style: Exhibits expressionism, abstraction, conceptualism, impressionism, photorealism, realism. Prefers contemporary.
Terms: Accepts work on consignment (50% commission). Retail price set by gallery and artist. Sometimes offers customer discounts and payment by installment. Gallery provides insurance, promotion, contract and shipping costs from gallery. Prefers artwork framed.
Submissions: Send query letter with résumé, 40 slides, bio and SASE. Call or write for appointment to show portfolio of originals (if possible), slides and transparencies. Responds in 2 months. Finds artists through word of mouth, exhibitions, publications, submissions and collector's referrals.
Tips: "Please send only slides or other visuals of current work accompanied by updated résumé. Check gallery representation prior to sending visuals. Always include SASE."

THE ROLAND GALLERY, Sun Valley Rd. & East Ave., P.O. Box 221, Ketchum ID 83340. (208)726-2333. Fax: (208)726-6266. E-mail: rolandgallery@aol.com. Website: Website: www.rolandgallery.com. **Owner:** Roger Roland. Retail gallery. Estab. 1990. Represents 100 emerging, mid-career and established artists. Sponsors 8 shows/year. Average display time 1 month. Open all year; daily 11-5. 800 sq. ft. 50% of space for special exhibitions; 50% of space for gallery artists. Clientele: 75% private collectors, 25% corporate collectors. Overall price range: $10-10,000; most work sold at $500-1,500.
Media: Considers oil, pen & ink, paper, fiber, acrylic, sculpture, glass, watercolor, mixed media, ceramic, installation, pastel, collage, craft and photography, engravings, mezzotints, etchings, lithographs. Most frequently exhibits glass, paintings and jewelry.
Style: Considers all styles and genres.
Terms: Accepts work on consignment (50% commission) or buys outright for 50% of the retail price (net 30 days). Retail price set by artist. Gallery provides insurance, promotion, shipping costs from gallery. Prefers artwork framed.
Submissions: Send query letter with résumé, slides, bio, brochure, photographs, SASE, business card and reviews. Write for appointment to show portfolio of photographs, slides and transparencies. Responds only if interested within 2 weeks.

⊞ WILLOWTREE GALLERY, 210 Cliff St., Idaho Falls ID 83402. (208)524-4464. E-mail: willow@sr
u.net. Website: www.sru.net/~willow/willow.html. **Owner:** Lisa Kelly. Retail gallery. Estab. 1987. Repre-
sents 12 emerging artists. Exhibited artists include Miller-Allen and Hansen. Average display time 2 months.
Open all year. Located on the fringe of downtown; 3,000 sq. ft.; "used to be a wrought-iron foundry;
triangular building." 40% of space for special exhibitions. Clientele: 100% private collectors. Overall price
range: $500-10,000; most work sold at $600-1,500.
Media: Considers oil, acrylic, watercolor, pastel, collage, works on paper, sculpture, ceramic, fiber, glass,
original handpulled prints, relief prints, engravings, mezzotints and serigraphs. Most frequently exhibits
watercolor, limited edition reproductions and oil.
Style: Exhibits expressionism, impressionism and photorealism. Genres include landscapes, florals, West-
ern and wildlife. Prefers landscapes, florals and expressionism.
Terms: Accepts artwork on consignment (40% commission). Retail price set by artist. Gallery provides
insurance and promotion; shipping costs are shared.
Submissions: Send query letter with photographs and SASE. Call for appointment to show portfolio of
originals. Responds in 1 week. Files material of interest.
Tips: Looks for "quality of the art itself and presentation, such as framing."

Illinois

☑ ARTCO, INCORPORATED, 3148 RFD, Long Grove IL 60047. (847)438-8420. Fax: (847)438-
6464. E-mail: SJTillman@prodigy.net. Website: www.e-Artco.com. **President:** Sybil Tillman. Retail and
wholesale gallery, art consultancy and artists' agent. Estab. 1970. Represents 60 mid-career and established
artists. Interested in seeing the work of emerging artists. Exhibited artists include Ed Paschke and Gary
Grotey. Open all year; daily and by appointment. Located "2 blocks outside of downtown Long Grove;
7,200 sq. ft.; unique private setting in lovely estate and heavily wooded area." 50% of space for special
exhibitions. Clientele: upper middle income. 65% private collectors, 20% corporate collectors. Overall
price range: $500-20,000; most work sold at $2,000-5,000.
Media: Considers paper, sculpture, fiber, glass, original handpulled prints, woodcuts, engravings, pochoir,
wood engravings, mezzotints, linocuts, etchings and serigraphs. Most frequently exhibits originals and
signed limited editions "with a small number of prints."
Style: Exhibits all styles, including expressionism, abstraction, surrealism, conceptualism, postmodern
works, impressionism, photorealism and hard-edge geometric abstraction. All genres. Likes American
contemporary and Southwestern styles.
Terms: Accepts artwork on consignment. Retail prices set by gallery. Customer discounts and payment
by installment are available. Gallery provides promotion and contract; artist pays for shipping.
Submissions: Send query letter with résumé, slides, transparencies, bio, brochure, photographs, SASE,
business card and reviews. Responds in 1 month. Files materials sent. Portfolio review required. Finds
artists through agents, by visiting exhibitions, word of mouth, various art publications and sourcebooks,
submissions/self-promotions and art collectors' referrals.
Tips: "We prefer established artists but will look at all new art."

FREEPORT ARTS CENTER, 121 N. Harlem Ave., Freeport IL 61032. (815)235-9755. Fax: (815)235-
6015. **Director:** Becky Connors. Estab. 1975. Interested in emerging, mid-career and established artists.
Sponsors 9 solo and group shows/year. Open all year; Tuesdays, 10-6; Wednesday-Sunday, 10-5. Clientele:
30% tourists; 60% local; 10% students. Average display time 7 weeks.
Media: Considers all media and prints.
Style: Exhibits all styles and genres. "We are a regional museum serving Northwest Illinois, Southern
Wisconsin and Eastern Iowa. We have extensive permanent collections and 8-9 special exhibits per year
representing the broadest possible range of regional and national artistic trends. Some past exhibitions
include 'Gifts for the Table,' 'Art in Bloom,' 'Au Naturel: American Wildlife Art,' and 'Midwestern
Romanticism.' "
Terms: Gallery provides insurance and promotion; artist pays shipping costs. Prefers artwork framed.
Submissions: Send query letter with résumé, slides, SASE, brochure, photographs and bio. Responds in
3-4 months. Files résumés.
Tips: "The Exhibition Committee meets three times each year to review the slides submitted."

ROBERT GALITZ FINE ART, 166 Hilltop Court, Sleepy Hollow IL 60118. (347)426-8842. **Owner:**
Robert Galitz. Art consultancy and wholesale gallery. Estab. 1986. Approached by many artists/year.
Represents 100 emerging artists. Sponsors 6 exhibits/year. Average display time 2 months. Open all week,
12-4. Closed in July. Located in western Chicago suburbs; 1,500 sq. ft. Overall price range: $400-1,200.

Media: Considers all media except installation and pen & ink. Considers all types of prints except posters.
Style: Exhibits: geometric abstraction, impressionism, minimalism and painterly abstraction. Considers all styles and genres.
Terms: Artwork is accepted on consignment and there is a 25-40% commission. Artwork is bought outright for 25% of retail price; net 30 days. Each transaction is separate and different—only the sale "cast in stone." Retail price set by the artist. Gallery provides insurance, promotion and contract. Accepted work should be framed, mounted and matted, unless discussed. Each "deal" different. Requires exclusive representation locally.
Submissions: Call or write to arrange a personal inverview to show portfolio of photographs and slides. Send query letter with photographs, SASE and slides. Returns material with SASE. Responds in 1 month. Finds artists through portfolio reviews, art fairs, and referrals by other artists.
Tips: "Collectors today want the best."

INTERARTS GALLERY, 49 S. Washington St., Hinsdale IL 60521. (630)887-8281. Fax: (630)455-6543. E-mail: interarts@aol.com. **President/Owner:** Anna Vojik. For-profit, wholesale gallery Estab. 1997. Approached by 30 artists/year. Exhibits 10 mid-career and established artists. Sponsors 10 exhibits/year. Average display time 3 weeks. Open all year; Monday-Saturday, 10-5. Clients include local community and upscale. Overall price range: $550-2,000; most work sold at $300.
Media: Considers ceramics, collage, craft, fiber and glass. Most frequently exhibits fiber (weavings), ceramics and craft. Considers etchings and woodcuts.
Style: Considers all styles and genres.
Terms: There is a 50% commission. 50% of retail price; net 30 days. Retail price set by the artist. Gallery provides insurance, promotion and contract. Requires exclusive representation locally.
Submissions: Write to arrange a personal interview to show portfolio of photographs. Mail portfolio for review. Send query letter with artist's statement and photographs. Returns material with SASE. Responds in 2 weeks. Finds artists through word of mouth, portfolio reviews and art exhibits.

NAF GALLERY, (formerly Arthurian Gallery), 4843 Dempster, Skokie IL 60077. (847)674-7990. **Owner:** Harry Hagen. Retail/wholesale gallery and art consultancy. Estab. 1987. Represents/exhibits 60-80 emerging, mid-career and established artists/year. Interested in seeing the work of emerging artists. Exhibited artists include Christana-Sahagian. Sponsors 3-4 shows/year. Average display time 4-6 weeks. Open all year; Monday-Sunday, 10-4. Located on main street of Skokie; 1,500 sq. ft. 80-100% of space for gallery artists. 5-10% private collectors, 5-10% corporate collectors. Overall price range: $50-3,000; most work sold at: $200-2,000.
Media: Considers all media and all types of prints. Most frequently exhibits oil, water color, acrylic and pastel.
Style: Exhibits expressionism, painterly abstraction, surrealism, all styles. All genres. Prefers impressionism, abstraction and realism.
Terms: Artwork is accepted on consignment (30% commission). Retail price set by the gallery and the artist. Gallery provides insurance and promotion. Artist pays for shipping costs. Prefers artwork framed.
Submissions: Send query letter with résumé, slides and SASE. Include price and size of artwork. Call or write for appointment to show portfolio of photographs, slides and transparencies. Responds in 2 weeks. Finds artists through word of mouth, referrals by other artists, visiting art fairs and exhibitions, submissions.
Tips: "Be persistent."

NIU ART MUSEUM, Northern Illinois University, DeKalb IL 60115. (815)753-1936. Fax: (815)753-7897. **Director:** Peggy Doherty. University museum. Estab. 1970. Exhibits emerging, mid-career and established artists. Sponsors 5 shows/year. Average display time 6 weeks. Open August-May. Located in DeKalb, Illinois. 50% of space for special exhibitions.
Media: Considers all media and all types of prints.
Style: Exhibits all styles and genres.
Terms: "All sales are referred to the artist." Retail price set by artist. Museum provides insurance and promotion; shipping costs are shared.
Submissions: Send query letter with résumé and slides. Responds ASAP. Files "maybes."

 A CHECKMARK PRECEDING A LISTING indicates a change in either the address or contact information since the 2002 edition.

☑ **NORTHWESTERN UNIVERSITY DITTMAR GALLERY**, 1999 S. Campus Dr., Evanston IL 60208. (847)491-2348. Fax: (847)491-4333. **Art Services Director:** Debra Blade. Nonprofit gallery. Estab. 1972. Approached by 30 artists/year. Represents more than 10 emerging and mid-career artists. Sponsors 7-8 exhibits/year. Average display time 1 month. Open all year; every day, 8-10. Closed December. The gallery is located within the Norris Student Center, on the main floor, behind the information desk. Clients include local community and students.

Media: Considers all media and all types of prints. Most frequently exhibits painting, sculpture and printmaking.

Style: Exhibits: conceptualism, expressionism, minimalism, neo-expressionism, postmodernism and surrealism. Most frequently exhibits conceptualism, realism and expressionism. Considers all genres.

Terms: Artwork is accepted on consignment and there is a 20% commission. Retail price set by the artist. Gallery provides promotion and contract. Accepted work should be mounted.

Submissions: Mail portfolio for review. Send query letter with artist's statement, brochure, photographs, résumé, 10-15 slides of work and reviews. Returns material with SASE. Responds in 3 months. Files all submitted material until answered accepted or rejected. Finds artists through word of mouth, submissions and referrals by other artists.

Tips: "Do not send photocopies. Send a typed letter. Send good photos or color photocopies. Send résumé of past exhibits, or if emerging, a typed statement. Art is more likely to be purchased if it is presented with a more traditional or professional framing."

Chicago

☒ **JEAN ALBANO GALLERY**, 211 W. Superior St., Chicago IL 60610. (312)440-0770. **Director:** Jean Albano Broday. Retail gallery. Estab. 1985. Represents 20 mid-career artists. Somewhat interested in seeing the work of emerging artists. Exhibited artists include Martin Facey and Jim Waid. Average display time 5 weeks. Open all year. Located downtown in River North gallery district; 1,600 sq. ft. 60% of space for special exhibitions; 40% of space for gallery artists. Clientele: 80% private collectors, 20% corporate collectors. Overall price range: $1,000-20,000; most work sold at $2,500-6,000.

Media: Considers oil, acrylic, sculpture and mixed media. Most frequently exhibits mixed media, oil and acrylic. Prefers non-representational, non-figurative and abstract styles.

Terms: Accepts artwork on consignment (50% commission). Retail price set by gallery and artist; shipping costs are shared.

Submissions: Send query letter with résumé, bio, SASE and well-labeled slides: "size, name, title, medium, top, etc." Write for appointment to show portfolio. Responds in 4-6 weeks. "If interested, gallery will file bio/résumé and selected slides."

Tips: "We look for artists whose work has a special dimension in whatever medium. We are interested in unusual materials and unique techniques."

ALTER ASSOCIATES, INC., 1040 Lake Shore Dr., Chicago IL 60611. (312)944-4304. Fax: (312)944-8480. **President:** Chickie Alter. Art consultancy. Estab. 1972. Represents 200 emerging, mid-career and established artists through slides. Open all year; Monday-Sunday. Clientele: upscale, residential and corporate. 60% private collectors, 40% corporate collectors. Overall price range: $500-10,000; most work sold at $1,000-8,000.

Media: Considers all media except conceptual. Most frequently sells acrylic, oil, mixed media and 3-D work.

Style: Exhibits expressionism, photorealism, neo-expressionism, pattern painting, color field, illustrative, painterly abstraction, realism and imagism.

Terms: Artwork is accepted on consignment (40% commission). Retail price set by the artist. Shipping costs are usually shared. Prefers artwork unframed.

Submissions: Accepts only artists from US. Send query letter with résumé, slides, bio and SASE. Portfolio should include slides and SASE. Reports in 2 weeks.

Tips: "Submit clear, well-marked slides and SASE."

BALZEKAS MUSEUM OF LITHUANIAN CULTURE ART GALLERY, 6500 S. Pulaski Rd., Chicago IL 60629. (773)582-6500. Fax: (773)582-5133. Museum, museum retail shop, nonprofit gallery and rental gallery. Estab. 1966. Approached by 20 mid-career and established artists/year. Sponsors 8 exhibits/year. Average display time 6 weeks. Open 7 days a week. Closed holidays. Clients include local community, tourists and upscale. 74% of sales are to corporate collectors. Overall price range: $150-6,000; most work sold at $545.

Media: Considers all media and all types of prints.

Style: Considers all styles and genres.

Terms: Artwork is accepted on consignment and there is a 33% commission. Retail price set by the gallery. Gallery provides promotion. Accepted work should be framed.

Submissions: Write to arrange a personal interview to show portfolio. Cannot return material. Responds in 2 months. Finds artists through word of mouth, art exhibits, and referrals by other artists.

▣ CONTEMPORARY ART WORKSHOP, 542 W. Grant Place, Chicago IL 60614. (773)472-4004. Fax: (773)472-4505. E-mail: info@contemporaryartworkshop.org. Website: www.contemporaryartworksh op.org. **Director:** Lynn Kearney. Nonprofit gallery. Estab. 1949. Interested in emerging and mid-career artists. Average display time is 4½ weeks "if it's a show, otherwise we can show the work for an indefinite period of time." Open Tuesday-Friday, 12:30-5:30; Saturday, 12-5. Clientele: art-conscious public. 75% private collectors, 25% corporate clients. Overall price range: $300-5,000; most artwork sold at $1,000 "or less."

• This gallery also offers studios for sculptors, painters and fine art crafts on a month-to-month arrangement, and open space for sculptors.

Media: Considers oil, acrylic, mixed media, works on paper, sculpture, installations and original handpulled prints. Most frequently exhibits paintings, sculpture and works on paper and fine art furniture.

Style: "Any high-quality work" is considered.

Terms: Accepts work on consignment (30% commission). Retail price set by gallery or artist. "Discounts and payment by installments are seldom and only if approved by the artist in advance." Exclusive area representation not required. Gallery provides insurance and promotion.

Submissions: Send query letter with résumé, slides and SASE. Slides and résumé are filed. "First we review slides and then send invitations to bring in a portfolio based on the slides." Finds artists through call for entries in arts papers; visiting local BFA, MFA exhibits; referrals from other artists, collectors.

Tips: "Looks for a professional approach and a fine art school degree (or higher). Artists a long distance from Chicago will probably not be considered."

CORTLAND-LEYTEN GALLERY, 815 N. Milwaukee Ave., Chicago IL 60622. (312)733-2781. E-mail: leyten@aol.com. **Director:** S. Gallas. Retail gallery. Estab. 1984. Represents 6 emerging artists/year. Exhibited artists include Martin Geese, Wayne Bertola, Judy Petacque. Sponsors 4 shows/year. Average display time 1 month. Open all year; Saturday, 12:30-6; Sunday, 12:30-4; and by appointment. Located in River West area near downtown; 2,000 sq. ft. 50% of space for special exhibitions; 50% of space for gallery artists. Clientele: upscale. 75% private collectors, 25% corporate collectors.

Media: Considers oil, pen & ink, acrylic, drawing, sculpture, mixed media, ceramics, collage, craft, engravings and lithographs. Most frequently exhibits sculpture, oil, mixed media.

Style: Exhibits all styles and all genres. Prefers figurative, oil.

Terms: Accepts work on consignment (50% commission). Retail price set by the gallery. Gallery provides insurance, promotion and contract; artist pays for shipping. Prefers artwork framed.

Submissions: Accepts local artists only. Send query letter with résumé, slides, bio. Write for appointment to show portfolio of slides. Responds only if interested within 2 weeks. Files slides, résumés. Finds artists through word of mouth, submissions.

DIX ART MIX, 2068 N. Leavitt, Chicago IL 60647. Phone/fax: (773)384-5142. Website: www.fota.com. **Director:** Thomas E. Prerk. Retail gallery, alternative space, art consultancy. Estab 1998. Represents 35 emerging artists and 12 consignment artists/year. Exhibited artists include Connie Hinkle, Kevin Orth and Adele Kiel. Sponsors 6 shows/year. Average display time 1 month. Open all year; Wednesday and Saturday evenings; Sunday afternoons by appointment. Clientele: local community—many diverse groups. 90% private collectors, 10% corporate collectors. Overall price range $100-2,000; most work sold at $200-500.

Media: Considers all media and all types of prints. Most frequently exhibits paintings, photography, mixed media, glass, jewelry, pottery, sculpture and consignment art.

Style: Exhibits neoexpressionism, conceptualism, street art, environmental/cultural, painterly abstraction and surrealism. Prefers conceptualism, mixed media, pop art, avant garde.

Terms: Accepts work on consignment (15-25% commissions) and/or rental fee for space. The rental fee covers 1 month; there is a per event price. Prices of artwork set by artist. Gallery provides promotion and contract; artist pays for shipping.

Submissions: Send query letter with résumé, business card, 3 or more slides, photographs, artist's statment, bio and SASE. Call for appointment to show portfolio of photographs and slides. Responds in 1 month. files color photocopies. Finds artists through visiting shows/openings, referrals and word of mouth.

Ⓝ OSKAR FRIEDL GALLERY, 300 W. Superior St., Chicago IL 60610. (312)867-1930. Fax: (312)867-1929. E-mail: o@friedlgallery.com. Website: www.friedlgallery.com. Retail gallery. Estab. 1988. Represents 10 emerging, mid-career and established artists. Exhibited artists include (Art)ⁿ Laboratory,

Miroslaw Rogala and Zhou Brothers. Sponsors 6 shows/year. Average display time 7 weeks. Open all year; Thursday, Friday, Saturday, 12-7. Located downtown in River North gallery district; 800 sq. ft. Clientele: emerging private collectors. 80% private collectors, 20% corporate collectors. Overall price range: $500-30,000; most work sold at $3,000-8,000.

● This gallery has an emphasis on interactive material and CD-ROM.

Media: Considers oil, acrylic, pastel, pen & ink, drawings, mixed media, collage, sculpture, interactive multimedia, CD-ROM and installation. Most frequently exhibits oil, acrylic and sculpture.

Style: Exhibits expressionism, neo-expressionism, conceptualism and painterly abstraction. Prefers contemporay, abstract expressionist and conceptualist styles.

Terms: Accepts artwork on consignment (50% commission). Retail price set by gallery and artist. Gallery provides insurance, promotion, contract and some shipping costs from gallery.

Submissions: Send query letter with résumé, sheet of slides, bio, brochure, photographs, SASE and reviews. Portfolio review requested if interested in artist's work. Portfolio should include photographs, slides and transparencies. Responds in 6 weeks.

Tips: "Apply only to galleries that you know are right for you. Have a body of work of 100 pieces before approaching galleries."

ROBERT GALITZ FINE ART, 166 Hilltop Court, Sleepy Hollow IL 60118. (847)426-8842. Fax: (847)426-8846. **Owner:** Robert Galitz. Wholesale representation to the trade. Makes portfolio presentations to corporations. Estab. 1986. Represents 40 emerging, mid-career and established artists. Exhibited artists include Marko Spalatin and Jack Willis. Open by appointment. Located in far west suburban Chicago.

Media: Considers oil, acrylic, watercolor, mixed media, collage, ceramic, fiber, original handpulled prints, engravings, lithographs, pochoir, wood engravings, mezzotints, serigraphs and etchings. "Interested in original works on paper."

Style: Exhibits expressionism, painterly abstraction, surrealism, minimalism, impressionism and hard-edge geometric abstraction. Interested in all genres. Prefers landscapes and abstracts.

Terms: Accepts artwork on consignment (variable commission) or artwork is bought outright (25% of retail price; net 30 days). Retail price set by artist. Customer discounts and payment by installment are available. Gallery provides promotion and shipping costs from gallery. Prefers artwork unframed only.

Submissions: Send query letter with SASE and submission of art. Portfolio review requested if interested in artist's work. Files bio, address and phone.

Tips: "Do your thing and seek representation—don't drop the ball! Keep going—don't give up!"

Ⓝ GALLERY 400, UNIVERSITY OF ILLINOIS AT CHICAGO, 400 S. Peoria St. (MC033), Chicago IL 60607. (312)996-6114. Fax: (312)355-3444. Website: http://gallery400.aa.uic.edu. **Director:** Lorelei Stewart. Nonprofit gallery. Estab. 1983. Approached by 500 artists/year. Exhibits 80 emerging and mid-career artists. Exhibited artists include: Öyvind Fahlström and Kristin Lucas. Sponsors 6 exhibits/year. Average display time 4-6 weeks. Open Tuesday-Friday, 10-5; Saturday, 12-5. Closed holiday season, end of July, early August. Located in 2,400 sq. ft. former factory. Clients include local community, students, tourists and upscale.

Media: Considers drawing, installation, mixed media and sculpture. Most frequently exhibits sculpture, drawing and photography.

Style: Exhibits: conceptualism, minimalism and postmodernism. Most frequently exhibits contemporary conceptually based artwork.

Terms: Gallery provides insurance and promotion.

Submissions: Send query letter with SASE. Returns material with SASE. Responds in 5 months. Files résumé only. Finds artists through word of mouth, art exhibits and referrals by other artists..

Tips: Please check our website for guidelines for proposing an exhibition.

GALLERY 1633, 1633 N. Damen Ave., Chicago IL 60647. (773)384-4441. **Director:** Montana Morrison. Consortium of contributing artists. Estab. 1986. Represents/exhibits a number of emerging, mid-career and established artists. Interested in seeing the work of emerging artists. Exhibited artists include painters, printmakers, sculptors, photographers. Sponsors 11 shows/year. Average display time 1 month. Open all year; Friday, 12-9:30; Saturday and Sunday, 12-5. Located in Bucktown; 900 sq. ft.; original tin ceiling, storefront charm. 35% of space for special exhibitions; 65% of space for gallery artists. Clientele: tourists, local community, local artists, "suburban visitors to popular neighborhood." Sells to both private collectors and commercial businesses. Overall price range: $50-5,000; most work sold at $250-500.

Media: Considers all media and types of prints. Most frequently exhibits painting and drawing; ceramics, sculpture and photography.

Style: Exhibits all styles including usable crafts (i.e. tableware). All genres. Montana Morrison shows neo-expressionism, activated minimalism and post modern works.

Terms: Artwork is accepted on consignment, and there is a 25% commission. There is a rental fee for space. Available memberships include "gallery artists" who may show work every month for 1 year; associate gallery artists who show work for 6 months; and guest artists, who show for one month. Retail price set by the artist. Gallery provides promotion and contract. Artist pays for shipping costs. Call for appointment to show portfolio. Artist should call and visit gallery.

Tips: "If you want to be somewhat independent and handle your own work under an 'umbrella' system where artists work together, in whatever way fits each individual—join us."

GALLERY 312, 312 N. May St., Suite 110, Chicago IL 60607. (312)942-2500. Fax: (312)942-0574. E-mail: gall312@megsinet.com. Website: www.gallery312.org. **Program Director:** Paul Brenner. Nonprofit, artist-run venue "committed to the exploration and exhibition of ideas and trends in artmaking relevant to today's world. By focusing on new art forms and emerging artists, and integrating educational strategies, Gallery 312 acts as a local lens for an international community." Sponsors 6 shows/year. Average display time 6 weeks. Open all year; Tuesday-Saturday, 11-5. Located in Fulton/Randolph Market District; 7,200 sq. ft.; 28 ft. ceiling. Gallery is in restored boiler room of large warehouse. 100% of space for special exhibitions. Clientele: "museum-goers," educators, artists, collectors, students. 50% private collectors, 50% corporate collectors. Overall price range: $500-25,000; most work sold at $500-5,000.

Media: Considers and exhibits all media.

Style: Exhibits conceptualism, minimalism, color field, postmodern. Prefers contemporary.

Terms: Accepts work on consignment for exhibition only. Retail price set by artist. Gallery provides insurance, promotion and contract; artist pays for shipping. Prefers paper and photographs framed; canvas etc. unframed.

Submissions: Send query letter with résumé, brochure, business card, slides, photographs, reviews, artists' statement, bio and SASE. Advisory Programming Committee reviews work. Responds in 1 month. Files catalogs. Finds artists through referrals by other galleries, museums, guest curators and submissions.

N GWENDA JAY/ADDINGTON GALLERY, 704 N. Wells, Chicago IL 60610. (312)664-3406. Fax: (312)664-3388. E-mail: director@gwendajay.com. Website: www.gwendajay.com. **President:** Gwenda Jay. Director: Dan Addington. Retail gallery. Estab. 1988. Represents 25 mainly mid-career artists, but emerging and established, too. Exhibited artists include painters Jean Larson, Ron Clayton and Howard Hersh and sculptor Bruce Beasley. Sponsors 8 shows/year. Average display time 5 weeks. Open all year; Tuesday, 11-6. Located in River North area; 2,000 sq. ft.; "intimate, warm feeling loft-type space"; 60% of space for 1-2 person and group exhibitions. Clientele: "all types—budding collectors to corporate art collections." 75% private collectors; 10% corporate collectors. Overall price range: $1,000-12,000; most artwork sold at $2,000-6,000.

Media: Considers all media except large-scale sculptures with a focus on painting.

Style: Exhibits lyrical and organic abstraction, romanticism, poetic architectural classicism. Genres include landscapes, abstraction and representational imagery. Styles are contemporary with traditional elements or classical themes.

Terms: Accepts work on consignment (50% commission). Retail price set by the gallery and the artist. Offers customer discounts and payment by installments. Gallery provides insurance and promotion; shipping costs are shared.

Submissions: Send query letter with résumé, slides, bio, reviews, artists' statement and SASE. No unsolicited appointments. Responds in 3 months. Finds artists through visiting exhibitions, referrals and submissions.

Tips: "Please send slides with résumé and SASE first. We will reply and schedule an appointment once slides have been reviewed if we wish to see more. Please be familiar with the gallery's style." Looking for "consistent style and dedication to career."

HYDE PARK ART CENTER, 5307 S. Hyde Park Blvd., Chicago IL 60615. (773)324-5520. Fax. (773)324-6641. E-mail: info@hydeparkart.org. Website: hydeparkart.org. **Executive Director:** Chuck Thurow. Nonprofit gallery. Estab. 1939. Exhibits emerging artists. Sponsors 9 group shows/year. Average display time is 4-6 weeks. Located in the historic Del Prado building, in a former ballroom. "Primary focus on Chicago area artists not currently affiliated with a retail gallery." Clientele: general public. Overall price range: $100-10,000.

Media: Considers all media. Interested in seeing "innovative, 'cutting edge' work by young artists; also interested in proposals from curators, groups of artists."

Terms: Accepts work "for exhibition only." Retail price set by artist. Sometimes offers payment by installment. Exclusive area representation not required. Gallery provides insurance and contract.

Submissions: Send query letter with résumé, no more than 15 slides and SASE. Will not consider poor slides. "A coherent artist's statement is helpful." Portfolio review not required. Responds in 6 weeks. Send Attn: Exhibition Coordinator. Finds artists through open calls for slides, curators, visiting exhibitions (especially MFA programs) and artists' submissions. Prefers not to receive phone calls.
Tips: "Do not bring work in person."

N ILLINOIS ART GALLERY, Suite 2-100, 100 W. Randolph, Chicago IL 60601. (312)814-5322. Fax: (312)814-3471. E-mail: jstevens@museum.state.il.us. Website: www.museum.state.il.us. **Assistant Administrator:** Jane Stevens. Museum. Estab. 1985. Exhibits emerging, mid-career and established artists. Sponsors 6-7 shows/year. Average display time 7-8 weeks. Open all year. Located "in the Chicago loop, in the James R. Thompson Center designed by Helmut Jahn." 100% of space for special exhibitions.
Media: All media considered, including installations.
Style: Exhibits all styles and genres, including contemporary and historical work.
Terms: "We exhibit work, do not handle sales." Gallery provides insurance and promotion; artist pays for shipping. Prefers artwork framed.
Submissions: Accepts only artists from Illinois. Send résumé, 10 high quality slides, bio and SASE.

✓ 🕴 ILLINOIS ARTISANS PROGRAM, James R. Thompson Center, 100 W. Randolph St., Chicago IL 60601. (312)814-5321. Fax: (312)814-3891. E-mail: cpatterson@museum.state.il.us. **Director:** Carolyn Patterson. Four retail shops operated by the nonprofit Illinois State Museum Society. Estab. 1985. Represents over 1,500 artists; emerging, mid-career and established. Average display time 6 months. "Accepts only juried artists living in Illinois." Clientele: tourists, conventioneers, business people, Chicagoans. Overall price range: $10-5,000; most artwork sold at $25-100.
Media: Considers all media. "The finest examples in all media by Illinois artists."
Style: Exhibits all styles. "Seeks contemporary, traditional, folk and ethnic arts from all regions of Illinois."
Terms: Accepts work on consignment (50% commission). Retail price set by gallery and artist. Sometimes offers customer discounts. Exclusive area representation not required. Gallery provides promotion and contract.
Submissions: Send résumé and slides. Accepted work is selected by a jury. Résumé and slides are filed. "The finest work can be rejected if slides are not good enough to assess." Portfolio review not required. Finds artists through word of mouth, requests by artists to be represented and by twice-yearly mailings to network of Illinois crafters announcing upcoming jury dates.

KLEIN ART WORKS, 400 N. Morgan, Chicago IL 60622. (312)243-0400. Fax: (312)243-6782. E-mail: info@kleinart.com. Website: www.kleinart.com. **Director:** Paul Klein and Monique Martin. Retail gallery. Estab. 1981. Represents 20 emerging, mid-career and established artists. Interested in seeing the work of emerging artists. Exhibited artists include Sam Gilliam and Ed Moses. Sponsors 10 shows/year. Average display time 5 weeks. Open all year. Located in industrial section of downtown; 4,500 sq. ft.; spacious, with steel floors, no columns and outdoor sculpture garden. 80% of space for special exhibitions; 20% of space for gallery artists. Clientele: 75% private collectors, 25% corporate collectors. Overall price range: $1,000-100,000.
Media: Considers oil, acrylic, mixed media, sculpture, ceramic, installation and photography. Most frequently exhibits painting and sculpture.
Style: Exhibits abstraction.
Terms: Accepts work on consignment (50% commission). Retail price set by gallery and artist. Gallery provides insurance, promotion and contract; shipping costs are shared.
Submissions: Send query letter with résumé, slides, bio, reviews and SASE. Responds in 6 weeks.
Tips: "Apply the creativity you use in your artwork to your career."

N PETER MILLER GALLERY, 118 N. Peoria St., Chicago IL 60607. (312)226-5291. Fax: (312)226-5441. E-mail: info@petermillergallery.com. Website: petermillergallery.com. **Co-Director:** Natalie R. Domchenko. Retail gallery. Estab. 1979. Represents 15 emerging, mid-career and established artists. Sponsors 9 solo and 3 group shows/year. Average display time is 1 month. Clientele: 80% private collectors, 20% corporate clients. Overall price range: $500-20,000; most artwork sold at $5,000 and up.
Media: Considers oil, acrylic, mixed media, collage, sculpture, installations and photography. Most frequently exhibits oil and acrylic on canvas and mixed media.
Style: Exhibits abstraction, conceptual and realism.
Terms: Accepts work on consignment (50% commission). Retail price set by gallery and artist. Exclusive area representation required. Insurance, promotion and contract negotiable.
Submissions: Send slides and SASE. Slides, show card are filed.
Tips: Looks for "classical skills underlying whatever personal vision artists express. Send a sheet of 20 slides of work done in the past 18 months with a SASE."

[N] JUDY A. SASLOW GALLERY, 300 W. Superior St., Chicago IL 60610. (312)943-0530. Fax: (312)943-3970. E-mail: jsaslow@corecomm.net. Website: www.jsaslowgallery.com. For-profit gallery. Estab. 1995. Approached by 50 artists/year. Exhibits 5 emerging, mid-career and established artists. Sponsors 6 exhibits/year. Average display time 2 months. Open all year; Tues-Saturday, 10-6. Large exhibition space in the River North gallery district. Clients include local community, students, tourists and upscale. Overall price range: $50-30,000; most work sold at $5,000.
Media: Considers all media and all types of prints. Most frequently exhibits paint, ink and sculpture.
Style: Considers all styles and genres. Most frequently exhibits self-taught, outsider and folk.
Terms: Artwork is accepted on consignment and there is a 50% commission. Retail price set by the gallery. Gallery provides insurance, promotion and contract.
Submissions: Send query letter with artist's statement, bio, photographs. Do not send original artwork. Returns material with SASE. Responds in 4 months. Finds artists through word of mouth, submissions, portfolio reviews, art exhibits, art fairs and referrals by other artists.
Tips: Collectors prefer materials that are archival-quality.

UNION STREET GALLERY, 1655 Union Ave., Chicago Heights IL 60411. (708)754-2601. Fax: (708)754-8779. Website: www.enterprisecenter.org. **Gallery Administrator:** Karen Leluga. Nonprofit gallery. Estab. 1995. Represents more than 100 emerging and mid-career artists. Studio artists include: Renee Klyczek/Nordstrom (acrylic) and Marikay Peter Witlock (graphic). Sponsors 6 exhibits/year. Average display time 6 weeks. Open all year; Monday-Friday, 10-2 or by appointment. Gallery's studio complex houses emerging, professional artists, creating, teaching, hosting seminars, and curating exhibitions for the state-of-the art gallery. Loft spaces with polished maple floors, tall paned windows, and a 3rd floor view energizes this space for artists and viewers alike. Overall price range: $30-3,000; most work sold at $300-600.
Media: Considers all media and all types of prints.
Style: Considers all styles.
Terms: Artwork is accepted on consignment and there is a 20% commission. Retail price set by the artist. Gallery provides promotion. Accepted work should be framed. Requires exclusive representation locally.
Submissions: To receive prospectus for all juried events, call, write or fax to be added to mailing list. Artists interested in studio space or solo/group exhibitions should contact Union Street to request information packets.

[✓] VALE CRAFT GALLERY, 230 W. Superior St., Chicago IL 60610. (312)337-3525. Fax: (312)337-3530. E-mail: peter@valecraftgallery.com. Website: www.valecraftgallery.com. **Owner:** Peter Vale. Retail gallery. Estab. 1992. Represents 100 emerging, mid-career artists/year. Exhibited artists include John Neering and Kathyanne White. Sponsors 6 shows/year. Average display time 2 months. Open all year; Monday-Friday, 10:30-5:30; Saturday, 11-5; Sunday, 12-4. Located in River North gallery district near downtown; 2,100 sq. ft.; lower level of prominent gallery building; corner location with street-level windows provides great visibility. 40% of space for special exhibitions; 60% of space for gallery artists. Clientele: private collectors, tourists, people looking for gifts, interior designers and art consultants. 50% private collectors, 10% corporate collectors. Overall price range; $50-2,000; most work sold at $100-500.
Media: Considers paper, sculpture, ceramics, craft, fiber, glass, metal, wood and jewelry. Most frequently exhibits fiber wall pieces, jewelry, glass, ceramic sculpture and mixed media.
Style: Exhibits contemporary craft. Prefers decorative, sculptural, colorful, whimsical, figurative, and natural or organic.
Terms: Accepts work on consignment (50% commission). Retail price set by the artist. Gallery provides insurance, promotion, contract and shipping costs from gallery; artist pays shipping costs to gallery.
Submissions: Accepts only artists from US. Only craft media. Send query letter with résumé, 10-20 slides (including slides of details), bio or artist's statement, photographs, record of previous sales, SASE and reviews if available and price list. Call for appointment to show portfolio of originals and photographs. Responds in 2 months. Files résumé (if interested). Finds artists through submissions, art and craft fairs, publishing a call for entries, artists' slide registry and word of mouth.
Tips: "Call ahead to find out if the gallery is interested in showing the particular type of work you do; send professional slides and statement about the work or call for an appointment to show original work. Try to visit the gallery ahead of time or check out the gallery's website to find out if your work fits into the gallery's focus. I would suggest you have completed at least 20 pieces in a body of work before approaching galleries."

SONIA ZAKS GALLERY, 311 W. Superior St., Suite 207, Chicago IL 60610. (312)943-8440. Fax: (312)943-8489. **Director:** Sonia Zaks. Retail gallery. Represents 25 emerging, mid-career and established artists/year. Sponsors 10 solo shows/year. Average display time is 1 month. Overall price range: $500-15,000.

© 2000 Tom Keesee

This woodcut designed by Tom Keesee is only one of many pieces featured in exhibits at Artlink, a contemporary gallery in Fort Wayne, Indiana. Gallery assistant Suzanne Galazka reports that the venue was so attracted to Keesee's representations of Indiana landscapes, they invited him to show woodcuts at four major shows in just one year. Aside from being the "woodcut master" at Artlink, Keesee teaches printmaking and painting to university students.

Media: Considers oil, acrylic, watercolor, drawings, sculpture.
Style: Specializes in contemporary paintings, works on paper and sculpture. Interested in narrative work.
Terms: Accepts work on consignment. Retail price is set by gallery and artist. Exclusive area representation required. Gallery provides insurance and contract.
Submissions: Send query letter with 20 slides plus SASE.
Tips: "A common mistake some artists make is presenting badly taken and unmarked slides."

Indiana

ARTLINK, 437 E. Berry St., Suite 202, Fort Wayne IN 46802-2801. (219)424-7195. Fax: (219)424-8453. E-mail: artlinkfw@juno.com. **Executive Director:** Betty Fishman. Nonprofit gallery. Estab. 1979. Exhibits emerging and mid-career artists. 620 members. Sponsors 18 shows/year, 2 galleries. Average display time 5-6 weeks. Open all year. Located 4 blocks from central downtown, 2 blocks from art museum and theater for performing arts; in same building as a cinema theater, dance group and historical preservation group; 1,600 sq. ft. 100% of space for special exhibitions. Clientele: "upper middle class." Overall price range: $100-500; most artwork sold at $200.
 ● Publishes a quarterly newsletter, *Genre*, which is distributed to members. Includes features about upcoming shows, profiles of members and other news. Some artwork shown at gallery is reproduced in b&w in newsletter. Send SASE for sample and membership information.
Media: Considers all media, including prints. Prefers work for annual print show and annual photo show, sculpture and painting.
Style: Exhibits expressionism, neo-expressionism, painterly abstraction, conceptualism, color field, postmodern works, photorealism, hard-edge geometric abstraction; all styles and genres. Prefers imagism, abstraction and realism. "Interested in a merging of craft/fine arts resulting in art as fantasy in the form of bas relief, photo/books, all experimental media in nontraditional form."
Terms: Accepts work on consignment only for exhibitions (35% commission). Retail price set by artist. Gallery provides insurance. Shipping costs are shared. Prefers framed artwork.
Submissions: Send query letter with résumé, no more than 6 slides and SASE. Reviewed by 14-member panel. Responds in 1 month. "Jurying takes place three times per year unless it is for a specific call for entry. A telephone call will give the artist the next jurying date."

Tips: "Call ahead to ask for possibilities for the future and an exhibition schedule for the next two years will be forwarded." Common mistakes artists make in presenting work are "bad slides and sending more than requested—large packages of printed material. Printed catalogues of artist's work without slides are useless." Sees trend of community-wide cooperation by organizations to present art to the community.

⬛Ｎ ⬛ HOOSIER SALON PATRONS ASSOCIATION & GALLERY, 6434 N. College, Suite C, Indianapolis IN 46220-6600. (317)253-5340. Fax: (317)259-1817. E-mail: hoosiersalon@iquest.net. Website: www.hoosiersalon.org. Nonprofit gallery. Estab. 1925. Membership of 500 emerging, mid-career and established artists. Sponsors 7 exhibits/year (6 in gallery, 1 juried show each year at the Indiana State Museum). Average display time 1 month. Open all year; Tuesday-Friday, 11-5; Saturday, 11-3. Closed over Christmas week. Gallery is in the Village of Broad Ripple, Indianapolis as part of a business building. Gallery occupies about 1,000 sq. ft. (800 sq. ft. for exhibit). Clients include local community and tourists. 20% of sales are to corporate collectors. Overall price range: $50-5,000; most work sold at $1,000.
Media: Considers acrylic, ceramics, collage, drawing, fiber, mixed media, oil, paper, pastel, pen & ink, sculpture, watercolor and hand-pulled prints. Most frequently exhibits oil, watercolor and pastel. Considers all types of prints.
Style: Exhibits: impressionism and painterly abstraction. Considers all genres.
Terms: Artwork is accepted on consignment and there is a 33% commission. Retail price set by the artist. Gallery provides insurance and contract. Accepted work should be framed. Requires membership. Criteria for membership is 1 year's residence in Indiana. Accepts only artists from Indiana (1 year residency). Gallery only shows artists who have been in one Annual Exhibit (jurried show of approx. 200 artists each year).
Submissions: Call or e-mail to show portfolio. Responds ASAP. We do not keep artists' materials unless they are members. Finds artists through word of mouth, art exhibits and art fairs.
Tips: While not required, all mats, glass etc. need to be archival-quality. Because the Association is widely regarded as exhibiting quality art, artists are generally careful to present their work in the most professional way possible.

INDIANAPOLIS ART CENTER, 820 E. 67th St., Indianapolis IN 46220. (317)255-2464. Fax: (317)254-0486. E-mail: exhibs@indplsartcenter.org. Website: www.indplsartcenter.org. Director of Exhibitions and Artist Services: Julia Moore. Exhibitions Associate: Stephanie Robertson. Nonprofit art center. Estab. 1934. Prefers emerging artists. Exhibits approximately 100 artists/year. 1,800 members. Sponsors 15-20 shows/year. Average display time 5 weeks. Open Monday-Friday, 9-10; Saturday, 9-3; Sunday, 12-3. Located in urban residential area; 2,560 sq. ft. in 3 galleries; "Progressive and challenging work is the norm!" 100% of space for special exhibitions. Clientele: mostly private. 90% private collectors, 10% corporate collectors. Overall price range: $50-15,000; most work sold at $100-5,000. Also sponsors annual Broad Ripple Art Fair in May.
Media: Considers all media and all types of original prints. Most frequently exhibits painting, sculpture installations and fine crafts.
Style: All styles. Interested in figurative work. "In general, we do not exhibit genre works. We do maintain a referral list, though." Prefers postmodern works, installation works, conceptualism.
Terms: Accepts work on consignment (35% commission). Commission is in effect for 3 months after close of exhibition. Retail price set by artist. Gallery provides insurance, promotion, contract; artist pays for shipping. Prefers artwork framed.
Submissions: "Special consideration for IN, OH, MI, IL, KY artists." Send query letter with résumé, minimum of 20 slides, SASE, reviews and artist's statement. Responds in 6 weeks. Season assembled in January.
Tips: "Research galleries thoroughly—get on their mailing lists, and visit them in person at least twice before sending materials. Always phone to get the gallery's preferred timing and method of viewing new work, and adhere to these preferences. Find out the 'power structure' of the targeted galleries and use it to your advantage. Most artists need to gain experience exhibiting in smaller or non-profit spaces before approaching a gallery—work needs to be of consistent, dependable quality. Have slides done by a professional if possible. Stick with one style—no scattershot approaches. Have a concrete proposal with installation sketches (if it's never been built). We book two years in advance—plan accordingly. Do not call. Put me on your mailing list one year before sending application so I can be familiar with your work and record—ask to be put on my mailing list so you know the gallery's general approach. It works!"

MIDWEST MUSEUM OF AMERICAN ART, 429 S. Main St., Elkhart IN 46516. Phone/fax: (219)293-6660. **Director:** Jane Burns. Curator: Brian D. Byrn. Museum. Estab. 1978. Represents mid-career and established artists. May be interested in seeing the work of emerging artists in the future. Sponsors 10-12

shows/year. Average display time 4-6 weeks. Open all year; Tuesday-Friday, 11 to 5; Saturday and Sunday, 1-4. Located downtown; 1,000 sq. ft. temporary exhibits; 10,000 sq. ft. total; housed in a renovated neoclassical style bank building; vault gallery. 10% for special exhibitions. Clientele: general public.

Media: Considers all media and all types of prints.

Style: Exhibits all styles, all genres.

Terms: Acquired through donations. Retail price set by the artist "in those cases when art is offered for sale." Gallery provides insurance, promotion and contract; artist pays shipping costs to and from gallery. Prefers artwork framed.

Submissions: Accepts only art of the Americas, professional artists 18 years or older. Send query letter with résumé, slides, bio, reviews and SASE. Write for appointment to show portfolio of slides. Responds in 6 months. Files résumé, bio, statement. Finds artists through visiting exhibitions, submissions, art publications.

Tips: "Keep portfolio updated. Have your work professionally framed."

SWOPE ART MUSEUM, 25 S. Seventh St., Terre Haute IN 47807-3604. (812)238-1676. Fax: (812)238-1677. E-mail: info@swope.org. Website: www.swope.org. Nonprofit museum. Estab. 1942. Approached by approximately 10 artists/year. Represents 1-3 mid-career and established artists. Average display time 4-6 weeks. Open all year; Tuesday-Friday, 10-5; Thursday, 10-8; weekends 12-5. Closed Mondays and national holidays. Located in downtown Terre Haute in a Renaissance-revival building with art deco interior.

Media: Considers all media except craft. Most frequently exhibits paintings, sculpture, and works on paper. Considers all types of prints except posters.

Style: Exhibits: impressionism, modern and representational. Exhibits permanent collection: representational, Indiana impressionists, regionalism. Genres include Americana, landscapes and Southwestern.

Terms: Accepts only local and regional paintings, sculptures and works on paper for "Wabash Currents," an exhibition that showcases local and regional artists (size and weight are limited because we do not have a freight elevator).

Submissions: Send query letter with artist's statement, brochure, résumé and SASE (if need items returned). Returns material with SASE. Responds in 5 months. Files only what fits the mission statement of the museum for special exhibitions. Finds artists through word of mouth, and annual juried exhibition at the museum.

Tips: "Send only art statement, slides, brochure, résumé. If returnable items are sent, they must have a SASE (with proper postage). Archival-quality materials guarantee a longer life span of artwork, and no viewable damage of artwork in the future they increase the future value of artwork and reduce conservation costs to museums."

Iowa

N ARTS FOR LIVING CENTER, P.O. Box 5, Burlington IA 52601-0005. Located at Seventh & Washington. (319)754-8069. Fax: (319)754-4731. **Executive Director:** Lois Rigdon. Nonprofit gallery. Estab. 1974. Exhibits the work of mid-career and established artists. May consider emerging artists. 425 members. Sponsors 10 shows/year. Average display time 3 weeks. Open all year; Tuesday-Friday, 12-5; weekends, 1-4. Located in Heritage Hill Historic District, near downtown; 2,500 sq. ft.; "former sanctuary of 1868 German Methodist church with barrel ceiling, track lights." 35% of space for special exhibitions. Clientele: 80% private collectors, 20% corporate collectors. Overall price range: $25-1,000; most work sold at $75-500.

Media: Considers all media and all types of prints. Most frequently exhibits watercolor, intaglio and sculpture.

Style: Exhibits all styles.

Terms: Accepts work on consignment (25% commission). Retail price set by artist. Gallery provides insurance, promotion and contract; artist pays for shipping. Prefers artwork framed.

Submissions: Send query letter with résumé, slides, bio, brochure, photographs, SASE and reviews. Call or write for appointment to show portfolio of slides and gallery experience verification. Responds in 1 month. Files résumé and photo for reference if interested.

✓ BLANDEN MEMORIAL ART MUSEUM, 920 Third Ave. S., Fort Dodge IA 50501. (515)573-2316. E-mail: info@blanden.org. Website: www.blanden.org. **Administrative Assistant:** Peg Stickrod. Director: Jo Ann Hendricks. Nonprofit municipal museum. Estab. 1930. Clientele: statewide through international. 75% private collectors, 25% corporate clients. Sponsors 8 solo and 6 group shows/year. Average display time is 2 months. Interested in emerging, mid-career and established artists.

Media: Paintings, drawing, prints, photography, sculpture in various media.
Style: Accepts all work.
Terms: Offers customer discount and payment by installation.
Submissions: Send query letter with résumé, slides and SASE. Slides and résumés are filed.

CORNERHOUSE GALLERY AND FRAME, 2753 First Ave. SE, Cedar Rapids IA 52402. (319)365-4348. Fax: (319)365-1707. E-mail: info@cornerhousegallery.com. Website: www.cornerhousegallery.com. **Director:** Janelle McClain. Retail gallery. Estab. 1976. Represents 150 emerging, mid-career and established midwestern artists. Exhibited artists include John Preston, Grant Wood and Stephen Metcalf. Sponsors 3 shows/year. Average display time 1 month. Open all year; Monday-Friday, 9:30-5:30; Saturday, 9:30-4. 3,000 sq. ft.; "converted 1907 house with 3,000 sq. ft. matching addition devoted to framing, gold leafing and gallery." 25% of space for special exhibitions. Clientele: "residential/commercial, growing collectors." 80% private collectors. Overall price range: $50-20,000; most artwork sold at $200-2,000.
Media: Considers oil, acrylic, watercolor, pastel, drawings, mixed media, collage, works on paper, sculpture, ceramic, fiber, glass, original handpulled prints, woodcuts, wood engravings, linocuts, engravings, mezzotints, jewelry, etchings, lithographs and serigraphs. Most frequently exhibits oil, acrylic, original prints and ceramic works.
Style: Exhibits all styles. Genres include florals, landscapes, figurative work. Prefers regionalist/midwestern subject matter. Exhibits only original work—no reproductions.
Terms: Accepts work on consignment (45% commission) or artwork is bought outright for 50% of retail price (net 30 days). Retail price set by artist and gallery. Gallery provides insurance and promotion. Prefers artwork unframed.
Submissions: Prefers only Midwestern artists. Send résumé, 20 slides, photographs and SASE. Portfolio review requested if interested in artist's work. Responds in 1 month. Files résumé and photographs. Finds artists through word of mouth, submissions/self promotions and art collectors' referrals. Do not stop in unannounced.
Tips: "Send a written letter of introduction along with five representative images and retail prices. Ask for a return call and appointment. Once appointment is established, send a minimum of 20 images and résumé so it can be reviewed before appointment. Do not approach a gallery with only a handful of works to your name. I want to see a history of good quality works. I tell artists they should have completed at least 50-100 high quality works with which they are satisfied. An artist also needs to know which works to throw away!"

N CSPS, 1103 Third St. SE, Cedar Rapids IA 52401-2305. (319)364-1580. Fax: (319)362-9156. E-mail: legionarts.org. Website: www.legionarts.org. **Artistic Director:** Mel Andringa. Alternative space, nonprofit gallery. Estab. 1991. Approached by 50 artists/year. Exhibits 15 emerging artists. Exhibited artists include: Stephen Gassman, photographs; Mel Andringa, puzzle collages. Sponsors 15 exhibits/year. Average display time 2 months. Open Wednesday-Sunday, 11-6. Closed June, July and August. Located in south end Cedar Rapids; old Czech meeting hall, 2 large galleries and off-site exhibits; track lights, carpet, ornamental tin ceilings. (65 events a year). Clients include local community. Overall price range: $50-500; most work sold at $200.
Media: Considers all media and all types of prints. Most frequently exhibits painting, mixed media and installation.
Style: Considers all styles. Most frequently exhibits postmodernism, conceptualism and surrealism.
Terms: Artwork is accepted on consignment and there is a 30% commission. Retail price set by the artist. Gallery provides insurance and promotion. Accepted work should be framed. Requires exclusive representation locally.
Submissions: Send query letter with artist's statement, bio, SASE and slides. Responds in 6 months. Files résumé, sample slide and statement. Finds artists through word of mouth, art exhibits and art trade magazines.

GUTHART GALLERY & FRAMING, 506 Clark St., Suite A, Charles City IA 50616. (515)228-5004. **Owner:** John R. Guthart. Retail gallery and art consultancy. Estab. 1992. Represents 12 emerging, mid-career and established artists. Exhibited artists include: John Guthart and Steve Schiller. Average display time is 2 months. Open all year; Monday-Saturday, 10-5, and by appointment. Located downtown—close to art center and central park. 700 sq. ft. 50% of space for special exhibitions; 50% of space for gallery artists. Clientele: tourists, upscale, local community and students. 80% private collectors, 20% corporate collectors. Overall price range: $25-10,000; most work sold at $200-800.
Media: Considers all media. Considers all types of prints. Most frequently exhibits watercolors, oils and prints.
Style: Exhibits expressionism, primitivism, painterly abstraction, surrealism, postmodernism, impressionism and realism. Exhibits all genres. Prefers florals, wildlife and architectural art.

Terms: Accepts artwork on consignment (30% commission) or buys outright for 50% of retail price (net 30 days). Retail price set by gallery. Gallery provides insurance and promotion. Shipping costs are shared. Prefers artwork framed.

Submissions: Send query letter with résumé, slides and brochure. Write for appointment to show portfolio of photographs and slides. Responds only if interested in 2 weeks. Files résumé, letter and slides. Finds artists through word of mouth, referrals, submissions and visiting art fairs and exhibitions.

[N] KAVANAUGH ART GALLERY, 131 Fifth St., W. Des Moines IA 50265. (515)279-8682. Fax: (515)279-7609. E-mail: kagallery@aol.com. Website: www.kavanaughgallery.com. **Director:** Carole Kavanaugh. Retail gallery. Estab. 1990. Represents 25 mid-career and established artists/year. May be interested in seeing the work of emerging artists in the future. Exhibited artists include Kati Roberts, Don Hatfield, Dana Brown, Gregory Steele, August Holland, Ming Feng and Larry Guterson. Sponsors 3-4 shows/year. Averge display time 3 months. Open all year; Monday-Saturday, 10-5. Located in Old Town shopping area; 6,000 sq. ft. 70% private collectors, 30% corporate collectors. Overall price range: $300-20,000; most work sold at $800-3,000.

Media: Considers all media and all types of prints. Most frequently exhibits oil, acrylic and pastel.

Style: Exhibits color field, impressionism, realism, florals, portraits, western, wildlife, southwestern, landscapes, Americana and figurative work. Prefers landscapes, florals and western.

Terms: Accepts work on consignment (50% commission). Retail price set by the artist. Gallery provides insurance, promotion and contract. Shipping costs are shared. Prefers artwork unframed.

Submissions: Send query letter with résumé, bio and photographs. Portfolio should include photographs. Responds in 2-3 weeks. Files bio and photos. Finds artists through word of mouth, referrals by other artists, visiting art fairs and exhibitions, artist's submissions.

Tips: "Get a realistic understanding of the gallery/artist relationship by visiting with directors. Be professional and persistent."

LUTHER COLLEGE GALLERIES, 700 College Dr., Decorah IA 52101. (563)387-1665. Fax: (563)387-1766. E-mail: kammdavi@Luther.edu. Website: Luther.edu. **Gallery Coordinator:** David Kamm. Nonprofit college gallery. Estab. 1989. Approached by 20 artists/year. Represents 12-14 emerging, mid-career and established artists. Sponsors 18-20 exhibits/year. Average display time 4-8 weeks. Open all year; Monday-Friday, 8-5; weekends 10-5. Closed college holidays and summer. Gallery has 4 exhibition spaces; 90-150′ wall space; low security, good visibility. Clients include local community, students, tourists and upscale.

Media: Considers all media. Most frequently exhibits painting, printmaking and mixed media. Considers all types of prints except posters.

Style: Considers all styles. Most frequently exhibits imagism, painterly abstraction and expressionism. Considers all genres.

Terms: Retail price set by the artist. Gallery provides insurance, promotion and contract. Accepted work should be framed.

Submissions: Send query letter with artist's statement, résumé, SASE and slides. Responds only if interested within 6 months. Files résumé and artist's statement. Finds artists through word of mouth, submissions, art exhibits, art fairs, and referrals by other artists.

Tips: "Communicate clearly, and have quality slides and professional résumé (form and content)."

[N] MACNIDER ART MUSEUM, 303 Second St. SE, Mason City IA 50401. (641)421-3666. Website: www.macniderart.org. Nonprofit gallery. Estab. 1966. Exhibits 5-10 emerging, mid-career and established artists. Sponsors 28 exhibits/year. Average display time 2 months. Open all year; Tuesday and Thursday, 9-9; Wednesday, Friday and Saturday, 9-5; Sunday, 1-5. Closed Mondays. Large gallery space with track system which we hang works on monofilament line. Smaller gallery items are hung or mounted. Clients include local community, students, tourists and upscale. Overall price range: $100-2,500; most work sold at $400.

Media: Considers all media and all types of prints.

Style: Considers all styles and genres.

Terms: Artwork is accepted on consignment and there is a 35% commission. Retail price set by the artist. Gallery provides insurance, promotion and contract. Accepted work should be framed. Does not require exclusive representation locally.

Submissions: Mail portfolio for review. Returns material with SASE. Responds only if interested within 1 month. Finds artists through word of mouth, submissions, portfolio reviews, art exhibits, art fairs and referrals by other artists.

[✓] WALNUT STREET GALLERY, 301 SW Walnut St., Ankeny IA 50021. (515)964-9434. Fax: (515)964-9438. E-mail: wsg@dwx.com. Website: www.walnutstreetgallery.com. **Owner:** Drue Wolfe. Re-

tail gallery. Estab. 1982. Represents 50 emerging, mid-career and established artists/year. Exhibited artists include Steve Hanks, Stew Buck, Larry Zach and Terry Redlin. Sponsors 1 show/year. Average display time 6 months. Open all year; Monday-Thursday, 9-7; Friday, 9-5; Saturday, 9-3. Located downtown; 1,500 sq. ft.; renovated building. 25% of space for special exhibitions. Clientele: local community and suburbs. Overall price range: $100-1,000; most work sold at $250-600.
Media: Considers all media and all types of prints. Most frequently exhibits watercolor, acrylic and oil.
Style: Exhibits: expressionism, impressionism and realism. Genres include florals, wildlife, landscapes and Americana. Prefers: impressionism, realism and expressionism.
Terms: Buys outright for 50% of retail price (net 30 days). Retail price set by the artist. Gallery provides promotion; gallery pays shipping. Prefers artwork unframed.
Submissions: Send query letter with brochure and photographs. Write for appointment to show portfolio of photographs. Responds only if interested within 3 weeks. Files all material. Finds artists through visiting art fairs and recommendations from customers.

Kansas

N PHOENIX GALLERY TOPEKA, 2900-F Oakley Dr., Topeka KS 66614. (913)272-3999. E-mail: Phnx@aol.com. Owner: Kyle Garcia. Retail gallery. Estab. 1990. Represents 60 emerging, mid-career and established artists/year. Exhibited artists include Dave Archer, Louis Copt, Nagel, Phil Starke, Robert Berkeley Green and Raymond Eastwood. Sponsors 6 shows/year. Average display time 6 weeks-3 months. Open all year, 7 days/week. Located downtown; 2,000 sq. ft. 100% of space for special exhibitions; 100% of space for gallery artists. Clientele: upscale. 75% private collectors, 25% corporate collectors. Overall price range: $500-20,000.
Media: Considers all media and engravings, lithographs, woodcuts, mezzotints, serigraphs, linocuts, etchings and collage. Most frequently exhibits oil, watercolor, ceramic and artglass.
Style: Exhibits expressionism and impressionism, all genres. Prefers regional, abstract and 3-D type ceramic; national glass artists. "We find there is increased interest in original work and regional themes."
Terms: Terms negotiable. Retail price set by the gallery and the artist. Prefers artwork framed.
Submissions: Call for appointment to show portfolio of originals, photographs and slides.
Tips: "We are scouting [for artists] constantly."

◼ STRECKER-NELSON GALLERY, 406.5 Poyntz Ave., Manhattan KS 66502. (785)537-2099. E-mail: gallery@kansas.net. Website: www.strecker-nelsongallery.com. **President:** Jay Nelson. Retail gallery. Estab. 1979. Represents 40 emerging and mid-career artists. Exhibited artists include Dean Mitchell, M.L. Moseman, Anthony Benton Gude and Judy Love. Sponsors 6 shows/year. Average display time 6 weeks. Open all year; Monday-Saturday, 10-6. Located downtown; 3,000 sq. ft.; upstairs in historic building. 50% of space for special exhibitions; 50% of space for gallery artists. Clientele: university and business. 95% private collectors, 5% corporate collectors. Overall price range: $300-20,000; most work sold at $300-1,000.
Media: Considers all media and all types of prints (no offset reproductions). Most frequently exhibits watercolor, intaglio and oil.
Style: All styles. Genres include landscapes, still life, portraits and figurative work. Prefers landscapes, figurative and architectural subjects.
Terms: Accepts work on consignment (50% commission). Retail price set by artist. Sometimes offers payment by installment. Gallery provides promotion; artist pays for shipping costs. Prefers artwork framed.
Submissions: Send query letter with résumé, slides, reviews, bio and SASE. Write for appointment to show portfolio of slides. Responds in 1-2 weeks.
Tips: "I look for uniqueness of vision, quality of craftsmanship and realistic pricing. Our gallery specializes in Midwest regionalists with a realistic or naturalistic approach."

N TOPEKA & SHAWNEE COUNTY PUBLIC LIBRARY GALLERY/ALICE C. SABATINI GALLERY, 1515 W. Tenth, Topeka KS 66604-1374. (785)580-4516. Fax: (785)580-4496. E-mail: lpeters @tscpl.lib.ks.us. Website: www.tscpl.org. **Gallery Director:** Larry Peters. Nonprofit gallery. Estab. 1976. Exhibits emerging, mid-career and established artists. Sponsors 8-9 shows/year. Average display time 1 month. Open all year; Monday-Saturday, 9-6; Sunday, 12-9. Located 1 mile west of downtown; 2,500 sq. ft.; security, track lighting, plex top cases; recently added five moveable walls. 100% of space for special exhibitions and permanent collections. Overall price range: $150-5,000.
Media: Considers oil, fiber, acrylic, sculpture, glass, watercolor, mixed media, ceramic, pastel, collage, metal work, woodcuts, wood engravings, linocuts, engravings, mezzotints, etchings, lithographs. Most frequently exhibits ceramic, oil and watercolor.

Style: Exhibits neo-expressionism, painterly abstraction, postmodern works and realism. Prefers painterly abstraction, realism and neo-expressionism.

Terms: Artwork accepted or not accepted after presentation of portfolio/résumé. Retail price set by artist. Gallery provides insurance; artist pays for shipping costs. Prefers artwork framed.

Submissions: Usually accepts only artists from KS, MO, NE, IA, CO, OK. Send query letter with résumé and 12-24 slides. Call or write for appointment to show portfolio of slides. Responds in 1-2 months. Files résumé. Finds artists through visiting exhibitions, word of mouth and submissions.

Tips: "Find out what each gallery requires from you and what their schedule for reviewing artists' work is. Do not go in unannounced. Have good quality slides—if slides are bad they probably will not be looked at. Have a dozen or more to show continuity within a body of work. Your entire body of work should be at least 50-100 pieces. Competition gets heavier each year. Looks for originality."

☑ **EDWIN A. ULRICH MUSEUM OF ART**, Wichita State University, 1845 Fairmount, Wichita KS 67260-0046. (978)689-3664. Fax: (978)689-3898. E-mail: david.butler@wichita.edu. Website: www.ulrich .wichita.edu. **Director:** Dr. David Butler. Museum. Estab. 1974. Represents mid-career and established artists. Sponsors 7 shows/year. Average display time 6-8 weeks. Open Monday-Friday, 9-5; Saturday and Sunday, 12-5; closed major holidays. Located on campus; 6,732 sq. ft.; high ceilings, neutral space. 75% of space for special exhibitions.

Media: Considers sculpture, installation, neon-light, new media.

Style: Exhibits conceptualism and new media.

Submissions: Send query letter with résumé, slides and SASE. Write for appointment to show portfolio of slides, transparencies and statement of intent. Responds only if interested within 6 weeks. Finds artists through word of mouth and art publications.

N WICHITA ART MUSEUM STORE SALES GALLERY, 619 Stackman Dr., Wichita KS 67203. (316)268-4975. Fax: (316)268-4980. **Manager/Buyer:** Kevin Bishop. Nonprofit retail and consignment gallery. Estab. 1963. Exhibits 150 emerging and established artists. Average display time is 6 months. 1,228 sq. ft. Accepts only artists from expanded regional areas. Clientele: tourists, residents of city, students. 75% private collectors, 25% corporate clients. Overall price range: $25-2,500; most work sold at $25-800.

Media: Considers sculpture, ceramic, fiber, glass and original handpulled prints.

Terms: Accepts work on consignment (40% commission). Retail price set by artist. Exclusive area representation not required. Gallery provides insurance and contract.

Submissions: Send query letter with résumé. Resumes and brochures are filed.

Tips: "We are constantly looking for and exhibiting new artists. We have a few artists who have been with us for many years, but our goal is to exhibit the emerging artist."

Kentucky

N CENTRAL BANK GALLERY, 300 W. Vine St., Lexington KY 40507. (606)253-6135. Fax: (606)253-6069. **Curator:** John Irvin. Nonprofit gallery. Estab. 1985. Interested in seeing the work of emerging artists. Represented more than 1,400 artists in the past 17 years. Exhibited artists include Helen Price Stacy and Catherine Wells. Sponsors 12 shows/year. Average display time 3 weeks. Open all year; Monday-Friday, 9-4:30. Located downtown. 100% of space for special exhibitions. Clientele: local community. 100% private collectors. Overall price range: $100-5,000; most work sold at $350-500.

• Central Bank Gallery considers Kentucky artists only.

Media: Considers all media. Most frequently exhibits oils, watercolor, sculpture.

Style: Exhibits all styles. "Please, no nudes."

Terms: Retail price set by the artist "100% of proceeds go to artist." Gallery provides insurance and promotion; artist pays for shipping.

Submissions: Call or write for appointment.

Tips: "Don't be shy, call me. We pay 100% of the costs involved once the art is delivered."

KENTUCKY ART & CRAFT GALLERY, 609 W. Main St., Louisville KY 40202. (502)589-0102. Fax: (502)589-0154. Website: www.kentuckycrafts.org. **Retail Marketing Director:** Chris Wedding. Retail gallery operated by the private nonprofit Kentucky Art & Craft Foundation, Inc. Estab. 1984. Represents more than 400 emerging, mid-career and established artists. Exhibiting artists include Arturo Sandoval, Stephen Powell and Rude Osolnik. Sponsors 10-12 shows/year. Open all year. Located downtown in the historic Main Street district; 5,000 sq. ft.; a Kentucky tourist attraction located in a 120-year-old cast iron building. 33% of space for special exhibitions. Clientele: tourists, the art-viewing public and schoolchildren. 10% private collectors, 5% corporate clients. Overall price range: $3-20,000; most work sold at $25-500.

Media: Considers mixed media, metal, glass, clay, fiber, wood and stone.

Terms: Accepts work on consignment (50% commission). Retail price set by artist. Gallery provides insurance, promotion, contract and shipping costs from gallery.

Submissions: Contact gallery for jury application and guidelines first; then send completed application, résumé and 5 samples. Responds in 3 weeks. "If accepted, we file résumé, slides, signed contract, promotional materials and PR about the artist."

Tips: "Our artists used to be exclusively from the state of Kentucky, however, we now have an American craft section and can accept work from outside Kentucky."

MAIN AND THIRD FLOOR GALLERIES, Northern Kentucky University, Nunn Dr., Highland Heights KY 41099. (859)572-5148. Fax: (859)572-6501. Gallery Director of Exhibitions and Collections: David Knight. University galleries. Program established 1975. Main gallery and third floor gallery. Represents emerging, mid-career and established artists. Sponsors 10 shows/year. Average display time 1 month. Open Monday-Friday, 9-9 or by appointment; closed major holidays and between Christmas and New Year's. Located in Highland Heights, KY, 8 miles from downtown Cincinnati; 3,000 sq. ft.; two galleries—one small and one large space with movable walls. 100% of space for special exhibitions. 90% private collectors, 10% corporate collectors. Overall price range; $25-50,000; most work sold at $25-2,000.

Media: Considers all media and all types of prints. Most frequently exhibits painting, printmaking and photography.

Style: Exhibits all styles, all genres.

Terms: Proposals are accepted for exhibition. Retail price set by the artist. Gallery provides insurance, promotion and contract; shipping costs are shared. Prefers artwork framed "but we are flexible." Commission rate is 20%.

Submissions: Send query letter with résumé, slides, bio, photographs, SASE and reviews. Write for appointment to show portfolio of originals, photographs and slides. Submissions are accepted in December for following academic school year. Files résumés and bios. Finds artists through agents, visiting exhibitions, word of mouth, art publications, sourcebooks and submissions.

✓ **YEISER ART CENTER INC.**, 200 Broadway, Paducah KY 42001-0732. (270)442-2453. E-mail: yacenter@apex.net. Website: www.yeiser.org. **Executive Director:** Bob Durden. Nonprofit gallery. Estab. 1957. Exhibits emerging, mid-career and established artists. 450 members. Sponsors 8-10 shows/year. Average display time 6-8 weeks. Open all year. Located downtown; 1,800 sq. ft.; "in historic building that was farmer's market." 90% of space for special exhibitions. Clientele: professionals and collectors. 90% private collectors. Overall price range: $200-8,000; most artwork sold at $200-1,000.

Media: Considers all media. Prints considered include original handpulled prints, woodcuts, wood engravings, linocuts, mezzotints, etchings, lithographs and serigraphs.

Style: Exhibits all styles and genres.

Terms: Accepts work on consignment (35% commission). Retail price set by artist. Gallery provides insurance and promotion; shipping costs are shared. Prefers artwork framed.

Submissions: Send résumé, slides, bio, SASE and reviews. Responds in 3 months.

Tips: "Do not call. Give complete information about the work: media, size, date, title, price. Have good-quality slides of work, indicate availability and include artist statement. Presentation of material is important."

Louisiana

N ◼ **BATON ROUGE GALLERY, INC.**, 1442 City Park Ave., Baton Rouge LA 70808-1037. (225)383-1470. **Director:** Kathleen Pheney. Cooperative gallery. Estab. 1966. Exhibits the work of 50 professional artists. 300 members. Sponsors 12 shows/year. Average display time 1 month. Open all year. Located in the City Park Pavilion; 1,300 sq. ft. Overall price range: $100-10,000; most work sold at $200-600.

● Every Sunday at 4 p.m. the gallery hosts a spoken word series featuring literary readings of all genres. We also present special performances including dance, theater and music.

Media: Considers oil, acrylic, watercolor, pastel, video, drawing, mixed media, collage, paper, sculpture, ceramic, fiber, glass, installation, photography, woodcuts, engravings, lithographs, pochoir, wood engravings, mezzotints, serigraphs, linocuts and etchings. Most frequently exhibits painting, sculpture and glass.

Style: Exhibits all styles and genres.

Terms: Co-op membership fee plus donation of time. Gallery takes 40% commission. Retail price set by artist. Artist pays for shipping. Artwork must be framed.

Submissions: Membership and guest exhibitions are selected by screening committee. Send query letter for application. Call for appointment to show portfolio of slides.
Tips: "The screening committee screens applicants in March and October each year. Call for application to be submitted with portfolio and résumé."

N BRUNNER GALLERY, 215 N. Columbia, Covington LA 70433. (985)893-0444. Fax: (985)893-0070. E-mail: BrunnerGal@aol.com. Website: www.brunnergallery.com. **Director:** Robin Hamaker. For-profit gallery. Estab. 1997. Approached by 400 artists/year. Exhibits 45 emerging, mid-career and established artists. Sponsors 10-12 exhibits/year. Average display time 1 month. Open all year; Tuesday-Saturday, 10-5; weekends, 10-5. Closed major holidays. Located 45 minutes from metropolitan New Orleans, one hour from capital of Baton Rouge and Gulf Coast; 2,500 sq. ft. Building designed by Rick Brunner, artist and sculptor and Susan Brunner, designer. Clients include local community, tourists, upscale and professionals. 20% of sales are to corporate collectors. Overall price range: $200-10,000; most work sold at $1,500-3,000.
Media: Considers all media, etchings and monoprints.
Style: Considers all styles and genres. Most frequently exhibits abstraction, expressionism and conceptualism.
Terms: Artwork is accepted on consignment and there is a 50% commission or bought outright for 90-100% of retail price; net 30 days. Retail price set by the gallery and the artist. Gallery provides insurance, promotion and contract. Accepted work should be framed. Requires exclusive representation locally.
Submissions: Photographs and slides. Mail portfolio for review. Send query letter with artist's statement, bio, brochure, business card, photocopies, photographs, résumé, reviews, SASE and slides. Returns material with SASE. Responds in 4 months as committee meets. Keeps on file possible future work. Finds artists through word of mouth, submissions, portfolio reviews, art exhibits, art fairs and referrals by other artists..

CONTEMPORARY ARTS CENTER, 900 Camp, New Orleans LA 70130. (504)528-3805. Fax: (504)528-3828. Website: cacno.org. **Curator of Visual Arts:** David S. Rubin. Alternative space, nonprofit gallery. Estab. 1976. Exhibits emerging, mid-career and established artists. Open all year; Tuesday-Sunday, 11-5; weekends 11-5. Closed Mardi Gras, Christmas and New Year's Day. Located in Central Business District of New Orleans; renovated/converted warehouse. Clients include local community, students, tourists and upscale.
Media: Considers all media and all types of prints. Most frequently exhibits painting, sculpture, installation and photography.
Style: Considers all styles. Exhibits anything contemporary.
Terms: Artwork is accepted on loan for curated exhibitions. Retail price set by the artist. CAC provides insurance and promotion. Accepted work should be framed. Does not require exclusive representation locally. The CAC is not a sales venue, but will refer inquiries. CAC receives 20% on items sold as a result of an exhibition.
Submissions: Send query letter with bio, SASE and slides. Responds in 4 months. Files letter and bio—slides when appropriate. Finds artists through word of mouth, submissions, art exhibits, art fairs, referrals by other artists, professional contacts and periodicals.
Tips: "Use only one slide sheet with proper labels (title, date, medium and dimensions)."

☑ HANSON GALLERY, 229 Royal, New Orleans LA 70130-2226. (504)524-8211. Fax: (504)524-8420. E-mail: info@hansongallery-nola.com. Website: www.hansongallery-nola.com. **Director:** Angela King. For profit gallery. Estab. 1977. Represents 22 emerging, mid-career and established artists. Exhibited artists include: Frederick Hart (sculptor) and Leroy Neiman (all mediums). Sponsors 6 exhibits/year. Average display time ongoing to 3 weeks. Open all year; Monday-Saturday, 10-6; Sunday, 11-5. Closed 3 days for Mardi Gras. Clients include local community, tourists and upscale. Overall price range: $650-100,000; most work sold at $4,000.
Media: Considers acrylic, drawing, oil, pastel, sculpture and watercolor. Most frequently exhibits oil, pastel and acrylic. Considers etchings, lithographs and serigraphs.
Style: Exhibits impressionism, neo-expressionism and surrealism. Considers all styles. Genres include figurative work and landscapes.
Terms: Retail price set by the gallery and the artist. Gallery provides insurance. Requires exclusive representation locally.
Submissions: Write to arrange a personal interview to show portfolio of photographs and slides. Mail portfolio for review. Send query letter with artist's statement, bio, brochure, photographs, résumé, reviews, SASE and slides. Responds in 6 weeks. Finds artists through word of mouth, submissions, art exhibits and art fairs.
Tips: "Archival-quality materials play a major role in selling fine art to collectors."

STELLA JONES GALLERY, 201 St. Charles Ave., New Orleans LA 70170. (504)568-9050. Fax: (504)568-0840.E-mail: jones6941@aol.com. Website: www.stellajones.com. **Contact:** Stella Jones. For profit gallery. Estab. 1996. Approached by 40 artists/year. Represents 121 emerging, mid-career and established artists. Exhibited artists include: Elizabeth Catlett (prints and sculpture), Richard Mayhew (paintings). Sponsors 7 exhibits/year. Average display time 6-8 weeks. Open all year; Monday-Friday, 11-6; Saturday, 12-5. Located in downtown New Orleans, one block from French Quarter. Clients include local community, tourists and upscale. 10% of sales are to corporate collectors. Overall price range: $500-150,000; most work sold at $1,000-5,000.
Media: Considers all media. Most frequently exhibits oil and acrylic. Considers all types of prints except posters.
Style: Considers all styles. Most frequently exhibits postmodernism and geometric abstraction. Exhibits all genres.
Terms: Artwork is accepted on consignment and there is a 50% commission. Retail price set by the artist. Gallery provides insurance, promotion and contract. Accepted work should be framed. Requires exclusive representation locally.
Submissions: To show portfolio of photographs, slides and transparencies, mail for review. Send query letter with artist's statement, bio, brochure, business card, photocopies, photographs, résumé, reviews, SASE and slides. Returns material with SASE. Responds in 1 month. Files all. Finds artists through word of mouth, submissions, portfolio reviews, art exhibits, and referrals by other artists.
Tips: "Send organized, good visuals."

N LE MIEUX GALLERIES, 332 Julia St., New Orleans LA 70130. (504)522-5988. Fax: (504)522-5682. **President:** Denise Berthiaume. Retail gallery and art consultancy. Estab. 1983. Represents 30 mid-career artists. Exhibited artists include Shirley Rabe Masinter and Kathleen Sidwell. Sponsors 7 shows/year. Average display time 6 months. Open all year. Located in the warehouse district/downtown; 1,400 sq. ft. 20-75% of space for special exhibitions. Clientele: 75% private collectors; 25% corporate clients.
Media: Considers oil, acrylic, watercolor, pastel, drawings, mixed media, works on paper, sculpture, ceramic, glass and egg tempera. Most frequently exhibits oil, watercolor and drawing.
Style: Exhibits impressionism, neo-expressionism, realism and hard-edge geometric abstraction. Genres include landscapes, florals, wildlife and figurative work. Prefers landscapes, florals and paintings of birds.
Terms: Accepts work on consignment (50% commission). Retail price set by artist. Exclusive area representation required. Gallery provides promotion and contract; artist pays for shipping.
Submissions: Accepts only artists from the Southeast. Send query letter with SASE, bio, brochure, résumé, slides and photographs. Write for appointment to show portfolio of originals. Responds in 3 weeks. All material is returned if not accepted or under consideration.
Tips: "Send information before calling. Give me the time and space I need to view your work and make a decision; you cannot sell me on liking or accepting it; that I decide on my own."

N MASUR MUSEUM OF ART, 1400 S. Grand St., Monroe LA 71202. (318)329-2237. Fax: (318)329-2847. E-mail: masur@ci.monroe.la.us. **Director:** Sue Prudhomme. Museum. Estab. 1963. Approached by 500 artists/year. Exhibits 150 emerging, mid-career and established artists. Exhibited artists include: Lin Emery, kinetic aluminum sculpture. Sponsors 8 exhibits/year. Average display time 2 months. Open Tuesday-Sunday, 9-5. Closed between exhibitions. Located in historic home. Approximately 400 running feet, 3,000 sq. ft. Clients include local community. 50% of sales are to corporate collectors. Overall price range: $100-12,000; most work sold at $300.
Media: Considers all media and all types of prints. Most frequently exhibits mixed media, acrylic and drawing.
Style: Considers all styles and genres. Most frequently exhibits conceptualism, painterly abstraction, expressionism.
Terms: Artwork is accepted on consignment and there is a 20% commission. Retail price set by the artist. Gallery provides insurance and promotion. Accepted work should be framed. Does not require exclusive representation locally.
Submissions: Send query letter with artist's statement, bio, résumé, reviews, SASE and slides. Returns material with SASE. Responds in 6 months. Finds artists through word of mouth, submissions, art exhibits and referrals by other artists.

N NEW ORLEANS ARTWORKS GALLERY/GLASSBLOWING AND PRINTMAKING STUDIO, 727 Magazine St., New Orleans. (504)529-7277. Fax: (504)539-5417. Website: www.glasswo@wave.tcs.tulane.edu. **Contact:** Geriod Baronne, president. Alternative space, art consultancy and nonprofit gallery. Estab. 1990. Approached by 250 artists/year. Represents 275 established artists. Exhibited artists include: Miriam Martin (prints) and Gerald Haessig (silver). Sponsors 12 exhibits/year. Average display time 3 weeks, but shows overlap. Open all year; Monday-Friday, 10:30-6; Saturday, 10-5. Closed holidays:

Christmas, New Year's Day and Mardis Gras. Located in the arts district, 3 blocks from the National D-Day Museum, walking distance from the French Quarter. Clients include upscale. 75% of sales are to corporate collectors. Overall price range: $25-30,000; most work sold at $300.

Media: Considers ceramics, collage, drawing, glass, installation, oil, paper, pastel, pen & ink, sculpture, watercolor, engravings, etchings, lithographs, mezzotints, serigraphs, woodcuts, woodprints made from glass plates, and reverse glass painting. Genres include figurative work, florals, landscapes and wildlife.

Terms: Artwork is accepted on consignment and there is a 40% commission. Retail price set by the artist after discussing it with the gallery director. Gallery provides insurance, promotion and contract. Accepted work should be framed, mounted and matted. Requires exclusive representation locally.

Submissions: Call or write to arrange a personal interview to show portfolio of photographs. Returns material with SASE. Responds in 2 weeks. Finds artists through submissions, portfolio reviews and art exhibits.

Tips: Submit photos and artist bid in SASE with letter where they can be reached.

N TURNER ART CENTER GALLERY, 2911 Centenary Blvd., Shreveport LA 71104. Fax: (318)869-5184. Website: www.centenary.edu/departme/art. **Contact:** Dr. Lisa Nicoletti, gallery director. Nonprofit gallery. Estab. 1990. Approached by 10 artists/year. Exhibits emerging and mid-career artists. Exhibited artists include: Shimon & Lindemann (photographers) and Daniel Piersol (painting). Sponsors 5 exhibits/year. Average display time 1 month. Open all year; Monday-Friday, 10-4. Closed May-August, holiday breaks. Located on a private college campus in an urban area of about 300,000. The gallery is small, but reputable. Clients include local community and students. Overall price range: $50-1,500; most work sold at $200.

Media: Considers all media and all types of prints. Most frequently exhibits photography, watercolor and acrylic.

Style: Considers all styles and genres. Most frequently exhibits Impressionism, postmodernism and expressionism,

Terms: Artwork is accepted on consignment and there is a 25% commission. Retail price set by the artist. Gallery provides promotion. Accepted work should be framed. Does not require exclusive representation locally.

Submissions: Mail portfolio for review. Send query letter with slides. Returns material with SASE. Finds artists through word of mouth and submissions.

Maine

BIRDSNEST GALLERY, 12 Mt. Desert St., Bar Harbor ME 04609. (207)288-4054. E-mail: fineart@birdsnestgallery.com. Website: www.birdsnestgallery.com. Owner: Barbara Entzminger. Retail gallery. Estab. 1972. Represents 40 mid-career and established artists/year. Interested in seeing the work of emerging artists. Exhibited artists include Rudolph Colao and Tony Van Hasselt. Sponsors 6-9 shows/year. Average display time 1-6 months. Open all year; May 15-October 30; daily 10-9; Sundays, 12-9. Located downtown, opposite Village Green; 4,800 sq. ft.; good track lighting, 5 rooms. 10% of space for special exhibitions; 90% of space for gallery artists. Clientele: tourists, summer residents, in-state collectors. 80% private collectors, 20% corporate collectors. Overall price range: $100-30,000; most work sold at $250-1,600.

Media: Considers all media except functional items and installations; types of prints include woodcuts, engravings, lithographs, wood engravings, mezzotints, serigraphs, linocuts and etchings. Original prints only, no reproductions. Most frequently exhibits oils, watercolors and serigraphs/etchings.

Style: Exhibits: expressionism, neo-expressionism, painterly abstraction, impressionism, photorealism, realism and imagism from traditional to semi-abstract. Genres include florals, wildlife, landscapes, figurative work and seascapes. Prefers: impressionism and traditional, contemporary realism and semi-abstract work.

Terms: Accepts work on consignment (50% commission). Retail price set by the artist. Gallery provides limited insurance and promotion; artist pays shipping. Gallery prefers artwork to be delivered and picked up; does not ship from gallery. Prefers artwork framed, matted and shrinkwrapped.

Submissions: Accepts only artists who paint in the Northeast. Prefers only oils and watercolor. Send query letter with résumé, 12 slides or photographs, bio, brochure, SASE and reviews. Call or write for appointment to show portfolio of photographs, slides. Final decision for acceptance of artwork is from the original. Responds only if interested with 1 month. Files photographs and bio. Finds artists through word of mouth, referrals by other artists and submissions.

Tips: "Test yourself by exhibiting in outdoor art shows. Are you winning awards? Are you winning awards and selling well? Enter all nationwide competitions, if you feel the subject matter is right for you. You will learn from it, whether you win or not. You should have 6 to 12 paintings before approaching galleries."

N JAMESON GALLERY & FRAME, 305 Commercial St., Portland ME 04101. (207)772-5522. Fax: (207)774-7648. E-mail: jamesib@maine.rr.com. Gallery Director: Martha Gilmartin. Retail gallery, custom framing, restoration, appraisals, consultation. Estab. 1992. Represents 20 emerging, mid-career and established artists/year. Exhibited artists include Ronald Frontin, Jon Marshall and W. Charles Nowell. Sponsors 6 shows/year. Average display time 6 weeks. Open all year; Monday-Saturday, 10-6; Holiday season Monday-Sunday, 10-6. Located on the waterfront in the heart of the shopping district; 1,800 sq. ft. 50% of space for special exhibitions; 50% of space for gallery artists. Clientele: local community, tourists, upscale. 80% private collectors, 20% corporate collectors. Overall price range: $150-25,000; most work sold at $500-3,000.
Media: Considers all media including woodcuts, engravings, wood engravings, mezzotints, linocuts and lithographs and serigraphs only if gallery carries original work. Most frequently exhibits oil, watercolor and fine woodworking.
Style: Exhibits: impressionism, photorealism and realism. Genres include florals, landscapes and still life. Prefers: still lifes and landscapes (Dutch Masters influence) and florals (Impressionistic).
Terms: Depends on each contract. Retail price set by the gallery. Gallery provides insurance, promotion and contract; artist pays for shipping costs. Prefers artwork unframed. Artist may buy framing contract with gallery.
Submissions: Send query letter with résumé, slides, bio, photographs, statement about why they want to show at the gallery and SASE. Gallery will contact for appointment to show portfolio of photographs and sample work. Returns only with SASE. Files name, address and bio. Finds artists through exhibits and artists approaching gallery.

N LIBRARY ART STUDIO, 1467 Rt. 32 at Munro Broo, Round Pond ME 04564. (207)529-4210.
Contact: Sally DeLorme Pedrick, owner/director. Art consultancy and nonprofit gallery. Estab. 1989. Exhibits established artists. Number of exhibits varies each year. Average display time 6 weeks. Open year round by appointment or chance. Located in a small coastal village (Round Pound) on the Pemaquid Peninsula, midcoast Maine. Clients include local community, tourists and upscale. Overall price range: $50-7,500; most work sold at $350.
Media: Considers all media. Most frequently exhibits oil, woodcuts, and mixed media with glass.
Style: Considers all styles. Most frequently exhibits painterly abstraction, expressionism, conceptualism. "Most art is associated with literature, thus *The Library Art Studio*."
Terms: Artwork is accepted on consignment and there is a 30% commission. Retail price set by the artist. Gallery provides promotion. Accepted work should be framed. Does not Require exclusive representation locally.
Submissions: Send query letter with SASE and slides. Returns material with SASE. Responds in 1 month.

ROUND TOP CENTER FOR THE ARTS GALLERY, Business Rt. 1, P.O. Box 1316, Damariscotta ME 04543. (207)563-1507. Fax: (202)563-6485. E-mail: RTCA@Lincoln.midcoast.com. Website: http://Lincoln.midcoast.com@RTCA/. Artistic Director: Nancy Freeman. Nonprofit gallery. Estab. 1988. Represents emerging, mid-career and established artists. 1,200 members (not all artists). Exhibited artists include Lois Dodd and Marlene Gerberick. Sponsors 12-14 shows/year. Average display time 1 month. Open all year; Monday-Saturday, 11-4; Sunday, 1-4. Located on a former dairy farm with beautiful buildings and views of salt water tidal river. Exhibition space is on 2 floors 30×60, several smaller gallery areas, and a huge barn. 50% of space for special exhibitions; 25% of space for gallery artists. "Sophisticated year-round community and larger summer population." 25% private collectors. Overall price range: $75-10,000; most work sold at $300-1,000.
Media: Considers all media and all types of prints. Most frequently exhibits watercolor, fiber arts (quilts) and mixed media.
Style: Exhibits all styles. Genres include landscapes, florals, Americana and figurative work.
Terms: Accepts work on consignment (30% commission). Retail price set by the artist. Gallery provides insurance, promotion and contract; shipping costs are shared. Prefers artwork simply framed.
Submissions: Send query letter with résumé, slides or photographs, bio and reviews. Write for appointment to show portfolio. Responds only if interested within 2 months. Files everything but slides, which are returned. Finds artists through visiting exhibitions, word of mouth and artists' submissions.

N UNIVERSITY OF MAINE MUSEUM OF ART, 109 Carnegie Hall, Orono ME 04469. (207)581-3255. Fax: (207)581-3083. E-mail: art@maine.edu. Website: umma.umecah.maine.edu. The Museum of Art hosts an annual calendar of exhibitions and programs featuring contemporary artists and ideas in a variety of traditional and non-traditional media, as well as exhibitions organized from the permanent collection. The permanent collection has grown to over 6,000 works of art. Included in the collection are works by artists such as Richard Estes, Ralph Blakelock, Georges Braque, Mary Cassatt, Honore Daumier, George Inness, Diego Rivera, Pablo Picasso and Giovanni Battista Piranesi. In addition, each year the

Museum organizes The Vincent Hartgen Traveling Exhibition Program: Museums by Mail, a statewide effort that circulates more than 50 exhibitions, drawn from the permanent collection. This program reaches hundreds of institutions such as schools, libraries, town halls and hospitals throughout the state.
Media: Considers all media and all types of prints.
Style: Exhibits all styles and genres.
Terms: Gallery provides insurance and promotion; shipping costs are shared. Prefers artwork framed.
Submissions: Send query letter with résumé, slides, bio and reviews. Write for appointment to show portfolio of originals and slides. Responds in 1 month. Files bio, slides, if requested, and résumé.

Maryland

ARTEMIS, INC., 4715 Crescent St., Bethesda MD 20816. (301)229-2058. Fax: (301)229-2186. E-mail: sjtropper@aol.com. **Owner:** Sandra Tropper. Retail and wholesale dealership and art consultancy. Represents more than 100 emerging and mid-career artists. Does not sponsor specific shows. Clientele: 40% private collectors, 60% corporate clients. Overall price range: $100-10,000; most artwork sold at $1,000-3,000.
Media: Considers oil, acrylic, watercolor, mixed media, collage, works on paper, sculpture, ceramic, craft, fiber, glass, installations, woodcuts, engravings, mezzotints, etchings, lithographs, pochoir, serigraphs and offset reproductions. Most frequently exhibits prints, contemporary canvases and paper/collage.
Style: Exhibits impressionism, expressionism, realism, minimalism, color field, painterly abstraction, conceptualism and imagism. Genres include landscapes, florals and figurative work. "My goal is to bring together clients (buyers) with artwork they appreciate and can afford. For this reason I am interested in working with many, many artists." Interested in seeing works with a "finished" quality.
Terms: Accepts work on consignment (50% commission). Retail price set by dealer and artist. Exclusive area representation not required. Gallery provides insurance and contract; shipping costs are shared. Prefers unframed artwork.
Submissions: Send query letter with résumé, slides, photographs and SASE. Write to schedule an appointment to show a portfolio, which should include originals, slides, transparencies and photographs. Indicate net and retail prices. Responds only if interested within 1 month. Files slides, photos, résumés and promo material. All material is returned if not accepted or under consideration.
Tips: "Many artists have overestimated the value of their work. Look at your competition's prices."

N GOMEZ GALLERY, 3600 Clipper Mill Rd., Suite 100, Baltimore MD 21211. (410)662-9510. Fax: (410)662-9496. E-mail: walter@gomez.com. Website: www.gomezgallery.com. **Director:** Walter Gomez. Contemporary art and photography gallery. Estab. 1988. Sponsors 8 shows/year. Average display time 4-5 weeks. Open all year. Located in Baltimore City; 7,000 sq. ft. 80% private collectors, 20% corporate collectors. Overall price range: $500-50,000.
Media: Considers painting, sculpture and photography in all media.
Style: Interested in all genres. Prefers figurative, abstract and landscapes with an experimental edge.
Terms: Accepts artwork on consignment. Retail price set by the gallery and the artist. Gallery provides insurance and promotion. Artist pays for shipping.
Submissions: Send query letter with résumé, slides, bio, brochure, SASE and reviews.
Tips: "Find out a little bit about this gallery first; if work seems comparable, send a slide package."

N INTERCULTURAL MUSEUM ART GALLERY (IMAG), 128-130 W. North Ave., Baltimore MD 21201. (410)347-3288. Fax: (410)347-3298. E--mail: museum@IMAG128.org. Website: www.IMAG128.org. **Contact:** Jimmie Jokulo Cooper, director. Alternative space, museum, museum retail shop, nonprofit and rental gallery. Estab. 1997. Approached by 100 artists/year. Represents 75 emerging, mid-career and established artists. Exhibited artists include: Jokulo Cooper (mixed media), Pat Underwood (mixed media). Average display time 25-45 days. Open all year; Monday-Sunday, 11-5.
Media: Considers all media; types of prints include etchings, linocuts, serigraphs and woodcuts.
Style: Considers all styles and genres. Most frequently exhibits imagism, expressionism and impressionism.
Terms: Artwork is accepted on consignment and there is a 30% commission. Retail price set by the gallery. Gallery provides insurance, promotion and contract. Accepted work should be framed, mounted and matted.
Submissions: Call or write to arrange a personal interview to show portfolio of photogrpahs, slides and transparencies. Mail portfolio for review. Send query letter with artist's statement, bio, résumé and slides. Responds in 2 weeks. Files slides, applications, artist's statement and artist's résumé. Finds artists through word of mouth, submissions, art exhibits and referrals by other artists.

MARLBORO GALLERY, 301 Largo Rd., Largo MD 20772. (301)322-0965. **Coordinator:** Tom Berault. Nonprofit gallery. Estab. 1976. Interested in emerging, mid-career and established artists. Sponsors 4 solo and 4 group shows/year. Average display time 1 month. Seasons for exhibition: September-May. 2,100 sq. ft. with 10 ft. ceilings and 25 ft. clear story over 50% of space—track lighting (incandescent) and daylight. Clientele: 100% private collectors. Overall price range: $200-10,000; most work sold at $500-700.
Media: Considers all media. Most frequently exhibits acrylics, oils, photographs, watercolors and sculpture.
Style: Exhibits expressionism, neo-expressionism, realism, photorealism, minimalism, primitivism, painterly abstraction, conceptualism and imagism. Exhibits all genres. "We are open to all serious artists and all media. We will consider all proposals without prejudice."
Terms: Accepts artwork on consignment. Retail price set by artist. Exclusive area representation not required. Gallery provides insurance. Artist pays for shipping. Prefers artwork ready for display.
Submissions: Send query letter with résumé, slides, SASE, photographs, artist's statement and bio. Portfolio review requested if interested in artist's work. Portfolio should include slides and photographs. Responds every 6 months. Files résumé, bio and slides. Finds artists through word of mouth, visiting exhibitions and submissions.
Tips: Impressed by originality. "Indicate if you prefer solo shows or will accept inclusion in group show chosen by gallery."

ROMBRO'S ART GALLERY, 1805 St. Paul St., Baltimore MD 21202. (410)962-0451. Retail gallery, rental gallery. Estab. 1984. Represents 3 emerging, mid-career and established artists/year. May be interested in seeing the work of emerging artists in the future. Exhibited artists include Dwight Whitley and Judy Wolpert. Sponsors 4 shows/year. Average display time 3 months. Open all year; Tuesday-Saturday, 9-5; closed August. Located in downtown Baltimore; 3,500 sq. ft. Clientele: upscale, local community. Overall price range: $350-15,000.
Media: Considers oil, acrylic, watercolor, pastel, pen & ink, drawing, mixed media, collage, paper, sculpture and ceramics. Considers all types of prints. Most frequently exhibits oil, pen & ink, lithographs.
Style: Exhibits expressionism, painterly abstraction, color field, postmodern works, hard-edge geometric abstraction. Genres include florals and figurative work. Prefers florals and figurative.
Terms: Accepts work on consignment (50% commission) or buys outright for 35% of the retail price; net 45 days. Rental fee for space ($650). Retail price set by the gallery and the artist. Gallery provides promotion and contract; artist pays for shipping costs to gallery. Prefers artwork framed.
Submissions: Send query letter with résumé, brochure, slides and artist's statement. Write for appointment to show portfolio of slides. Files slides. Finds artists through visiting exhibitions.

STEVEN SCOTT GALLERY, 515 N. Charles St., Baltimore MD 21201. (410)752-6218. Website: www.stevenscottgallery.com. **Director:** Steven Scott. Retail gallery. Estab. 1988. Represents 15 mid-career and established artists/year. May be interested in seeing the work of emerging artists in the future. Exhibited artists include Hollis Sigler, Gary Bukovnik. Sponsors 6 shows/year. Average display time 2 months. Open all year; Tuesday-Saturday, 12-6. Located downtown; 1,200 sq. ft.; white walls, grey carpet—minimal decor. 80% of space for special exhibitions; 20% of space for gallery artists. 80% private collectors, 20% corporate collectors. Overall price range: $300-15,000; most work sold at $1,000-7,500.
Media: Considers oil, acrylic, watercolor, pastel, pen & ink, drawing, mixed media, collage, paper and photography. Considers all types of prints. Most frequently exhibits oil, prints and drawings.
Style: Exhibits expressionism, neo-expressionism, surrealism, postmodern works, photorealism, realism and imagism. Genres include florals, landscapes and figurative work. Prefers florals, landscapes and figurative.
Terms: Retail price set by the gallery and the artist. Gallery provides insurance, promotion and contract; shipping costs are shared. Prefers artwork unframed.
Submissions: Accepts only artists from US. Send query letter with résumé, brochure, slides, photographs, reviews, bio and SASE. Call for appointment to show portfolio of photographs and slides. Responds in 2 weeks.
Tips: "Don't send slides which are unlike the work we show in the gallery, i.e. abstract or minimal."

VILLA JULIE COLLEGE GALLERY, 1525 Green Spring Valley Rd., Stevenson MD 21153. (410)602-7163. Fax: (410)486-3552. E-mail: dea-dian@mail.vjc.edu. Website: www.vjc.edu. **Contact:** Diane DiSalvo. College/university gallery. Estab. 1997. Approached by many artists/year. Represents numerous emerging, mid-career and established artists. Sponsors 8 exhibits/year. Average display time 6 weeks. Open all year; Monday-Tuesday and Thursday-Friday, 11-5; Wednesday, 11-8; Saturday, 1-4. Located in the Greenspring Valley 5 miles north of downtown Baltimore; beautiful space in renovated academic center. "We do not take commission; if someone is interested in an artwork we send them directly to the artist."

Media: Considers all media and all types of prints except posters. Most frequently exhibits painting, sculpture and photography.

Style: Considers all styles and genres.

Terms: Artwork is accepted on consignment and there is no commission. Retail price set by the artist. Gallery provides insurance. Does not require exclusive representation locally. Accepts only artists from mid-Atlantic, emphasis on Baltimore artists.

Submissions: Write to arrange a personal interview to show portfolio of slides. Send query letter with artist's statement, bio, résumé, reviews, SASE and slides. Returns material with SASE. Responds in 3 months. Files bio, statement, reviews, letter but will return slides. Finds artists through word of mouth, submissions, portfolio reviews, art exhibits, and referrals by other artists.

Tips: "Be clear and concise, and have good slides."

Massachusetts

N BOSTON CORPORATE ART, 27 Drydock Ave., 6th Floor, Boston MA 02210. (617)261-1700. Fax: (617)261-1701. Website: www.bostoncorporateart.com. **Gallery Director:** Elizabeth Erdreich. Retail gallery and art consultancy. Estab. 1986. Represents 2,000 (through consultancy) emerging, mid-career and established artists. Sponsors 6 shows/year. Average display time 2 months. Open all year; Monday-Friday 9-5. Located downtown, waterfront, near financial district; 4,000 sq. ft. "We use our gallery space in conjunction with our offices—for art consulting. Our gallery is more of a display area than a traditional gallery." Clientele: large corporations and small businesses. 5% private collectors; 95% corporate collectors. Overall price range: $1,000-35,000; most work sold at $4,000-20,000.

Media: Considers all media and all types of prints. Most frequently exhibits oil/acrylic on canvas, watercolor, pastel, sculpture and mixed media works.

Style: Exhibits all styles and genres.

Terms: Accepts work on consignment (50% commission). Retail price set by artist. Gallery provides insurance; shipping costs are shared. Prefers artwork unframed.

Submissions: Send query letter with résumé, slides, bio, SASE, price list and reviews. Responds in 6-8 weeks. Files slides, bio, résumé, price list. Finds artists through word of mouth and referrals.

Tips: "Please fill out a separate price list that includes price per piece on slides. Mark all slides with name, title, medium, size. When forwarding information, please be sure it's complete—it's impossible to review without complete info."

N BROMFIELD ART GALLERY, 11 Thayer St., Boston MA 02118. (617)451-3605. E-mail: bromfield artgallery@earthlink.net. Website: www.bromfieldartgallery.com. **Contact:** Laurie Alpert, director of exhibitions. Cooperative gallery. Estab. 1974. Represents 20 emerging and mid-career artists. Exhibited artists include Florence Yoshiko Montgomery, Adam Sherman, George Hancin and Tim Nichols. Sponsors 25 shows/year. Average display time 1 month. Open all year; Wednesday-Saturday 12-5. Located in South End. 50% of space for special exhibitions; 50% of space for gallery artists. Clientele: 70% private collectors, 30% corporate collectors. Overall price range: $300-6,000; most work sold at $300-2,000.

Media: Considers all media and original handpulled prints. Most frequently exhibits paintings, prints, sculpture.

Style: Exhibits all styles and genres.

Terms: Co-op membership fee plus donation of time (gallery charges 40% commission for members, 50% for visiting artists). Retail price set by artist. Offers customer discounts and payment by installments. Gallery provides promotion and contract; artist pays for shipping costs.

Submissions: Send query letter with résumé, slides and SASE. Write for appointment to show portfolio of originals. Responds in 1 month. Files all info on members and visiting artists. Finds artists through word of mouth, various art publications and sourcebooks, submissions/self-promotions and referrals.

✓ DEPOT SQUARE GALLERY, 1837 Massachusetts Ave., Lexington MA 02420. (781)863-1597. E-mail: depotsquaregallery@aol.com. Website: www.depotsquaregallery.com. **Treasurer:** Natalie Warshawer. Cooperative gallery. Estab. 1981. Represents emerging, mid-career and established artists. 25 members. Exhibited artists include Gracia Dayton, Natalie Warshawer, Carolyn Latanision, Dora Hsiung and Joan Carcia. Sponsors 10 shows/year. Average display time 1 month. Open all year; Tuesday-Saturday, 10-5:30; open Sunday, 12-4, (September-June only). Located downtown; 2,000 sq. ft.; 2 floors—street level and downstairs. 100% of space for gallery artists. 10% private collectors, 10% corporate collectors. Overall price range: $100-3,000; most work sold at $100-500.

Media: Considers oil, acrylic, watercolor, pastel, pen & ink, drawing, mixed media, collage, paper, sculpture, ceramics, fiber, glass, woodcuts, engravings, wood engravings, mezzotints, serigraphs, linocuts and etchings. Most frequently exhibits watercolor, oil and prints.

Style: Exhibits all styles, all genres. Prefers realism, impressionism (depends on makeup of current membership).

Terms: Co-op membership fee plus donation of time (40% commission). Retail price set by the artist. Prefers artwork framed. Do have print bins for works on paper.

Submissions: Accepts only local artists who must attend meetings, help hang shows and work in the gallery. Send query letter with résumé, slides, bio, SASE and reviews. Call for information. Responds in 6 weeks. Files bio and one slide—"if we want to consider artist for future membership." Finds artists through advertising for new members and referrals.

Tips: "The work needs to show a current direction with potential, and it must be professionally presented."

N: GALLERY NAGA, 67 Newbury St., Boston MA 02116. (617)267-9060. E-mail: mail@gallerynaga.com. Website: www.gallerynaga.com. **Director:** Arthur Dion. Retail gallery. Estab. 1977. Represents 30 emerging, mid-career and established artists. Exhibited artists include Robert Ferrandini and George Nick. Sponsors 9 shows/year. Average display time 1 month. Open Tuesday-Saturday 10-5:30. Closed August. Located on "the primary street for Boston galleries; 1,500 sq. ft.; housed in an historic neo-gothic church." Clientele: 90% private collectors, 10% corporate collectors. Overall price range: $500-40,000; most work sold at $2,000-10,000.

Media: Considers oil, acrylic, mixed media, sculpture, photography, studio furniture and monotypes. Most frequently exhibits painting and furniture.

Style: Exhibits expressionism, painterly abstraction, postmodern works and realism. Genres include landscapes, portraits and figurative work. Prefers expressionism, painterly abstraction and realism.

Terms: Accepts work on consignment (50% commission). Retail price set by gallery and artist. Gallery provides insurance and promotion; artist pays for shipping. Prefers artwork framed.

Submissions: "Not seeking submissions of new work at this time."

Tips: "We focus on Boston and New England artists. We exhibit the most significant studio furnituremakers in the country. Become familiar with any gallery to see if your work is appropriate before you make contact."

KAJI ASO STUDIO/GALLERY NATURE AND TEMPTATION, 40 St. Stephen St., Boston MA 02115. (617)247-1719. Fax: (617)247-7564. E-mail: kajiasostudio@rcn.com. **Administrator:** Kate Finnegan. Nonprofit gallery. Estab. 1975. Represents 40-50 emerging, mid-career and established artists. 35-45 members. Exhibited artists include Kaji Aso and Katie Sloss. Sponsors 10 shows/year. Average display time 3 weeks. Open all year by appointment. Located in city's cultural area (near Symphony Hall and Museum of Fine Arts); "intimate and friendly." 30% of space for special exhibitions; 70% of space for gallery artists. Clientele: urban professionals and fellow artists. 80% private collectors, 20% corporate collectors. Overall price range: $150-8,000; most work sold at $150-1,000.

Media: Considers oil, acrylic, watercolor, pastel, pen & ink, drawing, ceramics and etchings. Most frequently exhibits watercolor, oil or acrylic and ceramics.

Style: Exhibits painterly abstraction, impressionism and realism.

Terms: Co-op membership fee plus donation of time (35% commission). Retail price set by the artist. Gallery provides promotion; artist pays shipping costs to and from gallery. Prefers artwork framed.

Submissions: Send query letter with résumé, slides, bio, photographs and SASE. Write for appointment to show portfolio of originals, photographs, slides or transparencies. Does not reply; artist should contact. Files résumé. Finds artists through advertisements in art publications, word of mouth, submissions.

N: KINGSTON GALLERY, 37 Thayer St., Boston MA 02118. (617)423-4113. **Director:** Janet Hansen Kawada. Cooperative gallery. Estab. 1982. Exhibits the work of 12 emerging, mid-career and established artists. Sponsors 11 shows/year. Average display time 1 month. Closed August. Located "in downtown Boston (South End); 1,300 sq. ft.; large, open room with 12 ft. ceiling and smaller center gallery—can accomodate large installation." Overall price range: $100-7,000; most work sold at $600-1,000.

Media: Considers all media. 20% of space for special exhibitions.

Style: Exhibits all styles.

Terms: Co-op membership requires dues plus donation of time. 25% commission charged on sales by members. Retail price set by the artist. Sometimes offers payment by installments. Gallery provides insurance, some promotion and contract. Rental of center gallery by arrangement.

Submissions: Accepts only artists from New England for membership. Artist must fulfill monthly co-op responsibilities. Send query letter with résumé, slides, SASE and "any pertinent information. Slides are reviewed once a month. Gallery will contact artist within 1 month." Does not file material but may ask artist to re-apply in future.

Tips: "Please include thorough, specific information on slides: size, price, etc."

MEAD ART MUSEUM, Amherst College, Amherst MA 01002. (413)542-2335. Fax: (413)542-2117. E-mail: mead@unix.amherst.edu. Website: www.amherst.edu/~mead. **Advertising Manager:** Donna M. Abelli. Museum. Exhibits established artists. Sponsors 4 exhibits/year. Average display time 1 month. Open all year; Tuesday-Sunday, 10-4:30. Visitors include local community, students and tourists. Note: Though Mead exhibits, they do not sell art.
Media: Considers all media and all types of prints.
Style: Considers all styles and genres.
Submissions: Mail portfolio for review. Send query letter with bio, résumé, reviews, SASE and slides. Returns material with SASE. Responds only if interested within 1 month. Files résumé and slides.
Tips: "Keep it organized and concise. Slides and reviews are paramount."

R. MICHELSON GALLERIES, 132 Main St., Northampton MA 01060. (413)586-3964. Also 25 S. Pleasant St., Amherst MA 01002. (413)253-2500. E-mail: rm@rmichelson.com. Website: www.rmichelson. com. **Owner:** R. Michelson. Retail gallery. Estab. 1976. Represents 30 emerging, mid-career and established artists/year. Exhibited artists include Barry Moser and Leonard Baskin. Sponsors 6 shows/year. Average display time 1 month. Open all year; Monday-Saturday, 10-6; Sunday, 12-5. Located downtown; Northampton gallery has 3,500 sq. ft.; Amherst gallery has 1,800 sq. ft. 50% of space for special exhibitions. Clientele: 80% private collectors, 20% corporate collectors. Overall price range: $100-75,000; most artwork sold at $1,000-25,000.
Media: Considers all media and all types of prints. Most frequently exhibits oil, egg tempera, watercolor and lithography.
Style: Exhibits impressionism, realism and photorealism. Genres include florals, portraits, wildlife, landscapes, Americana and figurative work.
Terms: Accepts work on consignment (commission varies). Retail price set by gallery and artist. Customer discounts and payment by installment are available. Gallery provides promotion; shipping costs are shared.
Submissions: Prefers Pioneer Valley artists. Send query letter with résumé, slides, bio, brochure and SASE. Write for appointment to show portfolio. Responds in 3 weeks. Files slides.

N: NIELSEN GALLERY, 179 Newbury St., Boston MA 02116. (617)266-4835. Fax: (617)266-0480. **Owner/Director:** Nina Nielsen. Retail gallery. Estab. 1963. Represents 25 emerging, mid-career and established artists/year. Exhibited artists include Joan Snyder and John Walker. Sponsors 8 shows/year. Average display time 3-5 weeks. Open all year; closed in August. Located downtown; 2,500 sq. ft.; brownstone with 2 floors. 100% of space for gallery artists. 80% private collectors, 20% corporate collectors. Overall price range: $1,000-100,000; most work sold at $5,000-20,000.
Media: Considers contemporary painting, sculptures, prints, drawings and mixed media.
Style: Exhibits all styles.
Terms: Retail price set by the gallery and the artist. Gallery provides insurance and promotion.
Submissions: Send query letter with slides. Responds in 2 months. Finds artists through word of mouth, referrals by other artists, visiting art fairs and exhibitions, submissions.

N: PEPPER GALLERY, 38 Newbury St., Boston MA 02116. (617)236-4497. Fax: (617)236-4497. **Director:** Audrey Pepper. Retail gallery. Estab. 1993. Represents 20 emerging, mid-career and established artists/year. Exhibited artists include Ben Frank Moss, Nancy Friese, Phyllis Berman, Harold Reddicliffe, Marja Liamko, Daphne Cinfar, Damon Lehrer, Michael V. David and Kahn/Selesnick. Sponsors 9 shows/year. Average display time 6 weeks. Open all year; Tuesday-Saturday, 10-5. Located downtown, Back Bay; 700 sq. ft. 80% of space for special exhibitions. Clientele: private collectors, museums, corporate. 70% private collectors, 15% corporate collectors, 15% museum collectors. Overall price range: $600-25,000; most work sold at $1,000-7,000.
Media: Considers oil, watercolor, pastel, drawing, mixed media, glass, woodcuts, engravings, lithographs, mezzotints, etchings and photographs. Most frequently exhibits oil on canvas, lithos/etchings and photographs.
Style: Exhibits contemporary representational paintings, prints, drawings and photographs.
Terms: Accepts work on consignment (50% commission). Retail price set by the gallery and the artist. Gallery provides insurance and contract.

N: MARKETS NEW TO THIS EDITION

Submissions: Send query letter with résumé, slides, bio, SASE and reviews. Call for appointment to show portfolio of originals, photographs, slides and transparencies. Responds in 2 months. Finds artists through exhibitions, word of mouth, open studios and submissions.

N PUCKER GALLERY, INC., 171 Newbury St., Boston MA 02116. (617)267-9473. Fax: (617)424-9759. **Director:** Bernard Pucker. Retail gallery. Estab. 1967. Represents 30 emerging, mid-career and established artists. Exhibited artists include modern masters such as Picasso, Chagall, Braque, and Samuel Bak and Brother Thomas. Sponsors 10 shows/year. Average display time 4-5 weeks. Open all year. Located in the downtown retail district. 20% of space for special exhibitions. Clientele: private clients from Boston, all over the US and Canada. 90% private collectors, 10% corporate clients. Overall price range: $20-200,000; most artwork sold at $5,000-20,000.
Media: Considers all media. Most frequently exhibits paintings, prints and ceramics.
Style: Exhibits all styles.
Terms: Terms of representation vary by artist, "usually it is consignment." Retail price set by gallery. Gallery provides promotion; artist pays shipping. Prefers artwork unframed.
Submissions: Send query letter with résumé, slides, bio and SASE. Write for appointment to show portfolio of originals and slides. Responds in 3 weeks. Files résumés.

N THE NORMAN ROCKWELL MUSEUM, P.O. Box 308, Stockbridge MA 01262. (413)298-4100. Fax: (413)298-4145. E-mail: spunkett@NRM.org. Website: www.nrm.org. Associate Director for Exhibitions and Programs: Stephanie Plunkett. Museum. Estab. 1969. Exhibits 2-10 emerging, mid-career and established artists. Exhibited artists include: Charles Schulz and Maxfield Parrish. Sponsors 4 exhibits/year. Average display time 3 months. Open all year; Monday-Sunday, 10-5. Closed Thanksgiving, Christmas and New Years. Located in Stockbridge on 36-acre site bordering the Hausatomic River. 11,000 sq. ft. of exhibition space. Clients include local community, students, tourists, upscale and international.
Media: Considers all media. Most frequently exhibits oil, drawing media and acrylic.
Style: Considers all styles and genres.
Terms: Gallery provides insurance, promotion and contract. Requires exclusive representation locally.
Submissions: Send query letter with artist's statement, proposal and visuals. Responds in 2 months. Files proposals, bios and visuals. Finds artists through word of mouth, portfolio reviews, referrals by other artists, publications and research.

N JUDI ROTENBERG GALLERY, 130 Newbury St., Boston MA 02116. (617)437-1518. E-mail: jrgal@tiac.net. Website: www.fine-arts-unlimited.com/g4.htm. Retail gallery. Estab. 1964. Represents 14 emerging, mid-career and established artists. Average display time 3-4 weeks. Open all year. Located in the Back Bay; 1,400 sq. ft. 100% of space for special exhibitions. Overall price range: $500-30,000; most work sold at $1,200-7,000.
Media: Considers all media. Most frequently exhibits oil, watercolor and acrylic.
Style: Exhibits expressionism, painterly abstraction and postmodern works. Genres include landscapes and florals. Prefers expressionism and postmodernism.
Terms: Accepts artwork on consignment (50% commission). Retail price set by the gallery and artist. Gallery provides insurance, promotion and contract; artist pays shipping costs. Prefers artwork framed.
Submissions: Send query letter with résumé, slides, bio and photographs, reviews and SASE. Write for appointment to show portfolio of photographs. Responds only if interested.
Tips: "Please send SASE otherwise slides cannot be returned. Also send a consistent body of work that hangs well together."

N SIGNATURE AND THE GROHE GALLERY, 24 North St., Dock Square, Boston MA 02109. (617)227-4885. Fax: (617)723-5898. **Director:** Tom Bourne. Retail gallery. Estab. 1978. Represents 600 emerging, mid-career and established artists/year. Exhibited artists include Janna Ugone. Sponsors 6 shows/year. Average display time 1 month. Open all year; Monday-Saturday, 10-6; Sunday, 12-6. Located downtown; 2,400 sq. ft. 30% of space for special exhibitions; 30% of space for gallery artists. Clientele: tourists, upscale. 10% private collectors, 10% corporate collectors. Overall price range: $30-9,000; most work sold at $100 minimum.
Media: Considers paper, fiber, sculpture, glass, watercolor, mixed media, ceramics and craft. Most frequently exhibits glass, clay, mixed media.
Style: Exhibits all styles.
Terms: Accepts work on consignment (50% commission). Buys outright for 50% of retail price (net 30 days). Price set by the artist. Gallery provides insurance, promotion, contract; shipping costs are shared. Prefers artwork framed.
Submissions: Send query letter with résumé, slides, artist's statement, bio and SASE. Write for appointment to show portfolio of photographs or slides. Responds in 3 weeks.

Tips: "Include price sheets."

N J. TODD GALLERIES, 572 Washington St., Wellesley MA 02482. (781)237-3434. E-mail: jtodd@jt odd.com. Website: www.jtodd.com. **Owner:** Jay Todd. Retail gallery. Estab. 1980. Represents 55 emerging, mid-career and established artists. Sponsors 6 shows/year. Average display time 1 month. Open all year; Tuesday-Saturday, 10-5:30; Sunday, 1-5 October through April. Closed Sunday, May through September. Located "in Boston's wealthiest suburb"; 4,000 sq. ft.; vast inventory, professionally displayed. 30% of space for special exhibitions; 70% of space for gallery artists. Clientele: residential and corporate. 70% private collectors, 30% corporate collectors. Overall price range: $500-35,000; most work sold at $1,000-10,000.
Media: Considers oil, acrylic, watercolor, pen & ink, drawing, mixed media, woodcuts, engravings, lithographs, wood engravings, mezzotints, serigraphs, linocuts and etchings. Most frequently exhibits oils, woodcuts and etchings
Style: Exhibits primitivism, postmodern works, impressionism and realism. Genres include landscapes, florals, figurative work and still life. Prefers landscapes, figures and still life.
Terms: Accepts work on consignment (negotiable commission). Retail price set by the artist. Gallery provides promotion. Prefers artwork unframed.
Submissions: No abstract work. Send query letter with résumé, slides, bio, photographs and price list. Call or write for appointment to show portfolio of photographs or slides. Responds in 6 weeks. Enclose SASE for return of slides/photos. Files "all that is interesting to us." Finds artists through agents, visiting exhibitions, word of mouth, art publications and sourcebooks and submissions.
Tips: "Give us a minimum of six works that are new and considered to be your BEST. Maximum size: 30″×40″."

Michigan

N ARTQUOTE INTERNATIONAL, LLC, 6364 Ramwyck Court, West Bloomfield MI 48322. (248)851-6091. Fax: (248)851-6090. E-mail: artquote@BigFoot.com. **Contact:** M. Burnstein. Art consultancy, for-profit, wholesale gallery, corporate art and identity programs. Estab. 1985. Exhibits established artists. Exhibited artists include: Warhol, serigraph; and Bill Mack, sculpture. Clients include local community. 99% of sales are to corporate collectors. Overall price range: $500-500,000; most work sold at $3,000 and up!
Media: Considers acrylic, ceramics, collage, craft, glass, installation, mixed media, oil, paper, pastel, sculpture and watercolor. Considers all types of prints.
Style: Considers all styles.
Terms: Retail price set by the artist. Accepts only work from established artists.
Submissions: Depends on corporate client. Finds artists through word of mouth, art exhibits and art fairs.

N ARTS EXTENDED GALLERY, INC., 2966 Woodward Ave., The Art Bldg., Detroit MI 48204. (313)831-0321. Fax: (313)961-1335. **Director:** Dr. C.C. Taylor. Retail, nonprofit gallery, educational 501C3 space and art consultancy. Estab. 1959. Represents/exhibits many emerging, mid-career and established artists. Exhibited artists include: Michael Kelly Williams, Samuel Hodge and Charles McGee. Sponsors 10 shows/year. Average display time 4-6 weeks. Open all year; Wednesday-Saturday, 12-5. Located near Wayne State University; 1,000 sq. ft. Clients include tourists, upscale, local community. 80% of sales are to private collectors, 20% corporate collectors. Overall price range: $150-4,000 up; most work sold at $200-500 (for paintings—craft items are considerably less).
　• Gallery also sponsors art classes and exhibits outstanding work produced there.
Media: Considers all media, woodcuts, engravings, linocuts, etchings and monoprints. Most frequently exhibits painting, fibers, photographs and antique African art.
Style: "The work which comes out of the community we serve is varied but rooted in realism, ethnic symbols and traditional designs/patterns with some exceptions."
Terms: Artwork is accepted on consignment, and there is a 33⅓% commission, or artwork is bought outright for 50% of the retail price. Retail price set by the gallery and the artist. Gallery provides insurance, promotion and contract; shipping costs are shared. Prefers artwork framed or ready to install.
Submissions: Send query letter with résumé, slides, photographs and reviews. Call for appointment to show a portfolio of photographs, slides and bio. Responds in 3 weeks. Files biographical materials sent with announcements, catalogs, résumés, visual materials to add to knowledge of local artists, letters, etc.
Tips: "Our work of recruiting local artists is known, and consequently artists beginning to exhibit or seeking to expand are sent to us. Many are sent by relatives and friends who believe that ours would be a

logical place to inquire. Study sound technique—there is no easy way or scheme to be successful. Work up to a standard of good craftsmanship and honest vision. Come prepared to show a group of artifacts. Have clearly in mind a willingness to part with work and understand that market moves fairly slowly."

N BELIAN ART CENTER, 5980 Rochester Rd., Troy MI 48098. (248)828-1001. **Directors:** Garabed or Zabel Belian. Retail gallery and art consultancy. Estab. 1985. Represents 20 emerging, mid-career and established artists/year. Exhibited artists include Reuben Nakian and Edward Avesdisian. Sponsors 8-10 shows/year. Average display time 1 month. Open all year; Monday-Saturday, 12-6. Located in a suburb of Detroit; 2,000 sq. ft.; has outdoor area for pool side receptions; different levels of exhibits. 50% of space for special exhibitions; 50% of space for gallery artists. Clientele: 50-60% local, 30% Metropolitan area 10-20% national. 70-80% private collectors, 10-20% corporate collectors. Overall price range: $1,000-20,000.

Media: Considers oil, acrylic, watercolor, pastel, pen & ink, drawing, mixed media, collage, paper, sculpture, ceramics, installation, photography, woodcuts, engravings, lithographs, wood engravings, mezzotints and serigraphs. Most frequently exhibits oils, sculptures (bronze) and engraving.

Style: Exhibits expressionism, neo-expressionism, primitivism, painterly abstraction, surrealism, conceptualism, minimalism, color field, postmodern works, impressionism, photorealism, hard-edge geometric abstraction, realism and imagism. Includes all genres. Prefers abstraction, realism, mixed.

Terms: Accepts work on consignment (commission varies) or buys outright for varying retail price. Retail price set by the gallery and the artist. Gallery provides insurance and promotion; shipping costs are shared. prefers artwork framed.

Submissions: Send query letter with résumé, 6-12 slides, bio, brochure, photographs and reviews. Call or write for appointment to show portfolio of photographs, slides and transparencies. Responds only if interested within 3 weeks. Finds artists through catalogs, sourcebooks, exhibitions and magazines.

Tips: "Produce good art at an affordable price. Have a complete biography and representative examples of your characteristic style. Have enough art pieces for a viable exhibition, which will also show your artistic merit and ability."

☑ CENTRAL MICHIGAN UNIVERSITY ART GALLERY, Wightman 132, Art Department, Mt. Pleasant MI 48859. (989)774-3800. Fax: (989)774-2278. E-mail: julia.morrisroe@cmich.edu. Website: www.ccfa.cmich.edu/uag/. **Director:** Julia Morrisroe. Nonprofit gallery. Estab. 1970. Approached by 250 artists/year. Represents 40 emerging, mid-career and established artists. Exhibited artists include: Lou Cabeen and Carol Kumata. Sponsors 7 exhibits/year. Average display time 1 month. Open all year; Monday, Tuesday, Thursday and Friday, 10-5; Wednesday, 12-8; Saturday, 12-5. Clients include local community, students and tourists. Overall price range: $200-5,000.

Media: Considers all media and all types of prints. Most frequently exhibits sculpture, painting and photography.

Style: Considers all styles.

Terms: Buyers are referred to the artist. Gallery provides insurance, promotion and contract. Accepted work should be framed. Does not require exclusive representation locally.

Submissions: Write to arrange a personal interview to show portfolio of slides. Mail portfolio for review. Send query letter with artist's statement, bio, résumé, reviews, SASE and slides. Returns material with SASE. Responds only if interested within 2 months. Files résumé, reviews, photocopies and brochure. Finds artists through word of mouth, submissions, portfolio reviews, art exhibits, and referrals by other artists.

DE GRAAF FORSYTHE GALLERIES, INC., Park Place No. 4, 403 Water St. on Main, Saugatuck MI 49453. (616)857-1882. Fax: (616)857-3514. E-mail: degraaffa@aol.com. Website: www.degraaffineart. com. **Director:** Tad De Graaf. Retail gallery and art consultancy. Estab. 1950. Represents/exhibits 18 established artists/year. May be interested in seeing emerging artists in the future. Exhibited artists include: Stefan Davidek and C. Jagdish. Average display time 3-4 weeks. Open all year; May-December; Monday-Saturday, 11-5; Sunday, 1-5. Located in center of town, 1,171 sq. ft.; adjacent to two city parks. 60% of space for gallery artists. Clients include: upscale. 50% of sales are to private collectors; 10% corporate collectors. Overall price range: $500-50,000; most work sold at $2,000-5,000.

Media: Considers all media except photography and crafts. Most frequently exhibits sculpture, paintings and tapestry.

Style: Exhibits all styles.

Terms: Artwork is accepted on consignment and there is a 50% commission. Retail price set by the gallery and the artist. Gallery provides promotion. Shipping costs are shared.

Submissions: Accepts only artists with endorsements from another gallery or museum. Send query letter with résumé, brochure, slides, photographs, reviews, bio and SASE. Write for appointment to show portfolio. Responds in 2 months, or if interested 3 weeks. Files résumé if possible future interest.

☑ DETROIT ARTISTS MARKET, 4719 Woodward Ave., Detroit MI 48201. (313)832-8540. Fax: (313)832-8543. E-mail: contactus@detroitartistsmarket.org. **Exhibitions Associate:** Tracy Smith. Nonprofit gallery. Estab. 1932. Exhibits the work of emerging, mid-career and established artists/year; 1,000 members. Sponsors 6-8 shows/year. Average display time 6 weeks. Open Tuesday-Friday, 11-6; Thursday, 11-7; Saturday 11-4. Located in downtown Detroit; 2,600 sq. ft. 85% of space for special exhibitions. Clientele: "extremely diverse client base—varies from individuals to the Detroit Institute of Arts." 95% private collectors; 5% corporate collectors. Overall price range: $200-15,000; most work sold at $100-500.
Media: Considers all media. No posters. Most frequently exhibits multimedia.
Style: All contemporary styles and genres.
Terms: Accepts artwork on consignment (30% commission). Retail price set by the artist. Gallery provides insurance; artist pays for partial shipping.
Tips: "Our mission: Detroit Artists Market serves the Detroit arts community by exhibiting and promoting the work of emerging and established artists, as well as national and international artists. To achieve this mission, DAM will: mount exhibitions to be shown at DAM; develop and originate exhibitions which will tour throughout Michigan and beyond; show touring exhibitions at DAM; create arts education programs and publications in conjunction with DAM's exhibitions; and continue to develop DAM as a sales facility."

Ⓝ GALLERY SHOP AND GALLERIES: BIRMINGHAM BLOOMFIELD ART CENTER, 1516 S. Cranbrook Rd., Birmingham MI 48009. (248)644-0866. Fax: (248)644-7904. Nonprofit gallery shop. Estab. 1962. Represents emerging, mid-career and established artists. Sponsors ongoing exhibition. Open all year; Monday-Saturday, 9-5. Suburban location. 100% of space for gallery artists. Clientele: upscale, local. 100% private collectors. Overall price range: $50-2,000.
Media: Considers all media. Most frequently exhibits glass, jewelry, ceramics and 2D work.
Style: Exhibits all styles.
Terms: Accepts work on consignment (40% commission). Retail price set by the artist. Gallery provides promotion and contract; artist pays for shipping costs to gallery.
Submissions: Send query letter with résumé, brochure, slides, photographs, reviews, artist's statement, bio, SASE; "as much information as possible." Files résumé, bio, brochure, photos.
Tips: "We consider the presentation of the work (framing, matting, condition) and the professionalism of the artist."

Ⓝ GRAND RAPIDS ART MUSEUM, 155 Division N, Grand Rapids MI 49503-3154. (616)831-1000. Fax: (616)559-0422. E-mail: pr@gr-artmuseum.org. Website: www.gramonline.org. Museum. Estab. 1910. Exhibits established artists. Sponsors 3 exhibits/year. Average display time 4 months. Open all year; Tuesday-Sunday, 11-6; weekends, 11-6. Located in the heart of downtown Grand Rapids, the Grand Rapids Art Museum presents exhibitions of national caliber and regional distinction. The museum collection spans Renaissance to modern art, with particular strength in 19th and 20th century paintings, parts and drawings. Clients include: local community, students, tourists, upscale.
Media: Considers all media and all types of prints. Most frequently exhibits paintings, prints and drawings.
Style: Considers all styles and genres. Most frequently exhibits impressionist, modern and Renaissance.

ELAINE L. JACOB GALLERY, Wayne State University, 480 W. Hancock, Detroit MI 48202. (313)993-7813. Fax: (313)577-8935. E-mail: ac1370@wayne.edu. Website: www.art.wayne.edu. **Curator of Exhibition:** Sandra Dupret. Nonprofit university gallery. Estab. 1997. Exhibits national and international artists. Approached by 40 artists/year. Sponsors 5 exhibits/year. Average display time 6 weeks. Open all year; Tuesday-Friday, 10-6; Saturdays, 11-5. Closed week between Christmas and the New Year. Call for summer hours. Located in the annex of the Old Main building on campus. The gallery space is roughly 3,000 sq. ft. and is divided between 2 floors. Clients include local community, students, tourists.
Media: Considers all types of media.
Style: Mainly contemporary art exhibited.
Terms: Exhibition only, with occasional sales. Retail price set by the artist. Gallery provides insurance, promotion and contract. Accepted work should be framed, mounted and matted. Does not require exclusive representation locally.
Submissions: Send query letter with artist's statement, bio, brochure, business card, photocopies, photographs, résumé. reviews, SASE and slides. Responds in 2 months. Files slides, curriculum vitae and artist statements.
Tips: "Include organized and pertinent information, professional slides, and a clear and concise artist statement."

"Art comes from the heart!" an Irish proverb exclaims. What about the refrigerator? Sadashi Inuzuka's *y/east* was configured from bread, and swiftly accepted into the Elaine L. Jacob & Community Arts Gallery. This contemporary gallery in Detroit upholds a strict mission of presenting raw, extant creativity, and Senior Curator Sandra Dupret stresses that all mediums are fair game when it comes to hosting memorable exhibitions.

N KRASL ART CENTER, 707 Lake Blvd., St. Joseph MI 49085. (616)983-0271. Fax: (616)983-0275. E-mail: info@krasl.org. Website: www.krasl.org. **Director:** Dar Davis. Retail gallery of a nonprofit arts center. Estab. 1980. Clients include community residents and summer tourists. Sponsors 30 solo and group shows/year. Average display time is 1 month. Interested in emerging and established artists.
Media: Considers oils, acrylics, watercolor, pastels, pen & ink, drawings, mixed media, collage, paper, sculpture, ceramics, crafts, fibers, glass, installations, photography and performance.
Style: Exhibits all styles. "The works we select for exhibitions reflect what's happening in the art world. We display works of local artists as well as major traveling shows from SITES. We sponsor sculpture invitationals and offer holiday shows each December."
Terms: Accepts work on consignment (35% commission). Retail price is set by artist. Sometimes offers customer discounts. Exclusive area representation required. Gallery provides insurance, promotion, shipping and contract.
Submissions: Send query letter, résumé, slides, and SASE. Call for appointment to show portfolio of originals.

✓ JOYCE PETTER GALLERY, 161 Blue Star Highway, Douglas MI 49406. (616)857-7861. Website: www.joycepettergallery.com. **Owner:** Joyce Petter. Retail gallery. Estab. 1973. Represents 50 artists; emerging, mid-career and established. Exhibited artists include Harold Larsen and Fran Larsen. Sponsors group or individual shows each year. Average display time 2 weeks. Open all year. Located on the main corridor connecting the art mecca of Saugatuck and Douglas, Michigan. It is housed in a spacious 1930s building designed by Carl Hoerman, artist and architect. It offers 12,500 sq. ft. of exhibition space. It includes the main display area, a photography gallery, print gallery, sculpture barn and garden. Overall price range: $150-8,000; most artwork sold at $800-2,500.
Media: Considers oil, acrylic, watercolor, pastel, drawings, mixed media, sculpture, ceramic, glass, original handpulled prints, woodcuts, etchings, lithographs, serigraphs ("anything not mechanically reproduced") and photography.
Style: Exhibits painterly abstraction, surrealism, impressionism, realism, hard-edge geometric abstraction and all styles and genres. Prefers landscapes, abstracts, figurative and "art of timeless quality."

Terms: Accepts work on consignment (50% commission). Retail price set by the artist. Gallery provides insurance, promotion, contract and cost for return shipping of work. The artwork should be framed with the exception of prints and photographs.

Submissions: Send query letter with résumé and photographs or slides, including dimensions and prices. "It's a mistake not to have visited the gallery to see if the artist's work fits the feeling or culture of the establishment."

Tips: "Art is judged on its timeless quality. We are not interested in the 'cutting edge.' After 29 seasons we continue to maintain relationships with artists who joined at the onset and to take on new artists who exhibit those same traits of career longevity and solid commitment to their art."

PEWABIC POTTERY, 10125 E. Jefferson, Detroit MI 48214. (313)822-0954. Fax: (313)822-6266. E-mail: pewabic@pewabic.com. Website: www.pewabic.com. Historic, nonprofit gallery in ceramics education and fabrication center. Estab. 1906. Represents 80 emerging, mid-career and established artists/year. Sponsors 10 shows/year. Average display time 6-52 weeks. Open all year; Monday-Saturday, 10-6; open 7 days during holiday. Located 3 miles east of downtown Detroit; historic building (1906). 50% of space for special exhibitions; 50% of space for gallery artists. Clients include: tourists, ceramic collectors. 98% of sales are to private collectors, 2% corporate collectors. Overall price range: $15-1,500; most work sold at $50-100.

Media: Considers ceramics, mixed media, ceramic jewelry.

Style: Exhibits utilitarian and sculptural clay.

Terms: Accepts work on consignment (50% commission). Retail price set by the artist. Gallery provides insurance and promotion; shipping costs are shared.

Submissions: Only ceramics. Send query letter with résumé, slides, artist's statement and SASE. Write for appointment to show portfolio of slides. Responds in 1-3 months. Finds artists through word of mouth, referrals by other artists, visiting art fairs and exhibitions, submissions.

Tips: "Avoid sending poor-quality slides."

SAPER GALLERIES, 433 Albert Ave., East Lansing MI 48823. Phone/fax: (517)351-0815. E-mail: roy@sapergalleries.com. Website: www.sapergalleries.com. **Director:** Roy C. Saper. Retail gallery. Estab. in 1978 as 20th Century Fine Arts; in 1986 designed and built new location and name. Displays the work of 100 artists; mostly mid-career, and artists of significant national prominence. Exhibited artists include: Picasso, Peter Max, Rembrandt, Audubon and Pissarro. Sponsors 2 shows/year. Average display time 2 months. Open all year. Located downtown; 5,700 sq. ft.; "We were awarded *Decor* magazine's Award of Excellence for gallery design." 50% of space for special exhibitions. Clients include students, professionals, experienced and new collectors. 80% of sales are to private collectors, 20% corporate collectors. Overall price range: $100-100,000; most work sold at $1,000.

Media: Considers oil, acrylic, watercolor, pastel, drawings, mixed media, collage, paper, sculpture, ceramic, craft, glass and original handpulled prints. Considers all types of prints except offset reproductions. Most frequently exhibits intaglio, serigraphy and sculpture. "Must be of highest professional quality."

Style: Exhibits expressionism, painterly abstraction, surrealism, postmodern works, impressionism, realism, photorealism and hard-edge geometric abstraction. Genres include landscapes, florals, southwestern and figurative work. Prefers abstract, landscapes and figurative. Seeking outstanding artists who will continue to produce exceptional work.

Terms: Accepts work on consignment (negotiable commission); or buys outright for negotiated percentage of retail price. Retail price set by the artist. Offers payment by installments. Gallery provides insurance, promotion and contract; shipping costs are shared. Prefers artwork unframed (gallery frames).

Submissions: Send query letter with bio or résumé, brochure and 6-12 slides or photographs and SASE. Call for appointment to show portfolio of originals or photos of any type. Responds in 1 week. Files any material the artist does not need returned. Finds artists mostly through NY Art Expo.

Tips: "Present your very best work to galleries which display works of similar style, quality and media. Must be outstanding, professional quality. Student quality doesn't cut it. Must be great. Be sure to include prices and SASE."

URBAN INSTITUTE FOR CONTEMPORARY ARTS, 41 Sheldon Blvd.,Grand Rapids MI 49503. (616)459-5994. Fax: (616)459-9395. E-mail: jteunis@uica.org. Website: www.uica.org. **Visual Arts Program Manager:** Janet Teunis. Alternative space, nonprofit gallery. Estab. 1977. Approached by 250 artists/year. Exhibits 20 emerging, mid-career and established artists. "We have three galleries—one for each type." Exhibited artists include: Sally Mann, photography. Sponsors 20 exhibits/year. Average display time 6 weeks. Open all year; Tuesday-Saturday, 11-4. Closed week of Christmas and New Year's. Clients include local community and students.

Media: Considers all media and all types of prints. Most frequently exhibits mixed media and nontraditional.

Style: Exhibits: conceptualism and postmodernism.
Terms: Gallery provides insurance, promotion and contract.
Submissions: Call to arrange a personal interview to show portfolio. Send query letter with artist's statement, bio, résumé, reviews, SASE and slides. Returns material with SASE. Does not reply. Artist should see website, inquire about specific calls for submissions. Finds artists through submissions.
Tips: "Get submission requirements before sending materials."

Minnesota

CALLAWAY GALLERIES, INC., 101 SW First Ave., Rochester MN 55902. (507)287-6525. **Owner:** Barbara Callaway. Retail gallery. Estab. 1971. Represents 50+ emerging, mid-career and established artists/year. Average display time 1 month. Open all year; Monday-Friday, 9:30-5:30; Saturday, 10-4. Located downtown; 700 sq. ft. Clientele: tourists and upscale corporate. 30% corporate collectors. Overall price range: $100-4,000; most work sold at $200-1,000.
Media: Considers oil, acrylic, watercolor, collage, paper, sculpture, fiber and glass. Considers all types of prints except numbered photo repros. Most frequently exhibits pastel, mixed media and glass.
Style: Exhibits: expressionism, primitivism, painterly abstraction and realism. Genres include florals, southwestern, landscapes and figurative work.
Terms: Accepts work on consignment (50% commission) or buys outright for 50% of retail price (net 30 days). Retail price set by the artist. Shipping costs are shared. Prefers artwork unframed.
Submissions: Send query letter with bio, photographs, SASE, reviews and artist's statement. Write for appointment to show portfolio of photographs or slides. Responds in 1 month (if SASE provided). Finds artists through word of mouth, referrals by other artists, visiting art fairs and exhibitions and submissions.
Tips: "Dropping in does not work."

☑ **FARIBAULT ART CENTER, INC.**, 212 Central Ave., Suite A, Faribault MN 55021. (507)332-7372. E-mail: fac@deskmedia.com. Website: www.faribaultart.org. **Contact:** Executive Director. Nonprofit gallery. Represents 10-12 emerging and mid-career artists/year. 200 members. Sponsors 6 shows/year. Average display time 1 month. Open all year; Tuesday-Friday, 9:30-4:30; Saturday, 9:30-3:30. Located downtown; 300 sq. ft. 20% of space for special exhibitions; 30% of space for gallery artists. Clientele: local and tourists. 90% private collectors.
Media: Considers all media and all types of prints.
Style: Open.
Terms: Accepts work on consignment (30% commission for nonmembers). Retail price set by the artist. Artist pays for shipping. Prefers artwork framed.
Submissions: Accepts local and regional artists. Send query letter with slides, bio, photographs, SASE and artist's statement. Call or write for appointment to show portfolio of photographs or slides. Responds only if interested within 2 weeks. Artist should call. Finds artists through word of mouth, referrals by other artists, visiting art fairs and exhibitions and submissions.
Tips: "Artists should respond quickly upon receiving reply."

🔃 **GROVELAND GALLERY**, 25 Groveland Terrace, Minneapolis MN 55403. (612)377-7800. Fax: (612)377-8822. **Director:** Sally Johnson. Retail gallery. Estab. 1973. Represents 25-30 mid-career artists/ year. Interested in seeing the work of emerging artists. Exhibited artists include: Mike Lynch and Rod Massey. Sponsors 7 shows/year. Average display time 6 weeks. Open all year; Tuesday-Friday, 12-5; Saturday, 12-4. Located downtown in Kenwood neighborhood; 500 sq. ft.; in historic mansion, built in 1894 by F.B. Long. 100% of space for gallery artists. Clients include corporations, individuals and museums. 65% of sales are to private collectors; 35% corporate collectors. Overall price range: $500-15,000; most work sold at $1,000-2,000.
Media: Considers oil, acrylic, watercolor, pastel, pen & ink and drawing; types of prints include woodcuts, lithographs and etchings. Most frequently exhibits oil, pastel and watercolor.
Style: Exhibits: realism. Genres include landscapes and still life. Prefers: landscape, still life and cityscapes.
Terms: Accepts work on consignment (50% commission). Retail price set by the gallery and artist. Gallery provides promotion; shipping costs are shared. Prefers artwork framed.
Submissions: Accepts only artists from the Midwest. No photography or sculpture. Send query letter with résumé, slides, bio and SASE. Responds in 2 months.

🔃 **ICEBOX QUALITY FRAMING & GALLERY**, 2401 Central Ave. NE, Minneapolis MN 55418. (612)788-1790. E-mail: icebox@bitstream.net. Website: www.iceboxminnesota.com. **Fine Art Represen-**

tative: Howard Christopherson. Retail gallery and alternative space. Estab. 1988. Represents emerging and mid-career artists. Sponsors 4-7 shows/year. Average display time 1-2 months. Open all year. Intimate, black-walled space.

Media: Considers photography and all fine art with some size limitations.

Style: Exhibits: any thought-provoking artwork.

Terms: "Exhibit expenses and promotional material paid by the artist along with a sliding scale commission." Gallery provides great exposure, mailing list of 1,700 and good promotion.

Submissions: Accepts predominantly Minnesota artists but not exclusively. Send 20 slides, materials for review, letter of interest.

Tips: "Be more interested in the quality and meaning in your artwork than in a way of making money."

MIKOLS RIVER STUDIO INC., 717 Main St., Elk River MN 55330. (763)441-6385. Website: www.MikolsRiverStudio.com. **President:** Anthony Mikols. Retail gallery. Estab. 1985. Represents 12 established artists/year. Exhibited artists include: Terry Redlin. Sponsors 2 shows/year. Open all year; 6 days, 9-6. Located in downtown; 2,200 sq. ft. 10% of space for special exhibitions; 50% of space for gallery artists. Overall price range: $230-595.

Media: Considers watercolor, sculpture and photography; types of prints include lithographs. Most frequently exhibits paper, sculptures and gift items.

Style: Genres include florals, portraits and wildlife. Prefers: wildlife, florals and portraits.

Terms: Buys outright for 50% of retail price (net on receipt). Retail price set by the gallery. Gallery provides insurance; gallery pays for shipping.

Submissions: Send photographs. Artist's portfolio should include photographs. Responds only if interested within 2 weeks. Files artist's material. Finds artists through word of mouth.

N OPENING NIGHT GALLERY, 2836 Lyndale Ave. S., Minneapolis MN 55408-2108. (612)872-2325. Fax: (612)872-2385. E-mail: deen@onframe-art.com. Website: www.onframe-art.com. Rental gallery. Estab. 1974. Approached by 40 artists/year. Exhibits 15 emerging and mid-career artists. Exhibited artists include: Bonnie Cutts, paintings on paper and canvas; Greg Winters, Iris prints. Sponsors 6 exhibits/year. Average display time 6-10 weeks. Open all year; Monday-Saturday, 8:30-5; weekends, 10:30-4. Located on a main street the space is approximately 2,500 sq. ft. Clients include local community, tourists and upscale. 50% of sales are to corporate collectors. Overall price range: $300-15,000; most work sold at $2,500.

Media: Considers acrylic, ceramics, collage, drawing, fiber, glass, oil, paper, sculpture and watercolor. Most frequently exhibits paintings, drawings and pastels. Considers engravings, etchings, linocuts, lithographs, mezzotints, posters and serigraphs.

Style: Exhibits: impressionism and painterly abstraction. Genres include Americana, florals and landscapes.

Terms: Artwork is accepted on consignment and there is a 50% commission. Retail price set by the gallery. Gallery provides insurance, promotion and contract. Accepted work should be framed. Requires exclusive representation locally.

Submissions: Write to arrange a personal interview to show portfolio of photographs or slides. Mail portfolio for review. Send query letter with artist's statement, bio, résumé, SASE and slides. Responds in 2 months. Files slides and bio. Finds artists through word of mouth, submissions and portfolio reviews.

Tips: "Please include a cover letter, along with your most appealing creations. Archival-quality materials are everything—we are also a framing service whom museums use for framing."

N JEAN STEPHEN GALLERIES, 917 Nicollet Mall, Minneapolis MN 55402. (612)338-4333. Fax: (612)337-8435. E-mail: jsgalleries@mceddusa.net. Website: jeanstephengalleries.com. Directors: Steve or Jean Danko. Retail gallery. Estab. 1987. Represents 12 established artists. Interested in seeing the work of emerging artists. Exhibited artists include: Jiang, Hart and Max. Sponsors 2 shows/year. Average display time 4 months. Open all year; Monday-Saturday, 10-6. Located downtown; 2,300 sq. ft. 15% of space for special exhibitions; 85% of space for gallery artists. Clients include upper income. 90% of sales are to private collectors, 10% corporate collectors. Overall price range: $600-12,000; most work sold at $1,200-2,000.

Media: Considers oil, acrylic, pastel, pen & ink, drawing, mixed media, collage, paper, sculpture, ceramics, woodcuts, engravings, lithographs, wood engravings, mezzotints, serigraphs, linocuts and etchings. Most frequently exhibits serigraphs, stone lithographs and sculpture.

Style: Exhibits: expressionism, neo-expressionism, surrealism, minimalism, color field, postmodern works and impressionism. Genres include landscapes, southwestern, portraits and figurative work. Prefers Chinese contemporary, abstract and impressionism.

Terms: Accepts work on consignment (50% commission). Retail price set by the gallery. Gallery provides insurance and contract; artist pays shipping costs to and from gallery.

Submissions: Send query letter with résumé, slides and bio. Call for appointment to show portfolio of originals, photographs and slides. Responds in 2 months. Finds artists through art shows and visits.

N STUDIO 10, 1021 Bandana Blvd. E, St. Paul MN 55108. (612)646-3346. **Manager:** Kathi. Retail gallery owned and operated by artists. Estab. 1989. Represents 100 artists/year. Interested in seeing the work of emerging artists and fine craftspeople. Exhibited artists include Michael Bond, Michael Shoop and Joan Gray. Average display time 1 year. Open all year; daily, 10-9; Saturday, 10-6. Located in energy park; 1,400 sq. ft.; located in 100-year-old historic railroad building. 100% of space for gallery artists. 95% private collectors, 5% corporate collectors. Overall price range: $5-800; most work sold at $20-100.
Media: Considers all 2D and 3D media.
Style: Exhibits all styles and genres. Prefers florals, wildlife and southwestern.
Terms: Accepts work on consignment (36% commission and 3% on all charge sales). Retail price set by the artist. Gallery provides promotion and contract. Artist pays for shipping.
Submissions: Accepts only artists from Midwest. Send query letter with 10-12 slides, brochure, SASE, business card and artist's statement. Call or write for appointment to show portfolio of original art. Responds in 2 weeks. Finds artists through word of mouth, referrals by other artists, visiting art fairs and exhibitions and artist's submissions.
Tips: "Learn to frame and mat professionally, use top quality frames, mats, glass and wiring apparatus. Keep your work clean and unscratched. Strive to be an expert in one medium."

✓ FREDERICK R. WEISMAN ART MUSEUM, 333 East River Rd., Minneapolis MN 55455. (612)625-9494. Fax: (612)625-9630. Website: www.weisman.umn.edu. **Curator:** Patricia McDonnell. Frederick R. Weisman Art Museum opened in November 1993; University of Minnesota Art Museum established in 1934. Represents 15,000 works in permanent collection. Represents established artists. 1,500 members. Sponsors 6-7 shows/year. Average display time 10 weeks. Open all year; Tuesday, Wednesday, Friday, 10-5; Thursday, 10-8; Saturday-Sunday, 11-5. Located at the University of Minnesota, Minneapolis; 11,000 sq. ft.; designed by Frank O. Gehry. 40% of space for special exhibitions.
Media: Considers all media and all types of prints.
Style: Exhibits all styles, all genres.
Terms: Gallery provides insurance. Prefers artwork framed.
Submissions: "Generally we do not exhibit one-person shows. We prefer thematic exhibitions with a variety of artists. However, we welcome exhibition proposals. Exhibitions which are multi-disciplinary are preferred."

Mississippi

MERIDIAN MUSEUM OF ART, 628 25th Ave., P.O. Box 5773, Meridian MS 39302. (601)693-1501. **Director:** Terence Heder. Museum. Estab. 1970. Represents emerging, mid-career and established artists. Interested in seeing the work of emerging artists. Exhibited artists include Terry Cherry, Alex Loeb, Jere Allen, Patt Odom, James Conner, Joseph Gluhman, Bonnie Busbee and Hugh Williams. Sponsors 15 shows/year. Average display time 5 weeks. Open all year; Tuesday-Sunday, 1-5. Located downtown; 1,750 sq. ft.; housed in renovated Carnegie Library building, originally constructed 1912-13. 50% of space for special exhibitions. Clientele: general public. Overall price range: $150-2,500; most work sold at $300-1,000.
• Sponsors annual Bi-State Art Competition for Mississippi and Alabama artists.
Media: Considers all media, woodcut, engraving, lithograph, wood engraving, mezzotint, serigraphs, linocut and etching. Most frequently exhibits oils, watercolors and sculpture.
Style: Exhibits all styles, all genres.
Terms: Work available for sale during exhibitions (25% commission). Retail price set by the artist. Gallery provides insurance and promotion; shipping costs are shared. Prefers artwork framed.
Submissions: Prefers artists from Mississippi, Alabama and the Southeast. Send query letter with résumé, slides, bio and SASE. Responds in 3 months. Finds artists through submissions, referrals, work included in competitions and visiting exhibitions.

N MISSISSIPPI CRAFTS CENTER, Box 69, Ridgeland MS 39158. (601)856-7546. **Director:** Martha Garrott. Retail and nonprofit gallery. Estab. 1975. Represents 70 emerging, mid-career and established guild members. 250 members. Exhibited artists include Odie May Anderson, Choctaw basket-maker and Craig McMillin, Mudflap Pottery. Open all year. Located in a national park near the state capitol of Jackson;

1200 sq. ft.; a traditional dogtrot log cabin. Clientele: travelers and local patrons. 99% private collectors. Overall price range: $250-900; most work sold at $10-60. Also sells at 2 festivals a year and occasional teaching jobs.

Media: Considers paper, sculpture, ceramic, craft, fiber and glass. Most frequently exhibits clay, basketry and metals.

Style: Exhibits all styles. Crafts media only. Interested in seeing a "full range of craftwork—Native American, folk art, naive art, production crafts, crafts as art, traditional and contemporary. Work must be small enough to fit our limited space."

Terms: Accepts work on consignment (40% commission), first order; buys outright for 50% of retail price (net 30 days), subsequent orders. Retail price set by the gallery and the artist. Gallery provides promotion and shipping costs to gallery.

Submissions: Accepts only artists from the Southeast. Artists must be juried members of the Craftsmen's Guild of Mississippi. Ask for standards review application form. Standards Review: 1st Saturday in March and September.

Tips: "All emerging craftsmen should read *Crafts Report* regularly and know basic business procedures. Read books on the business of art like *Crafting as a Business* by Wendy Rosen, distributed by Chilton—available by mail order through our crafts center or the *Crafts Report*. An artist should have mastered the full range of his medium—numbers don't matter, except that you have to do a lot of practice pieces before you get good or fully professional."

☑ **THE UNIVERSITY MUSEUMS**, The University of Mississippi, P.O. Box 1848, University MS 38677. (662)915-7073. Fax: (662)915-7010. E-mail: museums@olemiss.edu. Website: olemiss.edu/depts/u_museum. Museum. Estab. 1939. Approached by 5 artists/year. Represents 2 emerging, mid-career and established artists. Average display time 3 months. Open all year; Tuesday-Saturday, 9:30-4:30; Sunday, 1-4. Closed 2 weeks at Christmas and major holidays. Clients include local community, students and tourists.

Media: Considers all media. Most frequently exhibits acrylic, oil and drawings. Considers all types of prints.

Style: Considers all styles. Genres include Americana, landscapes and wildlife.

Terms: Artwork is bought outright. Retail price set by the artist. Gallery provides insurance. Accepted work should be framed. Does not require exclusive representation locally. Accepts only artists from Mississippi, Tennessee, Alabama, Arkansas and Louisiana.

Submissions: Send query letter with artist's statement, bio, photographs and slides. Returns material with SASE. Responds in 3 months. Finds artists through word of mouth, submissions, and referrals by other artists.

Missouri

☑ **THE ASHBY-HODGE GALLERY OF AMERICAN ART**, Central Methodist College, Fayette MO 65248. (660)248-6324 or (660)248-6304. Fax: (660)248-2622. E-mail: jgeistecoin.org. Website: www.cmc.edu. **Curator:** Joseph E. Geist. Nonprofit gallery, "Not primarily a sales gallery—only with special exhibits." Estab. 1993. Exhibits the work of 47 artists in permanent collection. Exhibited artists include Robert MacDonald Graham, Jr. and Birger Sandzén. Sponsors 5 shows/year. Average display time 2 months. Open all year; Tuesday-Thursday, 1:30-4:30. Located on campus of Central Methodist college. 1,400 sq. ft.; on lower level of campus library. 100% of gallery artists for special exhibitions. Clientele: local community and surrounding areas of Mid-America. Physically impaired accessible. Tours by reservation.

Media: Considers all media. Most frequently exhibits acrylic, lithographs and oil.

Style: Exhibits Midwestern regionalists. Genres include portraits and landscapes. Prefers: realism.

Terms: Accepts work on consignment (30% commission.) Retail price set by the gallery. Gallery provides insurance and promotion; shipping costs are shared. Prefers artwork framed.

Submissions: Accepts primarily Midwestern artists. Send query letter with résumé, slides, photographs and bio. Call for appointment to show portfolio of photographs, transparencies and slides. Finds artists through word of mouth and submissions.

BOODY FINE ARTS, INC., 10734 Trenton Ave., St. Louis MO 63132. (314)423-2255. E-mail: boodyfinearts@earthlink.net. Website: www.bodyfinearts.com. Retail gallery and art consultancy. "Gallery territory is nationwide. Staff travels on a continual basis to develop collections within the region." Estab. 1978. Represents 200 mid-career and established artists. Clientele: 30% private collectors, 70% corporate clients. Overall price range: $500-1,000,000.

Media: Considers oil, acrylic, watercolor, pastel, drawings, mixed media, collage, sculpture, ceramic, fiber, metalworking, glass, works on handmade paper, neon and original handpulled prints.

Style: Exhibits color field, painterly abstraction, minimalism, impressionism and photorealism. Prefers non-objective, figurative work and landscapes.

Terms: Accepts work on consignment. Retail price is set by gallery and artist. Customer discounts and payment by installments available. Gallery provides insurance, promotion and contract; shipping costs are shared.

Submissions: Send query letter, résumé and slides. Write to schedule an appointment to show a portfolio, which should include originals, slides and transparencies. All material is filed. Finds artists by visiting exhibitions, word of mouth, artists' submissions and art collectors' referrals.

Tips: "I very seldom ever work with an artist until they have been out of college about ten years."

☑ **BYRON COHEN GALLERY FOR CONTEMPORARY ART,** (formerly Byron Cohen Lennie Berkowitz), 2020 Baltimore, Kansas City MO 64108. (816)421-5665. Fax: (816)421-5775. E-mail: byronco hen@aol.com. Website: www.artnet.com/cohen.html. **Owner:** Byron Cohen. Retail gallery. Estab. 1994. Represents emerging and established artists. Exhibited artists include: Squeak Carnwath. Sponsors 6-7 shows/year. Average display time 7 weeks. Open all year; Thursday-Saturday, 11-5. Located downtown; 1,500 sq. ft.; 100% of space for gallery artists. 90% of sales are to private collectors, 10% corporate collectors. Overall price range: $300-42,000; most work sold at $2,000-7,000.

Media: Considers all media. Most frequently exhibits painting, works on paper and sculpture.

Style: Exhibits: Considers all styles. Prefers contemporary painting and sculpture, contemporary prints, contemporary ceramics.

Terms: Accepts work on consignment (50% commission.) Retail price set by the gallery and the artist. Gallery provides insurance, promotion and contract; shipping costs are shared. Prefers artwork framed.

Submissions: Send query letter with résumé, slides, artist's statement and bio. Write for appointment to show portfolio of photographs, transparencies and slides. Files slides, bio and artist's statement. Finds artists through word of mouth, referrals by other artists, visiting art fairs and exhibitions.

☑ **CRAFT ALLIANCE GALLERY,** 6640 Delmar, St. Louis MO 63130. (314)725-1177, ext. 22. Fax: (314)725-2068. E-mail: randic@craftalliance.org. Website: www.craftalliance.org. **Manager:** Randi Chervitz. Nonprofit gallery. Estab. 1964. Represents 500 emerging, mid-career and established artists. Exhibited artists include: James Ibur, Sam Stang, Valerie Mitchell and Leon Niehnes. Sponsors 10-12 exhibits/year. Average display time 4-6 weeks. Open all year. Located in the university area; storefront; adjacent to education center. Clients include local community, students, tourists and upscale. 5% of sales are to corporate collectors. Overall price range: $20 and up. Most work sold at $100.

Media: Considers ceramics, metal, fiber and glass. Most frequently exhibits jewelry, glass and clay. Doesn't consider prints.

Style: Exhibits contemporary craft.

Terms: Artwork is accepted on consignment and there is a 50% commission. Artwork is bought outright for 50% of retail price. Retail price set by the gallery and the artist. Gallery provides insurance and promotion. Does not require exclusive representation locally.

Submissions: Call or write to arrange a personal interview to show portfolio of slides. Returns material with SASE.

Tips: "Call and talk. Have professional slides and attitude."

GALERIE BONHEUR, 10046 Conway Rd., St. Louis MO 63124. (314)993-9851. Fax: (314)993-9260. E-mail: gbonheur@aol.com. Website: www.galeriebonheur.com. **Owner:** Laurie Carmody. Gallery Assistant: Sharon Ross. Private retail and wholesale gallery. Focus is on international folk art. Estab. 1980. Represents 60 emerging, mid-career and established artists/year. Exhibited artists include: Milton Bond and Justin McCarthy. Sponsors 6 shows/year. Average display time 1 year. Open all year; by appointment. Located in Ladue (a suburb of St. Louis); 1,500 sq. ft.; art is displayed all over very large private home. 75% of sales to private collectors. Overall price range: $25-25,000; most work sold at $50-1,000.

• Galerie Bonheur also has a location at 9243 Clayton Rd., Ladue, MO.

Media: Considers oil, acrylic, watercolor, pastel, pen & ink, drawing, mixed media, collage, paper, sculpture, ceramics and craft. Most frequently exhibits oil, acrylic and metal sculpture.

Style: Exhibits: expressionism, primitivism, impressionism, folk art, self-taught, outsider art. Genres include landscapes, florals, Americana and figurative work. Prefers genre scenes and figurative.

Terms: Accepts work on consignment (50% commission) or buys outright for 50% of retail price. Retail price set by the gallery and the artist. Gallery provides promotion; artist pays shipping costs to and from gallery. Prefers artwork framed.

Submissions: Prefers only self-taught artists. Send query letter with bio, photographs and business card. Write for appointment to show portfolio of photographs. Responds only if interested within 6 weeks. Finds artists through agents, visiting exhibitions, word of mouth, art publications and sourcebooks and submissions.

Tips: "Be true to your inspirations. Create from the heart and soul. Don't be influenced by what others are doing; do art that you believe in and love and are proud to say is an expression of yourself. Don't copy; don't get too sophisticated or you will lose your individuality!"

N LYSS FINE ART, 722 S. Meramec, St. Louis MO 63105. (314)726-6140. **Owner:** Esther Lyss. Retail and wholesale gallery. Estab. 1971. Represents emerging, mid-career and established artists. Open all year by appointment. Located mid-town. Clientele: corporate and upper end.

Media: Considers all media and all types of prints.

Style: Exhibits all styles and genres.

Terms: Retail price set by gallery and/or artist. Prefers artwork unframed.

Submissions: Send query letter with résumé, slides, brochure, photographs, business card, reviews, bio and SASE. Call or write for appointment to show portfolio. Responds in 2-3 weeks. Files all material sent with query.

Tips: "I am always happy to speak with artists. I am a private dealer and specialize in helping my clients select works for their home or office."

MORTON J. MAY FOUNDATION GALLERY, Maryville University, 13550 Conway, St. Louis MO 63141. (314)576-9300. E-mail: nrice@maryville.edu. **Director:** Nancy N. Rice. Nonprofit gallery. Exhibits the work of 6 emerging, mid-career and established artists/year. Sponsors 10 shows/year. Average display time 1 month. Open all year. Located on college campus. 10% of space for special exhibitions. Clients include college community. Overall price range: $100-4,000.

● The gallery is long and somewhat narrow, therefore it is inappropriate for very large 2-D work. There is space in the lobby for large 2-D work but it is not as secure.

Media: Considers oil, acrylic, watercolor, pastel, pen & ink, drawings, mixed media, collage, works on paper, sculpture, ceramic, fiber, installation, photography, original handpulled prints, woodcuts, engravings, lithographs, wood engravings, mezzotints, linocuts and etchings. Exhibits all genres.

Terms: Artist receives all proceeds from sales. Retail price set by artist. Gallery provides insurance and promotion; artist pays for shipping. Prefers framed artwork.

Submissions: Prefers St. Louis area artists. Send query letter with résumé, slides, bio, brochure and SASE. Portfolio review requested if interested in artist's work. Portfolio should include slides, photographs and transparencies. Responds only if interested within 3 months. Finds artists through referrals by colleagues, dealers, collectors, etc. "I also visit group exhibits especially if the juror is someone I know and or respect."

Tips: Does not want "hobbyists/crafts fair art." Looks for "a body of work with thematic/aesthetic consistency."

N WILLIAM SHEARBURN FINE ART, 4740-A McPherson, 2nd Floor, St. Louis MO 63108. (314)367-8020. E-mail: wshfineart@aol.com. **Owner/Director:** William Shearburn. Sponsors 5 shows/year. Average display time 6 weeks. Open all year; Tuesday-Saturday, 1-4. Located midtown; 1,200 sq. ft. "Has feel of a second floor New York space." 60% of space for special exhibitions; 40% of space for gallery artists. Overall price range: $500-50,000; most work sold at $2,500-5,000.

Media: Considers all media including drawings, paintings, prints and photography.

Style: Specializes in 20th Century American art.

Terms: Artwork is accepted on consignment (50% commission). Retail price set by the gallery. Gallery provides promotion and contract; shipping costs are shared. Prefers artwork framed.

Submissions: Prefers established artists only. Send query letter with résumé, slides, reviews and SASE. Call for appointment to show portfolio of photographs or transparencies.

Tips: "Please stop by the gallery first to see the kind of work we show and the artists we represent before you send us your slides."

THE SOURCE FINE ARTS, INC., 4137 Pennsylvania, Kansas City MO 64111. (816)931-8282. Fax: (816)913-8283. **Owner:** Denyse Ryan Johnson. Gallery Director: Penny Plotsky. Retail gallery. Estab. 1985. Represents/exhibits 50 mid-career artists/year. Exhibited artists include: Jack Roberts and John Gary Brown. Sponsors 3-4 openings, monthly shows/year. Open all year; Monday-Friday, 9-5; Saturday, 11-4. Located in midtown Westport Shopping District; 2,000 sq. ft. 50% of space for special exhibitions. Clients include tourists and upscale. 60% of sales are to private collectors, 40% corporate collectors. Overall price range: $200-6,500; most work sold at $1,000-4,500.

Media: Considers all media except photography. Most frequently exhibits oil, acrylic, mixed media, ceramics and glass.

Style: Exhibits: expressionism, minimalism, color field, hard-edge geometric abstraction, painterly abstraction and impressionism. Genres include landscapes. Prefers: non-objective, abstraction and impressionism.
Terms: Artwork is accepted on consignment (50% commission). Retail price set by the gallery. Gallery provides insurance, promotion and contract; shipping costs are shared.
Submissions: Prefers Midwest artists with exhibit, sales/gallery record. Send query letter with résumé, brochure, business card, 8-12 slides, photographs, reviews and SASE. Call for appointment to show portfolio of photographs, slides and transparencies. Responds in 1 month. Files slides and résumé. Finds artists through word of mouth, referrals by other artists, visiting art fairs and exhibitions and artists' submissions. Reviews submissions in January and July.
Tips: Advises artists who hope to gain gallery representation to "visit the gallery to see what media and level of expertise is represented. If unable to travel to a gallery outside your region, review gallery guides for area to find out what styles the gallery shows. Prior to approaching galleries, artists need to establish an exhibition record through group shows. When you are ready to approach galleries, present professional materials and make follow-up calls."

Montana

☑ **HARRIETTE'S GALLERY OF ART**, 510 First Ave. N., Great Falls MT 59405. (406)761-0881. E-mail: harriette@msn.net. **Owner:** Harriette Stewart. Retail gallery. Estab. 1970. Represents 20 artists. Exhibited artists include: Larry Zabel, Frank Miller, Arthur Kober, Richard Luce, Susan Guy, Ross Docken, Alberto Mauri, Joseph Ziolhowski and Louis Stephenson. Sponsors 1 show/year. Average display time 6 months. Open all year. Located downtown; 1,000 sq. ft. 100% of space for special exhibitions. 90% of sales are to private collectors, 10% corporate collectors. Overall price range: $100-10,000; most artwork sold at $200-750.
Media: Considers oil, acrylic, watercolor, pastel, pencils, pen & ink, mixed media, sculpture, original handpulled prints, lithographs and etchings. Most frequently exhibits watercolor, oil and pastel.
Style: Exhibits: expressionism. Genres include wildlife, landscape, floral and western.
Terms: Accepts work on consignment (33⅓% commission); or outright for 50% of retail price. Retail price set by gallery and artist. Sometimes offers customer discounts and payment by installment. Gallery provides promotion; "buyer pays for shipping costs." Prefers artwork framed.
Submissions: Send query letter with résumé, slides, brochure and photographs. Portfolio review requested if interested in artist's work. "Have Montana Room in the largest Western Auction in U.S.—The Charles Russell Auction, in March every year—looking for new artists to display."
Tips: "Proper framing is important."

☒ **HOCKADAY MUSEUM OF ART**, 302 Second Ave. E., Kalispell MT 59901. (406)755-5268. Fax: (406)755-2023. E-mail: hockaday@aboutmontana.net. Website: www.hockadayartmuseum.org. **Executive Director:** Linda Engh-Grady. Museum. Estab. 1968. Exhibits emerging, mid-career and established artists. Interested in seeing the work of emerging artists. 500 members. Exhibited artists include: Theodore Waddell, Dale Chihuly, Pat Kihuk and David Shaner. Sponsors approximately 15 shows/year. Average display time 2 months. Open year round. Located 2 blocks from downtown retail area; 2,650 sq. ft.; historic 1906 Carnegie Library Building with new (1989) addition; wheelchair access to all of building. 50% of space for special exhibitions. Overall price range $500-35,000.
Media: Considers all media, plus woodcuts, wood engravings, linocuts, engravings, mezzotings, etchings, lithographs and serigraphs. Most frequently exhibits painting (all media), sculpture/installations (all media), photography and original prints.
Style: Exhibits all styles and genres. Prefers: contemporary art (all media and styles), historical art and photographs and traveling exhibits. "We are not interested in wildlife art and photography, mass-produced prints or art from kits."
Terms: Accepts work on consignment (40% commission). Also houses permanent collection: Montana and regional artists acquired through donations. Sometimes offers customer discounts and payment by installment to museum members. Gallery provides insurance, promotion and contract; shipping costs are shared. Prefers artwork framed.
Submissions: Send query letter with résumé, slides, bio, reviews and SASE. Portfolio should include b&w photographs and slides (20 maximum). "We review *all* submitted portfolios once a year, in spring." Finds artists through submissions and self-promotions.
Tips: "Present yourself and your work in the best possible professional manner. Art is a business. Make personal contact with the director, by phone or in person. You have to have enough work of a style or theme to carry the space. This will vary from place to place. You must plan for the space. A good rule to

follow is to present 20 completed works that are relative to the size of space you are submitting to. As a museum whose mission is education we choose artists whose work brings a learning experience to the community."

YELLOWSTONE GALLERY, 216 W. Park St., P.O. Box 472, Gardiner MT 59030. (406)848-7306. E-mail: jckahrs@aol.com. Website: yellowstonegallery.com. **Owner:** Jerry Kahrs. Retail gallery. Estab. 1985. Represents 20 emerging and mid-career artists/year. Exhibited artists include: Mary Blain and Nancy Glazier. Sponsors 2 shows/year. Average display time 2 months. Open all year; seasonal 7 days; winter, Tuesday-Saturday, 10-6. Located downtown; 3,000 sq. ft. new building. 25% of space for special exhibitions; 50% of space for gallery artists. Clientele: tourist and regional. 90% private collectors, 10% corporate collectors. Overall price range: $25-8,000; most work sold at $75-600.
Media: Considers oil, acrylic, watercolor, ceramics, craft and photography; types of prints include wood engravings, serigraphs, etchings and posters. Most frequently exhibits watercolors, oils and limited edition, signed and numbered reproductions.
Style: Exhibits: impressionism, photorealism and realism. Genres include western, wildlife and landscapes. Prefers: wildlife realism, western and watercolor impressionism.
Terms: Accepts work on consignment (45% commission). Retail price set by the artist. Gallery provides contract; artist pays for shipping. Prefers artwork framed.
Submissions: Send query letter with brochure or 10 slides. Write for appointment to show portfolio of photographs. Responds in 1 month. Files brochure and biography. Finds artists through word of mouth, regional fairs and exhibits, mail and periodicals.
Tips: "Don't show up unannounced without an appointment."

Nebraska

N ANDERSON O'BRIEN, 8724 Pacific St., Omaha NE 68114. (402)390-0717. Fax: (402)390-0479. **Owner:** Jo Anderson. Retail gallery. Estab. 1970. Represents 30 established artists/year. Exhibited artists include Hal Holoun. Sponsors 14 shows/year. Average display time 3 weeks. Open all year; Monday-Friday, 10:00-5:30; Saturday, 10-5. Located in suburbs; 2,000 sq. ft. 40% of space for special exhibitions; 60% of space for gallery artists. Clientele: upscale. 50% private collectors; 50% corporate collectors. Overall price range: $500-150,000; most work sold at $3,500-7,500.
Media: Considers all media except photography and craft; types of prints include woodcuts. Most frequently exhibits oil/canvas, acrylic/canvas and pastel
Style: Exhibits primitivism, painterly abstraction, conceptualism and minimalism. Genres include landscapes and figurative work. Prefers abstraction and landscapes.
Terms: Accepts work on consignment (50% commission). Retail price set by the artist. Gallery provides insurance and promotion; shipping costs are shared. Prefers artwork unframed.
Submissions: Accepts only artists with MFA degrees. Send résumé, slides and bio. Write for appointment to show portfolio of transparencies. Finds artists through university exhibitions.
Tips: "Make an appointment."

GALLERY 72, 2709 Leavenworth, Omaha NE 68105-2399. (402)345-3347. Fax: (402)348-1203. Website: gallery72@novia.net. **Director:** Robert D. Rogers. Retail gallery and art consultancy. Estab. 1972. Interested in emerging, mid-career and established artists. Represents 10 artists. Sponsors 4 solo and 4 group shows/year. Average display time is 3 weeks. Clients include individuals, museums and corporations. 75% of sales are to private collectors, 25% corporate clients. Overall price range: $750 and up.
Media: Considers oil, acrylic, watercolor, pastel, pen & ink, drawings, mixed media, collage, sculpture, ceramic, installation, photography, original handpulled prints and posters. Most frequently exhibits paintings, prints and sculpture.

**FOR EXPLANATIONS OF THESE SYMBOLS,
SEE THE INSIDE FRONT AND BACK COVERS OF THIS BOOK.**

Style: Exhibits: hard-edge geometric abstraction, color field, minimalism, impressionism and realism. Genres include landscapes and figurative work. Most frequently exhibits color field/geometric, impressionism and realism.

Terms: Accepts work on consignment (commission varies), or buys outright. Retail price is set by gallery or artist. Gallery provides insurance; shipping costs and promotion are shared.

Submissions: Send query letter with résumé, slides and photographs. Call to schedule an appointment to show a portfolio, which should include originals, slides and transparencies. Vitae and slides are filed.

Tips: "It is best to call ahead and discuss whether there is any point in sending your material."

N. NOYES ART GALLERY, 119 S. 9th St., Lincoln NE 68508. (402)475-1061. E-mail: rnoyes1348@aol.com. Website: www.noyesart.com. **Director:** Julia Noyes. Nonprofit gallery. Estab. 1992. Exhibits 150 emerging artists. 175 members. Average display time 1 month minimum. (If mutually agreeable this may be extended or work exchanged.) Open all year. Located downtown, "near historic Haymarket District; 3093 sq. ft.; renovated 100-year-old building." 25% of space for special exhibitions. Clientele: private collectors, interior designers and decorators. 90% private collectors, 10% corporate collectors. Overall price range: $100-5,000; most work sold at $200-750.

Media: Considers oil, acrylic, watercolor, pastel, pen & ink, drawings, mixed media, collage, paper, sculpture, ceramic, fiber, glass and photography; original handpulled prints, woodcuts, wood engravings, linocuts, engravings, mezzotints, etchings, lithographs and serigraphs. Most frequently exhibits oil, watercolor and mixed media.

Style: Exhibits expressionism, neo-expressionism, impressionism, realism, photorealism. Genres include landscapes, florals, Americana, wildlife, figurative work. Prefers realism, expressionism, photorealism.

Terms: Accepts work on consignment (10-35% commission). Retail price set by artist (sometimes in conference with director). Gallery provides promotion and contract; artist pays for shipping. Prefers artwork framed.

Submissions: Send query letter with résumé, slides, bio, SASE; label slides concerning size, medium, price, top, etc. Submit at least 6-8 slides. Reviews submissions monthly. Responds in 3-4 weeks. Files résumé, bio and slides of work by accepted artists (unless artist requests return of slides). All materials are returned to artists whose work is declined.

Nevada

N. ART ENCOUNTER, 3979 Spring Mountain Rd., Las Vegas NV 89102. (702)227-0220. Fax: (702)227-3353. E-mail: rod@artencounter.com. **Director:** Rod Maly. Retail gallery. Estab. 1992. Represents 100 emerging and established artists/year. Exhibited artists include: Hermon Adams. Sponsors 4 shows/year. Open all year; Tuesday-Friday, 10-6; Saturday and Monday, 12-5. Located near the famous Las Vegas strip; 6,000 sq. ft. 20% of space for special exhibitions; 80% of space for gallery artists. Clients include upscale tourists and locals. 95% of sales are to private collectors, 5% corporate collectors. Overall price range: $200-20,000; most work sold at $400-600.

Media: Considers all media and all types of prints. Most frequently exhibits watercolor, oil and acrylic.

Style: Exhibits all styles and genres.

Terms: Rental fee for space; covers 6 months. Retail price set by the gallery and artist. Gallery provides promotion and contract; artist pays for shipping. Prefers artwork framed.

Submissions: Send 5-10 slides, photographs and SASE. Write for appointment to show portfolio of photographs or slides. Responds only if interested within 2 weeks. Files artist bio and résumé. Finds artists by advertising in the *Artist's Magazine*, *American Artist*, art shows and word of mouth.

Tips: "Poor visuals and no SASE are common mistakes."

N. DAWN'S STUDIO WEST, 80 N. Pecos Rd., Suite B, Henderson NV 89074. (702)270-4215. **Owner:** Dawn Morrison. Retail gallery, framing. Estab. 1994. Represents 20 mid-career and established artists/year. May be interested in seeing the work of emerging artists in the future. Exhibited artists include: Thomas Kinkade, Robert Bateman, Carl Brender and Judy Larsen. Open all year; Monday-Friday, 9-5:30; Saturday, 9-5. 50% of space for special exhibitions; 50% of space for gallery artists. Clients include local community. 90% of sales are to private collectors, 10% corporate collectors. Overall price range: $100-1,200; most work sold at $700.

Media: Considers all media and all types of prints. Most frequently exhibits watercolor, paper and oil.

Style: Exhibits all styles and genres. Prefers landscape, wildlife and florals.

Terms: Accepts work on consignment (40% commission). Buys outright for 50% of the retail price. Retail price set by the artist. Gallery provides insurance, promotion and contract. Artists pays shipping costs.

Submissions: Send query letter with photographs. Call or write for appointment to show portfolio of photographs. Responds only if interested with 1 month. Files bio photos. Finds artists through word of mouth, referrals by other aritsts, visiting art fairs and exhibitions and artist's submissions.

New Hampshire

MCGOWAN FINE ART, INC., 10 Hills Ave., Concord NH 03301. (603)225-2515. Fax: (603)225-7791. E-mail: art@mcgowanfineart.com. Website: www.mcgowanfineart.com. **Gallery Director:** Sarah Hardy. Owner/Art Consultant: Mary McGowan. Retail gallery and art consultancy. Estab. 1980. Represents emerging, mid-career and established artists. Sponsors 8 shows/year. Average display time 1 month. Located just off Main Street. 75-100% of space for special exhibitions. Clients include residential and corporate. Most work sold at $125-9,000.
Media: Considers oil, acrylic, watercolor, pastel, mixed media, collage, works on paper, sculpture, woodcuts, wood engravings, linocuts, engravings, mezzotints, etchings, lithographs and serigraphs. Most frequently exhibits sculpture, watercolor and oil/acrylic.
Style: Exhibits: painterly abstraction, landscapes, etc.
Terms: Accepts work on consignment (50% commission). Retail price set by artist. Gallery provides insurance and promotion; negotiates payment of shipping costs. Prefers artwork unframed.
Submissions: Send query letter with résumé, 5-10 slides and bio. Responds in 1 month. Files materials.
Tips: "I am interested in the number of years you have been devoted to art. Are you committed? Do you show growth in your work?"

Ⓝ MILL BROOK GALLERY & SCULPTURE GARDEN, 236 Hopkinton Rd., Concord NH 03301. (603)226-2046. Website: www.themillbrookgallery.com. For-profit gallery. Estab. 1996. Exhibits 50 emerging, mid-career and established artists. Exhibited artists include: John Bott, painter; Jane Kaufmann, clay artist. Sponsors 7 exhibits/year. Average display time 6 weeks. Open every day, 11-5; April 1-December 24th. Otherwise, by appointment. Located 3 miles west of The Concord NH Center; surrounding gardens, field and pond; outdoor juried sculpture exhibit. Three rooms inside for exhibitions, 1,800 sw. ft. Clients include local community, tourists and upscale, 10% of sales are to corporate collectors. Overall price range: $80-30,000; most work sold at $500-1,000.
Media: Considers acrylic, ceramics, collage, drawing, glass, mixed media, oil, pastel, sculpture, watercolor, etchings, mezzotints, serigraphs and woodcuts. Most frequently exhibits oil, acrylic and pastel.
Style: Considers all styles. Most frequently exhibits color field/conceptualism, expressionism. Genres include landscapes.
Terms: Artwork is accepted on consignment and there is a 40% commission. Retail price set by the artist. Gallery provides insurance, promotion and contract. Accepted work should be framed and matted.
Submissions: Call or write to show portfolio of photographs and slides. Send query letter with artist's statement, bio, photocopies, photographs, résumé, SASE and slides. Returns material with SASE. Responds in 1 month. Finds artists through word of mouth, submissions, art exhibits and referrals by other artists.

THE OLD PRINT BARN—ART GALLERY, P.O. Box 978, Winona Rd., Meredith NH 03253-0978. (603)279-6479. Fax: (603)279-1337. Website: www.nhada.org/prints.htm. **Director:** Sophia Lane. Retail gallery. Estab. 1976. Represents 100-200 mid-career and established artists/year. May be interested in seeing the work of emerging artists in the future. Exhibited artists include: Michael McCurdy, Ryland Loos and Joop Vegter. Sponsors 3-4 shows/year. Average display time 3-4 months. Open daily 10-5 (except Thanksgiving and Christmas Day). Located in the country; over 4,000 sq. ft.; remodeled antique 19th century barn. 30% of space for special exhibitions; 70% of space for gallery artists. Clients include tourists and local. 99% of sales are to private collectors. Overall price range: $10-18,000; most work sold at $200-900.
Media: Considers oil, watercolor, pastel, pen & ink, drawing and photography; types of prints include woodcuts, engravings, lithographs, wood engravings, mezzotints, serigraphs, linocuts and etchings. Most frequently exhibits all works of art on paper.
Style: Exhibits: realism. Genres include florals, wildlife, landscapes and Americana. Prefers: landscapes, wildlife and antique engravings.
Terms: Accepts work on consignment. Retail price set by the gallery and artist. Gallery provides promotion; shipping costs are shared. Prefers artwork unframed but shrink-wrapped with 1 inch on top for clips so work can hang without damage to image or mat.
Submissions: Prefers only works of art on paper. No abstract art. Send query letter with résumé, brochure, 10-12 slides and artist's statement. Title, medium and size of artwork must be indicated clearly on slide

label. Call or write for appointment to show portfolio or photographs. Responds in a few weeks. Files query letter, statements, etc. Finds artists through word of mouth, referrals of other artists, visiting art fairs and exhibitions and submissions.

Tips: "Show your work to gallery owners in as many different regions as possible. Most gallery owners have a feeling of what will sell in their area. I certainly let artists know if I feel their images are not what will move in this area."

New Jersey

N: ARC-EN-CIEL, 267 Fairview Ave., Long Valley NJ 07853. (908)876-9671. E-mail: ruthreed@goes.com. **Owner:** Ruth Reed. Retail gallery and art consultancy. Estab. 1980. Exhibited artists include: Andre Pierre, Petian Savain, Alexander Gregoire, Micius Stephane, Gerard Valcin and Seymore Bottex. 50% of sales are to private collectors, 50% corporate clients. Open by appointment only. Represents emerging, mid-career and established artists. Overall price range: $150-158,000; most artwork sold at $250-2,000.
Media: Considers oil, acrylic, wood carvings, sculpture. Most frequently exhibits acrylic, painted iron, oil.
Style: Exhibits minimalism, primitivism and some insider art. "I exhibit country-style paintings, native art from around the world. The art can be on wood, iron or canvas."
Terms: Accepts work on consignment (50% commission). Retail price is set by gallery and artist. Customer discounts and payment by installment are available. Exclusive area representation required. Gallery provides promotion; shipping costs are shared.
Submissions: Send query letter, photographs and SASE. Portfolio review requested if interested in artist's work. Photographs are filed. Finds artists through word of mouth and art collectors' referrals.

MARY H. DANA WOMEN ARTISTS SERIES, Mabel Smith Douglass Library, Douglass College, New Brunswick NJ 08901-8527. (732)932-9407, ext. 26. Fax: (732)932-6667. E-mail: olin@rci.rutgers.edu. Website: www.libraries.rutgers.edu/rulib/abtlib/dglsslib/gen/events/was.htm. **Curator:** Dr. Ferris Olin. Alternative exhibition space for exhibitions of works by women artists. Estab. 1971. Represents/exhibits 4 emerging, mid-career and established artists/year. Interested in seeing the work of emerging artists. Sponsors 4 shows/year. Average display time 5-6 weeks. Open September-June; Monday-Sunday approximately 12 hours a day. Located on college campus in urban area; lobby-area of library. Clients include students, faculty and community.
Media: Considers all media.
Style: Exhibits all styles and genres.
Terms: Retail price by the artist. Gallery provides insurance, promotion and arranges transportation. Prefers artwork framed.
Submissions: Exhibitions are curated by invitation. Portfolio should include 5 slides. Finds artists through referrals.

N: THE GALLERY OF SOUTH ORANGE, Baird Center, 5 Mead St., S. Orange NJ 07079. (973)378-7755, ext. 3. Fax: (973)378-7833. E-mail: goso1@aol.com. Website: http://community.nj.com/cc/sogallery. **Director:** Judy Wukitsch. Nonprofit gallery. Estab. 1994. Approached by 75-185 artists/year. Exhitits 75-100 emerging, mid-career and established artists. Sponsors 6 openings, number of exhibits within each time slot varies. Average display time 6 weeks. Open all year; Wednesday-Thursday, 10-2 and 4-6; weekends, 1-4. Closed Mid-December through mid-January; August. Located in park setting, 100 year old building; 3 rooms from intimate to large on second floor with wrap-around porch for receptions. Artists enjoy the quality of exhibition space and professionalism of staff. Visitors include local community, students, upscale and artists. "As nonprofit we are not sales driven."
Media: Considers all media and prints, except posters—must be original works. Most frequently exhibits painting, mixed media/collage/sculpture.
Style: Considers all styles and genres.
Terms: Artwork is accepted on consignment and there is a 15% commission. Retail price set by the artist. Gallery provides insurance, promotion and contract. Accepted work should be framed. Does not require exclusive representation locally.
Submissions: Mail portfolio for review. GOSO has 3 portfolio reviews per year: January, June and October. Send query letter with artist's statement, résumé, slides and any other items they choose. Returns material with SASE. Responds in 2 months from review date. Accepted portfolios go in active file from which all exhibitions are curated. Finds artists through word of mouth, submissions, portfolio reviews and referrals by other artists.
Tips: Send legible, clearly defined, properly identified slides.

GALMAN LEPOW ASSOCIATES, INC., 1879 Old Cuthbert Rd., #12, Cherry Hill NJ 08034. (856)354-0771. **Contact:** Judith Lepow. Art consultancy. Estab. 1979. Represents emerging, mid-career and established artists. Open all year. 1% of sales are to private collectors, 99% corporate collectors. Overall price range: $300-20,000; most work sold at $500-5,000.
Media: Considers oil, acrylic, watercolor, pastel, mixed media, collage, paper, sculpture, ceramic, craft, fiber, glass, photography, original handpulled prints, woodcuts, engravings, lithographs, pochoir, wood engravings, mezzotints, linocuts, etchings, and serigraphs.
Style: Exhibits: painterly abstraction, impressionism, realism, photorealism, pattern painting and hard-edge geometric abstraction. Genres include landscapes, florals and figurative work.
Terms: Accepts artwork on consignment (40-50% commission). Retail price set by artist. Gallery provides insurance; shipping costs are shared. Prefers artwork unframed.
Submissions: Send query letter with résumé, slides and SASE. Call for appointment to show portfolio of originals, slides and transparencies. Responds in 3 weeks. Files "anything we feel we might ultimately show to a client."

DAVID GARY LTD. FINE ART, 158 Spring St., Millburn NJ 07041. (973)467-9240. Fax: (973)467-2435. **Director:** Steve Suskauer. Retail and wholesale gallery. Estab. 1971. Represents 17-20 mid-career and established artists. Exhibited artists include: John Talbot and Marlene Lenker. Sponsors 3 shows/year. Average display time 3 weeks. Open all year. Located in the suburbs; 2,000 sq. ft.; high ceilings with sky lights. Clients include "upper income." 70% of sales are to private collectors, 30% corporate collectors. Overall price range: $250-25,000; most work sold at $1,000-15,000.
Media: Considers oil, acrylic, watercolor, drawings, sculpture, pastel, woodcuts, engravings, lithographs, wood engravings, mezzotints, linocuts, etchings and serigraphs. Most frequently exhibits oil, original graphics and sculpture.
Style: Exhibits: primitivism, painterly abstraction, surrealism, impressionism, realism and collage. All genres. Prefers impressionism, painterly abstraction and realism.
Terms: Accepts artwork on consignment (50% commission). Retail price set by gallery and artist. Gallery services vary; artist pays for shipping. Prefers artwork unframed.
Submissions: Send query letter with résumé, photographs and reviews. Call for appointment to show portfolio of originals, photographs and transparencies. Responds in 2 weeks. Files "what is interesting to gallery."
Tips: "Have a basic knowledge of how a gallery works, and understand that the gallery is a business."

N LANDSMAN'S GALLERY & PICTURE FRAMING, 401 S. Rt. 30, Magnolia NJ 08049. (856) Fine Art. Fax: (856)784-0334. E-mail: landsman401@aol.com. **Owner:** Howard Landsman. Retail gallery and art consultancy. Estab. 1965. Represents/exhibits 25 emerging, mid-career and established artists/year. Interested in seeing the work of emerging artists. Open all year; Tuesday-Saturday, 9-5. Located in suburban service-oriented area; 2,000 sq. ft. "A refuge in an urban suburban maze." Clients include upscale, local and established. 50% of sales are to private collectors, 50% corporate collectors. Overall price range: $100-10,000; most work sold at $300-1,000.
Media: Considers all media and all types of prints. Most frequently exhibits serigraphs, oils and sculpture.
Style: Exhibits all styles and genres. Gallery provides insurance, promotion and contract. Artist pays for shipping costs. Prefers artwork framed.
Terms: Artwork is accepted on consignment (50% commission). Retail price set by artist. Gallery provides insurance, promotion, contract. Artist pays shipping costs. Prefers artwork framed.
Submissions: Send query letter with slides, photographs and reviews. Write for appointment to show portfolio of photographs and slides. Files slides, bios and résumé. Finds artists through word of mouth, referrals by other artists, visiting art fairs and exhibitions and submissions.

LIMITED EDITIONS & COLLECTIBLES, 697 Haddon, Collingswood NJ 08108. (856)869-5228. Website: www.LTDeditions.net. **Owner:** John Daniel Lynch, Sr. For profit gallery. Estab. 1997. Approached by 24 artists/year. Exhibited artists include: James Allen Flood and Gino Hollander. Open all year. Located in downtown Collingswood; 700 sq. ft. Overall price range: $190-20,000; most work sold at $450.
Media: Considers all media and all types of prints. Most frequently exhibits acrylic, watercolors and oil.
Style: Considers all styles and genres.
Terms: Artwork is accepted on consignment and there is a 30% commission. Retail price set by the artist. Gallery provides insurance, promotion and contract. Accepted work should be framed, mounted and matted. Does not require exclusive representation locally.
Submissions: Call or write to arrange a personal interview to show portfolio. Send query letter with bio, business card and résumé. Responds in 1 month. Finds artists through word of mouth, portfolio reviews, art exhibits, and referrals by other artists.

■ **MARKEIM ART CENTER**, Lincoln Ave. and Walnut St., Haddonfield NJ 08033. Phone/fax: (856)429-8585. E-mail: markeimartcenter@msn.com. Website: www.markeim.org. **Center Manager:** Lisa Hamill. Nonprofit gallery. Estab. 1956. Represents emerging, mid-career and established artists. 150 members. Exhibited artists include James P. Repenning and William Hoffman, Jr. Sponsors 8-10 shows/year, both on and off site. Average display time 4-6 weeks. Open all year; Monday-Thursday 10-3; Friday-Saturday, 11-3. Located downtown; 600 sq. ft. 75% of space for special exhibitions; 20% of space for gallery artists. Overall price range: $100-2,000.
Media: Considers all media. Must be original. Most frequently exhibits paintings, photography and sculpture.
Style: Exhibits all styles and genres.
Terms: Work not required to be for sale (20% commission taken if sold.) Retail price set by the artist. Gallery provides promotion and contract. Artwork must be ready to hang.
Submissions: Send query letter with résumé, slides, bio/brochure, photographs, SASE, business card, reviews and artist's statement. Write for appointment to show portfolio of photographs and slides. Files slide registry.

N THE NOYES MUSEUM OF ART, Lily Lake Rd., Oceanville NJ 08231. (609)652-8848. Fax: (609)652-6166. Website: www.noyesmuseum.org. Curator of Collections and Exhibitions: Hsiao-Ning Tu. Museum. Estab. 1983. Exhibits emerging, mid-career and established artists. Sponsors 9-12 shows/year. Average display time 6 weeks to 3 months. Open all year; Tuesday-Saturday, 10-4:30; Sunday, 12-5. 9,000 sq. ft.; "modern, window-filled building successfully integrating art and nature; terraced interior central space with glass wall at bottom overlooking Lily Lake." 75% of space for special exhibitions. Clients include rural, suburban, urban mix; high percentage of out-of-state vacationers during summer months.
Media: All types of fine art, craft and folk art.
Style: Exhibits all styles and genres.
Submissions: Send query letter with résumé, slides, photographs and SASE. "Letter of inquiry must be sent; then museum will set up portfolio review if interested." Portfolio should include slides. "Materials only kept on premises if artist is from New Jersey and wishes to be included in New Jersey Artists Resource File or if artist is selected for inclusion in future exhibitions."

N SERAPHIM FINE ARTS GALLERY, Dept. AM, 19 Engle St., Tenafly NJ 07020. (201)568-4432. **Directors:** E. Bruck and M. Lipton. Retail gallery. Represents 150 emerging, mid-career and established artists. 90% of sales are to private collectors, 10% corporate clients. Overall price range: $700-17,000; most work sold at $2,000-5,000.
Media: Considers oil, acrylic, watercolor, drawings, collage, sculpture and ceramic. Most frequently exhibits oil, acrylic and sculpture.
Style: Exhibits: impressionism, realism, photorealism, painterly abstraction and conceptualism. Considers all genres. Prefers impressionism, realism and figure painting. "We are located in New Jersey, but we function as a New York gallery. We put together shows of artists who are unique. We represent fine contemporary artists and sculptors."
Terms: Accepts work on consignment. Retail price set by gallery and artist. Exclusive area representation required. Gallery provides insurance and promotion. Prefers framed artwork.
Submissions: Send query letter with résumé, slides and photographs. Portfolio should include originals, slides and photographs. Responds in 2-4 weeks. Files slides and bios.
Tips: Looking for "artistic integrity, creativity and an artistic ability to express self." Notices a "return to interest in figurative work."

BEN SHAHN GALLERIES, William Paterson University, 300 Pompton Rd, Wayne NJ 07470. (973)720-2654. **Director:** Nancy Einreinhofer. Nonprofit gallery. Estab. 1968. Interested in emerging and established artists. Sponsors 5 solo and 10 group shows/year. Average display time is 6 weeks. Clients include college, local and New Jersey metropolitan-area community.
 • The gallery specializes in contemporary art and encourages site-specific installations. They also have a significant public sculpture collection and welcome proposals.
Media: Considers all media.
Style: Specializes in contemporary and historic styles, but will consider all styles.
Terms: Accepts work for exhibition only. Gallery provides insurance, promotion and contract; shipping costs are shared.
Submissions: Send query letter with résumé, brochure, slides, photographs and SASE. Write for appointment to show portfolio. Finds artists through submissions, referrals and exhibits.

N TALLI'S FINE ART, 15 N. Summit St., Tenafly NJ 07670. (201)569-3199. Fax: (201)569-3392. E-mail: tac@photal.com. **Contact:** Talli Rosan-Kozach, owner. Alternative space, art consultancy, for-profit

and wholesale gallery. Estab. 1991. Approached by 38 artists/year. Represents about 40 emerging, mid-career and established artists. Average display time 1 month. Open all year; Monday-Sunday, 9-5; weekends, 10-5. Closed holidays. Has 2 locations, Tenafly and East Hampton New York. Clients include local community, tourists and upscale. 10% of sales are to corporate collectors. Overall price range: $200-3,000; most work sold at $4,000.

Media: Considers ceramics, collage, fiber, glass, mixed media, paper and all types of prints. Most frequently exhibits photography, etchings and collage.

Style: Exhibits: conceptualism, expressionism, imagism, minimalism, surrealism and painterly abstraction. Most frequently exhibits minimalism, surrealism and imagism. Genres include figurative work, florals, landscapes and portraits.

Terms: Artwork is accepted on consignment and there is a 50% commission. Retail price set by the artist. Accepted work should be framed and matted. "We accept only ambitious, hardworking artists that know galleries already."

Submissions: Write to arrange a personal interview to show portfolio of slides. Send query letter with artist's statement, bio, brochure, business card, photocopies, résumé, SASE and slides. Cannot return material. Responds in 2 months. Files slides, bio and artist's statement. Finds artists through word of mouth, submissions, portfolio reviews, art exhibits, art fairs and referrals by other artists.

Tips: "Make *one* good *focused* prtfolio that shows the best of what you *did* and *do* now!"

N TRENTON CITY MUSEUM, 319 E. State St., Trenton NJ 08608. (609)989-3632. Fax: (609)989-3624. E-mail: bhill@ellarslie.org. Website: www.ellarslie.org. **Contact:** Brian Hill, director. Museum and retail shop. Estab. 1974. Approached by 175 artists/year. Represents 100 emerging, mid-career and established artists. Exhibited artists include: Tom Malloy (watercolor) and Marge Chavooshian (watercolor). Sponsors 2 exhibits/year. Average display time 50 days. Open all year; Tuesday-Saturday, 11-3; Saturday, 1-4. Located in historic house (1848) with 5 galleries, 4,000 sq. ft. Clients include local community, students and upscale. Overall price range: $5,000-12,000; most work sold at $400-2,000.

Media: Considers all media and all types of prints. Most frequently exhibits acrylic, oil and watercolor.

Style: Considers all styles and genres.

Terms: Artwork is accepted on consignment and there is a 30% commission. Artwork is bought outright for 50% of retail price. Retail price set by the artist. Gallery provides insurance, promotion and contract. Accepted work should be framed, mounted and matted. Does not require exclusive representation locally.

Submissions: Mail portfolio for review. Send artist's statement, bio, photographs, SASE and slides. Returns material with SASE. Responds only if interested within 2 months. Finds artists through word of mouth.

New Mexico

THE ALBUQUERQUE MUSEUM, 2000 Mountain Rd. NW, Albuquerque NM 87104. (505)243-7255. **Curator of Art:** Ellen Landis. Nonprofit museum. Estab. 1967. Interested in emerging, mid-career and established artists. Sponsors mostly group shows. Average display time is 3-6 months. Located in Old Town (near downtown).

Media: Considers all media.

Style: Exhibits all styles. Genres include landscapes, florals, Americana, western, portraits, figurative and nonobjective work. "Our shows are from our permanent collection or are special traveling exhibitions originated by our staff. We also host special traveling exhibitions originated by other museums or exhibition services."

Submissions: Send query letter, résumé, slides, photographs and SASE. Call or write for appointment to show portfolio.

Tips: "Artists should leave slides and biographical information in order to give us a reference point for future work or to allow future consideration."

BENT GALLERY AND MUSEUM, 117 Bent St., Box 153, Taos NM 87571. (505)758-2376. **Owner:** Faye Noeding. Retail gallery and museum. Estab. 1961. Represents 15 emerging, mid-career and established artists. Exhibited artists include E. Martin Hennings, Charles Berninghaus, C.J. Chadwell and Leal Mack. Open all year. Located 1 block off of the Plaza; "in the home of Charles Bent, the first territorial governor of New Mexico." 95% of sales are to private collectors, 5% corporate collectors. Overall price range: $100-10,000; most work sold at $500-1,000.

Media: Considers oil, acrylic, watercolor, pastel, pen & ink, drawings, sculpture, original handpulled prints, woodcuts, engravings and lithographs.

Style: Exhibits: impressionism and realism. Genres include traditional, landscapes, florals, southwestern and western. Prefers: impressionism, landscapes and western works. "We continue to be interested in collectors' art: deceased Taos artists and founders' works."

Terms: Accepts work on consignment (33⅓-50% commission). Retail price set by gallery and artist. Artist pays for shipping. Prefers artwork framed.

Submissions: Send query letter with brochure and photographs. Write for appointment to show portfolio of originals and photographs. Responds if applicable.

Tips: "It is best if the artist comes in person with examples of his or her work."

N PETER ELLER GALLERY & APPRAISERS, 206 Dartmouth NE, Albuquerque NM 87106. (505)268-7437. Fax: (505)268-6442. E-mail: pelgal@nmia.com. Website: www.peterellergallery.com. For-profit gallery. Estab. 1981. Approached by 20 artists a year. Exhibits 2-3 established artists. Sponsors 2-3 exhibits/year. Average display time 4-5 weeks. Open all year; Wednesday-Friday, 1-5; weekends, 11-4. A small gallery in Albuquerque's historic Nob Hill, specializing in Albuquerque artists and minor New Mexico masters, 1925-1985. Overall price range: $1,000-75,000.

Media: Considers acrylic, ceramics, drawing, mixed media, oil, pastel, pen & ink, sculpture, watercolor, engravings, etchings, linocuts, lithographs, mezzotints, serigraphs and woodcuts. Most frequently exhibits oil, sculpture and acrylic.

Style: Considers all styles and genres. Most frequently exhibits Southwestern realism and geometric abstraction.

Terms: Retail price set by the gallery. Gallery provides promotion. Accepted work should be framed, mounted and matted. Primarily accepts resale works. Holds shows for contemporary artists occasionally.

Submissions: Call or write to arrange a personal interview to show portfolio of photographs. Send query letter with artist's statement and résumé. Returns material with SASE. Responds only if interested within 3 weeks. Finds artists through word of mouth and art exhibits.

☑ 516 MAGNIFICO ARTSPACE, 516 Central SW, Albuquerque NM 87102. (505)242-8244. Fax: (505)242-0174. E-mail: melody@magnifico.org. Website: www.magnifico.org. **Executive Director:** Suzanne Sbarge. Associate Director: Melody Mock. Alternative space, nonprofit and rental gallery. Estab. 1999. Approached by 30 artists/year. Sponsors 10 exhibits/year. Average display time 1 month. Open all year; Tuesday-Saturday, 12-5. Closed between exhibitions. Located in downtown Albuquerque; features track lighting, cement floors and is 3,000 sq. ft. total; handicap accessible; approximately 90 ft. deep and 22 ft. wide, the east wall has 3 divider panels which divide the space into 4 areas; the front section is 2 stories high and lit by north facing glasswall. Overall price range: $300-3,000.

Media: Considers all media. Most frequently exhibits painting, photography and sculpture. Considers all types of prints except posters.

Style: Considers all styles.

Terms: There is a rental fee for space. The rental fee covers 1 month. Retail price set by the artist. Gallery provides insurance and contract. Does not require exclusive representation locally.

Submissions: Call for proposal information and entry form. Returns material with SASE. Responds in 1 month after the visual arts advisory committee meets. Files all selected materials; if not selected we will file the proposal and résumé. Finds artists through submissions, and proposals to gallery and referrals from our committee.

Tips: "Call for submission information and send only the required information. Write a specific and detailed proposal for the exhibition space. Do not send unsolicited materials, or portfolio, without the application materials from the gallery. Please call if you have questions about the application or your proposal."

N THE HARWOOD MUSEUM OF ART, 238 Ledoux St. 4080 NDCBU, Taos NM 87571-6004. (505)758-9826. Fax: (505)758-1475. E-mail: harwood@unm.edu. **Contact:** David Witt, curator. Museum. Estab. 1923. Approached by 100 artists/year. Represents more than 200 emerging, mid-career and established artists. Exhibited artists include: Agnes Martin (painting) and Chuck Close (painting). Sponsors 10 exhibits/year. Average display time 2 months. Open all year; Tuesday-Saturday, 10-5; Sunday, 1-5. Consists of 7 galleries, 2 of changing exhibitions. Clients include local community, students and tourists. 1% of sales are to corporate collectors. Overall price range: $5,000-10,000; most work sold at $2,000.

Media: Considers all media and all types of prints.

Style: Considers all styles and genres.

Terms: Artwork is accepted on consignment and there is a 40% commission. Retail price set by the artist. Gallery provides insurance and contract. Accepted work should be framed, mounted and matted. Does not require exclusive representation locally.

Submissions: Mail portfolio for review. Send query letter with artist's statement, bio, brochure, résumé, reviews, SASE and slides. Responds in 3 months. Returns slides. Files everything else. Finds artists through word of mouth, submissions, art exhibits and referrals by other artists.

Tips: Professional presentation and quality work are imperative.

☑ **IAC CONTEMPORARY ART**, POB 21426, Albuquerque NM 87154-1426. (505)292-3675. E-mail: s1@swcp.com. Website: www.iac1.freeservers.com. **Art Consultant/Broker:** Michael F. Herrmann. Estab. 1992. Represents emerging, mid-career and established artists from website. Coordinates studio visits for small groups and individuals. Represented artists include Michelle Cook and Vincent Distasio. Overall price range: $250-40,000; most work sold at $800-7,000.

Media: Considers all media. Most frequently exhibits acrylics on canvas.

Style: Exhibits painterly abstraction, postmodern works and surrealism. Genres include figurative work.

Terms: Artwork is accepted on consignment (50% commission). Retail price set by collaborative agreement with artist. Artist pays all shipping costs. Prefers artwork framed.

Submissions: Send query letter with résumé, brochure, business card, slides, photographs, reviews, bio and SASE. Call or write for appointment to show portfolio. Responds in 1 month.

Tips: "I characterize the work we show as Fine Art for the *Non*-McMainstream. We are always interested in seeing new work. We look for a strong body of work and when considering emerging artists we inquire about the artist's willingness to financially commit to their promotion. We prefer a website rather than slides. When sending slides, always include a SASE."

⟨N⟩ JOJUMA GALLERY, 919 Davidson Dr., Roswell NM 88201. (505)622-2921. E-mail: johnlbower919 @yahoo.com. Retail gallery. Estab. 1998. Represents emerging and mid-career artists.

● This gallery is in the process of being reorganized.

Media: Considers all media.

Style: Exhibits all styles and all genres. "We look for diversity in style and type."

Terms: Gallery provides promotions. Insurance provided by the artist.

Submissions: Write or e-mail for new submission guidelines and prospectus brochures for competitive exhibits.

⟨N⟩ JONSON GALLERY, UNIVERSITY OF NEW MEXICO, 1909 Las Lomas NE, Albuquerque NM 87131-1416. Alternative space, museum and nonprofit gallery. Estab. 1950. Approached by 20-30 artists/year. Represents emerging and mid-career artists. Exhibited artists include: Raymond Jonson (oil/acrylic on canvas/masonite). Sponsors 6-8 exhibits/year. Average display time 6 weeks. Open all year; Tuesday-Friday, 9-4. Closed Christmas through New Years. Clients include local community, students and tourists. Overall price range: $150-15,000; most work sold at $3,000-4,000.

Media: Considers acrylic, ceramics, collage, drawing, fiber, glass, installation, mixed media, oil, paper, pastel, pen & ink, sculpture, watercolor, engravings, etchings, linocuts, lithographs, mezzotints, serigraphs and woodcuts. Most frequently exhibits painting, mixed media and works on paper.

Style: Exhibits: conceptualism, geometric abstraction, minimalism and postmodernism. Most frequently exhibits conceptual, postmodernism and geometric abstraction.

Terms: Artwork is accepted on consignment and there is a 20% commission. Retail price set by dealer. Gallery provides insurance and promotion. Accepted work should be framed. Does not require exclusive representation locally.

Submissions: Write to arrange a personal interview to show portfolio of photographs, slides, transparencies and originals. Send query letter with artist's statement, bio, brochure, business card, photocopies, photographs, résumé, reviews, SASE and slides. Responds in 1 week. Files slides, bios, CVs, reviews of artists' works in exhibitions. Finds artists through word of mouth, submissions, art exhibits and referrals by other artists.

Tips: Submit a viable exhibition proposal.

☑ **NEDRA MATTEUCCI GALLERIES**, 1075 Paseo De Peralta, Santa Fe NM 87501. (505)982-4631. Website: www.matteucci.com. **Director of Advertising/Public Relations:** Alex Hanna. For-profit gallery. Estab. 1972. Approached by 20 artists/year. Represents 100 established artists. Exhibited artists include: Dan Ostermiller and Glenna Goodacre. Sponsors 3-5 exhibits/year. Average display time 1 month. Open all year; Monday-Saturday, 8:30-5. Clients include upscale.

Media: Considers ceramics, craft, drawing, oil, pen & ink, sculpture and watercolor. Most frequently exhibits oil, watercolor and bronze sculpture.

Style: Exhibits: impressionism. Most frequently exhibits impressionism, modernism and realism. Genres include Americana, figurative work, landscapes, portraits, Southwestern, Western and wildlife.

Terms: Artwork is accepted on consignment and there is a 50% commission. Retail price set by the gallery and the artist. Gallery provides insurance and promotion. Does not require exclusive representation locally.
Submissions: Write to arrange a personal interview to show portfolio of transparencies. Send query letter with bio, photographs and résumé.

MAYANS GALLERIES, LTD., 601 Canyon Rd., Santa Fe NM 87501; also at Box 1884, Santa Fe NM 87504. (505)983-8068. Fax: (505)982-1999. E-mail: arte4@aol.com. Website: www.artnet.com/mayans.html. **Contact:** Ernesto Mayans. Retail gallery and art consultancy. Estab. 1977. Represents 10 emerging, mid-career and established artists. Sponsors 2 solo and 2 group shows/year. Average display time 1 month. Clientele: 80% private collectors, 20% corporate clients. Overall price range: $350 and up; most work sold at $500-7,500.
Media: Considers oil, acrylic, watercolor, pastel, pen & ink, drawings, mixed media, sculpture, photography and original handpulled prints. Most frequently exhibits oil, photography, and lithographs.
Style: Exhibits 20th century American and Latin American art. Genres include landscapes and figurative work.
Terms: Accepts work on consignment. Retail price set by gallery and artist. Exclusive area representation required.
Submissions: Send query letter (or e-mail first), résumé, business card and SASE. Discourages the use of slides. Prefers 2 or 3 snapshots or color photocopies which are representative of body of work. Files résumé and business card.
Tips: "Currently seeking contemporary figurative work and still life with strong color and technique. Gallery space can accomodate small-scale work comfortably."

LYNNE WHITE'S SHRIVER GALLERY, 401 Paseo Del Pueblo Norte, Taos NM 87571. (505)758-4994. Fax: (505)758-8996. E-mail: shriver@newmex.com. Website: www.shrivergallery.com. **Owner/Director:** Lynne White. Art consultancy and for-profit gallery. Estab. 1970. Approached by 30 artists/year. Exhibits 30 established artists. Exhibited artists include: Star Liana York, bronze sculpture; Walt Gonske, painting. Sponsors 4 exhibits/year. Average display time 3 weeks. Open all year; Monday-Saturday, 10-5, Clients include local community, tourists and upscale. Overall price range: $1,000-70,000; most work sold at $5,000.
Media: Most frequently exhibits oils, bronze and watercolor.
Style: Exhibits: expressionism and impressionism. Most frequently exhibits representational, photorealistic, impressionistic. Genres include florals, landscapes and Southwestern.
Terms: Retail price set by the artist. Gallery provides insurance, promotion and contract. Accepted work should be framed. Does not require exclusive representation locally.
Submissions: Write to arrange a personal interview to show portfolio of photographs, slides and transparencies. Send query letter with artist's statement, bio, brochure, photographs, résumé, reviews, SASE and slides. Returns material with SASE. Responds in 1 week. Files bio, statement, and photocopies of photos (a few). Finds artists through word of mouth, portfolio reviews, art exhibits and referrals by other artists.
Tips: Do not just drop in! Any packet with all necessary components is professional.

New York

ADIRONDACK LAKES CENTER FOR THE ARTS, Route 28, Blue Mountain Lake NY 12812. (518)352-7715. E-mail: alca@telenet.net. **Director:** Ellen C. Bütz. Nonprofit gallery in multi-arts center. Estab. 1967. Represents 107 emerging, mid-career and established artists/year. Sponsors 6-8 summer shows/year. Average display time 1 month. Open Monday-Friday, 10-4; July and August daily. Located on Main Street next to post office; 176 sq. ft.; "pedestals and walls are white, some wood and very versatile." Clients include tourists, summer owners and year-round residents. 90% of sales are to private collectors, 10% corporate collectors. Overall price range: $100-10,000; most work sold at $100-1,000.
Media: Considers all media and all types of prints. Most frequently exhibits paintings, sculpture, wood and fiber arts.
Style: Exhibits all styles. Genres include landscapes, Americana, wildlife and portraits. Prefers landscapes, wildlife and folk art/crafts (quilts).
Terms: Accepts work on consignment (30% commission). Retail price set by the artist. Gallery provides insurance, contract; shares promotion. Prefers artwork framed.
Submissions: Send query letter with slides or photos and bio. Annual submission deadline November 1; selections complete by February 1. Files "slides, photos and bios on artists we're interested in." Reviews submissions once/year. Finds artists through word of mouth, art publications and artists' submissions.

Tips: "We love to feature artists who can also teach a class in their media for us. It increases interest in both the exhibit and the class."

N ART WITHOUT WALLS, INC., P.O. Box 341, Sayville NY 11782. (631)567-9418. Fax: (631-567-9418. E-mail: artwithoutwalls@webtv.net. **Contact:** Sharon Lippman, executive director. Nonprofit gallery. Estab. 1985. Approached by 300 artists/year. Represents 100 emerging, mid-career and established artists. Exhibited artists include: Tone aanderaa (painting), Yanka Cantor (sculpture) and Stephanie Isles (photogrpahy). Sponsors 10 exhibits/year. Average display time 1 month. Open all year; Sunday-Monday, 9-5. Closed December 22-January 5 and Easter week. Clients include students, upscale and emerging artists, Overall price range: $1,000-25,000; most work sold at $3,000-5,000.
Media: Considers all media and all types of prints. Most frequently exhibits painting, sculpture and drawing.
Style: Considers all styles and genres. Most frequently exhibits impressionism, expressionism, postmodernism.
Terms: Artwork is accepted on consignment and there is 20% commission. Retail price set by the artist. Gallery provides promotion and contract. Accepted work should be framed, mounted and matted.
Submissions: Mail portfolio for review. Send query letter with artist's statement, brochure, photographs, résumé, reviews, SASE and slides. Returns material with SASE. Responds in 1 month. Files artist résumé, slides, photos and artist's statement. Finds artists through submissions, portfolio reviews and art exhibits.
Tips: Work should be properly framed with name, year, medium, title and size.

N ARTISANITY, 26F Congress St., #160, Saratoga Springs NY 12866. Phone/fax: (518)884-2865. E-mail: info@artisanity.com. Website: www.artisanity.com. **Contact:** Michelle Paquette. For-profit gallery. Estab. 1997. Represents 30 emerging and mid-career artists. Exhibited artists include: Ann Diggory (oil and pastel) and Kelemen Kuatro (glass art). On-line gallery only. Overall price range: $30-1,500; most work sold at $250.
Media: Considers all media all types of prints except film, installation and posters.
Style: Considers all styles and genres.
Terms: Artwork is accepted on consignment and there is a 30% commission. Retail price by the artist. Gallery provides promotion and contract. Requires exclusive representation locally.
Submissions: Call to arrange a personal interview to show portfolio. Mail portfolio for review. Send query letter with artist's statement, bio, brochure, business card, photographs, résumé, reviews, SASE and slides. Responds in 2 months. Files artist statement, bio, résumé, brochure, reviews and business card. Finds artists through word of mouth, submissions, art exhibits, art fairs and referral by artists.

CHAPMAN ART CENTER GALLERY, Cazenovia College, Cazenovia NY 13035. (315)655-7162. Fax: (315)655-2190. Website: www.cazcollege.edu. **Director:** John Aistars. Nonprofit gallery. Estab. 1978. Interested in emerging, mid-career and established artists. Sponsors 8-9 shows/year. Average display time is 3 weeks. Clients include the greater Syracuse community. Overall price range: $50-3,000; most artwork sold at $100-200.
Media: Considers oil, acrylic, watercolor, pastel, pen & ink, drawings, sculpture, ceramic, fiber, photography, craft, mixed media, collage, glass and prints.
Style: Exhibits all styles. "Exhibitions are scheduled for a whole academic year at once. The selection of artists is made by a committee of the art faculty in early spring. The criteria in the selection process is to schedule a variety of exhibitions every year to represent different media and different stylistic approaches; other than that, our primary concern is quality. Artists are to submit to the committee by March 1 a set of slides or photographs and a résumé listing exhibitions and other professional activity."
Terms: Retail price set by artist. Exclusive area representation not required. Gallery provides insurance and promotion; works are usually not shipped.
Submissions: Send query letter, résumé, 10-12 slides or photographs.
Tips: A common mistake artists make in presenting their work is that the "overall quality is diluted by showing too many pieces. Call or write and we will mail you a statement of our gallery profiles."

N COURTHOUSE GALLERY, LAKE GEORGE ARTS PROJECT, 310 Canada St., Lake George NY 12845. (518)668-2616. Fax: (518)668-3050. E-mail: lgap@global2000.net. **Gallery Director:** Laura Von Rosk. Nonprofit gallery. Estab. 1986. Approached by 200 artists/year. Exhibits 10-15 emerging, mid-career and established artists. Sponsors 10-15 exhibits/year. Average display time 5-6 weeks. Open all year; Tuesday-Friday, 12-5; Saturday, 12-4. Closed mid-December to mid-January. Clients include local community, students, tourists and upscale. Overall price range: $100-5,000; most work sold at $500.
Media: Considers all media and all types of prints. Most frequently exhibits painting, mixed media and sculpture.
Style: Considers all styles and genres.

Terms: Artwork is accepted on consignment and there is a 25% commission. Retail price set by the artist. Gallery provides insurance, promotion and contract. Accepted work should be framed, mounted and matted.
Submissions: Write to arrange a personal interview to show portfolio of slides. Mail portfolio for review. Deadline always January 31st. Send query letter with artist's statement, bio, résumé, SASE and slides. Returns material with SASE. Responds in 2 months. Finds artists through word of mouth, submissions, portfolio reviews, art exhibits, art fairs and referrals by other artists.

N: SAMUEL DORSKY MUSEUM OF ART, SUNY New Paltz 75, S. Manheim Blvd., New Paltz NY 12561. (845)257-3844. Fax: (845)257-3854. E-mail: tragern@newpaltz.edu. Website: www.newpaltz.edu/museum. **Contact:** Nadine Wasserman, curator. Museum. Estab. 1964. Exhibits established artists. Average display time 2 months. Open all year; Tuesday-Friday, 12-4; weekends, 1-4. Closed holidays and school vacations. Includes 9,000 sq. ft. of exhibition space in 6 galleries. Clients include local community, students, tourists and upscale.
Media: Considers all media and all types of prints except posters. Most frequently exhibits photographs, prints and paintings.
Style: Considers all styles.
Submissions: Send query letter with bio and SASE. Returns material with SASE. Responds only if interested within 3 months. Finds artists through art exhibits.

N: EVERSON MUSEUM OF ART, 401 Harrison St., Syracuse NY 13202. (315)474-6064. Fax: (315)474-6943. E-mail: eversonadmin@everson.org. Website: www.everson.org. **Contact:** Tom Piché, curator. Museum. Estab. 1897. Approached by many artists/year. Represents 16-20 emerging artists. Exhibited artists include: Adelaide Alsop Robineau (ceramics) and Lynn Underhill (photography). Sponsors 22 exhibits/year. Average display time 3 months. Open all year; Tuesday-Friday, 12-5; Saturday, 10-5; Sunday, 12-5. Located in a distinctive I.M. Pei-designed building in downtown Syracuse NY. The museum features 4 large galleries with 24 ft. ceilings, back lighting and oak hardwood, a sculpture court, a children's gallery, a ceramic study center and 5 smaller gallery spaces.
Media: Considers all media. Most frequently exhibits painting, ceramics and works on paper.
Style: Considers all styles and genres. Most frequently exhibits contemporary work, realism and abstraction.
Submissions: Send query letter with artist's statement, bio, résumé, reviews, SASE and slides. Returns material with SASE. Responds in 3 months. If interested for future exhibition, files slides, résumé, bio, reviews and artist's statement. Finds artists through submissions, portfolio reviews and art exhibits.

GALLERY NORTH, 90 N. Country Rd., Setauket NY 11733. (516)751-2676. Fax: (516)751-0180. E-mail: gallerynorth@aol.com. Website: www.gallerynorth.usrc.net. **Director:** Colleen W. Hanson. Not-for-profit gallery. Estab. 1965. Exhibits the work of emerging, mid-career and established artists from Long Island. Sponsors 9 shows annually. Average display time 4-5 weeks. Open all year. Located 1 mile from the State University at Stony Brook; approximately 1,600 sq. ft.; "in a renovated Victorian house." 85% of space for special exhibitions. Clients include university faculty and staff, Long Island collectors and tourists. Overall price range: $100-25,000; most work sold at $1,500-2,500.
Media: Considers all media and original handpulled prints, frequent exhibits of paintings, prints and fine crafts, especially jewelry and ceramics.
Style: Prefers abstract and representational contemporary artists.
Terms: Accepts work on consignment (50% commission). Retail price set by gallery and artist. Gallery provides insurance, promotion and contract; shipping costs are shared. Requires well-framed artwork.
Submissions: Send query letter with résumé, slides, bio, SASE and reviews. Portfolio review requested if interested in artist's work. Portfolio should include framed originals. Responds in 1-2 months. Files slides and résumés when considering work for exhibition. Finds artists from other exhibitions, slides and referrals.
Tips: "If possible artists should visit to determine whether their work is compatible with overall direction of the gallery. A common mistake artists make is that slides are not fully labeled as to size medium, top and price."

N: CARRIE HADDAD HALLERY, 622 Warren St., Hudson NY 12534. (518)828-1915. Fax: (518)828-3341. E-mail: art@valstar.net. Website: www.carriehaddadgallery.com. **Owner:** Carrie Haddad. Art consultancy, nonprofit gallery. Estab. 1990. Approached by 50 artists/year. Exhibits 60 emerging, mid-career and established artists. Exhibited artists include: Jane Bloodgood-Abrams, oil; David Halliday, photography. Sponsors 8 exhibits/year. Average display time 5½ weeks. Open all year; Monday-Thursday, 11-5. Located on main street of Hudson; large, rambling space. Clients include local community, tourists and upscale. 10% of sales are to corporate collectors. Overall price range: $350-6,000; most work sold at $1,000.
Media: Considers all media except acrylic, craft, oil and paper. Considers all types of prints except posters.

Style: Exhibits: expressionism, impressionism and postmodernism. Most frequently exhibits representational landscapes. Genres include figurative work, landscapes and abstract.

Terms: Artwork is accepted on consignment and there is a 50% commission. Retail price set by the artist. Gallery provides insurance and promotion. Requires exclusive representation locally.

Submissions: Send query letter with bio, photocopies, photographs, SASE and price list. Returns material with SASE. Responds in 2 months. Files all materials if interested. Finds artists through word of mouth, submissions, art exhibits and referrals by other artists.

KIRKLAND ART CENTER, E. Park Row, P.O. Box 213 Clinton NY 13323-0213. (315)853-8871. Fax: (315)853-2076. E-mail: kacinc@dreamscape.com. **Contact:** Director. Nonprofit gallery. Estab. 1960. Interested in emerging, mid-career and established artists. Sponsors about 10 shows/year. Average display time is 5 weeks. Clients include general public and art lovers. 99% of sales are to private collectors, 1% corporate clients. Overall price range: $60-4,000; most artwork sold at $200-1,200.

Media: Considers oil, acrylic, watercolor, pastel, pen & ink, drawings, mixed media, collage, works on paper, sculpture, ceramic, craft, fiber, glass, installation, photography, performance art and original hand-pulled prints. Most frequently exhibits watercolor, oil/acrylic, prints, sculpture, drawings, photography and fine crafts.

Style: Exhibits: painterly abstraction, conceptualism, impressionism, photorealism, expressionism, realism and surrealism. Genres include landscapes, florals and figurative work.

Terms: Accepts work on consignment (25% commission). Retail price set by artist. Exclusive area representation not required. Gallery provides insurance, promotion and contract; artist pays for shipping.

Submissions: Send query letter, résumé, slides, slide list and SASE.

Tips: "Shows are getting very competitive—artists should send us slides of their most challenging work, not just what is most saleable. We are looking for artists who take risks in their work and display a high degree of both skill and imagination. It is best to call or write for instructions and more information."

⊞ LANDING GALLERY, 7956 Jericho Turnpike, Woodbury NY 11797. (516)364-2787. Fax: (516)364-2786. **President:** Bruce Busko. For-nprofit gallery. Estab. 1985. Approached by 40 artists/year. Exhibits 50 emerging, mid-career and established artists. Exhibited artists include: Bruce Busko, mixed media; Edythe Kane, watercolor. Sponsors 2 exhibits/year. Average display time 2-3 months. Open all year; Monday-Friday, 10-6; weekends 10-6. Closed Tuesdays. Located in the middle of Long Island's affluent North Shore communities, 30 miles east of New York City. 3,000 sq. ft. on 2 floors with 19 ft. ceilings. The brick building is on the corner of a major intersection. Clients include local community, tourists and upscale. 5% of sales are to corporate collectors. Overall price range: $100-12,000; most work sold at $1,500.

Media: Considers all media. Most frequently exhibits paintings, prints and sculpture. Considers engravings, etchings, lithographs, mezzotints and serigraphs.

Style: Considers all styles. Most frequently exhibits realism, abstract and impressionism. Considers figurative work, florals and landscapes.

Terms: Artwork is accepted on consignment and there is a 50% commission. Retail price set by the gallery. Gallery provides insurance, promotion and contract. Accepted work should be framed. Requires exclusive representation locally.

Submissions: Call to arrange a personal interview to show portfolio of photographs, slides and transparencies. Mail portfolio for review. Send query letter with artist's statement, bio, brochure, business card, photocopies, photographs, résumé, reviews, SASE and slides. Returns material with SASE. Responds in 2 weeks. Files photos, slides, photocopies and information. Finds artists through word of mouth, submissions, portfolio reviews, art exhibits, art fairs and referrals by other artists.

Tips: Permanence denotes quality and professionalism.

⊞ LEATHERSTOCKING GALLERY, 52 Pioneer St., P.O. Box 446, Cooperstown NY 13326. (607)547-5942. E-mail: drwells@hdpteam.com. (Gallery), (607)547-8044 (Publicity). **Publicity:** Dorothy V. Smith. Retail nonprofit cooperative gallery. Estab. 1968. Represents emerging, mid-career and established artists. 45 members. Sponsors 1 show/year. Average display time 3 months. Open in the summer (mid-June to Labor Day); daily 11-5. Located downtown Cooperstown; 300-400 sq. ft. 100% of space for gallery artists. Clients include varied locals and tourists. 100% of sales are to private collectors. Overall price range: $25-500; most work sold at $25-100.

Media: Considers oil, acrylic, watercolor, pastel, pen & ink, drawing, mixed media, collage, paper, sculpture, ceramics, craft, photography, handmade jewelry, woodcuts, engravings, lithographs, wood engravings, mezzotints, serigraphs, linocuts and etchings. Most frequently exhibits watercolor, oil and crafts.

Style: Exhibits: impressionism and realism, all genres. Prefers landscapes, florals and American decorative.

Terms: Co-op membership fee, a donation of time plus 10% commission. Retail price set by the artist. Gallery provides insurance, promotion and contract; artist pays shipping costs from gallery if sent to buyer. Prefers artwork framed.

Submissions: Accepts only artists from Otsego County; over 18 years of age; member of Leatherstocking Brush & Palette Club. Responds in 2 weeks. Finds artists through word of mouth locally; articles in local newspaper.

Tips: "We are basically non-judgmental (unjuried). You just have to live in the area!"

N MAXWELL FINE ARTS, 1204 Main St., Peekskill NY 10566-2606. (914)737-8622. Fax: (914)788-5310. E-mail: devitomax@aol.com. **Partner/Co-Director:** W.C. Maxwell. For-profit gallery. Estab. 2000. Approached by 25 artists/year. Exhibits 18 emerging and established artists. Exhibited artists include: Nadine Gordon-Taylor and Ed Radford. Sponsors 5-6 exhibits/year. Average display time 6 weeks. Open all year; Friday-Saturday, 12-5. Closed July/August. Located in Peekskill, NY downtown artist district; 800 sq. ft. in 1850s carriage house. Clients include local community and upscale. 10% of sales are to corporate collectors. Overall price range: $100-1,000; most work sold at $300.

Media: Considers acrylic, ceramics, collage, drawing, glass, mixed media, oil, paper, pastel, pen & ink, sculpture and watercolor. Most frequently exhibits paintings, drawings and prints. Considers all types of prints.

Style: Considers all styles and genres. Most frequently exhibits abstract, conceptual and representational.

Terms: Artwork is accepted on consignment and there is a 40% commission. Retail price set by the gallery in consultation with the artist. Gallery provides promotion. Accepted work should be framed. Does not require exclusive representation locally.

Submissions: Mail portfolio for review. Send query letter with artist's statement, bio, photocopies, résumé, SASE and slides. Returns material with SASE. Responds in 1 month. Files résumé and photos. Finds artists through word of mouth, submissions, art exhibits and referrals by other artists.

Tips: "Take a workshop on Business of Art."

N OXFORD GALLERY, 267 Oxford St., Rochester NY 14607. (716)271-5885. Fax: (716)271-2570. E-mail: info@oxfordgallery.com. Website: www.oxfordgallery.com. **Director:** Meghan M. Harrington. Retail gallery. Estab. 1961. Represents 70 emerging, mid-career and established artists. Sponsors 10 shows/year. Average display time 1 month. Open all year; Tuesday-Friday, 12-5; Saturday, 10-5; and by appointment. Located "on the edge of downtown; 1,000 sq. ft.; large gallery in a beautiful 1910 building." Overall price range: $100-30,000; most work sold at $1,000-2,000.

Media: Considers oil, acrylic, watercolor, pastel, pen & ink, drawings, mixed media, collage, paper, sculpture, ceramic, fiber, original handpulled prints, woodcuts, engravings, lithographs, wood engravings, mezzotints, serigraphs, linocuts and etchings.

Styles: All styles.

Terms: Accepts artwork on consignment (50% commission). Retail price set by gallery and artist. Gallery provides promotion and contract.

Submissions: Send query letter with résumé, slides, bio and SASE. Responds in 3 months. Files résumés, bios and brochures.

Tips: "Have professional slides done of your artwork. Have a professional résumé and portfolio. Do not show up unannounced and expect to show your slides. Either send in your information or call to make an appointment. An artist should have enough work to have a one-person show (20-30 pieces). This allows an artist to be able to supply more than one gallery at a time, if necessary. It is important to maintain a strong body of available work."

PRAKAPAS GALLERY, One Northgate 6B, Bronxville NY 10708. (914)961-5091. Fax: (914)961-5192. E-mail: eugeneprakapas@earthlink.net. Private dealers. Estab. 1976. Represents 50-100 established artists/year. Exhibited artists include: Leger and El Lissitsky. Located in suburbs. Clients include institutions and private collectors. Overall price range: $500-500,000.

Media: Considers all media with special emphasis on photography.

Style: Exhibits all styles. "Emphasis is on classical modernism, which does not encompass contemporary art."

Submissions: Finds artists through word of mouth, visiting art fairs and exhibitions. Does not consider unsolicited material.

☑ ROCHESTER CONTEMPORARY, (formerly Pyramid Arts Center), 137 East Ave., Rochester NY 14604. (585)461-2222. Fax: (585)461-2223. E-mail: info@rochestercontemporary.org. Website: www.rochestercontemporary.org. **Director:** Elizabeth McDade. Nonprofit gallery. Estab. 1977. Exhibits 200 emerging, mid-career and established artists/year. 400 members. Sponsors 12 shows/year. Average display time

2-6 weeks. Open 11 months. Business hours Wednesday-Friday, 10-5; gallery hours. Clients include artists, curators, collectors, dealers. 90% of sales are to private collectors, 10% corporate collectors. Overall price range: $25-15,000; most work sold at $40-500.

• Gallery strives to create a forum for challenging, innovative ideas and works.

Media: Considers all media, video, film, dance, music, performance art, computer media; all types of prints including computer, photo lithography.

Style: Exhibits all styles and genres.

Terms: During exhibition a 25% commission is taken on sold works. Retail price set by the artist. Gallery provides insurance, promotion and contract; shipping costs are shared, "depending upon exhibition, funding and contract." Prefers artwork framed.

Submissions: Includes regional national artists and alike in thematic solo/duo exhibitions. Send query letter with résumé and slides. Call for appointment to show portfolio of originals and slides. "We have a permanent artist archive for slides, bios, résumés and will keep slides in file if artist requests." Finds artists through national and local calls for work, portfolio reviews and studio visits.

Tips: "Present slides that clearly and accurately reflect your work. Label slides with name, title, medium and dimensions. Be sure to clarify intent and artistic endeavor. Proposals should simply state the artist's work. Documentation should be accompanied by clear, concise script."

N **BJ SPOKE GALLERY**, 299 Main St., Huntington NY 11743. (631)549-5106. Cooperative and non-profit gallery. Estab. 1978. Exhibits the work of 24 emerging, mid-career and established artists. Sponsors 2-3 invitationals and juried shows/year. Average display time 1 month. Open all year. "Located in center of town; 1,400 sq. ft.; flexible use of space—3 separate gallery spaces." Generally, 66% of space for special exhibitions. Overall price range: $300-2,500; most work sold at $900-1,600. Artist is eligible for a 2-person show every 2 years. Entire membership has ability to exhibit work 11 months of the year.

• Sponsors annual national juried show. Deadline December. Send SASE for prospectives.

Media: Considers all media except crafts, all types of printmaking. Most frequently exhibits paintings, prints and sculpture.

Style: Exhibits all styles and genres. Prefers painterly abstraction, realism and expressionism.

Terms: Co-op membership fee plus donation of time (25% commission). Monthly fee covers rent, other gallery expenses. Retail price set by artist. Payment by installment is available. Gallery provides promotion and publicity; artists pay for shipping. Prefers artwork framed; large format artwork can be tacked.

Submissions: For membership, send query letter with résumé, high-quality slides, bio, SASE and reviews. For national juried show send SASE for prospectus and deadline. Call or write for appointment to show portfolio of originals and slides. Files résumés; may retain slides for awhile if needed for upcoming exhibition.

Tips: "Send slides that represent depth and breadth in the exploration of a theme, subject or concept. They should represent a cohesive body of work."

N **VISUAL STUDIES WORKSHOP GALLERIES**, 31 Prince St., Rochester NY 14607. (716)442-8676. Fax: (716)442-1992. E-mail: gallery@vsw.org. Website: vsw.org. Alternative space, nonprofit gallery. Estab. 1971. Approached by 100 artists/year. Represents 20 emerging and mid-career artists. Sponsors 1-2 exhibits/year. Average display time 6-8 weeks. Open all year; Tuesday-Saturday, 12-5. Closed late summer/August. Located in a large old school building/third floor with 30-40 ft. cathedral ceilings; 2,300 sq. ft. in main gallery, 600 sq. ft. gallery 31. Clients include local community, students and tourists. Overall price range: $200-3,000; most work sold at $500.

Media: Considers mixed media and all types of prints.

Style: Exhibits: conceptualism, minimalism, postmodernism and conceptual.

Terms: Artwork is accepted on consignment and there is a 40% commission. Retail price set by the gallery and the artist. Gallery provides insurance. Accepted work should be framed, mounted and matted. Does not require exclusive representation locally.

Submissions: Write to arrange a personal interview to show portfolio of photographs. Mail portfolio for review. Send query letter with photographs, résumé and SASE. Returns material with SASE. Responds in 2 months. Finds artists through word of mouth, submissions, portfolio reviews, art exhibits and referrals by other artists.

Tips: Submit a letter explaining project, etc. copy prints, slides, résumé, and evidence that they have researched the gallery.

New York City

N **AGORA GALLERY**, 415 W. Broadway, Suite 55, New York NY 10012. (212)226-4151, ext. 206. Fax: (212)966-4380. E-mail: Angela@Agora-Gallery.com. Website: www.Agora-Gallery.com. **Director:** Angela DiBello. For-profit gallery. Estab. 1984. Approached by 1,500 artists/year. Exhibits 100 emerging,

mid-career and established artists. Sponsors 12 exhibits/year. Average display time 3 weeks. Open all year; Tuesday-Saturday, 12-6; weekends, 12-6. Closed national holidays. Located in Soho between Prince and Spring; 2,000 sq. ft. of exhibition space, landmark building; elevator to gallery, exclusive gallery block. Clients include upscale. 10% of sales are to corporate collectors. Overall price range: $550-10,000; most work sold at $2,500.

Media: Considers acrylic, collage, drawing, mixed media, oil, paper, pastel, pen & ink, sculpture, watercolor, engravings, etchings, linocuts, lithographs, mezzotints and woodcuts.

Style: Considers all styles.

Terms: There is a membership fee. There is a 35% commission to the gallery. Retail price set by the gallery and the artist. Gallery provides insurance and promotion. Accepted work should be framed, mounted and matted. Does not require exclusive representation locally.

Submissions: Mail portfolio for review. Send artist's statement, bio, brochure, photographs, reviews if available, SASE and slides. Responds in 3 weeks. Files bio, slides/photos and artist statement. Finds artists through word of mouth, submissions, portfolio reviews, art exhibits, referrals by other artists and website links.

Tips: "Follow instructions!" All materials must be archival quality.

N THE ARSENAL GALLERY, The Arsennal Bldg., Central Park, New York NY 10021. (212)360-8163. Fax: (212)360-1329. E-mail: adrian.sas@parks.nyc.gov. Website: www.nyc.gov/parks. **Public Art Curator:** Adrian Sas. Nonprofit gallery. Estab. 1971. Approached by 100 artists/year. Exhibits 8 emerging, mid-career and established artists. Sponsors 10 exhibits/year. Average display time 1 month. Open all year; Monday-Friday, 9-5. Closed holidays and weekends. 100 linear feet of wall space on the 3rd floor of the Administrative Headquarters of the Parks Department located in Central Park. Clients include local community, students, tourists and upscale. Overall price range: $100-1,000.

Media: Considers all media and all types of prints except 3-dimensional work.

Style: Considers all styles. Genres include florals, landscapes and wildlife.

Terms: Artwork is accepted on consignment and there is a 15% commission. Retail price set by the artist. Gallery provides promotion. Does not require exclusive representation locally.

Submissions: Mail portfolio for review. Send query letter with artist's statement, bio, brochure, business card, photocopies, résumé, reviews and SASE. Returns material with SASE. Responds only if interested within 6 months. Riles résumé and photocopies. Finds artists through word of mouth, portfolio reviews, art exhibits and referrals by other artists.

Tips: Appear organized and professional.

ART DIRECTORS CLUB GALLERY, 106 W. 29th St., New York NY 10001. (212)643-1440. Fax: (212)643-4266. Website: www.adcny.org. **Executive Director:** Myrna Davis. Nonprofit gallery. Exhibits groups in the field of visual communications (advertising, graphic design, publications, art schools). Estab. 1920. Exhibits emerging and professional work; 10-12 shows/year. Average display time 1 month. Closed August; Monday-Friday, 10-6. Located in Flower Market district; 3,500 sq. ft.; 1 gallery street level. 100% of space for special exhibitions. Clients include professionals, students.

Media: Considers all media and all types of prints. Most frequently exhibits posters, printed matter, photos, paintings, digital media and 3-D objects.

Style: Genres include advertising, graphic design, publications, packaging, photography, illustration and interactive media.

Terms: The space is available by invitation and/or approved rental.

Submissions: Submissions are through professional groups. Group rep should send reviews and printed work. Responds within a few months.

N ARTISTS SPACE, 38 Greene St., 3rd Floor, New York NY 10013. (212)226-3970. Fax: (212)966-1434. Website: www.artistsspace.org. **Curator:** Lauri Firstenberg. Nonprofit gallery, alternative space. Estab. 1973. Exhibits emerging artists. Sponsors 4-5 shows/year. Average display time 6-8 weeks. Open Tuesday-Saturday, 1-6. Located in Soho; 5,000 sq. ft. 100% of space for special exhibitions.

Media: Considers all media.

Terms: "All curated shows selected by invitation." Gallery provides insurance and promotion.

Submissions: Send query letter with 10 slides and SASE. Portfolio should include slides.

Tips: "Choose galleries carefully, i.e., look at work represented and decide whether or not it is an appropriate venue."

N ATLANTIC GALLERY, 40 Wooster St., 4th Floor, New York NY 10013. Phone/fax: (212)219-3183. Website: atlantic.artshost.com. Cooperative gallery. Estab. 1974. Approached by 50 artists/year. Represents 40 emerging, mid-career and established artists. Exhibited artists include: Kate O'Toole (oil, acrylic, pastel) and Rober Rabinowitz (oil, pastel). Average display time 3 weeks. Open all year; Tuesday-

Saturday, 12-6. Closed August. Located in Soho—has kitchenette. Clients include local community, tourists and upscale. 2% of sales are to corporate collectors. Overall price range: $100-13,000; most work sold at $1,500-5,000.

Media: Considers acrylic, ceramics, collage, drawing, installation, mixed media, oil, paper, pastel, pen & ink, sculpture, watercolor, engravings, etchings, linocuts, lithographs, mezzotints and woodcuts. Most frequently exhibits watercolor, prints and oil.

Style: Considers all styles and genres. Most frequently exhibits landscape, abstractions and interiors.

Terms: Artwork is accepted on consignment and there is a 20% commission. There is a co-op membership fee plus a donation of time. There is a 10% commission. Rental fee for space covers 3 weeks. Retail price set by the artist. Gallery provides promotion and contract. Accepted work should be framed. Does not require exclusive representation locally. Prefers only East Coast.

Submissions: Call or write to arrange a personal interview to show portfolio of slides. Send query letter with artist's statement, bio, brochure, SASE and slides. Returns material with SASE. Responds in 2 weeks. Files only accepted work. Finds artists through word of mouth, submissions, art exhibits and referrals by other artists.

Tips: Submit an organized folder with slides, bio, and 3 pieces of actual work; if we respond with interest, we then review again.

⚇ BLUE MOUNTAIN GALLERY, 530 W. 25th St., New York NY 10001. (646)486-4730. Fax: (646)486-4345. Website: www.artincontext.org/new_york/blue_mountain_gallery/. **Director:** Marcia Clark. Artist-run cooperative gallery. Estab. 1980. Exhibits 33 mid-career artists. Sponsors 13 solo and 1 group shows/year. Display time is 3 weeks. "We are located on the 4th floor of a building in Chelsea. We share our floor with two other well-established cooperative galleries. Each space has white partitioning walls and an individual floor-plan." Clients include art lovers, collectors and artists. 90% of sales are to private collectors, 10% corporate clients. Overall price range: $100-8,000; most work sold at $100-4,000.

Media: Considers painting, drawing and sculpture.

Style: "The base of the gallery is figurative but we show work that shows individuality, commitment and involvement with the medium."

Terms: Co-op membership fee plus donation of time. Retail price set by artist. Exclusive area representation not required. Gallery provides insurance, some promotion and contract; artist pays for shipping.

Submissions: Send name and address with intent of interest and sheet of 20 good slides. "We cannot be responsible for material return without SASE." Finds artists through artists' submissions and referrals.

Tips: "This is a cooperative gallery: it is important to represent artists who can contribute actively to the gallery. We look at artists who can be termed local or in-town more than out-of-town artists and would choose the former over the latter. The work should present a consistent point of view that shows individuality. Expressive use of the medium used is important also."

BROOKLYN BOTANIC GARDEN—STEINHARDT CONSERVATORY GALLERY, 1000 Washington Ave., Brooklyn NY 11225. (718)623-7200. Fax: (718)622-7839. E-mail: anitajacobs@bbg.org. Website: www.bbg.org. Director of Public Programs: Anita Jacobs. Nonprofit botanic garden gallery. Estab. 1988. Represents emerging, mid-career and established artists. 20,000 members. Sponsors 10-12 shows/ year. Average display time 4-6 weeks. Open all year; Tuesday-Sunday, 10-4. Located near Prospect Park and Brooklyn Museum; 1,200 sq. ft.; part of a botanic garden, gallery adjacent to the tropical, desert and temperate houses. Clients include BBG members, tourists, collectors. 100% of sales are to private collectors. Overall price range: $75-7,500; most work sold at $75-500.

Media: Considers all media and all types of prints. Most frequently exhibits watercolor, oil and photography.

Style: Exhibits all styles. Genres include landscapes, florals and wildlife.

Terms: Accepts work on consignment (20% commission). Retail price set by the artist. Gallery provides insurance, promotion and contract; artist pays shipping costs to and from gallery. Prefers artwork framed. Artists hang and remove their own shows.

Submissions: Work must have botanical, horticultural or environmental theme. Send query letter with résumé, slides, bio, brochure, photographs, SASE, business card and reviews in May, June, July or August for review in September. Write for appointment to show portfolio of slides.

Tips: "Artists' groups contact me by submitting résumé and slides of artists in their group. We favor seasonal art which echoes the natural events going on in the garden. Large format, colorful works show best in our multi-use space."

⚇ CERES, 584 Broadway, Room 306, New York NY 10012. (212)226-4725. E-mail: ceresgallery@earthl ink.net. Website: www.ceresgallery.org. **Administrator:** Olive H. Kelsey. Women's cooperative and non-profit, alternative gallery. Estab. 1984. Exhibits the work of emerging, mid-career and established artists. 48 members. Sponsors 11-14 shows/year. Average display time 1 month. Open all year; Tuesday-Saturday,

12-6. Located in Soho, between Houston and Prince Streets; 2,000 sq. ft. 30% of space for special exhibitions; 70% of space for gallery artists. Clients include artists, collectors, tourists. 85% of sales are to private collectors, 15% corporate collectors. Overall price range, $300-10,000; most work sold at $350-1,200.

Media: All media considered.

Style: All genres. "Work concerning politics of women and women's issues; although *all* work will be considered, still strictly women's co-op."

Terms: Co-op membership fee plus donation of time. Retail price set by artist. Gallery provides insurance; artists pays for shipping.

Submissions: Prefers women from tri-state area; "men may show in group/curated shows." Write with SASE for application. Responds in 1-3 weeks.

Tips: "Artist must have the ability to be a responsible gallery member and participant."

CITYARTS, INC., 525 Broadway, Suite 700, New York NY 10012. (212)966-0377. Fax: (212)966-0551. E-mail: tsipi@cityarts.org. Website: www.cityarts.org. **Executive Director:** Tsipi Ben-Haim. Art consultancy, nonprofit public art organization. Estab. 1968. Represents 1,000 emerging, mid-career and established artists. Produces 4-8 projects/year. Average display time varies. "A mural or public sculpture will last up to 15 years." Open all year; Monday-Friday, 10-5. Located in Soho; "the city is our gallery. CityArts's 200 murals are located in all 5 boroughs on NYC. We are funded by foundations, corporations, government and membership ('Friends of CityArts')."

Media: Considers oil, acrylic, drawing, sculpture, mosaic and installation. Most frequently exhibits murals (acrylic), mosaics and sculpture.

Style: Produces all styles and all genres depending on the site.

Terms: Artist receives a flat commission for producing the mural or public art work. Retail price set by the gallery. Gallery provides insurance, promotion, contract, shipping costs.

Submissions: "We prefer New York artists due to constant needs of a public art work created in the city." Send query letter with SASE. Call for appointment to show portfolio of originals, photographs and slides. Responds in 1 month. "We reply to original query with an artist application. Then it depends on commissions." Files application form, résumé, slides, photos, reviews. Finds artists through recommendations from other art professionals.

Tips: "We look for artists who are dedicated to making a difference in people's lives through art, working in collaboration with schools and community members."

CORPORATE ART PLANNING INC., 27 Union Square W., Suite 407, New York NY 10003. (212)242-8995. Fax: (212)242-9198. **Principal:** Maureen McGovern. Fine art exhibitors, virtual entities. Estab. 1986. Represents 2 illustrators, 2 photographers, 5 fine artists (includes 1 sculptor). Guidelines available for #10 SASE. Markets include: advertising agencies; corporations/client direct; design firms; editorial/magazines; publishing/books; architects; art publishers; corporate collections; private collections. Represents: Richard Rockwell and Alberto Allegri.

• Corporate Art Planning is not a physical art space, but requested to be in the Gallery section.

Handles: Fine art only.

Terms: Consultant receives 15%. Advertising costs are split: 50% paid by talent; 50% paid by representative. For promotional purposes, prefers all artists have museum connections and professional portfolios. Advertises in *Creative Black Book*, *The Workbook*, *Art in America*.

How to Contact: Responds in 15 days. After initial contact, write to schedule an appointment for portfolio review. Portfolio should include color photocopies only (nonreturnable).

THOMAS ERBEN GALLERY, 516 W. 20th St., New York NY 10011. (212)645-8701. Fax: (212)941-4158. E-mail: info@thomaserben.com. Website: www.thomaserben.com. For-profit gallery. Estab. 1996. Approached by 100 artists/year. Represents 15 emerging, mid-career and established artists. Exhibited artists include: Preston Scott Cohen (architecture) and Tom Wood (photography). Average display time 5-6 weeks. Open all year; Tuesday-Saturday, 10-6. Closed Christmas/New Year's and August. Clients include local community, tourists and upscale.

Media: Considers all media. Most frequently exhibits photography, paintings and installation.

Style: Exhibits: contemporary art.

Submissions: Mail portfolio for review. Returns material with SASE. Responds in 1 month.

STEPHEN E. FEINMAN FINE ARTS LTD., 448 Broome St., New York NY 10012. (212)925-1313. E-mail: sef29@aol.com. **Contact:** S.E. Feinman. Retail/wholesale gallery. Estab. 1972. Represents 20 emerging, mid-career and established artists/year. Exhibited artists include: Mikio Watanabe, Johnny Friedlaender, Andre Masson, Felix Sherman, Nick Kosciuk, Robert Trondsen and Miljenko Bengez. Sponsors 4-6 shows/year. Average display time 10 days. Open all year; Monday-Sunday, 12-6. Located in Soho;

1,000 sq. ft. 100% of space for gallery artists. Clients include prosperous middle-aged professionals. 90% of sales are to private collectors, 10% corporate collectors. Overall price range, $300-20,000; most work sold at $1,000-2,500.

Media: Considers oil, acrylic, watercolor, pastel, pen & ink, drawing, mixed media, sculpture, woodcuts, engravings, lithographs, mezzotints, serigraphs, linocuts and etchings. Most frequently exhibits mezzotints, aquatints and oils. Looking for artists that tend toward abstract-expressionists (watercolor/oil or acrylic) in varying sizes.

Style: Exhibits representational, painterly abstraction and surrealism, all genres. Prefers abstract, figurative and surrealist.

Terms: Mostly consignment but also buys outright for % of retail price (net 90-120 days). Retail price set by the gallery. Gallery provides insurance, promotion, contract and shipping costs from gallery; artist pays shipping costs to gallery. Prefers artwork unframed.

Submissions: Send query letter with résumé, slides and photographs. Responds in 3 weeks. No submissions by e-mail.

Tips: Currently seeking artists of quality who see a humorous bent in their works (sardonic, ironic) and are not pretentious. "Artists who show a confusing presentation drive me wild. Artists should remember that dealers and galleries are not critics. They are merchants who try to seduce their clients with aesthetics. Artists who have a chip on their shoulder or an 'attitude' are self-defeating. A sense of humor helps!"

FIRST STREET GALLERY, 526 W. 26th St., #915, New York NY 10001. (646)336-8053. Fax: (646)336-8054. E-mail: firststreetgallery@earthlink.net. Website: www.artincontext.org. or www.firststreetgallery.net. Contact: Members Meeting. Cooperative gallery. Estab. 1964. Represents emerging and mid-career artists. 30 members. Sponsors 10-13 shows/year. Average display time 1 month. Open Tuesday-Saturday, 11-6. Closed in August. 100% of space for gallery artists. Clients include collectors, consultants, retail. 50% of sales are to private collectors, 50% corporate collectors. Overall price range: $500-40,000; most work sold at $1,000-3,000.

Media: Considers oil, acrylic, watercolor, pastel, drawing, prints, sculpture. Considers prints "only in connection with paintings." Most frequently exhibits oil on canvas and works on paper.

Style: Exhibits: representational art. Genres include landscapes and figurative work. "First Street's reputation is based on showing representational art almost exclusively."

Terms: Co-op membership fee plus a donation of time (no commission). "We occasionally rent the space in August for $1,500-3,000." Retail price set by the artist. Artist pays shipping costs to and from gallery.

Submissions: Send query letter with résumé, slides, bio and SASE. "Artists' slides reviewed by membership at meetings once a month—call gallery for date in any month. We need to see original work to accept a new member." Responds in 1 month.

Tips: "Before approaching a gallery make sure they show your type of work. Physically examine the gallery if possible. Try to find out as much about the gallery's reputation in relation to its artists (many well-known galleries do not treat artists well). Show a cohesive body of work with as little paperwork as you can, no flowery statements, the work should speak for itself. You should have enough work completed in a professional manner to put on a cohesive-looking show."

FOCAL POINT GALLERY, 321 City Island, Bronx NY 10464. (718)885-1403. **Artist/Director:** Ron Terner. Retail gallery and alternative space. Estab. 1974. Interested in emerging and mid-career artists. Sponsors 2 solo and 6 group shows/year. Average display time 3-4 weeks. Clients include locals and tourists. Overall price range: $175-750; most work sold at $300-500.

Media: Most frequently exhibits photography. Will exhibit painting and etching and other material by local artists only.

Style: Exhibits all styles and genres. Prefers figurative work, landscapes, portraits and abstracts. Open to any use of photography.

Terms: Accepts work on consignment (30% commission). Exclusive area representation required. Customer discounts and payment by installment are available. Gallery provides promotion. Prefers artwork framed.

Submissions: "Please call for submission information. Do not include résumés. The work should stand by itself. Slides should be of high quality."

Tips: "Be nice (personality helps.)"

N. GALE-MARTIN FINE ART, 134 Tenth Ave., New York NY 10011. (646)638-2525. Fax: (646)486-7457. For-profit gallery. Estab. 1993. Exhibits mid-career and established artists. Exhibited artists include: D. Hamilton, Caranda-Martin and Francine Tint. Average display time 5 weeks. Open all year; Tuesday-Saturday, 11-6. Closed August and Christmas week. Located on ground floor space on Tenth Ave. in the Chelsea art district of Manhattan; 2,200 sq. ft./sky lights. Clients include upscale. Overall price range: $2,500-150,000; most work sold at $15,000.

Media: Considers acrylic, drawing, oil and paper. Most frequently exhibits paintings of all types.

Style: Exhibits: neo-expressionism and painterly abstraction.

Terms: Artwork is accepted on consignment and there is a 50% commission. Retail price set by the gallery and the artist. Gallery provides insurance. Accepted work should be framed according to our specifications. Requires exclusive representation locally. "We do not accept emerting artists, will consider artists with a strong following only."

Submissions: Cannot return material. Responds only if interested within 3 months. Finds artists through word of mouth and referrals by other artists.

GALLERY HENOCH, 555 W. 25th St., New York NY 10001. (917)305-0003. Fax: (917)305-0018. E-mail: ghenoch@earthlink.net. Website: www.galleryhenoch.com. **Assistant Director:** Jennifer Argenta. Retail gallery. Estab. 1983. Represents 20 emerging and mid-career artists. Exhibited artists include Burton Silverman and Popliteo. Sponsors 10 shows/year. Average display time 3 weeks. Closed August. Located in Chelsea; 4,000 sq. ft. 50% of space for special exhibitions. 95% of sales are to private collectors, 5% corporate clients. Overall price range: $1,000-90,000; most work sold at $10,000.

Media: Considers oil, acrylic, watercolor, pastel, pen & ink, drawings, and sculpture. Most frequently exhibits painting, sculpture, drawings and watercolor.

Style: Exhibits: realism. Genres include still life, cityscapes and figurative work. Prefers landscapes, cityscapes and still lifes.

Terms: Accepts work on consignment (50% commission). Retail price set by the artist. Gallery provides insurance and promotion; shipping costs are shared. Prefers artwork framed.

Submissions: Send query letter with 12-15 slides, bio and SASE. Portfolio should include slides and transparencies. Responds in 2 weeks.

Tips: "We suggest artists be familiar with the kind of work we show and be sure their work fits in with our styles."

GALLERY JUNO, 568 Broadway, Suite 604B, New York NY 10012. (212)431-1515. Fax: (212)431-1583. **Gallery Director:** June Ishihara. Retail gallery, art consultancy. Estab. 1992. Represents 18 emerging artists/year. Exhibited artists include: Pierre Jacquemon, Kenneth McIndoe and Otto Mjaanes. Sponsors 8 shows/year. Average display time 6 weeks. Open all year; Tuesday-Saturday, 11-6. Located in Soho; 1,000 sq. ft.; small, intimate space. 50% of space for special exhibitions; 50% of space for gallery artists. Clients include corporations, private, design. 20% of sales are to private collectors, 80% corporate collectors. Overall price range: $600-10,000; most work sold at $2,000-5,000.

Media: Considers oil, acrylic, watercolor, pastel, pen & ink, drawing, mixed media. Most frequently exhibits painting and works on paper.

Style: Exhibits: expressionism, neo-expressionism, painterly abstraction, pattern painting and abstraction. Genres include landscapes. Prefers: contemporary modernism and abstraction.

Terms: Accepts work on consignment (50% commission). Retail price set by the gallery and the artist. Gallery provides insurance and promotion; artist pays shipping costs. Prefers artwork framed.

Submissions: Send query letter with résumé, slides, bio, photographs, SASE, business card and reviews. Write for appointment to show portfolio of originals, photographs and slides. Responds in 3 weeks. Files slides, bio, photos, résumé. Finds artists through visiting exhibitions, word of mouth and submissions.

GALLERY 10, 7 Greenwich Ave., New York NY 10014. (212)206-1058. E-mail: marcia@gallery10.com. Website: www.gallery10.com. **Director:** Marcia Lee Smith. Retail gallery. Estab. 1972. Open all year. Represents approximately 150 emerging and established artists. 100% of sales are to private collectors. Overall price range: $24-1,000; most work sold at $50-300.

Media: Considers ceramic, craft, glass, wood, metal and jewelry.

Style: "The gallery specializes in contemporary American crafts."

Terms: Accepts work on consignment (50% commission); or buys outright for 50% of retail price (net 30 days). Retail price set by gallery and artist.

Submissions: Call or write for appointment to show portfolio of originals, slides, transparencies or photographs.

N SANDRA GERING GALLERY, 534 W. 22nd St., New York NY 10011. (646)336-7183. Fax: (646)336-7185. E-mail: sandra@geringgallery.com. Website: www.geringgallery.com. **Associate Director:** Marianna Baer. For-profit gallery. Estab. 1991. Approached by 240 artists/year. Exhibits 12 emerging, mid-career and established artists. Exhibited artists include: John F. Simon, Jr., computer software panels; Matthew McCaslin, video and light sculpturesX. Sponsors 9 exhibits/year. Average display time 5 weeks. Open all year; Tuesday-Saturday, 10-6; weekends, 10-6. Located on ground floor; 600 sq. ft. of storefront space.

Media: Considers mixed media, oil, sculpture and hightech/digital. Most frequently exhibits computer-based work, electric (light) sculpture and video/DVD.

Style: Exhibits: geometric abstraction. Most frequently exhibits cutting edge.

Terms: Artwork is accepted on consignment.

Submissions: Send query letter with bio and photocopies. Cannot return material. Responds only if interested within 6 months. Finds artists through word of mouth, art exhibits, art fairs and referrals by other artists.

Tips: Most important is to research the galleries and only submit to those that are appropriate. Visit websites if you don't have acces to galleries.

N GOLDSTROM GALLERY, 560 Broadway, Suite 303, New York NY 10012 (212)941-9175. Fax: (212)274-8650. E-mail: mgoldst188@aol.com. **Owner:** Monique Goldstrom. Retail gallery. Estab. 1970. Represents 14 artists; emerging and established. Sponsors 15 solo and 4 group shows/year. Average display time 2-3 weeks. Located in SoHo, "in a clean, medium space in a good location." 90% of sales are to private collectors, 10% corporate clients. Overall price range: $650-300,000.

Media: Considers oil, acrylic, drawings, mixed media, collage, works on paper, sculpture, ceramic and photography.

Style: Exhibits all styles and genres, both emerging artists and secondary market.

Terms: Accepts work on consignment (50% commission) or buys outright (50% retail price). Retail price set by gallery and artist. Exclusive area representation required.

Submissions: Send query letter with well-marked, clear slides and SASE. Responds in 1 month. All material is returned if not accepted or under consideration.

Tips: "Please come into gallery, look at our stable of work, and see first if your work fits our aesthetic."

O.K. HARRIS WORKS OF ART, 383 W. Broadway, New York NY 10012. E-mail: okharris@okharris.com. Website: www.okharris.com. **Director:** Ivan C. Karp. Commercial exhibition gallery. Estab. 1969. Represents 55 emerging, mid-career and established artists. Sponsors 50 solo shows/year. Average display time 1 month. Open fall, winter, spring and early summer. "Four separate galleries for four separate one-person exhibitions. The back room features selected gallery artists which also change each month." 90% of sales are to private collectors, 10% corporate clients. Overall price range: $50-250,000; most work sold at $12,500-100,000.

Media: Considers all media. Most frequently exhibits painting, sculpture and photography.

Style: Exhibits: realism, photorealism, minimalism, abstraction, conceptualism, photography and collectibles. Genres include landscapes, Americana but little figurative work. "The gallery's main concern is to show the most significant artwork of our time. In its choice of works to exhibit, it demonstrates no prejudice as to style or materials employed. Its criteria demands originality of concept and maturity of technique. It believes that its exhibitions have proven the soundness of its judgment in identifying important artists and its pertinent contribution to the visual arts culture."

Terms: Accepts work on consignment (50% commission). Retail price set by gallery. Customer discounts and payment by installment are available. Exclusive area representation required. Gallery provides insurance and limited promotion. Prefers artwork ready to exhibit.

Submissions: Send query letter with 1 sheet of slides (20 slides) "labeled with size, medium, etc." and SASE. Responds in 1 week.

Tips: "We suggest the artist be familiar with the gallery's exhibitions and the kind of work we prefer to show. Visit us either in person or online at www.okharris.com. Always include SASE." Common mistakes artists make in presenting their work are "poor, unmarked photos (size, material, etc.), submissions without return envelope, inappropriate work. We affiliate about one out of 10,000 applicants."

JEANETTE HENDLER, 55 E. 87th St., Suite 15E, New York NY 10128. (212)860-2555. Fax: (212)360-6492. Art consultancy. Represents/exhibits mid-career and established artists. Exhibited artists include: Warhol, Johns and Haring. Open all year by appointment. Located uptown. 50% of sales are to private collectors, 50% corporate collectors.

Media: Considers oil and acrylic. Most frequently exhibits oils, acrylics and mixed media.

Style: Exhibits: Considers all styles. Genres include landscapes, florals, figurative and Latin. Prefers: realism, classical, neo classical, pre-Raphaelite, still lifes and florals.

Terms: Artwork is accepted on consignment and there is a commission. Retail price set by the gallery and the artist. Gallery provides insurance, promotion and contract.

Submissions: Finds artists through word of mouth, referrals by other artists, visiting art fairs and exhibitions.

N HENRY STREET SETTLEMENT/ALBIONS ART CENTER, 466 Grand St., New York NY 10002. (212)598-0400. Fax: (212)505-8329. Website: www.henrystreetart.org. **Visual Arts Coordinator:**

Kirstin Bronssard. Alternative space, nonprofit gallery and community center. Estab. 1970. Approached by 100s of artists/year. Exhibits 30-100 emerging, mid-career and established artists. Exhibited artists include: Shirin Neshat, video and photography; Jeff Horsrane, painting. Sponsors 5-6 exhibits/year. Average display time 1-2 month. Open all year; Fridays, 10-6; weekends from 10-6. Closed major holidays and August. Located in lower east side; 2 galleries—1 large space upstairs—very basic white walls, large windows, smaller downstairs display case used as photography exhibition space. Clients include local community and students. Overall price range varies.

Media: Considers all media and all types of prints. Most frequently exhibits mixed media, sculpture and painting.

Style: Considers all styles and genres.

Terms: Artwork is accepted on consignment and there is a 10-20% commission. Gallery provides insurance, promotion and contract. Does not require exclusive representation locally.

Submissions: Send query letter with artist's statement, résumé and SASE. Returns material with SASE. Files résumés. Finds artists through word of mouth, submissions and referrals by other artists.

N ⯐ MICHAEL INGBAR GALLERY OF ARCHITECTURAL ART, 568 Broadway, New York NY 10012. (212)334-1100. **Curator:** Millicent Hathaway. Retail gallery. Estab. 1977. Represents 145 emerging, mid-career and established artists. Exhibited artists include: Richard Haas and Judith Turner. Sponsors 6 shows/year. Average display time 6 weeks. Open all year; Tuesday-Saturday, 12-6. Located in Soho; 1,000 sq. ft. 60% of sales are to private collectors, 40% corporate clients. Overall price range: $500-10,000; most work sold at $5,000.

Media: Considers all media and all types of prints. Most frequently exhibits paintings, works on paper and b&w photography.

Style: Exhibits: photorealism, realism and impressionism. Specializes in New York City architecture. Prefers: New York City buildings, New York City structures (bridges, etc.) and New York City cityscapes.

Terms: Artwork accepted on consignment (50% commission). Artists pays shipping costs.

Submissions: Accepts artists only from New York City metro area. Send query letter with SASE to receive "how to submit" information sheet. Responds in 1 week.

Tips: "Study what the gallery sells before you go through lots of trouble and waste their time. Be professional in your presentation." The most common mistakes artists make in presenting their work are "coming in person, constantly calling, poor slide quality (or unmarked slides) and not understanding how to price their work."

N INTAR HISPANIC AMERICAN ART CENTER, 508 W. 53rd St., New York NY 10019. (212)695-6135. Fax: (212)268-0102. **Gallery Curator:** Neyda Martinez. Nonprofit gallery. Estab. 1979. Exhibits emerging, mid-career, established artists. Sponsors 5-10 shows/year. Average display time 6 weeks. Open all year; Monday-Friday 12-6 or by appointment. Located midtown; 1,000 sq. ft. Publishes bilingual catalogs. Overall price range: $1,000-25,000.

Media: Considers oil, pen & ink, paper, acrylic, drawings, sculpture, watercolor, mixed media, ceramic, installation, pastel, collage, photography, woodcuts, linocuts, engravings, mezzotints, etchings, lithographs and serigraphs.

Style: Exhibits conceptualism, minimalism, hard-edge geometric abstraction, postmodern works and imagism.

Terms: Retail price set by artist. Gallery provides insurance, promotion, shipping costs to and from gallery. Prefers artwork framed.

Submissions: Accepts only artists from Latin America, Asian, Native and African-Americans. Send query letter with résumé, slides, reviews, bio and SASE. No portfolio reviews. Responds in 1 month.

JADITE GALLERIES, 413 W. 50th St., New York NY 10019. (212)315-2740. Fax: (212)315-2793. **Director:** Roland Sainz. Retail gallery. Estab. 1985. Represents 25 emerging and established, national and international artists. Sponsors 10 solo and 2 group shows/year. Average display time 3 weeks. Clientele: 80% private collectors, 20% corporate clients. Overall price range: $500-8,000; most artwork sold at $1,000-3,000.

Media: Considers oil, acrylic, watercolor, pastel, pen & ink, drawings, mixed media, collage, sculpture and original handpulled prints. Most frequently exhibits oils, acrylics, pastels and sculpture.

Style: Exhibits minimalism, postmodern works, impressionism, neo-expressionism, realism and surrealism. Genres include landscapes, florals, portraits, western collages and figurative work. Features mid-career and emerging international artists dealing with contemporary works.

Terms: Accepts work on consignment (40% commission). Retail price set by gallery and artist. Exclusive area representation not required. Gallery provides insurance, promotion and contract; exhibition costs are shared.

Submissions: Send query letter, résumé, brochure, slides, photographs and SASE. Call or write for appointment to show portfolio of originals, slides or photos. Resume, photographs or slides are filed.

[N] MADELYN JORDON FINE ART, 40 Cushman Rd., Scarsdale NY 10583. (914)472-4748. E-mail: mrjart@aol.com. Website: www.artnet.com/mjordon. **Contact:** Madelyn Jordon. Art consultancy, for-profit gallery. Estab. 1991. Approached by 50 artists/year. Exhibits 40 mid-career and established artists. Exhibited artists include: Ted Larsen and Derek Buckner. Clients include local community and upscale. 10% of sales are to corporate collectors. Overall price range: $500-20,000; most work sold at $3,000-5,000.
Media: Considers all media and all types of prints. Most frequently exhibits paintings, works on paper and sculpture.
Style: Considers all styles and genres.
Terms: Gallery provides insurance and promotion. Requires exclusive representation locally.
Submissions: Send artist's statement, bio, photographs, SASE or slides. Returns material with SASE.

[N] LIMNER GALLERY, 870 Avenue of the Americas, New York NY 10001. Phone/fax: (212)725-0999. E-mail: slowart@aol.com. Website: www.slowart.com. **Director:** Tim Slowinski. Limner Gallery is an artist-owned alternative retail (consignment) gallery. Estab. 1987. Represents emerging and mid-career artists. Hosts biannual exhibitions of emerging artists selected by competition, cash awards up to $1,000. Entry available for SASE or from website. Sponsors 6-8 shows/year. Average display time 3 weeks. Open Wednesday-Saturday, 12-6, July 15-August 30, by appointment. Located in Chelsea, 1,200 sq. ft.. 60-80% of space for special exhibitions; 20-40% of space for gallery artists. Clients include lawyers, real estate developers, doctors, architects. 95% of sales are to private collectors, 5% corporate collectors. Overall price range: $300-10,000.
Media: Considers all media, all types of prints except posters. Most frequently exhibits painting, sculpture and works on paper.
Style: Exhibits: primitivism, surrealism, all styles, postmodern works, all genres. "Gallery exhibits all styles but emphasis is on non-traditional figurative work."
Terms: Accepts work on consignment (50% commission). Retail price set by the gallery and the artist. Gallery provides promotion and contract; artist pays shipping costs to and from gallery. Prefers artwork framed.
Submissions: Send query letter with résumé, slides, bio and SASE. Call for appointment to show portfolio of originals, photographs, slides and transparencies. Responds in 3 weeks. Files slides, résumé. Finds artists through word of mouth, art publications and sourcebooks, submissions.
Tips: "Keep at least ten sets on slides out on review at all times."

THE MARBELLA GALLERY, INC., 28 E. 72nd St., New York NY 10021. (212)288-7809. **President:** Mildred Thaler Cohen. Retail gallery. Estab. 1971. Represents/exhibits established artists of the nineteenth century. . Exhibited artists include: The Ten and The Eight. Sponsors 1 show/year. Average display time 6 weeks. Open all year; Tuesday-Saturday, 11-5:30. Located uptown; 750 sq. ft. 100% of space for special exhibitions. Clients include tourists and upscale. 50% of sales are to private collectors, 10% corporate collectors, 40% dealers. Overall price range: $1,000-60,000; most work sold at $2,000-4,000.
Style: Exhibits: expressionism, realism and impressionism. Genres include landscapes, florals, Americana and figurative work. Prefers Hudson River, "The Eight" and genre.
Terms: Artwork is bought outright for a percentage of the retail price. Retail price set by the gallery. Gallery provides insurance.

[N] [I] MULTIPLE IMPRESSIONS, LTD., 128 Spring St., New York NY 10012. (212)925-1313. Fax: (212)431-7146. E-mail: info@multipleimpressions.com. Website: www.multipleimpressions.com. **President:** Elizabeth Feinman. Estab. 1972. Art gallery. Clients: young collectors, established clients, corporate, mature collectors.
Needs: Seeking creative art for the serious collector. Considers oil, watercolor, mixed media and printmaking. Prefers figurative, abstract, landscape. Approached by 300 artists/year. Works with 50 artists continuously. Seeks to promote at least one new emerging artist/year.
First Contact & Terms: Send or e-mail query letter with slides and transparencies. Samples are not filed and are returned by SASE. To show a portfolio, send transparencies. Pays flat fee. Offers advance when appropriate. Requires exclusive representation of artist in Manhattan market.

[N] NIKOLAI FINE ART, 505 W. 22nd St., New York NY 10011. (212)414-8511. Fax: (212)414-2763. E-mail: info@nikolaifineart.com. Website: www.nikolaifineart.com. For-profit gallery. Estab. 1999. Approached by 150 artists/year. Exhibits 20 emerging and established artists. Sponsors 3 exhibits/year. Average display time 2 months. Open all year; Tuesday-Saturday, 11-6; weekends, 11-6. Clients include local community, students, tourists and collectors. Overall price range: $1,500; most work sold at $2,000.

Media: Considers acrylic, collage, drawing, installation, mixed media, oil, paper, pastel, pen & ink, sculpture and watercolor. Considers all types of prints.

Style: Exhibits: conceptualism, geometric abstraction, minimalism, postmodernism and contemporary.

Terms: Artwork is accepted on consignment and there is a 50% commission. Retail price set by gallery and the artist. Gallery provides insurance, promotion and contract.

Submissions: Write to arrange a personal interview to show portfolio of slides. Send artist's statement and bio. Returns material with SASE. Responds in 3 weeks. Finds artists through word of mouth, submissions, portfolio reviews, art exhibits, art fairs and referrals by other artists.

N ANNINA NOSEI GALLERY, 530 W. 22nd St., 2nd Floor, New York NY 10011. (212)741-8695. Fax: (212)741-2379. Estab. 1983. Exhibits emerging artists. Exhibited artists include: Federico Uribe, sculptor; and Heidi McFall, works on paper. Open all year; Tuesday-Saturday, 11-6. Closed Christmas week and August. Located in Chelsea; includes 3 exhibition spaces. Clients include local community and upscale. Overall price range: $5,000-15,000; most work sold at $10,000.

Media: Considers all media. Most frequently exhibits paintings.

Style: Considers all styles and genres.

Submissions: Mail portfolio for review. Send query letter with artist's statement, reviews, SASE and slides.

N NURTUREART NON-PROFIT, INC., 160 Cabrini Blvd., Suite 134, New York NY 10033-1145. (212)795-5566. E-mail: gjrobins@erols.com. Website: www.nurtureart.org. **Executive Director:** George J. Robinson. Online art services organization. Estab. 1997. Approached by and exhibits 300 emerging and mid-career artists/year. Exhibited artists include: Robert Martinez, painting and works on paper. Sponsors 6 exhibits/year. Average display time 1 month. Open Monday-Friday, 10-6; Saturday, 11-5. Closed December 23-January 2; and July 1-August 31. Clients include local community, students, tourists and upscale. 25% of sales are to corporate collectors. Overall price range: $500-10,000; most work sold at $1,000-3,000.

Media: Considers all media except craft. Most frequently exhibits painting, work on paper and photography. Considers engravings, etchings, linocuts, lithographs, mezzotints and woodcuts.

Style: Considers all styles.

Terms: "Collector and artist are brought together for sale; if in commercial host venue, host new acts as host agent of sale for a commission. Retail price set by the artist. Gallery provides promotion and contract. Accepted work should be exhibition ready per prior discussion, agreement. Does not require exclusive representation locally. Accepts only artists over 21 years of age, who do not have ongoing gallery representation.

Submissions: Send artist's statement, bio, color photocopies, résumé, reviews, SASE and slides (required). Artist should inquire first via website; also by phone if in New York City ("we cannot return long-distance phone calls.") Finds artists through word of mouth, website, portfolio submissions, jurors, curators, portfolio reviews, art exhibits, referrals by other artists.

Tips: "Solicit experience of professionals (for instance, peers and artist reps)."

N BOSE PACIA MODERN, 508 W. 26th St., 11th Floor, New York NY 10001. (212)989-7074. Fax: (212)989-6982. E-mail: mail@bosepaciamodern.com. Website: www.bosepaciamodern.com. **Director:** Erik Wennermark. For-nprofit gallery. Estab. 1994. Approached by 100 artists/year. Exhibits 40 emerging and mid-career artists. Exhibited artists include: Jitish Kallat, mixed media/canvas; Arpita Singh, watercolor/paper, oil/canvas. Sponsors 8-10 exhibits/year. Average display time 5 weeks. Open all year; Tuesday-Saturday, 12-6; weekends, 12-6. Closed August and Christmas. Large gallery in building in Chelsea district of New York. Clients include local community and upscale. 5% of sales are to corporate collectors. Overall price range: $500-20,000; most work sold at $3,000.

Media: Considers acrylic, drawing, installation, mixed media, oil, paper, pastel, pen & ink, sculpture and watercolor. Most frequently exhibits oil/canvas, watercolor/paper. Considers all types of prints.

Style: Considers all styles and genres. Most frequently exhibits postmodernism, primitivism and neo-expressionism.

Terms: Artwork is accepted on consignment and there is a 50% commission. Retail price set by the gallery. Gallery provides promotion. Does not require exclusive representation locally. Accepts only artists from south Asia (India, Pakistan) also work influenced by region.

Submissions: Mail portfolio for review. Returns material with SASE. Responds only if interested within 1 month. Files portfolios. Finds artists through portfolio reviews and art exhibits.

Tips: "Simplify!"

N: THE PAINTING CENTER, 52 Greene St., New York NY 10013. Phone/fax: (212)343-1060. Website: www.thepaintingcenter.com. Nonprofit, cooperative gallery. Estab. 1993. Exhibits emerging mid-career and established artists. Open all year; Tuesday-Saturday, 11-6; weekends, 11-6. Closed Thanksgiving, Christmas/New Year's Day. Clients include local community, students, tourists and upscale.

Media: Considers acrylic, drawing, mixed media, oil, paper, pen & ink and watercolor. We only exhibit paintings, regardless the media or styles.

Style: Considers all styles and genres.

Terms: There is a 20% commission. Retail price set by the artist. Accepted work should be framed and mounted. Does not require exclusive representation locally.

Submissions: Mail portfolio for review. Send artist's statement, bio, résumé, SASE and slides. Returns material with SASE. responds in 8 months. Finds artists through word of mouth, submissions, art exhibits and referrals by other artists.

N: THE PHOENIX GALLERY, 568 Broadway, Suite 607, New York NY 10012. (212)226-8711. E-mail: info@phoenix-gallery.com. Website: www.gallery-guide.com/gallery/phoenix. **Director:** Linda Handler. Nonprofit gallery. Estab. 1958. Exhibits the work of emerging, mid-career and established artists. 32 members. Exhibited artists include: Gary Bauer and Pamela Flynn. Sponsors 10-12 shows/year. Average display time 1 month. Open fall, winter and spring. Located in Soho; 180 linear ft. "We are in a landmark building in Soho, the oldest co-op in New York. We have a movable wall which can divide the gallery into two large spaces." 100% of space for special exhibitions. 75% of sales are to private collectors, 25% corporate clients, also art consultants. Overall price range: $50-20,000; most work sold at $300-10,000.

 • In addition to providing a venue for artists to exhibit their work, the Phoenix Gallery also actively reaches out to the members of the local community, scheduling juried competitions, dance programs, poetry readings, book signings, plays, artists speaking on art panels and lectures. A special exhibition space, The Project Room, has been established for guest-artist exhibits.

Media: Considers oil, acrylic, watercolor, pastel, pen & ink, drawings, mixed media, collage, works on paper, sculpture, ceramic, photography, original handpulled prints, woodcuts, engravings, wood engravings, linocuts, etchings and photographs. Most frequently exhibits oil, acrylic and watercolor.

Style: Exhibits: painterly abstraction, minimalism, realism, photorealism, hard-edge geometric abstraction and all styles.

Terms: Co-op membership fee plus donation of time (25% commission). Retail price set by gallery. Offers customer discounts and payment by installment. Gallery provides promotion and contract; artist pays for shipping. Prefers artwork framed.

Submissions: Send query letter with résumé, slides and SASE. Call for appointment to show portfolio of slides. Responds in 1 month. Only files material of accepted artists. The most common mistakes artists make in presenting their work are "incomplete résumés, unlabeled slides and an application that is not filled out properly. We find new artists by advertising in art magazines and art newspapers, word of mouth, and inviting artists from our juried competition to be reviewed for membership."

Tips: "Come and see the gallery—meet the director."

QUEENS COLLEGE ART CENTER, Benjamin S. Rosenthal Library, Queens College/CUNY, Flushing NY 11367. (718)997-3770. Fax: (718)997-3753. E-mail: sbsqc@cunyvm.cuny.edu. Website: www.qc.edu/Library/art/artcenter.html. **Director:** Suzanna Simor. Curator: Alexandra de Luise. Nonprofit university gallery. Estab. 1955. Exhibits work of emerging, mid-career and established artists. Sponsors approximately 6 shows/year. Average display time 6 weeks. Open all year; when school is in session, hours are: Monday-Thursday, 10-8; Friday, 12-5. Call for summer and other hours. Located in borough of Queens; 1,000 sq. ft. The gallery is wrapped "Guggenheim Museum" style under a circular skylight in the library's atrium. 100% of space for special exhibitions. Clients include "college and community, some commuters." Nearly all sales are to private collectors. Overall price range: up to $10,000; most work sold at $300.

Media: Considers all media and all types of prints. Most frequently exhibits paintings, prints, drawings and photographs, smaller sculpture.

Style: Exhibits: Considers all styles.

Terms: Accepts work on consignment (40% commission). Retail price set by the artist. Gallery provides promotion. Artist pays for shipping costs, announcements and other materials. Prefers artwork framed.

Submissions: Cannot exhibit large 3-D objects. Send query letter with résumé, brochure, slides, photographs, reviews, bio and SASE. Responds in 3 weeks. Files all documentation.

Tips: "We are interested in high-quality original artwork by anyone. Please send sufficient information."

RAYDON GALLERY, 1091 Madison Ave., New York NY 10028. (212)288-3555. **Director:** Alexander R. Raydon. Retail gallery. Estab. 1962. Represents established artists. Sponsors 12 group shows/year. Clientele: tri-state collectors and institutions (museums). Overall price range: $100-100,000; most work sold at $1,800-4,800.

Media: Considers all media. Most frequently exhibits oil, prints and watercolor.

Style: Exhibits all styles and genres. "We show fine works of arts in all media, periods and schools from the Renaissance to the present with emphasis on American paintings, prints and sculpture." Interested in seeing mature works of art of established artists or artist's estates.

Terms: Accepts work on consignment or buys outright.

Tips: "Artists should present themselves in person with background back-up material (bios, catalogs, exhibit records and original work, slides or photos). Join local, regional and national art groups and associations for grants exposure, review, criticism and development of peers and collectors."

N: SCULPTURECENTER GALLERY, 44-19 Purves St., Long Island City NY 11101. (718)361-1750. Fax: (718)786-9336. E-mail: sculptur@interport.net. Website: www.interport.net/~sculptur. **Gallery Director:** Mary Cerudi. Alternative space, nonprofit gallery. Estab. 1928. Exhibits emerging and mid-career artists. Sponsors 8-10 shows/year. Average display time 3-4 weeks. Open September-June; Tuesday-Saturday, 11-5. 85% of space for gallery artists. 90% of sales are to private collectors, 10% corporate collectors. Overall price range: $100-100,000; most work sold at $200-3,000.

Media: Considers drawing, mixed media, sculpture and installation. Most frequently exhibits sculpture, installations and video installations.

Terms: Accepts work on consignment (25% commission). Retail price set by the gallery and the artist. Gallery provides promotion; artist pays shipping costs.

Submissions: Send query letter with résumé, 10-20 slides, bio and SASE. Call for appointment to show portfolio of photographs, slides and transparencies. Responds in 2 months. Files bios and slides. Finds artists through artists' and curators' submissions (mostly) and word of mouth.

N: ANITA SHAPOLSKY GALLERY, 152 E. 65th St., (patio entrance), New York NY 10021. (212)452-1094. Fax: (212)452-1096. E-mail: anitashap@aol.com. Website: www.artincontext.org/anita-shapolsky-gallery.html. For-profit gallery. Estab. 1982. Exhibits established artists. Exhibited artists include: Ernest Briggs, painting; Michael Loew, painting. Open all year; Wednesday-Saturday, 11-6. Call for summer hours. Clients include local community and upscale.

Media: Considers acrylic, collage, drawing, mixed media, oil, paper, pen & ink, sculpture, engravings, etchings, lithographs, serigraphs and woodcuts. Most frequently exhibits oil, acrylic and sculpture.

Style: Exhibits: expressionism and geometric abstraction and painterly abstraction. Genres include, 1950s abstract expressionism.

Terms: Prefers only 1950s abstract expressionism.

Submissions: Mail portfolio for review in May and October only. Send query letter with artist's statement, bio, SASE and slides. Returns material with SASE.

N: SYNCHRONICITY FINE ARTS, 106 W. 13th St., Ground Floor, New York NY 10011. (646)230-8199. Fax: (646)230-8198. E-mail: synchspa@bestweb.net. Website: www.synchronicityspace.com. Nonprofit gallery. Estab. 1989. Approached by several hundred artists/year. Exhibits 12-16 emerging and established artists. Exhibited artists include: Rosalyn Jacobs, oil on linen; Diana Postel, oil on linen; John Smith-Amato, oil on linen. Sponsors 6 exhibits/year. Average display time 1 month. Open all year; Tuesday-Saturday, 12-6. Closed in August for 2 weeks. Located in the heart of West Village—tree-lined street; 1,500 sq. ft; 8-9 ft. ceilings; all track/Halogen lighting. Clients include local community, students, tourists and upscale. 20% of sales are to corporate collectors. Overall price range: $1,500-10,000; most work sold at $3,000-5,000.

Media: Considers acrylic, collage, drawing, mixed media, oil, paper, pastel, pen & ink, sculpture, watercolor, engravings, etchings, mezzotints and woodcuts. Most frequently exhibits oil, sculpture and photography.

Style: Exhibits: color field, expressionism, impressionism, postmodernism and painterly abstraction. Most frequently exhibits semi-abstract and semi-representational abstract. Genres include figurative work, landscapes and portraits.

Terms: Alternative based upon existing funding resources. Retail price set by the gallery. Gallery provides insurance, promotion and contract. Accepted work should be framed, mounted and matted. Does not require exclusive representation locally. Only semi-abstract and semi-representational.

Submissions: Write to arrange a personal interview to show portfolio of photographs, slides and transparencies. Mail portfolio for review or make an appointment by phone. Send query letter with photocopies, photographs, résumé, SASE and slides. Returns material with SASE. Responds in 3 weeks. Files all unless artist requests return. Finds artists through submissions, portfolio reviews, art exhibits and referrals by other artists.

Tips: Include clear and accurate transparencies; cover letter; investigate gallery history to apply consistently with styles and type of work we show.

JOHN SZOKE EDITIONS, 591 Broadway, 3rd Floor, New York NY 10012. (212)219-8300. Fax: (212)966-3064. E-mail: info@johnszokeeditions.com. Website: www.johnszokeeditions.com. **President/ Director:** John Szoke. Retail gallery and art publisher. Estab. 1974. Represents 30 mid-career artists. Exhibited artists include Lichtenstein, Larry Rivers, Jim Dine and Jasper Johns. Publishes the work of Janet Fish, Peter Milton, Richard Haas and James Rizzi. Open all year. Located downtown in Soho. Clients include other dealers and collectors. 20% of sales are to private collectors.

 ● Not considering new artists at the present time.

Media: Exhibits works on paper, multiples in relief and intaglio and sculpture.

N **TIBOR DE NAGY GALLERY**, 724 Fifth Ave., New York NY 10019. (212)262-5050. Fax: (212)262-1841. **Directors:** Daniene Decker. Owners: Andrew H. Arnot and Eric Brown. Retail gallery. Estab. 1950. Represents emerging and mid-career artists. Exhibited artists include: Jane Freilicher, Estate of Nell Blaine, Robert Berlind, Gretna Campbell and Rudy Burckhardt. Sponsors 12 shows/year. Average display time 1 month. Closed August. Located midtown; 3,500 sq. ft. 100% of space for work of gallery artists. 60% private collectors, 40% corporate collectors. Overall price range: $1,000-100,000; most work sold at $5,000-20,000.

 ● The gallery focus is on painting within the New York school traditions and photography.

Media: Considers oil, pen & ink, paper, acrylic, drawings, sculpture, watercolor, mixed media, pastel, collage, etchings, and lithographs. Most frequently exhibits oil/acrylic, watercolor and sculpture.

Style: Exhibits representational work as well as abstract painting and sculpture. Genres include landscapes and figurative work. Prefers abstract, painterly realism and realism.

Submissions: Gallery is not looking for submissions at this time.

"U" GALLERY, 221 E. Second St., New York NY 10009. (212)995-0395. E-mail: saccadik@bellatlantic.n et. Website: www.ugallery.cjb.net. **Contact:** Darius. Alternative space, for-profit gallery, art consultancy and rental gallery. Estab. 1989. Approached by 100 artists/year. Represents 3 emerging, and established artists. Sponsors 2 exhibits/year. Open all year. Located in Manhattan; 800 sq. ft.

Media: Considers acrylic, drawing, oil, paper, pastel, sculpture and watercolor. Considers all types of prints.

Style: Exhibits: conceptualism, geometric abstraction, impressionism, minimalism and surrealism. Genres include figurative work, landscapes, portraits and wildlife.

Submissions: Write to arrange a personal interview to show portfolio of photographs and slides. Send query letter with artist's statement, photocopies, photographs and slides. Cannot return material. Finds artists through word of mouth and portfolio reviews.

N **ELAINE WECHSLER P.D.**, 245 W. 104th St., 5B, New York NY 10025. (212)222-4357. **Contact:** Elaine Wechsler. Art consultancy, private dealer. Estab. 1985. Represents emerging, mid-career and established artists/year. Open by appointment. Located uptown; 1,500 sq. ft.; pre-war suite—paintings hung as they would be in a home; art brokerage American painting: 1940s-1960s. Full catalog production/printing. Clientele: upscale. 80% private collectors, 20% corporate collectors. Overall price range: $800-50,000.

Media: Considers oil, acrylic, watercolor, pastel, mixed media, collage, paper, photography, gouache, lithograph, serigraphs and etching. Most frequently exhibits acrylic, oil, gouache, mixed media (canvas and paper).

Style: Exhibits expressionism, painterly abstraction, surrealism and realism. Small and medium-sized pieces. Genres include landscapes, florals and figurative work. Prefers landscape, abstractions and figurative. Finds appropriate New York venues for artists. Acts as career coach.

Terms: Charges 50% commission. Retail price set by the gallery and the artist. Gallery provides promotion and contract. Prefers artwork framed.

Submissions: Send query letter with résumé, slides, bio, brochure, SASE and reviews. Write for appointment to show portfolio of originals, photographs, slides and promotion material. Responds in 6 months. Files promotion brochures and bios. Finds artists through visiting exhibitions, slide files, referrals, artists' submissions.

Tips: Looks for "professional attitude, continuing production and own following of collectors."

N **WALTER WICKISER GALLERY**, 568 Broadway, #104B, New York NY 10012. (212)941-1817. Fax: (212)625-0601. E-mail: wwickiserg@aol.com. Website: www.walterwickisergallery.com. For-profit gallery. Exhibits mid-career artists. Exhibited artists include: Siri Bert, Irma Gilgore and David Hales.

Submissions: Mail portfolio for review. Send query letter with résumé and slides. Resopnds in 6 weeks. Finds artists through submissions, portfolio reviews and referrals by other artists.

N PHILIP WILLIAMS POSTERS, 534 La Guardia Place 2, New York NY 10012. (212)677-7111. **Contact:** Philip Williams. Retail and wholesale gallery. Represents/exhibits 40 emerging, mid-career and established artists. Open all year; Monday-Sunday, 11-7

Terms: Shipping costs are shared. Prefers artwork unframed.

Submissions: Prefers only vintage posters and outsider artist. Send query letter with photographs. Call for appointment to show portfolio of photographs.

N YESHIVA UNIVERSITY MUSEUM, 15 W. 16th St., New York NY 10011. (212)294-8330. Fax: (212)294-8335. **Director:** Sylvia A. Herskowitz. Nonprofit museum. Estab. 1973. Interested in emerging, mid-career and established artists. Sponsors 5-7 solo shows/year. Average display time 3 months. "4 modern galleries; track lighting." Clients include New Yorkers and tourists.

Media: Considers all media and original handpulled prints.

Style: Exhibits: postmodernism, surrealism, photorealism and realism with Jewish themes or subject matter. Genres include landscapes, florals, Americana, portraits and figurative work. "We mainly exhibit works of Jewish theme or subject matter or that reflect Jewish consciousness but are somewhat willing to consider other styles or mediums."

Terms: Accepts work for exhibition purposes only, no fee. Pieces should be framed. Retail price is set by gallery and artist. Gallery provides insurance, promotion and contract; artist pays for shipping and framing.

Submissions: Send query letter, résumé, brochure, good-quality slides, photographs and statement about your art. Prefers not to receive phone calls/visits. "Once we see the slides, we may request a personal visit." Resumes, slides or photographs are filed if work is of interest.

Tips: Mistakes artists make are sending "slides that are not identified, nor in a slide sheet." Notices "more interest in mixed media and more crafts on display."

North Carolina

N ASSOCIATED ARTISTS OF WINSTON-SALEM, 226 N. Marshall St., Winston-Salem NC 27101. (336)722-0340. Fax: (336)722-0446. E-mail: staff@associatedartists.org. Website: www.associated artists.org. **Executive Director:** Ramelle Pulitzer. Nonprofit gallery. Gallery estab. 1982; organization estab. 1956. Represents 500 emerging, mid-career and established artists/year. 600 members. Sponsors 12 shows/year. Average display time 1 month. Open all year; office hours: Monday-Friday, 9-5; gallery hours: Monday-Friday, 9-9; Saturday, 9-6. Located in the historic Sawtooth Building downtown. "Our gallery is 1,000 sq. ft., but we often have the use of 2 other galleries with a total of 3,500 sq. ft. The gallery is housed in a renovated textile mill (circa 1911) with a unique 'sawtooth' roof. 30% of space for special exhibitions; 70% of space for gallery artists. Clientele: "generally walk-in traffic—this is a multi-purpose public space, used for meetings, receptions, classes, etc." 85% private collectors, 15% corporate collectors. Overall price range: $50-3,000; most work sold at $400.

Media: Considers oil, acrylic, watercolor, pastel, pen & ink, drawing, mixed media, collage, paper, sculpture, photography, woodcuts, engravings, lithographs, wood engravings, mezzotints, serigraphs, linocuts and etchings (no photo-reproduction prints).

Style: Exhibits all styles, all genres.

Terms: "Artist pays modest entry fee for each show; if work is sold, we charge 30% commission. If work is unsold at close of show, it is returned to the artist." Retail price set by the artist; artist pays shipping costs to and from gallery. Artwork must be framed.

Submissions: Request membership information and/or prospectus for a particular show. Files "slides and résumés of our exhibiting members."

Tips: "Membership and competitions are open to all. We advertise call for entries for our major shows in national art magazines and newsletters. Artists can impress us by following instructions in our show prospecti and by submitting professional-looking slides where appropriate. Because of our non-elitist attitude, we strive to be open to all artists—from novice to professional, so first-time artists can exhibit with us."

N BLOUNT BRIDGERS HOUSE/HOBSON PITTMAN MEMORIAL GALLERY, 130 Bridgers St., Tarboro NC 27886. (252)823-4159. Fax: (252)823-6190. E-mail: edgecombearts@earthlink.net. Website: www.edgecombearts.org. Museum. Estab. 1982. Approached by 20 artists/year. Exhibits 6 emerging, mid-career and established artists. Sponsors 8 exhibits/year. Average display time 6 weeks. Open all year; Monday-Friday, 10-4; weekends 2-4. Closed major holidays, Christmas-New Year. Located in historic

house in residential area of small town; gallery on 2nd floor is accessible by passenger elevator. Room is approximately $48' \times 20'$. Clients include local community, students and tourists. Overall price range: $250-5,000; most work sold at $500.

Media: Considers acrylic, ceramics, collage, craft, drawing, fiber, glass, mixed media, oil, paper, pstel, pen & ink and watercolor. Most frequently exhibits oil, watercolor and ceramic. Considers all types of prints.

Style: Considers all styles and genres.

Terms: Artwork is accepted on consignment and there is a 30% commission. Retail price set by the artist. Gallery provides insurance and limited promotion. Accepted work should be framed. Does not require exclusive representation locally. Accepts artists from southeast and Pennsylvania.

Submissions: Send portfolio of photographs, slides or transparencies. Send query letter with artist's statement, bio, SASE and slides. Returns material with SASE. Responds in 3 months. Finds artists through word of mouth, submissions, art exhibits and referrals by other artists.

N BLUE SPIRAL I, 38 Biltmore Ave., Asheville NC 28801. (828)251-0202. Fax: (828)251-0884. E-mail: bluspiral1@aol.com. **Director:** John Cram. Retail gallery. Estab. 1991. Represents emerging, mid-career and established artists living in the Southeast. Exhibited artists include Julyan Davis, Gary Beecham, Suzanne Stryk, Tommie Rush and D. Lanford Kühn. Sponsors 10 shows/year. Average display time 6-8 weeks. Open all year; Monday-Saturday, 10-5. Located downtown; 15,000 sq. ft.; historic building. 85% of space for special exhibitions; 15% of space for gallery artists. Clientele: "across the range." 90% private collectors, 10% corporate collectors. Overall price range: less than $100-50,000; most work sold at $100-2,500.

Media: Considers all media. Most frequently exhibits painting, clay, sculpture and glass.

Style: Exhibits all styles, all genres.

Terms: Accepts work on consignment (50% commission). Retail price set by the artist. Gallery provides insurance, promotion and contract; artist pays shipping costs to and from gallery. Prefers artwork framed.

Submissions: Accepts only artists from Southeast. Send query letter with résumé, slides, prices, statement and SASE. Responds in 3 months. Files slides, name and address. Finds artists through word of mouth, referrals and travel.

Tips: "Work must be technically well executed and properly presented."

BROADHURST GALLERY, 2212 Midland Rd., Pinehurst NC 28374. (910)295-4817. **Owner:** Judy Broadhurst. Retail gallery. Estab. 1990. Represents/exhibits 25 established artists/year. Sponsors about 4 large shows and lunch and Artist Gallery Talks on most Fridays. Average display time 1-3 months. Open all year; Tuesday-Friday, 11-5; Saturday, 1-4; and by appointment. Located on the main road between Pinehurst and Southern Pines; 3,000 sq. ft.; lots of space, ample light, large outdoor sculpture garden. 50% of space for special exhibitions; 50% of space for gallery artists. Clientele: people building homes and remodeling, also collectors. 80% private collectors, 20% corporate collectors. Overall price range: $5,000-40,000; most work sold at $5,000 and up.

Media: Considers oil, acrylic, watercolor, pastel, mixed media and collage. Most frequently exhibits oil and sculpture (stone and bronze).

Style: Exhibits all styles, all genres.

Terms: Retail price set by the artist. Gallery provides insurance, promotion and contract; shipping costs are shared. Prefers artwork framed.

Submissions: Send query letter with résumé, slides and/or photographs, and bio. Write for appointment to show portfolio of originals and slides. Responds only if interested within 3 weeks. Files résumé, bio, slides and/or photographs. Finds artists through agents, by visiting exhibitions, word of mouth, various art publications and sourcebooks and artists' submissions.

Tips: "Talent is always the most important factor, but professionalism is very helpful."

N CHAPELLIER FINE ART, 105 Arlen Park Dr., Chapel Hill NC 27516. (919)967-9960. Fax: (919)969-7318. E-mail: chapellier@worldnet.att.net. Website: www.artnet.com/chapellier.html. **Director:** Shirley C. Lally. Retail gallery. Estab. 1916. Represents 5 established artists/year. Exhibited artists include Mary Louise Boehm. Sponsors 3-4 shows/year. Average display time 6-8 weeks. Open all year; Monday-Saturday by appointment. 1,000 sq. ft. 75% of space for special exhibitions; 25% of space for gallery artists. Clientele: upscale. 90% private collectors, 10% corporate collectors. Overall price range: $500-90,000; most work sold at $3,000-10,000.

Media: Considers oil, acrylic, watercolor, pastel, pen & ink, drawing, mixed media, paper, sculpture (limited to small pieces) and all types of prints. Most frequently exhibits oil, watercolor, pastel.

Style: Exhibits impressionism and realism. Exhibits all genres. Prefers realism and impressionism.

Terms: Accepts work on consignment (50% commission). Retail price set by the gallery. Gallery provides insurance, promotion and contract; shipping costs are shared. Prefers artwork framed.

Submissions: Accepts only artists from America. Send query letter with résumé, slides, bio or photographs, price list and description of works offered, exhibition record. Write for appointment to show portfolio of photographs, transparencies or slides. Responds in 1 month. Files material only if interested. Finds artists through word of mouth, visiting art fairs and exhibitions.

Tips: "Gallery owner and artist must be compatible and agree on terms of representation."

☑ **DURHAM ART GUILD, INC.**, 120 Morris St., Durham NC 27701. (919)560-2713. E-mail: artguild 1@yahoo.com. Website: www.durhamartguild.org. **Gallery Director:** Lisa Morton. Gallery Assistant: Diane Amato. Nonprofit gallery. Estab. 1948. Represents/exhibits 500 emerging, mid-career and established artists/year. Sponsors more than 20 shows/year including an annual juried art exhibit. Average display time 5 weeks. Open all year; Monday-Saturday, 9-9; Sunday, 1-6. Free and open to the public. Located in center of downtown Durham in the Arts Council Building; 3,600 sq. ft.; large, open, movable walls. 100% of space for special exhibitions. Clientele: general public. 80% private collectors, 20% corporate collectors. Overall price range: $100-14,000; most work sold at $200-1,200.

Media: Considers all media. Most frequently exhibits painting, sculpture and photography.

Style: Exhibits all styles, all genres.

Terms: Artwork is accepted on consignment (30-40% commission). Retail price set by the artist. Gallery provides insurance and promotion. Artist installs show. Prefers artwork framed.

Submissions: Artists 18 years or older. Send query letter with résumé, slides and SASE. We accept slides for review by February 1 for consideration of a solo exhibit or special projects group show. Artist should include SASE. Finds artists through word of mouth, referral by other artists, call for slides.

Tips: "Before submitting slides for consideration, be familiar with the exhibition space to make sure it can accommodate any special needs your work requires for showing. Does the gallery have moveable walls which cannot support heavy art work? These points are important."

Ⓝ **GALLERY C**, 3532 Wade Ave., Raleigh NC 27607. (919)828-3165. Fax: (919)828-7795. E-mail: art@galleryc.net. Website: www.galleryc.net. For-profit gallery. Estab. 1985. Approached by 80 artists/year. Exhibits 16 established artists. Exhibited artists include: Joseph Cave (oil on canvas) and Wayne Trapp (oil on canvas). Sponsors 12 exhibits/year. Average display time 1 month. Open all year; Monday-Saturday, 10-6; weekends, 10-5. 3,000 sq. ft., neoclassical interior, track lights, 10 foot ceilings. Clients include local community and upscale. 20% of sales are to corporate collectors. Overall price range: $100-20,000; most work sold at $3,000.

Media: Considers acrylic, drawing, fiber, installation, oil, paper, pastel, sculpture, watercolor, engravings, etchings, linocuts, stone lithographs, mezzotints and serigraphs. Most frequently exhibits oil, mixed and acrylic.

Style: Considers all styles. Most frequently exhibits abstract expressionism, figurative and landscape. Genres include figurative work and landscapes.

Terms: Artwork is accepted on consignment and there is a 50% commission. Retail price set by the artist. Gallery provides insurance, promotion and contract. Accepted work should be framed. Requires exclusive representation locally.

Submissions: Call to request 'guidelines for artists' form. Returns material with SASE. Responds in 3 months. Finds artists through portfolio reviews, art fairs and referrals by other artists.

Tips: "Follow the requirements outlined on our guidelines sheet."

Ⓝ **GREEN TARA GALLERY**, 241 S. Elliott Rd., Chapel Hill NC 27514. (919)932-6400. Fax: (919)918-7542. E-mail: greentaragallery@mindspring.com. Website: www.greentaragallery.com. Rental gallery. Estab. 1998. Approached by 150 artists/year. Exhibits 150 established artists. Exhibited artists include: Scott Gibbs and Pam Calore. Sponsors 12 exhibits/year. Average display time 7-8 weeks. Open all year; Tuesday-Saturday, 10-5. Closed July 4th and New Years. 4,000 sq. ft. fine art and fine craft gallery located in the heart of Chapel Hill, NC featuring one of a kind art and art objects for your home and office. Clients include local community, tourists and upscale. 10% of sales are to corporate collectors. Overall price range: $25-3,000; most work sold at $1,000.

Media: Considers acrylic, ceramics, collage, drawing, glass, mixed media, oil, pastel, sculpture, watercolor and woodcuts. Most frequently exhibits oil, acrylic, mixed media. Considers only original prints.

Style: Exhibits: conceptualism, expressionism, geometric abstraction, impressionism, minimalism, neo-expressionism, postmodernism, primitivism realism, surrealism and painterly abstraction. Most frequently exhibits impressionism, abstract expressionism and conceptualism. Genres include figurative work and landscapes.

Terms: Artwork is accepted on consignment and there is a 50% commission; or is bought outright for 40% of retail price. Retail price set by the gallery and the artist. Gallery provides insurance, promotion and contract. Accepted work should be framed, mounted and matted. Requires exclusive representation locally.

Submissions: Mail portfolio for review. Send query letter with artist's statement, bio, brochure, business card, photocopies, photographs, résumé, reviews, SASE and slides. Returns material with SASE. Files business card. Finds artists through word of mouth, submissions, portfolio reviews, art exhibits, art fairs, referrals by other artists and through other galleries.
Tips: "Include all the required information, and be reasonable in pricing and flexible. Act/behavior should be as if for any other job interview."

N RALEIGH CONTEMPORARY GALLERY, 323 Blake St., Raleigh NC 27601. (919)828-6500. E-mail: RCGallery@mindspring.com. **Director:** Rory Parnell. Retail gallery. Estab. 1984. Represents 20-25 emerging and mid-career artists/year. Sponsors 6 shows/year. Average display time 1 month. Open all year; Monday-Saturday, 11-4. Located downtown; 1,300 sq. ft.; architect-designed; located in historic property in a revitalized downtown area. 30% of space for special exhibitions; 70% of space for gallery artists. Clients include corporate and private. 35% of sales are to private collectors, 65% corporate collectors. Overall price range: $500-5,000; most work sold at $1,200-2,500.
Media: Considers oil, acrylic, watercolor, pastel, pen & ink, drawing, woodcut, engraving and lithograph. Most frequently exhibits oil/acrylic paintings, drawings and lithograph.
Style: Exhibits all styles. Genres include landscapes and florals. Prefers landscapes, realistic and impressionistic; abstracts.
Terms: Accepts work on consignment (50% commission). Retail price set by the gallery and the artist. Gallery provides insurance, promotion and contract; shipping costs are shared.
Submissions: Send query letter with résumé, slides, bio, SASE and reviews. Call or write for appointment to show portfolio of slides. Responds in 1 month. Finds artists through exhibitions, word of mouth, referrals.

N TYLER-WHITE COMPTON ART GALLERY, 307 State St. Station, Greensboro NC 27408. (336)279-1124. Fax: (336)279-1102. **Owners:** Marti Tyler and Judy White. Retail gallery. Estab. 1985. Represents 60 emerging, mid-career and established artists. Exhibited artists include Marcos Blahove, Geoffrey Johnson and Connie Winters. Sponsors 8 shows/year. Open all year. Located in State Street Station, a unique shopping district 1 mile from downtown. Overall price range: $100-4,000; most work sold at $1,500.
Media: Considers oil, acrylic, watercolor and pastel.
Style: Considers contemporary expressionism, impressionism and realism. Genres include landscapes, florals and figurative work.
Terms: Accepts artwork on consignment. Retail price set by the artist. Gallery provides some insurance, promotion and contract; artist pays for shipping. Prefers artwork framed if oil, or a finished canvas. Prefers matted watercolors.
Submissions: Send query letter with slides, résumé, brochure, photographs and SASE. Write to schedule an appointment to show a portfolio, which should include originals, slides and transparencies. Responds in 1 month. Files brochures, résumé and some slides.
Tips: "We only handle original work."

North Dakota

GANNON & ELSA FORDE GALLERIES, 1500 Edwards Ave., Bismarck ND 58501. (701)224-5520. Fax: (701)224-5550. E-mail: Michelle_Lindblom@bsc.nodak.com. Website: www.bismarckstate.com. **Gallery Director:** Michelle Lindblom. College gallery. Represents emerging, mid-career and established art exhibitions. Sponsors 6 shows/year. Average display time 6 weeks. Open all year; Monday-Thursday, 9-9; Friday, 9-4; Sunday, 6-9. Summer exhibit is college student work (May-August). Located on Bismarck State College campus; high traffic areas on campus. Clientele: all. 80% private collectors, 20% corporate collectors. Overall price range: $50-10,000; most work sold at $50-3,000.
Media: Considers oil, acrylic, watercolor, pastel, drawing, mixed media, collage, paper, sculpture, ceramics, fiber, photography, woodcut, engraving, lithograph, wood engraving, mezzotint, serigraphs, linocut and etching. Most frequently exhibits painting media (all), mixed media and sculpture.
Style: Exhibits expressionism, neo-expressionism, painterly abstraction, surrealism, impressionism, photorealism, hard-edge geometric abstraction and realism, all genres.
Terms: Accepts work on consignment (20% commission). Retail price set by the artist. Gallery provides insurance on premises, promotion, contract and shipping costs from gallery; artist pays shipping costs to gallery. Prefers artwork framed.
Submissions: Send query letter with résumé, slides, bio and SASE. Call or write for appointment to show portfolio of photographs and slides. Responds in 2 months. Files résumé, bio, photos if sent. Finds artists through word of mouth, art publications, artists' submissions, visiting exhibitions.

Tips: "Because our gallery is a university gallery, the main focus is to expose the public to art of all genres. However, we do sell work, occasionally."

N HUGHES FINE ART CENTER ART GALLERY, Department of Visual Arts, University of North Dakota, Grand Forks ND 58202-7099. (701)777-2257. E-mail: mcelroye@badland.nodak.edu. Website: www.nodak.edu/dept/fac/visual_home.html. **Director:** Brian Paulsen. Nonprofit gallery. Estab. 1979. Exhibits emerging, mid-career and established artists. Sponsors 5 shows/year. Average display time 3 weeks. Open all year. Located on campus; 96 running ft. 100% of space for special exhibitions.
 • Director states gallery is interested in "well-crafted, clever, sincere, fresh, inventive, meaningful, unique, well-designed compositions—surprising, a bit shocking, etc."
Media: Considers all media. Most frequently exhibits painting, photographs and jewelry/metal work.
Style: Exhibits all styles and genres.
Terms: Retail price set by artist. Gallery provides "space to exhibit work and some limited contact with the public and the local newspaper." Gallery pays for shipping costs. Prefers artwork framed.
Submissions: Send query letter with 10-20 slides and résumé. Portfolio review not required. Responds in 1 week. Files "duplicate slides, résumés." Finds artists from submissions through *Artist's & Graphic Designer's Market* listing, *Art in America* listing in their yearly museum compilation; as an art department listed in various sources as a school to inquire about; the gallery's own poster/ads.
Tips: "We are not a sales gallery. Send slides and approximate shipping costs."

☑ NORTHWEST ART CENTER, Minot State University, 500 University Ave. W., Minot ND 58707. (701)858-3264. Fax: (701)858-3894. E-mail: nac@misu.nodak.edu. **Director:** Zoe Spooner. Nonprofit gallery. Estab. 1970. Represents emerging, mid-career and established artists. Sponsors 15-25 shows/year. Average display time 4-6 weeks. Open all year. Two galleries: Hartnett Hall Gallery; Monday-Friday, 8-5; The Library Gallery; Monday-Friday, 8-10. Located on university campus; 1,000 sq. ft. 100% of space for special exhibitions. 100% private collectors. Overall price range: $100-40,000; most work sold at $100-4,000.
Media: Considers all media and all types of prints except posters.
Style: Exhibits all styles, all genres.
Terms: Retail price set by the artist. Gallery provides insurance, promotion and contract; shipping costs are shared. Prefers artwork framed.
Submissions: Send query letter with résumé, slides, bio, SASE and artist's statement. Call for appointment to show portfolio of originals, photographs, slides and transparencies. Responds in 2 months. Files all material. Finds artists through submissions, visiting exhibitions, word of mouth.
Tips: "Develop a professional presentation. Use excellent visuals—slides, etc."

Ohio

N ARTSPACE/LIMA, 65 Town Square, Lima OH 45801. (419)222-1721. Fax: (419)222-6587. E-mail: artspace@wcoil.com. Website: www.artspacelima.com. **Gallery Director:** David Cottrell. Nonprofit gallery. Exhibits 50-70 emerging and mid-career artists/year. Interested in seeing the work of emerging artists. Sponsors 8-10 shows/year. Average display time 6-8 weeks. Open all year; Monday-Friday, 10-5; Saturday, 12-3; Sunday, 2-4. Located downtown; 286 running ft. 100% of space for special exhibitions. Clientele: local community. 80% private collectors, 5% corporate collectors. Overall price range: $300-6,000; most work sold at $500-1,000.
 • Most shows are thematic and geared toward education. James H. Bassett: landscape architect reviewed in *Dialogue Magazine*, January 2002.
Media: Considers all media and all types of prints. Most frequently exhibits painting, sculpture, drawing.
Style: Exhibits all styles of contemporary and traditional work.
Terms: Accepts work on consignment (40% commission). Retail price set by the artist. Gallery provides insurance, promotion and contract. Artwork must be ready to hang.
Submissions: Send query letter with résumé, slides, artist's statement and SASE. Portfolio should include slides. Responds only if interested within 6 weeks. Files résumé.

CHELSEA GALLERIES, 28120 Chagrin Blvd., Woodmere OH 44122. (216)591-1066. Fax: (216)591-1068. E-mail: chelsea@chelseagalleries.com. **Director:** Jill T. Wieder. Retail gallery. Estab. 1975. Represents/exhibits 400 emerging and mid-career artists/year. Exhibited artists include Leonard Urso and Tom Seghi. Sponsors 5 shows/year. Average display time 6 months. Open all year; Monday-Friday, 10-6; Satur-

day, 10-5. Adjustable showroom; easy access, free parking, halogen lighting. 40% of space for special exhibitions; 100% of space for gallery artists. Clientele: upscale. 85% private collectors, 15% corporate collectors. Overall price range: $50-10,000; most work sold at $500-2,000.
Media: Considers all media and all types of prints. Most frequently exhibits painting, glass and ceramics.
Style: Exhibits all styles and all genres. Prefers: impressionism, realism and abstraction.
Terms: Artwork is accepted on consignment (50% commission). Retail price set by the gallery and the artist. Gallery provides insurance, promotion and contract; shipping costs are shared. Prefers artwork framed.
Submissions: Send query letter with résumé and slides. Must include information on size, media and retail price. Call for appointment to show portfolio of photographs and slides. Responds in 6 weeks. Files résumé and slides.
Tips: "Be realistic in pricing—know your market."

N: CINCINNATI ART MUSEUM, 953 Eden Park Dr., Cincinnati OH 45202. (513)639-2995. Fax: (513)639-2888. E-mail: information@cincyart.org. Website: www.cincinnatiartmuseum.org. Museum. Estab. 1881. Exhibits 6-10 emerging, mid-career and established artists. Sponsors 20 exhibits/year. Average display time 3 months. Open all year; Tuesday-Friday, 11-5; weekends from 10-5. General art museum with a collection spanning 6,000 years of world art. Over 100,000 objects in the collection with exhibitions on view annually. Clients include local community, students, tourists and upscale.
Media: Considers all media and all types of prints. Most frequently exhibits paper, mixed media and oil.
Style: Considers all styles and genres.
Submissions: Send query letter with artist's statement, photographs, reviews, SASE and slides.

N: CLEVELAND STATE UNIVERSITY ART GALLERY, 2307 Chester Ave., Cleveland OH 44114. (216)687-2103. Fax: (216)687-9340. E-mail: artgallery@csuohio.edu. Website: www.csuohio.edu/art/galle ry. **Director:** Robert Thurmer. Assistant Director: Tim Knapp. University gallery. Exhibits 50 emerging, mid-career and established artists. Exhibited artists include Joel Peter Witkin and Buzz Spector. Sponsors 6 shows/year. Average display time 1 month. Open Monday-Friday, 10-5; Saturday, 12-4. Closed Sunday and holidays. Located downtown: 4,500 sq. ft. (250 running ft. of wall space). 100% of space for special exhibitions. Clientele: students, faculty, general public. 85% private collectors, 15% corporate collectors. Overall price range: $250-50,000; most work sold at $300-1,000.
Media: Considers all media and all types of prints. Prefers painting, sculpture and new genres of work.
Style: Exhibits all styles and genres. Prefers: contemporary. Looks for challenging work.
Terms: 25% commission. Sales are a service to artists and buyers. Gallery provides insurance, promotion, shipping costs to and from gallery; artists handle crating. Prefers artwork framed.
Submissions: Send query letter with résumé and slides. Portfolio review requested if interested in artist's work. Files résumé and slides. Finds artists through visiting exhibitions, artists' submissions, publications and word of mouth. Submission guidelines available for SASE.
Tips: "No oversized or bulky materials please! 'Just the facts ma'am.' "

N: THE DAYTON ART INSTITUTE, 456 Belmonte Park North, Dayton OH 45405-4700. (937)223-5277. Fax: (937)223-3140. E-mail: info@daytonartinstitute.org. Website: www.daytonartinstitute.org. Museum. Estab. 1919. Open all year; Monday-Wednesday, 10-5; Thursday, 10-9; Friday-Sunday, 10-5. Open 365 days of the year! Clients include local community, students and tourists.
Media: Considers all media.
Submissions: Send query letter with artist's statement, reviews and slides.

☑ HILLEL JEWISH STUDENT CENTER GALLERY, 2615 Clifton Ave., Cincinnati OH 45220. (513)221-6728. Fax: (513)221-7134. E-mail: email@hillelcincinnati.org. Website: www.hillelcincinnati.o rg. **Director:** Rabbi Abie Ingber. Gallery Curator: Daniela Yovel. Nonprofit gallery, museum. Estab. 1982. Represents 5 emerging artists/academic year. Exhibited artists include Gordon Baer, Irving Amen and Lois Cohen. Sponsors 5 shows/year. Average display time 5-6 weeks. Open all year fall, winter, spring; Monday-Thursday, 9-5; Friday, 9-3; other hours in conjunction with scheduled programming. Located uptown (next to University of Cincinnati); 1,056 sq. ft.; features the work of Jewish artists in all media; listed in AAA Tourbook; has permanent collection of architectural and historic Judaica from synagogues. 20% of space for special exhibitions; 80% of space for gallery artists. Clientele: upscale, community, students. 90% private collectors, 10% corporate collectors. Overall price range: $150-3,000; most work sold at $150-800.
Media: Considers all media except installations. Considers all types of prints. Most frequently exhibits prints/mixed media, watercolor, photographs.
Style: Exhibits all styles. Genres include landscapes, figurative work and Jewish themes. Avoids minimalism and hard-edge geometric abstraction.

Terms: Artwork accepted for exhibit and there is a 30% commission. Retail price set by the artist. Gallery provides insurance, promotion, contract, opening reception; shipping costs are shared. Prefers artwork framed.

Submissions: "With rare exceptions, we feature Jewish artists." Send query letter with slides, bio or photographs, SASE. Call or write for appointment to show portfolio. Responds in 1 week. Files bios/ résumés, description of work.

N̄ MALTON GALLERY, 2703 Observatory, Cincinnati OH 45208. (513)321-8614. E-mail: maltonartga llery@zoomtown.com. Website: www.maltonartgallery.com. **Director:** Sylvia Rombis. Retail gallery. Estab. 1974. Represents about 100 emerging, mid-career and established artists. Exhibits 20 artists/year. Exhibited artists include Carol Henry, Mark Chatterley, Terri Hallman and Esther Levy. Sponsors 7 shows/ year. Average display time 1 month. Open all year; Tuesday-Friday, 11-5; Saturday, 12-5. Located in high-income neighborhood shopping district. 2,500 sq. ft. "Friendly, non-intimidating environment." 2-person shows alternate with display of gallery artists. Clientele: private and corporate. Overall price range: $250-10,000; most work sold at $400-2,500.

Media: Considers oil, acrylic, drawing, sculpture, watercolor, mixed media, pastel, collage and original handpulled prints.

Style: Exhibits all styles. Genres include contemporary landscapes, figurative and narrative and abstractions work.

Terms: Accepts work on consignment (50% commission). Retail price set by artist (sometimes in consultation with gallery). Gallery provides insurance, promotion, contract and shipping costs from gallery; artist pays shipping costs to gallery. Prefers framed works for canvas; unframed works for paper.

Submissions: Send query letter with résumé, slides or photographs, reviews, bio and SASE. Responds in 4 months. Files résumé, review or any printed material. Slides and photographs are returned.

Tips: "Never drop in without an appointment. Be prepared and professional in presentation. This is a business. Artists themselves should be aware of what is going on, not just in the 'art world,' but with everything."

☑ McDONOUGH MUSEUM OF ART, Youngstown State University, One University Plaza, Youngstown OH 44555. E-mail: labrothe@ysu.edu. Website: www.fpa.ysu.edu. **Director:** Leslie A. Brothers. Alternative space, museum and nonprofit gallery. Estab. 1991. Located in the center of campus; has 3 traditional galleries, a raw-space gallery and a 2-story, sky-lit large installation gallery.

Media: Considers all media and all types of prints. Most frequently exhibits installation, painting, sculpture and photography.

Style: Considers all styles and genres.

Terms: Artwork is accepted on consignment and there is a 20% commission. Retail price set by the artist. Gallery provides insurance, promotion and contract. Accepts only artists from 400-500 mile radius.

☑ THE MIDDLETOWN FINE ARTS CENTER, 130 N. Verity Pkwy., P.O. Box 441, Middletown OH 45042. (513)424-2417. E-mail: mfac@siscom.net. Website: www.middletownfinearts.com. **Contact:** Peggy Davish. Nonprofit gallery. Estab. 1957. Represents emerging, mid-career and established artists. Sponsors 5 solo and/or group shows/year. Average display time 3 weeks. Clientele: tourists, students, community. 95% private collectors, 5% corporate clients. Overall price range: $100-1,000; most work sold at $150-500.

Media: Considers all media except prints. Most frequently exhibits watercolor, oil, acrylic and drawings.

Style: Exhibits all styles and genres. Prefers: realism, impressionism and photorealism. "Our gallery does not specialize in any one style or genre. We offer an opportunity for artists to exhibit and hopefully sell their work. This also is an important educational experience for the community. Selections are chosen two years in advance by a committee."

Terms: Accepts work on consignment (30% commission). Retail price set by artist. Sometimes offers customer discounts and payment by installment. Exclusive area representation not required. Gallery provides promotion; artist pays for shipping. Artwork must be framed and wired.

Submissions: Send query letter with résumé, brochure, slides, photographs and bio. Write for an appointment to show portfolio, which should include originals, slides or photographs. Responds in 3 months (depends when exhibit committee meets.). Files résumé or other printed material. All material is returned if not accepted or under consideration. Finds artists through word of mouth, submissions and self-promotions.

Tips: "Decisions are made by a committee of volunteers, and time may not permit an on-the-spot interview with the director."

MILLER GALLERY, 2715 Erie Ave., Cincinnati OH 45208. (513)871-4420. Fax: (513)871-4429. E-mail: millergallery@fuse.net. Website: www.miller-gallery.com. **Owner:** Barbara Miller. Retail gallery. Estab.

1960. Interested in emerging, mid-career and established artists. Represents about 50 artists. Sponsors 5 solo and 4 group shows/year. Average display time 1 month. Located in affluent suburb. Clientele: private collectors. Overall price range: $100-35,000; most artwork sold at $300-12,000.
Media: Considers oil, acrylic, mixed media, collage, works on paper, ceramic, fiber, bronze, stone, glass and original handpulled prints. Most frequently exhibits oil or acrylic, glass, sculpture and ceramics.
Style: Exhibits impressionism, realism and painterly abstraction. Genres include landscapes, interior scenes and still lifes. "Everything from fine realism (painterly, impressionist, pointilist, etc.) to beautiful and colorful abstractions (no hard-edge) and everything in between. Also handmade paper, collage, fiber and mixed mediums."
Terms: Accepts artwork on consignment (50% commission). Retail price set by artist and gallery. Sometimes offers payment by installment. Exclusive area representation is required. Gallery provides insurance, promotion and contract; shipping and show costs are shared.
Submissions: Send query letter with résumé, brochure, 10-12 slides or photographs with sizes, wholesale (artist) and selling price and SASE. All submissions receive phone or written reply. Finds artists through agents, visiting exhibitions, word of mouth, various art publications and sourcebooks, submissions/self-promotions, art collectors' referrals, and *Artist's and Graphic Designer's Market.*
Tips: "Artists often either completely omit pricing info or mention a price without identifying as artist's or selling price. Submissions without SASE will receive reply, but no return of materials submitted. Make appointment—don't walk in without one. Quality, beauty, originality are primary. Minimal, conceptual, political works not exhibited."

N PUMP HOUSE CENTER FOR THE ARTS, P.O. Box 1613, Chillicothe OH 45601-5613. (740)772-5783. Fax: (740)772-5783. E-mail: pumpart@bright.net. Website: www.bright.net/~pumpart. **Executive Director:** Beverly J. Mullen. Nonprofit gallery. Estab. 1986. Approached by 6 artists/year. Exhibits 50 emerging, mid-career and established artists. Exhibited artists include: Alan Gough, oil; Roger Chapin, pastel. Sponsors 8 exhibits/year. Average display time 6 weeks. Open all year; Tuesday-Friday, 11-4; weekends, 1-4. Closed major holidays. The Pump House is located in a city park. The building was erected in 1882 and renovated in the late 80s as an art gallery. It is of Victorian architecture with a large central tower, palladian windows and state roof. The interior has piano key dentil work and 2 galleries: a main exhibit room and mezzanine and a smaller gift gallery. 1979 National Register of Historic Places. Clients include local community, tourists and upscale. 2% of sales are to corporate collectors. Overall price range: $150-600; most work sold at $300.
Media: Considers all media and all types of prints. Most frequently exhibits oil, acrylic and watercolor.
Style: Considers all styles and genres.
Terms: Artwork is accepted on consignment and there is a 30% commission. Gallery provides insurance and promotion. Accepted work should be framed, matted and wired for hanging. Does not require exclusive representation locally. The Pump House reserves the right to reject any artwork deemed inappropriate. Call or stop in to show portfolio of photographs, slides, originals or prints. Send query letter with bio, photographs, SASE and slides. Returns material with SASE. Responds in 1 month. Finds artists through word of mouth, submissions, portfolio reviews, art exhibits, art fairs and referrals by other artists.
Tips: All artwork must be original designs, framed, ready to hang (wired—no sawtooth hangers).

N REINBERGER GALLERIES, CLEVELAND INSTITUTE OF ART, 11141 E. Blvd., Cleveland OH 44106. (216)421-7407. Fax: (216)421-7438. **Director:** Bruce Checefsky. Nonprofit gallery, college. Estab. 1882. Represents established artists. 8 gallery committee members. Sponsors 9 shows/year. Average display time 4-6 weeks. Open all year; Sunday 1-4, Monday 9-4, Tuesday-Saturday, 9:30-9. Located University Circle; 5,120 sq. ft.; largest independant exhibit facility in Cleveland (for college or university). 100% of space for special exhibitions. Clientele: students, faculty and community at large. 80% private collectors, 30% corporate collectors. Overall price range: $50-75,000; most work sold under $1,000.
Media: Considers all media. Most frequently exhibits prints, drawings, paintings, sculpture, installation, fiber and experimental.
Style: Exhibits all styles, all genres.
Terms: Accepts work on consignment (15% commission). Retail price set by the artist. Gallery provides insurance, promotion, contract and shipping costs.
Submissions: Send query letter with résumé, slides, bio, photographs, SASE and reviews. No phone inquires. Responds in 6 months. Files bio and slides when applicable.

☑ RUTLEDGE GALLERY, Kettering Tower Lobby, 40 N. Main St. Suite 60, Dayton OH 45423. (937)226-7335. E-mail: rutledge@dnaco.net. Website: www.rutledge-art.com. **Director:** Jeff Rutledge. Director, Gallery Relations: Deborah Wittig. Retail gallery, art consultancy. Focus is on artists from the Midwest. Estab. 1991. Represents 45 emerging and mid-career artists/year. Sponsors 6 shows/year. Average display time 3 months. Exhibited artists include Natalya Romanovsky, Jeff Potter, Mike Madero and Jeff

Rutledge. Open all year; Tuesday-Friday, 11-6; Saturday, 11-5. Located 1 mile north of downtown in Dayton's business district; 2800 sq. ft. "We specialize in sculpture and regional artists. We also offer commissioned work and custom framing." 70% of space for special exhibitions; 30% of space for gallery artists. Clientele: residential, corporate, private collectors, institutions. 65% private collectors, 35% corporate collectors.

Media: Considers oil, acrylic, watercolor, pastel, pen & ink, drawing, mixed media, paper, sculpture, ceramic, craft, glass, woodcuts, engravings, lithographs, linocuts, etchings and posters. Most frequently exhibits paintings, drawings, prints and sculpture.

Style: Exhibits expressionism, painterly abstraction, surrealism, color field, impressionism and realism. Considers all genres. Prefers: contemporary (modern), geometric and abstract.

Terms: Accepts work on consignment (50% commission). Retail price set by gallery. Gallery provides insurance, promotion and contract; artists pays shipping costs. Prefers artwork framed.

Submissions: Accepts mainly Midwest artists. Send query letter with résumé, brochure, 20 slides and 10 photographs. Call for appointment to show portfolio of originals, photographs, slides and transparencies. Responds only if interested within 1 month. Files "only material on artists we represent; others returned if SASE is sent or thrown away."

Tips: "Be well prepared, be professional, be flexible on price and listen."

SPACES, 2220 Superior Viaduct, Cleveland OH 44113. (216)621-2314. Alternative space. Estab. 1978. Represents emerging artists. Has 300 members. Sponsors 10 shows/year. Average display time 6 weeks. Open all year; Tuesday-Sunday. Located downtown Cleveland; 6,000 sq. ft.; "loft space with row of columns." 100% private collectors.

Media: Considers all media. Most frequently exhibits installation, painting, video and sculpture.

Style: Exhibits all styles. Prefers challenging new ideas.

Terms: Accepts work on consignment. 20% commission. Retail price set by the artist. Sometimes offers payment by installment. Gallery provides insurance, promotion and contract.

Submissions: Send query letter with résumé, 15 slides and SASE. Annual deadline in spring for submissions.

Tips: "Present yourself professionally and don't give up."

Oklahoma

BONE ART GALLERY, 114 S. Broadway, Geary OK 73040. (405)884-2084. E-mail: jim@boneartgallery .com. Website: www.boneartgallery.com. **Owner/Operator:** Jim Ford. Retail and wholesale gallery. Estab. 1988. Represents 6 emerging, mid-career and established artists/year. Exhibited artists include Jim Ford and Jerome Bushyhead. Average display time 6 months. Open all year; Monday-Friday, 10-6; Saturday, 10-6; Sunday by appointment. Located downtown. ⅔% of space for gallery artists. Clientele: tourists, upscale. 50% private collectors; 50% corporate collectors. Overall price range: $15-1,000; most work sold at $15-650.

Media: Considers oil, acrylic, watercolor, pastel, drawing, mixed media, sculpture, ceramics, lithographs and posters. Most frequently exhibits watercolor, sculpture and carvings, pipe making.

Style: Exhibits primitivism. Genres include Western, wildlife, Southwestern and landscapes. Prefers Southwestern, Western and landscapes.

Terms: Accepts work on consignment (20% commission). Retail price set by the artist. Gallery provides insurance and promotion; shipping costs are shared. Prefers artwork framed.

Submissions: Prefers only Southwestern, Western, landscapes and wildlife. Send query letter with résumé, brochure, photographs and business card. Write for appointment to show portfolio of photographs. Responds in 1 month. Files business cards, résumé, brochure and letter of introduction. Finds artists through referrals and visiting art exhibitions.

Tips: "New artists should be familiar with the types of artwork each gallery they contact represents. If after contacting a gallery you haven't had a response after 2-3 months, make contact again. Be precise, but not overbearing with your presentations."

M.A. DORAN GALLERY, 3509 S. Peoria, Tulsa OK 74105. (918)748-8700. Fax: (918)744-0501. E-mail: madgallery@aol.com. Retail gallery. Estab. 1979. Represents 45 emerging, mid-career and established artists/year. Exhibited artists include: P.S. Gordon and Otto Duecker. Sponsors 10 shows/year. Average display time 1 month. Open all year; Tuesday-Saturday, 10:30-6. Located central retail Tulsa; 2,000 sq. ft.; up and downstairs, Soho like interior. 50% of space for special exhibitions; 50% of space for gallery artists. Clients include upscale. 65% of sales are to private collectors; 35% corporate collectors. Overall price range: $500-40,000; most work sold at $5,000.

Media: Considers all media except pen & ink, paper, fiber and installation; types of prints include woodcuts, engravings, lithographs, wood engravings, mezzotints, serigraphs, linocuts and etchings. Most frequently exhibits oil paintings, watercolor and crafts.

Style: Exhibits: painterly abstraction, impressionism, photorealism, realism and imagism. Exhibits all genres. Prefers landscapes, still life and fine American crafts.

Terms: Accepts work on consignment (50% commission). Retail price set by the gallery and artist. Gallery provides insurance and promotion; shipping costs are shared. Prefers artwork framed.

Submissions: Send query letter with résumé, bio, SASE and artist's statement. Call for appointment. Responds in 1 month. Files any potential corporate artists.

THE WINDMILL GALLERY, 3750 W. Robinson, Suite 103, Norman OK 73072. (405)321-7900. **Director:** Andy Denton. Retail gallery. Estab. 1987. Focus is on Oklahoma American Indian art. Represents 20 emerging, mid-career and established artists. Exhibited artists include Rance Hood, Gina Gray, Donald Vann and Darwin Tsoodle. Sponsors 4 shows/year. Average display time 1 month. Open all year. Located in northwest Norman (Brookhaven area); 900 sq. ft.; interior decorated Santa Fe style: striped aspen, adobe brick, etc. 30% of space for special exhibitions. Clientele: "middle-class to upper middle-class professionals/housewives." 100% private collectors. Overall price range $50-15,000; most artwork sold at $100-2,000.

Media: Considers oil, acrylic, watercolor, pastel, pen & ink, drawings, mixed media, works on paper, sculpture, craft, original handpulled prints, offset reproductions, lithographs, posters, cast-paper and serigraphs. Most frequently exhibits watercolor, tempera and acrylic.

Style: Exhibits primitivism and realism. Genres include landscapes, southwestern, western, wildlife and portraits. Prefers Native American scenes (done by Native Americans), portraits and western-southwestern and desert subjects.

Terms: Artwork is accepted on consignment (40% commission). Retail price set by the artist. Customer discounts and payment by installments available. Gallery provides insurance and promotion. Shipping costs are shared. Prefers framed artwork.

Submissions: Send query letter with slides, bio, brochure, photographs, SASE, business card and reviews. Responds only if interested within 1 month. Portfolio review not required. Files brochures, slides, photos, etc. Finds artists through agents, visiting exhibitions, word of mouth, art publications and sourcebooks, artists' submissions/self-promotions and art collectors' referrals.

Tips: Accepts artists from Oklahoma area; Indian art done by Indians only. Director is impressed by artists who conduct business in a very professional manner, have written biographies, certificates of limited editions for prints, and who have honesty and integrity. "Call, tell me about yourself, try to set up appointment to view works or to hang your works as featured artist. Fairly casual—but must have bios and photos of works or works themselves! Please, no drop-ins!"

Oregon

RICKERT ART CENTER, 1107 SW Coast Hwy., Newport OR 97365-0523.. (541)265-2466. Fax: (541)265-6969. **Manager/Director:** Lee Lindberg. Retail gallery. Represents more than 20 emerging, mid-career and established artists/year. Exhibited artists include Sharon Rickert, Don Driggars, Lyn Lasneski and Jesse Roadbruck. Sponsors 3 shows/year. Open all year; daily, weekdays and Saturdays, 10-5; Sundays, 10-4. Located south end of town on main street; 2,300 sq. ft.; 50-year-old building. 20% of space for special exhibitions; 60% of space for gallery artists. Overall price range: $200-6,000; most work sold at $800-3,000.

Media: Considers oil, acrylic, watercolor, pastel, mixed media, sculpture, lithographs, serigraphs and posters. Most frequently exhibits oil, acrylic, watercolor and pastel.

Style: Exhibits all styles. Genres include landscapes, florals, southwestern, western, wildlife, portraits, figurative work, seascapes. Prefers: seascapes, florals, landscapes.

Terms: Accepts work on consignment (50% commission). Retail price set by the gallery and the artist. Gallery provides promotion; artist pays shipping costs to and from gallery. Prefers artwork framed.

Submissions: Send query letter with résumé, 10 or less slides and photographs. Call or write for appointment to show portfolio of originals. Artist should follow up with call.

Tips: Looking for landscapes and seascapes in oil, as well as glass sculpture.

ROGUE GALLERY & ART CENTER, 40 S. Bartlett, Medford OR 97501. (541)772-8118. **Executive Director:** Judy Barnes. Nonprofit sales rental gallery. Estab. 1961. Represents emerging, mid-career and established artists. Sponsors 8 shows/year. Average display time 6 weeks. Open all year; Tuesday-Friday, 10-5; Saturday, 10-4. Located downtown; main gallery 240 running ft. (2,000 sq. ft.); rental/sales

and gallery shop, 1,800 sq. ft.; classroom facility, 1,700 sq. ft. "This is the only gallery/art center/exhibit space of its kind in the region, excellent facility, good lighting." 33% of space for special exhibitions; 33% of space for gallery artists. 95% of sales are to private collectors. Overall price range: $100-5,000; most work sold at $400-1,000.

Media: Considers all media and all types of prints. Most frequently exhibits mixed media, drawing, painting, sculpture, watercolor.

Style: Exhibits all styles and genres. Prefers: figurative work, collage, landscape, florals, handpulled prints.

Terms: Accepts work on consignment (35% commission to members; 40% non-members). Retail price set by the artist. Gallery provides insurance, promotion and contract; in the case of main gallery exhibit, gallery assumes cost for shipping 1 direction, artist 1 direction.

Submissions: Send query letter with résumé, 10 slides, bio and SASE. Call or write for appointment. Responds in 1 month.

Tips: "The most important thing an artist needs to demonstrate to a prospective gallery is a cohesive, concise view of himself as a visual artist and as a person working with direction and passion."

Pennsylvania

N: ART FORMS, 106 Levering St., Philadelphia PA 19127. Phone/fax: (215)483-3030. E-mail: artformsg allery@mac.com. **Gallery Manager:** Erin Bettejewski. Cooperative gallery, nonprofit gallery. Estab. 1993. Exhibits emerging, mid-career and established artists. Average display time 1 month. Open all year; Wednesday-Sunday, 12-5; weekends, 12-9. Closed from December 24-January 2. Located in a block of Main St., in Manayunk Philadelphia; features 1 large main gallery, which the solo show is held and a smaller back gallery where 3 artists are displayed; huge storefront window.

Media: Considers all media and all types of prints. Most frequently exhibits paintings and sculpture.

Style: Considers all styles and genres.

Terms: There is a co-op membership fee plus a donation of time. There is a 30% commission. Retail price set by the artist. Accepted work should be framed, mounted and matted.

Submissions: Call or write to arrange a personal interview to show portfolio of slides. Mail portfolio for review. Send query letter with artist's statement, bio, brochure, business card, résumé, reviews, SASE and slides. Responds in 2 months. Finds artists through word of mouth, submissions, portfolio reviews and referrals by other aritsts.

Tips: "Type statement, and research who you're sending materials to. Know if the gallery is commercial/co-op."

N: BREW HOUSE SPACE 101, 2100 Mary St., Pittsburgh PA 15203. (412)381-7767. Fax: (412)390-1977. E-mail: bhouse@angstrom. Website: www.brewhouse.org. Alternative space, cooperative gallery, nonprofit gallery, rental gallery. Estab. 1993. Approached by 100 artists/year. Exhibits 6-9 emerging artists. Exhibited artists include: Barbara Goldman. Sponsors 4-5 exhibits/year. Average display time 1 month. Open Wednesday, Thursday, Friday, Saturday, 11-4; weekends 11-4. Closed June-August. Gallery is located in Pittsburgh's historic south side. The size of the gallery is 1,360 sq. ft. with 23 ft. high ceilings; equipped with a kitchen and 2 bathrooms.

Media: Considers all media and all types of prints. Most frequently exhibits sculpture, painting and installation.

Style: Considers all styles and genres.

Terms: Artwork is accepted on consignment and there is a 20% commission. Retail price set by the artist. Gallery provides insurance, promotion and contract. Accepted work should be framed. Does not require exclusive representation locally. Accepts only artists within 150 miles of Pittsburgh.

Submissions: Mail portfolio for review. Returns material with SASE. Responds in 1 month. Files slides of exhibiting artists. Finds artists through submissions.

Tips: "Please send 35mm slides and a solid proposition."

✔ THE CLAY PLACE, 5416 Walnut St., Pittsburgh PA 15232. (412)682-3239. Fax: (412)682-3727. E-mail: clayplacel@aol.com. Website: www.clayplace.com. **Director:** Elvira Peake. Retail gallery. Estab. 1973. Represents 50 emerging, mid-career and established artists. Exhibited artists include Jack Troy and Kirk Mangus. Sponsors 12 shows/year. Open all year. Located in small shopping area; "second level modern building with atrium." 2,000 sq. ft. 50% of space for special exhibition. Overall price range: $10-2,000; most work sold at $40-100.

Media: Considers ceramic, sculpture, glass and pottery. Most frequently exhibits clay, glass and enamel.

Terms: Accepts artwork on consignment (50% commission) or buys outright for 50% of retail price (net 30 days). Retail price set by artist. Sometimes offers customer discounts and payment by installments. Gallery provides insurance, promotion and shipping costs from gallery.

Submissions: Prefers only clay, some glass and enamel. Send query letter with résumé, slides, photographs, bio and SASE. Write for appointment to show portfolio. Portfolio should include actual work rather than slides. Responds in 1 month. Does not reply when busy. Files résumé. Does not return slides. Finds artists through visiting exhibitions and art collectors' referrals.

Tips: "Functional pottery sells well. Emphasis on form, surface decoration. Some clay artists have lowered quality in order to lower prices. Clientele look for quality, not price."

GALLERY JOE, 302 Arch St., Philadelphia PA 19106. (215)592-7752. Fax: (215)238-6923. **Director:** Becky Kevlin. Retail and commercial exhibition gallery. Estab. 1993. Represents/exhibits 15-20 emerging, mid-career and established artists. Exhibited artists include Diana Moore and Harry Roseman. Sponsors 6 shows/year. Average display time 6 weeks. Open all year; Wednesday-Saturday, 12-5:30. Located in Old City; 1,400 sq. ft. 100% of space for gallery artists. 80% private collectors, 20% corporate collectors. Overall price range: $500-20,000; most work sold at $1,000-5,000.

Media: Only exhibits sculpture and drawing.

Style: Exhibits representational/abstract.

Terms: Artwork is accepted on consignment (50% commission). Retail price set by the gallery and the artist. Gallery provides insurance and promotion. Artist pays for shipping costs. Prefers artwork framed.

Submissions: Send query letter with résumé, slides, reviews and SASE. Responds in 6 weeks. Finds artists mostly by visiting galleries and through artist referrals.

LANCASTER MUSEUM OF ART, 135 N. Lime St., Lancaster PA 17602. (717)394-3497. **Executive Director:** Cindi Morrison. Nonprofit organization. Estab. 1965. Represents over 100 emerging, mid-career and established artists/year. 500 members. Sponsors 8 shows/year. Average display time 6 weeks. Open all year; Monday-Saturday, 10-4; Sunday, 12-4. Located downtown Lancaster; 4,000 sq. ft.; neoclassical architecture. 100% of space for special exhibitions. 100% of space for gallery artists. Overall price range: $100-25,000; most work sold at $100-10,000.

Media: Considers all media.

Terms: Accepts work on consignment (30% commission). Retail price set by the artist. Gallery provides insurance; shipping costs are shared. Artwork must be ready for presentation.

Submissions: Send query letter with résumé, slides, photographs, SASE, and artist's statement for review by exhibitions committee. Annual deadline: February 1st.

Tips: Advises artists to submit quality slides and well-presented proposal. "No phone calls."

N̄ MATTRESS FACTORY, 500 Sampsonia Way, Pittsburgh PA 15212. (412)231-3169. Fax: (412)322-2231. E-mail: info@mattress.org. Website: www.mattress.org. **Curator:** Michael Olijnyk. Nonprofit contemporary arts museum. Estab. 1977. Represents 8-12 emerging, mid-career and established artists/year. Exhibited artists include: James Turrell, Bill Woodrow, Ann Hamilton, Jessica Stockholder, John Cage, Allan Wexler, Winnifred Lutz and Christian Boltanski. Sponsors 8-12 shows/year. Average display time 6 months. Tuesday-Saturday, 10-5; Sunday 1-5; closed August. Located in Pittsburgh's historic Mexican War streets; 14,000 sq. ft.; a six-story warehouse and a turn-of-the century general store present exhibitions of temporary and permanent work.

Media: Considers site-specific installations—completed in residency at the museum.

Submissions: Send query letter with résumé, slides, bio. Responds in 1 year.

N̄ MCS GALLERY, 1110 Northampton St., Easton PA 18102. (610)253-2332, ext. 236. Fax: (610)253-6722. E-mail: mcsgallery@aol.com. Website: www.mcsgallery.com. **Director:** Thomas Burke. For-profit gallery. Estab. 1999. Approached by 20 artists/year. Exhibits 8 emerging, mid-career and established artists. Sponsors 6 exhibits/year. Average display time 6 weeks. Open all year; Tuesday-Saturday, 11-5; weekends, 12-5. Located in downtown Easton PA; approximately 4,000 sq. ft. that is divided in 3 gallery spaces. Clients include local community and upscale. 5% of sales are to corporate collectors. Overall price range: $500-5,000; most work sold at $1,500.

Media: Considers acrylic, collage, drawing, fiber, installation, mixed media, oil, paper, pen & ink, sculpture, watercolor, engravings, etchings, linocuts, lithographs, mezzotints, serigraphs and woodcuts. Most frequently exhibits paintings, sculpture and mixed media.

Style: Exhibits: expressionism, impressionism, postmodernism, surrealism and painterly abstraction. Most frequently exhibits painterly abstraction, impressionism and surrealism. Genres include figurative and landscapes.

Terms: Artwork is accepted on consignment and there is a 40% commission. Retail price set by the gallery and the artist. Gallery provides insurance, promotion and contract. Accepted work should be framed. Does not require exclusive representation locally.

Submissions: Write to arrange a personal interview to show portfolio of slides and transparencies. Mail portfolio for review. Send artist's statement, bio, résumé, SASE and slides. Returns material with SASE. Responds in 1 month. Files slides, résumé and statements. Finds artists through word of mouth, submissions, art exhibits and referrals by other artists.

☑ **NEWMAN GALLERIES**, 1625 Walnut St., Philadelphia PA 19103. (215)563-1779. Fax: (215)563-1614. E-mail: info@newmangalleries1865.com. Website: www.newmangalleries1865.com. **Owners:** Walter A. Newman, Jr., Walter A. Newman III, Terrence C. Newman. Retail gallery. Estab. 1865. Represents 10-20 emerging, mid-career and established artists/year. Exhibited artists include Timothy Barr, Randolph Bye, James Mcginley, Anthony J. Rudisill, Leonard Mizerek, Mary Anna Goetz, John Reilly, Richard C. Moore and John English. Sponsors 2-4 shows/year. Average display time 1 month. Open September through June, Monday-Friday, 9-5:30; Saturday, 10-4:30; July through August, Monday-Friday, 9-5. Located in Center City Philadelphia. 4,000 sq. ft. "We are the largest and oldest gallery in Philadelphia." 50% of space for special exhibitions; 100% of space for gallery artists. Clientele: traditional. 50% private collectors, 50% corporate collectors. Overall price range: $1,000-100,000; most work sold at $2,000-20,000.

Media: Considers oil, acrylic, watercolor, pastel, sculpture, engraving, mezzotint and etching. Most frequently exhibits watercolor, oil/acrylic, and pastel.

Style: Exhibits expressionism, impressionism, photorealism and realism. Genres include landscapes, florals, Americana, wildlife and figurative work. Prefers: landscapes, Americana and still life.

Terms: Accepts work on consignment (45% commission). Retail price set by gallery and artist. Gallery provides insurance. Promotion and shipping costs are shared. Prefers oils framed; prints, pastels and watercolors unframed but matted.

Submissions: Send query letter with résumé, 12-24 slides, bio and SASE. Call for appointment to show portfolio of originals, photographs and transparencies. Responds in 1 month. Files "things we may be able to handle but not at the present time." Finds artists through agents, visiting exhibitions, word of mouth, art publications, sourcebooks and artists' submissions.

PAINTED BRIDE ART CENTER, 230 Vine St., Philadelphia PA 19106. (215)925-9235. Fax: (215)925-7402. E-mail: ellen@paintedbride.org. Website: www.paintedbride.org. **Director or Programs:** Ellen M. Rosenholtz. Nonprofit gallery and alternative space. Estab. 1969. Represents emerging, mid-career and established artists. Sponsors 4 shows/year. Average display time 2 months. Open September-June. Located in Old City Philadelphia; 1,100 sq. ft.; "two levels and a large exhibit room contiguous to a performance space." Clientele: culturally, professionally diverse.

Media: Considers performance art and all media.

Style: Exhibits all styles. Promotes experimental works and non-traditional mediums.

Terms: "In the nonprofit/alternative space, artist pays 30% of retail price." Retail price set by the artist. Gallery provides insurance, promotion and contract; shipping costs are shared. "Artwork must be ready to present."

Submissions: All artists encouraged. Send query letter with résumé, slides, brochure, reviews and artist statement. Unsolicited submissions reviewed by Advisory Panel. Responds in 6 months.

Tips: "Include an artist statement, slide list and printed, not hand-written materials. Artist should be familiar with our institution, mission statement and artistic philosophy. Look on website for more information."

⋈ **PENTIMENTI GALLERY**, 133 N. Third St., Philadelphia PA 19106. (215)625-9990. Fax: (215)625-8488. E-mail: pentimen@earthlink.net. Website: www.pentimenti.com. **Contact:** Christine Pfister, director. For-profit gallery. Estab. 1992. Approached by many artists/year. Represents 20-30 emerging, mid-career and established artists. Sponsors 7-9 exhibits/year. Average display time 4-6 weeks. Open all year; Wednesday-Friday, 12-5:30; weekends 12-5. Closed Sundays, August. Located within the most historic square mile of the country in the heart of Old City Cultural district in Philadelphia. Overall price range: $250-12,000; most work sold at $2,000-7,000.

Media: Considers all media. Most frequently exhibits paintings—all media except pastel/watercolor.

Style: Exhibits: conceptualism, minimalism, postmodernism and painterly abstraction. Most frequently exhibits postmodernism, minimalism and conceptualism.

Terms: Artwork is accepted on consignment and there is a 50% commission. Retail price set by the gallery and the artist. Gallery provides insurance, promotion and contract. Requires exclusive representation locally.

Submissions: Call to arrange a personal interview to show portfolio of photographs, slides and transparencies. Send query letter with artist's statement, bio, brochure, photographs, résumé, SASE and slides. Returns material with SASE. Responds in 3 months. Finds artists through word of mouth, submissions, portfolio reviews, art exhibits, art fairs and referrals by other artists.

N. THE PRINT CENTER, 1614 Latimer St., Philadelphia PA 19103. (215)735-6090. Fax: (215)735-5511. E-mail: info@printcenter.org. Website: www.printcenter.org. Nonprofit gallery. Estab. 1915. Exhibits emerging, mid-career and established artists. Approached by 500 artists/year. Sponsors 11 exhibits/year. Average display time 6 weeks. Open all year; Tuesday-Saturday, 11-5:30. Closed December 21-January 3. Gallery houses 3 exhibit spaces as well as a separate gallery store. We are located in the historic Rittenhouse of Philadelphia. Clients include local community, students, tourists and upscale. 30% of sales are to corporate collectors. Overall price range: $15-15,000; most work sold at $200.
Media: Considers engravings, etchings, linocuts, lithographs, mezzotints, serigraphs and woodcuts. Send original artwork—no reproductions.
Style: Considers all styles and genres.
Terms: Artwork is accepted on consignment and there is a 50% commission. Retail price set by the artist. Gallery provides insurance, promotion and contract. Accepted work should be framed and matted. Does not require exclusive representation locally. Prefers prints and photos. Prefers only sculpture.
Submissions: Membership based—slides of members reviewed by committee. Send membership. Finds artists through submissions, art exhibits and membership.
Tips: Be sure to send proper labeling and display of slides with attached slide sheet.

N. ROSENFELD GALLERY, 113 Arch St., Philadelphia PA 19106. (215)922-1376. **Owner:** Richard Rosenfeld. Retail gallery. Estab. 1976. Represents 35 emerging and mid-career artists/year. Sponsors 18 shows/year. Average display time 3 weeks. Open all year; Wednesday-Saturday, 10-5; Sunday, noon-5. Located downtown, "Old City"; 2,200 sq. ft.; ground floor loft space. 85% of space for gallery artists. 80% private collectors, 20% corporate collectors. Overall price range: $200-6,000; most work sold at $1,500-2,000.
Media: Considers oil, acrylic, watercolor, pastel, drawing, mixed media, paper, sculpture, ceramics, craft, fiber, glass, woodcuts, engravings, lithographs, monoprints, wood engravings and etchings. Most frequently exhibits works on paper, sculpture and crafts.
Style: Exhibits all styles. Prefers painterly abstraction and realism.
Terms: Accepts work on consignment (50% commission). Retail price set by the gallery. Gallery provides insurance and promotion; shipping costs are shared. Prefers artwork framed.
Submissions: Send query letter with slides and SASE. Call or write for appointment to show portfolio of photographs and slides. Responds in 2 weeks. Finds artists through visiting exhibitions, word of mouth, various art publications and submissions.

N. SAMEK ART GALLERY OF BUCKNELL UNIVERSITY, Elaine Langone Center, Lewisburg PA 17837. (570)577-3792. Fax: (570)577-3215. E-mail: peltier@bucknell.edu. Website: www.departments.buc knell.edu/samek-artgallery/. **Director:** Dan Mills. Gallery Manager: Cynthia Peltier. Nonprofit gallery. Estab. 1983. Exhibits emerging, mid-career and established artists. Sponsors 6 shows/year. Average display time 6 weeks. Open all year; Monday-Friday, 11-5; Saturday-Sunday, 1-4. Located on campus; 3,500 sq. ft. including main gallery, project room and video screening room.
Media: Considers all media, all types of contemporary and historic prints. Most frequently exhibits painting, prints and photographs.
Style: Exhibits all styles, genres and periods.
Terms: Retail price set by the artist. Gallery provides insurance, promotion (local) and contract; artist pays shipping costs to and from gallery. Prefers artwork framed or prepared for exhibition.
Submissions: Send query letter with résumé, slides and bio. Write for appointment to show portfolio of originals. Responds in 3 months. Files bio, résumé, slides. Finds artists through occasional artist invitationals/competitions.
Tips: "We usually work with themes and then look for work to fit that theme."

N. THE WORKS GALLERY, Dept. AGDM, 303 Cherry St., Philadelphia PA 19106. (215)922-7775. **Owner:** Ruth Snyderman. Retail gallery. Estab. 1965. Represents 200 emerging, mid-career and established artists. Exhibited artists include Eileen Sutton and Patricia Sannit. Sponsors 10 shows/year. Average display time 1 month. Open all year; Tuesday-Saturday, 10-6. First Friday of each month hours extend to 9 p.m. as all galleries in this district have their openings together. Exhibitions usually change on a monthly basis

except through the summer. Located downtown; 2,000 sq. ft. 65% of space for special exhibitions. Clientele: designers, lawyers, businessmen and women, students. 90% private collectors, 10% corporate collectors. Overall price range: $25-10,000; most work sold at $200-600.

Media: Considers ceramic, fiber, glass, photography and metal jewelry. Most frequently exhibits jewelry, ceramic and fiber.

Style: Exhibits all styles.

Terms: Accepts artwork on consignment (50% commission); some work is bought outright. Gallery provides insurance, promotion and contract; shipping costs are shared.

Submissions: Send query letter with résumé, 5-10 slides and SASE. Files résumé and slides, if interested.

Tips: "Most work shown is one-of-a-kind. We change the gallery totally for our exhibitions. In our gallery, someone has to have a track record so that we can see the consistency of the work. We would not be pleased to see work of one quality once and have the quality differ in subsequent orders, unless it improved. Always submit slides with descriptions and prices instead of walking in cold. Enclose an self-addressed, stamped return envelope. Follow up with a phone call. Try to have a sense of what the gallery's focus is so your work is not out of place. It would save everyone some time."

Rhode Island

N ARTIST'S COOPERATIVE GALLERY OF WESTERLY, 12 High St., Westerly RI 02891. (401)596-2020. Cooperative gallery and nonprofit corporation. Estab. 1992. Represents 40 emerging, mid-career and established artists/year. Sponsors 12 shows/year. Average display time 1 month. Offers spring and fall open juried shows. Open all year; Tuesday-Saturday, 11-4. Located downtown on a main street; 30′×80′; ground level, store front, arcade entrance, easy parking. 80% of sales are to private collectors, 20% corporate collectors. Overall price range: $20-3,000; most work sold at $20-300.

Media: Considers all media and all types of prints. Most frequently exhibits oils, watercolors, ceramics, sculpture and jewelry.

Style: Exhibits: expressionism, primitivism, painterly abstraction, postmodern works, impressionism and realism.

Terms: Co-op membership fee of $120/year, plus donation of time and hanging/jurying fee of $10. Gallery takes no percentage. Regional juried shows each year. Retail price set by the artist. Gallery provides promotion; artist pays for shipping. Prefers artwork framed.

Submissions: Send query letter with 3-6 slides or photos and artist's statement. Call or write for appointment. Responds in 2-3 weeks. Membership flyer and application available on request.

Tips: "Take some good quality pictures of your work in person, if possible, to galleries showing the kind of work you want to be associated with. If rejected, reassess your work, presentation and the galleries you have selected. Adjust what you are doing appropriately. Try again. Be upbeat and positive."

☑ CADEAUX DU MONDE, 26 Mary St., Newport RI 02835. (401)848-0550. Fax: (401)849-3225. E-mail: info@cadeauxdumonde.com. Website: www.cadeauxdumonde.com. **Owners:** Jane Perkins, Katie Dyer and Bill Perkins. Retail gallery. Estab. 1987. Represents emerging, mid-career and established artists. Exhibited artists include: John Lyimo and A.K. Paulin. Sponsors 3 changing shows and 1 ongoing show/year. Average display time 3-4 weeks. Open all year; daily, 10-6 and by appointment. Located in commercial district; 1,300 sq. ft. Located in historic district in an original building with original high tin ceilings, wainscoting and an exterior rear Mediterranean-style courtyard garden that has rotating exhibitions during the summer months. 15% of space for special exhibitions; 85% of space for gallery artists. Clients include tourists, upscale, local community and students. 95% of sales are to private collectors, 5% corporate collectors. Overall price range: $20-5,000; most work sold at $100-300.

Media: Considers all media suitable for display in a garden atmosphere for special exhibitions. No prints.

Style: Exhibits: folk art. "Style is unimportant, quality of work is deciding factor—look for unusual, offbeat and eclectic."

Terms: Accepts work on consignment (30% commission). Retail price set by the artist. Gallery provides insurance. Artist pays shipping costs and promotional costs of opening. Prefers artwork framed.

Submissions: Send query letter with résumé, 10 slides, bio, photographs and business card. Call for appointment to show portfolio of photographs or slides. Responds only if interested within 2 weeks. Finds artists through word of mouth, referrals by other artists, visiting art fairs and exhibitions, artist's submissions.

Tips: Artists who want gallery representation should "present themselves professionally; treat their art and the showing of it like a small business; arrive on time and be prepared; and meet deadlines promptly."

☑ **THE DONOVAN GALLERY**, 3895 Main Rd., Tiverton Four Corners RI 02878. (401)624-4000. Fax: (401)624-4100. E-mail: kris@donovangallery.com. Website: www.donovangallery.com. **Owner:** Kris Donovan. Retail gallery. Estab. 1993. Represents 50 emerging, mid-career and established artists/year. Average display time 1 month. Open all year; Monday-Saturday, 10-5; Sunday, 12-5; shorter winter hours. Located in a rural shopping area; 2,000 sq. ft.; located in 1750s historical home. 100% of space for gallery artists. Clientele: tourists, upscale, local community and students. 90% private collectors, 10% corporate collectors. Overall price range: $80-6,500; most work sold at $250-800.

Media: Considers oil, acrylic, watercolor, pastel, mixed media, collage, paper, sculpture, ceramics, some craft, fiber and glass; and all types of prints. Most frequently exhibits watercolors, oils and pastels.

Style: Exhibits conceptualism, impressionism, photorealism and realism. Exhibits all genres. Prefers: realism, impressionism and representational.

Terms: Accepts work on consignment (45% commission). Retail price set by the artist. Gallery provides limited insurance, promotion and contract; artist pays for shipping. Prefers artwork framed.

Submissions: Accepts only artists from New England. Send query letter with résumé, 6 slides, bio, brochure, photographs, SASE, business card, reviews and artist's statement. Call or write for appointment to show portfolio of photographs or slides or transparencies. Responds in 1 week. Files material for possible future exhibition. Finds artists through networking and submissions.

Tips: "Do not appear without an appointment, especially on a weekend. Be professional, make appointments by telephone, be prepared with résumé, slides and (in my case) some originals to show. Don't give up. Join local art associations and take advantage of show opportunities there."

🆕 **FINE ARTS CENTER GALLERIES/UNIVERSITY OF R.I.**, 105 Upper College Rd., Kingston RI 02881-0820. (401)874-2627. Fax: (401)874-2007. E-mail: shar@uri.edu. Website: uri.edu/artsci/art/gallery. Nonprofit gallery. Estab. 1968. Exhibits emerging, mid-career and established. Sponsors 15-20 exhibits/year. Average display time 1-3 months. Open all year; Tuesday-Friday, 12-4; weekends, 1-4. Reduced hours in summer. Composed of 3 galleries—main (largest space), photography and corridor (hallway) galleries. Clients include local community, students, tourists and upscale.

Media: Considers all types of prints.

Style: Considers all styles and genres.

Terms: Retail price set by the artist. Gallery provides insurance. Accepted work should be framed. Does not require exclusive representation locally.

Submissions: Mail portfolio for review. Returns material with SASE. Responds in 1 month. Finds artists through word of mouth, submissions, art exhibits and referrals by other artists.

HERA EDUCATIONAL FOUNDATION, HERA GALLERY, 327 Main St., P.O. Box 336, Wakefield RI 02880. (401)789-1488. E-mail: info@heragallery.org. Website: www.heragallery.org. **Director:** Katherine Veneman. Nonprofit professional artist cooperative gallery. Estab. 1974. Located in downtown Wakefield, a Northeast area resort community (near beaches, Newport and Providence). Exhibits the work of emerging and established artists who live in New England, Rhode Island and throughout the US. 30 members. Sponsors 9-10 shows/year. Average display time 3 weeks. Hours: Wednesday, Thursday and Friday, 1-5; Saturday, 10-4. Closed January. Located downtown; 1,200 sq. ft. 40% of space for special exhibitions.

Media: Considers all media and original handpulled prints.

Style: Exhibits installations, conceptual art, expressionism, neo-expressionism, painterly abstraction, surrealism, conceptualism, postmodern works, realism and photorealism, basically all styles. "We are interested in innovative, conceptually strong, contemporary works that employ a wide range of styles, materials and techniques." Prefers "a culturally diverse range of subject matter which explores contemporary social and artistic issues important to us all."

Terms: Co-op membership. Retail price set by artist. Sometimes offers customer discount and payment by installments. Gallery provides promotion; artist pays for shipping and shares expenses like printing and postage for announcements. Commission is 25%. No insurance.

Submissions: Send query letter with SASE. "After sending query letter and SASE, artists interested in membership receive membership guidelines with an application. Twenty slides or a CD-Rom are required for application review along with résumé, artist statement and slide list." Portfolio required for membership; slides for invitational/juried exhibits. Finds artists through word of mouth, advertising in art publications, and referrals from members.

Tips: "Please write for membership guidelines. We have two categories of membership, one of which is ideal for out of state artists."

South Carolina

CECELIA COKER BELL GALLERY, Coker College, 300 E. College Ave., Hartsville, SC 29550. (843)383-8156. E-mail: lmerriman@pascal.coker.edu. Website: www.coker.edu/art/gallery.html. **Director:** Larry Merriman. "A campus-located teaching gallery which exhibits a great diversity of media and style to expose students and the community to the breadth of possibility for expression in art. Exhibits include regional, national and international artists with an emphasis on quality. Features international shows of emerging artists and sponsors competitions." Estab. 1984. Interested in emerging and mid-career artists. Sponsors 5 solo shows/year. Average display time 1 month. "Gallery is 30×40, located in art department; grey carpeted walls, track lighting."
Media: Considers oil, acrylic, drawings, mixed media, collage, works on paper, sculpture, installation, photography, performance art, graphic design and printmaking. Most frequently exhibits painting, sculpture/installation and mixed media.
Style: Considers all styles. Not interested in conservative/commercial art.
Terms: Retail price set by artist (sales are not common). Exclusive area representation not required. Gallery provides insurance, promotion and contract; shipping costs are shared.
Submissions: Send résumé, 10-15 good-quality slides and SASE by October 15. Write for appointment to show portfolio of slides.

N CITY ART GALLERY, 1224 Lincoln St., Columbia SC 29201. (803)252-3613. Fax: (803)252-3595. E-mail: gallerydirector@cityartonline.com. Website: www.cityartonline.com. **Contact:** Teri Tynes, gallery director. For-profit gallery. Estab. 1997. Approached by 100 artists/year. Represents 40 emerging, mid-career and established artists. Exhibited artists include: Tarleton Blackwell (oil, mixed media) and Preston Orr (mixed media). Sponsors 5 exhibits/year. Average display time 6 weeks. Open all year; Monday-Friday, 10-6; weekends, 11-3. Located in the Vista, the gallery is housed in a spacious 19th century warehouse. City Art features a large main gallery, an adjacent small works gallery and a large second floor exhibition space. 2% of sales are to corporate collectors. Overall price range: $65-5,000; most work sold at $2,500.
Media: Considers all media. Most frequently exhibits oil on canvas, mixed media and watercolor.
Style: Considers all styles and genres. Most frequently exhibits abstraction, narrative, contemporary realism and expressionism,
Terms: Artwork is accepted on consignment and there is a 40% commission. Retail price set by the artist. Gallery provides insurance, promotion and contract. Accepted work should be framed. Requires exclusive representation locally.
Submissions: Mail portfolio for review. Returns material with SASE. Responds in 3 weeks. Files slides and biography. Finds artists through word of mouth, portfolio reviews, art exhibits and referrals by other artists.
Tips: Include full résumé with list of collectors; include digital images as well as slides. Specific list of solo and group shows.

N COLEMAN FINE ART, 45 Hasell St., Charleston SC 29401. (843)853-7000. Fax: (843)722-2552. E-mail: colemanfinearts@aol.com. Website: www.colemanfineart.com. **Gallery Director:** Rebecca Ansert. Retail gallery, frame making and restoration. Estab. 1974. Represents 6 emerging, mid-career and established artists/year. Exhibited artists include Mary Whyte, Jan Pawlowski, Earl B. Lewis, J.P. Osborne, Kim Weiland and William P. Duffy. Sponsors 2 shows/year. Average display time 1 month. Open all year; Tuesday-Saturday, 10-6. Located in downtown historic Charleston; 900 sq. ft.; in 1840s building that once housed a grocery. Clientele: tourists, upscale and locals. 95-98% private collectors, 2-5% corporate collectors. Overall price range: $60-8,000; most work sold at $2,000-7,000.
Media: Considers oil, watercolor, pastel, pen & ink, drawing, mixed media, sculpture, ceramics, glass, woodcuts, engravings, lithographs, serigraphs and etchings. Most frequently exhibits watercolor, oil and glassworks.
Style: Exhibits expressionism, impressionism, photorealism and realism. Genres include portraits, landscapes, still lifes and figurative work. Prefers: figurative work/expressionism, realism and impressionism.
Terms: Accepts work on consignment (40% commission) or buys outright for 50% of retail price; net 90 days. Retail price set by the gallery and the artist. Gallery provides promotion and contract. Shipping costs are shared. Prefers artwork framed.

Submissions: Send query letter with brochure, 20 slides, reviews, bio and SASE. Write for appointment to show portfolio of photographs, slides and transparencies. Responds only if interested within 1 month. Files slides. Finds artists through submissions.

Tips: "Approach galleries with 20 slides, information on where artist has exhibited, sales, prices of work."

N STEVEN JORDAN GALLERY, 463 W. Coleman Blvd., Mt. Pleasant SC 29464. (843)881-1644. Website: www.stevenjordan.com. **Owner:** Steven Jordan. Retail gallery. Estab. 1987. Represents various 3 dimensional artists and 2 dimensional work by Steven Jordan A.W.S. Open all year; Monday-Saturday, 11-6. Located 5 miles from downtown; 1,600 sq. ft. Clientele: tourists, upscale, local community, students. 80% private collectors, 20% corporate collectors.

Media: Considers only sculpture and ceramics.

Style: Prefers coastal realism, humor and abstracts.

Terms: Accepts work on consignment (40% commission) to gallery. Retail price set by the artist. Gallery provides promotion. Shipping costs are shared.

Submissions: Accepts only artists from America. Prefers 3 dimensional work. Send query letter with slides, bio, brochure and photographs. Call for appointment to show portfolio of photographs or slides. Responds in 2 weeks. Finds artists through word of mouth, referrals by other artists, visiting art fairs and exhibitions and artist's submissions.

Tips: "Be optimistic! Don't be discouraged by failures. Perseverance is more important than talent."

PORTFOLIO ART GALLERY, 2007 Devine St., Columbia SC 29205. (803)256-2434. E-mail: portfolio @mindspring.com. **Owner:** Judith Roberts. Retail gallery and art consultancy. Estab. 1980. Represents 40-50 emerging, mid-career and established artists. Exhibited artists include Donald Holden, Sigmund Abeles and Joan Ward Elliott. Sponsors 4-6 shows/year. Average display time 3 months. Open all year. Located in a 1930s shopping village, 1 mile from downtown; 2,000 sq. ft.; features 12 foot ceilings. 100% of space for work of gallery artists. "A unique feature is glass shelves where matted and medium to small pieces can be displayed without hanging on the wall." Clientele: professionals, corporations and collectors. 40% private collectors, 40% corporate collectors. Overall price range: $150-12,500; most work sold at $300-3,000.

• Portfolio Art Gallery was selected by readers of the local entertainment weekly paper and by *Columbia Metropolitan* magazine as the best gallery in the area.

Media: Considers oil, acrylic, watercolor, pastel, mixed media, collage, works on paper, sculpture, ceramic, glass, original handpulled prints, woodcuts, wood engravings, linocuts, engravings, mezzotints, etchings, lithographs and serigraphs. Most frequently exhibits watercolor, oil and original prints.

Style: Exhibits neo-expressionism, painterly abstraction, imagism, minimalism, color field, impressionism, realism, photorealism and pattern painting. Genres include landscapes and figurative work. Prefers: landscapes/seascapes, painterly abstraction and figurative work. "I especially like mixed media pieces, original prints and oil paintings. Pastel medium and watercolors are also favorites. Kinetic sculpture and whimsical clay pieces."

Terms: Accepts work on consignment (40% commission). Retail price set by gallery and artist. Offers payment by installments. Gallery provides insurance, promotion and contract; artist pays for shipping. Artwork may be framed or unframed.

Submissions: Send query letter with slides, bio, brochure, photographs, SASE and reviews. Write for appointment to show portfolio of originals, slides, photographs and transparencies. Responds only if interested within 1 month. Files tearsheets, brochures and slides. Finds artists through visiting exhibitions and referrals.

Tips: "The most common mistake beginning artists make is showing all the work they have ever done. I want to see only examples of recent best work—unframed, originals (no copies)—at portfolio reviews."

THE SPARTANBURG COUNTY MUSEUM OF ART, 385 S. Spring St., Spartanburg SC 29306. (803)583-2776. Fax: (803)948-5353. E-mail: museum@spartanarts.org. Website: www.sparklenet.com/mu seum-of-art. **Executive Director:** Theresa H. Mann. Nonprofit art museum. Estab. 1968. Museum shop carries original art, pottery, glass and jewelry by South Carolina artists. Represents emerging, mid-career and established artists. Sponsors 25 shows/year. Average display time 6-8 weeks. Open all year; Monday-Friday, 9-5; Saturday, 10-2; Sunday, 2-5. Located downtown, in historic neighborhood; 2,500 sq. ft.; Overall price range: $150-20,000; most work sold at $150-800.

Media: Considers oil, acrylic, watercolor, pastel, pen & ink, drawings, mixed media, collage, works on paper, sculpture, ceramic, craft, fiber, glass, installation and photography.

Style: Exhibits all styles and genres.

Terms: Accepts artwork on consignment (33⅓% commission). Retail price set by artist. The museum provides insurance and promotion; shipping costs are negotiable. Artwork must be framed.

Submissions: Send query letter with résumé, 10 slides, bio, brochure, SASE and reviews. Write for appointment to show portfolio of slides. Responds in 4-6 weeks. Files bio, résumé and brochure.

South Dakota

N DAKOTA ART GALLERY, 713 Seventh St., Rapid City SD 57701. (605)394-4108. Fax: (605)394-6121. **Director:** Duane Baumgartner. Retail gallery. Estab. 1971. Represents approximately 200 emerging, mid-career and established artists, approximately 180 members. Exhibited artists include James Van Nuys and Russell Norberg. Sponsors 8 shows/year. Average display time 6 weeks. Also sponsors 6-week-long spotlight exhibits—8 times a year. Average display time 6 weeks. Open all year; Monday, 12-5; Tuesday-Saturday, 10-5; Sunday, 1-5. Memorial Day through Labor Day: Monday, 12-7; Tuesday-Saturday 10-7; Sunday, 1-7. Located in downtown Rapid City; 1,800 sq. ft. 40% of space for special exhibitions; 60% of space for gallery artists. 80% private collectors, 20% corporate collectors. Overall price range: $25-7,500; most work sold at $25-400.
Media: Considers all media and all types of prints. Most frequently exhibits oil, acrylics, watercolors, pastels, stained glass and ceramics.
Style: Exhibits expressionism, painterly abstraction and impressionism and all genres. Prefers: landscapes, western, regional, still lifes and traditional.
Terms: Accepts work on assignment (40% commission). Retail price set by the artist. Gallery provides insurance, promotion and contract. Artist pays shipping costs.
Submissions: "Our main focus is on artists from SD, ND, MN, WY, CO, MT and IA. We also show artwork from any state that has been juried in." Must be juried in by committee. Send query letter with résumé, 15-20 slides, bio and photographs. Call for appointment to show portfolio of photographs, slides, bio and résumé. Responds in 1 month. Files résumés and photographs. Finds artists through word of mouth, referrals by other artists, visiting art fairs and exhibitions, artist's submissions.
Tips: "Make a good presentation with professional résumé, biographical material, slides, etc. Know the gallery quality and direction in sales, including prices."

N THE HERITAGE CENTER, INC., Red Cloud Indian School, Pine Ridge SD 57770. (605)867-5491. Fax: (605)867-1291. E-mail: rcheritage@6asec.net. Website: 6asec.net/rcheritage/. **Director:** Brother Simon. Nonprofit gallery. Estab. 1984. Represents emerging, mid-career and established artists. Sponsors 6 group shows/year. Accepts only Native Americans. Average display time 10 weeks. Clientele: 80% private collectors. Overall price range: $50-3,000; most work sold at $100-400.
Media: Considers oil, acrylic, watercolor, pastel, pen & ink, drawings, sculpture and original handpulled prints.
Style: Exhibits contemporary, impressionism, primitivism, western and realism. Genres include western. Specializes in contemporary Native American art (works by Native Americans). Interested in seeing pictographic art in contemporary style. Likes clean, uncluttered work.
Terms: Accepts work on consignment (20% commission). Retail price set by artist. Customer discounts and payment by installments are available. Exclusive area representation not required. Gallery provides insurance and promotion; artist pays for shipping.
Submissions: Send query letter, résumé, brochure and photographs Wants to see "fresh work and new concepts, quality work done in a professional manner." Portfolio review requested if interested in artist's work. Finds artists through word of mouth, publicity in Native American newspapers.
Tips: "Show art properly matted or framed. Good work priced right always sells. We still need new Native American artists if their prices are not above $300. Write for information about annual Red Cloud Indian Art Show."

N SOUTH DAKOTA ART MUSEUM, Medary Ave. at Harvey Dunn St., P.O. Box 2250, Brookings SD 57007. (605)688-5423. Fax: (605)688-4445. **Curator of Exhibits:** John Rychtarik. Museum. Estab. 1970. Exhibits 12-20 emerging, mid-career and established artists. Sponsors 17 exhibits/year. Average display time 2-4 months. Open all year; Saturday, 10-4; Sunday, 12-4. Closed state holidays. Consists of 6 galleries; 26,000 sq. ft. Clients include local community, students, tourists and collectors. Overall price range: $200-6,000; most work sold at $500.
Media: Considers all media and all types of prints. Most frequently exhibits painting, sculpture and fiber.
Style: Considers all styles.
Terms: Artwork is accepted on consignment and there is a 30% commission. Retail price set by the artist. Gallery provides insurance and promotion. Accepted work should be framed. Does not require exclusive representation locally.

Submissions: Send artist's statement, bio, résumé, SASE and slides. Returns material with SASE. Responds only if interested within 3 months. Finds artists through word of mouth, portfolio reviews, art exhibits and referrals by other artists.

VISUAL ARTS CENTER, (formerly Civic Fine Arts Center), 301 S. Main, Sioux Falls SD 57104. (605)367-6000 or (877)WASH-PAV. Fax: (605)367-7399. E-mail: washingtonpavilion.org. Nonprofit museum. Estab. 1961. Open Monday-Saturday, 9-5; Sundays 11-5.
Media: Considers all media.
Style: Exhibits local, regional and national artists.
Submissions: Send query letter with résumé and slides.

Tennessee

BENNETT GALLERIES, 5308 Kingston Pike, Knoxville TN 37919. (865)584-6791. Fax: (865-588-6130. Website: www.bennettgalleries.com. **Director:** Mary Morris. Owner: Rick Bennett. Retail gallery. Represents emerging and established artists. Exhibited artists include Richard Jolley, Carl Sublett, Scott Duce, Andrew Saftel and Tommie Rush. Sponsors 10 shows/year. Average display time 1 month. Open all year; Monday-Thursday, 10-6; Friday-Saturday, 10-5:30. Located in West Knoxville. Clientele: 70% private collectors, 30% corporate collectors. Overall price range: $200-20,000; most work sold at $2,000-8,000.
Media: Considers oil, acrylic, watercolor, pastel, drawing, mixed media, works on paper, sculpture, ceramic, craft, photography, glass, original handpulled prints. Most frequently exhibits painting, ceramic/clay, wood, glass and sculpture.
Style: Exhibits contemporary works in abstraction, figurative, non-objective, narrative, primitivism.
Terms: Accepts artwork on consignment (50% commission). Retail price set by the gallery and the artist. Sometimes offers customer discounts and payment by installments. Gallery provides insurance on works at the gallery, promotion, contract from gallery. Prefers artwork framed. Shipping to gallery to be paid by the artist.
Submissions: Send query letter with résumé, no more than 20 slides, bio, photographs, SASE and reviews. Portfolio review requested if interested in artist's work. Portfolio should include originals, slides, photographs or transparencies. Responds in 6 weeks. Files samples and résumé. Finds artists through agents, visiting exhibitions, word of mouth, various art publications, sourcebooks, submissions/self-promotions and art collectors' referrals.
Tips: "When approaching a new gallery, do your research to determine if the establishment is the right venue for your work. Also make a professional presentation with clearly labeled slides and relevant reference material along with a self-addressed envelope."

☑ **JAY ETKIN GALLERY**, 409 S. Main St., Memphis TN 38103. (901)543-0035. E-mail: etkinart@hotmail.com. Website: www.jayetkingallery.com. **Owner:** Jay S. Etkin. Retail gallery. Estab. 1989. Represents/exhibits 20 emerging, mid-career and established artists/year. Exhibited artists include: Rob vander Schoor, Jeff Scott and Pamela Cobb. Sponsors 10 shows/year. Average display time 1 month. Open all year; Tuesday-Saturday, 11-5. Located in downtown Memphis; 10,000 sq. ft.; gallery features public viewing of works in progress. 30% of space for special exhibitions; 05% of space for gallery artists. Clientele: young upscale, corporate. 80% private collectors, 20% corporate collectors. Overall price range $200-12,000; most work sold at $1,000-3,000.
Media: Considers all media except craft, papermaking. Also considers kinetic sculpture and conceptual work. "We do very little with print work." Most frequently exhibits oil on paper canvas, mixed media and sculpture.
Style: Exhibits expressionism, conceptualism, neo-expressionism, painterly abstraction, postmodern works, realism, surrealism. Genres include landscapes and figurative work. Prefers: figurative expressionism, abstraction, landscape.
Terms: Artwork is accepted on consignment (60% commission). Retail price set by the gallery and the artist. Gallery provides promotion. Artist pays for shipping or costs are shared at times.
Submissions: Accepts artists generally from mid-south. Prefers only original works. Looking for long-term committed artists. Send query letter with 6-10 sildes or photographs, bio and SASE. Write for appointment to show portfolio of photographs, slides and cibachromes. Responds only if interested within 1 month. Files bio/slides if interesting work. Finds artists through referrals, visiting area art schools and studios, occasional drop-ins.

Tips: "Be patient. The market in Memphis for quality contemporary art is only starting to develop. We choose artists whose work shows technical know-how and who have ideas about future development in their work. Make sure work shows good craftsmanship and good ideas before approaching gallery. Learn how to talk about your work."

THE PARTHENON, Centennial Park, Nashville TN 37201. (615)862-8431. Fax: (615)880-2265. E-mail: susan_shockley@metro.nashville.org. Website: www.parthenon.org. **Curator:** Susan E. Shockley. Nonprofit gallery in a full-size replica of the Greek Parthenon. Estab. 1931. Exhibits the work of emerging to mid-career artists. Clientele: general public, tourists. Sponsors 6-12 shows/year. Average display time 2 months. Overall price range: $300-2,000; most work sold at $750. "We also house a permanent collection of American paintings (1765-1923)."
Media: Considers "nearly all" media.
Style: "Interested in both objective and non-objective work. Professional presentation is important."
Terms: "Sale requires a 20% commission." Retail price set by artist. Gallery provides a contract and limited promotion. The Parthenon does not represent artists on a continuing basis.
Submissions: Send 10-20 well-organized slides with SASE, résumé and supporting materials, addressed to Artist Submissions.
Tips: "We plan our gallery calendar at least one year in advance."

RIVER GALLERY, 400 E. Second St., Chattanooga TN 37403. (423)265-5033, ext. 5. Fax: (423)265-5944. E-mail: details@river-gallery.com. **Owner Director:** Mary R. Portera. Retail gallery. Estab. 1992. Represents 300 emerging and mid-career artists/year. Exhibited artists include: Leonard Baskin and Scott E. Hill. Sponsors 11 shows/year. Average display time 1 month. Open all year; Monday-Saturday, 10-5; Sunday, 1-5. Located in Bluff View Art District in downtown area; 2,500 sq. ft.; restored early New Orleans-style 1900s home; arched openings into rooms. 30% of space for special exhibitions; 70% of space for gallery artists. Clients include upscale tourists, local community. 95% of sales are to private collectors, 5% corporate collectors. Overall price range: $5-5,000; most work sold at $600-2,000.
Media: Considers all media. Considers woodcuts, engravings, lithographs, wood engravings, mezzotints, linocuts and etchnigs. Most frequently exhibits oil, photography, watercolor, mixed media, clay, jewelry and glass.
Style: Exhibits all styles and genres. Prefers painterly abstraction, impressionism, photorealism.
Terms: Accepts work on consignment (50% commission). Retail price set by the gallery. Gallery provides insurance, promotion and contract; shipping costs are shared. Prefers artwork framed.
Submissions: Send query letter with résumé, slides, bio, photographs, SASE, reviews and artist's statement. Call or e-mail for appointment to show portfolio of photographs and slides. Files all material "unless we are not interested then we return all information to artist." Finds artists through word of mouth, referrals by other artists, visiting art fairs and exhibitions, submissions, ads in art publications.

Texas

BLOSSOM STREET GALLERY & SCULPTURE GARDEN, 4809 Blossom, Houston TX 77007. Phone/fax: (713)869-1921. E-mail: Director@blossomstreetGallery.com. Website: www.blossomstreetgallery.com. **Contact:** Laurie, director. For-profit gallery. Estab. 1997. Approached by 40 artists/year. Represents 20 emerging, mid-career and established artists. Exhibited artists include: Richard Roederer (painting and sculpture) and William Webman (photography). Average display time 1 month. Open all year; Tuesday-Sunday, 11-6. Located in inner city Houston; 3 exhibit spaces and 1 acre sculpture park and garden area. Clients include local community, tourists and upscale. 20% of sales are to corporate collectors. Overall price range: $200-20,000; most work sold at $1,000.
Media: Considers acrylic, collage, drawing, fiber, glass, installation, mixed media, oil, paper, pastel, pen & ink, sculpture, watercolor, etchings, linocuts, lithographs, mezzotints, serigraphs and woodcuts. Most frequently exhibits oil, collage and photography.
Style: Considers all styles. Genres include Americana, figurative work and landscapes.
Terms: Artwork is accepted on consignment and there is a 50% commission. Retail price set by the gallery and the artist. Gallery provides insurance, promotion and contract. Accepted work should be hangable. Requires exclusive representation locally—if a one-person exhibit.
Submissions: Send query letter with artist's statement, bio, brochure, business card, photocopies, photographs, résumé, reviews, SASE, slides or send web page. Returns material with SASE. Responds in 1 month. Finds artists through word of mouth, submissions, portfolio reviews, art exhibits and referrals by other artists.

☑ 👤 **JULIA C. BUTRIDGE GALLERY AT THE DOUGHERTY ARTS CENTER**, 1110 Barton Springs Rd., Austin TX 78704. (512)397-1455. E-mail: megan.hill@ci.austin.tx. Website: www.ci.austin.tx .us/dougherty/butridge.htm. **Gallery Coordinator:** Megan Neiler. Nonprofit gallery. Represents emerging, mid-career and established artists. Exhibited artists include John Christensen and T. Paul Hernandez. Sponsors 12 shows/year. Average display time 1 month. Open all year; Monday-Thursday, 9-9:30; Friday 9-5:30; Saturday 10-2. Located in downtown Austin; 1,800 sq. ft.; open to all artists. 100% of space for special exhibitions. Clientele: citizens of Austin and central Texas. Overall price range: $100-5,000.
Media: Considers all media, all types of prints.
Style: Exhibits all styles, all genres. Prefers: contemporary.
Terms: "Gallery does not handle sales or take commissions. Sales are encouraged but must be conducted by the artist or his/her affiliate." Rental fee for space; covers 1 month. Retail price set by the artist. Gallery provides insurance and promotion; artist pays shipping costs to and from gallery. Artwork must be framed.
Submissions: Accepts only regional artists, central Texas. Send query letter with résumé and 10-20 slides. Write for appointment to show portfolio of photographs and slides. Responds in 1 month. Files résumé, slides. Finds artists through visiting exhibitions, publications, submissions.
Tips: "Since most galleries will not initially see an artist via an interview, have fun and be creative in your paper presentations. Intrigue them!"

N̲ CARSON COUNTY SQUARE HOUSE MUSEUM, P.O. Box 276, Panhandle TX 79068. (806)537-3524. Fax: (806)537-5628. **Execitove Director:** Viola Moore. Regional museum. Estab. 1967. Exhibits emerging, mid-career and established artists. Sponsors 12 shows/year (6 in each of 2 galleries). Average display time 2 months. Open all year. Purvines Gallery: 870 sq. ft (64.5 linear ft) in historic house; Brown Gallery: 1,728 sq. ft. (1,200 linear ft) in modern education building. Clientele: 100% private collectors. Overall price range: $50-1,200; most work sold at $150-500.
Media: Considers all media.
Style: All genres. No nudes.
Terms: Artwork accepted in exchange for a contributed piece at the end of the show. Artist and buyer make private arrangements; museum stays out of sale. Retail price set by artist. Gallery provides insurance, promotion and contract; artist pays shipping costs. Prefers artwork framed.
Submissions: Accepts only artists from Texas panhandle and adjacent states. Send query letter with résumé, slides, brochure, photographs, review and SASE. Write for appointment to show portfolio of photographs and slides. Responds only if interested within 1 month. Files all material.

CONTEMPORARY GALLERY, 4152 Shady Bend Dr., Dallas TX 75244. (972)247-5246. **Director:** Patsy C. Kahn. Private dealer. Estab. 1964. Interested in established artists. Clients include collectors and retail.
Media: Considers original handpulled prints.
Style: Contemporary, 20th-century art—graphics.
Terms: Accepts work on consignment or buys outright. Retail price set by gallery and artist; shipping costs are shared.
Submissions: Send query letter, résumé, slides and photographs. Write for appointment to show portfolio.

N̲ DALLAS MUSEUM OF ART, 1717 Harwood St., Dallas TX 75214. (214)922-1344. Fax: (214)922-1350. E-mail: ekey@m-art.org. Website: www.DallasMuseumofArt.org. **Contact:** Ellen Key, public relations manager. Museum. Estab. 1903. Exhibits emerging, mid-career and established: Exhibited artists include: Thomas Struth. Average display time 3 months. Open all year; Tuesday-Sunday, 11-5:30. Closed New Year's Day, Thanksgiving and Christmas. Clients include local community, students, tourists and upscale.
Media: Considers all media and all types of prints.
Style: Considers all styles and genres.

DIVERSEWORKS ARTSPACE, 1117 E. Freeway, Houston TX 77002. (713)223-8346. Fax: (713)223-4608. E-mail: info@diverseworks.org. **Visual Arts Director:** Diane Barber. Nonprofit gallery/performance space. Estab. 1982. Represents 1,400 members; emerging and mid-career artists. Sponsors 10-12 shows/year. Average display time 6 weeks. Open all year. Located just north of downtown (warehouse district).

NEED HELP? For tips on finding markets and understanding listings, see our Quick-Start Guide in the front of this book.

Has 4,000 sq. ft. for exhibition, 3,000 sq. ft. for performance. "We are located in the warehouse district of Houston. The complex houses five artists's studios (20 artists), and a conservator/frame shop." 75% of space for special exhibition.

Style: Exhibits all contemporary styles and all genres.

Terms: "DiverseWorks does not sell artwork. If someone is interested in purchasing artwork in an exhibit we have, the artist contacts them." Gallery provides insurance, promotion and shipping costs. Accepts artwork framed or unframed, depending on the exhibit and artwork.

Submissions: All proposals are put before an advisory board made up of local artists. Send query letter with résumé, slides and reviews. Call or write to schedule an appointment to show a portfolio, which should include originals and slides. Responds in 3 months.

Tips: "Call first for proposal guidelines."

N EL TALLER GALLERY-AUSTIN, 2438 W. Anderson Lane, #C-3, Austin TX 78757. (800)234-7362. Fax: (512)302-4895. **Owner:** Olga. Retail gallery, art consultancy. Estab. 1980. Represents 20 emerging, mid-career and established artists/year. Exhibited artists include R.C. Gorman and Amado Peña. Sponsors 3 shows/year. Average display time 2-4 weeks. Open all year; Tuesday-Saturday, 10-6. 1,850 sq. ft. 50% of space for special exhibitions; 100% of space for gallery artists. Clientele: tourists, upscale. 90% private collectors, 10% corporate collectors. Overall price range: $500-15,000; most work sold at $2,500-4,000.

Media: Considers all media and all types of prints. Most frequently exhibits mixed media, pastels and watercolors.

Style: Exhibits expressionism, primitivism, conceptualism, impressionism. Genres include florals, western, southwestern, landscapes. Prefers: southwestern, landscape, florals.

Terms: Accepts work on consignment (50% commission). Retail price set by the artist. Gallery provides insurance, promotion and contract; artist pays shipping costs. Prefers artwork framed.

Submissions: Send query letter with bio, photographs and reviews. Write for appointment to show portfolio of photographs and actual artwork. Responds only if interested within 2 months.

N F8 FINE ART GALLERY, 211 Earl Garrett, Kerrville TX 78028. (830)895-0646. Fax: (830)895-0680. E-mail: fineart@ktc.com. Website: www.f8fineart.com. For-profit gallery. Estab. 2001. Approached by 50 artists/year. Exhibits 45 emerging and mid-career artists. Exhibited artists include: Richard D. Griffin and Steven Dale Oleson. Sponsors 6 exhibits/year. Average display time 2 months. Open all year; Tuesday-Friday, 11-4; weekends, 11-4. Closed the week after Christmas. Located in a historical building in downtown Kerrville. A large two-story building with 16 ft. ceilings on each floor. It is beautifully restored, hardwood floors throughout—it is the area's premier gallery. Clients include local community and tourists. Overall price range: $195-6,000; most work sold at $300.

Media: Considers acrylic, drawing, oil, pastel, pen & ink, watercolor. Most frequently exhibits photography, pastel and oil. Considers all types of prints.

Style: Considers all styles.

Terms: Artwork is accepted on consignment and there is a 40% commission. Retail price set by the gallery. Gallery provides insurance, promotion and contract. Accepted work should be framed, mounted and matted. Does not require exclusive representation locally.

Submissions: Send query letter with artist's statement, bio, brochure, business card, photographs, résumé, reviews, SASE and slides. Returns material with SASE. Responds only if interested within 2 weeks. Files all information that doesn't need to be returned on artists we're interested in only. Finds artists through submissions, portfolio reviews and art exhibits.

Tips: Give us all of the information you think we might need in a clean, well-organized form. Do not send original work. All art submissions should represent the original as closely as possible. Archival-quality is a must. We ask that all work be printed archivally on fiber-based, gallery-quality paper for all exhibitions.

☑ GREMILLION & CO. FINE ART, INC., 3500 Jefferson, Austin TX 77005. (512)419-9524. E-mail: fineart@gremillion.com. Website: www.gremillion.com. **Director:** Jennifer Pech. Sales/Marketing: Ian MacMoy. Retail gallery. Estab. 1980. Represents 56 mid-career and established artists. May be interested in seeing the work of emerging artists in the future. Exhibited artists include John Pavlicek and Robert Rector. Sponsors 12 shows/year. Average display time 4-6 weeks. Open all year. Located "West University" area; 12,000 sq. ft. 50% of space for special exhibitions. 60% private collectors; 40% corporate collectors. Overall price range: $500-300,000; most work sold at $3,000-10,000.

Media: Considers oil, acrylic, watercolor, pastel, pen & ink, drawing, mixed media, collage, works on paper, sculpture, original handpulled prints, woodcuts, engravings, lithographs, wood engravings, mezzotints, linocuts, etchings and serigraphs.

Style: Exhibits painterly abstraction, minimalism, color field and realism. Genres include landscapes and figurative work. Prefers abstraction, realism and color field.

Terms: Accepts artwork on consignment (varying commission). Retail price set by the gallery and artist. Gallery provides insurance and promotion; shipping costs are shared. Prefers artwork unframed.
Submissions: Call for appointment to show portfolio of slides, photographs and transparencies. Responds only if interested within 3 weeks. Files slides and bios. Finds artists through submissions and word of mouth.

CAROL HENDERSON GALLERY, 3409 W. Seventh, Ft. Worth TX 76107. (817)878-2711. Fax: (817)878-2722. E-mail: carolhgallery@cs.com. Website: www.postpicasso.com. **Director:** Donna Craft. Retail gallery. Estab. 1989. Represents/exhibits 21 emerging, mid-career and established artists/year. Exhibited artists include Michael Bane, Art Werger and Cindi Holt. Sponsors 6 show/year. Average display time 3-4 weeks. Open all year; Tuesday-Saturday, 10-5:30. Located in West Fort Worth; 2,100 sq. ft. 90% of space for gallery artists. Clientele: upscale, local community. 90% private collectors, 10% corporate collectors. Overall price range: $100-10,000.
Media: Considers all media, woodcut, mezzotint and etching. Most frequently exhibits oil, acrylic and glass.
Style: Exhibits expressionism, photorealism, primitivism, painterly abstraction and realism. Genres include landscapes, florals and figurative work. Prefers figurative, abstract and landscape.
Terms: Artwork is accepted on consignment (50% commission). Retail price set by the gallery and the artist. Gallery provides insurance, promotion and contract; shipping costs are shared. Prefers artwork framed.
Submissions: Send query letter with résumé, brochure, business card, slides, photographs, reviews, bio and SASE. Call for appointment to show portfolio of photographs, slides and transparencies. Responds in 2 weeks. Finds artists through referrals, artists' submissions.

☑ **IRVING ARTS CENTER—GALLERIES AND SCULPTURE GARDEN**, 3333 N. MacArthur Blvd., Irving TX 75062. (972)252-7558. Fax: (972)570-4962. E-mail: minman@ci.irving.tx.us. Website: www.ci.irving.tx.us. **Gallery Director:** Marcie J. Inman. Municipal arts center. Estab. 1990. Represents emerging, mid-career and established artists. Sponsors 25-30 shows/year. Average display time 3-6 weeks. Open all year; Monday-Friday, 9-5; Thursday, 9-8; Saturday, 10-5; Sunday, 1-5. Located in the middle of residential, commercial area; 6,000 sq. ft.; utilizes two theater lobbies for rotating exhibitions in addition to the galleries—Main Gallery has 30' ceiling, skylights and 45' high barrel vault. 100% of space for special exhibitions. Clientele: local community. Overall price range: $200-80,000; most work sold at $200-4,000.
Media: Considers all media except craft. Considers all types of prints except posters. Most frequently exhibits painting, sculpture, photography.
Style: Exhibits all styles.
Terms: Artists may sell their work and are responsible for the sales. Retail price set by the artist. Gallery provides insurance, promotion, contract and some shipping costs. Prefers artwork framed ready to install.
Submissions: Send query letter with résumé, brochure, business card, 10-20 slides, photographs, reviews, artist's statement, bio and SASE. Call for appointment to show portfolio of photographs, transparencies or slides. Responds in 6-18 months. Files slides, résumé, artist's statement. Finds artists through word of mouth, referrals by other artists, visiting galleries and exhibitions, submissions, visiting universities' galleries and graduate students' studios.
Tips: "Have high-quality slides or photographs made. It's worth the investment. Be prepared—i.e. know something about the gallery or organization you are contacting. Present yourself professionally—whatever your level of experience."

☑ **IVÁNFFY & UHLER GALLERY**, 4623 W. Lovers Lane, Dallas TX 75209. (214)350-3500. E-mail: iug@flash.net. Website: www.ivanffyuhler.com. **Director:** Paul Uhler. Retail/wholesale gallery. Estab. 1990. Represents 20 mid-career and established artists/year. May be interested in seeing the work of emerging artists in the future. Sponsors 3-4 shows/year. Average display time 1 month. Open all year; Tuesday-Saturday, 10-6; Sunday, 1-6. Located near Love Field Airport. 4,000 sq. ft. 100% of space for gallery artists. Clientele: upscale, local community. 85% private collectors, 15% corporate collectors. Overall price range: $1,000-20,000; most work sold at $1,500-4,000.
Media: Considers oil, acrylic, watercolor, pastel, pen & ink, drawing, mixed media, collage, paper, sculpture, woodcuts, engravings, lithographs, wood engravings, mezzotints, serigraphs, linocuts and etchings. Most frequently exhibits oils, mixed media, sculpture.
Style: Exhibits neo-expressionism, painterly abstraction, surrealism, postmodern works, impressionism, hard-edge geometric abstraction, postmodern European school. Genres include florals, landscapes, figurative work.
Terms: Gallery provides promotion; shipping costs are shared.

© Stephen Lawrie

From the Earth, painted with acrylic on board by Stephen Lawrie, masterfully juxtaposes the physical stature of a human with the primal folds and grandeur of the earth. Exhibited at the Carol Henderson Gallery, this painting captivated patrons and received star reviews all over Fort Worth, Texas.

Submissions: Send query letter with résumé, photographs, bio and SASE. Write for appointment to show portfolio of photographs. Responds only if interested within 1 month.

Tips: "We prefer European-trained artists."

N LONGVIEW MUSEUM OF FINE ARTS, 215 E. Tyler St, P.O. Box 3484, Longview TX 75606. (903)753-8103. E-mail: foxhearne@kilgore.net. **Director:** Renee Hawkins. Museum. Estab. 1967. Represents 80 emerging, mid-career and established artists/year. 600 members. Sponsors 6-9 shows/year. Average display time 6 weeks. Open all year; Tuesday-Friday, 10-4; Saturday, 12-4. Located downtown. 75% of space for special exhibitions. Clientele: members, visitors (local and out-of-town) and private collectors. Overall price range: $200-2,000; most work sold at $200-800.

Media: Considers all media, all types of prints. Most frequently exhibits oil, acrylic and photography.

Style: Exhibits all styles and genres. Prefers contemporary American art and photography.

Terms: Accepts work on consignment (30% commission). Retail price set by the artist. Offers customer discounts to museum members. Gallery provides insurance and promotion. Prefers artwork framed.

Submissions: Send query letter with résumé and slides. Portfolio review not required. Responds in 1 month. Files slides and résumés. Finds artists through art publications and shows in other areas.

MUSEUM OF PRINTING HISTORY, 1324 W. Clay, Houston TX 77019. (713)522-4652. Fax: (713)522-5694. E-mail: info@printingmuseum.org. Website: www.printingmuseum.org. **Curator:** Sarah L. McNett. Museum. Estab. 1982. Represents 4-12 mid-career and established artists. Exhibited artists include: Dr. John Biggers and Charles Criner. Sponsors 6-8 exhibits/year. Average display time 6-16 weeks. Open all year; Tuesday-Saturday, 10-5; Sunday, 12:30-5. Closed Thanksgiving, Christmas Eve, Christmas, 4th of July, and New Year's Eve/Day. Located in downtown Houston; facility includes 2 galleries. Clients include local community, students, tourists and upscale. Overall price range: $1-1,500. Work produced by artists/printers on site and sold to benefit the museum, which is nonprofit.

Media: Most frequently exhibits prints of all media including photography. Considers all types of prints.

Style: Exhibits: color field, conceptualism, expressionism, geometric abstraction, imagism and pottery painting. Most frequently exhibits imagism, abstraction and expressionism. Exhibits all genres.

Terms: Artwork is accepted on consignment and there is a 0-10% commission. Artists donate a percentage of printed editions to benefit the museum. Retail price set by the artist. Gallery provides insurance and promotion. Accepted work should be mounted and matted. Does not require exclusive representation locally.

Submissions: Write to arrange a personal interview to show portfolio of photographs and slides. Mail portfolio for review. Send query letter with artist's statement, bio, brochure, business card, photocopies, photographs, résumé, reviews, SASE and slides. Returns material with SASE. Responds only if interested within 2 months. Files résumés, brochures, photocopies, artist's statement and bio. Finds artists through word of mouth, submissions, portfolio reviews, art exhibits, and referrals by other artists.

DEBORAH PEACOCK GALLERY, 1705 Guadalupe, #118, Austin TX 78701. (512)474-2235. Fax: (512)474-8188. E-mail: photo@art-n-music.com. Website: www.art-n-music.com. **Proprietor/Photographer:** Deborah Peacock. Alternative space, for-profit gallery and art consultancy. Estab. 1997. Approached by 100 artists/year. Represents 15 emerging, mid-career and established artists. Exhibited artists include: Nicolás Herrera and Ava Brooks. Sponsors 6-8 exhibits/year. Average display time 1 month. Open all year; first Thursday of the month and by appointment. Located in downtown Austin within The Art Guadalupe Arts Building. The studio/gallery photographs art, helps artists with promotional materials, portfolios, advertising and exhibits. Clients include local community and tourists. 20% of sales are to corporate collectors. Overall price range: $150-6,000; most work sold at $300.

• Universal Photographics is also owned by Deborah Peacock. In addition to promoting artists, they also cater to businesses, actors and musicians; product photography and graphic/web design.

Media: Considers all media and all types of prints. Most frequently exhibits oil, sculpture and photography.

Style: Considers all styles and genres. Most frequently exhibits conceptualism, expressionism and surrealism.

Terms: Artwork is accepted on consignment and there is a 50% commission. There is a rental fee for space. The rental fee covers 1 month. Retail price set by the artist. Gallery provides insurance, promotion and contract. Accepted work should be framed and mounted. Does not require exclusive representation locally.

Submissions: Write to arrange a personal interview to show portfolio of photographs and slides; or mail portfolio for review; or send query letter with artist's statement, bio, photographs, résumé, SASE and slides. Returns material with SASE. Responds only if interested within 1 month. Files artists statements, bios, review, etc. Finds artists through portfolio reviews.

Tips: "Use of archival-quality materials is very important to collectors."

N EVELYN SIEGEL GALLERY, 3700 W. Seventh, Fort Worth TX 76107. (817)731-6412. Fax: (817)731-6413 or (888)374-3435. E-mail: elsiegel@esartgal.com. Website: www.esartgal.com. **Owner:** E. Siegel. Retail gallery and art consultancy. Estab. 1983. Represents about 50 artists; emerging, mid-career and established. Interested in seeing the work of emerging artists. Exhibited artists include Judy Pelt, Carol

Anthony, Robert Daughters and Alexandra Nechita. Sponsors 9 shows/year. Average display time 3 weeks. Open all year; Monday-Friday, 11-5; Saturday, 11-4. Located in museum area; 2500 sq. ft.; diversity of the material and artist mix. "The gallery is warm and inviting; a reading area is provided with many art books and publications." 66% of space for special exhibitions. Clientele: upscale, community, tourists. 90% private collectors. Overall price range: $30-10,000.

Media: Considers oil, acrylic, watercolor, pastel, mixed media, collage, sculpture, ceramic; original hand-pulled prints; woodcuts, wood engravings, linocuts, engravings, mezzotints, etchings, lithographs and serigraphs. Most frequently exhibits painting and sculpture.

Style: Exhibits expressionism, neo-expressionism, painterly abstraction, color field, impressionism and realism. Genres include landscapes, florals and figurative work. Prefers: landscape, florals, interiors and still life.

Terms: Accepts work on consignment (50% commission), or is sometimes bought outright. Retail price set by gallery and artist. Gallery provides insurance, promotion and contract. Artist pays for shipping. Prefers artwork framed.

Submissions: Send query letter with résumé, slides and bio. Call or write for appointment to show portfolio of two of the following: originals, photographs, slides and transparencies.

Tips: Artists must have an appointment.

N: WEST END GALLERY, 5425 Blossom, Houston TX 77007. (713)861-9544. E-mail: kpackl1346@aol.com. **Owner:** Kathleen Packlick. Retail gallery. Estab. 1991. Exhibits emerging and mid-career artists. Exhibited artists include Kathleen Packlick and Maria Merrill. Open all year; Saturday, 12-4. Located 5 mintues from downtown Houston; 800 sq. ft.; "The gallery shares the building (but not the space) with West End Bicycles." 75% of space for special exhibitions; 25% of space for gallery artists. Clientele: 100% private collectors. Overall price range: $30-2,200; most work sold at $300-600.

Media: Considers oil, pen & ink, acrylic, drawings, watercolor, mixed media, pastel, collage, woodcuts, wood engravings, linocuts, engravings, mezzotints, etchings, lithographs and serigraphs. Prefers collage, oil and mixed media.

Style: Exhibits conceptualism, minimalism, primitivism, postmodern works, realism and imagism. Genres include landscapes, florals, wildlife, Americana, portraits and figurative work.

Terms: Accepts work on consignment (40% commission). Retail price set by artist. Payment by installment is available. Gallery provides promotion; artist pays shipping costs. Prefers artwork framed.

Submissions: Accepts only artists from Houston area. Send query letter with slides and SASE. Portfolio review requested if interested in artist's work.

✓ WOMEN & THEIR WORK GALLERY, 1710 Lavaca St., Austin TX 78701. (512)477-1064. Fax: (512)477-1090. E-mail: wtw@texas.net. Website: www.womenandtheirwork.org. **Associate Director:** Kathryn Davidson. Alternative space and nonprofit gallery. Estab. 1978. Approached by more than 200 artists/year. Represents 8-10 one person and seasonal juried shows of emerging and mid-career Texas women. Exhibited artists include: Lauren Levy and Kate Breakey. Sponsors 12 exhibits/year. Average display time 5 weeks. Open all year; Monday-Friday, 9-5; Saturday, 12-4. Closed Christmas holidays, December 24 through January 2. Located downtown; 2,000 sq. ft. Clients include local community, students, tourists and upscale. 10% of sales are to corporate collectors. Overall price range: $500-5,000; most work sold at $800-1,000.

Media: Considers all media and all types of prints. Most frequently exhibits photography, sculpture, installation and painting.

Style: Exhibits: contemporary. Most frequently exhibits minimalism, conceptualism and imagism.

Terms: Selects artists through a juried process and pays them to exhibit. Takes 25% commission if something is sold. Retail price set by the gallery and the artist. Gallery provides insurance, promotion and contract. Accepted work should be framed, mounted and matted. Does not require exclusive representation locally. Accepts Texas women-all media-in one person shows only. All other artists, male or female in juried show—once a year if member of W&TW organization.

Submissions: Call or e-mail to arrange a personal interview to show portfolio. Returns materials with SASE. Responds in 1 month. Filing of material depends on artist and if they are members. We have a slide registry for all our artists if they are members. Finds artists through submissions and annual juried process.

Tips: "Send quality slides, typed résumé, and clear statement with artistic intent. 100% archival material required for framed works. It's mportant for collectors to understand care of artwork."

Utah

✓ C GALLERY, 466 S. Fifth E., Salt Lake City UT 84102-2705. (801)359-8625 or (801)581-9239. Fax: (801)359-8995. E-mail: constance@xmission.com. **Director:** Constance Theodore. Retail gallery. Estab. 1992. Represents 8 emerging, mid-career and established artists/year Exhibited artists include Joan Nelson

© *Masks of Utah* 2002 © Joan Nelson

First unveiled at the C Gallery in Salt Lake City, Joan Nelson's *Masks of Utah* received outstanding reviews for its expert fusion of line and color. The original acrylic on canvas combines various shades of blue and dulled whites, which immediately capture the coolness of winter. "In this world of gut-wrenching experiences, I am compelled to seek out and paint the joy and laughter that I see in simple life situations," says Nelson.

and Michael Peglau. Sponsors 2 shows/year. Average display time 3 months. Open all year; Monday-Friday, 8-5. Located in downtown outskirts; 100 sq. ft.; attic loft of 1910 home converted to offices. 60% of space for special exhibitions; 40% of space for gallery artists. Clientele: upscale. 100% private collectors. Overall price range: $10-6,500; most work sold at $200.

Media: Considers bronze sculpture, landscape originals in oil, portraiture. Most frequently exhibits oil paintings on linen, acrylic on canvas, charcoal on paper portraits, cityscapes, interiors and soulscapes.

Style: Exhibits all styles. Genres include portraits, western contemporary, landscapes and Americana. Prefers: landscape, soulscapes, portraits and Americana. Shibusa aesthetics: simplicity, the implicit, modesty, silence, the natural, the everyday, the imperfect.

Terms: Accepts work on consignment (50% commission). Retail price set by the gallery. Gallery provides promotion. Shipping costs are shared. Prefers artwork framed.

Submissions: Accepts only artists with Utah heritage. Send query letter with résumé, 6 slides, bio, SASE, reviews and artist's statement. Call or write for appointment to show portfolio review of photographs and slides. Responds in 1 week. Finds artists through word of mouth, referrals by other artists, visiting art fairs and exhibitions, artist's submissions.

Tips: "I like to see the originals. Call personally for an appointment with the director. At your meeting, present at least one original work and slides or photos. Have a résumé and artists' statement ready to leave as your calling card."

N PHILLIPS GALLERY, 444 E. 200 S., Salt Lake City UT 84111. (801)364-8284. Fax: (801)364-8293. Website: www.phillips-gallery.com. **Director:** Meri DeCaria. Retail gallery, art consultancy, rental gallery. Estab. 1965. Represents 80 emerging, mid-career and established artists/year. Exhibited artists include Tony Smith, Doug Snow, Lee Deffebach. Sponsors 8 shows/year. Average display time 1 month. Open all year; Tuesday-Friday, 10-6; Saturday, 10-4; closed August 1-20 and December 25-January 1. Located downtown; has 3 floors at 2,000 sq. ft. and a 2,400 sq. ft. sculpture deck on the roof. 40% private collectors, 60% corporate collectors. Overall price range: $100-10,000; most work sold at $200-4,000.

Media: Considers all media, woodcuts, engravings, lithographs, wood engravings, linocuts, etchings. Most frequently exhibits oil, acrylic, sculpture/steel.

Style: Exhibits expressionism, conceptualism, neo-expressionism, minimalism, pattern painting, primitivism, color field, hard-edge geometric abstraction, painterly abstraction, postmodern works, realism, surrealism, impressionism. Genres include Western, Southwestern, landscapes, figurative work, contemporary. Prefers abstract, neo-expressionism, conceptualism.

Terms: Accepts work on consignment (50% commission). Gallery provides insurance and promotion; shipping costs are shared. Prefers artwork framed.

Submissions: Accepts only artists from western region/Utah. Send query letter with résumé, slides, reviews, artist's statement, bio and SASE. Finds artists through word of mouth, referrals.

☑ SERENIDAD GALLERY, 360 W. Main, P.O. Box 326, Escalante UT 84726. Phone/fax: (435)826-4720 and (888)826-4577. E-mail: hpriska@juno.com. Website: www.escalante-cc.com/serenidad/html. and www.escalanteretreat.com. **Co-owners:** Philip and Harriet Priska. Retail gallery. Estab. 1993. Represents 7 mid-career and established artists/year. May be interested in seeing the work of emerging artists in the future. Exhibited artists include Lynn Griffin, Rachel Bentley, Kipp Greene, Harriet Priska and Mary Kellog. All work is on continuous display. Open all year; Monday-Saturday, 8-8; Sunday, 1-8. Located on Highway 12 in Escalante; 1,700 sq. ft.; "rustic western decor with log walls." 50% of space for gallery artists. Clientele: tourists. 100% private collectors. Overall price range: $100-4,000; most work sold at $300-3,000.

Media: Considers oil, acrylic, watercolor, sculpture, fiber (Zapotec rugs), photography and china painting. Most frequently exhibits acrylics, watercolors and oils.

Style: Exhibits realism. Genres include western, southwestern and landscapes. Prefers: Utah landscapes— prefer local area here, northern Arizona-Navajo reservation and California-Nevada landscapes.

Terms: Accepts work on consignment (commission set by artist) or buys outright (prices set by artist). Retail price set by the gallery. Gallery provides promotion.

Submissions: Accepts only artists from Southwest. Prefers only oil, acrylic and watercolor. Realism only. Contact in person. Call for appointment to show portfolio of photographs. Responds in 3 weeks. Finds artists "generally by artists coming into the gallery."

Tips: "Work must show professionalism and have quality. This is difficult to explain; you know it when you see it."

Vermont

▣ TODD GALLERY, 614 Main, Weston VT 05161. (802)824-5606. E-mail: ktodd@sover.net. Website: www.toddgallery.com. **Manager:** Karin Todd. Retail gallery. Estab. 1986. Represents 10 established artists/year. May be interested in seeing the work of emerging artists in the future. Exhibited artists include Robert Todd and Judith Carbine. Sponsors 2 shows/year. Average display time 1 month. Open all year; daily, 10-5; closed Tuesday and Wednesday. Located at edge of small VT village; 2,000 sq. ft.; 1840 refurbished barn and carriage house—listed in National Register of Historic Places. Clientele: tourists, local community and second home owners. 80% private collectors, 20% corporate collectors. Overall price range: $200-5,000; most work sold at $400-1,000.

Media: Considers oil, acrylic, watercolor, pastel, ceramics, photography, woodcuts, engravings, lithographs, wood engravings, serigraphs, linocuts and etchings. Most frequently exhibits watercolor, oil and pastel.

Style: Exhibits expressionism, minimalism, impressionism and realism. Genres include florals, landscapes and Americana. Prefers landscapes (New England), foreign (Ireland and Britain) and seascapes (New England).

Terms: Accepts work on consignment (40% commission). Retail price set by the artist. Gallery provides insurance and promotion.

Submissions: Prefers only artists from Vermont or New England. Prefers only oil, watercolor and pastel. Send query letter with résumé, slides, bio, SASE and artist's statement. Call for appointment to show portfolio of slides, transparencies and originals. Responds in 2 weeks. Files for potential inclusion in gallery. "We generally seek artists out whose work we have seen."

Tips: "Don't make the mistake of having no appointment, staying too long, or having work badly preserved."

Ⓝ WOODSTOCK FOLK ART PRINTS & ANTIQUITIES, P.O. Box 300, Woodstock VT 05091. (802)457-2012. E-mail: wfolkart@souer.net. Website: www.woodstockfolkart.com. **Art Director:** Gael Contin. Communications Director: Rachel Feinberg. Retail gallery. Estab. 1985. Represents 45 emerging,

mid-career and established artists. Exhibited artists include Sabra Field and Anne Cady. Sponsors 5 shows/ year. Open all year; Monday-Saturday, 10-5; Sunday, 10-4. Located downtown in village; 900 sq. ft.. Clients include tourists, local. 20% of sales are to private collectors. Overall price range: $17-4,000; most work sold at $100-200.

Media: Considers oil, acrylic, watercolor, pastel, drawing, mixed media, sculpture, ceramics, glass, photography and woodcuts. Most frequently exhibits woodcuts (prints), oil and watercolor.

Style: Exhibits primitivism, color field, impressionism and photorealism. Genres include florals, landscapes and Americana. Prefers landscapes, Americana and florals.

Terms: Accepts work on consignment (50% commission). Retail price set by the artist. Gallery provides promotion. Prefers artwork framed.

Submissions: Send query letter with bio and photographs. Write for appointment to show portfolio of photographs. Responds only if interested within 1 month. Finds artists through word of mouth, referrals by other artists, visiting art fairs and exhibitions and artist's submissions.

Virginia

N THE ART LEAGUE, INC., 105 N. Union St., Alexandria VA 22314. (703)683-1780. Website: www.t heartleague.org. Executive Director: Linda Hafer. **Gallery Director:** Bonnie Jensen. Cooperative gallery. Estab. 1954. Interested in emerging, mid-career and established artists. 1,000-1,200 members. Sponsors 7-8 solo and 14 group shows/year. Average display time 1 month. Located in The Torpedo Factory Art Center. Accepts artists from metropolitan Washington area, northern Virginia and Maryland. 75% of sales are to private collectors, 25% corporate clients. Overall price range: $50-4,000; most work sold at $150-500.

Media: Considers oil, acrylic, watercolor, pastel, pen & ink, drawings, mixed media, collage, works on paper, sculpture, ceramic, fiber, glass, photography and original handpulled prints. Most frequently exhibits watercolor, photography, all printmaking media and oil/acrylic.

Style: Exhibits all styles and genres. Prefers impressionism, painted abstraction and realism. "The Art League is a membership organization open to anyone interested."

Terms: Accepts work by jury on consignment (40% commission) and co-op membership fee plus donation of time. Retail price set by artist. Offers customer discounts (designers only) and payment by installments (if requested on long term). Exclusive area representation not required.

Submissions: Work juried monthly for each new show from actual work (not slides). Work received for jurying on first Monday evening/Tuesday morning of each month; pick-up non-selected work throughout rest of week.

Tips: "Artists find us and join/exhibit as they wish within framework of our selections jurying process. It is more important that work is of artistic merit rather than 'saleable.'"

☑ HAMPTON UNIVERSITY MUSEUM, Huntington Building on Ogden Circle, Hampton VA 23668. (757)727-5308. Fax: (757)727-5170. Website: www.hamptonu.edu. **Director:** Ramona Austin. Curator of Exhibitions: Jeffrey Bruce. Museum. Estab. 1868. Represents/exhibits established artists. Exhibited artists include Elizabeth Catlett and Jacob Lawrence. Sponsors 4-5 shows/year. Average display time 6-8 weeks. Open all year; Monday-Friday, 8-5; Saturday, 12-4; closed on Sunday, major and campus holidays. Located on the campus of Hampton University.

Media: Considers all media and all types of prints. Most frequently exhibits oil or acrylic paintings, ceramics and mixed media.

Style: Exhibits African-American, African and/or Native American art.

Submissions: Send query letter with résumé and a dozen or more slides. Portfolio should include photographs and slides.

Tips: "Familiarize yourself with the type of exhibitions the Hampton University Museum typically mounts. Do not submit an exhibition request unless you have at least 35-45 pieces available for exhibition. Call and request to be placed on the Museum's mailing list so you will know what kind of exhibitions and special events we're planning for the upcoming year(s)."

MARSH ART GALLERY, University of Richmond Museums, Richmond VA 23173. (804)289-8276. Fax: (804)287-1894. E-mail: museums@richmond.edu. Website: www.arts.richmond.edu/cultural/museu ms. **Director:** Richard Waller. Museum. Estab. 1968. Represents emerging, mid-career and established artists. Sponsors 10 shows/year. Average display time 6 weeks. Open all year; with limited summer hours May-August. Located on University campus; 5,000 sq. ft. 100% of space for special exhibitions.

Media: Considers all media and all types of prints. Most frequently exhibits painting, sculpture, photography and drawing.

Style: Exhibits all styles and genres.

Terms: Work accepted on loan for duration of special exhibition. Retail price set by the artist. Gallery provides insurance, promotion, contract and shipping costs. Prefers artwork framed.

Submissions: Send query letter with résumé, 8-12 slides, brochure, SASE, reviews and printed material if available. Write for appointment to show portfolio of photographs, slides, transparencies or "whatever is appropriate to understanding the artist's work." Responds in 1 month. Files résumé and other materials the artist does not want returned (printed material, slides, reviews, etc.).

THE PRINCE ROYAL GALLERY, 204 S. Royal St., Alexandria VA 22314. (703)548-5151. E-mail: princeroyal@look.net. Website: www.princeroyalgallery.com and www.alexandriacity.com. **Director:** John Byers. Retail gallery. Estab. 1977. Interested in emerging, mid-career and established artists. Sponsors 6 shows/year. Average display time 3-4 weeks. Located in middle of Old Town Alexandria. "Gallery is the ballroom and adjacent rooms of historic hotel." Clientele: primarily Virginia, Maryland and Washington DC residents. 95% private collectors, 5% corporate clients. Overall price range: $75-8,000; most artwork sold at $700-1,200.

Media: Considers oil, acrylic, watercolor, pastel, mixed media, sculpture, egg tempera, engravings, etchings and lithographs. Most frequently exhibits oil, watercolor and bronze.

Style: Exhibits impressionism, expressionism, realism, primitivism and painterly abstraction. Genres include landscapes, florals, portraits and figurative work. "The gallery deals primarily in original, representational art. Abstracts are occasionally accepted but are hard to sell in northern Virginia. Limited edition prints are accepted only if the gallery carries the artist's original work."

Terms: Accepts work on consignment (40% commission). Retail price set by artist. Customer discounts and payment by installment are available, but only after checking with the artist involved and getting permission. Exclusive area representation required. Gallery provides insurance, promotion and contract. Requires framed artwork.

Submissions: Send query letter with résumé, brochure, slides and SASE. Call or write to schedule an appointment to show a portfolio, which should include originals, slides and transparencies. Responds in 1 week. Files résumés and brochures. All other material is returned.

Tips: "Write or call for an appointment before coming. Have at least six pieces ready to consign if accepted. Can't speak for the world, but in northern Virginia collectors are slowing down. Lower-priced items continue okay, but sales over $3,000 are becoming rare. More people are buying representational rather than abstract art. Impressionist art is increasing. Get familiar with the type of art carried by the gallery and select a gallery that sells your style work. Study and practice until your work is as good as that in the gallery. Then call or write the gallery director to show photos or slides."

N: PRINCIPLE GALLERY, 208 King St., Alexandria VA 22314. (703)739-9326. Fax: (703)739-0528. E-mail: principal@euols.com. Website: www.principlegallery.com. **Contact:** Sue Hogan. For-profit gallery. Estab. 1994. Approached by 60 artists/year. Exhibits 70 mid-career and established artists. Sponsors 10 exhibits/year. Average display time 2-3 weeks. Open all year; Sunday-Monday, 12-5; Tuesday-Wednesday, 10-6; Thursday, 10-7; Friday-Saturday, 10-9. Located in historic building with large brightly lit rooms. Clients include local community, tourists and upscale. 10% of sales are to corporate collectors. Overall price range: $400-20,000; most work sold at $2,500.

Media: Considers acrylic, drawing, oil, pen & ink, sculpture, etchings and mezzotints. Most frequently exhibits painting, sculpture and drawing.

Style: Exhibits: impressionism and painterly abstraction. Most frequently exhibits realism and impressionism. Genres include figurative work and landscapes.

Terms: Artwork is accepted on consignment. Retail price set by the gallery and the artist. Gallery provides insurance. Accepted work should be framed. Requires exclusive representation locally.

Submissions: Mail portfolio for review. Send query letter with artist's statement, bio, photographs, résumé, reviews, SASE and slides. Returns material with SASE. Responds only if interested within 1 month. Finds artists through word of mouth, portfolio reviews and referrals by other artists.

Washington

THE AMERICAN ART COMPANY, 1126 Broadway Plaza, Tacoma WA 98402. (253)272-4377. E-mail: amart-tac@msn.com. Website: www.americanartco.com. **Director:** Rick Gottas. Retail gallery. Estab. 1889. Represents/exhibits 50 emerging, mid-career and established artists/year. Exhibited artists include Doug Granum, Oleg Koulikov, Yoko Hara and Warren Pope. Sponsors 10 shows/year. Open all year;

Monday-Friday, 10-5:30; Saturday, 10-5. Located downtown; 3,500 sq. ft. 60% of space for special exhibitions; 40% of space for gallery artists. Clientele: local community. 95% private collectors, 5% corporate collectors. Overall price range: $500-15,000; most work sold at $1,800.

Media: Considers oil, fiber, acrylic, sculpture, glass, watercolor, mixed media, quilt art, pastel, collage, woodcuts, wood engravings, linocuts, engravings, mezzotints, etchings, lithographs and serigraphs. Most frequently exhibits works on paper, sculpture and oils.

Style: Exhibits all styles. Genres include landscapes, Chinese and Japanese.

Terms: Artwork is accepted on consignment (50% commission) or bought outright for 50% of retail price; net 30 days. Retail price set by the gallery and the artist. Gallery provides insurance and promotion; shipping costs are shared. Prefers artwork unframed.

Submissions: Send query letter with résumé, slides, bio and SASE. Write for appointment to show portfolio of slides. Responds in 3 weeks. Finds artists through word of mouth, referrals by other artists, visiting art fairs and exhibitions, submissions.

N **ART SHOWS**, P.O. Box 245, Spokane WA 99210-0245. (509)922-4545. E-mail: info@artshows.net. Website: www.artshows.net. **President:** Don Walsdorf. Major art show producer. Estab. 1988. Sponsors large group shows. Clientele: collectors, hotel guests and tourists. 70% private collectors, 30% corporate collectors. Overall price range $200-250,000; most work sold at $500-3,000.

Media: Considers all media except craft.

Style: Interested in all genres.

Submissions: Send query letter with bio, brochure and photographs. Portfolio review requested if interested in artist's work. Files biography and brochures.

Tips: Selecting quality art shows is important. Read all the prospectus materials. Then re-read the information to make certain you completely understand the requirements, costs and the importance of early responses. Respond well in advance of any suggested deadline dates. Producers cannot wait until 60 days in advance of a show, due to contractual requirements for space, advertising, programming etc. If you intend to participate in a quality event, seek applications a year in advance for existing events. Professional show producers are always seeking to upgrade the quality of their shows. Seek new marketing venues to expand your horizons and garner new collectors. List your fine art show events with info@artshow.net by providing name, date, physical location, full contact information of sponsor or producer. This is a free database at www.artshows.net. Any time you update a brochure, biography or other related materials, be certain to date the material. Outdated material in the hands of collectors works to the detriment of the artist.

✔ DAVIDSON GALLERIES, 313 Occidental Ave. S., Seattle WA 98104. (206)624-7684. E-mail: info@davidsongalleries.com. Website: www.davidsongalleries.com. **Director:** Sam Davidson. Retail gallery. Estab. 1973. Represents 150 emerging, mid-career and established artists. Sponsors 36 shows/year. Average display time 3½ weeks. Open all year; Tuesday-Saturday, 11-5:30. Located in old, restored part of downtown: 3,200 sq. ft.; "beautiful antique space with columns and high ceilings in 1890 style." 25% of space for special antique print exhibitions; 65% of space for gallery artists. Clientele: 90% private collectors, 10% corporate collectors. Overall price range: $10-35,000; most work sold at $150-5,000.

Media: Considers oil, acrylic, drawing (all types), sculpture, watercolor, mixed media, pastel, woodcuts, wood engravings, linocuts, engravings, mezzotints, etchings, lithographs, limited interest in photography, digital manipulation or collage.

Style: Exhibits expressionism, neo-expressionism, primitivism, painterly abstraction, postmodern works, realism, surrealism, impressionism.

Terms: Accepts work on consignment (50% commission). Retail price set by gallery and artist. Gallery provides insurance, promotion and contract; shipping costs are one way.

Submissions: Send query letter with résumé, 20 slides, bio and SASE. Responds in 6 weeks.

Tips: Impressed by "simple straight-forward presentation of properly labeled slides, résumé with SASE included. No videos."

FOSTER/WHITE GALLERY, 123 S. Jackson St., Seattle WA 98104. (206)622-2833. Fax: (206)622-7606. Website: www.fosterwhite.com. **Owner/Director:** Donald Foster. Retail gallery. Estab. 1973. Represents 90 emerging, mid-career and established artists/year. Interested in seeing the work of local emerging artists. Exhibited artists include Dale Chihuly, Mark Tobey, George Tsutakawa, Morris Graves, and William Morris. Average display time 1 month. Open all year; Monday-Saturday, 10-5:30; Sunday, 12-5. Located historic Pioneer Square; 5,800 sq. ft. Clientele: private, corporate and public collectors. Overall price range: $300-35,000; most work sold at $2,000-8,000.

• Gallery has additional spaces at 126 Central Way, Kirkland WA 98033 (425)822-2305. Fax: (425)828-2270, and City Centre, 1420 Fifth Ave., Suite 214, Seattle WA 98101, (206)340-8025. fax (206)340-8757.

Media: Considers oil, acrylic, watercolor, pastel, pen & ink, drawing, mixed media, collage, paper, sculpture, ceramics, craft, fiber, glass and installation. Most frequently exhibits glass sculpture, works on paper and canvas and ceramic and metal sculptures.
Style: Contemporary Northwest art. Prefers contemporary Northwest abstract, contemporary glass sculpture.
Terms: Gallery provides insurance, promotion and contract.
Submissions: Accepts only artists from Pacific Northwest. Send query letter with résumé, slides, bio and reviews. Write for appointment to show portfolio of slides. Responds in 3 weeks.

⯃ PAINTERS ART GALLERY, 30517 S.R. 706 E., P.O. Box 106, Ashford WA 98304-0106. (360)569-2644. E-mail: mtwoman@mashell.com. Website: www.mashell.com/~mtwoman/. **Owner:** Joan Painter. Retail gallery. Estab. 1972. Represents 20 emerging, mid-career and established artists. Open all year. Located 5 miles from the entrance to Mt. Rainier National Park; 1,200 sq. ft. 50% of space for work of gallery artists. Clientele: collectors and tourists. Overall price range $10-7,500; most work sold at $300-2,500.
• The gallery has over 60 people on consignment. It is a very informal, outdoors atmosphere.
Media: Considers oil, acrylic, watercolor, pastel, mixed media, stained glass, reliefs, offset reproductions, lithographs and serigraphs. "I am seriously looking for totem poles and outdoor carvings." Most frequently exhibits oil, pastel and acrylic.
Style: Exhibits primitivism, surrealism, imagism, impressionism, realism and photorealism. All genres. Prefers: Mt. Rainier themes and wildlife. "Indians and mountain men are a strong sell."
Terms: Accepts artwork on consignment (30% commission on prints and sculpture; 40% on paintings). Retail price set by gallery and artist. Gallery provides promotion; artist pays for shipping. Prefers artwork framed.
Submissions: Send query letter or call. "I can usually tell over the phone if artwork will fit in here." Portfolio review requested if interested in artist's work. Does not file materials.
Tips: "Sell paintings and retail price items for the same price at mall and outdoor shows that you price them in galleries. I have seen artists underprice the same paintings/items, etc. when they sell at shows. Do not copy the style of other artists. To stand out, have your own style."

West Virginia

⯃ THE ART STORE, 1013 Bridge Rd., Charleston WV 25314. (304)345-1038. Fax: (304)345-1858. **Director:** E. Schaul. Retail gallery. Estab. 1974. Represents 16 mid-career and established artists. Sponsors 6 shows/year. Average display time 3 weeks. Open all year. Located in a suburban shopping center; 2,000 sq. ft. 50% of space for special exhibitions. Clientele: professionals, executives, decorators. 80% private collectors, 20% corporate collectors. Overall price range: $200-8,000; most work sold at $2,000.
Media: Considers oil, acrylic, watercolor, pastel, mixed media, works on paper, ceramics, wood and metal.
Style: Exhibits expressionism, painterly abstraction, color field and impressionism.
Terms: Accepts artwork on consignment (50% commission). Retail price set by gallery and artist. Gallery provides insurance, promotion and shipping costs from gallery. Prefers artwork unframed.
Submissions: Send query letter with résumé, slides, SASE, announcements from other gallery shows and press coverage. Gallery makes the contact after review of these items; responds in 6 weeks.
Tips: "Do not send slides of old work."

Wisconsin

⯃ GRACE CHOSY GALLERY, 1825 Monroe St., Madison WI 53711. (608)255-1211. Fax: (608)663-2032. **Director:** Grace Chosy. Retail gallery. Estab. 1979. Represents/exhibits 80 emerging, mid-career and established artists/year. Exhibited artists include Wendell Arneson and William Weege. Sponsors 11 shows/year. Average display time 3 weeks. Open all year; Tuesday-Saturday, 11-5. Located downtown; 2,000 sq. ft.; "open uncluttered look." 45% of space for special exhibitions; 55% of space for gallery artists. Clientele: primarily local community. 60% private collectors, 40% corporate collectors. Overall price range: $200-7,000; most work sold at $500-2,000.
Media: Considers all media except photography and fiber; all types of prints except posters. Most frequently exhibits paintings, drawings and sculpture.
Style: Exhibits all styles. Genres include landscapes, florals and figurative work. Prefers landscapes, still life and abstract.

Terms: Artwork is accepted on consignment. Retail price set by the gallery and the artist. Gallery provides insurance, promotion and contract. Artist pays for shipping costs.
Submissions: Send query letter with résumé, bio and SASE. Call or write for appointment to show portfolio. Responds in 3 months.

THE FANNY GARVER GALLERY, 230 State St., Madison WI 53703. (608)256-6755. E-mail: art@fan nygarvergallery.com. Website: www.fannygarvergallery.com. **President:** Jack Garver. Retail Gallery. Estab. 1972. Represents 100 emerging, mid-career and established artists/year. Exhibited artists include Claude Fauchere, Leon Applebaum, David Goldhagen, Tim Lazer, Manel Onoro, Franklin Galambos, Art Werger, Lee Weiss, Harold Altman and Josh Simpson. Sponsors 11 shows/year. Average display time 1 month. Open all year; Monday-Wednesday, 10-6; Thursday-Saturday, 10-8, Sunday, 12-4. Located downtown; 3,000 sq. ft.; older refurbished building in unique downtown setting. 33% of space for special exhibitions; 95% of space for gallery artists. Clientele: private collectors, gift-givers, tourists. 40% private collectors, 10% corporate collectors. Overall price range: $10-10,000; most work sold at $100-1,000.
Media: Considers oil, pen & ink, paper, fiber, acrylic, drawing, sculpture, glass, watercolor, mixed media, ceramics, pastel, collage, craft, woodcuts, wood engravings, linocuts, engravings, mezzotints, etchings, lithographs and serigraphs. Most frequently exhibits watercolor, oil and glass.
Style: Exhibits all styles. Prefers: landscapes, still lifes and abstraction.
Terms: Accepts work on consignment (50% commission) or buys outright for 50% of retail price (net 30 days). Retail price set by gallery. Gallery provides promotion and contract, artist pays shipping costs both ways. Prefers artwork framed.
Submissions: Send query letter with résumé, 8 slides, bio, brochure, photographs and SASE. Write for appointment to show portfolio, which should include originals, photographs and slides. Responds only if interested within 1 month. Files announcements and brochures.
Tips: "Don't take it personally if your work is not accepted in a gallery. Not all work is suitable for all venues."

LATINO ARTS, INC., 1028 S. Ninth, Milwaukee WI 53204. (414)384-3100 ext. 61. Fax: (414)649-4411. **Visual Artist Specialist:** Zulay Oszkay. Nonprofit gallery. Represents emerging, mid-career and established artists. Sponsors up to 5 individual to group exhibitions/year. Average display time 2 months. Open all year; Monday-Friday, 10-4. Located in the near southeast side of Milwaukee; 1,200 sq. ft.; onetime church. Clientele: the general Hispanic community. Overall price range: $100-2,000.
Media: Considers all media, all types of prints. Most frequently exhibits original 2- and 3-dimensional works and photo exhibitions.
Style: Exhibits all styles, all genres. Prefers artifacts of Hispanic cultural and educational interests.
Terms: "Our function is to promote cultural awareness (not to be a sales gallery)." Retail price set by the artist. Artist is encouraged to donate 15% of sales to help with operating costs. Gallery provides insurance, promotion, contract, shipping costs to gallery; artist pays shipping costs from gallery. Prefers artwork framed.
Submissions: Send query letter with résumé, slides, bio, business card and reviews. Call or write for appointment to show portfolio of photographs and slides. Responds in 2 weeks. Finds artists through recruiting, networking, advertising and word of mouth.

N RAHR-WEST ART MUSEUM, 610 N. Fourth St., Manitowoc WI 54220. (920)683-4501. Fax: (920)683-5047. E-mail: rahrwest@manitowoc.org. Website: www.rahrwestartmuseum.org. **Contact:** Jan Smith. Museum. Estab. 1950. Six exhibits, preferably groups of mid-career and established artists. Sponsors 8-10 shows/year. Average display time 6-8 weeks. Open all year; Monday-Sunday, 10-4; Wednesday, 10-8. Closed major holidays. Clients include local community and tourists. Overall price range: $50-2,200; most work sold at $150-200.
Media: Considers all media and all types of prints except posters. Most frequently exhibits painting, pastel and prints.
Style: Considers all styles. Most frequently exhibits impressionism, realism and various abstraction. Genres include figurative work, florals, landscapes and portraits.
Terms: Artwork is accepted on consignment and there is a 30% commission. Retail price set by the artist. Gallery provides insurance. Accepted work should be framed.
Submissions: Send query letter with artist's statement, bio, SASE and slides. Returns material with SASE if not considered. Responds only if interested. Files slides, contact and bio.

✓ STATE STREET GALLERY, 1804 State St., La Crosse, WI 54601. (608)782-0101. E-mail: ssg1804 @yahoo.com. Website: www.statestreetartgallery.com. **President:** Ellen Kallies. Retail gallery. Estab. 2000. Approached by 15 artists/year. Represents 15 emerging, mid-career and established artists. Exhibited artists include: Diane French, Janet Miller, Robinson Scott, B. Bosco Designs, Lori Monson-Huus, Michael

Martino, William Lurcott, Jim Cox, Skydance Jewelry and various local artists. Sponsors 6 exhibits/year. Average display time 4-6 months. Open all year; Tuesday-Saturday, 10-2; weekends by appointment. Located across from the University of Wisconsin/La Crosse on one of the main east/west streets. "We are next to a design studio, parking behind gallery." Clients include local community, tourists, upscale. 30% of sales are to corporate collectors, 70% to private collectors. Overall price range: $150-1,600; most work sold at $500-800.
Media: Considers acrylic, collage, drawing, glass, mixed media, oil, pastel, sculpture, watercolor and photography. Most frequently exhibits dry pigment, drawing, watercolor and mixed media collage. Considers all types of prints.
Style: Considers all styles and genres. Most frequently exhibits contemporary representational, realistic watercolor, collage.
Terms: Artwork is accepted on consignment and there is a 40% commission. Retail price set by the gallery and the artist. Gallery provides insurance, promotion, contract. Accepted work should be framed and matted.
Submissions: Call to arrange a personal interview or mail portfolio for review. Send query letter with artist's statement, photographs or slides. Returns material with SASE. Responds in 1 month. Finds artists through word of mouth, art exhibits, art fairs, and referrals by other artists.
Tips: "Be organized, be professional in presentation, be flexible! Most collectors today are savvy enough to want recent works on archival quality papers/boards, mattes etc. Have a strong and consistant body of work to present."

WALKER'S POINT CENTER FOR THE ARTS, 911 W. National Ave., Milwaukee WI 53204. (414)672-2787. E-mail: wpca@execpc.com. Website: www.execpc.com/~wpca. **Staff Coordinator:** Linda Corbin-Pardee. Alternative space and nonprofit gallery. Estab. 1987. Represents emerging and established artists; 175 members. Exhibited artists include Sheila Hicks and Carol Emmons. Sponsors 6-8 shows/year. Average display time 2 months. Open all year. Located in urban, multicultural area; gallery 23'6"×70.
Media: Considers all media. Prefers installation, sculpture and video.
Style: Considers all styles. Our gallery often presents work with Latino themes.
Terms: We are nonprofit and do not provide honoria. Gallery assumes a 20% commission. Retail prices set by the artist. Gallery provides insurance, contract and shipping costs. Prefers artwork framed.
Submissions: Send query letter with résumé, slides, bio, photographs, SASE and reviews. Call to schedule an appointment to show a portfolio, which should include slides, photographs and transparencies. Responds in 6-12 months. Files résumés and slides.
Tips: "WPCA is an alternative space, showing work for which there are not many venues. Experimental work is encouraged. Suggesting an exhitib (rather than just trying to get your work shown) can work for a small, understaffed space like ours."

Wyoming

ARTISAN'S GALLERY, 215 S. Second, Laramie WY 82070. (307)745-3983. E-mail: brenda@artisansgallery.net. Website: www.artisansgallery.net. **Owners:** Scott & Brenda Hunter. Retail gallery. Estab. 1993. Represents emerging and mid-career artists varies. Exhibited artists include Paul Tweedy and John Werbelow. Sponsors 11 shows/year. Average display time 1 month. Open all year; Tuesday-Friday, 10:30-5; Saturday, 12-5. Located in historic downtown Laramie; 1,500 sq. ft. Clientele: tourists, upscale, local community and students. 90% private collectors, 10% corporate collectors. Overall price range: $150-3,800; most work sold at $300-1,000.
Media: Considers oil, acrylic, watercolor, pastel, mixed media, collage, sculpture, ceramics, fiber, glass, miniatures, photography; all types of prints. Most frequently exhibits pottery, watercolors and oil.
Style: Exhibits all styles and all genres. Prefers functional pottery, wildlife and realistic.
Terms: Accepts work on consignment (30% commission). Retail price set by the artist. Gallery provides promotion. Artwork must be framed.
Submissions: Accepts only artists from Wyoming. Prefers 3-D artwork, sculpture, pottery, blown and stained glass. Send query letter with brochure, photographs and artist's statement. Please include phone number. Call for appointment to show portfolio of photographs. Responds in 2 weeks, if interested within 1 week.
Tips: "It has often been said that sales are 98% presentation and 2% art itself. With this in mind, presentation (framing, mating, glazing etc.) should be as clean and clear-cut as possible. This always improves sales as your customers, the art collectors, want to see a professional presentation for the art they are about to purchase, without framing hassles. If you value your artwork and think it's sellable, then frame it as such."

☑ ⚍ **WYOMING ARTS COUNCIL GALLERY**, 2320 Capitol Ave., Cheyenne WY 82002. (307)777-7742. Fax: (307)777-5499. E-mail: lfranc@state.wy.us. Website: www.commerce.state.wy.us/cr/ arts. **Visual Arts Program Manager:** Liliane Francuz. Nonprofit gallery. Estab. 1990. Sponsors up to 5 exhibitions/year. Average display time 6 ½ weeks. Open all year, Monday-Friday 8-5. Located downtown in capitol complex; 660 sq. ft.; in historical carriage house. 100% of space devoted to special exhibitions. Clientele: tourists, upscale, local community. 98% private collectors. Overall price range $50-$1,500; most work sold at $100-250.
Media: Considers all media. Most frequently exhibits photography, paintings/drawings, mixed media and fine crafts.
Style: Exhibits all styles and all genres. Most frequently exhibits contemporary styles and craft.
Terms: Retail price set by the artist. Gallery provides insurance, promotion and contract. Shipping costs are shared. Prefers artwork framed.
Submissions: Accepts only artists from Wyoming. Send query letter with résumé, slides and bio. Call for portfolio review of photographs and slides. Responds in 2 weeks. Files résumé and slides. Finds artists through artist registry slide bank, word of mouth and studio visits.
Tips: "I appreciate artists letting me know what they are doing. Send me updated slides, show announcements, or e-mail to keep me current on your activities."

Canada

☑ ⚍ **DALES GALLERY**, 537 Fisgard St., Victoria, British Columbia V8W 1R3 Canada. Fax: (250)383-1552. **Manager:** Sheila Watson. Museum retail shop. Estab. 1976. Approached by 6 artists/year; represents 40 emerging, mid-career and established artists/year. Exhibited artists include: Grant Fuller and Graham Clarke. Sponsors 2-3 exhibits/year. Average display time 2 weeks. Open all year; Monday-Saturday, 10-5:30; Sunday, 12-4. Gallery situated in Chinatown (Old Town); approximately 650 sq. ft. of space— one side brick wall. Clients include: local community, students, tourists and upscale. Overall price range: $100-4,600; most work sold at $350.
Media: Considers most media except photography. Most frequently exhibits oils, etching and watercolor. Considers all types of prints.
Style: Exhibits: expressionism, impressionism, postmodernism, primitivism, realism and surrealism. Most frequently exhibits impressionism, realism and expressionism. Genres include figurative, florals, landscapes, humorous whimsical.
Terms: Accepts work on consignment (40% commission) or buys outright for 50% of retail price (net 30 days). Retail price set by both gallery and artist. Gallery provides promotion. Accepted work should be framed by professional picture framers. Does not require exclusive representation locally.
Submissions: Call to arrange a personal interview to show portfolio of photographs or slides or send query letter with photographs. Portfolio should include résumé, reviews, contact number and prices. Responds only if interested within 2 months. Finds artists through word of mouth, art exhibits, submissions, art fairs, portfolio reviews and referral by other artists.

⚿ ⚍ **MARCIA RAFELMAN FINE ARTS**, 10 Clarendon Ave., Toronto, Ontario M4V 1H9 Canada. (416)920-4468. Fax: (416)968-6715. E-mail: info@mrfinearts.com. Website: www.mrfinearts.com. **President:** Marcia Rafelman. Semi-private gallery. Estab. 1984. Approached by 100s of artists/year. Represents emerging and mid-career artists. Average display time 1 month. Open by appointment except the first 2 days of art openings which is open full days. Centrally located in Toronto's mid-town, 2,000 sq. ft. on 2 floors. Clients include local community, tourists and upscale. 40% of sales are to corporate collectors. Overall price range: $500-30,000; most work sold at $1,500-5,000.
Media: Considers all media. Most frequently exhibits photography, painting and graphics. Considers all types of prints.
Style: Exhibits: geometric abstraction, minimalism, neo-expressionism, primitivism and painterly abstraction. Most frequently exhibits high realism paintings. Considers all genres except southwestern, western and wildlife.
Terms: Artwork is accepted on consignment (50% commission); net 30 days. Retail price set by the gallery and the artist. Gallery provides insurance, promotion and contract. Requires exclusive representation locally.

Submissions: Prefer artists to send images by e-mail. Otherwise, mail portfolio of photographs, bio and reviews for review. Returns material with SASE if in Canada. Responds only if interested within 2 weeks. Files bios and visuals. Finds artists through word of mouth, submissions, art fairs and referrals by other artists.

International

N **⊕** **ABEL JOSEPH GALLERY**, Avenue Maréchal Foch, 89 Bruxelles Belgique 1030. Phone: 32-2-2456773. E-mail: abeljoseph_brsls@hotmail.com. Website: www.cardoeditions.com. **Directors:** Kevin and Christine Freitas. Commercial gallery and alternative space. Estab. 1989. Represents young and established national and international artists. Exhibited artists include Carrie Ungerman, Diane Cole, Régent Pellerin and Ron DeLegge. Sponsors 6-8 shows/year. Average display time 6 weeks. Open all year. Located in Brussels. 100% of space for work of gallery artists. Clientele: varies from first time buyers to established collectors. 80% private collectors; 20% corporate collectors. Overall price range: $500-15,000; most work sold at $1,000-8,000.
Media: Considers most media except craft. Most frequently exhibits sculpture, painting/drawing and installation (including active-interactive work with audience—poetry, music, etc.).
Style: Exhibits painterly abstraction, conceptualism, minimalism, post-modern works and imagism. "Interested in seeing all styles and genres." Prefers abstract, figurative and mixed-media.
Terms: Accepts artwork on consignment (50% commission). Retail price set by the gallery with input from the artist. Customer discounts and payment by installments are available. Gallery provides insurance, promotion and contract; shipping costs are shared.
Submissions: Send query letter with résumé, 15-20 slides, bio, SASE and reviews. Portfolio review requested if interested in artist's work. Portfolio should include slides, photographs and transparencies. Responds in 1 month. Files résumé, bio and reviews.
Tips: "Submitting work to a gallery is exactly the same as applying for a job in another field. The first impression counts. If you're prepared, interested, and have any initiative at all, you've got the job. Know what you want before you approach a gallery and what you need to be happy, whether its fame, glory or money, be capable to express your desires right away in a direct and honest manner. This way, the gallery will be able to determine whether or not it can assist you in your work."

N **⊕** **GOLDSMITHS FINE ART**, 3 High St., Lenham, Maidstone, Kent ME17 2QD United Kingdom. Phone: (01622)850011. E-mail: goldfineart@FSBDial.co.uk. Website: www.goldsmithandgate.com. **Partners:** Jane Ford and Simon Bate. Retail gallery. Estab. 1987. Approached by 4 artists/year. Represents 15 emerging, mid-career and established artists. Exhibited artists include: John Trickett, Nigel Hemming, Mackenzie Thorpe, Mark Spain and Martin Goode. Sponsors 2 exhibits/year. Open all year; Tuesday-Friday, 10-5; Saturday, 9:30-4:30. Located in a medieval village in Kent just off main village square in a 17th century building with timber and exposed fireplaces. 800 sq. ft. in 3 rooms. Clientele: local community, tourists aand upscale. 20% corporate collectors. Overall price range: £50-350. Most work sold at £100-150.
Media: Considers all media and all types of prints. Most frequently exhibits watercolor, mixed media and pen & ink.
Style: Exhibits contemporary original watercolors, etchings, mixed media and limited edition prints. Some abstracts but few oils. Considers landscape, animals and still life.
Terms: Artwork is accepted on consignment (40% commission) or is bought outright for 100% of retail price; net 30 days. Retail price set by the gallery or the artist. Gallery provides insurance and promotion. Accepted work should be framed and mounted after discussion with gallery regarding style.
Submissions: Call or write to arrange a personal interview to show portfolio of photographs. Send query letter with artist's statement, bio, brochure, business card, photographs, résumé, reviews and SASE. Returns material with SASE. Responds in 2 weeks. Files catalogs/brochures. Finds artists through word of mouth, submissions, art exhibits and referrals by other artists.
Tips: "Please discuss framing and mounting with us if submitting work. Inexperienced artists often submit without an eye to the commercial implications of retailing the work."

N **⊕** **HONOR OAK GALLERY**, 52 Honor Oak Park, London SE23 1DY United Kingdom. Phone: 020-8291-6094. **Contact:** John Broad or Sanchia Lewis. Estab. 1986. Approached by 15 artists/year. Represents 40 emerging, mid-career and established artists. Exhibited artists include: Jenny Devereux, Norman Ackroyd, Clare Leighton, Robin Tanner and Karolina Larusdoltir. Sponsors 2 total exhibits/year. Average display time 6 weeks. Open all year; Tuesday-Friday, 9:30-6; Saturday, 9:30-5. Closed 2 weeks

at Christmas, New Years and August. Located on a main thoroughfare in South London. Exhibition space of 1 room 12×17′. Clientele: local community and upscale. 2% corporate collectors. Overall price range: £18-2,000; most work sold at £150.

Media: Considers collage, drawing, mixed media, pastel, pen & ink, watercolor, engravings, etchings, linocuts, lithographs, mezzotints, engravings, woodcuts, screenprints, wood engravings. Most frequently exhibits etchings, wood engravings, watercolor.

Style: Exhibits: postmodernism, primitivism, realism, 20th century works on paper. Considers all styles. Most frequently exhibits realism. Genres include figurative work, florals, landscapes, wildlife, botanical illustrations.

Terms: Artwork is accepted on consignment (40% commission). Retail price set by the gallery and the artist. Gallery provides promotion. Does not require exclusive representation locally. Prefers only works on paper.

Submissions: Write to arrange a personal interview to show portfolio of recent original artwork. Send query letter with bio, photographs. Responds in 1 month. Finds artists through word of mouth, submissions, art fairs.

Tips: "Show a varied, but not too large selection of recent work. Be prepared to discuss a pricing policy. Present work neatly and in good condition. As a gallery which also frames work, we always recommend conservation mounting and framing and expect our artists to use good quality materials and appropriate techniques."

N ⊕ PARK WALK GALLERY, 20 Park Walk, London SW10 AQ United Kingdom. Pohne/fax: (0171)351 0410. **Gallery Owner:** Jonathan Cooper. Gallery. Estab. 1988. Approached by 5 artists/year. Represents 16 mid-career and established artists. Exhibited artists include: Jay Kirkman and Kate Nessler. Sponsors 8 exhibits/year. Average display time 3 weeks. Open all year; Monday-Saturday, 10-6:30; Sunday, 11-4. Located in Park Walk which runs between Fulham Rd. to Kings Rd. Clientele: upscale. 10% corporate collectors. Overall price range: £500-50,000; most work sold at £2,000.

Media: Considers drawing, mixed media, oil, paper, pastel, pen & ink, photography, sculpture, watercolor. Most frequently exhibits watercolor, oil and sculpture.

Style: Exhibits: conceptualism, impressionism. Genres include florals, landscapes, wildlife, equestrian.

Terms: Artwork is accepted on consignment (50% commission). Retail price set by the gallery. Gallery provides promotion. Requires exclusive representation locally.

Submissions: Call to arrange a personal interview to show portfolio. Returns material with SASE. Responds in 1 week. Finds artists through submissions, portfolio reviews, art exhibits, art fairs, referrals by other artists.

Tips: "Include full curriculum vitae and photographs of work."

N PEACOCK COLLECTION, The Smithy Old Warden, Biggleswade, Belfordshire SG18 9HQ United Kingdom. Phone: (01767)627711. Fax: (01767)627027. E-mail: peacockcol@aol.com. **Contact:** Elaine Baker. Retail gallery. Estab. 1997. Represents emerging artists. Exhibited artists include: Gary Hodges, Walasse Ting and Adrian Rigby. Average display time 2 weeks. Open all year; Monday-Friday, 9-5:30; weekends 1-4:30. Located in the beautiful 18th century award winning village of Old Warden. The gallery has 2 rooms both spotlit. Room 1 is 30×20 ft. Room 2 is 15×10 ft. Clientele: local community and tourists. 20% of sales are to corporate collectors. Overall price range: £29-4,500; most work sold at £200.

Media: Considers acrylic, ceramics, craft, drawing, glass, mixed media, oil, pastel, pen & ink, photography, sculpture, watercolor, etchings, linocuts, lithographs and posters. Most frequently exhibits watercolor, ceramics and sculptures.

Style: Considers all styles. Genres include figurative work, florals, landscapes and wildlife.

Terms: Artwork is accepted on consignment (30% commission). Retail price set by gallery. Gallery provides insurance, promotion and contract. Accepted work should be framed or mounted. Requires exclusive representation locally.

Submissions: Write with details and photographic samples. Send query letter with bio and photographs. Returns material with SASE. Responds in 2 weeks. "If we are allowed to keep artists photos we file in specific categories, i.e., sculpture work for future exhibitions, i.e., wildlife exhibition. Finds artists through word of mouth, submissions, art exhibits, referrals by other artists.

Tips: "Good, clear photographs of work with contact details with indication of best times to phone, i.e., day/evening."

Syndicates & Cartoon Features

Syndicates are agents who sell comic strips, panels and editorial cartoons to newspapers and magazines. They promote and distribute comic strips and other features in exchange for a cut of the profits.

The syndicate business is one of the hardest to break into because spaces for new strips don't open up often. Newspapers are reluctant to drop long-established strips for new ones. Syndicates look for a "sure thing," a feature they'll feel comfortable investing more than $25,000 in for promotion and marketing.

To crack this market, you have to be more than a fabulous cartoonist. The art won't sell if the idea isn't there in the first place. Work worthy of syndication must be original, salable and timely, and characters must have universal appeal in order to attract a diversity of readers.

Although newspaper syndication is still the most popular and profitable method of getting your comic strip to a wide audience, the Web has become an exciting new venue for comic strips.

There are hundreds of strips available on the Web. With the click of your mouse, you can be introduced to *Ashfield*, by Aric McKeown; *Boy on a Stick and Slither*, by Steven Cloud; and *Diesel Sweeties*, by R. Stevens. (Keenspot provides a great list of online comics at www.keenspot.com.)

It's hard to know if such sites are making money for cartoonists, although it's clear they are a great promotional tool. It is rumored that scouts for the major syndicates have been known to surf the more popular comic strip sites in search of fresh voices.

The Web may be the ideal venue for cartoonists to showcase their work. The beauty of posting your comic strip to the Web is that readers can find a sequential archive of hundreds of your past strips. They can click on a character, read background material, and be instantly linked to dozens of cartoons featuring that character.

HOW TO SUBMIT TO SYNDICATES

Each syndicate has a preferred method for submissions, and most have guidelines you can send for or access on the syndicate's website. Availability is indicated in the listings.

To submit a strip idea, send a brief cover letter (50 words or less is ideal) summarizing your idea, along with a character sheet (the names and descriptions of your major characters), and photocopies of 24 of your best strip samples on 8½ × 11 paper, six daily strips per page. Sending at least one month of samples, shows that you're capable of producing high-quality humor, consistent artwork and a long lasting idea. Never submit originals; always send photocopies of your work. Simultaneous submissions are acceptable. It is also appropriate to query syndicates online, attaching art files or links to your website. Response time can take several months. Syndicates understand it would be impractical for you to wait for replies before submitting your ideas to other syndicates.

Editorial cartoons

If you're an editorial cartoonist, you'll need to start out selling your cartoons to a base newspaper (probably in your hometown) and build up some clips before approaching a syndicate. Submitting published clips proves to the syndicate that you have a following and are able to produce cartoons on a regular basis. Once you've built up a good collection of clips, submit at least 12 photocopied samples of your published work along with a brief cover letter.

Payment and contracts

If you're one of the lucky few to be picked up by a syndicate, your earnings will depend on the number of publications in which your work appears. It takes a minimum of about 60 interested newspapers to make it profitable for a syndicate to distribute a strip. A top strip such as *Garfield* may be in as many as 2,000 papers worldwide.

Newspapers pay in the area of $10-15 a week for a daily feature. If that doesn't sound like much, multiply that figure by 100 or even 1,000 newspapers. Your payment will be a percentage of gross or net receipts. Contracts usually involve a 50/50 split between the syndicate and cartoonist. Check the listings for more specific payment information.

Before signing a contract, be sure you understand the terms and are comfortable with them.

Self-syndication

Self-syndicated cartoonists retain all rights to their work and keep all profits, but they also have to act as their own salespeople, sending packets to newspapers and other likely outlets. This requires developing a mailing list, promoting the strip (or panel) periodically, and developing a pricing, billing and collections structure. If you have a knack for business and the required time and energy, this might be the route for you. Weekly suburban or alternative newspapers are the best bet here (daily newspapers rarely buy from self-syndicated cartoonists).

For More Information

You'll get an excellent overview of the field by reading *Your Career in Comics*, by Lee Nordling (Andrews McMeel) available from the Newspaper Features Council (203)661-3386 and on Amazon.com. This is a comprehensive review of syndication from the viewpoints of the cartoonist, the newspaper editor and the syndicate.

If you have access to a computer, another great source of information is Stu's Comic Strip Connection at http://www.stus.com. Here you'll find links to most syndicates and other essential sources including helpful books, courtesy of Stu Rees.

ARTISTMARKET.COM (AKA A.D. KAHN, INC.), 35336 Spring Hill Rd., Farmington Hills MI 48331-2044. (248)661-8585. E-mail: Editors@artistmarket.com. Website: www.artistmarket.com. **Publisher:** David Kahn. Estab. 1960 (website estab. 1996). Syndicate serving daily and weekly newspapers, monthly magazines.

• Artistmarket.com proactively invites newspaper and magazine editors, website designers and book publishers to use the Internet's largest resource of professional cartoonists, puzzle makers and writers.

Needs: Approached by 40-60 freelancers/month. Considers comic strips, editorial/political cartoons, gag cartoons, puzzles/games, written features for publication.

First Contact & Terms: E-mail or postal sample package should include material that best represents artist's work. Files samples of interest; others returned by SASE if requested by artist. Pays 50% of net proceeds. Negotiates rights purchased according to project. The artist owns original art and characters.

ARTIZANS SYNDICATE, 11149 65th St. NW, Edmonton, Alberta T5W 4K2 Canada. **Submission Editor:** Malcom Mays. E-mail: submissions@artizans.com. Website: www.artizans.com. Estab. 1998. Syndicate providing political cartoons, global caricatures, humorous illustrations to magazines, newspapers, Internet, corporate and trade publications and ad agencies. Submission guidelines available on website. Artists syndicated include Jan Op De Beeck and Dan Murphy.

Needs: Works with 30-40 artists/year. Buys 30-40 features/year. Needs single panel cartoons, caricatures, illustrations, graphic and clip art. Prefers professional artists with a track records, who create artwork regularly and artists who have archived work or a series of existing cartoons, caricatures and/or illustrations.

First Contact & Terms: Send cover letter and copies of cartoons or illustrations. Send 6-20 examples if sending via e-mail; 24 if sending via snail mail. "In your cover letter tell us briefly about your career.

This should inform us about your training, what materials you use and where you work has been published." Résumé and samples of published cartoons would be helpful but are not required. E-mail submission should include a link to other online examples of your work. Replies in 2 months. Artist receives 50-80%. Pay varies depending on artist's sales. Artist's retains copyright. Our clients purchase a variety of rights from the artist.

Tips: We are only interested in professional artists with a track record. Link to our website www.artizans.c om for guidelines.

ATLANTIC SYNDICATION/EDITORS PRESS, 1970 Barber Rd., Sarasota FL 34240. (941)371-2252. Fax: (941)342-0999. E-mail: kslagle@atlanticsyndication.com. Website: www.atlanticsyndication.c om. President: Mr. Kerry Slagle. Estab. 1933. Syndicate representative servicing 1,700 publications: daily and weekly newspapers and magazines. International, US and Canadian sales. Recent introductions include *Ginger Meggs* and *Mr. Potato Head*.

Needs: Buys from 1-2 freelancers/year. Introduces 1-2 new strips/year. Considers comic strips, gag cartoons, caricatures, editorial/political cartoons and illustrations. Considers single, double and multiple panel, pen & ink. Prefers non-American themes. Maximum size of artwork: 11 × 17. Does not accept unsolicited submissions.

First Contact & Terms: Send cover letter, finished cartoons, tearsheets and photocopies. Include 24-48 strips/panels. Does not want to see original artwork. Include SASE for return of materials. Pays 50% of gross income. Buys all rights. Minimum length of contract: 2 years. Artist owns original art and characters.

Tips: "Look for niches. Study, but do not copy the existing competition. Read the newspaper!" Looking for "well written gags and strong character development."

N ASHLEIGH BRILLIANT ENTERPRISES, 117 W. Valerio St., Santa Barbara CA 93101. (805)682-0531. **Art Director:** Ashleigh Brilliant. Estab. 1967. Syndicate and publisher. Outlets vary. "We supply a catalog and samples for $2 plus SASE."

Needs: Considers illustrations and complete word and picture designs. Prefers single panel. Maximum size of artwork 5½ × 3½, horizontal only.

First Contact & Terms: Samples are returned by SASE if requested by artist. Responds in 2 weeks. **Pays on acceptance**; minimum flat fee of $60. Buys all rights. Syndicate owns original art.

Tips: "Our product is so unusual that freelancers will be wasting their time and ours unless they first carefully study our catalog."

CATHOLIC NEWS SERVICE, 3211 Fourth St. NE, Washington DC 20017. (202)541-3250. Fax: (202)541-3255. E-mail: cnsphotos@nccbuscce.org. Website: www.catholicnews.com. **Photos/Graphics Editor:** Nancy Wiechec. Estab. 1920. Syndicate serving 200 Catholic newspapers.
• This syndicate no longer accepts cartoons.

Needs: Assigns "occasional illustrators." Prefers religious, church or family themes.

First Contact & Terms: Sample package should include cover letter and roughs. Pays on publication. Pays $75-150 for illustration, mostly line drawings. Rights purchased vary according to project.

✓ CELEBRATION: AN ECUMENICAL RESOURCE, Box 419493, Kansas City MO 64141-6493. (800)444-8910. Fax: (816)968-2291. E-mail: patmarrin@aol.com. Website: www.ncrpub.com/celebration/ . **Editor:** Patrick Marrin. Syndicate serving churches, clergy and worship committees.

Needs: Buys 50 religious theme cartoons/year. Does not run an ongoing strip. Buys cartoons on church themes (worship, clergy, scripture, etc.) with a bit of the offbeat.

First Contact & Terms: Originals returned to artist at job's completion. Payment upon use, others returned. Send copies. Simultaneous submissions OK. Pays $30/cartoon. "We grant reprint permission to subscribers to use cartoons in parish bulletins, but request they send the artist an additional $5.

Tips: "We only use religious themes (black & white). The best cartoons tell the 'truth'—about human nature, organizations, by using humor."

✓ CONTINENTAL FEATURES/CONTINENTAL NEWS SERVICE, 501 W. Broadway, Plaza A, P.O. Box 265, San Diego CA 92101. (858)492-8696. E-mail: continentalnewstime@lycos.com. Website: www.mediafinder.com.cnstore. **Editor-in-Chief:** Gary P. Salamone. Parent firm established August, 1981. Syndicate serving 3 outlets: house publication, publishing business and the general public through the *Continental Newstime* magazine. Features include *Portfolio*, a collection of cartoon and caricature art.

Needs: Approached by 200 cartoonists/year. Number of new strips introduced each year varies. Considers comic strips and gag cartoons. Does not consider highly abstract, computer-produced or stick-figure art. Prefers single panel with gagline. Recent features include "Fusebox" by Greg Panneitz. Guidelines available for #10 SASE with first-class postage. Maximum size of artwork 8 × 10, must be reducible to 65% of original size.

First Contact & Terms: Sample package should include cover letter, photocopies (10-15 samples). Samples are filed or are returned by SASE if requested by artist. Responds in 1 month only if interested and if SASE is received. To show portfolio, mail photocopies and cover letter. Pays 70% of gross income on publication. Rights purchased vary according to project. Minimum length of contract is 1 year. The artist owns the original art and the characters.

Tips: "We need single-panel cartoon and comic strips appropriate for English-speaking, international audience. Do not send samples reflecting the highs and lows and different stages of your artistic development. CF/CNS wants to see consistency and quality, so you'll need to send your best samples."

CREATORS SYNDICATE, INC., 5777 W. Century Blvd., Suite 700, Los Angeles CA 90045. (310)337-7003. E-mail: cre8ors@aol.com. Website: www.creators.com. Address work to Editorial Review Board—Comics. **President:** Richard S. Newcombe. Director of Operations: Lori Sheehey. Estab. 1987. Serves 2,400 daily newspapers, weekly and monthly magazines worldwide. Guidelines on website.

Needs: Syndicates 100 writers and artists/year. Considers comic strips, caricatures, editorial or political cartoons and "all types of newspaper columns." Recent introductions: *One Big Happy*, by Rick Detorie and *Rubes*, by Leigh Rubin.

First Contact & Terms: Send query letter with brochure showing art style or résumé and "anything but originals." Samples are not filed and are returned by SASE. Responds in a minimum of 10 weeks. Considers saleability of artwork and client's preferences when establishing payment. Negotiates rights purchased.

Tips: "If you have a cartoon or comic strip you would like us to consider, we will need to see at least four weeks of samples, but not more than six weeks of dailies and two Sundays. If you are submitting a comic strip, you should include a note about the characters in it and how they relate to each other. As a general rule, drawings are most easily reproduced if clearly drawn in black ink on white paper, with shading executed in ink wash or Benday® or other dot-transfer. However, we welcome any creative approach to a new comic strip or cartoon idea. Your name(s) and the title of the comic or cartoon should appear on every piece of artwork. If you are already syndicated elsewhere, or if someone else owns the copyright to the work, please indicate this."

N GRAPHIC ARTS COMMUNICATIONS, Box 421, Farrell PA 16121. (412)342-5300. **President:** Bill Murray. Estab. 1980. Syndicates to 200 newspapers and magazines.

Needs: Buys 400 pieces/year from artists. Humor through youth and family themes preferred for single panel and multipanel cartoons and strips. Needs ideas for anagrams, editorial cartoons and puzzles, and for comic panel "Sugar & Spike." Introductions include "No Whining" by John Fragle and "Attach Cat" by Dale Thompson; both similar to past work—general humor, family oriented.

First Contact & Terms: Query for guidelines. Sample package should contain 5 copies of work, résumé, SASE and cover letter. Responds in 4-6 weeks. No originals returned. Buys all rights. Pays flat fee, $8-50.

Tips: "Inter-racial material is being accepted more."

JODI JILL FEATURES, 1705 14th St., Suite 321, Boulder CO 80302. E-mail: jjillone@aol.com or jjfeatures@hotmail.com. **Art Editor/President:** Jodi Jill. Estab. 1983. Syndicate serving 138 newspapers, magazines, publications.

Needs: Approached by 250 freelancers/year. "We try to average ten new strips per year." Considers comic strips, editorial/political cartoons and gag cartoons. "Looking for silly, funny material, not sick humor on lifestyles or ethnic groups." Introductions include *From My Eyes* by Arnold Peters and *Why Now?* by Ralph Stevens. Prefers single, double and multiple panel b&w line drawings. Needs art, photos and columns that are visual puzzles. Maximum size of artwork 8½×11.

First Contact & Terms: Sample package should include cover letter, résumé, tearsheets, finished cartoons and photocopies. 6 samples should be included. Samples are not filed and are returned by SASE if requested by artist. Portfolio review requested if interested in artist's work. Responds in 1 month. Portfolio should include b&w roughs and tearsheets. **Pays on acceptance**; 50-60% of net proceeds. Negotiates rights purchased. Minimum length of contract is 1 year. The artist owns original art and characters. Finds artists "by keeping our eyes open and looking at every source possible."

Tips: "Would like to see more puzzles with puns in their wording and visual effects that say one thing and look like another. We like to deal in columns. If you have a visual puzzle column we would like to look it over. Some of the best work is unsolicited. Think happy, think positive, and think like a reader. If the work covers the three 'T's we will pick it. Please remember a SASE and remember we are human too. No need to hate us if we return the work, we are doing our job, just like you. Believe in your work, but listen to critiques and criticism. Be patient."

☑ **KING FEATURES SYNDICATE**, 888 Seventh Ave., 2nd Floor, New York NY 10019. (212)455-4000. Website: KingFeatures.com. **Editor-in-Chief:** Jay Kennedy. Estab. 1915. Syndicate servicing 3,000 newspapers. Guidelines available for #10 SASE.

• This is one of the oldest, most established syndicates in the business. It runs such classics as *Blondie*, *Hagar*, *Dennis the Menace* and *Beetle Bailey* and such contemporary strips as *Zippy the Pinhead*, *Zits* and *Mutts*. If you are interested in selling your cartoons on an occasional rather than fulltime basis, refer to the listing for The New Breed (also run by King Features).

Needs: Approached by 6,000 freelancers/year. Introduces 3 new strips/year. Considers comic strips and single panel cartoons. Prefers humorous single or multiple panel, and b&w line drawings. Maximum size of artwork 8½×11. Comic strips must be reducible to 6½" wide; single panel cartoons must be reducible to 3½" wide.

First Contact & Terms: Sample package should include cover letter, character sheet that names and describes major characters and photocopies of finished cartoons. "Résumé optional but appreciated." 24 samples should be included. Returned by SASE. Responds in 2 months. Pays 50% of net proceeds. Rights purchased vary according to project. Artist owns original art and characters. Length of contract and other terms negotiated.

Tips: "We look for a uniqueness that reflects the cartoonist's own individual slant on the world and humor. If we see that slant, we look to see if the cartoonist is turning his attention to events other people can relate to. We also study a cartoonist's writing ability. Good writing helps weak art, better than good art helps weak writing."

☑ **LEW LITTLE ENTERPRISES, INC.**, 6827 E. Agua Fria Lane, Hereford AZ 85615. (520)803-1705. **Editor:** Lew Little. Estab. 1986. Syndicate serving all daily and weekly newspapers. Guidelines available for legal SASE with first-class postage.

Needs: Approached by 300-400 artists/year. Buys from 1-2 artists/year. Introduces 1-2 new strips/year. Considers comic strips, text features, editorial/political cartoons and gag cartoons. Recent introductions include *Warped*, a new daily and Sunday comic feature, by cartoonist Mike Cavna. Prefers single or multiple panel with gagline.

First Contact & Terms: Sample package should include cover letter ("would like to see an intelligent cover letter"), résumé, roughs and photocopies of finished cartoons or text feature samples. Minimum of 12 samples should be included. Samples are not filed and are returned by SASE. Responds in 6 weeks. Schedule appointment to show portfolio or mail final reproduction/product, b&w roughs, tearsheets and SASE. Pays on publication; negotiable percentage of net proceeds. Negotiates rights purchased. Minimum length of contract 5 years. Offers automatic renewal. Artist owns original art and syndicate owns characters during the contract term, after which rights revert to artist.

Tips: "Get a good liberal arts education. Read *The New York Times* daily, plus at least one other newspaper. Study all comic features carefully. Don't give up; most cartoonists do not make it to syndication until in their 30s or 40s."

⊞ **MINORITY FEATURES SYNDICATE, INC.**, P.O. Box 421, Farrell PA 16121. (724)342-5300. Fax: (724)342-6244. **Editor:** Bill Murray. Estab. 1980. Syndicate serving 150 daily newspapers, school papers and regional and national publications. Art guidelines available for #10 SASE.

Needs: Approached by 800 freelance artists/year. Buys from 650 freelancers/year. Introduces 100 new strips/year. Considers comic strips, gag cartoons and editorial/political cartoons. Prefers multiple panel b&w line drawing with gagline. Prefers family-oriented, general humor featuring multicultural, especially Black characters. Maximum size of artwork 8½×11; must be reducible to 65%.

First Contact & Terms: Sample package should include cover letter, tearsheets and photocopies. 5 samples should be included. Samples are filed or returned by SASE. Responds in 3 months. To show portfolio, mail b&w tearsheets. Pays flat fee of $50-150. Rights purchased vary according to project. No automatic renewal. Syndicate owns original art. Character ownership negotiable.

⊞ **NATIONAL NEWS BUREAU**, Box 43039, Philadelphia PA 19129. (215)849-9016. E-mail: nbafeature@aol.com. Website: www.nationalnewsbureau.com. **Editor:** Harry Jay Katz. Syndicates to 300 outlets and publishes entertainment newspapers on a contract basis.

Needs: Buys from 500 freelancers/year. Prefers entertainment themes. Uses single, double and multiple panel cartoons, illustrations; line and spot drawings.

First Contact & Terms: To show portfolio, send samples and résumé. Samples returned by SASE. Responds in 2 weeks. Returns original art after reproduction. Send résumé and samples to be kept on file for future assignments. Negotiates rights purchased. Pays on publication; flat fee of $5-100 for each piece.

⊞ **THE NEW BREED**, %King Features Syndicate, 888 Seventh Ave., New York NY 10019. (212)455-4000. Website: KingFeatures.com. **Contact:** *The New Breed* Editors. Estab. 1989. Syndicated feature.

insider report

Cartoonist finds his voice and a path to syndication success

Michael Jantze is a funny guy—no, really, he is. He just had to figure out how to get that funniness down on paper if he was going to realize his dream of being an internationally syndicated cartoonist. Fortunately for him and for the rest of us, he worked it out and now his strip, *The Norm*, is distributed by King Features Syndicate and featured in newspapers around the world.

The Norm deals with the thoughts and observations of a young man who, in the beginning, enjoyed the single life but then fell in love with and married his best friend, Reine. Jantze had originally drawn a strip called *Normal USA*, named after the Illinois town where he grew up. But people kept coming up to him and telling him that, while the strip was funny, he was much funnier in per-

Michael Jantze

son. So Jantze started keeping a diary to capture his own voice, and he found it when he allowed his main character Norm to speak directly to the readers. "This technique," he explains, "means I can literally write about anything. I'm not just doing observational humor. I'm adding pathos and developing characters."

Jantze had no formal art training other than high school art classes. But he was the kid who could always draw. "People would say, 'Hey, Mike, draw me a cowboy!' " he recalls. "I designed the float and filled any other graphic art needs for the class of 1980." When he went to college, he majored in film, but he always had a daily comic in the school paper. So his was more of an old-fashioned journeyman's training.

"Cartoonists used to rise from the ranks of newspaper artists on staff—it could take twenty years," Jantze explains. "Comic strips were ways to build circulation. After World War II, cartoonists like Mort Drucker came from magazine backgrounds and worked their chops out there. In the '70s, Garry Trudeau was the first college cartoonist. That's where you have a short training period, get a big head and think you know what you're doing and then go out and try to get syndicated. Now, everyone's drawing cartoons on the Internet until they're ready to try syndication."

Jantze began drawing *The Norm* in 1995 when he was working at a newspaper in California. He asked the editors to publish the strip for free on a daily basis. This gave him the opportunity to develop and polish it and see if he had what it took to keep it going. "The thinking at the syndicates is that everyone has thirty-six good jokes in them, so you might be able to draw that many strips. But then most artists fizzle out. They can't sustain it."

Looking back, Jantze recalls making a major mistake the first four times he sent *The Norm* off to a syndicate. "I quit drawing after I sent it. There's usually a one- to two-month wait before you get a response. If the editors like what they see, they'll ask to see more. If you haven't been drawing, you have nothing to show. So, the fifth time I submitted, I used that time to keep developing and polishing the strip. It made the difference."

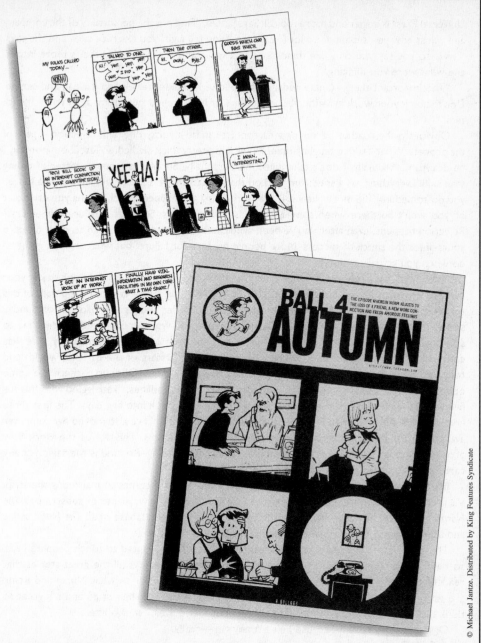

Michael Jantze found a simple yet effective way to promote his strip and try to get it into additional papers. He self-publishes a simple, inexpensively-produced quarterly zine featuring selected strips. It's funny and it's a great introduction to the characters who populate *The Norm*. It also includes an order form for Norm T-shirts, coffee mugs, and of course his website address, www.thenorm.com.

It's important to have a strategy when approaching a syndicate. Jantze went to the library and researched all the newspapers to get a feel for the kind of comics each one published and where *The Norm* would best fit in. For example, King Features is more family-oriented, while

Universal Press is edgier and more topical. Says Jantze, "Find out the personality of the company and adjust how you submit. It's a lot like dating—you tell a girl you like race cars, and she says, 'Eww,' so you say you only like them once in a while and really your brother's more into it, and what were you thinking?

"The important thing," Jantze adds, "is to follow the guidelines—keep it clean and simple. Don't submit your work in leather-bound folders or have stuffed animals made of your characters."

Obviously, the road to becoming a cartoonist can be a rocky one, and rejection is part of the process. What has that taught Jantze? "Well, I'm pretty thick-skulled, so just about nothing," he deadpans. "Actually, I don't take rejection personally. Success is more a matter of timing than skill. Everything has a spectrum, and on that spectrum are success and failure. The longer you do something, the more likely it is that something will happen, which means you can't quit or you won't be there when someone needs your services. So what if failure comes first? Rejection happens, even after you've been syndicated. What you really need to do is prepare yourself for the shock of success. More people prepare for failure, but what are you going to do when you actually make it?"

"Making it" definitely has its pressures. Deadlines are ever looming, and your day is your own, so it's pretty lonely. It's up to the artist to keep it going. Jantze realized the pitfalls of this early on. "You're supposed to work six weeks out on dailies and eight weeks out on Sunday strips. The exception is someone like Garry Trudeau, who works much closer to deadline to stay topical. I did fine with this in the beginning, but then I started slipping. My wife was concerned. Then we went to a Reubens ceremony (the Oscars of the cartoon world) and talked to other cartoonists and found out *everybody* was behind. Of course, there are some obnoxious ones who are way ahead, but most are pushing deadlines. "I struggled with this for five years, then I created a really solid routine. I break the week into five days. The first three involve cartooning. The rest I devote to business administration. I've also moved my computer away from my drawing board and put them in separate rooms. This solves the work flow problem, because when I'm at the computer, I can't be drawing. Routine is the savior of any cartoonist. You have to find ways to organize yourself."

Jantze has also found that having a website is useful when it comes to marketing the strip. Visitors to www.thenorm.com can download calendars, desktop wallpaper or subscribe to *The Norm* newsletter. In the works are plans to add a searchable database of all *The Norm* strips and a Web cam so fans can watch Jantze at his drawing board.

The main reason Jantze became a cartoonist is because he wanted to touch people's lives, so he makes a concerted effort to answer every e-mail. He enjoys all the great stories that readers share about how they're going through something similar to what Norm and Reine are going through. "Cartoonists rely on wanting people to read their stuff, and it's great to think that people are using the strip to think about themselves," says Jantze.

Or maybe they read it because he's a funny guy—really.

—*Cindy Duesing*

● *The New Breed* showcases single panel gag cartoons done by cartoonists with a contemporary or wild sense of humor. *The New Breed* is a place where people can break into newspaper syndication without making a commitment to producing a comic on a daily basis. The feature is intended as a means for King Features to encourage and stay in touch with promising cartoonists who might one day develop a successful strip for regular syndication.

Needs: Reviews 30,000 cartoons/year. Buys 500 cartoons/year. Maximum size of artwork 8½×11; must be reducible to 3½ wide.

First Contact & Terms: "Submissions should include 10-25 single panel cartoons per batch. The cartoons should be photocopied one per page and each page should have cartoonist's name and address on back. All submissions must include SASE large enough and with enough postage to return work. Do not send originals." Responds in 2 months. **Pays on acceptance**; flat fee of $50. Buys first worldwide serial rights.

TRIBUNE MEDIA SERVICES, INC., 435 N. Michigan Ave., Suite 1400, Chicago IL 60611. (312)222-5998. E-mail: tms@tribune.com. Website: www.comicspage.com. **Submissions Editor:** Tracy Clark. Creative Director, News and Features: Fred Schecker. Syndicate serving daily domestic and international and Sunday newspapers as well as weeklies and new media services. Strips syndicated include *Broom-Hilda*, *Dick Tracy*, *Brenda Starr* and *Helen, Sweetheart of the Internet*. "All are original comic strips, visually appealing with excellent gags." Art guidelines available on website or for SASE with first-class postage or on website.

• Tribune Media Services is a leading provider of Internet and electronic publishing content, including the WebPoint Internet Service.

Needs: Seeks comic strips and newspaper panels, puzzles and word games. Recent introductions include *Cats With Hands*, by Joe Martin; and *Dunagin's People*, by Ralph Dunagin. Prefers original comic ideas, with excellent art and timely, funny gags; original art styles; inventive concepts; crisp, funny humor and dialogue.

First Contact & Terms: Send query letter with résumé and photocopies. Sample package should include 4-6 weeks of daily strips or panels. Send 8½×11 copies of your material, not the original. "Interactive submissions invited." Samples not filed are returned only if SASE is enclosed. Responds in 2 months. Pays 50% of net proceeds.

Tips: "Comics with recurring characters should include a character sheet and descriptions. If there are similar comics in the marketplace, acknowledge them and describe why yours is different."

UNITED FEATURE SYNDICATE/NEWSPAPER ENTERPRISE ASSOCIATION, 200 Madison Ave., New York NY 10016. (212)293-8500. Website: www.unitedmedia.com. **Contact:** Comics Editor. Syndicate serving 2500 daily/weekly newspapers. Guidelines available for #10 SASE and on website.

• This syndicate told *AGDM* they receive more than 4,000 submissions each year and only accept two or three new artists. Nevertheless, they are always interested in new ideas.

Needs: Approached by 5,000 cartoonists/year. Buys from 2-3 cartoonists/year. Introduces 2-3 new strips/year. Strips introduced include *Dilbert*, *Over the Hedge*. Considers comic strips, editorial political cartoons and panel cartoons.

First Contact & Terms: Sample package should include cover letter and nonreturnable photocopies of finished cartoons. 18-36 dailies. . Color Sundays are not necessary with first submissions. Responds in 3 months. Does not purchase one shots. Does not accept submissions via fax or e-mail.

Tips: "No oversize packages, please."

☑ **UNITED MEDIA**, 200 Madison Ave., New York NY 10016. (212)293-8500. Website: www.unitedfeatures.com. **Editorial Director:** Liz DeFranco. Estab. 1978. Syndicate servicing US and international newspapers. Guidelines for SASE. "United Media consists of United Feature Syndicate and Newspaper Enterprise Association. Submissions are considered for both syndicates. Duplicate submissions are not needed." Guidelines available on website.

Needs: Introduces 2-4 new strips/year. Considers comic strips and single, double and multiple panels. Recent introductions include *Frazz*, by Jef Mallett. Prefers pen & ink.

First Contact & Terms: Send cover letter, résumé, finished cartoons and photocopies. Include 36 dailies; "Sundays not needed in first submissions." Do not send "oversize submissions or concepts without strips." Samples are not filed and are returned by SASE. Responds in 3 months. "Does not view portfolios." Payment varies by contract. Buys all rights.

Tips: "Send copies, but not originals. Do not send mocked-up licensing concepts." Looks for "originality, art and humor writing. Be aware of long odds; don't quit your day job. Work on developing your own style and humor writing. Worry less about 'marketability'—that's our job."

UNITED NEWS SERVICE, 139 Corsen Ave., St. George NY 10301-2933. (718)981-2365. Fax: (718)981-6292. **Assignment Desk:** Jane Marie Johnson. Estab. 1936. Syndicate servicing 500 regional newspapers. Considers caricatures, editorial political cartoons, illustrations and spot drawings. Prefers b&w line drawings.

First Contact & Terms: Sample package should include cover letter and résumé. Samples are filed or returned by SASE if requested. Responds in weeks. Mail appropriate materials. Pays on publication; $50-100. Buys reprint rights. Syndicate owns original art; artist owns characters.

UNIVERSAL PRESS SYNDICATE, 4520 Main St., Suite 700, Kansas City MO 64111. (816)932-6600. Website: www.uexpress.com. **Editorial Director:** Lee Salem. Syndicate serving 2,750 daily and weekly newspapers.
Needs: Considers single, double or multiple panel cartoons and strips; b&w and color. Requests photocopies of b&w, pen & ink, line drawings.
First Contact & Terms: Responds in 6 weeks. To show a portfolio, mail photostats. Send query letter with photocopies.
Tips: "Be original. Don't be afraid to try some new idea or technique. Don't be discouraged by rejection letters. Universal Press receives 100-150 comic submissions a week, and only takes on two or three a year, so keep plugging away. Talent has a way of rising to the top."

WHITEGATE FEATURES SYNDICATE, 71 Faunce Dr., Providence RI 02906. (401)274-2149. Website: www.whitegatefeatures.com. **Talent Manager:** Eve Green. Estab. 1988. Syndicate serving daily newspapers internationally, book publishers and magazines. Guidelines available on website.
 • Send nonreturnable samples. This syndicate says they are not able to return samples "even with SASE" because of the large number of submissions they receive.
Needs: Introduced Dave Berg's *Roger Kaputnik*. Considers comic strips, gag cartoons, editorial/political cartoons, illustrations and spot drawings; single, double and multiple panel. Work must be reducible to strip size. Also needs artists for advertising and publicity. Looking for fine artists and illustrators for book publishing projects.
First Contact & Terms: Send cover letter, résumé, tearsheets, photostats and photocopies. Include about 12 strips. Does not return materials. To show portfolio, mail tearsheets, photostats, photographs and slides; include b&w. Pays 50% of net proceeds upon syndication. Negotiates rights purchased. Minimum length of contract 5 years (flexible). Artists owns original art; syndicate owns characters (negotiable).
Tips: Include in a sample package "info about yourself, tearsheets, notes about the strip and enough samples to tell what it is. Don't write asking if we want to see; just send samples." Looks for "good writing, strong characters, good taste in humor. No hostile comics. We like people who have cartooned for a while and are printed. Get published in local papers first."

CARTOON markets are listed in the Cartoon Index located within the Niche Marketing Index at the back of this book.

Stock Illustration & Clip Art Firms

These two images from Afrocentrex's *Fashion Klips* collection prove that clip art images can be exciting and fun. Founded in 1993 to meet the demand for images of African Americans, Afrocentrex now offers more than 8 volumes of clips, many of which can be viewed at www.afrocentrex.com. These images were created by artist Otis Richardson.

Marketing your work as stock allows you to sell an illustration again and again instead of filing it away in a drawer. That illustration can mean extra income every time someone chooses it from a stock catalog. But selling previously published illustrations isn't the only way to work with stock illustration agencies. You can also sell work directly to stock illustration agencies. But you'll have to create images agencies want.

Stock illustration is a concept that has its origins in the photography market. Photographers have known that reselling photos can be profitable for both the photographers and publishers who purchase rights to reprint photos at reduced rates. Realizing that what works for photographers could work for illustrators, businesses began to broker illustrations the same way. They promoted the illustrations to art directors through catalogs, brochures, CD-ROMs and websites. The idea took off. Art directors (already accustomed to using stock photography) quickly adapted to flipping through stock illustration catalogs or browsing the Web for artwork at reduced prices, while firms split fees with illustrators.

There are those who maintain stock illustration hurts freelancers. They say it encourages art directors to choose ready-made artwork from catalogs at reduced rates instead of assigning illustrators for standard industry rates. Others maintain the practice gives freelancers a vehicle to resell their work. Defenders of stock point out that advertising agencies and major magazines continue to assign original illustrations. Stock just gives them another option. To find out more about the debate, log into http://www.theispot.com and head for one of the discussion groups posted there. Where do *you* stand? Educate yourself about both sides of this issue before considering stock as a potential market.

Stock vs. clip art

Stock illustration firms market relatively high-end images to book publishers, advertising agencies, magazines, corporations and other businesses through catalogs and websites. When most people think of clip art, they think of booklets of copyright-free graphics and cartoons, the kind used in church bulletins, high school newspapers, club newsletters and advertisments for small businesses. But these days, especially with some of the digital images available on disk and CD-ROMs, perceptions are changing. With the popularity of desktop publishing, newsletters that formerly looked homemade look more professional.

Copyright and payment

Aside from the subtle differences between the "look" of stock illustration as opposed to that of clip art, there is another crucial distinction between the two. That distinction is copyright. Stock illustration firms do not sell illustrations. They license the right to reprint illustrations, working out a "pay-per-use" agreement. Fees charged depend on how many times and for what length of time their clients want to reproduce the artwork. Stock illustration firms generally split their fees 50-50 with artists, and pay the artist every time his image is used. You should be aware that some agencies offer better terms than others. So weigh your options before signing any contracts.

Clip art, on the other hand, generally implies the buyer has been granted a license for any use. Buyers can use the image as many times as they want, and furthermore, they can alter it, crop it or retouch it to fit their purposes. Some clip art firms repackage artwork created many years ago because it is in the public domain, and therefore, they don't have to pay an artist for the use of the work. But in the case of clip art created by living artists, firms either pay the artists an agreed-upon fee for all rights to the work, or will negotiate a royalty agreement. Keep in mind that if you sell all rights to your work, you will not be compensated each time it is used unless you also negotiate a royalty agreement. Once your work is sold as clip art, the buyer of that clip art can alter your work and resell it without giving you credit or compensation.

How to submit artwork

Companies are identified as either stock illustration or clip art firms in the first paragraph of each listing. Some firms, such as Metro Creative Graphics and Dynamic Graphics, seem to be hybrids of clip art firms and stock illustration agencies. Read the information under "Needs" to find out what type of artwork each firm needs. Then check "First Contact & Terms" to find out what type of samples you should send. Most firms accept samples in the form of slides, photocopies and tearsheets. Increasingly, disk and e-mail submissions are encouraged in this market.

☑ **AFROCENTREX**, P.O. Box 4375, Chicago IL 60680. (708)848-0850. Fax: (708)848-2450. E-mail: lexist@jps.net. Website: www.afrocentrex-software.com. Chief Executive Officer: Keith Coleman. Estab. 1993. Clip art firm. Specializes in multicultural clip art. Recently introduced Hispanic clip art, Asian clip art, multicultural/language websites. Distributes to over 20 outlets, including newspapers, schools and corporate accounts.
Needs: Approached by 2 cartoonists and 4-10 illustrators/year. Buys from 2-4 illustrators/year. Considers caricatures and illustrations. Prefers b&w line drawings and digital art.
First Contact & Terms: Send cover letter with résumé and photocopies or tearsheets and SASE. Include 3-5 samples. Samples are filed. Responds in 2 weeks. Write for appointment to show portfolio of final art. Pays flat fee; $25-150. **Pays on acceptance.** Negotiates rights purchased. Offers automatic renewal. Clip art firm owns original art and characters.
Tips: Looks for "persistence, professionalism and humbleness."

[N] **AGFA MONOTYPE TYPOGRAPHY**, 200 Ballardvale St., Wilmington MA 01887. (978)284-5932. Fax: (978)657-8268. E-mail: allan.haley@monotype.com. Website: www.fonts.com. **Director of Words & Letters:** Allan Haley. Estab. 1897. Font foundry. Specializes in high-quality Postscript and Truetype fonts for graphic design professionals and personal use. Clients include advertising agencies, magazines and desktop publishers.
• Does not want clip art or illustration—only fonts.
Needs: Approached by 10 designers/year. Works with 5 typeface designers/year. Prefers typeface and font designs. Freelance work demands knowledge of Illustrator, Photoshop, QuarkXPress.
First Contact & Terms: E-mail examples of font (PDF files or EPS or TIFF). Samples are not filed. Responds only if interested. Rights purchased vary according to project. Finds designers through word of mouth.

🌐 **ARTBANK ILLUSTRATION LIBRARY**, 8 Woodcroft Ave., London NW7 2AG England. Phone: (+44)181 906 2288. Fax: (+44)181 906 2289. E-mail: info@artbank. ltd.uk. Website: www.artbank.ltd.uk. Estab. 1989. Picture library. Clients include advertising agencies, design groups, book publishers, calendar companies, greeting card companies and postcard publishers.
Needs: Prefers 4×5 transparencies.

CUSTOM MEDICAL STOCK PHOTO, INC., The Custom Medical Building, 3660 W. Irving Park Rd., Chicago IL 60618-4132. (800)373-2677. Fax: (773)267-6071. E-mail: info@cmsp.com. Website: www.mediamd.com. Contact: Mike Fisher or Henry Schleichkorn. Estab. 1985. Medical and scientific stock image agency. Specializes in medical photography, illustration, medical cartoons and animation for the healthcare industry. Distributes to magazines, advertising agencies and design firms. Clients include Satchi & Satchi, Foote Cone Belding, Merck, Glaxo, etc. Guidelines available for #10 SASE.
Needs: Approached by 20 illustrators/year. Works with 50 illustrators and animators/year. Prefers airbrush art, animation, 3-D and soundfiles, clip art, medical and technical illustration, multimedia projects and pen & ink. Themes include healthcare. Knowledge of Photoshop, Illustrator and Aldus Freehand helpful.
First Contact & Terms: "Call first to discuss before shipping." Accepts disk submission compatible with Mac or PC; send "low res files for viewing." Responds in 1 month. Call or write for portfolio review. Pays royalties of 40%. Licenses non-exclusive rights to clients. Finds artists through word of mouth. "Our reputation precedes us among individuals who produce medical imagery. We also advertise in several medical and photographer's publications."
Tips: "Our industry is motivated by current events and issues that affect healthcare—new drug discoveries, advances and F.D.A. approval on drugs and medical devices."

[N] DREAM MAKER SOFTWARE, P.O. Box 260050, Highlands Ranch CO 80163-0050. (303)350-8557. Fax: (303)683-2646. E-mail: david@coolclipart.com. Website: www.coolclipart.com. Art Director: David Sutphin. Estab. 1986. Clip art firm, computer software publisher serving homes, schools and businesses.

Needs: Approached by 20-30 freelancers/year. Considers a variety of work including cartoon type and realistic illustrations suitable for publication as clip art with a broad market appeal. Also interested in small watercolor illustrations in styles suitable for greeting cards.

First Contact & Terms: Sample package should include cover letter. 8-12 samples should be included. Samples are not filed and are returned by SASE. Reports back to the artist in 1-2 months only if interested. Considers both traditional and computer based (Illustrator) artwork. Does not accept initial samples on disk. Pays $10-50 flat fee on completion of contract. Typical contract includes artist doing 50-150 illustrations with full payment made upon completion and acceptance of work. Rights purchased include assignment of copyright from artist.

[✓] DYNAMIC GRAPHICS INC., 6000 N. Forest Park Dr., Peoria IL 61614-3592. (800)255-8800 or (309)688-8800. Fax: (309)688-8515. Website: www.dgusa.com. Art Director: Steve Justice. Distributes clip art, stock images and animation to thousands of magazines, newspapers, agencies, industries and educational institutions.

● Dynamic Graphics is a clip art firm and publisher of *Step-by-Step Graphics* magazine. Uses illustrators from all over the world; 99% of all artwork sold as clip art is done by freelancers.

Needs: Works with more than 50 freelancers/year. Prefers illustration, graphic design and elements; primarily b&w, but will consider some 2- and full-color. Recently introduced colorized TIFF and EPS images. "We are currently seeking to contact established illustrators capable of handling b&w or color stylized representational illustrations of contemporary subjects and situations."

First Contact & Terms: Submit portfolio with SASE. Responds in 1 month. **Pays on acceptance.** Negotiates payment. Buys all rights.

Tips: "We are interested in quality, variety and consistency. Illustrators contacting us should have top-notch samples that show consistency of style (repeatability) over a range of subject matter. We often work with artists who are getting started if their portfolios look promising. Because we publish a large volume of artwork monthly, deadlines are extremely important, but we do provide long lead time (4-6 weeks is typical). We are also interested in working with illustrators who would like an ongoing relationship. Not necessarily a guaranteed volume of work, but the potential exists for a considerable number of pieces each year for marketable styles."

[✓][✓] GETTY IMAGES, 601 N. 34th St., Seattle WA 98103. (206)925-5000. Fax: (206)268-20001. Website: www.gettyone.com. Visual content provider offering licensed and royalty-free images.

● Getty Images offers the Artville Collection, Eyewire and many photographic images. Check their website to see the type of images they buy.

Needs: Approached by 1,500 artists/year. Buys from 100 freelancers/year. Considers illustrations, photos, typefaces and spot drawings.

First Contact & Terms: Sample package should include submission form (from website), tearsheets, slides, photocopies or digital files. 10 samples should be included. Samples are filed. Buys all rights or licenses image. Minimum length of contract is indefinite. Offers automatic renewal.

GRAPHIC CORP., a division of Corel Corporation, 1600 Carling Ave., Ottawa, Ontario K1Z 8R7 Canada. (613)728-0826. E-mail: janiesh@corel.com. Website: www.corel.com and www.creativeanywhere.com/clipart/.com. Contact: Creative Director. Estab. 1986. Software company specializing in clip art, animation, stock illustration, photos and fonts for use by computer hardware and software companies.

● If you are adept at creating artwork using Corel software, attempt to submit work using a corel graphic program.

Needs: Approached by 50 cartoonists and 50 illustrators/year. Buys from 20 cartoonists and 20 illustrators/year. Considers custom created clip art, software, photos, gag cartoons, caricature and illustrations. Prefers single panel. Also uses freelancers for computer illustration.

First Contact & Terms: Sample package should include cover letter, finished clip art in electronic samples. Maximum amount of samples possible should be included. "GraphicCorp recommends that image submissions: be provided in .WMF and/or .EPS format (preferably both); be provided on diskette; contain a *minimum* of 50 color images; (no black & white images, please); and contain the following subject-matter: holidays, borders, greeting card-style, animals, religious, flowers, office and business imagery, family and educational subjects. ("See our website for the type of graphics we use.") Samples are not filed and are returned by SASE if requested by artist. Responds only if interested. Negotiates rights purchased.

Tips: "We prefer prolific artists or artists with large existing collections. Images must be in electronic format. We are not interested in expensive works of art. We buy simple, but detailed, images that can be used by anybody to convey an idea in one look. We are interested in quantity, with some quality."

IDEAS UNLIMITED FOR EDITORS, Omniprint Inc., 9700 Philadelphia Court, Lanham MD 20706. (301)731-5202. Fax: (301)731-5203. E-mail: editor@omniprint.net. Editorial Director: Rachel Brown. Stock illustration and editorial firm serving corporate in-house newsletters. Guidelines not available.
 • This new clip art firm is a division of Omni Print, Inc., which provides publishing services to corporate newsletter editors. Ideas Unlimited provides clip art in both hard copy and disk form.
Needs: Buys from 2 cartoonists and 5 illustrators/year. Prefers single panel with gagline.
First Contact & Terms: Sample package should include cover letter, tearsheets, résumé and finished cartoons or illustrations. 10 samples should be included. Samples are filed. Responds only if interested. Mail photocopies and tearsheets. Pays $50-100. **Pays on acceptance**. Buys all rights. Minimum length of contract is 6 months.

☑ **INDEX STOCKWORKS**, 23 W. 18th St., 3rd Floor, New York NY 10011. (800)690-6979. Fax: (212)633-1914. E-mail: editing@indexstock.com. Website: www.stockwork.com and www.indexstock.c om. **Contact:** Desmond Powell. Estab. 1988. Stock illustration firm. Specializes in stock illustration for corporations, advertising agencies and design firms. Clients include IBM, First Fidelity, Macmillan Publishing, Lexis Nexis. Guidelines available for large SAE with 5 first-class stamps.
Needs: Approached by 100 illustrators/year. Works with 300 illustrators/year. Themes include animals, business, education, healthcare, holidays, conceptual, technology and computers, industry, education.
First Contact & Terms: For traditional artwork provide 1-3 4×5 original transparencies of each image. Digital artists should provide two 35mm original slides of the image and 1-3 disks of each image. Samples are filed or are returned with SASE. Responds only if interested. Call for portfolio review of available stock images and leave behinds. Pays royalties of 50% for illustration. Negotiates rights purchased. Finds artists through *Workbook*, *Showcase*, *Creative Illustration*, magazines, submissions.
Tips: "Stockworks likes to work with artists to create images specifically for stock. We provide concepts and sometimes rough sketches to aid in the process. Creating or selling stock illustration allows the artist a lot of leeway to create images they like, the time to do them and the possibility of multiple sales. We like to work with illustrators who are motivated to explore an avenue other than just assignment to sell their work."

ⓝ INNOVATION MULTIMEDIA, 41 Mansfield Ave., Essex Junction VT 05452. (802)879-1164. Fax: (802)878-1768. E-mail: innovate@ad-art.com. Website: www.ad-art.com/innovation. Owner: David Dachs. Estab. 1985. Clip art publisher. Specializes in clip art for publishers, ad agencies, designers. Clients include US West, Disney, *Time* Magazine.
Needs: Prefers clip art, illustration, line drawing. Themes include animals, business, education, food/cooking, holidays, religion, restaurant, schools. 100% of design demands knowledge of Illustrator.
First Contact & Terms: Send samples and/or Macintosh disks (Illustrator files). Artwork should be saved as EPS files. Samples are filed. Responds only if interested. Pays by the project. Buys all rights.

☑ **METRO CREATIVE GRAPHICS, INC.**, 519 Eighth Ave., New York NY 10018. (212)947-5100. Fax: (212)714-9139. Website: www.metrocreativegraphics.com. Senior Art Director: Darrell Davis. Estab. 1910. Creative graphics/art firm. Distributes to 7,000 daily and weekly paid and free circulation newspapers, schools, graphics and ad agencies and retail chains. Guidelines available (send letter with SASE or e-mail art director on website).
Needs: Buys from 100 freelancers/year. Considers all styles of illustrations and spot drawings; b&w and color. Editorial style art, cartoons for syndication not considered. Special emphasis on computer-generated art for Macintosh. Send floppy disk samples using Illustrator 5.0. or Photoshop. Prefers all categories of themes associated with newspaper advertising (retail promotional and classified). Also needs covers for special-interest newspaper, tabloid sections.
First Contact & Terms: Send query letter with non-returnable samples, such as photostats, photocopies, slides, photographs or tearsheets to be kept on file. Accepts submissions on disk compatible with Illustrator 5.0 and Photoshop. Send EPS or TIFF files. Samples returned by SASE if requested. Responds only if interested. Works on assignment only. **Pays on acceptance**; flat fee of $25-1,500 (buy out). Considers skill and experience of artist, saleability of artwork and clients' preferences when establishing payment.
Tips: This company is "very impressed with illustrators who can show a variety of styles." When creating electronic art, make sure all parts of the illustration are drawn completely, and then put together. "It makes the art more versatile to our customers."

N̄ MILESTONE GRAPHICS, 1093 A1A Beach Blvd., #388, St. Augustine FL 32080. Phone/fax: (904)823-9962. E-mail: miles@aug.com. Website: www.milestonegraphics.com. Owner: Jill O. Miles. Estab. 1993. Clip art firm providing targeted markets with electronic graphic images.

Needs: Buys from 20 illustrators/year. 50% of illustration demands knowledge of Illustrator.

First Contact & Terms: Sample package should include nonreturnable photocopies or samples on computer disk. Accepts submissions on disk compatible with Illustrator on the Macintosh. Send EPS files. Interested in b&w and some color illustrations. All styles and media are considered. Macintosh computer drawings accepted (Illustrator preferred). "Ability to draw people a plus, but many other subject matters needed as well. We currently have a need for golf and political illustrations." Reports back to the artist only if interested. Pays flat fee of $25 minimum/illustration, based on skill and experience. A series of illustrations is often needed.

N̄ NOVA DEVELOPMENT CORPORATION, 23801 Calabasas Rd., Suite 2005, Calabasas CA 91302-1547. (818)591-9600. Fax: (818)591-8885. E-mail: submit@novadevelopment.com. Website: www.novadevelopment.com. Director of Business Development: Lisa Helfstein. Estab. 1983. Computer software publisher. Specializes in digital, royalty-free art for consumers and small businesses. Distributes to consumers via retail stores.

Needs: Approached by 100 illustrators/year. Works with 20 illustrators/year. Prefers watercolor paintings, greeting card art and humorous illustration in electronic format. Recent products: Art Explosion, Scrapbook Factory and Greeting Card Factory.

First Contact & Terms: Send cover letter and electronic samples. No phone calls, please. Accepts disk submissions. Samples are filed. Responds only if interested. Pays royalties of 7-20% of gross income depending on product type. Artist owns original art. Minimum length of contract is 5 years.

Tips: "We are looking for greeting card designs and associated sentiments."

ONE MILE UP, INC., 7011 Evergreen Court, Annandale VA 22003. (703)642-1177. Fax: (703)642-9088. E-mail: gene@onemileup.com. Website: www.onemileup.com. President: Gene Velazquez. Estab. 1988.

● Gene Velazquez told *AGDM* he is also looking for 3-D art and has a strong interest in aviation graphics. He does not use cartoons.

Needs: Approached by 10 illustrators and animators/year. Buys from 5 illustrators/year. Prefers illustration and animation.

First Contact & Terms: Send 3-5 samples via e-mail with résumé and/or link to your website. Pays flat fee; $30-120. **Pays on acceptance.** Negotiates rights purchased.

STOCK ILLUSTRATION SOURCE, 16 W. 19th St., 9th Floor, New York NY 10011. (212)849-2900, (800)4-IMAGES. Fax: (212)691-6609. E-mail: sis@images.com. Website: www.images.com. Acquisitions Manager: Barbara Preminger. Estab. 1992. Stock illustration agency. Specializes in illustration for corporate, advertising, editorial, publishing industries. Guidelines available.

● This agency is rebranding itself to Images.com—an umbrella agency which include S.I.S. and "spots on the spot."

Needs: "We deal with 500 illustrators." Prefers painterly, conceptual images, including collage and digital works, occasionally humorous illustrations. Themes include corporate, business, education, family life, healthcare, law and environment.

First Contact & Terms: Illustrators should scan sample work onto CD or disk and send that rather than e-mailing links to their sites. Will do portfolio review. Pays royalties of 50% for illustration sales. Negotiates rights purchased.

☑ STOCKART.COM, 155 N. College Ave., Suite 225, Ft. Collins CO 80524. (970)493-0087 or (800)297-7658. Fax: (970)493-6997. E-mail: art@stockart.com. Website: www.stockart.com. Art Manager: Maile Fink. Estab. 1995. Stock illustration and representative. Specializes in b&w and color illustration for ad agencies, design firms and publishers. Clients include BBDO, Bozell, Pepsi, Chase, Saatchi & Saatchi.

Needs: Approached by 250 illustrators/year. Works with 150 illustrators/year. Themes include business, family life, healthcare, holidays, religion.

First Contact & Terms: Illustrators send at least 10 samples of work. Accepts disk submissions compatible with Photoshop EPS files less than 600k/image. Pays 50% stock royalty, 70% commission royalty (commissioned work-artist retains rights) for illustration. Rights purchased vary according to project. Finds artists through sourcebooks, on-line, word of mouth.

Tips: "We have both high-quality black & white and color illustration."

Advertising, Design & Related Markets

Illustrator Gary Ciccarelli worked with designer Ruben Santiago to come up with this memorable P.O.P. display for Jarritos mineral water.

The firms in this section vary in size, ranging from two-person operations to huge, international corporations. All, however, rely on freelancers. If you have the required talent and skills, these markets offer a steady stream of assignments.

The agencies on the following pages are the tip of the proverbial iceberg. There are thousands of advertising agencies; public relations, design and marketing firms across the country and around the world. Though we alert you to a number of them, our page-count is limited. Look for additional firms in industry directories, such as *Workbook* (Scott & Daughters Publishing), *Standard Directory of Advertisers* (National Register Publishing) and *The Design Firm Directory* (Wefler & Associates), available in the business section of most large public libraries. Find local firms in the yellow pages and your city's business-to-business directory. You can also pick up leads by reading *AdWeek*, *HOW*, *Print*, *Step-by-Step Graphics*, *Communication Arts* and other design and marketing publications.

Target appropriate clients for your work

Read listings to identify firms whose clients and specialties are in line with the type of work you create. (You'll find clients and specialties in the first paragraph of each listing.) For example, if you create charts and graphs, contact firms whose clients include financial institutions. Fashion illustrators should approach firms whose clients include department stores and catalog publishers. Sculptors and modelmakers might find opportunities with firms specializing in exhibition design.

WHAT THEY PAY

Advertising is the most lucrative market for freelancers. You will most likely be paid by the hour for work done on the firm's premises (in-house), and by the project if you take the assignment back to your studio. Most checks are issued 40-60 days after completion of assignments. Fees depend on the client's budget, but most companies are willing to negotiate, taking into consideration the experience of the freelancer, the lead time given, and the complexity of the project. Be prepared to offer an estimate for your services and ask for a purchase order (P.O.) before you begin an assignment.

Some art directors will ask you to provide a preliminary sketch, which, if approved by the client, can land you a plum assignment. If you are asked to create something "on spec," be aware that you may not receive payment beyond an hourly fee for your time if the project falls through. So be sure to ask upfront about payment policy before you start an assignment.

If you're hoping to retain usage rights to your work, you'll want to discuss this upfront, too. You can generally charge more if the client is requesting a buyout. If research and travel are required, make sure you find out ahead of time who will cover these expenses.

Alabama

COMPASS MARKETING, INC., 175 Northshore Place, Gulf Shores AL 36542. (251)968-4600. Fax: (251)968-5938. E-mail: awboone@compasspoints.com. Website: www.compasspoints.com. **Editor:** April W. Boone. Estab. 1988. Number of employees: 2. Approximate annual billing: $4 million. Integrated marketing communications agency and publisher. Specializes in tourism products and programs. Product specialties are business and consumer tourism. Current clients include Alabama Bureau of Tourism, Gulf Shores Golf Assoc. and Alabama Gulf Coast CVB. Client list available upon request. Professional affiliations: STS, Mobile 7th Dist. Ad Fed, MCAN and AHA.
Needs: Approached by 2-10 illustrators/year and 5-20 designers/year. Works with 2 illustrators and 4-6 designers/year. Prefers freelancers with experience in magazine work. Uses freelancers mainly for sales collateral, advertising collateral and illustration. 5% of work is with print ads. 100% of design demands skills in Photoshop 5.0 and QuarkXPress. Some illustration demands computer skills.
First Contact & Terms: Designers send query letter with photocopies, résumé and tearsheets. Illustrators send postcard sample of work. Samples are filed and are not returned. Responds in 1 month. Art director

insider report

The benefits of collaborative design—Pylon Studios exposed

JP Collins

Are you a recluse, or do you tend to reaffirm your former art teacher's praise for "team effort?" While many designers prefer to take all the credit for a job well done, there are benefits of working in a group environment. After all, it's no secret that some of the most prominent designers have no idea how to squeeze in the appropriate wording on a brochure, manage an efficient business meeting with a client, or budget a checkbook, for instance.

San Francisco-based Pylon Studios started as a small Web design business in 1997. JP Collins, the company's founder, set out to form a collaborative studio to broaden his own efforts and acquire steady business in many areas of interactive media. Educated in art and conceptual design, Collins began his graphics career working for venues such as CNET, Studio Archetype, Vivid Studios, and Egreetings. As interactive media progressively evolved and competition rapidly became fierce, Collins saw an overwhelming need to maximize his economic and creative potential by networking. Eventually, he gained an alliance with other professional designers who specialized in areas he was not specifically trained in. Here, Collins discusses the rewards of working in teams and how to deal with budgets, perhaps the most unpopular conceptualization for a creative type like him.

How did you find the independent contractors you collaborate with?
Most are skilled friends, people I've met through business networking or small design groups I meet with. I've established strategic partnerships with graphic designers, multimedia designers, copywriters and programmers. It's really important to align with a wide variety of individuals because each can bring more business, as well as serve as a resource to help you in projects you may acquire for yourself.

How often does the group meet while working on a project and while in between? Do you set a schedule at the beginning of an assignment?
All this depends on the project. Generally, we will work on a phase of a project and check in with each other when each phase is complete. I like to create a timeline at the beginning of the project after getting estimates of time from each team member. This helps establish milestones in the project, which lead to generating incremental payment from the client. The most important thing is communication, but it doesn't require constant meetings. That's what email and the phone are for.

Are you in charge of the budget and payroll for each of your team members, and do you use a particular financial sheet all designers may benefit from using?

Yes, I do take care of the finances. I use a variety of financial statements to help me, such as the basic "profit and loss statement" (also known as an income statement) and the "cash flow statement," which shows me the cash going in and out of the business. There's also the "balance sheet" to determine new worth and a "breakeven analysis," which demonstrates the amount per hour that should be charged to a client in order to subsequently make a profit. As far as the payroll, I pay people as free agents, and we use a contract so there is no misunderstanding. I use their rate per hour as a base and add a percentage on top because I am managing the project, and more importantly, the relationship with a client.

How does a visually charged artist or designer begin to learn about budgeting and net worth, for instance?
Although costly, I would suggest working with a professional accountant to understand how to use financial documents—especially when you have people to pay on a timely fashion. Obviously, accountants do think differently than designers. Math seems wacky sometimes, and it's important to gain a better understanding of this stuff in order to have better control of your money.

Does Pylon Studios work with an outside copywriter for presentation outlines, brochures or promotional material?
We do work with copywriters for client projects, but I have done some writing in the past as well. I write agreements, proposals and timelines, along with explanation text for site architecture documents. Currently, I write ads for the business—quick, pithy postcards to attract more clients via snail mail and HTML e-mail.

Consequently, is there a set writing guide that should be followed in business graphics?
Yes, we stay away from jargon and industry terms as much as possible. When I write project documents, for instance, I try to create explanations that are accessible and provide a context for what is being described or displayed. Information architectural documents, or otherwise glorified flow charts, can be hard to understand by a client who has never seen one. Not everyone thinks in pictures. I write context so that people who like to read information as text can see the words near the diagram and make the connection.

What is the basis for "information architecture," and does Pylon work more in this emphasis?
Information architecture relates to the Web predominantly. It approaches site design from the perspective of how a specific site should be organized, how someone moves through it and how someone interacts with it. Creating structure and meaning are the key roles of this concept. Pylon Studios has an emphasis in information architecture for the needs of small businesses, marketing firms, and creative departments.

What are the long-term goals for Pylon Studios?
Well, I would like to have billing for every workday of the week, first of all. I envision two to four clients per month or perhaps more for the business. At this point, most of our work centers around browser-based media. Eventually, I want Pylon Studios to offer a diversity of services without being dependent on the Web as our most lucrative media.

will contact artist for portfolio review of slides and tearsheets if interested. Pays by the project, $100 minimum. Rights purchased vary according to project. Finds artists through sourcebooks, networking and print.

Tips: "Be fast and flexible. Have magazine experience."

A. TOMLINSON/SIMS ADVERTISING, INC., (formerly A. Tomlinson Advertising, Inc.), 250 S. Poplar St., Florence AL 35630. (256)766-4222. Fax: (256)766-4106. E-mail: atsadv@hiwaay.net. Website: ATSA-USA.com. **President:** Allen Tomlinson. Estab. 1990. Number of employees: 15. Approximate annual billing: $5.0 million. Ad agency. Specializes in magazine, collateral, catalog—business-to-business. Product specialties are home building products. Client list available upon request.

Needs: Approached by 20 illustrators and 20 designers/year. Works with 5 illustrators and 5 designers/year. Also for airbrushing, billboards, brochure and catalog design and illustration, logos and retouching. 35% of work is with print ads. 85% of design demands skills in PageMaker 6.5, Photoshop, Illustrator and QuarkXPress 4.1. 85% of illustration demands skills in PageMaker 6.5, Photoshop, Illustrator and QuarkXPress 4.1.

First Contact & Terms: Designers send query letter with brochure and photocopies. Illustrators send query letter with brochure, photocopies, résumé and transparencies. Samples are filed and are not returned. Does not reply; artist should call. Artist should also call to arrange for portfolio review of color photographs, slides, thumbnails and transparencies. Pays by the project. Rights purchased vary according to project.

Arizona

ANGEL FIRE PRODUCTIONS, INC., Box 1866, Prescott AZ 86302. (520)445-5050. Fax: (520)445-3763. E-mail: steve@afpmall.com. Website: www.angelfireproductions.com. **President:** Linda Landrum. Vice President: Jim Valamier. Secretary/Treasurer: Steve LaVigne. Estab. 1997. Number of employees: 3. Approximate annual billing: $150,000. AV firm. Full-service, multimedia firm handling video and audio production for various clients, as well as some print. Specializes in documentaries, educational, cable and direct distribution. Product specialties are educational, nature, old West, entertainment. Current clients include Ralph Rose Productions, Prism Productions and Current Productions.

Needs: Approached by 7-8 freelancers/year. Works with 3 freelance illustrators and 4 designers/year. Prefers artists with experience in video, computer graphics, animation on Mac and PC. Uses freelance artists mainly for graphics and animation. Also for print ad and slide illustration, storyboards, posters, TV/film graphics, lettering and logos. 20% of work is with print ads. 90% of freelance work demands knowledge of Mac software: Toaster and Power Mac: Premiere, Photoshop, Strata, Studio, Illustrator, etc.

First Contact & Terms: Send query letter with brochure, photocopies, SASE, résumé, photographs, slides, computer disks or VHS videotape. Samples are filed or are returned by SASE if requested by artist. Responds in 2 weeks. To show portfolio, mail photographs, computer disks (Mac), VHS or SVHS video tape. Payment for design and illustration varies by job and client.

ARIZONA CINE EQUIPMENT, INC., 2125 E. 20th St., Tucson AZ 85719. (520)623-8268. Fax: (520)623-1092. **Vice President:** Linda A. Bierk. Estab. 1967. Number of employees: 11. Approximate annual billing: $850,000. AV firm. Full-service, multimedia firm. Specializes in video. Product specialty is industrial.

Needs: Approached by 5 freelancers/year. Works with 5 illustrators and 5 freelance designers/year. Prefers local artists. Uses freelancers mainly for graphic design. Also for brochure and slide illustration, catalog design and illustration, print ad design, storyboards, animation and retouching. 20% of work is with print ads. Also for multimedia projects. 70% of design and 80% of illustration demand knowledge of PageMaker, QuarkXPress, FreeHand, Illustrator or Photoshop.

First Contact & Terms: Send query letter with brochure, résumé, photocopies, tearsheets, transparencies, photographs, slides and SASE. Samples are filed. Responds only if interested. Will contact artist for portfolio review if interested. Portfolio should include color thumbnails, final art, tearsheets, slides, photo-stats, photographs and transparencies. Pays for design by the project, $100-5,000. Pays for illustration by the project, $25-5,000. Buys first rights or negotiates rights purchased.

N **⚑** **BOELTS-STRATFORD ASSOCIATES**, 345 E. University, Tucson AZ 85705-7848. (520)792-1026. Fax: (520)792-9720. Website: www.boelts-stratford.com. **President:** Jackson Boelts. Estab. 1986. Specializes in annual reports, brand identity, corporate identity, display design, direct mail design, package design, publication design and signage. Client list available upon request.
 • This firm has won over 400 international, national and local awards.

Needs: Approached by 100 freelance artists/year. Works with 10 freelance illustrators and 5-10 freelance designers/year. Works on assignment only. Uses designers and illustrators for brochure, poster, catalog, P-O-P and ad illustration, mechanicals, retouching, airbrushing, charts/graphs and audiovisual materials.

First Contact & Terms: Send query letter with brochure, tearsheets and résumé. Samples are filed. Responds only if interested. Call to schedule an appointment to show portfolio. Portfolio should include roughs, original/final art, slides and transparencies. Pays for design by the hour and by the project. Pays for illustration by the project. Negotiates rights purchased.

Tips: When presenting samples or portfolios, artists "sometimes mistake quantity for quality. Keep it short and show your best work."

CRICKET CONTRAST GRAPHIC DESIGN, 6232 N. 7th St., Suite 208, Phoenix AZ 85014. (602)258-6149. Fax: (602)258-0113. E-mail: cricket@thecricketcontrast.com. **Owner:** Kristie Bo. Estab. 1982. Number of employees: 5. Specializes in annual reports, corporate identity, web page design, advertising, package and publication design. Clients: corporations. Professional affiliations: AIGA, Phoenix Society of Communicating Arts, Phoenix Art Museum, Phoenix Zoo.

Needs: Approached by 25-50 freelancers/year. Works with 5 freelance illustrators and 5 designers/year. Also uses freelancers for ad illustration, brochure design and illustration, lettering and logos. Needs computer-literate freelancers for design and production. 100% of freelance work demands knowledge of Illustrator, Photoshop and QuarkXPress.

First Contact & Terms: Send photocopies, photographs and résumé. Will contact artist for portfolio review if interested. Portfolio should include b&w photocopies. Pays for design and illustration by the project. Negotiates rights purchased. Finds artists through self-promotions and sourcebooks.

Tips: "Beginning freelancers should call and set up an appointment or meeting and show their portfolio and then make a follow-up call or calls."

☑ **GODAT DESIGN INC.**, (formerly Godat/Jonczyk Inc.), 101 W. Simpson St., Tucson AZ 85701-2268. (520)620-6337. E-mail: ken@godatdesign.com. Website: www.godatdesign.com. **Principal:** Ken Godat. Estab. 1983. Number of employees: 6. Specializes in corporate identity, annual reports, marketing communications, publication design and signage. Clients: corporate, retail, institutional, public service. Current clients include Tucson Electric Power, Tucson Airport Authority, Rain Bird and IBM. Professional affiliations: AIGA, ACD.

Needs: Approached by 75 freelancers/year. Works with 0-3 freelance illustrators and 2-3 designers/year. Freelancers should be familiar with QuarkXPress, FreeHand, Photoshop or Illustrator. Needs technical illustration.

First Contact & Terms: Send query letter with samples. Samples are filed. Request portfolio review in original query. Will contact artist for portfolio review if interested. Pays for design by the hour, $40-60 or by the project. Pays for illustration by the project. Finds artists through sourcebooks.

N **THE M. GROUP GRAPHIC DESIGN**, 8722 E. Via De Commercio, Scottsdale AZ 85258. (480)998-0600. Fax: (480)998-9833. E-mail: mail@themgroupinc.com. Website: www.themgroupinc.com. **President:** Gary Miller. Estab. 1987. Number of employees: 7. Approximate annual billing: 2.75 million. Specializes in annual reports, corporate identity, direct mail and package design, and advertising. Clients: corporations and small business. Current clients include Arizona Public Service, Comtrade, Sager, Dole Foods, Giant Industries, Microchip, Coleman Spas, ProStar, Teksoft and CYMA.

Needs: Approached by 50 freelancers/year. Works with 5-10 freelance illustrators/year. Uses freelancers for ad, brochure, poster and P-O-P illustration. 95% of freelance work demands skills in Illustrator, Photoshop and QuarkXPress.
First Contact & Terms: Send postcard sample or query letter with samples. Samples are filed or returned by SASE if requested by artist. Responds only if interested. Request portfolio review in original query. Artist should follow-up. Portfolio should include b&w and color final art, photographs and transparencies. Rights purchased vary according to project. Finds artists through publications (trade) and reps.
Tips: Impressed by "good work, persistence, professionalism."

N: MILES ADVERTISING, 3661 N. Campbell Ave., #276, Tucson AZ 85719. (520)795-2919. **Contact:** Bill Miles. Estab. 1973. Number of employees: 2. Approximate annual billing: $750,000. Ad agency. Full-service, multimedia firm. Specializes in local TV advertising, outdoor. Product specialty is automotive, home builders and ad associations. Client list available upon request.
Needs: Approached by 30 freelancers/year. Works with 1 freelance illustrator and 3 designers/year. Prefers local freelancers only. Uses freelancers mainly for newspaper and outdoor design and layout, plus television graphics. Also for signage. 20% of work is with print ads. Needs computer-literate freelancers for design and production.
First Contact & Terms: Send query letter with photocopies. Samples are filed and are not returned. Will contact artist for portfolio review if interested. Portfolio should include b&w and color final art and roughs. Pays for design by the project, $40-2,500. Pays for illustration by the project. Buys all rights.

☑ RAIN VISUAL STRATEGY, (formerly Caldera Design), 710 S. Third St., Phoenix AZ 85004. (602)495-1300. Fax: (602)495-1403. E-mail: studio@calderadesign.com. Website: www.visualrain.com.
Principal-Designer: S. Steve Smit. Principal Designer: David Rengifo. Estab. 1985. Specializes in annual reports, product and capability brochures, strategic planning and branding, brand and corporate identity and package and publication design, web design. Clients: corporations, retailers and manufacturers. Client list not available.
Needs: Approached by 50-75 artists/year. Works with 5-10 illustrators/year. Uses freelance computer designers for tight comps and layouts. Works on assignment only. Uses freelancers mainly for corporate systems, packaging, brochures and web. Also for retouching, airbrushing, computer needs and catalog and ad illustration.
First Contact & Terms: Send query letter with brochure, résumé, tearsheets, photographs and photocopies. Samples are filed. Responds in 2 weeks, only if interested. To show a portfolio mail photostats. Pays for illustration by the project, $500-5,000. Rights purchased vary according to project.

TIEKEN DESIGN & CREATIVE SERVICES, 3838 N. Central Ave., Suite 100, Phoenix AZ 85012. (602)230-0060. Fax: (602)230-7574. E-mail: team@tiekendesign.com. Website: www.tiekendesign.com.
General Manager: Gail Tieken. Estab. 1980. Specializes in annual reports, corporate identity, package and publication design, signage, multimedia, websites. Clients: corporations and associations. Client list not available.
Needs: Approached by 30-40 freelance artists/year. Works with 3-4 freelance illustrators and 1-2 freelance designers/year. Prefers artists with experience in Macintosh. Works on assignment only.
First Contact & Terms: Send query letter with résumé. Samples are filed. Responds only if interested. To show a portfolio, mail thumbnails, roughs and tearsheets. Pay varies by project and artist. Buys all rights.
Tips: It is important for freelancers to have "a referral from an associate and a strong portfolio."

Arkansas

TAYLOR MACK ADVERTISING, 124 W. Meadow, Fayetteville AR 72071. (501)444-7770. Fax: (501)444-7977. E-mail: Greg@TaylorMack.com. Website: www.TaylorMack.com. **Creative Director:** Greg Mack. Estab. 1990. Number of employees: 16. Approximate annual billing: $3 million. Ad agency. Specializes in collateral. Current clients include Cobb, Colliers, Jose's, Honeysuckle White and Marathon. Client list available upon request.
Needs: Approached by 12 illustrators and 20 designers/year. Works with 4 illustrators and 6 designers/ year. Uses freelancers mainly for brochure, catalog and technical illustration, TV/film graphics and web page design. 30% of work is with print ads. 50% of design and illustration demands skills in Photoshop, Illustrator and QuarkXPress.

First Contact & Terms: Designers send query letter with brochure and photocopies. Illustrators send postcard sample of work. Samples are filed or are returned. Responds only if interested. Art director will contact artist for portfolio review of photographs if interested. Pays for design by the project or by the day; pays for illustration by the project, $10,000 maximum. Rights purchased vary according to project.

[N] MANGAN/HOLCOMB/RAINWATER/CULPEPPER & PARTNERS, 320 W. Capitol Ave., Suite 911, Little Rock AR 72201. (501)376-0321. **Vice President Creative Director:** Chip Culpepper. Number of employees: 12. Marketing, advertising and public relations firm. Approximate annual billing: $3 million. Ad agency. Clients: recreation, financial, tourism, retail, agriculture.

Needs: Approached by 50 freelancers/year. Works with 8 freelance illustrators and 20 designers/year. Uses freelancers for consumer magazines, stationery design, direct mail, brochures/flyers, trade magazines and newspapers. Also needs illustrations for print materials. Needs computer-literate freelancers for production and presentation. 30% of freelance work demands skills in Macintosh page layout and illustration software.

First Contact & Terms: Query with samples, flier and business card to be kept on file. Include SASE. Responds in 2 weeks. Call or write for appointment to show portfolio of final reproduction/product. Pays by the project, $250 minimum.

California

[✓] [▣] THE ADVERTISING CONSORTIUM, 10536 Culver Blvd., Suite D, Culver City CA 90232. (310)287-2222. Fax: (310)287-2227. E-mail: theadco@packbell.net. **Contact:** Kim Miyade. Estab. 1985. Ad agency. Full-service, multimedia firm. Specializes in print, collateral, direct mail, outdoor, broadcast. Current clients include Bernini, Davante, Westime, Modular Communication Systems.

Needs: Approached by 5 freelance artists/month. Works with 1 illustrator and 2 art directors/month. Prefers local artists only. Works on assignment only. Uses freelance artists and art directors for everything (none on staff), including brochure, catalog and print ad design and illustration and mechanicals and logos. 80% of work is with print ads. Also for multimedia projects. 100% of freelance work demands knowledge of PageMaker, QuarkXPress, FreeHand, Illustrator and Photoshop.

First Contact & Terms: Send postcard sample or query letter with brochure, tearsheets, photocopies, photographs and anything that does not have to be returned. Samples are filed. Write for appointment to show portfolio. "No phone calls, please." Portfolio should include original/final art, b&w and color photostats, tearsheets, photographs, slides and transparencies. Pays for design by the hour, $60-75. Pays for illustration by the project, based on budget and scope.

Tips: Looks for "exceptional style."

BASIC/BEDELL ADVERTISING & PUBLISHING, 1236-R Coast Village Circle, Box 30571, Santa Barbara CA 93130. (805)695-0079. **President:** C. Barrie Bedell. Specializes in advertisements, direct mail, how-to books, direct response websites and manuals. Clients: publishers, direct response marketers, retail stores, software developers, web entrepreneurs, plus extensive self-promotion of proprietary advertising how-to manuals.

● This company's president is seeing "a glut of 'graphic designers,' and an acute shortage of 'direct response' designers."

Needs: Uses artists for publication and direct mail design, book covers and dust jackets, and camera-ready computer desktop production. Especially interested in hearing from professionals experienced in e-commerce and in converting printed training materials to electronic media, as well as designers of direct response websites.

First Contact & Terms: Portfolio review not required. Pays for design by the project, $100-2,500 and up and/or royalties based on sales.

Tips: "There has been a substantial increase in use of freelance talent and increasing need for true professionals with exceptional skills and responsible performance (delivery as promised and 'on target'). It is very difficult to locate freelance talent with expertise in design of advertising and direct mail with heavy use of type. Contact with personal letter and photocopy of one or more samples of work that needn't be returned."

THE BASS GROUP, Dept. AM, 102 Willow Ave., Fairfax CA 94930. (415)455-8090. **Producer:** Herbert Bass. Number of employees: 2. Approximate annual billing: $300,000. "A multimedia, full-service production company providing corporate communications to a wide range of clients. Specializes in multimedia presentations, video/film, and events productions for corporations."

Needs: Approached by 30 freelancers/year. Works with a variety of freelance illustrators and designers/year. Prefers solid experience in multimedia and film/video production. Works on assignment only. Uses freelancers for logos, charts/graphs and multimedia designs. Needs graphics, meeting theme logos, electronic speaker support and slide design. Needs computer-literate freelancers for design, illustration and production. 90% of freelance work demands skills in QuarkXPress, FreeHand, Illustrator and Photoshop.

First Contact & Terms: Send résumé and slides. Samples are filed and are not returned. Responds in 1 month if interested. Will contact artist for portfolio review if interested. Sometimes requests work on spec before assigning a job. Pays by the project. Considers turnaround time, skill and experience of artist and how work will be used when establishing payment. Rights purchased vary according to project. Finds illustrators and designers mainly through word-of-mouth recommendations.

Tips: "Send résumé, samples, rates. Highlight examples in speaker support—both slide and electronic media—and include meeting logo design."

■ BERSON, DEAN, STEVENS, 29229 Canwood St., Suite 108, Agoura Hills CA 91301. (818)713-0134. Fax: (818)713-0417. **Owner:** Lori Berson. Estab. 1981. Specializes in annual reports, brand and corporate identity, collateral, direct mail, trade show booths, promotions, websites, packaging, and publication design. Clients: manufacturers, ad agencies, corporations and movie studios. Professional affiliation: L.A. Ad Club.

Needs: Approached by 50 freelancers/year. Works with 10-20 illustrators and 5 designers/year. Works on assignment only. Uses illustrators mainly for brochures, packaging and comps. Also for catalog, P-O-P, ad and poster illustration, mechanicals retouching, airbrushing, lettering, logos and model-making. 90% of freelance work demands skills in PageMaker, Illustrator, QuarkXPress, Photoshop, as well as web authoring Dreamweaver, Flash/HTML, CGI, Java, etc.

First Contact & Terms: Send query letter with tearsheets and photocopies. Samples are filed. Will contact artist for portfolio review if interested. Pays for design and illustration by the project. Rights purchased vary according to project. Considers buying second rights (reprint rights) to previously published work. Finds artists through word of mouth, submissions/self-promotions, sourcebooks and agents.

BRAINWORKS DESIGN GROUP, INC., 2 Harris Court, #A7, Monterey CA 93940. (408)657-0650. Fax: (408)657-0750. E-mail: mail@brainwks.com. Website: www.brainwks.com. **Art Director:** Al Kahn. Vice President Marketing: Michele Strub. Creative Services Coordinator: Monica O. Aguilar. Estab. 1970. Number of employees: 7. Specializes in ERC (Emotional Response Communications), graphic design, corporate identity, direct mail and publication. Clients: colleges, universities, nonprofit organizations; majority are colleges and universities. Current clients include Rutgers University, City University (New York), Manhattan College, Mount St. Vincent, Queens College, Baptist College of Health Sciences, Florida Tech, Vincennes University, Daemen College, American International College, Loyola Chicago University, Audrey Cohen College, Old Westbury State University of New York and University of South Carolina-Spartanburg.

Needs: Approached by 100 freelancers/year. Works with 4 freelance illustrators and 10 designers/year. Prefers freelancers with experience in type, layout, grids, mechanicals, comps and creative visual thinking. Works on assignment only. Uses freelancers mainly for mechanicals and calligraphy. Also for brochure, direct mail and poster design; mechanicals; lettering; and logos. 100% of design work demands knowledge of PageMaker, QuarkXPress, FreeHand and Photoshop.

First Contact & Terms: Send brochure or résumé, photocopies, photographs, tearsheets and transparencies. Samples are filed. Artist should follow up with call and/or letter after initial query. Will contact artist for portfolio review if interested. Portfolio should include thumbnails, roughs, final reproduction/product and b&w and color tearsheets, photostats, photographs and transparencies. Pays for design by the project, $200-2,000. Considers complexity of project and client's budget when establishing payment. Rights purchased vary according to project. Finds artists through sourcebooks and self-promotions.

Tips: "Creative thinking and a positive attitude are a plus." The most common mistake freelancers make in presenting samples or portfolios is that the "work does not match up to the samples they show." Would like to see more roughs and thumbnails.

JANN CHURCH PARTNERS, INC. ADVERTISING & GRAPHIC DESIGN, INC., P.O. Box 9527, Newport Beach CA 92660. (949)640-6224. Fax: (949)640-1706. **President:** Jann Church. Estab. 1970. Specializes in annual reports, brand and corporate identity, display, interior, direct mail, package and publication design, and signage. Clients: real estate developers, medical/high technology corporations, private and public companies. Current clients include The Nichols Institute, The Anden Group, Institute for Biological Research & Development, Universal Care, Inc., Alton Industries, The J. David Gladstone Institutes, Transportation Corridor Agencies and Datatape Incorporated, a Kodak company. Client list available upon request.

Needs: Approached by 100 freelance artists/year. Works with 3 illustrators and 5 designers/year. Works on assignment only. Needs technical illustration. 10% of freelance work demands computer literacy.

First Contact & Terms: Send query letter with résumé, photographs and photocopies. Samples are filed. Responds only if interested. To show a portfolio, mail appropriate materials. Portfolio should be "as complete as possible." Pays for design and illustration by the project. Rights purchased vary according to project.

☑ ⚐ **CINTARA**, 25 Post St., San Jose CA 95113. (408)293-5300. Fax: (408)293-5389. Website: www.t ollner.com. **Creative Director:** Christopher Canote. Estab. 1980. Specializes in corporate identity, direct mail, package design and collateral. Clients: ad agencies, high tech industry and corporations. Current clients include Hewlett Packard, CIDCO. Client list available upon request.

Needs: Approached by 50 freelance artists/year. Works with 15 freelance illustrators/year. Prefers local artists. Works on assignment only. Uses freelance illustrators for brochure, catalog, P-O-P, poster and ad illustration. Needs computer-literate freelancers for design. Freelancers should be familiar with QuarkX-Press or Illustrator and Flash.

First Contact & Terms: Send query letter with tearsheets, photographs, photocopies, photostats, slides and transparencies. Samples are filed. Request portfolio review in original query. Will contact artist for portfolio review if interested. Portfolio should include tearsheets, photographs, slides and transparencies. Pays for design and illustration by the project, $75-3,000. Rights purchased vary according to project. Considers buying second rights (reprint rights) to previously published work. Finds artists through self-promotions.

⚐ **CLIFF & ASSOCIATES DESIGN**, 715 Fremont Ave., South Pasadena CA 91030. (626)799-5906. Fax: (626)799-9809. E-mail: design@cliffassoc.com. **Owner:** Greg Cliff. Estab. 1984. Number of employees: 10. Approximate annual billing: $1 million. Specializes in annual reports, corporate identity, direct mail and publication design and signage. Clients: Fortune 500 corporations and performing arts companies. Current clients include BP, IXIA, WSPA, IABC, Capital Research and ING.

Needs: Approached by 50 freelancers/year. Works with 30 freelance illustrators and 10 designers/year. Prefers local freelancers and Art Center graduates. Uses freelancers mainly for brochures. Also for technical, "fresh" editorial and medical illustration; mechanicals; lettering; logos; catalog, book and magazine design; P-O-P and poster design and illustration; and model-making. Needs computer-literate freelancers for design and production. 90% of freelance work demands knowledge of QuarkXPress, FreeHand, Illustrator, Photoshop, etc.

First Contact & Terms: Send query letter with résumé and a nonreturnable sample of work. Samples are filed. Art director will contact artist for portfolio review if interested. Portfolio should include thumbnails, b&w photostats and printed samples. Pays for design by the hour, $25-35. Pays for illustration by the project, $50-3,000. Buys one-time rights. Finds artists through sourcebooks.

⚐ **COAKLEY HEAGERTY ADVERTISING & PUBLIC RELATIONS**, 1155 N. First St., Suite 201, San Jose CA 95112-4925. (408)275-9400. Fax: (408)995-0600. E-mail: chcre8ad@hooked.net. Website: www.coakleyheagerty.com. **Art Director:** Bob Meyerson. Estab. 1961. Number of employees: 25. Approximate annual billing: $300 million. Full-service ad agency. Clients: consumer, senior care, banking/financial, insurance, automotive, real estate, tel com, public service. Client list available upon request. Professional affiliation: MAAN (Mutual Advertising Agency Network).

Needs: Approached by 100 freelancers/year. Works with 50 freelance illustrators and 3 designers/year. Works on assignment only. Uses freelancers for illustration, retouching, animation, lettering, logos and charts/graphs. Freelance work demands skills in Illustrator, Photoshop or QuarkXPress.

First Contact & Terms: Send query letter with nonreturnable samples showing art style or résumé, slides and photographs or e-mail link to website or PDF files. Samples are filed or are returned by SASE. Does not report back. Call for an appointment to show portfolio. Pays for design and illustration by the project, $600-5,000.

⚐ **DENTON DESIGN ASSOCIATES**, 491 Arbor St., Pasadena CA 91105. (626)792-7141. **President:** Margi Denton. Estab. 1975. Specializes in annual reports, corporate identity and publication design. Clients: nonprofit organizations and corporations. Current clients include California Institute of Technology, Huntington Memorial Hospital and University of Southern California.

Needs: Approached by 12 freelance graphic artists/year. Works with roughly 5 freelance illustrators and 4 freelance designers/year. Prefers local designers only. "We work with illustrators from anywhere." Works with designers and illustrators for brochure design and illustration, lettering, logos and charts/graphs. Demands knowledge of QuarkXPress, Photoshop and Illustrator.

First Contact & Terms: Send résumé, tearsheets and samples (illustrators just send samples). Samples are filed and are not returned. Responds only if interested. Art director will contact artist for portfolio

This image, created by illustrator David Moore and art directed by Rex Pieper for Cliff & Associates Design, enhanced a colorful issue of Communication World, which is exclusively distributed to communication managers all over the world. Especially illustration-heavy, the high-end publication is one of many that Cliff & Associates Design is responsible for in the area of layout and art direction.

review if interested. Portfolio should include color samples "doesn't matter what form." Pays for design by the hour, $20-25. Pays for illustration by the project, $250-6,500. Rights purchased vary according to project. Finds artists through sourcebooks, AIGA, *Print* and *CA*.

DESIGN AXIOM, 50 B, Peninsula Center Dr., 156, Rolling Hills Estates CA 90274. (310)377-0207. E-mail: tschorer@aol.com. **President:** Thomas Schorer. Estab. 1973. Specializes in graphic, environmental and architectural design, product development and signage.
Needs: Approached by 100 freelancers/year. Works with 5 freelance illustrators and 10 designers/year. Works on assignment only. Uses designers for all types of design. Uses illustrators for editorial and technical illustration. 50% of freelance work demands knowledge of PageMaker or QuarkXPress.
First Contact & Terms: Send query letter with appropriate samples. Will contact artist for portfolio review if interested. Portfolio should include appropriate samples. Pays for design and illustration by the project. Finds artists through word of mouth, self-promotions, sourcebooks and colleges.

☑ ▣ **DESIGN COLLABORATIVE**, 1617 Lincoln Ave., San Rafael CA 94901-5400. (415)456-0252. Fax: (415)479-2001. E-mail: mail@designco.com. Website: www.designco.com. **Creative Director:** Bob Ford. Estab. 1987. Number of employees: 7. Approximate annual billing: $350,000. Ad agency/design firm. Specializes in publication design, package design, environmental graphics. Product specialty is consumer. Current clients include B of A, Lucas Film Ltd., Broderbund Software. Client list available upon request. Professional affiliations: AAGD, PINC, AAD.
Needs: Approached by 20 freelance illustrators and 60 designers/year. Works with 15 freelance illustrators and 20 designers/year. Prefers local designers with experience in package design. Uses freelancers mainly for art direction production. Also for brochure design and illustration, mechanicals, multimedia projects, signage, web page design. 25% of work is with print ads. 80% of design and 85% of illustration demand skills in PageMaker, FreeHand, Photoshop, QuarkXPress, Illustrator, PageMill.
First Contact & Terms: Designers send query letter with photocopies, résumé, color copies. Illustrators send postcard sample and/or query letter with photocopies and color copies. After introductory mailing send follow-up postcard samples. Accepts disk submissions. Send EPS files. Samples are filed or returned. Responds in 1 week. Artist should call. Portfolio review required if interested in artist's work. Portfolios of final art and transparencies may be dropped off every Monday. Pays for design by the hour, $40-80. Pays for illustration by the hour, $40-100. Buys first rights. Rights purchased vary according to project. Finds artists through creative sourcebooks.
Tips: "Listen carefully and execute well."

▣ ▣ **ESSANEE UNLIMITED, INC.**, P.O. Box 5168, Santa Monica CA 90409-5168. (310)396-0192. Fax: (310)392-4673. E-mail: essanee@earthlink.net. **Art Director:** Sharon Rubin. Estab. 1982. Integrated marketing communications agency/design firm. Specializes in packaging and promotion. Product specialties are film, TV, video, food, pet food, sporting goods, travel, entertainment marketing. Current clients include M&M Mars.
Needs: Works with 3-5 freelance illustrators and 3-5 designers/year. Prefers local freelancers with experience in graphic design. Also for brochure and web page design, mechanicals, multimedia projects. 20% of work is with print ads. 100% of design and some illustration demands skills in Photoshop, QuarkXPress.
First Contact & Terms: Send nonreturnable postcard sample. Accepts disk submissions compatible with QuarkXPress 7.5/version 3.3 and CD-Rom. Samples are filed or returned by SASE. Responds in 2 weeks. Portfolio review required only if interested in artist's work. Artist should follow-up with call. Finds artists through word of mouth, submissions.

▣ **EVENSON DESIGN GROUP**, 4445 Overland Ave., Culver City CA 90230. (310)204-1995. Fax: (310)204-4879. E-mail: edgmail@evensondesign.com. Website: evensondesign.com. **Principal:** Stan Evenson. Estab. 1976. Specializes in annual reports, brand and corporate identity, display design, direct mail, package design and signage. Clients: ad agencies, hospitals, corporations, law firms, entertainment companies, record companies, publications, PR firms. Current clients include MGM, Columbia Tri-Star, Sony Pictures Entertainment.
Needs: Approached by 75-100 freelance artists/year. Works with 10 illustrators and 15 designers/year. Prefers artists with production experience as well as strong design capabilities. Works on assignment only. Uses illustrators mainly for covers for corporate brochures. Uses designers mainly for logo design, page layouts, all overflow work. Also for brochure, catalog, direct mail, ad, P-O-P and poster design and illustration, mechanicals, lettering, logos and charts/graphs. 100% of design work demands skills in QuarkXPress, FreeHand, Photoshop or Illustrator.
First Contact & Terms: Send query letter with résumé and samples or send samples via e-mail. Responds only if interested. Portfolio should include b&w and color photostats and tearsheets and 4×5 or larger transparencies.

Tips: "Be efficient in the execution of design work, producing quality designs over the quantity of designs. Professionalism, as well as a good sense of humor, will prove you to be a favorable addition to any design team."

■ **FREEASSOCIATES**, 2800 28th St., Suite 305, Santa Monica CA 90405-2934. (310)399-2340. Fax: (310)399-4030. E-mail: jfreeman@freeassoc.com. Website: www.freeassoc.com. **President:** Josh Freeman. Estab. 1974. Number of employees: 4. Design firm. Specializes in marketing materials for corporate clients. Client list available upon request. Professional affiliations: AIGA.

Needs: Approached by 50 illustrators and 30 designers/year. Works with 5 illustrators and 5 designers/ year. Prefers freelancers with experience in top level design and advertising. Uses freelancers mainly for design, production, illustration. Also for airbrushing, brochure design and illustration, catalog design and illustration, lettering, logos, mechanicals, multimedia projects, posters, retouching, signage, storyboards, technical illustration and web page design. 10% of work is with print ads. 90% of design and 50% of illustration demand skills in Photoshop, QuarkXPress, Illustrator.

First Contact & Terms: Designers send query letter with photocopies, photographs, résumé, tearsheets and transparencies. Illustrators send postcard sample of work and/or photographs and tearsheets. Accepts Mac-compatible disk submissions to view in current version of major software or self-running presentations. CD-ROM OK. Samples are filed or returned by SASE. Will contact for portfolio review if interested. Pays for design and illustration by the project; negotiable. Rights purchased vary according to project. Finds artists through *LA Workbook*, *CA*, *Print*. *Graphis*, submissions and samples.

Tips: "Designers should have their own computer and high speed internet connection. Must have sensitivity to marketing requirements of projects they work on. Deadline commitments are critical."

DENNIS GILLASPY/BRANDON TAYLOR DESIGN, 6498 Weathers Place, Suite 100, San Diego CA 92121-2752. (858)623-9084. Fax: (858)452-6970. E-mail: dennis@brandontaylor.com. Website: brand ontaylor.com. **Owner:** Dennis Gillaspy. Co-Owner: Robert Hines. Estab. 1977. Specializes in corporate identity, displays, direct mail, package and publication design and signage. Clients: corporations and manufacturers. Client list available upon request.

Needs: Approached by 20 freelance artists/year. Works with 15 freelance illustrators and 10 freelance designers/year. Prefers local artists. Works on assignment only. Uses freelance illustrators mainly for technical and instructional spots. Uses freelance designers mainly for logo design, books and ad layouts. Also uses freelance artists for brochure, catalog, ad, P-O-P and poster design and illustration, retouching, airbrushing, logos, direct mail design and charts/graphs.

First Contact & Terms: Send query letter with brochure, résumé, photocopies and photostats. Samples are filed. Responds in 2 weeks. Write to schedule an appointment to show a portfolio or mail thumbnails, roughs, photostats, tearsheets, comps and printed samples. Pays for design by the assignment. Pays for illustration by the project, $400-1,500. Rights purchased vary according to project.

GRAFICA DESIGN SERVICE, 7053 Owensmouth Ave., Canoga Park CA 91303. (818)712-0071. Fax: (818)348-7582. E-mail: graficaeps@aol.com. Website: www.graficaeps.com. **Designer:** Larry Girardi. Estab. 1974. Specializes in corporate identity, package and publication design, signage and technical illustration. Clients: ad agencies, corporations, government and medium- to large-size businesses; majority are high-tech.

Needs: Approached by 25-50 freelance artists/year. Works with 5-10 freelance illustrators and designers/ year. Prefers local artists and artists with experience in airbrush and Macintosh computer graphics. Works on assignment only. Uses illustrators mainly for technical, medical and airbrush illustration. Uses designers mainly for design-layout/thumbnails and comps. Also uses artists for brochure design and illustration, catalog design and illustration, mechanicals, retouching, airbrushing, lettering, logos, ad design and illustration, P-O-P illustration, charts/graphs and production. Needs computer-literate freelancers for illustration and production. 90% of freelance work demands computer literacy in QuarkXPress, Illustrator, Photoshop.

First Contact & Terms: Send query letter with brochure, résumé, SASE, tearsheets, photographs, photocopies, photostats and slides. Samples are filed or are returned by SASE if requested. Responds only if interested. To show a portfolio, mail thumbnails, roughs, b&w and color photostats, tearsheets, photographs, slides and transparencies. Pays for design by the hour, $10-50; or by the project, $75-5,000. Pays for illustration by the hour, $10-50; or by the project, $50-5,000. "Payment is based on complexity of project, budget and the experience of the artist." Rights purchased vary according to project.

Tips: " 'Doing is honest philosophy.' Get the projects and do as much work as you can. Experience is much more important than money. If your work is good, money will follow. Enjoy what you do and enjoy the people you work with. Too many creatives want to work in an ivory tower. Much like life, being able to adapt to change and transform challenges into success is what happy and fulfilling work is all about."

HARTUNG & ASSOCIATES, LTD., 10279 Field Lane, Forestville CA 95436. (707)887-2825. Fax: (707)887-1214. Website: www.grafted1@sonic.net. **President:** Tim Hartung. Estab. 1976. Specializes in display, marketing and consulting, direct mail, package and publication design and corporate identity, web design and signage. Clients: corporations. Current clients include Marina Cove, Crown Transportation, Exigent, Intelegy Corp. Client list available upon request.

Needs: Approached by 20 freelance graphic artists/year. Works with 5 freelance illustrators and 1 freelance designer/year. Prefers local artists "if possible." Works on assignment only. Uses illustrators and designers mainly for brochures. Also uses freelance artists for brochure and package design and illustration, direct mail design, Web design, P-O-P illustration and design, mechanicals, retouching, airbrushing, audiovisual materials, lettering, logos and charts/graphs. 50% of freelance work demands skills in QuarkXPress or Illustrator.

First Contact & Terms: Send query letter with brochure, tearsheets and résumé. Samples are filed. Does not reply. Artist should follow up with call. Portfolio should include b&w and color thumbnails, roughs, final art, photostats and tearsheets. Pays for design by the hour or by the project. Pays for illustration by the project. "Rate depends on size, detail, etc. of project." Buys all rights. Finds artists through sourcebooks and artists' submissions.

THE HITCHINS COMPANY, 22756 Hartland St., Canoga Park CA 91307. (818)715-0150. Fax: (775)806-2687. E-mail: whitchins@socal.rr.com. **President:** W.E. Hitchins. Estab. 1985. Advertising agency. Full-service, multimedia firm.

Needs: Works with 1-2 illustrators and 3-4 designers/year. Works on assignment only. Uses freelance artists for brochure and print ad design and illustration, storyboards, mechanicals, retouching, TV/film graphics, lettering and logo. Needs editorial and technical illustration and animation. 60% of work is with print ads. 90% of design and 50% of illustration demand knowledge of PageMaker, Illustrator, QuarkXPress or FreeHand.

First Contact & Terms: Send postcard sample. Samples are filed if interested and are not returned. Responds only if interested. Call for appointment to show portfolio. Portfolio should include tearsheets. Pays for design and illustration by the project, according to project and client. Rights purchased vary according to project.

LEKASMILLER, 1460 Maria Lane, Suite 260, Walnut Creek CA 94596. (925)934-3971. Fax: (925)934-3978. E-mail: jenna@lekasmiller.com. **Production Manager:** Jenna O'Neill. Estab. 1979. Specializes in annual reports, corporate identity, advertising, direct mail and brochure design. Clients: corporate and retail. Current clients include Cork Supply USA, California Cable & Telecommunications Association, Sun Valley Mall, UC Berkeley School of Law, Cost Plus World Market and Interhealth.

Needs: Approached by 80 freelance artists/year. Works with 1-3 illustrators and 5-7 designers/year. Prefers local artists only with experience in design and production. Works on assignment only. Uses artists for brochure design and illustration, mechanicals, direct mail design, logos, ad design and illustration. 100% of freelance work demands knowledge of QuarkXPress, Photoshop and Illustrator.

First Contact & Terms: Designers and illustrators should e-mail PDF or résumé and portfolio. Responds only if interested. Considers skill and experience of artist when establishing payment. Negotiates rights purchased.

THE LEPREVOST CORPORATION, 6781 Wildlife Rd., Malibu CA 90265. (310)457-3742. **President:** John LePrevost. Specializes in corporate identity, television and film design. Current clients include: NBC News, NBC Television, The Nashville Network.

Needs: Approached by 30 freelance artists/year. Works with 10 designers/year. Prefers "talented and professional" artists only. Works on assignment only. Uses freelancers for animation and film design and illustration, lettering and logo design. Animation and design becoming more sophisticated. Needs storyboards. Needs computer-literate freelancers for design, illustration and animation. 95% of freelance work demands skills in Illustrator, Photoshop or Electric Image.

First Contact & Terms: Call for appointment. Samples not returned. Provide information to be kept on file for possible future assignments; reports back. Payment for design by the project. Considers complexity of project, client's budget, skill and experience of artist, how work will be used, turnaround time and rights purchased when establishing payment.

LINEAR CYCLE PRODUCTIONS, P.O. Box 2608, San Fernando CA 91393-0608. **Producer:** Rich Brown. Production Manager: R. Borowy. Estab. 1980. Number of employees: 30. Approximate annual billing: $200,000. AV firm. Specializes in audiovisual sales and marketing programs and also in teleproduction for CATV. Current clients include Katz, Inc. and McDave and Associates.

Needs: Works with 7-10 freelance illustrators and 7-10 designers/year. Prefers freelancers with experience in teleproductions (broadcast/CATV/non-broadcast). Works on assignment only. Uses freelancers for storyboards, animation, TV/film graphics, editorial illustration, lettering and logos. 10% of work is with print ads. 25% of freelance work demands knowledge of FreeHand, Photoshop or Tobis IV.

First Contact & Terms: Send query letter with résumé, photocopies, photographs, slides, transparencies, video demo reel and SASE. Samples are filed or are returned by SASE if requested by artist. Responds only if interested. To show portfolio, mail audio/videotapes, photographs and slides; include color and b&w samples. Pays for design and illustration by the project, $100 minimum. Considers skill and experience of artist, how work will be used and rights purchased when establishing payment. Negotiates rights purchased. Finds artists through reviewing portfolios and published material.

Tips: "We see a lot of sloppy work and samples, portfolios in fields not requested or wanted, poor photos, photocopies, graphics, etc. Make sure your materials are presentable."

■ **LORD & BENTLEY PERSUASIVE MARKETING**, 32 Eugene St., Mill Valley CA 94941. (415)389-9444. **Creative Director:** Alan Barsky. Ad and marketing agency.

Needs: Works with 10 artists/year. Prefers experienced local artists only. Works on assignment only. Uses artists for design and illustration of advertisements, brochures, magazines, newspapers, billboards, posters, direct mail, websites, packages and logos. Artists must "understand reproduction process; the job is to enhance copy strategy."

First Contact & Terms: Send URL to art@lordb.com. Pays for design by the project or hour, $50-150. Pays for illustration by the project. Considers skill and experience of artist when establishing payment. Buys all rights.

JACK LUCEY/ART & DESIGN, 84 Crestwood Dr., San Rafael CA 94901. (415)453-3172. **Contact:** Jack Lucey. Estab. 1960. Art agency. Specializes in annual reports, brand and corporate identity, publications, signage, technical illustration and illustrations/cover designs. Clients: businesses, ad agencies and book publishers. Current clients include U.S. Air Force, TWA Airlines, California Museum of Art & Industry, CNN, NBC Television News, Lee Books, High Noon Books. Client list available upon request. Professional affiliations: Art Directors Club, Academy of Art Alumni.

• Recent assignments include courtroom artist work for CNN, ABC News, NBC News, criminal and civil trials such as that for "unabomber" Ted Kacynski. Also completed assignments with Associated Press for print media.

Needs: Approached by 20 freelancers/year. Works with 1-2 freelance illustrators/year. Uses mostly local freelancers. Uses freelancers mainly for type and airbrush. Also for lettering for newspaper work.

First Contact & Terms: Query. Prefers photostats and published work as samples. Provide brochures, business card and résumé to be kept on file. Portfolio review not required. Originals are not returned to artist at job's completion. Requests work on spec before assigning a job. Pays for design by the project.

Tips: "Show variety in your work. Many samples I see are too specialized in one subject, one technique, one style (such as air brush only, pen & ink only, etc.). Subjects are often all similar too."

N **MARKETING BY DESIGN**, 2012 19th St., Suite 200, Sacramento CA 95818. (916)441-3050. **Creative Director:** Joel Stinghen. Estab. 1977. Specializes in corporate identity and brochure design, publications, direct mail, trade show, signage, display and packaging. Client: associations and corporations. Client list not available.

Needs: Approached by 50 freelance artists/year. Works with 6-7 freelance illustrators and 1-3 freelance designers/year. Works on assignment only. Uses illustrators mainly for editorial. Also uses freelance artists for brochure and catalog design and illustration, mechanicals, retouching, lettering, ad design and charts/graphs.

First Contact & Terms: Send query letter with brochure, résumé, tearsheets. Samples are filed or are not returned. Does not report back. Artist should follow up with call. Call for appointment to show portfolio of roughs, b&w photostats, color tearsheets, transparencies and photographs. Pays for design by the hour, $10-30; by the project, $50-5,000. Pays for illustration by the project, $50-4,500. Rights purchased vary according to project. Finds designers through word of mouth; illustrators through sourcebooks.

SUDI MCCOLLUM DESIGN, 3244 Cornwall Dr., Glendale CA 91206. (818)243-1345. Fax: (818)243-1345. E-mail: sudimccollum@earthlink.net. **Contact:** Sudi McCollum. Specializes in product design and illustration. Majority of clients are medium-to-large-size businesses. "No specialty in any one industry." Clients: home furnishing and giftware manufacturers and agencies, design studios.

Needs: Use freelance production people—either on computer or with painting and product design skills. Potential to develop into full-time job.

First Contact & Terms: Send query letter "with whatever you have that's convenient." Samples are filed. Responds only if interested.

■ **MEDIA ENTERPRISES**, 1644 S. Clementine St., Anaheim CA 92802. (714)778-5336. Fax: (714)778-6367. Website: www.media-enterprises.com. **Creative Director:** John Lemieux Rose. Estab. 1982. Number of employees: 8. Approximate annual billing: $2 million. Integrated marketing communications agency. Specializes in interactive multimedia, CD-ROMs, Internet, magazine publishing. Product specialty high tech. Client list available upon request. Professional affiliations: Orange County Multimedia Users Group (OCMUG), Software Council of Southern California, Association of Internet Professionals.
Needs: Approached by 30 freelance illustrators and 10 designers/year. Works with 8-10 freelance illustrators and 3 designers/year. Also for animation, humorous illustration, lettering, logos, mechanicals, multimedia projects. 30% of work is with print ads. 100% of freelance work demands skills in PageMaker, Photoshop, QuarkXPress, Illustrator, Director.
First Contact & Terms: Send postcard sample and/or query letter with photocopies, photographs or URL. Accepts disk submissions compatible with Mac or PC. Samples are filed. Will contact for portfolio review of color photographs, slides, tearsheets, transparencies and/or disk. Pays by project; negotiated. Buys all rights.

Ⓝ **ON-Q PRODUCTIONS, INC.**, 618 E. Gutierrez St., Santa Barbara CA 93103. (805)963-1331. Website: www.onqpro.com. **President:** Vincent Quaranta. AV firm. "We are producers of multi-projector slide presentations and websites. We produce computer-generated slides for business presentations and interactive presentations on CD-ROM." Clients: banks, ad agencies, R&D firms and hospitals.
Needs: Works with 10 freelancers/year. Uses freelancers mainly for slide presentations. Also for editorial and medical illustration, retouching, animation, web design and programming, and lettering. 75% of freelance work demands skills in QuarkXPress, FreeHand Photoshop or Aldus Persuasion.
First Contact & Terms: Send query letter with brochure or résumé. Responds only if interested. Write for appointment to show portfolio of original/final art and slides. Pays for design and illustration by the hour, $25 minimum; or by the project, $100 minimum.
Tips: "Artist must be *experienced* in computer graphics and on the board. The most common mistakes freelancers make are poor presentation of a portfolio (small pieces fall out, scratches on cover acetate) and they do not know how to price out a job. Know the rates you're going to charge and how quickly you can deliver a job. Client budgets are tight."

RUBIN POSTAER & ASSOCIATES, Dept. AM, 1333 Second St., Santa Monica CA 90401. (310)917-2425. **Manager, Art Services:** Annie Ross. Ad agency. Serves clients in automobile industry, finance, health care provider.
Needs: Works with about 24 freelance illustrators/year. Uses freelancers for all media.
First Contact & Terms: Contact manager of art services for appointment to show portfolio. Selection based on portfolio review. Negotiates payment.
Tips: Wants to see a variety of techniques.

☑ ■ 📋 **SOFTMIRAGE, INC.**, 4223 Glencoe Ave., Suite C210, Marina Del Rey CA 90292. (310)578-7638 E-mail: Stevepollack@hotmail.com. Website: www.softmirage.com. **Art Director:** Steve Pollack. Estab. 1995. Number of employees: 12. Approximate annual billing: $2 million. Visual communications agency. Specializes in architecture, real estate and entertainment. Need people with strong spatial design skills, modeling and ability to work with computer graphics. Current clients include Four Seasons Hotels, UCLA, Ford, Koll Development and various architectural firms.
Needs: Approached by 15 freelance illustrators and 5 designers/year. Works with 6 freelance 3D modelers, and 10 graphic designers/year. Prefers local designers with experience in architecture, technology. Uses freelancers mainly for concept, work in process computer modeling. Also for animation, brochure design, mechanicals, multimedia projects, retouching, technical illustration, TV/film graphics. 50% of work is renderings. 100% of design and 30% of illustration demand skills in Photoshop, 3-D Studio Max, SoftImage, VRML, Flash and Director. Need Macromedia Flash developers.
First Contact & Terms: Designers send query letter or e-mail with samples. 3-D modelers send postcard sample, e-mail query letter with photocopies. Accepts disk submissions. Samples are filed or returned by SASE. Will contact for portfolio review if interested. Pays for design by the hour, $15-85. Pays for modeling by the project, $100-2,500. Rights purchased vary according to project. Finds artists through Internet, AIGA and referrals.
Tips: "Be innovative, push the creativity, understand the business rationale and accept technology. Check our website, www.softimage.com. as we do not use traditional illustrators. Send information electronically, making sure work is progressive and emphasizing types of projects you can assist with."

▼ **JULIA TAM DESIGN**, 2216 Via La Brea, Palos Verdes CA 90274. (310)378-7583. Fax: (310)378-4589. E-mail: taandm888@earthlink.net. **Contact:** Julia Tam. Estab. 1986. Specializes in annual reports,

Get Your 2004 Edition Delivered Right to Your Door—and Save!

The most savvy artists and designers turn to *Artist's & Graphic Designer's Market* for the most up-to-date info on the people and places that will get their work sold, commissioned and shown.

You get more than 2,500 current listings for...

- Publishers
- Design firms
- Ad agencies
- Greeting card companies
- Galleries
- And more!

Plus, you'll find insider tips from today's art professionals to help you make the most of every business opportunity. Through this special offer, you get the completely updated *2004 Artist's & Graphic Designer's Market* at the low 2003 price—just $24.99.

Order today and save!

Completely UPDATED

"AN EXCELLENT RESOURCE FOR ARTISTS AND ILLUSTRATORS."
—American Reference Book Annual

Insider Reports and interviews with Andy Cowles, Art Director for Rolling Stone Magazine, and Yvonne Groenvelt, Product Development Coordinator for the Lang Company

2004 Artist's & Graphic Designer's Market will be published and ready for shipment in August 2003. **#10846-K/$24.99/720 pgs/pb**

Turn over for more books to help you sell your work!

☑ **Yes!** I want the most current edition of *Artist's & Graphic Designer's Market*. Please send me the 2004 edition at the 2003 price—just $24.99. (#10846-K)

| # 10846-K | $ 24.99 |

(NOTE: *2004 Artist's & Graphic Designer's Market* will be shipped in August 2003.)

I also want these books listed on back:

Book		Price
#	-K	$
#	-K	$
#	-K	$
#	-K	$
#	-K	$
Subtotal		$

In the U.S., please add $3.95 s&h for the first book, $1.95 for each additional book. In CO, NY, OH and MI, please add applicable state tax. In Canada, add $5.00 for the first book, $3.00 for each additional book, and 7% GST. Payment in U.S. funds must accompany order.

| Shipping & Handling | $ |
| Total | $ |

Credit card orders call
TOLL FREE 1-800-448-0915
or visit
www.writersdigest.com/catalog

☐ Payment enclosed $ _____ (or)

Charge my: ☐ VISA ☐ MC ☐ AmEx Exp. _____

Account # _____

Signature _____
(required)

Name _____

Address _____

City _____

State/Prov. _____ ZIP/PC _____

☐ Check here if you do not want your name added to our mailing list.

| 30-Day Money Back Guarantee on every book you buy! |

Mail to: Writer's Digest Books • PO Box 9274 • Central Islip, NY 11722-9274

ZAH02B3

corporate identity, brochures, promotional material, packaging and design. Clients: corporations. Current clients include Southern California Gas Co., *Los Angeles Times*, UCLA. Client list available upon request. Professional affiliations: AIGA.

• Julia Tam Design won numerous awards including American Graphic Design Award, Premier Print Award, *Creativity, American Corporate Identity* and work showcased in Rockport Madison Square Press and Northlight graphic books.

Needs: Approached by 10 freelancers/year. Works with 6-12 freelance illustrators 2 designers/year. "We look for special styles." Works on assignment only. Uses illustrators mainly for brochures. Also uses freelancers for brochure design and illustration; catalog and ad illustration; retouching; and lettering. 50-100% of freelance work demands knowledge of QuarkXPress, Illustrator or Photoshop.

First Contact & Terms: Designers send query letter with brochure and résumé. Illustrators send query letter with résumé and tearsheets. Samples are filed. Responds only if interested. Artist should follow up. Portfolio should include b&w and color final art, tearsheets and transparencies. Pays for design by the hour, $10-20. Pays for illustration by the project. Negotiates rights purchased. Finds artists through *LA Workbook*.

THARP DID IT, 50 University Ave., Loft 21, Los Gatos CA 95030. Website: www.TharpDidIt.com. **Art Director/Designer:** Mr. Tharp. Estab. 1975. Specializes in brand identity; corporate, non-corporate, and retail visual identity; packaging; and environmental graphic design. Clients: direct and through agencies. Current clients include Harmony Foods, Hooked on Phonics, Mirassou Vineyards, LeBoulanger Bakeries and Cinequest (San Jose Film Festival). Professional affiliations: American Institute of Graphic Arts (AIGA), Society for Environmental Graphic Design (SEGD), Western Art Directors Club (WADC), TDCT-JHTBIPC (The Design Conference That Just Happens to be in Park City).

• Tharp Did It won a gold medal in the International Packaging Competition at the 30th Vinitaly in Verona, Italy, for wine label design. Their posters for BRIO Toys are in the Smithsonian Institution's National Design Museum archives.

Needs: Approached by 150-300 freelancers/year. Works with 5-10 freelance illustrators each year.

First Contact & Terms: Send query letter with printed promotional material. Samples are filed or are returned by SASE. Will contact artist for portfolio review if interested. "No phone calls please. We'll call you." Pays for illustration by the project, $100-10,000. Considers client's budget and how work will be used when establishing payment. Rights purchased vary according to project. Finds artists through awards annuals, sourcebooks, and submissions/self-promotions.

TRIBOTTI DESIGNS, 22907 Bluebird Dr., Calabasas CA 91302-1832. (818)591-7720. Fax: (818)591-7910. E-mail: bob4149@aol.com. Website: www.tribotti.com. **Contact:** Robert Tribotti. Estab. 1970. Number of employees: 2. Approximate annual billing: $200,000. Specializes in graphic design, annual reports, corporate identity, packaging, publications and signage. Clients: PR firms, ad agencies, educational institutions and corporations.

Needs: Approached by 8-10 freelancers/year. Works with 2-3 freelance illustrators and 1-2 designers/year. Prefers local freelancers only. Works on assignment only. Uses freelancers mainly for brochure illustration. Also for catalogs, charts/graphs, lettering and ads. Prefers computer illustration. 100% of freelance design and 50% of illustration demand knowledge of PageMaker, Illustrator, QuarkXPress, Photoshop, FreeHand. Needs illustration for annual reports/brochures.

First Contact & Terms: Send postcard sample or query letter with brochure, photocopies and résumé. Accepts submissions on disk compatible with PageMaker 6.5, Illustrator or Photoshop. Send EPS files. Will contact artist for portfolio review if interested. Portfolio should include thumbnails, roughs, original/final art, final reproduction/product and b&w and color tearsheets, photostats and photographs. Pays for design by the hour, $50-75. Pays for illustration by the project, $100-1,000. Rights purchased vary according to project. Finds artists through word of mouth and self-promotion mailings.

Tips: "We will consider experienced artists only. Must be able to meet deadlines. Send printed samples. We look for talent and a willingness to do a very good job."

THE VAN NOY GROUP, 3315 Westside Rd., Healdsburg CA 95448-9453. (707)433-3944. Fax: (707)433-0375. E-mail: jim@vannoygroup.com. Website: www.vannoygroup.com. **Vice President:** Ann

● **SPECIAL COMMENTS** within listings by the editor of *Artist's & Graphic Designer's Market* are set off by a bullet.

Van Noy. Estab. 1972. Specializes in package design, brand and corporate identity, displays and package design. Clients: corporations. Current clients include Waterford, Wedgewood USA, Leiner Health Products, Pentel of America. Client list available upon request.

Needs: Approached by 1-10 freelance artists/year. Works with 2 illustrators and 3 designers/year. Prefers artists with experience in Macintosh design. Works on assignment only. Uses freelancers for packaging design and illustration, Quark and Photoshop production and lettering.

First Contact & Terms: Send query letter with résumé and photographs. Samples are filed. Will contact artist for portfolio review if interested. If no reply, artist should follow up. Pays for design by the hour, $35-100. Pays for illustration by the hour or by the project at a TBD fee. Finds artists through sourcebooks, self-promotions and primarily agents. Also have permanent positions available.

Tips: "I think more and more clients will be setting up internal art departments and relying less and less on outside designers and talent. The computer has made design accessible to the user who is not design-trained."

N VIDEO RESOURCES, Box 18642, Irvine CA 92623. (949)261-7266. Fax: (949)261-5908. E-mail: brad@videoresouces.com. **Producer:** Brad Hagen. Number of employees: 7. Video and multimedia firm. Specializes in automotive, banks, restaurants, computer, health care, transportation and energy.

Needs: Approached by 10-20 freelancers/year. Works with 5-10 freelance illustrators and 5-10 designers/year. Works on assignment only. Uses freelancers for graphics, multimedia, animation, etc.

First Contact & Terms: Send query letter with brochure showing art style or résumé, business card, photostats and tearsheets to be kept on file. Samples not filed are returned by SASE. Considers complexity of the project and client's budget when establishing payment. Buys all rights.

VISUAL AID/VISAID MARKETING, Box 4502, Inglewood CA 90309. (310)399-0696. **Manager:** Lee Clapp. Estab. 1961. Number of employees: 3. Distributor of promotion aids, marketing consultant service, "involved in all phases." Specializes in manufacturers, distributors, publishers and graphics firms (printing and promotion) in 23 SIC code areas.

Needs: Approached by 25-50 freelancers/year. Works with 1-2 freelance illustrators and 6-12 designers/year. Uses freelancers for advertising, brochure and catalog design, illustration and layout; product design; illustration on product; P-O-P display; display fixture design; and posters. Buys some cartoons and humorous cartoon-style illustrations. Additional media: fiber optics, display/signage, design/fabrication.

First Contact & Terms: Works on assignment only. Send postcard sample or query letter with brochure, photostats, duplicate photographs, photocopies and tearsheets to be kept on file. Responds if interested and has assignment. Write for appointment to show portfolio. Pays for design by the hour, $5-75. Pays for illustration by the project, $100-500. Considers skill and experience of artist and turnaround time when establishing payment.

Tips: "Do not say 'I can do anything.' We want to know the best media you work in (pen & ink, line drawing, illustration, layout, etc.)."

DANA WHITE PRODUCTIONS, INC., 2623 29th St., Santa Monica CA 90405. (310)450-9101. E-mail: dwprods@aol.com. **Owner/Producer:** Dana C. White. AV firm. "We are a full-service audiovisual production company, providing multi-image and slide-tape, video and audio presentations for training, marketing, awards, historical and public relations uses. We have complete inhouse production resources, including computer multimedia, photo digitizing, image manipulation, program assembly, slidemaking, soundtrack production, photography and AV multi-image programming. We serve major industries such as US Forest Services, GTE, Occidental Petroleum; medical, such as Whittier Hospital, Florida Hospital; schools, such as University of Southern California, Pepperdine University, Clairbourne School; publishers, such as McGraw-Hill, West Publishing; and public service efforts, including fundraising."

Needs: Works with 8-10 freelancers/year. Prefers freelancers local to greater Los Angeles, "with timely turnaround, ability to keep elements in accurate registration, neatness, design quality, imagination and price." Uses freelancers for design, illustration, retouching, characterization/animation, lettering and charts. 50% of freelance work demands knowledge of Illustrator, FreeHand, Photoshop, Quark and Premier.

First Contact & Terms: Send query letter with brochure or tearsheets, photostats, photocopies, slides and photographs. Samples are filed or are returned only if requested. Responds in 2 weeks only if interested. Call or write for appointment to show portfolio. Pays by the project. Payment negotiable by job.

Tips: "These are tough times. Be flexible. Negotiate. Your work should show that you have spirit, enjoy what you do and that you can deliver high quality work on time"

■ YAMAGUMA & ASSOCIATES, YAD2M Creative, 255 N. Market St., #120, San Jose CA 95110-2409. (408)279-0500. Fax: (408)293-7819. E-mail: sayd2m@aol.com or info@yad2m.com. Website: www.

yad2m.com. Estab. 1980. Specializes in corporate identity, displays, direct mail, publication design, signage and marketing. Clients: high technology, government and business-to-business. Current clients include Sun Microsystems, ASAT, BOPS and Xporta. Client list available upon request.

Needs: Approached by 6 freelancers/year. Works with 3 freelance illustrators and 2 designers/year. Works on assignment only. Uses illustrators mainly for 4-color, airbrush and technical work. Uses designers mainly for logos, layout and production. Also uses freelancers for brochure, catalog, ad, P-O-P and poster design and illustration; mechanicals; retouching; lettering; book, magazine, model-making; direct mail design; charts/graphs; and AV materials. Also for multimedia projects (Director SuperCard). Needs editorial and technical illustration. 100% of design and 75% of illustration demand knowledge of PageMaker, QuarkX-Press, FreeHand, Illustrator, Model Shop, Strata, MMDir. or Photoshop.

First Contact & Terms: Send postcard sample or query letter with brochure and tearsheets. Accepts disk submissions compatible with Illustrator, QuarkXPress, Photoshop and Strata. Samples are filed. Will contact artist for portfolio review if interested. Portfolio should include thumbnails, roughs, b&w and color photostats, tearsheets, photographs, slides and transparencies. Sometimes requests work on spec before assigning a job. Pays for design by the hour, $15-50. Pays for illustration by the project, $300-3,000. Rights purchased vary according to project. Finds artists through self-promotions.

Tips: Would like to see more Macintosh-created illustrations.

Los Angeles

N ASHCRAFT DESIGN, 11832 W. Pico Blvd., Los Angeles CA 90064. (310)479-8330. Fax: (310)473-7051. E-mail: info@ashcraftdesign.com. Website: www.ashcraftdesign.com. Estab. 1986. Specializes in corporate identity, display and package design and signage. Client list available upon request.

Needs: Approached by 2 freelance artists/year. Works with 1 freelance illustrator and 2 freelance designers/year. Works on assignment only. Uses freelance illustrators mainly for technical illustration. Uses freelance designers mainly for packaging and production. Also uses freelance artists for mechanicals and model making.

First Contact & Terms: Send query letter with tearsheets, résumé and photographs. Samples are filed and are not returned. Responds only if interested. To show a portfolio, e-mail samples or mail color copies. Pays for design and illustration by the project. Rights purchased vary according to project.

N FOOTE, CONE & BELDING, 17600 Gillette Ave., Irvine CA 92614. (949)851-3050. Website: www.fcb.com. **Art Buyer:** Connie Mangam. Estab. 1950. Ad agency. Full-service, multimedia firm. Product specialties are package goods, toys, entertainment and retail.

● This is just one office of FCB, a global agency with offices all over the world. FCB is one of the top 3 agencies in the United States, with 188 offices in 102 countries.

Needs: Approached by 15-20 freelance artists/month. Works with 3-4 freelance illustrators and 2-3 freelance designers/month. Prefers local artists only with experience in design and sales promotion. Designers must be able to work in-house and have Mac experience. Uses freelance artists for brochure, catalog and print ad design and illustration, storyboards, mechanicals, retouching, lettering, logos and computer (Mac). 30% of work is with print ads.

First Contact & Terms: Designers send query letter with résumé, photocopies and tearsheets. Illustrators send postcard, color photocopies, tearsheets or other nonreturnable samples. Samples are filed. Responds only if interested. Write to schedule an appointment to show a portfolio. Portfolio should include roughs and color. Pays for design based on estimate on project from concept to mechanical supervision. Pays for illustration per project. Rights purchased vary according to project.

✓ ▣ GRAPHIC DESIGN CONCEPTS, 15329 Yukon Ave., El Camino Village CA 90260-2452. (310)978-8922. **President:** C. Weinstein. Estab. 1980. Specializes in package, publication and industrial design, annual reports, corporate identity, displays and direct mail. "Our clients include public and private corporations, government agencies, international trading companies, ad agencies and PR firms." Current projects include new product development for electronic, hardware, cosmetic, toy and novelty companies.

Needs: Works with 15 illustrators and 25 designers/year. "Looking for highly creative idea people, all levels of experience." All styles considered. Uses illustrators mainly for commercial illustration. Uses designers mainly for product and graphic design. Also uses freelancers for brochure, P-O-P, poster and catalog design and illustration; book, magazine, direct mail and newspaper design; mechanicals; retouching; airbrushing; model-making; charts/graphs; lettering; logos. Also for multimedia design, program and content development. 50% of freelance work demands knowledge of PageMaker, Illustrator, QuarkXPress, Photoshop or FreeHand.

First Contact & Terms: Send query letter with brochure, résumé, tearsheets, photostats, photocopies, slides, photographs and/or transparencies. Accepts disk submissions compatible with Windows on the IBM. Samples are filed or are returned if accompanied by SASE. Responds in 10 days with SASE. Portfolio should include thumbnails, roughs, original/final art, final reproduction/product, tearsheets, transparencies and references from employers. Pays for design by the hour, $15 minimum; pays for illustration by the hour, $50 minimum. Considers complexity of project, client's budget, skill and experience of artist, how work will be used, turnaround time and rights purchased when establishing payment.

Tips: "Send a résumé if available. Send samples of recent work or *high quality* copies. Everything sent to us should have a professional look. After all, it is the first impression we will have of you. Selling artwork is a business. Conduct yourself in a business-like manner."

RHYTHMS PRODUCTIONS, P.O. Box 34485, Los Angeles CA 90034. (310)836-4678. **President:** Ruth White. Estab. 1955. AV firm. Specializes in CD-ROM and music production/publication. Product specialty is educational materials for children.

Needs: Works with 2 freelance illustrators and 2 designers/year. Prefers artists with experience in cartoon animation and graphic design. Works on assignment only. Uses freelancers artists mainly for cassette covers, books, character design. Also for catalog design, multimedia, animation and album covers. 2% of work is with print ads. 75% of design and 50% of illustration demands graphic design computer skills.

First Contact & Terms: Send query letter with photocopies and SASE (if you want material returned). Samples are returned by SASE if requested. Responds in 2 months only if interested. Will contact artist for portfolio review if interested. Pays for design and illustration by the project. Buys all rights. Finds artists through word of mouth and submissions.

San Francisco

🔲 **THE AD AGENCY**, P.O. Box 470572, San Francisco CA 94147. **Creative Director:** Michael Carden. Estab. 1972. Ad agency. Full-service multimedia firm. Specializes in print, collateral, magazine ads. Client list available upon request.

Needs: Approached by 120 freelancers/year. Works with 120 freelance illustrators and designers/year. Uses freelancers mainly for collateral, magazine ads, print ads. Also for brochure, catalog and print ad design and illustration, mechanicals, billboards, posters, TV/film graphics, multimedia, lettering and logos. 60% of freelance work is with print ads. 50% of freelance design and 45% of illustration demand computer skills.

First Contact & Terms: Send query letter with brochure, photocopies and SASE. Samples are filed or returned by SASE. Responds in 1 month. Portfolio should include color final art, photostats and photographs. Buys first rights or negotiates rights purchased. Finds artists through word of mouth, referrals and submissions.

Tips: "We are an eclectic agency with a variety of artistic needs."

BRENT A. JONES DESIGN, 328 Hayes St., San Francisco CA 94102. (415)626-8337. E-mail: jonesdes @pacbell.net. **Principal:** Brent Jones. Estab. 1983. Specializes in corporate identity and advertising design. Clients: corporations, museums, book publishers, retail establishments. Client list available upon request.

Needs: Approached by 1-3 freelancers/year. Works with 2 freelance illustrators and 1 designer/year. Prefers local freelancers only. Works on assignment only. Uses illustrators mainly for renderings. Uses designers mainly for production. Also uses freelancers for brochure and ad design and illustration, mechanicals, catalog illustration and charts/graphs. "Computer literacy a must." Needs computer-literate freelancers for production. 95% of freelance work demands knowledge of QuarkXPress, Illustrator and Photoshop.

First Contact & Terms: Send query letter with brochure and tearsheets. Samples are filed and are not returned. Responds in 2 weeks only if interested. Write for appointment to show portfolio of slides, tearsheets and transparencies. Pay for design is negotiable; or by the project. Pays for illustration by the project. Rights purchased vary according to project.

ROY RITOLA, INC., 100 Ebbtide, Sausalito CA 94965. (415)332-8611. **President:** Roy Ritola. Specializes in brand and corporate identity, displays, direct mail, packaging, signage. Clients: manufacturers.

Needs: Works with 6-10 freelancers/year. Uses freelancers for design, illustration, airbrushing, model-making, lettering and logos.

First Contact & Terms: Send query letter with brochure showing art style or résumé, tearsheets, slides and photographs. Samples not filed are returned only if requested. Responds only if interested. To show

portfolio, mail final reproduction/product. Pays for design by the hour, $25-100. Considers complexity of project, client's budget, skill and experience of artist, turnaround time and rights purchased when establishing payment.

N TOKYO DESIGN CENTER, 703 Market St., Suite 252, San Francisco CA 94103. (415)543-4886. **Creative Director:** Kaoru Matsuda. Specializes in annual reports, brand identity, corporate identity, packaging and publications. Clients: consumer products, travel agencies and retailers.
Needs: Uses artists for design and editorial illustration.
First Contact & Terms: Send business card, slides, tear sheets and printed material to be kept on file. Samples not kept on file are returned by SASE only if requested. Will contact artist for portfolio review if interested. Pays for design and illustration by the project, $100-1,500 average. Sometimes requests work on spec before assigning job. Considers client's budget, skill and experience of artist, turnaround time and rights purchased when establishing payment. Interested in buying second rights (reprint rights) to previously published work.
Tips: Finds artists through self-promotions and sourcebooks.

Colorado

N ☒ BARNSTORM DESIGN/CREATIVE, 530 E. Colorado Ave., Colorado Springs CO 80903. (719)630-7200. Fax: (719)630-3280. Website: www.barnstormdesign.com. **Owner:** Becky Houston. Estab. 1975. Specializes in corporate identity, brochure design, publications, web design and Internet marketing. Clients: high-tech corporations, nonprofit fundraising, business-to-business and restaurants. Current clients include Liberty Wire and Cable, Colorado Springs Visitors Bureau and Kaiser Crow Gatherings.
Needs: Works with 2-4 freelance artists/year. Prefers local, experienced (clean, fast and accurate) artists. Works on assignment only. Uses freelancers mainly for paste-up, editorial and technical illustration and layout. Also uses freelancers for design, mechanicals, retouching and calligraphy. Needs computer-literate freelancers for production. 90% of freelance work demands knowledge of Illustrator, QuarkXPress, Photoshop and Macromedia FreeHand.
First Contact & Terms: Send query letter with résumé and samples to be kept on file. Prefers "good originals or reproductions, professionally presented in any form" as samples. Samples not filed are returned by SASE. Responds only if interested. Call or write for appointment to show portfolio. Pays for design by the project, $300-500. Pays for illustration by the project, $100 minimum for b&w; $300 for color. Considers client's budget, skill and experience of artist, and turnaround time when establishing payment.
Tips: "Portfolios should reflect an awareness of current trends. We try to handle as much inhouse as we can, but we recognize our own limitations (particularly in illustration). Do not include too many samples in your portfolio."

CINE DESIGN FILMS, Box 6495, Denver CO 80206. (303)777-4222. E-mail: jghusband@aol.com. **Producer/Director:** Jon Husband. AV firm. Clients: automotive companies, banks, restaurants, etc.
Needs: Works with 3-7 freelancers/year. Works on assignment only. Uses freelancers for layout, titles, animation and still photography. Clear concept ideas that relate to the client in question are important.
First Contact & Terms: Send query letter to be kept on file. Responds only if interested. Write for appointment to show portfolio. Pays by the project. Considers complexity of project, client's budget and rights purchased when establishing payment. Rights purchased vary according to project.

N JO CULBERTSON DESIGN, INC., 939 Pearl St., Denver CO 80203. (303)861-9046. E-mail: joculdes@aol.com. **President:** Jo Culbertson. Estab. 1976. Number of employees: 1. Approximate annual billing: $200,000. Specializes in direct mail, packaging, publication and marketing design, annual reports, corporate identity, and signage. Clients: corporations, not-for-profit organizations. Current clients include Love Publishing Company, American Cancer Society, Nurture Nature, Clarus Products Intl., Sun Gard Insurance Systems. Client list available upon request.
Needs: Approached by 15 freelancers/year. Works with 2 freelance illustrators/year. Prefers local freelancers only. Works on assignment only. Uses illustrators mainly for corporate collateral pieces, illustration and ad illustration. 50% of freelance work demands knowledge of QuarkXPress, Photoshop, CorelDraw.
First Contact & Terms: Send query letter with résumé, tearsheets and photocopies. Samples are filed. Reports back to the artist only if interested. Artist should follow up with call. Portfolio should include b&w and color thumbnails, roughs and final art. Pays for design by the project, $250 minimum. Pays for illustration by the project, $100 minimum. Finds artists through file of résumés, samples, interviews.

N MITCHELL ADVERTISING, 545 Collyer St., Longmont CO 80501. (303)443-3306. Fax: (303)678-0895. E-mail: mitchlink@aol.com. **Contact:** Jim Mitchell. Estab. 1974. Number of employees: 8. Ad

agency. Full-service, multimedia firm. Specializes in print and broadcast advertising, creative, production, strategic planning, media planning, collateral, PR. Product specialties are sports and fitness. Current clients include Alpine Design, Connelly Skis, Gerry Sportswear, Nevica Skiwear, Schuller Ecotherm, Volki Skis, Tennus.

Needs: Approached by hundreds of freelancers/year. Works with 6-10 freelance illustrators and 5-8 designers/year. Uses freelancers mainly for ads, collateral. Also for animation, billboards, brochure and catalog design and illustration, logos, mechanicals, posters, retouching, signage, TV/film graphics. 75% of work is with print ads. 90% of work demands knowledge of Photoshop, QuarkXPress and Illustrator.

First Contact & Terms: Send query letter with brochure, photostats, résumé, SASE, tearsheets and transparencies. Samples are filed. Will contact artist for portfolio review if interested. Rights purchased vary according to project.

Tips: Finds artists through *Creative Black Book*, word of mouth and artists' submissions.

☑ 🖳 **PAGEWORKS COMMUNICATION DESIGN, INC.**, 7535 E. Hampden Ave., Suite 350, Denver CO 80231. (303)337-7770. Fax: (303)337-7780. E-mail: info@pageworksthebigidea.com. Website: www.pageworksthebigidea.com. **CEO:** Michael Guzofsky. Estab. 1981. Specializes in annual reports, corporate identity, direct mail, product development and packaging and publication design. Clients: corporations, associations. Current clients include Cherry Creek Country Club, Tetra Tech Wired Communication Group, Miller Global Properties, Loup Development Company, Liteye MicroDisplay Systems.

Needs: Approached by 50 freelance artists/year. Works with 5 illustrators and 5 designers/year. Prefers local artists with computer experience. Works on assignment only. Uses freelance designers and illustrators for brochure, catalog, magazine, direct mail and ad design; brochure, catalog and ad illustration; logos; and charts/graphs. Needs computer-literate freelancers for design, illustration and production. 90% of freelance work demands knowledge of QuarkXPress, Illustrator or Photoshop.

First Contact & Terms: Send query letter with brochure, résumé, tearsheets and photocopies. Samples are filed and are not returned. Responds only if interested. Write for appointment to show portfolio or mail appropriate materials. Portfolio should include thumbnails, roughs, b&w and color tearsheets, printed samples. Pays for design and illustration by the hour, $20-50 or by the project. Negotiates rights purchased.

Connecticut

🆖 **COPLEY MEDIAWORKS**, 18 Reef Rd., Fairfield CT 06430. Mailing address: P.O. Box 751, Fairfield CT 06430. (203)259-0525. Fax: (203)259-3321. E-mail: copley@snet.net. **Production Director:** Melissa Capasse. Estab. 1987. Number of employees: 6. Approximate annual billing: $2,600,000. Integrated marketing communications agency. Specializes in television, business-to-business print. Product specialties are sports, publishing.

Needs: Approached by 12 freelance illustrators and 20 designers/year. Works with 2 freelance illustrators and 2 designers/year. Uses freelancers mainly for brochures and ads. Also for brochure illustration, catalog design, lettering, logos, mechanicals, storyboards, TV/film graphics. 25% of work is with print ads. 100% of freelance design demands skills in PageMaker, Photoshop, QuarkXPress, Illustrator. 50% of freelance illustration demands skills in Photoshop and Illustrator.

First Contact & Terms: Send query letter with brochure and résumé. Accepts disk submissions compatible with QuarkXPress. Samples are filed. Will contact for portfolio review if interested. Pays by project. Buys all rights. Finds artists through word of mouth, magazines, submissions.

Tips: "Bring overall business sense plus sense of humor. Must be punctual, trustworthy."

🆖 **DONAHUE ADVERTISING, LLC**, 227 Lawrence St., Suite 300, Hartford CT 06106. (860)728-0000. Fax: (860)247-9247. **President:** James Donahue. Estab. 1979. Number of employees: 11. Approximate annual billing: $8 million. Ad agency. Full-service, multimedia firm. Specializes in collateral, trade ads, packaging and PR. Product specialties are computer, tool and spirits.

Needs: Approached by 15 freelancers/year. Works with 3 freelance illustrators and 3 designers/year. Prefers freelancers with experience in reproduction, tight comps and mechanicals. Uses freelancers mainly for inhouse work: brochure and print ad design, catalog design and illustration, technical and editorial illustration, mechanicals, posters, lettering and logos. 80% of freelance work demands skills in QuarkXPress, Illustrator and Photoshop.

First Contact & Terms: Send query letter with résumé and tearsheets. Samples are filed. Will contact artist for portfolio review if interested. Portfolio should include thumbnails, roughs, original/final art and tearsheets. Sometimes requests work on spec before assigning a job. Pays for design by the hour, $20-65. Pays for illustration by the project, $200-5,000 maximum. Rights purchased vary according to project.

FREELANCE EXCHANGE, INC., P.O. Box 1165, Glastonbury CT 06033-6165. (860)633-8116. Fax: (860)633-8106. E-mail: stella@freelance-exchange.com. Website: www.freelance-exchange.com. **President:** Stella Neves. Estab. 1983. Number of employees: 3. Approximate annual billing: $850,000. Specializes in annual reports, brand and corporate identity, direct mail, package and publication design, web page design, illustration (cartoon, realistic, technical, editorial, product and computer). Clients: corporations, nonprofit organizations, state and federal government agencies and ad agencies. Current clients include Lego Systems, PHS, Hartford Courant, Abrams Publishing Co., Otis Elevator, Phoenix Life Insurance Co., CIGNA, The Travelers, The Allied Group. Client list available upon request. Professional affiliations: GAIG, Connecticut Art Directors Club.

Needs: Approached by 350 freelancers/year. Works with 25-40 freelance illustrators and 30-50 designers/year. Prefers freelancers with experience in publications, website design, consumer products and desktop publishing. "Home page and website design are becoming more important and requested by clients." Works on assignment only. Uses illustrators mainly for editorial and computer illustration. Design projects vary. 100% of design and 50% of illustration demand knowledge of PageMaker, QuarkXPress, FreeHand, Illustrator, Photoshop, Persuasion, Powerpoint, Macromind Director, Page Mill or Hot Metal.

First Contact & Terms: Designers send postcard sample or query letter with résumé, SASE, brochure, tearsheets and photocopies. Illustrators send postcard sample or query letter with résumé, photocopies, photographs, SASE, slides and tearsheets. Samples are filed and are returned by SASE. Visit website for contact information. Write for appointment to show portfolio of thumbnails, roughs, final art (if appropriate) and b&w and color photostats, slides, tearsheets, photographs. Pays for design by the project, $500 minimum. Pays for illustration by the project, $300 minimum. Rights purchased vary according to project.

Tips: "Send us one sample of your best work that is unique and special. All styles and media are OK, but we're really interested in computer-generated illustration and websites. If you want to make money, learn to use the new technology. The 'New Media' is where our clients want to be, so adjust your portfolio accordingly. Your portfolio must be spectacular (I don't want to see student work). Having lots of variety and being well-organized will encourage us to take a chance on an unknown artist."

IDC, Box 312, Farmington CT 06034. (860)678-1111. Fax: (860)793-0293. E-mail: idcdesign@juno.com. Website: www.industrial-design.com. **President:** Dick Russell. Estab. 1960. Number of employees: 6-8. Specializes in industrial design and engineering. Clients: corporations. Clients include Bayer, Hanilton Sunstrand, Hubble, B/E Aerospace.

Needs: Approached by 5 freelance industrial designers/year. Works with 5-10 industrial designers/year. Prefers local freelancers. Uses designers mainly for product design. Also uses freelancers for model-making and industrial design. Needs computer-literate freelancers for design. 50% of freelance work demands knowledge of CADKey, AutoCAD or Solidworks.

First Contact & Terms: Send résumé. Responds only if interested. Designer should follow up with call after initial query. Will contact for portfolio review if interested. Portfolio should include thumbnails and roughs. Pays for design by the hour.

MACEY NOYES ASSOCIATES, INC., 232 Danbury Rd., Wilton CT 06897. (203)762-9002. Fax: (203)762-2629. E-mail: j.arena@maceynoyes.com. Website: www.maceynoyes.com. **Designer:** Jason Arena. **Structural Design Director:** Tod Dawson. Estab. 1979. Specializes in corporate and brand identity systems, graphic and structural packaging design, retail merchandising systems, naming and nomenclature systems, Internet and digital media design. Clients: corporations (marketing managers, product managers). Current clients include Duracell, Pepperidge Farm, Norelco, BDF, Comstock, Motorola, Remington, Pitney Bowes, Altec Lansing, Philips, Medeco, Targus International, Iomega Corp. Majority of clients are retail suppliers of consumer goods.

Needs: Approached by 25 artists/year. Works with 2-3 illustrators and 5 designers/year. Prefers local and international artists with experience in package comps, Macintosh and type design. Uses technical and product illustrators mainly for ad slick, in-use technical and front panel product. Uses designers for conceptual layouts and product design. Also uses freelancers for mechanicals, retouching, airbrushing, lettering, logos and industrial/structural design. Needs computer-literate freelancers for design, illustration and production. 40% of freelance work demands knowledge of QuarkXPress, Illustrator, Photoshop, Director, Flash and Shockwave.

First Contact & Terms: Send query letter with résumé. Samples are filed or are returned by SASE if requested by artist. Responds only if interested. Will contact artist for portfolio review if interested. Portfolio should include thumbnails, roughs and transparencies. Pays for design by the hour, $25-50. Pays for illustration by the project, $100-2,500. Rights purchased vary according to project. Finds new artists through sourcebooks and agents.

MCKENZIE/HUBBELL CREATIVE SERVICES, 5 Iris Lane, Westport CT 06880. (203)454-2443. Fax: (203)222-8462. E-mail: dmckenzie@mckenziehubbell.com. Website: www.mckenziehubbell.com.

Principal: Dona McKenzie. Specializes in annual reports, corporate identity, direct mail and publication design. Expanded services include: copywriting and editing, advertising and direct mail, marketing and public relations, website design and development, and multimedia and CD-ROM.

Needs: Approached by 100 freelance artists/year. Works with 5 freelance designers/year. Uses freelance designers mainly for computer design. Also uses freelance artists for brochure and catalog design. 100% of design and 50% of illustration demand knowledge of QuarkXPress 4.0, Illustrator 8.0 and Photoshop 5.5.

First Contact & Terms: Send query letter with brochure, résumé, photographs and photocopies. Samples are filed or are returned by SASE if requested by artist. Write to schedule an appointment to show a portfolio. Pays for design by the hour, $25-75. Pays for illustration by the project, $150-3,000. Rights purchased vary according to project.

⊞ REALLY GOOD COPY CO., 92 Moseley Terrace, Glastonbury CT 06033. (860)659-9487. Fax: (860)633-3238. E-mail: copyqueen@aol.com. **President:** Donna Donovan. Estab. 1982. Number of employees: 2. Ad agency. Full-service, multimedia firm. Specializes in direct mail and catalogs. Product specialties are medical/health care, consumer products and services. Current clients include The Globe-Pequot Press, Motherwear, Health Management Resources, Plow & Hearth, 1-800-FLOWERS, Mag Systems and CIGNA. Professional affiliations: Connecticut Art Directors Association, New England Mail Order Association.

Needs: Approached by 40-50 freelancers/year. Works with 1-2 freelance illustrators and 6-8 designers/year. Prefers local freelancers whenever possible. Works on assignment only. Uses freelancers for all projects. "There are no on-staff artists." 50% print, 50% web. 100% of design and 50% of illustration demand knowledge of QuarkXPress, Illustrator or Photoshop and HTML.

First Contact & Terms: Designers send query letter with résumé. Illustrators send postcard samples. Accepts disk and CD submissions. Send EPS files only. Samples are filed or are returned by SASE only if requested. Responds only if interested. Portfolio review not required, but portfolio should include roughs and original/final art. Pays for design by the hour, $50-125. Pays by the project or by the hour.

Tips: "I continue to depend upon word of mouth from other satisfied agencies and local talent. I'm fortunate to be in an area that's overflowing with good people. Send two or three good samples—not a bundle."

Delaware

⊠ ALOYSIUS BUTLER & CLARK (AB&C), 819 N. Washington St., Wilmington DE 19801. (302)655-1552. Fax: (302)655-3105. Website: www.a-b-c.com. **Contact:** Tom Desanto. Ad agency. Clients: healthcare, banks, industry, restaurants, hotels, businesses, government offices.

Needs: Works with 12 or more illustrators and 3-4 designers/year. Uses artists for trade magazines, billboards, direct mail packages, brochures, newspapers, stationery, signage and posters. 95% of design and 15% of illustration demand skills in QuarkXPress, Illustrator or Photoshop.

First Contact & Terms: Designers send query letter with résumé and photocopies. Illustrators send postcard samples. Samples are filed; except work that is returned only if requested. Responds only if interested. Works on assignment only. Pays for design by the hour, $20-50. Pays for illustration by the hour; or by the project, $250-1,000.

CUSTOM CRAFT STUDIO, 310 Edgewood St., Bridgeville DE 19933. (302)337-3347. Fax: (302)337-3444. **Vice President:** Eleanor H. Bennett. AV producer.

Needs: Works with 12 freelance illustrators and 12 designers/year. Works on assignment only. Uses freelancers mainly for work on filmstrips, slide sets, trade magazines and newspapers. Also for print finishing, color negative retouching and airbrush work. Prefers pen & ink, airbrush, watercolor and calligraphy. 10% of freelance work demands knowledge of Illustrator. Needs editorial and technical illustration.

First Contact & Terms: Send query letter with résumé, slides or photographs, brochure/flyer and tearsheets to be kept on file. Samples returned by SASE. Responds in 2 weeks. Originals not returned. Pays by the project, $25 minimum.

Washington DC

⊠ ⊞ ARNOLD & ASSOCIATES PRODUCTIONS, 21 Keiths Lane, Alexandria VA 22314. (703)837-8850. **President:** John Arnold. AV/video firm. Clients include United Airlines, Colt 45, Amtrak and US Postal Service.

Needs: Works with 30 artists/year. Prefers local artists, award-winning and experienced. "We're an established, national firm." Works on assignment only. Uses freelancers for multimedia, slide show and staging production.

First Contact & Terms: Send query letter with brochure, tearsheets, slides and photographs to be kept on file. Call for appointment to show portfolio, which should include final reproduction/product and color photographs. Pays for design by the hour, $50-100 or by the project, $500-3,500. Pays for illustration by the project, $500-4,000. Considers complexity of the project, client's budget and skill and experience of artist when establishing payment.

N ▼ LOMANGINO STUDIO INC., 1042 Wisconsin Ave., Washington DC 20007. (202)338-4110. Fax: (202)338-4111. Website: www.lomangino.com. **President:** Donna Lomangino. Estab. 1987. Number of employees: 6. Specializes in annual reports, corporate identity and publication design. Clients: corporations, nonprofit organizations. Client list available upon request. Professional affiliations: AIGA Washington DC.

Needs: Approached by 25-50 freelancers/year. Works with 1 freelance illustrator/year. Uses illustrators and production designers occasionally for publication. Also for multimedia projects. Accepts disk submissions, but not preferable. 99% of design work demands skills in Illustrator, Photoshop and QuarkXPress.

First Contact & Terms: Send postcard sample of work. Samples are filed. Will contact artist for portfolio review if interested. Pays for design and illustration by the project. Finds artists through sourcebooks, word of mouth and studio files.

Tips: "Please don't call. Send samples for consideration."

N ▼ VISUAL CONCEPTS, 5410 Connecticut Ave., Washington DC 20015. (202)362-1521. **Owner:** John Jacobin. Estab. 1984. Service-related firm. Specializes in visual presentation, mostly for retail stores. Clients: retail stores, residential and commercial spaces. Current clients include Cafe Paradiso, Urban Outfitters, Steve Madden Shoes, Guess Jean/neckwear.

Needs: Approached by 15 freelancers/year. Works with 2 freelance illustrators and 6 designers/year. Assigns 10-20 projects/year. Prefers local artists with experience in visual merchandising and 3-D exhibit building. Works on assignment only. Uses freelancers mainly for design and installation. Prefers contemporary, vintage or any classic styles. Also uses freelancers for editorial, brochure and catalog illustration, advertising design and layout, illustration, signage, and P-O-P displays.

First Contact & Terms: Contact through artist rep or send query letter with brochure showing art style or résumé and samples. Samples are filed. Responds in 2 weeks. Call for appointment to show portfolio of thumbnails, roughs and color photographs or slides. Pays for design and illustration by the hour, $6.50-30. Rights purchased vary according to project.

Florida

AURELIO & FRIENDS, INC., 14971 SW 43 Terrace, Miami FL 33185. (305)225-2434. Fax: (305)225-2121. E-mail: aurelio97@aol.com. **President:** Aurelio Sica. Vice President: Nancy Sica. Estab. 1973. Number of employees: 3. Specializes in corporate advertising and graphic design. Clients: corporations, retailers, large companies, hotels and resorts.

Needs: Approached by 4-5 freelancers/year. Works with 1-2 freelance illustrators and 3-5 designers/year. Also uses freelancers for ad design and illustration, brochure, catalog and direct mail design, and mechanicals. 50% of freelance work demands knowledge of Adobe Ilustrator, Photoshop and QuarkXPress.

First Contact & Terms: Send brochure and tearsheets. Samples are filed. Will contact artist for portfolio review if interested. Portfolio should include b&w and color final art, photographs, roughs and transparencies. Pays for design and illustration by the project. Buys all rights.

N ▼ BUGDAL GROUP INC., 7314 SW 48th St., Miami FL 33155. (305)665-6686. Fax: (305)663-1387. E-mail: bugdal@bellsouth.net. **Vice President:** Margarita Spencer. Estab. 1971. Specializes in annual reports, brand and corporate identity, displays/signage design. Clients: corporations, public agencies. Current clients include Spillis Candella & Partners, Ampco Products, Arquitectonica, Camilo Office Furniture and Hellmuth, Obata and Kassabaum. Client list available upon request.

Needs: Approached by 50 freelancers/year. Works with 1 freelance illustrator/year. Prefers local freelancers with experience in signage and corporate. Works on assignment only. Uses illustrators mainly for print, brochure, catalog and ad illustration. Needs computer-literate freelancers for illustration and production. 100% of freelance work demands knowledge of PageMaker, FreeHand, Illustrator or Photoshop.

First Contact & Terms: Send query letter with brochure, résumé, photographs and transparencies. Samples are filed. Responds only if interested. Request portfolio review in original query. Portfolio should include roughs, tearsheets and slides. "Pay depends on the job."

EXHIBIT BUILDERS INC., 150 Wildwood Rd., Deland FL 32720. (386)734-3196. Fax: (386)734-9391. E-mail: art@exhibitbuilders.com. Website: exhibitbuilders.com. **President:** Penny D. Morford. Produces themed custom trade show exhibits and distributes modular and portable displays, and sales centers. Clients: museums, primarily manufacturers, government agencies, ad agencies, tourist attractions and trade show participants.
 • Looking for freelance trade show designers.
Needs: Works on assignment only. Uses artists for exhibit/display design murals.
First Contact & Terms: Provide résumé, business card and brochure to be kept on file. Samples returned by SASE. Reports back for portfolio review. Considers complexity of project, skill and experience of artist, how work will be used, turnaround time and rights purchased when establishing payment.
Tips: "Wants to see examples of previous design work for other clients; not interested in seeing school-developed portfolios."

GOLD & ASSOCIATES INC., 6000-C Sawgrass Village Circle, Ponte Vedra Beach FL 32082. (904)285-5669. Fax: (904)285-1579. **Creative Director/President:** Keith Gold. Incorporated in 1988. Full-service multimedia communications firm. Specializes in graphic design and advertising. Product specialties are entertainment, medical, publishing, tourism and sports. Two locations. Total staff of 40+.
 • The president of GOLD & Associates believes agencies will offer more services than ever before, as commissions are reduced by clients.
Needs: Approached by over 50 freelancers/year. Works with approximately 15 freelance illustrators and 2-3 freelance designers/year. Works primarily with artist reps. Works on assignment only. Uses freelancers for annual reports, books, brochures, editorial, technical, print ad illustration; storyboards, animatics, animation, music videos. 50% of work is with print ads. 50% of freelance work demands knowledge of Illustrator, QuarkXPress and Photoshop.
First Contact & Terms: Contact through artist rep or send query letter with photocopies, tearsheets and capabilities brochure. Samples are filed. Responds only if interested. Request portfolio review in original query. Will contact artists for portfolio review if interested. Follow up with letter after initial query. Portfolio should include tearsheets. Pays for design by the hour, $35-150. "Maximum number of hours is negotiated up front." Pays for illustration by the project, $200-7,500. Buys all rights. Finds artists primarily through sourcebooks and reps.

TOM GRABOSKI ASSOCIATES, INC., 4649 Ponce de Leon Blvd., #401, Coral Gables FL 33146. (305)669-2550. Fax: (305)669-2539. E-mail: mail@tgadesign.com. **President:** Tom Graboski. Estab. 1980. Specializes in exterior/interior signage, environmental graphics, corporate identity, urban design and print graphics. Clients: corporations, cities, museums, a few ad agencies. Current clients include Universal Studios, Florida, Royal Caribbean Cruise Line, The Equity Group, Disney Development, The United States Lines, Delta Queen & American Classic Voyages.
Needs: Approached by 50-80 freelance artists/year. Works with approximately 4-8 designers/draftspersons/year. Prefers artists with a background in signage and knowledge of architecture. Freelance artists used in conjunction with signage projects, occasionally miscellaneous print graphics. 100% of design and 10% of illustration demand knowledge of PageMaker, Illustrator, QuarkXPress or FreeHand.
First Contact & Terms: Send query letter with brochure and résumé. "We will contact designer/artist to arrange appointment for portfolio review. Portfolio should be representative of artist's work and skills; presentation should be in a standard portfolio format." Pays by the project. Payment varies by experience and project. Rights purchased vary by project.
Tips: "Look at what type of work the firm does. Tailor presentation to that type of work." For this firm "knowledge of environmental graphics, detailing, a plus."

STEVE POSTAL PRODUCTIONS, P.O. Box 429, Carraway St., Bostwick FL 32007-0429. (386)325-9356. E-mail: Stepostal@aol.com. Website: www.postalproductions.com. **Director:** Steve Postal. Assistant Director: Gail Postal. Estab. 1958. Number of employees: 8. Approximate annual billing: $1 million. AV firm. Full-service multimedia firm. Specializes in documentaries, feature films. Product specialty is films and videos. Professional affiliations: Directors Guild of Canada, FMPTA.
Needs: Approached by 150 freelancers/year. Works with 10 freelance illustrators and 5 designers/year. Prefers artists with experience in advertising, animation, design for posters. Works on assignment only. Uses freelancers mainly for films and film ads/VHS boxes. Also for brochure, catalog and print ad design and illustration, animation, TV/film graphics and lettering. 10% of work is with print ads. 10% of design and 15% of illustration demand knowledge of FreeHand.

First Contact & Terms: Send query letter with résumé, brochure, photocopies and SASE. Samples are filed. Responds only if interested. "Artist should follow up their mailing with at least two telephone calls within two weeks of mailing." Portfolio should include b&w and color final art, tearsheets and photographs; send ten samples of work. Pays for design and illustration by the project. Buys all rights. Finds artists through submissions.

Tips: "The one who contacts me the most wins the job!"

N ▣ 🖐 ROBERTS COMMUNICATIONS & MARKETING, INC., 5405 Cypress Center Dr., Suite 250, Tampa FL 33609-1025. (813)281-0088. Fax: (813)281-0271. Website: www.robertscommunicati ons.com. **Creative Director:** Amy Phillips. Art Directors: Susan Farrow and Jennifer Chastain. Estab. 1986. Number of employees: 13. Ad agency, PR firm. Full-service multimedia firm. Specializes in integrated communications campaigns using multiple media and promotion. Professional affiliations: AIGA, PRSA, AAF, TBAF and Pinnacle Worldwide.

Needs: Approached by 50 freelancers/year. Works with 10 freelance illustrators and designers/year. Prefers local artists with experience in conceptualization and production knowledge. Uses freelancers for billboards, brochure design and illustration, lettering, logos, mechanicals, posters, retouching and website production. 60% of work is with print ads. 80% of freelance work demands knowledge of Photoshop 5.5, QuarkXPress 4.0 and Illustrator 8.0.

First Contact & Terms: Send postcard sample or query letter with photocopies, résumé and SASE. Samples are filed or are returned by SASE if requested by artist. Portfolios may be dropped off every Monday. Will contact artist for portfolio review if interested. Portfolio should include b&w and color final art, roughs and thumbnails. Pays for design by the hour, $40-80; by the project, $200 minimum; by the day, $200-600. Pays for illustration by the project, negotiable. Refers to Graphic Arts Guild Handbook for fee structure. Rights purchased vary according to project. Finds artists through agents, sourcebooks, seeing actual work done for others, annuals (*Communication Arts*, *Print*, *One Show*, etc.).

Tips: Impressed by "work that demonstrates knowledge of product, willingness to work within budget, contributing to creative process, delivering on-time."

▣ VAN VECHTEN & COMPANY PUBLIC RELATIONS, P.O. Box 99, Boca Raton FL 33429. (561)243-2900. E-mail: vanveco@aol.com. **President:** Jay Van Vechten. Number of employees: 8. Approximate annual billing: $1.5 million. PR firm. Clients: medical, consumer products, industry. Client list available for SASE.

Needs: Approached by 20 freelancers/year. Works with 4 freelance illustrators and 4 designers/year. Works on assignment only. Uses artists for editorial and medical illustration, consumer and trade magazines, brochures, newspapers, stationery, signage, AV presentations and press releases. 100% of freelance work demands computer skills.

First Contact & Terms: Send query letter with brochure, résumé, business card, photographs or photostats. Samples not returned. Responds only if interested. Pays for design and illustration by the project. Considers client's budget when establishing payment. Buys all rights.

Tips: Advises freelancers starting out in the field to research agencies. "Find out what clients the agency has. Create a thumbnail sketch or original idea to get yourself in the door."

🏆 🖐 MICHAEL WOLK DESIGN ASSOCIATES, 3841 NE Second Ave., Suite #303, Miami FL 33137-3639. (305)576-2898. Fax: (305)576-2899. E-mail: mwolk@wolkdesign.com. Website: www.wolkd esign.com. **Creative Director:** Michael Wolk. Estab. 1985. Specializes in corporate identity, displays, interior design and signage. Clients: corporate and private. Client list available on website.

Needs: Approached by 10 freelancers/year. Works with 5 illustrators and 5 freelance designers/year. Prefers local artists only. Works on assignment only. Needs editorial and technical illustration mainly for brochures. Uses designers mainly for interiors and graphics. Also for brochure design, mechanicals, logos and catalog illustration. Needs "progressive" illustration. Needs computer-literate freelancers for design, production and presentation. 75% of freelance work demands knowledge of PageMaker, QuarkXPress, FreeHand, Illustrator or other software.

First Contact & Terms: Send query letter with slides. Samples are not filed and are returned by SASE. Responds only if interested. To show a portfolio, mail slides. Pays for design by the hour, $10-20. Rights purchased vary according to project.

Georgia

N COMPRO PRODUCTIONS, 2080 Peachtree Industrial Court, Suite 114, Atlanta GA 30341-2281. (770)455-1943. Fax: (770)455-3356. **Creative Director:** Nels Anderson. Estab. 1977. AV firm. Specializes in film and video. Product specialties are travel industry and airlines.

Needs: Approached by 12-24 freelancers/year. Uses freelancers mainly for animation.
First Contact & Terms: Send query letter with videotape demo reel, VHS, ¾″, betacam sp. Samples are filed. Responds only if interested. Call or write for appointment to show portfolio. Buys all rights.

◻ ▓ **EJW ASSOCIATES, INC.**, (formerly EJW Associates & Trade PR Service), 1602 Abbey Court, Alpharetta GA 30004. (770)664-9322. Fax: (770)664-9324. E-mail: advertise@ejwassoc.com. Website: www.ejwassoc.com. **President:** Emil Walcek. Estab. 1980. Ad agency. Specializes in magazine ads, public relations, collateral and website design. Product specialty is business-to-business.
Needs: Works with 24 freelance illustrators and 12 designers/year. Prefers local freelancers with experience in Mac computer design and illustration and Photoshop expertise. Works on assignment only. Uses freelancers for brochure, website development, catalog and print ad design and illustration, editorial, technical illustration and logos. 50% of work is with print ads. Needs computer-literate freelancers for design, illustration, production and presentation. 75% of freelance work demands skills in FreeHand, Photoshop, web coding, FLASH.
First Contact & Terms: Send query letter with résumé, photostats, slides and website. Samples are filed or are returned by SASE if requested by artist. Responds only if interested. Write for appointment to show portfolio of thumbnails, roughs, final art, tearsheets. Pays for design by the hour, $40-80; by the day, $300-600; or by the project. Pays for illustration by the project. Buys all rights.
Tips: Looks for "experience in non-consumer, industrial or technology account work. Visit our website first—then e-mail or call. Do not send e-mail attachments."

N̄ FITZGERALD & CO., 1 Buckhead Plaza, 3060 Peachtree Rd., Suite 500, Atlanta GA 30305. (404)504-0600. Fax: (404)504-0638. **Executive Creative Director:** John Padgett. Ad agency. Full-service, multimedia firm. Specializes in TV and radio broadcast, all forms of print media, collateral and research. Product specialty is consumer. Current clients include Georgia Power, Coca-Cola USA, Chiquita and Zoo Atlanta.
Needs: Approached by 25 freelance artists/month. Works with 10 freelance illustrators and 2 freelance designers/month. Works on assignment only. Uses freelance artists mainly for illustration, storyboards, comps. Also uses freelance artists for brochure design and illustration, print ad and slide illustration, animatics, animation, retouching, TV/film graphics, lettering, logos. 50% of work is with print ads.
First Contact & Terms: Send query letter with brochure, photocopies, résumé, photographs, tearsheets and transparencies. Samples are filed. Responds only if interested. Call to schedule an appointment to show a portfolio. Portfolio should include "anything you feel is important to represent yourself." Pays for design by the hour, $25-75. Pays for illustration by the project, $250 minimum. Negotiates rights purchased.

N̄ HULSEY GRAPHICS, 130-A Townview Plaza, Suite 206, Gainesville GA 30501. (770)534-6624. Fax: (770)718-9991. E-mail: hulgraph@applied.net. Website: www.applied.net/~hulgraph. **President:** Clay Hulsey. Estab. 1989. Specializes in annual reports; brand and corporate identity; and direct mail, package and publication design. Clients: advertising agencies, banks, colleges, hospitals, corporations, real estate. Current clients include: Northeast Georgia Medical Center, Brenau University, Pittman Dental Laboratories. Client list not available.
Needs: Approached by 17 freelance artists/year. Works with 2 illustrators and 5 designers/year. Prefers local artists with experience in airbrush. Works on assignment only. Uses illustrators and designers mainly for overload work, airbrushing and editorial and technical illustration. Also for brochure, catalog, direct mail, ad and newspaper design; brochure, catalog and ad illustration; mechanicals; retouching; airbrushing; lettering; logos; and charts/graphs. Needs computer-literate freelancers for design and production. 25% of freelance work demands knowledge of QuarkXPress or FreeHand.
First Contact & Terms: Send query letter with brochure, résumé, tearsheets and nonreturnable samples. Samples are filed. Will contact artist for portfolio review if interested. Pays for design and illustration by the hour, $30-50 or by the project, $100 minimum. Rights purchased vary according to project.
Tips: Finds artists through word of mouth and artists' submissions. "Send nonreturnable samples that can be filed. I will contact the freelancer when I have a project that goes with his/her style or qualifications."

N̄ LORENC & YOO DESIGN, INC., 109 Vickery St., Roswell GA 30075. (770)645-2828. Fax: (770)998-2452. E-mail: jan@lorencyoodesign.com. Website: www.lorencyoodesign.com. **President:** Mr. Jan Lorenc. Specializes in architectural signage design; environmental, exhibit, furniture and industrial design. Clients: corporate, developers, product manufacturers, architects, real estate and institutions. Current clients include Gerald D. Hines Interests, MCI, Georgia-Pacific, IBM, Urban Retail, Mayo Clinic. Client list available upon request.
Needs: Approached by 25 freelancers/year. Works with 5 illustrators and 10 designers/year. Local senior designers only. Uses freelancers for design, illustration, brochures, catalogs, books, P-O-P displays, me-

chanicals, retouching, airbrushing, posters, direct mail packages, model-making, charts/graphs, AV materials, lettering and logos. Needs editorial and technical illustration. Especially needs architectural signage and exhibit designers. 95% of freelance work demands knowledge of QuarkXPress, Illustrator or FreeHand.

First Contact & Terms: Send brochure, weblink, or CD, résumé and samples to be kept on file. Prefers digital files as samples. Samples are filed or are returned. Call or write for appointment to show portfolio of thumbnails, roughs, original/final art, final reproduction/product and color photostats and photographs. Pays for design by the hour, $40-100; by the project, $250-20,000; by the day, $80-400. Pays for illustration by the hour, $40-100; by the project, $100-2,000; by the day, $80-400. Considers complexity of project, client's budget, and skill and experience of artist when establishing payment.

Tips: "Sometimes it's more cost-effective to use freelancers in this economy, so we have scaled down permanent staff."

N ROKFALUSI DESIGN, 2953 Crosswycke Forest Circle, Atlanta GA 30319. (404)262-2561. **Designer/Owner:** J. Mark Rokfalusi. Estab. 1982. Number of employees: 1. Approximate annual billing: $100,000. Specializes in annual reports; display, direct mail, package and publication design; and technical illustration. Clients: ad agencies, direct clients, studios, reps. Current clients include Atlanta Market Center, Hewitt Associates, Stouffer Pine Isle Resort. Professional affiliations: AIGA.

Needs: Approached by 10-20 freelancers/year. Works with 1-5 freelance illustrators/year. Uses illustrators for almost all projects. Also uses freelancers for airbrushing, audiovisual materials, catalog illustration, charts/graphs, model making and retouching. Needs computer-literate freelancers for production and presentation. 50% of freelance work demands knowledge of Illustrator, Photoshop, FreeHand, PageMaker and QuarkXPress. Send brochure, résumé and tearsheets Samples are filed. Responds only if interested. Request portfolio review in original query. Portfolio should include b&w and color final art, photographs, roughs, slides and transparencies. Pays for design and illustration by the project. Rights purchased vary according to project. Finds artists through sourcebooks, other publications, agents, submissions.

Tips: Impressed by "quality work, professional attitude. Do not call every week to see if there is anything coming up. I have a good memory and remember the right talent for the right project."

N J. WALTER THOMPSON COMPANY, One Atlanta Plaza, 950 E. Paces Ferry Rd., 30th Floor, Atlanta GA 30326. (404)365-7300. Fax: (404)365-7499. Website: www.jwtworld.com. **Executive Art Director:** Bill Tomassi. Executive Creative Director: Mike Lollis. Ad agency. Clients: mainly financial, industrial and consumer. "This office does creative work for Atlanta and the southeastern U.S."

Needs: Works on assignment only. Uses freelancers for billboards, consumer and trade magazines and newspapers. Needs computer-literate freelancers for design, production and presentation. 60% of freelance work demands skills in Illustrator, Photoshop or QuarkXPress.

First Contact & Terms: *Deals with artist reps only.* Send slides, original work, stats. Samples returned by SASE. Responds only if interested. Originals not returned. Call for appointment to show portfolio. Pays by the hour, $20-80; by the project, $100-6,000; by the day, $140-500.

Tips: Wants to see samples of work done for different clients. Likes to see work done in different mediums, variety and versatility. Freelancers interested in working here should "be *professional* and do top-grade work."

Hawaii

N MILICI VALENTI NG PACK, 999 Bishop St., 24th Floor, Honolulu HI 96813. (808)536-0881. Fax: (808)529-6208. Website: www.milici.com. **Creative Director:** Walter Wanger. Ad agency. Number of employees: 74. Approximate annual billing: $40,000,000. Serves clients in food, finance, utilities, entertainment, chemicals and personal care products. Clients include First Hawaiian Bank, Aloha Airlines, Sheraton Hotels.

Needs: Works with 2-3 freelance illustrators/month. Artists must be familiar with advertising demands; used to working long distance through the mail; and be familiar with Hawaii. Uses freelance artists mainly for illustration, retouching and lettering for newspapers, multimedia kits, magazines, radio, TV and direct mail.

First Contact & Terms: Send brochure, flier and tearsheets to be kept on file for future assignments. Pays $200-2,000.

N ERIC WOO DESIGN, INC., 733 Bishop St., Suite 1280, Honolulu HI 96813. (808)545-7442. Fax: (808)545-7445. E-mail: woostuff@hawaii.rr.com. Website: www.ericwoodesign.com. **Principal:** Eric

Woo. Estab. 1985. Number of employees: 3.5. Approximate annual billing: 500,000. Design firm. Specializes in image development, packaging, web and CD-ROM design, print. Specializes in state/corporate. Current clients include State of Hawaii and University of Hawaii. Client list available upon request.

Needs: Approached by 5-10 illustrators and 10 designers/year. Works with 1-2 illustrators/year. Prefers freelancers with experience in multimedia. Uses freelancers mainly for multimedia projects and lettering. 5% of work is with print ads. 90% of design demands skills in Photoshop, Illustrator, Quark, Flash, Go Live, Dreamweaver and Metropolis.

First Contact & Terms: Designers send query letter with brochure, photocopies, photographs, résumé, slides and tearsheets. Illustrators send postcard sample of work or query letter with brochure, photocopies, photographs, photostats, résumé, slides, tearsheets, transparencies. Send follow-up postcard samples every 1-2 months. Accepts submissions on disk in above software. Samples are filed. Will call if interested. Will contact for portfolio review of final art, photographs, photostats, roughs, slides, tearsheets, thumbnails and transparencies. Pays for design by the hour, $15-50. Pays for illustration by the project. Rights purchased vary according to project.

Tips: "Design and draw constantly. Have a good sense of humor and enjoy life."

Idaho

N ▣ ⌘ HEDDEN-NICELY & ASSOC., 1524 W. Hays St., Boise ID 83702. (208)344-4631. Fax: (208)344-2458. E-mail: tony@hedden-nicely.com. Website: www.hedden-nicely.com. **Production Coordinator:** Tony Uria. Estab. 1986. Number of employees: 3. Approximate annual billing: $300,000. Ad agency. Specializes in print materials—collateral, display, direct mail. Product specialties are industrial, manufacturing.

Needs: Approached by 5 illustrators and 10 designers/year. Works with 1 illustrator and 6 designers/year. Prefers local freelancers. Prefers that designers work electronically with own equipment. Uses freelancers mainly for logos, brochures. Also for airbrushing, animation, billboards, brochure, brochure illustration, lettering, model-making, posters, retouching, storyboards. 10% of work is with print ads. 90% of design demands knowledge of PageMaker, Photoshop, Illustrator 8.0. 40% of illustration demands knowledge of Photoshop 4.0, Illustrator 8.0.

First Contact & Terms: Designers send query letter with brochure and résumé. Illustrators send postcard sample of work. Accepts any Mac-compatible Photoshop or Adobe file on CD or e-mail. Samples are filed. Responds only if interested when an appropriate project arises. Art director will contact artists for portfolio review of color, final art, tearsheets if interested. Pays by the project. Rights purchased vary according to project, all rights preferred. "All of our freelancers have approached us through query letters or cold calls."

Illinois

BEDA DESIGN, 38663 Thorndale Place, Lake Villa IL 60046. Phone/fax: (847)245-8939. **President:** Lynn Beda. Estab. 1971. Number of employees: 2-3. Approximate annual billing: $250,000. Design firm. Specializes in packaging, publishing, film and video documentaries. Current clients include business-to-business accounts, producers to writers, directors and artists.

Needs: Approached by 6-12 illustrators and 6-12 designers/year. Works with 6 illustrators and 6 designers/year. Prefers local freelancers. Also for retouching, technical illustration and production. 50% of work is with print ads. 75% of design demands skills in Photoshop, QuarkXPress, Illustrator, Premiere, Go Live.

First Contact & Terms: Designers send query letter with brochure, photocopies and résumé. Illustrators send postcard samples and/or photocopies. Samples are filed and are not returned. Will contact for portfolio review if interested. Payments are negotiable. Buys all rights. Finds artists through word of mouth.

⌘ BENTKOVER'S DESIGN & MORE, 1222 Cavell, Suite 3C, Highland Park IL 60035. (847)831-4437. Fax: (847)831-4462. **Creative Director:** Burt Bentkover. Estab. 1989. Number of employees: 2. Approximate annual billing: $200,000. Specializes in annual reports, ads, package and brochure design. Clients: business-to-business, FOODSERVICE.

Needs: Works with 3 freelance illustrators/year. Works with artist reps. Prefers local artists only. Uses freelancers for ad and brochure illustration, airbrushing, lettering, mechanicals, retouching, desktop mechanicals and food photography. 80% of freelance work demands computer skills.

First Contact & Terms: Send brochure, photocopies and tearsheets. No original art—only disposable copies. Samples are filed. Responds in 1 week if interested. Request portfolio review in original query.

Will contact artist for portfolio review if interested. Portfolio should include b&w and color photocopies. "No final art or photographs." Pays for design and illustration by the project. Rights purchased vary according to project. Finds artists through sourcebooks and agents.

■ ⚜ **BRAGAW PUBLIC RELATIONS SERVICES**, 800 E. Northwest Hwy., Palatine IL 60067. (847)934-5580. Fax: (847)934-5596. **President:** Richard S. Bragaw. Vice President: Pattie Klein Vandenack. Number of employees: 3. PR firm. Specializes in newsletters and brochures. Clients: professional service firms, associations and industry. Current clients include Arthur Andersen, Kaiser Precision Tooling, Inc. and Nykiel-Carlin and Co., Ltd.
Needs: Approached by 12 freelancers/year. Works with 2 freelance illustrators and 2 designers/year. Prefers local freelancers only. Works on assignment only. Uses freelancers for direct mail packages, brochures, signage, AV presentations and press releases. 90% of freelance work demands knowledge of PageMaker. Needs editorial and medical illustration.
First Contact & Terms: Send query letter with brochure to be kept on file. Responds only if interested. Pays by the hour, $25-75 average. Considers complexity of project, skill and experience of artist and turnaround time when establishing payment. Buys all rights.
Tips: "We do not spend much time with portfolios."

🅽 ■ **LEE DeFOREST COMMUNICATIONS**, 300 W. Lake St., Elmhurst IL 60126. (630)834-7200. Fax: (630)834-0908. E-mail: ldc@deforestgroup.com. **Art Director:** Wendy Weaver. Estab. 1983. Number of employees: 4. AV firm. Full-service, multimedia firm. Specializes in electronic speaker support, Internet web art and meeting modules. Professional affiliations: President's Resource Group.
Needs: Approached by 50 freelance artists/year. Works with 3 freelance designers/year. Prefers artists with experience in TVL, HTML, PowerPoint (PC). Uses freelancers mainly for TVL and PowerPoint. Needs computer-literate freelancers production and presentation. 75% of work demands skills in PowerPoint 4.0, HTML, TVL.
First Contact & Terms: Send query letter with résumé, slides and video. Samples are filed or returned by SASE if requested by artist. To arrange for portfolio review artist should follow-up with call after initial query. Pays for production by the hour, $25-50. Finds designers through word of mouth and artists' submissions.
Tips: "Be hardworking, honest, and good at your craft."

DESIGN RESOURCE CENTER, 1979 N. Mill, Suite 208, Naperville IL 60565. (630)357-6008. Fax: (630)357-6040. E-mail: drc1@ix.netcom.com. Website: www.designresourcecenter.com. **President:** John Norman. Estab. 1990. Number of employees: 5. Approximate annual billing: $400,000. Specializes in package design and display, brand and corporate identity. Clients: corporations, manufacturers, private label.
Needs: Approached by 5-10 freelancers/year. Works with 3-5 freelance illustrators and 3-5 designers/year. Uses illustrators mainly for illustrating artwork for scanning. Uses designers mainly for Macintosh or concepts. Also uses freelancers for airbrushing, brochure, poster and P-O-P design and illustration, lettering, logos and package design. Needs computer-literate freelancers for design, illustration and production. 100% of freelance work demands knowledge of Illustrator 8.0, FreeHand, QuarkXPress, Photoshop.
First Contact & Terms: Send query letter with brochure, photocopies, photographs and résumé. Samples are filed. Does not reply. Artist should follow up. Portfolio review sometimes required. Portfolio should include b&w and color final art, photocopies, photographs, photostats, roughs and thumbnails. Pays for design by the hour, $10-30. Pays for illustration by the project. Buys all rights. Finds artists through word of mouth, referrals.

IDENTITY CENTER, 1110 Idaho St., Carol Stream IL 60188. E-mail: wk@identitycenter.com. Website: www.identitycenter.com. **President:** Wayne Kosterman. Number of employees: 3. Approximate annual billing: $250,000. Specializes in brand and corporate identity, print communications and signage. Clients: corporations, hospitals, manufacturers and banks. Professional affiliations: AIGA, American Center for Design, SEGD.
 • Seventeen corporate identity programs (before and after) appeared in *Design/Redesign*, a book by David Carter. More than 75 of their programs have appeared in his books over the past 18 years.
Needs: Approached by 40-50 freelancers/year. Works with 4 freelance illustrators and 4 designers/year. Prefers 3-5 years of experience minimum. Uses freelancers for editorial and technical illustration, mechanicals, retouching and lettering. 50% of freelance work demands knowledge of QuarkXPress, Photoshop, Illustrator and Dreamweaver.
First Contact & Terms: Designers send résumé and photocopies. Illustrators send postcard samples, color photocopies or other nonreturnable samples. To show a portfolio, send photocopies or e-mail. Do

not send samples you need back without checking with us first. Pays for design by the hour, $20-50. Pays for illustration by the project, $200-5,000. Considers client's budget, skill and experience of artist and how work will be used when establishing payment. Rights purchased vary according to project.
Tips: "Not interested in amateurs or 'part-timers.' "

🖼 INNOVATIVE DESIGN & GRAPHICS, 1234 Sherman Ave., Suite 214, Evanston IL 60202-1375. (847)475-7772. E-mail: idgemail@sprintmail.com. **Contact:** Tim Sonder. Clients: corporate communication and marketing departments.
Needs: Works with 1-5 freelance artists/year. Prefers local artists only. Uses artists for editorial and technical illustration and desktop (CorelDraw, FreeHand, Illustrator).
First Contact & Terms: Send query letter with résumé or brochure showing art style, tearsheets, photostats, slides and photographs. Will contact artist for portfolio review if interested. Pays for design by the hour, $20-45. Pays for illustration by the project, $200-1,000 average. Considers complexity of project, client's budget and turnaround time when establishing payment. Interested in buying second rights (reprint rights) to previously published work.
Tips: "Interested in meeting new illustrators, but have a tight schedule. Looking for people who can grasp complex ideas and turn them into high-quality illustrations. Ability to draw people well is a must. Do not call for an appointment to show your portfolio. Send nonreturnable tearsheets or self-promos, and we will call you when we have an appropriate project for you."

QUALLY & COMPANY, INC., 2238 Central St., Suite 3, Evanston IL 60201-1457. (847)864-6316. **Creative Director:** Robert Qually. Specializes in integrated marketing/communication and new product development. Clients: major corporations, high net worth individuals and think tanks.
Needs: Works with 10-12 freelancers/year. "Freelancers must have talent and the right attitude." Works on assignment only. Uses freelancers for design, copywriting, illustration, retouching, and computer production.
First Contact & Terms: Send query letter with résumé, business card and samples that we can keep on file. Call or write for appointment to show portfolio.
Tips: Looking for "people with ideas, talent, point of view, style, craftsmanship, depth and innovation" in portfolio or samples. Sees "too many look-alikes, very little innovation."

[N] JOHN STRIBIAK & ASSOCIATES, INC., 11160 SW Hwy., Palos Hills, IL 60465. (708)430-3380. Fax: (708)974-4975. Website: www.jsa@stribiak.com. **President:** John Stribiak. Estab. 1981. Number of employees: 2. Approximate annual billing: $300,000. Specializes in corporate identity and package design. Clients: corporations. Professional affiliations: IOPP, PDC.
Needs: Approached by 75-100 freelancers/year. Works with 20 freelance illustrators and 2 designers/year. Prefers artists with experience in illustration, design, retouching and packaging. Uses illustrators mainly for packaging and brochures. Uses designers mainly for new products. Also uses freelancers for ad and catalog illustration, airbrushing, brochure design and illustration, lettering, model-making and retouching. Needs computer-literate freelancers for production. 70% of freelance work demands skills in Illustrator, Photoshop and QuarkXPress.
First Contact & Terms: Send postcard sample of work. Samples are filed. Will contact artist for portfolio review if interested. Portfolio should include b&w and color roughs and transparencies. Pays for design and illustration by the project. Rights purchased vary according to project. Finds artists through sourcebooks.

[N] 🖼 TEMKIN & TEMKIN, INC., 450 Skokie Blvd., Bldg. 800, Northbrook IL 60062. (847)498-1700. Fax: (847)498-3162. E-mail: steve@temkin.com. **President:** Steve Temkin. Estab. 1945. Number of employees: 10. Ad agency. Specializes in business-to-business collateral, consumer direct mail. Product specialties are food, gifts, electronics and professional services. Current clients include Hershey Foods, Oreck Vacuum Cleaner and Michigan Bulb.
Needs: Approached by 100 freelancers/year. Works with 5-10 freelance illustrators and 10 designers/year. Prefers local artists only. Uses freelancers mainly for design, concept and comps. Also for brochure and catalog design, mechanicals and retouching. 95% of work is with print ads. Needs computer-literate freelancers for design and production. 75% of freelance work demands knowledge of Photoshop, QuarkXPress, InDesign, Draw and Illustrator.
First Contact & Terms: Send query letter with photocopies and résumé. To arrange portfolio review artist should follow up with call or letter after initial query. Portfolio should include roughs, tearsheets and thumbnails. Pays for design by the project, $250-5,000. Rights purchased vary according to project.
Tips: "Present evidence of hands-on involvement with concept and project development.

[N] WATERS & WOLFE, 1603 Orrington, Suite 990, Evanston IL 60201. (847)475-4500. Fax: (847)475-3947. E-mail: jbeuving@wnwolfe.com. Website: www.wnwolfe.com. **Senior Art Director:** Jeff Beuving.

President: Paul Frankel. Estab. 1984. Number of employees: 15. Approximate annual billing: $2 million. Ad agency, AV firm, PR firm. Full-service, multimedia firm. Specializes in collateral, annual reports, magazine ads, trade show booth design, videos, PR. "We are full service from logo design to implementation of design." Product specialty is business-to-business. Client list not available.

Needs: Approached by 50 freelancers/year. Works with 5 freelance illustrators and 5 designers/year. Uses freelancers mainly for layout and illustrations. Also for animation, lettering, logos, mechanicals, retouching, signage and TV/film graphics. 25% of work is with print ads. Needs computer-literate freelancers for design, web programming, illustration, production and presentation. 90% of freelance work demands knowledge of Photoshop 5.0, QuarkXPress 4.0, Illustrator 8.0.

First Contact & Terms: Send query letter with brochure, photocopies, photographs, résumé and tearsheets. Will also accept printouts of artist's samples. Samples are filed. Will contact artist for portfolio review if interested. Portfolio should include color final art, roughs, tearsheets and thumbnails. Pays for design by the hour or by the project. Pays for illustration by the project. Rights purchased vary according to project. Finds artists through sourcebooks, word of mouth, artists' submissions and agents.

Tips: "I am impressed by professionalism. Complete projects on timely basis, have thorough knowledge of task at hand."

Chicago

N THE CHESTNUT HOUSE GROUP INC., 1980 Berkeley Rd., Highland Park IL 60035. (847)831-0757. Fax: (847)831-2527. E-mail: chestnuthouse@compuserve.com or mileszim@attbi.com. **Contact:** Miles Zimmerman. Clients: major educational publishers.

Needs: Illustration, layout and electronic page production. Needs computer-literate freelancers for production. Uses experienced freelancers only. Freelancers should be familiar with QuarkXPress and various drawing and painting programs for illustrators. Pays for production by the hour. Pays for illustration by the project.

First Contact & Terms: "Illustrators submit samples."

N CLEARVUE, INC., 6465 N. Avondale, Chicago IL 60631. (773)775-9433. E-mail: custserv@clearvue.com. Website: www.clearvue.com. **President:** Mark Ventling. Art Department Manager: Jeffrey Hytta. Educational publishing and distribution.

Needs: Works with 1-2 freelance artists/year. Works on assignment only. Uses freelance artists mainly for catalog layout.

First Contact & Terms: Send query letter with SASE to be kept on file. Responds in 10 days. Write for appointment to show portfolio.

Tips: "Have previous layout skills."

N ◼ GETER ADVERTISING INC., 5415 N. Sheridan Rd., Suite 3607, Chicago IL 60640. (312)782-7300. **Account Executive:** Jill Rubin. Estab. 1978. Ad agency. Full-service, multimedia firm. Product specialty is professional services. Client list not available.

Needs: Approached by 20-50 freelancers/year. Permanent part-time positions in design available. Prefers artists with experience in computer layout—work done at our office. Uses freelancers mainly for print ads, brochures and outdoor design. Also uses freelancers for billboards, brochure design, logos, posters, signage and TV/film graphics. 50% of work is with print ads. Needs computer-literate freelancers for design, illustration, production and presentation. 100% of freelance work demands skills in PageMaker, FreeHand, Photoshop, QuarkXPress, Illustrator and Corel Draw (latest versions).

First Contact & Terms: Send query letter with photocopies and résumé. Samples are reviewed immediately and filed or returned. Agency will contact artist for portfolio review if interested. Portfolio should include b&w and color final art and tearsheets. Pays for design by the hour, $15-25; by the project, $50-2,000; by the day, $100-200. Buys all rights.

Tips: Impressed with freelancers who possess "skill on computer, good artistic judgment, speed, and who can work with our team."

◼ HIRSCH O'CONNOR DESIGN INC., 205 W. Wacker Dr., Suite 622, Chicago IL 60606. (312)329-1500. **Chairman:** David Hirsch. President: Joseph O'Connor. Senior Design Manager: Chris Mulligan. Number of employees: 11. Specializes in annual reports, corporate identity, publications, promotional literature, trade show design and web design. Clients: manufacturing, PR, real estate, printing, associations, financial and industrial firms. Professional affiliations: American Center for Design, AIGA and IABC.

Needs: Approached by more than 100 freelancers/year. Works with 6-10 freelance illustrators and 3-5 designers/year. Uses freelancers for illustration, brochures, retouching, AV materials, lettering and photography. Freelancers should be familiar with Photoshop and Illustrator.

First Contact & Terms: Send query letter with promotional materials showing art style or samples. Samples not filed are returned by SASE. Responds only if interested. Call for appointment to show portfolio of roughs, final reproduction/product, tearsheets and photographs. Pays for design and illustration by the project. Considers complexity of project, client's budget and how work will be used when establishing payment. Interested in buying second rights (reprint rights) to previously published work. Finds artists primarily through sourcebooks and self-promotions.

Tips: "We're always looking for talent at fair prices."

HUTCHINSON ASSOCIATES, INC., 1147 W. Ohio, Suite 305, Chicago IL 60622. (312)455-9191. Fax: (312)455-9190. E-mail: hutch@hutchinson.com. Website: www.hutchinson.com. **Contact:** Jerry Hutchinson. Estab. 1988. Number of employees: 3. Specializes in annual reports, corporate identity, publication design and website design and development. Clients: corporations, associations and PR firms. Professional affiliations: AIGA, ACD.

• Work from Hutchinson Associates has been published in the design books *Work With Computer Type* Vols. 1-3 by Rob Carter (Rotovision) and *Graphic Design 97*.

Needs: Approached by 5-10 freelancers/year. Works with 3-4 freelance illustrators and 5-15 designers/year. Uses freelancers mainly for brochure design, annual reports, multimedia and web designs. Also uses freelancers for ad and direct mail design, catalog illustration, charts/graphs, logos, multimedia projects and mechanicals.

First Contact & Terms: Send postcard sample of work or send query letter with résumé, brochure, photocopies and photographs. Accepts disk submissions. Samples are filed. Request portfolio review in original query. Artist should follow up with call. Will contact artist for portfolio review if interested. Portfolio should include transparencies and printed pieces. Pays by the project, $100-10,000. Rights purchased vary according to project. Finds artists through sourcebooks, Illinois reps, submissions.

Tips: "Persistence pays off."

KAUFMAN RYAN STRAL INC., 650 N. Dearborn St., Suite 700, Chicago IL 60610. (312)467-9494. Fax: (312)467-0298. E-mail: lkaufman@bworld.com. Website: www.bworld.com. **President/Creative Director:** Laurence Kaufman. Production Manager: Marc Turner. Estab. 1993. Number of employees: 7. Ad agency. Specializes in all materials in print and website development. Product specialty is business-to-business. Client list available upon request. Professional affiliations: BMA, American Israel Chamber of Commerce.

Needs: Approached by 30 freelancers/year. Works with 6 freelance illustrators and 5 designers/year. Prefers local freelancers. Uses freelancers for design, production, illustration and computer work. Also for brochure, catalog and print ad design and illustration, animation, mechanicals, retouching, model-making, posters, lettering and logos. 30% of work is with print ads. 50% of freelance work demands knowledge of QuarkXPress, html programs FrontPage or Page Mill, Photoshop or Illustrator.

First Contact & Terms: Send query letter with résumé and photostats. Samples are filed or returned by SASE. Responds only if interested. Artist should follow up with call and/or letter after initial query. Will contact artist for portfolio review if interested. Portfolio should include b&w and color roughs and final art. Pays for design by the hour, $40-120; or by the project. Pays for illustration by the project, $75-8,000. Buys all rights. Finds artists through sourcebooks, word of mouth, submissions.

MSR ADVERTISING, INC., P.O. Box 10214, Chicago IL 60610-0214. (312)573-0001. Fax: (312)573-1907. E-mail: marc@msradv.com. Website: msradv.com. **President:** Marc S. Rosenbaum. Vice President: Peter Miller. Art Director: Linda Gits. Office Manager: Danielle Davidson. Estab. 1983. Number of employees: 6. Approximate annual billing: $2.5 million. Ad agency. Full-service multimedia firm. Specializes in collateral. Product specialties are medical, food, industrial and aerospace. Current clients include Baxter Healthcare, Mama Tish's, Pizza Hut, hospitals, health-care, Helene Curtis, Colgate-Palmolive.

• MSR opened a Tampa, Florida office at the end of 1996 and has new clients including insurance agencies, law firms and an engineering firm interested in growing their identities in the marketplace.

Needs: Approached by 6-10 freelancers/year. Works with 5-10 freelance illustrators and 5-10 designers/year. Prefers local artists who are "innovative, resourceful and hungry." Works on assignment only. Uses freelancers mainly for creative thought boards. Also for brochure, catalog and print ad design and illustration, multimedia, storyboards, mechanicals, billboards, posters, lettering and logos. 30% of work is with print ads. 75% of design and 25% of illustration demand computer skills.

First Contact & Terms: Send query letter with brochure, photographs, photocopies, slides, SASE and résumé. Accepts submissions on disk. Samples are filed or returned. Responds in 2 weeks. Write for

appointment to show portfolio or mail appropriate materials: thumbnails, roughs, finished samples. Artist should follow up with call. Pays for design by the hour, $45-95. Buys all rights. Finds artists through submissions and agents.

Tips: "We maintain a relaxed environment designed to encourage creativity; however, work must be produced in a timely and accurate manner. Normally the best way for a freelancer to meet with us is through an introductory letter and a follow-up phone call a week later. Repeat contact every 2-4 months. Be persistent and provide outstanding representation of your work."

☑ **TESSING DESIGN, INC.**, 3822 N. Seeley Ave., Chicago IL 60618-3912. (773)525-7704. Fax: (773)525-7756. E-mail: tess46@aol.com. **Principals:** Arvid V. Tessing and Louise S. Tessing. Estab. 1975. Number of employees: 2. Specializes in corporate identity, marketing promotions and publications. Clients: publishers, educational institutions and nonprofit groups. Majority of clients are publishers. Professional affiliation: Women in Design, Chicago Book Clinic, and the Society of Typographic Arts.

Needs: Approached by 30-80 freelancers/year. Works with 3 freelance illustrators and 2 designers/year. Works on assignment only. Uses freelancers mainly for publications. Also for book and magazine design and illustration, charts/graphs and lettering. 90% of design and 75% of illustration demand knowledge of QuarkXPress, Photoshop or Illustrator. Needs textbook, editorial and technical illustration.

First Contact & Terms: Designers send query letter with photocopies. Illustrators send postcard samples. Samples are filed and are not returned. Request portfolio review in original query. Artist should follow up with letter after initial query. Will contact artist for portfolio review if interested. Portfolio should include original/final art, final reproduction/product and photographs. Pays for design by the hour, $40-60. Pays for illustration by the project, $100 minimum. Rights purchased vary according to project. Finds artists through word of mouth, submissions/self-promotions and sourcebooks.

Tips: "We prefer to see original work or slides as samples. Work sent should always relate to the need expressed. Our advice for artists to break into the field is as always—call prospective clients, show work and follow up."

Ⓝ **L.C. WILLIAMS & ASSOCIATES**, 150 N. Michigan Ave., Suite 3800, Chicago IL 60601. (312)565-3900. Fax: (312)565-1770. E-mail: ccalvert@lcwa.com. **Creative Director:** Cindy Calvert. Estab. 2000. Number of employees: 8. Approximate annual billing: $3.5 million. PR firm. Full-service multimedia firm. Specializes in marketing, communication, publicity, direct mail, brochures, newsletters, trade magazine ads, AV presentations. Product specialty is consumer home products. Current clients include Blue Cross Blue Shield, IBM, La-Z-Boy Inc. and Union Carbide. Promotional Products Association International. Professional affiliations: Chicago Direct Marketing Association, Sales & Marketing Executives of Chicago, Public Relations Society of America, Publicity Club of Chicago.

• LCWA is among the top 15 public relations agencies in Chicago. It maintains satellite offices in New York and North Carolina.

Needs: Approached by 50-100 freelancers/year. Works with 5-6 freelance illustrators and 2-5 designers/year. Works on assignment only. Uses freelancers mainly for brochures, ads, newsletters. Also for print ad design and illustration, editorial and technical illustration, mechanicals, retouching and logos. 90% of freelance work demands computer skills.

First Contact & Terms: Send query letter with brochure and résumé. Samples are filed. Does not report back. Request portfolio review in original query. Artist should call within 1 week. Portfolio should include printed pieces. Pays for design and illustration by the project, fee varies. Rights purchased vary according to project. Finds artists through word of mouth and queries.

Tips: "Many new people are opening shop and you need to keep your name in front of your prospects."

ZÜNPARTNERS INCORPORATED, (formerly Zündesign Incorporated), 35 E. Wacker Dr., Suite 1700, Chicago IL 60611. (312)494-7788. Fax: (312)494-9988. E-mail: request@zunpartners.com. Website: www.zunpartners.com. **Partners:** William Ferdinand and David Philmlee. Estab. 1991. Number of employees: 9. Specializes in annual reports, brand and corporate identity, capability brochures, package and publication design, electronic and interactive. Clients: from Fortune 500 to Internet startup companies. Current clients include Arthur Andersen, Unicom, B.P. and Sears. Client list available upon request. Professional affiliations: AIGA, ACD.

Needs: Approached by 30 freelancers/year. Works with 10-15 freelance illustrators and 15-20 designers/year. Looks for strong personal style (local and national). Uses illustrators mainly for editorial. Uses designers mainly for design and layout. Also uses freelancers for collateral and identity design, illustration; web, video, audiovisual materials; direct mail, magazine design and lettering; logos; and retouching. Needs computer-literate freelancers for design, illustration, production and presentation. 90% of freelance work demands knowledge of Illustrator, Photoshop, QuarkXPress and Director, Flash, Dreamweaver and Go Live.

First Contact & Terms: Send postcard sample of work or send query letter with brochure or résumé. Samples are filed. Responds only if interested. Portfolios may be dropped off every Friday. Artist should follow up. Portfolio should include b&w and color samples. Pays for design by the hour and by the project. Pays for illustration by the project. Rights purchased vary according to project. Finds artists through reference books and submissions.

Tips: Impressed by "to the point portfolios. Show me what you like to do and what you brought to the projects you worked on. Don't fill a book with extra items (samples) for sake of showing quantity."

Indiana

◨ BOXFIRE, (formerly C.R.E. Inc.), 400 Victoria Centre, 22 E. Washington St., Indianapolis IN 46204. (317)631-0260. E-mail: mark_gause@burnthatbox.com. Website: www.burnthatbox.com. **CEO/Creative Director:** Mark Gause. Associate Creative Directors: Mary Hayes and Sean Cunat. Art Directors: Jim Collins and Kevin Nelson. Designer: Jason Cummings. Production Coordinator: Jennifer Cannestra. Number of employees: 30. Approximate annual billing: $26 million. Ad agency. Specializes in business-to-business, food service, transportation products and services, computer equipment, medical, life sciences and electronics.

Needs: Approached by 50 freelancers/year. Works with 15 freelance illustrators and 2 designers/year. Works on assignment only. Uses freelancers for technical line art, color illustrations and airbrushing. Also for multimedia, primarily CD-ROM and Internet applications. 100% of freelance design and 25% of illustration demand computer skills.

First Contact & Terms: Send query letter with résumé and photocopies. Accepts disk submissions. Samples not filed are returned. Responds only if interested. Call or write for appointment to show portfolio, or mail final reproduction/product and tearsheets. Pays by the project, $100 minimum. Buys all rights.

Tips: "Show samples of good creative talent."

Ⓝ GRIFFIN MARKETING SERVICES, INC., 802 Wabash Ave., Chesterton IN 46304-2250. (219)929-1616. Fax: (219)921-0388. E-mail: mgriffin45@aol.com. Website: www.griffinmarketingservice s.com. **President:** Michael J. Griffin. Estab. 1974. Number of employees: 20. Approximate annual billing: $4 million. Integrated marketing firm. Specializes in collateral, direct mail, multimedia. Product specialty is industrial. Current clients include Hyatt, USX, McDonalds.

Needs: Works with 20-30 freelance illustrators and 2-30 designers/year. Prefers artists with experience in computer graphics. Uses freelancers mainly for design and illustration. Also uses freelancers for animation, model making and TV/film graphics. 75% of work is with print ads. Needs computer-literate freelancers for design, illustration, production and presentation. 95% of freelance work demands knowledge of PageMaker, FreeHand, Photoshop, QuarkXPress and Illustrator.

First Contact & Terms: Send query letter with SASE or e-mail. Samples are not filed and are returned by SASE if requested by artist. Responds in 1 month. Will contact artist for portfolio review if interested. Pays for design and illustration by the hour, $20-150; or by the project.

Tips: Finds artists through *Creative Black Book*.

Ⓝ ◨ JMH CORPORATION, 921 E. 66th St., Indianapolis IN 46220. (317)255-3400. E-mail: jmh@j mhdesign.com. Website: jmhdesign.com. **President:** J. Michael Hayes. Number of employees: 3. Specializes in annual reports, corporate identity, advertising, collateral, packaging, publications and website development. Clients: publishers, consumer product manufacturers, corporations and institutions. Professional affiliations: AIGA.

Needs: Approached by 30-40 freelancers/year. Works with 5 freelance illustrators and 2 designers/year. Prefers experienced, talented and responsible freelancers only. Works on assignment only. Uses freelancers for advertising, brochure and catalog design and illustration, P-O-P displays, retouching, charts/graphs and lettering. Needs editorial and medical illustration. 100% of design and 30% of illustration demand skills in QuarkXPress, Illustrator or Photoshop (latest versions).

First Contact & Terms: Send query letter with brochure/flyer, résumé, photocopies, photographs, tearsheets and slides. Accepts disk submissions compatible with QuarkXPress 4.0 and Illustrator 8.0. Send EPS files. Samples returned by SASE, "but we prefer to keep them." Response time "depends entirely on our needs." Write for appointment to show portfolio. Pays for design by the hour, $20-50, or by the project, $100-1,000. Pays for illustration by the project, $300-5,000.

Tips: "Prepare an outstanding mailing piece and 'leave-behind' that allows work to remain on file. Keep doing great work and stay in touch." Advises freelancers entering the field to "send samples regularly. Call to set a portfolio presentation. Do great work. Be persistent. Love what you do. Have a balanced life."

Kansas

[N] [I] BRYANT, LAHEY & BARNES, INC., 5300 Foxridge Dr., Shawnee Mission KS 66202. (913)262-7075. **Art Director:** Michael Gunther. Ad agency. Clients: agriculture and veterinary firms.
Needs: Local freelancers only. Uses freelancers for illustration and production, via Mac format only; uding keyline and paste-up; consumer and trade magazines and brochures/flyers.
First Contact & Terms: Query by phone. Send business card and résumé to be kept on file for future assignments. Originals not returned. Negotiates pay.

[■] GRETEMAN GROUP, 1425 E. Douglas Ave., Wichita KS 67211. (316)263-1004. Fax: (316)263-1060. E-mail: info@gretemangroup.com. Website: www.gretemangroup.com. **Owner:** Sonia Greteman. Estab. 1989. Number of employees: 19. Capitalized billing: $20 million. Creative agency. Specializes in corporate identity, advertising, annual reports, signage, website design, interactive media, brochures, collateral. Professional affiliations: AIGA.
Needs: Approached by 2 illustrators and 10-20 designers/year. Works with 2 illustrators and 2 designers/year. Also for brochure illustration. 10% of work is with print ads. 100% of design demands skills in PageMaker, FreeHand, Photoshop, QuarkXPress, Illustrator. 30% of illustration demands computer skills.
First Contact & Terms: Send query letter with brochure and résumé. Accepts disk submissions. Send EPS files. Samples are filed. Will contact for portfolio review of b&w and color final art and photostats if interested. Pays for design by the hour. Pays for illustration by the project. Rights purchased vary according to project.

[I] TASTEFUL IDEAS, INC., 5822 Nall Ave., Mission KS 66205. (913)722-3769. Fax: (913)722-3967. E-mail: one4ideas@aol.com. Website: www.tastefulideas.com. **President:** John Thomsen. Estab. 1986. Number of employees: 4. Approximate annual billing: $500,000. Design firm. Specializes in consumer packaging. Product specialties are largely, but not limited to, food and foodservice.
Needs: Approached by 15 illustrators and 15 designers/year. Works with 3 illustrators and 3 designers/year. Prefers local freelancers. Uses freelancers mainly for specialized graphics. Also for airbrushing, animation, humorous and technical illustration. 10% of work is with print ads. 75% of design and illustration demand skills in Photoshop and Illustrator.
First Conact & Terms: Designers send query letter with photocopies. Illustrators send query letter with photostats. Accepts disk submissions from designers and illustrators compatible with Illustrator, Photoshop—Mac based. Samples are filed. Responds only if interested. Art director will contact artist for portfolio review of final art of photostats if interested. Pays by the project. Finds artists through submissions.

Kentucky

HAMMOND DESIGN ASSOCIATES, INC., 206 W. Main, Lexington KY 40507. (859)259-3639. Fax: (859)259-3697. Website: www.hammonddesign.com. **Vice-President:** Mr. Jeff Hounshell. Estab. 1986. Specializes in direct mail, package and publication design and annual reports, brand and corporate identity, display and signage. Clients: corporations, universities and medical facilities.
Needs: Approached by 35-50 freelance/year. Works with 5-7 illustrators and 5-7 designers/year. Works on assignment only. Uses freelancers mainly for brochures and ads. Also for editorial, technical and medical illustration, airbrushing, lettering, P-O-P and poster illustration; and charts/graphs. 100% of design and 50% of illustration require computer skills.
First Contact & Terms: Send postcard sample or query letter with brochure or résumé. "Sample in query letter a must." Samples are filed or returned by SASE if requested by artist. Responds only if interested. Will contact artist for portfolio review if interested. Sometimes requests work on spec before assigning job. Pays by the project, $100-10,000. Rights negotiable.

[N] [I] MERIDIAN COMMUNICATIONS, 325 W. Main St., Suite 300, Lexington KY 40507. (859)252-3350. Fax: (859)254-5511. Website: www.meridiancomm.com. **Senior Vice President, Creative Service:** Mary Ellen Slone. Estab. 1975. Number of employees: 65. Ad agency. Full-service, multimedia firm. Specializes in ads (magazine and newspaper), grocery store handbills, TV and radio spots, packaging,

newsletters, etc. Current clients include Toyota, Big Valu, Lexmark, Fazoli's, Three Chimneys Farm, Incredipet, Vetsmart, Slone's Signature Markets, American Horseshow Association, Georgetown College, University of KY College of Fine Arts, UK Children's Hospital and Southern Belle.

Needs: Approached by 6 artists/month. Works with 2 illustrators and 3 designers/month. Prefers local artists. Works on assignment only. Uses freelancers for brochure and catalog design and illustration, print ad illustration, storyboards, animatics, animation, posters, TV/film graphics, logos. 60% of work is with print ads.

First Contact & Terms: Send query letter with résumé, photocopies, photographs and tearsheets. Samples are filed. Responds in 2 weeks. To show portfolio, mail b&w and color tearsheets and photographs. Pays negotiable rates for design and illustration. Rights purchased vary according to project.

☑ **THE WILLIAMS McBRIDE GROUP**, 344 E. Main St., Lexington KY 40507. (859)253-9319. Fax: (859)233-0180. Second location, 709 E. Market St., Louisville KY 40202. (502)583-9972. Fax: (502)583-7009. E-mail: mail@williamsmcbride.com. Website: www.williamsmcbride.com. **Partners:** Robin Williams Brohm and Kimberly McBride. Estab. 1988. Number of employees: 10. Design firm specializing in brand management, corporate identity and business-to-business marketing.

Needs: Approached by 7-10 freelance artists/year. Works with 4 illustrators and 6 designers/year. Prefers freelancers with experience in corporate design, branding. Works on assignment only. 100% of freelance design work demands knowledge of QuarkXPress, Photoshop and Illustrator. Knowledge of Director and Flash a plus.

First Contact & Terms: Designers send query letter with résumé, tearsheets or photocopies. Illustrators send postcard sample of work. Accepts electronic submissions compatible with Macintosh. Samples are filed. Responds only if interested. Pays for design by the hour, $45-65. Pays for illustration by the project, $100-3,500. Rights purchased vary according to project. Finds artists through submissions, word of mouth, *Creative Black Book*, *Workbook* and *American Showcase*, artist's representatives.

Tips: "Keep our company on your mailing list; remind us that you are out there."

Louisiana

☑ 🎭 **ANTHONY DI MARCO**, 301 Aris Ave., Metairie LA 70005. (504)833-3122. **Creative Director:** Anthony Di Marco. Estab. 1972. Number of employees: 1. Specializes in illustration, sculpture, costume design, and art photo restoration and retouching. Current clients include Audubon Institute, Louisiana Nature and Science Center, Fair Grounds Race Course, City of New Orleans, churches, agencies. Client list available upon request. Professional affiliations: Art Directors Designers Association, Entergy Arts Council, Louisiana Crafts Council, Louisiana Alliance for Conservation of Arts.

● Anthony DiMarco recently completed the re-creation of a 19th-century painting, *Life on the Metairie*, for the Fair Grounds racetrack. The original painting was destroyed by fire in 1993.

Needs: Approached by 50 or more freelancers/year. Works with 5-10 freelance illustrators and 5-10 designers/year. Seeks "local freelancers with ambition. Freelancers should have substantial portfolios and an understanding of business requirements." Uses freelancers mainly for fill-in and finish: design, illustration, mechanicals, retouching, airbrushing, posters, model-making, charts/graphs. Prefers highly polished, finished art in pen & ink, airbrush, charcoal/pencil, colored pencil, watercolor, acrylic, oil, pastel, collage and marker. 25% of freelance work demands computer skills.

First Contact & Terms: Send query letter with résumé, business card, slides, brochure, photocopies, photographs, transparencies and tearsheets to be kept on file. Samples not filed are returned by SASE. Responds in 1 week if interested. Call or write for appointment to show portfolio. Pays for illustration by the hour or by the project, $100 minimum.

Tips: "Keep professionalism in mind at all times. Put forth your best effort. Apologizing for imperfect work is a common mistake freelancers make when presenting a portfolio. Include prices for completed works (avoid overpricing). Three-dimensional works comprise more of our total commissions than before."

Ⓝ ▣ **THE O'CARROLL GROUP**, 710 W. Prien Lake Rd., Suite 209, Lake Charles LA 70601. (337)478-7396. Fax: (337)478-0503. E-mail: info@ocarroll.com. Website: www.ocarroll.com. **Contact:** Art Director. Estab. 1978. Ad agency. Specializes in newspaper, magazine, outdoor, radio and TV ads. Product specialty is consumer. Current clients include Players Casino, Greengate Garden Center and Cellular One. Client list available upon request.

Needs: Approached by 1 freelancer/month. Works with 1 illustrator every 3 months. Prefers freelancers with experience in computer graphics. Works on assignment only. Uses freelancers mainly for time-consuming computer graphics. Also for brochure and print ad illustration and storyboards. Needs website programmers. 65% of work is with print ads. 50% of freelance work demands skills in Illustrator and Photoshop.

First Contact & Terms: Send query letter with résumé and paper or electronic samples. Samples are filed or returned by SASE if requested. Responds only if interested. Will contact artist for portfolio review if interested. Pays for design by the project. Pays for illustration by the project. Rights purchased vary according to project. Find artists through viewing portfolios, submissions, word of mouth, American Advertising district conferences and conventions.

Maine

⬚ ⬛ MICHAEL MAHAN GRAPHICS, 48 Front, P.O. Box 642, Bath ME 04530-0642. (207)443-6110. Fax: (207)443-6085. E-mail: m2design@ime.net. **Contact:** Linda Delorme. Estab. 1986. Number of employees: 5. Approximate annual billing: $500,000. Design firm. Specializes in publication design—catalogs and direct mail. Product specialties are furniture, fine art and high tech. Current clients include Bowdoin College, Bath Iron Works and Bradco Chair. Client list available upon request. Professional affiliations: G.A.G., AIGA and Art Director's Club-Portland, ME.

Needs: Approached by 5-10 illustrators and 10-20 designers/year. Works with 2 illustrators and 2 designers/year. Uses freelancers mainly for production. Also for brochure, catalog and humorous illustration and lettering. 5% of work is with print ads. 100% of design demands skills in Photoshop and QuarkXPress.

First Contact & Terms: Designers send query letter with photocopies and résumé. Illustrators send query letter with photocopies. Accepts disk submissions. Samples are filed and are not returned. Responds only if interested. Art director will contact artist for portfolio review of final art roughs and thumbnails if interested. Pays for design by the hour, $15-40. Pays for illustration by the hour, $18-60. Rights purchased vary according to project. Finds artists through word of mouth and submissions.

Maryland

⬚ AVRUM I. ASHERY—GRAPHIC DESIGNER, 515 Meadow Hall Dr., Rockville MD 20851. (301)279-0648. Estab. 1968. Number of employees: 2 (part time). Specializes in brand identity, corporate identity (logo), exhibit, publication design and signage. "Specialty is Judaic design for synagogues, Jewish organizations/institutions." Current clients include U.S. Committee for Sports in Israel, Temple Emanuel Hebrew Day Institute, Jewish federations (many cities), Washington Hebrew Confederation, Masorti (conservative movement in Israel), Embassy of Israel, B'nai B'rith International. Professional affiliations: Federal Design Council, Artists Guild for Judaic Arts.

Needs: Approached by 2-3 freelancers/year. Works with 2-3 freelance illustrators and 2-3 designers/year. Prefers artists with experience in "all around illustration." Uses designers mainly for work overload (logos). Also uses freelancers for brochure design, logos and model making. Needs computer-literate freelancers for production. 20% of freelance work demands knowledge of Illustrator, Photoshop and PageMaker.

First Contact & Terms: Send postcard sample of work or send tearsheets. Samples are filed. Will contact artist for portfolio review if interested. Portfolio should include b&w and color final art and thumbnails. Pays for design and illustration by the hour or by the project. Rights purchased vary according to project. Finds artists through word of mouth.

Tips: Does not want a "trendy designer/illustrator. Have a specialty or developing interest in Judaic themes for design." Advises freelancers entering the field to "have a healthy ego. Make sure you know what constitutes good, effective, well-balanced, readable visuals. Knowing many software packages does not make a professional designer."

☑ ⬚ SAM BLATE ASSOCIATES LLC, 10331 Watkins Mill Dr., Montgomery Village MD 20886-3950. (301)840-2248. Fax: (301)990-0707. Toll-Free: (877)821-6824. E-mail: info@writephotopro.com. Website: www.writephotopro.com. **President:** Sam Blate. Number of employees: 2. Approximate annual billing: $120,000. AV and editorial services firm. Clients: business/professional, US government, private.

Needs: Approached by 6-10 freelancers/year. Works with 1-5 freelance illustrators and 1-2 designers/year. Only works with freelancers in the Washington DC metropolitan area. Works on assignment only. Uses freelancers for cartoons (especially for certain types of audiovisual presentations), editorial and technical illustrations (graphs, etc.) for 35mm and digital slides, pamphlet and book design. Especially important are "technical and aesthetic excellence and ability to meet deadlines." 80% of freelance work demands knowledge of PageMaker, Photoshop, and/or Powerpoint for Windows.

First Contact & Terms: Send query letter with résumé and website, tearsheets, brochure, photocopies, slides, transparencies or photographs to be kept on file. Accepts disk submissions compatible with Photoshop and PageMaker. IBM format only. "No original art." Samples are returned only by SASE. Responds

only if interested. Pays by the hour, $20-50. Rights purchased vary according to project, "but we prefer to purchase first rights only. This is sometimes not possible due to client demand, in which case we attempt to negotiate a financial adjustment for the artist."

Tips: "The demand for technically-oriented artwork has increased."

N ▢ FSP COMMUNICATIONS, 609 Allegheny Ave. Towson MD 21204. (410)296-8680. E-mail: fspcom@home.com. Website: www.members.home.net:80/fil/. **President:** Fil Sibley. Co-Producer: Barbara Thompson. Estab. 1981. Number of employees: 2. Approximate annual billing: $80,000. AV firm. Specializes in multimedia graphics, animation, video and still photography. Product specialties are music, education, PR, sales training. Client list available upon request.

Needs: Approached by 10 freelance illustrators and 10 designers/year. Works with 2 freelance illustrators and 2 designers/year. Prefers freelancers with experience in video and multimedia. Also for animation, brochure design and illustration, humorous illustration, lettering, logos, mechanicals, multimedia projects, posters, signage, storyboards, TV/film graphics, web page design. 10% of work is with print ads. 50% of freelance work demands skills in PageMaker, FreeHand, Photoshop, Illustrator.

First Contact & Terms: Send query letter with brochure, photographs, résumé, slides. Accepts websites and disk submissions compatible with Windows or Mac. Samples are filed or returned by SASE. Portfolio review not required. Pays by the project; negotiable. Finds artists through sourcebooks and recommendations.

Tips: Looks for freelancers who are "willing to have passion for the project and do their best and act with integrity."

N ▣ SPIRIT CREATIVE SERVICES INC., 3157 Rolling Rd., Edgewater MD 21037. (410)956-1117. Fax: (410)956-1118. Website: www.webspiritcreativeservices.com. **President:** Alice Yeager. Estab. 1992. Number of employees: 2. Approximate annual billing: $90,000. Specializes in catalogs, signage, books, annual reports, brand and corporate identity, display, direct mail, package and publication design, web page design, technical and general illustration, copywriting, photography and marketing. Clients: associations, corporations, government. Client list available upon request.

Needs: Approached by 30 freelancers/year. Works with local designers only. Uses freelancers for ad, brochure, catalog, poster and P-O-P design and illustration, books, direct mail and magazine design, audiovisual materials, crafts/graphs, lettering, logos and mechanicals. Also for multimedia and Internet projects. 100% of design and 10% of illustration demands knowledge of Illustrator, Photoshop and PageMaker, A Type Manager and QuarkXPress. Also HTML coding and knowledge of web design.

First Contact & Terms: Send 2-3 samples of work with résumé. Accepts hardcopy submissions. Samples are filed. Responds in 1-2 weeks if interested. Request portfolio review in original query. Artist should follow up with call and/or letter after initial query. Portfolio should include b&w and color final art, tearsheets, sample of comping ability. Pays for design by the project, $50-6,000.

Tips: "Paying attention to due dates, details, creativity, communication and intuition is vital."

Massachusetts

N ▣ A.T. ASSOCIATES, 63 Old Rutherford Ave., Charlestown MA 02129. (617)242-6004. **Partner:** Annette Tecce. Estab. 1976. Specializes in annual reports, industrial, interior, product and graphic design, model making, corporate identity, signage, display and packaging. Clients: nonprofit companies, high tech, medical, corporate clients, small businesses and ad agencies. Client list available upon request.

Needs: Approached by 20-25 freelance artists/year. Works with 3-4 freelance illustrators and 2-3 freelance designers/year. Prefers local artists; some experience necessary. Uses artists for posters, model making, mechanicals, logos, brochures, P-O-P display, charts/graphs and design.

First Contact & Terms: Send résumé and nonreturnable samples. Samples are filed or are returned by SASE if requested by artist. Responds only if interested. Call to schedule an appointment to show a portfolio, which should include a "cross section of your work." Pays for design and illustration by the hour or by the project. Rights purchased vary according to project.

▣ RICHARD BERTUCCI/GRAPHIC COMMUNICATIONS, 3 Juniper Lane, Dover MA 02030-2146. (508)785-1301. Fax: (508)785-2072. E-mail: rich.bert@netzero.net. **Owner:** Richard Bertucci. Estab. 1970. Number of employees: 2. Approximate annual billing: $500,000. Specializes in annual reports, corporate identity, display, direct mail, package design, print advertising, collateral material. Clients: companies and corporations. Professional affiliations: AIGA.

Needs: Approached by 12-24 freelancers/year. Works with 6 freelance illustrators and 3 designers/year. Prefers local artists with experience in business-to-business advertising. Uses illustrators mainly for feature

products. Uses designers mainly for fill-in projects, new promotions. Also uses freelancers for ad, brochure and catalog design and illustration, direct mail, magazine and newspaper design and logos. 50% of design and 25% of illustration demand knowledge of Illustrator, Photoshop and QuarkXPress.

First Contact & Terms: Send postcard sample of work or send query letter with brochure and résumé. Samples are filed. Will contact artist for portfolio review if interested. Portfolio should include b&w and color roughs. Pays for design by the project, $500-5,000. Pays for illustration by the project, $250-2,500. Rights purchased vary according to project.

Tips: "Send more information, not just a postcard with no written information." Chooses freelancers based on "quality of samples, turn-around time, flexibility, price, location."

BODZIOCH DESIGN, 30 Robbins Farm Rd., Dunstable MA 01827. (978)649-2949. Website: www.bod ziochdesign.com. Estab. 1986. Number of employees: 1. Specializes in annual reports, corporate identity and direct mail design. Clients: corporations. Current clients include Quadtech Inc., New England Business Service, Analog Devices, Inc., Centra Software, Simpley Time Recorder Co., Codem Systems, Cetan Technologies. Client list available upon request.

Needs: Works with freelance illustrators and designers. Prefers local artists with experience in direct mail and corporate work. Uses illustrators mainly for charts, graphs and spot illustration. Uses designers mainly for concept, ad and logo design. Also uses freelancers for airbrushing, brochure and direct mail design, retouching. Needs computer-literate freelancers for design, illustration, production and presentation. 90% of freelance work demands knowledge of Illustrator, Photoshop, FreeHand and QuarkXPress.

First Contact & Terms: Send postcard sample of work. Samples are filed. Will contact artist for portfolio review if interested. Portfolio should include b&w and color final art and roughs. Pays for design by the hour, or project. Pays for illustration by the project (supply quote). Rights purchased as dictated by client (usually all rights). Finds artists through *American Showcase*, *Communication Arts*, *Workbook*, *Direct Stock*, mailings from reps, and websites such as www.monster.com and www.guru.com.

FLAGLER ADVERTISING/GRAPHIC DESIGN, Box 280, Brookline MA 02446. (617)566-6971. Fax: (617)566-0073. **President/Creative Director:** Sheri Flagler. Specializes in corporate identity, brochure design, ad campaigns and package design. Clients: finance, real estate, high-tech and direct mail agencies, infant/toddler manufacturers.

Needs: Works with 10-20 freelancers/year. Works on assignment only. Uses freelancers for illustration, photography, retouching, airbrushing, charts/graphs and lettering.

First Contact & Terms: Send résumé, business card, brochures, photocopies or tearsheets to be kept on file. Call or write for appointment to show portfolio. Samples filed and are not returned. Responds only if interested. Pays for design and illustration by the project, $150-2,500. Considers complexity of project, client's budget and turnaround time when establishing payment.

Tips: "Send a range and variety of styles showing clean, crisp and professional work."

[N] DAVID FOX, PHOTOGRAPHER, 59 Fountain St., Framingham MA 01702. (508)820-1130. Fax: (508)820-0558. E-mail: foxphoto@earthlink.net. Website: www.davidfoxphotographer.com. **President:** David Fox. Estab. 1983. AV firm. Full-service photography and video firm. Specializes in training, marketing, sales, education and industrial. Product specialties are corporate and consumer. Current clients include Staples, Inc., American Heart Association, Vision Sciences, Magicfire.

• Even though this market accepts mostly photography, President David Fox remains interested in illustration for the growing needs of his company.

Needs: Approached by 0-1 freelancer/month. Works with 1-2 freelance illustrators and 1-2 designers/month. Works on assignment only. Uses freelancers mainly for logo designs and image presentation. Also for brochure, catalog and print ad design and illustration; storyboards; multimedia; animation; retouching. 10-20% of work is with print ads. 90% of freelance work demands knowledge of Illustrator and Photoshop.

First Contact & Terms: Send postcard sample or query letter with brochure, tearsheets, photographs, slides, transparencies and SASE. Accepts disk submissions compatible with Mac. Samples are filed. Does not reply. Artist should follow up. Call or write for appointment to show portfolio or mail b&w and color photographs and slides. Pays for design and illustration by the project. Buys all rights.

Tips: "Do not send original promos, slides, etc. We would prefer copies or dupes only. DVD and DCs of work acceptable as well. Work tends to be by assignment only. Most work we handle in-house but occasionally use subcontractors."

[N] G2 PARTNERS, 209 W. Central St., Natick MA 01760. (508)651-8158. Fax: (508)655-1637. Website: www.g2partners.com. Estab. 1975. Number of employees: 2. Ad Agency. Specializes in advertising, direct mail, branding programs, literature, annual reports, corporate identity. Product specialty is business-to-business.

Needs: Uses freelancers mainly for advertising, direct mail and literature. Also for brochure and print ad illustration.

First Contact & Terms: Samples are filed or are returned by SASE if requested by artist. Does not reply. Portfolio review not required. Pays for illustration by the project, $500-3,500. Finds artists through annuals and sourcebooks.

N McGRATHICS, 18 Chestnut St., Marblehead MA 01945. (781)631-7510. E-mail: www.mcgrathics.com. Website: www.mcgrathics.com. **Art Director:** Vaughn McGrath. Estab. 1978. Number of employees: 4-6. Specializes in corporate identity, annual reports, package and publication and web design. Clients: corporations and universities. Professional affiliations: AIGA, VUGB.

Needs: Approached by 30 freelancers/year. Works with 8-10 freelance illustrators/year. Uses illustrators mainly for advertising, corporate identity (both conventional and computer). Also for ad, brochure, catalog, poster and P-O-P illustration; charts/graphs. Computer and conventional art purchased.

First Contact & Terms: Send postcard sample of work or send brochure, photocopies, photographs, résumé, slides and transparencies. Samples are filed. Responds only if interested. Portfolio review not required. Pays for illustration by the hour or by the project. Rights purchased vary according to project. Finds artists through sourcebooks and mailings.

Tips: "Annually mail us updates for our review."

N DONYA MELANSON ASSOCIATES, 5 Bisson Lane, Merrimac MA 01860. (978)346-9240. Fax: (978)346-8345. E-mail: dmelanson@dmelanson.com. Website: www.dmelanson.com. **Contact:** Donya Melanson. Advertising agency. Number of employees: 6. Clients: industries, institutions, education, associations, publishers, financial services and government. Current clients include: US Geological Survey, Mannesmann, Cambridge College, American Psychological Association, Brookings Institution Press and US Dept. of Agriculture. Client list available upon request.

Needs: Approached by 30 artists/year. Works with 3-4 illustrators/year. Most work is handled by staff, but may occasionally use illustrators and designers. Uses artists for stationery design, direct mail, brochures/flyers, annual reports, charts/graphs and book illustration. Needs editorial and promotional illustration. 50% of freelance work demands skills in Illustrator, QuarkXPress or Photoshop.

First Contact & Terms: Query with brochure, résumé, photostats and photocopies. Provide materials (no originals) to be kept on file for future assignments. Originals returned to artist after use only when specified in advance. Call or write for appointment to show portfolio or mail thumbnails, roughs, final art, final reproduction/product and color and b&w tearsheets, photostats and photographs. Pays for design and illustration by the project, $100 minimum. Considers complexity of project, client's budget, skill and experience of artist and how work will be used when establishing payment.

Tips: "Be sure your work reflects concept development. We would like to see more electronic design and illustration capabilities."

✓ ♟ MONDERER DESIGN, INC., (formerly Stewart Monderer Design, Inc.), 2067 Massachusetts Ave., 3rd Floor, Cambridge MA 02140. (617)661-6125. Fax: (617)661-6152. E-mail: info@monderer.com. Website: www.monderer.com. **Creative Director:** Jeffrey Gobin. Estab. 1982. Specializes in annual reports, corporate identity, package and publication design, employee benefit programs, corporate capability brochures. Clients: corporations (hi-tech, industry, institutions, healthcare, utility, consulting, service) and nonprofit organizations. Current clients include Aspen Technology, Spotfire, eCredit.com, Dynisco, Harvard AIDS Project and Project Hope. League School, Pegasystems and Millipore. Client list on website.

Needs: Approached by 40 freelancers/year. Works with 5-10 freelance illustrators and 1-5 designers/year. Works on assignment only. Uses illustrators mainly for corporate communications. Uses designers for design and production assistance. Also uses freelancers for mechanicals and illustration. Needs computer-literate freelancers for design, illustration and production. 50% of freelance work demands knowledge of Illustrator, QuarkXPress, Photoshop or FreeHand. Needs editorial and corporate illustration.

First Contact & Terms: Send query letter with brochure, tearsheets, photographs, photocopies or nonreturnable postcards. Will look at links and PRF files. Samples are filed. Will contact artist for portfolio review if interested. Portfolio should include b&w and color-finished art samples. Sometimes requests work on spec before assigning a job. Pays for design by the hour, $15-25; by the project. Pays for illustration by the project, $250 minimum. Negotiates rights purchased. Finds artists through submissions/self-promotions and sourcebooks.

✓ RUTH MORRISON ASSOCIATES, INC., 246 Brattle St., Cambridge MA 02138. (617)354-4536. Fax: (617)354-6943. **Account Executive:** Cindy Simon. Estab. 1972. PR firm. Specializes in food, travel, design, education, non-profit. Assignments include logo/letterhead design, invitations and brochures.

Needs: Prefers local freelancers with experience in advertising and/or publishing. Other assignments include catalog, poster and print ad design. 5% of work is with print ads. 25% of freelance work demands computer skills.

First Contact & Terms: Send query letter with photocopies. Samples are filed or returned by SASE only if requested by artist. Does not reply. Pays for design and illustration by the project. Rights purchased vary according to project. Finds artists through word of mouth, magazines and advertising.

RSVP MARKETING, INC., 450 Plain St., Suite 4, Marshfield MA 02050. (781)837-2804. Fax: (781)837-5389. E-mail: rsvpmktg@aol.com. **President:** Edward C. Hicks. Direct marketing consultant services—catalogs, direct mail, brochures and telemarketing. Clients: insurance, wholesale, manufacturers and equipment distributors.

Needs: Works with 1-2 illustrators and 7-8 designers/year. Prefers local freelancers with direct marketing skills. Uses freelancers for advertising, copy and catalog design, illustration and layout, and technical illustration. Needs line art for direct mail. 80% of design and 50% of illustration demands skills in Page-Maker, QuarkXPress and Illustrator.

First Contact & Terms: Designers send query letter with résumé and finished, printed work. Illustrators send postcard sample. Samples are kept on file. Accepts disk submissions. Will contact artist for portfolio review if interested. Sometimes requests work on spec before assigning a job. Pays for design and illustration by the hour, $25-70 or by the project $300-5,000. Considers skill and experience of artist when establishing payment.

Tips: "We are an agency and therefore mark up pricing. Artists should allow for agency mark up."

SELBERT-PERKINS DESIGN COLLABORATIVE, 11 Water St., Arlington MA 02476. (781)574-6605. Fax: (781)574-6606. E-mail: eastcsd@aol.com. Website: www.selbertperkinsdesign.com. Estab. 1980. Number of employees: 50. Specializes in annual reports, brand identity design, displays, landscape architecture and urban design, direct mail, product and package design, exhibits, interactive media and CD-ROM design and print and environmental graphic design. Clients: airports, colleges, theme parks, corporations, hospitals, computer companies, retailers, financial institutions, architects. Professional affiliations: AIGA, SEGD.

- This firm has an office at 1916 Main St., Santa Monica CA 90405. (310)664-9100. Fax: (310)452-7180. E-mail: westcsd@aol.com.

Needs: Approached by "hundreds" of freelancers/year. Works with 10 freelance illustrators and 20 designers/year. Prefers artists with "experience in all types of design and computer experience." Uses freelance artists for brochures, mechanicals, logos, P-O-P, poster and direct mail. Also for multimedia projects. 100% of freelance work demands knowledge of QuarkXPress, FreeHand, Photoshop, PageMaker, Canvas and Persuasion.

First Contact & Terms: Send query letter with brochure, résumé, tearsheets, photographs, photocopies, slides and transparencies. Samples are filed. Responds only if interested. Portfolios may be dropped off every Monday-Friday. Artist should follow up with call and/or letter after initial query. Will contact artist for portfolio review if interested. Pays for design by the hour, $15-35 or by the project. Pays for illustration by the project. Rights purchased vary according to project. Finds artists through word of mouth, magazines, submissions/self-promotions, sourcebooks and agents.

SPECTRUM BOSTON CONSULTING, INC., 9 Park St., Boston MA 02108. (617)367-1008. Fax: (617)367-5824. E-mail: gboesel@spectrumboston.com. **President:** George Boesel. Estab. 1985. Specializes in brand and corporate identity, display and package design and signage. Clients: consumer, durable manufacturers.

Needs: Approached by 50 freelance artists/year. Works with 15 illustrators and 3 designers/year. All artists employed on work-for-hire basis. Works on assignment only. Uses illustrators mainly for package and brochure work. Also for brochure design and illustration, mechanicals, logos, P-O-P design and illustration and model-making. 100% of design and 85% of illustration demand knowledge of Illustrator, QuarkXPress, Photoshop or FreeHand. Needs technical and instructional illustration.

First Contact & Terms: Designers send query letter with résumé and photocopies. Illustrators send query letter with tearsheets, photographs and photocopies. Accepts any Mac-formatted disk submissions except for PageMaker. Samples are filed. Responds only if interested. Call or write for appointment to show portfolio of roughs, original/final art and color slides.

TR PRODUCTIONS, 1031 Commonwealth Ave., Boston MA 02215. (617)783-0200. Fax: (617)783-4844. Website: trprod.com. **Creative Director:** Cary M. Benjamin. Estab. 1947. Number of employees: 12. AV firm. Full-service multimedia firm. Specializes in slides, collateral, AV shows, web graphics and video.

Needs: Approached by 15 freelancers/year. Works with 5 freelance illustrators and 5 designers/year. Prefers local freelancers with experience in slides, web, multimedia, collateral and video graphics. Works on assignment only. Uses freelancers mainly for slides, web, multimedia, collateral and video graphics. Also for brochure and print ad design and illustration, slide illustration, animation and mechanicals. 25% of work is with print ads. Needs computer-literate freelancers for design, production and presentation. 95% of work demands skills in FreeHand, Photoshop, Premier, After Effects, Powerpoint, QuarkXPress, Illustrator, Flash and Front Page.
First Contact & Terms: Send query letter. Samples are filed. Does not report back. Artist should follow up with call. Will contact artist for portfolio review if interested. Rights purchased vary according to project.

TVN-THE VIDEO NETWORK, 31 Cutler Dr., Ashland MA 01721-1210. (508)881-1800. E-mail: tvnvideo@aol.com. Website: www.tvnvideo.com. **Producer:** Gregg McAllister. Estab. 1986. AV firm. Full-service multimedia firm. Specializes in video production for business, broadcast and special events. Product specialties "cover a broad range of categories." Current clients include Marriott, Digital, IBM, Waters Corp., National Park Service.
Needs: Approached by 1 freelancer/month. Works with 1 illustrator/month. Prefers freelancers with experience in Mac/NT, Amiga PC, The Video Toaster, 2D and 3D programs. Works on assignment only. Uses freelancers mainly for video production, technical illustration, flying logos and 3-D work. Also for storyboards, animation, TV/film graphics and logos.
First Contact & Terms: Send query letter with videotape or computer disk. Samples are filed or are returned. Responds in 2 weeks. Will contact artist for portfolio review if interested. Portfolio should include videotape and computer disk. Pays for design by the hour, $50; by the project, $1,000-5,000; by the day, $250-500. Buys all rights. Finds artists through word of mouth, magazines and submissions.
Tips: Advises freelancers starting out in the field to find a company internship or mentor program.

N **WAVE DESIGN WORKS**, P.O. Box 995, Norfolk MA 02056. Phone/fax: (508)541-9171. E-mail: ideas@wavedesignworks.com. **Principal:** John Buchholz. Estab. 1986. Specializes in corporate identity and display, package and publication design. Clients: corporations—primarily biotech and software. Current clients include Genzyme, New England Biolabs, Siemens Medical, Neurometrix.
Needs: Approached by 24 freelance graphic artists/year. Works with 1-5 freelance illustrators and 1-5 freelance designers/year. Works on assignment only. Uses illustrators mainly for ad illustration. Also uses freelance artists for brochure, catalog, poster and ad illustration; lettering; and charts/graphs. 100% of design and 50% of illustration demand knowledge of QuarkXPress, Illustrator or Photoshop, Indesign.
First Contact & Terms: Send query letter with brochure, résumé, photocopies, photographs, SASE, slides, transparencies and tearsheets. Accepts disk submissions compatible with above programs. Samples are filed. Responds only if interested. Artist should follow up with call and/or letter after initial query. Portfolio should include b&w and color thumbnails and final art. Pays for design by the hour, $12.50-25. Pays for illustration by the project. Rights purchased vary according to project. Finds artists through submissions and sourcebooks.

Michigan

BIGGS GILMORE COMMUNICATIONS, 261 E. Kalamazoo Ave., Suite 300, Kalamazoo MI 49007-3990. (616)349-7711. Fax: (616)349-3051. Website: www.biggs-gilmore.com. **Creative Department Office Manager:** Launa Rogers. Estab. 1973. Ad agency. Full-service, multimedia firm. Specializes in magazine and newspaper ads and collateral. Product specialties are consumer, business-to-business, marine and healthcare.
- This is one of the largest agencies in southwestern Michigan. Clients include Pharmacia, Sea Ray Boats, US Marine, Armstrong Machine Works, Union Planters Bank and Proctor & Gamble.
Needs: Approached by 10 artists/month. Works with 1-3 illustrators and designers/month. Works both with artist reps and directly with artist. Prefers artists with experience with client needs. Works on assignment only. Uses freelancers mainly for completion of projects needing specialties. Also for brochure, catalog and print ad design and illustration, storyboards, slide illustration, animatics, animation, mechanicals, retouching, billboards, posters, TV/film graphics, lettering and logos.
First Contact & Terms: Send query letter with brochure, photocopies and résumé. Samples are filed. Respondss only if interested. Call for appointment to show portfolio. Portfolio should include all samples the artist considers appropriate. Pays for design and illustration by the hour and by the project. Rights purchased vary according to project.

N ▪ **LEO J. BRENNAN, INC. Marketing Communications**, 2359 Livernois, Troy MI 48083-1692. (248)362-3131. Fax: (248)362-2355. E-mail: lbrennan@ljbrennan.com. Website: www.ljbrennan.com. **Vice President:** Virginia Janusis. Estab. 1969. Number of employees: 11. Ad agency, PR and marketing firm. Clients: industrial, electronics, robotics, automotive, banks and CPAs.
Needs: Works with 2 illustrators and 2 designers/year. Prefers experienced artists. Uses freelancers for design, technical illustration, brochures, catalogs, retouching, lettering, keylining and typesetting. Also for multimedia projects. 50% of work is with print ads. 100% of freelance work demands knowledge of IBM software graphics programs.
First Contact & Terms: Send query letter with résumé and samples. Samples not filed are returned only if requested. Responds only if interested. Call for appointment to show portfolio of thumbnails, roughs, original/final art, final reproduction/product, color and b&w tearsheets, photostats and photographs. Payment for design and illustration varies. Buys all rights.

N **COMMUNICATIONS ELECTRONICS, INC.**, Dept AM, Box 2797, Ann Arbor MI 48106-2797. (734)996-8888. E-mail: cei@usascan.com. **Editor:** Ken Ascher. Estab. 1969. Number of employees: 38. Approximate annual billing: $5 million. Manufacturer, distributor and ad agency (13 company divisions). Specializes in marketing. Clients: electronics, computers.
Needs: Approached by 500 freelancers/year. Works with 40 freelance illustrators and 40 designers/year. Uses freelancers for brochure and catalog design, illustration and layout, advertising, product design, illustration on product, P-O-P displays, posters and renderings. Needs editorial and technical illustration. Prefers pen & ink, airbrush, charcoal/pencil, watercolor, acrylic, marker and computer illustration. 30% of freelance work demands skills in PageMaker or QuarkXPress.
First Contact & Terms: Send query letter with brochure, résumé, business card, samples and tearsheets to be kept on file. Samples not filed are returned by SASE. Responds in 1 month. Will contact artist for portfolio review if interested. Pays for design and illustration by the hour, $10-120; by the project, $10-15,000; by the day, $40-800.

N ▪ **CREATIVE HOUSE MARKETING**, 222 Main St., Suite 111, Rochester MI 48307. (248)601-5223. Fax: (248)928-0473. E-mail: results@creative-house.com. **Executive Vice President/Creative Director:** Don Anderson. Estab. 1964. Full service advertising/marketing firm. Clients: home building products, sporting goods, automotive OEM, industrial manufacturing OEM, residential and commercial construction, land development, consumer, retail, finance, manufacturing, b to b and healthcare.
Needs: Assigns 20-30 jobs; buys 10-20 illustrations/year. Works with 6 illustrators and 4 designers/year. Prefers local artists. Uses freelancers for work on filmstrips, consumer and trade magazines, multimedia kits, direct mail, television, brochures/flyers and newspapers. Most of work involves illustration, design and comp layouts of ads, brochures, catalogs, annual reports and displays. 25% of work is with print ads.
First Contact & Terms: Query with résumé, business card and brochure/flier or postcard sample to be kept on file. Artist should follow up with call. Samples returned by SASE. Responds in 2 weeks. Originals not returned. Prefers to see online portfolios. Pays for design by the hour, $25-45; by the day, $240-400; or by the project. Pays for illustration by the project, $200-2,000. Considers complexity of project, client's budget and rights purchased when establishing payment. Reproduction rights are purchased as a buy-out.

N **HEART GRAPHIC DESIGN**, 501 George St., Midland MI 48640. (517)832-9710. Fax: (517)832-9420. **Owner:** Clark Most. Estab. 1982. Number of employees: 3. Approximate annual billing: $200,000. Specializes in corporate identity, magazine advertising and publication design. Clients: corporations. Current clients include Tannoy North America (Canadian Company), Snow Makers.
Needs: Approached by 6 freelancers/year. Works with 1-2 freelance illustrators and 2-3 designers/year. Uses illustrators mainly for computer illustration. Uses designers mainly for brochure design. Also uses freelancers for ad design, brochure illustration, charts/graphs, logos and mechanicals. 100% of design and 50% of illustration demands skills in Illustrator, Photoshop, FreeHand, Painter, PageMaker and QuarkXPress.
First Contact & Terms: Send postcard sample or query letter with brochure and résumé. Accepts disk submissions. Send EPS or TIFF files. Samples are filed (if interested) or returned if requested. Responds only if interested. Artist should follow up with call and/or letter after initial query. Portfolio should include b&w and color final art, photographs, roughs and transparencies. Pays for design and illustration by the project. Negotiates rights purchased. Finds artists through word of mouth, sourcebooks and design books.
Tips: "Present yourself as diligent, punctual and pliable. Let your portfolio speak for itself (it should)."

N ▪ **PHOTO COMMUNICATION SERVICES, INC.**, 6055 Robert Dr., Traverse City MI 49864. (231)943-5050. E-mail: artists@UtopianEmpire.com. Website: www.UtopianEmpire.com. **Contact:** Ms. M'Lynn Hartwell. Estab. 1970. Full-service, multimedia firm. Specializes in corporate and industrial products, as well as radio spots.

Needs: Works on assignment. Uses freelancers mainly for internet web page, brochure, catalog and print ad design and illustration storyboards, animation, logos and more. 70% of work is with print ads.

First Contact & Term: Send query with brochure, SASE and tearsheets. Samples are filed or returned by SASE if requested by artist. Responds only if interested. To show portfolio, mail tearsheets and transparencies, CD-ROM. Pays for design and illustration by the project, negotiated rate. Rights purchased vary according to project.

WILLIAM M. SCHMIDT ASSOCIATES, 1991 Severn Rd., Gross Pointe MI 48236. (313)881-8075. Fax: (313)881-1930. Website: www.wmsa.com. **President:** John M. Schmidt. Estab. 1942. Primarily specializes in product and transportation design, as well as corporate identity, displays, interior and package design, signage and technical illustration. Clients: companies and agencies. Majority of clients are in Fortune 500. Client list available upon request.

Needs: Approached by 30-40 freelance artists/year. Works with 2-3 freelance illustrators and designers/year. Prefers local artists with experience in automotive and product design. Works on assignment only. Also uses freelance artists for brochure design and illustration, mechanicals, airbrushing, logos and model-making. Needs technical illustrations. Needs computer-literate freelancers for design and production. 40% of freelance work demands computer literacy in PageMaker, FreeHand, Photoshop, Illustrator, Alias/Wavefront.

First Contact & Terms: Send query letter with résumé, SASE and slides. Samples are not filed and are returned by SASE. Responds in 2 weeks. To show a portfolio, mail slides, roughs and preliminary sketches. Pays for design and illustration by the hour, $15-30 or by the project. Buys all rights.

ROGER SHERMAN PARTNERS, INC., 15301 Century Dr., Suite 204, Dearborn MI 48120. (313)271-7240. Fax: (313)271-7506. **Contact:** Joy Walker. Interior design and contract purchasing firm providing architectural and interior design for commercial restaurants, stores, hotels, shopping centers; complete furnishing purchasing. Clients: commercial and hospitality firms.

Needs: Artists with past work experience only, able to provide photos of work and references. Works on assignment only. Uses artists for architectural renderings, furnishings, landscape and graphic design, model making and signage; also for special decor items as focal points for commercial installations, such as paintings, wood carvings, etc.

First Contact & Terms: Send query letter with brochure/flyer or résumé and samples to be kept on file. Prefers slides and examples of original work as samples. Samples not returned. Reporting time depends on scope of project. Call or write for appointment. Pays for design by the project, $300-5,000. Negotiates payment; varies according to client's budget.

Tips: "Art is used as accessories and focal points in architectural projects so the project concept will affect our design and the art we use. The economy has minimized the amount and price paid for the art we select. We still use artists to create these pieces but less often and price is a major concern to clients."

J. WALTER THOMPSON USA, 500 Woodward Ave., Detroit MI 48226-3428. (313)964-3800. **Art Administrator:** Steve Brouwer. Number of employees: 450. Approximate annual billing: $50 million. Ad agency. Clients: automotive, consumer, industry, media and retail-related accounts.

Needs: Approached by 50 freelancers/year. Works with 15 freelance illustrators and 5 designers/year. "Prefer using local talent. Will use out-of-town talent based on unique style." 75% of design and 50% of illustration demand knowledge of Photoshop. Deals primarily with established artists' representatives and art/design studios. Uses in-house computer/graphic studio.

First Contact & Terms: Send postcard sample. Assignments awarded on lowest bid. Call for appointment to show portfolio of thumbnails, roughs, original/final art, final reproduction/product, color tearsheets, photostats and photographs. Pays for design and illustration by the project.

Tips: "Portfolio should be comprehensive but not too large. Organization of the portfolio is as important as the sample. Mainly, consult professional rep."

Minnesota

BUTWIN & ASSOCIATES ADVERTISING, INC., 8700 Westmoreland Lane, Minneapolis MN 55426. Phone/fax: (952)545-3886. **President:** Ron Butwin. Estab. 1977. Ad agency. "We are a full-line ad agency working with both consumer and industrial accounts on advertising, marketing, public relations and meeting planning." Clients: banks, restaurants, clothing stores, food brokerage firms, corporations and a "full range of retail and service organizations."

● This agency offers some unique services to clients, including uniform design, interior design and display design.

Needs: Works with 10-15 illustrators and 10-12 designers/year. Prefers local artists when possible. Uses freelancers for design and illustration of brochures, catalogs, newspapers, consumer and trade magazines, P-O-P displays, retouching, animation, direct mail packages, motion pictures and lettering. 20% of work is with print ads. Prefers realistic pen & ink, airbrush, watercolor, marker, calligraphy, computer, editorial and medical illustration. Needs computer-literate freelancers for design and illustration. 40% of freelance work demands computer skills.

First Contact & Terms: Send brochure or résumé, tearsheets, photostats, photocopies, slides and photographs. Samples are filed or are returned only if SASE is enclosed. Responds only if interested. Call for appointment to show portfolio. Pays for design and illustration by the project; $25-3,000. Considers client's budget, skill and experience of artist and how work will be used when establishing payment. Buys all rights.

Tips: "Portfolios should include layouts and finished project." A problem with portfolios is that "samples are often too weak to arouse enough interest."

■ PATRICK REDMOND DESIGN, P.O. Box 75430-AGDM, St. Paul MN 55175-0430. (651)503-4480. E-mail PatrickRedmond@apexmail.com and redmond@patrickredmonddesign.com. Website (for business) www.PatrickRedmondDesign.com. **Designer/Owner/President:** Patrick M. Redmond, M.A. Estab. 1966. Number of employees: 1. Specializes in book cover design, logo and trademark design, brand and corporate identity, package, publication and direct mail design, website design, design consulting and education and posters. Has provided design services for many clients in the following categories: publishing, advertising, marketing, retail, financial, food, arts, education, computer, manufacturing, small business, healthcare, government and professions. Recent clients include: independent publishers, performing artists, etc.

Needs: Clients use freelancers mainly for editorial and technical illustration, publications, books, brochures and newsletters. Also for website and multimedia projects. 80% of freelance work demands knowledge of Macintosh, QuarkXPress, Photoshop, Illustrator, InDesign (latest versions).

First Contact & Terms: Send postcard sample and/or photocopies. Samples not filed are thrown away. No samples returned. Responds only if interested. "Artist will be contacted for portfolio review if work seems appropriate for client needs. Patrick Redmond Design will not be responsible for acceptance of delivery or return of portfolios not specifically requested from artist or rep. Samples must be presented in person unless other arrangements are made. Unless specifically agreed to in writing in advance, portfolios should not be sent unsolicited." Client pays for design and illustration by the project. Rights purchased vary according to project. Considers buying second rights (reprint rights) to previously published work. Finds artists through word of mouth, magazines, submissions/self-promotions, exhibitions, competitions, CD-ROM, sourcebooks, agents and WWW.

Tips: "Provide website address so samples of your work may be viewed on the WWW. I see trends toward extensive use of the WWW and a broader spectrum of approaches to images, subject matter and techniques. Clients also seem to have increasing interest in digitized, copyright-free stock images of all kinds." Advises freelancers starting out in the field to "create as much positive exposure for your images or design examples as possible. Make certain your name and location appear with image or design credits. Photos, illustrations and design are often noticed with serendipity. For example, your work may be just what a client needs—so make sure you have name and UFL in credit. If possible, include your e-mail address and www URL with or on your work. Do not send samples via e-mail unless specifically requested. At times, client and project demands require working in teams online, via internet, sending/receiving digital files to and from a variety of locations. *Do not* send digital files/images as attachments to e-mails unless specifically requested. Provide names of categories you specialize in, website addresses/url's where your work/images may be viewed."

Ⓝ TAKE 1 PRODUCTIONS, 9969 Valley View Rd., Minneapolis MN 55344. (952)831-7757. Fax: (952)831-2193. Website: www.take1productions.com. **Producer:** Rob Hewitt. Estab. 1985. Number of employees: 10. Approximate annual billing: $800,000. AV firm. Full-service multimedia firm. Specializes in video and multimedia production. Specialty is industrial. Current clients include 3M, NordicTrack and Kraft. Client list available upon request. Professional affiliations: MCAI, SME, IICS.

Needs: Approached by 100 freelancers/year. Works with 10 freelance illustrators/year. Prefers freelancers with experience in video production. Uses freelancers for graphics, sets. Also for animation, brochure design, logos, model making, signage and TV/film graphics. 2% of work is with print ads. 90% of freelance work demands knowledge of Photoshop and Lightwave.

First Contact & Terms: Send query letter with video. Samples are filed. Will contact artist for portfolio review if interested. Pays for design and illustration by the hour or by the project. Rights purchased vary according to project. Finds artists through sourcebooks, word of mouth.

Tips: "Tell me about work you have done with videos."

☑ ▣ ⚱ **UNO HISPANIC ADVERTISING AND DESIGN**, 2836 Lindale S., Suite 002, Minneapolis MN 55408. (612)874-1920. E-mail: unoonline.com. Website: www.unoonline.com. **Creative Director:** Luis Fitch. Marketing Director: Carolina Ornelas. Estab. 1990. Number of employees: 6. Approximate annual billing: $950,000. Specializes in brand and corporate identity, display, package and retail design and signage for the US Hispanic markets. Clients: Latin American corporations, retail. Current clients include MTV Latino, Target, Mervyn's, 3M, Dayton's, SamGoody, Univision, Wilson's. Client list available upon request. Professional affiliations: AIGA, GAG.

Needs: Approached by 33 freelancers/year. Works with 40 freelance illustrators and 20 designers/year. Works only with artists' reps. Prefers local artists with experience in retail design, graphics. Uses illustrators mainly for packaging. Uses designers mainly for retail graphics. Also uses freelancers for ad and book design, brochure, catalog and P-O-P design and illustration, audiovisual materials, logos and model making. Also for multimedia projects (Interactive Kiosk, CD-Educational for Hispanic Market). 60% of design demands computer skills in Illustrator, Photoshop, FreeHand and QuarkXPress.

First Contact & Terms: Designers send postcard sample, brochure, résumé, photographs, slides, tearsheets and transparencies. Illustrators send postcard sample, brochure, photographs, slides and tearsheets. Accepts disk submissions compatible with Illustrator, Photoshop, FreeHand. Send EPS files. Samples are filed. Will contact artist for portfolio review if interested. Portfolio should include color final art, photographs and slides. Pays for design by the project, $500-6,000. Pays for illustration by the project, $200-20,000. Rights purchased vary according to project. Finds artists through artist reps, *Creative Black Book* and *Workbook*.

Tips: "It helps to be bilingual and to have an understanding of Hispanic cultures."

Missouri

☒ ▣ **ANGEL FILMS COMPANY**, 967 Hwy. 40, New Franklin MO 65274-9778. Phone/fax: (573)698-3900. E-mail: phoenix@phoenix.org. Website: www.phoenix.org. **Vice President of Marketing/Advertising:** Linda G. Grotzinger. Vice President Production: Matthew P. Eastman. Senior Art Director: Wilhelm Von Otto. Estab. 1980. Number of employees: 9. Approximate annual billing: more than $10 million. Ad agency, AV firm, PR firm. Full-service multimedia firm. Specializes in "all forms of television and film work plus animation (both computer and art work)." Product specialties are feature films, TV productions, cosmetics. Current clients include Azian, Mesn, Angel One Records.

● Angel Films recently purchased a CD production house.

Needs: Approached by 100 freelancers/year. Works with 10 freelance illustrators and 10 designers/year. Prefers freelancers with experience in graphic arts and computers. Works on assignment only. Uses freelancers mainly for primary work ("then we computerize the work"). Also for brochure and print ad design and illustration, storyboards, animation, model-making, posters and TV/film graphics. 45% of work is with print ads. 50% of freelance work demands knowledge of Illustrator, Photoshop or CorelDraw.

First Contact & Terms: Send query letter with résumé and SASE. Samples are filed. Responds in 6 weeks. Will contact artist for portfolio review if interested. Portfolio should include b&w and color slides and computer disks (IBM). Pays for design and illustration by the hour, $9 minimum. Buys all rights.

Tips: "You can best impress us with what you can do now, not what you did ten years ago. Times change; the way people want work done changes also with the times. Disney of today is not the same as Disney of ten or five years ago."

☑ ▣ **MEDIA CONSULTANTS**, P.O. Box 130, Sikeston MO 63801. (573)472-1116. Fax: (573)472-3299. E-mail: rwrather@sbcglobal.net. **President:** Rich Wrather. Estab. 1981. Number of employees: 10. Ad agency, AV and PR firm. Full-service multimedia firm. Specializes in print, magazines, AV. Product specialty is business-to-business. Client list not available.

Needs: Appoached by 25 freelancers/year. Works with 10-15 freelance illustrators and 5-10 designers/year. Works on assignment only. Uses freelancers mainly for layout and final art. Also for brochure, catalog and print ad design and illustration, storyboards, animation, billboards, TV/film graphics and logos. 40% of work is with print ads. Needs computer-literate freelancers for design, illustration, production and presentation. 100% of freelance work demands knowledge of PageMaker, FreeHand or Photoshop.

First Contact & Terms: Send query letter with brochure, résumé, photocopies, photographs, SASE and tearsheets. Samples are filed. Will contact artist for portfolio review if interested. Portfolio should include b&w and color roughs, final art, tearsheets, photostats and photographs. Pays for design by the project, $150-1,000. Pays for illustration by the project, $25-250. Buys all rights. Finds artists through word of mouth.

Tips: Advises freelancers starting out to "accept low fees first few times to build a rapport. Put yourself on the buyer's side."

GET A FREE ISSUE OF I.D.
THE INTERNATIONAL DESIGN MAGAZINE

I.D. gives you in-depth, multi-disciplinary analysis of design trends, practices, experiments and innovators. From furniture and posters to packaging and Web sites, I.D. brings you the latest work from emerging designers.

And now you can get a **FREE** issue — with no obligation and no risk. Just send in your reply card and try I.D. today.

○ **YES!** Send my FREE issue of I.D. Magazine. If I like what I see, I'll pay just $30 for 7 more issues (8 in all) — that's a savings of 65% off the newsstand price. If not, I'll write "cancel" on the invoice, return it and owe nothing. The FREE issue is mine to keep.

Name _____

Address _____

City _____

State_____ ZIP _____

SEND NO MONEY NOW.

PLEASE CHECK ONE
- ○ **11** Independent designer
- ○ **12** Principal/design firm
- ○ **13** Designer or architect with firm/studio
- ○ **14** Design firm or studio library
- ○ **21** Designer or architect agency company or government
- ○ **22** Executive other than designer
- ○ **31** Educator, design school
- ○ **32** General interest, college library
- ○ **41** Student
- ○ **51** Other _____

I.D.® www.idonline.com

T6AB9

THE BEST IN...

PRODUCT DESIGN: from cars to kitchen sinks, tires to televisions, we cover the new and notable

GRAPHIC DESIGN: breakout design in books, periodicals, brochures, annual reports, packaging, signage and more

INTERACTIVE DESIGN: the latest games, Web sites, CD-ROMs and software

ENVIRONMENTAL DESIGN: from restaurants and museums to schools, offices and boutiques, you'll take a tour of the world's best environmental design

I.D.® THE BEST IN DESIGN

[N] [□] [▣] **PHOENIX LEARNING GROUP, INC.**, 2349 Chaffee Dr., St. Louis MO 63146. (314)569-0211. Website: phoenixlearninggroup.com. **President:** Heinz Gelles. Executive Vice President: Barbara Bryant. Vice President, Market Development: Kathy Longsworth. Number of employees: 50. Clients: libraries, museums, religious institutions, US government, schools, universities, film societies and businesses. Produces and distributes educational films.

Needs: Works with 1-2 freelance illustrators and 2-3 designers/year. Prefers local freelancers only. Uses artists for motion picture catalog sheets, direct mail brochures, posters and study guides. Also for multimedia projects. 85% of freelance work demands knowledge of PageMaker, QuarkXPress and Illustrator.

First Contact & Terms: Send postcard sample and query letter with brochure (if applicable). Send recent samples of artwork and rates to director of promotions. "No telephone calls please." Responds if need arises. Buys all rights. Keeps all original art "but will loan to artist for use as a sample." Pays for design and illustration by the hour or by the project. Rates negotiable. Free catalog upon written request.

[■] **STOBIE GROUP, LLC**, (formerly Stobie Brace Group, LLC), 240 Sovereign Court, St. Louis MO 63011. (314)256-9400. Fax: (314)256-0943. E-mail: mtuttle@stibiegroup.com. **Creative Director:** Mary Tuttle. Estab. 1935. Number of employees: 10. Approximate annual billing: $8 million. Ad agency. Full-service, multimedia firm. Product specialties are business-to-business, industrial, healthcare and consumer services. Current clients include Star Manufacturing, Cellular One, RehabCare Group, Mallinckrodt.

Needs: Approached by 100-150 freelancers/year. Works with 12 freelance illustrators and 6 designers/year. Uses freelancers for art direction, design, illustration, photography, production. Also for brochure, catalog, print ad and slide illustration. 80% of work is with print. 75% of freelance work demands knowledge of QuarkXPress, Illustrator and Photoshop. Needs technical, medical and creative illustration.

First Contact & Terms: Send query letter with résumé, photostats, photocopies, and slides. Samples are filed or are returned by SASE if requested by artist. Will contact artist for portfolio review if interested. Portfolios may be dropped off Monday-Friday. Portfolio should include thumbnails, roughs, original/final art and tearsheets. Sometimes requests work on spec before assigning a job. Pays for design by the project. Pays for illustration by the project. Negotiates rights purchased. Finds artists through word of mouth, reps and work samples.

Tips: Freelancers "must be well organized, meet deadlines, listen well and have a concise portfolio of abilities."

[N] [▼] [■] **WEST CREATIVE, INC.**, 428 W. 42nd St., Kansas City MO 64111-3176. (913)661-0561. Fax: (816)561-2688. Website: www.westcreative.com. **Creative Director:** Stan Chrzanowski. Estab. 1974. Number of employees: 8. Approximate annual billing: $600,000. Design firm and agency. Full-service, multimedia firm. Client list available upon request. Professional affiliation: AIGA.

Needs: Approached by 50 freelancers/year. Works with 4-6 freelance illustrators and 1-2 designers/year. Uses freelancers mainly for illustration. Also for animation, lettering, mechanicals, model-making, retouching and TV/film graphics. 20% of work is with print ads. Needs computer-literate freelancers for design, illustration and production. 95% of freelance work demands knowledge of FreeHand, Photoshop, QuarkXPress and Illustrator. Full service web design capabilities.

First Contact & Terms: Send postcard-size sample of work or send query letter with brochure, photocopies, résumé, SASE, slides, tearsheets and transparencies. Samples are filed or returned by SASE if requested by artist. Responds only if interested. Portfolios may be dropped off every Monday-Thursday. Portfolios should include color photographs, roughs, slides and tearsheets. "Each project is bid." Rights purchased vary according to project.

Tips: Finds artists through *Creative Black Book* and *Workbook*.

Montana

[■] **WALKER DESIGN GROUP**, 47 Dune Dr., Great Falls MT 59404. (406)727-8115. Fax: (406)791-9655. **President:** Duane Walker. Number of employees: 6. Design firm. Specializes in annual reports and corporate identity. Professional affiliations: AIGA and Ad Federation.

Needs: Uses freelancers for animation, annual reports, brochure, medical and technical illustration, catalog design, lettering, logos and TV/film graphics. 80% of design and 90% of illustration demand skills in PageMaker, Photoshop and Adobe Illustration.

First Contact & Terms: Send query letter with brochure, photocopies, photographs, résumé, slides and/or tearsheets. Accepts disk submissions. Samples are filed and are not returned. Responds only if interested. To arrange portfolio review, artist should follow up with call or letter after initial query. Portfolio should include color photographs, photostats and tearsheets. Pays by the project; negotiable. Finds artists through *Workbook*.

Tips: "Stress customer service and be very aware of time lines."

Nebraska

BRIARDY DESIGN, 5414 NW Radial Hwy., Suite 200, Omaha NE 68104. (402)561-1000. E-mail: mbriardy@briardydesign.com. Website: www.briardydesign.com. **Creative Director/Owner:** Michael P. Briardy. Estab. 1995. Number of employees: 1. Design firm. Specializes in packaging, P.O.P., corporate identity, environmental graphic design. Product specialties are food, financial, construction. Professional affiliations: AIGA, Nebraska.

● Briardi Design also has an office in Denver.

Needs: Approached by 5 illustrators and 5 designers/year. Uses freelancers for humorous, medical and technical illustration, model making and signage. 20% of work is with print ads. 90% of design demands knowledge of Photoshop 3.0, FreeHand 5.0, QuarkXPress 3.0. 50% of illustration demands knowledge of Photoshop 3.0, Illustrator 5.0, FreeHand 5.0, QuarkXPress 3.0.

First Contact & Terms: Designers send query letter with brochure, photocopies and résumé. Illustrators send postcard sample of work. Illustrators send query letter with brochure, photocopies, résumé. Send follow-up postcard samples every 6 months. Accepts disk submissions. Send EPS, FreeHand, Illustrator, TIFF, BMP or Quark 3.0 files. Samples are not filed and are not returned. Does not report back. Artist should call. Will contact artist for portfolio review of color, final art and photographs if interested. Payment negotiable. Finds artists through both word of mouth and creative sourcebooks and trade journals.

Tips: "Meet the objective on time."

MICHAEL EDHOLM DESIGN, 4201 Teri Lane, Lincoln NE 68502. (402)489-4314. Fax: (402)489-4300. E-mail: edholmdes@aol.com. **President:** Michael Edholm. Estab. 1989. Number of employees: 1. Approximate annual billing: $100,000. Specializes in annual reports; corporate identity; direct mail, package and publication design. Clients: ad agencies, insurance companies, universities and colleges, publishers, broadcasting. Professional affiliations: AIGA.

Needs: Approached by 6 freelancers/year. Also uses freelancers for ad, catalog and poster illustration; brochure design and illustration; direct mail design; logos; and model-making. 20% of freelance work demands knowledge of Illustrator, Photoshop, FreeHand, PageMaker and QuarkXPress.

First Contact & Terms: Contact through telephone or mail. Send postcard sample of work or send brochure, photocopies, SASE and tearsheets. Samples are filed. Will contact artist for portfolio review if interested. Portfolio should include b&w and color final art, photographs and slides. Pays for design and illustration by the project. Rights purchased vary according to project. Finds artists through *Workbook*, *Showcase*, direct mail pieces.

J. GREG SMITH, 1004 Farnam St., Burlington Place, Suite 102, Omaha NE 68102. (402)444-1600. **Senior Art Director:** Greg Smith. Estab. 1974. Number of employees: 8. Approximate annual billing: $1.5 million. Ad agency. Clients: financial, banking, associations, agricultural, travel and tourism, insurance. Professional affiliation: AAAA.

Needs: Approached by 1-10 freelancers/year. Works with 4-5 freelancers illustrators and 1-2 designers/year. Works on assignment only. Uses freelancers mainly for mailers, brochures and projects. Also for consumer and trade magazines, catalogs and AV presentations. Needs illustrations of farming, nature, travel.

First Contact & Terms: Send query letter with samples showing art style and/or photocopies. Responds only if interested. To show portfolio, mail final reproduction/product, color and b&w. Pays for design and illustration by the project, $500-5,000. Buys first, reprint or all rights.

WEBSTER DESIGN ASSOCIATES, INC., 5060 Dodge St., Omaha NE 68132. (402)551-0503. (402)551-1410. **Contact:** Tammy Williams. Estab. 1982. Number of employees: 12. Approximate annual billing: $16.3 million. Design firm specializing in 3 dimensional direct mail, corporate identity, human resources, print communications, web-interactive brochure/annual report design. Product specialites are telecommunications, corporate communications and human resources. Client list available upon request. Member of AIGA, Chamber of Commerce and Metro Advisory Council.

● Webster Design has chalked up a long list of awards for their exciting 3-D direct mail campaigns for clients. Work has been featured in *American Corporate Identity* and *Print's Regional Design Annual 1996*.

Needs: Approached by 50 freelance illustrators and 50-75 freelance designers/year. Works with 12 freelance illustrators and 6 freelance designers/year. Prefers national and international artists with experience

in QuarkXPress, Illustrator and Photoshop. Uses freelancers mainly for illustration, photography and annual reports. 15% of work is with print ads. 100% of freelance design and 70% of freelance illustration require knowledge of Aldus Freehand, Photoshop, Illustrator and QuarkXPress.

First Contact & Terms: Designers send brochure, photographs and résumé. Illustrators send postcard sample of work or query letter with brochure and photographs. Send follow-up postcard every 3 months. Accepts submissions on disk, Photoshop and Illustrator. EPS preferred in most cases. Sample are filed or returned. Responds only if interested. To show portfolio, artist should follow-up with a call and/or letter after initial query. Portfolio should include b&w and color tearsheets, thumbnails and transparencies. Pays by the project. Rights purchased vary according to project. Finds artists through *Creative Black Book*, magazines and submissions.

Nevada

N **I** **VISUAL IDENTITY**, 6250 Mountain Vista, L-5, Henderson NV 89014. (702)454-7773. Fax: (702)454-6293. Website: www.visualid.net. **Creative Designer:** William Garbacz. Estab. 1987. Number of employees: 5. Approximate annual billing: $500,000. Specializes in annual reports; brand and corporate identity; display, direct mail, package and publication design; signage and gaming brochures. Clients: ad agencies and corporations. Current clients include Sam's Town, Sports Club L.V. and Westward-Ho.

Needs: Approached by 50 freelancers/year. Works with 3 freelancers and 3 designers/year. Prefers local artists with experience in gaming. Uses illustrators and designers mainly for brochures and billboards. Also uses freelancers for ad, P-O-P and poster design and illustration; direct mail, magazine and newspaper design; lettering; and logos. Needs computer-literate freelancers for design, illustration, production, presentation and 3D. 99% of freelance work demands knowledge of Illustrator, Photoshop, FreeHand, QuarkXPress, Painter, Ray Dream.

First Contact & Terms: Send résumé and tearsheets. Samples are filed. Will contact artist for portfolio review if interested. Portfolio should include photocopies and roughs. Pays for design and illustration by the project, $100-1,000. Rights purchased varied according to project.

Tips: Finds artists through "any and every source available."

New Hampshire

YASVIN DESIGNERS, 45 Peterborough Rd., Box 116, Hancock NH 03449. (603)525-3000. Fax: (603)525-3300. **Contact:** Creative Director. Estab. 1990. Number of employees: 4. Specializes in annual reports, brand and corporate identity, package design and advertising. Clients: corporations, colleges and institutions.

Needs: Approached by 10-15 freelancers/year. Works with 6 freelance illustrators and 2 designers/year. Uses illustrators mainly for annual report and advertising illustration. Uses designers mainly for production, logo design. Also uses freelancers for brochure illustration and charts/graphs. Needs computer-literate freelancers for design and production. 50% of freelance work demands knowledge of Illustrator, Photoshop, FreeHand and/or QuarkXPress.

First Contact & Terms: Send postcard sample of work or send query letter with photocopies, SASE and tearsheets. Samples are filed. Responds only if interested. Request portfolio review in original query. Portfolio should include b&w and color photocopies, roughs and tearsheets. Pays for design by the project and by the day. Pays for illustration by the project. Rights purchased vary according to project. Finds artists through sourcebooks and artists' submissions.

Tips: "Show us rough sketches that describe the creative process."

New Jersey

AM/PM ADVERTISING, INC., 345 Claremont Ave., Suite 26, Montclair NJ 07402. (973)824-8600. Fax: (973)824-6631. **President:** Bob Saks. Estab. 1962. Number of employees: 130. Approximate annual billing: $24 million. Ad agency. Full-service multimedia firm. Specializes in national TV commercials and print ads. Product specialties are health and beauty aids. Current clients include J&J, Bristol Myers, Colgate Palmolive. Client list available upon request. Professional affiliations: AIGA, Art Directors Club, Illustration Club.

Needs: Approached by 35 freelancers/year. Works with 3 freelance illustrators and designers/month. Works only with artist reps. Works on assignment only. Uses freelancers mainly for illustration and design.

Also for brochure and print ad design and illustration, storyboards, slide illustration, animation, mechanicals, retouching, model-making, billboards, posters, TV/film graphics, lettering and logos and multimedia projects. 30% of work is with print ads. 50% of work demands knowledge of PageMaker, QuarkXPress, FreeHand, Illustrator or Photoshop.

First Contact & Terms: Send postcard sample and/or query letter with brochure, résumé and photocopies. Samples are filed or returned. Responds in 10 days. Portfolios may be dropped off every Friday. Artist should follow up after initial query. Portfolio should include b&w and color thumbnails, roughs, final art, tearsheets, photographs and transparencies. Pays for design by the hour, $35-100; by the project, $300-5,000; or by the day, $150-700. Pays for illustration by the project, $500-10,000. Rights purchased vary according to project.

Tips: "When showing work, give time it took to do job and costs."

CUTRO ASSOCIATES, INC., 47 Jewett Ave., Tenafly NJ 07670. (201)569-5548. Fax: (201)569-8987. E-mail: cutroassoc@aol.com. **Manager:** Ronald Cutro. Estab. 1961. Number of employees: 2. Specializes in annual reports, corporate identity, direct mail, fashion, package and publication design, technical illustration and signage. Clients: corporations, business-to-business, consumer.

Needs: Approached by 5-10 freelancers/year. Works with 2-3 freelance illustrators and 2-3 designers/year. Prefers local artists only. Uses illustrators mainly for wash drawings, fashion, specialty art. Uses designers for comp layout. Also uses freelancers for ad and brochure design and illustration, airbrushing, catalog and P-O-P illustration, direct mail design, lettering, mechanicals, and retouching. Needs computer-literate freelancers for design, illustration and production. 98% of freelance work demands knowledge of Illustrator, QuarkXPress and Photoshop.

First Contact & Terms: Send postcard sample of work. Samples are filed. Will contact artist for portfolio review if interested. Portfolio should include final art and photocopies. Pays for design and illustration by the project. Buys all rights.

NORMAN DIEGNAN & ASSOCIATES, 3 Martens Rd., Lebanon NJ 08833. (908)832-7951. **President:** N. Diegnan. Estab. 1977. Number of employees: 5. Approximate annual billing: $1 million. PR firm. Specializes in magazine ads. Product specialty is industrial.

Needs: Approached by 10 freelancers/year. Works with 20 freelancers illustrators/year. Works on assignment only. Uses freelancers for brochure, catalog and print ad design and illustration, storyboards, slide illustration, animatics, animation, mechanicals, retouching and posters. 50% of work is with print ads. Needs editorial and technical illustration.

First Contact & Terms: Send query letter with brochure and tearsheets. Samples are filed and not returned. Responds in 1 week. To show portfolio, mail roughs. Pays for design and illustration by the project. Rights purchased vary according to project.

JANUARY PRODUCTIONS, INC., 116 Washington Ave., Hawthorne NJ 07506. (201)423-4666. Fax: (201)423-5569. E-mail: awpeller@inetmail.att.net. Website: www.awpeller.com. **Art Director:** Karen Birchak. Estab. 1973. Number of employees: 12. AV producer. Serves clients in education. Produces children's educational materials—videos, sound filmstrips, read-along books, cassettes and CD-ROM.

Needs: Works with 1-2 freelance illustrators/year. "While not a requirement, a freelancer living in the same geographic area is a plus." Works on assignment only, "although if someone had a project already put together, we would consider it." Uses freelancers mainly for illustrating children's books. Also for artwork for filmstrips, sketches for books and layout work. 50% of freelance work demands knowledge of QuarkXPress and Photoshop.

First Contact & Terms: Send query letter with résumé, tearsheets, SASE, photocopies and photographs. Will contact artist for portfolio review if interested. "Include child-oriented drawings in your portfolio." Requests work on spec before assigning a job. Pays for design and illustration by the project, $20 minimum. Originals not returned. Buys all rights. Finds artists through submissions.

KJD TELEPRODUCTIONS, 30 Whyte Dr., Voorhees NJ 08043. (856)751-3500. Fax: (856)751-7729. E-mail: kjdteleproductions.com. Website: www.kjdteleproductions.com. **President:** Larry Scott. Senior Editor: Kevin Alexander. Estab. 1989. Ad agency/AV firm. Full-service multimedia firm. Specializes in magazine, radio and television. Current clients include ICI America's and Taylors Nightclub.

Needs: Works with 20 freelance illustrators and 12 designers/year. Prefers freelancers with experience in TV. Works on assignment only. Uses freelancers for brochure and print ad design and illustration, storyboards, animatics, animation, TV/film graphics. 70% of work is with print ads. Also for multimedia projects. 90% of freelance work demands knowledge of QuarkXPress, Illustrator 6.0, PageMaker and FreeHand.

First Contact & Terms: Send query letter with brochure, photographs, slides, tearsheets or transparencies and SASE. Samples are filed or are returned by SASE. Accepts submissions on disk from all applications. Send EPS files. Responds only if interested. To show portfolio, mail roughs, photographs and slides. Pays for design and illustration by the project; rate varies. Buys first rights or all rights.

PRINCETON MARKETECH, (formerly Princeton Direct, Inc.), 5 Vaughn Dr., Princeton NJ 08540. (609)520-8575. Fax: (609)520-0695. E-mail: renee@princetonmarketech.com. Website: www.princetonmarketech.com. **Creative Director:** Reneé Hobbs. Estab. 1987. Number of employees: 10. Approximate annual billing: $8 million. Ad agency. Specializes in direct mail, multimedia, web sites. Product specialties are financial, computer. Current clients include Prudential Insurance, Summit Bank, Dow Jones, Hershey Foods, Unisys. Client list available upon request.

Needs: Approached by 12 freelance illustrators and 25 designers/year. Works with 6 freelance illustrators and 10 designers/year. Prefers local designers with experience in Macintosh. Uses freelancers for airbrushing, animation, brochure design and illustration, multimedia projects, retouching, technical illustration, TV/film graphics. 10% of work is with print ads. 90% of design demands skills in Photoshop, QuarkXPress, Illustrator, Macromedia Director. 50% of illustration demands skills in Photoshop, Illustrator.

First Contact & Terms: Send query letter with résumé, tearsheets, video or sample disk. Send follow-up postcard every 6 months. Accepts disk submissions compatible with QuarkXPress, Photoshop. Send EPS, PICT files. Samples are filed. Responds only if interested. Pay negotiable. Rights purchased vary according to project.

SMITH DESIGN ASSSOCIATES, 205 Thomas St., Box 8278, Glen Ridge NJ 07028. (973)429-2177. Fax: (973)429-7119. E-mail: laraine@smithdesign.com. Website: www.smithdesign.com. **Vice President:** Laraine Blauvelt. Clients: cosmetics firms, toy manufacturers, life insurance companies, office consultants. Current clients: Popsicle, Good Humor, Breyer's and Schering Plough. Client list available upon request.

Needs: Approached by more than 100 freelancers/year. Works with 10-20 freelance illustrators and 2-3 designers/year. Requires quality and dependability. Uses freelancers for advertising and brochure design, illustration and layout, interior design, P-O-P and design consulting. 90% of freelance work demands knowledge of Illustrator, QuarkXPress, Photoshop and Painter. Needs children's, packaging and product illustration.

First Contact & Terms: Send query letter with brochure showing art style or résumé, tearsheets and photostats. Samples are filed or are returned only if requested by artist. Responds in 1 week. Call for appointment to show portfolio of color roughs, original/final art and final reproduction. Pays for design by the hour, $25-100; by the project, $175-5,000. Pays for illustration by the project, $175-5,000. Considers complexity of project and client's budget when establishing payment. Buys all rights. Also buys rights for use of existing non-commissioned art. Finds artists through word of mouth, self-promotions/sourcebooks and agents.

Advertising agencies on the East Coast are plentiful, and that is precisely why Smith Design Associates are painfully selective about the freelancers they choose. While paying up to $5,000 by the project, the firm expects a phenomenal end result each time to secure their choice reputation. This electrifying Fruit Blasters ad for Motts, Inc. is representative of the images Smith Design Associates releases for clients including toy manufacturers, cosmetic firms, and life insurance companies. Character Illustration: © Motts, Inc; Fruit Illustrations: © Rosenbaum Illustration; Tubes and Product Illustrations: © 2001 Smith Design Associates; Brand Identity and Package Design: Smith Design Associates for Mott's Inc. © 2001 Motts, Inc.

Tips: "Know who you're presenting to, the type of work we do and the quality we expect. We use more freelance artists not so much because of the economy but more for diverse styles."

N ▢ SORIN PRODUCTIONS INC., 919 Hwy. 33, Suite 46, Freehold NJ 07728. (732)462-1785. Fax: (732)462-8411. E-mail: info@sorinproductions.com. Website: www.sorinproductions.com. **President:** David Sorin. Estab. 1982. AV firm. Full-service multimedia firm. Specializes in corporate video, web, audio. Current clients include AT&T, First Fidelity Bank, J&J. Client list available upon request.
Needs: Approached by 2-3 freelance artists/month. Works with 1 freelance illustrator and designer/month. Prefers local artists only with experience in graphics for video and web. Works on assignment only. Uses artists for storyboards, animation, and TV/film graphics. 5% of work is with print ads. 75% of freelance work demands knowledge of Photoshop, QuarkXPress, Fractal Paint, Infini-D, After Effects.
First Contact & Terms: Send query letter with brochure. Samples are not filed and are returned by SASE if requested. Responds only if interested. Will contact artist for portfolio review if interested. Pays for design and illustration by the project. Buys all rights.

STRONGTYPE, 177 Oakwood Ave., P.O. Box 1520, Orange NJ 07802-1520. (973)674-3727. Fax: (973)674-8752. E-mail: talentbank@strongtype.com. Website: www.strongtype.com. **Contact:** Richard Puder. Estab. 1985. Number of employees: 1. Approximate annual billing: $300,000. Specializes in annual reports, direct mail and publication design, technical illustration. Client history includes Hewlett-Packard, Micron Electronics, R.R. Bowker, Scholastic, Simon & Schuster and Sony. Professional affiliation: Type Directors Club.
Needs: Approached by 100 freelancers/year. Uses designers mainly for corporate, publishing clients. Also uses freelancers or ad and brochure design and illustration, book, direct mail, magazine and poster design, charts/graphs, lettering, logos and retouching. 90% of freelance work demands skills in Illustrator, Photoshop, FreeHand, Acrobat, QuarkXPress, Director, Flash, Fireworks and Dreamweaver.
First Contact & Terms: Send postcard sample of work or send résumé and tearsheets. Samples are filed. Will contact artist for portfolio review if interested. Portfolio should include b&w and color photocopies, photographs, roughs and thumbnails. Pays for design and production by the hour, depending on skills, $10-100. Pays for illustration by the job. Buys first rights or rights purchased vary according to project. Finds artists through sourcebooks (e.g., *American Showcase* and *Workbook*) and by client referral.
Tips: Impressed by "listening, problem-solving, speed, technical competency and creativity."

VIDEO PIPELINE INC., 16 Haddon Ave., Haddonfield NJ 08033. (856)427-9799. Fax: (856)427-9046. E-mail: MitchC@videopipeline.com. Website: www.videopipeline.com. **President:** Jed Horovitz. Director of Production: Mitchell Canter. Estab. 1985. Number of employees: 9. Approximate annual billing: $1 million. Point of purchase firm. Specializes in video and interactive display. Product specialties are movies, music, CD-ROM, video games. Current clients include Circuit City, Best Buy, Netflix.com.
Needs: Approached by 2 freelance illustrators and 1 designer/year. Works with 1 freelance illustrator and 1 designer/year. Prefers experienced freelancers. Uses freelancers mainly for fliers, ads, logos. Also for brochure illustration, catalog and web page design, TV/film graphics. 25% of work is with print ads. 100% of freelance work demands skills in PageMaker, FreeHand, Photoshop, QuarkXPress, Illustrator, AfterEffects.
First Contact & Terms: Send query letter with résumé. Accepts disk submissions. Send EPS files. Samples are filed. Will contact for portfolio review if interested. Pays by the project. Buys all rights.

New Mexico

BOOKMAKERS LTD., P.O. Box 1086, Taos NM 87571. (505)776-5435. Fax: (505)776-2762. E-mail: bookmakers@newmex.com. Website: www.bookmakersltd.com. **President:** Gayle Crump McNeil. "We are agents for children's book illustrators and provide design and product in services to the publishing industry."
First Contact & Terms: Send query letter with samples showing style and SASE if samples need returning. Responds in 1 month.
Tips: The most common mistake freelancers make in presenting samples or portfolios is "too much variety—not enough focus."

✓ ▢ R H POWER AND ASSOCIATES, INC., 320 Osuna NE, Bldg. B, Albuquerque NM 87107. (505)761-3150. Fax: (503)761-3153. E-mail: rhpower@2west.net. Website: www.rhpower.com. **Art Director:** Bruce Yager. Creative Director: Roger L. Vergara. Estab. 1989. Number of employees: 12. Ad agency. Full-service, multimedia firm. Specializes in TV, magazine, billboard, direct mail, newspaper, radio. Prod-

uct specialties are recreational vehicles and automotive. Current clients include Kem Lite Corporation, RV Sales & Rentals of Albany, Ultra-Fab Products, Collier RV, Nichols RV, American RV and Marine. Client list available upon request.

Needs: Approached by 10-50 freelancers/year. Works with 5-10 freelance illustrators and 5-10 designers/year. Prefers freelancers with experience in retail automotive layout and design. Uses freelancers mainly for work overload, special projects and illustrations. Also for annual reports, billboards, brochure and catalog design and illustration, logos, mechanicals, posters and TV/film graphics. 50% of work is with print ads. 100% of design demands knowledge of Photoshop 6.0, QuarkXPress and Illustrator 8.0.

First Contact & Terms: Send query letter with photocopies or photographs and résumé. Accepts disk submissions in PC format compatible with CorelDraw, QuarkXPress or Illustrator 8.0. Send PC EPS files. Samples are filed and are not returned. Will contact artist for portfolio review if interested. Portfolio should include b&w and color final art, roughs and thumbnails. Pays for design and illustration by the hour, $12 minimum; by the project, $100 minimum. Buys all rights.

Tips: Impressed by work ethic and quality of finished product. "Deliver on time and within budget. Do it until it's right without charging for your own corrections."

New York

N DESIGN CONCEPTS, 137 Main St., Unadilla NY 13849. (607)369-4709. **Owner:** Carla Schroeder Burchett. Estab. 1972. Specializes in annual reports, brand identity, design and package design. Clients: corporations, individuals. Current clients include American White Cross and Private & Natural.

Needs: Approached by 6 freelance graphic artists/year. Works with 2 freelance illustrators and designers/year. Prefers artists with experience in packaging, photography, interiors. Uses freelance artists for mechanicals, poster illustration, P-O-P design, lettering and logos.

First Contact & Terms: Send query letter with tearsheets, brochure, photographs, résumé and slides. Samples are filed or are returned by SASE if requested by artist. Responds. Artists should follow up with letter after initial query. Portfolio should include thumbnails and b&w and color slides. Pays for design by the hour, $30 minimum. Negotiates rights purchased.

Tips: "Artists and designers are used according to talent; team cooperation is very important. If a person is interested and has the professional qualification, he or she should never be afraid to approach us—small or large jobs."

☑ ▣ FINE ART PRODUCTIONS, RICHIE SURACI PICTURES, MULTIMEDIA, INTERACTIVE, 67 Maple St., Newburgh NY 12550-4034. Phone/fax: (845)561-5866. E-mail: rs7fap@idsi.net. Websites: www.idsi.net/~rs7.fap/networkEROTICA.html, www.idsi.net/~rs7fap/tentsales.htm, www.woodstock69.com and www.idsi.net/~rs7ap/OPPS5.html. **Contact:** Richie Suraci. Estab. 1990. Ad agency, AV and PR firm. Full-service multimedia firm. Specializes in film, video, print, magazine, documentaries and collateral. "Product specialties cover a broad range of categories."

• Fine Art Productions is looking for artists who specialize in science fiction and erotic art for upcoming projects.

Needs: Approached by 288 freelancers/year. Works with 1-6 freelance illustrators and 1-6 designers/year. "Everyone is welcome to submit work for consideration in all media." Works on assignment only. Uses freelancers for brochure, catalog and print ad design and illustration, storyboards, slide illustration, animatics, animation, mechanicals, retouching, billboards, posters, TV/film graphics, lettering and logos. Also for multimedia projects. Needs editorial, technical, science fiction, jungle, adventure, children's, fantasy and erotic illustration. 20% of work is with print ads. 50% of freelance work demands knowledge of "all state-of-the-art software."

First Contact & Terms: Send query letter with brochure, photocopies, résumé, photographs, tearsheets, photostats, slides, transparencies and SASE. Accepts submissions on disk compatible with Macintosh format. Samples are filed or returned by SASE if requested by artist. Responds in 1-2 years if interested. Will contact artist for portfolio review if interested. Portfolio should include thumbnails, roughs, b&w and color photostats, tearsheets, photographs, slides and transparencies. Requests work on spec before assigning a job. Pays for design and illustration by the project; negotiable. Rights purchased vary according to project.

Tips: "We need more freelance artists. Submit your work for consideration in field of interest specified."

GARRITY COMMUNICATIONS, INC., 217 N. Aurora St., Ithaca NY 14850. (607)272-1323. Website: www.garrity.com. **Art Director:** Steve Carver. Estab. 1978. Ad agency, AV firm. Specializes in trade ads, newspaper ads, annual reports, video, etc. Product specialties are financial services, industrial.

Needs: Approached by 8 freelance artists/month. Works with 2 freelance illustrators and 1 freelance designer/month. Works on assignment only. Uses freelance artists mainly for work overflow situations;

some logo specialization. Also uses freelance artists for brochure design and illustration, print ad illustration, TV/film graphics and logos. 40% of work is with print ads. 90% of freelance work demands knowledge of PageMaker (IBM) or Corel.

First Contact & Terms: Send query letter with brochure and photocopies. Samples are filed and are not returned. Responds only if interested. Will contact artist for portfolio review if interested. Pays for design by the hour, $15-50. Pays for illustration by the project, $150-500. Rights purchased vary according to project. Finds artists through sourcebooks, submissions.

⊠ HUMAN RELATIONS MEDIA, 175 Tompkins Ave., Pleasantville NY 10570. (914)769-6900. E-mail: hrm@aol.com. **Editor-in-Chief, President:** Anson W. Schloat. Number of employees: 18. Approximate annual billing: $5 million. AV firm. Clients: junior and senior high schools, colleges.
Needs: Approached by 25 freelancers/year. Works with 10-15 freelance illustrators/year and 10-15 designers/year. Prefers local freelancers. Uses artists for illustration for print, video and advertising. Computer graphics preferred for video. Increasing need for illustrators.
First Contact & Terms: Send query letter with résumé and samples to be kept on file. Samples not filed are returned by SASE. Responds only if interested. Call for appointment to show portfolio of videotape, slides or tearsheets. Pays for illustration by the project, $65-15,000. Rights purchased vary according to project.
Tips: "We're looking for talented artists, illustrators, CD-ROM developers and graphics arts personnel with experience."

⊠ ▣ IMAC, Inter-Media Art Center, 370 New York Ave., Huntington NY 11743. (631)549-9666. Fax: (631)549-9423. **Executive Director:** Michael Rothbard. Estab. 1974. AV firm. Full-service, multimedia firm. Specializes in TV and multimedia productions.
Needs: Approached by 12 freelancers/month. Works with 3 illustrators and 2 designers/month. Prefers freelancers with experience in computer graphics. Uses freelancers mainly for animation, TV/film graphics and computer graphics. 50% of work is with print ads.
First Contact & Terms: Send query letter with photographs. Samples are not filed and are not returned. Responds in 10 days. Rights purchased vary according to project.

⊠ LEONE DESIGN GROUP INC., 7 Woodland Ave., Larchmont NY 10538. (914)834-5700. Fax: (914)834-6190. E-mail: leonegroup@earthlink.net. Website: www.leonedesign.com. **President:** Lucian J. Leone. Specializes in corporate identity, publications, signage and exhibition design. Clients: nonprofit organizations, museums, corporations, government agencies. Client list not available. Professional affiliations: AAM, SEGD, MAAM, AASLH, NAME.
Needs: Approached by 30-40 freelancers/year. Works with 10-15 freelance designers/year. Uses freelancers for exhibition design, brochures, catalogs, mechanicals, model making, charts/graphs and AV materials. Needs computer-literate freelancers for design and presentation. 100% of freelance work demands knowledge of QuarkXPress, Photoshop, Illustrator.
First Contact & Terms: Send query letter with résumé, samples and photographs. Samples are filed unless otherwise stated. Samples not filed are returned only if requested. Responds in 2 weeks. Write for appointment to show portfolio of thumbnails, b&w and color original/final art, final reproduction/product and photographs. Pays for design by the hour, $20-45 or on a project basis. Considers client's budget and skill and experience of artist when establishing payment.

▣ McANDREW ADVERTISING, 210 Shields Rd., Red Hook NY 12571. Phone/fax: (845)756-2276. E-mail: robertrmca@aol.com. **Art/Creative Director:** Robert McAndrew. Estab. 1961. Number of employees: 3. Approximate annual billing: $225,000. Ad agency. Clients: industrial and technical firms. Current clients include Yula Corp. and Electronic Devices, Inc.
Needs: Approached by 20 freelancers/year. Works with 2 freelance illustrators and 2 designers/year. Uses mostly local freelancers. Uses freelancers mainly for design, direct mail, brochures/flyers and trade magazine ads. Needs technical illustration. Prefers realistic, precise style. Prefers pen & ink, airbrush and occasionally markers. 50% of work is with print ads. 30% of freelance work demands computer skills.
First Contact & Terms: Query with photocopies, business card and brochure/flier to be kept on file. Samples not returned. Responds in 1 month. Originals not returned. Will contact artist for portfolio review if interested. Portfolio should include roughs and final reproduction. Pays for illustration by the project, $35-300. Pays for design by the project. Considers complexity of project, client's budget and skill and experience of artist when establishing payment. Finds artists through sourcebooks, word of mouth and business cards in local commercial art supply stores.
Tips: Artist needs "an understanding of the product and the importance of selling it."

N ■ **MIRANDA DESIGNS INC.**, 745 President St., Brooklyn NY 11215. (718)857-9839. **President:** Mike Miranda. Estab. 1970. Number of employees: 3. Approximate annual billing: $350,000. Solves marketing problems, specializes in "giving new life to old products, creating new markets for existing products, and creating new products to fit existing manufacturing/distribution facilities." Clients: agencies, manufacturers, PR firms, corporate and retail companies. Professional affiliation: Art Directors Club.

Needs: Approached by 80 freelancers/year. Works with 6 freelance illustrators and 10 designers/year; at all levels, from juniors to seniors, in all areas of specialization. Works on assignment only. Uses freelancers for editorial, food, fashion, product illustration, design; and mechanicals. Also for catalog design and illustration; brochure, ad, magazine and newspaper design; mechanicals; model-making; direct mail packages and multimedia projects. 60% of freelance work demands knowledge of PageMaker, QuarkXPress, Photoshop or Illustrator.

First Contact & Terms: Send postcard sample. Samples are filed and are not returned. Will contact artist for portfolio review if interested. Portfolio should include thumbnails, roughs, original/final art and final reproduction/product. Pays for design and illustration by the project, "whatever the budget permits." Considers complexity of project, client's budget and skill and experience of artist when establishing payment. Rights purchased vary according to project. Considers buying second rights (reprint rights) to previously published work; depends on clients' needs. Finds artists through submissions/self-promotions, sourcebooks and agents.

Tips: "Don't call, persevere with mailings. Show a variety of subject material and media."

✓ MITCHELL STUDIOS DESIGN CONSULTANTS, 1810-7 Front St., East Meadow NY 11554. (516)832-6230. Fax: (516)832-6232. E-mail: msdcdesign@aol.com. **Principals:** Steven E. Mitchell and E.M. Mitchell. Estab. 1922. Specializes in brand and corporate identity, displays, direct mail and packaging. Clients: major corporations.

Needs: Works with 5-10 freelance designers and 20 illustrators/year. "Most work is started in our studio." Uses freelancers for design, illustration, mechanicals, retouching, airbrushing, model-making, lettering and logos. 100% of design and 50% of illustration demands skills in Illustrator 5, Photoshop 5 and QuarkXPress 3.3. Needs technical illustration and illustration of food, people.

First Contact & Terms: Send query letter with brochure, résumé, business card, photographs and photocopies to be kept on file. Accepts nonreturnable disk submissions compatible with Illustrator, QuarkXPress, FreeHand and Photoshop. Responds only if interested. Call or write for appointment to show portfolio of roughs, original/final art, final reproduction/product and color photostats and photographs. Pays for design by the hour, $25 minimum; by the project, $250 minimum. Pays for illustration by the project, $250 minimum.

Tips: "Call first. Show actual samples, not only printed samples. Don't show student work. Our need has increased—we are very busy."

N **THE PHOTO LIBRARY INC.**, P.O. Box 691, Chappaqua NY 10514. (914)238-1076. Fax: (914)238-3177. **Vice President Marketing:** M. Berger. Estab. 1978. Number of employees: 3. Specializes in brand identity, package and publication design, photography and product design. Clients: corporations, design offices.

Needs: Approached by 6-12 freelancers/year. Works with 6-9 freelance illustrators and 3-6 designers/year. Uses designers mainly for product design. Also uses freelancers for magazine and poster design, mechanicals and model making. Needs computer-literate freelancers for design, presentation and mechanicals. 50% of freelance work demands knowledge of Illustrator 5.5, Photoshop 3.0, FreeHand, PageMaker and Form 2 Strata.

First Contact & Terms: Send brochure, photographs and résumé. Samples are not filed and are returned. Will contact artist for portfolio review if interested. Portfolio should include photographs and slides. Pays for design and illustration by the hour and by the project. Buys all rights. Finds artists through sourcebooks, other publications, agents and artists' submissions.

☒ JACK SCHECTERSON ASSOCIATES, 5316 251 Place, Little Neck NY 11362. (718)225-3536. Fax: (718)423-3478. **Principal:** Jack Schecterson. Estab. 1967. Ad agency. Specializes in 2D and 3D visual product marketing; package design, corporate and graphic design; new product introduction.

Needs: Works direct and with artist reps. Prefers local freelancers only. Works on assignment only. Uses freelancers for package, product and corporate design; illustration, brochures, catalogs, logos. 100% of design and 90% of graphic illustration demands skills in Illustrator, Photoshop and QuarkXPress.

First Contact & Terms: Send query letter with brochure, photocopies, tearsheets, résumé, photographs, slides, transparencies and SASE; "whatever best illustrates work." Samples not filed are returned by SASE only if requested by artist. Request portfolio review in original query. Will contact artist for portfolio review if interested. Portfolio should include roughs, b&w and color—"whatever best illustrates creative abilities/work." Pays for design and illustration by the project; depends on budget. Buys all rights.

N **SCHROEDER BURCHETT DESIGN CONCEPTS**, 137 Main St. Route 7, Unadilla NY 13849-3303. (607)369-4709. **Designer & Owner:** Carla Schroeder Burchett. Estab. 1972. Specializes in packaging, marketing and restoration. Clients: manufacturers.

Needs: Works on assignment only. Uses freelancers for design, mechanicals, lettering and logos. 20% of freelance work demands knowledge of PageMaker or Illustrator. Needs technical and medical illustration.

First Contact & Terms: Send résumé. "If interested, we will contact artist or craftsperson and will negotiate." Write for appointment to show portfolio of thumbnails, final reproduction/product and photographs. Pays for illustration by the project. Pays for design by the hour, $15 minimum. "If it is excellent work, the person will receive what he asks for!" Considers skill and experience of artist when establishing payment.

Tips: "Creativity depends on each individual. Artists should have a sense of purpose and dependability and must work for long and short range plans. Have perseverance. Top people still get in any agency. Don't give up."

and color thumbnails, roughs, final art and tearsheets. Pays for design by the hour or by the project. Pays for illustration by the project. Buys all rights.

Tips: Finds artists through submissions and word of mouth.

N **SMITH & DRESS**, 432 W. Main St., Huntington NY 11743. (631)427-9333. **Contact:** A. Dress. Specializes in annual reports, corporate identity, display, direct mail, packaging, publications and signage. Clients: corporations.

Needs: Works with 3-4 freelance artists/year. Prefers local artists only. Works on assignment only. Uses artists for illustration, retouching, airbrushing and lettering.

First Contact & Terms: Send query letter with brochure showing art style or tearsheets to be kept on file (except for works larger than 8½×11). Pays for illustration by the project. Considers client's budget and turnaround time when establishing payment.

VISUAL HORIZONS, 180 Metro Park, Rochester NY 14623. (716)424-5300. Fax: (716)424-5313. E-mail: slides1@aol.com. or info@visualhorizons.com. Website: www.visualhorizons.com. Estab. 1971. AV firm. Full-service multimedia firm. Specializes in presentation products. Current clients include US government agencies, corporations and universities.

Needs: Works on assignment only. Uses freelancers mainly for catalog design. 10% of work is with print ads. 100% of freelance work demands skills in PageMaker and Photoshop.

First Contact & Terms: Send query letter with tearsheets. Samples are not filed and are not returned. Responds if interested. Portfolio review not required. Pays for design and illustration by the hour or project, negotiated. Buys all rights.

New York City

N **AVANCÉ DESIGNS, INC.**, 1775 Broadway, Suite 419, New York NY 10019-1903. (212)420-1255. Fax: (212)876-3078. Website: www.avance-designs.com. Estab. 1986. "Avancé Designs are specialists in visual communications for branded cosmetics and luxury products. We maintain our role by managing multiple design disciplines from print and information design to packaging and interactive media."

Needs: Illustrators, designers, 2/3-dimensional computer artists, web designers, programmers strong in Photoshop, Illustrator and Quark as well as HTML, CGI scriptings, Flash animation and Director.

First Contact & Terms: Send query letter. Samples of interest are filed and are not returned. Responds only if interested. Samples of best work may be dropped off every Monday-Friday. Pays for design by the hour. Pays for illustration by the project. Rights purchased vary according to project.

N **BBDO NEW YORK**, 1285 Avenue of the Americas, New York NY 10019-6028. (212)459-5000. Fax: (212)459-6645. Website: www.bbdo.com. **Manager of Digital Creative:** Richard Raskov. Illustration Manger/Creative Project Coordinator: Ron Williams. Estab. 1891. Number of employees: 850. Annual billing: $50,000,000. Specializes in business, consumer advertising, sports marketing and brand development. Clients include Texaco, Frito Lay, Bayer, Campbell Soup, FedEx, Visa and Pizza Hut. Ad agency. Full-service multimedia firm.

● BBDO Art Director Richard Raskov told our editors he is always open to new ideas and maintains an open drop-off policy. If you call and arrange to drop off your portfolio, he'll review it, and you can pick it up in a couple days. Contact Richard Raskov for freelance graphic design; Ron Williams for freelance illustration.

N **BARRY DAVID BERGER & ASSOCIATES, INC.**, 54 King St., New York NY 10014. (212)255-4100. **Art Director:** Barry Berger. Number of employees: 5. Approximate annual billing: $500,000. Spe-

cializes in brand and corporate identity, P-O-P displays, product and interior design, exhibits and shows, corporate capability brochures, advertising graphics, packaging, publications and signage. Clients: manufacturers and distributors of consumer products, office/stationery products, art materials, chemicals, healthcare, pharmaceuticals and cosmetics. Current clients include Dennison, Timex, Sheaffer, Bausch & Lomb and Kodak. Professional affiliations IDSA, AIGA, APDF.

Needs: Approached by 12 freelancers/year. Works with 5 freelance illustrators and 7 designers/year. Uses artists for advertising, editorial, medical, technical and fashion illustration, mechanicals, retouching, direct mail and package design, model-making, charts/graphs, photography, AV presentations and lettering. Needs computer-literate freelancers for illustration and production. 50% of freelance work demands computer skills.

First Contact & Terms: Send query letter, then call for appointment. Works on assignment only. Send "whatever samples are necessary to demonstrate competence" including multiple roughs for a few projects. Samples are filed or returned. Responds immediately. Provide brochure/flyer, résumé, business card, tearsheets and samples to be kept on file for possible future assignments. Pays for design by the project, $1,000-10,000. Pays for illustration by the project.

Tips: Looks for creativity and confidence.

N ANITA HELEN BROOKS ASSOCIATES, PUBLIC RELATIONS, 155 E. 55th St., New York NY 10022. (212)755-4498. **President:** Anita Helen Brooks. PR firm. Specializes in fashion, "society," travel, restaurant, political and diplomatic, and publishing. Product specialties are events, health and health campaigns.

Needs: Works on assignment only. Uses freelancers for consumer magazines, newspapers and press releases. "We're currently using more abstract designs."

First Contact & Terms: Send query letter with résumé. Call for appointment to show portfolio. Responds only if interested. Considers client's budget and skill and experience of artist when establishing payment.

Tips: "Artists interested in working with us must provide rate schedule, partial list of clients and media outlets. We look for graphic appeal when reviewing samples."

N ■ CANON & SHEA ASSOCIATES, INC., 39 W. 32nd St., 10th Floor, New York NY 10001. (212)564-8822. E-mail: canonshea@aol.com. Website: members.aol.com/canonshea. **Art Buyer:** Sal Graci. Estab. 1978. Print, Internet, multimedia, advertising/PR/marketing firm. Specializes in business-to-business and financial services.

Needs: Works with 20-30 freelance illustrators and 2-3 designers/year. Mostly local freelancers. Uses freelancers mainly for design and illustrations. 100% of freelance work demands knowledge of QuarkXPress, Illustrator, Photoshop, Director, Pagemill or FrontPage.

First Contact & Terms: Send postcard sample and/or query letter with résumé, photocopies and tearsheets. Accepts submissions on disk. Will contact artist for portfolio review if interested. Pays by the hour: $10-40 for design, annual reports, catalogs, trade and consumer magazines; $25-50 for packaging; $50-250 for corporate identification/graphics; $10-45 for layout, lettering and paste-up. Pays for illustration by the hour, $10-20. Finds artists through art schools, design schools and colleges.

Tips: "Artists should have business-to-business materials as samples and should understand the marketplace. Do not include fashion or liquor ads. Common mistakes in showing a portfolio include showing the wrong materials, not following up and lacking understanding of the audience."

CARNASE, INC., 21 Dorset Rd., Scarsdale NY 10583. (212)777-1500. Fax: (914)725-9539. **President:** Tom Carnase. Estab. 1978. Specializes in annual reports, brand and corporate identity, display, landscape, interior, direct mail, package and publication design, signage and technical illustration. Clients: agencies, corporations, consultants. Current clients include: Clairol, Shisheido Cosmetics, Times Mirror, Lintas: New York. Client list not available.

● President Tom Carnase predicts "very active" years ahead for the design field.

Needs: Approached by 60 freelance artists/year. Works with 2 illustrators and 1 designer/year. Prefers artists with 5 years experience. Works on assignment only. Uses artists for brochure, catalog, book, magazine and direct mail design and brochure and collateral illustration. Needs computer-literate freelancers. 50% of freelance work demands skills in QuarkXPress or Illustrator.

First Contact & Terms: Send query letter with brochure, résumé and tearsheets. Samples are filed. Responds in 10 days. Will contact artist for portfolio review if interested. Portfolio should include photostats, slides and color tearsheets. Negotiates payment. Rights purchased vary according to project.

Tips: Finds artists through word of mouth, magazines, artists' submissions/self-promotions, sourcebooks and agents.

COUSINS DESIGN, 330 E. 33rd St., New York NY 10016. (212)685-7190. Fax: (212)689-3369. E-mail: cousinsdesign@aol.com. Website: www.cousinsdesigning.com. **President:** Michael Cousins. Number of employees: 4. Specializes in packaging and product design. Clients: marketing and manufacturing companies. Professional affiliation: IDSA.

Needs: Works with freelance designers. Prefers local designers. Works on assignment only. Uses artists for design, illustration, mechanicals, retouching, airbrushing, model making, lettering and logos.

First Contact & Terms: Send nonreturnable postcard sample or e-mail your link. Samples are filed. Responds in 2 weeks only if interested. Write for appointment to show portfolio of roughs, final reproduction/product and photostats. Pays for design by the hour or flat fee. Considers skill and experience of artist when establishing payment. Buys all rights.

Tips: "Send great work that fits our direction."

CSOKA/BENATO/FLEURANT, INC., 134 W. 26th St., New York NY 10001. (212)242-6777. **President:** Robert Fleurant. Estab. 1969. Specializes in brand and corporate identity, display, direct mail, package and publication design. Clients: corporations and foundations. Current clients include Metropolitan Life Insurance and RCA/BMG Special Products.

Needs: Approached by approximately 120 freelancers/year by mail. Works with 3-4 freelance illustrators/year. Prefers local freelancers with experience in print, full color, mixed media. Seeks freelancers "with professionalism and portfolio who can meet deadlines, work from layouts and follow instructions." Works on assignment only. Uses illustrators mainly for album covers, publications and promotions. Also for brochure, catalog and P-O-P illustration, mechanicals, retouching, airbrushing and lettering. 90% of freelance work demands skills in PageMaker, QuarkXPress, FreeHand, Illustrator, Photoshop, Adobe Streamline, OmniPage and Microsoft Word 5.1.

First Contact & Terms: Send query letter with tearsheets and résumé. Samples are filed. Responds only if interested. Write for appointment to show portfolio of thumbnails, roughs, final art and b&w and color tearsheets. Pays for design by the hour, $20-35. Pays for illustration by the project (estimated as per requirements). Buys all rights.

DE FIGLIO DESIGN, 11 W. 30th St., Suite 6, New York NY 10001-4405. (212)695-6109. Fax: (212)695-4809. **Creative Director:** R. De Figlio. Estab. 1981. Number of employees: 2. Design firm. Specializes in magazine ads, annual reports, collateral, postage stamps, CD albums and website development.

Needs: Approached by 10 illustrators and 10 designers/year. Works with 4 illustrators and 10 designers/year. Prefers local designers with experience in Mac-based programs. Uses freelancers mainly for mechanicals on the Mac. Also for airbrushing, annual reports, brochure design and illustration, logos, posters, retouching and web page design. Currently seeking freelance programmers. 80% of design and 25% of illustration demands skills in latest versions of Photoshop, QuarkXPress and Illustrator. Illustrators can use any version that works for project.

First Contact & Terms: Designers send photocopies and résumé. Illustrators send postcard sample or photocopies and résumé. Samples are filed. Does not reply. Payment negotiable. Finds artists through submissions and networking.

DLS DESIGN, 156 Fifth Ave., New York NY 10010. (212)255-3464. E-mail: info@dlsdesign.com. Website: www.dlsdesign.com. **President:** David Schiffer. Estab. 1986. Number of employees: 4. Approximate annual billing: $150,000. Graphic design firm. Specializes in high-end print work; logo design; and implementation of graphically rich websites and other on-screen interfaces. Product specialties are corporate, publishing, nonprofit, entertainment, fashion, media and industrial companies. Current clients include The Foundation Center, Disney Magazine Publishing, American Management Association, Timex Watchbands, Newcastle/Acoustone Fabrics, CHIC Jeans and many others. Professional affiliation: WWWAC (World Wide Web Artists' Consortium).

● Recent awards include: Award of Distinction and Honorable Mention (The Communicator Awards 2001); Bronze Award/Nonprofit Category (The Summit Creative Awards 2001).

Needs: "Over 50% of our work is high-end corporate websites. Work is clean, but can also be high in the 'delight factor.' " Requires designers and illustrators fluent in Photoshop, Image Ready, Dreamweaver and Flash for original website art, including splash screens, banners, GIF animations and interactive banners. Other essential programs include BBEdit, GIF Builder, DeBabelizer. Also uses freelancers fluent in clean, intermediate to advanced HTML, as well as an understanding of Javascript and CGI.

First Contact & Terms: E-mail is acceptable, but unsolicited attached files will be rejected. "Please wait until we say we are interested, or direct us to your URL to show samples." Uses some hourly freelance help in website authoring; rarely needs editorial illustrations in traditional media.

N **FREELANCE EXPRESS, INC.**, 111 E. 85th St., New York NY 10028. (212)427-0331. Multiservice company. Estab. 1988.

Needs: Uses freelancers for cartoons, charts, graphs, illustration, layout, lettering, logo design and mechanicals.

First Contact & Terms: Mail résumé and photocopied nonreturnable samples. "Say you saw the listing in *Artist's & Graphic Designer's Market*." Provide materials to be kept on file. Originals are not returned.

HILL AND KNOWLTON, INC., 466 Lexington Ave., New York NY 10017. (212)885-0300. Fax: (212)885-0570. E-mail: maldinge@hillandknowlton.com. Website: www.hillandknowlton.com. **Corporate Design Group:** Michael Aldinger. Estab. 1927. Number of employees: 1,200 (worldwide). PR firm. Full-service multimedia firm. Specializes in annual reports, collateral, corporate identity, advertisements and sports marketing.

Needs: Works with 0-10 freelancers/illustrators/month. Works on assignment only. Uses freelancers for editorial, technical and medical illustration. Also for storyboards, slide illustration, animatics, mechanicals, retouching and lettering. 10% of work is with print ads. Needs computer-literate freelancers for illustration. Freelancers should be familiar with QuarkXPress, FreeHand, Illustrator, Photoshop or Delta Graph.

First Contact & Terms: Send query letter with promo and samples. Samples are filed. Does not reply, in which case the artist should "keep in touch by mail—do not call." Call and drop-off only for a portfolio review. Portfolio should include dupe photographs. Pays for illustration by the project, $250-5,000. Negotiates rights purchased.

Tips: Looks for "variety; unique but marketable styles are always appreciated."

LEO ART STUDIO, INC., 276 Fifth Ave., Suite 610, New York NY 10001. (212)685-3174. Fax: (212)685-3170. E-mail: leoart2765@aol.com. Website: www.leoartstudio.com. **President:** Leopold Schein. Studio Manager and Art Director: Robert Schein. Number of employees: 3. Approximate annual billing: $500,000. Specializes in textile design for home furnishings. Clients: wallpaper manufacturers/stylists, glassware companies, furniture and upholstery manufacturers. Current clients include Burlington House, Blumenthal Printworks, Eisenhart Wallcoverings, Victoria's Secret, Town and Country, Culp, Inc. and Notra Trading. Client list available upon request.

Needs: Approached by 25-30 freelancers/year. Works with 3-4 freelance illustrators and 20-25 textile designers/year. Prefers freelancers trained in textile field, not fine arts. Must have a portfolio of original art designs. Should be able to be in NYC on a fairly regular basis. Works both on assignment and speculation. Prefers realistic and traditional styles. Uses freelancers for design, airbrushing, coloring and repeats. "We will look at any freelance portfolio to add to our variety of hands. Our recent conversion to CAD system may require future freelance assistance. Knowledge of Coreldraw, Photoshop or others is a plus."

First Contact & Terms: Send query letter with résumé. Do not send slides. Request portfolio review in original query. "We prefer to see portfolio in person. Contact via phone is OK—we can set up appointments with a day or two's notice." Samples are not filed and are returned. Responds in 5 days. Portfolio should include original/final art. Sometimes requests work on spec before assigning job. Pays for design by the project, $500-1,500. "Payment is generally a 60/40 split of what design sells for—slightly less if reference material, art material, or studio space is requested." Considers complexity of project, skill and experience of artist and how work will be used when establishing payment. Buys all rights.

Tips: "Stick to the field we are in (home furnishing textiles, upholstery, fabrics, wallcoverings). Understand manufacture and print methods. Walk the market; show that you are aware of current trends. Go to design shows before showing portfolio. We advise all potential textile designers and students to see the annual design show—Surtex—at the Jacob Javitz Center in New York, usually in spring. Also attend High Point Design Show in North Carolina and Heimtex America in Florida."

LIEBER BREWSTER DESIGN, INC., 19 W. 34th St., Suite 618, New York NY 10001. (212)279-9029. E-mail: office@lieberbrewster.com. **Principal:** Anna Lieber. Estab. 1988. Specializes in annual reports, corporate identity, direct mail and package design, publications, exhibits, environments, advertising, web development, interactive presentation, branding and signage. Clients: publishing, nonprofits, corporate, financial services, foodservice, retail. Client list available upon request. Professional affiliations: NAWBO, AIGA.

Needs: Approached by more than 100 freelancers/year. Works with 10 freelance illustrators, photographers and 10 designers/year. Works on assignment only. Uses freelancers for HTML programming, multimedia presentations, web development, logos, direct mail design, charts/graphs, audiovisual materials. Needs computer-literate freelancers for design, illustration, production and presentation. 90% of freelance work demands skills in Illustrator, QuarkXPress or Photoshop. Needs editorial, technical, medical and creative color illustration, photography, photo montage, icons.

First Contact & Terms: Send query letter with résumé, tearsheets and photocopies. Samples are filed. Will contact artist for portfolio review if interested. Portfolio should include b&w and color work. Pays for design by the hour. Pays for illustration and photography by the project. Rights purchased vary according to project. Finds artists through promotional mailings.

KEN LIEBERMAN LABORATORIES, INC., 139 W. 22 St., 2nd Floor, New York NY 10011. (212)633-0500. Fax: (212)675-8269. Website: www.lieberman-labs.com. **President:** Ken Lieberman. Estab. 1972. Specializes in custom lab services, prints, dupes and mounting.

■ **LUBELL BRODSKY INC.**, 21 E. 40th St., Suite 1806, New York NY 10016. (212)684-2600. **Art Directors:** Ed Brodsky and Ruth Lubell. Number of employees: 5. Specializes in corporate identity, direct mail, promotion, consumer education and packaging. Clients: ad agencies and corporations. Professional affiliations: ADC, TDC.
Needs: Approached by 100 freelancers/year. Works with 10 freelance illustrators and photographers and 1-2 designers/year. Works on assignment only. Uses freelancers for illustration, retouching, charts/graphs, AV materials and lettering. 100% of design and 30% of illustration demands skills in Photoshop.
First Contact & Terms: Send postcard sample, brochure or tearsheets to be kept on file. Responds only if interested.
Tips: Looks for unique talent.

▣ **JODI LUBY & COMPANY, INC.**, 808 Broadway, New York NY 10003. (212)473-1922. E-mail: jluby@nyc.rr.com. **President:** Jodi Luby. Estab. 1983. Specializes in corporate identity, promotion and direct mail design. Clients: magazines, corporations.
Needs: Approached by 10-20 freelance artists/year. Works with 5-10 illustrators/year. Prefers local artists only. Uses freelancers for brochure and catalog illustration. 100% of freelance work demands computer skills.
First Contact & Terms: Send postcard sample or query letter with résumé and photocopies. Samples are not filed and are not returned. Will contact artist for portfolio review if interested. Portfolio should include thumbnails, roughs, b&w and color printed pieces. Pays for design by the hour, $25 minimum; by the project, $100 minimum. Pays for illustration by the project, $100 minimum. Rights purchased vary according to project. Finds artists through word of mouth.

▣ **MARKEFXS**, 449 W. 44th St., Suite 4-C, New York NY 10036. (212)581-4827. Fax: (212)265-9255. Website: www.mfxs.com. **Creative Director/Owner:** Mark Tekushan. Estab. 1985. Full-service multimedia firm. Specializes in TV, video, advertising, design and production of promos, show openings and graphics. Current clients include ESPN and HBO.
Needs: Prefers freelancers with experience in television or advertising production. Works on assignment only. Uses freelancers mainly for design production. Also for animation, TV/film graphics and logos. Needs computer-literate freelancers for design, production and presentation.
First Contact & Terms: Send query letter with résumé and demo reels. Samples are filed. Coordinating Producer will contact artist for portfolio review if interested. Portfolio should include 3/4″ video or VHS. Pays for design by the hour, $25-50. Finds artists through word of mouth.
Tips: Considers "attitude (professional, aggressive and enthusiastic, not cocky), recommendations and demo sample."

MIZEREK DESIGN INC., 333 E. 14th St., New York NY 10003. (212)777-3344. E-mail: mizerek@aol.com. Website: www.mizerek.net. **President:** Leonard Mizerek. Estab. 1975. Specializes in catalogs, direct mail, jewelry, fashion and technical illustration. Clients: corporations—various product and service-oriented clientele. Current clients include: Rolex, Leslie's Jewelry, World Wildlife, The Baby Catalog, Time Life and Random House.
Needs: Approached by 20-30 freelancers/year. Works with 10 freelance designers/year. Works on assignment only. Uses freelancers for design, technical illustration, brochures, retouching and logos. 85% of freelance work demands skills in Illustrator, Photoshop and QuarkXPress.
First Contact & Terms: Send postcard sample or query letter with résumé, tearsheets and transparencies. Accepts disk submissions compatible with Illustrator and Photoshop 3.0. Will contact artist for portfolio review if interested. Portfolio should include original/final art and tearsheets. Pays for design by the project, $500-5,000. Pays for illustration by the project, $500-3,500. Considers client's budget and turnaround time when establishing payment. Finds artists through sourcebooks and self-promotions.
Tips: "Let the work speak for itself. Be creative. Show commercial product work, not only magazine editorial. Keep me on your mailing list!"

MCCAFFERY RATNER GOTTLIEB & LANE, INC., 370 Lexington Ave., New York NY 10017. (212)661-8940. E-mail: hjones@mrgl.net. Website: www.mrgl.net. **Senior Art Director:** Howard Jones. Estab. 1983. Ad agency specializing in advertising and collateral material. Current clients include Olympus Corporation, General Cigar (Macandudo, Partagas), Jean Patou Fragrances, Northwest Airlines, Tetra Foods, Italian Trade Commission, New Plan Excel, Realty Trust.

Needs: Works with 6 freelance photographers/illustrators/year. Works on assignment only. Also uses artists for brochure and print ad illustration, mechanicals, retouching, billboards, posters, lettering and logos. 80% of work is with print ads.

First Contact & Terms: Send query letter with brochure, tearsheets, photostats, photocopies and photographs. Responds only if interested. To show a portfolio, mail appropriate materials or drop off samples. Portfolio should include original/final art, tearsheets and photographs; include color and b&w samples. Pays for illustration by the project, $75-5,000. Rights purchased vary according to project.

Tips: "Send mailers and drop off portfolio."

LOUIS NELSON ASSOCIATES INC., 80 University Place, New York NY 10003. (212)620-9191. Fax: (212)620-9194. E-mail: info@louisnelson.com. Website: www.louisnelson.com. **President:** Louis Nelson. Estab. 1980. Number of employees: 12. Approximate annual billing: $1.2 million. Specializes in environmental, interior and product design and brand and corporate identity, displays, packaging, publications, signage, exhibitions and marketing. Clients: nonprofit organizations, corporations, associations and governments. Current clients include Stargazer Group, Rocky Mountain Productions, Wildflower Records, Port Authority of New York & New Jersey, Richter + Ratner Contracting Corporation, MTA and NYC Transit. Professional affiliations: IDSA, AIGA, SEGD, APDF.

Needs: Approached by 30-40 freelancers/year. Works with 30-40 designers/year. Works on assignment only. Uses freelancers mainly for specialty graphics and 3-dimensional design. Also for design, photoretouching, model-making and charts/graphs. 100% of design demands knowledge of PageMaker, QuarkXPress, Photoshop, Velum, Autocad, Vectorworks or Illustrator. Needs editorial illustration.

First Contact & Terms: Send postcard sample or query letter with résumé. Accepts disk submissions compatible with Illustrator 8.0 or Photoshop 5.0. Send EPS files. Samples are returned only if requested. Responds in 2 weeks. Write for appointment to show portfolio of roughs, color final reproduction/product and photographs. Pays for design by the hour, $15-25 or by the project, negotiable. Less need for illustration or photography.

Tips: "I want to see how the artist responded to the specific design problem and to see documentation of the process—the stages of development. The artist must be versatile and able to communicate a wide range of ideas. Mostly, I want to see the artist's integrity reflected in his/her work."

NICOSIA CREATIVE EXPRESSO, LTD., 355 W. 52nd St., New York NY 10019. (212)515-6600. Fax: (212)265-5422. E-mail: info@niceltd.com. Website: www.niceltd.com. **President/ Creative Director:** Davide Nicosia. Estab. 1993. Number of employees: 30. Specializes in graphic design, corporate/brand identity, brochures, promotional material, packaging, signage, marketing, website design and 3-D animations. Current clients include Calvin Klein, Victoria's Secret, Elizabeth Arden, Tiffany & Co., Bath & Body Works and *The New York Times*.

● NICE is an innovative graphic firm with offices in Madrid, Spain and New York. Their team of multicultural designers deliver design solutions for the global marketplace.

Needs: Approached by 70 freelancers/year. Works with 6 freelance illustrators and 8 designers/year. Works by assignment only. Uses illustrators, designers, 3-D computer artists and computer artists familiar with Illustrator, Photoshop, After Effects, Premiere, QuarkXPress, Macromedia Director, Flash and Maxon Cinema 4D.

First Contact & Terms: Send query letter and résumé. Responds for portfolio review only if interested. Pays for design by the hour. Pays for illustration by the project. Rights purchased vary according to project.

Tips: Looks for "promising talent and an adaptable attitude."

NOSTRADAMUS ADVERTISING, 884 West End Ave., Suite #2, New York NY 10025. Website: www.nostradamus.net. **Creative Director:** B.N. Sher. Specializes in book design, publications, web design, fliers, posters, advertising and direct mail. Clients: ad agencies, book publishers, nonprofit organizations and politicians.

Needs: Works with 5 artists/year. Uses freelancers for advertising design, illustration and layout and brochure design, mechanicals, posters, direct mail packages, catalogs, books and magazines. Needs computer-literate freelancers for design and production.

First Contact & Terms: Send query letter with brochure, résumé, business card, samples and tearsheets. Do *not* send slides as samples; will accept "anything else that doesn't have to be returned." Samples not

kept on filed are not returned. Responds only if interested. Call for appointment to show portfolio. Pays for design and mechanicals by the hour, $20-30 average. Pays for illustration by the project, $100 minimum. Considers skill and experience of artist when establishing payment.

N POSNER ADVERTISING, 300 E. 42nd, New York NY 10017. (212)867-3900. Fax: (212)818-0083. E-mail: pposner@npm.com. Website: www.posneradv.com. **Contact:** VP/Creative Director. Estab. 1959. Number of employees: 85. AD agency. Full-service multimedia firm. Specializes in ads, collaterals, packaging, outdoor. Product specialties are healthcare, real estate, consumer business to business, corporate.
Needs: Approached by 25 freelance aritsts/month. Works with 1-3 illustrators and 5 designers/month. Prefers local artists only with traditional background with experience in computer design. Uses freelancers mainly for graphic design, production, illustration. 80% of work is with print ads. Needs computer-literate freelancers for design, illustration and production. 90% of freelance work demands knowledge of Illustrator, QuarkXPress, Photoshop or FreeHand.
First Contact & Terms: Send query letter with photocopies or disk. Samples are filed. Responds only if interested. Write for appointment to show portfolio. Portfolio should include thumbnails, roughs, b&w and color tearsheets, printed pieces. Pays for design by the hour, $15-35 or by the project, $300-2,000. Pays for illustration by the project, $300-2,000. Negotiates rights purchased.
Tips: Advises freelancers starting out in advertising field to offer to intern at agencies for minimum wage.

MIKE QUON/DESIGNATION INC., 53 Spring St., New York NY 10012. (212)226-6024. Fax: (212)219-0331. E-mail: mikequon@aol.com. Website: www.mikequondesign.com. **President:** Mike Quon. Estab. 1982. Number of employees: 3. Specializes in corporate identity, displays, direct mail, packaging, publications and web design. Clients: corporations (financial, healthcare, high technology) and ad agencies. Current clients include Pfizer, NBC, Bristol-Myers Squibb, American Express, JP Morgan Chase, Paine Webber, Hasbro, Verizon, AT&T. Client list available upon request. Professional affiliations: AIGA, Society of Illustrators, Graphic Artists Guild.
Needs: Approached by 50 illustrators and 50 designers/year. Works with 10 designers/year. Prefers local freelancers. Works on assignment only. Prefers graphic style. Uses artists for brochures, design and catalog illustration, P-O-P displays, logos, mechanicals, charts/graphs and lettering. Especially needs computer artists with skills in QuarkXPress, Illustrator, Photoshop.
First Contact & Terms: Send query letter with résumé and photocopies. Samples are filed or are returned if accompanied by SASE. Responds only if interested. No portfolio drop-offs. Mail only. Pays for design by the hour, $20-45. Pays for illustration by the project, $100-500. Buys first rights.
Tips: "Do good work and continually update art directors with mailed samples."

ARNOLD SAKS ASSOCIATES, 350 E. 81st St., New York NY 10028. (212)861-4300. Fax: (212)535-2590. E-mail: afiorillo@saksdesign.com. **Vice President:** Anita Fiorillo. Estab. 1967. Specializes in annual reports and corporate communications. Clients: Fortune 500 corporations. Current clients include Alcoa, American Home Products, Hospital for Special Surgery, McKinsey & Co., Xerox and UBS. Client list available upon request.
Needs: Works with 1 or 2 mechanical artists and 1 designer/year. "Mechanical artists: accuracy and speed are important, as is a willingness to work late nights and some weekends." Uses illustrators for technical illustration and occasionally for annual reports. Uses designers mainly for in-season annual reports. Also uses artists for brochure design and illustration, mechanicals and charts/graphics. Needs computer-literate freelancers for production and presentation. 80% of freelance work demands knowledge of QuarkXPress, Illustrator or Photoshop.
First Contact & Terms: Send query letter with brochure and résumé. Samples are filed. Responds only if interested. Write for appointment to show portfolio. Portfolio should include finished pieces. Pays for design by the hour, $25-60. Pays for illustration by the project, $200 minimum. Payment depends on experience and terms and varies depending upon scope and complication of project. Rights purchased vary according to project.

☑ STROMBERG CONSULTING, 866 Second Ave., 5th Floor, New York NY 10017. (646)935-4300. Website: www.scny.com. **Creative Director:** Chad Latz. Number of employees: 60. Product specialties are direct marketing, internal and corporate communication using traditional print base as well as Web and new media. Clients: industrial and corporate. Produces multimedia, presentations, videotapes and print materials.
Needs: Assigns 25-35 jobs/year. Prefers local freelancers only (Manhattan and its 5 burroughs). Uses freelancers for design catalogs, corporate brochures, presentations, annual reports, slide shows, layouts, mechanicals, illustrations, computer graphics and desk-top publishing web development, application development. Rarely uses illustrators.

First Contact & Terms: "Send note on availability and previous work." Responds only if interested. Provide materials to be kept on file for future assignments. Originals are not returned. Pays by the project. **Tips:** Finds designers through word of mouth and submissions.

[N] TMP WORLDWIDE ADVERTISING & COMMUNICATIONS, 205 Hudson St., 6th Floor, New York NY 10013. (646)613-2000. Fax: (646)613-9719. Website: www.tmp.com. **Associate Creative Director:** Ted Kirschner. Estab. 1990. Approximate annual billing: $1,297,000,000. Ad agency. Full-service, multimedia firm. Specializes in recruitment advertising, interactive communications, and employer branding.
 • This agency has offices and affiliates all over the world. The New York office told AGDM they are cutting down on freelancers because of the economy.
Needs: Approached by 12 freelancers/year. Works with 3-4 freelance illustrators/year. Prefers local artists. Uses freelance artists mainly for brochure and print ad illustration, animation, mechanicals, retouching, model making, billboards, TV/film graphics and lettering.
First Contact & Terms: Contact only through artist rep. Send nonreturnable samples. Samples are filed. Responds only if interested. Rep should follow up with call and/or letter after initial query. Pays for illustration by the project, $250-3,000. Rights purchased vary according to project.

[N] TRITON ADVERTISING, INC., 15 W. 44th St., New York NY 10036. (212)840-3040. Fax: (212)575-9391. E-mail: tritonco@aol.com. Website: www.tritonadv.com. **Creative Director:** Eric Friedmann. Number of employees: 20. PR firm. Estab. 1950. Clients: fashion industry, entertainment and Broadway shows.
Needs: Works with 6 illustrators and 6 designers/year. Uses freelancers for consumer magazines, brochures/flyers and newspapers; occasionally buys cartoon-style illustrations. Prefers pen & ink and collage. 90% of work is with print ads. 100% of design and 70% of illustration demand knowledge of QuarkXPress, FreeHand and Photoshop.
First Contact & Terms: Send postcard sample with brochure and résumé to B. Epstein. Accepts submissions on disk compatible with Mac. Originals not returned. Pays for illustration and design by the project, $100-3,500.
Tips: "Don't get too complex—make it really simple. Don't send originals."

North Carolina

BOB BOEBERITZ DESIGN, 247 Charlotte St., Asheville NC 28801. (828)258-0316. E-mail: bobb@main.nc.us. Website: www.bobboeberitzdesign.com. **Owner:** Bob Boeberitz. Estab. 1984. Number of employees: 1. Approximate annual billing: $80,000. Specializes in graphic design, corporate identity and package design. Clients: retail outlets, hotels and restaurants, textile manufacturers, record companies, publishers, professional services. Majority of clients are business-to-business. Current clients include Para Research Software, Blue Duck Music, Quality America, Owen Manufacturing Co., Cross Canvas Co. and High Windy Audio. Professional affiliations: AAF, Asheville Chamber, NARAS, Asheville Freelance Network, Business Network Int'l (BNI).
 • Owner Bob Boeberitz predicts "everything in art design will be done on computer; more electronic; more stock images; photo image editing and conversions will be used; there will be less commissioned artwork."
Needs: Approached by 50 freelancers/year. Works with 5 freelance illustrators/year. Works on assignment only. Uses freelancers primarily for technical illustration and comps. Prefers pen & ink, airbrush and acrylic. 50% of freelance work demands knowledge of PageMaker, Illustrator, Photoshop or CorelDraw.
First Contact & Terms: Send query letter with résumé, brochure, SASE, photographs, slides and tearsheets. "Anything too large to fit in file" is discarded. Accepts disk submissions compatible with IBM PCs. Send AI-EPS, PDF, JPG, GIF, HTML and TIFF files. Samples are returned by SASE if requested. Responds only if interested. Will contact artist for portfolio review if interested. Portfolio should include thumbnails, roughs, final art, b&w and color slides and photographs. Sometimes requests work on spec before assigning a job. Pays for design and illustration, by the project, $50 minimum. Rights purchased vary according to project. Will consider buying second rights to previously published artwork. Finds artists through word of mouth, submissions/self-promotions, sourcebooks, agents.
Tips: "Show sketches—sketches help indicate how an artist thinks. The most common mistake freelancers make in presenting samples or portfolios is not showing how the concept was developed, what their role was in it. I always see the final solution, but never what went into it. In illustration, show both the art and how it was used. Portfolios should be neat, clean and flattering to your work. Show only the most memorable work, what you do best. Always have other stuff, but don't show everything. Be brief. Don't just toss a

portfolio on my desk; guide me through it. A 'leave-behind' is helpful, along with a distinctive-looking résumé. Be persistent but polite. Call frequently. I don't recommend cold calls (you rarely ever get to see anyone) but it is an opportunity for a 'leave behind.' I recommend using the mail. I like postcards. They get noticed, maybe even kept. They're economical. And they show off your work. And you can do them more frequently. Plus you'll have a better chance to get an appointment. After you've had an appointment, send a thank you note. Say you'll keep in touch and do it!''

N **▣** **IMAGE ASSOCIATES INC.**, 4909 Windy Hill Dr., Raleigh NC 27609. (919)876-6400. Fax: (919)876-7064. E-mail: carla@imageassociates.com. Website: www.imageassociates.com. **President:** Carla Davenport. Estab. 1984. Number of employees: 35. Marketing communications group offering advanced Web-based solutions, multimedia and print. Visual communications firm specializing in computer graphics and AV, multi-image, interactive multimedia, Internet development, print and photographic applications.

Needs: Approached by 10 freelancers/year. Works with 4 freelance illustrators and 4 designers/year. Prefers freelancers with experience in Web, CD-ROM and print. Works on assignment only. Uses freelancers mainly for Web design and programming. Also for print ad design and illustration and animation. 90% of freelance work demands skills in Flash, HTML, DHTML, ASP, Photoshop and Macromind Director.

First Contact & Terms: Send query letter with brochure, résumé and tearsheets. Samples are filed or are returned by SASE if requested by artist. Responds only if interested. To show portfolio, mail roughs, finished art samples, tearsheets, final reproduction/product and slides. Pays for assignments by the project, $100 minimum. Considers complexity of project, client's budget and how work will be used when establishing payment. Rights purchased vary according to project.

HOWARD MERRELL & PARTNERS, 8521 Six Forks Rd., Suite 500, Raleigh NC 27615. (919)848-2400. Fax: (919)876-2344. E-mail: scrawford@merrellgroup.com. **Creative Director:** Scott Crawford. Estab. 1993. Number of employees: 80. Approximate annual billing: $90 million. Ad agency. Full-service, multimedia firm. Specializes in ads, collateral, full service TV, broadcast. Product specialties are industrial and hi-tech. Clients include Kimberly-Clark and Miravant.

● This agency was acquired by the Bozell Group, a unit of True North, in 2000. The agency will continue to operate autonomously under its current name and management.

Needs: Approached by 25-50 freelancers/year. Works with 10-12 freelance illustrators and 20-30 designers/year. Prefers local artists only. Uses freelancers for brochure design and illustration, catalog design, logos, mechanicals, posters, signage and P-O-P. 40% of work is with print ads. Needs computer-literate freelancers for design, illustration, production and presentation. 100% of freelance work demands knowledge of Photoshop 3.0, QuarkXPress 3.31 and Illustrator 5.5

First Contact & Terms: Send postcard sample of work or query letter with photocopies. Samples are filed. Request portfolio review in original query. Will contact artist for portfolio review if interested. Portfolio should include b&w and color final art. Pays for design by the hour, $25-65. Payment for illustration varies by project.

N **▣** **POTTER & ASSOCIATES**, 4507 Forest Glen Rd., Greensboro NC 27410-3743. (336)854-0800. Fax: (336)854-2216. Alex or Gary Potter. Estab. 1982. Number of employees: 2. Approximate annual billing: $1.5 million. Ad agency. Full-service, multimedia firm. Specializes in collateral, direct mail, client campaigns including print and broadcast. Product specialties are consumer and business-to-business. Client list available upon request.

Needs: Approached by 15-20 freelancers/year. Works with 4-5 freelance illustrators and 3-4 designers/year. Prefers freelancers with experience in computer graphics. Uses freelancers mainly for computer illustrations, mechanicals, design. Also for brochure design and illustration, logos, mechanicals, posters, retouching and TV/film graphics. 20% of work is with print ads. Needs computer-literate freelancers for production and presentation. 95% of freelance work demands skills in Photoshop, QuarkXPress and Illustrator.

First Contact & Terms: Send query letter with nonreturnable sample such as brochure, photocopies, résumé, disks or tearsheets. Samples are filed. Will contact artist for portfolio review if interested. Finds artists through *Creative Black Book*, word of mouth and artists' submissions.

☑ **SMITH ADVERTISING & ASSOCIATES**, 321 Arch St., Fayetteville NC 28301. (910)323-0920. Fax: (910)486-8075. E-mail: kcastle@smithadv.com. Website: www.smithadv.com. **Production Manager:** Kelley Castle. Estab. 1974. Ad agency. Full-service, multimedia firm. Specializes in newspaper, magazine, broadcast, collateral, PR, custom presentations and web design. Product specialties are financial, healthcare, manufacturing, business-to-business, real estate, tourism. Current clients include Sarasota CVB, NC Ports, Southeastern Regional Medical Center, Standard Tobacco Corp. Client list available upon request.

Needs: Approached by 0-5 freelance artists/month. Works with 5-10 freelance illustrators and designers/month. Prefers artists with experience in Macintosh. Works on assignment only. Uses freelance artists

mainly for mechanicals and creative. Also uses freelance artists for brochure, catalog and print ad illustration and animation, mechanicals, retouching, model-making, TV/film graphics and lettering. 50% of work is with print ads. Needs computer-literate freelancers for design, illustration, production and presentation. 95% of freelance work demands knowledge of QuarkXPress, Illustrator or Photoshop.

First Contact & Terms: Send query letter with résumé and copies of work. Samples are returned by SASE if requested by artist. Responds in 3 weeks. Artist should call. Will contact artist for portfolio review if interested. Portfolio should include b&w and color thumbnails, final art and tearsheets. Pays for design and illustration by the project, $100. Buys all rights.

North Dakota

N **FLINT COMMUNICATIONS**, 101 Tenth St. N., Fargo ND 58102. (701)237-4850. Fax: (701)234-9680. Website: www.flintcom.com. **Art Directors:** Gerri Lien and Dawn Koranda. Estab. 1947. Number of employees: 30. Approximate annual billing: $9 million. Ad agency. Full-service, multimedia firm. Product specialties are agriculture, manufacturing, healthcare, insurance and banking. Client list available upon request. Professional affiliations: AIGA.

Needs: Approached by 50 freelancers/year. Works with 6-10 freelance illustrators and 3-4 designers/year. Uses freelancers for annual reports, brochure design and illustration, lettering, logos and TV/film graphics. 40% of work is with print ads. 20% of freelance work demands knowledge of PageMaker, Photoshop, QuarkXPress and Illustrator.

First Contact & Terms: Send postcard-size or larger sample of work and query letter. Samples are filed. Will contact artist for portfolio review if interested. Pays for illustration by the project, $100-2,000. Rights purchased vary according to project.

N **INK INC.**, 3401 Fiechtner Dr., Fargo ND 58103. (701)241-9204. Fax: (701)239-1748. Website: www. directmailforprinters.com. **Contact:** Mike Stevens. Number of employees: 11. Approximate annual billing: $600,000. Newsletter printer and publisher. Full-service multimedia firm. Specializes in direct mail advertising and newsletters. "We produce industry-specific newsletters that local printers re-sell to small businesses in their area." Current clients include more than 700 printers nationwide. Client list not available.

Needs: Approached by 12-15 freelancers/year. Works with 5 freelance illustrators and 4 designers/year. Uses freelancers mainly for illustration and line art. Also for brochure design and illustration, lettering and logos. 80% of work is with newsletter design and advertisements. Knowledge of PageMaker and Photoshop helpful but not necessary.

First Contact & Terms: Send query letter with photocopies. Samples are filed. "Will return if necessary." Responds in 1 month. Portfolio review not required. Pays for design and illustration by the project. Rights purchased vary according to project.

Tips: "Do good work, be friendly, meet deadlines, and charge small-town prices. We can't afford New York City rates. We buy lots of artwork and design. Our artists love us because we're easy to work with and pay fast!"

N **SIMMONS/FLINT ADVERTISING**, P.O. Box 5700, Grand Forks ND 58206-5700. (701)746-4573. Fax: (701)746-8067. E-mail: YvonneRW@simmonsadv.com. Website: www.simmonsflint.com. **Contact:** Yvonne Westrum. Estab. 1947. Number of employees: 8. Approximate annual billing: $5.5 million. Ad agency. Specializes in magazine ads, collateral, documentaries, web design etc. Product specialties are agriculture, gardening, fast food/restaurants, electric utilities. Client list available upon request.

• A division of Flint Communications, Fargo ND. See listing in this section.

Needs: Approached by 3-6 freelancers/year. Works with 3 freelance illustrators and 2 designer/year. Works on assignment only. Uses freelancers mainly for illustration. Also for brochure, catalog and print ad design and illustration; storyboards; billboards; and logos. 10% of work is with print ads. 10% of freelance work demands knowledge of QuarkXPress, Photoshop, Illustrator.

First Contact & Terms: Send postcard sample or tearsheets. Samples are filed or are returned. Will contact artist for portfolio review if interested. Portfolio should include color thumbnails, roughs, tearsheets, photostats and photographs. Pays for design and illustration by the hour, by the project, or by the day. Rights purchased vary according to project.

Ohio

N **BFL MARKETING COMMUNICATIONS**, 2000 Sycamore St., 4th Floor, Cleveland OH 44113-2340. (216)875-8860. Fax: (216)875-8870. E-mail: dpavan@bfl.com. Website: www.bfl.com. **President:** Dennis Pavan. Estab. 1955. Number of employees: 12. Approximate annual billing: $6.5 million. Marketing

communications firm. Full-service, multimedia firm. Specializes in new product marketing, Internet website design, interactive media. Product specialty is consumer home products. Client list available upon request. Professional affiliations: North American Advertising Agency Network, BPAA.

Needs: Approached by 20 freelancers/year. Works with 5 freelance illustrators and 5 designers/year. Prefers freelancers with experience in advertising design. Uses freelancers mainly for graphic design, illustration. Also for brochure and catalog design and illustration, lettering, logos, model making, posters, retouching, TV/film graphics. 80% of work is with print ads. Needs computer-literate freelancers for design, illustration, production and presentation. 50% of freelance work demands knowledge of FreeHand, Photoshop, QuarkXPress, Illustrator.

First Contact & Terms: Send postcard-size sample of work or send query letter with brochure, photostats, tearsheets, photocopies, résumé, slides and photographs. Samples are filed or returned by SASE. Responds in 2 weeks. Artist should follow-up with call and/or letter after initial query. Will contact artist for portfolio review if interested. Portfolio should include b&w and color final art, photographs, photostats, roughs, slides and thumbnails. Pays by the project, $200 minimum.

Tips: Finds artists through *Creative Black Book, Illustration Annual, Communication Arts*, local interviews. "Seeking specialist in Internet design, CD-ROM computer presentations and interactive media."

☑ ▣ **EVENTIV**, (formerly Terry Robie Communications), 7654 W. Bancroft St., Toledo OH 43617-1656. (419)843-7735. E-mail: jan@eventiv.com. Website: www.terryrobie.com. **President/Creative Director:** Janice Robie. Ad agency specializing in graphics, promotions and electronic media. Product specialties are industrial, consumer.

Needs: Assigns 30 freelance jobs/year. Works with 5 illustrators/year and 20 designers/year. Works on assignment only. Uses freelancers for consumer and trade magazines, brochures, catalogs, P-O-P displays, AV presentations, posters and illustrations (technical and/or creative). 100% of design and 50% of illustration require computer skills. Also needs freelancers experienced in electronic authoring, animation, web design, programming and design.

First Contact & Terms: Send query letter with résumé and slides, photographs, photostats or printed samples. Accepts disk submissions compatible with Mac or Windows. Samples returned by SASE if not filed. Responds only if interested. Write for appointment to show portfolio, which should include roughs, finished art, final reproduction/product and tearsheets. Pays by the hour, $25-80 or by the project, $100-2,500. Considers client's budget and skill and experience of artist when establishing payment. Negotiates rights purchased.

Tips: "We are interested in knowing your specialty."

⊞ ☒ **FIREHOUSE 101 ART + DESIGN INC.**, 641 N. High St., Suite 106, Columbus OH 43215. (614)464-0928. Fax: (614)464-0200. E-mail: fh101@ee.net. **Creative Director:** Kirk Richard Smith. Estab. 1990. Number of employees: 2. Approximate annual billing: $350,000. Design studio. Specializes in CD packaging, book cover, brochure, poster, logo identity, illustration. Product specialties are entertainment, software, retail fashion. Current clients include Express, NBA, Fox Movie Channel, CompuServe, Structure, Sony Music, Nickelodeon, Levi Strauss & Co., MCA Records, Arista Records, Locomotion Channel. Client list available upon request. Professional affiliations: CSCA (Columbus Society of Communicating Arts).

● Firehouse 101 has won over 200 design awards. Look for work in *Graphis Poster, Print Regional, Graphis Logo, HOW International Annual, Graphic Design America: 2, Cool Type 2*, and *Powerful Page Design*.

Needs: Approached by 20 illustrators and 30 designers/year. Works with 4 illustrators and 6 designers/year. Uses freelancers mainly for design production. Also for lettering, mechanicals and marketing/proposals. 5% of work is with print ads. 80% of design demands skills in FreeHand 9.0, Photoshop 6.1 and QuarkXPress 4.1. 30% of illustration demands skills in Photoshop 6.1.

First Contact & Terms: Designers send query letter with brochure, photocopies, résumé and tearsheets. Illustrators send postcard sample of work. Accepts submissions on disk or CD. Send EPS files. Samples are filed and are not returned. Responds only if interested. Request portfolio review in original query. Portfolio should include tearsheets and transparencies. Pays for design by the hour, $30-50. Pays for illustration by the project, $200-2,000. Buys one-time or all rights. Finds artists through postcard mailings, *Print, Graphis, HOW* and *Eye*.

Tips: "Be open to working hard and learning new methodologies. Stay informed of the industry and art world."

⊞ **INSTANT REPLAY**, Dept. AM, 1349 E. McMillan, Cincinnati OH 45206. (513)569-8600. Fax: (513)569-8608. **President:** Terry Hamad. Estab. 1977. AV/Post Production/Graphic Design firm. "We are a full-service film/video production and video post production house with our own sound stage. We also do traditional animation, paintbox animation with Harry, and 3-D computer animation for broadcast groups,

corporate entities and ad agencies. We do many corporate identity pieces as well as network affiliate packages, car dealership spots and general regional and national advertising for TV market." Current clients include Procter and Gamble, General Electric, NBC, CBS, ABC and FOX affiliates.

Needs: Works with 1 designer/month. Prefers freelancers with experience in video production. Works on assignment only. Uses freelancers mainly for production. Also uses freelancers for storyboards, animatics, animation and TV/film graphics.

First Contact & Terms: Send query letter with résumé, photocopies, slides and videotape. "Interesting samples are filed." Samples not filed are returned by SASE only if requested. Responds only if interested. Call for appointment to show slide portfolio. Pays by the hour, $25-50 or by the project and by the day (negotiated by number of days.) Pays for production by the day, $75-300. Considers complexity of project, client's budget and turnaround time when establishing payment. Buys all rights.

LIGGETT-STASHOWER, 1228 Euclid Ave., Cleveland OH 44115. (216)348-8500. Fax: (216)736-8113. E-mail: inquiries@liggett.com. Website: www.liggett.com. **Art Buyer:** Caterina Gibson. Estab. 1932. Ad agency. Full-service multimedia firm. Works in all formats. Handles all product categories. Current clients include Sears Optical, Evenflo, Forest City Management, Cleveland Cavaliers, Cedar Point, Manco and Medical Mutual.

Needs: Approached by 120 freelancers/year. Works with freelance illustrators and designers. Prefers local freelancers. Works on assignment only. Uses freelancers mainly for brochure, catalog and print ad design and illustration, storyboards, slide illustration, animatics, animation, retouching, billboards, posters, TV/film graphics, lettering and logos. Needs computer-literate freelancers for illustration and production. 90% of freelance work demands skills in QuarkXPress, FreeHand, Photoshop or Illustrator.

First Contact & Terms: Send query letter. Samples are filed. Responds only if interested. To show portfolio, mail tearsheets and transparencies. Pays for design and illustration by the project. Negotiates rights purchased.

Tips: Please consider that art buyers and art directors are very busy and receive at least 25 mailings per day from freelancers looking for work opportunities. We might have loved your promo piece, but chances of us remembering it by your name alone when you call are slim. Give us a hint—"it was red and black" or whatever. We'd love to discuss your piece, but it's uncomfortable if we don't know what you're talking about.

LOHRE & ASSOCIATES, 2330 Victory Parkway, Suite 701, Cincinnati OH 45206. (513)961-1174. E-mail: sales@lohre.com. Website: www.lohre.com. **President:** Chuck Lohre. Number of employees: 8. Approximate annual billing: $1 million. Ad agency. Specializes in industrial firms. Professional affiliation: BMA.

Needs: Approached by 24 freelancers/year. Works with 10 freelance illustrators and 10 designers/year. Works on assignment only. Uses freelance artists for trade magazines, direct mail, P-O-P displays, multimedia, brochures and catalogs. 100% of freelance work demands knowledge of PageMaker, FreeHand, Photoshop and Illustrator.

First Contact & Terms: Send postcard sample or e-mail. Accepts submissions on disk, any Mac application. Pays for design and illustration by the hour, $10 minimum.

Tips: Looks for artists who "have experience in chemical and mining industry, can read blueprints and have worked with metal fabrication. Also needs Macintosh-literate artists who are willing to work at office, during day or evenings."

CHARLES MAYER STUDIOS INC., 168 E. Market St., Akron OH 44308. (330)535-6121. **President:** C.W. Mayer, Jr. AV producer. Estab. 1934. Number of employees: 65. Approximate annual billing: $2 million. Clients: mostly industrial. Produces film and manufactures visual aids for trade show exhibits.

Needs: Uses illustrators for catalogs, filmstrips, brochures and slides. Also for brochures/layout, photo retouching and cartooning for charts/visuals. In addition, has a large gallery and accepts paintings, watercolors, etc. on a consignment basis, 33%-40% commissions.

First Contact & Terms: Send slides, photographs, photostats or b&w line drawings or arrange interview to show portfolio. Samples not filed are returned by SASE. Responds in 1 week. Provide résumé and a sample or tearsheet to be kept on file. Originals returned to artist at job's completion. Negotiates payment.

ART MERIMS COMMUNICATIONS, 600 Superior Ave., Suite 1300, Cleveland OH 44114-2650. (216)522-1909. Fax: (216)479-6801. E-mail: amerims@anational.com. **Creative Director:** Larry Hohman. Number of employees: 4. Approximate annual billing: $800,000. Ad agency/PR firm. Current clients include Ohio Pest Control Association, Woodruff Foundation, Associated Builders and Contractors, Inc.

Needs: Approached by 10 freelancers/year. Works with 1-2 freelance illustrators and 3 designers/year. Prefers local freelancers. Works on assignment only. Uses freelancers mainly for work on trade magazines, brochures, catalogs, signage, editorial illustrations and AV presentations. 20% of freelance work demands computer skills.

First Contact & Terms: Send query letter with samples to be kept on file. Call for appointment to show portfolio of "copies of any kind" as samples. Sometimes requests work on spec before assigning a job. Pays for design and illustration by the hour, $40-60, or by the project, $300-1,200. Considers complexity of project, client's budget and skill and experience of artist when establishing payment. Finds artists through contact by phone or mail.

Tips: When reviewing samples, makes decisions based on "subjective feeling about abilities and cost if budget is low."

N PARKER ADVERTISING COMPANY, 3131 S. Dixie Dr., Suite 218, Dayton OH 45439. (937)293-3300. Fax: (937)293-7423. Estab. 1925. Number of employees: 7. Ad agency. Specializes in magazine ads, annual reports, spec sheets and catalogs. Product specialty is industrial. Client list not available.

Needs: Approached by 10 freelancers/year. Works with 4 freelance illustrators and 2 designers/year. Prefers artists with experience in industrial advertising. Uses freelancers for brochure and catalog illustration. 60% of work is with print ads. Needs computer-literate freelancers for production. Freelancers should be familiar with PageMaker, Photoshop and QuarkXPress.

First Contact & Terms: Send postcard-size sample of work. Samples are filed and are not returned. Does not reply. Portfolio review not required. Pays for design and illustration by the project. Buys all rights.

N ▼ WATT/FLEISCHMAN-HILLARD, 127 Public Square, Suite 5200, Cleveland OH 44114. (216)566-7019. Fax: (216)566-0857. Website: www.fleischman.com. **Vice President Design:** Tom Federico. Estab. 1981. Number of employees: 20. Approximate annual billing: $3 million. Integrated marketing communications agency. Specializes in annuals, sales literature, ads. Product specialties are manufacturing, high tech, healthcare. Current clients include NCR, RPM, TRW, AT&T. Professional affiliations: AIGA, Cleveland Ad Club.
 ● Parent company is Fleischman-Hillard, a global marketing communications agency.

Needs: Approached by 30 freelance illustrators and 20 designers/year. Works with 3 freelance illustrators and 6 designers/year. Prefers local freelancers. Uses freelancers mainly for overflow. Also for animation; humorous, medical and technical illustration; lettering, mechanicals, model making, multimedia projects, storyboards, TV/film graphics. 10% of work is with print ads. 100% of design demands skills in PageMaker, FreeHand, Photoshop, QuarkXPress, Illustrator. 50% of illustration demands skills in FreeHand, Photoshop, Illustrator.

First Contact & Terms: Designers send query letter with photocopies. Illustrators send postcard sample of work. Accepts disk submissions compatible with QuarkXPress 7.5/version 3.3. Send EPS files. Samples are filed. Responds only if interested. Portfolio of color, final art, photographs may be dropped off. Pays for design by the hour, $30-50. Pays for illustration by the project. Negotiates rights purchased. Finds artists through word of mouth, creative outlet books.

Tips: "Be flexible and fast."

WILDER-FEARN & ASSOC., INC., 2035 Dunlap St., Cincinnati OH 45214. (513)621-5237. Fax: (513)621-4880. E-mail: wfa@wilderfearn.com. Website: www.wilderfearn.com. **President:** Gary Fearn. Creative Director: Matt Fearn. Estab. 1946. Number of employees: 6. Specializes in brand and corporate identity; and display, package and publication design. Clients: ad agencies, corporations, packaging. Current clients include Jergens Co., Trillium Healthcare, State Dock Marina, Spear, Inc., Gold Medal Products and Kroger. Client list available upon request. Professional affiliation: Art Directors Club of Cincinnati.

Needs: Approached by 20-25 freelancers/year. Works with 5-10 freelance illustrators and 2-5 designers/year. Also need photographers. Prefers freelancers with experience in packaging and illustration comps. Uses freelance illustrators mainly for comps and finished art on various projects. Uses freelance designers mainly for packaging and brochures. Freelancers should be familiar with QuarkXPress, Illustrator, Dream Weaver and Photoshop.

First Contact & Terms: Send query letter with photocopies, résumé and slides. Accepts disk submissions. Samples are filed or are returned by SASE if requested by artist. Responds only if interested. Call for appointment to show portfolio of roughs, original/final art and color tearsheets and slides. Payment for design and illustration is based upon talent, client and project. Rights purchased vary according to project.

Tips: "We prefer experience in packaging—also Internet design and programming."

Oklahoma

■ **THE FORD AGENCY**, P.O. Box 521180, Tulsa OK 74152-1180. (918)743-3673. Website: www.thef ordagency.com. **Creative Director:** C.A. Ford. Estab. 1985. Design firm specializing in corporate identity and positioning in the fields of business, financial, food and retail.
Needs: Uses freelancers mainly for logo work, custom lettering, type design and technical illustration. Also for animation, medical and technical illustration, mechanicals, multimedia projects, retouching, storyboards, TV/film graphics and web page design.
First Contact & Terms: Designers send query letter with résumé. Illustrators send sample. Accepts disk submissions compatible with Macintosh format only. Samples are filed. Responds only if interested. Will contact artist for portfolio review of final art, roughs, tearsheets, thumbnails if interested. Pays $50-1,000. Finds artists through sourcebooks, graphics magazines and networking at speakers events and affiliated peer organizations.

▩ **PLANT & ASSOCIATES**, 1831 E. 71st St., Tulsa OK 74136. (918)877-2792. **Vice President:** Jennifer Payne. Estab. 1990. Number of employees: 4. Specializes in collateral pieces, packaging, P.O.P., promotional products and annual reports. Current clients include Hilti and Vintage Petroleum. Client list available upon request.
Needs: Approached by 6-8 illustrators and 6-8 designers/year. Works with 3-4 illustrators and 4-5 designers/year. Prefers local designers only. Uses freelancers mainly for concepts for packaging, print collateral and audiovisual work. Also for billboards, brochure design and illustration, catalog design, logos. 10-15% of work is with print ads. 100% of design demands knowledge of PageMaker, FreeHand, Photoshop, QuarkXPress, Illustrator. 50% of illustration demands computer knowledge.
First Contact & Terms: Send query letter with résumé. Accepts disk submissions compatible with QuarkXPress 7.5/version 3.32. Samples are filed, but can be returned. Responds only if interested. Will contact for portfolio review of photographs, roughs, thumbnails, transparencies. Pays by the hour. Finds artists through word of mouth, artists or agency contact.
Tips: "Have great attitude. Have great work ethic. You must love working with professional happy women."

Oregon

ADFILIATION ADVERTISING, P.O. Box 5855, Eugene OR 97405. (541)687-8262. Fax: (541)687-8576. E-mail: vip@adfiliation.com. Website: www.adfiliation.com. **President/Creative Director:** Gary Schubert. Media Director/VP: Gwen Schubert. Estab. 1976. Ad agency. "We provide full-service advertising to a wide variety of regional and national accounts. Our specialty is print media, serving predominantly industrial and business-to-business advertisers." Product specialties are forest products, heavy equipment, software, sporting equipment, food and medical.
Needs: Works with approximately 4 freelance illustrators and 2 designers/year. Works on assignment only. Uses freelancers mainly for specialty styles. Also for brochure and magazine ad illustration (editorial, technical and medical), retouching, animation, films and lettering. 80% of work is with print ads. 80% of freelance work demands knowledge of Illustrator, QuarkXPress, FreeHand, Director, Photoshop, multimedia program/design.
First Contact & Terms: Send query letter, brochure, résumé, slides and photographs. Samples are filed or are returned by SASE only if requested. Responds only if interested. Write for appointment to show portfolio. Pays for design and illustration and by the hour, $25-100. Rights purchased vary according to project.
Tips: "We're busy. So follow up with reminders of your specialty, current samples of your work and the convenience of dealing with you. We are looking at more electronic illustration. Find out what the agency does most often and produce a relative example for indication that you are up for doing the real thing! Follow up after initial interview of samples. Do not send fine art, abstract subjects."

☑ **CREATIVE COMPANY, INC.**, 726 NE Fourth St., McMinnville OR 97128. (866)363-4433. Fax: (866)363-6817. E-mail: jlmorrow@creativeco.com. Website: www.creativeco.com. **President/Owner:** Jennifer Larsen Morrow. Specializes in marketing-driven corporate identity, collateral, direct mail, packaging and P-O-P displays. Product specialties are food, garden products, financial services, colleges, manufacturing, pharmaceutical, medical, transportation programs.

Needs: Works with 6-10 freelance designers and 3-7 illustrators/year. Prefers local artists. Works on assignment only. Uses freelancers for design, illustration, computer production (Mac), retouching and lettering. "Looking for clean, fresh designs!" 100% of design and 60% of illustration demand skills in QuarkXPress, Pagemaker, FreeHand, Illustrator and Photoshop.

First Contact & Terms: Send query letter with brochure, résumé, business card, photocopies and tearsheets to be kept on file. Samples returned by SASE only if requested. Will contact for portfolio review if interested. "We require a portfolio review. Years of experience not important if portfolio is good. We prefer one-on-one review to discuss individual projects/time/approach." Pays for design by the hour or project, $50-90. Pays for illustration by the project. Considers complexity of project and skill and experience of artist when establishing payment.

Tips: Common mistakes freelancers make in presenting samples or portfolios are: "1) poor presentation, samples not mounted or organized; 2) not knowing how long it took them to do a job to provide a budget figure; 3) not demonstrating an understanding of the audience, the problem or printing process and how their work will translate into a printed copy; 4) just dropping in without an appointment; 5) not following up periodically to update information or a résumé that might be on file."

■ ☰ **OAKLEY DESIGN STUDIOS**. 921 SW Morrison St., Suite 540, Portland OR 97205. (503)241-3705. Fax: (503)241-3812. E-mail: oakleyds@oakleydesign.com. **Creative Director:** Tim Oakley. Estab. 1992. Number of employees: 2. Specializes in brand and corporate identity, display, package and publication design and advertising. Clients: ad agencies, record companies, surf apparel manufacturers, mid-size businesses. Current clients include Restart Nutritional Bars, M3 Productions, Michael Allen Clothiers, Miller Nash, LLP, Hawaiian Isle, Judan Records, Amigo Records, Barran Liebman, Mira Mobile Television, Kink FM 102. Professional affiliations OMPA, AIGA, PDXAD and PAF.

Needs: Approached by 5-10 freelancers/year. Works with 3 freelance illustrators and 2 designers/year. Prefers local artists with experience in technical illustration, airbrush. Also for multimedia projects. Uses illustrators mainly for advertising. Uses designers mainly for logos. Also uses freelancers for ad and P-O-P illustration, airbrushing, catalog illustration, lettering and retouching. 60% of design and 30% of illustration demands skills in Illustrator, Photoshop and QuarkXPress.

First Contact & Terms: Contact through artist rep or send query letter with brochure, photocopies, photographs, résumé and tearsheets. Accepts disk submissions compatible with Illustrator 9.0. Send EPS files. Samples are filed or returned by SASE if requested by artist. Responds in 6 weeks. Request portfolio review in original query. Will contact artist for portfolio review if interested. Portfolio should include b&w and color final art, photocopies, photostats, roughs and slides. Pays for design by the project, $200 minimum. Pays for illustration by the project. Rights purchased vary according to project. Finds artists through design workbooks.

Tips: "Be yourself. No phonies. Be patient and have a good book ready."

Ⓝ **WISNER ASSOCIATES, Advertising, Marketing & Design**, 2237 NE Wasco, Portland OR 97232. (503)282-3929. Fax: (503)282-0325. **Creative Director:** Linda Wisner. Estab. 1979. Number of employees: 1. Specializes in brand and corporate identity, book design, direct mail, packaging and publications. Clients: small businesses, manufacturers, restaurants, service businesses and book publishers.

Needs: Approached by 2-3 freelancers/year. Works with 3-5 freelance illustrators/year. Prefers experienced freelancers and "fast, clean work." Works on assignment only. Uses freelancers for technical and fashion illustration and some Windows-based computer work. Knowledge of QuarkXPress, CorelDraw, Photoshop, Illustrator and other Windows-compatible software required.

First Contact & Terms: Send query letter with résumé, photocopies and tearsheets. Prefers "examples of completed pieces which show the fullest abilities of the artist." Samples not kept on file are returned by SASE only if requested. Will contact artist for portfolio review if interested. Portfolio should include thumbnails, roughs and final reproduction/product. Pays for illustration by the hour, $20-45 average or by the project, by bid. Pays for computer work by the hour, $15-25.

Tips: "Bring a complete portfolio with up-to-date pieces."

Pennsylvania

Ⓝ **DICCICCO BATTISTA COMMUNICATIONS**, Dept. AM, 655 Business Center Dr., Horsham PA 19044. (215)957-0300. Website: www.dbcommunications.net. **Creative Director:** Carol Corbett. Estab. 1967. Full-service, multimedia, business-to-business ad agency. "High Creative." Specializes in food and business-to-business. Current clients include Hatfield Meats, Primavera, Hallowell and Caulk Dental Supplies.

Needs: Works with 10 freelance illustrators and 25 freelance designers/month. Uses freelance artists mainly for paste-up and mechanicals, illustration, photography and copywriting. Also uses artists for brochure design, slides, print ads, animatics, animation, retouching, TV/film grapics, lettering and logos. 60% of work is with print ads.

First Contact & Terms: Send query letter with brochure, résumé, tearsheets, photostats, photocopies, photographs, slides and SASE. Samples are filed or are returned by SASE only if requested by artist. Responds only if interested. Write to schedule an appointment to show a portfolio, which should include roughs, original/final art, tearsheets, final reproduction/product, photographs, slides; include color and b&w samples. Pays for design by the hour, $15-50. Pays for illustration by the project. Rights purchased vary according to project.

Tips: "Not everything they've had printed is worth showing—good ideas and good executions are worth more than mediocre work that got printed. Check on agency's client roster in the Red Book—that should tell you what style or look they'll be interested in."

N. CROSS KEYS ADVERTISING & MARKETING, INC., 329 S. Main St., Doylestown PA 18901. (215)345-5435. Fax: (215)345-4570. **President:** Laura T. Barnes. Estab. 1981. Number of employees: 10. Approximate annual billing: $2 million. Ad agency.

Needs: Approached by 30 freelancers/year. Works with 4 freelance illustrators and 5 designers/year. Prefers local freelancers. Uses freelancers for design and illustration, logos, mechanicals and retouching. 80% of work is with print ads. 50% of freelance work demands knowledge of Photoshop, QuarkXPress and Illustrator on Mac.

First Contact & Terms: Send query letter with photocopies and résumé. "We will accept work in Illustrator or as EPS files and in QuarkXPress." Samples are filed. Will contact artist for portfolio review if interested. Portfolio should include b&w and color final art, roughs. Pays for design and illustration by the project. Rights purchased vary according to project.

☑ FULLMOON CREATIONS INC., 100 Mechanic St., Doylestown PA 18901. (215)345-1233. E-mail: artist@fullmooncreations.com. Website: www.fullmooncreations.com. **Contact:** Art Director. Estab. 1986. Number of employees: 5. Specializes in brand and corporate identity; packaging design; corporate and product collateral; new brand and product concept development, and website development. Clients: Fortune 500 corporations. Current clients include M&M Mars, Educom, Paris Technology and The Atlantic Group.

Needs: Approached by 100-120 freelancers/year. Works with 5-15 freelance illustrators and 10-20 designers/year. Uses freelancers for ad, brochure and catalog design and illustration; airbrushing; audiovisual materials; book, direct mail and magazine design; logos; mechanicals; poster and P-O-P illustration. Needs computer-literate freelancers for design, illustration and production. 50% of freelance work demands knowledge of Illustrator, Photoshop, FreeHand and QuarkXPress.

First Contact & Terms: Send postcard sample of work, photocopies, résumé and URL. Samples are filed. Responds in 1 month with SASE. Will contact artist for portfolio review if interested. Portfolio should include b&w and color roughs, thumbnails and transparencies.

Tips: "Fullmoon Creations, Inc. is a multi-dimensional creative development team, providing design and marketing services to a growing and diverse group of product and service organizations and staffed by a team of professionals. Complementing these professionals is a group of talented, motivated (you) copywriters, illustrators, web designers and programmers who are constantly challenging their creative skills, working together with us as a team. We are above all, a professional service organization with a total dedication to our client's marketing needs."

N. ■ MITCHELL & RESNIKOFF, 8003 Old York Rd., Elkins Park PA 19027-1410. (215)635-1000. Fax: (215)635-6542. E-mail: rehabursky@mitch-res.com. **Executive Art Director:** John Byrnes. Executive Creative Director: Frank Tatulli. Estab. 1970. Number of employees: 9. Ad agency. Full-service, multimedia firm. Generates direct response, print and collateral for business-to-business and consumer advertising.

Needs: Approached by 10 freelance artists/month. Works with 2 illustrators and 4 designers/month. Uses local talent almost exclusively on project or hourly basis to design brochures, catalogs, print ads, illustrations, storyboards and logos. 90% of work is in print media. Needs computer-literate freelancers with high skill levels in all major Mac programs and marker comp abilities to work on-site, or off-site through MACNet.

First Contact & Terms: Send letter with samples and résumé. Samples are filed. Will respond if interested. Pays for design by the hour, $25-45. Pays fixed price for illustration, $150-2,000. Buys all rights.

▮ ■ NAISH, COHEN & ASSOC. (NC&A INC.), 1420 Locust St., Suite 310, Philadelphia PA 19102. (215)985-1144. Fax: (215)985-1077. E-mail: ads@p3.net. **President:** Frank Naish. Estab. 1969.

Number of employees: 7. Approximate annual billing: $3.5 million. Ad agency. Full-service, multimedia firm. Specializes in business-to-business ads, radio and TV, brochures. Product specialty is healthcare and graphic arts. Client list not available.

Needs: Approached by 20-30 freelancers/year. Works with 5-10 freelance illustrators/year. Prefers local freelancers only. Uses freelancers mainly for brochures. Also for lettering, logos and TV/film graphics. 30% of work is with print ads. Needs computer-literate freelancers for design. 50% of freelance work demands skills in PageMaker, FreeHand, Photoshop, QuarkXPress and Illustrator.

First Contact & Terms: Send postcard-size sample of work or query letter with brochure and photocopies. Samples are filed and are not returned. Artist should follow up with call after initial query to arrange portfolio review. Portfolio should include b&w and color photographs. Pays for design by the hour $15; by the project, $200. Pays for illustration by the project. Negotiates rights purchased.

N. THE NEIMAN GROUP, Harrisburg Transportation Center, 614 N. Front St., Harrisburg PA 17101. (717)232-5554. Fax: (717)232-7998. E-mail: neimangrp@aol.com. Website: www.neimangroup.com. **Senior Art Director:** Frank Arendt. Estab. 1978. Full-service ad agency specializing in print collateral and ad campaigns. Product specialties are healthcare, banks, retail and industry.

● This firm won a Golden Quill award for excellence from the IABC (International Association of Business Communicators) for their Statutory Rape Public Awareness Campaign.

Needs: Works with 5 illustrators and 4 designers/month. Prefers local artists with experience in comps and roughs. Works on assignment only. Uses freelancers mainly for advertising illustration and comps. Also uses freelancers for brochure design, mechanicals, retouching, lettering and logos. 50% of work is with print ads. 3% of design and 1% of illustration demand knowledge of Illustrator and Photoshop.

First Contact & Terms: Designers send query letter with résumé. Illustrators send postcard sample, query letter or tearsheets. Samples are filed. Will contact artist for portfolio review if interested. Portfolio should include color thumbnails, roughs, original/final art, photographs. Pays for design and illustration by the project, $300 minimum. Finds artists through sourcebooks and workbooks.

Tips: "Try to get a potential client's attention with a novel concept. Never, ever, miss a deadline. Enjoy what you do."

■ PERCEPTIVE MARKETERS AGENCY, LTD., P.O. Box 408, Bala Cynwyd PA 19004-0408. (610)668-4699. Fax: (610)668-4698. E-mail: info@perceptivemarketers.com. Website: perceptivemarketers.com. **Creative Director:** Jason Solovitz. Estab. 1972. Number of employees: 8. Approximate annual billing: $4 million. Ad agency. Product specialties are communications, sports, hospitals, healthcare consulting, computers (software and hardware), environmental products, automotive, insurance, financial, food products and publishing. Professional Affiliation: Philadelphia Ad Club, Philadelphia Direct Marketing Association, AANI, Second Wind Network, Philadelphia Art Directors Club.

Needs: Approached by 50 freelancers/year. Works with 6 freelance illustrators and 8 designers/year. Uses 80% local talent. In order of priority, uses freelancers for computer production, photography, illustration, comps/layout and design/art direction. Also for multimedia. "Concepts, dynamic design, ability to follow instructions/layouts and precision/accuracy are important." 50% of work is with print ads. 100% of design and 50% of illustration demands skills in QuarkXPress, Illustrator or Photoshop.

First Contact & Terms: Send résumé and photostats, photographs and tearsheets to be kept on file. Accepts as samples "whatever best represents artist's work—but preferably not slides." Accepts submissions on disk. Samples not filed are returned by SASE only. Responds only if interested. Graphic designers call for appointment to show portfolio. Pays for design by the hour or by the project. Pays for illustration by the project, up to $3,500. Considers complexity of the project, client's budget and turnaround time when establishing payment. Buys all rights.

Tips: "Freelance artists should approach us with unique, creative and professional work. And it's especially helpful to follow up interviews with new samples of work (i.e., to send a month later a 'reminder' card or sample of current work to keep on file)."

N. ■ SAI COMMUNICATIONS, 15 S. Bank St., Philadelphia PA 19106. (215)923-6466. Fax: (215)851-9410. AV firm. Full-service, multimedia firm.

Needs: Approached by 5 freelance artists/month. Works with 3 freelance designers/month. Uses freelance artists mainly for computer-generated slides. Also uses freelance artists for brochure and print ad design, storyboards, slide illustration and logos. 1% of work is with print ads.

First Contact & Terms: Send query letter with résumé. Samples are filed. Call to schedule an appointment to show a portfolio. Portfolio should include slides. Pays for design by the hour, $15-20. Pays for illustration by the project. Buys first rights.

WILLIAM SKLAROFF DESIGN ASSOCIATES, 124 Sibley Ave., Ardmore PA 19003. (610)649-6035. Fax: (610)649-6063. E-mail: wsklaroff@aol.com. **Design Director:** William Sklaroff. Public Rela-

tions: Lori L. Minassian-Sigmund. Marketing: Stefan C. Sklaroff. Estab. 1956. Specializes in display, interior, package and publication design and corporate identity and signage. Clients: contract furniture, manufacturers, healthcare corporations. Current clients include: Kaufman, Halcon Corporation, L.U.I. Corporation, McDonald Products, Shoup Electronic Voting Solutions, BK/Barrit, Herman Miller, Smith Metal Arts, Baker Furniture, Novikoff and Metrologic Instruments. Client list available upon request.

Needs: Approached by 2-3 freelancers/year. Works with 2-3 freelance illustrators and 2-3 designers/year. Works on assignment only. Uses freelancers mainly for assistance on graphic projects. Also for brochure design and illustration, catalog and ad design, mechanicals and logos.

First Contact & Terms: Send query letter with brochure, résumé and slides to Lori L. Minassian-Sigmund, PR Coordinator. Samples are returned. Responds in 3 weeks. Pays for design by the hour. Rights purchased vary according to project. Finds artists through word of mouth and submissions.

☑ **WARKULWIZ DESIGN ASSOCIATES INC.**, 2218 Race St., Philadelphia PA 19103. (215)988-1777. Fax: (215)988-1780. E-mail: wda@warkulwiz.com. Website: www.warkulwiz.com. **President:** Bob Warkulwiz. Estab. 1985. Number of employees: 6. Approximate annual billing: $1 million. Specializes in annual reports, publication design and corporate communications. Clients: corporations and universities. Current clients include Citibank, Bell Atlantic and Wharton School. Client list available upon request. Professional affiliations: AIGA, 1ABC.

Needs: Approached by 100 freelancers/year. Works with 10 freelance illustrators and 5-10 photographers/year. Works on assignment only. Uses freelance illustrators mainly for editorial and corporate work. Also uses freelance artists for brochure and poster illustration and mechanicals. Freelancers should be familiar with most recent versions of QuarkXPress, Illustrator, Photoshop, FreeHand and Director.

First Contact & Terms: Send query letter with tearsheets and photostats. Samples are filed. Responds only if interested. Call for appointment to show portfolio of "best edited work—published or unpublished." Pays for illustration by the project, "depends upon usage and complexity." Rights purchased vary according to project.

Tips: "Be creative and professional."

SPENCER ZAHN & ASSOCIATES, 2015 Sansom St., Philadelphia PA 19103. (215)564-5979. Fax: (215)564-6285. E-mail: szahn@erols.com. **President:** Spencer Zahn. Business Manager: Brian Zahn. Estab. 1970. Number of employees: 10. Specializes in brand and corporate identity, direct mail design, marketing and retail advertising. Clients: corporations.

Needs: Approached by 100 freelancers/year. Works with freelance illustrators and designers. Prefers artists with experience in Macintosh computers. Uses freelancers for ad, brochure and poster design and illustration; direct mail design; lettering; and mechanicals. Needs computer-literate freelancers for design, illustration and production. 80% of freelance work demands knowledge of Illustrator, Photoshop, FreeHand and QuarkXPress.

First Contact & Terms: Send query letter with samples. Samples are not filed and are returned by SASE if requested by artist. Responds only if interested. Artist should follow up with call. Portfolio should include final art and printed samples. Buys all rights.

Rhode Island

☑ **MARTIN THOMAS, INC.**, 334 County Rd., Barrington RI 02806-4108. (401)245-8500. Fax: (401)245-1242. Website: www.martinthomas.com. **Creative Director:** Joe Shansky. Estab. 1987. Number of employees: 12. Approximate annual billing: $7 million. Ad agency, PR firm. Specializes in industrial, business-to-business. Product specialties are plastics, medical and automotive. Professional affiliations: American Association of Advertising Agencies, Boston Ad Club.

Needs: Approached by 10-15 freelancers/year. Works with 6 freelance illustrators and 10-15 designers/year. Prefers freelancers with experience in business-to-business/industrial. Uses freelancers mainly for design of ads, literature and direct mail. Also for brochure and catalog design and illustration. 85% of work is print ads. 70% of design and 40% of illustration demands skills in QuarkXPress.

First Contact & Terms: Send query letter with brochure and résumé. Samples are filed and are returned. Responds in 3 weeks. Will contact artist for portfolio review if interested. Portfolio should include b&w and color final art. Pays for design and illustration by the hour and by the project. Buys all rights. Finds artists through *Creative Black Book*.

Tips: Impress agency by "knowing industries we serve."

N ☑ **SILVER FOX ADVERTISING**, 11 George St., Pawtucket RI 02860. (401)725-2161. Fax: (401)726-8270. E-mail: sfoxstudios@earthlink.net. Website: www.silverfoxstudios.com. **President:** Fred

Marzocchi, Jr. Estab. 1979. Number of employees: 8. Approximate annual billing: $1 million. Specializes in annual reports; brand and corporate identity; display, package and publication design; and technical illustration. Clients: corporations, retail. Client list available upon request.

Needs: Approached by 16 freelancers/year. Works with 6 freelance illustrators and 12 designers/year. Works only with artist reps. Prefers local artists only. Uses illustrators mainly for cover designs. Also for multimedia projects. 50% of freelance work demands knowledge of Illustrator, Photoshop, PageMaker and QuarkXPress.

First Contact & Terms: Send query letter with résumé and photocopies. Accepts disk submissions compatible with Photoshop 5.0 or Illustrator 8.0. Samples are filed. Does not reply. Artist should follow up with call and/or letter after initial query. Portfolio should include final art, photographs, photostats, roughs and slides.

Tennessee

N: ANDERSON STUDIO, INC., 2609 Grissom Dr., Nashville TN 37204. (615)255-4807. Fax: (615)255-4812. **Contact:** Andy Anderson. Estab. 1976. Number of employees: 8. Approximate annual billing: $800,000. Specializes in T-shirts (designing and printing of art on T-shirts for retail/wholesale promotional market). Clients: business, corporate retail, gift and specialty stores.

Needs: Approached by 20 freelancers/year. Works with 1-2 freelance illustrators and 1-2 designers/year. "We use freelancers with realistic (photorealistic) style or approach to various subjects, animals and humor. Also contemporary design and loose film styles accepted." Works on assignment only. Needs freelancers for retail niche markets, resorts, museums, theme ideas, animals, zoos, educational, science, American motorcycle and hot rod art, hip kid art (skateboarder/BMX bike type art for T's), humor-related themes and hot rod art. Also creative graphic work for above. Catchy marketable ideas welcome. Educational and science art needed.

First Contact & Terms: Send postcard sample or query letter with color copies, brochure, photocopies, photographs, SASE, slides, tearsheets and transparencies. Samples are filed and are returned by SASE if requested by artist. Portfolio should include slides, color tearsheets, transparencies and color copies. Sometimes requests work on spec before assigning a job. Pays for design and illustration by the project, $300-1,000 or in royalties per piece of printed art. Negotiates rights purchased. Considers buying second rights (reprint rights) to previously published work.

Tips: "We're looking for fresh ideas and solutions for art featuring animals, zoos, science, humor and education. We need work that is marketable for specific tourist areas—state parks, beaches, islands; also for women's markets. Be flexible in financial/working arrangements. Most work is on a commission or flat buy out. We work on a tight budget until product is sold. Art-wise, the more professional the better." Advises freelancers entering the field to "show as much work as you can. Even comps or ideas for problem solving. Let art directors see how you think. Don't send disks. Takes too long to review. Most art directors like hard copy art."

N: HARMON GROUP, 807 Third Ave. S., Nashville TN 37210. (615)256-3393. Fax: (615)256-3464. E-mail: abinfo@abstudios.com. Website: www.abstudios.com. **President:** Rick Arnemann. Estab. 1988. Number of employees: 20. Approximate annual billing: $3.7 million. Specializes in brand identity, display and direct mail design and signage. Clients: ad agencies, corporations, mid-size businesses. Current clients include Best Products, Service Merchandise, WalMart, Hartmann Luggage. Client list available upon request. Professional affiliations: Creative Forum.

Needs: Approached by 20 freelancers/year. Works with 4-5 freelance illustrators and 5-6 designers/year. Uses illustrators mainly for P-O-P. Uses designers mainly for fliers and catalogs. Also uses freelancers for ad, brochure, catalog, poster and P-O-P design and illustration, logos, magazine design, mechanicals and retouching. 85% of freelance work demands skills in Illustrator 5.5, Photoshop 3.0 and QuarkXPress 3.31.

First Contact & Terms: Send photographs, résumé, slides and transparencies. Samples are filed. Will contact artist for portfolio review if interested. Portfolio should include color final art, roughs, slides and thumbnails. Pays for design and illustration by the project. Rights purchased vary according to project. Finds artists through sourcebooks and portfolio reviews.

■ MEDIA GRAPHICS (division of Dev. Kinney/Media Graphics, Inc.), 717 Spring St., P.O. Box 820525, Memphis TN 38182-0525. (901)324-1658. Fax: (901)323-7214. E-mail: mediagraphics@devkinney.com. Website: www.devkinney.com. **CEO:** J.D. Kinney. Estab. 1973. Integrated marketing communications agency. Specializes in all visual communications. Product specialties are financial, fundraising, retail, business-to-business. Client list available upon request. Professional affiliations: Memphis Area chamber, B.B.B.

● This firm reports they are looking for top illustrators only. When they find illustrators they like, they generally consider them associates and work with them on a continual basis.

First Contact & Terms: Send query letter with résumé and tearsheets. Accepts disk submissions compatible with Mac or PC. Only 1 sample JPEG, 65K maximum; prefer HTML reference. Send PDF file. Also CD-ROM. Samples are filed and are not returned. Will contact for portfolio review on web or via e-mail if interested. Rights purchased vary according to project.

Tips: Chooses illustrators based on "portfolio, availability, price, terms and compatibility with project."

[N] ODEN MARKETING & DESIGN, 22 N. Front St., Suite 300, Memphis TN 38103-2162. (901)578-8055. Fax: (901)578-1911. Website: www.oden.com. **Creative Director:** Bret Terwilleger. Estab. 1971. Specializes in annual reports, brand and corporate identity, design and package design. Clients: corporations. Current clients include International Paper, Maybelline, Federal Express.

Needs: Approached by 15-20 freelance graphic artists/year. Works with 5-8 freelance illustrators and 4-6 freelance designers/year. Works on assignment only. Uses illustrators and designers mainly for collateral. Also uses freelance artists for brochure design and illustration, mechanicals and ad illustration. Need computer-literate freelancers for design and production. 50% of freelance work demands knowledge of QuarkXPress or Photoshop.

First Contact & Terms: Send query letter with brochure, photographs, slides and transparencies. Samples are filed and are not returned. Responds only if interested. Portfolio review not required. Pays for design by the hour, $55-70; or by the project. Pays for illustration by the project, $500. Rights purchased vary according to project.

Tips: Finds artists through sourcebooks.

[N] THOMPSON & COMPANY, 50 Peabody Place, 5th Floor, Memphis TN 38103. (901)527-8000. Fax: (901)527-3697. Website: www.thompson-co.com. **Creative Director:** Michael Thompson. Senior Art Director: Jeff Joiner. Estab. 1981. Number of employees: 86. Full-service ad agency. Current clients include Seabrook Wallcoverings, Thomas & Betts, First Tennessee Bank, UC Lending.

Needs: Works with various number of illustrators and designers/month. Works on assignment only. Uses freelancers mainly for ads. Also for brochure design and illustration, slide illustration, storyboards, animatics, animation, mechanicals, retouching, billboards, posters, TV/film graphics, lettering and logos. 70% of work is with print ads.

First Contact & Terms: Send query letter with samples. Samples are filed or are returned by SASE only if requested by artist. Will contact artist for portfolio review if intereted. Portfolio should include "fresh ideas." Rights purchased vary according to project.

■ THE TOMBRAS GROUP, 630 Concord St., Knoxville TN 37919. (865)524-5376. Fax: (865)524-5667. E-mail: mmccampbell@tombras.com. Website: www.tombras.com. **Executive Creative Director:** Mitch McCampbell. Estab. 1946. Number of employees: 60. Approximate annual billing: $35 million. Ad agency. Full-service multimedia firm. Specializes in full media advertising, collateral, PR. Current clients include The State of Tennessee and Eastman Chemical. Client list available upon request. Professional affiliations: AAAA, Worldwide Partners, PRSA.

Needs: Approached by 20-25 freelancers/year. Works with 20-30 freelance illustrators and 10-15 designers/year. Uses freelancers mainly for illustration and photography. Also for brochure design and illustration, model-making and retouching. 60% of work is with print ads. Needs computer-literate freelancers for design and presentation. 25% of freelance work demands skills in FreeHand, Photoshop and QuarkXPress.

First Contact & Terms: Send query letter with photocopies and résumé. Samples are filed. Will contact artist for portfolio review if interested. Portfolio should include b&w and color samples. Pays for design by the hour, $25-75; by the project, $250-2,500. Pays for illustration by the project, $100-10,000. Rights purchased vary according to project.

Tips: "Stay in touch with quality promotion. 'Service me to death' when you get a job."

Texas

■ THOMAS S. BELL ADVERTISING & DESIGN, 485 Milam, Beaumont TX 77701. (409)832-5901. Fax: (409)833-2625. E-mail: texbags@ih2000.net. Website: www.texbags.com. **Owner:** Tom Bell. Estab. 1977. Number of employees: 3. Approximate annual billing: $1 million. Ad agency. Full-service, multimedia firm. Specializes in graphics, logo designs, brochures and magazine ads. Product specialty is manufactured products. Current clients include: Bo-Mac Contractors, M&P Sealing Co. and Transcon. Client list available upon request.

● Thomas S. Bell was given a local silver Addy Award for their work for Koshkin Properties. They also won a Southeast Texas Advertising Award for the logo/trademark design of Poco Loco Angler's "Spoondog lures."

Needs: Approached by 10-20 freelancers/year. Works with 2 freelance illustrators and 2 designers/year. Uses freelancers for billboards, brochure and catalog design and illustration, posters and TV/film graphics. 30% of work is with print ads. Computer-literate freelancers are helpful for design and production. "They don't have to be computer experts."

First Contact & Terms: Send query letter. Samples are filed and are not usually returned. "I will return samples if needed." To arrange portfolio review artist should follow up with call after initial query. Portfolio should include "whatever is available." Pays for design and illustration by the project, $100 minimum. Rights purchased vary according to project. Finds artists through word of mouth and artists' submissions.

Tips: "Show me good work. Computers don't make you a designer. I'm more interested in design and illustration skills than knowledge of computers."

DYKEMAN ASSOCIATES INC., 4115 Rawlins, Dallas TX 75219. (214)528-2991. Fax: (214)528-0241. E-mail: adykeman@airmail.net. Website: dykemanassoc.com. **Contact:** Alice Dykeman. PR/marketing firm. Specializes in business, industry, hospitality, sports, environmental, energy, health.

Needs: Works with 12 illustrators and designers/year. Local freelancers only. Uses freelancers for editorial and technical illustration, brochure design, exhibits, corporate identification, POS, signs, posters, ads and all design and finished artwork for graphics and printed materials. PC or Mac—all formats.

First Contact & Terms: Request portfolio review in original query. Pays by the project, $250-3,000. "Artist makes an estimate; we approve or negotiate."

Tips: "Be enthusiastic. Present an organized portfolio with a variety of work. Portfolio should reflect all that an artist can do. Don't include examples of projects for which you only did a small part of the creative work. Have a price structure but be willing to negotiate per project. We prefer to use artists/designers/illustrators who will work with barter (trade) dollars and join one of our associations. We see steady growth ahead."

EGAN DESIGN ASSOCIATES, 18768 Wainsborough Lane, Dallas TX 75287. (972)931-7001. Fax: (972)931-7141. E-mail: abby-design@mindspring.com. **Art Director:** Abby Egan Smith. Estab. 1980. Number of employees: 6. Specializes in brand and corporate identity; display, direct mail and package design; and signage. Clients: corporations and manufacturers. Current clients include Frito Lay, Atmos Energy, T.C.B.Y., Winn-Dixie. Client list available upon request.

Needs: Approached by 50 freelancers/year. Works with 20 freelance illustrators and 10 designers/year. "Experience in food illustration is helpful." Uses illustrators mainly for package design and brochures. Uses designers mainly for computer production. Also uses freelancers for brochure and catalog design and illustration, lettering, logos, mechanicals and poster and P-O-P illustration. Needs computer-literate freelancers for illustration and production. 100% of freelance work demands knowledge of Illustrator, Photoshop, FreeHand, Aldus Pagemaker and QuarkXPress.

First Contact & Terms: Send postcard sample of work, brochure, photocopies, photographs, photostats, résumé and tearsheets. Samples are filed. Will contact artist for portfolio review if interested. Rights purchased vary according to project.

THE EMERY GROUP, Dept. AM, 1519 Montana, El Paso TX 79902. (915)532-3636. Fax: (915)544-7789. E-mail: gothman@aol.com. **Art Directors:** Henry Martinez and Edward Robledo. Number of employees: 25. Ad agency. Specializes in automotive and retail firms, banks and restaurants. Current clients include Whataburger and Pepsi of El Paso.

Needs: Approached by 3-4 freelancers/year. Works with 2-3 freelance illustrators and 4-5 designers/year. Uses freelancers mainly for design, illustration and production. Needs technical illustration and cartoons.

First Contact & Terms: Works on assignment only. Send query letter with résumé and samples to be kept on file. Will contact artist for portfolio review if interested. Prefers tearsheets as samples. Samples not filed are returned by SASE. Replies. Sometimes requests work on spec before assigning a job. Pays for design by the hour, $15 minimum; by the project, $100 minimum; by the day, $300 minimum. Pays for illustration by the hour, $15 minimum; by the project, $100 minimum. Considers complexity of project, client's budget and turnaround time when establishing payment. Rights purchased vary according to project.

Tips: Especially looks for "consistency and dependability; high creativity; familiarity with retail, Southwestern and Southern California look."

FUTURETALK TELECOMMUNICATIONS COMPANY, INC., P.O. Box 270942, Dallas TX 75227-0942. E-mail: futuretalktele@yahoo.com. Website: www.tex-lotto-assn.com. **Contact:** Marketing Department Manager. Estab. 1993. Ad agency and PR firm. Full-service multimedia firm and telecommunications company. Current clients include small to medium businesses and individuals.

Needs: Approached by 20-30 freelancers/year. Works with 10-15 illustrators and 2-3 designers/year. Prefers freelancers with experience in computer graphics. Works on assignment only. Uses freelancers mainly for promotional projects. Also for brochure and catalog illustration, storyboards, animation, model-making, billboards and TV/film graphics. 20% of work is with print ads. 60% of freelance work demands computer skills.

First Contact & Terms: Send query letter with résumé, photocopies, photographs and SASE. Samples are filed or are returned by SASE if requested by artist. Responds in 3 weeks. Art Director will contact artist for portfolio review if interested. Portfolio should include b&w and color final art, tearsheets and photostats. Pays for design by the hour, $10-25; by the project, $250-2,500; by the day, $250-2,500. Pays for illustration by the hour, $20-40; by the project, $250-2,500; by the day, $250-2,500. Rights purchased vary according to project. Finds artists through sourcebooks, word of mouth and artists' submissions.

Tips: "Send $5 for 'guidelines information packet' that explains project before submitting prospective ideas and samples. Address envelope to: Artists/Production Guidelines, Futuretalk Telecom, P.O. Box 270942, Dallas, Texas 75227-0942. Include note with your interest for guidelines."

JUDE STUDIOS, (formerly Penn-Jude Partners), 8000 Research Forest, Suite 115-266, The Woodlands TX 77382. (281)364-9366. Fax: (281)364-9529. **Creative Director:** Judith Dollar. Estab. 1994. Number of employees: 2. Design firm. Specializes in printed material, brochure, trade show, collateral. Product specialties are industrial, restaurant, homebuilder, financial, high-tech business to business. Professional affiliations: Art Directors of Houston, AAF.

Needs: Approached by 20 illustrators and 6 designers/year. Works with 10 illustrators and 2 designers/year. Prefers local designers only. Uses freelancers mainly for newsletter, logo and brochures. Also for airbrushing; brochure design and illustration; humorous, medical, technical illustration; lettering, logos, mechanicals and retouching. 90% of design demands skills in FreeHand, Photoshop, QuarkXPress. 30% of illustration demands skills in FreeHand, Photoshop, QuarkXPress.

First Contact & Terms: Designers send brochure, photocopies, photographs, photostats, résumé, tearsheets. Illustrators send sample of work. Send query letter with brochure, photocopies, photographs or tearsheets. Accepts disk submissions. Send TIFF, EPS, PDF or JPEG files. Samples are filed and are not returned. Art director will contact artist for portfolio review if interested. Pays by the project; varies. Negotiates rights purchased. Finds artists through *American Show Case*, *Workbook*, *RSVP* and artist's reps.

Tips: Wants freelancers with good type usage who contribute to concept ideas. We are open to designers and illustrators who are just starting out their careers.

ORIGIN DESIGN, INC., 2014 Platinum St., Garland TX 75042. (972)276-1722. Fax: (972)272-5570. E-mail: origin@ont.com. Website: www.origin2000.net. **Owners:** Kathleen Zierhut and Clarence Zierhut. Estab. 1955. Specializes in display, product and package design and corporate identity. Clients: corporations, museums, individuals. Client list available.

Needs: Works with 1-2 freelance graphic artists and 3-4 freelance designers/year. Works on assignment only. Uses designers mainly for renderings and graphics. Also uses freelance artists for illustration, mechanicals, retouching, airbrushing and model-making. Needs computer-literate freelancers for design. 100% of freelance work demands knowledge of CAD and/or Pro-Engineering.

First Contact & Terms: Send query letter with résumé. Samples are filed. Responds only if interested. Will contact artist for portfolio review if interested. Porfolio should include b&w and color final art and photographs. Pays for design by the hour, $15-50, by the project or by direct quote. Buys all rights. Finds artists through sourcebooks and word of mouth.

Tips: "Be computer-literate and persistent."

STEVEN SESSIONS INC., 5177 Richmond, Suite 500, Houston TX 77056. (713)850-8450. Fax: (713)850-9324. E-mail: Steven@Sessionsgroup.com. Website: www.sessionsgroup.com. **President, Creative Director:** Steven Sessions. Estab. 1981. Number of employees: 8. Approximate annual billing: $2.5 million. Specializes in annual reports; brand and corporate identity; fashion, package and publication design. Clients: corporations and ad agencies. Current clients include Compaq Computer, Kellogg Foods, Stroh Foods, Texas Instruments, Del Monte Foods, Old Milwaukee Beer and Medical Care International. Client list available upon request. Professional affiliations: AIGA, Art Directors Club, American Ad Federation.

Needs: Approached by 50 freelancers/year. Works with 10 illustrators and 2 designers/year. Uses freelancers for brochure, catalog and ad design and illustration; poster illustration; lettering; and logos. 100% of freelance work demands knowledge of Illustrator, QuarkXPress, Photoshop or FreeHand. Needs editorial, technical and medical illustration.

First Contact & Terms: Designers send query letter with brochure, tearsheets, slides and SASE. Illustrators send postcard sample or other nonreturnable samples. Samples are filed. Responds only if interested. To show portfolio, mail slides. Payment depends on project, ranging from $1,000-30,000/illustration. Rights purchased vary according to project.

[N] TEMERLIN McCLAIN/McCANN-ERICKSON SOUTHWEST, 6555 Sierra Dr., Irving TX 75039. (972)556-1100. **Group Creative Director:** Mark Daspit. Advertising, marketing and communications ad agency. Clients: all types including consumer, industrial, gasoline, transportation/air, entertainment, computers and high-tech.

- McCann-Erickson Southwest and Temerlin McClain merged in October, 2001. Temerlin McClain is one of the largest agencies in the United States with offices in Dallas, Houston, Austin, New Orleans and Toronto, and is a subsidiary of McCann-Erickson World Group, a part of Interpublic Group.

Needs: Works with about 20 illustrators/month. Uses freelancers in all media.

First Contact & Terms: Send nonreturnable postcard sample or tearsheets. Will contact artist for portfolio review if interested. Selection based on portfolio review. Pays for design by the hour, $40 minimum. Pays for illustration by the project, $100 minimum. Negotiates payment based on client's budget and where work will appear. Finds artists through word of mouth.

Tips: Wants to see full range of work including past work used by other ad agencies and tearsheets of published art in portfolio.

EVANS WYATT ADVERTISING, P.O. Box 18958, Corpus Christi TX 78480-8958. (361)939-7200. Fax: (361)939-7999. **Creative Director:** E. Wyatt. Estab. 1975. Ad agency. Full-service, multimedia firm. Specializes in general and industrial advertising.

Needs: Approached by 3-5 freelance artists/month. Works with 5-6 illustrators and 6-9 designers/month. Works on assignment only. Uses freelancers for ad design and illustration, brochure and catalog design and illustration, storyboards, retouching, billboards, posters, TV/film graphics, logos, industrial/technical art, websites and E-marketing. 70% of work is with print ads.

First Contact & Terms: Send a query letter with brochure, photocopies, SASE, résumé and photographs. Samples are filed or are returned by SASE if requested by artist. Responds in 1 month. Call for appointment to show portfolio or mail b&w and color copies, tearsheets and photographs. Pays by the hour, by the project or by arrangement. Buys all rights.

Tips: "Illustrators and graphic designers should be skilled, experienced and professional. Because of our market, size should also be reasonable in price and delivery."

Utah

[N] ALAN FRANK & ASSOCIATES INC., Dept. AM, 1524 S. 1100 E., Salt Lake City UT 84105. (801)486-7455. **Art Director:** Kazuo Shiotani. Serves clients in travel, fast food chains and retailing. Clients include KFC, ProGolf.

Needs: Uses freelancers for illustrations, animation and retouching for annual reports, billboards, ads, letterheads, TV and packaging.

First Contract & Terms: Mail art with SASE. Responds in 2 weeks. Minimum payment: $500, animation; $100, illustrations; $200, brochure layout.

Vermont

HARRY SPRUYT DESIGN, P.O. Box 706, Putney VT 05346-0706. Specializes in design/invention of product, package and device, design counseling service shows "in-depth concern for environments and human factors with the use of materials, energy and time; product design evaluation and layout." Clients: product manufacturers, design firms, consultants, ad agencies, other professionals and individuals. Client list available.

The Artist's
MAGAZINE

Discover why artists just like you rate *The Artist's Magazine* as the "Most Useful Art Magazine!"

Packed with innovative ideas, creative inspiration, and detailed demonstrations from the best artists in the world, *The Artist's Magazine* brings you everything you need to take your art to the next level. Here's just a sample of what you'll find inside…

- Top artists discuss the benefits of applying various techniques to your art for greater success
- Expert floral painters offer tips on how to set up a stunning floral still life
- Artists from around the globe share ideas on how to choose your subjects
- Special Reports on painting outdoors, using your computer in the studio, colored pencils…and much more!

The Artist's Magazine always gives you easy-to-understand instructions, inspiration to spark your creativity, and advice from the most-trusted artists in the world.

Send for your 2 FREE ISSUES today!

How to Reach Your Art Goals

The Artist's
MAGAZINE
www.artistsmagazine.com

The Year's Best Art
Bring Your Landscapes to Life

Needs: Works on assignment only.

Virginia

ALPERT AND ALPERT, INC., 360 Herndon Pkwy., Suite 1200, Herndon VA 20170. (703)689-4577. Fax: (703)689-4578. Website: www.alpert2.com. Estab. 1981. Specializes in annual reports, corporate identity, direct mail and package and publication design. Clients: corporations, associations. Current clients include Homestead Funds, Valley Heath System, Lafarge North America, LCC International. The AES Corporation. Client list available upon request.

Needs: Approached by 15-20 freelance artists/year. Works with 1-2 illustrators and designers/year. Prefers local designers ("illustrators are hired from all around US"). Works on assignment only. Uses illustrators mainly for corporate communication/collateral. Uses designers and illustrators for brochure and ad design and illustration, magazine and direct mail design, retouching, airbrushing, lettering, logos and chart/graphs. Needs computer-literate freelancers for design. 100% of design work demands knowledge of QuarkXPress, Illustrator or Photoshop.

First Contact & Terms: Send query letter with résumé, tearsheets, photocopies and slides. Samples are filed. Will contact artist for portfolio review if interested. Portfolio should include color slides, tearsheets, photographs and final art. Pays for design by the hour, $40-65. Pays for illustration by the project, $450-5,000. Rights purchased vary according to project.

Tips: Finds artists through word of mouth, mailings and sourcebooks. "The best way for a freelancer to get an assignment is to show a portfolio, do great work and charge a fair price. Designers must have computer skills!"

DEADY ADVERTISING, Dept. AM, 17 E. Cary St., Richmond VA 23219. (804)643-4011. Website: www.deady.com. **President:** Jim Deady. Specializes in industrial, manufacturing.

Needs: Works with 10-12 freelance illustrators and 8-10 designers/year. Seeks only local or regional artists with minimum of 2 years experience with an agency. Works on assignment only. Uses freelancers for design and illustration, brochures, magazine ads, websites and interactive presentation.

First Contact & Terms: Designers send query letter with résumé to be kept on file; also send photocopies with SASE to be returned. Responds only if interested. Call or write for appointment to show portfolio, which should include photostats. Pays for design by the project, $2,500-10,000. Pays for illustration by the project, $1,500-7,500 average.

Tips: "Agency is active; freelancers who are accessible are our most frequently used resource."

EDDINS MADISON CREATIVE, 6121 Lincolnia Rd., #410 Alexandria VA 22312. (703)750-0030. Fax: (703)750-0990. E-mail: 450-3440@mcimail.com. **Creative Director:** Marcia Eddins. Estab. 1983. Number of employees: 9. Specializes in brand and corporate identity and publication design. Clients: corporations, associations and nonprofit organizations. Current clients include 3COM, Reuters, ABC, National Fire Protection Assoc. Client list available upon request.

Needs: Approached by 20-25 freelancers/year. Works with 4-6 freelance illustrators and 2-4 designers/year. Uses only artists with experience in Macintosh. Uses illustrators mainly for publications and brochures. Uses designers mainly for simple design and Mac production. Also uses freelancers for airbrushing, brochure and poster design and illustration, catalog design, charts/graphs. Needs computer-literate freelancers for design, production and presentation. 100% of freelance work demands knowledge of Illustrator, Photoshop, FreeHand and QuarkXPress.

First Contact & Terms: Send postcard sample of work or send query letter with photocopies and résumé. Samples are filed. Will contact artist for portfolio review if interested. Rights purchased vary according to project. Finds artists through sourcebooks, design/illustration annuals and referrals.

Tips: Impressed by "great technical skills, nice cover letter, good/clean résumé and good work samples."

Washington

AUGUSTUS BARNETT ADVERTISING/DESIGN, P.O. Box 197, Fox Island WA 98333. (253)549-2396. Fax: (253)549-4707. E-mail: charlieb@augustusbarnett.com. **President/Creative Director:** Charlie Barnett. Estab. 1981. Approximate annual billing: $1.2 million. Specializes in food, beverages, mass merchandise, retail products, corporate identity, package design, business-to-business advertising, marketing, financial. Clients: corporations, manufacturers. Current clients include Tree Top, Inc., Vitamilk Dairy, Frank Russell Co., University of Washington, Gilbert Global, Russell/Mellon Analytical Services,

Tamer Pharmaceuticals, Robinson & Nobel Geologists, Martinac Shipbuilding, Washington State Fruit Commission/NW Cherry Growers. Client list available upon request. Professional affiliations: AAF and AIGA.

Needs: Approached by more than 50 freelancers/year. Works with 2-4 freelance illustrators and 2-3 designers/year. Prefers freelancers with experience in food/retail and Mac usage. Works on assignment only. Uses illustrators for product, theme and food illustration, some identity and business-to-business. Also uses freelancers for illustration, multimedia projects and lettering. 90% of freelance work demands skills in FreeHand 8.01 and Photoshop 4.01. Send query letter with samples, résumé and photocopies. Samples are filed. Responds in 1 month. Pays for design by the hour, negotiable. Pays for illustration by project/use and buyouts. Rights purchased vary according to project.

Tips: "Freelancers must understand design is a business, deadlines and budgets. Design for the sake of design alone is worthless if it doesn't meet or exceed clients' objectives. Communicate clearly. Be flexible."

▓ BELYEA, 1809 Seventh Ave., Suite 1250, Seattle WA 98101. (206)682-4895. Fax: (206)623-8912. Website: www.belyea.com. Estab. 1988. Design firm. Specializes in brand and corporate identity, marketing collateral, in-store P-O-P, direct mail, package and publication design. Clients: corporate, manufacturers, retail. Current clients include Weyerhaeuser, Hogue Cellars and Princess Tours. Client list available upon request.

Needs: Approached by 20-30 freelancers/year. Works with 10 freelance illustrators/photographers and 3-5 designers/year. Prefers local design freelancers only. Works on assignment only. Uses illustrators for "any type of project." Uses designers mainly for overflow. Also uses freelancers for brochure, catalog, poster and ad illustration; and lettering. 100% of design and 70% of illustration demands skills in QuarkXPress, FreeHand or Photoshop.

First Contact & Terms: Send postcard sample and résumé. Accepts disk submissions. Samples are filed. Responds only if interested. Pays for illustration by the project. Rights purchased vary according to project. Finds artists through submissions by mail and referral by other professionals.

Tips: "Designers must be computer-skilled. Illustrators must develop some styles that make them unique in the marketplace. When pursuing potential clients, send something (one or more) distinctive. Follow up. Be persistent (it can take one or two years to get noticed) but not pesky. Get involved in local AIGA. Always do the best work you can—exceed everyone's expectations."

☑ ▢ CREATIVE CONSULTANTS, 2608 W. Dell Dr., Spokane WA 99208-4428. (509)326-3604. Fax: (509)327-3974. E-mail: ebruneau@creativeconsultants.com. Website: www.creativeconsultants.com. **President:** Edmond A. Bruneau. Estab. 1980. Approximate annual billing: $300,000. Ad agency and design firm. Specializes in collateral, logos, ads, annual reports, radio and TV spots. Product specialties are business and consumer. Client list available upon request.

Needs: Approached by 20 illustrators and 25 designers/year. Works with 10 illustrators and 15 designers/year. Uses freelancers mainly for animation, brochure, catalog and technical illustration, model-making and TV/film graphics. 36% of work is with print ads. Designs and illustration demands skills in PageMaker 6.5, FreeHand 9.0, Photoshop and QuarkXPress 4.1.

First Contact & Terms: Designers send query letter. Illustrators send postcard sample of work and e-mail. Accepts disk submissions if compatible with Photoshop, QuarkXPress, PageMaker and FreeHand. Samples are filed. Responds only if interested. Pays by the project. Buys all rights. Finds artists through Internet, word of mouth, reference books and agents.

▓ ▢ ▓ DAIGLE DESIGN INC., 180 Olympic Dr. SE, Bainbridge Island WA 98110. (206)842-5356. Fax: (206)780-2526. E-mail: candace@daigle.com. Website: www.daigle.com. **Creative Director:** Candace Daigle. Estab. 1987. Number of employees: 6. Approximate annual billing: $600,000. Design firm. Specializes in brochures, catalogs, logos, magazine ads, trade show display and websites. Product specialties are dot coms, communication, restaurant and automotive. Professional affiliations: AIGA.

Needs: Approached by 20 illustrators and 40 designers/year. Works with 5 illustrators and 5 designers/year. Prefers local designers with experience in Photoshop, Illustrator, DreamWeaver, Flash and PageMaker and FreeHand. Uses freelancers mainly for concept and production. Also for airbrushing, brochure design and illustration, lettering, logos, multimedia projects, signage, technical illustration and web page design. 15% of work is with print. 90% of design demands skills in PageMaker, Photoshop, Illustrator and FreeHand. 50% of illustration demands skills in Illustrator and FreeHand. and DreamWeaver.

First Contact & Terms: Designers send query letter with résumé. Illustrators send query letter with photocopies. Accepts disk submissions compatible with Adobe pdft browsers. Send JPEG files. Samples are filed and are not returned. Responds only if interested. Will contact for portfolio review of b&w, color, final art, slides and tearsheets if interested. Pays for design by the hour, $25; pays for illustration by the project, $100-4,000. Buys all rights. Finds artists through submissions, reps, temp agencies and word of mouth.

DITTMANN DESIGN, P.O. Box 31387, Seattle WA 98103-1387. (206)523-4778. E-mail: dittdsgn@nwl ink.com. **Owner/Designer:** Martha Dittmann. Estab. 1981. Number of employess: 2. Specializes in brand and corporate identity, display and package design and signage. Clients: corporations. Client list available upon request. Professional affiliations: AIGA.

Needs: Approached by 50 freelancers/year. Works with 5 freelance illustrators and 2 designers/year. Uses illustrators mainly for corporate collateral and packaging. Uses designers mainly for color brochure layout and production. Also uses freelancers for brochure and P-O-P illustration, charts/graphs and lettering. Needs computer-literate freelancers for design, illustration, production and presentation. 75% of freelance work demands knowledge of Illustrator, Photoshop, PageMaker, Persuasion, FreeHand and Painter.

First Contact & Terms: Send postcard sample of work or brochure and photocopies. Samples are filed. Will contact artist for portfolio review if interested. Portfolio should include final art, roughs and thumbnails. Pays for design by the hour, $35-100. Pays for illustration by the project, $250-5,000. Rights purchased vary according to project. Finds artists through sourcebooks, agents and submissions.

Tips: Looks for "enthusiasm and talent."

■ EMMAL BUTLER CREATIVES, 1735 Westlake N. #207, Seattle WA 98109. (206)283-7223. Fax: (206)284-9362. E-mail: cemmal@aol.com. **Contact:** Cheryl Butler. Estab. 1989. Number of employees: 1. Approximate annual billing: 150,000. Integrated marketing communications agency/broker of art talent. Specializes in print and web design/illustration.

• Emmal Butler is involved in several pro bono projects per year for child advocacy causes. To be included, please contact.

Needs: Approached by 200 illustrators and 200 designers/year. Works with 10 illustrators and 10 designers/year. Uses freelancers mainly for print/web design. Also for airbrushing, annual reports, billboards, brochure and catalog design and illustration, lettering, logos, multimedia projects, posters, retouching, signage, storyboards, technical illustration and web page design. 25% of work is with print ads. 95% of design demands skills in Photoshop, Illustrator, FreeHand, QuarkXPress and Web software. 50% of illustration demands skills in Photoshop, Illustrator and FreeHand.

First Contact & Terms: Designers and illustrators send examples of work (any form). Postcards preferred. Send follow-up every 6 months. Accepts digital portfolios and e-mail queries with links to websites. Samples are filed and are not returned. Does not reply. Artist should check in. To arrange portfolio review, follow up with call. Payment determined by value of work. Rights purchased vary according to project. Finds artists through word of mouth and submissions.

Tips: "Specialize—become known for one area of expertise and one distinctive style. Be persistent or get a good rep."

GIRVIN STRATEGIC BRANDING AND DESIGN, 1601 Second Ave., 5th Floor, Seattle WA 98101-1575. (206)674-7808. Fax: (206)674-7909. Website: www.girvin.com. Design Firm. Estab. 1977. Number of employees: 34. Specializes in corporate identity and brand strategy, naming, Internet strategy, film and video production, graphic design, signage, packaging and mulitmedia design. Current clients include Microsoft, Warner Bros., Intel, Lifesavers, Procter & Gamble, Paramount and Wells Fargo.

Needs: Works with several freelance illustrators, production artists and designers/year.

First Contact & Terms: Designers send query letter with appropriate samples. Illustrators send postcard sample or other nonreturnable samples. Will contact for portfolio review if interested. Payment negotiable.

■ ▼ HORNALL ANDERSON DESIGN WORKS, INC., 1008 Western Ave., Suite 600, Seattle WA 98104. (206)467-5800. Fax: (206)467-6411. E-mail: info@hadw.com. Website: www.hadw.com. Estab. 1982. Number of employees: 70. Design firm. Specializes in full range—brand and marketing strategy consultation; corporate, integrated brand and product identity systems; new media; interactive media websites; packaging; collateral; signage; trade show exhibits; environmental graphics and annual reports. Product specialties are large corporations to smaller businesses. Current clients include Microsoft, Space Needle, K2 Corporation, Ghiradelli Chocolates, Weyerhaeuser, Novell, Seattle Sonics, Quantum, Leatherman Tools. Professional affiliations: AIGA, Society for Typographic Arts, Seattle Design Association, Art Directors Club.

• This firm has received numerous awards and honors, including the International Mobius Awards, National Calendar Awards, London International Advertising Awards, Northwest and National ADDY Awards, Industrial Designers Society of America IDEA Awards, Communication Arts, Los Angeles Advertising Women LULU Awards, Brand Design Association Gold Awards, AIGA, Clio Awards, Communicator Awards, Web Awards.

Needs: "Interested in all levels, from senior design personnel to interns with design experience. Additional illustrators and freelancers are used on an as needed basis in design and online media projects."

First Contact & Terms: Designers send query letter with photocopies and résumé. Illustrators send query letter with brochure and follow-up postcard. Accepts disk submissions compatible with QuarkXPress,

FreeHand or Photoshop, "but the best is something that is platform/software independent (i.e., Director)." Samples are filed. Responds only if interested. Portfolios may be dropped off. Rights purchased vary according to project. Finds designers through word of mouth and submissions; illustrators through sourcebooks, reps and submissions.

◼ **TMA TED MADER ASSOCIATES, INC.**, 2562 Dexter Ave. N., Seattle WA 98109. (206)270-9360. Also 280 Euclid Ave., Oakland, CA. E-mail: info@tmadesign.com. Website: www.tmadesign.com. **Principal:** Ted Mader. General Manager: Cindy Dieter. Design firm. Number of employees: 16. Specializes in corporate and brand identity, displays, direct mail, fashion, packaging, publications, signage, book covers, interactive media and CD-ROM. Client list available upon request.
Needs: Approached by 150 freelancers/year. Works with 25 freelance illustrators and 10-20 designers/year. Uses freelancers for illustration, retouching, electronic media, production and lettering. Freelance work demands knowledge of QuarkXPress, FreeHand, Illustrator, Photoshop, Director or HTML programming.
First Contact & Terms: Send postcard sample or query letter with résumé and samples. Accepts disk submissions compatible with Mac. Samples are filed. Write or call for an appointment to show portfolio. Pays by the project. Considers skill and experience of freelancer and project budget when establishing payment. Rights purchased vary according to project.

Wisconsin

N ◼ **AGA COMMUNICATIONS**, 2400 E. Bradford Ave., Suite 206, Milwaukee WI 53211-4165. (414)962-9810. E-mail: greink@juno.com. **CEO:** Art Greinke. Estab. 1984. Number of employees: 8. Marketing communications agency (includes advertising and public relations). Full-service multimedia firm. Specializes in special events (large display and photo work), print ads, TV ads, radio, all types of printed material (T-shirts, newsletters, etc.). Current clients include Great Circus Parade, Circus World Museum, GGS, Inc., IBM, Universal Savings Bank and Landmark Theatre Chain. Also sports, music and entertainment personalities. Professional affiliations: PRSA, IABC, NARAS.
Needs: Approached by 125 freelancers/year. Works with 25 freelance illustrators and 25 designers/year. Uses freelancers for "everything and anything"—brochure and print ad design and illustration, storyboards, slide illustration, retouching, model making, billboards, posters, TV/film graphics, lettering and logos. Also for multimedia projects. 40% of work is with print ads. 75% of freelance work demands skills in PageMaker, Illustrator, Quark, Photoshop, FreeHand or Powerpoint.
First Contact & Terms: Send postcard sample and/or query letter with brochure, résumé, photocopies, photographs, SASE, slides, tearsheets, transparencies. Accepts disk submissions compatible with BMP files, PageMaker, Quark and Illustrator. Samples are filed and are not returned. Responds only if interested. Will contact artists for portfolio review if interested. Portfolio should include b&w and color thumbnails, roughs, final art, tearsheets, photographs, transparencies, etc. Pays by personal contract. Rights purchased vary according to project. Finds artists through submissions and word of mouth.
Tips: "We look for stunning, eye-catching work—surprise us! Fun and exotic illustrations are key!"

N ◼ **IMAGINASIUM, INC.**, 321 St. George St., Green Bay WI 54302-1310. (920)431-7872. Fax: (920)431-7875. E-mail: joe@imaginasium.com. Website: www.imaginasium.com. **Creative Director:** Joe Bergner. Estab. 1991. Number of employees: 9. Approximate annual billing: $1.5 million. Advertising, graphic design, and marketing firm. Specializes in brand development, graphic design, advertising. Product specialties are industrial, business to business. Current clients include Wisconsin Public Service, Schneider Logistics, Shopko. Client list available upon request. Professional affiliation: Green Bay Advertising Federation.
Needs: Approached by 50 illustrators and 25 designers/year. Works with 5 illustrators and 2 designers/year. Prefers local designers. Uses freelancers mainly for overflow. Also for brochure illustration and lettering. 15-20% of work is with print ads. 100% of design and 50% of illustration demands skills in Photoshop, QuarkXPress and Illustrator.
First Contact & Terms: Designers send query letter with brochure, photographs and tearsheets. Illustrators send sample of work with follow-up every 6 months. Accepts Macintosh disk submissions of above programs. Samples are filed and are not returned. Will contact for portfolio review of color tearsheets, thumbnails and transparencies if interested. Pays for design by the hour, $50-75. Pays for illustration by the project. Rights purchased vary according to project. Finds artists through submissions, word of mouth, Internet.

UNICOM, 9470 N. Broadmoor Rd., Bayside WI 53217. (414)352-5070. Fax: (414)352-4755. **Senior Partner:** Ken Eichenbaum. Estab. 1974. Specializes in annual reports, brand and corporate identity, display, direct, package and publication design and signage. Clients: corporations, business-to-business communications, and consumer goods. Client list available upon request.

Needs: Approached by 15-20 freelancers/year. Works with 1-2 freelance illustrators/year. Works on assignment only. Uses freelancers for brochure, book and poster illustration.

First Contact & Terms: Send query letter with brochure. Samples not filed or returned. Does not reply; send nonreturnable samples. Write for appointment to show portfolio of thumbnails, photostats, slides and tearsheets. Pays by the project, $200-6,000. Rights purchased vary according to project.

Record Labels

Lynda Kusnetz, creative director for Roadrunner Records, commissioned Toronto-based Amoeba Corp. to create a striking image for Nickelback's *Silver Side Up* CD package. Amoeba designer Mikey Richardson came up with the concept, design and illustration which features a digitally created mercury tear. The image has become almost as popular with fans as "How You Remind Me," a runaway hit on the same CD. The eye and tear image also graces T-shirts sold on the band's website. When the CD went platinum, Roadrunner graciously presented a copy of the platinum CD to the designers.

The labels listed in this section use freelance artists for CD covers, packaging, and merchandising of material. You could be hired to design store displays, T-shirts or posters, but your greatest challenge will be working within the size constraints of CD and cassette covers. The dimensions of a CD cover are 4¾ × 4¾ inches, packaged in a 5 × 5 inch jewel box. Inside each CD package is a 4-5 panel fold-out booklet, inlay card and CD. Photographs of the recording artist, illustrations, liner notes, titles, credit lines and lyrics all must be placed into that relatively small format.

LANDING THE ASSIGNMENT

Check the listings in the following section to see how the art director prefers to be approached and what type of samples to send. Disk and e-mail submissions are encouraged by many of these listings. Check also to see what type of music they produce. Assemble a portfolio of your best work in case an art director wants to see more of your work.

Be sure your portfolio includes quality samples. It doesn't matter if the work is of a different genre—quality is key. If you don't have any experience in the industry create your own CD package, featuring one of your favorite recording artists or groups.

Get the name of the art director or creative director from the listings in this section and send a cover letter with samples, asking for a portfolio review. If you are not contacted within a couple of months, send a follow-up postcard or sample to the art director or other contact person.

Once you nail down an assignment, get an advance and a contract. Independent labels usually provide an advance and payment in full when a project is done. When negotiating a contract, ask for a credit line on the finished piece and samples for your portfolio.

You don't have to live in one of the recording capitals to land an assignment, but it does help to familiarize yourself with the business. Visit record stores and study the releases of various labels. For further information about CD design read *Rock Art*, by Spencer Drate (PBC International) and *The Best Music CD Art & Design* (Rockport).

For More Information

Learn more about major labels and "indies" by reading industry trade magazines, like *Spin*, *Rolling Stone*, *Vibe*, *Revolver*, *Hit Parader* and *Billboard*. Each year around March, the Recording Industry Association of America releases sales figures for the industry. The RIAA's report also gives the latest trends on packaging and format, and music sales by genre. To request the most recent report, call the RIAA at (202)775-0101.

ACTIVATE ENTERTAINMENT, 11328 Magnolia Blvd., Suite 3, North Hollywood CA 91601. (818)505-6573. Fax: (818)508-1101. **President:** James Warsinske. Estab. 2000. Produces CDs and tapes: rock & roll, R&B, soul, dance, rap and pop by solo artists and groups.
Needs: Produces 2-6 soloists and 2-6 groups/year. Uses 4-10 visual artists for CD and album/tape cover design and illustration; brochure design and illustration; catalog design, layout and illustration; direct mail packages; advertising design and illustration. 50% of freelancers work demands knowledge of PageMaker, Illustrator, QuarkXPress, Photoshop.
First Contact & Terms: Send query letter with SASE, tearsheets, photographs, photocopies, photostats, slides and transparencies. Samples are filed. Responds in 1 month. To show portfolio, mail roughs, printed samples, b&w and color photostats, tearsheets, photographs, slides and transparencies. Pays by the project, $100-1,000. Buys all rights.
Tips: "Get your art used commercially, regardless of compensation. It shows what applications your work has."

☑ ▣ **ALBATROSS RECORDS/R'N'D PRODUCTIONS**, P.O. Box 540102, Houston TX 77254-0102. (713)521-2616. Fax: (713)529-4914. E-mail: rpds2405@aol.com. Website: www.rndproductions.c

om. **Art Director:** Victor Ivey. National Sales Director: Jeff Troncoso. Estab. 1987. Produces CDs, cassettes: country, jazz, R&B, rap, rock and pop by solo artists and groups. Recent releases: *Act Ah Fool*, by 214 Thugz; *Southern Hospitality*, by Luscious Ice; and "Untitled," by Nu Ground.

Needs: Produces 22 releases/year. Works with 3 freelancers/year. Prefers freelancers with experience in QuarkXPress, Freelance. Uses freelancers for cassette cover design and illustration; CD booklet design; CD cover design and illustration; poster design; Web page design; advertising design/illustration. 50% of freelance work demands knowledge of QuarkXPress, FreeHand, Photoshop.

First Contact & Terms: Send postcard sample of work. Samples are filed and not returned. Will contact for portfolio review of b&w and color final art if interested. Pays for design by the project, $400 maximum. Pays for illustration by the project, $250 maximum. Buys all rights. Finds freelancers through word of mouth.

N: ALEAR RECORDS, Rt. 2, Box 2910, Berkeley Springs WV 25411. (304)258-2175. E-mail: mccoytr oubadour@aol.com. **Owner:** Jim McCoy. Estab. 1973. Produces tapes and CDs: country/western. Releases: "The Taking Kind," by J.B. Miller; "If I Throw away My Pride," by R.L. Gray; and "Portrait of a Fool," by Kevin Wray.

Needs: Produces 12 solo artists and 6 groups/year. Works with 3 freelancers/year. Works on assignment only. Uses artists for CD cover design and tape cover illustration.

First Contact & Terms: Send query letter with résumé and SASE. Samples are filed. Responds in 1 month. To show portfolio, mail roughs and b&w samples. Pays by the project, $50-250.

✓ ALIAS RECORDS, 10153½ Riverside Dr., Suite 115, Toluka Lake CA 91602. (818)566-1034. Fax: (818)566-6623. E-mail: alias@aliasrecords.com. Website: www.aliasrecords.com. **Contact:** Art Director. Estab. 1989. Produces albums, CDs, cassettes and videos: pop, progressive and rock by solo artists and groups. Recent releases: *Squinting Before the Dazzle*, by Throneberry.

Needs: Produces 20 releases/year. Works with 5-10 freelancers/year. Prefers local designers and illustrators who own Macs. Uses freelancers for album/cassette/CD cover design and illustration, CD booklet design and illustration, poster and World Wide Web page design and stickers. 50% of design demands knowledge of PageMaker 5, Illustrator 5, QuarkXPress 3.3, Photoshop 3.0 and FreeHand 5.0.

First Contact & Terms: Send postcard sample and brochure, tearsheets, résumé and photographs. Accepts disk submissions compatible with Zip or Syquest for large files. EPS preferred. Samples filed. Report back to artist only if interested. Will contact for portfolio review of b&w, color final art and tearsheets if interested. Pays by the project for design, $500-2,000; for illustration, $50-1,000. Buys all rights. Finds artists through submissions.

Tips: "We look for something new, different and fresh in portfolios."

N: ALJONI MUSIC CO., P.O. Box 52417, Jacksonville FL 32201. (904)742-4278. E-mail: aljonimusic @aol.com. **Production Manager:** Al Hall, Jr. Estab. 1971. Produces albums, CDs, cassettes, videos: classical, country, gospel, jazz, R&B, rap, rock, soul, world by solo artists and groups. Recent releases: *Buffalo Soldier Suite*, by Cosmos Dwellers; *Stingers, Jingles and Traxx* (remix), *Makin' Cash Money* (MCM compilations).

Needs: Produces 4 releases/year. Works with minimum of 2 freelancers/year. Uses freelancers for album cover design and illustration; animation; cassette cover design and illustration; CD booklet design and illustration; CD cover design and illustration; poster design, web page design. 50% of freelance work demands computer skills.

First Contact & Terms: Send postcard sample or query letter with brochure, résumé, photographs, SASE. Samples are filed or returned by SASE if requested by artist. Responds only if interested. Portfolio review not required. Pays for design by the project; negotiable. Negotiates rights purchased. Rights purchased vary according to project.

Tips: "Be bold, different. Make your work jump out at the viewer—I keep my eyes open for Great Stuff! 2002 offers success for me and you."

N: ⊕ ALPHABEAT, Box 12 01, D-97862 Wertheim/Main, West Germany. Phone/fax: 09342-841 55. E-mail: alphabeat@t-online.de. **Owner:** Stephan Dehn. A&R: Marga Zimmerman. Marketing: Alexandra Tagscherer. Sales: Katria Tagscherer. Produces CDs, tapes and albums: R&B, soul, dance, rap, pop, new wave, electronic and house; solo artists and groups.

Needs: Uses freelancers for CD/album/tape cover, brochure and advertising design and illustration; catalog design, illustration and layout; and direct mail packages.

First Contact & Terms: Send query letter with brochure, tearsheets, photostats, résumé, photographs, slides, SASE, photocopies and IRCs. Samples are returned by SAE with IRCs. To show portfolio, mail appropriate materials. Payment depends on product. Rights purchased vary according to project.

AMERICAN MUSIC NETWORK INC., P.O. Box 7018, Warner Robins GA 31095. (478)953-2800. Estab. 1986. Produces albums, CDs, cassettes, videos: country, folk, gospel, jazz, pop, progressive, R&B, rock, soul by solo artists and groups.
Needs: Produces 12 releases/year. Works with 6 freelancers/year. Uses freelancers for album cover design and illustration; cassette cover design and illustration; CD booklet design and illustration; CD cover design and illustration; poster design. 50% of freelance design and illustration demands knowledge of PageMaker, Illustrator, QuarkXPress, Photoshop or FreeHand.
First Contact & Terms: Send query letter with résumé. Samples are filed or returned by SASE if requested by artist. Responds in 4 months. Portfolio review not required. Pays by the project, $50-500. Negotiates rights purchased.
Tips: Looks for "originality."

AMERICATONE INTERNATIONAL—U.S.A., 1817 Loch Lomond Way, Las Vegas NV 89102-4437. (702)384-0030. Fax: (702)382-1926. E-mail: jjj@americatone.com. Website: www.americatone.com. **President:** Joe Jan Jaros. Estab. 1983. Produces jazz. Recent releases by: Joe Farrell, Bobby Shew, Gabriel Rosati, Carl Saunders and Raoul Romero.
Needs: Produces 10 solo artists and 3 groups/year. Uses artists for direct mail packages and posters.
First Contact & Terms: Samples are returned by SASE. Responds within 2 months only if interested. To show a portfolio, mail appropriate materials.

AQUARIUS RECORDS/TACCA MUSIQUE, 1445 Lambert-Closse, Suite 300, Montreal, Quebec H3H 1Z5 Canada. (514)939-3775. Fax: (514)939-1691. E-mail: rene@dkd.com. Website: www.dkd.com. **Production Manager:** Rene LeBlanc. Estab. 1970. Produces CDs, cassettes and CD-ROMs: folk, pop, progressive and rock by solo artists and groups. Recent releases: "All Filler, No Killer," by Sum 41.
Needs: Produces 2-8 releases/year. Works with 4 freelancers/year. Prefers designers who own IBM PCs. Uses freelancers for album, cassette and CD cover design and illustration; CD booklet design and illustration; CD-ROM design and packaging; poster design; advertising and brochure. 90% of freelance work demands knowledge of Photoshop, Illustrator and QuarkXPress.
First Contact & Terms: Send postcard sample of work or query letter with brochure, résumé and photographs. Samples are filed and are not returned. Will contact for portfolio review of b&w and color photocopies and photographs if interested. Pays for design and illustration by the project. Rights purchased vary according to project. Finds artists through word of mouth, showcases and buzz.
Tips: "Be creative. Understand that each project is different and unique. Stay away from generics!"

ARIANA RECORDS, 1312 S. Avenida Polar, #A-8, Tucson AZ 85710. (520)790-7324. E-mail: jimigas/@earthlink.net. Website: www.arianarecords.com. **President:** Jim Gasper. Estab. 1980. Produces CDs: folk, spacefunk and rock, by solo artists and groups. Recent releases: "What's Your Story," by Thank God for Fingers; Jtiom, Sound Hole, Baby Fish Mouth and Scuba Tails.
Needs: Produces 5 releases/year. Works with 2 freelancers/year. Prefers freelancers with experience in cover design. Uses freelancers for album cover design and illustration; cassette cover design and illustration; CD cover design and illustration and multimedia projects. 70% of design and 50% of illustration demands computer skills. "We are looking at CD covers for the next two years."
First Contact & Terms: Send postcard sample of work. Samples are filed or returned by SASE if requested by artist. Responds in 1 month. Portfolio review not required. Pays by the project.
Tips: "We like simple, but we also like wild graphics! Give us your best shot!"

ARK 21, The Copeland Group, 14724 Ventura Blvd., Penthouse Suite, Sherman Oaks CA 91403. (818)461-1700. Fax: (818)461-1745. E-mail: jbevilaqua@ark21.com. Website: www.ark21.com. **Production Manager:** John Bevilacqua. President: Miles Copeland. Estab. 1996. Produces CDs and cassettes for a variety of niche markets: swing, hillbilly by solo artists and groups. Recent releases: *The Red Planet* soundtrack and *Secrets*, by The Human League.
Needs: Produces 20-30 releases/year. Works with 5-10 freelancers/year. Prefers local designers and illustrators who own Macs. Uses freelancers for album and CD cover and CD booklet design and illustration; poster design; point of purchase and production work. 100% of design demands knowledge of Illustrator, QuarkXPress, Photoshop.
First Contact & Terms: Send postcard sample of work. Accepts disk submissions compatible with Mac. Samples are filed or returned by SASE if requested. Does not reply. Artist should send a different promo in a few months. Portfolios may be dropped off Monday through Friday. Will contact for portfolio review if interested. Portfolio should include b&w and color final art, photocopies, photographs, photostats, roughs, slides, tearsheets, thumbnails or transparencies. Pays by the project. Buys all rights. Finds artists through interesting promos, *"The Alternative Pick."*

ART ATTACK RECORDINGS/MIGHTY FINE RECORDS, 3305 N. Dodge Blvd., Tucson AZ 85716. (602)881-1212. **President:** William Cashman. Produces rock, country/western, jazz, pop, R&B; solo artists.
Needs: Produces 12 albums/year. Works with 1-2 freelance designers and 1-2 illustrators/year. Uses freelancers for CD/album/tape cover design and illustration; catalog design and layout; advertising design, illustration and layout; posters; multimedia projects.
First Contact & Terms: Works on assignment only. Send postcard sample or brochure to be kept on file. Samples not filed are returned by SASE only if requested. Responds only if interested. Write for appointment to show portfolio. Original artwork is not returned. Pays for design by the hour, $15-25 or by the project, $100-500. Pays for illustration by the project, $100-500. Considers complexity of project and available budget when establishing payment. Buys all rights. Sometimes interested in buying second rights (reprint rights) to previously published artwork.

ATLAN-DEC/GROOVELINE RECORDS, 2529 Green Forest Ct., Snellville GA 30078-4183. (770)985-1686. E-mail: atlandec@prodigy.net. Website: www.atlan-dec.com. **Art Director:** Wileta J. Hatcher. Estab. 1994. Produces CDs and cassettes: gospel, jazz, pop, R&B, rap artists and groups. Recent releases: *Stepping Into the Light*, by Mark Cocker.
Needs: Produces 2-4 releases/year. Works with 1-2 freelancers/year. Prefers freelancers with experience in CD and cassette cover design. Uses freelancers for album cover, cassette cover, CD booklet and poster design. 80% of freelance work demands knowledge of Photoshop.
First Contact & Terms: Send postcard sample of work or query letter with brochure, photocopies, photographs and tearsheets. Samples are filed. Will contact for portfolio review of b&w, color, final art if interested. Pays for design by the project, negotiable. Negotiates rights purchased. Finds artists through submissions.

■ **BACKWORDS RECORDINGS**, P.O. Box 802, Mishawaka IN 46546. **Owner:** Tim Backer. Produces CDs and cassettes: classical, composer-rock and performed literature. Recent releases: *The Subtle Dawn* by Tim Backer.
Needs: Works with 2 freelancers/year. Prefers designers who own Mac computers with experience in QuarkXPress and SyQuest. Uses freelancers for cassette cover illustration and design, CD booklet design and illustration, poster design and World Wide Web page design. "Need freelancers in poster design and World Wide Web page design for future releases."
First Contact & Terms: Send postcard sample of work and send query letter with résumé and "statement of vision." Samples are filed or are returned by SASE if requested by artist. Responds only if interested. Art director will contact artist for portfolio review of b&w and color photocopies and photographs if interested. Pays by the project; "freelancers must submit a bid." Rights purchased vary according to project.

BAL RECORDS, Box 369, LaCanada CA 91012. (818)548-1116. E-mail: balmusic@pacbell.net. **President:** Adrian P. Bal. Secretary-Treasurer: Berdella Bal. Estab. 1965. Produces 1-2 CDs: rock & roll, jazz, R&B, pop, country/western and church/religious. Recent releases: *Travel With Me*, by Adrian Bal.
First Contact & Terms: Samples are not filed and are returned by SASE. Responds ASAP. Portfolio review requested if interested in artist's work. Sometimes requests work on spec before assigning a job.
Tips: Finds new artists through submissions. "I don't like the abstract designs."

N **BATOR & ASSOCIATES**, 31 State St., Suite 44D, Monson MA 01057. **Art Director:** Joan Bator. Estab. 1969. Handles rock and country.
Needs: Buys 5,000 line drawings and logo designs/year. Illustrations, full-color and line for various advertising and books—adult and children.
First Contact & Terms: Slides and photostats welcome. Also have special need for top-notch calligraphy. Samples welcome. Works with freelancers on assignment only. SASE. $350-500/hr., $750-950/day. Buys one-time rights; other rights negotiable. Send no originals, only your copies.

✓ **BELUGA BLUE**, 836 Columbus Blvd., Coral Gables Fl 33134. (305)531-2830. Fax: (305)567-1367. E-mail: nil_lara@mac.com. **Art Director:** nil lara. Estab. 1986. Produces CDs: Afro-Cuban. Recent releases: *nil lara*, *My First Child* and *The Monkey*, by nil lara.
First Contact & Terms: Send postcard sample of work. Accepts disk submissions compatible with Mac. Samples are filed. Responds only if interested. Pay negotiable. Negotiates rights purchased. Finds artists through word of mouth, or "seeing work in an art show."
Tips: Sees a trend toward "organic and raw, environment-friendly packaging."

⊕ **BIG BEAR RECORDS**, P.O. Box, Birmingham B16 8UT England. (021)454-7020. Fax: (21)454-9996. E-mail: bigbearmusic@compuserve.com. Website: www.bigbearmusic.com. **Managing Director:** Jim Simpson. Produces CDs and tapes: jazz, R&B. Recent releases: *Let's Face the Music*, by Bruce Adams/Alan Barnes Quintet and *Blues & Rhythm, Volume One*, by King Pleasure & The Biscuit Boys; and *The Boss Is Home*, by Kenny Bakers Dozen; *Smack Dab in the Middle*, King Pleasure and The Biscuit Boys.
Needs: Produces 4-6 records/year. Works with 2-3 illustrators/year. Uses freelancers for album cover design and illustration. Needs computer-literate freelancers for illustration.
First Contact & Terms: Works on assignment only. Send query letter with photographs or photocopies to be kept on file. Samples not filed are returned only by SAE (nonresidents include IRC). Negotiates payment. Considers complexity of project and how work will be used when establishing payment. Buys all rights. Interested in buying second rights (reprint rights) to previously published work.

BLACK DIAMOND RECORDS INCORPORATED, P.O. Box 222, Pittsburg CA 94565. (510)980-0893. Fax: (510)432-4342. **Art Director:** Catrina Washington. Estab. 1988. Produces tapes, CDs and vinyl 12-inch and 7-inch records: jazz, pop, R&B, soul, urban hib hop by solo artists and groups. Recent releases: "X-Boyfriend," by Héye featuring Dashawn and "Simple and Easy," by Dean Gladney.
Needs: Produces 2 solo artists and 3 groups/year. Works with 2 freelancers/year. Prefers freelancers with experience in album cover and insert design. Uses freelancers for CD/tape cover and advertising design and illustration; direct mail packages; and posters. Needs computer-literate freelancers for production. 85% of freelance work demands knowledge of PageMaker, FreeHand.
First Contact & Terms: Send query letter with résumé. Samples are filed or returned. Responds in 3 months. Write for appointment to show portfolio of b&w roughs and photographs. Pays for design by the hour, $100; by the project, varies. Rights purchased vary according to project.
Tips: "Be unique, simple and patient. Most of the time success comes to those whose artistic design is unique and has endured rejection after rejection."

BLASTER BOXX HITS, 519 N. Halifax Ave., Daytona Beach FL 32118. (386)252-0381. Fax: (386)252-0381. E-mail: blasterboxxhits@aol.com. Website: blasterboxxhits.bizland.com/. **C.E.O.:** Bobby Lee Cude. Estab. 1978. Produces CDs, tapes and albums: rock, R&B. Releases: *Blow Blow Stero*, by Zonky-Honky; and *Hootchie-Cootch Girl*.
Needs: Approached by 15 designers and 15 illustrators/year. Works with 3 designers and 3 illustrators/year. Produces 6 CDs and tapes/year. Works on assignment only. Uses freelancers for CD cover design and illustration.
First Contact & Terms: Send query letter with appropriate samples. Samples are filed. Responds in 1 week. To show portfolio, mail thumbnails. Sometimes requests work on spec before assigning a job. Pays by the project. Buys all rights.

BLUE NOTE AND ANGEL RECORDS, 304 Park Ave. S., New York NY 10010. (212)253-3000. Fax: (212)253-3170. Website: www.bluenote.com. **Creative Director:** Gordon H. Jee. Estab. 1939. Produces albums, CDs, cassettes, advertising and point-of-purchase materials. Produces classical, jazz, pop, and world music by solo artists and groups. Recent releases by Cassandra Wilson, Vanessa Mae, Itzhak Perlman, Holly Cole, Mose Allison, Medeski Martin and Wood.
Needs: Produces approximately 200 releases in US/year. Works with about 10 freelancers/year. Prefers designers with experience in QuarkXPress, Illustrator, Photoshop who own Macs. Uses freelancers for album cover design and illustration; cassette cover design and illustration; CD booklet and cover design and illustration; poster design. Also for advertising. 100% of design demands knowledge of Illustrator, QuarkXPress, Photoshop (most recent versions on all).
First Contact & Terms: Send postcard sample of work. Samples are filed. Responds only if interested. Portfolios may be dropped off every Thursday and should include b&w and color final art, photographs and tearsheets. Pays for design by the hour, $12-20; by the project, $1,000-5,000. Pays for illustration by the project, $750-2,500. Rights purchased vary according to project. Finds artists and designers through submissions, portfolio reviews, networking with peers.

BOUQUET-ORCHID ENTERPRISES, P.O. Box 1335, Norcross GA 30091. (770)814-2420. Website: www.bswrecords.com. **President:** Bill Bohannon. Estab. 1972. Produces CDs and tapes: rock, country, pop and contemporary Christian by solo artists and groups. Releases: *Memories of Hank Williams Sr.*, by Larry Butler and Willie Nelson; and *Once in a Lifetime*, by Laurie Hayes.
Needs: Produces 6 solo artists and 4 groups/year. Works with 8-10 freelancers/year. Works on assignment only. Uses freelancers for CD/tape cover and brochure design; direct mail packages; advertising illustration. 25% of freelance work demands knowledge of PageMaker, Illustrator and QuarkXPress.
First Contact & Terms: Send query letter with brochure, SASE, résumé and samples. "I prefer a brief but concise overview of an artist's background and works showing the range of his talents." Include SASE.

Samples are not filed and are returned by SASE if requested by artist. Responds in 1 month. To show a portfolio, mail b&w and color tearsheets and photographs. Pays for design by the project, $100-500. Rights purchased vary according to project.

Tips: "Study current packaging design on cassette and CD releases. Be creative and willing to be different with your approach to design."

N BRIARHILL RECORDS, 3484 Nicolette Dr., Crete IL 60417. (708)672-6457. Fax: (708)672-1277. **President/A&R Director:** Danny Mack. Estab. 1984. Produces tapes, CDs and records: pop, gospel, country/western, polka, Christmas by solo artists and groups. Recent releases: *Ordinary People* and *The Ballad of Paul Bunyan*, by Danny Mack; *Sad State of Affairs*, by Rebecca Thompson.

Needs: Produces 2-5 solo artists/year. Approached by 30 designers and 30 illustrators/year. Works with 4 designers and 4 illustrators/year. Prefers artists with experience in album covers. Works on assignment only. Uses freelancers for CD/tape cover design and illustration; brochure design and advertising illustration.

First Contact & Terms: Send postcard sample with brochure, photographs and SASE. Samples are filed and are not returned. Responds in 3 weeks. To show portfolio, mail photostats. Pays for design by the project, $100 minimum. Buys all rights.

Tips: "Especially for the new freelance artist, get acquainted with as many recording studio operators as you can and show your work. Ask for referrals. They can be a big help in getting you established locally. When sending samples for submission, always include illustrations that relate in some way to the types of music we produce as listed. This is the best way to receive consideration for upcoming projects. We keep on file only those who have done similar work."

BSW RECORDS, Box 2297, Universal City TX 78148. (210)599-0022. Fax: (210)653-3989. E-mail: bsw18@txdirect.net. Website: www.bswrecords.com. Website: www.bswrecords.com. **President:** Frank Willson. Estab. 1987. Produces tapes and albums: rock, country/western by solo artists. Releases 8 CDs/tapes each year. Recent releases: *Memories of Hank Williams*, by Larry Butler and Willie Nelson; and *Once In A Lifetime*, by Laurie Hayes.

Needs: Produces 25 solo artists and 5 groups/year. Works with 4-5 freelance designers, 4-5 illustrators/year. Uses 3-4 freelancers/year for CD cover design; album/tape cover, advertising and brochure design and illustration; direct mail packages; and posters. 25% of freelance work demands knowledge of FreeHand.

First Contact & Terms: Send postcard sample and brochure. Samples are filed. Responds in 1 month. To show portfolio, mail photographs. Requests work on spec before assigning a job. Pays by the project. Buys all rights. Sometimes interested in buying second rights (reprint rights) to previously published work. Finds new artists through submissions and self-promotions.

N C.P.R. RECORD COMPANY, 4 West St., Massapequa Park NY 11762. (516)797-7752. E-mail: d.yannacone@aol.com. **President:** Denise Thompson. Estab. 1996. Produces CDs, CD-ROMs, cassettes: R&B, rap, rock, soul by solo artists and groups.

Needs: Produces 3-4 releases/year. Works with 5 freelancers/year. Prefers local freelancers who own IBM-compatible PCs. Uses freelancers for album cover design and illustration; animation; cassette cover design; CD booklet design and illustration; CD cover design and illustration; CD-ROM design and packaging and multimedia projects. Design demands knowledge of PageMaker, FreeHand, Photoshop.

First Contact & Terms: Send postcard sample or query letter with photocopies, tearsheets, résumé, photographs and photostats. Samples are filed or returned by SASE if requested by artist. Responds in 2 months. Will contact artist for portfolio review of b&w, color photocopies, photographs if interested. Pays for design by the project; negotiable. Pays for illustration by the project, $500-5,000. Rights purchased vary according to project; negotiable. Finds artists through *Black Book* and *Workbook*.

Tips: "Be original. We always look for new and fresh material with a new twist. Don't be scared of rejection. It's the only way you learn, and always be positive! Be professional, be flexible, work hard and never stop learning."

CAPITOL RECORDS, 1750 N. Vine St., Hollywood, CA 90028-5274. (323)462-6252. Website: www.ho llywoodandvine.com. **Art Director:** Tommy Steele. Produces CDs, tapes and albums. Recent releases: *Kid A*, by Radiohead.

● Under the Capitol Record label, there are several art departments with various labels and looks. For rock and pop labels, send CD art samples to the L.A. address % Tommy Steele. For jazz and classics, send to Creative Director Gordon Jee or Assistant Art Director Jessica Novod to Capitol, Angel, Blue Note, 304 Park Ave. S., New York NY 10010. (212)253-3000.

Needs: Uses freelance designers and illustrators for CD projects. Works on assignment only.

First Contact & Terms: Send nonreturnable samples. Responds only if interested. If you are planning a visit to Los Angeles or New York, call to make arrangements to drop off your portfolio.

CHATTAHOOCHEE RECORDS, P.O. 5754, Sherman Oaks CA 91413. (818)788-6863. Fax: (818)788-4229. **A&R:** Chris Yardum. Estab. 1958. Produces CDs and tapes: rock & roll, pop by groups. Recent releases: "Thanks for Nothing," by DNA.

Needs: Produces 1-2 groups/year. Works with 1 visual artist/year. Prefers local artists only. Works on assignment only. Uses artists for CD cover design and illustration; tape cover design and illustration; advertising design and illustration; posters. 50% of freelance work demands knowledge of Illustrator.

First Contact & Terms: Send query letter with brochure, résumé and photographs. Samples are filed and are not returned. Responds only if interested. To show portfolio, mail final art and photographs. Pays for design by the project. Rights purchased vary according to project.

CHERRY STREET RECORDS, INC., P.O. Box 52681, Tulsa OK 74152. (918)742-8087. E-mail: ryoun g@cherrystreetrecords.com. Website: www.cherrystreetrecords.com. **President:** Rodney Young. Estab. 1991. Produces CDs and tapes: rock, R&B, country/western, soul, folk by solo and group artists. Recent releases: *Land of the Living*, by Richard Elkerton; *Find You Tonight*, by Brad Absher; and *Rhythm Gypsy*, by Steve Hardin.

Needs: Produces 2 solo artists/year. Approached by 10 designers and 25 illustrators/year. Works with 2 designers and 2 illustrators/year. Prefers freelancers with experience in CD and cassette design. Works on assignment only. Uses freelancers for CD/album/tape cover design and illustration; catalog design; multimedia projects; and advertising illustration. 100% of design and 50% of illustration demand knowledge of Illustrator and CorelDraw for Windows.

First Contact & Terms: Send postcard sample or query letter with photocopies and SASE. Accepts disk submissions compatible with Windows '95 in above programs. Samples are filed or are returned by SASE. Responds only if interested. Write for appointment to show portfolio of printed samples, b&w and color photographs. Pays by the project, up to $1,250. Buys all rights.

Tips: "Compact disc covers and cassettes are small—your art must get consumer attention. Be familiar with CD and cassette music layout on computer in either Adobe or Corel. Be familiar with UPC bar code portion of each program. Be under $500 for layout to include buyout of original artwork and photographs. Copyright to remain with Cherry Street—no reprint rights or negatives retained by illustrator, photographer or artist."

CMH RECORDS, P.O. Box 39439, Los Angeles CA 90039. (323)663-8073. Fax: (323)669-1470. E-mail: mailbox@cmhrecords.com. Website: www.cmhrecords.com. **Art Director:** Karrie M. Miller. Estab. 1975. Produces CDs: bluegrass, country, electronic. Recent releases: *Music for Elevators*, by Anthony Stewart Head and George Sarah; *Breathe: The Bluegrass Tribute to the Songs of Dave Matthews*; *Strung Out on OK Computer, the String Tribute to Radiohead*.

Needs: Produces 50-75 releases/year. Works with 5-10 freelancers/year. Prefers local illustrators. Uses freelancers for CD booklet and cover illustration.

First Contact & Terms: Send postcard sample and/or query letter with brochure, photocopies, photographs and tearsheets. Samples are filed. Will contact for portfolio review if interested. Pays by the project, $400-600. Rights purchased vary according to project.

Tips: "We are always looking for creative, clever cover artwork. We have a graphic designer who puts all of our projects together."

CREEK RECORDS/CREEKER MUSIC PUB., Box 1946, Cave Creek AZ 85327. (602)488-8132. **Junior Vice President:** Jeff Lober. Estab. 1996. Produces albums, CDs, CD-ROMs, cassettes: classical, country, folk, jazz, pop, progressive, R&B, rock, soul, Latin-Spanish and Middle Eastern by solo artists and groups. Recent releases: "Rescue Me," by Chrissy Williams; *30 Second Dream*, by Richard Towers; *Camelon Soul (Going Through the Changes)*, by Will; and *Baby Don't Look Good Being Blue*, by Chrissy Williams.

Needs: Produces 30-35 releases/year. Works with 5-6 freelancers/year. Uses freelancers for album cover design and illustration; cassette cover design and illustration; CD booket design and illustration; CD cover design and illustration; CD-ROM design and packaging. 50% of freelance work demands knowledge of QuarkXPress, Photoshop, FreeHand.

First Contact & Terms: Send query letter with brochure and photostats. Accepts Mac-compatible disk submissions. Samples are filed or returned by SASE. Will contact artist for portfolio review of b&w, color art if interested. Pays by the project, $200-1,000. Buys all rights.

Tips: Look at CD covers in stores and use your own ideas from there. Looks for "something that will sell the CD besides the music."

N **CRS ARTISTS**, 724 Winchester Rd., Broomall PA 19008. (610)544-5920. Fax: (610)544-5921. E-mail: crsnews@erols.com. Website: www.erols.com/crsnews. **Administrative Assistant:** Caroline Hunt. Estab. 1981. Produces CDs, tapes and albums: jazz and classical by solo artists and compilations. Recent releases: *Mostly French*; *Drama in Music*; and *Tribute to German Leaders*.
 • Sponsors Competition for Performing Artists and National Competition for Composers Recording.
Needs: Produces 20 CDs/year. Works with 4 designers and 5 illustrators/year on assignment only. Also uses freelancers for multimedia projects. 50% of freelance work demands knowledge of Word Perfect and Wordstar.
First Contact & Terms: Send query letter with brochure, résumé, SASE and photocopies. Samples are filed or are returned by SASE if requested by artist. Responds in 1 month only if interested. Call for appointment to show portfolio or mail roughs, b&w tearsheets and photographs. Requests work on spec before assigning a job. Pays by the project. Buys all rights; negotiable. Finds new artists through *Artist's and Graphic Designer's Market*.

DAPMOR PUBLISHING COMPANY, 3031 Acorn St., Kenner LA 70065. (504)468-9820. Fax: (504)466-2896. **Owner:** Kelly Jones. Estab. 1977. Produces CDs, cassettes: country, jazz, pop, R&B, rap, rock and soul by solo artists and groups.
First Contact & Terms: Send postcard sample of work. Samples are not filed and not returned. Responds in 1 month.
Tips: "Only contact if you are willing to sign a contract and share some of the expense involved."

⊕ DEMI MONDE RECORDS & PUBLISHING, Foel Studio, Llanfair Caereinion, Powys SY21 ODS Wales. Phone: (44)1938-810758. Fax: (44)1938-810758. E-mail: demi.monde@dial.pipex.com. Website: www.demimonde.co.uk/demimonde. **Managing Director:** Dave Anderson. Estab. 1984. Produces albums and cassettes: pop, progressive, R&B and rock by solo artists and groups.
Needs: Produces 12 releases/year. Works with 5-10 freelancers/year. Prefers designers who own Macs or PCs. Uses freelancers for album cover design and illustration; cassette cover illustration and design; CD booklet design and illustration; CD cover design and illustration; poster design; web page design. 100% of freelance work demands knowledge of Illustrator, QuarkXPress, Photoshop.
First Contact & Terms: Send postcard sample, brochure or photocopies. Accepts PC-compatible disk submissions. Samples are filed. Responds in 6 weeks if interested. Buys all rights.

DM/BELLMARK/CRITIQUE RECORDS, 1791 Blount Rd., Suite 712, Pompano Beach FL 33069. (954)969-1623. Fax: (954)969-1997. Website: www.dmrecords.com. **Art Director:** Deryck Ragoonan. Estab. 1983. Produces albums, CDs and cassettes: country, gospel, urban, pop, R&B, rap, rock. Recent releases: *Beautiful Experience*, by Prince; *Affection*, by Jody Watley; and *Best of Engelbert Humperdink*.
 • This label recently bought Ichiban Records.
Needs: Approached by 6 designers and 12 illustrators/year. Works with 4 illustrators/year. Uses freelancers for album, cassette and CD booklet and cover illustration. 100% of design and 50% of illustration demand knowledge of PageMaker, Illustrator, QuarkXPress, Photoshop, FreeHand.
First Contact & Terms: Send postcard sample of work. Samples are filed. Will contact for portfolio review if interested. Pays for illustration by the project, $250-500. Buys all rights. Finds artists through magazines.
Tips: "Style really depends on the performing artist we are pushing. I am more interested in illustration than typography when hiring freelancers."

N **EARACHE RECORDS**, 43 W. 38th St., New York NY 10018. (212)840-9090. Fax: (212)840-4033. E-mail: usaproduction@earache.com. Website: www.earache.com. **Product Manager:** Tim McVicker. Estab. 1993. Produces albums, CDs, CD-ROMs, cassettes, 7″ and 10″ vinyl: rock, industrial, heavy metal techno, death metal, grind core. Recent releases: *The Haunted Made Me Do It*, by The Haunted; *Gateways to Annihilation*, by Morbid Angel.
Needs: Produces 12 releases/year. Works with 4-6 freelancers/year. Prefers designers with experience in music field who own Macs. Uses freelancers for album cover design; cassette cover illustration; CD booklet design and illustration; CD cover design and illustration; CD-ROM design. Also for advertising and catalog design. 90% of freelance work demands knowledge of Illustrator 7.0, QuarkXPress 3.3, Photoshop 4.0, FreeHand 7.
First Contact & Terms: Send postcard sample of work. Samples are filed and not returned. Does not report back. Artist should follow-up with call and/or letter after initial query. Will contact artist for portfolio review of color, final art, photocopies, photographs if interested. Pays by the project. Buys all rights.
Tips: "Know the different packaging configurations and what they are called. You must have a background in music production/manufacturing."

☑ **EMI LATIN**, 5750 Wilshire Blvd., Suite 300, Los Angeles CA 90036. (323)692-1143. Fax: (323)692-1133. Website: www.emilatin.com. **Art and Production Manager:** Nelson González. Estab. 1989. Produces albums, CDs and cassettes: pop, rock, salsa, Merengue, Regional Mexican and Tejano by solo artists and groups. Recent releases: *Para Que*, by Oscar de la Hoya; and *Nubes Y Claros*, by Tam Tam Go.; Carlos Vives, Dejame entrar; Thalia, con Banda.
Needs: Produces 250 releases/year. Works with 10 designers/year. Prefers local designers. Uses freelancers for the design of packages: CD and cassette covers, CD booklets, inlays and posters. 100% of design work demands knowledge of Adobe Illustration, QuarkXPress, Photoshop.
First Contact & Terms: Send postcard sample of work. Samples are filed. Responds only if interested. Pays for design: by the project, $1,000-$1,500. Negotiates rights purchased. Finds artists through artists' submissions.

N **THE ETERNAL SONG AGENCY**, P.O. Box 121, Worthington OH 43085. E-mail: leopold@eternal-song.agency.com. Website: www.eternal-song.agency.com. **Art Director:** Leopold Crawford. Estab. 1986. Produces CDs, tapes and videos: rock, jazz, pop, R&B, soul, progressive, classical, gospel, country/western. Recent releases: *The Ultimate Answer*, by Jennifer Bates; and *Now I See the Truth*, by Laura Sanders.
Needs: Produces 6 releases/year. Works with 5-7 freelancers/year. Prefers freelancers with experience in illustration and layout. "Designers need to be computer-literate and aware of latest illustration technology." Uses freelancers for CD/tape cover, and advertising design and illustration, direct mail packages, posters, catalog design and layout.
First Contact & Terms: Send postcard sample of work or send query letter with brochure, photocopies, résumé, photographs. Samples are filed. Responds in 5 weeks. Art Director will contact artist for portfolio review if interested. Portfolio should include b&w and color final art and photocopies. Pays for design by the project, $300-5,000. Pays for illustration by the hour, $15-35; by the project, $300-5,000. Finds artists through word of mouth, seeing previously released albums and illustration, art colleges and universities. "Be persistent. Know your trade. Become familiar with technical advances as related to your chosen profession."

ETHEREAN MUSIC/ELATION ARTISTS, Planet Earth Music, 12640 W. Cedar Dr., #300, Lakewood CO 80228. (303)988-1221. Fax: (303)985-0292. E-mail: etherean@etherean.com. Website: www.etherean. com. **Director of Creative Services:** Tom Rome. Estab. 1988. Produces 4 CDs and tapes/year: jazz and New Age/Native American. Recent releases: *Visiones De Mis Antepasados*, by Kenny Passarelli.
Needs: Produces 2 soloists and 2 groups/year. Works with 1 designer and 1 illustrator/year for CD and tape cover design and illustration. Needs computer-literate freelancers for illustration. 80% of freelance work demands knowledge of Director 5.0 or 6.0, QuarkXPress, Illustrator and Photoshop.
First Contact & Terms: Send query letter with brochure, résumé, photostats and photocopies. "No original artwork." Samples are filed or are returned by SASE if requested. Responds only if interested. Write for appointment to show portfolio. Sometimes requests work on spec before assigning a job. Pays for design by the project, $200-1,000. Pays for illustration by the hour, $100-500. Rights purchased vary according to project.

FIRST POWER ENTERTAINMENT GROUP, 5801 Riverdale Rd., Suite 105, Riverdale MD 20737. (301)277-1671. Fax: (301)277-0173. E-mail: powerpla@mail.erols.com. **Vice President:** Adrianne Harris. Estab. 1992. Produces albums, CDs, cassettes and 2 television entertainment programs.
Needs: Produces 2-4 releases/year. Works with 3-6 freelancers/year. Prefers local freelancers with experience in PageMaker, Photoshop, Extreme 3D. Uses freelancers for album cover design and illustration, animation, cassette cover design, CD booklet design and illustration, CD cover design and illustration, CD-ROM design, poster design, multimedia projects, *Street Jam* magazine and corporate TV/film/video productions. A segment of our upcoming new program, Streetjam Television, will broadcast and highlight the talented works of creative up and coming animators. Animated segments should be 2-4 minutes in length and should be of (non-X rated) sci-fi, space-age or comedic content. The animator's name and contact information will be broadcast during our program. All submissions should be forwarded on Mini DV, DV, or SVHS tape to the traffic department at the address above. 100% of design and illustration work demands knowledge of Illustrator, Photoshop and PageMaker
First Contact & Terms: Send brochure, résumé, photostats, photocopies, photographs, tearsheets, SASE. Samples are filed or are returned by SASE if requested. Responds only if interested. Request portfolio review of b&w and color photographs ("whatever you have available; work samples") in original query. Artist should follow-up with call. Pays by the project. Buys all rights. Finds artists through advertising and word of mouth.
Tips: "Trends are always changing. Know your business and get all the experience you can. However, don't just follow trends. Be creative, break barriers and present yourself and your work as something unique. Keep up with trends, be original and stand out from the norm. Strive to break barriers. Know the

value of your work, but never think that your works, talent and services are so great that you will never consider doing some jobs, for free or for cheap labor, because sometimes, the small things (or the free things) that you do in life, can turn out to be a blessing that can lead you to unimaginable contacts and opportunities. Have patience, believe and have faith in yourself (and God), and hang in there!''

☑ **FOREFRONT RECORDS/EMI CHRISTIAN MUSIC GROUP**, 230 Franklin Rd., Bldg. 21st Floor, Franklin TN 37067. (615)771-2900. Fax: (615)771-2901. E-mail: sparrish@forefrontrecords.com. Website: www.forefrontrecords.com. **Creative Services Manager:** Susannah Parrish. Estab. 1988. Produces CDs, CD-ROMs, cassettes: Christian alternative rock by solo artists and groups. Recent releases: *Lift*, by Audio Adrenaline; *Worship God*, by Rebecca St. James; *Momentum*, by Toby Mac; and *Genuine*, by Stacie Orrico.
Needs: Produces 15-20 releases/year. Works with 5-10 freelancers/year. Prefers designers who own Macs with experience in cutting edge graphics and font styles/layout, ability to send art over e-mail, and attention to detail and company spec requirements. Uses freelancers for cassette cover design and illustration; CD booklet design and illustration; CD cover design and illustration; CD-ROM design and packaging; poster design. 100% freelance design and 50% of illustration demands knowledge of Illustrator, QuarkXPress, Photoshop.
First Contact & Terms: Send postcard sample or query letter with résumé, photostats, transparencies, photocopies, photographs, slides, SASE, tearsheets. Accepts disk submissions compatible with Mac/Quark, Photoshop or Illustrator, EPS files. Samples are filed or returned by SASE if requested by artist. Responds only if interested. Portfolios may be dropped every Tuesday and Wednesday. Will contact artist for portfolio review if interested. Payment depends on each project's budgeting allowance. Negotiates rights purchased. Finds artists through artist's submissions, sourcebooks, web pages, reps, word-of-mouth.
Tips: ''I look for cutting edge design and typography along with interesting use of color and photography. Illustrations must show individual style and ability to be conceptual.''

☑ **GODDESS RECORDS/CALIFORNIA SONG MAGAZINE**, (formerly Goddess Records/McCarley Entertainment Media), 465 Stoney Point Rd., #240, Santa Rosa CA 95401. (310)281-1934. E-mail: mem@monitor.net. **President:** Kevin McCarley. Estab. 1990. Produces enhanced CDs, albums, CDs, CD-ROMs, cassettes, merchandise: psychedelic hard pop and dance metal. Recent releases: *Venus Envy*, by Star 69; ''Savior Self,'' by FreeQ. ''*California Song Magazine* is the only ''golden state-wide'' music mag publishing 50,000 copies eight times annually. Editorial focus is on songcraft and lyric writing for and about California songwriters, music publishers, record producers and musicians who are creating cybermedia in the digital age.''
Needs: Produces 2 releases/year. Works only with artist reps. Prefers designers who own the best computers with experience in illustration and animation. Uses freelancers for album cover design and illustration, animation, cassette cover design and illustration, CD booklet design and illustration, CD cover design and illustration, CD-ROM design, CD-ROM packaging, poster design, World Wide Web page design. 100% of design and illustration demands knowledge of Illustrator, Photoshop, FreeHand, PageMaker, QuarkXPress.
First Contact & Terms: Samples are filed. Responds in 1 month. Artist should follow-up with letter after initial query. Will contact for portfolio review of b&w, color, final art, photographs, tearsheets, transparencies if interested. Pays for design by the project. Rights purchased vary according to project, negotiable.
Tips: ''Try anything once. Use your imagination. Find a vision.''

▨ **GRASS ROOTS PRODUCTIONS**, Box 532, Malibu CA 90265. (213)858-7282. **President:** Lee Magid. Produces jazz, rock, country, blues, instrumental, gospel, classical, folk, educational, pop and reggae; group and solo artists. Recent releases: *Super-Heavy Blues*, by various artists; *Blues, Blues and More Blues*, by various artists. Assigns 15 jobs/year.
Needs: Produces 15-20 records/year. Approached by 30 designers and 30 illustrators/year. Works with 3 designers and 6 illustrators/year. Local artists only. Works on assignment only. Uses artists for album cover design and illustration; brochure design, illustration and layout; catalog design, direct mail packages, posters and advertising illustration. Sometimes uses cartoons and humorous and cartoon-style illustrations depending on project.
First Contact & Terms: Send brochure to be kept on file. Include SASE. Samples not filed are returned by SASE. Responds only if interested. Write for appointment to show portfolio. Pays by the project. Considers available budget when establishing payment. Buys all rights.
Tips: ''It's important for the artist to work closely with the producer, to coincide with the feeling of the album, rather than throwing a piece of art against the wrong sound.'' Artists shouldn't ''get overly progressive. 'Commercial' is the name of the game.''

GREEN LINNET RECORDS, INC., 43 Beaver Brook Rd., Danbury CT 06810. (203)730-0333. Fax: (203)730-0345. Website: www.greenlinnet.com. **Production Manager:** Diane Hassan. Estab. 1975. Produces CDs: Celtic folk, world music (Irish, African, Cuban). Recent releases: *The Merry Sisters of Fate*, by Lunasa; *In God Company*, by Kevin Crawford; and *Fit?*, by Old Blind Dogs.
Needs: Produces 12 releases/year. Works with 5 freelancers/year. Prefers local freelancers with experience in CD packaging. Uses freelancers for CD cover design and illustration; catalog design; direct mail packages, posters. Needs computer-literate freelancers for production.
First Contact & Terms: Samples are not filed. Responds only if interested. Artist should send only disposable reproductions (no originals). Art director will contact artist for portfolio review if interested. Rights purchased vary according to project.

☑ **HARD HAT RECORDS AND CASSETTE TAPES**, 519 N. Halifax Ave., Daytona Beach FL 32118-4017. (386)252-0381. Fax: (386)252-0381. E-mail: hardhatrecirds@aol.com. Website: www.hardhat records.homestead.com/. **CEO:** Bobby Lee Cude. Produces rock, country/western, folk and educational by group and solo artists. Publishes high school/college marching band arrangements. Recent releases: *Broadway USA* CD series (a 3-volume CD program of new and original music); and *Times-Square Fantasy Theatre* (CD release with 46 tracks of new and original Broadway style music).
● Also owns Blaster Boxx Hits.
Needs: Produces 6-12 records/year. Works with 2 designers and 1 illustrator/year. Works on assignment only. Uses freelancers for album cover design and illustration; advertising design; and sheet music covers. Prefers "modern, up-to-date, on the cutting edge" promotional material and cover designs that fit the music style. 60% of freelance work demands knowledge of Photoshop.
First Contact & Terms: Send query letter with brochure to be kept on file one year. Samples not filed are returned by SASE. Responds in 2 weeks. Write for appointment to show portfolio. Sometimes requests work on spec before assigning a job. Pays by the project. Buys all rights.

N **C** **HICKORY LANE RECORDS**, 19854 Butternut Lane, Pitt Meadows, British Columbia V3Y 2S7 Canada. (604)465-1258. Fax: (604)987-0616. E-mail: cmu@web.net. **President:** Chris Michaels. A&R Manager: David Rogers. Estab. 1985. Produces CDs and tapes: country/western. Recent releases: *All Fired Up and Country*, by Chris Urbanski.
Needs: Produces 5 solo artists and 2 groups/year. Approached by 15 designers and 15 illustrators/year. Works with 2 designers and 2 illustrators/year. Works on assignment only. Uses freelancers for CD/tape cover, brochure and advertising design and illustration; and posters. 25% of freelance work demands knowledge of PageMaker, Illustrator, QuarkXPress, Photoshop, FreeHand.
First Contact & Terms: Send query letter with brochure, résumé, photostats, transparencies, photocopies, photographs, SASE and tearsheets. Samples are filed and are returned by SASE if requested by artist. Responds in 6 weeks. Call or write for appointment to show portfolio of b&w and color roughs, final art, tearsheets, photostats, photographs, transparencies and computer disks. Pays for design by the project, $250-650. Negotiates rights purchased.
Tips: "Keep ideas simple and original. If there is potential in the submission we will contact you. Be patient and accept criticism. Send us samples via email."

HOTTRAX RECORDS, 1957 Kilburn Dr., Atlanta GA 30324. (770)662-6661. E-mail: hotwax@hottrax. com. Website: www.hottrax.com. **Publicity and Promotion:** Teri Blackman. Estab. 1975. Produces CDs and tapes: rock, R&B, country/western, jazz, pop and blues/novelties by solo and group artists. Recent releases: "Everythang & Mo'," by Sammy Blue; and *Lady That Digs The Blues*, by Big Al Jano & The Blues Mafia.
Needs: Produces 2 soloists and 4 groups/year. Approached by 90-100 designers and 60 illustrators/year. Works with 6 designers and 6 illustrators/year. Prefers freelancers with experience in multimedia—mixing art with photographs—and caricatures. Uses freelancers for CD/tape cover, catalog and advertising design and illustration; and posters. 25% of freelance work demands knowledge of PageMaker, Illustrator and Photoshop.
First Contact & Terms: Send postcard samples. Accepts disk submissions compatible with Illustrator and CorelDraw. Some samples are filed. If not filed, samples are not returned. Responds only if interested. Pays by the project, $150-1,250 for design and $1,000 maximum for illustration. Buys all rights.
Tips: "We file all samples that interest us even though we may not respond until the right project arises. We like simple designs for blues and jazz, including cartoon/caricatures, abstract for New Age and fantasy for heavy metal and hard rock."

N **HULA RECORDS**, 99-139 Waiua Way, Unit #56, Aiea HI 96701. (808)485-2294. E-mail: hularecord s@hawaii.rr.com. Website: www.hawaiian-music.com. **President:** Donald P. McDiarmid III. Produces educational and Hawaiian records; group and solo artists.

Needs: Produces 1-2 soloists and 3-4 groups/year. Works on assignment only. Uses artists for album cover design and illustration, brochure and catalog design, catalog layout, advertising design and posters.
First Contact & Terms: Send query letter with tearsheets and photocopies. Samples are filed or are returned only if requested. Responds in 2 weeks. Write for appointment to show portfolio. Pays by the project, $50-350. Considers available budget and rights purchased when establishing payment. Negotiates rights purchased.

IMAGINARY ENTERTAINMENT CORP., P.O. Box 66, Whites Creek TN 37189. (615)299-9237. E-mail: jazz@imaginaryrecords.com. Website: www.imaginaryrecords.com. **Proprietor:** Lloyd Townsend. Estab. 1982. Produces CDs, tapes and LP's: rock, jazz, classical, folk and spoken word. Releases include: *Kaki*, by S.P. Somtow; *Triologue*, by Stevens, Siegel and Ferguson; and *Fifth House*, by the New York Trio Project.
Needs: Produces 1-2 solo artists and 1-2 groups/year. Works with 1-2 freelancers/year. Works on assignment only. Uses artists for CD/LP/tape cover design and illustration.
First Contact & Terms: Send query letter with brochure, tearsheets, photographs and SASE if sample return desired. Samples are filed or returned by SASE if requested by artist. Responds in 2-3 months. To show portfolio, mail thumbnails, roughs and photographs. Pays by the project, $25-500. Negotiates rights purchased.
Tips: "I always need one or two dependable artists who can deliver appropriate artwork within a reasonable time frame."

N: IRISH MUSIC CORPORATION, 701 River St., Troy NY 12180. (518)266-0765. Fax: (518)266-0925. E-mail: info@regorecords.com. Website: www.regorecords.com. **Managing Director:** T. Julian McGrath. Estab. 1953. Produces CDs, video, DVD: Irish, Celtic, folk.
Needs: Produces 12 releases/year. Works with 2 freelancers/year. Prefers local designers. Uses freelancers for CD booklet and cover design and illustration; poster design. 100% of illustration demands computer skills.
First Contact & Terms: Send query letter with brochure, résumé, tearsheets. Samples are filed. Will contact artist for portfolio review of final art, tearsheets and transparencies. Pays by the project, $1,500 maximum. Assumes all rights.

JAY JAY RECORD, TAPE & VIDEO CO., P.O. Box 41-4156, Miami Beach FL 33141. Phone/fax: (305)758-0000. **President:** Walter Jagiello. Produces CDs and tapes: country/western, jazz and polkas. Recent releases: *Super Hits*, by Li'l Wally Jagiello; and *A Salute to Li'l Wally*, by Florida's Harmony Band with Joe Oberaitis.
Needs: Produces 7 CDs, tapes and albums/year. Works with 3 freelance designers and 2 illustrators/year. Works on assignment only. Uses freelancers for album cover design and illustration; brochure design; catalog layout; advertising design, illustration and layout; and posters. Sometimes uses freelancers for newspaper ads. Knowledge of MIDI-music lead sheets helpful for freelancers.
First Contact & Terms: Send brochure and tearsheets to be kept on file. Call or write for appointment to show portfolio. Samples not filed are returned by SASE. Responds in 2 months. Requests work on spec before assigning a job. Pays for design by the project, $20-50. Considers skill and experience of artist when establishing payment. Buys all rights.

N: KALIFORNIA KILLER RECORDINGS (KKR), 1815 Garnet Ave., San Diego CA 92109. (858)539-3989. **President:** Mark Whitney Mehran. Produces albums and CDs: rock. Recent releases: "Know My Name" by Antie Pete and *HotRod Paradise* by The Green Leaf.
Needs: Produces 2-7 releases/year. Works with 3 freelancers/year. Prefers local artists. Uses freelancers for CD booklet design, CD cover illustration, poster design, negative prep and shooting.
First Contact & Terms: Send query letter and postcard with sample of work. Samples are not filed and are not returned. Responds only if interested. Art director will contact artist for portfolio review if interested. Pays by the project. Buys one-time rights.

KIMBO EDUCATIONAL, 10 N. Third Ave., Long Branch NJ 07740. E-mail: kimboed@aol.com. Website: www.kimboed.com. **Production Manager:** Amy Laufer. Educational CD/cassette company. Produces 8 cassettes and compact discs/year for schools, teacher-supply stores and parents. Primarily early childhood/physical fitness.
Needs: Works with 3 freelancers/year. Prefers local artists on assignment only. Uses artists for CD/cassette/covers; catalog and flier design; and ads. Helpful if artist has experience in the preparation of CD cover jackets or cassette inserts.

First Contact & Terms: "It is very hard to do this type of material via mail." Send letter with photographs or actual samples of past work. Responds only if interested. Pays for design and illustration by the project, $200-500. Considers complexity of project and budget when establishing payment. Buys all rights.

Tips: "The jobs at Kimbo vary tremendously. We produce material for various levels—infant to senior citizen. Sometimes we need cute 'kid-like' illustrations, and sometimes graphic design will suffice. We are an educational firm, so we cannot pay commercial record/cassette/CD art prices."

✓ ◻ L.A. RECORDS, P.O. Box 1096, Hudson, Quebec J0P 1H0 Canada. (514)869-3236. Fax: (514)458-2819. E-mail: la_records@excite.com. Website: www.radiofreedom.com. **Manager:** Tina Sexton. Estab. 1991. Produces CD and tapes: rock, pop, R&B, alternative; solo artists and groups. Recent releases: *Zarie*, by Mario Ms.; and *No White in the Blues*, by Band of Thieves.

Needs: Produces 8-12 releases/year. Works with 2-5 freelancers/year. Prefers local freelancers. Uses freelancers for CD/tape cover, brochure and advertising design and illustration. Needs computer-literate freelancers for design and illustration. 80% of freelance work demands computer skills.

First Contact & Terms: Send postcard sample of work or query letter with brochure, résumé, photostats, photocopies and photographs. Samples are filed. Art director will contact artist for portfolio review if interested. Portfolio should include color photocopies and photographs. Pays for design and illustration by the project. Rights purchased vary according to project. Finds artists through word of mouth.

Tips: "Make an emotional impact."

LAMON RECORDS INC., P.O. Box 25371, Charlotte NC 28229. Phone/fax: (704)882-2657. E-mail: dmoodyjrnc@aol.com. Website: www.lamonrecords.com. **Chairman of Board:** Dwight L. Moody Jr. Produces CDs and tapes: rock, country/western, folk, R&B and religious music; groups. Releases: *Play Fiddle*, by Dwight Moody; *Western Hits*, by Ruth and Ted Reinhart; *Now and Then*, by Cathy and Dwight Moody.

Needs: Works on assignment only. Works with 3 designers and 4 illustrators/year. Uses freelancers for album cover design and illustration, brochure and advertising design, and direct mail packages. 50% of freelance work demands knowledge of Photoshop.

First Contact & Terms: Send brochure and tearsheets. Samples are filed and are not returned. Responds only if interested. Call for appointment to show portfolio or mail appropriate materials. Considers skill and experience of artist and how work will be used when establishing payment. Buys all rights.

Tips: "Include work that has been used on album, CD or cassette covers."

✓ ◻ LCDM ENTERTAINMENT, Box 79564, 1995 Weston Rd., Toronto, Ontario M9N 3W9 Canada. E-mail: GuitarBabe@hotmail.com. Website: www.angelfire.com/ca3/liana and www.indie-music-toronto. c2. **Publisher:** L.C. DiMarco. Estab. 1991. Produces CDs, tapes, publications (quarterly): pop, folk, country/western and original. Recent releases: "Amazon Trail," by LIANA; *Glitters & Tumbles*, by Liana; *Indie Tips & the Arts* (publication); and indie-music-toronto@yahoogroups.com (on-line newsletter).

Needs: Prefers local artists but open to others. Uses freelancers for CD cover design, brochure illustration, posters and publication artwork. Needs computer-literate freelancers for production, presentation and multimedia projects.

First Contact & Terms: Send query letter by e-mail or snail mail with brochure, résumé, photocopies, photographs, SASE, tearsheets, terms of renumeration (i.e., pay/non-pay/alternative). No attachments in e-mail please. Samples are filed. Art director will contact artist for portfolio review if interested. Pays for design, illustration and film by the project. Rights purchased vary according to project.

Tips: "The best experience is attainable through indie labels. Ensure that the basics (phone/fax/address) are on all of your correspondence. Seldom do indie labels return long distance calls. Include SASE in your mailings always. Get involved and offer to do work on a volunteer or honorarium basis. We usually work with artists who have past volunteer experience first."

PATTY LEE RECORDS, 6034½ Graciosa Dr., Hollywood CA 90068. (323)469-5431. **Contact:** Susan Neidhart. Estab. 1986. Produces CDs and tapes: New Orleans rock, jazz, folk, country/western, cowboy poetry and eclectic by solo artists. Recent releases: *Return to BeBop*, by Jim Sharpe; *Alligator Ball*, by Armand St. Martin; *Horse Basin Ranch*, by Timm Daughtry; *Afternoon Candy*, by Angelyne; and *Stand on the Side of Love*, by Armand St. Martin.

Needs: Produces 2-3 soloists/year. Works with several designers and illustrators/year. Works on assignment only. Uses freelancers for CD/tape cover, sign and brochure design; and posters.

First Contact & Terms: Send postcard sample. Samples are filed or are returned by SASE. Responds only if interested. "Please do not send anything other than an introductory letter or card." Payment varies. Rights purchased vary according to project. Finds new artists through word of mouth, magazines, submissions/self-promotional material, sourcebooks, agents and reps and design studios.

Tips: "Our label is small. The economy does not affect our need for artists. Sending a postcard representing your 'style' is very smart and inexpensive. We can keep your card on file. We are 'mom and pop' and have limited funds so if you don't hear back from us, it is no reflection on your talent. Keep up the good work!"

☑ ⊕ **LEMATT MUSIC**, (Pogo Records Ltd., Swoop Records, Grenouille Records, Zarg Records, Lee Sound Productions, R.T.F.M., Lee Music Ltd., Check Records, Value For Money Productions and X.R.L. Records), White House Farm, Shropshire TF9 4HA England. (01630) 647374. Fax: (01630)647612. **Manager, Director:** Xavier Lee. Lawyer: Keith Phillips. Produces CDs, tapes and albums: rock, dance, country/western, pop, and R&B by group and solo artists. Recent releases: *Nightmare*, by Nightmare; *Fire*, by Nightmare; "Beautiful Sunday" and *Then and Now*, by Daniel Boone.
Needs: Produces 25 CDs, tapes/year. Works with 3-4 freelance designers and 3-4 illustrators/year. Works on assignment only. Uses a few cartoons and humorous and cartoon-style illustrations where applicable. Uses freelancers for album cover design and illustration; advertising design, illustration and layout; and posters. Needs computer-literate freelancers for design, illustration and presentation. 30% of freelance work demands computer skills.
First Contact & Terms: Send query letter with brochure, résumé, business card, slides, photographs and videos to be kept on file. Samples not filed are returned by SASE (nonresidents send IRCs). Responds in 3 weeks. To show portfolio, mail final reproduction/product and photographs. Original artwork sometimes returned to artist. Payment negotiated. Finds new artists through submissions and design studios.

LIVING MUSIC, P.O. Box 72, Litchfield CT 06759. (860)567-8796. Fax: (860)567-4276. E-mail: pwclmr @aol.com. Website: www.livingmusic.com. **Director of Communications:** Kathi Fragione. Estab. 1980. Produces CDs and tapes: classical, jazz, folk, progressive, world, New Age. Recent releases: *Celtic Solstice*, by Paul Winter & Friends; *Journey with the Sun*, by Paul Winter and the Earth Band; *Every Day is a New Life*, by Arto Tunchboyaciyan; and *Brazilian Days*, by Oscar Castro-Neves and Paul Winter.
Needs: Produces 1-3 releases/year. Works with 1-5 freelancers/year. Uses freelancers for CD/tape cover and brochure design and illustration; direct mail packages; advertising design; catalog design, illustration and layout; and posters. 70% of freelance work demands knowledge of PageMaker, Illustrator, QuarkXPress, Photoshop, FreeHand.
First Contact & Terms: Send postcard sample of work or query letter with brochure, transparencies, photographs, slides, SASE, tearsheets. Samples are filed or returned by SASE if requested by artist. Responds only if interested. Art director will contact artist for portfolio review of b&w and color roughs, photographs, slides, transparencies and tearsheets. Pays for design by the project. Rights purchased vary according to project.
Tips: "We look for distinct 'earthy' style." Prefers nature themes.

☑ **LMNOP**®, P.O. Box 33369, Decatur GA 30033. Websites: www.babysue.com and www.LMNOP.com. **President:** Don W. Seven. Estab. 1983. Produces CDs, tapes and albums: rock, jazz, classical, country/western, folk and pop. Releases: *Homo Trip*, by The Stereotypes; and *Bad is Good*, by Lisa Shame.
Needs: Produces 6 solo artists and 10 groups/year. Uses 5 freelancers/year for CD/album/tape cover design and illustration, catalog design, advertising design and illustration and posters. 20% of design and 50% of illustration demand computer skills.
First Contact & Terms: Send postcard sample or query letter with SASE, photographs, photostats and slides. Samples are not filed and are not returned. Responds only if interested. To show portfolio, mail roughs, b&w and color photostats and photographs. Pays by the day, $250-500. Rights purchased vary according to project.

LUCIFER RECORDS, INC., Box 263, Brigantine NJ 08203. (609)266-2623. **President:** Ron Luciano. Produces pop, dance and rock.
Needs: Produces 2-12 records/year. Prefers experienced freelancers. Works on assignment only. Uses freelancers for album cover and catalog design; brochure and advertising design, illustration and layout; direct mail packages; and posters.
First Contact & Terms: Send query letter with résumé, business card, tearsheets, photostats or photocopies. Responds only if interested. Original art sometimes returned to artist. Write for appointment to show portfolio, or mail tearsheets and photostats. Pays by the project. Negotiates pay and rights purchased.

🅽 **MAGGIE'S MUSIC, INC.**, Box 490, Shady Side MD 20764. E-mail: mail@maggiesmusic.com. Website: www.maggiesmusic.com. **President:** Maggie Sansone. Estab. 1984. Produces CDs and tapes: contemporary acoustic, Christmas and Celtic. Recent releases: *Celtic Roots*, by Hesperus; *Scottish Fire*, by Bonnie Rideout; and *A Traveler's Dream*, by Maggie Sansone; and *Women of Ireland*, by Ceoltoiri Celtic Ensemble.

Needs: Produces 3-4 albums/year. Works with freelance graphic designers. Prefers freelancers with experience in album covers and Celtic designs. Works on assignment only.

First Contact & Terms: Send query letter with color or b&w samples, brochure. Samples are filed. Responds only if interested. Company will contact artist for portfolio review if interested. Requests work on spec before assigning a job. Pays for design and illustration by the project, $500-1,000. Sometimes interested in buying second rights (reprint rights) to previously published work, or as edited. Buys all rights.

Tips: This company asks that the artist request a catalog first "to see if their product is appropriate for our company, then send samples (nonreturnable for our files)."

N JIM McCOY MUSIC, Rt. 2 Box 2910, Berkeley Springs WV 25411. (304)258-9381. E-mail: mccoytr oubador@aol.com. **Owner:** Bertha McCoy. Estab. 1972. Produces CDs and tapes: country/western. Recent releases: *Mysteries of Life*, by Carroll County Ramblers.

Needs: Produces 12 solo artists and 10 groups/year. Works on assignment only. Uses artists for CD cover design and illustration; tape cover illustration.

METAL BLADE RECORDS, INC., 2828 Cochran St., Suite 302, Simi Valley CA 93065. (805)522-9111. Fax: (805)522-9380. E-mail: metalblade@metalblade.com. Website: www.metalblade.com. **Senior Vice President/General Manager:** Tracy Vera. Estab. 1982. Produces CDs and tapes: rock by solo artists and groups. Recent releases: *Revelation*, by Armored Saint; and *Maximum Violence*, by Six Feet Under.

Needs: Produces 30-50 releases/year. Approached by 10 designers and 10 illustrators/year. Works with 1 designer and 1 illustrator/year. Prefers freelancers with experience in album cover art. Uses freelancers for CD cover design and illustration. Needs computer-literate freelancers for design and illustration. 80% of freelance work demands knowledge of PageMaker, Illustrator, QuarkXPress, Photoshop.

First Contact & Terms: Send postcard sample of work or query letter with brochure, résumé, photostats, photocopies, photographs, SASE, tearsheets. Samples are filed or returned by SASE if requested by artist. Responds only if interested. Art director will contact artist for portfolio review if interested. Portfolio should include b&w and color, final art, photocopies, photographs, photostats, roughs, slides, tearsheets. Pays for design and illustration by the project. Buys all rights. Finds artists through *Black Book*, magazines and artists' submissions.

Tips: "Please send samples of work previously done. We are interested in any design."

N MIA MIND MUSIC, 259 W. 30th St., 12th Floor, New York NY 10001. (212)564-4611. Fax: (212)564-4448. E-mail: mimimus@aol.com. Website: www.miamindmusic.com. **Contact:** Stevie B. "Mia Mind Music works with bands at the stage in their careers where they need CD artwork and promotional advertisements. The record label Mia Mind signs about 12 artists per year and accepts artwork through the mail or call for appointment." Recent releases: *Easy Life*, by Chris Butler; and *Un Petit Gouter*, by Kilopop.

Needs: Approached by 40 designers and 50 illustrators/year. Works with 6 designers and 2 illustrators/year.

First Contact & Terms: Send query letter with résumé, photocopies, tearsheets. Samples are filed. Responds in 2 weeks. Call for appointment to show portfolio of b&w and color final art and photographs or mail appropriate materials. Pays for design by the project, $200 minimum; pays for illustration by the project, $200 minimum. Rights purchased vary according to project.

Tips: "Be willing to do mock-ups for samples to be added to company portfolio." Looks for "abstract, conceptual art, the weirder, the better. 'Extreme' sells in the music market."

N MIGHTY RECORDS, BMI Music Publishing Co.—Corporate Music Publishing Co.—AS-CAP, Stateside Music Publishing Co.—BMI, 150 West End Ave., Suite 6-D, New York NY 10023. (212)873-5968. **Manager:** Danny Darrow. Estab. 1958. Produces CDs and tapes: jazz, pop, country/western; by solo artists. Releases: *Falling In Love*, by Brian Dowen; and *A Part of You*, by Brian Dowen/Randy Lakeman.

Needs: Produces 1-2 solo artists/year. Works on assignment only. Uses freelancers for CD/tape cover, brochure and advertising design and illustration; catalog design and layout; and posters.

First Contact & Terms: Samples are not filed and are not returned. Rights purchased vary according to project.

MOJO RECORDS, 1531 14th St., Santa Monica 90404. (310)260-3181. Fax: (310)260-3180. Website: www.mojorecords.com. **Art Director:** Kristine Ripley. Produces CDs: pop. Recent releases: *Everything Sucks*, by Reel Big Fish; *Stomping Ground*, by GoldFinger; *The Massed Albert Sands*, by Weston; *Mankind*, by Factory 81.

Needs: Produces 5 releases/year. Works with 5 freelancers/year. Prefers local designers and illustrators. Uses freelancers for album cover design and illustration; CD booklet design and illustration; poster design.

First Contact & Terms: Send postcard sample of work. Samples are filed or returned by SASE if requested by artist. Will contact artist for portfolio review if interested. Pays for design and illustration by the project. Negotiates rights purchased. Finds artists through word of mouth, sourcebooks, World Wide Web, etc.

Tips: "We really review portfolios on a project by project basis with the objective of matching the illustrator's style to the band's album."

N MUSIC FOR LITTLE PEOPLE/EARTHBEAT! RECORD COMPANY, P.O. Box 1460, Redway CA 95560. (707)923-3991. Fax: (707)923-3241. Website: www.mflp.com. **Contact:** Sheron Sherman or Marianne McCormick. Estab. 1984. Produces music, interactive CD-ROM and collateral materials. "The Music For Little People label specializes in culturally diverse, nurturing music for families and children. EarthBeat! promotes an eclectic, global vision that allows cultural barriers to disappear and reveals music to be a truly unifying force."

Needs: Produces about 20 releases/year. All work done on a freelance, contractual basis. Uses freelancers also for interactive CD-ROM projects. Prefers illustrators specializing in portraying diverse cultures: kids and adults in imaginative, lively scenes for CD/cassette cover and booklet art. Works on assignment only. 80% of design and 20% of illustration demand knowledge of QuarkXPress, Photoshop, Illustrator and Live Picture.

First Contact & Terms: Send query letter with résumé, tearsheets, photocopies and/or Macintosh compatible floppy disk. Accepts disk submissions. Samples are filed or are returned by SASE if requested by artist. Responds only if interested. Frequently reviews portfolios. To show portfolio, mail or fax roughs.

Tips: This company looks for a "vibrant, lively, non-derivative style."

N NEURODISC RECORDS, INC., 3801 N. University Dr., Suite #403, Ft. Lauderdale FL 33351. (954)572-0289. Fax: (954)572-2874. E-mail: info@neurodisc.com. Website: www.neurodisc.com. **Contact:** John Wai and Tom O'Keefe. Estab. 1990. Produces albums, CDs, cassettes: pop, progressive, rap, urban, New Age and electronic. Recent releases: *No Gravity*, by DJ Session One; *Without Words*, by Eric Hansen; and *Odonata*, by Amethystium.

Needs: Produces 10 releases/year. Works with 5 freelancers/year. Prefers designers with experience in designing covers. Uses freelancers for album cover design and illustration; animation; cassette cover design and illustration; CD booklet design and illustration; cover design and illustration; poster design; Web page design. Also for print ads. 100% of freelance work demands computer skills.

First Contact & Terms: Send postcard sample or query letter with brochure, photocopies and tearsheets. Samples are not filed and are returned by SASE if requested by artist. Will contact artist for portfolio review if interested. Pays by the project. Buys all rights.

N NORTH STAR MUSIC INC., 22 London St., East Greenwich RI 02818. (401)886-8888. Fax: (401)886-8886. E-mail: nstarpfm@aol.com. Website: www.northstarmusic.com. **President:** Richard Waterman. Estab. 1985. Produces CDs and tapes: jazz, classical, folk, traditional, contemporary, world beat, New Age by solo artists and groups. Recent releases: *The Mysts of Time*, by Aine Minogue.

Needs: Produces 8 solo artists and 8 groups/year. Works with 4 freelancers/year. Prefers freelancers with experience in CD and cassette cover design. Works on assignment only. Uses artists for CD/tape cover and brochure design and illustration; catalog design, illustration and layout; direct mail packages. 80% of design and 20% of illustration demand knowledge of QuarkXPress 3.3.

First Contact & Terms: Send postcard sample or query letter with brochure, photocopies and SASE. Accepts disk submissions compatible with QuarkXPress 3.3. Send EPS or TIFF files. Samples are filed. Responds only if interested. To show portfolio, mail color roughs and final art. Pays for design by the project, $500-1,000. Buys first rights, one-time rights or all rights.

Tips: "Learn about our label style of music/art. Send appropriate samples."

✓ ⚑ OH BOY RECORDS, 33 Music Square W., Suite 102B, Nashville TN 37066. (615)742-1250. Fax: (615)742-1360. Website: www.ohboy.com. Produces CDs: folk, gospel, jazz, pop.

Needs: Produces 6-10 releases/year. Works with 4 freelancers/year. Prefers local designers who own Macs with experience in film output. Uses freelancers for CD booklet design and illustration, poster and advertising design. 100% of freelance work demands knowledge of QuarkXPress, Photoshop and FreeHand.

First Contact & Terms: Send query letter with brochure, transparencies, photographs, slides and SASE. Accepts disk submissions compatible with PC/IBM. Samples are not filed and are returned by SASE. Will contact for portfolio review if interested. Pays for design by the project, $100-1,000. Buys all rights.

ONE STEP TO HAPPINESS MUSIC, % Jacobson & Colfin, P.C., 19 W, 21st, #603A, New York NY 10010. (212)691-5630. Fax: (212)645-5038. **Attorney:** Bruce E. Colfin. Produces CDs, tapes and albums: reggae group and solo artists. Release: *Make Place for the Youth,* by Andrew Tosh.
Needs: Produces 1-2 soloists and 1-2 groups/year. Works with 1-2 freelancers/year on assignment only. Uses artists for CD/album/tape cover design and illustration.
First Contact & Terms: Send query letter with brochure, résumé and SASE. Samples are filed or returned by SASE if requested by artist. Responds in 6-8 weeks. Call or write for appointment to show portfolio of tearsheets. Pays by the project. Rights purchased vary according to project.

OPUS ONE, Box 604, Greenville ME 04441. (207)997-3581. **President:** Max Schubel. Estab. 1966. Produces CDs, LPs, 78s, contemporary American concert and electronic music.
Needs: Produces 6 releases/year. Works with 1-2 freelancers/year. Prefers freelancers with experience in commercial graphics. Uses freelancers for CD cover design.
First Contact & Terms: Send postcard sample or query letter with rates and example of previous artwork. Samples are filed. Pays for design by the project. Buys all rights. Finds artists through meeting them in arts colonies, galleries or by chance.
Tips: "Contact record producer directly. Send samples of work that relate in size and subject matter to what Opus One produces. We want witty and dynamic work."

N OREGON CATHOLIC PRESS, 5536 NE Hassalo, Portland OR 97213-3638. (503)281-1191. Fax: (503)282-3486. E-mail: jeang@ocp.org. Website: www.ocp.org/. **Art Director:** Jean Germano. Estab. 1934. Produces liturgical music CDs, cassettes, songbooks, missalettes, books.
Needs: Produces 10 collections/year. Works with 5 freelancers/year. Uses freelancers for cassette cover design and illustration; CD booklet illustration; CD cover design and illustration. Also for spot illustration.
First Contact & Terms: Send query letter with brochure, transparencies, photocopies, photographs, slides, tearsheets and SASE. Samples are filed or returned by SASE. Responds in 2 weeks. Will contact artist if interested. Pays for illustration by the project, $35-500. Finds artists through submissions and the Web.
Tips: Looks for attention to detail.

N ▣ PALM PICTURES, 601 W. 26th St., 11th Floor, New York NY 10001. (212)320-3600. Fax: (212)320-3749. E-mail: art@palmpictures.com. Website: www.palmpictures.com. **Studio Director:** Lee Johnston. Creative Director: Tony Wright. Estab. 1959. Produces films, albums, CDs, CD-ROMs, cassettes, LPs: folk, gospel, pop, progressive, R&B, rap and rock by solo artists and groups.
Needs: Works with 15 freelancers/year. Prefers designers who own Mac computers. Uses freelancers for album, cassette, CD, DVD and VHS cover design and illustration; CD booklet design and illustration; and poster design; advertising; merchandising. 99% of design and 20% of illustration demand knowledge of Illustrator, QuarkXPress, Photoshop and FreeHand.
First Contact & Terms: Send postcard sample and or query letter with tearsheets. Accepts disk submissions. Samples are filed. Portfolios of b&w and color final art and tearsheets may be dropped off Monday through Friday. Pays for design by the project, $50-5,000; pays for illustration by the project, $500-5,000. Rights purchased vary according to project. Finds artists through submissions, word of mouth and sourcebooks.
Tips: "Have a diverse portfolio."

PANDISC MUSIC/STREET BEAT RECORDS, 6157 NW 167th St., Suite F-11, Miami FL 33015. (305)557-1914. Fax: (305)557-9262. E-mail: beth@pandisc.com. Website: www.pandisc.com and www.str eetbeatrecords.com. **Director of Production:** Beth Sereni. Estab. 1982. Produces CDs and vinyl: dance, underground/club, electronica, bass and rap.
Needs: Produces 35-50 releases/year as well as many print ads and miscellaneous jobs. Works with many freelancers and design firms. Prefers freelancers with experience in record industry. Uses freelancers for CD/records jacket design, posters, direct mail packages as well as print ads, promotional materials, etc. Needs computer-literate freelancers for design and production. 75% of freelance work demands computer knowledge.
First Contact & Terms: Send query letter with samples of work or via e-mail. Samples are filed. Art director will contact artist if interested. "Call for per-job rates." Buys all rights.
Tips: "Must be deadline conscious and versatile."

N PARALLAX RECORDS, 14110 N. Dallas Pkwy., Suite 130, Dallas TX 75240. (972)726-9203. Fax: (972)726-7749. E-mail: parallax@airmail.net. Website: parallaxrecords.com. **Art Director:** Jason Abbott. Estab. 1995. Produces albums, CDs, cassettes: pop, R&B, rap, rock. by solo artists and groups. Recent releases: *Pawn Shop from Heaven,* by Junky Southern; *Hellafied Funk Crew,* by Hellafied Funk Crew.

Needs: Produces 2-3 releases/year. Works with 3 freelancers/year. Uses freelancers for album cover design and illustration; cassette cover design and illustration; CD booklet design and illustration; CD cover design and illustration; poster design. 75% of freelance work demands knowledge of PageMaker, Illustrator, QuarkXPress, Photoshop, FreeHand, Corel 7-8.

First Contact & Terms: Send query letter with brochure, résumé, photographs, tearsheets. Samples are filed. Portfolios may be dropped off every Tuesday. Will contact artist for portfolio review of final art, photocopies and photographs if interested. Pays for design by the project, $200-2,500. Pays for illustration by the hour. Buys all rights.

N: PPI ENTERTAINMENT GROUP, 88 St. Francis St., Newark NJ 07105. (973)344-4214. **Creative Director:** Eric Lewandoski. Estab. 1923. Produces CDs, DVDs and tapes: rock and roll, dance, soul, pop, educational, rhythm and blues; aerobics and self-help videos; group and solo artists. Specializes in children's health and fitness. Also produces children's books, cassettes and DVDs. Recent releases: *The Quick Fix™ Workout Series* and *Peeps® Sing-Along 14 Sweet Tweets*.

Needs: Produces 200 records and videos/year. Works with 10-15 freelance designers/year and 10-15 freelance illustrators/year. Uses artists for album cover design and illustration; brochure, catalog and advertising design, illustration and layout; direct mail packages; posters; and packaging.

First Contact & Terms: Works on assignment only. Send query letter with samples to be kept on file; call or write for appointment to show portfolio. Prefers photocopies or tearsheets as samples. Samples not filed are returned only if requested. Responds only if interested. Original artwork returned to artist. Pays by the project. Considers complexity of project and turnaround time when establishing payment. Purchases all rights.

■ PPL ENTERTAINMENT GROUP, P.O. Box 8442, Universal City CA 91618. (818)506-8533. Fax: (818)506-8534. E-mail: pplzmi@aol.com. Website: www.pplzmi.com. **Art Director:** Kaitland Diamond. Estab. 1979. Produces albums, CDs, cassettes: country, pop, R&B, rap, rock and soul by solo artists and groups. Recent releases: "Destiny," by Buddy Wright; and *American Dream*, by Riki Hendrix.

Needs: Produces 12 releases/year. Works with 2 freelancers/year. Prefers designers who own Mac or IBM computers. Uses freelancers for album cover design and illustration; cassette cover design and illustration; CD booklet design and illustration; CD cover design and illustration; CD-ROM design and packaging; poster design; Web page design. Freelance work demands knowledge of PageMaker, Illustrator, Photoshop, QuarkXPress.

First Contact & Terms: Send query letter with brochure, photocopies, tearsheets, résumé, photographs, photostats, slides, transparencies and SASE. Accepts disk submissions. Samples are filed or returned by SASE if requested by artist. Responds in 2 months. Request portfolio review in original query. Pays by the project, monthly.

PRAIRIE MUSIC LTD., P.O. Box 492, Anita IA 50020. (712)762-4363. E-mail: bobeverhart@yahoo.com. **President:** Bob Everhart. Media Specialist: Sheila Everhart. Estab. 1967. Produces tapes and CDs: folk, traditional, country and bluegrass. Releases: *Paid Our Dues*, by Bob and Sheila Everhart; and *Headed West*, by Bobbie Everhart.

Needs: Produces 2 solo artists and 2 groups/year. Prefers freelancers with experience in traditional rural values. Works on assignment only. Uses artists for album/tape cover design and illustration and posters.

First Contact & Terms: Send query letter with résumé, photocopies and photostats. Samples are filed. Responds in 4 months only if interested. To show portfolio, mail b&w photostats. Pays by the project, $100-250. Buys one-time rights.

N: PRAVDA RECORDS, 6311 N. Neenah, Chicago IL 60631. (773)763-7509. Fax: (773)763-3252. E-mail: pravdausa@aol.com. Website: www.pravdamusic.com. **Contact:** Kenn Goodman. Estab. 1986. Produces CDs, tapes and posters: rock, progressive by solo artists and groups. Recent releases: *Greatest Bits*, by New Duncan Imperials; *Soul Bucket*, by The Civiltones.

Needs: Produce 1 solo artist and 3-6 groups/year. Works with 1-2 freelancers/year. Works on assignment only. Uses freelancers for CD/tape covers and advertising design and illustration; catalog design and layout; posters. Needs computer-literate freelancers for design and production. 100% of freelance work demands knowledge of Illustrator, QuarkXPress and Photoshop.

First Contact & Terms: Send query letter with résumé, photocopes, SASE. Samples are not filed and are returned by SASE if requested by artist. Responds in 2 months. Portfolio should include roughs, tearsheets, slides, photostats, photographs. Pays for design by the project, $250-1,000. Rights purchased vary according to project.

N ▪ **PUTUMAYO WORLD MUSIC**, 324 Lafayette St., 7th Floor, New York NY 10012. (212)625-1400, ext. 214. Fax: (212)460-0095. E-mail: info@putumayo.com. Website: www.putumayo.com. **Production Manager:** Lisa Lee. Estab. 1993. Produces CDs, cassettes: folk, world. Recent releases: *Mississippi Blues*, by various artists; and *Carnival*, by various artists.

• All covers feature the distinctive naïve art of Nicola Heindl. Production says they rarely need freelancers, but visit the Putumayo website to see some great covers.

Needs: Produces 16 releases/year. Works with 1-4 freelancers/year. Prefers local designers who own computers with experience in digi-pak CDs. Uses freelancers for album and cassette design and World Wide Web page design. 90% of design demands knowledge of QuarkXPress, Photoshop.

First Contact & Terms: Send postcard sample. Samples are not filed and are returned by SASE if requested. Will contact for portfolio review of final art if interested. Pays by the project.

Tips: "We use a CD digi-pak rather than the standard jewel box. Designers should have experience working with illustrations as the primary graphic element."

R.E.F. RECORDING COMPANY/FRICK MUSIC PUBLISHING COMPANY, 404 Bluegrass Ave., Madison TN 37115. (615)865-6380. **Contact:** Bob Frick. Produces CDs and tapes: southern gospel, country gospel and contemporary Christian. Recent releases: *Seasonal Pickin*, by Bob Scott Frick; *Righteous Pair* and *Pray When I Want To*.

Needs: Produces 30 records/year. Works with 10 freelancers/year on assignment only.

First Contact & Terms: Send résumé and photocopies to be kept on file. Write for appointment to show portfolio. Samples not filed are returned by SASE. Responds in 10 days only if interested.

N ▪ **RAMMIT RECORDS**, 3282 Ivernia Rd., Mississauga, Ontario L4Y 3E8 Canada. (905)275-8182. **President:** Trevor G. Shelton. Estab. 1988. Produces CDs, tapes and 12-inch vinyl promos for CDs: rock, pop, R&B and soul by solo artists and groups. Recent releases: *2 Versatile*, by 2 Versatile, hip hop/R&B, A&M distribution; *Hopping Penguins*, by Trombone Chromosome, ska/reggae, MCA distribution; *Line Up In Paris*, by Line Up in Paris, rock, A&M distribution.

Needs: Produces 4 releases/year. Works with 3-5 freelancers/year. Uses freelancers for CD cover design and illustration, tape cover illustration, advertising design and posters. 75% of freelance work demands computer skills.

First Contact & Terms: Send query letter with "whatever represents you the best." Responds only if interested. Artist should follow-up with call and/or letter after initial query. Portfolio should include b&w and color photostats. Pays for design by the project, $1,000-3,000. Negotiates rights purchased. Finds artists through word of mouth, referrals and directories.

N ▪ **RHINO ENTERTAINMENT COMPANY**, 10635 Santa Monica Blvd., Los Angeles CA 90025. (310)474-4778. Fax: (310)441-6579. Website: www.rhino.com. **Creative Director:** Hugh Brown. Director, Creative Services: Lori Carfora. Estab. 1977. Produces albums, CDs, CD-ROMs, cassettes: country, folk, gospel, jazz, pop, progressive, R&B, rap, rock, soul. Recent releases: *This Year's Model*, by Elvis Costello; and *The Very Best of Dee-Lite*.

Needs: Produces 200 releases/year. Works with 10 freelancers/year. Prefers local designers and illustrators who own Mac computers. Uses freelancers for album, cassette and CD cover design and illustration; CD booklet design and illustration; and CD-ROM design and packaging. 100% of design demands knowledge of Illustrator, QuarkXPress, Photoshop, FreeHand.

First Contact & Terms: Send postcard sample. Accepts disk submissions compatible with Mac. Samples are filed. Does not reply. Artist should "keep us updated." Portfolios of tearsheets may be dropped off every Tuesday. Buys one-time rights. Rights purchased vary according to project. Finds artists through word of mouth, sourcebooks.

RHYTHMS PRODUCTIONS/TOM THUMB MUSIC, Box 34485, Los Angeles CA 90034-0485. **President:** R.S. White. Estab. 1955. Produces CDs, cassettes of children's music.

Needs: Works on assignment only. Works with 3-4 freelance artists/year. Prefers Los Angeles artists who have experience in advertising, catalog development and cover illustration/design. Uses freelance artists for album, cassette and CD cover design and illustration; animation; CD booklet design and illustration; CD-ROM packaging. Also for catalog development. 95% of design and 50% of illustration demand knowledge of QuarkXPress and Photoshop.

First Contact & Terms: Send query letter photocopies and SASE. Samples are filed or are returned by SASE if requested. Responds in 6 weeks. "We do not review portfolios unless we have seen photocopies we like." Pays by the project. Buys all rights. Finds artists through submissions and recommendations.

Tips: "We like illustration that is suitable for children. We find that cartoonists have the look we prefer. However, we also like art that is finer and that reflects a 'quality look' for some of our more classical publications. Our albums are for children and are usually educational. We don't use any violent or extreme art which is complex and distorted."

☑ ▣ **ROCK DOG RECORDS**, P.O. Box 3687, Hollywood CA 90078. (323)661-0259. E-mail: g.cann izzaro@att.net. **Vice President of Production:** Gerry North. CEO Finance: Patt Connolly. Estab. 1987. Produces CDs and tapes: rock, R&B, dance, New Age, contemporary instrumental, ambient and music for film, TV and video productions. Recent releases: *This Brave New World*, by Brainstorm; *Fallen Angel*, by Iain Hersey; and *The Best of Brainstorm*, by Brainstorm.
• This company has a second location at P.O. Box 884, Syosset, NY 11791-0899. (516)544-9596. Fax: (516)364-1998. E-mail: rockdogrec@aol.com. A&R, Promotion and Distribution: Maria Cuccia.

Needs: Produces 2-3 solo artists and 2-3 groups/year. Approached by 50 designers and 200 illustrators/year. Works with 5-6 designers and 25 illustrators/year. Prefers freelancers with experience in album art. Uses artists for CD album/tape cover design and illustration, direct mail packages, multimedia projects, ad design and posters. 95% of design and 75% of illustration demand knowledge of Print Shop or Photoshop.

First Contact & Terms: Send postcard sample or query letter with photographs, SASE and photocopies. Accepts disk submissions compatible with Windows '95. Send Bitmap, TIFF, GIF or JPG files. Samples are filed or are returned by SASE. Responds in 2 weeks. To show portfolio, mail photocopies. Sometimes requests work on spec before assigning a job. Pays for design by the project, $50-500. Pays for illustration by the project, $50-500. Interested in buying second rights (reprint rights) to previously published work. Finds new artists through submissions from artists who use *Artist's & Graphic Designer's Market*.

Tips: "Be open to suggestions; follow directions. Don't send us pictures, drawings (etc.) of people playing an instrument. Usually we are looking for something abstract or conceptual. We look for prints that we can license for limited use."

▣ **ROTTEN RECORDS**, P.O. Box 56, Upland CA 91786. (909)920-4567. Fax: (909)920-4577. E-mail: rotten@rottenrecords.com. Website: www.rottenrecords.com. **President:** Ron Peterson. Estab. 1988. Produces CDs and tapes: rock by groups. Recent releases: *When the Kite String Pops*, by Acid Bath; *Do Not Spit*, by Damaged.

Needs: Produces 4-5 releases/year. Works with 3-4 freelancers/year. Uses freelancers for CD/tape cover design; and posters. Needs computer-literate freelancers for desigin, illustration, production.

First Contact & Terms: Send postcard sample of work or query letter with photocopies, tearsheets (any color copies samples). Samples are filed and not returned. Responds only if interested. Artist should follow-up with call. Portfolio should include color photocopies. Pays for design and illustration by the project.

☑ **ROWENA RECORDS & TAPES**, 195 S. 26th St., San Jose CA 95116. (408)286-9840. Fax: (408)286-9845. E-mail: jlo'neal@earthlink.com. **Owner:** Jeannine O'Neal. Estab. 1967. Produces CDs, tapes and albums: rock, rhythm and blues, country/western, soul, rap, pop and New Age; by groups. Recent releases: *Narrow Road*, by Jeannine O'Neal; and *Purple Jungle*, by Jerry Lee.

Needs: Produces 20 solo artists and 5 groups/year. Uses freelancers for CD/album/tape cover design and illustration and posters.

First Contact & Terms: Send query letter with brochure, résumé, SASE, tearsheets, photographs, photocopies and photostats. Samples are filed or are returned by SASE. Responds in 1 month. To show a portfolio, mail original/final art. "Artist should submit prices."

☑ **SAHARA RECORDS AND FILMWORKS ENTERTAINMENT**, 28 E. Jackson Bldg., 10th Floor, #S627, Chicago IL 60604-2263. (773)509-6381. Fax: (312)922-6964. **Marketing Director:** Dwayne Woolridge. Estab. 1981. Produces CDs, cassettes: jazz, pop, R&B, rap, rock, soul, TV-film music by solo artists and groups. Recent releases: "Moments," by Steve Lynn and "Games," by D'von Edwards.

Needs: Produces 10 releases/year. Works with 2 illustrators and 2 designers/year. Prefers freelancers with experience in pop/rock art, commercial ad designs and layouts. Uses freelancers for album cover design and illustration; cassette cover design and illustration; CD booklet design and illustration; CD cover design and illustration; poster design. 50% of freelance work demands knowledge of PageMaker, Illustrator, QuarkXPress, Photoshop, FreeHand.

First Contact & Terms: Send postcard sample of work. Samples are filed and not returned. Responds only if interested. Will contact for portfolio review of b&w, color, final art, photocopies, photographs. Pays for design and illustration by the project, $500-2,500. Buys all rights. Finds artists through word of mouth and sourcebooks.

[N] SAN FRANCISCO SOUND, 29903 Harvester Rd., Malibu CA 90265. (310)457-4844. Fax: (310)457-1855. **Owner:** Matthew Katz. Produces CDs and tapes: rock and jazz. Recent releases: *Then and Now*, Volumes 1 and 2, featuring Jefferson Airplane, Moby Grape and many others; *Fraternity of Man*, by Tripsichord; and *It's a Beautiful Day*, by Indian Puddin and Pipe.

Needs: Produces 2 soloists and 2 groups/year. Works with 2 artists/year with experience in airbrush and computer graphics. Works on assignment only. Uses artists for CD cover, brochure and advertising design; catalog and advertising illustration; posters; and catalog layout.

First Contact & Terms: Send query letter with brochure, tearsheets, photographs, photocopies, photostats, slides and transparencies. Samples are filed. Responds only if interested. Call or mail appropriate materials. Portfolio should include photostats, slides, color tearsheets, printed samples and photographs. Pays by the project, $250-1,200. Buys all rights.

Tips: "Know the style of 1960s San Francisco artists—Mause, Kelley-Moscoso, Griffin— and bring it up to date. Know our products."

[N] SCRUTCHINGS MUSIC, 429 Homestead St., Akron OH 44306. (330)773-8529 or (330)724-6940. **Owner/President:** Walter Scrutchings. Estab. 1980. Produces CDs, tapes and albums: gospel music (black). Recent releases: *He Keeps Blessing Me*, by The Arch Angel Concert Choir; *You're Worthy of All The Praise*, by Elvin Dent Jr. and the United Voices; and *Just Call on Jesus*, by Walter Scrutchings and Company.

Needs: Produces 2-5 solo artists and 2-5 groups/year. Works with 2-3 freelancers/year. Prefers freelancers with experience in jacket and cover design. Works on assignment only. Uses artists for CD/album/tape cover and brochure design, direct mail packages and posters.

First Contact & Terms: Send query letter with résumé. Samples are filed or are returned by SASE if requested by artist. Responds only if interested. To show portfolio, mail b&w and color photographs. Pays by the project, $200-2,000. Buys all rights.

[N] SELECT RECORDS, 19 W. 21st St., Suite 1004, New York NY 10010. (212)691-1200. Fax: (212)691-3375. **Art Director:** Angie Hunt. Produces CDs, tapes, 12-inch singles and marketing products: rock, R&B, rap and comedy solo artists and groups. Recent releases: *Jerky Boys II*, by Jerky Boys; and *To the Death*, by M.O.P.

Needs: Produces 6-10 releases/year. Works with 6-8 freelancers/year. Prefers local freelancers with experience in computer (Mac). Uses freelancers for CD/tape cover design and illustration, brochure design, posters. 70-80% of freelance work demands knowledge of Illustrator, QuarkXPress, Photoshop and FreeHand.

First Contact & Terms: Send postcard sample of work or query letter with photostats, transparencies, slides and tearsheets. Samples are not filed or returned. Portfolios may be dropped off Monday-Friday. Art Director will contact artist for portfolio review if interested. Portfolio should include slides, transparencies, final art and photostats. Payment depends on project and need. Rights purchased vary according to project. Finds artists through submissions, *Black Book*, agents.

Tips: Impressed by "good creative work that shows you take chances; clean presentation."

[N] SHAOLIN COMMUNICATIONS, P.O. Box 900457, San Diego CA 92190. Phone/fax: (801)595-1123. E-mail: taichiyouth@worldnet.att.net. **Vice President of A&R:** Don DeLaVega. Estab. 1984. Produces albums, CDs, CD-ROMs, cassettes, books and videos: folk, pop, progressive, rock, Chinese meditation music by solo artists and groups. Recent releases: *Levell*, by American Zen; *Tai Chi Magic*, by Master Zhen.

Needs: Produces 14 releases/year. Works with 4 freelancers/year. Prefers local freelancers who own Macs. Uses freelancers for album cover design and illustration; animation; cassette cover design and illustration; CD booklet design and illustration; CD cover design and illustration; CD-ROM design and packaging; poster design; Web page design. Also for multimedia, brochures and newsletter: *Shaolin Zen* . 80% of design and 20% of illustration demands knowledge of Dreamweaver, Canvas and Photoshop.

First Contact & Terms: Send query letter with brochure, résumé, SASE. Samples are filed or returned by SASE if requested by artist. Responds in 6 weeks if interested. Will contact for portfolio review if interested. Pays for design and illustration by the hour, $15-25; by the project, $250-500. Buys all rights. Finds artists through submissions and social contacts.

Tips: "Find projects to do for friends, family . . . to build your portfolio and experience. A good designer must have some illustration ability and a good illustrator needs to have design awareness—so usually our designer is creating a lot of artwork short of a photograph or piece of cover art."

[icon] SILVER WAVE RECORDS, 2475 Broadway, Suite 300, Boulder CO 80304. (303)443-5617. Fax: (303)443-0877. E-mail: valerie@silverwave.com. Website: www.silverwave.com. **Art Director:** Valerie Sanford. Estab. 1986. Produces CDs, cassettes: Native American and world by solo artists and groups.

Recent releases: *Beneath the Raven Moon*, by Mary Youngblood; *Music from A Painted Cave*, by Robert Mirabal; *Through Windows & Walls*, by Peter Kater and R. Carlos Nakai; *The Prophecy of the Eagle and the Condor*, by Tito Larosa.

Needs: Produces 4 releases/year. Works with 4-6 illustrators or artists a year. Illustrators need not be local. Uses illustrators for CD booklet and cover illustration.

First Contact & Terms: Send postcard sample or query letter with 2 or 3 samples. Samples are filed. Will contact for portfolio review if interested. Pays by the project. Rights purchased vary according to project.

Tips: "Try to work with someone at first and get some good samples and experience. I look in galleries and southwest art magazines. Word of mouth is effective. I also look for artists at Native American 'trade shows'. I look at *Workbook* and other sourcebooks but haven't hired from there yet. We will call if we like work or need someone." When hiring freelance illustrators, looks for style for a particular project. "Currently we are producing contemporary Native American music and will look for art that expresses that."

N ☐ SOMERSET ENTERTAINMENT, 250 Ferrand Dr., Suite 1100, Don Mills, Ontario M3C 3G8 Canada. (416)510-2800. Fax: (416)510-3070. E-mail: elahman@somersetent.com. Website: www.somerset ent.com. **Art Director:** Elliot Lahman. Estab. 1994. Produces CDs, cassettes and enhanced CDs: classical, country, folk, jazz, soul, children's music, solo artists and groups—some enhanced by nature sounds. Recent releases: *Jazz by Twilight*; *Shorelines-Classical Guitar*; *Spring Awakening*, by Dan Gibson and Joan Jerberman.

Needs: Produces 30 releases/year. Works with 5 freelancers/year. Prefers local freelancers who own Mac computers with experience in illustration and photography. Uses freelancers for album cover and cassette illustration; CD booklet design; web page design. 80% of design demands knowledge of Illustrator, Quark-XPress, Photoshop.

First Contact & Terms: Send query letter with résumé, nonreturnable samples. Accepts Mac-compatible disk submissions. Samples are filed or returned. Responds only if interested. Art Director will contact artist for portfolio review of final art, photocopies, photographs, roughs, transparencies. Pays for design and illustration by the project. Negotiates rights purchased. Finds artists through word of mouth; other designers may refer.

Tips: "The work the artists do should have a wide appeal for various audiences and markets."

N SOMNIMAGE CORPORATION, P.O. Box 24, Bradley IL 60915. E-mail: bgrecords@aol.com. Website: members.aol.com/bgrecords/bgr.html. **Contact:** Mykel Boyd. Estab. 1998. Produces albums, CDs, CD-ROMs, cassettes and vinyl: classical, folk, jazz, pop, progressive, rap, rock, experimental and electronic music by solo artists and groups. Recent releases: "The Tears of Things," by Benjamin Stauffer; Kafka tribute CD compilation.

Needs: Produces 10 releases/year. Works with 10 freelancers/year. Looking for creative art. Uses freelancers for cover design and illustration; cassette cover design and illustration; CD booklet design and illustration; CD cover design and illustration; CD-ROM design and packaging and poster design. Freelancers should be familiar with PageMaker, Illustrator, QuarkXPress, Photoshop, FreeHand.

First Contact & Terms: Send query letter with brochure, résumé, photostats, transparencies, photocopies, photographs, slides, SASE, tearsheets. Accepts disk submissions. Samples are filed or returned by SASE if requested by artist. Responds in 3 months. Will contact artist for portfolio review of b&w and color final art, photocopies, photographs, photostats, roughs, slides, tearsheets, thumbnails and transparencies, if interested. Pays by the project. Negotiates rights purchased. Finds artists through word of mouth.

Tips: "We are interested in surreal art, dada art, dark themed photography too."

SONY MUSIC CANADA, 1121 Leslie St., North York, Ontario M3C 2J9 Canada. (416)391-3311. Fax: (416)447-1823. E-mail: catherine_mcrae@sonymusic.ca. **Art Director:** Catherine McRae. Estab. 1962. Produces albums, CDs, cassettes: classical, country, folk, jazz, pop, progressive, R&B, rap, rock, soul. Recent releases: LPs by Celine Dion, Chantal Kreviazuk, Edwin, B4-4 and Prozzak.

Needs: Produces 40 domestic releases/year. Works with 10-15 freelancers/year. Prefers local designers who own Mac computers. Uses freelancers for album, cassette and CD cover design and illustration, CD booklet design and illustration, poster design. 80% of design and photography and 20% of illustration demand knowledge of Illustrator, Photoshop, QuarkXPress.

First Contact & Terms: Send query letter with photocopies, photographs, photostats, tearsheets. Accepts disk submissions compatible with Mac TIFF or EPS files. Responds only if interested. Will contact for portfolio review of b&w, color, photocopies, photographs, tearsheets if interested. Pays by the project. Buys all rights. Finds artists through other CD releases, magazines, art galleries, word of mouth.

Tips: "Know what is current musically and visually."

STARDUST RECORDS/WIZARD RECORDS/THUNDERHAWK RECORDS, 341 Billy Goat Hill Rd., Winchester TN 37398. (931)649-2577. Fax: (931)649-2732. E-mail: cbd@vallnet.com. Website: http://stardustcountrymusic.com. **Contact:** Col. Buster Doss, Produces CDs, tapes and albums: rock, folk, country/western. Recent releases: *13 Red Roses Plus One*, by Jerri Arnold; and *It's the Heart*, by Brant Miller.
Needs: Produces 12-20 CDs and tapes/year. Works with 2-3 freelance designers and 1-2 illustrators/year on assignment only. Uses freelancers for CD/album/tape cover design and illustration; brochure design; and posters.
First Contact & Terms: Send query letter with brochure, tearsheets, résumé and SASE. Samples are filed. Responds in 1 week. Call for appointment to show portfolio of thumbnails, b&w photostats. Pays by the project. Finds new artists through *Artist's & Graphic Designer's Market*.

STRICTLY RHYTHM RECORDS, 920 Broadway, #1403, New York NY 10010. (212)254-2400. Fax: (212)254-2629. E-mail: info@strictly.com. Website: www.strictly.com. **Vice President Promotion:** Bari G. Estab. 1989. Produces albums and CDs: pop, dance, underground, house. Recent releases: *Party Time 2002*, by Darude; *The Ultimate Underground, The Ultimate Afterhours*, by Jonathan Peters, Andrea Brown, Ultra Nate and Crystal Waters.
Needs: Produces 20 releases/year. Works with "as many freelance artists as possible." Prefers designers who own Mac computers with experience in CD cover art. Uses freelancers for album cover design and illustration, cassette cover design and illustration, CD booklet design and illustration, CD cover design and illustration, poster design, World Wide Web page design. Also for catalog design/illustration, slip mats, postcards, clothing etc. 100% of design and 50% of illustration demand knowledge of Illustrator, Photoshop, QuarkXPress.
First Contact & Terms: Send postcard sample of work and call. Samples are filed. Responds only if interested. Will contact for portfolio review of b&w, color, final art, photographs, photostats, slides if interested. Pays for design by the project, $250-2,000; pays for illustration by the project. Rights purchased vary according to project. Finds artists through word of mouth, NY design schools.
Tips: "Be willing to work cheap for exposure. If your work is good, you'll get higher paying projects and great references for other companies."

SUGAR BEATS ENTERTAINMENT, 48 W. 21st St., Suite 900, New York NY 10010. (212)604-0005. Fax: (212)604-0006. Website: www.sugarbeats.com. **Vice President Marketing:** Bonnie Gallanter. Estab. 1993. Produces CDs, cassettes: children's music by groups. Recent releases: "Start Dreaming," by Mr. Ray and "Can You Hear a Lullaby," by Dee Carstensen.
Needs: Produces 1 release/year. Works with 1-2 freelancers/year. Prefers local freelancers who own Macs with experience in QuarkXPress, Photoshop, Illustrator and web graphics. Uses freelancers for album cover design; cassette cover design and illustration; CD booklet design and illustration; CD cover design and illustration; poster design; Web page design. Also for ads, sell sheets and postcards. 100% of freelance design demands knowledge of Illustrator, QuarkXPress, Photoshop, FreeHand.
First Contact & Terms: Send postcard sample or query letter with brochure, tearsheets, résumé and photographs. Accepts Mac-compatible disk submissions. Will contact artist for portfolio review of b&w and color art. Pays by the project. Rights purchased vary according to project. Finds freelancers through referrals.

SWOOP RECORDS, White House Farm, Shropshire, TF9 4HA United Kingdom. Phone: 01630-647374. Fax: 01630-647612. **A&R International Manager:** Xavier Lee. International A&R: Tanya Woof. Estab. 1971. Produces albums, CDs, cassettes and video: classical, country, folk, gospel, jazz, pop, progressive, R&B, rap, rock, soul by solo artists and groups. Recent releases: *It's a Very Nice*, by Groucho; *New Orleans*, by Nightmare; "Sight 'n Sound;" and *Emmit Till*.
Needs: Produces 40 releases/year. Works with 6 freelancers/year. Prefers album cover design and illustration; cassette cover design and illustration; CD booklet design and illustration; CD cover design and illustration; poster design.
First Contact & Terms: Send sample of work with SASE. Samples are filed for future reference. Responds in 6 weeks. Payment negotiated. Buys all rights. Finds artists through submissions.

TANGENT® RECORDS, P.O. Box 383, Renoldsburg OH 43068-0383. (614)751-1962. Fax: (614)751-6414. E-mail: info@tangentrecords.com. **President:** Andrew J. Batchelor. Estab. 1986. Produces CDs, DVDs, CD-ROMs, cassettes, videos: contemporary, classical, jazz, progressive, rock, electronic, world beat and New Age fusion. Recent releases: "Moments Edge," by Andrew Batchelor.
Needs: Produces 20 releases/year. Works with 5 freelancers/year. Prefers local illustrators and designers who own computers. Uses freelancers for CD booklet design and illustration; CD cover design and illustra-

tion; CD-ROM design and packaging; poster design; Web page design. Also for advertising and brochure design/illustration and multimedia projects. Most freelance work demands knowledge of Illustrator, Quark-XPress, Photoshop, FreeHand and PageMaker.

First Contact & Terms: Send postcard sample or query letter with brochure, one-sheets, photocopies, tearsheets, résumé, photographs. Accepts both Macintosh and IBM-compatible disk submissions. Send JPG file and on 3.5″ diskette, CD-ROM, Mac-compatible Zip 100MB disk or Superdisk 120MB. Samples are filed and not returned. Will contact artist for portfolio review of b&w, color, final art, photocopies, photographs, photostats, slides, tearsheets, thumbnails, transparencies if interested. Pays by the project. "Amount varies by the scope of the project." Negotiates rights purchased. Finds artists through college art programs and referrals.

Tips: Looks for "creativity and innovation."

TOM THUMB MUSIC, (division of Rhythms Productions), Box 34485, Los Angeles CA 90034. **President:** Ruth White. Record and book publisher for children's market.

Needs: Works on assignment only. Prefers Los Angeles freelancers with cartooning talents and animation background. Uses freelancers for catalog cover and book illustration, direct mail brochures, layout, magazine ads, multimedia kits, paste-up and album design. Needs computer-literate freelancers for animation. Artists must have a style that appeals to children.

First Contact & Terms: Buys 3-4 designs/year. Send query letter with brochure showing art style or résumé, tearsheets and photocopies. Samples are filed or are returned by SASE. Responds in 3 weeks. Pays by the project. Considers complexity of project, available budget and rights purchased when establishing payment. Buys all rights on a work-for-hire basis.

Tips: "You need to be up to date with technology and have a good understanding of how to prepare art projects that are compatible with printers' requirements."

TOPNOTCH® ENTERTAINMENT CORP., Box 1515, Sanibel Island FL 33957-1515. (941)982-1515. E-mail: topnotch@wolanin.com. Website: www.wolanin.com. **Chairman/CEO:** Vincent M. Wolanin. Estab. 1973. Produces aviation art, advertising layouts, logos, albums, CDs, CD-ROMs, tour merchandise, cassettes: pop, progressive, R&B, rock, soul by solo artists and groups.

Needs: Produces 6-8 unique designs/year. Works with 3-6 freelancers/year on work-for-hire basis. Prefers designers who own IBM computers. Uses freelancers for design and illustration; animation; creative design and illustration; CD booklet design and illustration; CD cover design and illustration; CD-ROM design and packaging; poster design; web page design. Also for outside entertainment projects like Superbowl-related events and aviation-related marketing promotions and advertising. 90% of design and illustration demands knowledge of PageMaker, Illustrator, QuarkXPress, Photoshop, FreeHand, Corel, FrontPage, Astound.

First Contact & Terms: Send query, e-mail or letter with brochure, résumé, photostats, transparencies, photocopies, photographs, slides, SASE, tearsheets. Accepts disk or e-mail submissions compatible with IBM. Samples are filed. Does not report back. Artist should contact again in 4-6 months. Request portfolio review in original query. Artist should follow up with letter after initial query. Portfolio should include color, final art, photographs, slides, tearsheets. Pays for design and illustration by the project. Buys all rights. Also accepts link submissions to artists' websites.

Tips: "We look for new ways, new ideas, eye catchers—let me taste the great wine right away. Create great work and be bold. Don't get discouraged."

N TROPIKAL PRODUCTIONS/WORLD BEATNIK RECORDS, 20 Amity Lane, Rockwall TX 75087. Phone/fax: (972)771-3797. E-mail: tropikal@juno.com. Website: www.tropikalproductions.com. **Contact:** Jim Towry. Estab. 1981. Produces albums, CDs, cassettes: world beat, soca, jazz, reggae, hip-hop, latin, Hawaiian, gospel. Recent releases: *Cool Runner*; *Alive Montage*; *The Island*, by Watusi; and *Inna Dancehall*, by Ragga D.

Needs: Produces 5-10 releases/year. Works with 5-10 freelancers/year. Prefers freelancers with experience in CD/album covers, animation and photography. Uses freelancers for CD cover design and illustration; animation; cassette cover design and illustration; CD booklet design and illustration; CD cover design and illustration; poster design. 50% of freelance work demands knowledge of Illustrator, Photoshop.

First Contact & Terms: Send brochure, résumé, photostats, photocopies, photographs, tearsheets. Accepts Mac or IBM-compatible disk submissions. Send EPS files. "No X-rated material please." Samples are filed or returned by SASE if requested by artist. Responds in 15 days. Will contact for portfolio review of b&w, color, final art, photocopies, photographs, roughs if interested. Pays by the project; negotiable. Rights purchased vary according to project; negotiable. Finds artists through referrals, submissions.

Tips: "Show versatility; create theme connection to music."

N ❖ TRUE NORTH RECORDS/FINKELSTEIN MANAGEMENT CO. LTD., 260 Richmond St. W., Suite 501, Toronto, Ontario M5V 1W5 Canada. (416)596-8696. Fax: (416)596-6861. E-mail: truenorth@ca.inter.net. **Contact:** Dan Broome. Estab. 1969. Produces CDs, tapes and albums: rock and roll, folk and pop; solo and group artists. Recent releases: *The Charity of Night*, by Bruce Cockburn; *Industrial Lullaby*, by Stephen Fearing; *King of Love*, by Blackie and the Rodeo Kings; and *Raggle Taggle*, by John Bottomley.

Needs: Produces 2 soloist and 2 groups/year. Works with 4 designers and 1 illustrator/year. Prefers artists with experience in album cover design. Uses artists for CD cover design and illustration, album/tape cover design and illustration, posters and photography. 50% of freelance work demands computer skills.

First Contact & Terms: Send postcard sample, brochure, résumé, photocopies, photographs, slides, transparencies with SASE. Samples are filed or are returned by SASE if requested by artist. Responds only if interested. Pays by the project. Buys all rights.

■ 28 RECORDS, 19700 NW 86 Court, Miami FL 33015. (305)829-8142. Fax: (305)829-8142. E-mail: rec28@aol.com. **President/CEO:** Eric Diaz. Estab. 1994. Produces CDs: pop, rock, alternative, metal, punk by solo artists and groups. Recent releases: "Fractured Fairytales," and "Near Life Experience," by Eric Knight and *Julian Day*, by Hell Town's Infamous Vandal.

Needs: Produces 4 releases/year. Works with 2 freelancers/year. Prefers designers who own Macs. Uses freelancers for CD booklet design and illustration; CD cover design and illustration; poster design, web page design. 80% of freelance work demands knowledge of QuarkXPress, Photoshop.

First Contact & Terms: Send query letter with résumé, photocopies. Samples are filed and not returned. Responds only if interested. Artist should follow up with call and/or letter after initial query. Pays by the project, $300-700. Buys all rights. Finds artists through word of mouth.

Tips: "Get out there and sell yourself. Get multiple portfolios out there to everyone you can." Looks for cutting-edge and original design.

N TWILIGHT SOULS MUSIC, 264 S. La Cienega Blvd., Beverly Hills CA 90211. E-mail: twilightsoulsmusic@prodigy.net. **Director of Promotions:** Michael Parker. Estab. 1992. Produces CDs and cassettes: pop, adult contemporary, inspirational and metaphysical by solo artists and groups.

Needs: Produces 1-2 releases/year. Works with 1-2 freelancers/year. Prefers local freelancers. Uses freelancers for cassette cover design and illustration; CD booklet design and illustration; CD cover design and illustration; poster design. 100% of design and 50% of illustration demands knowledge of Illustrator, Photoshop, FreeHand.

First Contact & Terms: Send postcard sample. Samples are filed and not returned. Will contact artist for portfolio review of b&w and color tearsheets and thumbnails. Pays for design by the hour; pays for illustration by the project. Buys all rights. Finds artists through music trade magazines.

Tips: "We are a new company on a shoe-string budget."

N UNIVERSAL RECORDS/MOTOWN RECORDS, 1755 Broadway, 7th Floor, New York NY 10019. (212)373-0600. **Creative Art Director:** Sandy Brummels. Estab. 1959. Produces CDs, tapes and video. Produces all genres.

Needs: Prefers artists with experience in computer graphics (QuarkXPress, Illustrator and Photoshop). Uses artists for CD cover, tape cover and advertising design and illustration. 100% of freelance work demands computer skills.

First Contact & Terms: Designers send query letter with tearsheets, résumé, slides and photocopies. Illustrators send postcard sample or other nonreturnable sample. Samples are filed. Responds only if interested. Call for appointment to show portfolio of final art and b&w and color tearsheets, photographs and slides. Pays by the project. Buys all rights.

☑ VALARIEN PRODUCTIONS, 15237 Sunset Blvd., Suite 105, Pacific Palisades CA 90272. (310)445-7737. Fax: (310)455-7735. E-mail: valarien@gte.net. **Owner:** Eric Reyes. Estab. 1990. Produces CDs, cassettes: progressive, New Age, ambient, acoustic, film scores by solo artists. Recent releases: "In Paradise," by Valarien.

Needs: Produces 1-4 releases/year. Works with 1-2 freelancers/year. Prefers local freelancers who own Macs. Uses freelancers for album cover design and illustration; animation; cassette cover design and illustration; CD booklet design and illustration; CD cover design and illustration. Also for ads. 100% of freelance work demands knowledge of Illustrator, QuarkXPress.

First Contact & Terms: Send postcard sample of work. Samples are filed and not returned. Will contact artist for portfolio review of b&w, color, final art if interested. Pays by the project. Rights purchased vary according to project. Finds artists through word of mouth, submissions, sourcebooks.

VAN RICHTER RECORDS, 100 S. Sunrise Way, Suite 219, Palm Springs CA 92262. (760)320-5577. Fax: (760)320-4474. E-mail: vrichter@netcom.com. Website: vr.dv8.net. **Label Manager:** Paul Abramson. Estab. 1993. Produces CDs: rock, industrial. Recent releases: *Nightmare*, by Girls Under Glass.

Needs: Produces 3-4 releases/year. Works with 2-3 freelancers/year. Prefers freelancers with experience in production design. Uses freelancers for CD booklet design and illustration; CD cover design and illustration; posters/pop. 100% of freelance work demands knowledge of Illustrator, QuarkXPress, Photoshop.

First Contact & Terms: Send postcard sample or query letter with brochure, tearsheets, photographs, print samples. Accepts Mac-compatible disk submissions. Samples are not filed and are returned by SASE if requested by artist. Will contact artist for portfolio review of final art if interested. Payment negotiable. Buys all rights. Finds artists through World Wide Web and submissions.

Tips: "You may have to work for free until you prove yourself/make a name."

VARESE SARABANDE RECORDS, 11846 Ventura Blvd., Suite 130, Studio City CA 91604. (818)753-4143. Fax: (818)753-7596. Website: www.varesesarabande.com. **Vice President:** Robert Townson. Estab. 1978. Produces CDs and tapes: film music soundtracks. Recent releases: "Cleopatra," by Alex North; Robert Townson's 500th CD "In Session: A Film Music Celebration"; and *Cast Away* soundtrack, by Alan Silvestri.

Needs: Works on assignment only. Uses artists for CD cover illustration and promotional material.

First Contact & Terms: Send query letter with photostats, slides and transparencies. Samples are filed. Responds only if interested. Pays by the project.

Tips: "Be familiar with the label's output before approaching them."

✔ **VERVE MUSIC GROUP**, (formerly Verve Records), 1755 Broadway, 3rd Floor, New York NY 10019. (212)331-2000. Fax: (212)331-2065. Website: www.grp.com. Vice President Creative Department: Hollis King. **Creative Director:** Sherni Smith. Produces albums, CDs: jazz, progressive by solo artists and groups. Recent releases: *The Look of Love*, by Diana Krall.

• Verve Music Group houses the Verve, GRP, Impulse! and Blue Thumb Record labels.

Needs: Produces 120 releases/year. Works with 20 freelancers/year. Prefers local designers with experience in CD cover design who own Macs. Uses freelancers for album cover design and illustration; CD booklet design and illustration; CD cover design and illustration. 100% of freelance design demands computer skills.

First Contact & Terms: Send nonreturnable postcard sample of work. Samples are filed. Does not report back. Portfolios may be dropped off every Monday through Friday. Will contact artist for portfolio review if interested. Pays for design by the project, $1,500 minimum; pays for illustation by the project, $2,000 minimum. Buys all rights.

✔ **VIRGIN RECORDS**, 338 N. Foothill Rd., Beverly Hills CA 090210. (310)278-1181. Fax: (310)288-1490. **Contact:** Art Director. Uses freelancers for CD and album cover design and illustration. Send query letter with samples. Samples are filed. Responds only if interested.

V2 RECORDS, 14 E. Fourth, Suite 3, New York NY 10012. (212)320-8588. Fax: (212)320-8600. E-mail: davidcalderley@v2music. Website: v2music.com. **Head of Design:** David Calderley. Estab. 1996. Produces 12″ CDs, DVDs: pop, alternative and electronica. Recent releases: *People, Do You Know House?*, by D:Fuse; *18*, by Moby; and *Music Kills Me*, by Rinôçérôse.

Needs: Produces 15 releases/year. Works with 3 freelancers/year. Prefers local designers with experience in music packaging and typography who own Macs. Uses freelancers for album cover design and illustration; CD booklet design and illustration; CD cover design and illustration and poster design. 100% of freelance design and 50% of illustration demands knowledge of Illustrator, QuarkXPress, Photoshop, Strata, 3D, After Effect.

First Contact & Terms: Send postcard sample or query letter with brochure and tearsheets. Samples are returned by SASE if requested by artist. Responds in 4 days if interested. Request portfolio review of photographs, roughs and tearsheets in original query. Pays for design by the project, $75-5,000; pays for illustration by the project, $200-2,000. Buys all rights. Finds artists through submissions, sourcebooks, magazines, Web, artists' reps.

Tips: "Some CD-ROMs are starting to appear as samples. It can be irritating to stop work to load in a portfolio. Show as near to what is final (i.e. real print) as possible—create own briefs if necessary. We look for originality, playfulness, good sense of design and pop culture."

N WARLOCK RECORDS, INC., 133 W. 25th St., 9th Floor, New York NY 10001. (212)206-0800. Fax: (212)206-1966. E-mail: info@warlockrecords.com. Website: www.warlockrecords.com. **Art Direc-**

HOW
THE GRAPHIC DESIGN MAGAZINE THAT COVERS IT ALL.

And now you can get a FREE ISSUE.

From creativity crises to everyday technology, HOW covers every aspect of graphic design — so you have all the tools, techniques and resources you need for design success.

CREATIVITY idea-boosting tips from the experts and the inspiration behind some innovative new designs

BUSINESS how to promote your work, get paid what you're worth, find new clients and thrive in any economy

DESIGN an inside look at the hottest design workspaces, what's new in production and tips on designing for different disciplines

TECHNOLOGY what's happening with digital design, hardware and software reviews, plus how to upgrade on a budget

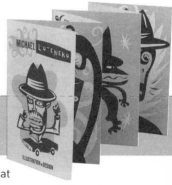

I WANT TO TRY HOW.

Yes! Send my FREE issue and start my trial subscription. If I like what I see, I'll pay just $29.96 for 5 more issues (6 in all). If not, I'll write "cancel" on the invoice, return it and owe nothing. The FREE issue is mine to keep.

Name _____

Company _____

Address _____

City _____

State _____ ZIP _____

SEND NO MONEY NOW.

Canadian orders will be billed an additional $15 (includes GST/HST). Overseas, add $22; airmail, add $65. Remit in U.S. funds. Allow 4-6 weeks for first issue delivery (12 weeks overseas). Annual newsstand rate $68.70.

Important! Please take a moment to complete the following information.

My business is best described as: (choose one)
○ 1 Advertising agency
○ 3 Design studio
○ 4 Graphic arts vendor
○ 2 Company
○ 7 Educational institution
○ 63 Other
(specify)_____

My job title/occupation is: (choose one)
○ 16 Owner/management
○ 22 Creative director
○ 12 Art director/designer
○ 13 Advertising/marketing staff
○ 25 Instructor
○ 19 Student
○ 63 Other
(specify)_____

T6MB6

You get three huge annuals:

SELF-PROMOTION — discover the keys to promoting your work and see the winners of our exclusive Self-Promotion Competition

INTERNATIONAL DESIGN — explore the latest design trends from around the world, plus the winning entries from the HOW International Design Competition

BUSINESS — get the scoop on protecting your work, building your business and your portfolio, and growing your career

Plus, get three acclaimed special issues — each focused on one aspect of design, so you'll get everything you need to know about Digital Design, Creativity and Trends & Type.

tor: Amy Quong. Estab. 1986. Produces CDs, tapes and albums: rhythm and blues, jazz, rap and dance. Recent releases: *No Nagging*, by Froggy Mit; *Lyrical Warfoure*, by Chocolate Bandit; and *Just Be Free*, by Christina Aguilera.

Needs: Produces 5 soloists and 12-15 groups/year. Approached by 30 designers and 75 illustrators/year. Works with 3 designers and 4 illustrators/year. Prefers artists with experience in record industry graphic art and design. Works on assignment only. Uses artists for CD and album/cassette cover design; posters; and advertising design. Seeking artists who both design and produce graphic art, to "take care of everything, including typesetting, stats, etc." 99% of freelance work demands knowledge of Illustrator 6.0, Quark XPress 4.0, Photoshop 4,0, Flight Check 3.2.

First Contact & Terms: Send query letter with brochure, résumé, photocopies and photostats. Samples are filed and are not returned. "I keep information on file for months." Responds only if interested; as jobs come up. Call to schedule an appointment to show a portfolio, or drop off for a day or half-day. Portfolio should include photostats, slides and photographs. Pays for design by the project, $50-1,000; pays for illustration by the project, $50-1,000. Rights purchased vary according to project. Finds artists through submissions.

Tips: "Create better design than any you've ever seen and never miss a deadline—you'll be noticed. Specialize in excellence."

WARNER BROS. RECORDS, 3300 Warner Blvd., Burbank CA 91505. (818)953-3361. Fax: (818)953-3232. Website: www.wbr.com. **Art Dept. Assistant:** Michelle Barish. Produces the artwork for CDs, tapes and sometimes albums: rock, jazz, hip-hop, alternative, rap, R&B, soul, pop, folk, country/western by solo and group artists. Releases include: *Living Proof*, by Cher; *GHVZ*, by Madonna; and *Barricades and Brickwalls*, by Kasey Chambers. Releases approximately 300 total packages/year.

Needs: Works with freelance art directors, designers, photographers and illustrators on assignment only. Uses freelancers for CD and album tape cover design and illustration; brochure design and illustration; catalog design, illustration and layout; advertising design and illustration; and posters. 100% of freelance work demands knowledge of QuarkXPress, FreeHand, Illustrator or Photoshop.

First Contact & Terms: Send query letter with brochure, tearsheets, résumé, slides and photographs. Samples are filed or are returned by SASE if requested by artist. Responds only if interested. Submissions should include roughs, printed samples and b&w and color tearsheets, photographs, slides and transparencies. "Any of these are acceptable." Do not submit original artwork. Pays by the project.

Tips: "Send a portfolio—we tend to use artists or illustrators with distinct/stylized work—rarely do we call on the illustrators to render likenesses; more often we are looking for someone with a conceptual or humorous approach."

■ **WATCHESGRO MUSIC, BMI—INTERSTATE 40 RECORDS**, 9208 Spruce Mountain Way, Las Vegas NV 89134. (702)363-8506. **President:** Eddie Lee Carr. Estab. 1975. Produces CDs, tapes and albums: rock, country/western and country rock. Releases include: *Reflections in the Night*; *Table for Two*; *Princess Fatima*; *Oz*; *All At Once We Were Old*; *Heaven's in a Hell of a Mood*; and *Faith Makes A Difference—Lost Then Found* (gospel).

 ● Watchesgro Music has placed songs in feature films: *Mafia*, *Out of Sight*, *Best of Show*, *Rush House*, *There's Something About Mary*, *The Bachelor*, *Dogma*, *Fight Club* and *Billy Elliot*.

Needs: Produces 8 solo artists/year. Works with 3 freelancers/year for CD/album/tape cover design and illustration; and videos.

First Contact & Terms: Send query letter with photographs. Samples are filed or are returned by SASE. Responds in 1 week only if interested. To show portfolio, mail b&w samples. Pays by the project. Negotiates rights purchased.

▨ **WELK MUSIC GROUP**, 2700 Pennsyvania Ave., Santa Monica CA 90404. (310)829-9355. Fax: (310)394-4148. E-mail: vangardrec@aol.com or gcartwright@e-znet.com. **Contact:** Preproduction Coordinator. Estab. 1987. Produces CDs, tapes and albums; R&B, jazz, soul, folk, country/western, solo artists. Recent release: *Acoustic Traveler*, by John McEuen.

 ● This label recently acquired Sugar Hill Records. Sugar Hill will maintain its Durham NC headquarters. Welk Music Group, a division of The Welk Group encompasses Vanguard Records and Ranwood Records.

Needs: Produces 2 soloists and 6 groups/year. Works with 4 designers/year. Prefers artists with experience in the music industry. Uses artists for CD cover design and illustration, album/tape cover design and illustration; catalog design, illustration and layout; direct mail packages; advertising design. 100% of freelance work demands knowledge of QuarkXPress, Illustrator or Photoshop.

First Contact & Terms: Send postcard sample with brochure, photocopies, photographs and tearsheets. Samples are filed. Responds only if interested. To show a portfolio, mail tearsheets and printed samples. Pays for design by the hour, $25-45; by the project, $800-2,000. Pays for illustration by the project, $200-500. Buys all rights.

Tips: "We need to have artwork for cover combined with CD booklet format."

[N] WIND-UP ENTERTAINMENT, 72 Madison Ave., 8th Floor, New York NY 10016. (212)251-9665. Fax: (212)251-0779. E-mail: mdroescher@wind-up.com. Website: www.wind-up.com. **Creative Director:** Mark Droescher. Estab. 1997. Produces CDs, cassettes, music videos and TV commercials: pop, R&B, rock by solo artists and groups. Recent releases: *Weathered*, by Creed; *Sinner*, by Drowning Pool; and *The Greyest of Blue Skies*, by Finger Eleven.

Needs: Produces 8 releases/year. Works with 8-10 freelancers/year. Prefers local freelancers who own Macs. Uses freelancers for album cover design and illustration; cassette cover design and illustration; CD booklet design and illustration; CD cover design and illustration; poster design and web page design. 100% of design and 50% of illustration demands knowledge of QuarkXPress 4, Photoshop 6.

First Contact & Terms: Send query letter with brochure, résumé, transparencies, photocopies, photographs, SASE, tearsheets or website link. Accepts disk submissions compatible with Mac. Samples are filed or returned by SASE if requested by artist. Will contact artist for portfolio review if interested. Pays for design by the hour, $25-50. Finds artists through word of mouth, magazines, reps, directories.

Tips: "Work should be as personal as possible."

[N] WORD ENTERTAINMENT INC., 25 Music Square West, Nashville TN 37203. (615)457-2077. Fax: (615)457-2099. E-mail: mlee@wordentertainment.com. Website: www.wordentertainment.com or www.wordrecords.com. **Contact:** Art Director. Produces albums, CDs, CD-ROMs, cassettes, videotapes: classical, gospel, pop, progressive, R&B, rock by solo artists and groups. Recent releases: *All the Best . . . Vive*, by Sandi Patti; and *Storm*, by Fernando Ortega.

Needs: Produces 80 releases/year. Works with lots of freelancers/year. Prefers designers who own Macs with experience in the music industry. Uses freelancers for album cover design and illustration; cassette cover design and illustration; CD booklet design and illustration; CD cover design and illustration. 100% of freelance design demands knowledge of QuarkXPress (current), Photoshop (current).

First Contact & Terms: Send postcard sample of work. Send query letter with appropriate samples. Samples are filed. Responds only if interested. Will contact artist for portfolio review if interested. Pays by the project. Buys all rights. Finds artists through wide net of local artists and people who call us.

Tips: "Know the market, stay appropriate but new."

MARKET CONDITIONS are constantly changing! If you're still using this book and it is 2004 or later, buy the newest edition of *Artist's & Graphic Designer's Market* at your favorite bookstore or order directly from Writer's Digest Books (1-800-289-0963).

Resources
Artists' Reps

Produced by Arena Design, this sophisticated assortment of postcards was used as a promotional tool for new artists represented by Langley Creative Promotion. Lushly colored and detailed, the images have a narrative quality and lasting effect on the viewer. Located in Chicago, Langley Creative Promotion currently represents 21 illustrators including Mina Reimer, Mona Daly and Ted Burn.

Many artists find leaving promotion to a rep allows them more time for the creative process. In exchange for actively promoting an artist's career, the representative receives a percentage of sales (usually 25-30%). Reps concentrate on either the commercial or fine art markets, rarely both. Very few reps handle designers.

Fine art reps promote the work of fine artists, sculptors, craftspeople and fine art photographers to galleries, museums, corporate art collectors, interior designers and art publishers. Commercial reps help illustrators obtain assignments from advertising agencies, publishers, magazines and other art buyers. Some reps also act as licensing agents.

What reps do

Reps work with you to bring your portfolio up-to-speed and will work to get you some great clients. Usually a rep will recommend advertising in one of the many creative directories such as *American Showcase* or *Creative Illustration* so that your work will be seen by hundreds of art directors. (Expect to make an initial investment in costs for duplicate portfolios and mailings). Reps also negotiate contracts, handle billing and collect payments.

Getting representation isn't as easy as you might think. Reps are choosy about who they represent, not just in terms of talent, but in terms of marketability and professionalism. A rep will only take on talent she knows will sell.

What to send

Once you've narrowed down a few choices, contact them with a brief query letter and nonreturnable copies of your work. Check each listing for specific information.

For More Information

The Society of Photographers and Artists Representatives (SPAR) is an organization for professional representatives. SPAR members are required to maintain certain standards and follow a code of ethics. For more information, write to SPAR, 60 E. 42nd St., Suite 1166, New York NY 10165, phone (212)779-7464.

ADMINISTRATIVE ARTS, INC., P.O. Box 547935, Orlando FL 32854-1266. (407)849-9744. E-mail: mangoarts@att.net. Website: www.mangoarts.com. **President:** Brenda B. Harris. Fine art advisor. Estab. 1983. Registry includes 1,000+ fine artists (includes fine art crafts). Markets include: architects, corporate collections, developers, private collections, public art.

● The software division of this company develops and distributes management software, Mango Arts Management System™, for artists, art festivals, art organizations, consultants and advisors that focus on project, inventory and marketing management (for artists) and presentation development. The advisory division assists corporations with art acquisitions. They analyze artistic growth, experience record and conduct an interview with the artist to determine the artist's professional management skills in order to advise artists on career growth.

Handles: Fine art. "We prefer artists with established regional and national credentials. We also review and encourage emerging talent."

Terms: "Trade discount requested varies from 15-50% depending on project and medium."

How to Contact: "For first contact, submissions must include: 1) complete résumé; 2) artist's statement or brief profile; 3) labeled slides (artist's name, title of work, date, medium, image size and *retail price*); 4) availability of works submitted. E-mail contact also acceptable." SASE. Responds in 1 month.

Tips: "Artists are generally referred by their business or art agent, another artist or art professional, educators, or art editors who know our firm. A good impression starts with a cover letter and a well organized, typed résumé. *Always place your name and slide identification on each slide.* Make sure that

slides are good representations of your work. Know your retail and net pricing and the standard industry discounts. Invite the art professional to visit your studio. To get placements, be cooperative in getting art to the art professional when and where it's needed."

☑ **FRANCE ALINE ASSOCIATES**, 1460 N. Mansfield Ave., Suite 319, Hollywood CA 90028. (323)933-2500. Fax: (323)467-0210. E-mail: franceealin@aol.com. **Owner:** France Aline. Commercial illustration, photography and graphic design representative. Specializes in advertising. Markets include: advertising, corporations, design firms, movie studios, record companies. Artists include: Susan Barr, Lendon Flanagan, Mark Tuschman, Jill Sabella, Bruce Wolfe, Craig Mullins, Ezra Tucker, Elisa Cohen, Todd White and Tomas Black.
Handles: Illustration, photography.
Terms: Rep receives 25% commission. Exclusive area representation is required. Advertises in *American Showcase*, *The Workbook* and *Blackbook*.
How to Contact: For first contact, send tearsheets. Responds in a few days. Mail in appropriate materials. Portfolio should include tearsheets, photographs.
Tips: "Send promotions. No fashion."

▣ **AMERICAN ARTISTS, REP. INC.**, 353 W. 53rd St., #1W, New York NY 10019. (212)582-0023. Fax: (212)582-0090. E-mail: amerart@aol.com. Commercial illustration representative. Estab. 1930. Member of SPAR. Represents 40 illustrators. Markets include: advertising agencies; corporations/client direct; design firms; editorial/magazines; paper products/greeting cards; publishing/books; sales/promotion firms.
Handles: Illustration, design.
Terms: Rep receives 30% commission. "All portfolio expenses billed to artist." Advertising costs are split: 70% paid by talent; 30% paid by representative. "Promotion is encouraged; portfolio must be presented in a professional manner—8×10, 4×5, tearsheets, etc." Advertises in *American Showcase*, *Black Book*, *RSVP*, *The Workbook*, medical and Graphic Artist Guild publications.
How to Contact: For first contact, send query letter, direct mail flier/brochure, tearsheets. Responds in 1 week if interested. After initial contact, drop off or mail appropriate materials for review. Portfolio should include tearsheets, slides.
Tips: Obtains new talent through recommendations from others, solicitation, conferences.

▣ **ART LICENSING INTERNATIONAL**, 1532 US 41 By Pass S #272, Venice FL 34293. (941)488-8464. Fax: (941)488-8454. E-mail: artlicensing@comcast.net. Website: www.artlicensing.com. **President:** Michael Woodward. Licensing agent. Estab. 1986. Licensing agents for artists, illustrators, photographers, concept designers and TV cartoon concepts. Handles collections of work submitted by artists for licensing across a range of product categories such as greeting cards, calendars, stationery and gift products, jigsaw puzzles, partyware, textiles, housewares, etc.
Needs: Prefers collections of art, illustrations of photography which have wide consumer appeal.
First Contact & Terms: Send examples on CD (TIF or JPEG files), color photocopies or slides/transparencies with SASE. Fine artists should send short bio. Terms are 50/50 with no expenses to artists "as long as artist can provide high resolution scans if we agree on representation. Our agency specializes in aiming to create a full licensing program so we can license art across a varied product range. We are therefore only interested in collections, or groups of artworks or concepts which have commercial appeal. Artists need to consider actual products when creating new art.
Tips: "Look at actual products in retail outlets and get a feel for what is selling well. Ask store owners or sales assistants what's 'hot.' Get to know the markets you are actually trying to sell your work to."

ART SOURCE L.A., INC., 2801 Ocean Park Blvd., PMB 7, Santa Monica CA 90405. (310)452-4411. Fax: (310)452-0300. E-mail: ellmanart@aol.com. Website: www.artsourcela.com. **Contact:** Francine Ellman, president. Fine art representative. Estab. 1980. Represents artists in all media in fine art and accessories. Specializes in fine art consulting and curating worldwide. Markets include: architects; corporate collections; developers; hospitality public space; interior designers; private collections and government projects.
 • Art Source has additional offices in Monterey, CA and Rockville, MD.
Handles: Fine art in all media, including works on paper/canvas, giclees, photography, sculpture, and other accessories handmade by American artists. Artists represented include Linda Adlestein, Betsy Bauer, Sandi Seltzer Bryant, Sarah Einstein, Phil Gallagher, Frances Hamilton, Sarah Hinckley, Aleah Kowry, Michael Ledet, Donna McGinnis, Michael Pauker, Livia Stein, Inez Storer, Jacqueline Warren and Cheryl Warrick.

Terms: Agent receives commission, amount varies. Exclusive area representation required in some cases. No geographic restrictions. "We request artists submit a minimum of 20 slides/visuals, résumé and SASE." Advertises in *Art News*, *Artscene*, *Art in America*, *Blue Book*, *Gallery Guide*, *Art Diary*, *Art & Auction*, *Guild*, and *Internet*.

How to Contact: For first contact, send résumé, bio, slides or photographs and SASE. Responds in 2 months. After initial contact, "we will call to schedule an appointment" to show portfolio of original art, slides, photographs. Obtains new talent through recommendations, artists' submissions and exhibitions.

Tips: "Be professional when submitting visuals. Remember—first impressions can be critical! Submit a body of work that is consistent and of the highest quality. Work should be in excellent condition and already photographed for your records. Framing does not enhance the presentation to the client. Please send all submissions to the Southern California Corporate Office."

ARTCO INCORPORATED, 3148 RFD Cuba Rd., Long Grove IL 60047-9606. (847)438-8420. Fax: (847)438-6464. E-mail: sjtillman@prodigy.net. Website: www.e-Artco.com. **Contact:** Sybil Tillman. Fine art representative. Estab. 1970. Member of International Society of Appraisers and Appraisers Association of America Inc. Represents 60 fine artists. Specializes in contemporary artists' originals and limited edition graphics. Markets include: architects; art publishers; corporate collections; galleries; private collections.

Handles: Fine art.

Terms: "Each commission is determined mutually. For promotional purposes, I would like to see original work or transparencies." No geographic restrictions. Advertises in newspapers, magazines, etc.

How to Contact: For first contact, send query letter, résumé, bio, slides, SASE, photographs or transparencies. After initial contact, call for appointment to show portfolio of original art, slides, photographs. Obtains new talent through recommendations from others, solicitation, conferences, advertising.

N **ARTIST DEVELOPMENT GROUP**, 21 Emmett St., Suite 2, Providence RI 02903-4503. (401)521-5774. Fax: (401)521-5176. **Contact:** Rita Campbell. Represents photography, fine art, graphic design, as well as performing talent to advertising agencies, corporate clients/direct. Staff includes Rita Campbell. Estab. 1982. Member of Rhode Island Women's Advertising Club, NE Collaborative of Artist's Representatives. Co-Op America; Mass Land Trust. Markets include: advertising agencies; corporations/client direct. Clients include Hasbro, Etonic, Puma, Tretorn, Federal Computer Week. Client list available upon request.

Handles: Illustration, photography.

Terms: Rep receives 20-25% commission. Advertising costs are split: 50% paid by talent; 50% paid by representative. For promotional purposes, talent must provide direct mail promotional piece; samples in book for sales meetings.

How to Contact: For first contact, send résumé, bio, direct mail flier/brochure. Will respond if interested. Portfolios should include tearsheets, photographs. Obtains new talent through "referrals as well as inquiries from talent exposed to agency promo."

ARTVISIONS, 12117 SE 26th St., Suite 202A, Bellevue WA 98005-4118. E-mail: mkt.art@artvisions.com. Website: www.artvisions.com. **President:** Neil Miller. Estab. 1993. ArtVision is a service of avidre, inc. Markets include publishers, manufacturers of paper products, posters, greeting cards, stationery, textiles, calendars, decor items and giftwrap.

Handles: Fine art licensing only.

Terms: Agent's commission is 35%. "We produce highly targeted direct marketing programs focused on opportunities to license art. We develop a marketing portfolio at your expense based on information and pictures you provide. Requires exclusive world-wide representation for licensing (the artist is free to market original written contract provided).

How to Contact: Send slides/photos/tearsheets or brochures via mail, with SASE for return. Always label your materials. "We cannot respond to inquiries that do not include examples of your art."

Tips: "We do not buy art, we are a licensing agent for artists. Our income is derived from commissions from licensing fees we generate for you, so, we are very careful about selecting artists for our service. To gain an idea of the type of art we seek, please view our website: www.artvisions.com before submitting. Our way of doing business is very labor intensive and each artist's market plan is unique. Be prepared to invest in yourself including a share of your promotional costs."

✓ ASCIUTTO ART REPS., INC., 1712 E. Butler Circle, Chandler AZ 85225. (480)899-0600. Fax: (480)899-3636. E-mail: aartreps@aol.com. **Contact:** Mary Anne Asciutto. Children's illustration representative. Estab. 1980. Member of SPAR, Society of Illustrators. Represents 20 illustrators. Specializes in children's illustration for books, magazines, posters, packaging, etc. Markets include: publishing/packaging/advertising.

Handles: Illustration only.

Terms: Rep receives 25% commission. No geographic restrictions. Advertising costs are split: 75% paid by talent; 25% paid by representative. For promotional purposes, talent should provide "prints (color) or originals within an 8½×11 size format."

How to Contact: Send a direct mail flier/brochure, tearsheets, photocopies and SASE. Responds in 2 weeks. After initial contact, send appropriate materials if requested. Portfolio should include original art on paper, tearsheets, photocopies or color prints of most recent work. If accepted, materials will remain for assembly.

Tips: In obtaining representation "be sure to connect with an agent who handles the kind of accounts you (the artist) *want.*"

☑ **CAROL BANCROFT & FRIENDS**, 121 Dodgingtown Rd., P.O. Box 266, Bethel CT 06801. (203)748-4823. Fax: (203)748-4581. E-mail: artists@carolbancroft.com. Website: www.carolbancroft.com. **Owner:** Carol Bancroft. Illustration representative for children's publishing. Estab. 1972. Member of SPAR, Society of Illustrators, Graphic Artists Guild, SCBWI. Represents over 40 illustrators. Specializes in illustration for children's publishing—text, trade and any children's-related material. Clients include Scholastic, Holt, HarperCollins, Penguin USA. Artist list available upon request.

Handles: Illustration for children of all ages.

Terms: Rep receives 30% commission. Advertising costs are split: 75% paid by talent; 25% paid by representative. For promotional purposes, artist must provide "laser copies (not slides), tearsheets, promo pieces, books, good color photocopies, etc.; 6 pieces or more; narrative scenes with children and/or animals interacting." Advertises in *RSVP, Picture Book, Directory of Illustration.*

How to Contact: Send samples and SASE. "Artists must call no sooner than one month after sending samples."

Tips: "We look for artists who can draw animals and people with imagination and energy, depicting engaging characters with action in situational settings."

Ⓝ **SAL BARRACCA ASSOC. INC.**, 96 Wood Creek Rd., Bethlehem CT 06751. (203)266-6750. Fax: (203)266-6751. **Contact:** Sal Barracca. Commercial illustration representative. Estab. 1988. Represents 23 illustrators. "90% of our assignments are book jackets." Markets include: advertising agencies; publishing/books. Artists include Alan Ayers, Matt Stawicki, Ken Laager, Kristin Sorra, Bleu Turreil, Patrick Whelan and Roger Loveless.

Handles: Illustration.

Terms: Rep receives 25% commission. Exclusive area representation is required. Advertising costs are split: 75% paid by talent; 25% paid by representative. For promotional purposes "portfolios must be 8×10 chromes that are matted. We can shoot original art to that format at a cost to the artist. We produce our own promotion and mail out once a year to over 16,000 art directors."

How to Contact: For first contact, send direct mail flier/brochure, tearsheets and SASE. Responds in 1 week; 1 day if interested. After initial contact, drop off or mail in appropriate materials for review. Portfolio should include tearsheets, slides.

Tips: "Make sure you have at least three years of working on your own so that you don't have any false expectations from an agent."

BERENDSEN & ASSOCIATES, INC., 2233 Kemper Lane, Cincinnati OH 45206. (513)861-1400. Fax: (513)861-6420. E-mail: bob@illustratorsrep.com. Website: www.illustratorsrep.com and www.Stock ArtRep.com. **President:** Bob Berendsen. Commercial illustration, photography, artists' representative. Incorporated 1986. Represents 25 illustrators, 15 photographers. Specializes in "high-visibility consumer accounts." Markets include: advertising agencies; corporations/client direct; design firms; editorial/magazines; paper products/greeting cards; publishing/books; sales/promotion firms. Clients include Disney, CNN, Pentagram, F&W Publications. Client list available upon request. Represents: Bruce Armstrong, Jake Ellison, Bill Fox, George Hardebeck, Marcia Hartsock, Mahammad Mansoor, Tom Marcotte, Thomas O. Miller, Garry Nichols, Duff Orlemann, Jack Pennington, Dave Reed, Garry Richardson, Ursula Roma, Robert Schuster, Fariba Shiadaz, Kevin Torline, Christina Wald, Dave Warren, Wendy Wassink Ackison, Misty Wheatley-Maxwell, Lee Wollery, Mike Bonilla, Mike Kreffel.

● This rep has four websites: illustratorsrep.com, photographersrep.com, designersrep.com and stock artrep.com. The fast-loading pages are easy for art directors to access—a great promotional tool for their talent.

Handles: Illustration, photography. "We are always looking for illustrators who can draw people, product and action well. Also, we look for styles that are metaphoric in content, and it's a plus if the stock rights are available."

Terms: Rep receives 25% commission. Charges "mostly for postage but figures not available." No geographic restrictions. Advertising costs are split: 75% paid by talent; 25% paid by representative. For

promotional purposes, "artist must co-op in our direct mail promotions, and sourcebooks are recommended. Portfolios are updated regularly." Advertises in *RSVP*, *Creative Illustration Book*, *Directory of Illustration* and *American Showcase*.

How to Contact: For first contact, send an e-mail with no more than 6 jpegs attached or send query letter, résumé, and any nonreturnable tearsheets, slides, photographs or photocopies. Follow up with a phone call.

Tips: Artists should have a "proven style with at least ten samples of that style."

N SAM BRODY, ARTISTS & PHOTOGRAPHERS REPRESENTATIVE & CONSULTANT, 77 Winfield St., Apt. 4, E. Norwalk CT 06855-2138. Phone/fax: (203)854-0805 (for fax, add 999). **Contact:** Sam Brody. Commercial illustration and photography representative and broker. Estab. 1948. Member of SPAR. Represents 4 illustrators, 3 photographers, 2 designers. Markets include: advertising agencies; corporations/client direct; design firms; editorial/magazines; publishing/books; sales/promotion firms.

Handles: Illustration, photography, design, "great film directors."

Terms: Agent receives 30% commission. Exclusive area representation is required. For promotional purposes, talent must provide back-up advertising material, i.e., cards (reprints—*Workbook*, etc.), websites and self-promos.

How to Contact: For first contact, send bio, direct mail flier/brochure, tearsheets. Responds in 3 days or within 1 day if interested. After initial contact, call for appointment or drop off or mail in appropriate materials for review. Portfolio should include tearsheets, slides, photographs. Obtains new talent through recommendations from others, solicitation.

Tips: Considers "past performance for clients that I check with and whether I like the work performed."

☑ PEMA BROWNE LTD., HCR Box 104B, 71 Pine Rd., Neversink NY 12762. (845)985-2936 or (845)985-2062. Fax: (845)985-7635. **Contact:** Pema Browne or Perry Browne. Commercial illustration representative. Estab. 1966. Represents 7 illustrators. Specializes in general commercial. Markets include: all publishing areas; children's picture books; collector plates and dolls; advertising agencies. Clients include HarperCollins, Thomas Nelson, Bantam Doubleday Dell, Nelson/Word, Hyperion, Putnam. Client list available upon request. Represents: John Sandford, Richard Hull, Todd Doney, Maren Scott and Robert Barrett, Bob Dorsey, Robin Boyer.

Handles: Illustration. Looking for "professional and unique" talent.

Terms: Rep receives 30% commission. Exclusive area representation is required. For promotional purposes, talent must provide color mailers to distribute. Representative pays mailing costs on promotion mailings.

How to Contact: For first contact, send query letter, direct mail flier/brochure and SASE. If interested, will ask to mail appropriate materials for review. Portfolios should include tearsheets and transparencies or good color photocopies, plus SASE. Obtains new talent through recommendations and interviews (portfolio review).

Tips: "We are doing more publishing—all types—less advertising." Looks for "continuity of illustration and dedication to work. No e-mail or fax queries, please."

N BRUCK AND MOSS ASSOCIATES, 100 Bleeker St., New York NY 10012. (212)980-8061 or (212)982-6533. Fax: (212)832-8778 or (212)674-0194. **Contact:** Eileen Moss or Nancy Bruck. Commercial illustration representative. Estab. 1978. Represents 12 illustrators. Markets include: advertising agencies; corporations/client direct; design firms; editorial/magazines; publishing/books; sales/promotion firms; direct marketing.

Handles: Illustration.

Terms: Rep receives 30% commission. Exclusive representation is required. No geographic restrictions. Advertising costs are split: 70% paid by talent; 30% paid by representative. For promotional purposes, talent must provide "4×5 transparencies mounted on 7×9 black board. Talent pays for promotional card for the first year and for trade ad." Advertises in *American Showcase* and *The Workbook*.

How to Contact: For first contact, send tearsheets, "if sending slides, include SASE." After initial contact, drop off or mail in appropriate materials for review. Portfolios should include tearsheets. If mailing portfolio include SASE or Federal Express form.

Tips: Obtains new talent through referrals by art directors and art buyers, mailings of promo card, source books, art shows, *American Illustration* and *Print Annual*. "Make sure you have had experience repping yourself. Don't approach a rep on the phone, they are too busy for this. Put them on a mailing list and mail samples. Don't approach a rep who is already repping someone with the same style."

☑ SID BUCK SYDRA TECHNIQUES CORP., 998C Old Country Rd., Plainview NY 11803. (516)496-0953. Fax: (516)682-8153. E-mail: sydra@optonline.com. **President:** Sid Buck. Commercial illustration representative. Estab. 1964. Markets include: advertising agencies; corporations/client direct;

design firms; editorial/magazines; paper products/greeting cards; publishing/books; fashion. **Represents:** Jerry Schurr, Ken Call and Glenn Iunstull, Robert Melendez, Robert Passantino, Howard Rose, Dee Densmore D'Amico.

Handles: Illustration, fashion and editorial.

Terms: Rep receives 25% commission. Exclusive area represention is required. Advertising costs are split: 75% paid by talent; 25% paid by representative.

How to Contact: For first contact, send photocopies, photostats. Responds in 1 week. After initial contact, call to schedule an appointment for portfolio review. Portfolio should include photostats, photocopies.

WOODY COLEMAN PRESENTS, INC., dba Portsort.com (artist-controlled cooperative). 490 Rockside Rd., Cleveland OH 44131. (216)661-4222. Fax: (216)661-2879. E-mail: woody@portsort.com. Website: www.portsort.com. **Contact:** Woody. Creative services representative. Estab. 1978. Member of Graphic Artists Guild. Specializes in illustration. Markets include: advertising agencies; corporations/client direct; design firms; editorial/magazines; paper products/greeting cards; publishing/books; sales/promotion firms; public relations firms.

Handles: Illustration.

Terms: Organization receives 25% commission. If chosen—will place free 12-image portfolio on Internet Database (see www.portsort.com). For promotional purposes, talent must provide "all 12 or more image portfolios in 4×5 transparencies as well as 12 scans." Advertises in *American Showcase*, *Black Book*, *The Workbook*, other publications.

How to Contact: For first contact, send query letter, tearsheets, slides, SASE. Responds in 1 month, only if interested. Portfolio should include tearsheets, 4×5 transparencies.

Tips: "Solicitations are made directly to our agency. Concentrate on developing 12 specific examples of a single style exhibiting work aimed at a particular specialty, such as fantasy, realism, Americana or a particular industry such as food, medical, architecture, transportation, film, etc."

✓ JAN COLLIER REPRESENTS, INC., P.O. Box 470818, San Francisco CA 94147. (415)383-9026. E-mail: jan@collierreps.com. Website: www.jan.collier/represents.com. **Contact:** Leah Gagné. President: Jan Collier. Commercial illustration representative. Estab. 1978. Represents 12 illustrators. Markets include: advertising agencies; design firms and editorial. **Represents:** 20 illustrators including Richard Borlte, Gary Baseman, Nicholas Wilton, Bustamante, Katherine Dunn, Jennie Oppenheimer.

Handles: Illustration.

Terms: Rep receives 25% commission. Exclusive national representation is required. Advertising costs are split: 75% paid by talent; 25% paid by representative. Advertises in *American Showcase*, *The Workbook*, *Alternative Pick*.

How to Contact: For first contact, send tearsheets, slides and SASE. Responds in 1 week, only if interested. "After initial contact, we will call for portfolio if interested."

DANIELE COLLIGNON, 200 W. 15th St., New York NY 10011. (212)243-4209. **Contact:** Daniele Collignon. Commercial illustration representative. Estab. 1981. Member of SPAR, Graphic Artists Guild, Art Director's Club. Represents 12 illustrators. Markets include: advertising agencies; corporations/client direct; design firms; editorial/magazines; publishing/books.

Handles: Illustration.

Terms: Rep receives 30% commission. Exclusive area representation is required. No geographic restrictions. Advertising costs are split: 75% paid by talent; 25% paid by representative. For promotional purposes, talent must provide 8×10 transparencies (for portfolio) to be mounted, printed samples, professional pieces. Advertises in *American Showcase*, *Black Book*, *The Workbook*.

How to Contact: For first contact, send direct mail flier/brochure, tearsheets. Responds in 5 days, only if interested. After initial contact, drop off or mail in appropriate materials for review. Portfolio should include tearsheets, transparencies.

CONRAD REPRESENTS . . ., 2149 Lyon St., #5, San Francisco CA 94115. (415)921-7140. E-mail: art@conradereps.com. Website: www.conradreps.com. **Contacts:** James Conrad and Jennifer Vaughn.

 SPECIAL COMMENTS within listings by the editor of *Artist's & Graphic Designer's Market* are set off by a bullet.

Commercial art rep for assignment and stock illustration. Estab. 1984. Represents 20-30 illustrators. Markets include: advertising agencies; corporate art departments; graphic designers and publishers of books; magazines, posters; calendars and greeting cards.

Handles: Illustration.

Terms: Rep receives 25-30% commission. Exclusive national representation is required. No geographic restrictions. For promotional purposes, talent must provide a portfolio "and participate in promotional programs."

How to Contact: For first contact, send samples. Follow up with phone call.

N: CORNELL & McCARTHY, LLC, 2-D Cross Hwy., Westport CT 06880. (203)454-4210. Fax: (203)454-4258. E-mail: cmartreps@aol.com. **Contact:** Merial Cornell. Children's book illustration representative. Estab. 1989. Member of SCBWI and Graphic Artists Guild. Represents 30 illustrators. Specializes in children's books: trade, mass market, educational.

Handles: Illustration.

Terms: Agent receives 25% commission. Advertising costs are split: 75% paid by talent; 25% paid by representative. For promotional purposes, talent must provide 10-12 strong portfolio pieces relating to children's publishing.

How to Contact: For first contact, send query letter, direct mail flier/brochure, tearsheets, photocopies and SASE. Responds in 1 month. Obtains new talent through recommendations, solicitation, conferences.

Tips: "Work hard on your portfolio."

☑ ♔ CREATIVE ARTS OF VENTURA, P.O. Box 684, Ventura CA 93002. E-mail: ulrichxcal@aol.c om. Websites: www.justoriginals.com and www.ojai.net/v2art. Owners: Don and Lamia Ulrich. Representative not currently seeking new talent. Clients include Tempe Arts Center, Arizona; City of New York, slide registry, public art programs; City of Los Angeles, Cultural Affairs Dept.; Urban Arts, Boston; Beverly Hills Recreation Parks Dept.; U.S. Embassy in Riga, Latvia and U.S. Embassy in Panama/U.S. State Dept. Represents: Don Ulrich, Cameron Kempsell and Elianne Kempsell.

● This agency has recently won awards including Photo Award for Contemporary Sculpture from Manhattan Arts International 2000.

Tips: "High quality photographic imagery of artist's art form or product is most important. Lengthy résumés are of secondary value to us."

CREATIVE FREELANCERS INC., (formerly Creative Freelancers), 99 Park Ave., #210A, New York NY 10016. (800)398-9544. Fax: (203)532-2927. E-mail: cfonline@freelancers.com. Website: www.freelan cers.com. **Contact:** Marilyn Howard. Commercial illustration and designers representative. Estab. 1988. Represents 30 illustrators and designers. "Our staff members have art direction, art buying or illustration backgrounds." Specializes in children's books, advertising, architectural, conceptual. Markets include: advertising agencies; corporations/client direct; design firms; editorial/magazines; paper products/greeting cards; publishing/books; sales/promotion firms.

Handles: Illustration and design. Artists must have published work.

Terms: Rep receives 30% commission. Exclusive area representation is preferred. Advertising costs are split: 75% paid by talent; 25% paid by representative. For promotional purposes, talent should provide "printed pages to leave with clients and be listed at our website. Transparency portfolio preferred if we take you on, but we are flexible." Advertises in *American Showcase*, *Workbook*.

How to Contact: For first contact, send tearsheets or "whatever best shows work." Responds only if interested.

Tips: Looks for experience, professionalism and consistency of style. Obtains new talent through "word of mouth and website."

N: LINDA DE MORETA REPRESENTS, 1839 Ninth St., Alameda CA 94501. (510)769-1421. Fax: (510)521-1674. E-mail: ldmreps@prodigy.net. **Contact:** Ron Lew. Commercial illustration and photography representative; also portfolio and career consultant. Estab. 1988. Represents 8 illustrators, 5 photographers. Markets include: advertising agencies; design firms; corporations/client direct; editorial/magazines; paper products/greeting cards; publishing/books; sales/promotion firms. Represents: Chuck Pyle, Pete McDonnell, Tina Healey, Barbara Callow, Janet Hyun, Colin Poole, Halstead Craig Hannah, Monica Dengo, Tina Rachelle, James Chiang, John Lund, Susan Vogel, Ron Miller and John Branscombe.

Handles: Illustration, lettering/title design, photography.

Terms: Rep receives 25% commission. Exclusive representation requirements vary. Advertising costs are according to individual agreements. Materials for promotional purposes vary with each artist. Advertises in *The Workbook*, *American Showcase*, *Directory of Illustration*, *Alternative Pick*.

How to Contact: For first contact, send direct mail flier/brochure, slides or photocopies and SASE. "Please do *not* send original art. SASE for any items you wish returned." Responds to any inquiry in which there is an interest. Portfolios are individually developed for each artist and may include transparencies, prints or tearsheets.

Tips: Obtains new talent through client and artist referrals primarily, some solicitation. "I look for great creativity, a personal vision and style of illustration or photography combined with professionalism, maturity and a willingness to work hard."

N: DWYER & O'GRADY, INC., P.O. Box 239, Lempster NH 03605. (603)863-9347. Fax: (603)863-9346. **Contact:** Elizabeth O'Grady. Agents for children's picture book artists and writers. Estab. 1990. Member of Society of Illustrators, SCBWI, ABA. Represents 13 illustrators and 6 writers. Staff includes Elizabeth O'Grady, Jeffrey Dwyer. Specializes in children's picture books (middle grade and young adult). Markets include: publishing/books, audio/film. Represents: Earl B. Lewis, Mary Azarian, Irving Toddy, Peter Sylvada, Leonard Jenkins.

Handles: Illustrators and writers of children's books. "Favor realistic and representational work for the older age picture book. Artist must have full command of the figure and facial expressions."

Terms: Receives 15% commission domestic, 20% foreign. Additional fees are negotiable. Exclusive representation is required (world rights). Advertising costs are paid by representative. For promotional purposes, talent must provide both color slides and prints of at least 20 sample illustrations depicting the figure with facial expression.

How to Contact: Not accepting new clients.

FORTUNI, 2508 E. Belleview Place, Milwaukee WI 53211. (414)964-8088. Fax: (414)332-9629. **Contact:** Marian F. Deegan. Commercial illustration, photography representative. Estab. 1989. Member of Graphic Artists Guild. Represents 6 illustrators, 2 photographers. Markets include: advertising agencies; corporations/client direct; design firms; editorial/magazines; publishing/books. Artists include Peter Carter, Samantha Burton, Janet Drew, Dick Baker, Zelda Bean, Rijalynne Saari, Jody Winger and Kendra Shaw.

Handles: Illustration, photography. "I am interested in artists who have developed a consistent, distinctive style of illustration, and target the national advertising market."

Terms: Rep receives 30% commission. Advertising costs are split: 70% paid by talent; 30% paid by representative. For promotional purposes, talent must provide direct mail support, advertising, and a minimum of 4 duplicate transparency portfolios. "All promotional materials are developed and produced within my advertising specifications." Advertises in *Directory of Illustration, The Workbook*.

How to Contact: For first contact, send direct mail flier/brochure, slides, photographs, photocopies, SASE. Responds in 2 weeks if SASE is enclosed.

(PAT) FOSTER ARTIST REP., 32 W. 40th St. #2 South, New York NY 10018-3907. (212)575-6887. E-mail: PFosterRep@aol.com. Website: www.patfosterartrep.com. **Contact:** Pat Foster. Commercial illustration representative. Estab. 1981. Member of SPAR, Graphic Artists Guild. Represents 8 illustrators. Markets include: advertising agencies; corporations/client direct; sales/promotion firms.

Handles: Illustration.

Terms: Rep receives 25% commission. "No additional charge for my services, i.e., shooting, obtaining pix ref/costumes." No geographic restrictions. Advertises in *American Showcase*.

How to Contact: For first contact, send direct mail flier/brochure, tearsheets and SASE.

Tips: Obtains new talent through recommendations mostly from associates in the business. "Work must look fresh; good design sense incorporated into illustration."

N: FREELANCE ADVANCERS, INC., 420 Lexington Ave., Suite 2007, New York NY 10170. (212)661-0900. Fax: (212)661-1883. E-mail: info@freelanceadvancers.com. Website: www.freelanceadvancers.com. President: Gary Glauber. Commercial illustration, graphic design, freelance artist representative. Estab. 1987. Member of Society of Illustrators. Represents 150 illustrators, 250 designers. Specializes in freelance project work. Markets include: advertising agencies; corporations/client direct; design firms; editorial/magazines; publishing/books.

Handles: Illustration, design. web design and art direction. Looks for artists with Macintosh software and multimedia expertise.

Terms: Rep receives 20% commission. 100% of advertising costs are paid by the representative. Advertises in *Art Direction, Adweek*.

How to Contact: For first contact, send query letter, résumé, tearsheets. After initial contact, call to schedule an appointment.

Tips: Looking for "talent, flexibility and reliability" in an artist. "Always learn, but realize you are good enough now."

ROBERT GALITZ FINE ART/ACCENT ART, 166 Hilltop Court, Sleepy Hollow IL 60118. (847)426-8842. Fax: (847)426-8846. **Contact:** Robert Galitz. Fine art representative. Estab. 1985. Represents 100 fine artists (includes 2 sculptors). Specializes in contemporary/abstract corporate art. Markets include: architects; corporate collections; galleries; interior decorators; private collections. Represents: Roland Poska, Jan Pozzi, Diane Bartz and Louis De Mayo.
Handles: Fine art.
Terms: Agent receives 25-40% commission. No geographic restrictions; sells mainly in Chicago, Illinois, Wisconsin, Indiana and Kentucky. For promotional purposes talent must provide "good photos and slides." Advertises in monthly art publications and guides.
How to Contact: For first contact, send query letter, slides, photographs. Responds in 2 weeks. After initial contact, call for appointment to show portfolio of original art. Obtains new talent through recommendations from others, solicitation, conferences.
Tips: "Be confident, persistent. Never give up or quit."

✔ **RITA GATLIN REPRESENTS INC.**, 83 Walnut Ave., Corte Madera CA 94925. (415)924-7881. Fax: (415)924-7891. E-mail: gatlin@ritareps.com. Website: www.ritareps.com. Agent: Rita Gatlin. Commercial illustration. Estab. 1991. Member of Society of Illustrators. Represents 12 illustrators. Markets include: advertising agencies; corporations/client direct; design firms; editorial/magazines; paper products/greeting cards; publishing/books. Artists include Sudi McCollum, Mary Ross, Anne Crosse, Tom Hennessy, Andrew Boerger, Stephanie Langley and more. See our website.
Handles: Commercial illustrators only.
Terms: Rep receives 25% commission. Charges fees for portfolio materials (mounting and matting); postage for yearly direct mail divided among artists. Advertising costs are split: 75% paid by talent; 25% paid by representative. For promotional purposes, talent must provide at least one 8½ × 11 printed page. Portfolios can be in transparency form or reflective art. Advertises in *American Showcase*, *The Workbook*, *Creative Illustration*, *Blackbook*.
How to Contact: For first contact, send query letter and tearsheets. Responds in 5 days. After initial contact, call to schedule an appointment for portfolio review.
Tips: "Artists must have a minimum of five years experience as commercial illustrators." When asked what their illustration style is, artists should never say they can do all styles—it's "a sign of a beginner. Choose a medium and excel."

DENNIS GODFREY REPRESENTING ARTISTS, 201 W. 21st St., Suite 10G, New York NY 10011. Phone/fax: (212)807-0840. E-mail: dengodfrey@aol.com. **Contact:** Dennis Godfrey. Commercial illustration representative. Estab. 1985. Represents 7 illustrators. Specializes in publishing and packaging. Markets include: advertising agencies; corporations/client direct; design firms; publishing/books. Clients include Putnam Berkley, Dell, Avon, Ogilvy & Mather, Oceanspray, Tropicana, Celestial Seasonings.
Handles: Illustration.
Terms: Rep receives 25% commission. Prefers exclusive area representation in NYC/Eastern US. Advertising costs are split: 75% paid by talent; 25% paid by representative. For promotional purposes, talent must provide mounted portfolio (at least 20 pieces), as well as promotional pieces. Advertises in *The Workbook*, *American Showcase*.
How to Contact: For first contact, send tearsheets. Responds in 2 weeks, only if interested. After initial contact, write for appointment to show portfolio of tearsheets, slides, photographs, photostats.

BARBARA GORDON ASSOCIATES, LTD., 165 E. 32nd St., New York NY 10016. (212)686-3514. Fax: (212)532-4302. **Contact:** Barbara Gordon. Commercial illustration and photography representative. Estab. 1969. Member of SPAR, Society of Illustrators, Graphic Artists Guild. Represents 9 illustrators, 1 photographer. "I represent only a small, select group of people and therefore give a great deal of personal time and attention to the people I represent."
Terms: No information provided. No geographic restrictions in continental US.
How to Contact: For first contact, send direct mail flier/brochure. Responds in 2 weeks. After initial contact, drop off or mail appropriate materials for review. Portfolio should include tearsheets, slides, photographs; "if the talent wants materials or promotion piece returned, include SASE." Obtains new talent through recommendations from others, solicitation, conferences, etc.
Tips: "I do not care if an artist or photographer has been published or is experienced. I am essentially interested in people with a good, commercial style. Don't send résumés and don't call to give me a verbal description of your work. Send promotion pieces. *Never* send original art. If you want something back, include a SASE. Always label your slides in case they get separated from your cover letter. And always include a phone number where you can be reached."

ANITA GRIEN—REPRESENTING ARTISTS, 155 E. 38th St., New York NY 10016. E-mail: agrien@aol.com. Representative not currently seeking new talent.

CAROL GUENZI AGENTS, INC., 865 Delaware St., Denver CO 80210. (303)820-2599. E-mail: mac@artagent.com. Website: www.artagent.com. **Contact:** Carol Guenzi. Commercial illustration, film and animation representative. Estab. 1984. Member of Denver Advertising Federation and Art Directors Club of Denver. Represents 26 illustrators, 5 photographers, 8 computer illustrators, 4 multimedia developers and 1 animator. Specializes in a "wide selection of talent in all areas of visual communications." Markets include: advertising agencies; corporations/client direct; design firms; editorial/magazine, paper products/greeting cards, sales/promotions firms. Clients include The Integer Group, Karsh & Hagan, BB00, DDB Needham. Partial client list available upon request. Represents Kelly Hume, Michael Fisher, Christer Erikkson.
Handles: Illustration, photography. Looking for "unique style application."
Terms: Rep receives 25% commission. Exclusive area representative is required. Advertising costs are split: 75% paid by talent; 25% paid by the representation. For promotional purposes, talent must provide "promotional material after six months, some restrictions on portfolios." Advertises in *American Showcase*, *Black Book*, *Rocky Mountain Sourcebook*, *The Workbook*.
How to Contact: For first contact, send direct mail flier/brochure. Responds in 3 weeks, only if interested. Call or write for appointment to drop off or mail in appropriate materials for review, depending on artist's location. Portfolio should include tearsheets, slides, photographs. Obtains new talent through solicitation, art directors' referrals, an active pursuit by individual artist.
Tips: "Show your strongest style and have at least 12 samples of that style, before introducing all your capabilities. Be prepared to add additional work to your portfolio to help round out your style. Have a digital background."

GUIDED IMAGERY DESIGN & PRODUCTIONS, (formerly Guided Imagery Productions), 2995 Woodside Rd., #400, Woodside CA 94062. (650)324-0323. Fax: (650)324-9962. Owner/Director: Linda Hoffman. Fine art representative. Estab. 1978. Member of Hospitality Industry Association. Represents 2 illustrators, 12 fine artists. Specializes in large art production—perspective murals (trompe l'oiel); unusual painted furniture/screens. Markets include: design firms; interior decorators; hospitality industry.
Handles: Looking for "mural artists (realistic or trompe l'oiel) with good understanding of perspectives."
Terms: Rep receives 33-50% commission. 100% of advertising costs paid by representative. For promotional purposes, talent must provide a direct mail piece to preview work, along with color copies of work (SASE too). Advertises in *Hospitality Design* and *Traditional Building Magazine*.
How to Contact: For first contact, send query letter, résumé, photographs, photocopies and SASE. Responds in 2-4 weeks. After initial contact, drop off or mail appropriate materials. Portfolio should include photographs.
Tips: Wants artists with talent, references and follow-through. "Send color copies of original work that show your artistic style. Never send one-of-a-kind artwork. My focus is 3-D murals. References from previous clients very helpful."

☑ **PAT HACKETT/ARTIST REPRESENTATIVE**, 7014 N. Mercer Way, Mercer Island WA 98040. (206)447-1600. Fax: (206)447-0739. E-mail: pathackett@aol.com. Website: www.pathackett.com. **Contact:** Pat Hackett. Commercial illustration and photography representative. Estab. 1979. Represents 12 illustrators, 1 photographer. Markets include: advertising agencies; corporations/client direct; design firms; editorial/magazines.
Handles: Illustration.
Terms: Rep receives 25-33% commission. Exclusive representation is required. Advertising costs are split: 75% paid by talent; 25% paid by representative. For promotional purposes, talent must provide "standardized portfolio, i.e., all pieces within the book are the same format. Reprints are nice, but not absolutely required." Advertises in *Showcase*, *The Workbook*.
How to Contact: For first contact, send direct mail flier/brochure. Responds in 1 week, only if interested. After initial contact, drop off or mail in appropriate materials: tearsheets, slides, photographs, photostats, photocopies. Obtains new talent through "recommendations and calls/letters from artists moving to the area."
Tips: Looks for "experience in the *commercial* art world, professional presentation in both portfolio and person, cooperative attitude and enthusiasm."

☑ **HOLLY HAHN & CO.**, 837 W. Grand Ave., 3rd Floor, Chicago IL 60622. (312)633-0500. Fax: (312)633-0484. E-mail: hzartrep@aol.com. Website: www.hollyhahn.com. Commercial illustration and

photography representative. Estab. 1988. Member of CAR (Chicago Artists Representatives). Represents 3 illustrators, 3 photographers. Markets include: advertising agencies; corporations/client direct; design firms; editorial/magazines; publishing/books.

Handles: Illustration, photography.

Terms: Rep receives 30% commission. Advertises in *The Workbook*, *Black Book*, *Klik*, *Tilt* and *The Alternative Pick*.

How to Contact: To contact, send direct mail flier/brochure and tearsheets.

Tips: Wants artists with "professional attitudes and knowledge, unique abilities or application, interest and motivation and a strong commitment to the work and the imagery."

N HANKINS & TEGENBORG, LTD., 60 E. 42nd St., Suite 1940, New York NY 10165. (212)867-8092. Fax: (212)949-1977. E-mail: dhlt@aol.com. Website: www.ht-ltd.com. Commercial illustration representative. Estab. 1980. Represents 50 illustrators. Specializes in realistic and digital illustration. Markets include: advertising agencies; publishing/book covers/promotion.

- This rep will be moving to another location in New York City as of May 1, 2002. Check website for new address.

Handles: Illustration, computer illustration.

Terms: Rep receives 25% commission. "All additional fees are charged per job if applicable." Exclusive area representation is required. Advertising costs are split: 75% paid by talent; 25% paid by representative. For promotional purposes, talent must provide 8×10 transparencies or digital files. Advertises in *American Showcase* "and own promotion book."

How to Handle: For first contact, send query letter, direct mail flier/brochure, tearsheets and SASE. Responds if interested. Portfolio can be dropped off.

BARB HAUSER, ANOTHER GIRL REP, P.O. Box 421443, San Francisco CA 94142-1443. (415)647-5660. Fax: (415)546-4180. E-mail: barb@girlrep.com. Website: www.girlrep.com. Estab. 1980. Represents 10 illustrators. Markets include: primarily advertising agencies and design firms; corporations/client direct.

Handles: Illustration.

Terms: Rep receives 25-30% commission. Exclusive representation in the San Francisco area is required.

How to Contact: For first contact, send direct mail flier/brochure, tearsheets, slides, photographs, photocopies and SASE. Responds in 1 month.

N JOANNE HEDGE/ARTIST REPRESENTATIVE, 1415 Garden St., Glendale CA 91201. (818)244-0110. Fax: (818)244-0136. E-mail: hedgegrafx@aol.com. Website: www.hedgereps.com. **Contact:** J. Hedge. Commercial illustration representative. Estab. 1975. Represents 12 illustrators. Specializes in "high-quality, painterly and realistic illustration, digital art and lettering." Markets include advertising agencies, design firms, movie studios, package design firms and web/interactive clients.

Handles: Illustration. Seeks established realists in airbrush, painting and digital art.

Terms: Rep receives 30% commission. Artist pays quarterly portfolio maintenance expenses. Advertising costs are split: 75% paid by talent; 25% paid by representative. For promotional purposes, talent should provide "ad reprint flier, 4×5 or 8×10 copy transparencies, matted on 11×14 laminate mattes." Advertises in *The Workbook*, *Directory of Illustration* and website.

How to Contact: Send query letter with direct mail flier/brochure or e-mail. Responds if interested. After initial contact, call or write for appointment to show portfolio of tearsheets (laminated), photocopies, 4×5 or 8×10 transparencies, or output.

Tips: Obtains new talent after talent sees *Workbook* directory ad, or through referrals from art directors or other talent. "Have as much experience as possible and zero or one other rep. That, and a good looking $8\frac{1}{2} \times 11$ flier!"

HK PORTFOLIO, 666 Greenwich St., New York NY 10014. (212)675-5719. E-mail: harriet@hkportfolio .com. Website: www.hkportfolio.com. **Contact:** Harriet Kasak or Mela Bolinao. Commercial illustration representative. Estab. 1986. Member of SPAR, Society of Illustrators and Graphic Artists Guild. Represents 50 illustrators. Specializes in illustration for juvenile markets. Markets include: advertising agencies; editorial/magazines; publishing/books.

Handles: Illustration.

Terms: Rep receives 25% commission. No geographic restrictions. Advertising costs are split: 75% paid by talent; 25% paid by representative. Advertises in *Picture Book* and *Workbook*.

How to Contact: No geographic restrictions. For first contact, send query letter, direct mail flier/brochure, tearsheets, slides, photographs, photostats and SASE. Responds in 1 week. After initial contact, drop off or mail in appropriate materials for review. Portfolio should include tearsheets, slides, photographs, photostats, photocopies.

Tips: Leans toward "highly individual personal styles."

N **MARY HOLLAND & COMPANY, INC.**, 6638 N. 13th St., Phoenix AZ 85014. (602)263-8990. Fax: (602)277-0680. Owner: Mary Holland. Commercial illustration, photography representative. Estab. 1984. Member of SPAR, Graphic Artists Guild. Represents 18 illustrators, 2 photographers. Markets include: advertising agencies; corporations/client direct; design firms; editorial/magazines; paper products/greeting cards; publishing/books.
Handles: Illustration, photography.
Terms: Rep receives 25% commission. Advertising costs are split: 75% paid by talent; 25% paid by representative. For promotional purposes, talent must provide direct mail piece, tearsheets or promotional material. Advertises in *Southwest Portfolio*, *Workbook*.
How to Contact: For first contact, send query letter, direct mail flier/brochure, tearsheets. Responds in 3 weeks. After initial contact, call to schedule an appointment. Portfolio should include tearsheets, photographs.

N **IRMEL HOLMBERG**, 280 Madison Ave., New York NY 10016. (212)545-9155. Fax: (212)545-9462. Rep: I. Holmberg. Commercial illustration representative. Estab. 1980. Member of SPAR. Represents 30 illustrators. Markets include: advertising agencies; corporations/client direct; design firms; editorial/magazines; publishing/books.
Terms: Rep receives 30% commission. Exclusive area representation is required. Advertising costs are split: 70% paid by talent; 30% paid by representative. For promotional purposes, talent must provide versatile portfolio with new fresh work. Advertises in *American Showcase*, *The Workbook*.
How to Contact: For first contact, send direct mail flier/brochure. Responds in 2 weeks only if interested. After initial contact, call to schedule an appointment. Portfolio should include original art, tearsheets, slides, photocopies.

SCOTT HULL ASSOCIATES, 68 E. Franklin S., Dayton OH 45459. (937)433-8383. Fax: (937)433-0434. E-mail: scott@scotthull.com. Website: www.scotthull.com. **Contact:** Scott Hull or Lynn Roberts. Commercial illustration representative. Estab. 1981. Represents 30 plus illustrators.
Terms: No information provided.
How to Contact: Contact by sending e-mail samples, tearsheets or appropriate materials for review. Follow up with phone call. Responds in 2 weeks.
Tips: Looks for "an interesting style and a desire to grow, as well as a marketable portfolio."

N **THE IVY LEAGUE OF ARTISTS**, 10 E. 39th St., 7th Floor, New York NY 10016. (212)545-7766. Fax: (212)545-9437. E-mail: ilartists@aol.com. Graphic design representative, illustration or photography broker. Commercial illustration, photography, fine art, graphic design representative. Estab. 1985. Represents 5 illustrators, 2 designers. Staff includes sales and graphic designers. Specializes in graphic design, illustration representatives. Markets include: advertising agencies, corporations/clients direct, publishing/books.
Will Handle: Interested in reviewing illustration, design.
Terms: Rep receives 30% commission.
How to Contact: For first contact, send tearsheets. Responds in 2 weeks. Portfolio should include prints, tearsheets.
Tips: "At this point, we are not looking for new talent."

VINCENT KAMIN & ASSOCIATES, 520 W. Erie St., Chicago IL 60610. (312)787-8834. Fax: (312)787-8172. Website: http://vincekamin.com. Commercial photography, graphic design representative. Estab. 1971. Member of CAR (Chicago Artists Representatives) and S.P.A.R. Represents 6 illustrators, 6 photographers, 1 designer, 1 fine artist (includes 1 sculptor). Markets include: advertising agencies. Represents Steve Bjorkman, Lee Duggan, Edmund Guy, Andrzej Dudzinski and Gail Randall.
Handles: Illustration, photography.
Terms: Rep receives 30% commission. Advertising costs are split: 90% paid by talent; 10% paid by representative. Advertises in *The Workbook* and *Chicago Directory*.
How to Contact: For first contact, send tearsheets. Responds in 10 days. After initial contact, call to schedule an appointment. Portfolio should include tearsheets.

N **KASTARIS & ASSOCIATES**, 6483A Chippewa, St. Louis MO 63019. (314)752-2227. Fax: (314)752-2260. E-mail: harriet@kastaris.com. Website: www.kastaris.com. **Contact:** Harriet Kastaris. Commercial illustration representative. Estab. 1987. Represents 21 illustrators. Markets include: advertising agencies; design firms; editorial/magazines; publishing/books; sales promotion firms.
Handles: Illustration.

Terms: Rep receives 30% commission. Exclusive area representation is negotiable. Advertising costs are split: 75% paid by talent; 25% paid by representative. Talent must advertise with my firm; must provide 4×5 transparencies for portfolio." Produces own promotional book every year with a distribution of 12,000.
How to Contact: For first contact, send direct mail flier/brochure, tearsheets and SASE if you want sampler back. Responds in 1 month if interested. After initial contact, call for appointment.
Tips: "Show me your style. I enjoy reviewing samples. Have a strong portfolio that includes images of people, products, animals, food and typography."

N TANIA KIMCHE, 137 5th Ave., 11th Floor, New York NY 10010. (212)529-3556. Fax: (212)353-0831. **Contact:** Tania. Commercial illustration representative. Estab. 1981. Member of SPAR. Represents 9 illustrators. "We do everything, a lot of design firm, corporate/conceptual work." Markets include: advertising agencies; corporations/client direct; design firms; editorial/magazines; publishing books; sales/promotion firms.
Handles: Illustration. Looking for "conceptual/corporate work."
Terms: Rep receives 25% commission if the artist is in town; 30% if the artist is out of town. Splits postage and envelope expense for mailings with artists. Advertising costs are split: 75% paid by the talent; 25% paid by the representative. For promotional purposes, talent advertists both online and off.
How to Contact: For first contact, send bio, tearsheets, slides. Responds in months, only if interested. After initial contact, drop off or mail in appropriate materials for review. Portfolio should include tearsheets, slides, photostats.
Tips: Obtains new talent through recommendations from others or "they contact me. Do not call. Send promo material in the mail. Don't waste time with a résumé—let me see the work."

KIRCHOFF/WOHLBERG, ARTISTS REPRESENTATION DIVISION, 866 United Nations Plaza, #525, New York NY 10017. (212)644-2020. Fax: (212)223-4387. Website: www.kirchoffwohlberg.com.
President: Morris A. Kirchoff. Director of Operations: John R. Whitman. Artist's Representative: Elizabeth Ford. Estab. 1930s. Member of SPAR, Society of Illustrators, AIGA, Associaton of American Publishers, Bookbuilders of Boston, New York Bookbinders' Guild. Represents over 50 illustrators. Specializes in juvenile and young adult trade books and textbooks. Markets include: publishing/books.
Handles: Illustration and photography (juvenile and young adult).
Terms: Rep receives 25% commission. Exclusive representation to book publishers is usually required. Advertising costs paid by representative ("for all Kirchoff/Wohlberg advertisements only"). "We will make transparencies from portfolio samples; keep some original work on file." Advertises in *American Showcase*, *Art Directors' Index*, *Society of Illustrators Annual*, *The Black Book*, children's book issues of *Publishers Weekly*.
How to Contact: Please send all correspondence to the attention of Elizabeth Ford. For first contact, send query letter, "any materials artists feel are appropriate." Responds in 6 weeks. "We will contact you for additional materials." Portfolios should include "whatever artists feel best represents their work. We like to see children's illustration in any style."

KLIMT REPRESENTS, 15 W. 72nd St., 7-U, New York NY 10023. (212)799-2231. E-mail: klimt@prodigy.net. Website: www.klimtreps.com. **Contact:** Bill or Maurine. Commercial illustration representative. Estab. 1978. Member of Society of Illustrators, Graphic Artists Guild. Represents 14 illustrators. Specializes in paperback covers, young adult, romance, science fiction, mystery, etc. Markets include: advertising agencies; corporations/client direct; design firms; editorial/magazines; paper products/greeting cards; publishing/books; sales/promotion firms. Represents: Frank Morris, Tom Patrick, Ben Stahl, Blattel Ovnbar, Ron Spears, Fred Smith, Carl Salter and Terry Herman.
Handles: Illustration.
Terms: Rep receives 25% commission, 30% commission for "out of town if we do shoots. The artist is responsible for only his own portfolio. Exclusive area representation is required. Advertising costs are split: 75% paid by talent; 25% paid by representative. For promotional purposes, talent must provide 4×5 or 8×10 mounted transparencies. Advertises through direct mail.
How to Contact: For first contact, send direct mail flier/brochure, and "any image that doesn't have to be returned unless supplied with SASE." Responds in 5 days. After initial contact, call for appointment to show portfolio of professional, mounted transparencies.

CLIFF KNECHT–ARTIST REPRESENTATIVE, 309 Walnut Rd., Pittsburgh PA 15202. (412)761-5666. Fax: (412)761-4072. E-mail: cliff@artrep1.com. Website: www.artrep1.com. **Contact:** Cliff Knecht. Commercial illustration representative. Estab. 1972. Represents 20 illustrators. Markets include: advertising agencies; corporations/client direct; design firms; editorial/magazines; paper products/greeting cards; publishing/books; sales/promotion firms.

Discover a World of Watercolor Inspiration

If you're passionate about watercolor, acrylic, gouache or any other water-based media, then you'll love *Watercolor Magic*. Open an issue and you'll find all of the creative inspiration, excitement, and superior instruction of a professional art lesson. Develop your unique personal style to its fullest potential and...

- **Probe new ideas guaranteed to get your creative juices flowing**

- **Experiment with new painting approaches to help you stretch your artistic boundaries**

- **Explore painting techniques and advice from the world's best watermedia artists!**

Now, through this special trial offer in *Artist's and Graphic Designer's Market*, you can get an issue of *Watercolor Magic* absolutely FREE!

Return the attached No-Risk RSVP card today!

NO-RISK RSVP

☐ *Yes!* Send my FREE trial issue of *Watercolor Magic* and start my introductory subscription. If I like what I see, I'll get 3 more issues (total of 4) for just $15.96. If not, I'll write "cancel" on the bill, return it and owe nothing. The **FREE ISSUE** will be mine to keep!

Send no money now...we'll bill you later.

Name _____

Address _____

City _____

State/Prov._____ ZIP/PC _____

Orders outside the U.S. will be billed an additional $7 (includes GST/HST in Canada). Allow 4-6 weeks for first-issue delivery. Annual newsstand rate is $19.96.

Watercolor Magic™ *www.watercolormagic.com*

T6AM5

\mathcal{G}et a **FREE ISSUE** of *Watercolor Magic!*

From the Publishers of *The Artist's Magazine* and *Artist's and Graphic Designer's Market*

\mathcal{P}acked with innovative ideas, creative inspiration, and detailed demonstrations from the best watermedia artists in the world, *Watercolor Magic* will offer you everything you need to take your art to the next level. You'll learn how to:

- Choose a great subject every time

- Capture light and shadows to add depth and drama

- Experiment by combining media

- Master shape, detail, texture and color

- Explore cutting-edge techniques and materials

- Get inspired and create breathtaking art!

See for yourself how *Watercolor Magic* will help you turn ordinary works into extraordinary art. Mail the card below for your FREE TRIAL ISSUE!

PROCESS IMMEDIATELY!

Handles: Illustration.

Terms: Rep receives 25% commission. No geographic restrictions. Advertising costs are split: 75% paid by the talent; 25% paid by representative. For promotional purposes, talent must provide a direct mail piece. Advertises in *Graphic Artists Guild Directory of Illustration*.

How to Contact: For first contact, send résumé, direct mail flier/brochure, tearsheets, slides. Responds in 1 week. After initial contact, call for appointment to show portfolio of original art, tearsheets, slides, photographs. Obtains new talent directly or through recommendations from others.

ANN KOEFFLER ARTIST REPRESENTATION, 1020 W. Riverside Dr., #45, Burbank CA 91506. (818)260-8980. Fax: (818)260-8990. E-mail: annartrep@aol.com. Website: www.annkoeffler.com. **Owner/ Operator:** Ann Koeffler. Commercial illustration representative. Estab. 1984. Member of Society of Illustrators. Represents 20 illustrators. Markets include: advertising agencies, corporations/client direct, design firms, editorial/magazines, paper products/greeting cards, publishing/books, individual small business owners.

Will Handle: Interested in reviewing illustration. Looking for artists who are digitally adept.

Terms: Rep receives 25-30% commission. Advertising costs 100% paid by talent. For promotional purposes, talent must provide an initial supply of promotional pieces and a committment to advertise regularly. Advertises in *The Workbook*.

How to Contact: For first contact, send tearsheets or send images digitally. Responds in 1 week. Portfolio should include photocopies, 4×5 chromes.

Tips: "I only carry artists who are able to communicate clearly and in an upbeat and professional manner."

[N] SHARON KURLANSKY ASSOCIATES, 192 Southville Rd., Southborough MA 01772. (508)872-4549. Fax: (508)460-6058. E-mail: laughstoc@aol.com. Website: www.laughing-stock.com. **Contact:** Sharon Kurlansky. Commercial illustration representative. Estab. 1978. Represents 9 illustrators. Markets include: advertising agencies; corporations/client direct; design firms; editorial/magazines; paper products/ greeting cards; publishing/books; sales/promotion firms. Client list available upon request. Represents: Tim Lewis, Bruce Hutchison and Blair Thornley. Licenses stock illustration for all markets.

Handles: Illustration.

Terms: Rep receives 25% commission. Exclusive area representation is required. Advertising costs are split: 75% paid by talent; 25% paid by representative. "Will develop promotional materials with talent. Portfolio presentation formated and developed with talent also." Advertises in *American Showcase*, *The Creative Illustration Book*, under artist's name.

How to Contact: For first contact, send direct mail flier/brochure, tearsheets, slides and SASE. Responds in 1 month if interested. After initial contact, call for appointment to show portfolio of tearsheets, photocopies. Obtains new talent through various means.

[✓] LANGLEY CREATIVE, (formerly Langley & Associates Representing Illustrators), 333 N. Michigan Ave., Suite 1322, Chicago IL 60601. (312)782-0244. Fax: (312)782-1535. E-mail: artrepsjl@aol.com. Website: www.SharonLangley.com. **Contact:** Sharon Langley. Commercial illustration representative. Estab. 1988. Member of CAR (Chicago Artists Representatives). Represents 23 illustrators. Markets include: advertising agencies; corporations/client direct; design firms; editorial/magazines; publishing/books; sales/ promotion firms. Clients include Leo Burnett Advertising, BBDOchgo, DDB Chicago/Frankel. Represents: Tim Jonke, Matt Zumbo, Clem Bedwell, Mona Daly, Toni Pawlowsky, Jill Arena and Dan Andreasen.

Handles: Illustration. Although representative prefers to work with established talent, "I am receptive to reviewing all illustrators' work."

Terms: Rep receives 25% commission. Exclusive area representation is preferred. Advertising costs are split: 75% paid by talent; 25% paid by representative. For promotional purposes, talent must provide printed promotional piece, well organized portfolio. Advertises in *The Workbook*, *Directory of Illustration*.

How to Contact: For first contact, send printed promotional piece. Responds in 3 weeks if interested. After initial contact, call for appointment to show portfolio of tearsheets, transparencies. Obtains new talent through art directors, clients, referrals.

Tips: "Know that you need to be focused in your direction and style. Be willing to be a 'team player.' The agent and the artist form a partnership and the goal is success. Don't let your ego get in the way. Listen to constructive criticism."

[N] JEFF LAVATY & ASSOCIATES, 217 E. 86th St., Suite 212, New York NY 10028-3617. (212)427-5632. Website: www.lavatyart.com. Commercial illustration and fine art representative. Represents 30 artists.

Handles: Illustration.

How to Contact: For first contact, send query letter, direct mail flier/brochure, tearsheets, slides and SASE. Responds in 1 week. After initial contact, call for appointment to show portfolio of tearsheets, 8×10 or 4×5 transparencies. Obtains new talent through solicitation.

Tips: "Specialize! Your portfolio must be focused."

LEIGHTON & COMPANY, INC., 7 Washington St., Beverly MA 01915. (978)921-0887. Fax: (978)921-0223. E-mail: leighton@leightonreps.com. Website: www.leightonreps.com. **Contact:** Leighton O'Connor. Commercial illustration representative. Estab. 1986. Member of Graphic Artists Guild, SCBWI. Represents 35 illustrators. Markets include: advertising agencies; corporations/clients direct; design firms; editorial/magazines; publishing/books.

Handles: Illustration. "Looking for illustrators with children's book ms."

Terms: Rep receives 25% commission. Advertising costs are split: 75% paid by talent; 30% paid by representative. Advertises in *Blackbook*, *Graphic Artist Guild Directory of Illustration*, *American Showcase*, *Workbook*.

How to Contact: For first contact, send query letter, nonreturnable samples such as direct mail flier/brochure, tearsheets or e-mail your web link. After initial contact, drop off or mail in appropriate materials for review. Portfolio should include tearsheets, slides, photographs.

Tips: "My new talent is almost always obtained through referrals. Occasionally, I will solicit new talent from direct mail pieces they have sent to me. It is best to send work first, i.e., tearsheet, web link or direct mail pieces. Only send a portfolio when asked to. If you need your samples returned, always include a SASE. Follow up with one phone call. It is very important to get the correct spelling and address of the representative. Also, make sure you are financially ready for a representative, having the resources available to create a portfolio and direct mail campaign."

LESLI ART, INC., Box 6693, Woodland Hills CA 91364. (818)999-9228. Fax: (818)999-0833. E-mail: artlesli@aol.com. **Contact:** Stan Shevrin. Fine art agent, publisher and advisor. Estab. 1965. Represents emerging, mid-career and established artists. Specializes in artists painting in oil or acrylic, in traditional subject matter in realistic or impressionist style. Also represents illustrators who want to establish themselves in the fine art market. Sells to leading art galleries throughout the US. Represents: Tom Darro, Greg Harris, Christa Kieffer, Roger LaManna, Dick Pionk, Rick Peterson and John Stephens. Licenses period costumed figures and landscapes for prints, calendars and greeting cards.

Terms: Receives 50% commission. Pays all expenses including advertising and promotion. Artist pays one-way shipping. All artwork accepted unframed. Exclusives preferred. Contract provided.

How to Contact: For first contact, send either color prints or slides with short bio and SASE if material is to be returned. Material will be filed if SASE is not included. Responds in 1 month. Obtains new talent through "reviewing portfolios."

Tips: "Artists should show their most current works and state a preference for subject matter and medium. Know what subject you're best at and focus on that."

LINDGREN & SMITH, 250 W. 57th St., #521, New York NY 10107. (212)397-7330. Fax: (212)397-7334. E-mail: inquiry@lindgrensmith.com. Website: www.lindgrensmith.com. Website: www.stock.lindgrensmith.com. **Assistant:** Pamela Wilson. Commercial illustration representative. Estab. 1984. Member of SPAR. Markets include advertising agencies; corporations/client direct; design firms; editorial/magazines; paper products/greeting cards; publishing/books, children's books. Represents: Doug Fraser, Pol Turgeon, Michael Paraskevas, Steven Salerno, Stefano Vitale and Bill Mayer.

Handles: Illustration and picture books.

Terms: Exclusive representation is required. Advertises in *Workbook*, *Black Book* and *Picture Book*.

How to Contact: For first contact, send direct mail flier/brochure, tearsheets, photocopies. "We will respond by mail."

Tips: "Check to see if your work seems appropriate for the group. We only represent experienced artists who have been professionals for some time."

N LONDON CONTEMPORARY ART, 6950 Phillips Hwy., Suite 51, Jacksonville FL 32216. (904)296-4982. E-mail: lcausa@mindspring.com. Website: www.lcausa.com. **Contact:** Marketing Manager. Fine art representative and publisher. Estab. 1977. Represents 45 fine artists. Specializes in "selling to art galleries." Markets include: galleries; corporate collections; interior designers.

Handles: Fine art.

Terms: Publisher of original art. Exclusive representation is required. For promotional purposes talent must provide biography, slides, color prints, "any visuals." Advertises in *Art Business News*, *Art & Antiques*, *Preview* and *Art World News*.

How to Contact: For first contact, send tearsheets, slides, photographs and SASE. LCA will respond in 1 month, only if interested. "If interested, we will call you." Portfolio should include slides, photographs. Obtains new talent through recommendations from others and word of mouth.

N MARLENA AGENCY, 145 Witherspoon St., Princeton NJ 08542. (609)252-9405. Fax: (609)252-1949. E-mail: marzena@bellatlantic.net. Website: marlenaagency.com. **Artist Rep:** Marlena Torzecka. Commercial illustration representative. Estab. 1990. Member of Art Directors Club of New York. Represents 25 illustrators. Specializes in conceptual illustration. Markets include: advertising agencies; corporations/client direct; design firms; editorial/magazines; publishing/books; theaters. Represents: Cyril Cabry, Gerard Dubois, Ferruccio Sardella, Linda Helton and Waldemar Shierzy.
 ● This agency collaborated with a design firm to create promotional wrapping paper for their illustrators.
Handles: Illustration, fine art.
Terms: Rep receives 30% commission. Costs are shared by all artists. Exclusive area representation is required. Advertising costs are split: 70% paid by talent; 30% paid by representative. For promotional purposes, talent must provide slides (preferably 8×10 framed); direct mail piece helpful. Advertises in *American Showcase*, *Black Book*, *Illustrators 35* (New York City), *Workbook*, *Alternative Pick*.
How to Contact: For first contact send tearsheets. Responds in 1 week only if interested. After initial contact, drop off or mail appropriate materials. Portfolio should include tearsheets.
Tips: Wants artists with "talent, good concepts—intelligent illustration, promptness in keeping up with projects, deadlines, etc."

MARTHA PRODUCTIONS, INC., 7550 W. 82nd St., Playa Del Rey CA 90239. (310)670-5300. Fax: (310)670-3644. E-mail: marthaprod@earthlink.net. Website: www.marthaproductions.com or www.retroreps.com. **Contact:** Martha Spelman. Commercial illustration and graphic design representative. Estab. 1978. Member of Graphic Artists Guild. Represents 25 illustrators. Staff includes Martha Spelman (artist representative). Specializes in b&w and 4-color illustration. Markets include: advertising agencies; corporations/client direct; design firms; editorial/magazines; paper products/greeting cards. Represents: Steve Vance, Peter Siu, Catherine Leary, Dennis Mukai, Retro Reps, Edd Patton, Winston Smith and Atomic Battery.
Handles: Illustration.
Terms: Rep receives 30% commission. Exclusive area representation is required. No geographic restrictions. Advertising costs are split: 70% paid by talent; 30% paid by representative. For promotional purposes, talent must provide "a minimum of 12 images, 4×5 transparencies of each. (We put the transparencies into our own format.) In addition to the transparencies, we require 4-color promo/tearsheets and participation in the biannual Martha Productions brochure." Advertises in *The Workbook*, *Single Image* and online.
How to Contact: For first contact, send query letter, direct mail flier/brochure, tearsheets, slides and SASE (if materials are to be returned). Responds only if interested. After initial contact, drop off or mail in appropriate materials for review. Portfolio should include tearsheets, slides, photographs. Obtains new talent through recommendations and solicitation.
Tips: "Artists should have a style we feel would sell that does not compete with those artists we are currently representing, as well as a solid body of consistent (in style and execution) work that includes a variety of topics (i.e., people, landscape, product concept, etc.). We'll often work with the artist on a job-to-job basis prior to representation to see how competent the artist is and how smooth the working relationship will be."

MONTAGANO & ASSOCIATES, 211 E. Ohio, #2006, Chicago IL 60611. (312)527-3283. Fax: (312)527-2108. E-mail: dm@davidmontagano.com. Website: davidmontagano.com. **Contact:** David Montagano. Commercial illustration, photography and television production representative and broker. Estab. 1983. Represents 8 illustrators, 3 photographers. Markets include: advertising agencies; corporations/client direct; design firms; editorial/magazines; paper products.
Handles: Illustration, photography, design, marker and storyboard illustration.
Terms: Rep receives 30% commission. No geographic restrictions. Advertises in *American Showcase*, *The Workbook*, *CIB*.
How to Contact: For first contact, send direct mail flier/brochure, tearsheets, photographs. Portfolio should include original art, tearsheets, photographs.

N MORGAN GAYNIN INC., 194 Third Ave., New York NY 10003. (212)475-0440. Fax: (212)353-8538. E-mail: info@morgangaynin.com. Website: www.morgangaynin.com. **Partners:** Vicki Morgan and Gail Gaynin. Commercial illustration representative. Estab. 1974. Member of SPAR, Graphic Artists Guild, Society of Illustrators, AIGA. Markets include: advertising agencies; corporations/client direct; design firms; magazines; books; sales/promotion firms.
Handles: Illustration. "Fulltime illustrators only."

Terms: Rep receives 30% commission. Exclusive area representation is required. No geographic restrictions. Advertising costs are split: 70% paid by talent; 30% paid by representative. "We require samples for three duplicate portfolios; the presentation form is flexible." Advertises in directories, on the Web, direct mail.

How to Contact: For first contact, send any of the following: direct mail flier/brochure, tearsheets, slides with SASE. "If interested, we keep on file and consult these samples first when considering additional artists. No drop-off policy." Obtains new talent through "recommendations from artists we represent and from artists' samples on file."

⃞ THE NEWBORN GROUP, INC., 115 W. 23rd St., Suite 43A, New York NY 10011. (212)989-4600. Fax: (212)989-8998. Website: www.newborngroup.com. **Owner:** Joan Sigman. Commercial illustration representative. Estab. 1964. Member of SPAR, Society of Illustrators, Graphic Artists Guild. Represents 12 illustrators. Markets include: advertising agencies; design firms; editorial/magazines; publishing/books. Clients include Leo Burnett, Berkley Publishing, Weschler Inc.

Handles: Illustration.

Terms: Rep receives 25% commission. Exclusive area representation is required. Advertising costs are split: 75% paid by talent; 25% paid by representative. Advertises in *American Showcase*, *The Workbook*, *Directory of Illustration*.

How to Contact: "Not reviewing new talent."

Tips: Obtains new talent through recommendations from other talent or art directors.

LORI NOWICKI AND ASSOCIATES, 310 W. 97th St., #24, New York NY 10025. E-mail: lori@lorin owicki.com. Website: www.lorinowicki.com. Estab. 1993. Represents 16 illustrators. Markets include: advertising agencies; design firms; editorial/magazines; publishing/books, children's publishing.

Handles: Illustration.

Terms: Rep receives 25-30% commission. Cost for direct mail promotional pieces is paid by illustrator. Exclusive area representation is required. Advertising costs are split: 75% paid by talent; 25% paid by representative. Advertises in *The Workbook*, *Black Book*, *Showcase*, *Directory of Illustration*.

How to Contact: For first contact, send query letter, résumé, tearsheets. Samples are not returned. "Do not phone, will contact if interested." Wants artists with consistent style. "We are aspiring to build a larger children's publishing division."

⃞ CHRISTINE PRAPAS/ARTIST REPRESENTATIVE, 12480 SE Wiese Rd., Boring OR 97009. (503)658-7070. Fax: (503)658-3960. E-mail: cprapas@teleport.com. Website: www.christineprapas.com. **Contact:** Christine Prapas. Commercial illustration and photography representative. Estab. 1978. Member of AIGA. "Promotional material welcome."

GERALD & CULLEN RAPP, INC., 108 E. 35th St., New York NY 10016. (212)889-3337. Fax: (212)889-3341. E-mail: john@rappart.com. Website: www.theispot.com/rep/rapp. **Contact:** John Knepper. Commercial illustration representative. Estab. 1944. Member of SPAR, Society of Illustrators, Graphic Artists Guild. Represents 50 illustrators. Markets include: advertising agencies; corporations/client direct; design firms; editorial/magazines; paper products/greeting cards; publishing/books; sales/promotion firms. Represents: Drew Struzan, Natalie Ascencios, Jack Davis, Beth Adams, Mark Fredrickson, Leo Espinosa, Robert De Michiell, Mike Witte, John Pirman, Hal Mayforth, Mark Rosenthal and James Steinberg.

Handles: Illustration.

Terms: Rep receives 25-30% commission. Exclusive area representation is required. No geographic restrictions. Split of advertising costs is negotiated. Advertises in *American Showcase*, *The Workbook*, *Graphic Artists Guild Directory* and *CA*, *Print* magazines. "Conducts active direct mail program and advertises on the Internet."

How to Contact: For first contact, send query letter, direct mail flier/brochure. Responds in 1 week. After initial contact, call for appointment to show portfolio of tearsheets, slides. Obtains new talent through recommendations from others, solicitations.

⃞ KERRY REILLY: REPS, 1826 Asheville Place, Charlotte NC 28203. Phone/fax: (704)372-6007. **Contact:** Kerry Reilly. Commercial illustration and photography representative. Estab. 1990. Represents 16 illustrators, 3 photographers. Markets include: advertising agencies; corporations/client direct; design firms; editorial/magazines. Clients include GM, VW, Disney World, USPO.

Handles: Illustration, photography. Looking for computer graphics: Photoshop, Illustrator, FreeHand, etc.

Terms: Rep receives 25% commission. Exclusive area representation is required. No geographic restrictions. Advertising costs are split: 75% paid by talent; 25% paid by representative. For promotional purposes, talent must provide at least 2 pages printed leave-behind samples. Preferred format is 9 × 12 pages, portfolio work on 4 × 5 transparencies. Advertises in *American Showcase*, *The Workbook*.

How to Contact: For first contact, send direct mail flier/brochure or samples of work. Responds in 2 weeks. After initial contact, call for appointment to show portfolio or drop off or mail tearsheets, slides, 4×5 transparencies.
Tips: "Have printed samples and electronic samples (in JPEG format)."

N: REPERTOIRE, 2029 Custer Pkwy., Richardson TX 75080. (972)761-0500. Fax: (972)761-0501. E-mail: info@repertoireart.com. Website: www.repertoireart.com. **Contact:** Larry Lynch (photography) or Andrea Lynch (illustration). Commercial illustration and photography representative and broker. Estab. 1974. Member of SPAR. Represents 3 illustrators and 10 photographers. Specializes in "importing specialized talent into the Southwest." Markets include advertising agencies, corporations/client direct, design firms, editorial/magazines. Artists include Aaron Jones and Eric Dinyer.
Handles: Illustration, photography, design.
Terms: Rep receives 25-30% commission. Exclusive area representation is required. Advertising costs are split; printing costs are paid by talent; distribution costs are paid by representative. Talent must provide promotion, both direct mail and a national directory. Advertises in *The Workbook*.
How to Contact: For first contact, send direct mail flier/brochure, tearsheets. Responds in 1 month. After initial contact, write for appointment or drop off or mail portfolio of tearsheets, slides, photographs. Obtains new talent through referrals, solicitations.
Tips: Looks for "sense of humor, honesty, maturity of style, ability to communicate clearly and relevance of work to our clients."

THE ROLAND GROUP, 4948 St. Elmo Ave., Suite #201, Bethesda MD 20814. (301)718-7955. Fax: (301)718-7958. E-mail: info@therolandgroup.com. Website: www.therolandgroup.com. Commercial illustration and photography representative. Estab. 1988. Member of SPAR, Society of Illustrators, Ad Club, Production Club. Represents 20 illustrators and over 200 photographers. Markets include: advertising agencies; corporations/client direct; design firms; editorial/magazines; paper products/greeting cards; publishing books.
Handles: Illustration and photography.
Terms: Rep receives 35% commission. Exclusive and non-exclusive representation available. Also work with artists on a project-by-project basis. For promotional purposes, talent must provide 8½×11 promo sheet. Advertises in *American Showcase*, *The Workbook*, *International Creative Handbook*, *Black Book* and *KLIK*.
How to Contact: For first contact, send query letter, tearsheets and photocopies. Replies if interested. Portfolio should include nonreturnable tearsheets, photocopies.

N: ROSENTHAL REPRESENTS, 3850 Eddingham Ave., Calabasas CA 91302. (818)222-5445. Fax: (818)222-5650. E-mail: eliselicenses@hotmail.com. Commercial illustration representative and licensing agent for artists who do advertising, entertainment, action/sports, children's books, giftware, collectibles, figurines, children's humorous, storyboard, animal, graphic, floral, realistic, impressionistic and game packaging art. Estab. 1979. Member of SPAR, Society of Illustrators, Graphic Artists Guild, Women in Design and Art Directors Club. Represents 100 illustrators, 2 designers and 5 fine artists. Specializes in game packaging, personalities, licensing, merchandising art and storyboard artists. Markets include: advertising agencies; corporations/client direct; paper products/greeting cards; sales/promotion firms; licensees and manufacturers.
Handles: Illustration.
Terms: Rep receives 30% as a rep; 50% as a licensing agent. Exclusive area representation is required. No geographic restrictions. Advertising costs are paid by talent. For promotion purposes, talent must provide 1-2 sets of transparencies (mounted and labeled). Also include 1-3 promos. Advertises in *American Showcase* and *The Workbook*.
How to Contact: For first contact, send direct mail flier/brochure, tearsheets, slides, photocopies, photostats and SASE. Responds in 1 week. After initial contact, call for appointment to show portfolio of tearsheets, slides, photographs, photocopies.
Tips: Obtains new talent through seeing their work in an advertising book or at award shows, *Art Decor*, *Art Business News* and by referrals.

JOAN SAPIRO ART CONSULTANTS, 4750 E. Belleview Ave., Littleton CO 80121. (303)793-0792. **Contact:** Joan Sapiro. Art consultant. Estab. 1980. Specializes in "corporate art with other emphasis on hospitality, health care and art consulting/advising to private collectors."
Handles: All mediums of artwork and all prices if applicable for clientele.
Terms: "50/50. Artist must be flexible and willing to ship work on consignment. Also must be able to provide sketches, etc. if commission piece involved." No geographic restrictions.

How to Contact: For first contact, send résumé, bio, direct mail flier/brochure, tearsheets, slides, photographs, price list—net (wholesale) and SASE. Responds in 2 weeks. After initial contact, drop off or mail in appropriate materials for review. Portfolios should include tearsheets, slides, price list and SASE.
Tips: Obtains new talent through recommendations, publications, travel, research, university faculty.

✓ **FREDA SCOTT, INC.**, 383 Missouri St., San Francisco CA 94107. (415)550-9121. Fax: (415)550-9120. E-mail: freda@fredascott.com. Website: www.fredascott.com. **Contact:** Freda Scott. Commercial illustration and photography representative. Estab. 1980. Member of SPAR. Represents 10 illustrators, 15 photographers. Markets include: advertising agencies; corporations/client direct; design firms; editorial/magazines; paper products/greeting cards; publishing/books; sales/promotion firms. Clients include Saatchi & Saatchi, Young & Rubicam, J. Walter Thompson, Anderson & Lembke, Oracle Corp., Sun Microsystems. Client list available upon request.
Handles: Illustration, photography.
Terms: Rep receives 25% commission. No geographic restrictions. Advertising costs are split: 75% paid by talent; 25% paid by representative. For promotional purposes, talent must provide "promotion piece and ad in a directory. I also need at least three portfolios." Advertises in *American Showcase*, *Black Book*, *The Workbook*.
How to Contact: For first contact, send direct mail flier/brochure, tearsheets and SASE. If you send transparencies, reports in 1 week, if interested. "You need to make follow up calls." After initial contact, call for appointment to show portfolio of tearsheets, photographs, 4×5 or 8×10.
Tips: Obtains new talent sometimes through recommendations, sometimes solicitation. "If you are seriously interested in getting repped, keep sending promos—once every six months or so. Do it yourself a year or two until you know what you need a rep to do."

N. FRAN SEIGEL, ARTIST REPRESENTATIVE, 160 W. End Ave., #23-S, New York NY 10023. (212)712-0830. Fax: (212)712-0857. Commercial illustration. Estab. 1982. Member of SPAR, Graphic Artists Guild. Represents 6 illustrators. Specializes in stylized realism leaning toward the conceptual or fantasy direction. Markets include advertising agencies; client direct; design firms; magazines; paper products/greeting cards; book jackets; licensing.
Handles: Illustration, fine art. "Artists in my group must have work applicable to my key markets: book jackets and a high level unique style. Themed groups of works and/or multicultural subjects is also a plus."
Terms: Rep receives 30% commission. Exclusive national representation is required. Advertising costs are split: 70% paid paid by talent; 30% paid by representative. "First promotion is designed by both of us, paid for by talent; subsequent promotion costs are split." Advertises in *Graphic Artists Guild Directory of Illustration*.
How to Contact: For first contact, send 12-20 images, direct mail flier/brochure, tearsheets, slides and SASE. Responds in 2 weeks only if SASE is included.
Tips: Looking for artists with " 'uniquely wonderful' artwork, vision and energy, market-oriented portfolio, and absolute reliability and professionalism. Prefer talent with a minimum of three to five years freelance experience."

N. SHARPE + ASSOCIATES INC.(V), 25 W. 68th St., Suite 9A, New York NY 10023. (212)595-1125. Fax: (212)579-6460. Website: www.sharpeonline.com. **Contact:** Colleen Hedleston. Commercial illustration and photography representative. Estab. 1987. Member of APA, ADLA. Represents 6 illustrators, 4 photographers. Not currently seeking new talent but "always willing to look at work." Staff includes: John Sharpe (in Los Angeles) and Colleen Hedleston (general commercial—advertising and design), "both have ad agency marketing backgrounds. We tend to show more non-mainstream work." Markets include: advertising agencies; corporations/client direct; design firms; editorial/magazines; sales/promotion firms.
 • Sharpe + Associates has a Los Angeles office. Contact John Sharpe, 7536 Ogelsby Ave., Los Angeles CA 90045, (310)641-8556.
Handles: Illustration, photography.
Terms: Agent recieves 25% commission. Exclusive area representation is required. For promotional purposes, "promotion and advertising materials are a shared responsibility, though the talent must be able to afford 75% of the material/media. The portfolios are 100% the talent's responsiblity and we like to have at least 6 complete books." Advertises in *The Workbook*, *Klik*, *Archive*.
How to Contact: For first contact, call, then followup with printed samples. Responds in 2 weeks. Call for appointment to show portfolio of c- or r-prints of original work for illustration and transparencies or prints for photography.
Tips: Obtains new talent mostly through referrals, occasionally through solicitations. "Once you have a professional portfolio together and at least one representative promotional piece, target reps along with potential buyers of your work as if the two groups are one and the same. Market yourself to reps as if the reps are potential clients."

N SUSAN AND CO., 5002 92nd Ave. SE, Mercer Island WA 98040. (206)232-7873. Fax: (206)232-7908. E-mail: susan@susanandco.com. Website: www.susanandco.com. **Owner:** Susan Trimpe. Commercial illustration, photography representative. Estab. 1979. Member of SPGA. Represents 19 illustrators, 2 photographers. Specializes in commercial illustrators and photographers. Markets include advertising agencies; corporations/client direct; design firms; publishing/books. Artists include: Greg Stadler, Fred Ingram, Eric Larsen and Larry Jost.
Handles: Illustration, photography. Looks for "computer illustration, corporate, conceptual."
Terms: Rep receives 30% commission. Charges postage if portfolios are shipped out of town. National representation is required. Advertising costs are split: 70% paid by talent; 30% paid by representative. "Artists must take out a page in a publication, i.e., *American Showcase*, and *The Workbook* with rep."
How to Contact: For first contact, send query letter and direct mail flier/brochure. Responds in 2 weeks only if interested. After initial contact, call to schedule an appointment. Portfolio should include tearsheets, slides, photographs, photostats, photocopies.
Tips: Wants artists with "unique well-defined style and experience."

N THOSE 3 REPS, 2909 Cole, Suite #118, Dallas TX 75204. (214)871-1316. Fax: (214)880-0337. **Contact:** Debbie Bozeman, Carol Considine, Lisa Button. Artist representative. Estab. 1989. Member of Dallas Society of Visual Community, ASMP, SPAR and Dallas Society of Illustrators. Represents 15 illustrators, 8 photographers. Specializes in commercial art. Markets include: advertising agencies; corporations/client direct; design firms; editorial/magazines.
Handles: Illustration, photography (including digital).
Terms: Rep receives 30% commission; 30% for out-of-town jobs. Exclusive area representation is required. Advertising costs are split: 70% paid by talent; 30% paid by representative. For promotional purposes, talent must provide 2 new pieces every 2 months, national advertising in sourcebooks and at least 1 mailer. Advertises in *Workbook*, own book.
How to Contact: For first contact, send query letter and tearsheets. Responds in days or weeks only if interested. After initial contact, call to schedule an appointment, drop off or mail in appropriate materials. Portfolio should include tearsheets, photostats, transparencies, digital prints.
Tips: Wants artists with "strong unique consistent style."

T-SQUARE, ETC., 1426 Main St., Venice CA 90291. (310)581-2200. Fax: (310)581-2204. E-mail: diane@t-squareetc.com. Website: www.t-squareetc.com. **Managing Director:** Diane Pirritino. Graphic design representative. Estab. 1990. Member of Advertising Production Association of California, Ad Club of LA. Represents 50 illustrators, 100 designers. Specializes in computer graphics. Markets include advertising agencies; corporations/client direct; design firms; editorial/magazines.
Handles: Design.
Terms: Rep receives 25% commission. Advertising costs are split: 25% paid by talent; 75% paid by representative. For promotional purposes, talent must provide samples from their portfolio (their choice).
How to Contact: For first contact, send résumé. Responds in 5 days. After initial contact, call to schedule an appointment. Portfolio should include thumbnails, roughs, original art, tearsheets, slides.
Tips: Artists must possess "good design, computer skills, flexibility, professionalism."

✔ CHRISTINA A. TUGEAU: ARTIST AGENT, 110 Rising Ridge Rd., Ridgefield CT 06877. (203)438-7307. Fax: (203)894-1993. E-mail: catartrep@aol.com. Website: www.catugeau.com. **Owner:** Chris Tugeau. Children's publishing market illustration representative K-12. Estab. 1994. Member of Graphic Artists Guild, SPAR, SCBWI. Represents 40 illustrators. Specializes in children's book publishing and educational market and related areas. Represents: Stacey Schuett, Larry Day, Bill Farnsworth, Melissa Iwai, Paul Kratter, Keiko Motoyama, Teri Sloat, Jason Wolff, Jeremy Tugeau, Priscilla Burris, John Kanzler, Ann Barrow, Wayne McCloughlin, Lisa Carlson, Heather Maione, Meryl Treatner, Karen Stormer-Brooks, Martha Avilés, Margie Moore and others.
Handles: Illustration. Must be proficient at illustrating children and animals in a variety of interactive situations, backgrounds, full color/b&w, and with a strong narrative sense.
Terms: Rep receives 25% commission. Exclusive USA representation is required (self-promotion is OK). For promotional purposes, talent must provide a direct mail promo piece, 8-10 good "back up" samples (multiples), 3 strong portfolio pieces. Advertises in *RSVP* and *GAG Directory of Illustration* and *Picturebook*.
How to Contact: For first contact, send direct mail flier/brochure, tearsheets, photographs, photocopies, books, SASE, "prefer no slides! No originals." Responds by 2 weeks. No e-mailed samples, please.
Tips: "You should have a style uniquely and comfortably your own and be great with deadlines. Will consider young, new artists with great potential and desire, as well as published, more experienced illustrators. Best to study and learn the market standards and expectations by representing yourself for a while when new to the market."

▓ JAE WAGONER, ARTIST REPRESENTATIVE, Unit #C, 654 Pier Ave., Santa Monica CA 90405. (310)392-4877. Website: www.jaewagoner.com. **Contact:** Jae Wagoner "by mail only—send copies or tear sheets only for us to keep—do not call!" Commercial illustration representative. Estab. 1975. Represents 12 illustrators. Markets include: advertising agencies; corporations/client direct; design firms; editorial/magazines; paper products/greeting cards; publishing/books; sales/promotion firms.
Handles: Illustration.
Terms: Agent receives 25% commission locally; 30% outside of Los Angeles. Exclusive area representation required. Advertising costs depend. For promotional purposes talent must advertise once a year in major promotional book (ex: Workbook) exclusively with us. "Specifications and details are handled privately." Advertises in *American Showcase* and *The Workbook*.
How to Contact: When making first contact, send: query letter (with other reps mentioned), photocopies ("examples to keep only. No unsolicited work returned.") Responds in weeks only if interested. After initial contact, talent should wait to hear from us.
Tips: "We select first from 'keepable' samples mailed to us. The actual work determines our interest, not verbal recommendation or résumés. Sometimes we search for style we are lacking. It is *not* a good idea to call a rep out of the blue. You are just another voice on the phone. What is important is your work, *not* who you know, where you went to school, etc. Unsolicited work that needs to be returned creates a negative situation for the agent. It can get lost, and the volumn can get horrendous. Also—do your homework—do not call and expect to be given the address by phone. It's a waste of the reps time and shows a lack of effort. Be brief and professional." Sometimes, even if an artist can't be represented, Jae Wagoner provides portfolio reviews, career counseling and advice for an hourly fee (with a 5 hour minimum fee). If you are interested in this service, please request this in your cover letter.

GWEN WALTERS, 50 Fuller Brook Rd., Wellesley MA 02181. (617)235-8658. E-mail: Artincgw@aol.c om. Website: www.GwenWaltersartrep.com. Commercial illustration representative. Estab. 1976. Member of Graphic Artists Guild. Represents 17 illustrators. "I lean more toward book publishing." Markets include: advertising agencies; corporations/client direct; editorial/magazines; paper products/greeting cards; publishing/books; sales/promotion firms. Represents: Gerardo Suzan, Fabricio Vanden Broeck, Resario Valderrama, Lave Gregory, Susan Spellman, Sally Schaedler, Judith Pfeiffer, Yvonne Gilbert, Gary Torrisi, Larry Johnson, Pat Davis and Linda Pierce.
Handles: Illustration.
Terms: Rep receives 30% commission. Charges for color photocopies. Advertising costs are split; 50% paid by talent; 50% paid by representative. For promotional purposes, talent must provide direct mail pieces. Advertises in *RSVP*, *Directory of Illustration* and *Picture Book*.
How to Contact: For first contact, send résumé bio, direct mail flier/brochure. After initial contact, representative will call. Portfolio should include "as much as possible."
Tips: "You need to pound the pavement for a couple of years to get some experience under your belt. Don't forget to sign all artwork. So many artists forget to stamp their samples."

DEBORAH WOLFE LTD., 731 N. 24th St., Philadelphia PA 19130. (215)232-6666. Fax: (215)232-6585. Website: www.deborahwolfe.com. **Contact:** Deborah Wolfe. Commercial illustration representative. Estab. 1978. Represents 25 illustrators. Markets include: advertising agencies; corporations/client direct; design firms; editorial/magazines; publishing/books.
Handles: Illustration.
Terms: Rep receives 25% commission. Advertises in *American Showcase*, *Black Book*, *The Workbook*, *Directory of Illustration* and *Picturebook*.
How to Contact: For first contact, send direct mail flier/brochure, tearsheets, slides. Responds in 3 weeks.

The Internet as Your All-Purpose Bulletin: Websites for Artists

BY CANDI LACE

Your computer serves as one gigantic toolbox. Likewise, all the information you are able to access on the Internet may prove to be better than any newspaper classified page or job directory. The World Wide Web remains new, adaptable and expeditiously accommodating to all types of artists, no matter what their needs are. The Internet, which is being used by millions of people at this moment, spotlights pertinent information for artists, and offers instant reference to countless galleries, dealers, buyers, and representatives. Thousands of résumés and portfolios are just a few clicks away, and online registration for conferences, contests and exhibitions is almost effortless. If you haven't already explored the digital world, perhaps your first trip may present possibilities you never knew existed. A thorough search may connect you with the appropriate licenser or agent, for instance. AGDM understands your changing needs and aspirations, and we recommend only the best, most efficient websites in your target markets.

Greeting Cards, Gifts & Products
- Greeting Card Association—www.greetingcard.org
- Writers Write: Greeting Cards—www.writerswrite/greetingcards.com

Magazines
- Magazines A-Z—www.magazinesatoz.com
- The Magazine Rack—www.magazine-rack.com

Posters & Prints
- The Art & Framing Headquarters—www.artframing.com
- Art Republic—www.artrepublic.com
- ArtSelect—www.artselect.com

Book Publishers
- Book Publisher's Directory—www.book-publishers.org
- WWW Virtual Library-Publishers—www.comlab.ox.ac.uk/archive/publishers.html

Galleries
- Art Dealers Association of America-www.artdealers.org
- Art Network—www.artmarketing.com
- Artline—www.artline.com

Syndicates & Cartoon Features
- Creators.com—www.creators.com
- Electric Cartoon Syndicate—www.clstoons.com/es.htm
- Internet Cartoon Forum—www.cartoonsforum.com

Stock Illustration & Clip Art Firms
- Illo.com: The Online Illustration Source—www.illo.com
- Indexed Visuals—www.indexedvisuals.com

Animation & Computer Games
- Animation Salad—www.animamundi.com

- Animation World Network—www.awn.com
- International Animation Association (ASIFA)—www.swcp.com/~asifa/

Advertising, Design & Related Markets
- Advertising Age—www.adage.com
- Graphic Artists Guild—www.gag.org
- Guide to Advertising—www.4adagencies.com

Record Labels
- Music Connection—www.musicconnection.com
- Record Labels on the Web—www.arancidamoeba.com/labels.html
- Universal Music Group—www.universalstudios.com/music

Fine Art Competitions
- Art Deadlines List—www.xensei.com/ad/
- Sanders Studios Art Resources—www.sanders-studios.com/linkedpages/artresources
- Fine Art-The Worldwide Art Gallery—www.theartgallery.com

Portfolios
- Altpick.com: The Source for Creative Talent & Imagination—www.altpick.com
- Portfolio Central—www.portfoliocentral.com
- U.S. Creative Directory—www.uscreative.com

Workshops/Retreats
- Artists' Retreats—http://drawsketch.about.com
- Colonies for Painters—http://painting.about.com/hobbies/painting/cs/coloniesretreats

Business
- Arts Business Exchange—www.artsbusiness.com
- Institute of Art and Law—www.ial.uk.com
- Starving Artists Law—www.starvingartistslaw.com

Glossary

Acceptance (payment on). An artist is paid for his work as soon as a buyer decides to use it.

Adobe Illustrator®. Drawing and painting computer software.

Adobe PageMaker. Illustration software (formerly Aldus PageMaker).

Adobe Photoshop®. Photo manipulation computer program.

Advance. Amount paid to an artist before beginning work on an assigned project. Often paid to cover preliminary expenses.

Airbrush. Small pencil-shaped pressure gun used to spray ink, paint or dye to obtain gradated tonal effects.

Aldus FreeHand. Illustration software (see Macromedia FreeHand).

Aldus PageMaker. Page layout software (see Adobe PageMaker).

Anime. Japanese word for animation.

Art director. In commercial markets, the person responsible for choosing and purchasing artwork and supervising the design process.

Biannually. Occurring twice a year.

Biennially. Occurring once every two years.

Bimonthly. Occurring once every two months.

Biweekly. Occurring once every two weeks.

Book. Another term for a portfolio.

Buy-out. The sale of all reproduction rights (and sometimes the original work) by the artist; also subcontracted portions of a job resold at a cost or profit to the end client by the artist.

Calligraphy. The art of fine handwriting.

Camera-ready. Art that is completely prepared for copy camera platemaking.

Capabilities brochure. A brochure, similar to an annual report, outlining for prospective clients the nature of a company's business and the range of products or services it provides.

Caption. See gagline.

Carriage trade. Wealthy clients or customers of a business.

CD-ROM. Compact disc read-only memory; non-erasable electronic medium used for digitized image and document storage and retrieval on computers.

Collateral. Accompanying or auxiliary pieces, such as brochures, especially used in advertising.

Color separation. Photographic process of separating any multi-color image into its primary component parts (cyan, magenta, yellow and black) for printing.

Commission. 1) Percentage of retail price taken by a sponsor/salesman on artwork sold. 2) Assignment given to an artist.

Comprehensive. Complete sketch of layout showing how a finished illustration will look when printed; also called a comp.

Copyright. The exclusive legal right to reproduce, publish and sell the matter and form of a literary or artistic work.

Consignment. Arrangement by which items are sent by an artist to a sales agent (gallery, shop, sales rep, etc.) for sale with the understanding the artist will not receive payment until work is sold. A commission is almost always charged for this service.

Direct-mail package. Sales or promotional material that is distributed by mail. Usually consists of an outer envelope, a cover letter, brochure or flier, SASE, and postpaid reply card, or order form with business reply envelope.

Dummy. A rough model of a book or multi-page piece, created as a preliminary step in determining page layout and length. Also, a rough model of a card with an unusual fold or die cut.

Edition. The total number of prints published of one piece of art.

Elhi. Abbreviation for elementary/high school used by publishers to describe young audiences.

Environmental graphic design (EGD). The planning, designing and specifying of graphic elements in the built and natural environment; signage.

EPS files. Encapsulated PostScript—a computer format used for saving or creating graphics.

Estimate. A ballpark figure given to a client by a designer anticipating the final cost of a project.

Etching. A print made by the intaglio process, creating a design in the surface of a metal or other plate with a needle and using a mordant to bite out the design.

Exclusive area representation. Requirement that an artist's work appear in only one outlet within a defined geographical area.

Finished art. A completed illustration, mechanical, photo, or combination of the three that is ready to go to the printer. Also called camera-ready art.

Gagline. The words printed with a cartoon (usually directly beneath); also called a caption.

Giclée Method of creating limited and unlimited edition prints using computer technology in place of traditional methods of reproducing artwork. Original artwork or transparency is digitally scanned, and the stored information is manipulated on screen using computer software (usually Photoshop). Once the image is refined on screen, it is printed on an Iris printer, a specialized ink-jet printer designed for making giclée prints.

Gouache. Opaque watercolor with definite, appreciable film thickness and an actual paint layer.

Halftone. Reproduction of a continuous tone illustration with the image formed by dots produced by a camera lens screen.

IRC. International Reply Coupon; purchased at the post office to enclose with artwork sent to a foreign buyer to cover his postage cost when replying.

Iris print. Limited and unlimited edition print or giclée output on an Iris or ink-jet printer (named after Iris Graphics of Bedford, Massachusetts, a leading supplier of ink-jet printers).

JPEG files. Joint Photographic Experts Group—a computer format used for saving or creating graphics.

Keyline. Identification of the positions of illustrations and copy for the printer.

Kill fee. Portion of an agreed-upon payment an artist receives for a job that was assigned, started, but then canceled.

Layout. Arrangement of photographs, illustrations, text and headlines for printed material.

Licensing. The process whereby an artist who owns the rights to his or her artwork permits (through a written contract) another party to use the artwork for a specific purpose for a specified time in return for a fee and/or royalty.

Lithography. Printing process based on a design made with a greasy substance on a limestone slab or metal plate and chemically treated so image areas take ink and non-image areas repel ink.

Logo. Name or design of a company or product used as a trademark on letterhead, direct mail packages, in advertising, etc., to establish visual identity.

Mechanicals. Preparation of work for printing.

Multimedia. A generic term used by advertising, public relations and audiovisual firms to describe productions involving animation, video, web graphics or other visual effects. Also, a term used to reflect the varied inhouse capabilities of an agency.

Naif. Native art of such cultures as African, Eskimo, Native American, etc., usually associated with daily life.

Offset. Printing process in which a flat printing plate is treated to be ink-receptive in image areas and ink-repellent in non-image areas. Ink is transferred from the printing plate to a rubber plate, and then to the paper.

Overlay. Transparent cover over copy, on which instruction, corrections or color location directions are given.

Panel. In cartooning, the boxed-in illustration; can be single panel, double panel or multiple panel.

Photostat. Black & white copies produced by an inexpensive photographic process using paper negatives; only line values are held with accuracy. Also called stat.

PMT. Photomechanical transfer; photostat produced without a negative.

P-O-P. Point-of-purchase; in-store marketing display that promotes a product.

Prima facie. Evidence based on the first impression.

Print. An impression pulled from an original plate, stone, block screen or negative; also a positive made from a photographic negative.

Production artist. In the final phases of the design process, the artist responsible for mechanicals and sometimes the overseeing of printing.

QuarkXPress. Page layout computer program.

Query. Letter to an art director or buyer eliciting interest in a work an artist wants to illustrate or sell.

Quotation. Set fee proposed to a client prior to commencing work on a project.

Rendering. A drawn representation of a building, interior, etc., in perspective.

Retail. The sale of goods in small quantities directly to the consumer.

Roughs. Preliminary sketches or drawings.

Royalty. An agreed percentage paid by a publisher to an artist for each copy of a work sold.

SASE. Self-addressed, stamped envelope.

Self-publishing. In this arrangement, an artist coordinates and pays for printing, distribution and marketing of his/her own artwork and in turn keeps all ensuing profits.

Semiannual. Occurring twice a year.

Semimonthly. Occurring twice a month.

Semiweekly. Occurring twice a week.

Serigraph. Silkscreen; method of printing in which a stencil is adhered to a fine mesh cloth stretched over a wooden frame. Paint is forced through the area not blocked by the stencil.

Speculation. Creating artwork with no assurance that a potential buyer will purchase it or reimburse expenses in any way; referred to as work on spec.

Spot illustration. Small illustration used to decorate a page of type, or to serve as a column ending.

Storyboard. Series of panels that illustrate a progressive sequence or graphics and story copy of a TV commercial, film or filmstrip. Serves as a guide for the eventual finished product.

Tabloid. Publication whose format is an ordinary newspaper page turned sideways.

Tearsheet. Published page containing an artist's illustration, cartoon, design or photograph.

Thumbnail. A rough layout in miniature.

TIFF files. Tagged Image File Format—a computer format used for saving or creating graphics.

Transparency. A photographic positive film such as a color slide.

Type spec. Type specification; determination of the size and style of type to be used in a layout.

Velox. Photoprint of a continuous tone subject that has been transformed into line art by means of a halftone screen.

VHS. Video Home System; a standard videotape format for recording consumer-quality videotape, most commonly used in home videocassette recording and portable camcorders.

Video. General category comprised of videocassettes and videotapes.

Wash. Thin application of transparent color or watercolor black for a pastel or gray tonal effect.

Wholesale. The sale of commodities in large quantities usually for resale (as by a retail merchant).

Niche Marketing Index

The following indexes can help you find the most appropriate listings for the kind of artwork you create. Check the individual listings for specific information about submission requirements.

Architectural Renderings

Gallery Joe 480
Guthart Gallery & Framing 415
Ingbar Gallery of Architectural Art, Michael 463

Calendars

A&B Publishers Group 284
Alaska Momma, Inc. 52
Amcal Inc. 52
ArtVisions 640
Avalanche Press, Ltd. 290
Brush Dance Inc. 57
Cactus Game Design, Inc. 296
Catch Publishing, Inc. 60
Cedco Publishing Co. 60
Cruise Creative Services, Inc. 63
Current, Inc. 63
Fine Art Productions, Richie Suraci Pictures, Multimedia, InterActive 68
Fotofolio, Inc. 69
Gallery Graphics, Inc. 70
Graphique de France 254
Hannah-Pressley Publishing 72
Intercontinental Greetings Ltd. 74
Intermarketing Group, The 74
Lang Companies, The 77
Legacy Publishing Group 77
Lesli Art, Inc. 652
New Deco, Inc. 85
Nouvelles Images Inc. 264
Porterfield's Fine Art Licensing 91
Pratt & Austin Company, Inc. 92
Price Stern Sloan 344
Sanghavi Enterprises Pvt Ltd. 97
Sparrow & Jacobs 98
Sunshine Art Studios, Inc. 99
Syracuse Cultural Workers 100, 276
Vargas Fine Art Publishing, Inc. 278

Calligraphy

Acme Graphics, Inc. 50
Allyn and Bacon, Inc. 286
Amberley Greeting Card Co. 52
AR-EN Party Printers, Inc. 54
Brainworks Design Group, Inc. 531
Bristol Gift Co., Inc. 57
Brush Dance Inc. 57
Butwin & Associates Advertising, Inc. 568
Cape Shore, Inc. 58
Carole Joy Creations, Inc. 58
Cleo, Inc. 61
Courage Center 62

Current, Inc. 63
Custom Craft Studio 546
Fine Art Productions, Richie Suraci Pictures, Multimedia, InterActive 68
Hannah-Pressley Publishing 72
Heath Greeting Cards, Inc., Marian 72
Heaven Bone 157
Inkadinkado, Inc. 74
Inspirations Unlimited 74
Legacy Publishing Group 77
Lemon Tree Stationery Corp., The 77
Life Greetings 80
Novo Card Publishers Inc. 86
Paramount Cards Inc. 90
Pratt & Austin Company, Inc. 92
Printery House of Conception Abbey, The 92
Prizm Inc. 93
Prudent Publishing 93
Renaissance Greeting Cards 95
RubberStampede 96
Sea Magazine 215
Second Nature, Ltd. 98
Sparrow & Jacobs 98
Sunrise Publications Inc. 99
Sunshine Art Studios, Inc. 99
Warner Press, Inc. 102

Caricatures

Afrocentrex 519
Atlantic Syndication/Editors Press 509
California Journal 126
CED 128
Cobblestone, Discover American History 135
Continental Features/Continental News Service 509
Girlfriends Magazine 151
Guitar Player 154
Ladybug 171
Musclemag International 181
Plus Magazine 199
Potpourri 201
Prime Time Sports & Fitness 203
Sales & Marketing Management Magazine 212
Sinister Wisdom 217
United News Service 515
Vibe 232
Washington City Paper 232

Cartoons

Aim 108
American Legion Magazine, The 111
Artistmarket.com (AKA A.D. Kahn, Inc.) 508

Association of Brewers 116
Atlantic Syndication/Editors Press 509
Authorship 117
Automundo 118
Balloon Life Magazine 118
Bartender Magazine 119
Black Lily, The 122
Blate Associates LLC, Sam 561
Bow & Arrow Hunting Magazine 123
Buckmasters Whitetail Magazine 124
Bulletin of the Atomic Scientists 125
Business Law Today 125
Business London Magazine 125
Cat Fancy 127
Catholic Forester 128
CED 128
Celebration: An Ecumenical Resource 509
Chesapeake Bay Magazine 129
Christian Century, The 131
Christian Home & School 132
Cleaning Business 134
Clergy Journal, The 134
Common Ground 135
Commonweal 135
Comstock Cards, Inc. 61
Conservatory of American Letters 137
Continental Features/Continental News Service 509
Creators Syndicate, Inc. 510
Cricket 139
Custom Medical Stock Photo, Inc. 519
Dairy Goat Journal 139
Delaware Today Magazine 140
Diversion Magazine 141
East Bay Monthly, The 142
Electrical Apparatus 142
Environment 143
Fanjoy & Bell, Ltd. 308
Fantagraphics Books 144
Films for Christ 309
Final Edition, The 146
First For Women 146
Fly Fisherman Magazine 147
Fravessi Greetings, Inc. 69
Gallery Magazine 149
Gibbs Smith, Publisher 312
Golf Illustrated 151
Golf Journal 152
Gray Areas 153
Habitat Magazine 155
Hadassah Magazine 156
Healthcare Financial Management 156
Heartland Boating Magazine 156
Heartland USA 157
High Country News 158

Hill and Wang 317
Home Education Magazine 159
Horse Illustrated 160
Hottrax Records 619
HX Magazine 162
In Touch for Men 163
Japanophile 166
Jewish Action 166
Jill Features, Jodi 510
Judicature 167
Kalliope 169
Kentucky Living 169
King Features Syndicate 511
L.A. Weekly 171
Lematt Music 622
Listen Magazine 171
Little Enterprises, Inc., Lew 511
Lutheran, The 172
Lynx Eye 173
Metro Creative Graphics, Inc. 521
MetroKids 176
MetroSports Magazine 176
Millimac Licensing Co. 83
Modern Drummer 178
Moment 179
Mother Jones 180
Musclemag International 181
Mushing 181
Mutual Funds Magazine 182
National Lampoon 184
National Notary, The 184
Naturally Magazine 185
New Mystery Magazine 187
New Times LA 188
New Yorker, The 188
Now And Then 189
O&A Marketing News 190
Oatmeal Studios 86
Off Our Backs 190
Optimist, The 191
Oregon River Watch 192
Outer Darkness 194
Pacific Yachting Magazine 195
Phi Delta Kappan 198
Planning 198
Play Station Magazine 199
Playboy Magazine 199
PN/Paraplegia News 199
Presbyterians Today 202
Proceedings 204
Professional Tool & Equipment News
 and Bodyshop Expo 204
Protooner 205
QECE (Question Everything Challenge
 Everything) 206
Queen's Mystery Magazine, Ellery 207
Richmond Magazine 210
Rotarian, The 211
Rural Heritage 212
Saturday Evening Post, The 213
Scrap 215
Sheep! Magazine 216
Sinister Wisdom 217
Skipping Stones 218
Skydiving Magazine 218
Solidarity Magazine 220
Sparrow & Jacobs 98
Sports 'n Spokes 221
Strain, The 222

Technical Analysis of Stocks & Com-
 modities 224
Techniques 224
Thrasher 225
Tom Thumb Music 632
TROIKA Magazine 228
Training Magazine 227
Tribune Media Services, Inc. 515
United Feature Syndicate/Newspaper
 Enterprise Association 515
United Media 515
United News Service 515
Universal Press Syndicate 516
Unmuzzled Ox 230
U.S. Lacrosse Magazine 230
Vegetarian Journal 231
Vibe 232
Videomaker Magazine 232
Visual Aid/visaid Marketing 540
Whitegate Features Syndicate 516
Worcester Magazine 234
World Trade 235
Wy'East Historical Journal 236

Children's Books

A&B Publishers Group 284
Advantage Publishers' Group 285
American Bible Society, The 286
Atheneum Books for Young Readers
 289
Behrman House, Inc. 292
Bethlehem Books 293
Broadman & Holman Publishers 295
Browne Ltd., Pema 642
Cartwheel Books 296
Children's Digest 131
Christian School International 300
Council for Exceptional Children 302
Crumb Elbow Publishing 303
Gallopade International/Carole Marsh
 Family CD-ROM 311
Grosset & Dunlap 313
Honor Books 319
Hopscotch, The Magazine for Girls 160
Houghton Mifflin Company 320
Huntington House Publishers 321
Kar-Ben Copies, Inc. 325
Kendall/Hunt Publishing Co. 325
Kid Stuff 76
L.A. Parent Magazine 170
Lugus Publications 330
Mothering Magazine 180
Northland Publishing 335
Novalis Publishing, Inc. 336
Orchard Books 337
Overlook Press, The 338
Pauline Books & Media 339
Pelican Publishing Co. 341
Price Stern Sloan 344
Puffin Books 345
Putnam's Sons, G.P. 346
Random House Children's Book Group
 347
Random House Value Publishing 347
Scholastic Inc. 349
Simon & Schuster 350
Soundprints 351
Speech Bin, Inc., The 351

Spider 220
Troll Communications 355
Twenty-First Century Books/A Division
 of Millbrook Press, Inc. 355

Collectibles

Alaska Momma, Inc. 52
Applejack Licensing International 53
Arts Uniq' Inc. 245
Ashton-Drake Galleries, The 54
Current, Inc. 63
Franklin Mint, The 69
Kid Stuff 76
Millimac Licensing Co. 83
NAPCO Marketing 84
Papel Giftware™ 88
Prizm Inc. 93
Reco International Corporation 94
Rite Lite Ltd./The Rosenthal Judaica-
 Collection 95
Roman, Inc. 96
TJ's Christmas 101
United Design 101
Vargas Fine Art Publishing, Inc. 278
Willitts Designs 102

Fashion

Ashton-Drake Galleries, The 54
Berger & Associates, Inc., Barry David
 580
Bitch: Feminist Response to Pop Cul-
 ture 120
Brooks Associates, Public Relations,
 Anita Helen 581
Gentry Magazine 150
Made to Measure 173
Mizerek Design Inc. 584
Modern Salon 179
Orange Coast Magazine 192
Quite Specific Media Group Ltd. 346
Redbook Magazine 209
Sinister Wisdom 217
TMA Ted Mader Associates, Inc. 606
Wisner Associates 594

Humorous Illustration

Adams Media Corporation 285
Advocate, PKA's Publication 107
Aging Today 108
Aguilar Expression, The 108
Aim 108
Alaska Magazine 109
Alternative Therapies in Health and
 Medicine 110
Amberley Greeting Card Co. 52
American Atheist, The 110
American Brewer Magazine 111
American Legion Magazine, The 111
American Libraries 112
American Spectator, The 113
American Woman Road & Travel 113
Anderson Studio, Inc. 598
Andrews McMeel Publishing 287
Appalachian Trailway News 114
Aquarium Fish Magazine 115
Army Magazine 115
Artemis Creations 289
Artist's Magazine, The 115

Art:Mag 116
Association of Brewers 116
Atlantic Syndication/Editors Press 509
Automundo 118
Avalanche Press, Ltd. 290
Avon Books 290
Balloon Life Magazine 118
Baltimore Magazine 119
BePuzzled/University Games 55
Binary Arts Corp. 294
Bitch: Feminist Response to Pop Culture 120
Black Lily, The 122
Bostonia Magazine 123
Briardy Design 572
Bride's Magazine 124
Brilliant Enterprises, Ashleigh 509
Broadman & Holman Publishers 295
Bugle—Journal of Elk and the Hunt 124
Bulletin of the Atomic Scientists 125
Business Law Today 125
Business Travel News 126
California Home & Design 126
Campus Life 126
Canadian Dimension 127
Candy Cane Press 296
Cape Shore, Inc. 58
Catholic News Service 509
CCC Publications 297
Celebration: An Ecumenical Resource 509
Chesapeake Bay Magazine 129
Chickadee 130
Child Life 130
Children's Playmate 131
Chronicle Books 300
Chronicle of the Horse, The 132
City Limits 133
Clay Art 61
Cleaning Business 134
Cleveland Magazine 134
Colors By Design 61
Common Ground 135
Community Banker 136
Continental Features/Continental News Service 509
Contract Professional 137
Cook Communications Ministries 137
Countryman Press, The 302
Covenant Companion, The 138
Creative With Words Publications 302
Creators Syndicate, Inc. 510
Cricket 139
Crockett Cards 62
Crumb Elbow Publishing 303
Custom Medical Stock Photo, Inc. 519
Dakota Outdoors 139
DC Comics 140
Decorative Artist's Workbook 140
Delaware Today Magazine 140
Design Design, Inc. 64
Designer Greetings, Inc. 64
Discoveries 141
Diversion Magazine 141
Dream Maker Software 520
Electrical Apparatus 142
Emery Group, The 600
Emmal Butler Creatives 605
Entrepreneur Magazine 143

Equity Marketing, Inc. 67
Esquire 143
Eye for the Future 143
Fantagraphics Books, Inc. 308
Fifty Something Magazine 145
Filipinas Magazine 145
First For Women 146
First Hand Magazine 147
Focus On The Family 147
Foodservice Director Magazine 148
Ford Agency, The 593
Fravessi Greetings, Inc. 69
Freelance Exchange, Inc. 545
Freelance Express, Inc. 583
FSP Communications 562
Future Publishing Ltd. 148
Gallant Greetings Corp. 70
Gallopade International/Carole Marsh Family CD-ROM 311
Game & Fish 149
Gentry Magazine 150
Georgia Magazine 150
Gibbs Smith, Publisher 312
Girlfriends Magazine 151
Glamour 151
Golf Journal 152
Golf Tips Magazine 152
Graphic Arts Communications 510
Graphic Corp. 520
Grass Roots Productions 618
Gray Areas 153
Great Quotations Publishing 313
Group Publishing Book Product 314
Group Publishing—Magazine Division 153
Guided Imagery Design & Productions 647
Hadassah Magazine 156
Hannah-Pressley Publishing 72
Hardwood Matters 156
HarperCollins Publishers, Ltd. (Canada) 316
Heartland USA 157
Heaven Bone 157
HerbalGram 157
Highlights for Children 158
Hispanic Magazine 158
Home Furnishings Retailer 159
Hopscotch, The Magazine for Girls 160
House Calls 161
Humpty Dumpty's Magazine 161
HX Magazine 162
Impact Images 257
In Touch for Men 163
Information Week 164
Ingrams Magazine 164
Intercontinental Greetings Ltd. 74
Intermarketing Group, The 74
Jack and Jill 165
Jain Publishing Co. 322
Japanophile 166
Jewish Action 166
Jillson & Roberts 76
Judicature 167
jude studios 601
Kaeden Books 324
Kaleidoscope: Exploring the Experience of Disability through Literature and the Fine Arts 169

Kalliope 169
Kentucky Living 169
King Features Syndicate 511
Kiplinger's Personal Finance 170
Kipling's Creative Dare Devils 76
Kiwanis 170
Koehler Companies 76
L.A. Parent Magazine 170
L.A. Weekly 171
Ladybug 171
Leader Paper Products/Paper Adventures 77
Lematt Music 622
Listen Magazine 171
Little Enterprises, Inc., Lew 511
Log Home Living 172
Lolo Company, The 81
Lookout, The 172
Lugus Publications 330
Lynx Eye 173
Macey Noyes Associates, Inc. 545
Mad Magazine 173
Made to Measure 173
Madison Park Greetings 82
Mahan Graphics, Michael 561
Main Line Today 173
Meadowbrook Press 331
Media Enterprises 538
Meetings In the West 176
Millimac Licensing Co. 83
Minority Features Syndicate, Inc. 511
Mobile Beat 177
Model Railroader 178
Modern Healthcare Magazine 178
Modern Maturity 178
Montana Magazine 180
Mother Jones 180
Mushing 181
Mutual Funds Magazine 182
NA'AMAT Woman 182
Nailpro 183
Nails 183
National News Bureau 511
National Notary, The 184
National Review 184
Nation's Restaurant News 185
Natural Life 185
Nerve Cowboy 186
Nevada 186
New Breed, The 511
New Writer's Magazine 188
Nightlife Magazine 189
Noble Works 85
Northern Cards 85
Northwoods Press 336
Nova Development Corporation 522
Nurseweek 190
new renaissance, the 187
Oatmeal Studios 86
Octameron Press 337
Ohio Magazine 191
Oklahoma Today Magazine 191
Orange Coast Magazine 192
Oregon River Watch 192
Other Side, The 193
Outdoor Canada Magazine 194
Outdoor Life Magazine 194
Outer Darkness 194
Pacific Yachting Magazine 195

Paint Horse Journal 195
Papel Giftware® 88
Paper Moon Graphics, Inc. 89
Paperpotamus Paper Products Inc. 89
Paramount Cards Inc. 90
Parents' Press 196
Passport 197
Peachtree Publishers 340
Pennsylvania Lawyer 197
Peregrine 341
Perfection Learning Corporation,
 Cover-to-Cover 342
Persimmon Hill 197
Phi Delta Kappan 198
Plus Magazine 199
Pockets 200
Polish Associates, Marc 90
Popcorn Factory, The 90
Poptronics 200
Powder Magazine 201
Presbyterian Record, The 202
Prime Time Sports & Fitness 203
Prismatix, Inc. 92
Private Pilot 204
Profit Magazine 205
Progressive, The 205
Protooner 205
P.S. Greetings, Inc. 87
Psychology Today 206
QECE (Question Everything Challenge
 Everything) 206
Racquetball Magazine 207
Random House Value Publishing 347
Ranger Rick 207
Really Good Copy Co. 546
Red Deer Press 348
Redbook Magazine 209
Reform Judaism 209
Regnery Publishing Inc. 348
Renaissance Greeting Cards 95
Rhythms Productions 542
Rhythms Productions 627
Rosenthal Represents 655
Running Times 211
San Francisco Bay Guardian 213
Sangray Corporation 97
Saturday Evening Post, The 213
School Administrator, The 214
Science News 214
Science Teacher, The 214
Seek 216
17th Street Productions 350
Shepherd Express 217
Signed, Sealed, Delivered 98
Sinister Wisdom 217
Skipping Stones 218
Slack Publications 218
Small Business Times and Employment
 Times 219
Small Pond Magazine of Literature, The
 219
Soldiers Magazine 220
Sparrow & Jacobs 98
Spinsters Ink Books 352
Spitball 221
Sports Afield 221
Stock Illustration Source 522
Stone Soup 222
Strategic Finance 222

Stratton Magazine 222
Sunrise Publications Inc. 99
Sunshine Art Studios, Inc. 99
Tampa Bay Magazine 223
Tasteful Ideas, Inc. 559
Texas Observer, The 225
Thomson Medical Economics 225
Thrasher 225
Tom Thumb Music 632
Triton Advertising, Inc. 587
True West Magazine 228
Turtle Magazine, For Preschool Kids
 229
Tyndale House Publishers, Inc. 356
U. The National College Magazine 229
United Media 515
United News Service 515
US Kids: A Weekly Reader Magazine
 230
U.S. Lacrosse Magazine 230
Utne Reader 231
Vagabond Creations Inc. 101
Visual Aid/visaid Marketing 540
Washington City Paper 232
Watt/Fleischman-Hillard 592
Whitegate Features Syndicate 516
Whitney Pink, Inc. 102
Wilshire Book Co. 361
Wilson Fine Arts, Inc., Carol 103
Wilson Fine Arts, Inc., Carol 103
Worcester Magazine 234
World Trade 235
Writer's Digest 235
Writer's Yearbook 236
Yachting Magazine 236
YM 237

Informational Graphics

American Spectator, The 113
Aopa Pilot 114
Balloon Life Magazine 118
Business London Magazine 125
Business Travel News 126
Canadian Business 127
Charleston Magazine 128
Community Banker 136
Contract Professional 137
Dermascope 141
Facts on File 308
Federal Computer Week 145
Foodservice Director Magazine 148
Golf Tips Magazine 152
Hammond Design Associates, Inc. 559
Home Business Magazine 159
Home Furnishings Retailer 159
House Calls 161
Ingrams Magazine 164
Journal of Accountancy 167
Managed Care 175
Michigan Living 177
Microsoft Certified Professional Maga-
 zine 177
Modern Healthcare Magazine 178
Modern Reformation Magazine 179
Musclemag International 181
My Friend 182
New Moon: The Magazine for Girls and
 Their Dreams 187

Ohio Magazine 191
Oxygen 195
Prime Time Sports & Fitness 203
Proceedings 204
Profit Magazine 205
Protooner 205
Repro Report 209
Runner's World 211
Sales & Marketing Management Maga-
 zine 212
Server/Workstation Expert 216
Skipping Stones 218
Slack Publications 218
Washington City Paper 232
Yachting Magazine 236

Licensing

Acme Graphics, Inc. 50
Alaska Momma, Inc. 52
AMCAL Fine Art 243
Amcal Inc. 52
Art Impressions, Inc. 244
ArtEffects Designs & Licensing Inc.
 245
Arts Uniq' Inc. 245
ArtVisions 640
Bentley Publishing Group 245
Blue Sky Publishing 56
Centric Corp. 60
Courage Center 62
Creatif Licensing 62, 249
Cruise Creative Services, Inc. 63
Dare to Move 249
Directional Publishing, Inc. 250
DLM Studio 65
Fiddler's Elbow 68
Galaxy of Graphics, Ltd. 252
Gango Editions 253
Gatlin Represents, Inc., Rita 646
Geme Art Inc. 253
Golden Books 312
Great American Puzzle Factory Inc. 71
Gregory Editions 255
Intermarketing Group, The 74
Kurlansky Associates, Sharon 651
Lang Companies, The 77
Lesli Art, Inc. 652
Levy Fine Art Publishing Inc., Leslie
 258
Lindgren & Smith 652
Mill Pond Press Companies 261
Millimac Licensing Co. 83
Mixedblessing 83
Moriah Publishing, Inc. 262
New Deco, Inc. 263
New Deco, Inc. 85
Nova Media Inc. 265
Old World Prints, Ltd. 265
Porterfield's Fine Art Licensing 91
Portfolio Graphics, Inc. 267
Prestige Art Inc. 269
Printery House of Conception Abbey,
 The 92
Rights International Group 95, 270
Rosenstiel's Widow & Son Ltd., Felix
 271
Rosenthal Represents 655
Scafa Art Publishing Co. Inc. 272

Seabright Press Inc. 97
Second Nature, Ltd. 98
Signed, Sealed, Delivered 98
Sjatin BV 274
Spencer Gifts, Inc. 98
Talicor, Inc. 100
TJ's Christmas 101
Vibrant Fine Art 279
Wild Apple Graphics, Ltd. 281

Medical Illustration

Adfiliation Advertising 593
Advocate, The 107
Berger & Associates, Inc., Barry David 580
Bostonia Magazine 123
BoxFire 558
Bragaw Public Relations Services 553
Briardy Design 572
Butwin & Associates Advertising, Inc. 568
Cat Fancy 127
Child Life 130
Children's Digest 131
Cliff & Associates Design 532
Creative Company, Inc. 593
Custom Medical Stock Photo, Inc. 519
Emergency Medicine Magazine 143
Eye for the Future 143
Ford Agency, The 593
Grafica Design Service 535
Hammond Design Associates, Inc. 559
House Calls 161
Humpty Dumpty's Magazine 161
IEEE Spectrum 163
JEMS 166
JMH Corporation 558
jude studios 601
Lieber Brewster Design, Inc. 583
Lippincott Williams & Wilkins 328
Massage Magazine 175
Meadowbrook Press 331
Michigan Living 177
Modern Healthcare Magazine 178
Musclemag International 181
On-Q Productions, Inc. 538
Pediatric Annals 197
Prime Time Sports & Fitness 203
Psychology Today 206
Resident and Staff Physician 209
Runner's World 211
Running Times 211
Scientific American 215
Slack Publications 218
Texas Medicine 225
Thomson Medical Economics 225
Walker Design Group 571

Mugs

Bentley Publishing Group 245
Bergquist Imports, Inc. 55
CCC Publications 297
Centric Corp. 60
Cruise Creative Services, Inc. 63
Imagination Association, The 73
Papel Giftware™ 88
Spencer Gifts, Inc. 98
Whitney Pink, Inc. 102

Multicultural

Afrocentrex 519
American Bible Society, The 286
ArtEffects Designs & Licensing Inc. 245
Artful Greetings 54
Bentley Publishing Group 245
Black Enterprise 122
Candy Cane Press 296
Career Focus 127
Children's Book Press 299
Courage Center 62
CRC Product Services 302
Fairfield Art Publishing 251
Galaxy of Graphics, Ltd. 252
Ghawaco International Inc. 253
Golden Books 312
Greenberg Art Publishing, Raymond L. 254
Guernica Editions 315
Hampton University Museum 498
Hippocrene Books Inc. 318
Hispanic Magazine 158
Impact Images 257
Intercultural Press, Inc. 322
Leader Paper Products/Paper Adventures 77
Liturgy Training Publications 329
Marlboro Fine Art & Publishing, Ltd. 261
Mitchell Lane Publishers, Inc. 332
Mixedblessing 83
Perfection Learning Corporation, Cover-to-Cover 342
Pilgrim Press/United Church Press, The 343
Seal Press 350
Skipping Stones 218
Spider 220
Syracuse Cultural Workers 100, 276
Things Graphics & Fine Art 277
Umoja Fine Arts 278
University of Nebraska Press, The 357
Vargas Fine Art Publishing, Inc. 278
Vibrant Fine Art 279
Vida Publishers 358
Wallace Associates, Wanda 280
Willitts Designs 102

Multimedia

28 Records 633
AAIMS Publishers 284
Ad Agency, The 542
Advertising Consortium, The 530
AGA Communications 606
AGFA Monotype Typography 519
ALBATROSS Records/R'N'D Productions 609
AM/PM Advertising, Inc. 573
Angel Films Company 570
Aquarius Records/Tacca Musique 611
Ariana Records 611
Arizona Cine Equipment, Inc. 527
Arnold & Associates Productions 546
Art Attack Recordings/Mighty Fine Records 612
Backwords Recordings 612

Barnett Advertising/Design, Augustus 603
Bass Group, The 530
Bell Advertising & Design, Thomas S. 599
Bentley Publishers, Robert 293
Berson, Dean, Stevens 531
Black Bear Publications/Black Bear Review 120
Bonus Books, Inc. 294
BoxFire 558
Bragaw Public Relations Services 553
Brennan, Inc. Marketing Communications, Leo J. 567
Briardy Design 572
Buckmasters Whitetail Magazine 124
Bureau for At-Risk Youth, The 295
Canon & Shea Associates, Inc. 581
Cherry Street Records, Inc. 615
Compass Marketing, Inc. 524
Compro Productions 549
Council for Exceptional Children 302
C.P.R. Record Company 614
CRS Artists 616
Creative Consultants 604
Creative House Marketing 567
Custom Medical Stock Photo, Inc. 519
Daigle Design Inc. 604
De Figlio Design 582
DeForest Communications, Lee 553
Design Collaborative 534
Donahue Advertising, LLC 544
Elton-Wolf Publishing 306
Emmal Butler Creatives 605
Essanee Unlimited, Inc. 534
Eventiv 590
Fine Art Productions, Richie Suraci Pictures, Multimedia, InterActive 68, 577
Fitzgerald & Co. 550
Flint Communications 589
Ford Agency, The 593
Fox Photographer, David 563
FreeAssociates 535
Freelance Advancers, Inc. 645
Freelance Exchange, Inc. 545
FSP Communications 562
Futuretalk Telecommunications Company, Inc. 600
Gallopade International/Carole Marsh Family CD-ROM 311
Geter Advertising Inc. 555
Giftware News 150
Giftware News UK 151
Goddess Records/California Song Magazine 618
Gold & Associates Inc. 548
Graphic Corp. 520
Graphic Design Concepts 541
Greteman Group 559
Guenzi Agents, Inc., Carol 647
Hay House, Inc. 316
Hedden-Nicely & Assoc. 552
HerbalGram 157
Hirsch O'Connor Design Inc. 555
Hitchins Company, The 536
Hollow Earth Publishing 318
Hottrax Records 619
Hutchinson Associates, Inc. 556

IEEE Spectrum 163
IMAC 578
Image Associates Inc. 588
JMH Corporation 558
Kaufman Ryan Stral Inc. 556
Kendall/Hunt Publishing Co. 325
Kirkbride Bible Co. Inc. 325
KJD Teleproductions 574
L.A. Parent Magazine 170
LCDM Entertainment 621
Lieber Brewster Design, Inc. 583
Liggett-Stashower 591
Linear Cycle Productions 536
Lohre & Associates 591
Lomangino Studio Inc. 547
Lord & Bentley Persuasive Marketing 537
Lubell Brodsky Inc. 584
Mack Advertising, Taylor 529
Mahan Graphics, Michael 561
Mayer Studios Inc., Charles 591
Media Consultants 570
Media Enterprises 538
Media Graphics 598
Merims Communications, Art 591
Miles Advertising 529
Miranda Designs Inc. 579
Mitchell & Resnikoff 595
MSR Advertising, Inc. 556
Music For Little People/EarthBeat! Record Company 624
Naish, Cohen & Assoc. (NC&A Inc.) 595
New Mystery Magazine 187
Nicosia Creative Expresso Ltd. 585
Oakley Design Studios 594
One Mile Up, Inc. 522
Outdoor Canada Magazine 194
Palm Pictures 625
Pauline Books & Media 339
Perceptive Marketers Agency, Ltd. 596
Phoenix Learning Group, Inc. 571
Photo Communication Services, Inc. 567
Postal Productions, Steve 548
Potter & Associates 588
Power and Associates, RH 626
PPI Entertainment Group 626
PPL Entertainment Group 626
Prime Time Sports & Fitness 203
Princeton MarketTech 575
Putumayo World Music 627
Really Good Copy Co. 546
Redmond Design, Patrick 569
Rhino Entertainment Company 627
Rhythms Productions 542, 627
Roberts Communications & Marketing, Inc. 549
Rock Dog Records 628
SAI Communications 596
Second Nature, Ltd. 98
Selbert-Perkins Design Collaborative (MA) 565
Shaolin Communications 629
Silver Fox Advertising 597
SoftMirage, Inc. 538
Somerset Entertainment 630
Sorin Productions Inc. 576
Spirit Creative Services Inc. 562

Stobie Group, LLC 571
Sugar Beats Entertainment 631
Take 1 Productions 569
Tangent® Records 631
Tehabi Books, Inc. 354
Tieken Design & Creative Services 529
TMA Ted Mader Associates, Inc. 606
Tom Thumb Music 632
Tombras Group, The 599
Topnotch® Entertainment Corp. 632
TR Productions 565
TROIKA Magazine 228
Treehaus Communications, Inc. 355
UNO Hispanic Advertising and Design 570
Van Vechten & Company Public Relations 549
Video Resources 540
Visual Horizons 580
W Publishing Group 358
Walker Design Group 571
Watchesgro Music, BMI—Interstate 40 Records 635
Waters & Wolfe 554
Watt/Fleischman-Hillard 592
West Creative, Inc. 571
Williams & Associates, L.C. 557
Woo Design, Inc., Eric 551
Wyatt Advertising, Evans 602
XICAT Interactive Inc. 362
Yachting Magazine 236
Yamaguma & Associates 540

Religious/Spiritual

Acme Graphics, Inc. 50
America 110
American Bible Society, The 286
Angels on Earth Magazine 114
Barbour Publishing 291
Behrman House, Inc. 292
Berkshire Originals 246
Bernard Fine Art 246
Bethlehem Books 293
Bradford Exchange, The 56
Bristol Gift Co., Inc. 57
Broadman & Holman Publishers 295
Cactus Game Design, Inc. 296
Catholic Forester 128
Catholic News Service 509
Celebration: An Ecumenical Resource 509
Chariot Victor Publishing 297
Christian Century, The 131
Christian Home & School 132
Christian Parenting Today Magazine 132
Christian Reader 132
Christian School International 300
Commonweal 135
Concord Litho Group 62
Cook Communications Ministries 137
Courage Center 62
Covenant Companion, The 138
CRC Product Services 302
Cross Cultural Publications, Inc. 303
Crumb Elbow Publishing 303
David Publishers, Jonathan 304
Discoveries 141

Films for Christ 309
Focus On The Family 147
Focus Publishing 309
Forward Movement Publications 310
Graphic Corp. 520
Greenberg Art Publishing, Raymond L. 254
Group Publishing Book Product 314
Guildhall, Inc. 255
Hadassah Magazine 156
Harvest House Publishers 316
Hillel Jewish Student Center Gallery 474
Honor Books 319
Huntington House Publishers 321
Ignatius Press 321
Innovation Multimedia 521
Jain Publishing Co. 322
Jewish Action 166
Jewish Lights Publishing 323
Judson Press 323
Kar-Ben Copies, Inc. 325
Kirkbride Bible Co. Inc. 325
Life Greetings 80
Liturgy Training Publications 329
Llewellyn Publications 329
Lookout, The 172
Lutheran, The 172
Mennonite Publishing House/Herald Press 332
Mill Pond Press Companies 261
Mixedblessing 83
Modern Reformation Magazine 179
Morehouse Publishing Group 333
Moyer Bell 335
NA'AMAT Woman 182
Nova Development Corporation 522
Novalis Publishing, Inc. 336
Oregon Catholic Press 192
Oregon Catholic Press 337
Other Side, The 193
Panda Ink 88
Passport 197
Pauline Books & Media 339
Paulist Press 339
Pilgrim Press/United Church Press, The 343
Presbyterian Record, The 202
Presbyterians Today 202
Printery House of Conception Abbey, The 92
Queen of All Hearts 207
Rainbow Books, Inc. 346
Red Farm Studio 94
Reform Judaism 209
Rite Lite Ltd./The Rosenthal Judaica-Collection 95
Roman, Inc. 96
Seek 216
Signs of the Times 217
Somerset House Publishing 274
Starburst Publishers 352
Stock Illustration Source 522
Stockart.com 522
Today's Christian Woman 227
Torah Aura Productions/Alef Design Group 354
Treehaus Communications, Inc. 355
Tyndale House Publishers, Inc. 356

UAHC Press 356
Vida Publishers 358
W Publishing Group 358
Warner Press, Inc. 102
White Mane Publishing Company, Inc. 360

Science Fiction/Fantasy

Arjuna Library Press 288
Artemis Creations 289
Artlink 412
Atlas Games 289
Avalanche Press, Ltd. 290
Baen Books 291
Binary Arts Corp. 294
Black Lily, The 122
Blue Mountain Gallery 458
Bradford Exchange, The 56
Cactus Game Design, Inc. 296
Circlet Press, Inc. 300
Crumb Elbow Publishing 303
Fine Art Productions, Richie Suraci Pictures, Multimedia, InterActive 68, 577
Fort Ross Inc. 309
Gryphon Publications 314
Guardians Of Order 315
Hollow Earth Publishing 318
Hottrax Records 619
Impact Images 257
Jewish Lights Publishing 323
Klimt Represents 650
Lugus Publications 330
NBM Publishing Co. 335
Nova Express 189
Orlando Gallery 378
Outer Darkness 194
Overlook Press, The 338
Paperpotamus Paper Products Inc. 89
Parabola Magazine 196
Peregrine 341
Perfection Learning Corporation, Cover-to-Cover 342
Prestige Art Inc. 269
Pulsar Games, Inc. 345
Random House Value Publishing 347
Red Wheel/Weiser 348
Spartacus Publishing, LLC 351
Stone Soup 222
TSR, Inc. 355
White Wolf Publishing 360
Williamson Publishing 361
Windstorm Creative 361
Wizards Of The Coast 361

Sport Art

Action Images Inc. 242
Chasin Fine Arts, Martin 387
Decorcal Inc. 64
Dykeman Associates Inc. 600
Gibson, Creative Papers, C.R. 70
Hill And Knowlton, Inc. 583
Koehler Companies 76
Lyons Press, The 330
MetroSports Magazine 176
Nottingham Fine Art 264
Sport'en Art 275

Sports Art Inc 275
University of Nebraska Press, The 357
U.S. Lacrosse Magazine 230

Textiles & Wallpaper

Alaska Momma, Inc. 52
Applejack Licensing International 53
Cruise Creative Services, Inc. 63
Dimensions, Inc. 64
DLM Studio 65
Fiddler's Elbow 68
Graham & Brown 71
Imagination Association, The 73
Leo Art Studio Inc. 583
Millimac Licensing Co. 83
Offray 87
Porterfield's Fine Art Licensing 91
Rainbow Creations, Inc. 93
Rights International Group 95, 270
Seabrook Wallcoverings, Inc. 97
Vibrant Fine Art 279
Wild Apple Graphics, Ltd. 281

T-Shirts

AGA Communications 606
Anderson Studio, Inc. 598
Applejack Licensing International 53
Artful Greetings 54
CCC Publications 297
Centric Corp. 60
Dimensions, Inc. 64
Fiddler's Elbow 68
Fotofolio, Inc. 69
Imagination Association, The 73
Millimac Licensing Co. 83
NALPAC, Ltd. 84
Paperpotamus Paper Products Inc. 89
Polish Associates, Marc 90
Portal Publications, Ltd. 91
Poster Porters 268
Spencer Gifts, Inc. 98
Syracuse Cultural Workers 100, 276
United Design 101
Vermont T's 101
Whitney Pink, Inc. 102

Wildlife Art

Adirondack Lakes Center for the Arts 451
Alaska Momma, Inc. 52
Alexandre Enterprises 243
Anderson Studio, Inc. 598
Animals 114
Art Encounter 443
Art Shows 500
Artisan's Gallery 503
Artist's Cooperative Gallery of Westerly 483
BC Outdoors, Hunting and Shooting 119
Bentley Publishing Group 245
Bergquist Imports, Inc. 55
Bernard Fine Art 246
Birdsnest Gallery 422
Bone Art Gallery 477
Bow & Arrow Hunting Magazine 123
Bradford Exchange, The 56
Brooklyn Botanic Garden—Steinhardt Conservatory Gallery 458

Bugle—Journal of Elk and the Hunt 124
Crumb Elbow Publishing 303
Dakota Outdoors 139
Dawn's Studio West 443
Decorcal Inc. 64
Devin Galleries 402
Duck Club Gallery 371
Game & Fish 149
Golden Books 312
Goldsmiths Fine Art 505
Great American Puzzle Factory Inc. 71
Greenleaf Gallery 375
Guildhall, Inc. 255
Guthart Gallery & Framing 415
Hadley House Publishing 255
Harriettes Gallery Harriette's Gallery of Art 441
Honor Oak Gallery 505
IGPC 73
Images of America Publishing Company 256
Impact Images 257
Kavanaugh Art Gallery 416
Ladybug 171
Lawrence Gallery, E.S. 385
Le Mieux Galleries 421
Levy Fine Art Publishing Inc., Leslie 258
Michelson Galleries, R. 428
Michigan Out of Doors 177
Mikols River Studio Inc. 436
Mill Pond Press Companies 261
Montana Magazine 180
Moriah Publishing, Inc. 262
Newman Galleries 481
North American Whitetail Magazine 189
Nova Development Corporation 522
Noyes Art Gallery 443
Old Print Barn—Art Gallery, The 444
Oregon River Watch 192
Painters Art Gallery 501
Paperpotamus Paper Products Inc. 89
Park Walk Gallery 506
Porterfield's Fine Art Licensing 91
Prime Art Products 269
Ranger Rick 207
Rickert Art Center 478
River Heights Publishing Inc. 270
Sanghavi Enterprises Pvt Ltd. 97
Schiftan Inc. 272
Soundprints 351
Sports Afield 221
Studio 10 437
Texas Parks & Wildlife 225
Universal Publishing 278
Voyageur Press 358
Walnut Street Gallery 416
Warner Press, Inc. 102
West End Gallery 495
Wild Wings Inc. 281
Willowtree Gallery 404
Windmill Gallery, The 478
Wy'East Historical Journal 236
Yellowstone Gallery 442
Youngman Galleries, Lee 380

General Index

Companies or galleries that appeared in the 2002 edition but do not appear in this edition are identified by a two-letter code explaining why the market was omitted: (**ED**)—Editorial Decision, (**NS**)—Not Accepting Submissions, (**NR**)—No (or late) Response to Listing Request, (**OB**)—Out of Business, (**M**)—Merged with Another Company, (**RR**)—Removed by listing's Request, (**UC**)—Unable to Contact.

A

A. & U. Magazine 106
A.T. Associates 562
AAIMS Publishers 284
A&B Publishers Group 284
Aaron Ashley Inc. 242
Abel Joseph Gallery 505
Abstein Gallery 397
Academy Gallery 381
Acme Graphics, Inc. 50
Action Images Inc. 242
Activate Entertainment 609
Active Life 107
Ad Agency, The 542
Adams Media Corporation 285
Addison/Ripley Fine Art 389
Adfiliation Advertising 593
Adirondack Lakes Center for the Arts 451
Adler Inc., Kurt S. 50
Administrative Arts, Inc. 638
Advance Cellocard Co., Inc. 51
Advantage Publishers' Group 285
Adventure Cyclist 107
Advertising Consortium, The 530
Advocate, The 107
Advocate, PKA's Publication 107
Aeroprint, (AKA Spofford House) 243
Afrocentrex 519
AGA Communications 606
AGFA Monotype Typography 519
Aging Today 108
Agora Gallery 456
Aguilar Expression, The 108
Aim 108
AKC Gazette 109
Alaska Business Monthly 109
Alaska Magazine 109
Alaska Momma, Inc. 52
Albano Gallery, Jean 406
ALBATROSS Records/R'N'D Productions 609
Albuquerque Museum, The 448
Alear Records 610
Alexander Fine Arts 391
Alexandre Enterprises 243
Alfred Publishing Co., Inc. 285
Alias Records 610
Aline Associates, France 639
Aljoni Music Co. 610
All Animals 109
Allport Editions 52

Allyn and Bacon, Inc. 286
Aloysius Butler & Clark (AB&C) 546
Alpert And Alpert, Inc. 603
Alphabeat 610
Alter Associates, Inc. 406
Alternative Therapies in Health and Medicine 110
Alva Gallery 386
Amberley Greeting Card Co. 52
AMCAL Fine Art 243
Amcal Inc. 52
Amelia (OB)
America 110
America West Airlines Magazine 110
American Art Company, The 499
American Artists, Rep. Inc. 639
American Atheist, The 110
American Bible Society, The 286
American Biographical Institute 286
American Brewer Magazine 111
American Fitness 111
American Gardener The 111
American Greetings Corporation 53
American Judicature Society 287
American Legion Magazine, The 111
American Libraries 112
American Medical News 112
American Muscle Magazine 112
American Music Network Inc. 611
American Music Teacher 112
American School Board Journal 112
American Spectator, The 113
American Traditional Stencils 53
American Woman Road & Travel 113
Americatone International—U.S.A. 611
Amherst Media, Inc. 287
Ampersand Press (RR)
AM/PM Advertising, Inc. 573
Amscan Inc. 53
Analog 113
Anderson O'Brien 442
Anderson Studio, Inc. 598
Andrews McMeel Publishing 287
Angel Films Company 570
Angel Fire Productions, Inc. 527
Angels on Earth Magazine 114
Animals 114
Aopa Pilot 114
Apex Magazine (OB)
Appalachian Mountain Club Books 288
Appalachian Trailway News 114
Applejack Licensing International 53

Applejack Limited Editions 243
Aquarium Fish Magazine 115
Aquarius Records/Tacca Musique 611
Arc-En-Ciel 445
Area Development Magazine 115
AR-EN Party Printers, Inc. 54
Ariana Records 611
Arizona Cine Equipment, Inc. 527
Arjuna Library Press 288
Ark 21 611
Arkansas Arts Center, The 370
Army Magazine 115
Arnold & Associates Productions 546
Arnold Art Store & Gallery 243
Arnot, Inc., Herbert 244
Arsenal Gallery, The 457
Art Attack Recordings/Mighty Fine Records 612
Art Beats, Inc. 244
Art Brokers of Colorado 244
Art Center/South Florida 392
Art Collector, The 371
Art Direction (OB)
Art Direction Book Co. Inc. 288
Art Directors Club Gallery 457
Art Emotion Corp. 244
Art Encounter 443
Art Forms 479
Art Hotel Inc. (OB)
Art Impressions, Inc. 244
Art League, Inc., The 498
Art Licensing International 639
Art Shows 500
Art Source LA Inc. 372, 639
Art Store, The 501
Art Without Walls, Inc. 452
Artbank Illustration Library 519
Artco, Incorporated 404, 640
ArtEffects Designs & Licensing Inc. 245
Artemis Creations 289
Artemis, Inc. 424
Artful Greetings 54
Arthritis Today Magazine 115
Arthur's International (RR)
Artisanity 452
Artisan's Gallery 503
Artisimo Artspace 368
Artist Development Group 640
Artistmarket.com (AKA A.D. Kahn, Inc.) 508

Artist's & Graphic Designer's Market 289
Artist's Cooperative Gallery of Westerly 483
Artist's Magazine, The 115
Artists Space 457
Artizans Syndicate 508
Artlink 412
Art:Mag 116
ArtQuote International, LLC 430
Arts Extended Gallery, Inc. 430
Arts for Living Center 414
Arts on Douglas 392
Arts Uniq' Inc. 245
Artspace/Lima 473
ArtVisions 245, 640
Asciutto Art Reps., Inc. 640
Ashby-Hodge Gallery of American Art, The 438
Ashcraft Design 541
Ashton-Drake Galleries, The 54
Asimov's Science Fiction Magazine, Isaac 116
Aspire (OB)
Associated Artists of Winston-Salem 469
Association of Brewers 116
Atheneum Books for Young Readers 289
Atlan-Dec/Grooveline Records 612
Atlanta Magazine 117
Atlantic Center for the Arts, Inc. 392
Atlantic Gallery 457
Atlantic Gallery of Georgetown 390
Atlantic Syndication/Editors Press 509
Atlas Games 289
Augsburg Fortress Publishers 290
Aurelio & Friends, Inc. 547
Authorship 117
Automobile Magazine 117
Automundo 118
Avalanche Press, Ltd. 290
Avalon Publishing Group 290
Avancé Designs, Inc. 580
Averil S. Smith, Artist Representative (OB)
Avon Books 290
Avrum I. Ashery—Graphic Designer 561

B
Babybug 118
Backpacker Magazine 118
Backwords Recordings 612
Baen Books 291
BAL Records 612
Balloon Life Magazine 118
Baltimore Jewish Times 118
Baltimore Magazine 119
Balzekas Museum of Lithuanian Culture Art Gallery 406
Bancroft & Friends, Carol 641
Barbour Publishing 291

Barnett Advertising/Design, Augustus 603
Barnstorm Design/Creative 543
Barracca Assoc. Inc., Sal 641
Bartender Magazine 119
Basic/Bedell Advertising & Publishing 530
Bass Group, The 530
Baton Rouge Gallery, Inc. 419
Bator & Associates 612
Battista Communications, Diccicco 594
Bay Books & Tapes 291
BBDO New York 580
BC Outdoors, Hunting and Shooting 119
Bear Deluxe, The 119
Beaver Pond Publishing 292
Beck Originals, Frederick 54
Beda Design 552
Bedford/St. Martin's 292
Behrman House, Inc. 292
Beistle Company 55
Belian Art Center 431
Bell Advertising & Design, Thomas S. 599
Bell Gallery, Cecilia Coker 485
Beluga Blue 612
Belyea 604
Benefactory, Inc., The 293
Bennett Galleries 488
Bent Gallery and Museum 448
Bentkover's Design & More 552
Bentley Publishers, Robert 293
Bentley Publishing Group 245
BePuzzled/University Games 55
Berendsen & Associates, Inc. 641
Berger & Associates, Inc., Barry David 580
Bergquist Imports Inc. 55, 246
Berkshire Originals 246
Berman Fine Arts, Mona 387
Bernard Fine Art 246
Berson, Dean, Stevens 531
Bertucci/Graphic Communications, Richard 562
Bethlehem Books 293
Beverage World Magazine 120
BFL Marketing Communications 589
Big Bear Records 613
Biggs Gilmore Communications 566
Billiard Library Co., The 246
Binary Arts Corp. 294
Bird Times (RR)
Bird-in-Hand Bookstore & Gallery 390
Birdsnest Gallery 422
Bitch: Feminist Response to Pop Culture 120
Black Bear Publications/Black Bear Review 120
Black Diamond Records Incorporated 613
Black Enterprise 122
Black Lily, The 122

Blackmar Collection, The 247
Blanden Memorial Art Museum 414
Blaster Boxx Hits 613
Blate Associates LLC, Sam 561
Bliley Stationery, Gene 55
Bliss House Inc (RR)
Bloomin' Flower Cards 56
Blossom Street Gallery & Sculpture Garden 489
Blount Bridgers House/Hobson Pittman Memorial Gallery 469
Blue Dolphin Gallery 392
Blue Mountain Gallery 458
Blue Note and Angel Records 613
Blue Sky Publishing 56
Blue Spiral 1 470
B'nai B'rith IJM, The 122
Boca Raton Museum of Art 393
Body & Soul 122
Bodzioch Design 563
Boeberitz Design, Bob 587
Boelts-Stratford Associates 528
Bone Art Gallery 477
Bonus Books, Inc. 294
Boody Fine Arts, Inc. 438
Book 123
Book Design 294
Bookmakers Ltd. 576
Boston Corporate Art 426
Bostonia Magazine 123
Boulder Museum of Contemporary Art, The 384
Bouquet-Orchid Enterprises 613
Bouregy & Co., Inc., Thomas 294
Bow & Arrow Hunting Magazine 123
Boxboard Containers International 123
BoxFire 558
Boyds Mills Press 295
Bradford Exchange, The 56
Bragaw Public Relations Services 553
Brainworks Design Group, Inc. 531
Brazen Images, Inc. 56
Brenau University Galleries 398
Brennan, Inc. Marketing Communications, Leo J. 567
Brest Museum/Gallery, Alexander 393
Brew House Space 101 479
Briardy Design 572
Briarhill Records 614
Bride's Magazine 124
Brilliant Enterprises 57
Brilliant Enterprises, Ashleigh 509
Brinton Lake Editions 247
Bristol Gift Co., Inc. 57
Broadhurst Gallery 470
Broadman & Holman Publishers 295
Brody, Artists & Photographers Representative & Consultant, Sam 642
Bromfield Art Gallery 426
Brooklyn Botanic Garden—Steinhardt Conservatory Gallery 458
Brooks Associates, Public Relations, Anita Helen 581

Browne Ltd., Pema 642
Brown's Galleries 402
Brownsboro Gallery (OB)
Bruck and Moss Associates 642
Brunner Gallery 420
Brush Dance Inc. 57
Bryant, Lahey & Barnes, Inc. 559
BSW Records 614
Buck Sydra Techniques Corp, Sid 642
Buckmasters Whitetail Magazine 124
Bugdal Group Inc. 547
Bugle—Journal of Elk and the Hunt 124
Buildings Magazine 124
Bulletin of the Atomic Scientists 125
Bunnell Street Gallery 368
Bureau for At-Risk Youth, The 295
Burgoyne, Inc. 57
Buschlen Mowatt Annex (RR)
Buschlen Mowatt Gallery 247
Business Law Today 125
Business London Magazine 125
Business NH Magazine (RR)
Business of Art Center 384
Business Travel News 126
Butridge Gallery at the Dougherty Arts
 Cetner, Julia C. 490
Butwin & Associates Advertising, Inc.
 568

C

C Gallery 495
C.P.R. Record Company 614
Cactus Game Design, Inc. 296
Cadeaux du Monde 483
California Home & Design 126
California Journal 126
Callaway Galleries, Inc. 435
Campus Life 126
Canadian Art Prints Inc. 247
Canadian Business 127
Canadian Dimension 127
Candy Cane Press 296
Canon & Shea Associates, Inc. 581
Cape Shore, Inc. 58
Capitol Records 614
CardMakers 58
Career Focus 127
Careers and Colleges 127
Carmel Fine Art Productions, Ltd. 248
Carnase, Inc. 581
Carole Joy Creations, Inc. 58
Carson County Square House Museum
 490
Carspecken Scott Gallery 388
Cartwheel Books 296
Case Stationery Co., Inc. 59
Caspari, Inc., H. George 59
Cat Fancy 127
Catch Publishing, Inc. 60
Catholic Forester 128
Catholic News Service 509
Cats & Kittens (RR)
Cavendish, Marshall 296
CCC Publications 297
CED 128
Cedar Street Galleries 400
Cedco Publishing Co. 60

Celebration: An Ecumenical Resource
 509
Center For Western Studies, The 297
Centerstream Publishing 297
Central Bank Gallery 418
Central Michigan University Art Gal-
 lery 431
Centric Corp. 60
Ceres 458
Chalk & Vermilion Fine Arts 248
Channel One Productions, Inc. (OB)
Chapellier Fine Art 470
Chapman Art Center Gallery 452
Chapman Recording Studios (NS)
Chariot Victor Publishing 297
Charleston Magazine 128
Charlotte Magazine 129
Chasin Fine Arts, Martin 387
Chatham Press, Inc. 298
Chattahoochee Records 615
Chelsea Galleries 473
Chelsea House Publishers 298
Chemical Specialties 129
Cherry Street Records, Inc. 615
Chesapeake Bay Magazine 129
Chestnut House Group Inc., The 555
Chic Magazine (OB)
Chickadee 130
Chicago Review Press (RR)
Child Life 130
Children's Book Press 299
Children's Digest 131
Children's Playmate 131
Children's Press 299
Childswork/Childsplay, LLC 299
Chile Pepper Magazine 131
China Books and Periodicals 299
Chislovsky Design, Inc., Carol (OB)
Chosy Gallery, Grace 501
Chozen Gallery 372
Christian Century, The 131
Christian Home & School 132
Christian Parenting Today Magazine
 132
Christian Reader 132
Christian School International 300
Chronicle Books 300
Chronicle of the Horse, The 132
Church Partners, Inc. Advertising &
 Graphic Design, Inc., Jann 531

Cicada 132
Cincinnati Art Museum 474
Cincinnati CityBeat 133
Cincinnati Magazine 133
Cine Design Films 543
Cintara 532
Circa Gallery (RR)
Circle K Magazine 133
Circlet Press, Inc. 300
Cirrus Editions 248
City Art Gallery 485
City Limits 133
City of Los Angeles' Cultural Affairs
 Department Slide Registry 381
CityArts, Inc. 459
Claretian Publications 134
Clarion Books 301
Clarke American 60

Classic Collections Fine Art 248
Clay Art 61
Clay Place, The 479
Cleaning Business 134
Clearvue, Inc. 555
Clearwater Navigator (OB)
Cleo, Inc. 61
Clergy Journal, The 134
Cleveland Magazine 134
Cleveland State University Art Gallery
 474
Cliff & Associates Design 532
CMH Records 615
Coakley Heagerty Advertising & Public
 Relations 532
Cobblestone, Discover American His-
 tory 135
Coffee House Press 301
Cohen Gallery for Contemporary Art,
 Byron 439
Coleman Fine Art 485
Coleman Presents, Inc., Woody 643
Collier Represents, Inc., Jan 643
Collignon, Daniele 643
Colonial Art Co., The 249
Color Circle Art Publishing (NS)
Colors By Design 61
Combat Aircraft: The International
 Journal of Military Aviation 135
Common Ground 135
Commonweal 135
Communications Electronics, Inc. 567
Communicore (OB)
Community Banker 136
Compass Marketing, Inc. 524
Compro Productions 549
Computeruser 136
Computerworld (RR)
Comstock Cards, Inc. 61
Conari Press 301
Concord Litho Group 62
Condé Nast Traveler 136
Confrontation: A Literary Journal 136
Conrad Represents . . . 643
Conservatory of American Letters 137
Construction Dimensions 137
Contemporary Art Workshop 407
Contemporary Arts Center 420
Contemporary Center 372
Contemporary Gallery 490
Continental Features/Continental News
 Service 509
Contract Professional 137
Cook Communications Ministries 137
Copley Mediaworks 544
Cornell & McCarthy 644
CornerHouse Gallery and Frame 415
Corporate Art Planning Inc. 459
Corporate Art Source 366
Corporate Report (OB)
Cortland-Leyten Gallery 407
Corwin Press, Inc. (NS)
Cosmo Girl 138
Cosmopolitan 138
Coulter + Bass Design (OB)
Council for Exceptional Children 302
Council for Indian Education (NS)
Countryman Press, The 302
Courage Center 62

Courthouse Gallery, Lake George Arts Project 452
Cousins Design 582
Covenant Companion, The 138
Craft Alliance Gallery 439
Crafts 'n Things 138
Crafts Report, The 138
Crazy Horse Prints 249
CRC Product Services 302
Creatif Licensing 62, 249
Creative Arts of Ventura 644
Creative Company, Inc. 593
Creative Consultants 604
Creative Freelancers Inc. 644
Creative House Marketing 567
Creative With Words Publications 302
Creators Syndicate, Inc. 510
Creek Records/Creeker Music Pub. 615
Cricket 139
Cricket Contrast Graphic Design 528
Crockett Cards 62
Cross Cultural Publications, Inc. 303
Cross Keys Advertising & Marketing, Inc. 595
Crossing Press, The 303
Crown Publishers, Inc. 303
CRS Artists 616
Cruise Creative Services, Inc. 63
Crumb Elbow Publishing 303
Crystal Creative Products, Inc. 63
Csoka/Benato/Fleurant, Inc. 582
CSPS 415
Cuesta College Art Gallery 372
Culbertson Design, Inc., Jo 543
Cumberland Gallery (RR)
Current, Inc. 63
Custom Craft Studio 546
Custom Medical Stock Photo, Inc. 519
Cutro Associates, Inc. 574

D

Dadian Gallery 390
Dahl & Associates, Steve (OB)
Daigle Design Inc. 604
Dairy Goat Journal 139
Dakota Art Gallery 487
Dakota Outdoors 139
Dales Gallery 504
Dallas Museum of Art 490
Dana Women Artist Series, Mary H. 445
Dancing USA Magazine 139
Dapmor Publishing Company 616
Dare to Move 249
DarkTales Publications 304
Dauphin Island Art Center 250
David Publishers, Jonathan 304
Davidson Galleries 500
Dawn's Studio West 443
Dayton Art Institute, The 474
DC Comics 140
De Figlio Design 582
De Graaf Forsythe Galleries, Inc. 431
de Gruyter, New York, Aldine 304

De Moreta Represents, Linda 644
Deady Advertising 603
Decker/Morris Gallery 368
Decorative Artist's Workbook 140
Decorative Expressions, Inc. 250
Decorcal Inc. 64
DeForest Communications, Lee 553
Delaware Art Museum Art Sales & Rental Gallery 388
Delaware Center for the Contemporary Arts 389
Delaware Today Magazine 140
Delicious! Magazine 140
Delirium Books 305
Delphine Gallery 374
Demi Monde Records & Publishing 616
Denton Design Associates 532
Denver Art Company, Inc. 250
Depot Square Gallery 426
Dermascope 141
Design Axiom 534
Design Collaborative 534
Design Concepts 577
Design Design, Inc. 64
Design Resource Center 553
Designer Greetings, Inc. 64
Detroit Artists Market 432
Detroit Free Press Magazine 141
Devin Galleries 402
DeVorzon Gallery 381
Di Marco, Anthony 560
Diegnan & Associates, Norman 574
Dimensions, Inc. 64
Directional Publishing, Inc. 250
DIRT Gallery 381
Discover 141
Discoveries 141
Dittmann Design 605
DiverseWorks Artspace 490
Diversion Magazine 141
Dix Art Mix 407
DLM Studio 65
DLS Design 582
DM/Bellmark/Critique Records 616
Dodo Graphics, Inc. 251
Dolphin Log 141
Dominie Press, Inc. 305
Donahue Advertising, LLC 544
Donovan Gallery, The 484
Doran Gallery, M.A. 477
Dorsky Museum of Art, Samuel 453
Dream Maker Software 520
Dreams of Decadence 142
Dubnick Gallery, Solomon 374
Duck Club Gallery 371
Durham Art Guild, Inc. 471
Dutton Children's Books 305
Dwyer & O'Grady, Inc. 645
Dykeman Associates Inc. 600
Dynamic Graphics Inc. 520

E

Earache Records 616
East Bay Monthly, The 142

Ebert Gallery 382
Ecco Press, The 306
Eddins Madison Creative 603
Edholm Design, Michael 572
Editions Limited Galleries, Inc. 251
Editions Limited/Frederick Beck 65
Educational Impressions, Inc. 306
Egan Design Associates 600
EJW Associates, Inc. 550
El Taller Gallery-Austin 491
Electrical Apparatus 142
Eleven East Ashland Independent Art Space 369
Elgar Publishing Inc., Edward 306
Eller Gallery & Appraisers, Peter 449
Elliott, Inc., Kristin 65
Elton-Wolf Publishing 306
EMC/Paradigm Publishing 307
Emergency Medicine Magazine 143
Emery Group, The 600
EMI Latin 617
Emmal Butler Creatives 605
Encore Graphics & Fine Art 251
Enesco Group, Inc. 66
Entrepreneur Magazine 143
Environment 143
Epic Products Inc. 67
Equity Marketing, Inc. 67
Erben Gallery, Thomas 459
Esquire 143
Essanee Unlimited, Inc. 534
Eternal Song Agency, The 617
Etherean Music/Elation Artists 617
Etherton Gallery 369
Etkin Gallery, Jay 488
Evans & Company, Inc., M. 307
Evenson Design Group 534
Eventiv 590
Everson Museum of Art 453
Excelsior Cee Publishing 307
Exhibit Builders Inc. 548
Eye for the Future 143
Eyecare Business/Boucher Communications, Inc. 144

F

Faber & Faber, Inc. 308
Facts on File 308
Fairfield Art Publishing 251
Falkirk Cultural Center 374
Family Circle 144
Fanjoy & Bell, Ltd. 308
Fantagraphics Books 144
Fantagraphics Books, Inc. 308
Fantazia Marketing Corp. 67
Faribault Art Center, Inc. 435
Farrar, Straus & Giroux, Inc. 309
Fashion Accessories 144
Fast Company 145
Faultline 145
Federal Computer Week 145
F8 Fine Art Gallery 491
Feinman Fine Arts Ltd., Stephen E. 459

Fenton Art Glass Company 67
Fiddler's Elbow 68
Fifty Something Magazine 145
Filipinas Magazine 145
Films for Christ 309
Final Edition, The 146
Fine Art Productions, Richie Suraci Pictures, Multimedia, InterActive 68, 577
Fine Arts Center Galleries/University of R.I. 484
Finescale Modeler 146
Firehouse 101 Art + Design Inc. 590
First Books 309
First For Women 146
First Hand Magazine 147
First Power Entertainment Group 617
First Street Gallery 460
First Visit & Beyond (OB)
Fisher-Price 68
Fitzgerald & Co. 550
516 Magnifico Artspace 449
Flagler Advertising/Graphic Design 563
Flint Communications 589
Florida Leader Magazine 147
Florida State University Museum of Fine Arts 393
Fly Fisherman Magazine 147
Focal Point Gallery 460
Focus On The Family 147
Focus Publishing 309
Folio 148
Foodservice And Hospitality 148
Foodservice Director Magazine 148
Foote, Cone & Belding 541
Ford Agency, The 593
Forde Galleries, Gannon & Elsa 472
ForeFront Records/EMI Christian Music Group 618
Fort Ross Inc. 309
Fortuni 645
Forward Movement Publications 310
Foster Artist Rep., (Pat) 645
Foster Publishing, Walter 310
Foster/White Gallery 500
Fotofolio, Inc. 69
Foundation News & Commentary 148
Fox, Photographer, David 563
Foxhall Gallery 391
Frank & Associates Inc., Alan 602
Franklin Mint, The 69
Fraser Gallery, The 391
Fravessi Greetings, Inc. 69
FreeAssociates 535
Freelance Advancers, Inc. 645
Freelance Exchange, Inc. 545
Freelance Express, Inc. 583
Freeport Arts Center 404
Friedl Gallery, Oskar 407
FSP Communications 562
Fullmoon Creations Inc. 595
Fundora Art Gallery 252
Future Publishing Ltd. 148
Futuretalk Telecommunications Company, Inc. 600
Futurist, The 149

G

G.C.W.A.P. Inc. 252
Galaxy of Graphics, Ltd. 252
Gale-Martin Fine Art 460
Galerie Bonheur 439
Galerie Europa/Flying Colours (OB)
Galerie Timothy Tew 398
Galison Books 69
Galison Books/Mudpuppy Press 311
Galitz Fine Art, Robert 252, 404, 408
Galitz Fine Art/Accent Art, Robert 646
Gallant Greetings Corp. 70
Gallery By The Lake (OB)
Gallery Four Inc. (RR)
Gallery 400, University of Illinois at Chicago 408
Gallery C 471
Gallery Eight 375
Gallery 825 382
Gallery 54, Inc. 367
Gallery Graphics, Inc. 70
Gallery Henoch 461
Gallery Joe 480
Gallery Juno 461
Gallery M 385
Gallery Magazine 149
Gallery NAGA 427
Gallery North 453
Gallery of South Orange, The 445
Gallery 1633 408
Gallery 72 442
Gallery Shop and Galleries: Birmingham Bloomfield Art Center 432
Gallery 10 461
Gallery 312 409
Gallopade International/Carole Marsh Family CD-ROM 311
Galman Lepow Associates, Inc. 446
Game & Fish 149
Gango Editions 253
Garden Gate Magazine 150
Garrity Communications, Inc. 577
Garver Gallery, The Fanny 502
Gary Ltd. Fine Art, David 446
Gatlin Represents, Inc., Rita 646
Gauntlet Press 311
Gayot Publications 311
Gem Guides Book Co. 311
Geme Art Inc. 253
Genesis Marketing Group (RR)
Gentry Magazine 150
Georgia Magazine 150
Gerald & Cullen Rapp, Inc. (RR)Gering Gallery, Sandra 461
Geter Advertising Inc. 555
Getty Images 520
Ghawaco International Inc. 253
Gibbs Smith, Publisher 312
Gibson, Creative Papers, C.R. 70
Gifted Line, The 70
Giftware News 150
Giftware News UK 151
Gilbert Luber Gallery (OB)
Gillaspy/Brandon Taylor Design, Dennis 535
Girlfriends Magazine 151
Girls' Life 151

Girvin Strategic Branding and Design 605
Glamour 151
Glass Factory Directory (RR)
Glitterwrap Inc. 71
GM Recordings (NS)
Godat Design Inc. 528
Goddess Records/California Song Magazine 618
Godfrey Representing Artists, Dennis 646
Goff, Inc., Bill 387
Gold & Associates Inc. 548
Gold and Treasure Hunter Magazine (OB)
Golden Books 312
Goldsmiths Fine Art 505
Goldsmith Yamasaki Specht (OB)
Goldstrom Gallery 462
Golf Illustrated 151
Golf Journal 152
Golf Tips Magazine 152
Golfer, The 152
Goltz Group/Chicago Art Source, The 254
Gomez Gallery 424
Goose Lane Editions Ltd. 312
Gordon Associates, Ltd., Barbara 646
Governing 152
Graboski Associates Inc., Tom 548
Graduate Group, The 313
Grafica Design Service 535
Graham & Brown 71
Grand Rapids Art Museum 432
Graphic Arts Communications 510
Graphic Arts Monthly 153
Graphic Corp. 520
Graphic Design Concepts 541
Graphique de France 254
Graphix in Motion (OB)
Grass Roots Productions 618
Gray Areas 153
Graywolf Press 313
Great American Puzzle Factory Inc. 71
Great Arrow Graphics 71
Great Quotations Publishing 313
Green Linnet Records, Inc. 619
Green Tara Gallery 471
Greenberg Art Publishing, Raymond L. 254
Greenleaf Gallery 375
GreenPrints 153
Greenwich Workshop, Inc., The 254
Gregory Editions 255
Gremillion & Co. Fine Art Inc. 491
Greteman Group 559
Grien—Representing Artists, Anita 647
Griffin Marketing Services, Inc. 558
Grosset & Dunlap 313
Group Publishing Book Product 314
Group Publishing—Magazine Division 153
Groveland Gallery 435
Gryphon Publications 314
G2 Partners 563
Guardians Of Order 315
Guenzi Agents, Inc., Carol 647
Guernica Editions 315
Guide for Expectant Parents (OB)

Guided Imagery Design & Productions 647
Guideposts For Teens 154
Guideposts Magazine 154
Guildhall, Inc. 255
Guitar Player 154
Gulf Coast Media 155
Gulfshore Life Magazine 155
Gulfshore Life's Home & Condo Magazine 155
Guthart Gallery & Framing 415
Gwenda Jay/Addington Gallery 409

H

Habitat Magazine 155
Hackett/Artist Representative, Pat 647
Hadassah Magazine 156
Haddad Gallery, Carrie 453
Haddad's Fine Arts Inc. 255
Hadley House Publishing 255
Hahn & Co., Holly 647
Hale Gallery, Judith 375
Hallmark Cards, Inc. 72
Hammond Design Associates, Inc. 559
Hampton University Museum 498
Hana Coast Gallery 400
Hankins & Tegenborg, Ltd. 648
Hannah-Pressley Publishing 72
Hanson Gallery 420
Hard Hat Records and Cassette Tapes 619
Hardwood Matters 156
Harlan Davidson, Inc. 315
Harmon Group 598
Harmony House Publishers—Louisville 316
HarperCollins Publishers, Ltd. (Canada) 316
Harper's Magazine 156
Harriettes Gallery Harriette's Gallery of Art 441
Harris Works of Art, O.K. 462
Hartung & Associates, Ltd. 536
Harvest House Publishers 316
Harwood Museum of Art, The 449
Hauser, Another Girl Rep, Barb 648
Havu Gallery, William 385
Hay House, Inc. 316
Healthcare Financial Management 156
Hearst Art Gallery, Saint Mary's College 376
Heart Graphic Design 567
Heart Steps Inc. 72
Heartland Boating Magazine 156
Heartland USA 157
Heath Greeting Cards, Inc., Marian 72
Heaven Blue Rose Contemporary Gallery 398
Heaven Bone 157
Heaven Bone Press 317
Hedden-Nicely & Assoc. 552
Hedge/Artist Representative, Joanne 648

Hemkunt Publishers Ltd. 317
Hemphill Fine Arts 391
Henderson Gallery, Carol 492
Hendler, Jeanette 462
Henry Street Settlement/Albions Art Center 462
Hera Educational Foundation, Hera Gallery 484
HerbalGram 157
Heritage Center, Inc., The 487
Hickory Lane Records 619
High Country News 158
Highlights for Children 158
Hill And Knowlton, Inc. 583
Hill and Wang 317
Hillel Jewish Student Center Gallery 474
Hippocrene Books Inc. 318
Hirsch O'Connor Design Inc. 555
Hispanic Magazine 158
Hitchcock Magazine, Alfred 159
Hitchins Company, The 536
Hixon & Fiering, Inc. (OB)
HK Portfolio 648
Hockaday Museum of Art 441
Holcomb Hathaway, Publishers 318
Holland & Company, Inc., Mary 649
Hollow Earth Publishing 318
Holmberg, Irmel 649
Holt Books For Young Readers, Henry 319
Home Business Magazine 159
Home Education Magazine 159
Home Furnishings Retailer 159
Homestead Publishing 319
Honolulu Academy of Arts 401
Honor Books 319
Honor Oak Gallery 505
Hoosier Salon Patrons Association & Gallery 413
Hopscotch, The Magazine for Girls 160
Hornall Anderson Design Works, Inc. 605
Horse Illustrated 160
Hottrax Records 619
Houghton Mifflin Company 320
House Beautiful 160
House Calls 161
How 161
Howell Press, Inc. 320
HR Magazine 161
Hughes Fine Art Center Art Gallery 473
Hula Records 619
Hull Associates, Scott 649
Hulsey Graphics 550
Human Relations Media 578
Humanics Publishing Group 320
Humpty Dumpty's Magazine 161
Huntington House Publishers 321
Hurricane Alice: A Feminist Quarterly 161
Hustler's Barely Legal 162
Hustler's Leg World 162

Hutchinson Associates, Inc. 556
HX Magazine 162
Hyde Park Art Center 409

I

IAC Contemporary Art 450
Icebox Quality Framing & Gallery 435
IDC 545
Ideals Magazine 162
Ideas Unlimited for Editors 521
Identity Center 553
IEEE Spectrum 163
Ignatius Press 321
IGPC 73
Illinois Art Gallery 410
Illinois Artisans Program 410
IMAC 578
Image Associates Inc. 588
Image Connection 256
Image Conscious 256
Images of America Publishing Company 256
Imaginary Entertainment Corp. 620
Imaginasium, Inc. 606
Imagination Association, The 73
Imcon 257
Impact Images 257
Impact Weekly 163
In Touch for Men 163
Incentive Publications, Inc. 321
Incolay Studios Incorporated 73
Independent Weekly, The 164
Index Stock/Stockworks 521
Indianapolis Art Center 413
Information Week 164
Ingbar Gallery of Architectural Art, Michael 463
Ingrams Magazine 164
Ink Inc. 589
Inkadinkado, Inc. 74
Inner Traditions International/Bear & Company 321
Innovation Multimedia 521
Innovative Design & Graphics 554
Inside 164
Inspirations Unlimited 74
Instant Replay 590
Intar Hispanic American Art Center 463
Interarts Gallery 405
Intercontinental Greetings Ltd. 74, 257
Intercultural Museum Art Gallery (IMAG) 424
Intercultural Press, Inc. 322
Intermarketing Group, The 74
International Graphics GMBH 257
International Marine/Ragged Mountain Press 322
Intelplex (OB)
Interrace (OB)
Intersection for the Arts 383
Irish Music Corporation 620
Irving Arts Center—Galleries and Sculpture Garden 492

Islands 165
Ivánffy & Uhler Gallery 492
Ivy League of Artists, The 649

J

J.B. Fine Arts/Central Gallery (RR)
Jack and Jill 165
Jacksonville 165
Jacob Gallery, Ann 399
Jacob Gallery, Elaine L. 432
Jadite Galleries 463
Jain Publishing Co. 322
Jalmar Press/Innerchoice Publishing 323
Jameson Gallery & Frame 423
January Productions, Inc. 574
Japanophile 166
Jay Jay Record, Tape & Video Co. 620
Jazziz 166
JEMS 166
Jewish Action 166
Jewish Lights Publishing 323
Jewish News of Western Massachusetts (OB)
Jill Features, Jodi 510
Jillson & Roberts 76
J-Mar, Inc. (RR)
JMH Corporation 558
Jojuma Gallery 450
Jones Design, Brent A. 542
Jones Gallery, Stella 421
Jonson Gallery, University of New Mexico 450
Jordan Gallery, Steven 486
Jordon Fine Art, Madelyn 464
Journal of Accountancy 167
Journal of Health Education 167
Journal of Light Construction, The (RR)
JSA Publications, Inc. (OB)
jude studios 601
Judicature 167
Judson Press 323

K

Kaeden Books 324
Kaji Aso Studio/Gallery Nature and Temptation 427
Kaleidoscope: Exploring the Experience of Disability through Literature and the Fine Arts 169
Kalifornia Killer Recordings (KKR) 620
Kalliope 169
Kalmbach Publishing Co. 324
Kamehameha Schools Press 324
Kamin & Associates, Vincent 649
Kaplan Co., Inc., Arthur A. 258
Kar-Ben Copies, Inc. 325
Kastaris & Associates 649
Kaufman Ryan Stral Inc. 556
Kavanaugh Art Gallery 416
Kendall Campus Art Gallery, Miami-Dade Community College 394
Kendall/Hunt Publishing Co. 325
Kentucky Art & Craft Gallery 418
Kentucky Living 169
KETC Guide, The 169
Keynoter 170

Kid Stuff 76
Kimbo Educational 620
Kimche, Tania 650
King Features Syndicate 511
Kingston Gallery 427
Kiplinger's Personal Finance 170
Kipling's Creative Dare Devils 76
Kirchoff/Wohlberg, Artists Representation Division 650
Kirkbride Bible Co. Inc. 325
Kirkland Art Center 454
Kite Lines (OB)
Kiwanis 170
KJD Teleproductions 574
Klein Art Works 410
Klein Publications Inc., B. 326
Klimt Represents 650
Knecht—Artist Representative, Cliff 650
Kneeland Gallery 402
Knopf, Alfred A., Inc. 326
Koeffler Artist Representation, Ann 651
Koehler Companies 76
Krasl Art Center 433
K-Tel International (USA) Inc. (OB)
Kunstwerk Galerie (RR)
Kurlansky Associates, Sharon 651

L

L.A. Parent Magazine 170
L.A. Records 621
L.A. Weekly 171
Ladybug 171
Lamon Records Inc. 621
Lancaster Museum of Art 480
Landing Gallery 454
Landsman's Gallery & Picture Framing 446
Lang Companies, The 77
Lang Publishing, Inc., Peter 326
Langley Creative 651
Laredo Publishing Co./Renaissance House 326
Latino Arts, Inc. 502
Laugh Lines Press (NS)
Lavaty & Associates, Jeff 651
Law Practice Management 171
Lawrence Gallery, E.S. 385
LCDM Entertainment 621
Le Mieux Galleries 421
Leader Paper Products/Paper Adventures 77
Learsi Gallery 376
Leatherstocking Gallery 454
Lee & Low Books 327
Lee Records, Patty 621
Legacy Publishing Group 77
Leighton & Company, Inc. 652
Leisure Books/Love Spell 328
Lekasmiller 536
Lematt Music 622
Lemon Tree Stationery Corp., The 77
Leo Art Studio Inc. 583
Leone Design Group Inc. 578
Leprevost Corporation, The 536
Lesli Art, Inc. 258, 652
Levy Design, Howard (RR)

Levy Fine Art Publishing Inc., Leslie 258
Libraries Unlimited/Teacher Ideas Press 328
Library Art Studio 423
Lieber Brewster Design, Inc. 583
Lieberman Laboratories, Inc., Ken 584
Life Greetings 80
Liggett-Stashower 591
Limited Editions & Collectibles 446
Limner Gallery 464
Lindgren & Smith 652
Linear Cycle Productions 536
Lipman Publishing 259
Lippincott Williams & Wilkins 328
Listen Magazine 171
Little Enterprises, Inc., Lew 511
Liturgy Training Publications 329
Living Music 622
Lizardi/Harp Gallery 376
Llewellyn Publications 329
LMNOP® 622
Loard Gallery of Fine Arts, Leon 367
Log Home Living 172
Lohre & Associates 591
Lola Ltd./Lt'ee 259
Lolo Company, The 81
Lomangino Studio Inc. 547
London Contemporary Art 259, 652
Longview Museum of Fine Arts 494
Lookinglass, Inc. 82
Lookout, The 172
Loompanics Unlimited 329
Lord & Bentley Persuasive Marketing 537
Lorenc Design, Inc. 550
Los Angeles Magazine 172
Los Angeles Municipal Art Gallery 382
Lowe Gallery, The 399
LPG Greetings, Inc. 82
Lubell Brodsky Inc. 584
Luby & Company, Inc., Jodi 584
Lucey/Art & Design, Jack 537
Lucifer Records, Inc. 622
Lugus Publications 330
Lunt Silversmiths 82
Luther College Galleries 416
Lutheran, The 172
Lynese Octobre Inc. 260
Lynx Eye 173
Lyons Press, The 330
Lyss Fine Art 440

M

M. Group Graphic Design, The 528
McCaffery Ratner Gottlieb & Lane, Inc. 585
Macey Noyes Associates, Inc. 545
Mack Advertising, Taylor 529
MacNider Art Museum 416
Mad Magazine 173
Made to Measure 173
Mademoiselle (OB)
Madison Books 330
Madison Park Greetings 82
Maggie's Music, Inc. 622
Magical Blend 173
Mahan Graphics, Michael 561

Main and Third Floor Galleries 419
Main Floor Editions 260
Main Line Today 173
Malton Gallery 475
Maltz Gallery 377
Managed Care 175
Management Review (OB)
Mangan/Holcomb/Rainwater/
 Culpepper & Partners 530
Mann, Inc., Seymour 260
Manor Art Enterprises, Ltd. 260
Many Mountains Moving 175
MapEasy, Inc. 331
Marbella Gallery, Inc., The 464
Marco Fine Arts 260
Margieart (OB)Markefxs 584
Markeim Art Center 447
Marketing by Design 537
Marks Collection, The (OB)
Marlboro Fine Art & Publishing, Ltd.
 261
Marlboro Gallery 425
Marlena Agency 653
Marsh Art Gallery 498
Martha Productions, Inc. 653
Martin Thomas, Inc. 597
Massage Magazine 175
Masur Museum of Art 421
Matteucci Galleries, Nedra 450
Mattress Factory 480
Mature Outlook (OB)
Maxwell Fine Arts 455
May Foundation Gallery, Morton J. 440
Mayans Galleries, Ltd. 451
Mayer Studios Inc., Charles 591
Mayor's Office of Culture and the Arts
 401
Mbusiness 175
McAndrew Advertising 578
McClanahan Graphics Inc. (OB)
McCollum Design, Sudie 537
McCoy Music, Jim 623
McDonough Museum of Art 475
McFarland & Company, Inc. (RR)
McGowan Fine Art, Inc. 444
McGaw Graphics, Inc., Bruce 261
McGrathics 564
McKenzie/Hubbell Creative Services
 545
MCS Gallery 480
Mead Art Museum 428
Meadowbrook Press 331
Means Co., Inc., R.S. 331
Media Consultants 570
Media Enterprises 538
Media Graphics 598
Mediphors, A Literary Journal (OB)
Meeting Professional, The 175
Meetings In the West 176
Melanson Associates, Donya 564
Mellblom Studio, Barbara (OB)
Mennonite Publishing House/Herald
 Press 332

Meridian Communications 559
Meridian Museum of Art 437
Merims Communications, Art 591
Merrell & Partners, Howard 588
Merrill Johnson Gallery 386
Mesa Contemporary Arts 369
Metal Blade Records, Inc. 623
Metro Creative Graphics, Inc. 521
Metro Pulse 176
MetroKids 176
MetroSports Magazine 176
Meyer Inc., Frances 83
Mia Mind Music 623
Miami Art Museum 394
Michelle's of Delaware 389
Michelson Galleries, R. 428
Michigan Living 177
Michigan Out of Doors 177
Microsoft Certified Professional Maga-
 zine 177
Mid-American Review 177
Middletown Fine Arts Center, The 475
Midwest Museum of American Art 413
Mighty Records 623
Mikols River Studio Inc. 436
Miles Advertising 529
Milestone Graphics 522
Milici Valenti NG PACK 551
Milkweed Editions 332
Mill Brook Gallery & Sculpture Garden
 444
Mill Pond Press Companies 261
Miller Gallery 475
Miller Gallery, Peter 410
Millimac Licensing Co. 83
Minority Features Syndicate, Inc. 511
Miranda Designs Inc. 579
Mississippi Crafts Center 437
Mitchell Advertising 543
Mitchell & Resnikoff 595
Mitchell Lane Publishers, Inc. 332
Mitchell Studios Design Consultants
 579
Mixedblessing 83
Mizerek Design Inc. 584
Mobile Beat 177
Model Railroader 178
Modares Art Publishing 262
Modern Drummer 178
Modern Healthcare Magazine 178
Modern Language Association 333
Modern Maturity 178
Modern Plastics 178
Modern Publishing 333
Modern Reformation Magazine 179
Modern Salon 179
Modernart Editions 262
Mojo Records 623
Moment 179
Monderer Design, Inc. 564
Mondo Publishing 333
Money 179
Montagano & Associates 653

Montana Magazine 180
Montezuma Books & Gallery 377
Morehouse Publishing Group 333
Morgan Gaynin Inc. 653
Morgan Horse, The 180
Morgan Kaufmann Publishers, Inc. 334
Moriah Publishing, Inc. 262
Morrison Associates, Inc., Ruth 564
Morrow & Co. Inc., William 334
Mother Jones 180
Mothering Magazine 180
Motor Magazine 181
Mountain Press Publishing Co. 334
Moyer Bell 335
MSR Advertising, Inc. 556
Multiple Impressions, Ltd. 464
Munson Graphics 263
Murphy Co., J.T. 83
Musclemag International 181
Museo Italoamericano 383
Museum of Printing History 494
Mushing 181
Music For Little People/EarthBeat! Re-
 cord Company 624
Mutual Funds Magazine 182
My Friend 182
My Sentiments (OB)
Mystery Review, The 182

N

NAF Gallery 405
NA'AMAT Woman 182
Nailpro 183
Nails 183
Naish, Cohen & Assoc. (NC&A Inc.)
 595
NALPAC, Ltd. 84
NAPCO Marketing 84
Nashville Life (OB)
Nation, The 183
National Design Corp. 84
National Enquirer 183
National Lampoon 184
National News Bureau 511
National Notary, The 184
National Review 184
National Wildlife Galleries/art-
 finders.com 263
Nation's Restaurant News 185
Natural History 185
Natural Life 185
Naturally Magazine 185
Nature Conservancy 185
NBM Publishing Co. 335
NCE, New Creative Enterprises, Inc. 84
Neiman Group, The 596
Nelson Associates Inc., Louis 585
Nerve Cowboy 186
Network Computing 186
Network Magazine 186
Neurodisc Records, Inc. 624
Nevada 186
New Breed, The 511

New Deco, Inc. 85, 263
New England Card Co. 85
New England Press, The 335
New Hampshire Magazine 186
New Leaf Gallery, A 377
New Moon: The Magazine for Girls and Their Dreams 187
New Mystery Magazine 187
New Orleans Artworks Gallery/Glass-blowing and Printmaking Studio 421
new renaissance, the 187
New Times LA 188
New Writer's Magazine 188
New York Graphic Society 263
New Yorker, The 188
Newborn Group, Inc., The 654
Newman Galleries 481
Newsweek 188
NextMonet 263
Nexus Gallery (OB)
Nicosia Creative Expresso Ltd. 585
Nielsen Gallery 428
Nightlife Magazine 189
Nikolai Fine Art 464
Niu Art Museum 405
N-M Letters, Inc. 85
Noble Works 85
North American Whitetail Magazine 189
North Star Music Inc. 624
Northern Cards 85
Northland Poster Collective 264
Northland Publishing 335
Northwest Art Center 473
Northwest Publishing & Sun Dance Graphics 264
Northwestern Products, Inc. 336
Northwestern University Dittmar Gallery 406
Northwoods Press 336
Nosei Gallery, Annina 465
Nostradamus Advertising 585
Notes & Queries 86
Noteworthy Company, The (RR)
Notre Dame Magazine 189
Nottingham Fine Art 264
Nouvelles Images Inc. 264
Nova Development Corporation 522
Nova Express 189
Nova Media Inc. 265
Novalis Publishing, Inc. 336
Novo Card Publishers Inc. 86
Nõvus, Inc. 399
Now And Then 189
Nowicki and Associates, Lori 654
Noyes Art Gallery 443
Noyes Museum of Art, The 447
NRN Designs, Inc. 86
Nuance Galleries 394
Nurseweek 190
NURTUREart Non-Profit, Inc. 465

O

Oakley Design Studios 594
O&A Marketing News 190
Oatmeal Studios 86
O'Carroll Group, The 560

Octameron Press 337
Octavia's Haze Gallery 383
Oden Marketing & Design 599
Off Our Backs 190
OfficePRO 190
Offray 87
Oh Boy Records 624
Ohio Magazine 191
Oklahoma Today Magazine 191
Old Grange Graphics 265
Old Print Barn—Art Gallery, The 444
Old World Prints, Ltd. 265
Omni (OB)
One Mile Up, Inc. 522
One Step To Happiness Music 625
Online Access Magazine (OB)
On-Q Productions, Inc. 538
Ontario Federation of Anglers and Hunters 87
Opening Night Gallery 436
Optimist, The 191
Opus 71 Galleries, Headquarters 394
Opus One 625
Opus One Publishing 266
Orange Coast Magazine 192
Orange County Center for Contemporary Art 377
Orchard Books 337
Oregon Catholic Press 192, 337, 625
Oregon Historical Society Press 337
Oregon Quarterly (NS)
Oregon River Watch 192
Oregon State University Press 338
Organic Gardening 193
Origin Design, Inc. 601
Orlando Gallery 378
Orlando Magazine 193
Other Side, The 193
Ottenheimer Publishers, Inc. (OB)
Our State: Down Home in North Carolina 193
Our Sunday Visitor 193
Outdoor Canada Magazine 194
Outdoor Life Magazine 194
Outer Darkness 194
Over The Back Fence 194
Overlook Press, The 338
Overmountain Press, The 338
Overtime Station (RR)
Owen Publications Inc., Richard C. 338
Oxford American, The 195
Oxford Gallery 455
Oxford University Press 339
Oxygen 195

P

P.O.V. (OB)
P.S. Greetings, Inc. 87
Pacia Modern, Bose 465
Pacific Yachting Magazine 195
Pageworks Communication Design, Inc. 544
Paint Horse Journal 195
Painted Bride Art Center 481
Painted Hearts & Friends 87
Painters Art Gallery 501
Painting Center, The 466
Palatino Editions 266

Palm Avenue Gallery 395
Palm Pictures 625
Palo Alto Weekly 196
Panache Editions Ltd 266
Panda Ink 88
Pandisc Records 625
Papel Giftware℠ 88
Paper Magic Group Inc. 88
Paper Moon Graphics, Inc. 89
Paperpotamus Paper Products Inc. 89
Paperproducts Design U.S. Inc. 89
Papillon International Giftware Inc. 90
Parabola Magazine 196
Parade Magazine 196
Paradise Prints, Inc. (OB)
Parallax Records 625
Paramount Cards Inc. 90
Parents 196
Parents' Press 196
Park Walk Gallery 506
Parker Advertising Company 592
Parthenon, The 489
Passerine Press Publishers (OB)
Passport 197
Pauline Books & Media 339
Paulist Press 339
PC Magazine 197
Peachpit Press, Inc. 340
Peachtree Publishers 340
Peacock Collection 506
Peacock Gallery, Deborah 494
Pearson Technology Group 340
Pediatric Annals 197
Pelican Publishing Co. 341
Pen Notes, Inc. 341
Penguin Books 341
Pennsylvania Lawyer 197
Penny Lane Pubishing Inc. 266
Pensacola Museum of Art 395
Pentimenti Gallery 481
Pepper Gallery 428
Perceptive Marketers Agency, Ltd. 596
Peregrine 341
Perfection Learning Corporation, Cover-to-Cover 342
Persimmon Hill 197
Pet Business 198
Peter Pauper Press, Inc. 342
Petter Gallery, Joyce 433
Pewabic Pottery 434
Phi Delta Kappan 198
Philadelphia Weekly 198
Phillips Gallery 496
Phoenix Gallery, The 466
Phoenix Gallery Topeka 417
Phoenix Learning Group, Inc. 571
Photo Communication Services, Inc. 567
Photo Library Inc., The 579
Phun Phit Designs, Ltd. (RR)
Pickard China. 90
Picture Co., The 267
Pieces of the Heart (OB)
Pihera Advertising Association (OB)
Pilgrim Press/United Church Press, The 343
Pincushion Press 343
Pine Cone Gallery Inc (RR)
Planning 198

Plant & Associates 593
Play Station Magazine 199
Playboy Magazine 199
Players Press 343
Plus Magazine 199
PN/Paraplegia News 199
Pockets 200
Policy Review 200
Polish Associates, Marc 90
Polk Museum of Art 395
Popcorn Factory, The 90
Poptronics 200
Popular Science 200
Portal Publications, Ltd. 91, 267
Porter Design—Editions Porter 267
Porter Sesnon Gallery, The Mary 378
Porterfield's Fine Art Licensing 91
Portfolio Art Gallery 486
Portfolio Graphics, Inc. 92, 267
Posner Advertising 586
Posner Fine Art 268, 378
Postal Productions, Steve 548
Poster Porters 268
Posters International 268
Potpourri 201
Potter And Assoc 588
Potter's Center, The 403
Powder Magazine 201
Power and Associates,Inc., R H 576
PPI Entertainment Group 626
PPL Entertainment Group 626
Prairie Journal Trust 201
Prairie Music Ltd. 626
Prairie Schooner 201
Prakapas Gallery 455
Prakken Publications, Inc. 344
Prapas/Artist Representative, Christine
 654
Pratt & Austin Company, Inc. 92
Pravda Records 626
Premier Film & Recording Co. (OB)
Premiere Magazine 202
Prentice Hall 344
Prentice Hall College Division 344
Presbyterian Record, The 202
Presbyterians Today 202
President & CEO 202
Prestige Art Inc. 269
Prevention 203
Price Stern Sloan 344
Prime Art Products 269
Prime Time Sports & Fitness 203
Prince Royal Gallery, The 499
Princeton Alumni Weekly 203
Princeton MarketTech 575
Principle Gallery 499
Print Center, The 482
Print Magazine 203
Printery House of Conception Abbey,
 The 92
Prints And The Paper, The 269
Prism international 204
Prismatix, Inc. 92

Private Pilot 204
Prizm Inc. 93
Pro Image Greetings, Inc. 93
Proceedings 204
Professional Tool & Equipment News
 and Bodyshop Expo 204
Profit Magazine 205
Progressive, The 205
Progressive Editions 269
Progressive Rentals 205
Prolingua Associates 345
Protooner 205
Prudent Publishing 93
Psychology Today 206
Public Citizen News 206
Publishers Weekly 206
Pucker Gallery, Inc. 429
Puffin Books 345
Pulsar Games, Inc. 345
Pulse-Finger Press 346
Pump House Center for the Arts 476
Putnam's Sons, G.P. 346
Putumayo World Music 627

Q
Qbadisc (NS)
QECE (Question Everything Challenge
 Everything) 206
Qually & Company, Inc. 554
Queen Emma Gallery (OB)
Queen of All Hearts 207
Queens College Art Center 466
Queen's Mystery Magazine, Ellery 207
Quill & Quire 207
Quite Specific Media Group Ltd. 346
Quon/Designation Inc., Mike 586

R
R.E.F. Recording Company/Frick Mu-
 sic Publishing Company 627
Racquetball Magazine 207
Rafelman Fine Arts, Marcia 504
Rahr-West Art Museum 502
Rain Visual Strategy 529
Rainbow Books, Inc. 346
Rainbow Creations, Inc. 93
Raleigh Contemporary Gallery 472
Rammit Records 627
Ramsay Museum 401
Random House Children's Book Group
 347
Random House Value Publishing 347
Ranger Rick 207
Rapp, Inc., Gerald & Cullen 654
Rapport 208
Raydon Gallery 466
RDH 208
Reader's Digest 208
Read'N Run Books 347
Really Good Copy Co. 546
Reason Magazine (NS)
Reco International Corporation 94
Recycled Paper Greetings Inc. 94

Red Deer Press 348
Red Farm Studio 94
Red Wheel/Weiser 348
Redbook Magazine 209
Redmond Design, Patrick 569
Reed Gallery, Anne 403
Reedproductions 94
Reform Judaism 209
Regnery Publishing Inc. 348
Reilly: Reps, Kerry 654
Reinberger Galleries, Cleveland Insti-
 tute of Art 476
Renaissance Greeting Cards 95
Renner Studios 396
Repertoire 655
Reporter, The 209
Repro Report 209
Resident and Staff Physician 209
Restaurant Hospitality 210
Rhino Entertainment Company 627
Rhode Island Monthly 210
Rhythms Productions 542, 627
Richmond Magazine 210
Rickert Art Center 478
Rights International Group 92, 270
Rinehart Fine Arts, Inc. 270
Rite Lite Ltd./The Rosenthal Judaica-
 Collection 95
Ritola, Inc., Roy 542
River Gallery 489
River Heights Publishing Inc. 270
Roberts Communications & Marketing,
 Inc. 549
Rochester Contemporary 455
Rock Dog Records 628
Rockshots Greeting Cards 95
Rockwell Museum, The Norman 429
Rogue Gallery & Art Center 478
Rokfalusi Design 551
Roland Gallery, The 403
Roland Group, The 655
Rolling Stone Magazine 210
Roman, Inc. 96
Rombro's Art Gallery 425
Romm Art Creations, Ltd. 271
Rosenfeld Gallery 482
Rosenstiel's Widow & Son Ltd., Felix
 271
Rosenthal Represents 655
Rotarian, The 211
Rotenberg Gallery, Judi 429
Rotten Records 628
Rough Notes (NS)
Round Top Center for the Arts Gallery
 423
Rowena Records & Tapes 628
Rowman & Littlefield Publishers, Inc.
 349
Royal Records (OB)
RSVP Marketing, Inc. 565
RubberStampede 96
Rubin Postaer & Associates 538
Runner's World 211

Running Times 211
Rural Heritage 212
Rutledge Gallery 476

S

Sacramento Magazine 212
Sagebrush Fine Art 271
Sahara Records and Filmworks Entertainment 628
SAI Communications 596
Sailing Magazine 212
St. Argos Co., Inc. 96
Saks Associates, Arnold 586
Sales & Marketing Management Magazine 212
Salt Water Sportsman 213
Samek Art Gallery 482
San Francisco Arts Commission Gallery 384
San Francisco Bay Guardian 213
San Francisco Sound 629
Sanghavi Enterprises Pvt Ltd. 97
Sangray Corporation 97
Sangre De Cristo Arts Center and Buell Children's Museum 386
Santa Barbara Contemporary Arts Forum 378
Santa Barbara Magazine 213
Saper Galleries 434
Sapiro Art Consultants, Joan 655
Sarut Group, The 97
Saslow Gallery, Judy A. 411
Saturday Evening Post, The 213
Sawyier Art Collection, Inc., Paul 271
Scafa Art Publishing Co. Inc. 272
Scandecor Marketing AB 272
Schecterson Associates, Jack 579
Scherer Gallery 370
Schiftan Inc. 272
Schlumberger Gallery 272
Schmidt Associates, William M. 568
Scholarly Resources Inc. 349
Scholastic Inc. 349
School Administrator, The 214
School Business Affairs 214
Schroeder Burchett Design Concepts 580
Science News 214
Science Teacher, The 214
Scientific American 215
Scott Gallery, Steven 425
Scott, Inc., Freda 656
Scrap 215
Scrutchings Music 629
Sculpturecenter Gallery 467
Sea Magazine 215
Seabright Press Inc. 97
Seabrook Wallcoverings, Inc. 97
Seal Press 350
Seattle Magazine 215
Seattle Weekly 216
Second Nature, Ltd. 98
Seek 216
Segal Fine Art 273
Seigel, Artist Representative, Fran 656
Selavy of Vermont, Rose 273
Selbert-Perkins Design Collaborative (MA) 565

Select Records 629
Self Employed America 216
Seraphim Fine Arts Gallery 447
Serenidad Gallery 497
Server/Workstation Expert 216
Sessions Inc., Steven 601
17th Street Productions 350
Shahn Galleries, Ben 447
Shamwari Gallery 379
Shaolin Communications 629
Shapolsky Gallery, Anita 467
Sharpe + Associates Inc. 656
Shearburn Fine Art, William 440
Sheep! Magazine 216
Shepherd Express 217
Sherman Partners, Inc., Roger 568
Side Roads Publications 273
Siegel Gallery, Evelyn 494
Signature and the Grohe Gallery 429
Signed, Sealed, Delivered 98
Signs of the Times 217
Silver Fox Advertising 597
Silver Wave Records 629
Silvermine Guild Gallery 388
Simmons/Flint Advertising 589
Simon & Schuster 350
Sinister Wisdom 217
Sipan LLC 273
Six/12 (RR)
Sjatin BV 274
Skene Design, Paula 98
SkillsUSA Professional 218
Skipping Stones 218
Sklaroff Design Associates, William 596
Skydiving Magazine 218
Slack Publications 218
Small Business Times and Employment Times 219
Small Pond Magazine of Literature, The 219
Small Space Gallery 388
Smart Money 219
Smith Advertising & Associates 588
Smith & Dress 580
Smith Design Associates 575
Smith, J. Greg 572
Smithsonian Magazine 219
Soap Opera Update Magazine 220
SoftMirage, Inc. 538
Soho Graphic Arts Workshop 274
Soldiers Magazine 220
Solidarity Magazine 220
Somerset Entertainment 630
Somerset House Publishing 274
Somnimage Corporation 630
Songwriter's Monthly (OB)
Sony Music Canada 630
Sorin Productions Inc. 576
Soundprints 351
Source Fine Arts, Inc., The 440
Sourcebooks, Inc. 351
Soussana Graphics, Jacques 274
South Dakota Art Museum 487
Southern Accents Magazine 220
Spaces 477
Sparrow & Jacobs 98
Spartacus Publishing, LLC 351

Spartanburg County Museum of Art, The 486
Spectrum Boston Consulting, Inc. 565
Speech Bin, Inc., The 351
Spencer Gifts, Inc. 98
Spider 220
Spinsters Ink Books 352
Spirit Creative Services Inc. 562
Spitball 221
Spizel Advertising Inc., Edgar S. (OB)
Spoke Gallery, BJ 456
Sport'en Art 275
Sports Afield 221
Sports Art Inc 275
Sports 'n Spokes 221
Spruyt Design, Harry 602
Standard Cellulose & Nov Co., Inc. 99
Starburst Publishers 352
Stardust Records/Wizard Records/Thunderhawk Records 631
State Street Gallery 502
Steele Gallery at Rocky Mountain College of Art & Design, Philip J. 386
Stemmer House Publishers, Inc. 353
Stephen Galleries, Jean 436
Stereophile 222
Stern Fine Arts, Louis 382
Stetson University Duncan Gallery of Art 397
Stobie Brace Group (OB)
Stobie Group, LLC 571
Stock Illustration Source 522
Stockart.com 522
Stone Soup 222
Stotter & Norse 99
Strain, The 222
Strategic Finance 222
Stratton Magazine 222
Strecker-Nelson Gallery 417
Stribiak & Associates, Inc., John 554
Strictly Rhythm Records 631
Stromberg Consulting 586
Strongtype 576
Student Lawyer 223
Student Leader Magazine 223
Studio 7 Fine Arts 379
Studio 10 437
Sugar Beats Entertainment 631
Sulier Art Publishing and Design Resource Network 275
Summerfield Editions (NS)
Summit Publishing 275
Sun Valley Magazine 223
Sunbird Gallery (OB)
Sunrise Publications Inc. 99
Sunset Marketing 276
Sunshine Art Studios, Inc. 99
Susan and Co. 657
Swamp Press 353
Switch In Art, Gerald F. Prenderville, Inc., A 100
Swoop Records 631
Swope Art Museum 414
Synchronicity Fine Arts 467
Syracuse Cultural Workers 100, 276
Szoke Editions, John 276, 468

T

Taharaa Fine Art 277
Take 1 Productions 569
Taku Graphics 277
Talicor, Inc. 100
Talli's Fine Art 447
Tam Design, Julia 538
Tampa Bay Magazine 223
Tangent® Records 631
Tarcher, Inc., Jeremy P. 353
Tasteful Ideas, Inc. 559
TBS Records (OB)
Techlinks 224
Technical Analysis, Inc. 354
Technical Analysis of Stocks & Commodities 224
Techniques 224
'Teen Magazine 224
Tehabi Books, Inc. 354
Teleky Inc., Bruce 277
Temerlin McClain/McCann-Erickson Southwest 602
Temkin & Temkin, Inc. 554
Temple Beth Israel Sylvia Plotkin Judaica Museum/Contemporary Arts Gallery 370
Tennis 225
Terrace Gallery 397
Tessing Design, Inc. 557
Texas Medicine 225
Texas Observer, The 225
Texas Parks & Wildlife 225
Tharp Did It 539
Things Graphics & Fine Art 277
Thistledown Press Ltd. 354
Thompson & Company 599
Thompson & Company, Arthur 100
Thompson Art Gallery, Natalie and James 379
Thompson Company, J. Walter 551
Thompson USA, J. Walter 568
Thomson Medical Economics 225
Those 3 Reps 657
Thrasher 225
Tibor de Nagy Gallery 468
Tieken Design & Creative Services 529
Tikkun Magazine 226
TIME 226
TJ's Christmas 101
TMA Ted Mader Associates, Inc. 606
TMP Worldwide Advertising & Communications 587
Toastmaster, The 226
Today's Christian Woman 227
Today's Parent 227
Todd Galleries, J. 430
Todd Gallery 497
Tokyo Design Center 543
Tole World 227
Tom Thumb Music 632
Tombras Group, The 599
Tomlinson/Sims Advertising, Inc., A. 527

Topeka & Shawnee County Public Library Gallery/Alice C. Sabatini Gallery 417
Topnotch® Entertainment Corp. 632
Torah Aura Productions/Alef Design Group 354
Touchwood Records LLC (OB)
TR Productions 565
Training & Development Magazine 227
Training Magazine 227
Trains 228
Travel & Leisure 228
Treehaus Communications, Inc. 355
Trenton City Museum 448
Triad Art Group 278
Tribotti Designs 539
Tribune Media Services, Inc. 515
Triton Advertising, Inc. 587
TROIKA Magazine 228
Troll Communications 355
Tropikal Productions/World Beatnik Records 632
True North Records/Finkelstein Management Co. Ltd. 633
True West Magazine 228
T-Square, etc. 657
TSR, Inc. 355
Tugeau: Artist Agent, Christina A. 657
Turner Art Center Gallery 422
Turtle Magazine, For Preschool Kids 229
TV Guide 229
TVN-The Video Network 566
28 Records 633
Twenty-First Century Books/A Division of Millbrook Press, Inc. 355
Twilight Souls Music 633
Tyler-White Compton Art Gallery 472
Tyndale House Publishers, Inc. 356

U

"U" Gallery 468
U. The National College Magazine 229
UAHC Press 356
Ulrich Museum of Art, Edwin A. 418
Umoja Fine Arts 278
Unicom 607
Union Street Gallery 411
Unique Opportunities (RR)
Unit One, Inc. (RR)
United Design 101
United Feature Syndicate/Newspaper Enterprise Association 515
United Media 515
United News Service 515
Univelt Inc. 356
Universal Press Syndicate 516
Universal Publishing 278
Universal Records/Motown Records 633
University Museums, The 438
University of Alabama Press, The 356
University of Maine Museum of Art 423

University of Nebraska Press, The 357
University of Oklahoma Press 357
University Of Pennsylvania Press 357
Unmuzzled Ox 230
UNO Hispanic Advertising and Design 570
Upside 230
Urban Institute for Contemporary Arts 434
Urban Park-Detroit Art Center (OB)
U.S. Lacrosse Magazine 230
US Kids: A Weekly Reader Magazine 230
Utne Reader 231

V

Vagabond Creations Inc. 101
Valarien Productions 633
Vale Craft Gallery 411
Van der Plas Publications, Inc. 357
Van Noy Group, The 539
Van Richter Records 634
Van Vechten & Company Public Relations 549
Vancouver Magazine 231
Vanity Fair 231
Varese Sarabande Records 634
Vargas Fine Art Publishing, Inc. 278
Vegetarian Journal 231
Vermont T's 101
Vernon Fine Art And Editions 279
Verve Music Group 634
Vespermann Glass Gallery 400
VFW Magazine (RR)
Vibe 232
Vibrant Fine Art 279
Vida Publishers 358
Video Pipeline Inc. 576
Video Resources 540
Videomaker Magazine 232
Villa Julie College Gallery 425
Vim & Vigor 232
Vinson Fine Art, Shawn 279
Virgin Records 634
Virtue Magazine (OB)
Visual Aid/visaid Marketing 540
Visual Arts Center 488
Visual Arts Center of Northwest Florida 397
Visual Concepts 547
Visual Horizons 580
Visual Identity 573
Visual Studies Workshop Galleries 456
Vladimir Arts USA Inc. 280
Volcano Art Center Gallery 401
Von Liebig Art Center, The (RR)
Voyageur Press 358
V2 Records 634

W

W Publishing Group 358
Wagoner, Artist Representative, Jae 658
Walch Publishing, J. Weston 359

Walker Design Group 571
Walker's Point Center for the Arts 503
Wallace Associates, Wanda 102, 280
Walnut Street Gallery 416
Walters, Gwen 658
Walton Arts Center 371
Warkulwiz Design Associates Inc. 597
Warlock Records, Inc. 634
Warne Marketing & Communications (RR)
Warner & Associates, Inc. (OB)
Warner Books Inc. 359
Warner Bros. Records 635
Warner Press, Inc. 102
Washington City Paper 232
Watchesgro Music, BMI—Interstate 40 Records 635
Watercolor Magic 233
Waters & Wolfe 554
Watt/Fleischman-Hillard 592
Wave Design Works 566
Webster Design Associates, Inc. 572
Webster Fine Art Ltd. 280
Wechsler P.D., Elaine 468
Weekly Planet 233
Weisman Art Museum, Frederick 437
Welk Music Group 635
West Creative, Inc. 571
West End Gallery 495
West Graphics (RR)
Western Dairy Business 233
Weston Fine Art, Edward 379
Westways 233
Whalesback Books 360
White Contemporary Artists' Services, Sylvia 380
White Mane Publishing Company, Inc. 360

White Productions, Inc., Dana 540
White Wolf Publishing 360
Whitegate Features Syndicate 102, 280, 516
White's Shriver Gallery, Lynne 451
Whitman & Company, Albert 360
Whitney Pink, Inc. 102
Wichita Art Museum Store Sales Gallery 418
Wickiser Gallery, Walter 468
Wild Apple Graphics, Ltd. 281
Wild Wings Inc. 281
Wilder-Fearn & Assoc., Inc. 592
Williams & Associates, L.C. 557
Williams McBride Group, The 560
Williams Posters, Philip 469
Williamson Publishing 361
Willitts Designs 102
Willowtree Gallery 404
Wilshire Book Co. 361
Wilson Fine Arts, Inc., Carol 103
Wilson Gallery, Jan (OB)
Windmill Gallery, The 478
Windstorm Creative 361
Wind-up Entertainment 636
Winn Devon Art Group 281
Wisconsin Review 233
Wisconsin Trails 234
Wisner Associates 594
Wizards Of The Coast 361
Wolfe Ltd., Deborah 658
Wolk Design Associates, Michael 549
Women & Their Work Gallery 495
Women's Center Art Gallery 380
Women's Sports & Fitness (OB)
Woo Design, Inc., Eric 551
Woodenboat Magazine 234
Woodsong Graphics Inc. (NS)

Woodstock Folk Art Prints & Antiquities 497
Worcester Magazine 234
Word Entertainment Inc. 636
Workbench 235
Workforce 235
Working Mother Magazine 235
Works Gallery, The 482
World Trade 235
Wright Group-McGraw Hill 362
Writer's Digest 235
Writer's Yearbook 236
Wyatt Advertising, Evans 602
Wy'East Historical Journal 236
Wyoming Arts Council Gallery 504

X
XICAT Interactive Inc. 362

Y
Yachting Magazine 236
Yamaguma & Associates 540
Yasvin Designers 573
Ye Galleon Press 362
Yeiser Art Center Inc. 419
Yellowstone Gallery 442
Yeshiva University Museum 469
YM 237
Yoga Journal 237
Youngman Galleries, Lee 380
Your Money Magazine (OB)

Z
Zahn & Associates, Spencer 597
Zaks Gallery, Sonia 411
Zapp Studio 362
Zoland Books, Inc. (OB)
Zünpartners Incorporated 557